ART HISTORY

VOLUME TWO

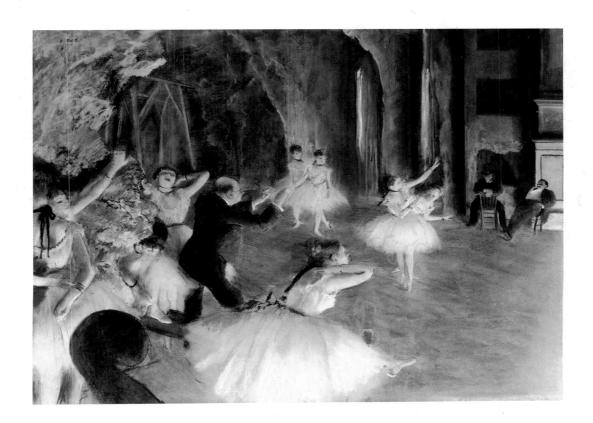

MARILYN STOKSTAD

DISTINGUISHED PROFESSOR OF ART HISTORY EMERITA
THE UNIVERSITY OF KANSAS

IN COLLABORATION WITH DAVID CATEFORIS
THE UNIVERSITY OF KANSAS

WITH CHAPTERS BY STEPHEN ADDISS, CHU-TSING LI, MARYLIN M. RHIE, AND CHRISTOPHER D. ROY

DEC 1 2 2005

Santa Rosa JC Book Store

DEDICATED TO MY SISTER, KAREN L. S. LEIDER, AND TO MY NIECE, ANNA J. LEIDER

Library of Congress Cataloging-in-Publication Data

Stokstad, Marilyn,

Art history / Marilyn Stokstad in collaboration with David Cateforis with chapters by

Stephen Addiss ... [et al.].—Rev. 2nd ed.

p. cm

Includes bibliographical references and index.

ISBN 0-13-145527-3

1. Art—History. I. Cateforis, David II. Addiss, Stephen, III. Title.

N5300.S923 2005

709—dc22

2003190061

VP, Editorial Director: Charlyce Jones Owen

Editor in Chief: Sarah Touborg Editorial Assistant: Sasha Anderson

Editor in Chief, Development: Rochelle Diogenes

Developmental Editor: *Karen Dubno*Media Project Manager: *Anita Castro*Executive Marketing Manager: *Sheryl Adams*Marketing Assistant: *Jennifer Bryant*

AVP. Director of Production and Manufacturing: Barbara Kittle

Production Editor: Harriet Tellem

Copy Editor: Karen Verde

Proofreaders: Alison Lorber and Barbara DeVries

Permissions Supervisor: Ronald Fox Manufacturing Manager: Nick Sklitsis Manufacturing Buyer: Sherry Lewis Creative Design Director: Leslie Osher Design Manager: Ximena Tamvakopoulos

Interior and Cover Design: Ximena Tamvakopoulos

Line Art Supervisor: Guy Ruggiero

Line Art Coordinator: Mirella Signoretto

Cartographer: Cartographics

Central Scanning Services: Greg Harrison, Corrin Skidds, Robert Uibelhoer, Ron Walko, Shayle Keating,

and Dennis Sheehan

Site Supervisor Central Scanning Services: *Joe Conti* Photo Researcher: *Jennifer Sanfilippo*, Photosearch, Inc. Image Permission Coordinator: *Debbie Latronica*

Composition: *Preparé*Printer/Binder: *RR Donnelley*

Cover Printer: Phoenix Color Corporation

Cover Photo: Hilaire-Germain-Edgar Degas (1834–1917). *The Rehearsal Onstage*. Pastel over brush-and-ink drawing on thin cream-colored woven paper, laid down on bristol board and mounted on canvas. H. 21" × W. 28 ½" (53.3 × 72.4 cm). The Metropolitan Museum of Art, Havemeyer Collection, Bequest of Mrs. H.O. Havemeyer, 1929. (29.100.39). Photograph ©1978 The Metropolitan Museum

of Art.

Credits and acknowledgments borrowed from other sources and reproduced, with permission, in this textbook appear on the appropriate page within text or on the credit pages in the back of this book.

Copyright © 2005 by Pearson Education, Inc., Upper Saddle River, New Jersey, 07458. All rights reserved. Printed in the United States of America. This publication is protected by Copyright and permission should be obtained from the publisher prior to any prohibited reproduction, storage in a retrieval system, or transmission in any form or by any means, electronic, mechanical, photocopying, recording, or likewise. For information regarding permission(s), write to: Rights and Permissions Department.

Pearson Education LTD.
Pearson Education Australia PTY, Limited
Pearson Education Singapore, Pte. Ltd
Pearson Education North Asia Ltd

Pearson Education, Canada, Ltd Pearson Educación de Mexico, S.A. de C.V. Pearson Education—Japan Pearson Education Malaysia, Pte. Ltd

10 9 8 7 6 5 4 3 2

BRIEF CONTENTS

	Contents	V
	Preface	xi
	Expanded Ancillary Package	XV
	Art History Interactive	xvii
	Use Notes	xxi xxiii
	Starter Kit Introduction	xxix
	Introduction	AAIA
CHAPTER 17	EARLY RENAISSANCE ART IN EUROPE	577
CHAPTER 18	RENAISSANCE ART IN SIXTEENTH-CENTURY EUROPE	645
CHAPTER 19	BAROQUE ART IN EUROPE AND NORTH AMERICA	719
CHAPTER 20	ART OF INDIA 1200	787
CHAPTER 21	CHINESE ART AFTER 1280	801
CHAPTER 22	JAPANESE ART AFTER 1392	817
CHAPTER 23	ART OF THE AMERICAS AFTER 1300	837
CHAPTER 24	ART OF PACIFIC CULTURES	859
CHAPTER 25	ART OF AFRICA IN THE MODERN ERA	875
CHAPTER 26	EIGHTEENTH-CENTURY ART IN EUROPE AND NORTH AMERICA	897
CHAPTER 27	NINETEENTH-CENTURY ART IN EUROPE AND THE UNITED STATES	941
CHAPTER 28	THE RISE OF MODERNISM IN EUROPE AND NORTH AMERICA	1019
CHAPTER 29	THE INTERNATIONAL AVANT-GARDE SINCE 1945	1083
	GLOSSARY	Glossary 1
	BIBLIOGRAPHY	Bibliography 1
	CREDITS	Credits 1
	INDEX	Index 1

CONTENTS

Preface	xi		
Expanded Ancillary Package	xv		
Art History Interactive	xvii		
Use Notes	xxi		
Starter Kit	xxiii		
Introduction	xxix		
7 EARLY RENAISSANCE ART		THE GRAPHIC ARTS	608
IN EUROPE		ART OF ITALY	610
IN EUROI E	577	Architecture and Its Decoration	611
THE RENAISSANCE AND HUMANISM	578	Sculpture Painting	622 628
ART OF THE FRENCH DUCAL COURTS	583		020
Manuscript Illumination	584	BOXES	
Painting and Sculpture for the Chartreuse		Technique	500
de Champmol	587	Painting on Panel Woodcuts and Engravings on Metal	592 612
Flamboyant-Style Architecture	588	Text	012
ART OF FLANDERS	589	Renaissance Perspective Systems	583
First-Generation Panel Painters	591	Italian Artists' Names and Nicknames	584
Second-Generation Panel Painters	597	Women Artists in the Late Middle Ages	
Luxury Arts	602	and the Renaissance	585
THE SPREAD OF THE FLEMISH STYLE	606	Altars and Altarpieces	590
The Iberian Peninsula	606	The Printed Book	603 617
France	607	Alberti's Art Theory in the Renaissance	617
Germany	608	THE OBJECT SPEAKS: The Foundling Hospital	614
1 Renaissance art in		RENAISSANCE ART IN FRANCE	702 702
SIXTEENTH-CENTURY EUROPE	6.1=	Painting Architecture and Its Decoration	702
SIXTEENTH-CENTURY EUROPE	645		
EUROPE IN THE SIXTEENTH CENTURY	646	RENAISSANCE ART IN SPAIN	705 705
The Changing Status of Artists	647	Architecture	705
ITALY IN THE EARLY SIXTEENTH CENTURY:	01,	Painting RENAISSANCE PAINTING IN THE NETHERLANDS	707
THE CLASSICAL PHASE OF THE RENAISSANCE	647		
	648	RENAISSANCE ART IN ENGLAND	712
Three Great Artists of the Early Sixteenth Century Architecture in Rome and the Vatican	662	Painting Architecture	713 715
Architecture and Painting in Northern Italy	664	Architecture	/15
THE RENAISSANCE AND REFORMATION	001	BOXES	
IN GERMANY	671	Elements of Architecture	
		Saint Peter's Basilica	663
Early-Sixteenth-Century Sculpture	672	The Renaissance Palace Facade	665
Early-Sixteenth-Century Painting and Printmaking	675	Parts of the Church Facade	686
The Reformation and the Arts	680	Technique	669
LATE-SIXTEENTH-CENTURY ARCHITECTURE	000	Painting on Canvas	665
AND ART IN ITALY	682	Text Great Papal Patrons of the Sixteenth Century	647
	682	The Vitruvian Man	651
Architecture in Rome and the Vatican	685	The Sistine Ceiling Restoration	659
Michelangelo and Titian Italian Mannerism	690	Women Patrons of the Arts	672
Women Painters	695	The Grotto	710
Painting and Architecture in Venice		Armor for Royal Games	717

697

and the Veneto

THE OBJECT SPEAKS: Feast in the House of Levi

698

BAROQUE ART IN EUROPE AND NORTH AMERICA	719	Views of the World Genre Painting Still Lifes and Flower Pieces ENGLAND	770 775 778 778
THE BAROQUE PERIOD	720	Architecture and Landscape Design	779
ITALY	722	ENGLISH COLONIES IN NORTH AMERICA	783
Urban Design, Architecture, and Architectural Sculpture	722	Architecture	783
Independent Sculpture Illusionistic Ceiling Painting	730 730	Painting	784
Painting on Canvas	733	■ BOXES	
FRANCE	739	Technique	
Architecture and Its Decoration at Versailles	739	Etching and Drypoint	772
Painting	743	Text	
HABSBURG GERMANY AND AUSTRIA	746	Science and the Changing Worldview	721
HABSBURG SPAIN	747	Great Papal Patrons of the Seventeenth Century	722
Architecture	749	Caravaggio and The New Realism Grading the Old Masters	736 740
Painting	749	French Baroque Garden Design	741
SPANISH COLONIES IN THE AMERICAS	755	Wölfflin's Principles of Art History	760
THE SOUTHERN NETHERLANDS/FLANDERS	758	The Dutch Art Market	771
THE NORTHERN NETHERLANDS/ UNITED		The English Court Masque	780
DUTCH REPUBLIC	764	THE OBJECT SPEAKS: Brueghel and Rubens's	
Portraits	764	Allegory of Sight	763

20 ART OF INDIA AFTER 1200	787	Mughal Painting Rajput Painting MODERN PERIOD	793 794 799
LATE MEDIEVAL PERIOD Buddhist Art Jain Art Hindu Art	788 788 789 791	■ BOXES Technique Indian Painting on Paper Text	793
MUGHAL PERIOD Mughal Architecture	792 792	Foundations of Indian Culture Luxury Arts	790 796

21 CHINESE ART AFTER 1280	801	Orthodox Painting Individualist Painting THE MODERN PERIOD	813 814 814
THE MONGOL INVASIONS YUAN DYNASTY	802 803	BOXES	
MING DYNASTY Court and Professional Painting Description Arts and Cordons	807 807	Technique Formats of Chinese Painting Text	806
Decorative Arts and Gardens Architecture and City Planning Literati Painting QING DYNASTY	808 809 810 813	Foundations of Chinese Culture Marco Polo The Secret of Porcelain Geomancy, Cosmology, and Chinese Architecture	803 804 808 811

$\mathbb{Q}\mathbb{Q}$		Nanga School Painting Zen Painting	828 830
JAPANESE ART AFTER 1392	817	Maruyama-Shijo School Painting	830
		Ukiyo-e: Pictures of the Floating World	831
MUROMACHI PERIOD	818	THE MEIJI AND MODERN PERIODS	833
Ink Painting	819	THE MEDITAND MODERN LEMODS	033
The Zen Dry Garden	821	BOXES	
MOMOYAMA PERIOD	822	Elements of Architecture	
Architecture	823	Shoin Design	825
Kano School Decorative Painting	823	Technique	
S		Lacquer	828
The Tea Ceremony	824	Japanese Woodblock Prints	833
EDO PERIOD	826	Text	
The Tea Ceremony	826	Foundations of Japanese Culture	819
Rimpa School Painting	826	Inside a Writing Box	829

07. PT OF THE AMERICAS	CONTEMPORARY NATIVE AMERICAN ARTISTS			
ART OF THE AMERICAS AFTER 1300	837	■ BOXES Elements of Architecture		
INDIGENOUS AMERICAN ART	838	Inca Masonry	844	
MEXICO AND SOUTH AMERICA The Aztec Empire The Inca Empire	839 839 842	Technique Basketry Text	846	
NORTH AMERICA Eastern Woodlands and the Great Plains The Northwest Coast	845 845 848	Foundations of Civilization in the Americas Craft or Art? Navajo Night Chant	839 840 855	
The Southwest	851	THE OBJECT SPEAKS: Hamatsa Masks	852	

94		866 866	
☐ ART OF PACIFIC CULTURES	859	Marquesas Islands	867
THE PEOPLING OF THE PACIFIC	860	Hawaiian Islands New Zealand	867 868
AUSTRALIA	861	RECENT ART IN OCEANIA	871
MELANESIA	862		
Papua New Guinea	863	BOXES	
Irian Jaya	863	Text	
New Ireland	865	Paul Gauguin on Oceanic Art	866
MICRONESIA	865	Art and Science: The First Voyage of Captain Cook	869

25 art of Africa In the modern era	875	LEADERSHIP DEATH AND ANCESTORS CONTEMPORARY ART	886 890 892
TRADITIONAL AND CONTEMPORARY AFRICA LIVING AREAS CHILDREN AND THE CONTINUITY OF LIFE	876 879 879	■ BOXES Text Foundations of African Cultures	877
Initiation THE SPIRIT WORLD	881 883	African Furniture and the Art Deco Style Numumusow and West African Ceramics	878 895

© C EIGHTEENTH-CENTURY ART IN EUROPE		Neoclassicism in Architecture and the Decorative Arts Painting	917 919
∠ U AND NORTH AMERICA	897	LATER EIGHTEENTH-CENTURY ART IN FRANCE	927
THE BUILDING WENT AND ITS DEVOLUTIONS	000	Architecture	927
THE ENLIGHTENMENT AND ITS REVOLUTIONS	898	Painting and Sculpture	929
THE ROCOCO STYLE IN EUROPE	899	ART IN NORTH AMERICA	934
Architecture and Its Decoration in Germany		Architecture	934
and Austria	900	Painting	936
Painting in France	902		
Decorative Arts and Sculpture	908	BOXES	
ART IN ITALY	909	Text	
Art of the Grand Tour	909	Academies and Academy Exhibitions	906
Neoclassicism in Rome	912	Women and Academies	910
REVIVALS AND ROMANTICISM IN BRITAIN	913	Iron as a Building Material	935
Classical Revival in Architecture and Landscaping	913		
Gothic Revival in Architecture and Its Decoration	916	THE OBJECT SPEAKS: Georgian Silver	918

NINETEENTH-CENTURY ART		NATURALISTIC, ROMANTIC, AND NEOCLASSICAL	
IN EUROPE AND		AMERICAN ART	958
THE UNITED STATES	941	Landscape and Genre Painting	959
ELIBORE AND THE UNITED CTATES		Sculpture	960
EUROPE AND THE UNITED STATES IN THE NINETEENTH CENTURY	942	REVIVAL STYLES IN ARCHITECTURE BEFORE 1850	962
	742	EARLY PHOTOGRAPHY IN EUROPE	964
Early-Nineteenth-Century Art: Neoclassicism and Romanticism	943	NEW MATERIALS AND TECHNOLOGY	
Late-Nineteenth-Century Art: Realism	710	IN ARCHITECTURE AT MIDCENTURY	967
and Antirealism	943	FRENCH ACADEMIC ART AND ARCHITECTURE	969
NEOCLASSICISM AND ROMANTICISM IN FRANCE	944	FRENCH NATURALISM AND REALISM	
David and His Students	944	AND THEIR SPREAD	971
Romantic Painting	946	French Naturalism	971
Romantic Sculpture	952	French Realism	973
ROMANTICISM IN SPAIN	953	Naturalism and Realism Outside France	975
ROMANTIC LANDSCAPE PAINTING IN EUROPE	954	LATE-NINETEENTH-CENTURY ART IN BRITAIN	977

IMPRESSIONISM Later Impressionism	979 990	Religious Art Architecture	1014 1014
POST-IMPRESSIONISM Symbolism in Painting Late-Nineteenth-Century French Sculpture Art Nouveau	993 998 1002 1003	■ BOXES Technique Lithography	951
LATER NINETEENTH-CENTURY ART IN THE UNITED STATES	1005	How Photography Works Text Artistic Allusions in Manet's Art	965 980
Later Neoclassical Sculpture Landscape Painting and Photography Civil War Photography and Sculpture	1005 1007 1009	The Print Revivals Japonisme The City Park	984 988 1017
Post-Civil War Realism Urban Photography	1009 1011	THE OBJECT SPEAKS: Raft of the "Medusa"	948

THE RISE OF MODERNISM		Rationalism in the Netherlands	1051
IN EUROPE AND NORTH		Classicism and Purism in France	1053
∠ O AMERICA	1019	Bauhaus Art in Germany	1057
		Dada	1060
EUROPE AND THE UNITED STATES IN THE EARLY		Surrealism	1062
TWENTIETH CENTURY	1020	Modernism in Sculpture	1066
EARLY MODERNIST TENDENCIES IN EUROPE	1021	ART AND ARCHITECTURE IN THE	
Late-Flowering Art Nouveau	1021	UNITED STATES BETWEEN THE WARS	1067
The Fauves	1023	Precisionism	1068
Die Brücke	1025	American Scene Painting and Photography	1068
Independent Expressionists	1026	The Harlem Renaissance	1072
Der Blaue Reiter	1027	Abstraction	1074
Early Modernist Sculpture	1031	Architecture	1075
CUBISM IN EUROPE	1032	ART IN MEXICO BETWEEN THE WARS	1078
Picasso's Early Art	1032	EARLY MODERN ART IN CANADA	1079
Analytic Cubism	1035		
Synthetic Cubism	1037		
Responses to Cubism	1038	BOXES	
EARLY MODERNIST TENDENCIES IN		Elements of Architecture	
THE UNITED STATES	1042	The Skyscraper	1049
EARLY MODERN ARCHITECTURE	1043	The International Style Text	1056
American Modernism	1043	Suppression of the Avant-Garde in Germany	1059
The American Skyscraper	1046	Federal Patronage for American Art During	1039
European Modernism	1046	the Depression	1069
MODERNISM IN EUROPE BETWEEN THE WARS	1048	•	
Utilitarian Art Forms in Russia	1049	THE OBJECT SPEAKS: Portrait of a German Officer	1044

O O THE INTERNATIONAL		The Second Generation of Abstract Expressionism	1095
AVANT-GARDE SINCE 1945	1083	ALTERNATIVES TO ABSTRACT EXPRESSIONISM	1095
THE WORLD SINCE 1945 The "Mainstream" Crosses the Atlantic	1084 1085	Return to the Figure Happenings Assemblage	1096 1098 1099
POSTWAR EUROPEAN ART	1085	Pop Art	1101
ABSTRACT EXPRESSIONISM	1087	Post-Painterly Abstraction and Op Art	1105
The Formative Phase	1088	Minimalism and Post-Minimalism	1106
Action Painting	1090	Conceptual and Performance Art	1108
Color Field Painting	1093	Postwar American Photography	1110
Sculpture of the New York School	1094	The Rise of American Craft Art	1111

FROM MODERNISM TO POSTMODERNISM	1113	Constructed Realities	1138
Architecture	1114	Public Art	1140
Earthworks and Site-Specific Sculpture	1121	Installation, Video, and Digital Art	1146
Super Realism	1123		
Feminist Art	1124	BOXES	
POSTMODERNISM	1129	Text	
Neo-Expressionism	1129	The Idea of the Mainstream	1086
Neo-Conceptualism	1132	Appropriation	1130
Later Feminist Art	1134	Recent Controversies over Public Funding for the Arts	1142
The Persistence of Modernism	1135	Digital Art	1143
Recent Craft Art	1136	Digital Fut	1110
The Return to the Body	1137	THE OBJECT SPEAKS: The Dinner Party	1126

Glossary	Glossary 1
Bibliography	Bibliography 1
Credits	Credits 1
Index	Index 1

PREFACE

tudents ought to enjoy their first course in art history. Only if they do will they want to experience and appreciate the visual arts—for the rest of their lives—as offering connections to the most tangible creations of the human imagination. To this end, we continue to seek ways to make each edition of *Art History* a more sensitive, engaging, supportive, and accessible learning resource. The characteristics that elicited such a warm welcome when *Art History* was first published in 1994 remain its hallmarks today in the revised second edition.

HALLMARKS OF ART HISTORY

Art History is contextual in its approach and object-based in its execution. Throughout the text we treat the visual arts, not in isolation, but within the essential contexts of history, geography, politics, religion, and other humanistic studies, and we carefully define the parameters—social, religious, political, and cultural—that either have constrained or have liberated individual artists. A feature called The Object Speaks explores the role of a work of art within its context by focusing in depth on some of the many things a work of art may have to say. At the same time that we stay grounded in the works of art that make art history distinctive among other humanistic disciplines, we emphasize the significance of the work of art.

Art History reflects the excitement and pleasures gained by studying art. In writing about art's history, we try to express our affection for the subject. Each chapter opens with a **scene-setting vignette** that concentrates on a work of art from that chapter. Set-off **text boxes,** many illustrated, present interesting, thought-provoking material. A number of them follow the theme of women in the arts—as artists and as patrons. Others give insights into discoveries and controversies. The discipline of art history is many dimensional in its possibilities, and *Art History* invites a positive sampling of these possibilities.

Art History is comprehensive. We reach beyond the Western tradition to examine the arts of other regions and cultures, from their beginnings to the twenty-first century. We cover not only the world's most significant paintings and works of sculpture and architecture but also drawings and prints; photographs; works in metal, ceramic, and glass; textiles; jewelry; furniture and aspects of interior design (things that were once considered only utilitarian); such temporal arts as happenings and performance art; and new mediums such as video art, installation art, and digital art. Acknowledging that the majority of survey courses concentrate on the Western tradition, we have organized the chapters on non-Western arts and cultures so that art can be studied from a global perspective within an

integrated sequence of Western and non-Western art. Just as smoothly, non-Western material can be skipped over without losing the thread of the Western narrative.

Art History offers a pedagogical advantage. When first published, Art History was instantly embraced for its groundbreaking use of drawings and diagrams to aid readers in mastering the terminology of art history. The Elements of Architecture and Technique boxes visually explain how buildings are constructed and how artists use materials to do everything from creating cave paintings to decorating armor to making photographs. Maps and timelines guide the reader visually through the narrative. Every chapter has at least one map and a timeline, and the maps identify every site mentioned in the text. Terms specific to art history are printed in boldface type, which indicates their inclusion in the 900 word Glossary. The Bibliography, compiled for the second edition by distinguished art librarian, Susan Craig, has been updated by us for this edition.

As much as possible, without distorting the narrative of art history, we have chosen works of art that are in North American museums, galleries, and collections so that readers can most easily experience these works directly. This selection includes works from college and university galleries and museums.

Art History has a Companion WebsiteTM that makes it possible to integrate the art history survey course with the vast power of the Internet. For students, the Stokstad Companion WebsiteTM features Study Guide, Reference, Communication, and Personalization Modules. For instructors, the Companion WebsiteTM has a special Faculty Module and Syllabus ManagerTM.

Art History comes with a complete ancillary package that includes an interactive CD-ROM with hundreds of images from the book, a student Study Guide, and an Instructor's Resource Manual with Test Bank.

WHAT'S NEW?

We responded to your suggestions for making Art History even more teachable. In this revised second edition, we improved the Use Notes and Starter Kit, particularly the definitions of the formal elements, adding new color and diagrams and clarifying the discussions of content, style, and medium. The Introduction continues to be organized around a series of questions but has been revised. The section Nature or Art? has been upgraded and includes subsections on Styles of Representation and The Human Body as Idea and Ideal. The section What Is Art History? includes a subsection on Studying Art Formally and Contextually.

We fine-tuned our coverage of Ancient and Medieval art and used the opportunity of a revised edition to make a few organizational changes. The discussions of Greek and Roman art in Chapters 5 and 6 now have greater chronological flow. For example, the Canon of Polykleitos (Chap. 5) has become a text box at the beginning of the section on the Mature Classical period, where it is closer to the discussion of freestanding sculpture in the Early Classical period. The Roman Republic (Chap. 6) is now a separate topic, with Augustan styles treated under the Early Empire, along with architecture, the Roman city and home, and wall painting. Likewise, Imperial Rome is a separate topic encompassing Imperial architecture, mosaics, the urban plan, monumental sculpture, and portrait sculpture.

In Chapters 7 and 8 we introduce three of the major religions of the Western world in chronological order: Judaism, Christianity, and Islam. In Chapter 7 the discussion of early Jewish art is followed by early Christian art and then moves on to the art of the Western Catholic and the Eastern Orthodox churches. We have also reorganized and added images to Chapter 8, which is dedicated to Islamic art. The new organization and illustrations give readers the opportunity to study and compare the use, meaning, and appearance of such major building types as synagogues, churches, and mosques.

Art History has been updated to include the most recent scholarship, scholarly opinion, technical analysis, archaeological discoveries, and controversies. While the text's currency is not always conspicuous, revised opinion has been incorporated into discussions of art works included in previous editions. Examples include revised opinion on who commissioned the Hunt of the Unicorn tapestries and new research on the original ownership of Uccello's Battle of San Romano. We have included a page from the newly purchased Morgan Library Picture Bible with its multilingual commentaries, reevaluated and updated the discussion of Islamic art, and given increased attention to the sixteenth-century masters. We have also brought the text into the twenty-first century, with the inclusion in Chapter 29 of cutting edge contemporary artists Jeff Wall, Jennifer Steinkamp, Matthew Barney, and architect Daniel Libeskind, and with discussions of constructed realities and digital art.

More canonical works are included. We have added text and pictures for thirty-seven works of art new to this edition, including a wall painting from the Chauvet cave, the Cathedral of Santiago de Compostela, Bronzino's Allegory with Venus and Cupid, Claude Lorrain's Embarkation of the Queen of Sheba, Rembrandt's Anatomy Lesson of Dr. Tulp, and Courbet's The Stone Breakers, among others.

Recently cleaned and/or restored works of art and architecture are now illustrated in their cleaned or restored states. Among the many new images are Polykleitos's Spear Bearer, Cimabue's Virgin and Child Enthroned, Masaccio's Trinity with the Virgin, Saint John the Evangelist, and Donors, and Borromini's San Carlo alle Quattro Fontane.

We have enhanced the picture program in several other ways. Many works formerly in black and white are now reproduced in color. We have added plans, details,

additional views, or an enlarged viewing area of eleven other key images to permit closer and more accurate analysis of the art. And we have substituted higher-quality images or larger and better views for many others. These changes have appreciably increased the total number of color images.

We have strengthened the pedagogy of Art History. We are proud to present a book that is new and also looks new. Working with Sarah Touborg and her team at Prentice Hall, we have tweaked the handsome design of the second edition. The chapter opening essays and the text boxes are now easier to read. We have also revised the timelines to be more inclusive and have redrawn the maps to show topographical detail and to more clearly distinguish political or cultural boundaries. To improve the illustration program without increasing the number of pages (and the weight of the book!), we have dropped the "Parallels" feature. In addition, nine of the "boxes" are either significantly revised or new, including one on church furniture in Chapter 16, one on luxury arts in Chapter 20, and one on digital art in Chapter 29.

Many of these changes and additions have been made in response to requests from readers, and I would like to acknowledge them and others who contributed to the development of this and prior editions more fully now.

ACKNOWLEDGEMENTS AND GRATITUDE

A preface gives the author yet another opportunity to thank the many readers, faculty members, and students who have contributed to the development of a book. To all of you who have called, written, e-mailed, and just dropped by my office in the Art History Department or my study in the Spencer Research Library at the University of Kansas, I want to express my heartfelt thanks. Some of you worried about pointing out defects, omissions, or possible errors in the text or picture program of the previous edition. I want to assure you that I am truly grateful for your input and that I have made all the corrections and changes that seemed right and possible. (I swear the Weston photograph in the Introduction is correctly positioned in this edition, and that, no, I was not just being witty by showing only the Gallic trumpeter's back side in Chapter 5—that slip has been corrected!)

Art History represents the cumulative efforts of a distinguished group of scholars and educators. Single authorship of a work such as this is no longer viable, especially because of its global coverage. The work done by Stephen Addiss (Chapters 11 and 22), Chu-tsing Li (Chapters 10 and 21), Marylin M. Rhie (Chapters 9 and 20), and Christopher D. Roy (Chapters 13 and 25) for the original edition is still largely intact, as is the work by David Cateforis, who reworked material by Bradford R. Collins in Chapters 26–29 for the second edition.

As ever, this edition has benefited from the assistance and advice of scores of other teachers and scholars who have generously answered my questions, given recommendations on organization and priorities, and provided specialized critiques. I want to especially thank the anonymous reviewers and my friends, and Kansas University colleagues Paul Rehak and John Younger for their advice about reorganizing and revising the Greek and Roman chapters. For help with the content of the Islamic chapter I wish to thank Walter B. Denny, University of Massachusetts, Amherst; Jonathan Bloom, Boston University; and Joseph Dye, Virginia Museum of Fine Arts. Of course, I continue to depend on the research and insights of Jerrilynn Dodds, Oleg Grabar, and D.D. Ruggles.

In addition, I want to thank University of Kansas faculty members Sally Cornelison, Amy McNair, Marsh Haufler, and Charles Eldredge, and graduate students Martha Mundis, Reed Anderson, and Jerry Smith for their insightful suggestions and intelligent reactions to revised material. I also want to mention, gratefully, graduate students who also helped: Annie Allen, Stephanie Fox, Jennifer Green, Kate Meyer, Jennifer Neuburger, Madeline Rislow, and Jerry Smith.

David Cateforis extends special thanks to Alexei Kurbanovsky, State Russian Museum, Saint Petersburg; Marni Kessler, Kansas University; Reinhild Janzen, Washburn University; Whitney Gameson, Johnson County Community College Gallery of Art; and Judith F. Baca, artist, all of whom generously responded to his inquiries and requests for assistance.

David and I are additionally grateful for the detailed critiques that the following readers across the country prepared for this revised edition: Fred Albertson, University of Memphis; Diane Boze, Northeastern State University; Carol Crown, The University of Memphis; Helen Evans, The Metropolitan Museum of Art; Marleen Hoover, San Antonio College; Elizabeth B. Heuer, University of North Florida; Henry Luttikhuizen, Calvin College; Seonaid McArthur, Mesa College; Diane Mankin, University of Cincinnati; Elizabeth K. Menon, Purdue University; Vernon Hyde Minor, University of Colorado; Debra Schaffer, San Antonio College; and Norman Schwab, Los Angeles City College. I hope that these readers will recognize the important part they have played in this new revised edition of Art History and that they will enjoy the fruits of all our labors. Please continue to share your thoughts and suggestions with me.

Many people reviewed the original edition of Art History and have continued to assist with its revision. Every chapter was read by one or more specialists. For work on the original book and assistance with the second edition my thanks go to: Barbara Abou-el-Haj, SUNY Binghamton; Roger Aiken, Creighton University; Molly Aitken; Anthony Alofsin, University of Texas, Austin; Christiane Andersson, Bucknell University; Kathryn Arnold; Julie Aronson, Cincinnati Art Museum; Larry Beck; Evelyn Bell, San Jose State University; Janetta Rebold Benton, Pace University; Janet Berlo, University of Rochester; David Binkley, The National Museum of African Art, Smithsonian Institution; Sara Blick, Kenyon College; Suzaan Boettger; Judith Bookbinder, University of Massachusetts, Boston; Marta Braun, Ryerson Polytechnic University; Elizabeth Broun, Smithsonian American Art Museum; Claudia Brown, Arizona State University; Glen R. Brown, Kansas State University; Maria Elena Buszek, Kansas City Art Institute; Robert G. Calkins; April Clagget, Keene State College; William W. Clark, Queens College, CUNY; John Clarke, University of Texas, Austin; Jaqueline Clipsham; Ralph T. Coe; Robert Cohon, The Nelson-Atkins Museum of Art; Bradford Collins, University of South Carolina; Alessandra Comini, Southern Methodist University; Sally Cornelison and Susan Craig, University of Kansas; Charles Cuttler; Patricia Darish; James D'Emilio, University of South Florida; Lois Drewer, Index of Christian Art; Susan Earle, Edmund Eglinski, and Charles Eldredge, University of Kansas; James Farmer, Virginia Commonwealth University; Grace Flam, Salt Lake City Community College; Patrick Frank; Mary D. Garrard, American University; Paula Gerson, Florida State University; Walter S. Gibson; Dorothy Glass, SUNY Buffalo; Stephen Goddard, University of Kansas; Randall Griffey, The Nelson-Atkins Museum of Art; Cynthia Hahn, Florida State University; Sharon Hill, Virginia Commonwealth University; John Hoopes, University of Kansas; Carol Ivory, Washington State University; Marni Kessler, University of Kansas; Alison Kettering, Carleton College; Wendy Kindred, University of Maine at Fort Kent; Alan T. Kohl, Minneapolis College of Art; Ruth Kolarik, Colorado College; Carol H. Krinski, New York University; Aileen Laing, Sweet Briar College; Janet Le Blanc, Clemson University; Charles Little, The Metropolitan Museum of Art; Laureen Reu Liu, McHenry County College; Loretta Lorance; Brian Madigan, Wayne State University; Janice Mann, Bucknell University; Judith Mann, St. Louis Art Museum; Richard Mann, San Francisco State University; James Martin, Sprint Corporation; Elizabeth Parker McLachlan, Rutgers University; Gustav Medicus, Kent State University; Tamara Mikailova, St. Petersburg, Russia, and Macalester College; Vernon Minor, University of Colorado, Boulder; Anta Montet-White; Anne E. Morganstern, Ohio State University; Winslow Myers, Bancroft School; Lawrence Nees, University of Delaware; Amy Ogata, Cleveland Institute of Art; Judith Oliver, Colgate University; Edward Olszewski, Case University; Sarah Orel, Truman State University; Sara Jane Pearman, The Cleveland Museum of Art; John G. Pedley University of Michigan; Michael Plante, Tulane University; John Pultz, University of Kansas; Eloise Quiñones-Keber, Baruch College and the Graduate Center, CUNY; Virginia Raguin, College of the Holy Cross; Nancy H. Ramage, Ithaca College; Ann M. Roberts, University of Iowa; Lisa Robertson, The Cleveland Museum of Art; Barry Rubin, Talmudic College of Florida; Charles Sack; Jan Schall, The Nelson-Atkins Museum of Art; Diane Scillia, Kent State University; Tom Shaw, Kean College; Pamela Sheingorn, Baruch College, CUNY; Raechell Smith, Kansas City Art Institute; Lauren Soth, Carleton College; Anne R. Stanton, University of Missouri, Columbia; Michael Stoughton; Thomas Sullivan, OSB, Benedictine College (Conception Abbey); Pamela Trimpe, University of Iowa; Richard Turnbull, Fashion Institute of Technology; Elizabeth Valdez del Alamo, Montclair State College; Lisa Vergara; Monica Visoná, Metropolitan State College of Denver; Roger Ward, Norton Museum of Art; Mark Weil, Washington University, St. Louis; David Wilkins, University of Pittsburgh; and Marcilene Wittmer, University of Miami.

I would be remiss if I did not thank the members of the book team at Prentice Hall, who responded enthusiastically to my ideas and dealt so ably with the challenges of fully integrating this revised edition into the Pearson Education family without loss of production quality or the author's voice. These professionals include editor in chief Sarah Touborg, developmental editor Karen Dubno, senior production editor Harriet Tellem, editorial assistant Sasha Anderson, senior art director Ximena Tamvakopoulos, executive marketing manager Sheryl Adams, and manufacturing buyer Sherry Lewis. Finally, I extend warm thanks to Susan Wechsler and Jennifer Sanfilippo of PhotoSearch, Inc., who assiduously tracked down images of the works of

art new to this revised edition as well as photos of newly cleaned art and architecture.

I hope you will enjoy this revised second edition of *Art History* and, as you have done so generously and graciously over the past years, will continue to share your responses and suggestions with me.

Marilyn Stokstad Lawrence, Kansas

AN EXPANDED ANCILLARY PACKAGE FOR STUDENTS AND INSTRUCTORS

Prentice Hall is pleased to present an outstanding array of complimentary resources for teaching and learning with Stokstad's *Art History*, Revised Second Edition. Please contact your local Prentice Hall representative for more details on how to obtain these items.

PRINT RESOURCES

ArtNotes is a notebook lecture companion for students featuring many small reproductions of key works in the text, along with the captions and page references for all of the images. Space is provided next to each object or caption for note taking during lectures and class discussions. ArtNotes is an optional package item free with every new copy of

Stokstad's Art History, Revised Second Edition.

Practice Tests is a two-volume set of booklets to help students prepare for exams by offering sample multiple choice and short essay exam questions. This excellent resource features 40–50 questions for every chapter in Stokstad's *Art History*, Revised Second Edition, complete with suggested answers, to help students evaluate their grasp of the material.

Instructor's Manual & Test Item File by William Allen of Arkansas State University is an invaluable professional resource and reference for new and experienced faculty, containing transition notes, sample syllabi, hundreds of sample test questions, and outstanding guidance on incorporating media technology into your course.

DIGITAL AND VISUAL RESOURCES

Art History Interactive: 1,000 Images for Study & Presentation (CD-ROM) is an outstanding study tool for students and a new slide resource for instructors. Images are viewable by Prentice Hall book title, by period, or by artist. Students can quiz

themselves in flashcard mode or by answering any number of excellent short answer and compare/contrast questions. Instructors can use the slide show function of the CD-ROM for lectures, incorporating any of their own electronic

images as well. This CD-ROM is included with every new copy of Stokstad's *Art History*. See the visual walk-through on the pages that follow.

OneKey is our Web-based course system that delivers all instructor and student online course materials for this text. With OneKey, all of

your resources are in one place for maximum convenience, simplicity, and success. Here is what is key for this title for instructors: a complete library of instructor resources including images, powerpoints, downloadable line art and maps, instructor's manual, and test item file. Included for students are: interactive exercises based on fine art, self-assessment quizzes, an audio pronunciation guide for art terms, a complete starter kit, and image links. Visit our gallery at www.prenhall.com/onekey.

Prentice Hall Test Generator is a commercial-quality computerized test management program, available for both Microsoft® Windows and Macintosh® environments.

Fully Customizable Online Courses are available for instructors who want a Web presence for their course. Powered by WebCTTM, BlackboardTM, or CourseCompassTM, online course content can extend and enhance your use of Stokstad's *Art History*, Revised Second Edition.

Visit the Companion Website at www.prenhall.com/

stokstad for a comprehensive online resource featuring a variety of learning and teaching modules, all correlated to the chapters of Stokstad's *Art History*, Revised Second Edition.

Fine Art Slides and Videos are also available to qualified adopters. Please contact your local Prentice Hall sales representative to discuss your slide and video needs. To find your representative, use our rep locator at **www.prenhall.com.**

Research NavigatorTM is a powerful tool for online research that provides students

access to three exclusive databases of reliable source material: *The New York Times* Search by Subject Archive, ContentSelect Academic Journal Database, and Link Library. Students receive access through a complete guide.

ART HISTORY INTERACTIVE

1,000 Images for Study and Presentation

his dynamic CD-ROM is designed to help you get the most out of your art history survey course, whether you are a student or an instructor.

As you can see from the sample introductory screen below, the program is divided into three major areas identified by the main navigation tabs: Image Explorer, Study Sets/Quizzes, and Slide Shows. There is also a comprehensive Audio Glossary you can use at any time in the program.

Click on the blue Image Explorer tab at any time to activate the Image Explorer panel, from which you can browse all of the images on the CD, by Prentice Hall book, by artist, or by art history period.

Within the Book Tab, select the chapter you want to study. Then click on the green tab labeled Study Sets/Quizzes to create a customized study set. You'll notice that all of the images pertaining to the chapter you want to study appear in thumbnail form.

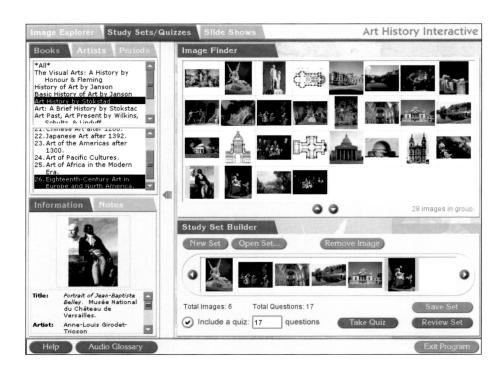

Now you can drag and drop images from the Image Finder panel into the Study Set Builder. When you've selected all of the images you want to study, select "Include a quiz." Note that you control the number of questions you want to be asked. Space is provided for you to write your answer. You may either save your answer as a file to review later, or as a file you can email your instructor (if he or she requests it).

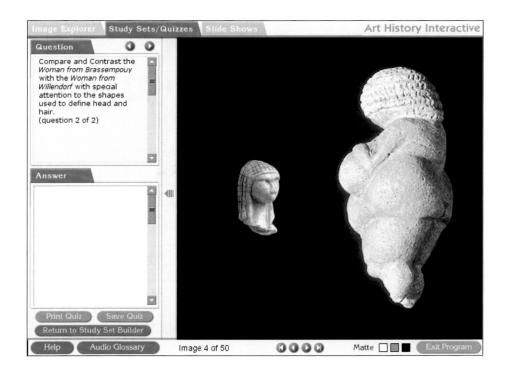

You can also test yourself anytime on simple identification of the image by hiding the Information section by clicking on the gray arrow that appears to the left of the image.

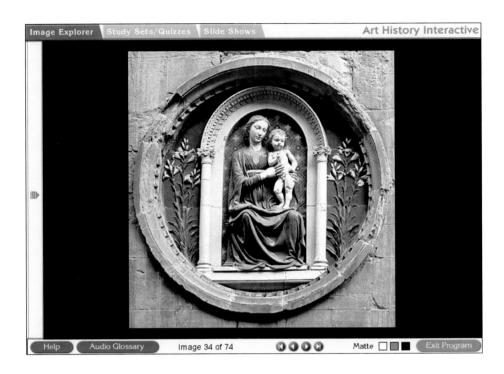

If you are an instructor, be sure to review the Slide Show function. Within Image Explorer, click on the Slide Show tab. Note that all of the images pertaining to the period (or book or artist) you have selected now appear in the Image Finder. Drag and drop the images you want to present into Slide Show Builder.

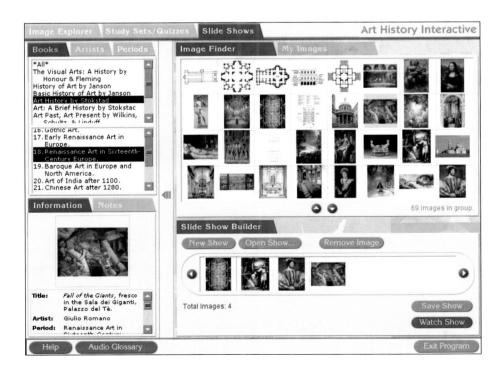

Do you have images of your own that you would like to incorporate into this slide show? Click on the My Images tab. Your images need to be saved as jpegs. Click on Load Images and follow the computer prompts.

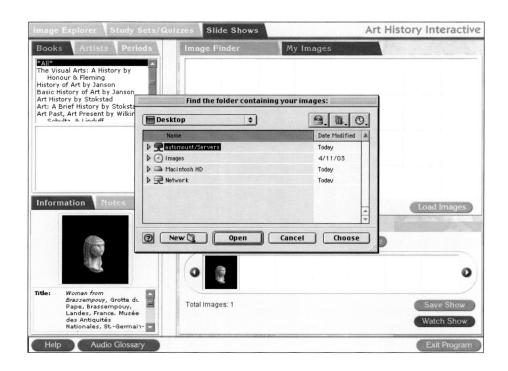

When you leave the program, you will be prompted to save any notes you have taken.

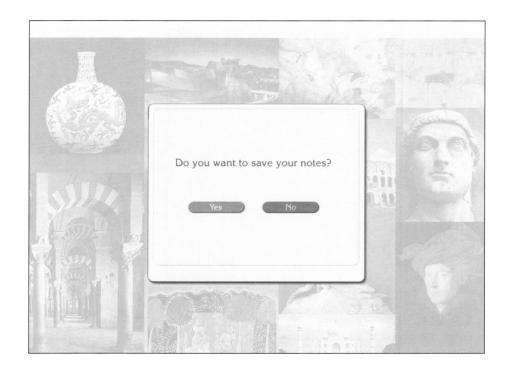

USE NOTES

The various features of this book reinforce each other, helping the reader to become comfortable with terminology and concepts that are specific to art history.

Starter Kit and Introduction The Starter Kit is a highly concise primer of basic concepts and tools. The outer margins of the Starter Kit pages are tinted to make them easy to find. The Introduction is an invitation to the many pleasures of art history.

Captions There are two kinds of captions in this book: short and long. Short captions identify information specific to the work of art or architecture illustrated:

artist (when known)
title or descriptive name of work
date
original location (if moved to a museum or other site)

material or materials a work is made of size (height before width) in feet and inches, with meters and centimeters in parentheses

present location

The order of these elements varies, depending on the type of work illustrated. Dimensions are not given for architecture, for most wall paintings, or for most architectural sculpture. Some captions have one or more lines of small print below the identification section of the caption that gives museum or collection information. This is rarely required reading.

Long captions contain information that complements the narrative of the main text.

Definitions of Terms You will encounter the basic terms of art history in three places:

IN THE TEXT, where words appearing in **boldface** type are defined, or glossed, at their first use. Some terms are boldfaced and explained more than once, especially those that experience shows are hard to remember.

IN BOXED FEATURES on technique and other subjects, where labeled drawings and diagrams visually reinforce the use of terms.

IN THE GLOSSARY at the end of the volume, which contains all the words in **boldface** type in the text and boxes. The Glossary begins on page Glossary 1, and the outer margins are tinted to make it easy to find.

Maps and Timelines At the beginning of each chapter you will find a map with all the places mentioned in the chapter. Above the map, a timeline runs from the earliest through the latest years covered in that chapter.

Boxes Special material that complements, enhances, explains, or extends the text is set off in three types of tinted boxes. Elements of Architecture boxes clarify specifically architectural features, such as "Space-Spanning Construc-

tion Devices" in the Starter Kit (page xxviii). Technique boxes (see "Lost-Wax Casting," page xxvii) amplify the methodology by which a type of artwork is created. Other boxes treat special-interest material related to the text.

Bibliography The bibliography at the end of this book beginning on page Bibliography 1 contains books in English, organized by general works and by chapter, that are basic to the study of art history today, as well as works cited in the text.

Dates, Abbreviations, and Other Conventions This book uses the designations BCE and CE, abbreviations for "before the Common Era" and "Common Era," instead of BC ("before Christ") and AD ("Anno Domini," "the year of our Lord"). The first century BCE is the period from 99 BCE to 1 BCE; the first century CE is from the year 1 CE to 99 CE. Similarly, the second century BCE is the period from 199 BCE to 100 BCE; the second century CE extends from 100 CE to 199 CE.

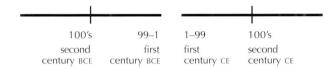

Circa ("about" or "approximately") is used with dates, spelled out in the text and abbreviated to "c." in the captions, when an exact date is not yet verified.

An illustration is called a "figure," or "fig." Thus, figure 6-70 is the seventieth numbered illustration in Chapter 6. Figures 1 through 28 are in the Introduction. There are two types of figures: photographs of artworks or of models, and line drawings. Drawings are used when a work cannot be photographed or when a diagram or simple drawing is the clearest way to illustrate an object or a place.

When introducing artists, we use the words *active* and *documented* with dates, in addition to "b." (for "born") and "d." (for "died"). "Active" means that an artist worked during the years given. "Documented" means that documents link the person to that date.

Accents are used for words in French, German, Italian, and Spanish only.

With few exceptions, names of museums and other cultural bodies in Western European countries are given in the form used in that country.

Titles of Works of Art Most paintings and works of sculpture created in Europe and North America in the past 500 years have been given formal titles, either by the artist or by critics and art historians. Such formal titles are printed in italics. In other traditions and cultures, a single title is not important or even recognized. In this book we use formal descriptive titles of artworks where titles are not established. If a work is best known by its non-English title, such as Manet's *Le Déjeuner sur l'Herbe (The Luncheon on the Grass)*, the original language precedes the translation.

STARTER KIT

The Starter Kit contains basic information and concepts that underlie and support the study of art history, which concerns itself with the visual arts—traditionally painting and drawing, sculpture, prints, photography, and architecture. It presents the vocabulary used to classify and describe art objects and is therefore indispensable to the student of art history. Use the Starter Kit as a quick reference guide to understanding terms you will encounter again and again in reading *Art History* and in experiencing art directly.

Let us begin with the basic properties of art. In concrete, nonphilosophical terms, a work of art has two components: FORM and CONTENT. It is also described and categorized according to STYLE and MEDIUM.

FORM

Referring to purely visual aspects of art and architecture, the term *form* encompasses qualities of LINE, SHAPE, COLOR, TEXTURE, SPACE, MASS and VOLUME, and COMPOSITION. When art historians use the term *formal* they mean "relating to form." These qualities all are known as FORMAL ELEMENTS.

Line and **shape** are attributes of form between which there is a subtle distinction. Line is a form—usually drawn or painted—the length of which is so much greater than the width that we perceive it as having only length. Line can be actual, as when the line is visible, or implied, as when the movement of the viewer's eyes over the surface of a work follows a path determined by the artist. Shape, on other hand, is the two-dimensional, or flat, area defined by the borders of an enclosing *outline*, or *contour*. Shape can be *geometric*, *biomorphic* (suggesting living things), *closed*, or *open*. The *outline*, or *contour*, of a three-dimensional object can also be perceived as line.

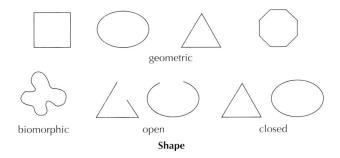

Color has several attributes. These include HUE, VALUE, and SATURATION.

HUE is what we think of when we hear the word *color*, and the terms are interchangeable. We perceive hues as the result of differing wavelengths of electromagnetic energy. The visible spectrum, which can be seen in a rainbow, runs from red through violet. When the ends of the spectrum are connected through the hue red-violet, the result may be diagrammed as a color wheel. The PRIMARY

HUES (numbered 1) are red, yellow, and blue. They are known as primaries because all the other colors are made of a combination of these hues. Orange, green, and violet result from the mixture of two primaries and are known as secondary Hues (numbered 2). Intermediate Hues, or tertiaries (numbered 3), result from the mixture of a primary and a secondary. Complementary colors are the two colors directly opposite on the color wheel, such as red and green. Red, orange, and yellow are regarded as warm colors and appear to advance toward us. Blue, green, and violet, which seem to recede, are called cool colors. Black and white are not considered colors but neutrals; in terms of light, black is understood as the absence of all color and white as the mixture of all colors.

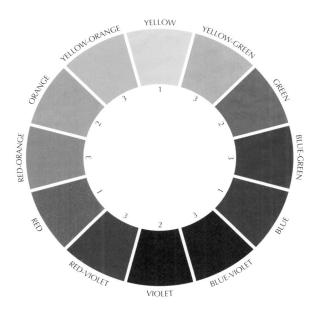

VALUE is the relative degree of lightness or darkness of a given color and is created by the amount of light reflected from an object's surface. A dark green has a deeper value than a light green, for example. In black-and-white reproductions of colored objects, you see only value, and some artworks—for example, a drawing made with black ink—possesses only value, not hue or saturation.

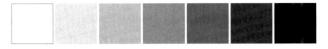

Value scale from white to black.

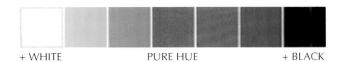

Value variation in red.

SATURATION, also sometimes referred to as INTENSITY, is a color's quality of brightness or dullness. A color described as highly saturated looks vivid and pure; a hue of low saturation may look a little muddy.

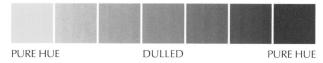

Intensity scale from bright to dull.

Texture, another attribute of form, is the tactile (or touch-perceived) quality of a surface. It is experienced and described with words such as *smooth*, *polished*, *rough*, *grainy*, or *oily*. Texture takes two forms: the texture of the actual surface of the work of art and the implied (illusionistically depicted) surface of the object the work represents.

Space is what contains objects. It may be actual and threedimensional, as it is with sculpture and architecture, or it may be represented illusionistically in two dimensions, as when artists represent recession into the distance on walls, paper, or canvas.

Mass and **volume** are properties of three-dimensional things. Mass is matter—whether sculpture or architecture—that takes up space. Volume is enclosed or defined space, and may be either solid or hollow. Like space, mass

and volume may be illusionistically represented in two dimensions.

Composition is the organization, or arrangement, of form in a work of art. Pictorial depth (spatial recession) is a specialized aspect of composition in which the three-dimensional world is represented in two dimensions on a flat surface, or picture plane. The area "behind" the picture plane is called the picture space and conventionally contains three "zones": Foreground, MIDDLE GROUND, and BACKGROUND. Perpendicular to the picture plane is the GROUND PLANE.

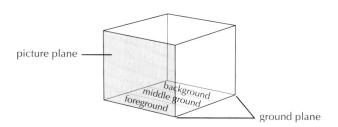

Various techniques for conveying a sense of pictorial depth have been devised and preferred by artists in different cultures and at different times. A number of them are diagrammed below. In Western art, the use of various systems of Perspective has created highly convincing illusions of recession into space. In other cultures, perspective is not the most favored way to treat objects in space.

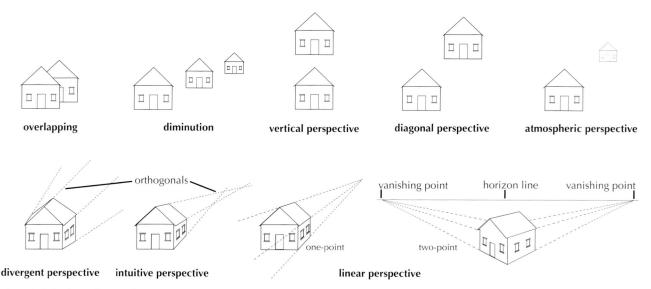

Pictorial devices for depicting recession in space

The top row shows several comparatively simple devices, including overlapping, in which partially covered elements are meant to be seen as located behind those covering them, and diminution, in which smaller elements are to be perceived as being farther away than larger ones. In vertical and diagonal perspective, elements are stacked vertically or diagonally, with the higher elements intended to be perceived as deeper in space. Another way of suggesting depth is through atmospheric perspective, which depicts objects in the far distance, often in bluish gray hues, with less clarity than nearer objects and treats sky as paler near the horizon than higher up. In the lower row, divergent perspective, in which forms widen slightly and lines diverge as they recede in space, was used by East Asian artists. Intuitive perspective, used in some late medieval European art, takes the opposite approach: forms become nar-

rower and converge the farther they are from the viewer, approximating the optical experience of spatial recession. Linear Perspective, also called Scientific, Mathematical, One-Point, and Renaissance Perspective, is an elaboration and standardization of intuitive perspective and was developed in fifteenth-century Italy. It uses mathematical formulas to construct illusionistic images in which all elements are shaped by imaginary lines called Orthogonals that converge in one or more vanishing Points on a horizon line. Linear perspective is the system that most people living in Western cultures think of as perspective. Because it is the visual code they are accustomed to reading, they accept as "truth" the distortions it imposes. One of these distortions is foreshortening, in which, for instance, the soles of the feet in the foreground are the largest elements of a figure lying on the ground.

CONTENT

Content includes SUBJECT MATTER, which is what a work of art represents. Not all works of art have subject matter; many buildings, paintings, sculptures, and other art objects include no recognizable imagery but feature only lines, colors, masses, volumes, and other formal elements. However, all works of art—even those without recognizable subject matter—have content, or meaning, insofar as they seek to convey feelings, communicate ideas, or affirm the beliefs and values of their makers and, often, the people who view or use them.

Content may comprise the social, political, religious, and economic contexts in which a work was created, the INTENTION of the artist, the RECEPTION of the work by the beholder (the audience), and ultimately the meanings of the work to both artist and audience. Art historians applying different methods of INTERPRETATION often arrive at different conclusions regarding the content of a work of art.

The study of subject matter is ICONOGRAPHY (literally, "the writing of images"). The iconographer asks, What are we looking at? Iconography includes the fascinating study of SYMBOLS and SYMBOLISM—the process of representing one thing by another through association, resemblance, or convention.

STYLE

Expressed very broadly, style is the combination of form and composition that makes a work distinctive. Stylistic analysis is one of art history's most developed practices, because it is how art historians recognize the work of an individual artist or the characteristic manner of several artists working in a particular time or place. Some of the most commonly used terms to discuss artistic styles include period style, regional style, representational style, abstract style, linear style, and painterly style.

Period style refers to the common traits detectable in works of art and architecture from a particular historical era. For instance, Roman portrait sculpture is distinguishable according to whether it was created during the Roman Republican era, at the height of the Empire, or in the time of the late Empire. It is good practice not to use the words *style* and *period* interchangeably. Style is the sum of many influences and characteristics, including the period of its creation. An example of good usage is "an American house from the Colonial period built in the Georgian style."

Regional style refers to stylistic traits that persist in a geographic region. An art historian whose specialty is medieval art can recognize French style through many successive medieval periods and can distinguish individual objects created in medieval France from other medieval objects that were created in, say, Germany or the Low Countries.

Representational styles are those that create recognizable subject matter. Realism, Naturalism, Illusionism, and IDEALIZATION are often-found names for representational styles.

Realism is the attempt to depict objects as they are in actual, visible reality.

Naturalism is closely linked to realism and the terms are often used interchangeably. Naturalism, however,

refers to the attempt to depict objects as they appear in nature.

Illusionism refers to a highly detailed style that seeks to create a convincing illusion of reality. *Flower Piece with Curtain* is a good example of this trick-the-eye form of realism (see fig. 3, Introduction).

Idealization strives to realize an image of physical perfection according to the prevailing values of a culture. *The Medici Venus* is idealized, as is Utamaro's *Woman at the Height of Her Beauty* (see figs. 7, 9, Introduction).

Abstract styles depart from literal realism to produce work that appears artificial or stylized. An abstract artist may work from nature or from a memory image of nature's forms and colors, which are simplified, distorted, or otherwise transformed to achieve a desired expressive effect. Georgia O'Keeffe's *Red Canna* and the Indian bronze statue of *Punitavati* are both abstracted (see figs. 5, 10, Introduction). Nonrepresentational art and expressionism are particular kinds of abstract styles.

Nonrepresentational (or nonobjective) art is a form of complete abstraction. It does not produce recognizable imagery. *Cubi XIX* is nonrepresentational (see fig. 6, Introduction).

Expressionism refers to styles in which the artist uses exaggeration of form and technique to appeal to the beholder's subjective response or to project the artist's own subjective feelings. The Hellenistic sculpture *Laocoön* and van Gogh's *Large Plane Trees* are both expressionistic (see figs. 24, 25, 28, Introduction).

Linear describes style as well as technique. In the linear style the artist uses line as the primary means of definition and may use a smooth form of MODELING—the creation of an illusion of three-dimensional substance through shading—in which brushstrokes nearly disappear. Utamaro's *Woman at the Height of Her Beauty* is stylistically linear (see fig. 9, Introduction).

Painterly describes a style of painting in which vigorous, evident brushstrokes dominate and shadows and highlights are brushed in freely. Van Gogh's *Large Plane Trees* is painterly, though it exhibits linear qualities as well (see fig. 28, Introduction).

MEDIUM

What is meant by *medium* or *mediums* (the plural we use in this book to distinguish the word from print and electronic news media) is the material or materials from which a work of art is made.

Technique is the process used to make the work. Today, literally anything can be used to make a work of art, including not only traditional materials like paint, ink, and stone, but also rubbish, food, and the earth itself. When several mediums are used in a single work of art, we employ the term *mixed mediums*. Two-dimensional mediums include Painting, Drawing, Prints, and Photography. Three-dimensional mediums are sculpture, Architecture, and many Ornamental and Functional Arts.

Painting includes WALL PAINTING and FRESCO, ILLUMINATION (the decoration of books with paintings), PANEL PAINTING (painting on wood panels) and painting on canvas, miniature painting (small-scale painting), and HANDSCROLL and HANGING SCROLL painting. Paint is pigment mixed with a liquid vehicle, or binder. Various kinds of paint and painting are explained throughout this book in Technique boxes.

Graphic arts are those that involve the application of lines and strokes to a two-dimensional surface or support, most often paper. Drawing is a graphic art, as are the various forms of printmaking. Drawings may be sketches (quick visual notes made in preparation for larger drawings or paintings); studies (more carefully drawn analyses of details or entire compositions); cartoons (full-scale drawings made in preparation for work in another medium, such as fresco); or complete artworks in themselves. Drawings are made with such materials as ink, charcoal, crayon, and pencil. Prints, unlike drawings, are reproducible. The various forms of printmaking include woodcut, wood engraving, etching, drypoint, metal engraving, and lithography.

Photography (literally "light writing") is a medium that involves the rendering of optical images on light-sensitive surfaces. Photographic images are typically recorded by a camera

Sculpture is three-dimensional art that is CARVED, MODELED, CAST, Or ASSEMBLED. Carved sculpture is subtractive in the sense that the image is created by taking away material. In fact, wood, stone, and ivory can be carved into sculpture only because they are not pliant, malleable materials. Modeled sculpture is considered additive, meaning that the object is built up from a material, such as clay, that is soft enough to be molded and shaped. Metal sculpture is usually cast (see "Lost-Wax Casting," page xxvii) or is assembled by welding or a similar means of permanent joining.

Sculpture is either freestanding (that is, not attached) or in relief. Relief sculpture projects from the background surface of which it is a part. High relief sculpture projects far from its background; low relief sculpture is only slightly raised; and sunken relief, found mainly in Egyptian art, is carved into the surface, with the highest part of the relief being the flat surface.

Ephemeral arts include processions and festival decorations and costumes, performance art, earthworks, cinema, video art, and some forms of digital and computer art. All have a central temporal aspect in that the artwork is viewable for a finite period of time and then disappears forever, is in a constant state of change, or must be replayed to be experienced again.

Architecture is three-dimensional, highly spatial, functional, and closely bound with developments in technology and materials. An example of the relationship among technology, materials, and function is how space is spanned (see "Space-Spanning Construction Devices," page xxviii). Several types of two-dimensional schematic drawings are commonly used to enable the visualization of a building. These architectural graphic devices include PLANS, ELEVATIONS, SECTIONS, and CUTAWAYS.

PLANS depict a structure's masses and voids, presenting a view from above—as if the building had been sliced horizontally at about waist height.

ELEVATIONS show exterior sides of a building as if seen from a moderate distance without any perspective distortion.

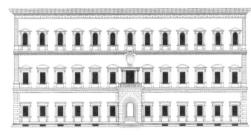

elevation

SECTIONS reveal a building as if it had been cut vertically by an imaginary slicer from top to bottom.

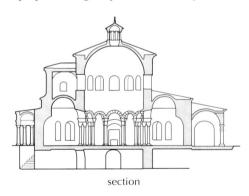

CUTAWAYS show both inside and outside elements from an oblique angle.

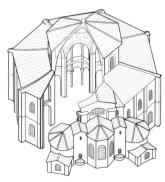

cutaway

The lost-wax casting process (also called *cire perdue*, the French term) has been used for many centuries. It probably started in Egypt. By 200 BCE the technique was known in China and

ancient Mesopotamia and was soon after used by the Benin peoples in Africa. It spread to ancient Greece sometime in the sixth century BCE and was widespread in Europe until the eighteenth century, when a piece-mold process came to predominate. The usual metal is bronze, an alloy of copper and tin, or sometimes brass, an alloy of copper and zinc.

The progression of drawings here shows the steps used by Benin sculptors. A heat-resistant "core" of clay approximating the shape of the sculpture-to-be (and eventually becoming the hollow inside the sculpture) was covered by a layer of wax about the thickness of the

TECHNIQUE

Lost-Wax Casting final sculpture. The sculptor carved the details in the wax. Rods and a pouring cup made of wax were attached to the model. A thin layer of fine, damp sand was pressed very firmly into the sur-

face of the wax model, and then model, rods, and cup were encased in thick layers of clay. When the clay was completely dry, the mold was heated to melt out the wax. The mold was then turned upside down to receive the molten metal, which for the Benin was brass, heated to the point of liquification. The cast was placed in the ground. When the metal was completely cool, the outside clay cast and the inside core were broken up and removed, leaving the cast brass sculpture. Details were polished to finish the piece of sculpture, which could not be duplicated because the mold had been destroyed in the process.

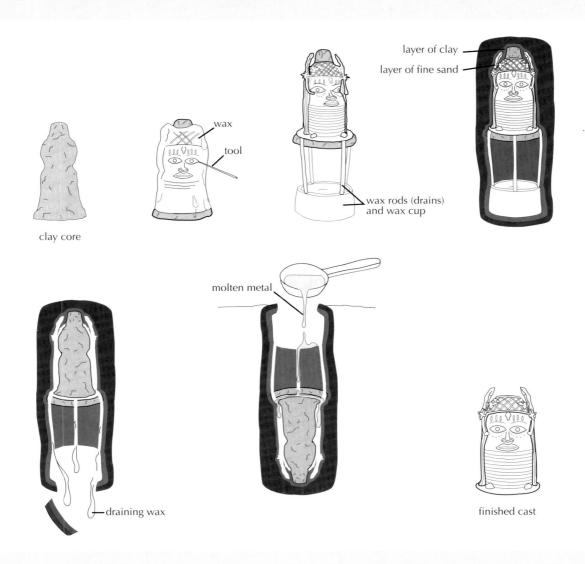

ELEMENTS OF ARCHITECTURE

SPACE-SPANNING CONSTRUCTION DEVICES

Gravity pulls on everything, presenting great challenges to the need to cover spaces. The purpose of the spanning element is to transfer weight to the ground. The simplest space-spanning device is post-and-lintel construction, in which uprights are spanned by a horizontal element. However, if not flexible, a horizontal element over a wide span breaks under the pressure of its own weight and the weight it carries.

Corbeling, the building up of overlapping stones, is another simple method for transferring weight to the ground. Arches, round or pointed, span space. Vaults, which are essentially extended arches, move weight out from the center of the covered space and down through the corners. The cantilever is a variant of post-and-lintel construction. When concrete is reinforced with steel or iron rods, the inherent brittleness of cement and stone is overcome because of metal's flexible qualities. The concrete can then span much more space and bear heavier loads. Suspension works to counter the effect of gravity by lifting the spanning element upward. Trusses of wood or metal are relatively lightweight spanners but cannot bear heavy loads. Large-scale modern construction is chiefly steel frame and relies on steel's properties of strength and flexibility to bear great loads. The balloon frame, an American innovation, is based in post-and-lintel principles and exploits the lightweight, flexible properties of wood.

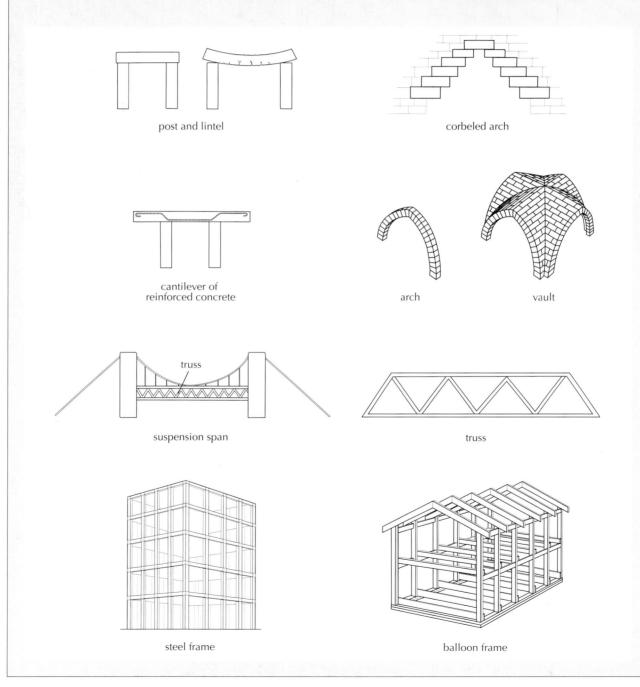

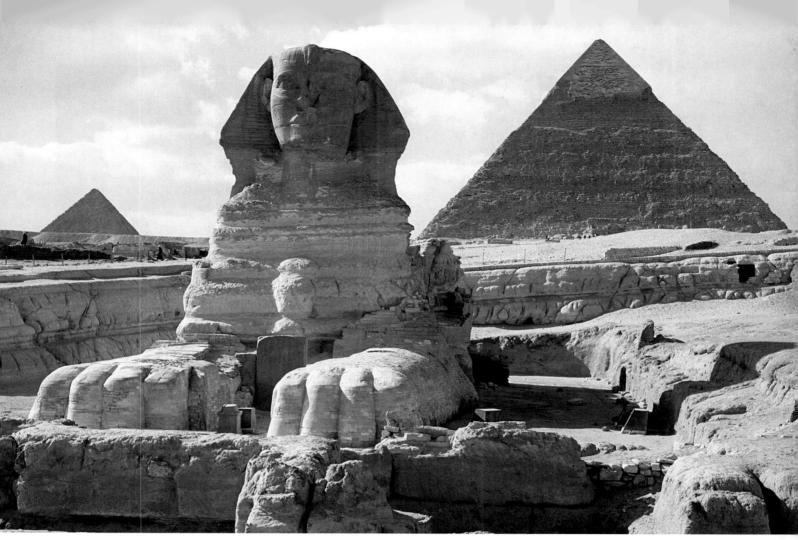

1. The Great Sphinx, Giza, Egypt. Dynasty 4, c. 2613–2494 BCE. Sandstone, height approx. 65' (19.8 m).

INTRODUCTION

ROUCHING IN FRONT OF THE PYRAMIDS OF EGYPT AND CARVED FROM the living rock of the Giza plateau, the Great Sphinx is one of the best-known monuments in the world (fig. 1). By placing the head of the ancient Egyptian king Khafra on the body of a huge lion, the sculptors joined human intelligence and animal strength in a single image to evoke the superhuman power of the ruler. For some 4,600 years the Sphinx has defied encroaching desert sands and other assaults of nature; today it also must withstand the human-made sprawl of urban Cairo and the impact of air pollution. The Sphinx, in its majesty, symbolizes mysterious wisdom and dreams of permanence, of immortality. But is such a monument a work of art? Does it matter that the people who carved the Sphinx—unlike today's independent, individualistic artists—followed time-honored, formulaic conventions and the precise instructions of their priests? No matter how viewers of the time may have labeled it, today most people would answer, "Certainly it is art. Human imagination conceived this amazing creature, and human skill gave material form to the concept of man-lion. Using imagination and skill to create huge, simplified shapes, the creators have defined the idea of awesome grandeur and have created a work of art." But what is art?

IS ART?

WHAT What is art? At one time the answer would have been easier than it is today. The severe geometric forms of the Great Sphinx or of the pyramids behind it on

the Giza plateau are beautiful, and so is the work of the skillful photographer who took the photo we just looked at in figure 1, but in our day art is not dependent on some ideal of beauty that is the product of formulaic conventions, or on the skill of an artist. Sometimes even the word art seems strange. Art comes from the Latin word ars, or "skill"; however, the Greek word for art, tekne, is the source for the English word technique. Should we, then, like our ancestors, assume that fine craftsmanship must be considered in identifying art, even when we no longer link works of art to an ideal of physical perfection? When images can be captured with a camera, why should one draw, paint, build, or chip away at a knob of stone? Which is the work of art—the Great Sphinx itself or a photograph of it in a book called Art History?

The ancient Greek philosophers Aristotle (384–322 BCE) and Plato (428-348/7 BCE) considered the nature of art and beauty in purely intellectual terms. They optimistically expected the study of beauty and truth to lead to universal good. Today a consideration of beauty belongs to a branch of philosophy known as **aesthetics**, which considers the nature of beauty, art, and taste as well as the creation of beauty and art. Aristotle evaluated works of art on the basis of mimesis ("imitation"), that is, on how faithfully artists recorded what they saw in the natural world. His ideas led to **styles**, or manners of representation, that we call **realistic** or **naturalistic**. But we need to be aware that while artists working in a realistic or naturalistic style can make images that seem like untouched snapshots of actual objects, their skill can also render lifelike such fictions as a unicorn or the Wicked Witch of the West—or a creature with the body of a lion and the head of a king, like the Great Sphinx.

In contrast to Aristotle, Plato looked beyond nature for a definition of art. In his view even the greatest work of art was only a shadow or approximation of the material world, several times removed from reality. Plato defined an ideal style, in which physical beauty depended on the harmony created by symmetry and proportion, on a rational, even mathematical, view of the world. The contemplation of such ideal physical beauty, Plato's followers hoped, would eventually lead the viewer to a new kind of artistic truth to be found in the realm of pure idea. The terms classic and classical, which derive from the style of art in the period in ancient Greek history when this type of idealism emerged, have come to define the art of ancient Greece and Rome in general and are used even more broadly as synonyms for the peak of perfection in any period. Today we speak of classic films and classic automobiles.

To achieve Plato's ideal images and represent things "as they ought to be," classical sculpture and painting established ideals that have inspired Western art ever since. In a triumph of human reason over nature, the sculptors

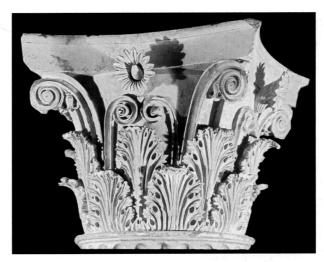

2. Corinthian capital from the tholos at Epidaurus. c. 350 BCE. Archaeological Museum, Epidaurus, Greece.

eliminated all irregularities in their depictions of nature and instead sought perfect balance and harmony.

Let us examine a simple example from architecture: the carved top, or capital, of a Corinthian column, a popular type, or order, of column that appeared in ancient Greece about 450 BCE. The Corinthian capital has an inverted bell shape surrounded by acanthus leaves (fig. 2). Although this foliage was inspired by the appearance of natural vegetation, the sculptors who carved the leaves eliminated blemishes and created ideal leaves by first looking at nature and then carving the essence of the form, the Platonic ideal of foliage. No insect has ever nibbled at such timelessly perfect, idealized leaves.

In the past such ideas inspired artists and those who commissioned or bought their works, but today, while we admire the achievements of the past, we realize that artists can think and work in very different ways. The anonymous builders of the pyramids would not have said they were creating works of art. Nor, in the twentieth century, would such artists as James Hampton and Olowe of Ise, whom we will meet later in this section. Underlying the assumptions of both those who commission art and those who make works of art is the idea that art has a message and that it can educate and convince viewers.

What gives an image meaning and expressive power? Why do some images fascinate and inspire us? Why do great works of art escape the time and place of their origin? Why have people treasured some things and let others molder away? These are difficult questions. Specialists studying individual art objects, scholars studying the history of art in its cultural context, philosophers studying cosmic questions—these people often disagree. While all of them may say, "This piece is good but that one is better," they make such statements only after carefully analyzing forms, considering evidence, and weighing the ideas and opinions of others. Often the most informed people conclude, "I just don't know." So before we begin to look, read, and think about works of art and architecture historically, from the earliest times to

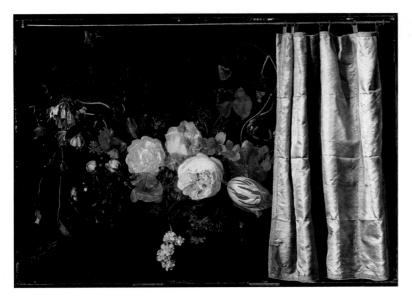

3. Adriaen van der Spelt and Frans van Mieris. Flower Piece with Curtain. 1658. Oil on panel, $18^{1}/_{4} \times 25^{1}/_{4}$ " (46.5 × 64 cm). The Art Institute of Chicago. Wirt D. Walker Fund, (1949.585)

our own day, let us consider a few general questionswhat is the relation of art to nature, why do we need art, who is considered an artist, what is a patron, and just what is art history? Let us begin with some old stories.

OR ART?

NATURE Like many people today, ancient Greeks enjoyed the work of especially skillful artists working in increasingly realistic styles. Their admiration for

naturalistic depiction is illustrated in a famous story about a competition between rival Greek painters named Zeuxis and Parrhasios in the late fifth century BCE. Zeuxis painted a picture of grapes so accurately that birds flew down to peck at them. Then Parrhasios took his turn, and when Zeuxis asked his rival to remove the curtain hanging over the picture, Parrhasios gleefully pointed out that the curtain was his painting. Zeuxis agreed that Parrhasios had won the competition since he, Zeuxis, had fooled only birds but Parrhasios had tricked an intelligent fellow artist.

In the seventeenth century, painter Adriaen van der Spelt (1630-73) and his artist friend Frans van Mieris (1635-81) paid homage to the story of Parrhasios's curtain with Flower Piece with Curtain, their painting of blue satin drapery drawn aside to show a garland of flowers (fig. 3). More than a tour-de-force of eye-fooling naturalism, the work is an intellectual delight. The artists not only re-created Parrhasios's curtain illusion but also included a reference to another Greek story that was popular in the fourth century BCE, the tale of Pausias, who depicted in a painting the exquisite floral garlands made by a young woman, Glykera. This second story raises the troubling and possibly unanswerable question of who was the true artist—the painter who copied nature in his art or the garland maker who made works of art out of nature. The seventeenth-century people who bought such paintings knew those stories and appreciated the artists' classical references as well as their skill in drawing and manipulating colors on canvas.

Only if we know something about the **iconography** (meaning and interpretation) of these images in their

own time does the larger meaning of Flower Piece with Curtain become clear. The brilliant red and white tulip just to the left of the blue curtain was the most desirable and expensive flower in the seventeenth century; thus, it symbolizes wealth and power. Yet insects creep out of it, and a butterfly-fragile and transitory-hovers above the flower. Consequently the flower garland also symbolizes the passage of time and the fleeting quality of human riches. After studying the iconography and cultural context of the painting, we begin to understand that this is much more than a simple flower piece, a type of **still-life** painting popular in the Netherlands in van der Spelt's and van Mieris's time.

STYLES OF REPRESENTATION

Just as Dutch flower pieces were ideal expressions of naturalism, so today modern photography seems like a perfect medium for expressing the natural beauty of plants, especially when they are selected and captured at perfect moments in their life cycles. In his photograph Succulent, Edward Weston (1886-1958) did just that by using straightforward camera work, without manipulating the film in the darkroom (fig. 4, page xxxii). Aristotle might have appreciated this example of mimesis, but Weston did more than accurately portray his subject; he made photography an expressionistic medium by perfecting the close-up view to evoke an emotional response. He argued that although the camera sees more than the human eye, the quality of the image depends not on the camera, but on the choices made by the photographer-artist.

Many people even today think that naturalism represents the highest accomplishment in art. But not everyone agrees. The first artist to argue persuasively that observation alone produced "mere likeness" was the Italian master Leonardo da Vinci (1452-1519), who said that the painter who copied the external forms of nature was acting only as a mirror. He believed that the true artist should engage in intellectual activity of a higher order and attempt to capture the inner life-the

4. Edward Weston. Succulent. 1930. Gelatin silver print, $7^1/2 \times 9^1/2$ " (19.1 \times 24 cm). Collection Center for Creative Photography, The University of Arizona, Tucson.

energy and power—of a subject. In the twentieth century, Georgia O'Keeffe (1887–1986), like van der Spelt and van Mieris and Weston, studied living plants; however, when she painted *Red Canna*, she, like Leonar-

do, sought to capture the plant's essence (fig. 5). By painting the canna lily's organic energy rather than the way it actually looked, she created a new **abstract** beauty, conveying in paint the pure vigor of its life force.

5. Georgia O'Keeffe. *Red Canna.* 1924. Oil on canvas mounted on Masonite, $36 \times 29^{7}/8''$ (91.44 \times 75.88 cm). Collection of the University of Arizona Museum of Art, Tucson. Gift of Oliver James, (50.1.4)

6. David Smith. *Cubi XIX.* 1964. Stainless steel, $9'5^3/8'' \times 1'9^3/4'' \times 1'8''$ (2.88 \times 0.55 \times 0.51 m). Tate Gallery, London.

Furthest of all from naturalism, or the Greek concept of *mimesis*, are the pure geometric creations of polished stainless steel made by David Smith (1906–65). His *Cubi* works, such as the sculpture in figure 6, are usually called **nonrepresentational** art—art so abstract that it does not represent the natural world. With works like *Cubi XIX*, it is important to distinguish between subject matter and content. Abstract art has both subject matter and content, or meaning. Nonrepresentational art does not have subject matter but it does have meaning, which is a product of the interaction between the artist's intention and the viewer's interpretation. Some viewers may see the *Cubi* works as robotic plants sprung from the core of an unyielding earth, a reflection of today's mechanistic society that challenges the natural forms of trees and hills.

Because meaning can change over time, one goal of art history—one that this book exemplifies—is to identify the cultural factors that produce a work, to determine what it probably meant for the artist and the original audience, and to acknowledge that no interpre-

tation is definitive. This approach is known as **contextualism**. Again, such interpretations are in the "eye of the beholder."

In short, artists have worked in a variety of styles. Sometimes they have valued naturalistic styles and seem to have recorded exactly what they saw with greater or lesser accuracy. At other times artists transformed what they saw into patterns or ideal shapes that may or may not suggest the visible world.

THE HUMAN BODY AS IDEA AND IDEAL

Ever since people first made what we call art, they have been fascinated with their own image and have used the human body to express ideas and ideals. Popular culture in the twenty-first century seems obsessed with beautiful people—Miss USA, Miss Universe, the Ten Best-Dressed Men or Women, the Fifty Most Desirable Partners. Today the *Medici Venus*, with her plump arms and legs and sturdy body, would surely be forced to slim down, yet for generations this Venus represented the peak of female

7. *The Medici Venus.* Roman copy of a 1st century BCE. Greek statue. Marble, height 5' (1.53 m) without base. Villa Medici, Florence, Italy.

beauty (fig. 7). This image of the goddess of love inspired artists and those who commissioned their work from the fifteenth through the nineteenth century. Clearly the artist had the skill to represent a woman as she actually appeared but instead chose to generalize her form and adhere to the classical **canon** (rule) of proportions. In so doing, the sculptor created a universal image, an ideal rather than a specific woman.

The *Medici* Venus represents a goddess, but a living person might also be represented as an idealized figure when the artist's intention is to turn a portrait into a symbol. The sculptor Leone Leoni (1509–90), commissioned by Charles V (1519–56) to create a monumental bronze statue of himself, expressed the power of this ruler, whose reign over the Holy Roman Empire was punctuated by decades of religious civil war, just as vividly as did the sculptors of the Egyptian king Khafra, the subject of the Great Sphinx (see fig. 1). Whereas in the sphinx Khafra took on the body of a vigilant crouching lion, in *Charles V Triumphing over Fury* the emperor has been endowed with the muscular torso and proportions of the classical ideal male athlete (fig. 8). The body

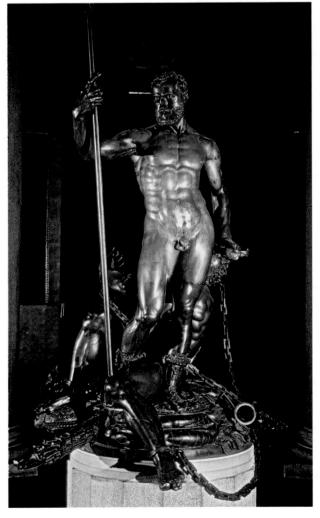

8. Leone Leoni, *Charles V Triumphing over Fury,* **without armor.** c. 1549–55. Bronze, height to top of head 5'8" (1.74 m). Museo Nacional del Prado, Madrid.

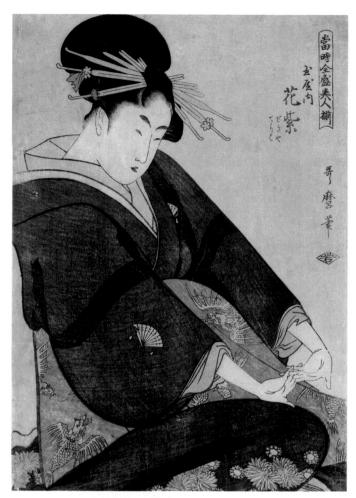

9. Kitagawa Utamaro. Woman at the Height of Her Beauty. Mid-1790s. Color woodblock print, $15^{1}/_{8} \times 10''$ (38.5 × 25.5 cm). Spencer Museum of Art, The University of Kansas, Lawrence. William Bridges Thayer Memorial, (1928.7879)

of a Greek god or Roman hero—the Olympian Zeus or the victorious Hercules, for example—supports this portrait of a living man. Charles does not inhabit a fragile human body; rather, in his muscular nakedness he embodies the idea of triumphant authoritarian rule. (Not everyone approved. A full suit of armor was made for the statue by the artist, and today museum officials usually exhibit the sculpture clad in armor.)

Very different from the classical ideal of beauty is the abstract vision of woman depicted in a woodblock print by Japanese artist Kitagawa Utamaro (1753–1806). In its stylization, *Woman at the Height of Her Beauty* (fig. 9) reflects a complex society regulated by convention and ritual. Simplified shapes suggest underlying human forms, although the woman's dress and hairstyle defy the laws of nature. Rich textiles turn her body into an abstract pattern, and pins hold her hair in elaborate shapes. Utamaro rendered the decorative silks and carved pins meticulously, but he depicted the woman's face with a few sweeping lines. The elaboration of surface detail combined with an effort to capture the essence of form is characteristic of abstract art of Utamaro's time and place. Images of men were equally simplified and elegant.

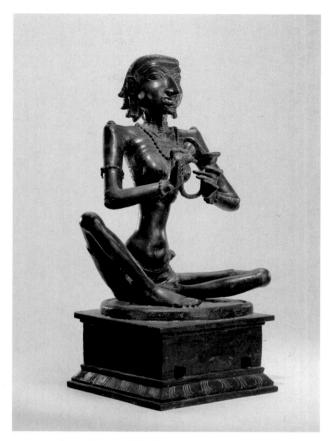

10. *Punitavati (Karaikkalammaiyar)*, Shiva saint, from Karaikka, India. c. 1050. Bronze, height $12^5/_8$ " (32.1 cm). The Nelson-Atkins Museum of Art, Kansas City, Missouri. Purchase: Nelson Trust (33–533)

How different from these ideas of physical beauty can be the perception and representation of spiritual beauty! A fifteenth-century bronze sculpture from India represents Punitavati, a beautiful and generous woman who was deeply devoted to the Hindu god Shiva. Abandoned by her husband because she gave one of his mangos to a beggar, Punitavati offered her beauty to Shiva. Shiva accepted the offering and in taking her loveliness turned her into an emaciated, fanged hag (fig. 10). According to legend, Punitavati, with clanging cymbals, provides the music for Shiva as he keeps the universe in motion by dancing the cosmic dance of destruction and creation. The bronze sculpture, although it depicts Punitavati's hideous appearance, is beautiful both in its formal qualities as a work of art and in its message of generosity and sacrifice.

WHY DO WE NEED ART?

Biologists account for the human desire for art by explaining that human beings have very large brains that demand stimulation. Curious, active, and inventive, we humans constantly ex-

plore, and in so doing invent things that appeal to our

11. James Hampton. Throne of the Third Heaven of the Nations' Millennium General Assembly. c. 1950-64. Gold and silver aluminum foil, colored Kraft paper, and plastic sheets over wood, paperboard, and glass, 10'6" × 27' × 14'6" $(3.2 \times 8.23 \times 4.42 \text{ m}).$ Smithsonian American Art Museum. Smithsonian Institution, Washington, D.C. Gift of anonymous donors,

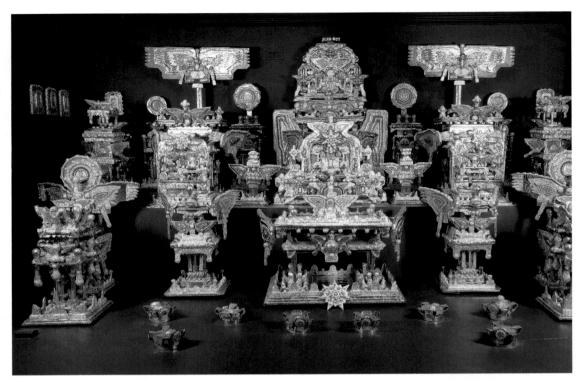

senses—fine art, fine food, fine scents, and fine music. Ever since our prehistoric ancestors developed their ability to draw and speak we have visually and verbally been communicating with each other. We speculate on the nature of things and the meaning of life. In fulfilling our need to understand and our need to communicate, the arts serve a vital function.

ART AND THE SEARCH FOR MEANING

Throughout history art has played an important part in our search for the meaning of the human experience. In an effort to understand the world and our place in it, we turn both to introspective personal art and to communal public art. Following a personal vision, James Hampton (1909-64) created profoundly stirring religious art. Hampton worked as a janitor to support himself while, in a rented garage, he built Throne of the Third Heaven of the Nations' Millennium General Assembly (fig. 11), his monument to his faith. In rising tiers, thrones and altars have been prepared for Jesus and Moses. Hampton made this fabulous assemblage out of discarded furniture, flashbulbs, and all sorts of refuse tacked together and wrapped in gold and silver aluminum foil and purple tissue paper. How can such worthless materials be turned into such an exalted work of art? Today we recognize that the genius of the artist transcends any material. Placing New Testament imagery on the right and Old Testament imagery on the left, Hampton labeled and described everything. He even invented his own language to express his visions. On one of many placards he wrote his credo: "Where there is no vision, the people perish" (Proverbs 29:18).

In contrast to James Hampton, most artists and viewers participate in more public expressions of art and belief. People create rituals hoping to establish ties to unseen powers and also with the past and the future. When they employ special objects in their rituals such as statues, masks, and vessels, these pieces may be seen as works of art by outsiders who do not know about their intended use and original significance. Two ceremonial offering bowls—a European chalice and an African cup—will illustrate our point.

The cup known as the Chalice of Abbot Suger was used for the most important ceremony of the Christian religion (fig. 12). For Christians, communication between God and humans becomes possible through the ritual enactment of Jesus' Last Supper with his friends and disciples. For Catholic Christians, a complex rite enacted at a consecrated altar changes ordinary wine into the blood of Christ. For Protestants, the wine remains the symbol of that blood. For both groups the chalice—the vessel for the sacramental wine—plays a central role. In the twelfth century in France, Abbot Suger, head of the monastery dedicated to Saint Denis near Paris, found an ancient agate vase in the storage chests of the abbey. He ordered his goldsmiths to add a foot, a rim, and handles as well as semiprecious stones and medallions to the vase, turning an entirely secular piece—an object of prestige and delight—into a chalice to be used at the altar of his church.

The Yoruba offering bowl, like the chalice, served the Yoruba people of Africa in rituals designed to communicate with their gods (fig. 13). It once held the palm nuts offered at the beginning of ceremonies in which

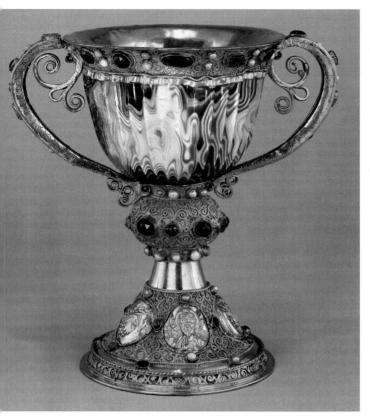

12. Chalice of Abbot Suger, from Abbey Church of Saint-Denis, France. Cup: Ptolemaic Egypt (2nd–1st century BCE) or Byzantine 11th century, sardonyx; mounts: France, 1137–40, silver gilt, adorned with filigree, semiprecious stones, pearls, glass insets, and opaque white glass with modern replacements. $7\frac{1}{2} \times 4^{1}/4$ " (19 × 10.8 cm). National Gallery of Art, Washington, D.C.

Widener Collection, (1942.9.277)

people call on the god Olodumare (or Olorun) to reveal their destiny. Carved by the Yoruba master Olowe of Ise in about 1925, this sculpture appears to be a woman with a child on her back holding an ornate covered cup. Men and women help the woman support the bowl, and more women link arms in a ritual dance on the cover. A bearded head rolls freely in the cage formed by the figures. The child suggests the life-giving power of women and perhaps ultimately of Olodumare. The richly decorative and symbolic wood carving, even when isolated in a museum case, reminds us of all who sought to learn from Olodumare, the god of destiny, certainty, and order.

Today Suger's chalice no longer functions in the liturgy of the Mass and Olowe's cup stands empty. Placed in museums, these ritual vessels take on a new secular life, enshrined as precious works of art. By linking today's viewers with people in the distant past and in faraway places, they serve an educational purpose very different from the original intention of their makers.

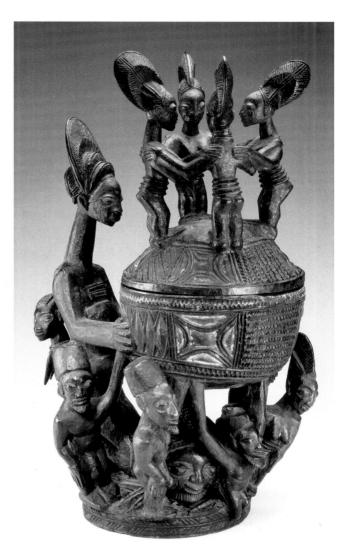

13. Olowe of Ise. Offering bowl, Nigeria, c. 1925. Wood and pigment, height $25^1/_{16}$ " (63.7 cm). National Museum of African Art, Smithsonian Institution, Washington, D.C. Bequest of William A. McCarty-Cooper, (95-10-1)

ART AND THE SOCIAL CONTEXT

The visual arts are among the most sophisticated forms of human communication, at once shaping and being shaped by their social context. Artists may unconsciously interpret their times, but they may also be enlisted to consciously serve social ends in ways that range from heavy-handed propaganda to subtle suggestion. From ancient Egyptian priests to elected officials today, religious and political leaders have understood the educational and motivational value of the visual arts.

How governments—that is, civic leaders—can use the power of art to strengthen the unity that nourishes society was well illustrated in sixteenth-century Venice. There, city officials ordered Veronese (Paolo Caliari, 1528–88) and his assistants to fill the ceiling of the Council Chamber in the ruler's palace with a huge and

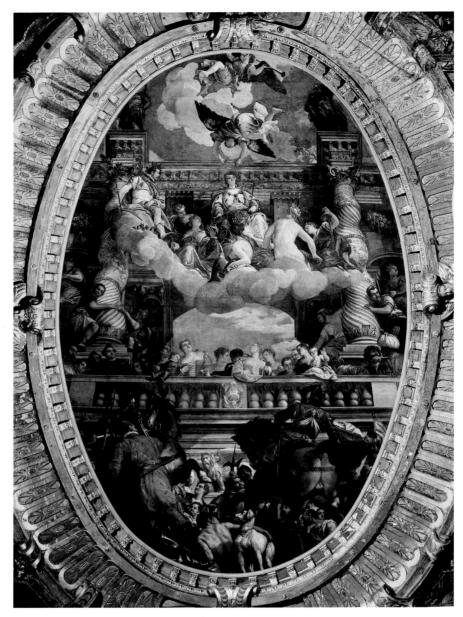

14. Veronese. *The Triumph of Venice*, ceiling painting in the Council Chamber, Palazzo Ducale, Venice, Italy. c. 1585. Oil on canvas, $29'8'' \times 19'$ (9.04×5.79 m).

colorful painting, The Triumph of Venice (fig. 14). Their contract with the artist survives, proclaiming their intention. They wanted a painting that showed their beloved Venice surrounded by peace, abundance, fame, happiness, honor, security, and freedom-all in vivid colors and idealized forms. Veronese complied by painting the city personified as a mature, beautiful, and splendidly robed woman enthroned between the towers of the arsenal, a building where ships were built for worldwide trade, the source of the city's wealth and power. Veronese painted enthusiastic crowds of cheering citizens, while personifications of Fame blow trumpets and Victory crowns Venice with a wreath. Supporting this happy throng, bound prisoners and piles of armor attest to Venetian military power. The Lion of Venice—the symbol of the city and its patron, Saint Mark—oversees the triumph. Veronese has created a splendid propaganda piece as well as a work of art. Although Veronese created his work to serve the purposes of his patron, his artistic vision was as individualistic as that of James Hampton, whose art was purely a form of self-expression.

WHO ARE ARTISTS?

We have focused so far on works of art. But what of the artists who make them? How artists have viewed themselves and been viewed by their con-

temporaries has changed dramatically over time. In Western art, artists were first considered artisans or craftspeople. Ancient Greeks and Romans, for example, ranked artists among the skilled workers; they admired the creations, but not the creators. People in the Middle Ages went to the opposite extreme and attributed especially fine works of art to angels or to Saint Luke. Artists

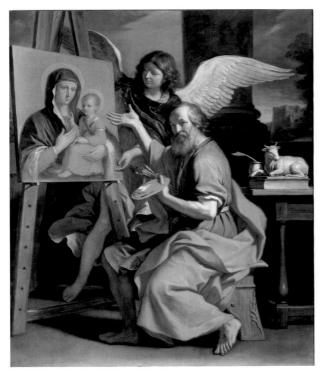

15. Il Guercino. Saint Luke Displaying a Painting of the Virgin. 1652-53. Oil on canvas, $7'3''\times5'11''$ (2.21 \times 1.81 m). The Nelson-Atkins Museum of Art, Kansas City, Missouri.

Purchase (F83-55)

16. Dale Chihuly. *Violet Persian Set with Red Lip Wraps.* 1990. Glass, $26 \times 30 \times 25$ " ($66 \times 76.2 \times 63.5$ cm). Spencer Museum of Art, The University of Kansas, Lawrence. Museum purchase: Peter T. Bohan Art Acquisition Fund, (1992.2)

continued to be seen as craftspeople—admired, often prosperous, but not particularly special—until the Renaissance, when artists such as Leonardo da Vinci proclaimed themselves to be geniuses with unique God-given abilities.

Soon after Leonardo's declaration of superiority, the Italian painter Il Guercino (Giovanni Francesco Barbieri, 1591–1666) synthesized the idea that saints and angels have miraculously made art with the concept that human painters have special, even divinely inspired, gifts. In his painting Saint Luke Displaying a Painting of the Virgin (fig. 15), Guercino portrays the evangelist who was regarded as the patron saint of artists because Christians widely believed that Luke had painted a portrait of the Virgin Mary holding the Christ Child. In Guercino's work, Luke, seated before just such a painting and assisted by an angel, holds his palette and brushes. A book, a quill pen, and an inkpot decorated with a statue of an ox (Saint Luke's symbol) rest on a table, reminders of his status as an evangelist. Guercino seems to say that if Saint Luke is a divinely endowed artist, then surely all other artists share in this special power and status. This image of the artist as an inspired genius has continued into the twenty-first century.

Because art is often a communal creation, we often need to use the plural of the word: *artists*. Even after the idea of "specially endowed" creators emerged, numerous artists continued to see themselves, as they had in many historical periods, as craftspeople led by the head

of a workshop, and oftentimes artwork continued to be a team effort. In the eighteenth century, for example, Utamaro's color woodblock prints (see fig. 9) were the product of a number of people working together. Utamaro painted pictures for his assistants to transfer to blocks of wood. They carved the lines and areas to be colored, covered the surface with ink or colors, and then transferred the image to paper; nevertheless, Utamaro—as the one who conceived the work—is the "creative center."

The same spirit is evident today in the complex glassworks of American artist Dale Chihuly (b. 1941). His team of artist-craftspeople is skilled in the ancient art of glass-making, but Chihuly remains the controlling mind and imagination. Once created, many of his multipart pieces are transformed every time they are assembled; they take on a new life in accordance with the will of every owner. The viewer/owner thus becomes part of the creative team. Made in 1990, *Violet Persian Set with Red Lip Wraps* (fig. 16) has twenty separate pieces, and the person who assembles them determines the composition. Artist and patron thus unite in an ever-changing act of creation.

Whether artists work individually or communally, even the most brilliant ones typically spend years in study and apprenticeship. In his painting *The Drawing Lesson*, Dutch artist Jan Steen (1626–79) takes us into an artist's studio where two people—a boy apprentice and a young woman—are learning the rudiments of their art.

17. Jan Steen. The Drawing Lesson. 1665. Oil on wood, $19^3/_8 \times 16^1/_4$ " (49.3 \times 41 cm). The J. Paul Getty Museum, Los Angeles, California.

The pupil has been drawing from sculpture and plaster casts because women were not permitted to work from nude models (fig. 17). *The Drawing Lesson* records contemporary educational practice and is a valuable record of an artist's workplace in the seventeenth century.

Even the most mature artists learned from each other. In the seventeenth century Rembrandt van Rijn (1606–69) carefully studied Leonardo de Vinci's painting of *The Last Supper* (fig. 18). Leonardo turned this traditional theme into a powerful human drama by portraying the moment when Christ announced that one of the assembled apostles would betray him. The men react with surprise and horror to this shocking news, yet Leonardo depicts the scene as a balanced symmetrical composition with the apostles in groups of three on each side of Christ. The regularly spaced tapestries and ceiling panels lead the viewers' eyes to Christ, who is silhouetted in front of an open window (the door seen in the photograph was cut through the painting at a later date.)

18. Leonardo da Vinci. *The Last Supper*, wall painting in the refectory, Monastery of Santa Maria delle Grazie, Milan, Italy. 1495-98. Tempera and oil on plaster, $15'2'' \times 28'10''$ ($4.6 \times 8.8 \text{ m}$).

19. Rembrandt van Rijn. The Last Supper, after Leonardo da Vinci's fresco. Mid-1630s. Drawing in red chalk, $14^3/8 \times 18^3/4$ " $(36.5 \times 47.5 \text{ cm})$. The Metropolitan Museum of Art, New York. Robert Lehman Collection, 1975 (1975.1.794)

Rembrandt, working 130 years later, in the Netherlands, could only have known the Italian master's painting from a print, since he never went to Italy. Rembrandt copied Leonardo's The Last Supper in hard red chalk (fig. 19). Then he reworked the drawing in a softer chalk, assimilating Leonardo's lessons but revising the composition and changing the mood of the original. With heavy overdrawing he re-created the scene, shifting Jesus' position to the left, giving Judas more emphasis, and adding a dog at the right. Gone are the wall hangings and ceiling, replaced by a huge canopy. The space is undetermined and expansive rather than focused.

Rembrandt's drawing is more than an academic exercise; it is a sincere tribute from one great master to another. The artist must have been pleased with his version of Leonardo's masterpiece because he signed his drawing boldly in the lower right-hand corner.

PATRON?

WHAT IS A As we have seen, the person or group who commissions or supports a work of art—the patron—can have significant impact on it. The

Great Sphinx (see fig. 1) was "designed" by the conventions of priests in ancient Egypt; the monumental statue

of Charles V was cast to glorify totalitarian rule (see fig. 8); the content of Veronese's Triumph of Venice (see fig. 14) was determined by that city's government; Chihuly's glassworks (see fig. 16) are assembled according to the collector's desires, wishes, or whims. Although some artists work independently, hoping to sell their work on the open market, throughout art history both individuals and institutions have acted as patrons of the arts. Patrons very often have been essential factors in the development of arts, but all too often have been overlooked when we study the history of art. Today, not only individuals but also museums, other institutions, and national governments (for example, the United States, through the National Endowment for the Arts) provide support for the arts.

INDIVIDUAL PATRONS

People who are not artists often want to be involved with art, and patrons of art constitute a very special audience for artists. Many collectors truly love works of art, but some who collect art do so to enhance their own prestige, creating for themselves an aura of power and importance. Patrons vicariously participate in the creation of a work when they provide economic support to

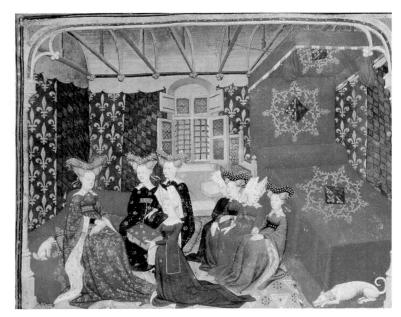

20. Christine de Pizan Presenting Her Book to the Queen of France. 1410–15. Tempera and gold on vellum, image approx. $5^1/_2 \times 6^3/_4$ " (14 × 17 cm). The British Library, London.

MS. Harley 4431, folio 3

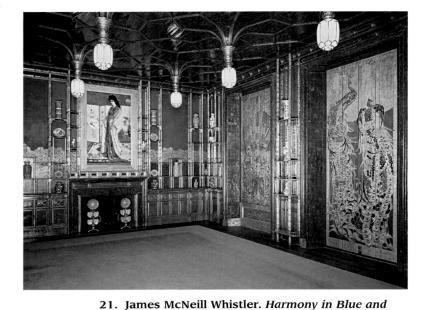

Gold. The Peacock Room, northeast corner, from a house owned by Frederick Leyland, London. 1876–77. Oil paint and metal leaf on canvas, leather, and wood, $13'11^{7}/_{8}" \times 33'2" \times 19'11^{1}/_{2}"$ (4.26 \times 10.11 \times 6.83 m). Over the fireplace, Whistler's *the Princess from the Land of Porcelain*. Freer Gallery of Art, Smithsonian Institution, Washington, D.C.

Gift of Charles Lang Freer, (F1904.61)

the artist. Such individual patronage can spring from a cordial relationship between a patron and an artist, as is evident in an early-fifteenth-century manuscript illustration in which the author, Christine de Pizan, presents her work to Isabeau, the Queen of France. Christine, a widow who supported her family by writing, hired

painters and scribes to copy, illustrate, and decorate her books. She especially admired the painting of a woman named Anastaise, whose work she considered unsurpassed in the city of Paris. Queen Isabeau was Christine's patron; Christine was Anastaise's patron; and all the women seen in the painting were patrons of the brilliant textile workers who supplied the brocades for their gowns, the tapestries for the wall, and the embroideries for the bed (fig. 20).

Relations between artists and patrons do not always prove to be as congenial as Christine portrayed them. Patrons may change their minds and sometimes fail to pay their bills. Artists may ignore their patron's wishes, to the dismay of everyone. In the late nineteenth century, the Liverpool shipping magnate Frederick Leyland asked James McNeill Whistler (1834-1903), an American painter living in London, what color to paint the shutters in the dining room where he planned to hang Whistler's painting The Princess from the Land of Porcelain. The room had been decorated with expensive embossed and gilded leather and finely crafted shelves to show off Leyland's blue-and-white porcelain. Whistler, inspired by the Japanese theme of his own painting as well as by the Asian porcelain, painted the window shutters with splendid turquoise, blue, and gold peacocks. But he did not stop there: While Leland was away, Whistler painted the entire room, covering the gilded leather on the walls with turquoise peacock feathers (fig. 21). Leyland was shocked and angry at what seemed to him to be wanton destruction of the room. Luckily, he did not destroy Whistler's "Peacock Room" (which Whistler called simply Harmony in Blue and Gold), for it is an extraordinary example of total interior design.

INSTITUTIONAL PATRONAGE: MUSEUMS AND CIVIC BODIES

From the earliest times, people have gathered and preserved precious objects that convey the idea of power and prestige. Today both private and public museums are major patrons, collectors, and preservers of art. Curators of such collections acquire works of art for their museums and often assist patrons in obtaining especially fine pieces, although the idea of what is best and what is worth collecting and preserving changes from one generation to another. For example, the collection of abstract and nonrepresentational art formed by members of the Guggenheim family was once considered so radical that few people—and certainly no civic or governmental group—would have considered the art worth collecting at all. Today the collection fills more than one major museum.

Frank Lloyd Wright's (1867–1959) Solomon R. Guggenheim Museum (fig. 22), with its snail-like, continuous spiral ramp, is a suitably **avant-garde** (strikingly new or of a radical nature for the time) home for the collection in New York City. Sited on Fifth Avenue, beside the public green space of Central Park and surrounded on the other three sides by relentless quadrangles of the city buildings, the Guggenheim Museum challenges and relieves the inhumanity of the modern city. The Guggen-

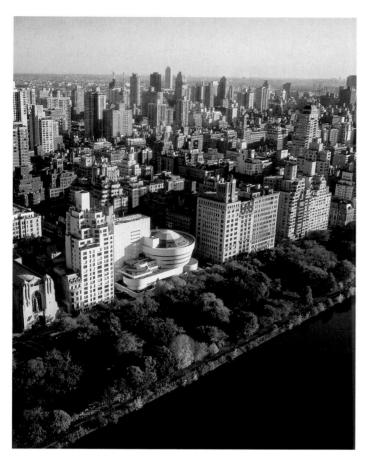

22. Frank Lloyd Wright. Solomon R. Guggenheim Museum, New York City. 1956-59. Aerial view.

heim Foundation recently opened another home for art, in Bilbao, Spain, designed by Frank Gehry (b. 1929), a leader of the twenty-first-century avant-garde in architecture. As both Guggenheim museums show, such structures can do more than house collections; they can be works of art themselves.

Civic sponsorship of art is epitomized by the citizens of fifth-century BCE Athens, a Greek city-state where the people practiced an early form of democracy. Led by the statesman and general Pericles, the Athenians defeated the Persians, then rebuilt Athens's civic and religious center, the Acropolis, as a tribute to the goddess Athena and a testament to the glory of Athens. In figure 23, a nineteenth-century British artist, Sir Lawrence Alma-Tadema (1836-1912), conveys the accomplishment of the Athenian architects, sculptors, and painters, who were led by the artist Pheidias. Alma-Tadema imagines the moment when Pheidias showed the sculpted and painted frieze at the top of the wall of the Temple of Athena (the Parthenon) to Pericles and a privileged group of Athenian citizens—his civic sponsors. We can also see civic sponsorship today in the architecture, including the museums, of most modern national capitals and in the wide variety of public monuments around the world.

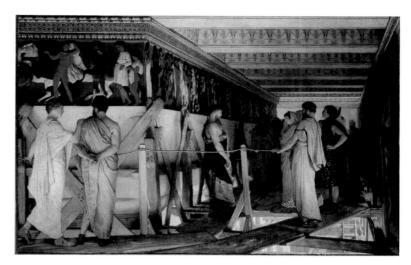

23. Lawrence Alma-Tadema. Pheidias and the Frieze of the Parthenon, Athens. 1868. Oil on canvas, $29^{3}/_{5} \times 42^{1}/_{3}$ " (75.3 × 108 cm). Birmingham City Museum and Art Gallery, England.

WHAT IS As we have seen, common defini-**ART** tions of art usually refer to the product of some combination of skill, HISTORY? training, and observation. But art also depends on what is created, when it

was created, how it was created, the intention of the creator and the anticipated "role" of the creation, perhaps who commissioned it, and certainly the response of the viewer—both at the historical time it was created and in the present. It is the role of art history to help us with these complexities.

Art history became an academic field of study relatively recently. Many art historians consider the first art history book to be the 1550 publication Lives of the Most Excellent Italian Architects, Painters, and Sculptors, by the Italian artist and writer Giorgio Vasari (1511-74). As the name implies, art history combines two very different special studies-the study of an individual work of art outside time and place (formal analysis and theory) and the study of art in its historical and cultural context (contextualism), the primary approach taken in this book. The scope of art history is immense. It shows how people have represented their world and how they have expressed their ideas and ideals. As a result, art history today draws on many other disciplines and diverse methodologies.

STUDYING ART FORMALLY AND CONTEXTUALLY

At the most sophisticated level, the intense study of individual art objects is known as connoisseurship. Through years of close contact with and study of the formal qualities that make up various styles in art (such as design, composition, the way materials are manipulated, an approach known as formalism), the connoisseur places an unknown work with related pieces, attributing

it to a period, a place, and even to an artist. Today such experts also make use of all the scientific tests available to them—such as X-ray radiography, electron microscopy, infrared spectroscopy, and X-ray diffraction—but ultimately they depend on their visual memory and their skills in formal analysis.

Art history as a humanistic discipline adds theoretical and contextual studies to the formal analysis of works of art. Art historians draw on biography to learn about artists' lives, social history to understand the economic and political forces shaping artists, their patrons, and their public, and the history of ideas to gain an understanding of the intellectual currents influencing artists' work (see "The Object Speaks: *Large Plane Trees*," page xlvii). They also study the history of other arts—including music, drama, and literature—to gain a richer sense of the context of the visual arts. Their work results in an understanding of the **iconography** (the narrative and allegorical significance) and the context (social history) of the artwork.

When we become captivated by the mysteriousness of a creation such as the Great Sphinx, with which we began this introduction, art history can help us understand its striking imagery and meaning. We need to know the artwork's total cultural context. We must work with scholars in many other fields; for example, someone has to be able to read Egyptian hieroglyphs to tell us that we are looking at the face of a king. By studying the translations of these hieroglyphs, we study the historical period in which the sculpture was made and learn about the king's earthly power, the culture's belief in an afterlife, and the overwhelming cultural importance of ceremony—all defined and expressed by the monumental Sphinx.

Such intense study of the history of art is also enhanced by the work of anthropologists and archaeologists, who study the wide range of material culture produced by a society. Archaeologists often experience the excitement of finding new and wonderful objects as they reconstruct the social context of the works. They do not, however, single out individual works of perceived excellence, produced for an elite culture, for special attention.

Today art historians study a wider range of artworks than ever before, and many reject the idea of a fixed canon of superior pieces. The distinction between elite fine arts and popular utilitarian arts has become blurred, and the notion that some mediums, techniques, or subjects are better than others has almost disappeared. This is one of the most telling characteristics of art history today, along with the breadth of studies it now encompasses and its changing attitude to challenges such as preservation and restoration.

DEFENDING ENDANGERED OBJECTS

Art historians must be concerned with natural and human threats to works of art. Even as methodological sophistication and technological advances soar in art history today, art historians and other viewers are faced

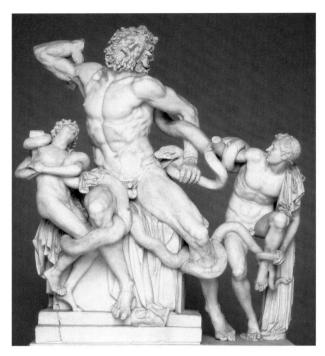

24. Hagesandros, Polydoros, and Athanadoros of Rhodes. *Laocoön and His Sons*, as restored today. Probably the original of 1st century ce or a Roman copy of the 1st century ce. Marble, height 8' (2.44 m). Musei Vaticani, Museo Pio Clementino, Cortile Ottagono, Rome, Italy.

with some special challenges of interpretation, especially regarding works that have been damaged or restored. As we try to understand such works of art, we must remain quizzical and flexible; damaged artworks may have had large parts replaced—the legs of a marble figure or a section of wall in a mural painting, for example. Many of the works seen in this book have been restored, and many have recently been cleaned. Let's look more closely at some of the challenges those issues pose to art historians today.

In some cases, the threats result from well-meaning actions. The dangers inherent in restoration, for example, are blatantly illustrated by what happened during two restorations, hundreds of years apart, of the renowned sculpture *Laocoön and His Sons*.

Laocoön was a priest who warned the Trojans of an invasion by the Greeks in Homer's account of the Trojan War. Although Laocoön told the truth, the goddess Athena, who took the Greeks' side in the war, dispatched serpents to strangle him and his sons. A tragic hero, Laocoön represents a virtuous man destroyed by unjust forces. In the powerful ancient Greek sculpture, his features twist in agony, and the muscles of his and his sons' superhuman torsos and arms extend and knot as they struggle (figs. 24 and 25). When the sculpture was discovered in Rome in 1506, artists such as Michelangelo rushed to see it, and it inspired many artists to develop an ideal, heroic style. The pope acquired it for the papal collection, and it can still be seen in the Vatican Museums.

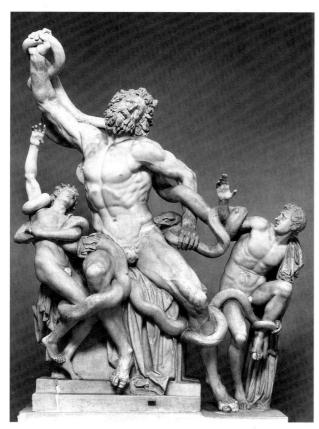

25. Hagesandros, Polydoros, and Athanadoros of Rhodes. *Laocoön and His Sons*, in an earlier restoration.

In piecing together the past of this one work, we know that mistakes were made during an early restoration. The broken pieces of the *Laocoön* group first were reassembled with figures flinging their arms out in the melodramatic fashion seen in figure 25—this was the sculpture the Renaissance and Baroque artists knew. Modern conservation methods, however, have produced a different image and with it a changed mood (fig. 24). Lost pieces are not replaced and Laocoön's arm turns back upon his body, making a compact composition that internalizes the men's agony. This version speaks directly to a self-centered twenty-first century. We can only wonder if twenty-fifth-century art historians will re-create yet another *Laocoön*.

Restoration of works like *Laocoön* is intended to conserve precious art. But throughout the world, other human acts intentionally or mindlessly threaten works of art and architecture—and this is not a recent problem. Egyptian tombs were plundered and vandalized many hundreds of years ago—and such theft continues to this day. Objects of cultural and artistic value in places like Iraq are being poached from official and unofficial excavation sites, then sold illegally.

In industrialized regions of the world, emissions from cars, trucks, buses, and factories turn into corrosive rain that damages and sometimes literally destroys the works of art and architecture on which it falls. For art, however, war is by far the most destructive of all human enterprises. History is filled with examples of plundered

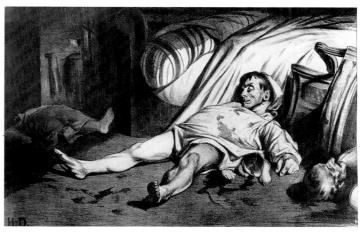

26. Honoré Daumier. *Rue Transonain, Le 15 Avril* **1834.** Lithograph, $11\times17^3/8$ " (28 \times 44 cm). Bibliothèque Nationale, Paris.

works of art that, as spoils of war, were taken elsewhere and paraded and protected. But countless numbers of churches, synagogues, mosques, temples, and shrines have been burned, bombed, and stripped of decoration in the name of winning a war or confirming an ideology. In modern times, with weapons of mass destruction, so much that is lost is absolutely irrecoverable.

Individuals are sometimes moved to deface works of art, but nature itself can be equally capricious: Floods, hurricanes, tornadoes, avalanches, mudslides, and earthquakes all damage and destroy priceless treasures. For example, an earthquake on the morning of September 27, 1997, convulsed the small Italian town of Assisi, where Saint Francis was born and where he founded the Franciscan order. It shook the thirteenth-century Basilica of Saint Francis of Assisi—one of the richest repositories of Italian Gothic and Early Renaissance wall painting—causing great damage to architecture and paintings.

In all the examples mentioned, art historians have played a role in trying to protect the treasures that are the cultural heritage of us all. But they play another role that also affects our cultural heritage: helping to increase our understanding of the social and political factors that contribute to the artwork's context.

UNCOVERING SOCIOPOLITICAL INTENTIONS

Because art history considers the role and intention of artists, art historians have explored—but not always discovered—whether the sculpture of Laocoön, for example, had a political impact in its own time. As we have seen, artists throughout history have been used to promote the political and educational agendas of powerful patrons, but modern artists are often independent—minded, astute commentators in their own right. Art history needs to look at these motivations too. For example, among Honoré Daumier's (1808–79) most powerful critiques of the French government is his print *Rue Transonain*, *Le 15 Avril 1834* (fig. 26). During a

27. Roger Shimomura. *Diary* (Minidoka Series #3). 1978. Acrylic on canvas, $4'11^7/8'' \times 6'^1/16''$ (1.52 × 1.83 m). Spencer Museum of Art, The University of Kansas, Lawrence Museum purchase, (1979.51).

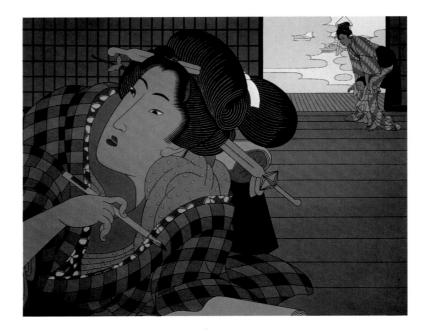

period of urban unrest, the French National Guard fired on unarmed citizens, killing fourteen people. For his depiction of the massacre, Daumier used lithography—a cheap new means of illustration. He was not thinking in terms of an enduring historical record, but rather of a medium that would enable him to spread his message as widely as possible. Daumier's political commentary created such horror and revulsion that the government reacted by buying and destroying all the newspapers in which the print appeared. As this example shows, art historians need to consider not just the historical context but also the political content and the medium of a work of art to have a complete understanding of it.

Another, more recent, work with a powerful sociopolitical message is a reminder to those of us in the twenty-first century who may not know or may have forgotten that American citizens of Japanese ancestry were removed from their homes and confined in internment camps during World War II. Roger Shimomura (b. 1939) in 1978 painted Diary, recalling his grandmother's record of the family's experience in one such camp in Idaho (fig. 27). Shimomura has painted his grandmother writing in her diary, while he (the toddler) and his mother stand by an open door-a door that does not signify freedom but opens on to a field bounded by barbed wire. In this painting—a commentary on twentiethcentury discrimination and injustice-Shimomura combines two formal traditions-the Japanese art of color woodblock prints and American Pop art—to create a personal style that expresses his own dual culture.

Art historians must examine such sociopolitical factors as critical aspects of the historical context of works of art. But what is our responsibility as viewers?

WHAT IS THE VIEWER'S RESPONSIBILITY?

We as viewers enter into an agreement with artists, who in turn make special demands on us. We re-create the works

of art for ourselves as we bring to them our own experiences, our intelligence, even our prejudices. Without our participation, artworks are only chunks of stone or painted canvas. But we must also remember that styles change with time and place. From extreme realism at one end of the spectrum to entirely nonrepresentational art at the other—from van der Spelt and van Mieris's Flower Piece with Curtain (see fig. 3) to Smith's Cubi (see fig. 6)—artists have worked with varying degrees of naturalism, idealism, and abstraction. The challenge for the student of art history is to discover not only how but also why those styles evolved, and ultimately what of significance can be learned from that evolution.

Our involvement with art may be casual or intense, naive or sophisticated. At first we may simply react instinctively to a painting or building or photograph, but this level of "feeling" about art—"I know what I like" can never be fully satisfying. Because as viewers we participate in the re-creation of a work of art, its meaning changes from individual to individual, from era to era. Once we welcome the arts into our lives, we have a ready source of sustenance and challenge that grows, changes, mellows, and enriches our daily experience. This book introduces us to works of art in their historical context, but no matter how much we study or read about art and artists, eventually we return to the contemplation of an original work itself, for art such as Vincent van Gogh's Large Plane Trees (fig. 28, "The Object Speaks") is the tangible evidence of the ever-questing human spirit.

THE OBJECT SPEAKS

LARGE PLANE TREES

In Vincent van Gogh's *Large Plane Trees*, huge trees writhe upward from an undulating earth as tiny men labor to repair a street in the southern French town of Saint-Rémy. The painting depicts an ordinary scene in an ordinary little town. Although the canvas is unsigned, stylistic and technical analysis confirms its attribution to the Post-Impressionist master Vincent van Gogh (1853–90). *Large Plane Trees* now hangs in The Cleveland Museum of Art. Museum curators, who study and care for works of art, have analyzed its physical condition and formed opinions about its quality. They have also traced its **provenance** (the history of its ownership) from the time the painting left the artist's studio until the day it entered their collection.

What Large Plane Trees says to us depends upon who we are. Art historians and art critics looking at this painting from the perspectives of their own specialties and approaches to the study of art's history can and do see many different meanings. Thus, this art object speaks in various ways.

Some art historians have looked at the work through the prism of the biographical facts of van Gogh's life. At the time he painted *Large Plane Trees*, he was suffering from depression and living in an asylum in Saint-Rémy. His brother, Theo, an art dealer in Paris, supported him and saved Vincent's letters, including two that mention this work. Archival research—study in libraries that have original documents, such as letters—is an essential part of art history.

Art historians steeped in the work of Sigmund Freud (1856–1939)—whose psychoanalytic theory addresses creativity, the unconscious mind, and art as expression of repressed feelings—will find in this painting images infused with psychoanalytic meaning. The painting, despite its light, bright colors, might seem to suggest something ominous in the uneasy relationship between the looming trees and tiny people.

In contrast to Freud's search into the individual psyche, the political philosopher Karl Marx (1818–83) saw human beings as products of their economic environment. Marxist art critics might see in van Gogh's life and art a reflection of Marx's critique of humanity's overconcern with material values: van Gogh worked early in his life as a lay minister, identified with the underclass, and never achieved material success. This painting might also speak to such art critics of the economic structures that transform an unsalable nineteenth-century painting into a twentieth-century status symbol for the wealthy elite. Similarly, feminist art critics would challenge how the worth of a painting is determined and question the assumption that a painting by Van Gogh should bring a higher price than a painting by Georgia O'Keeffe (see fig. 4).

Works of art can also be pproached from a purely theoretical point of view. Early in the twentieth century, the Swiss linguist Ferdinand de Saussure (1857–1913) developed structuralist theory, which defines language as a system of arbitrary signs. Painting, too, can be treated as a

language in which the marks of the artist (the lines and colors) replace words as signs. In the 1960s and 1970s, structuralism evolved into other critical tools to determine what a painting may have to say, such as semiotics (the theory of signs and symbols) and deconstruction.

To the semiologist, *Large Plane Trees* is an arrangement of colored marks on canvas. To decode the message, the critic is not concerned with the artist's meaning or intention but rather with the "signs" van Gogh used. The "correct" interpretation is no longer of interest. Similarly, the deconstructionism of the French philosopher Jacques Derrida (b. 1930) questions all assumptions and frees the viewer from the search for a single, correct interpretation. So many interpretations emerge from the creative interaction between the viewer and the work of art that in the end the artwork is "deconstructed."

Today, critics and art historians have begun to reconsider artworks as tangible objects. Many have turned their attention from pure theory to a contextual or social history of art. Some have even taken up connoisseurship again.

The existence of so many approaches to a work of art may lead us to the conclusion that any idea or opinion is equally valid. But art historians, regardless of their theoretical stance, would argue that the informed mind and eye are absolutely necessary. The creation of works of art remains a uniquely human activity, and knowledge of the history of art is essential if art is to truly speak to us.

28. Vincent van Gogh. *Large Plane Trees.* 1889. Oil on canvas, $28\times35^1/_8$ " (73.4 \times 91.8 cm). The Cleveland Museum of Art.

Gift of the Hanna Fund, 1947.209

17-1. Paolo Uccello. The Battle of San Romano. 1438–40. Tempera on wood panel, approx. $6' \times 10'7''$ (1.83 \times 3.23 m). National Gallery, London. Reproduced by courtesy of the Trustees.

17

EARLY RENAISSANCE ART IN EUROPE

HE FEROCIOUS BUT BLOODLESS BATTLE WE SEE AT LEFT (FIG. 17-1) COULD take place only in our dreams. Under an elegantly fluttering banner, the Florentine general Niccolò da Tolentino leads his men against the Sienese at the Battle of San Romano, which took place June 1, 1432, near Pisa, in Italy. Niccolò holds aloft his baton of command, a sign of his absolute authority and obedience. His gesture, together with his white horse and fashionable gold damask hat, ensure that Niccolò dominates the scene. The general's knights charge into the fray, and when they fall, like the soldier at the lower left, they join the many broken lances on the ground—all arranged in conformity with the new mathematical depiction of space, one-point (also called linear) perspective.

The battle rages across a shallow stage, defined by the debris of warfare arranged in a neat pattern on the pink ground and backed by a tapestry-like hedge of blooming orange trees and rose bushes. In the cultivated hills beyond, crossbowmen prepare their lethal bolts. An eccentric painter nicknamed Paolo Uccello ("Paul of the Birds") (c. 1397–1475) created this panel painting, housed in London's National Gallery. Uccello also painted two others like it, which reside in major museums in Florence and Paris.

The strange history of these paintings has only recently come to light. Lionardo Bartolini Salimbeni (1404–79), who headed the Florentine Council of Ten during the war against Lucca and Siena, probably commissioned the paintings. Uccello's remarkable accuracy when depicting armor from the 1430s, heraldic banners, and even fashionable fabrics and crests would appeal to civic pride. The hedges of oranges, roses, and pomegranates—all ancient fertility symbols—suggest that Lionardo might have commissioned the paintings at the time of his wedding, in 1438. He and his wife Maddalena had six sons, two of whom inherited the paintings. According to a complaint brought by one of the heirs, Damiano, Lorenzo de' Medici "forcibly removed" the paintings from his house. The paintings were never returned to Damiano, and Uccello's masterpieces are recorded in a 1492 inventory as hanging in Lorenzo's private chamber in the Medici Palace. Perhaps Lorenzo, who was called "the Magnificent," saw Uccello's heroic pageant as a trophy worthy of a Medici merchant prince.

In the sixteenth century the artist, courtier, and historian Giorgio Vasari devoted a chapter to Paolo Uccello (whose real name was Paolo di Dono) in his book, *The Lives of the Most Excellent Italian Architects, Painters, and Sculptors*. He described Uccello as a man so obsessed with the study of perspective that he neglected his painting, his family, and even his beloved birds, until he finally became "solitary, eccentric, melancholy, and impoverished." (Vasari, p. 79). His wife "used to declare that Paolo stayed at his desk all night, searching for the vanishing points of perspective, and when she called him to bed, he dawdled, saying: 'Oh, what a sweet thing this perspective is!'" (Vasari, p. 83).

(translation by J.C. and P. Bondanella, Oxford, 1991)

TIMELINE 17-1. Early Renaissance Europe. The fifteenth century in Europe was an intense period of transformation, aided by the introduction of printing, the growth of cities, and a rapid secularization of whole societies.

Map 17-1. Early Renaissance Europe.

The Renaissance flourished first in northern Europe, then in Italy.

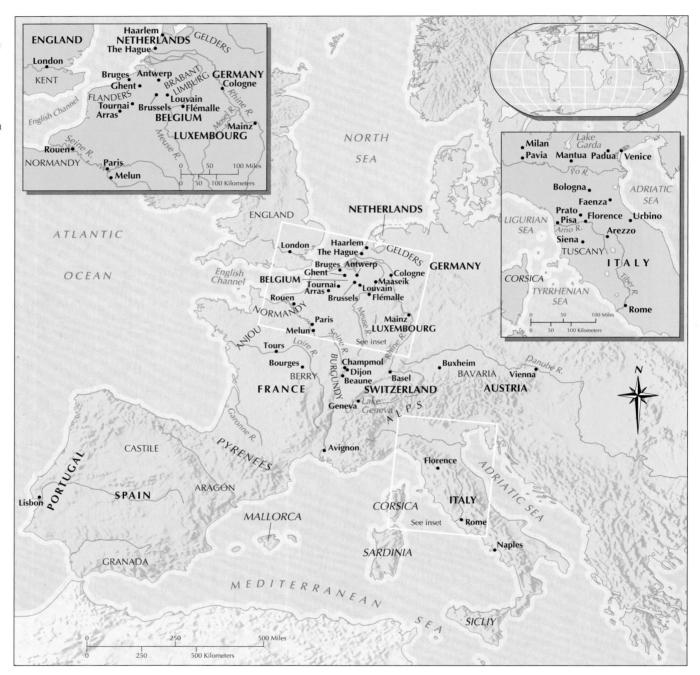

THE RENAISSANCE AND HUMANISM

In western Europe, many of the developments of the late Middle Ages, such as urbanization, intellectualism, and vigorous artistic

patronage, reached maturity in the fifteenth century. Underlying these changes was the economic growth in the late fourteenth century that gave rise to a prosperous middle class of merchants and bankers. Unlike the hereditary aristocracy that had dominated society through the

late Middle Ages, these businesspeople had attained their place in the world through personal achievement. In the early fifteenth century, the newly rich middle class supported scholarship, literature, and the arts. Their generous patronage resulted in the explosion of learning and creativity known as the Renaissance. Artists and patrons, especially in Italy, began to appreciate classical thought and art, as well as the natural world.

The characterization of the period as a renaissance (from the French word for "rebirth") originated with

- ▲ 1452 HAPSBURGS BEGIN RULE OF HOLY ROMAN EMPIRE
 - ▲ 1453 HUNDRED YEARS' WAR ENDS
- ▲ 1469–92 LORENZO DE' MEDICI RULES FLORENCE

1492–98 COLUMBUS DISCOVERS THE ▲
WEST INDIES AND SOUTH AMERICA
1498 SAVONAROLA EXECUTED ▲

fourteenth-century scholars like the great humanist and poet Petrarch. Petrarch looked back at the thousand years extending from the collapse of the Roman Empire to his own time and determined that history fell into three distinct periods: The ancient classical world, a time of high human achievement, was followed by a decline during the Middle Ages, or "dark ages." The third period was the modern world—his own era—a revival, a rebirth, a renaissance, when humanity began to emerge from an intellectual and cultural stagnation and scholars again appreciated the achievements of the ancients. For all our differences, we still live in Petrarch's modern period—a time when human beings, their deeds, and their beliefs have primary importance. But today, we view the past differently. Unlike fourteenth-century scholars, we understand history as a gradual unfolding of events, changing over time. We can see now that the modern worldview that emerged during the fourteenth century was based on continuity and change through the preceding centuries.

Humanism, a nineteenth-century term, is used narrowly to designate the revival of classical learning and literature. More generally, in fourteenth- and fifteenth-century western Europe, humanism embodied a world-view that focused on human beings; an education that perfected individuals through the study of past models of civic and personal virtue; a value system that emphasized personal effort and responsibility; and a physically or intellectually active life that was directed at a common good as well as individual nobility. To this end, the Greek and Latin languages had to be mastered so that classical literature—history, biography, poetry, letters, orations—could be studied.

For Petrarch and his contemporaries in Italy, the defining element of the age was an appreciation of Greek and Roman writers. In fact, throughout the Middle Ages, classical texts had been essential for scholarsfrom the monks in Charlemagne's eighth-century monasteries, who preserved the books, to the students who mastered them in the universities that arose in the twelfth and thirteenth centuries in Italy, France, and England. Especially important to the Renaissance was the balance of faith and reason addressed by philosophers in the twelfth century and achieved by the Scholasticist Thomas Aquinas in the Summa theologica of 1267-73, which still forms the basis of Roman Catholic philosophy. Scholasticism underlay such literary works as the Divine Comedy of Dante-who with literary figures like Petrarch and Boccaccio and the artists Cimabue (active c. 1272-1302), Duccio (active 1278–1318), and Giotto (1266/7–1337) fueled the cultural explosion of fourteenth-century Italy.

In literature Petrarch was a towering figure of change, a poet whose love lyrics were written not in Latin but for the first time in the spoken language of his

own time. A similar role was played in painting by the Florentine Giotto di Bondone, who observed the people around him and captured their gestures and emotions in deeply moving mural paintings. Essentially a Gothic artist, Giotto created massive three-dimensional figures, modeled by a natural and consistent light and depicted in a shallow yet clearly defined space. One of art's great storytellers, Giotto made biblical events and their theological implications immediately understandable to the new patrons of art in northern Italy-merchants and bankers like Enrico Scrovegni of Padua, who commissioned Giotto to decorate a chapel dedicated in 1305 to the Virgin of Charity and the Virgin of the Annunciation (fig. 17-2, page 580). As viewers look toward the altar they see the story of Mary and Joseph unfolding before them in a series of rectangular panels.

Both Giotto's narrative skills and his awareness of the medieval tradition of **typology**—in which earlier Old Testament events foreshadow the New Testament—are apparent in the paintings of the chapel (fig. 17-3, page 581). The life of the Virgin Mary begins the series. Events in the life and ministry of Jesus circle the chapel in the middle register, or layer of space, while scenes of the Passion (the arrest, trial, and Crucifixion of Jesus) fill the lowest register. Thus, the first miracle, when Jesus changes water to wine during the wedding feast at Cana (recalling that his blood will become the wine of the Eucharist, or Communion), is followed by the raising of Lazarus (a reference to his own Resurrection). Below, the Lamentation over the body of Jesus by those closest to him leads to the Resurrection, indicated by angels at the empty tomb and his appearance to Mary Magdalen in the Noli Me Tangere ("Do not touch me"). The juxtaposition of dead and live trees in the two scenes becomes a telling detail of death and resurrection. Giotto used only a few large figures and essential props in settings that never distract by their intricate detail. The scenes are reminiscent of the tableaux vivants ("living pictures," in which people dressed in costume re-created poses from familiar works of art) that were played out in the piazza in front of the chapel in Padua.

Outside Italy, interest in the natural world manifested itself in the detailed observation and recording of nature. Artists depicted birds, plants, and animals with breath-taking accuracy. They observed that the sky is more colorful straight above than at the horizon, and they painted it that way and so developed **aerial perspective**. They, like Giotto, emphasized three-dimensional modeling of forms with light and shadow.

Along with the desire for accurate depiction came a new interest in individual personalities. Fifteenth-century portraits have an astonishingly lifelike quality, combining careful—sometimes even unflattering—description with an uncanny sense of vitality. In a number of religious paintings, even the saints and angels

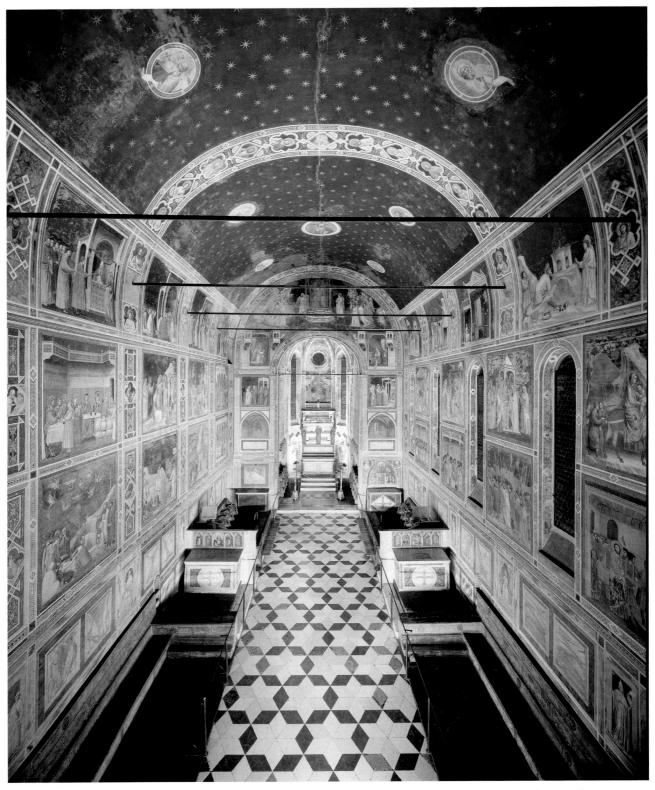

17-2. Giotto di Bondone. Frescoes, Scrovegni (Arena) Chapel, Padua. 1305–1306. View toward east wall.

seem to be portraits. Indeed, individuality became important in every sphere. More names of artists survive from the fifteenth century, for example, than in the entire span from the beginning of the Common Era to the year 1400. A similar observation might be made in nearly every other field.

One reason for this new emphasis on individuality was the humanist interest not only in antiquity but also in people. Humanists sought the physical and literary records of the ancient world—assembling libraries, collecting sculpture and fragments of architecture, and beginning archaeological investigations of ancient

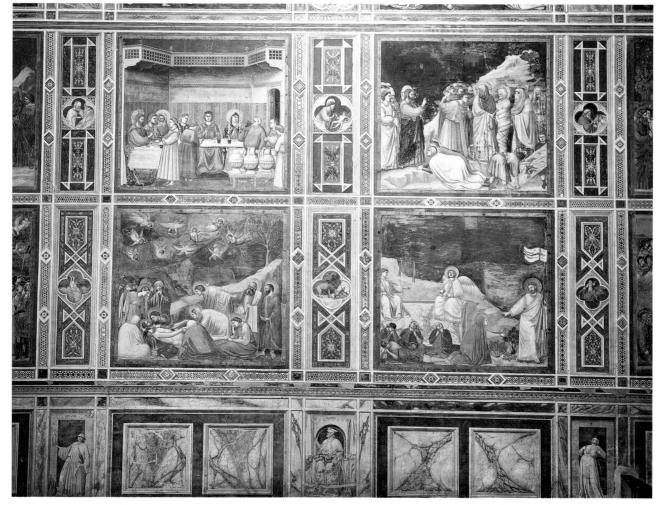

17-3. Giotto di Bondone. *Marriage at Cana, Raising of Lazarus, Resurrection and Noli Me Tangere,* and *Lamentation* (clockwise from upper left), frescoes on north wall of Scrovegni (Arena) Chapel, Padua. 1305–6.

Rome—so that they could understand an imagined golden age in order to achieve personal freedom and dignity for everyone in their own time. Their aim was to live a rich, noble, and productive life within the framework of Christianity. Needless to say, the humanist ideal was seldom achieved. Nevertheless, these people extended education to the laity, investigated the natural world, and subjected philosophical and theological positions to logical scrutiny. They constantly invented new ways to extend humans' intellectual and physical reach.

The rise of humanism did not signify a decline in the importance of Christian belief. In fact, an intense Christian spirituality continued to inspire and pervade most European art through the fifteenth century and long after. But despite the enormous importance of Christian faith, the established Western Church was plagued with problems in the fifteenth century. Its hierarchy was bitterly criticized for a number of practices, including a perceived indifference to the needs of common people. These strains within the Western Church exemplified the skepticism of the Renaissance mind. In the next century, they would give birth to the Protestant Reformation.

While wealthy and sophisticated men in the highest ranks of the clergy—bishops, cardinals, and the pope himself—and the royal and aristocratic courts continued to play major roles in the support of the arts, increasingly the urban lay public sought to express personal and civic pride by sponsoring secular architecture, sculpted monuments, and paintings directed toward the community, as well as town houses, fine furnishings, and portraits of family members. The commonsense values of the merchants formed a solid underpinning for humanist theories and enthusiasms.

Two ideal cities, as seen through contemporary eyes, exemplify the fifteenth-century view as it emerged in northern and southern Europe. In Robert Campin's *Mérode Altarpiece* (see fig. 17-11), windows in Joseph's carpentry shop open onto a view of a prosperous Flemish city (fig. 17-4, page 582). Tall, well-kept houses crowd around churches, whose towers dominate the skyline. People gather in the open market square, walk up a major thoroughfare, and enter the shops, whose open doors and windows suggest security as well as commercial activity. The tall, narrow buildings recall the

17-4. Robert Campin. *Joseph in His Carpentry Shop*, detail of right wing of the *Mérode Altarpiece (Triptych of the Annunciation)*, fig. 17-11. c. 1425–28. Oil on wood panel, approx. $25\frac{3}{8} \times 10^3/4$ " (64.5 × 27.3 cm). The Metropolitan Museum of Art, New York.

The Cloisters Collection, 1956 (56.70)

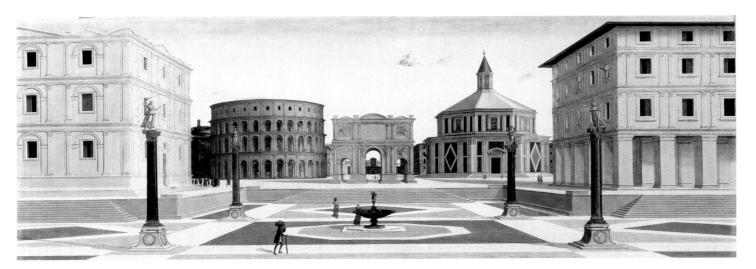

17-5. Anonymous. *Ideal City with a Fountain and Statues of the Virtues.* c. 1500. Oil on wood panel, $2'6^1/2'' \times 7'1^5/8''$ (0.77 × 2.17 m). Walters Art Gallery, Baltimore.

picturesque look of a medieval town; and the painter, with detailed realism, represents the architecture and people as a visual record.

The ideal Italian city depicted by an anonymous north Italian painter in figure 17-5 is based on different assumptions. Walking through this balanced and harmonious piazza would feel quite different from dropping in on one of the Flemish shops. The Italian cityscape—with its classical references and precise **linear perspective** (see "Renaissance Perspective Systems," opposite)—invites us, instead, to contemplate the look and clarity of a well-ordered civic life. Cubical palaces flank a vast square closed off by three buildings that re-

call the Roman Colosseum, Constantine's triumphal arch, and the Florentine Baptistry, monuments of much earlier periods. In the center of the piazza, a woman draws water from a splendid community well, evidence of the ruler's (or town council's) generosity in providing fresh water for the citizens.

These images of two ideal cities present us with different but congenial aspects of fifteenth-century life and art: the observable reality and bustle of human activity viewed from an artisan's workshop, its spaces suggested through an observed, intuitive atmosphere, as compared to the orderly city controlled by a benevolent government depicted in a logical, intellectual construct

RENAISSANCE PERSPECTIVE SYSTEMS

The humanists' scientific study of the natural world and their belief that "man is the measure of all things" led to the invention of a mathematical system enabling artists to represent the visible world in a convincingly illusionistic way. This system—known variously as mathematical, linear, or **one-point perspective**—was first demonstrated by the architect Filippo Brunelleschi about 1420. In 1435 Leon Battista Alberti codified mathematical perspective in his treatise De pictura (On Painting), making a standardized, somewhat simplified method available to a larger number

of draftspeople, painters, and relief sculptors. One artist, Paolo Uccello (1397–1475), devoted his life to the study of perspective (see fig. 17-1).

These artists considered the picture's surface a flat plane that intersected the viewer's field of vision at a right angle. In Alberti's highly artificial system, a one-eyed viewer was to stand at a prescribed distance from a work, dead center. From this fixed vantage point everything in a picture appeared to recede into the distance at the same rate, following imaginary lines called **orthogonals** that met at a single vanishing point on the horizon. Using orthogonals as a guide, artists could distort—or

foreshorten—objects, replicating the optical illusion that things appear smaller and closer together the farther away they are from us. Despite its limitations, mathematical perspective extends pictorial space into real space, providing the viewer with a direct, almost physical connection to the picture. It creates a compelling, even exaggerated sense of depth.

Early Renaissance artists following Alberti's system relied on a number of mechanical methods. Many constructed devices with peepholes through which they sighted the figure or object to be represented. They used mathematical formulas to translate three-dimensional forms onto the picture plane, which they overlaid with a grid to provide reference points, or emphasized the orthogonals by including linear forms, such as tiled floors and buildings, in the composition. As Italian artists became more comfortable with mathematical perspective over the course of the fifteenth century, they came to rely less on peepholes, formulas, and linear forms. Many artists adopted multiple vanishing points, which gave their work a more relaxed, less tunnel-like feeling.

In the north, artists such as Jan van Eyck refined intuitive perspective to approximate the appearance of things growing smaller and closer together in the distance, coupling it with atmospheric, or aerial, perspective. This technique—applied to the landscape scenes that were a northern specialty-was based on the observation that haze in the atmosphere causes distant elements to appear less distinct and less colorful, the sky to become paler as it nears the horizon, and the distant landscape to turn to a bluish Among southern artists, Leonardo da Vinci made extensive use of atmospheric perspective, while in the north, the German artist Albrecht Dürer adopted the Italian system of mathematical perspective toward the end of the fifteenth century (Chapter 18).

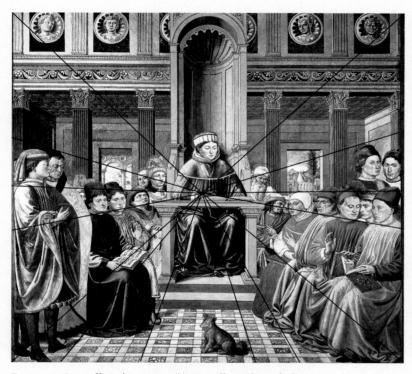

Benozzo Gozzoli. *Saint Augustine Reading Rhetoric in Rome*, fresco in the choir of the Church of Sant'Agostino, San Gimignano, Italy. 1464–65.

In the 1460s Benozzo Gozzoli (1421–97) began to paint scenes from the life of Saint Augustine for the church dedicated to him in the Tuscan hill town of San Gimignano. In this painting, he shows his debt to Alberti's theories of perspective, from the coffered ceiling to the tiled floor. Gozzoli's use of strict one-point perspective here also suggests the orderliness and rationality of Augustine's thought. Distant views flank the thronelike seat of the professor-saint, while rows of solemn students at either side of Augustine's desk fill a foreground space that is carefully defined by classical columns and friezes. Only the small dog at the saint's feet breaks the driving force of one-point perspective in the pattern of the floor tiles.

of linear perspective. One has a warm picturesqueness, while the other suggests a cool, balanced, unachievable ideal. To explore how these two images were forged, we will begin in the powerful courts of French royalty, whose patronage supported and in fact spread the early Renaissance style in northern Europe.

ART OF THE FRENCH DUCAL COURTS

In the late Middle Ages, French kings, with their capital in Paris, began to emerge as the powerful rulers of a national state. Nevertheless, in the fourteenth and fifteenth centuries, their royal

authority was constrained by the nobles who controlled large territories outside the Paris region. Some of these nobles were even powerful enough to pursue their own policies independently of the king. Many of the great dukes were members of the royal family, although their interests rarely coincided with those of the king. One strong unifying factor was the threat of a common enemy: England, whose kings held large territories in western France and repeatedly fought France between 1337 and 1453 in a series of conflicts known as the Hundred Years' War.

While the French king held court in Paris, the most powerful of the dukes held even more splendid courts in their own capitals. Through much of the fourteenth century, these centers were arbiters of taste for most of Europe. From the last decades of the fourteenth century up to the 1420s, French court patronage was especially influential in northern Europe. The French king and his relatives the dukes of Anjou, Berry, and Burgundy employed not only local artists but also gifted painters and sculptors from the Low Countries (present-day Belgium, Luxembourg, and the Netherlands; Map 17-1). In the south of France, a truly international style emerged at the papal court at Avignon, where artists from Italy, France, and Flanders worked side by side. Of major importance in the creation and spread of the new International Gothic style was the construction and decoration of a monastery and funeral chapel at Champmol near Dijon, for the duke of Burgundy (see pages 587-88).

The International Gothic style, the prevailing manner of the late fourteenth century, is characterized by gracefully posed figures, sweet facial expressions, and naturalistic details, including carefully rendered costumes and textile patterns, presented in a palette of bright and pastel colors with liberal touches of gold. The

International Gothic style was so universally appealing that patrons throughout Europe continued to commission such works throughout the fifteenth century.

MANUSCRIPT ILLUMINATION

Many nobles collected illustrated manuscripts, and in the late fourteenth century workshops in France and the Netherlands produced outstanding manuscripts for them. Besides religious texts, secular writings such as herbals (encyclopedias of plants), health manuals, and both ancient and contemporary works of history and literature were in great demand.

The painters in the Netherlands and Burgundy, skilled at creating an illusion of reality, increasingly influenced France and the illumination, or illustration, of books at the beginning of the fifteenth century. Women artists gained increasing importance too (see "Women Artists in the Late Middle Ages and the Renaissance," opposite). The most famous Netherlandish illuminators of the time were three brothers—Paul, Herman, and Jean—commonly known as the Limbourg brothers. In the fifteenth century, people were known by their first names, often followed by a reference to their place of origin, parentage, or occupation (see "Italian Artists' Names and Nicknames," below). The name used by the three Limbourg brothers, for example, refers to their home region. (Similarly, Jan van Eyck means "Jan from [the town of] Eyck." This chapter uses the forms of artists' names as they most commonly appear today.)

The Limbourg brothers are first recorded as apprentice goldsmiths in Paris around 1390. About 1404 they entered the service of the duke of Berry, for whom they produced their major work, the so-called *Très Riches Heures (Very Sumptuous Hours)*, between 1413 and 1416. For the calendar section of this Book of Hours—a

ITALIAN ARTISTS' NAMES AND NICKNAMES

Italy's best-known artists are still known by their nicknames. Who today knows Botticelli by his real name, Alessandro di Mariano Filipepi? Botticelli was raised by an older brother who was a pawnbroker with the nickname Botticello ("The Keg"). Evidently the nickname stuck to the artist brother too. Ghirlandaio was born Domenico di Tommaso Bigordi. His father, a goldsmith who made the gilded garlands Florentines wore on special occasions, took the name Ghirlandaio ("Garland Maker"), so the son became Domenico Ghirlandaio. Antonio di Jacopo Benci, who was known as Pollaiuolo, came from a family of chicken (pollo) sellers.

Other nicknames were more personal. Tommaso di Ser Giovanni di Mone Cassai became Masaccio. "Maso" is the short form of "Tommaso," and *-accio* is a derogatory suffix, so the nickname means "Ugly Tom," or "Clumsy Tom," or "Cruderude Tom." Paolo di Dono was called Paolo Uccello ("Paul of the Birds") because of his love for birds.

Donatello, however, is simply a friendly version of Donato di Niccolò de Betto di Bardi. The painter Guido di Pietro, who became a Dominican friar, came to be known as Fra Angelico ("The Angelic Brother") because of his piety and the beauty of his painting.

Traditional artists' names may indicate the artist's place of birth rather than family. Andrea del Castagno was born in Castagno as Andrea degli Impiccati, just as Leonardo da Vinci was born in Vinci. When the surname refers to a place rather than a family name (a patronymic), the artist is usually referred to by the baptismal (first) name. Thus, Leonardo da Vinci should be shortened to Leonardo, not da Vinci. However, in the case of the two painters named Michelangelo, Michelan-Buonarroti (a family gelo name) is known simply Michelangelo, while Michelangelo da Caravaggio (a place-name) is called Caravaggio.

WOMEN ARTISTS IN THE LATE MIDDLE AGES AND THE RENAISSANCE

Medieval and Renaissance women artists typically learned to paint from their husbands and fathers because formal apprenticeships were not open to them. Noblewomen, who were often educated in convents, learned to draw, paint, and embroider. One of the earliest examples of a signed work by a woman painter is a tenth-century manuscript of the

Apocalypse illustrated in Spain by a woman named Ende, who describes herself "painter and helper of God." In Germany, women began to sign their work in the twelfth century. For example, a collection of sermons was decorated by a nun named Guda, who not only signed her work but also included a selfportrait, one of the earliest in Western art.

Jeanne de Montbaston and her husband, Richart, worked together as book illuminators under the auspices of the University of Paris in the fourteenth century. After Richart's death, Jeanne continued the workshop and, following the custom of the time, was sworn in as a libraire (publisher) by the university in 1353. In the fifteenth century, women could be admitted to the guilds in some cities, including the Flemish towns of Ghent, Bruges, and Antwerp, and by the 1480s one-quarter of the painters' guild of Bruges was female.

Particularly talented women received commissions of the highest order. Bourgot, the daughter of the miniaturist Jean le Noir, illuminated books for Charles V of France and Jean, Duke of Berry. Christine de Pizan (1365–c. 1430), a well-known writer patronized

by Philip the Bold of Burgundy and Queen Isabeau of France, described the work of an illuminator named Anastaise, "who is so learned and skillful in painting manuscript borders and miniature backgrounds that one cannot find an artisan . . . who can surpass her . . . nor whose work is more highly esteemed" (*Le Livre de la Cité des Dames*, I.41.4, translated by Earl J. Richards).

In a French edition of a book by the Italian author Boccaccio entitled Concerning Famous Women, presented to Philip the Bold in 1403, the anonymous illuminator shows Thamyris, an artist of antiquity, at work in her studio. She is depicted in fifteenth-century dress, painting an image of the Virgin and Child. At the right, an assistant grinds and mixes the colors Thamyris will need to complete her painting. In the foreground, her brushes and paints are laid out conveniently on a table.

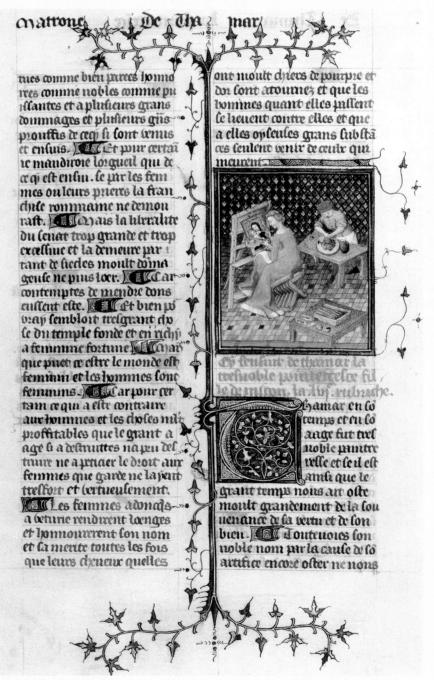

Detail of page with *Thamyris*, from Giovanni Boccaccio's *De Claris Mulieribus (Concerning Famous Women)*. 1402. Ink and tempera on vellum. Bibliothèque Nationale de France, Paris.

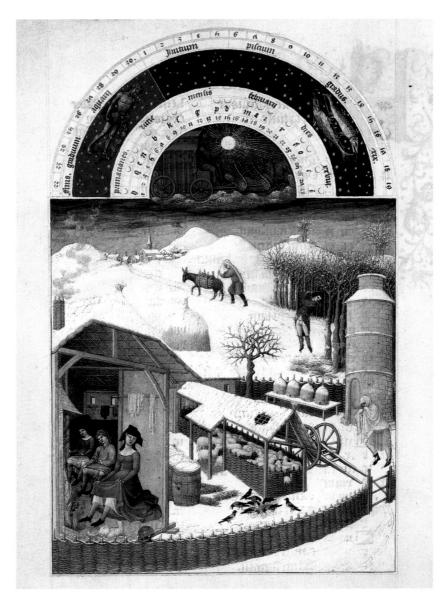

17-6. Paul, Herman, and Jean Limbourg. Page with February, Très Riches Heures. 1413–16. Colors and ink on parchment, $8^7/_8 \times 5^3/_8$ " (22.5 \times 13.7 cm). Musée Condé, Chantilly, France.

selection of prayers and readings keyed to daily prayer and meditation—the Limbourgs created full-page paintings to introduce each month, with subjects including both peasant labors and aristocratic pleasures. Like most European artists of the time, the Limbourgs showed the laboring classes in a light acceptable to aristocrats—that is, happily working for their benefit. But the Limbourgs also showed peasants enjoying their own pleasures. Haymakers on the August page shed their clothes to take a swim in a stream, and September grape pickers pause to savor the sweet fruit they are gathering. In the February page (fig. 17-6), farm people relax cozily before a blazing fire. This farm looks comfortable and well maintained, with timber-framed buildings, a row of beehives, a sheepfold, and tidy woven wattle fences. In the distance are a village and church.

Most remarkably, the artists convey the feeling of cold winter weather: the breath of the bundled-up worker turning to steam as he blows on his hands, the leaden sky and bare trees, the snow covering the landscape, and the comforting smoke curling from the farmhouse chimney. The painting employs several International Gothic conventions: the high placement of the horizon line, the small size of trees and buildings in relation to people, and the cutaway view of the house showing both interior and exterior. The muted palette is sparked with touches of yellowish orange, blue, and a patch of bright red on the man's turban at the lower left. The landscape recedes continuously from foreground to middle ground to background. An elaborate calendar device, with the chariot of the sun and the zodiac symbols, fills the upper part of the page.

PAINTING AND SCULPTURE FOR THE CHARTREUSE DE CHAMPMOL

One of the most lavish projects of Philip the Bold, the duke of Burgundy (ruled 1363–1404) and son of the French king, was the Carthusian monastery, or *chartreuse* ("charterhouse"), founded in 1385 at Champmol, near his capital at Dijon. Its church was intended to house his family's tombs. A Carthusian monastery was particularly expensive to maintain because the Carthusians lived a solitary life as a brotherhood, in effect a brotherhood of hermits. Carthusians did not provide for themselves by farming or other physical work but were dedicated to prayer and solitary meditation. The brothers were expected to pray at all hours for the souls of Philip and his family.

Philip commissioned the Flemish sculptor Jean de Marville (active 1366-89) to direct the sculptural decoration of the monastery. At Jean's death in 1389, he was succeeded by his assistant Claus Sluter (1379–1406), from Haarlem, in Holland. Although much of this splendid complex was destroyed 400 years later during the French Revolution, the quality of Sluter's work can still be seen on the Well of Moses, a monumental sculpted well at the center of the main cloister (fig. 17-7). Begun in 1395, the sculpture was unfinished at Sluter's death. A pier rose from the water to support a large freestanding Crucifixion, with figures of the Virgin Mary, Mary Magdalen, and John the Evangelist. Forming a pedestal for the Crucifixion group are lifesize stone figures of Old Testament men who either foretold the coming of Christ or were in some sense his precursors: Moses (the ancient Hebrew prophet and lawgiver), David (king of Israel and an ancestor of Jesus), and the prophets Jeremiah, Zechariah, Daniel, and Isaiah. These images and their texts must have been based on two contemporary plays, The Trial of Jesus and The Procession of Prophets.

Sluter depicted the Old Testament figures as physically and psychologically distinct individuals. Moses' sad old eyes blaze out from a memorable face entirely covered with a fine web of wrinkles. Even his hornstraditionally given to him because of a mistranslation in the Latin Bible—are wrinkled. A mane of curling hair and a beard cascade over his heavy shoulders and chest, and an enormous cloak envelops his body. Beside him stands David, in the voluminous robes of a medieval king, the personification of nobility. The drapery, with its deep folds creating dark pockets of shadow, is an innovation of Sluter's. While its heavy sculptural masses conceal the body beneath, its strong highlights and shadows visually define the body's volumes. With these vigorous, imposing, and highly individualized figures, Sluter transcended the limits of the International Gothic style and introduced a new style in northern sculpture.

Between 1394 and 1399, the duke also ordered a large altarpiece for the Chartreuse de Champmol (see "Altars and Altarpieces," page 590). This was a **triptych**, a work in three panels, hinged together side by side so that the two side panels, or **wings**, fold over the central one (for an example of a carved altarpiece in a church,

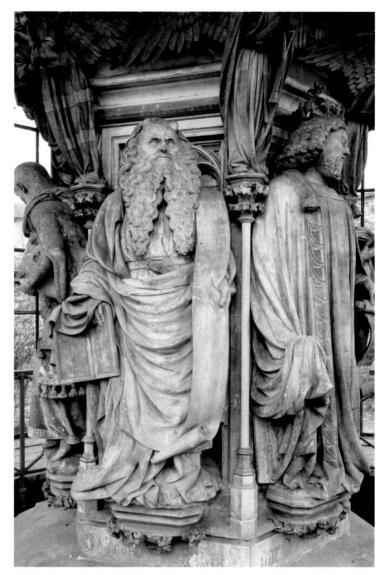

17-7. Claus Sluter. *Well of Moses*, detail of Moses and David, from the Chartreuse de Champmol, Dijon, France. 1395–1406. Limestone with traces of paint, height of figures 5'8" (1.69 m).

The sculpture's original details included metal used for buckles and even eyeglasses. It was also painted: Moses wore a gold mantle with a blue lining over a red tunic; David's gold mantle had a painted lining of ermine, and his blue tunic was covered with gold stars and wide bands of ornament.

see fig. 18-29). Jacques de Baerze, a wood carver, executed the central panel with the Crucifixion in carved reliefs. Melchior Broederlam painted the exteriors of the two protective wings, illustrating scenes from the Life of the Virgin and the Infancy of Christ (fig. 17-8, page 588). The events take place in both architectural and land-scape settings that fill the panels. In International Gothic fashion, both interior and exterior of the building are shown, and the floors are tilted up to give clear views of the action. The landscapes have been arranged to lead the eye up from the foreground and into the distance along a rising ground plane. Despite the imaginative

architecture, fantasy mountains, miniature trees, and solid gold sky, the artist has created a sense of light and air around solid figures.

On the left wing, in the Annunciation, under the benign eyes of God, the archangel Gabriel greets Mary with the news of her impending motherhood. A door leads into the dark interior of the tall pink rotunda meant to represent the Temple of Jerusalem, a symbol of the Old Law, where, according to legend, Mary was an attendant prior to her marriage to Joseph. A tiny enclosed garden and a pot of lilies are symbols of Mary's virginity. In the Visitation, just outside the temple walls, the nowpregnant Mary greets her older cousin Elizabeth, who is also pregnant and will soon give birth to John the Baptist. On the right wing, in the Presentation in the Temple, Mary and Joseph have brought the newborn Jesus to the temple for the Jewish purification rite, where the priest Simeon takes him in his arms to bless him (Luke 2:25–32). At the far right, the Holy Family flees into Egypt to escape King Herod's order that all Jewish male infants be killed. The family travels along treacherous terrain similar to that in the Visitation scene. Much of the detail comes not from New Testament accounts but from legends. Reflecting a new humanizing element creeping into art, Joseph drinks from a flask and carries the family belongings over his shoulder. The statue of a pagan god, visible at the upper right, breaks and tumbles from its pedestal as the Christ Child approaches. Typical of paintings of this period, every detail has meaning.

FLAMBOYANT-STYLE ARCHITECTURE

The great age of cathedral building that had begun about 1150 was over by the end of the fourteenth century, but the growing urban population needed more parish churches and a wide variety of secular buildings. The richest patrons commissioned sculptors to cover their buildings with elaborate decoration inspired by Gothic architectural sculpture and by their increased interest in the realistic depiction of nature, such as ivy and hawthorn leaves. Called the Flamboyant ("flaming" in French) style because of its repeated, twisted, flamelike shapes, this intricate, elegant decoration covered new buildings and was added to older buildings being modernized with spires, porches, or window **tracery**.

The facade of the Church of Saint-Maclou in Rouen, which was begun after a fund-raising campaign in 1432 and dedicated in 1521, perhaps designed by the Paris architect Pierre Robin, is an outstanding example of the Flamboyant style (fig. 17-9). The projecting porch bends to enfold the facade of the church in a screen of tracery. Sunlight on the flame-shaped openings casts flickering, changing shadows across the intentionally complex surface. **Crockets**, small knobby leaflike ornaments that line the steep **gables** and slender **buttresses**, break every defining line. In the Flamboyant style, decoration sometimes seems divorced from structure. Loadbearing walls and buttresses often have stone overlays; traceried **pinnacles**, gables, and **S**-curve **moldings** combine with a profusion of ornament in geometric and

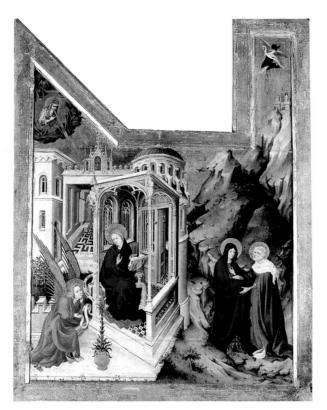

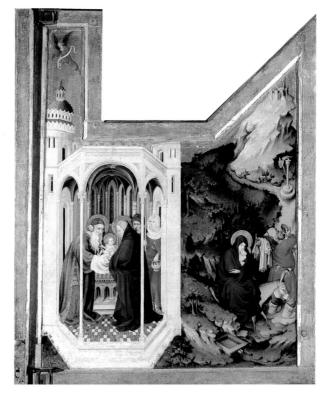

17-8. Melchior Broederlam. Annunciation and Visitation (left); Presentation in the Temple and Flight into Egypt (right), wings of an altarpiece for the Chartreuse de Champmol. 1394–99. Oil on wood panel, $5'5^3/4'' \times 4'1^1/4''$ (1.67 × 1.25 m). Musée des Beaux-Arts, Dijon.

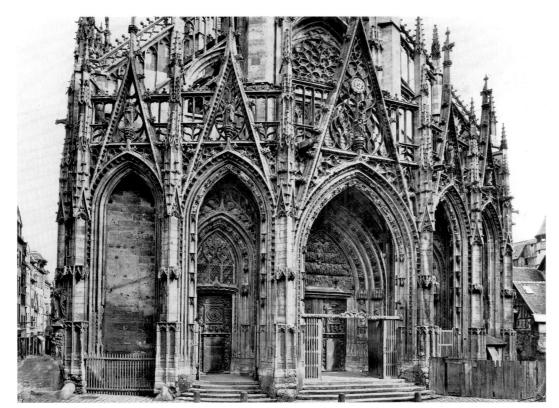

17-9. Pierre Robin (?). West facade, Church of Saint-Maclou, Rouen, Normandy, France. Dedicated 1521; facade c. 1500-14.

natural shapes, all to dizzying effect. The interior of such a church, filled with light from huge windows of grisaille glass, can be seen in the Hours of Mary of Burgundy (see fig. 17-23), and a church under construction is represented by Memling on the Saint Ursula reliquary (see fig. 17-21).

The house of the fabulously wealthy merchant Jacques Coeur in Bourges, in central France, built at great expense between 1443 and 1451, reflects the popularity of the Flamboyant style for secular architecture (fig. 17-10). The rambling, palatial house has many rooms of varying sizes on different levels, all arranged around an open courtyard. Spiral stairs in octagonal towers give access to the rooms. Tympana over doors indicate the function of the rooms within; for example, over the door to the kitchen a cook stirs the contents of a large bowl. Flamboyant decoration enriches the cornices, balustrades, windows, and gables. Among the carved decorations are puns on the patron's surname, Coeur ("heart" in French). The house was also Jacques Coeur's place of business, so it had large storerooms for goods and a strong room for treasure. (A wellstocked merchant's shop can be seen in the painting of A Goldsmith in His Shop; see fig. 17-18.)

FLANDERS

ART OF The southern Netherlands, known as Flanders (today's Belgium and northeastern France), became the leading center of painting outside Italy in the

fifteenth century. Flanders, with its major seaport at Bruges, was the commercial power of northern Europe, rivaled in southern Europe by the Italian city-states of

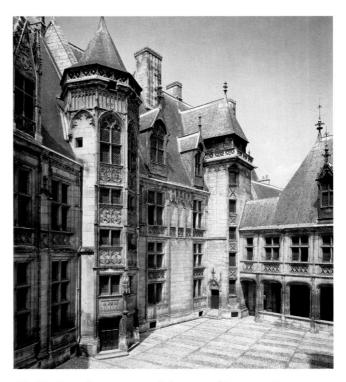

17-10. Interior courtyard, house of Jacques Coeur, Bourges, France. 1443-51.

Illuminated manuscripts, such as that of Christine de Pizan (see fig. 20, Introduction), give some indication of the interior richness of a palace or town house owned by a wealthy family. The architecture was often painted and the walls were hung with rich and colorful tapestries. Furnishings were also covered with tapestry and embroideries. Glass windows might be enriched with stained-glass inserts illustrating coats of arms.

ALTARS AND ALTARPIECES

The altar in a Christian church symbolizes both the table of Jesus' Last Supper and the tombs of Christ and the saints. The altar, whether on leglike supports or a block of stone, has named parts: the top surface is the **mensa** and the support is the **stipes**. The front surface of a block altar is the **antependium**. Relics of the church's patron saint may be placed in a reliquary on the altar, beneath the floor on which the altar rests, or even within the altar itself.

Altarpieces are painted or carved constructions placed at the back of the mensa or behind the altar in a way that makes altar and altarpiece appear to be visually joined. Their original purpose was to identify the saint or the mystery to which the altar was dedicated. Over time, the altarpiece evolved from a low panel to a large and elaborate architectonic structure filled with images and protected by movable wings that function like shutters. An altarpiece may have a firm base, called a **predella**, decorated with images,

usually on panel inserts. A winged altarpiece can be a **diptych**, in which two panels are hinged in the middle (see fig. 17-28); a **triptych**, in which two wings fold over a center section (see fig. 17-11); or a **polyptych**, in which sets of wings can be opened and closed in different arrangements according to specific liturgical uses through the church year (see fig. 17-16). Wings bear images, usually painted, on both sides. The wings and center section are sometimes decorated with sculpture.

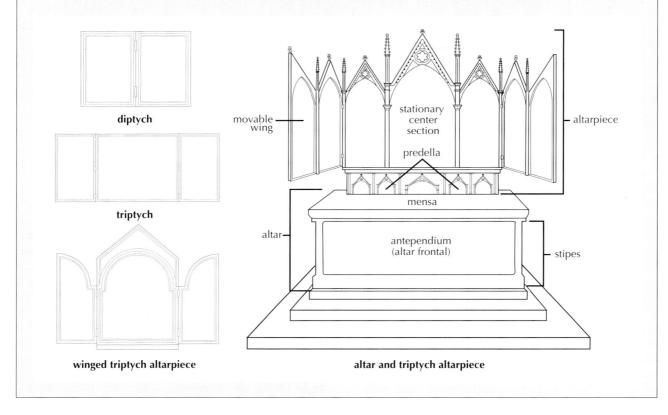

Milan, Florence, and Venice. The chief sources of Flemish wealth were the wool trade and the manufacture of fine fabrics. Most professionals belonged to a powerful local guild—an association of people engaged in the same business or craft. Guilds oversaw nearly every aspect of their members' lives, and high-ranking guild members served on town councils and helped run city governments.

Artists might work independently in their own studios without the sponsorship of an influential patron, but they had to belong to a local guild. Experienced artists who moved from one city to another usually had to work as assistants in a local workshop until they met the requirements for guild membership. Different kinds of artists belonged to different guilds. Painters, for example, joined the Guild of Saint Luke, the guild of the physicians and pharmacists, because painters used the same techniques of grinding and mixing raw ingredients

for their pigments and varnishes that physicians and pharmacists used to prepare salves and potions.

Civic groups, town councils, and wealthy merchants were important art patrons in the Netherlands, where the cities were self-governing, largely independent of the landed nobility. The diversity of clientele encouraged artists to experiment with new types of images—with outstanding results. The dukes of Burgundy also ruled the Netherlands, and they provided stability and money for the arts to flourish there. Throughout most of the fifteenth century, Flemish art and artists were greatly admired; artists from abroad studied Flemish works, and their influence spread throughout Europe, including Italy. Only at the end of the fifteenth century did a general preference for the Netherlandish painting style give way to a taste for the new styles of art and architecture developing in Italy.

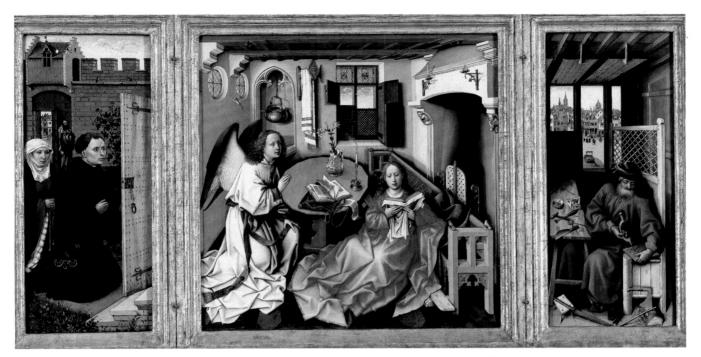

17-11. Robert Campin. *Mérode Altarpiece (Triptych of the Annunciation)* (open). c. 1425–28. Oil on wood panel, center $25^{1}/_{4} \times 24^{7}/_{8}$ " (64.1 × 63.2 cm); each wing approx. $25^{3}/_{8} \times 10^{3}/_{4}$ " (64.5 × 27.6 cm). The Metropolitan Museum of Art, New York. The Cloisters Collection, 1956 (56.70)

FIRST-GENERATION PANEL PAINTERS

The Flemish style originated in manuscript illumination of the late fourteenth century, when artists began to create full-page scenes set off with frames that functioned almost as windows looking into rooms or out onto land-scapes with distant horizons. Artists also designed tapestries and stained glass, and painted on wood **panels** (see "Painting on Panel," page 592). Tapestries had the greatest value and prestige, but panel painting became increasingly important. Like the manuscript illuminations before them, the panel paintings provided a window onto a scene, which fifteenth-century Flemish painters typically rendered with keen attention to individual features—whether of people, human-made objects, or the natural world—in works laden with symbolic meaning.

The most outstanding exponents of the new Flemish style were Robert Campin (documented from 1406; d. 1444), Jan van Eyck (c. 1370/90–1441), and Rogier van der Weyden (c. 1399–1464). Scholars have been able to piece together sketchy biographies for these artists from contracts, court records, account books, and references to their work by contemporaries. Reasonable attributions of a number of paintings have been made to each of them, but written evidence is limited. Signatures are rarely found on fifteenth-century paintings, in part because artists customarily signed the frames, which usually have been lost.

The paintings of Robert Campin (formerly known as the Master of Flémalle, after a pair of panel paintings once thought to have come from the Abbey of Flémalle) reflect the Netherlandish taste for lively narrative and a

bold three-dimensional treatment of figures reminiscent of the sculptural style of Claus Sluter. About 1425-28, Campin painted an altarpiece now known as the Mérode Altarpiece from the name of later owners. Slightly over 2 feet tall and about 4 feet wide with the wings open, it probably was made to be placed on the altar of a small private chapel (fig. 17-11). By depicting the Annunciation inside a Flemish home, Campin turned common household objects into religious symbols. The lilies in the majolica (glazed earthenware) pitcher on the table, for example, which symbolize Mary's virginity, were a traditional element of Annunciation imagery (see fig. 17-8). The white towel and hanging waterpot in the niche symbolize Mary's purity and her role as the vessel for the Incarnation of God. These accouterments of a middle-class home now have a religiously sanctioned status. Such objects are often referred to as "hidden" symbols because they are treated as an ordinary part of the scene, but their religious meanings would have been widely understood by contemporary people.

Unfortunately, the precise meanings are not always clear today. The central panel may simply portray Gabriel telling Mary that she will be the Mother of Christ. Another interpretation suggests that the painting shows the moment immediately following Mary's acceptance of her destiny. A rush of wind riffles the book pages and snuffs the candle as a tiny figure of Christ carrying a cross descends on a ray of light. Having accepted the miracle of the Incarnation (God assuming human form), Mary reads her Bible while sitting humbly on the footrest of the long bench as a symbol of her submission to God's will. But another interpretation of

For works ranging from enormous altarpieces to small portraits, wood **panels** were favored by fifteenth-century European painters and their patrons. First the wood surface was

sanded to make it smooth, then the panel was coated—in Italy with **gesso**, a fine solution of plaster, and in northern Europe with a solution of chalk. These coatings soaked into and closed the pores of the wood. Fine linen was often glued over the whole surface or over the joining lines on large panels made of two or more pieces of wood. The cloth was then also coated with gesso or chalk

Once the surface was ready, the artist could paint on it with pigments held in water (**tempera** painting) or **oil**. Italian artists favored tempera, using it almost exclusively for panel painting until the end of the fifteenth century. Northern European artists preferred the oil technique

TECHNIQUE

Painting on Panel

that Flemish painters so skillfully exploited. Tempera had to be applied in a very precise manner, because it dried almost as quickly as it was laid down. Shading had to be done with careful

overlying strokes in varied tones. Because tempera is opaque—light striking its surface does not penetrate to lower layers of color and reflect back—the resulting surface was matte, or dull, and had to be varnished to give it sheen.

Oil paint, on the other hand, took much longer to dry, and errors could be corrected while it was still wet. Oil could also be made translucent by applying it in very thin layers, called **glazes**. Light striking a surface of built up glazes penetrates to the lower layers and is reflected back, creating a glow from within. In both tempera and oil the desired result in the fifteenth century was a smooth surface that betrayed no brushstrokes.

the scene suggests that it represents the moment just prior to the Annunciation. In this view, Mary is not yet aware of Gabriel's presence, and the rushing wind is the result of the angel's rapid entry into the room, where he appears before her, half kneeling and raising his hand in salutation.

The complex treatment of light in the *Mérode Altarpiece* was an innovation of the Flemish painters. The strongest illumination comes from an unseen source at the upper left in front of the **picture plane**, as if the sun entered through a miraculously transparent wall that allows the viewer to observe the scene. In addition, a few rays enter the round window at the left as the vehicle for the Christ Child's descent. More light comes from the window at the rear of the room, and areas of reflected light can also be detected.

Campin maintained the spatial conventions typical of the International Gothic style; the abrupt recession of the bench toward the back of the room, the sharply uplifted floor and tabletop, and the disproportionate relationship between the figures and the architectural space create an inescapable impression of instability. In an otherwise intense effort to mirror the real world, this treatment of space may be a conscious remnant of medieval style, serving the symbolic purpose of visually detaching the religious realm from the world of the viewers. Unlike figures by such International Gothic painters as the Limbourg brothers (see fig. 17-6), the Virgin and Gabriel are massive rather than slender, and their abundant draperies increase the impression of their material weight.

Although in the biblical account Joseph and Mary were not married at the time of the Annunciation, this house clearly belongs to Joseph, shown in his carpentry shop on the right. A prosperous Flemish city can be seen through the shop window, with people going about their business unaware of the drama taking place inside the carpenter's home. One clue indicates that this is not an everyday scene: The shop, displaying car-

pentry wares—mousetraps, in this case—should be on the ground floor, but its window opens from the second floor. The significance of the mousetraps would have been recognized by knowledgeable people in the fifteenth century as Saint Augustine's reference to Christ as the bait in a trap set by God to catch Satan. Joseph is drilling holes in a small board that may be a drainboard for wine making, symbolizing the central rite of the Church, the Eucharist.

Joseph's house opens onto a garden planted with a rosebush, which alludes to the Virgin and also to the Passion. It has been suggested that the man standing behind the open entrance gate, clutching his hat in one hand and a document in the other, may be a self-portrait of the artist. Alternatively, the figure may represent an Old Testament prophet, because rich costumes like his often denoted high-ranking Jews of the Bible. Kneeling in front of the open door to the house are the donors of the altarpiece. They appear to observe the Annunciation through the door, but their gazes seem unfocused. The garden where they kneel is unrelated spatially to the chamber where the Annunciation takes place, suggesting that the scene is a vision induced by their prayers. Such a presentation, often used by Flemish artists, allowed the donors of a religious work to appear in the same space and time—and often on the same scale—as the figures of the saints represented.

Campin's contemporary Jan van Eyck was a trusted official in the court of the duke of Burgundy as well as a painter. Nothing is known of Jan's youth or training, but he was born sometime between 1370 and 1390 in Maaseik, on the Maas (Meuse) River, now in Belgium on the present-day border between Belgium and the Netherlands. He was from a family of artists, including two brothers, Lambert and Hubert, and a sister, Margareta, whom sixteenth-century Flemish writers still remembered with praise. The earliest references to Jan are in 1422 in The Hague, where he was probably involved in the renovation of a castle. He was appointed painter to

Philip the Good, the duke of Burgundy, in Bruges on May 19, 1425. His appointment papers state that he had been hired because of his skillfulness in the art of painting, that the duke had heard about Jan's talent from people in his service, and that the duke himself recognized those qualities in Jan van Eyck. The special friendship that developed between the duke and his painter is a matter of record.

Although there are a number of contemporary accounts of Jan's activities, the only reference to specific art works is to two portraits of Princess Isabella of Portugal, which he painted in that country in 1429 and sent back to Philip in Flanders. Philip and Isabella were married in 1430. The duke alluded to Jan's remarkable technical skills in a letter of 1434-35, saying that he could find no other painters equal to his taste or so excellent in art and science. Part of the secret of Jan's "science" was his technique of painting with oil glazes on wood panel. So brilliant were the results of his experiments that Jan has been mistakenly credited with being the inventor of oil painting. Actually, the medium had been known for several centuries, and medieval painters had used oil paint to decorate stone, metal, and occasionally plaster walls.

For his paintings on wood panel, Jan built up the images in transparent oil layers, a procedure called **glazing**. His technique permitted a precise, objective description of what he saw, with tiny, carefully applied brushstrokes so well blended that they are only visible at very close range. Other northern European artists of the period worked in the oil medium, although oil and **tempera** were still combined in some paintings, and tempera was used for painting on canvas (see "Painting on Panel," opposite).

Jan's Annunciation (fig. 17-12), a small independent panel, is an excellent example of the Flemish desire to paint more than the eye can see and almost more than the mind can grasp. We can enjoy the painting for its visual characteristics-the drawing, colors, and arrangement of shapes—but we need information about the painting's cultural context to understand it fully. The Annunciation takes place in a richly appointed church, not Mary's house, as we saw in Robert Campin's painting. Gabriel, a richly robed youth with splendid multicolored wings, has interrupted Mary's reading. The two figures gesture gracefully upward toward a dove flying down through beams of gold. As the angel Gabriel tells the Virgin Mary that she will bear the Son of God, Jesus Christ, golden letters floating from their lips capture their words, "Hail, full of grace" and "Behold the handmaiden of the Lord." The story is recounted in the Gospel of Luke (1:26-38). In the painting every detail has a meaning. The dove symbolizes the Holy Spirit; the white lilies are symbols of Mary. The signs of the zodiac in the floor tiles indicate the traditional date of the Annunciation, March 25. The one stained-glass window representing God rises above the three windows enclosing Mary and representing the Trinity of Father, Son, and Holy Spirit.

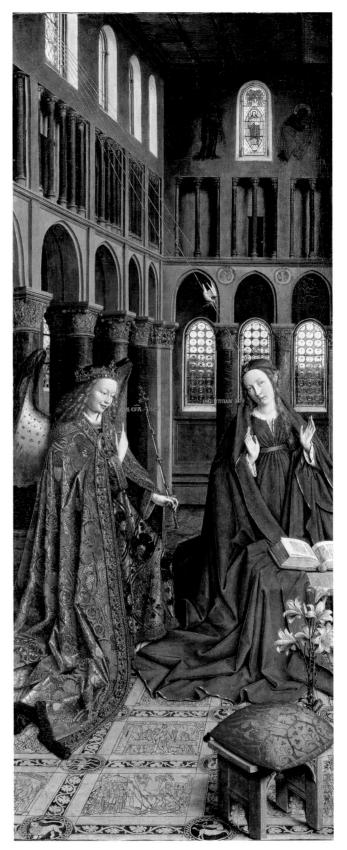

17-12. Jan van Eyck. *The Annunciation.* c. 1434–36. Oil on canvas, transferred from wood panel, painted surface $35^3/_8 \times 13^7/_8$ " (90.2 × 34.1 cm). National Gallery of Art, Washington, D.C.

Andrew W. Mellon Collection 1937.1.39

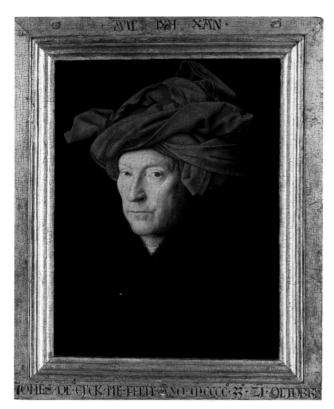

17-13. Jan van Eyck. *Man in a Red Turban.* 1433. Oil on wood panel, $13^1/8'' \times 10^1/4''$ (33.3 \times 25.8 cm). The National Gallery, London.

Man in a Red Turban of 1433 (fig. 17-13) is widely believed to be Jan's self-portrait, partly because of the strong sense of personality it projects, partly because the frame, signed and dated by him, also bears his personal motto, Als ich chan ("The best that I am capable of doing"). This motto, derived from classical sources, is a telling illustration of the humanist spirit of the age and the confident expression of an artist who knows his capabilities and is proud to display them. If the Man in a Red Turban is, indeed, the face of Jan van Eyck, it shows his physical appearance as if in a magnifying mirror every wrinkle and scar, the stubble of a day's growth of beard on the chin and cheeks, and the tiny reflections of light from a studio window in the pupils of the eyes. The outward gaze of the subject is new in portraiture, and it suggests the subject's increased sense of pride as he seems to catch the viewer's eye.

Jan's best-known painting today is an elaborate portrait of a couple, traditionally identified as Giovanni Arnolfini and his wife, Giovanna Cenami (fig. 17-14). This fascinating work has been, and continues to be, subject to a number of interpretations, most of which suggest that it represents a wedding or betrothal. One remarkable detail is the artist's inscription above the mirror on the back wall: *Johannes de eyck fuit hic 1434* ("Jan van Eyck was here, 1434"). Normally, a work of art in fifteenth-century Flanders would have been signed "Jan van Eyck made this." The wording here specifically refers to a witness to a legal document, and indeed, two

witnesses to the scene are reflected in the mirror, a man in a red turban—perhaps the artist—and one other. The man in the portrait, identified by early sources as a member of an Italian merchant family living in Flanders, the Arnolfini, holds the right hand of the woman in his left (symbolizing a marriage between people of different classes) and raises his right to swear to the truth of his statements before the two onlookers. In the fifteenth century, a marriage was rarely celebrated with a religious ceremony. The couple signed a legal contract before two witnesses, after which the bride's dowry might be paid and gifts exchanged. However, it has been suggested that, instead of a wedding, the painting might be a pictorial "power of attorney," by which the husband states that his wife may act on his behalf in his absence. The discovery of a document proving that Arnolfini married in 1447, thirteen years after this painting and six years after Jan's death, adds to the mystery.

Whatever event the painting depicts, the artist has juxtaposed the secular and the religious in a work that seems to have several levels of meaning. On the man's side of the painting, the room opens to the outdoors, the external world in which men function, while the woman is silhouetted against the domestic interior, with its allusions to the roles of wife and mother. The couple is surrounded by emblems of wealth, piety, and married life. The convex mirror reflecting the entire room and its occupants is a luxury object described in many inventories of the time, but it may also symbolize the all-seeing eye of God, before whom the man swears his oath. The **roundels** decorating its frame depict the Passion of Christ, a reminder of Christian redemption.

Many other details have religious significance, suggesting the piety of the couple: the crystal prayer beads on the wall; the image of Saint Margaret, protector of women in childbirth, carved on the top of a high-backed chair next to the bed; and the single burning candle in the chandelier, which may be a symbol of Christ's presence. But the candle can also represent a nuptial taper or a sign that a legal event is being recorded. The fruits shown at the left, seemingly placed there to ripen in the sun, may allude to fertility in a marriage and also to the Fall of Adam and Eve in the Garden of Eden. The small dog may simply be a pet, but it serves also as a symbol of fidelity, and its rare breed—affenpinscher—suggests wealth.

One of the most enigmatic of the major early Flemish artists is Rogier van der Weyden. Although his biography has been pieced together from documentary sources, not a single existing work of art bears his name or has an entirely undisputed connection with him. He was thought at one time to be identical with the Master of Flémalle, but evidence now suggests that he studied under Robert Campin, which would explain the similarities in their painting styles. Even his relationship with Campin is not altogether certain, however. At the peak of his career, Rogier maintained a large workshop in Brussels, to which apprentices and shop assistants came from as far away as Italy to study.

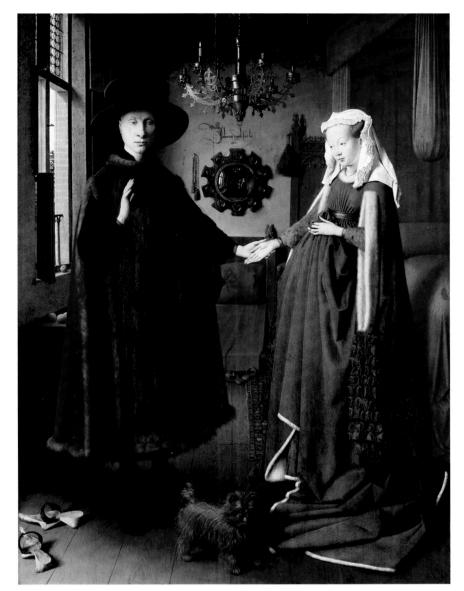

17-14. Jan van Eyck. *Portrait of Giovanni Arnolfini (?) and His Wife, Giovanna Cenami (?).* 1434. Oil on wood panel, $33 \times 22^1/_2$ " (83.8 \times 57.2 cm). The National Gallery, London.

The merchant class copied the fashions of the court, and a beautifully furnished room containing a large bed hung with rich draperies was often a home's primary public space, not a private retreat. According to a later inventory description of this painting, the original frame (now lost) was inscribed with a quotation from Ovid, a Roman poet known for his celebration of romantic love. The woman wears an aristocratic costume, a fur-lined overdress with a long train. Fashion dictated that the robe be gathered up and held in front of the abdomen, giving an appearance of pregnancy. This ideal of feminine beauty emphasized women's potential fertility.

To establish the thematic and stylistic characteristics for Rogier's art, scholars have turned to a painting of the Deposition, the central panel of an altarpiece that once had wings painted with the Four Evangelists—Matthew, Mark, Luke, and John—and Christ's Resurrection (fig. 17-15, page 596). The altarpiece was commissioned by the Louvain Crossbowmen's Guild sometime before 1443, the date of the earliest known copy after it by another artist.

The Deposition was a popular theme in the fifteenth century because of its dramatic, personally engaging character. Like a *tableau vivant*, the act of removing

Jesus' body from the Cross is set on a shallow stage closed off by a wood backdrop that has been **gilded**, or covered with a thin overlay of gold. The solid, three-dimensional figures seem to press forward toward the viewer's space, forcing the viewer to identify with the grief of Jesus' friends—made palpably real by their portraitlike faces and elements of contemporary dress—as they tenderly and sorrowfully remove his body from the Cross for burial. Rogier has arranged Jesus, the lifesize corpse at the center of the composition, in a graceful curve, echoed by the form of the fainting Virgin, thereby

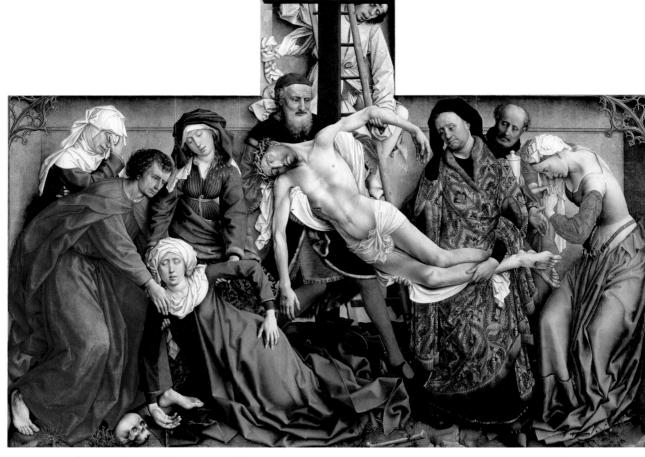

17-15. Rogier van der Weyden. *Deposition,* from an altarpiece commissioned by the Crossbowmen's Guild, Louvain, Brabant, Belgium. c. 1442. Oil on wood panel, $7'2^5/8'' \times 8'7^1/8''$ (2.2 × 2.62 m). Museo del Prado, Madrid.

increasing the viewer's emotional identification with both the Son and the Mother. The artist's compassionate sensibility is especially evident in the gestures of John the Evangelist, who supports the Virgin at the left, and Jesus' friend Mary Magdalen, who wrings her hands in anguish at the right. Many scholars see Rogier's emotionalism as a tie with the Gothic past, but it can also be interpreted as an example of fifteenth-century humanism in its concern for individual expressions of emotion. Although united by their sorrow, the mourning figures react in personal ways.

Rogier's choice of color and pattern balances and enhances his composition. For example, the complexity of the gold brocade worn by Joseph of Arimathea, who offered his new tomb for the burial, and the contorted pose and vivid dress of Mary Magdalen increase the visual impact of the right side of the panel and counter the larger number of figures at the left. The palette of subtle, slightly muted colors is sparked with red and white accents to focus the viewer's attention on the main subject. The whites of the winding cloth and the tunic of the youth on the ladder set off Jesus' pale body, as the white headdress and neck shawl emphasize the ashen face of Mary.

Rogier painted his largest and most elaborate work, the altarpiece of the *Last Judgment*, for a hospital in Beaune founded by the chancellor of the duke of Burgundy (fig. 17-16). Whether Rogier painted this altarpiece

before or after he made a trip to Rome for the Jubilee of 1450 is debated by scholars. He would have known the Last Judgments so common in medieval churches, but he could also have been inspired by the paintings and mosaics in Rome. The tall, straight figure of the archangel Michael, dressed in a white robe and priest's cope (a ceremonial cloak), dominates the center of the wide polyptych (multiple-panel work) as he weighs souls under the direct order of Christ, who sits on the arc of a giant rainbow above him. The Virgin Mary and John the Baptist kneel at either end of the rainbow. Behind them on each side, six apostles, then men at the left (the right side of Christ) and women at the right witness the scene. The cloudy gold background serves, as it did in medieval art, to signify events in the heavenly realm or in a time remote from that of the viewer.

The bodily resurrection takes place on a narrow, barren strip of earth that runs across the bottom of all but the outer panels. Men and women climb out of their tombs, turning in different directions as they react to the call to Judgment. The scale of justice held by Michael tips in an unexpected direction; instead of Good weighing more than Bad, the Saved Soul has become pure spirit and rises, while the Damned one sinks, weighed down by unrepented sins. The Damned throw themselves into the flaming pit of hell; those moving to the left (the right hand of Christ)—notably far less

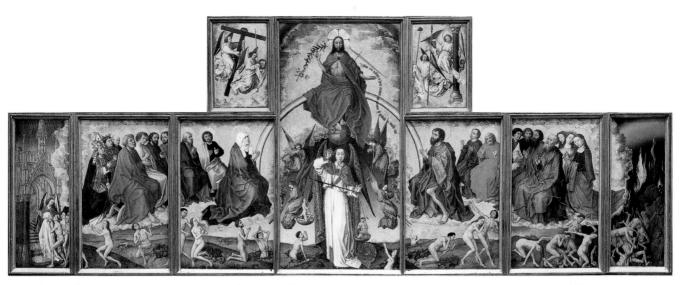

17-16. Rogier van der Weyden. Last Judgment Altarpiece (open). After 1443. Oil on wood panel, open $7'4^{5}/8'' \times 17'11''$ (2.25 \times 5.46 m). Musée de l'Hôtel-Dieu, Beaune, France.

numerous—are greeted by the archangel Gabriel at the shining Gate of Heaven, depicted as Gothic architecture.

In his portraiture, Rogier balanced a Flemish love of detailed individuality with a flattering idealization of the features of men and women. In Portrait of a Lady, dated about 1460, Rogier transformed an ordinary young woman into a vision of exquisite but remote beauty (fig. 17-17, page 598). Her long, almond-shape eyes, regular features, and smooth translucent skin characterize women in portraits attributed to Rogier. He popularized the half-length pose that includes the woman's high waistline and clasped hands, which he used for images of the Virgin and Child that often formed diptychs (two-panel works) with small portraits of this type. The woman is pious and humble, wealthy but proper and modest. The portrait expresses the complex and often contradictory attitudes of the new middle-class patrons of the arts, who balanced pride in their achievements with appropriate modesty.

SECOND-GENERATION PANEL PAINTERS

The extraordinary accomplishments of Robert Campin, Jan van Eyck, and Rogier van der Weyden attracted many followers in Flanders. The work of this second generation of Flemish painters was simpler, more direct, and easier to understand than that of their predecessors. These artists produced high-quality work of great emotional power, and they were in large part responsible for the rapid spread of the Flemish style through Europe.

Among the most interesting of the second-generation painters was Petrus Christus (documented from 1444–c. 1475/76). Nothing is known of his life before 1444, when he became a citizen of Bruges. Although many paintings attributed to him resemble the work of Jan van Eyck, they probably did not know each other, because Jan died three years before Christus's arrival in Bruges.

In 1449 Christus painted *A Goldsmith (Saint Eligius?) in His Shop* (fig. 17-18, page 599). According to Christian tradition, Eligius, a seventh-century ecclesiastic, goldsmith, and mintmaster for the French court, used his wealth to

ransom Christian captives. He became the patron saint of metalworkers. Here he weighs a jeweled ring, as a handsome couple looks on. This may be a specific betrothal or wedding portrait. The counter and shelves hold a wide range of metalwork and jewelry. All the objects can be identified. The coins are Burgundian gold ducats and gold "angels" of Henry VI of England (ruled 1422-61, 1470-71), and on the bottom shelf are a box of rings, two bags with precious stones, and pearls. Behind them stands a crystal reliquary with a gold dome and a ruby and amethyst pelican. Many of the objects on the shelves had a protective function—for example, the red coral and the serpents' tongues (fossilized sharks' teeth) hanging above the coral could ward off the evil eye, and the coconut cup at the left neutralized poison. Slabs of porphyry and rock crystal were "touchstones," used to test gold and precious stones, such as the pendant and two brooches of gold with pearls and precious stones pinned to a dark fabric. Rosary beads and a belt end hang from the top shelf, where two silver flagons and a covered cup stand. A belt similar to the one worn in Rogier's Portrait of a Lady curls across the counter, where the coins and a convex mirror stand. Such a combination of pieces suggests that the painting expresses the hope for health and well-being for the couple whose betrothal or wedding portrait this may be.

The young couple are certainly aristocrats: The man wears a badge identifying him as a member of the court of the duke of Gelders; the young woman, dressed in Italian gold brocade, wears a jeweled double-horned headdress fashionable at mid-century (worn by Christine de Pizan and the ladies of the queen of France [see fig. 20, Introduction]).

As in Jan's *Portrait of Giovanni Arnolfini* (see fig. 17-14), a convex mirror extends the viewer's field of vision, in this instance to the street outside, where two men appear. One is stylishly dressed in red and black, and the other holds a falcon, another indication of high status since only the nobility hunted with falcons. Whether or not the reflected image has symbolic meaning, the mirror had a practical value in allowing the goldsmith to note the approach of a potential customer.

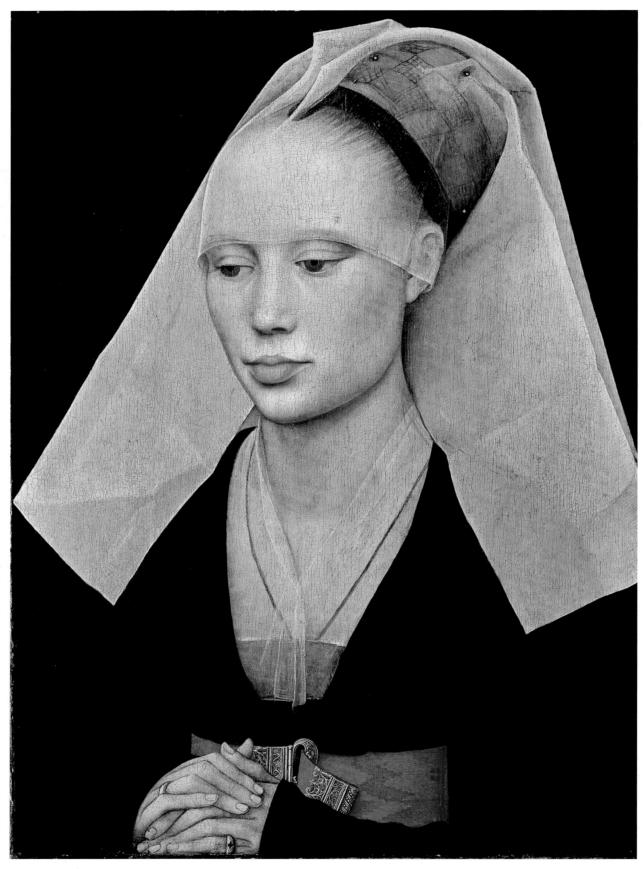

17-17. Rogier van der Weyden. Portrait of a Lady. c. 1460. Oil and tempera on wood panel, $14^{1}/_{16} \times 10^{5}/_{8}$ " (37 × 27 cm). National Gallery of Art, Washington, D.C. Andrew W. Mellon Collection (1937.1.44)

17-18. Petrus Christus. A Goldsmith (Saint Eligius?) in His Shop. 1449. Oil on oak panel, $38^5/_8 \times 33^1/_2$ " (98 × 85 cm). The Metropolitan Museum of Art, New York. Robert Lehman Collection, 1975 (1975.1.110)

The artist signed and dated his work on the house reflected in the mirror.

An outstanding Haarlem painter who moved south to Flanders, Dirck Bouts (documented from 1457; d. 1475) became the official painter of the city of Louvain in 1468. His mature style shows a strong debt to Jan van Eyck and, especially, Rogier van der Weyden, but not at the expense of his own clear-cut individuality. Bouts was an excellent storyteller, skillful in direct narration rather than complex symbolism. His best-known works today are two remaining panels (fig. 17-19) from a set of four on the subject of justice. Such paintings were often commissioned for display in municipal buildings, and the town council of Louvain had ordered this set from Bouts for the city hall. The subject of the panels was a fictional twelfth-century story about a real-life emperor. In a continuous narrative in the left panel, Wrongful Execution of the Count, the empress falsely accuses a count of a sexual impropriety. Otto III tries and convicts the

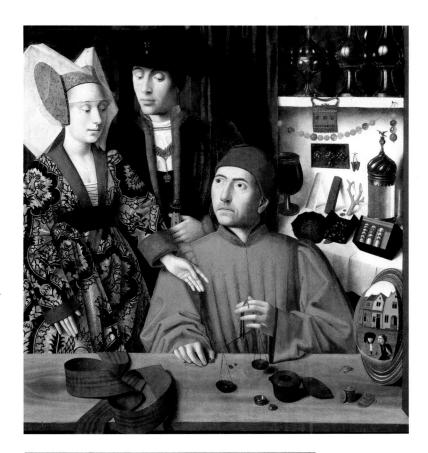

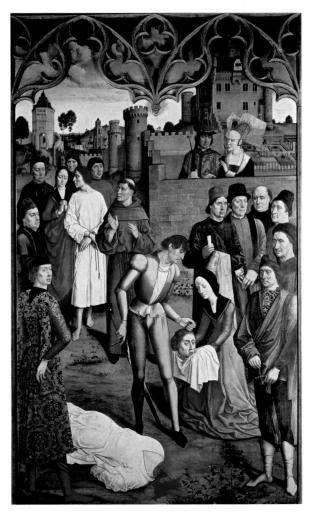

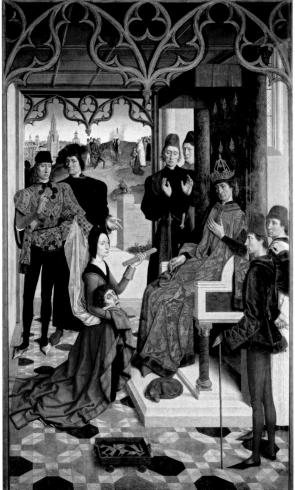

17-19. Dirck Bouts. Wrongful Execution of the Count (left), and companion piece, Justice of Otto III (right). 1470–75. Oil on wood panel, each $12'11'' \times 6'7^{1/2}''$ (3.9 \times 2 m). Musées Royaux des Beaux-Arts de Belgique, Brussels, Belgium-Koninklijke Musea voor Schone Kunsten van Belgie, Brussels.

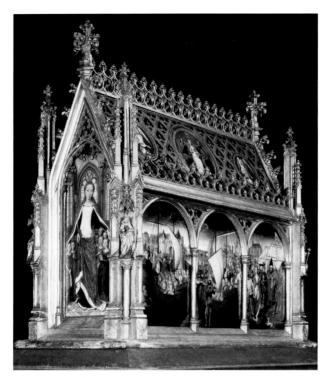

17-20. Hans Memling. Saint Ursula reliquary. 1489. Painted and gilded oak, $34 \times 36 \times 13''$ ($86.4 \times 91.4 \times 33$ cm). Memling Museum, Hospital of Saint John, Bruges, Belgium.

The reliquary was commissioned presumably by the two women dressed in the white habits and black hoods worn by hospital sisters and depicted on the end of the reliquary not visible here. One hypothesis is that they are Jossine van Dudzeele and Anna van den Moortele, two administrators of the hospital where the churchshaped chest has remained continuously for more than five centuries. The story of Ursula, murdered in the fourth century by Huns in Cologne after she returned from a visit to Rome, is told on the six side panels. Shown from the left: the pope bidding Ursula good-bye at the port of Rome; the murder of her female companions in Cologne harbor; and Ursula's own death. On the "roof" are roundels with musician angels flanking the Coronation of the Virgin. At the corners are carved saints, and on the end is Saint Ursula in the doorway of the "church," sheltering her followers under her mantle. In early stories, Ursula was accompanied on her trip by ten maidens. By the tenth century, however, she had become the leader of 11,000 women martyrs.

count, who is beheaded. In the right panel, *Justice of Otto III*, the widowed countess successfully endures a trial by ordeal to prove her husband's innocence. She kneels unscathed before the repentant emperor, holding her husband's head on her right arm and a red-hot iron bar in her left hand. In the far distance, the evil empress is executed by burning at the stake.

Dirck Bouts's work is notable for its spacious outdoor settings. Carefully adjusting the scale of his figures to the landscape and architecture, the artist created an illusion of space that recedes continuously and gradually from the picture plane to the far horizon. For this effect, he employed devices such as walkways, walls, and winding roads along which characters in the scene are placed. Bouts's figures are extraordinarily tall and slender and have little or no facial expression. Bouts is credited as the inventor of a type of official group portrait in which individuals are integrated into a narrative scene with fictional or religious characters, so the Louvain justice panels, with

their distinctly individualized protagonists, may have been a vehicle for a group portrait of the town council.

By far the most successful of the second-generation Flemish school painters was Hans Memling. Memling combines the intellectual depth and virtuoso rendering of his predecessors with a delicacy of feeling and exquisite grace. Memling was born in one of the German states about 1430–35. He may have worked in Rogier van der Weyden's Brussels workshop in the 1460s, for Rogier's style remained the dominant influence on his art. Soon after Rogier's death in 1464, Memling moved to Bruges, where he worked until his death in 1494. Memling had an international clientele, and his style was widely emulated both at home and abroad.

Among the works securely assigned to Memling is a large wooden **reliquary**, a container for the sacred relics of Saint Ursula, in the form of a Gothic chapel (fig. 17-20). It was made in 1489 for the Hospital of Saint John in Bruges, now a museum of Memling's works. The painting illustrates the story of Saint Ursula's martyrdom. According to legend, Ursula, the daughter of the Christian king of Brittany, in France, was betrothed to a pagan English prince. She requested a three-year delay in the marriage to travel with 11,000 virgin attendants to Rome, during which time her husband-to-be was to convert to Christianity. On the trip home, the women stopped in Cologne, which had been taken over by Attila the Hun and his nomadic warriors from Central Asia. They murdered her companions, and when Ursula rejected an offer of marriage, they killed her as well, with an arrow through the heart (fig. 17-21). Although the events sup-

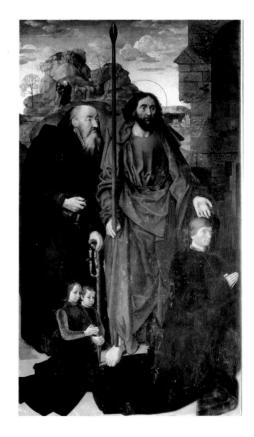

posedly took place in the fourth century, Memling has set them in contemporary Cologne: The city's Gothic cathedral, under construction, looms in the background of the *Martyrdom of Saint Ursula* panel. Memling created this deep space as a foil for his idealized female martyr, a calm aristocratic figure amid active men-at-arms. The surface pattern and intricately arranged folds of the drapery draw our attention to her.

Hugo van der Goes (c. 1440-82) united the intellectualism of Jan van Eyck and the emotionalism of Rogier van Weyden in an entirely new style. Hugo's major work was an exceptionally large altarpiece, exceeding 8 feet in height, commissioned by an Italian living in Bruges, Tommaso Portinari, who managed the Medici bank there (fig. 17-22). Painted in Flanders, probably between 1474 and 1476, the triptych was transported to Italy and installed in 1483 in the Portinari family chapel in the Church of Sant'Egidio, in Florence, where it had a profound impact on Florentine painters such as Ghirlandaio. Tommaso, his wife, Maria Baroncelli, and their three eldest children are portrayed kneeling in prayer on the wings, their patron saints behind them. On the left wing, looming larger than life behind Tommaso and his son Antonio, are their name saints, Thomas and Anthony. The younger son, Pigello, born in 1474, was apparently added after the original composition was set and has no patron saint. On the right wing, Maria and her daughter Margherita are presented by Saints Mary Magdalen and Margaret. The theme of the altarpiece is the Nativity, with the central panel representing the Adoration of the newborn Child by Mary and Joseph, a host of angels, and the

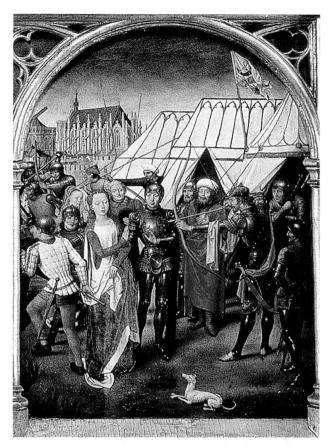

17-21. Hans Memling. *Martyrdom of Saint Ursula*, detail of the Saint Ursula reliquary. Panel $13^3/4 \times 10''$ (35 × 25.3 cm).

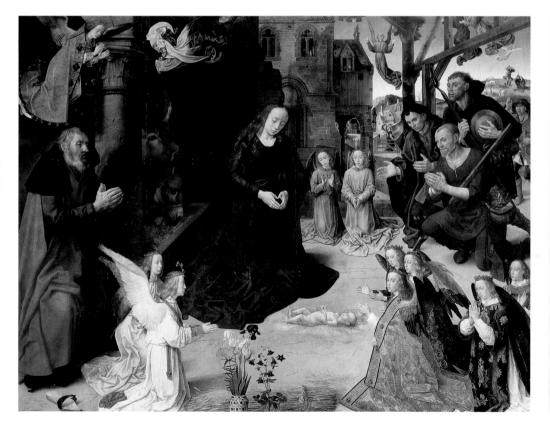

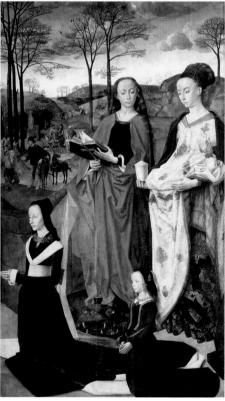

17-22. Hugo van der Goes. *Portinari Altarpiece* (open). c. 1474–76. Tempera and oil on wood panel; center $8'3^{1}/_{2}" \times 10'$ (2.53 × 3.01 m), wings each $8'3^{1}/_{2}" \times 4'7^{1}/_{2}"$ (2.53 × 1.41 m). Galleria degli Uffizi, Florence.

shepherds who have rushed in from the fields. In the middle ground of the wings are scenes that precede the Adoration. Winding their way through the winter land-scape are two groups headed for Bethlehem, Jesus' birthplace. On the left wing, Mary and Joseph travel to their native city to take part in a census ordered by the region's Roman ruler. Near term in her pregnancy, Mary has dismounted from her donkey and staggers before it, supported by Joseph. On the right wing, a servant of the Three Magi, who are coming to honor the awaited Savior, is asking directions from a poor man. The continuous landscape across the wings and central panel is the finest evocation of cold, barren winter since the Limbourg brothers' February (see fig. 17-6).

Hugo's technique is firmly grounded in the terrestrial world despite the visionary subjects. Meadows and woods are painted leaf by leaf and petal by petal. He noted, too, that the farther away colors are, the more muted they seem; he therefore painted more-distant objects with a grayish or bluish cast and the sky paler toward the horizon, an effect called **atmospheric perspective** (see "Renaissance Perspective Systems," page 583).

Although Hugo's brilliant palette and meticulous accuracy recall Jan van Eyck and the intense but controlled feelings suggest the emotional content of Rogier van der Weyden's works, the composition and interpretation of the altarpiece are entirely Hugo's. The huge figures of Joseph, Mary, and the shepherds dominating the central panel are the same size as the patron saints on the wings, in contrast to the Portinari family and angels. Hugo uses color as well as the gestures and gazes of the figures to focus our eyes on the center panel, where the mystery of the Incarnation takes place. Instead of lying swaddled in a manger or in his mother's arms, the Child rests naked and vulnerable on the barren ground with rays of light emanating from his body. The source of this image was the visionary writing of the Swedish mystic Bridget (declared a saint in 1391), composed about 1360-70, which specifically mentions Mary kneeling to adore the Child immediately after giving birth.

The foreground still life of ceramic pharmacy jar (albarello; see fig. 17-58), glass, flowers, and wheat has multiple meanings. The glass vessel symbolizes the entry of the Christ Child into the Virgin's womb without destroying her virginity, the way light passes through glass without breaking it. The albarello is decorated with vines and grapes, alluding to the wine of Communion at the Eucharist, which represents the Blood of Christ. The wheat sheaf refers both to the location of the event at Bethlehem, which in Hebrew means "house of bread," and to the Host, or bread, at Communion, which represents the Body of Christ. Even a little flower has a meaning. The majolica *albarello* holds a red lily for the Blood of Christ and three irises—white for purity and purple for Christ's royal ancestry. The three irises may refer to the Trinity of Father (God), Son (Jesus), and Holy Ghost. The iris, or "little sword," also refers to Simeon's prophetic words to Mary at the Presentation in the Temple: "And you yourself a sword will pierce so that the thoughts of

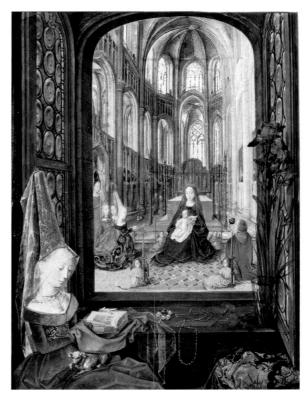

17-23. Mary of Burgundy Painter. Page with *Mary at Her Devotions*, in *Hours of Mary of Burgundy*. Before 1482. Colors and ink on parchment, $7\frac{1}{2} \times 5\frac{1}{4}$ " (19.1 \times 13.3 cm). Österreichische Nationalbibliothek, Vienna.

many hearts may be revealed" (Luke 2:35). The three irises together with the seven blue columbines in a glass (the Virgin Mary) remind the viewer of the Virgin's future sorrows. Scattered on the ground are violets, symbolizing humility. Hugo's artistic vision goes far beyond this formal religious symbolism. For example, the shepherds, who stand in unaffected awe before the miraculous event, are among the most sympathetically rendered images of common people to be found in the art of this period. The portraits of the children are among the most sensitive studies of children's features.

LUXURY ARTS

The rise in popularity of panel painting in the fifteenth century did not diminish the production of richly illustrated books for wealthy patrons (see "The Printed Book," page 603). Not surprisingly, developments in manuscript illumination were similar to those in panel painting, although in miniature. Each scene was a tiny image of the world rendered in microscopic detail. Complexity of composition and ornateness of decoration were commonplace, with the framed image surrounded by a fantasy of vines, flowers, insects, animals, shellfish, or other objects painted as if seen under a magnifying glass. Ghent and Bruges were major centers of this exquisite art, and one of the finest practitioners was an anonymous artist known as the Mary of Burgundy Painter from a Book of Hours traditionally thought to have been made for Mary—the daughter and only heir of Charles the Bold, the duke of Burgundy—who married Maximilian of Austria. The manuscript dates to sometime prior to Mary's early death, in 1482 (fig. 17-23).

THE PRINTED BOOK

The explosion of learning in Europe in the fifteenth century precipitated experiments in faster and cheaper ways to produce books than copying them by hand. The earliest printed books were block printed: each page of text, with or without illustrations, was cut in relief on a single block of wood, which could be repeatedly inked and printed. The process was greatly simplified by the development-first achieved in the workshop of Johann Gutenberg in Mainz, Germany-of movable-type printing, in which indi- vidual, carved letters could be locked together, inked, and printed onto paper by a mechanical press. More than forty copies of Gutenberg's Bible, printed in 1456, still exist. With the invention of this fast way to make identical books, the intellectual and spiritual life of Europe changed forever, as did the arts. Use of the new technique spread quickly: As early as 1465, two German printers were working in Italy, and by the 1470s there were presses in France, Flanders, Holland, and Spain. England got its first printing press when William Caxton, who had been a cloth merchant in Bruges, returned to London in 1476 to launch England's first publishing house.

The finest of all early books was Hypnerotomachia Poliphili (The Love-Dream Struggle of Poliphilo). This charming romantic allegory tells of the search of Poliphilo through exotic places for his lost love, Polia. The book, written in the 1460s or 1470s by Fra Francesco Colonna, was published in 1499 by the noted Venetian printer Aldo Manuzio (Aldus Manutius), who had established a press in Venice in 1490 (often called the Aldine Press). Many historians of book printing consider Aldo's Hypnerotomachia to be the most beautiful book ever produced, from the standpoint of type and page design.

Finito che la nympha cum comitate blandissima hebbe il suo benì gno suaso & multo acceptissima recordatióe, che la mia acrocoma Polia propera & másuetissima leuatose cum gli sui sesseuoli, & facetissimi simu lachri, ouero sembianti, & cum punicante gene, & rubete buccule da ho nesto & uenerate rubore susfuse a patause di uolere per omni uia satissare di natura prompta ad omni uirtute, & dare opera alla honesta petitione. Non che prima pero ese potesse alare & dicio retinere alquato che ella intrinsicamente non suspirulasse. Il quale dulcissimo suspirulo penetro reflectendo nel intimo del mio, immo suo core, per la uniforme conuenientia. Quale aduene a dui parimente participati & concordi litui. Et ciascuna cum diuo obtuto respecta intrepidulamente, cum quegli ludibondi & micanti ochii, Da fare (Ome) gli adamanti fresi in mille fragme ticuli. Cum pie & summisse uoce, & cum elegantissimi gesti decentemen te reuerita ogni una, ritorno e al suo solatios sedere supra il serpilaceo solo. La initiata opera sequendo sellularia. Cum accommodata pronunti

Fra Francesco Colonna. Page with *Garden of Love, Hypnerotomachia Poliphili,* published by Aldo Manuzio (Aldus Manutius), Venice, 1499. Woodcut, image $5^1/_8 \times 5^1/_8$ " (13.5 \times 13.5 cm). The Pierpont Morgan Library, New York. PML 373

The **woodcut** illustrations in the *Hypnerotomachia*, such as the *Garden of Love*, incorporate linear perspective and pseudoclassical structures that would influence future architects.

Although woodcuts, constantly refined and increasingly complex,

would remain a popular medium of book illustration for centuries to come, books also came to be illustrated with **engravings**. The innovations in printing at the end of the 1400s held great promise for the spread of knowledge and ideas in the following century.

In the Book of Hours frontispiece, the painter has attained a new complexity in treating pictorial space; we look not only through the "window" of the illustration's frame but through another window in the wall of the room depicted in the painting. The young Mary of Burgundy appears twice: once seated in the foreground, reading from her Book of Hours; and again in the background, in a vision inspired by her reading, kneeling with attendants before the Virgin and Child in a church. On

the window ledge is an exquisite still life—a rosary (symbol of Mary's devotion), carnations (symbolizing the nails of the Crucifixion), and a glass vase holding purple irises (having the same meaning as in the *Portinari Altarpiece*). The artist has skillfully executed the filmy veil covering Mary's hat, the transparent glass vase, and the bull's-eye panes of the window, circular panes whose center "lump" was formed by the glassblower's pipe. The spatial recession leads the eye into the far reaches of the church

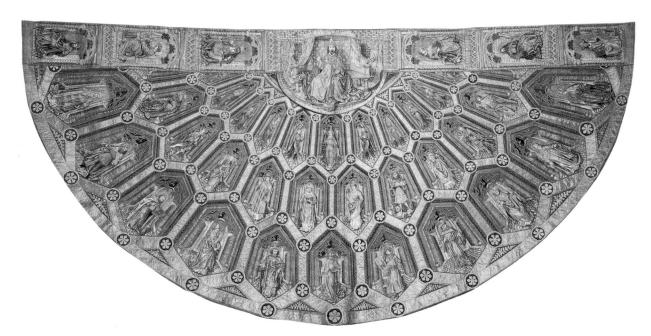

17-24. Cope of the Order of the Golden Fleece. Flemish, mid-15th century. Cloth with gold and colored silk embroidery, $5'4^9/_{16}" \times 10'9^5/_{16}" (1.64 \times 3.3 \text{ m})$. Imperial Treasury, Vienna.

The Order of the Golden Fleece was an honorary fraternity founded by Duke Philip the Good of Burgundy in 1430 with twenty-three knights chosen for their moral character and bravery. Religious services were an integral part of the order's meetings, and opulent liturgical and clerical objects were created for the purpose. The insignia of the order, worn by each knight, were a collar (chain) formed of stylized flints and flames from which hung a tiny golden fleece, the ram's skin taken by Jason and the Argonauts. These insignia were the property of the order and had to be returned at the member's death. The gold ram referred to the Greek legend of Jason, who went off on his ship *Argo* to search for the Golden Fleece, the wool of a magical ram that had been sacrificed to Zeus.

interior, past the Virgin and the gilded altarpiece in the sanctuary to two people conversing in the far distance at the left. Within an illumination in a book only $7^1/_2$ by $5^1/_4$ inches in size, reality and vision have been rendered equally tangible, as if captured by a Jan van Eyck or a Robert Campin on a large panel.

The lavish detail with which textiles are depicted in all these Flemish works reflects their great importance to fifteenth-century society. A remarkable example of Flemish fiber arts is a sumptuous embroidered cope now in the Imperial Treasury in Vienna (fig. 17-24). (To view the full effect of a cope, see the angels at the right in the center panel of the Portinari Altarpiece, fig. 17-22.) The surface of this vestment is divided into compartments, with the standing figure of a saint in each one. At the top of the cloak's back, as if presiding over the standing saints, is an enthroned figure of Christ, flanked by scholar-saints in their studies. The designer of this outstanding piece of needlework was clearly familiar with contemporary Flemish painting, and the embroiderers were able to copy the preliminary drawings with great precision. The particular stitch used here is a kind of couching, consisting of double gold threads tacked down with unevenly spaced colored silk threads to create an iridescent effect.

In the fifteenth and sixteenth centuries, Flemish tapestry making was considered the best in Europe. Major weaving centers at Brussels, Tournai, and Arras produced intricately designed wall hangings for royal and aristocratic patrons, important church officials, and even town councils. Among the most common subjects were foliage and flower patterns, scenes from the lives of the

saints, and themes from classical mythology and history. Tapestries provided both insulation and luxurious decoration for the stone walls of castles, churches, and municipal buildings. Often they were woven for specific places or for festive occasions such as weddings, coronations, and other public events. Many were given as diplomatic gifts, and the wealth of individuals can often be judged from the number of tapestries listed in their household inventories. Some of the finest surviving weavings were originally in royal chambers. In one earlyfifteenth-century painting, tapestries can be seen hanging on the walls in the private rooms where the French queen Isabeau of Bavaria accepts a bound manuscript from the author Christine de Pizan (see fig. 20, Introduction). More sumptuous woven and embroidered textiles covered the queen's bed and were sewn into robes for her and the ladies-in-waiting who are gathered with her.

One of the best-known tapestry suites (now in The Metropolitan Museum of Art, New York) is the *Hunt of the Unicorn*. The unicorn, a mythological horselike animal with cloven hooves, a goat's beard, and a single long twisted horn, appears in stories from ancient India, the Near East, and Greece. The creature was said to be supernaturally swift and, in medieval belief, could only be captured by a young virgin, to whom it came willingly. Thus, it became a symbol of the Incarnation, with Christ as the unicorn captured by the Virgin Mary, and also a metaphor for romantic love, suitable as a subject for wedding tapestries.

Each piece in the suite exhibits many people and animals in a dense field of trees and flowers, with a distant

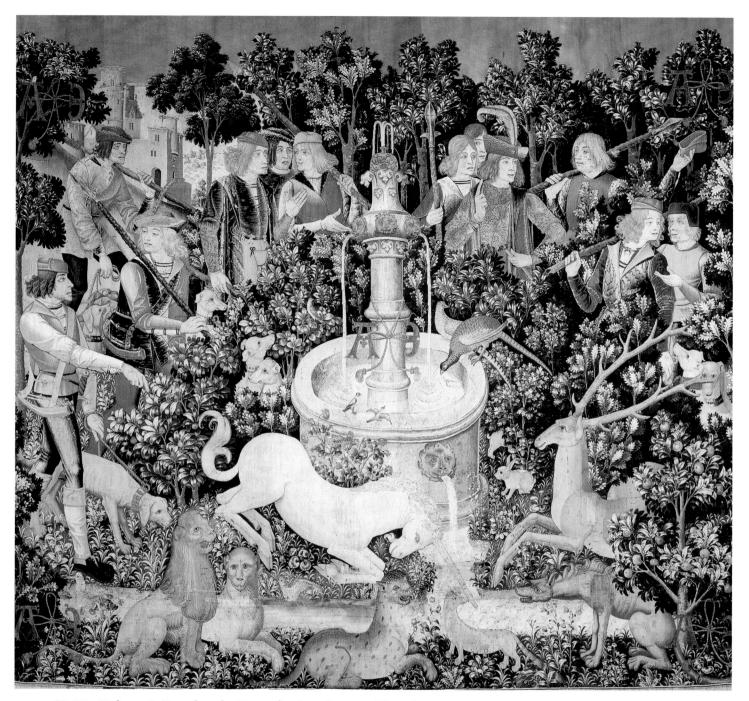

17-25. Unicorn Is Found at the Fountain, from the Hunt of the Unicorn tapestry series. c. 1495–1505. Wool, silk, and silver and gilt wrapped thread (13–21 warp threads per inch), $12'1'' \times 12'5''$ (3.68 \times 3.78 m). The Metropolitan Museum of Art, New York. Gift of John D. Rockefeller Jr., the Cloisters Collection, 1937 (37.80.2)

The price of a tapestry depended on the materials used. Rarely was a fine, commissioned series woven only with wool; instead, tapestry producers enhanced it to varying degrees with silk, silver, and gold wrapped threads. The richest kind of tapestry was made almost entirely of silk and gold. Because silver and gold threads were made of silk wrapped with real metal, people later burned many tapestries to retrieve the precious materials. As a result, few royal tapestries in France survived the French Revolution. Many existing works show obvious signs, however, that the metallic threads were painstakingly pulled out in order to get the gold but preserve the tapestries.

view of a castle, as in the *Unicorn Is Found at the Fountain* (fig. 17-25). The unusually fine condition of the piece allows us to appreciate its rich coloration and the subtlety in modeling the faces, creating tonal variations in the animals' fur, and depicting reflections in the water.

Because of its religious connotations, the unicorn was an important animal in the medieval **bestiary**, an encyclopedia of real and imaginary animals that gave information of both moral and practical value. For ex-

ample, the unicorn's horn (in fact, the narwhale's horn) was thought to be an antidote to poison. Thus, the unicorn purifies the water by dipping its horn into it. This beneficent act, resulting in the capture and killing of the unicorn, was equated with Christ's death on the cross to save humanity. The prominence of the red roses (symbols of the Passion and of Mary) growing behind the unicorn suggests that the tapestries may have celebrated Christian doctrine rather than a marriage. The tapestries

could have been made for the wedding of Anne of Brittany, although attempts to link letters A and E, hanging by a cord, to her name or motto (A ma vie, "By my life") have been challenged.

The woodland creatures included here have symbolic meanings as well. For instance, lions, ancient symbols of power, represent valor, faith, courage, and mercy; the stag is a symbol of Christian resurrection and a protector against poisonous serpents and evil in general; and the gentle, intelligent leopard was said to breathe perfume. Not surprisingly, the rabbits symbolize fertility and the dogs fidelity. The pair of pheasants is an emblem of human love and marriage, and the goldfinch is another symbol of fertility. Only the ducks swimming away have no known message.

The plants, flowers, and trees in the tapestry, identifiable from their botanically correct depictions, reinforce the theme of protective and curative powers. Each has both religious and secular meanings, but the theme of marriage, in particular, is referred to by the presence of such plants as the strawberry, a common symbol of sexual love; the pomegranate, for fertility; the pansy, for remembrance; and the periwinkle, a cure for spiteful feelings and jealousy. The trees include oak for fidelity, beech for nobility, holly for protection against evil, hawthorn for the power of love, and orange for fertility. The parklike setting with its prominent fountain is rooted in the biblical love poem the Song of Songs (4:12, 13, 15-16):

"You are an enclosed garden, my sister, my bride, an enclosed garden, a fountain sealed. You are a park that puts forth pomegranates, with all choice fruits.

. . . You are a garden fountain, a well of water flowing fresh from Lebanon.

Let my lover come to his garden and eat its choice fruits."

In contrast to the elegant intellectualism of the unicorn tapestries is the so-called Monkey Cup (fig. 17-26). The cup seems almost too rich to touch, but it is a perfectly functional drinking vessel. Unlike medieval enamel, with its carefully separated colors, the enamel here was applied like paint to the silver cup. The sophistication of the enamel technique contrasts with the earthy theme of the decoration, where monkeys—actually tailless Barbary apes-steal a peddler's satchel and play wickedly in the curling foliage. The colors—black, white, and gold—were the heraldic colors of Charles the Bold's father, Philip the Good, the duke of Burgundy (ruled 1419-67), whose court set the fashion in clothes, manners, entertainment, and fine dining, as well as art and pageantry, throughout Europe.

OF THE

THE SPREAD Flemish art—its complex and provocative symbolism, its realism and atmospheric FLEMISH STYLE space, its brilliant colors and sensuous textures-delight-

ed wealthy patrons and well-educated courtiers both in-

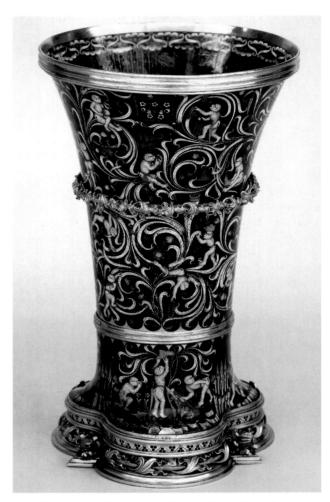

17-26. Beaker, known as the Monkey Cup, from Flanders. 2nd quarter of 15th century. Silver, silver gilt, and painted enamel, height $7^{7}/8$ " (20 cm), diameter $4^{5}/8$ " (11.7 cm). The Metropolitan Museum, New York. The Cloisters Collection, 1952 (52.50)

side and outside of Flanders. At first, Flemish artists were imported to foreign courts; then many artists from outside Flanders went to study there. Flemish manuscripts, tapestries, altarpieces, and portraits began appearing in palaces and chapels throughout Europe. As the art works spread, local artists were able to learn Flemish oil painting techniques and emulate the Flemish style, until by the later years of the fifteenth century, distinctive regional variations of Flemish art could be found throughout Europe, from the Atlantic Ocean to the Danube.

THE IBERIAN PENINSULA

Many Flemish paintings and artists traveled to the Iberian peninsula (modern Spain and Portugal), where they were held in high esteem. Queen Isabella of Castile, for example, preferred Flemish painting to all other styles. Local painters such as Nuño Gonçalves (active 1450-91), a major artist connected with the court of Portugal, quickly absorbed the Flemish style. Among his inspirations was Jan van Eyck, who had visited Portugal to paint the portrait of a princess who was a candidate for marriage to the duke of Burgundy.

Gonçalves's intense interest in detail, monumental figures, and rich colors reflect Jan's influence—although his portraiture, for which he was renowned, was closer in the sense of a severe or simpler style to Dirck Bouts's and Hans Memling's than to Jan's. Gonçalves's only securely attributed works are six panels from a large altarpiece made for the Convent of Saint Vincent de Fora in Lisbon perhaps as early as 1465–67 (fig. 17-27). The paintings hold a special interest for Americans because the painter has included a portrait of Prince Henry the Navigator, the man who inspired and financed Portuguese exploration. Prince Henry sent ships down the west coast of Africa and out into the Atlantic, but he died before Columbus's ships reached the Americas. Dressed in black, he kneels behind his nephew, King Alfonso V.

Saint Vincent, magnificent in red and gold vestments, stands in a tightly packed group of people, with members of the royal family at the front and courtiers forming a solid block across the rear. With the exception of the idealized features of the saint, all are portraits: At the right, King Alfonso V kneels before Saint Vincent, while his young son and his deceased uncle, Henry the Navigator, look on. Alfonso and his son rest their hands on their swords; Henry's hands are tented in prayer. At the left, Alfonso's deceased wife and mother hold rosaries. The appearance of Saint Vincent is clearly a vision, brought on by the intense prayers of the individuals around him.

FRANCE

France and England's centuries-long struggle for power and territory continued well into the fifteenth century. When Charles VI of France died in 1422, England claimed the throne for his nine-month-old grandson, Henry VI of England. The infant king's uncle, the duke of Bedford, then assumed control of the French royal territories as regent, with the support of the duke of Burgundy. Charles VII, the late French king's son, had been exiled, inspiring Joan of Arc to lead a crusade to return him to the throne. Although Joan was burned at the stake in 1431, the revitalized French forces captured Paris in 1436 and by 1453 had driven the English from French lands. In 1461 Louis XI succeeded his father. Charles VII, as king of France. Under his rule the French royal court again became a major source of patronage for the arts.

The leading court artist of the period, Jean Fouquet (c. 1420–81), was born in Tours and may have trained in Paris as an illuminator. He probably traveled to Italy in about 1445, but by about 1450 he was back in Tours, a renowned painter. He painted Charles VII, the royal family, and courtiers, and he illustrated manuscripts and designed tombs. Fouquet knew contemporary Italian architectural decoration, and he was also strongly influenced by Flemish realism. Among the court officials painted by Fouquet is Étienne Chevalier, the treasurer of France under Charles VII, for whom he painted a diptych showing Chevalier praying to the Virgin and Child (fig. 17-28, page 608). According to an inscription,

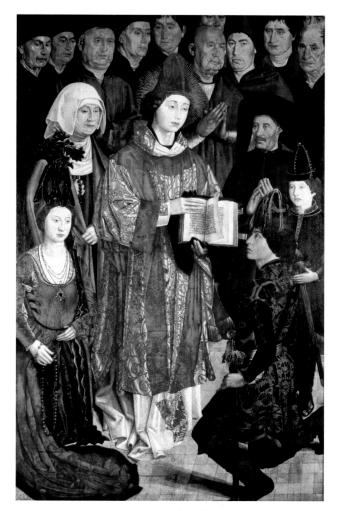

17-27. Nuño Gonçalves. *Saint Vincent with the Portuguese Royal Family,* panel from the *Altarpiece of Saint Vincent.* c. 1471–81. Oil on wood panel, $6'9^3/_4" \times 4'2^5/_8"$ (2.07 × 1.28 m). Museu Nacional de Arte Antiga, Lisbon.

the painting was made to fulfill a vow made by Chevalier to the king's much-loved and respected mistress, Agnès Sorel, who died in 1450. Sorel, whom contemporaries described as a highly moral, extremely pious woman, was probably the model for the Virgin, her features taken from her death mask, which is still preserved.

Chevalier, who kneels in prayer with clasped hands and a meditative gaze, wears a houppelande, the voluminous costume of the time. Fouquet has followed the Flemish manner in depicting the courtier's ruddy features with the truthful detail of a reflection in a mirror; his accuracy is confirmed by other known portraits. Chevalier is presented to the Virgin by his name saint, Stephen ("Étienne" in French), whose features are also distinctive enough to have been a portrait. According to legend and biblical accounts, Stephen, a deacon in the early Christian Church in Jerusalem, was the first Christian martyr, stoned to death for defending his beliefs. Here the saint wears liturgical, or ritual, vestments and carries a large stone on a closed Gospel book. A trickle of blood can be seen on his tonsure, the shaved head adopted as a sign of humility by male members of religious orders. The two figures are shown in a large hall

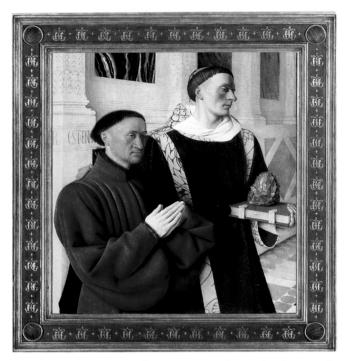

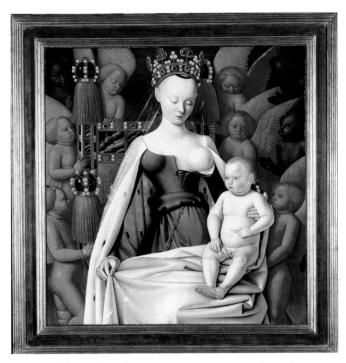

17-28. Jean Fouquet. Étienne Chevalier and Saint Stephen, left wing of the Melun Diptych. c. 1450. Oil on wood panel, $36\frac{1}{2} \times 33\frac{1}{2}$ " (92.7 × 85.5 cm). Staatliche Museen zu Berlin, Preussischer Kulturbesitz, Gemäldegalerie. *Virgin and Child*, right wing of the *Melun Diptych*. c. 1451. Oil on wood panel, $37\frac{1}{4} \times 33\frac{1}{2}$ " (94.5 × 85.5 cm). Koninklijk Museum voor Schone Kunsten, Antwerp, Belgium.

The diptych was separated long ago and the two paintings went to collections in different countries. They are reunited on this page.

decorated with marble paneling and classical pilasters. Fouquet has arranged the figures in an unusual spatial setting, with the diagonal lines of the wall and uptilted tile floor receding toward an unseen vanishing point at the right. Despite his debt to Flemish realism and his nod to Italian architectural forms and to linear perspective, Fouquet's somewhat austere style is uniquely his own.

GERMANY

In the Holy Roman Empire, a loose confederation of primarily Germanic states that lasted as the Habsburg Empire until the early twentieth century, two major stylistic strains of art existed simultaneously during the first half of the fifteenth century. One continued the International Gothic style with increased prettiness, softness, and sweetness of expression. The other was an intense investigation and detailed description of the physical world. The major exponent of the latter style was Konrad Witz (documented from 1434; d. 1445/46). Witz, a native of what is now southern Germany, was drawn, like many artists, to Basel (in modern Switzerland), where the numerous Church officials were a rich source of patronage. Witz's last large commission before his early death (probably from the plague) was an altarpiece dedicated to Saint Peter for the Cathedral of Saint Peter in Geneva, the wings of which he signed and dated in 1444. In the Miraculous Draft of Fish (fig. 17-29), a scene from the life of the apostle Peter, the Flemish influence can be perceived in the handling of drapery and in details of the landscape setting that ultimately engages our

attention. The painter has created an identifiable topographical portrayal of Lake Geneva, with its dark mountain rising on the far shore behind Jesus and the snow-covered Alps shining in the distance. Witz records every nuance of light and water—the rippling surface, the reflections of boats, figures, and buildings, even the lake bottom. Peter's body and legs, visible through the water, are distorted by the refraction. The floating clouds above create shifting light and dark passages over the water. Witz, perhaps for the first time in European art, recorded and captured the appearance and spirit of nature.

GRAPHIC ARTS

THE Printmaking emerged in Europe with the increased local manufacture of paper at the end of the fourteenth century. Paper had been made in China as early as the second century, and small

amounts were imported into Europe from the eighth century on. Paper was made in Europe from the twelfth century on, but it was rare and expensive. By the beginning of the fifteenth century, however, commercial paper mills in nearly every European country were turning out large supplies, making paper fairly inexpensive to use for printing. Woodblocks cut in relief had long been used to print designs on cloth, but only in the fifteenth century did the printing of images and texts on paper and the production of books in multiple copies of a single edition, or version, begin to replace the copying of each book by hand. Soon both handwritten and printed books were illustrated with printed images.

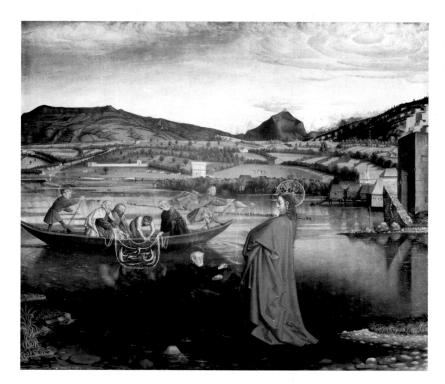

17-29. Konrad Witz. *Miraculous Draft of Fish*, from an altarpiece from the Cathedral of Saint Peter, Geneva, Switzerland. 1444. Oil on wood panel, 4'3" × 5'1" (1.29 × 1.55 m). Musée d'Art et d'Histoire, Geneva.

Printed books and single-sheet printed images were sometimes embellished with **watercolor paints**.

Single-sheet prints in the **woodcut** and **engraving** techniques were made in large quantities in the early decades of the fifteenth century (see "Woodcuts and Engravings on Metal," page 612). Initially, woodcuts were made primarily by woodworkers with no training in drawing, but soon artists began to draw the images for them to cut from the block. Simply executed devotional images sold as souvenirs to pilgrims at holy sites were popular, such as Saint Christopher (found in the Carthusian Monastery of Buxheim, in southern Germany), dated 1423, one of the earliest woodcuts to survive (fig. 17-30). Saint Christopher, patron saint of travelers, carries the Christ Child across the river; in this image his efforts are witnessed by a monk at the monastery door. Not all prints were made for religious purposes, or even for sale. Some artists seem to have made them as personal studies, in the manner of drawings, or for use in their shops as models.

Engravings, by contrast, seem to have developed from the metalworking techniques of goldsmiths and armorers. When paper became relatively plentiful around 1400, these artisans began to make impressions of the designs they were engraving on metal by rubbing the lines with lampblack and pressing paper over them. German artist Martin Schongauer (1430/50-91), who learned engraving from his goldsmith father, was an immensely skillful printmaker who excelled in drawing and the difficult technique of shading from deep blacks to faintest grays. One of his best-known prints today is the Temptation of Saint Anthony, engraved about 1480-90 (fig. 17-31, page 610). Schongauer illustrated the original biblical meaning of temptation, expressed in the Latin word tentatio, as a physical assault rather than a subtle inducement. Wildly acrobatic, slithery, spiky demons lift

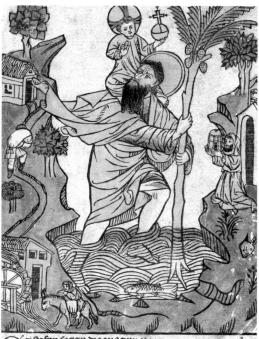

Thofon facin dequation mens :- Mustino ecce

17-30. *The Buxheim Saint Christopher*. 1423. Hand-colored woodcut, The John Rylands University Library. Courtesy of the Director and Librarian, The John Rylands University Library of Manchester, England.

Anthony up off the ground to torment and terrify him in midair. The engraver intensified the horror of the moment by condensing the action into a swirling vortex of figures beating, scratching, poking, tugging, and no doubt shrieking at the stoical saint, who remains impervious to all by reason of his faith.

17-31. Martin Schongauer. *Temptation of Saint Anthony*. c. 1480–90. Engraving, $12^{1}/_{4} \times 9''$ (31.1 \times 22.9 cm). The Metropolitan Museum of Art, New York. Rogers Fund, 1920 (20.5.2)

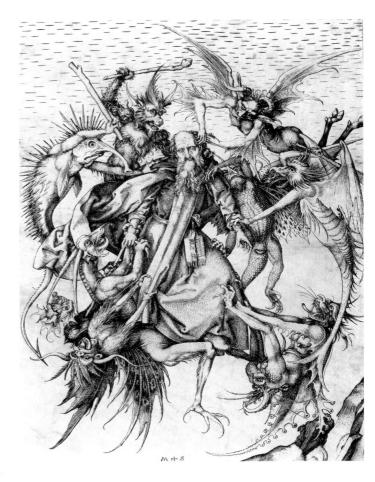

During the fifteenth century, printmaking flourished in Italy, as it did in northern Europe, but did so with the special regard for the sculpture and literature of classical antiquity that marked the Renaissance in Italy.

ART OF ITALY

FALY

By the end of the Middle Ages, the most important Italian cultural centers were north of Rome at Florence, Pisa, Milan, Venice, and the smaller duchies of

Mantua, Ferrara, and Urbino. Much of the power and art patronage was in the hands of wealthy families: the Medici in Florence, the Visconti and Sforza in Milan, the Gonzaga in Mantua, the Este in Ferrara, and the Montefeltro in Urbino. Cities grew in wealth and independence as people moved to them from the countryside in unprecedented numbers, and commerce became increasingly important. In some of the Italian states a noble lineage was no longer necessary for-nor did it guarantee-political and economic success. Now money conferred status, and a shrewd business or political leader could become very powerful. Patronage of the arts was an important public activity with political overtones. As one Florentine merchant, Giovanni Rucellai, succinctly noted, he supported the arts "because they serve the glory of God, the honour of the city, and the commemoration of myself" (cited in Baxandall, page 2).

The Medici of Florence were leaders in intellectual and artistic patronage, as they were in business—and their city was the cradle of the Italian Renaissance. Cosimo de' Medici the Elder (1389–1464) founded an

academy devoted to the study of the classics, especially the works of Plato and his followers, the Neoplatonists. Neoplatonism sharply distinguishes between the spiritual (the ideal or Idea) and the carnal (Matter) and argues that the latter can be overcome by severe discipline and denial of the world of the senses. Writers, philosophers, and musicians dominated the Medici Neoplatonic circle. Few architects, sculptors, or painters were included, however, for although some artists had studied Latin or Greek, most had learned their craft in apprenticeships and thus were still considered little more than manual laborers. Nevertheless, interest in the ancient world rapidly spread beyond the Medici circle to artists and craftspeople, who sought to reflect the new interests of their patrons in their work. Gradually, artists began to see themselves as more than artisans and society recognized their best works as achievements of a very high order.

Artists, like humanist scholars, turned to classical antiquity for inspiration. Because few examples of ancient Roman painting were known in the fifteenth century, Renaissance painters looked to Roman sculpture and literature. Despite this interest in antiquity, fifteenth-century Italian painting and sculpture continued to be predominantly Christian. Secular works were rare until the second half of the century, and even these were chiefly portraits. Allegorical and mythological themes also appeared in the latter decades as patrons began to collect art for their personal enjoyment. The male nude became an acceptable subject in Renais-

sance art, mainly in religious images—Adam, Jesus on the cross, and martyrdoms of saints such as Sebastian. Other than representations of Eve or an occasional allegorical or mythological figure such as Venus, female nudes were rare until the end of the century.

The Florentine goldsmith and sculptor Antonio del Pollaiuolo's *Battle of the Nudes* (fig. 17-32), an engraving, illustrates many of these interests: the study of classical sculpture, anatomical research that leads to greater realism, as well as the artist's technical skill. Pollaiuolo may have intended this, his only known—but highly influential—print, as a study in composition involving the human figure in action. The naked men fighting each other ferociously against a tapestrylike background of foliage seem to have been drawn from a single model in a variety of poses, many of which were taken from classical sources. Like the artist's *Hercules and Antaeus* (see fig. 17-57), much of the engraving's fascination lies in how it depicts muscles of the male body reacting under tension.

Like their Flemish counterparts, Italian painters and sculptors moved gradually toward a greater precision in rendering the illusion of physical reality. They did so in a more analytical way than the Flemings had, with the goal of achieving correct but perfected generic figures set within a rationally, rather than visually, defined

space. Painters and relief sculptors developed a mathematical system of linear perspective to achieve the illusion of continuously receding space (see "Renaissance Perspective Systems," page 583), just as Italian architects came to apply abstract, mathematically derived design principles to their plans and elevations.

ARCHITECTURE AND ITS DECORATION

Travelers from across the Alps in the mid-fifteenth century found Italian cities very different in appearance from their northern counterparts. In Florence, for example, they did not find church spires piercing the sky, but a skyline dominated, as it still is today, by the enormous mass of the cathedral dome rising above low houses, smaller churches, and the blocklike palaces and towers of the wealthy, all of which had minimal exterior decoration.

Florence. The major civic project of the early years of the fifteenth century was to complete the Florence Cathedral, begun in the late thirteenth century and continued intermittently during the fourteenth century. As early as 1367, its architects had envisioned a very tall dome to span the huge interior space of the **crossing**, but they lacked the engineering know-how to construct it. When interest in completing the cathedral revived, around 1407, the technical solution was proposed by a

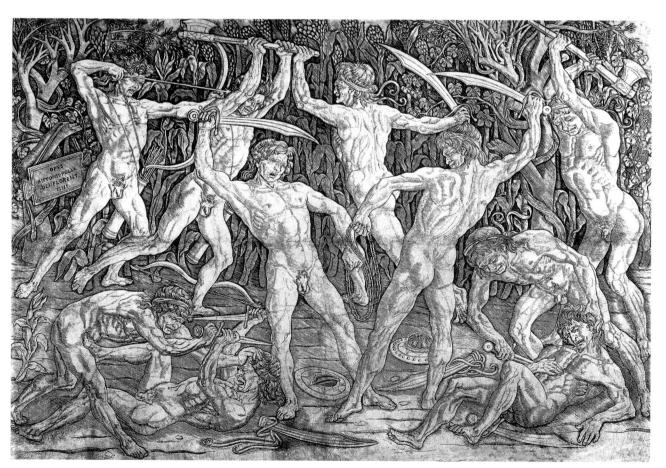

17-32. Antonio del Pollaiuolo. *Battle of the Nudes.* c. 1465–70. Engraving, $15\frac{1}{8} \times 23\frac{1}{4}$ " (38.3 × 59 cm). Cincinnati Art Museum, Ohio.

Bequest of Herbert Greer French. 1943.118

Woodcuts are made by drawing on the smooth surface of a block of finegrained wood, then cutting away all the areas around the lines with a sharp tool called a gouge, leaving the lines in

high relief. When the block's surface is inked and a piece of paper pressed down hard on it, the ink on the relief areas transfers to the paper to create a reverse image. The effects can be varied by making thicker and thinner lines, and shading can be achieved by placing the lines closer or farther apart. Sometimes the resulting black-and-white images were then painted by hand.

Engraving on metal requires a technique called **intaglio**, in which the lines are cut into the plate with tools called gravers or **burins**. The engraver then carefully burnishes the plate to ensure a clean, sharp image. Ink is applied over the whole plate and forced down into the lines, then the plate's surface is carefully wiped clean of the excess ink. When paper and plate are held tightly together by a press, the ink in the lines transfers to the paper.

Woodblocks and metal plates could be used repeatedly to make nearly identical images. If the lines of the block or plate wore down, the artists could repair them. Printing large numbers of identical prints of a single version, called an **edition**, was usually a team effort in a busy workshop. One artist would make the drawing.

TECHNIQUE

Woodcuts and Engravings on Metal

Sometimes it was drawn directly on the block or plate with ink, in reverse of its printed direction, sometimes on paper to be transferred in reverse onto the plate or block by another person,

who then cut the lines. Others would ink and print the images.

Prints often were inscribed with the names and occupations (usually given in Latin, and frequently abbreviated) of those who carried out these various tasks. The following are some of the most common inscriptions (Hind, volume 2, page 26):

Sculpsit (sculp., sc.), sculptor: engraved or cut, engraver or cutter Fecit (fec., f.): literally "made"; engraved or cut, engraver or cutter Pinxit (pinx.), pictor: painted, painter Delineavit (delin.), delineator: drew, draftsperson

In the illustration of books, the plates or blocks would be reused to print later editions and even adapted for use in other books. A set of blocks or plates for illustrations was a valuable commodity often sold by one workshop to another. Early in publishing, there were no copyright laws, and many entrepreneurs simply had their workers copy book illustrations onto woodblocks and cut them for their own publications.

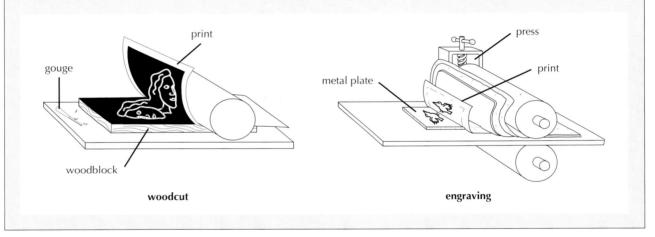

young sculptor-turned-architect, Filippo Brunelleschi (1377–1446). Brunelleschi's intended career as a sculptor had ended with his failure to win a competition in 1402 to design bronze doors for the Baptistry of San Giovanni, opposite the cathedral (see fig. 17-50). Brunelleschi declined a role as assistant on that project and traveled to Rome, probably with his sculptor friend Donatello, where he studied ancient Roman sculpture and architecture.

Brunelleschi, whose father had been involved in the original plans for the cathedral dome in 1367, advised constructing first a tall **drum**, or cylindrical base. The drum was finished in 1410, and in 1417 Brunelleschi was commissioned to design the dome itself (fig. 17-33). He proposed his solution to the engineering problems in 1418. Work began in 1420 and was completed by 1471.

A revolutionary feat of engineering, the dome is a double shell of masonry that combines Gothic and Renaissance elements. Gothic construction is based on the pointed arch, using stone shafts, or ribs, to support the vault, or ceiling. The octagonal outer shell is essentially a structure of this type, supported on ribs and in a pointed-arch profile; however, like Roman domes, it is cut at the top with an oculus (opening) and is surmounted by a **lantern**, a crowning structure made up of Roman architectural forms. The dome's 138-foot diameter would have necessitated the use of **centering**, temporary wooden construction supports that were costly and even dangerous. Therefore, Brunelleschi devised machinery to hoist building materials as needed and invented an ingenious system by which each portion of the structure reinforced the next one as the

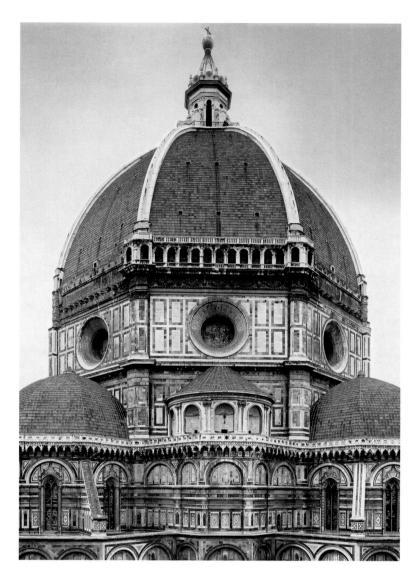

17-33. Filippo Brunelleschi. Dome of Florence Cathedral. 1417–36; lantern completed 1471.

The cathedral dome was a source of immense local pride from the moment of its completion. Renaissance architect and theorist Leon Battista Alberti described it as rising "above the skies, large enough to cover all the peoples of Tuscany with its shadow" (cited in Goldwater and Traves, page 33; see "Alberti's Art Theory in the Renaissance," page 617). While Brunelleschi maintained the Gothic pointedarch profile of the dome established in the fourteenth century, he devised an advanced construction technique that was more efficient, less costly, and safer than earlier systems. An arcaded gallery he planned to install at the top of the tall drum was never built, however. In 1507 Baccio d'Agnolo won a competition to design the gallery, using supports installed on the drum nearly a century earlier. The first of the eight sections, seen here, was completed in 1515.

dome was built up **course**, or layer, by course. The reinforcing elements were vertical marble ribs and horizontal sandstone rings connected with iron rods, with the whole reinforced by oak staves and beams tying rib to rib (fig. 17-34). The inner and outer shells were also linked internally by a system of arches. When completed, this self-buttressed unit required no external support to keep it standing.

The cathedral dome was a triumph of engineering and construction technique for Brunelleschi, who was a pioneer in Renaissance architectural design. Other commissions came quickly after the cathedral-dome project, and Brunelleschi's innovative designs were well received by Florentine patrons. He designed a foundling hospital for the city in 1419 (fig. 17-35, "The Object Speaks: The Foundling Hospital," page 614). From about 1418 until his death, in 1446, Brunelleschi was involved in projects for the Medici. For the Medici's parish Church of San Lorenzo, he designed a **sacristy** (a room where ritual attire and vessels are kept) as a burial chapel for

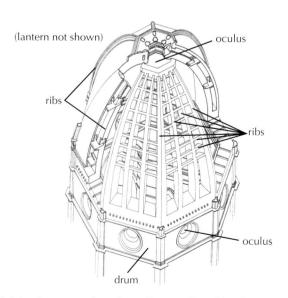

17-34. Cutaway drawing of Brunelleschi's dome, Florence Cathedral. (Drawing by P. Sanpaolesi)

THE OBJECT SPEAKS

THE FOUNDLING HOSPITAL

ecorated with blue-and-white medallions bearing images of swaddled babies, this ancient orphanage in one of the world's most beautiful public spaces, Florence's Piazza della Santissima Annunziata, echoes the long-ago cries of children. Built in 1444, the Foundling Hospital, the Ospedale degli Innocenti, was the first of its kind—although the need to care for abandoned children went back to the thirteenth century with the explosive growth of city populations and consequent social disruption.

Care of the helpless and destitute had been the responsibility of families, the village, and the Church. In 1410 a merchant of Prato, Francesco Datini, had left 1,000 florins to build a hospital. Then in 1419 the Guild of Silk Manufacturers and Goldsmiths in Florence undertook an unprecedented public service: It established a public orphanage and commissioned the brilliant young architect Filippo Brunelleschi to build it (fig. 17-35) next to the Church of the Santissima Annunizata ("Holiest Annunciation"), which housed a miracle-working painting of the Annunciation.

Brunelleschi created a building that paid homage to traditional forms while introducing what came to be known as Renaissance style. Traditionally, a charitable foundation's building had a portico open to the street to provide shelter. Brunelleschi built an arcade of hitherto unimagined lightness and elegance, using smooth round columns and richly carved Corinthianesque capitals—his own interpretation of a classical order. The underlying mathematical basis for his design creates a sense of classical harmony. Each bay of the arcade encloses a cube of space defined by the 10-braccia

(20-foot) height of the columns and diameter of the arches. Hemispherical **pendentive domes**, half again as high as the columns, cover the cubes. The bays at the end of the arcade are slightly larger than the rest, creating a subtle frame for the composition. Brunelleschi defined the perfect squares and circles of his building with dark gray stone (*pietra serena*) against plain white walls. His training as a goldsmith and sculptor served him well as he led his artisans to carve crisp, elegantly detailed capitals and moldings for the *loggia*, an open covered gallery.

A later addition to the building seems eminently suitable: Andrea della Robbia's glazed **terra-cotta** medallions in the **spandrels** of the arches. Brunelleschi may have intended to divide the triangular spaces with pilasters to create a pattern that would harmonize with the pedimented windows above. If so, they were never executed. Instead, about 1487 Andrea della Robbia, who had inherited the family firm and its secret glazing formulas from his uncle Luca, created blue-and-white glazed medallions that signified the building's function. The babies in swaddling clothes, one in each medallion, are among the most beloved images of Florence.

The medallions seem to embody the human side of Renaissance humanism, reminding viewers that the city's wealthiest guild, led by its most powerful citizen, Cosimo de' Medici, cared for the most helpless members of society. Perhaps the Foundling Hospital spoke to fifteenth-century Florentines of an increased sense of social responsibility. Or perhaps, by so publicly demonstrating social concerns, the wealthy guild that sponsored it solicited the approval and support of the lower classes in the cutthroat power politics of the day.

17-35. Filippo Brunelleschi. Foundling Hospital, Florence, Italy. Designed 1419; built 1421-44.

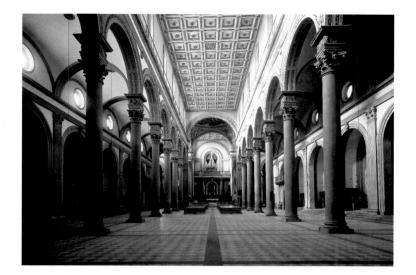

17-36. Filippo Brunelleschi; continued by Michelozzo di Bartolomeo. Nave, Church of San Lorenzo, Florence. c. 1421–28, 1442–70.

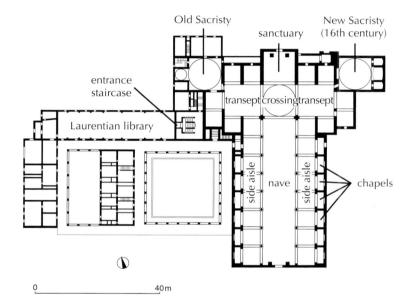

17-37. Plan of the Church of San Lorenzo, including later additions and modifications

Giovanni de Bicci de' Medici and his wife. Completed in 1425, it today is called the Old Sacristy to distinguish it from one built in the sixteenth century. Brunelleschi may have worked on the church itself, replacing the eleventh-century basilica. The precise history of this second project is obscured by interruptions in the construction and later alterations. Brunelleschi conceived the plans for the new church at the same time that he designed and built the sacristy between 1421 and 1428. Michelozzo di Bartolomeo (1396–1474), whose name appears in the construction documents, may be credited with finishing the building after Brunelleschi's death in 1446.

The Church of San Lorenzo has a basilican plan, with a long **nave**, flanked by single side aisles opening into shallow side chapels (fig. 17-36). A short **transept** and square crossing lead to a square **sanctuary** flanked by chapels opening off the transept. Projecting from the left transept, as one faces the altar, is Brunelleschi's sacristy and the older Medici tomb. Brunelleschi may have left the project as early as 1428—certainly by 1442—leaving others to carry out his design.

San Lorenzo is unusual in its mathematical regularity and symmetry. Brunelleschi based his plan on a square, traditionally medieval, module—a basic unit of measure that could be multiplied or divided and applied to every element of the design. The result was a series of clear, rational interior spaces in harmony with one another. Brunelleschi's modular system was also carried through in the proportions of the church's interior elevation (fig. 17-37). Ornamental details, all in a classical style, were carved in *pietra serena*, a grayish stone that became synonymous with Brunelleschi's interiors. Below the plain clerestory (upper-story wall of windows) with its unobtrusive openings, the arches of the nave arcade are carried on tall, slender Corinthian columns made even taller by the insertion of a favored Brunelleschian device, an impost block between the column capital and the springing of the round arches. The arcade is repeated in the outer walls of the side aisles in the arched openings to the chapels surmounted by arched lunettes. Flattened architectural forms in pietra serena articulate the wall surfaces, and each bay is covered by its own shallow vault. The square crossing

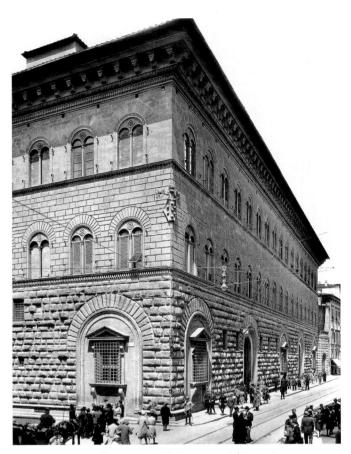

17-38. Attributed to Michelozzo di Bartolomeo. Palazzo Medici-Riccardi, Florence. Begun 1446.

Cosimo de' Medici the Elder decided to build a new palace not just to provide more living space for his family. He also incorporated into the plans offices and storage rooms for conducting his business affairs. For the palace site, he chose the Via de' Gori at the corner of the Via Larga, the widest city street at that time. Despite his practical reasons for constructing a large residence and the fact that he chose simplicity and austerity over grandeur in the exterior design, his detractors commented and gossiped. As one exaggerated: "[Cosimo] has begun a palace which throws even the Colosseum at Rome into the shade."

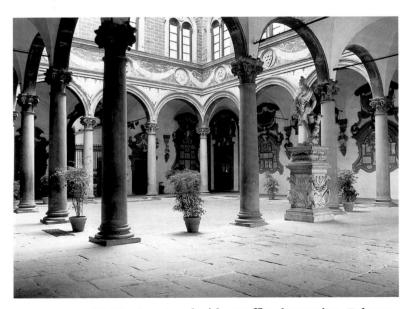

17-39. Courtyard with *sgraffito* decoration, Palazzo Medici-Riccardi, Florence. Begun 1446.

is covered by a hemispherical dome, the nave and transept by flat ceilings. San Lorenzo was an experimental building combining old and new elements, but Brunelleschi's rational approach, unique sense of order, and innovative incorporation of classical motifs were inspirations to later Renaissance architects, many of whom learned from his work firsthand by completing his unfinished projects.

Brunelleschi's role in the Medici palace (now known as the Palazzo Medici-Riccardi) in Florence, begun in 1446, is unclear. According to the sixteenth-century painter, architect, and biographer Giorgio Vasari, Brunelleschi's model for the palazzo (any large house was called a palace—palazzo—and the word does not imply aristocratic ownership) was rejected as too grand by Cosimo de' Medici the Elder, who may have hired Michelozzo, whom many scholars have accepted as the designer of the building. In any case, the palace established a tradition for Italian town houses that, with interesting variations, remained the norm for a century (fig. 17-38). The plain exterior was in keeping with political and religious thinking in Florence, which was strongly influenced by Christian ideals of poverty and charity. Like many other European cities, Florence had sumptuary laws, which forbade ostentatious displays of wealth—but they were often ignored. Under Florentine law, for example, private homes were limited to a dozen rooms; Cosimo, however, acquired and demolished twenty small houses to provide the site for his new residence. The house was more than a dwelling place; it symbolized the family and established the family's place in society.

Huge in scale (each story is more than 20 feet high), the building, nevertheless, has fine proportions and details. On one side, the ground floor originally opened through large, round arches onto the street and provided space for the family business. These arches were walled up in the sixteenth century and given windows designed by Michelangelo. The facade of large, **rusticated** stone blocks—that is, with their outer faces left rough, typical of Florentine town house exteriors—was derived from fortifications. On the palace facade, the stories are clearly set off from each other by the change in the stone surfaces from very rough at the ground level to almost smooth on the third.

The builders followed the time-honored tradition of placing rooms around a central courtyard. Unlike the still Medieval plan of the House of Jacques Coeur (see fig. 17-10), however, the Medici Palace courtyard is square with rooms arranged symmetrically (fig. 17-39). Round arches on slender columns form a continuous **arcade** and support an enclosed second story. Tall windows in the second story match the exterior windows. The third story was originally a *loggia*, an open covered gallery. Discs bearing the Medici arms surmount each arch in a frieze decorated with swags in *sgraffito* work (tinted and engraved plaster). Such classical elements, inspired by the study of Roman ruins, gave the great house an aura of dignity and stability and undoubtedly enhanced the status of its owners. Wealthy Florentine

ALBERTI'S ART THEORY IN THE RENAISSANCE

Alberti's books on painting, sculpture, and architecture present the first coherent exposition of aesthetic theory since classical Rome. Leon Battista Alberti developed his ideas in three books: De pictura (On Painting), 1435; De statua (On Sculpture), written in the 1440s and published later; and De re aedificatoria (On Architecture), finished in 1452 and published in 1485. He dedicated On Painting to the architect Brunelleschi. In it he expounded his ideas that painting is the most important of the three arts and that narrative painting, especially allegory, is the highest form of painting.

Painting, he wrote, should be the product of the intellect, not a craft, and the artists' skill rather than costly materials should determine the value.

Alberti developed and codified Brunelleschi's rules of perspective into a mathematical system for representing three dimensions on a two-dimensional surface. The goal he articulated is to make an image resemble a "view through a window," the view being the image represented and the window, the picture plane.

Artists should be intelligent, educated, and, he argued, of high moral character. To achieve these high goals, the artist should not only imitate nature but also improve upon it. Similarly, *On Sculpture* analyzed the

ideal proportions of the human figure.

Alberti's *On Architecture*, which he worked on from the 1430s until 1452, was the first such book since the Roman architect Vitruvius's *On Architecture*, written in the first century. Alberti adopted Vitruvius's definition of fine architecture as embodying strength, utility, and beauty, and he supplemented his theoretical discussions with classical references and evidence from archaeology.

He developed a specific vocabulary for discussing architecture. For example, he further defined the Vitruvian "hierarchy of orders" of architecture—Tuscan, Doric, Ionic, and Corinthian—and added a fifth, "Italic" order, known today as Composite.

families soon copied the Medici Palace in their own houses. The Medici palace inaugurated a new monumentality and regularity of plan in residential urban architecture.

The relationship of the facade to the body of the building behind it was a continuing challenge for Italian Renaissance architects. Early in his architectural career, Leon Battista Alberti (1404-72), a humanist turned architect and author (see "Alberti's Art Theory in the Renaissance," above), devised a facade—begun in 1455 but never finished—to be the unifying front for a planned merger of eight adjacent houses in Florence acquired by Giovanni Rucellai (fig. 17-40). Alberti's design, influenced in its basic approach by the Palazzo Medici, was a simple rectangular front suggesting a coherent, cubical three-story building capped with an overhanging cornice, the heavy, projecting horizontal molding at the top of the wall. The double windows under round arches were a feature of Michelozzo's Palazzo Medici, but other aspects of the facade were entirely new. Inspired by the ancient Colosseum in Rome, Alberti articulated the surface of the lightly rusticated wall with a horizontal-vertical pattern of pilasters and architraves that superimposed the classically inspired orders: **Doric** on the ground floor, floral rather than Ionic on the second, and Corinthian on the third (see "The Renaissance Palace Facade," page 665). The Palazzo Rucellai provided a visual lesson for local architects in the use of classical elements and mathematical proportions, and Alberti's enthusiasm for classicism and his architectural projects in other cities were catalysts for the spread of the Renaissance movement. Later, Alberti worked in Mantua and other north Italian cities.

Mantua, Prato, and Urbino. In the second half of the fifteenth century, the classicizing ideas of artists like Brunelleschi began to expand from Florence to the rest of Italy, combining with local styles to form the distinctive

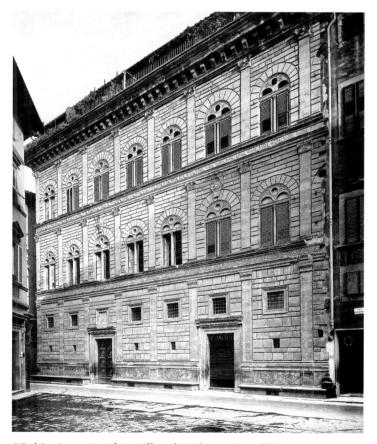

17-40. Leon Battista Alberti. Palazzo Rucellai, Florence. Left five bays 1455–58; later extended but never finished.

Italian Renaissance. Renaissance ideas were often spread by artists who trained or worked in Florence, then traveled to other cities to work, either temporarily or permanently—including Donatello (Padua, Siena), Alberti (Mantua, Rimini, Rome), Piero della Francesca (Urbino, Ferrara, Rome), Uccello (Venice, Urbino, Padua), Giuliano

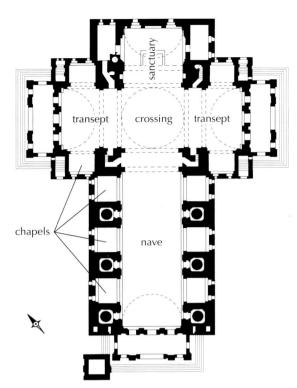

17-41. Leon Battista Alberti. Plan of the Church of Sant'Andrea, Mantua. Designed 1470.

da Sangallo (Rome), and Botticelli (Rome). Northern Italy embraced the new classical ideas swiftly, with the ducal courts at Mantua and Urbino taking the lead. The Republic of Venice and the city of Padua, which Venice had controlled since 1404, also emerged as innovative art centers in the last quarter of the century.

The spread of Renaissance architectural style beyond Florence was due in significant part to Leon Battista Alberti, who traveled widely, wrote on architecture, and expounded his views to potential patrons. In 1470 the ruler of Mantua, Ludovico Gonzaga, commissioned Alberti to enlarge the small Church of Sant'Andrea, which housed a sacred relic believed to be the actual blood of Jesus. To satisfy his patron's desire for a sizable building to handle crowds coming to see the relic, Alberti proposed to build an "Etruscan temple." Work began on the new church in 1472, but Alberti died that summer. Construction went forward slowly, at first according to his original plan, but it was finally completed only at the end of the eighteenth century. Thus, it is not always clear which elements belong to Alberti's original design.

The **Latin-cross plan** (fig. 17-41)—a nave more than 55 feet wide intersected by a transept of equal width; a square, domed crossing; and a rectangular sanctuary on axis with the nave—is certainly in keeping with Alberti's ideas. Alberti was responsible, too, for the barrel-vaulted chapels the same height as the nave and the low chapel niches carved out of the huge piers supporting the barrel vault of the nave. His dome, however, would not have been perforated and would not have been raised on a drum, as this one finally was.

Alberti's design for the facade of Sant'Andrea (fig. 17-42) fuses a classical temple front and triumphal arch, but the facade now has a clear volume of its own, which sets it off visually from the building behind. Two sets of colossal Corinthian pilasters articulate the porch face. Those flanking the barrel-vaulted triumphal-arch en-trance are two stories high, whereas the others, raised on pedestals, run through three stories to support the entablature and pediment of the temple form. The arch itself has lateral barrel-vaulted spaces opening through two-story arches on the left and right.

Neither the simplicity of the plan nor the complexity of the facade hints at the grandeur of Sant'Andrea's interior (fig. 17-43). Its immense barrel-vaulted nave extended on each side by tall chapels was inspired by the monumental interiors of such ancient ruins as the Basilica of Maxentius and Constantine in the Roman Forum. In this clear reference to Roman imperial art put to fully Christian use, Alberti created a building of such colossal scale, spatial unity, and successful expression of Christian humanist ideals that it affected architectural design for centuries.

Another fifteenth-century Florentine architect whose work influenced developments in the sixteenth century was Giuliano da Sangallo (c. 1443-1516). From 1464 to 1472, he worked in Rome, where he produced a number of meticulous drawings after the city's ancient monuments, many of which are known today only from his work. Back in Florence, he became a favorite of Lorenzo the Magnificent, a great humanist and patron of the arts. Soon after completing a country villa for Lorenzo, Giuliano submitted a model for a votive church (a church built as a special offering to a saint) that was to house a painting of the Virgin that a child in 1484 claimed had come to life. The painting was to be relocated from its site on the wall of the town prison to the new church, to be named Santa Maria delle Carceri ("Saint Mary of the Prisons"), in Prato, near Florence. Giuliano began work on it in 1485.

Although the need to accommodate processions and the gathering of congregations made the long nave of a basilica almost a necessity for local churches, the votive church became a natural subject for Renaissance experimentation with the central plan. The existing tradition of **central-plan** churches extended back to the Early Christian martyrium (a round shrine to a martyred saint) and perhaps ultimately to the Classical tholos, or round temple. Alberti in his treatise on architecture had spoken of the central plan as an ideal, derived from the humanist belief that the circle was a symbol of divine perfection and that both the circle inscribed in a square and the cross inscribed in a circle were symbols of the cosmos. Thus, Giuliano's Church of Santa Maria delle Carceri, built on Alberti's ideal Greekcross plan, is one of the finest early Renaissance examples of humanist symbolism in architectural design (fig. 17-44, page 620). It is also the first Renaissance church with a true central plan; Brunelleschi's earlier experiment in the Old Sacristy of San Lorenzo, for example,

17-42. Facade, Church of Sant'Andrea.

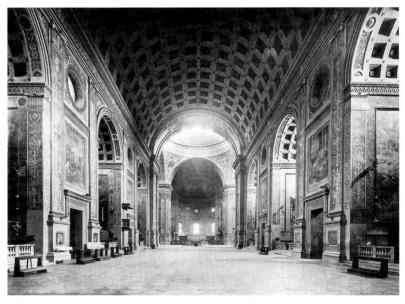

17-43. Nave, Church of Sant'Andrea. Vault width 60' (18.3 m).

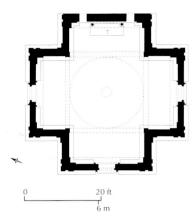

17-44. Giuliano da Sangallo. Plan of the Church of Santa Marie delle Carceri, Prato. 1485-92.

was for an attached structure, and Alberti's Greek-cross plan was never actually built. Drawing on his knowledge of Brunelleschi's works, Giuliano created a square, dome-covered central space extended in each direction by arms whose length was one-half the width of the central space. The arms are covered by barrel vaults extended from the round arches supporting the dome. Giuliano raised his dome on a short, round drum that increased the amount of natural light entering the church. He also articulated the interior walls and the twelve-ribbed dome and drum with *pietra serena* (fig. 17-45). The exterior of the dome is capped with a conical roof and a tall lantern in Brunelleschian fashion.

The exterior of the church is a marvel of Renaissance clarity and order (fig. 17-46). To understand the designer's intention one has but to look at the buildings represented in a painting by Piero della Francesca in Arezzo (see fig. 17-67). Giuliano's ground-floor system of slim Doric pilasters clustered at the corners is repeated in the Ionic order on the shorter upper level, as if the entablature of a small temple had been surmounted with a

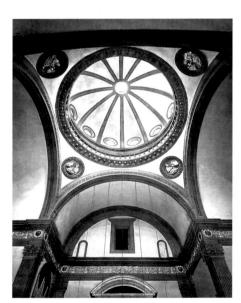

17-45. Interior view of dome, Church of Santa Marie delle Carceri. 1485-92.

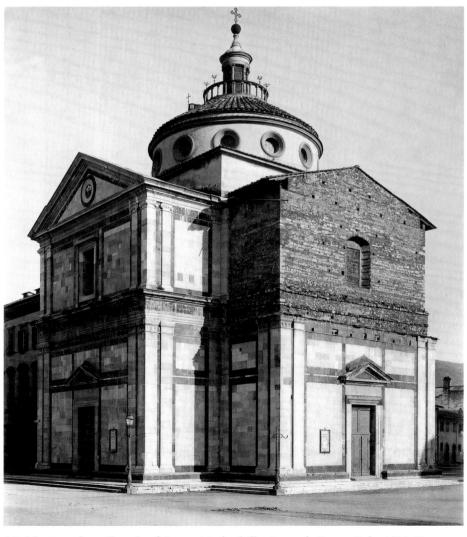

17-46. Exterior, Church of Santa Maria delle Carceri, Prato, Italy. 1485–92.

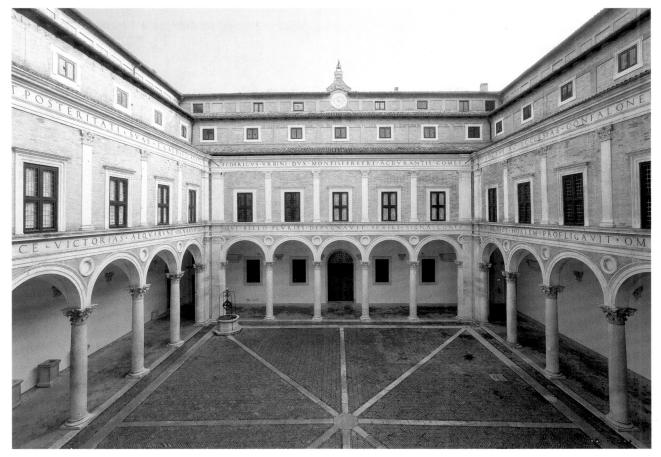

17-47. Luciano Laurana. Courtyard, Ducal Palace, Urbino. Courtyard c. 1467–72; palace begun c. 1450.

second, smaller one. The church was entirely finished in 1494 except for installation of the fine green- and white-marble veneer above the first story. In the 1880s, one section of the upper level was veneered; however, the philosophy of present-day conservation requires that the rest of the building be left in rough stone, as it is today.

East of Florence lay another outstanding artistic center, the court of Urbino, which, under the patronage of Federico da Montefeltro, attracted the finest artists of the day. Construction of Federico's ducal palace (palazzo ducale) had begun about 1450, and in 1468 Federico hired Luciano Laurana, who had been an assistant on the project, to direct the work. Among Laurana's major contributions were closing the courtyard with a fourth wing and redesigning the courtyard facades (fig. 17-47). The result is a superbly rational solution to the problems of courtyard elevation design, particularly the awkward juncture of the arcades at the four corners. The ground-level portico on each side has arches supported by columns; the corner angles are bridged with piers having engaged columns on the arcade sides and pilasters facing the courtyard. This arrangement avoided the awkward visual effect of two arches springing from a single column and gave the corner a greater sense of stability. The **Composite** capital (Corinthian with added Ionic **volutes**) was used, perhaps for the first time, on the ground level. Corinthian pilasters flank the windows in the story above, forming divisions that repeat the bays of the portico. (The two short upper stories were added later.) The plain architrave faces were engraved with inscriptions identifying Federico and lauding his many humanistic virtues. Not visible in the illustration is an innovative feature that became standard in palace courtyard design: the monumental staircase from the courtyard to the main floor.

The interior of the ducal palace likewise reflected its patron's embrace of new Renaissance ideas and interest in classical antiquity. In creating luxurious home furnishings and interior decorations for educated clients such as Federico, Italian craft artists found freedom to experiment with new subjects, treatments, and techniques. Among these was the creation of *trompe l'oeil* ("fool-the-eye") effects, which had become more convincing with the development of linear perspective. *Trompe l'oeil*, commonly used in painting, was carried to its ultimate expression in **intarsia** (wood inlay) decoration, exemplified by the walls of Federico da Montefeltro's *studiolo*, a room for his private collection of fine books and art objects (fig. 17-48, page 622).

The elaborate scene in the small room is created entirely of wood inlaid on flat surfaces with scrupulously applied linear perspective and **foreshortening** (a contraction of forms that supports the overall perspectival system). Each detail is rendered in *trompe l'oeil* design: the illusionistic pilasters, carved cupboards with latticed doors, niches with statues, paintings, and built-in tables. Prominent is the prudent and industrious squirrel, a Renaissance symbol of the ideal ruler, which Federico da Montefeltro was considered to be. A large window looks

17-48. Studiolo of Federico da Montefeltro, Ducal Palace, Urbino, Italy. c. 1470 Intarsia, height 7'3" (2.21 m).

Paintings of great scholars by Justus of Ghent and others have been moved to museums and replaced by photographs.

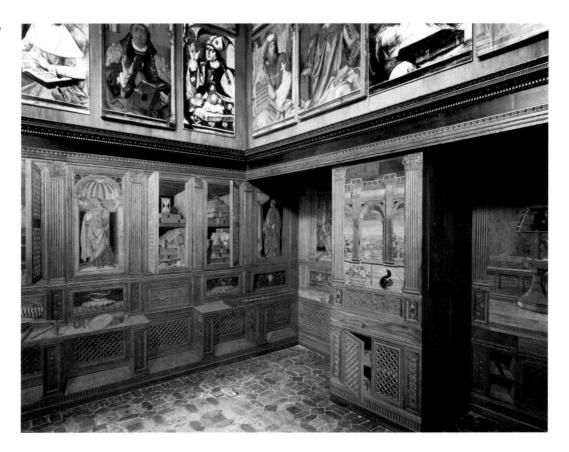

out onto an elegant marble *loggia* with a distant view of the countryside through its arches; and the shelves, cupboards, and tables are filled with all manner of fascinating things—scientific instruments, books, even the duke's armor hanging like a suit in a closet. On the walls above were paintings by Italian, Spanish, and Flemish artists.

SCULPTURE

In the early fifteenth century, the two most important sculptural commissions in Florence were the exterior decoration of the Church of Orsanmichele and the new bronze doors for the Florence Cathedral Baptistry. Orsanmichele, once an open-arcaded market, was both the municipal granary and a shrine for the local guilds. After its ground floor was walled up near the end of the fourteenth century, each of the twelve niches on the outside of the building was assigned to a guild, which was to commission a large figure of its patron saint or saints to stand there.

Nanni di Banco (c. 1385–1421), son of a sculptor in the Florence Cathedral workshop, produced statues for three of Orsanmichele's niches in his short but brilliant career. The *Four Crowned Martyrs* was commissioned about 1410–13 by the stone carvers' and woodworkers' guild, to which Nanni himself belonged (fig. 17-49). These martyrs, according to legend, were third-century Christian sculptors executed for refusing to make an image of a Roman god. Although the architectural setting resembles a small-scale Gothic chapel, Nanni's figures—with their solid bodies, heavy, form-revealing togas, and stylized hair and beards—have the appearance of ancient Roman sculpture. Standing in a semicir-

cle with forward feet and drapery protruding beyond the floor of the niche, the saints convey a sense of realism. They appear to be four individuals talking together. In the relief panels below, showing the four sculptors at work, the forms have a similar solid vigor. Both figures and objects have been deeply **undercut** to cast shadows and enhance the illusion of three-dimensionality.

In 1402, a competition had been held to determine who would design bronze relief panels for a new set of doors for the north side of the Florence Baptistry of San Giovanni. The commission was awarded to Lorenzo Ghiberti (1381?–1455), a young artist trained as a painter, at the very beginning of his career. His panels were such a success that in 1425 he was awarded the commission for another set of doors for the east side of the Baptistry. Michelangelo reportedly said that those doors, installed in 1452, were worthy of being the Gates of Paradise (fig. 17-50). Overall gilding unifies the ten large, square reliefs. Ghiberti organized the space either by a system of linear perspective, approximating the one described by Alberti in his 1435 treatise on painting (see "Renaissance Perspective Systems," page 583) or by a series of arches or rocks or trees leading the eye into the distance. Foreground figures are grouped in the lower third of the panel, while the other figures decrease gradually in size, suggesting deep space. In some panels, the tall buildings suggest ancient Roman architecture and illustrate the emerging antiquarian tone in Renaissance art.

In the relief with the story of Jacob and Esau (Genesis 25 and 27), the center panel of the left door, Ghiberti creates a unified space peopled by graceful, idealized figures (fig. 17-51). He pays careful attention to one-point

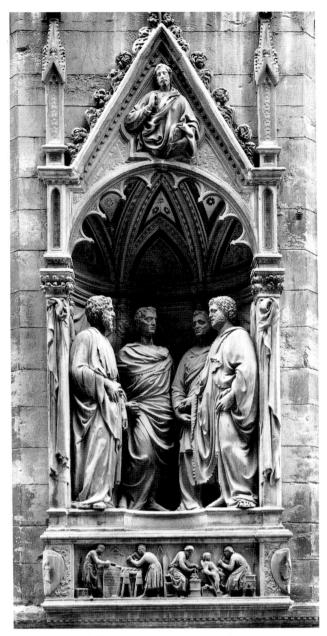

17-49. Nanni di Banco. *Four Crowned Martyrs*. c. 1412–17. Marble, height of figures 6' (1.83 m). Orsanmichele, Florence (photographed before removal of figures).

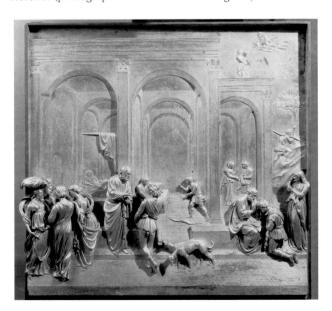

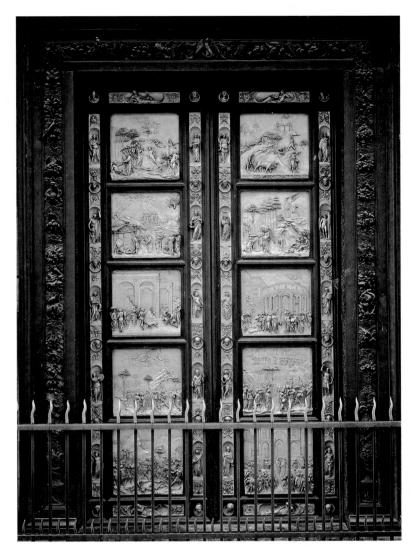

17-50. Lorenzo Ghiberti. Gates of Paradise (East Doors), Baptistry of San Giovanni, Florence. 1425–52. Gilt bronze, height 15' (4.57 m). Museo dell'Opera del Duomo, Florence.

The door panels, commissioned by the Wool Manufacturers' Guild, contain ten Old Testament scenes, from the Creation to the reign of Solomon. The upper left panel depicts the Creation, Temptation, and Expulsion of Adam and Eve from Eden. The murder of Abel by his brother, Cain, follows in the upper right panel, succeeded in the same left-right paired order by the Flood and the drunkenness of Noah, Abraham sacrificing Isaac, the story of Jacob and Esau, Joseph sold into slavery by his brothers, Moses receiving the Tablets of the Law, Joshua and the fall of Jericho, David and Goliath, and finally Solomon and the Queen of Sheba. Ghiberti, whose bust portrait appears at the lower right corner of *Jacob and Esau*, wrote in his *Commentaries* (c. 1450–55): "I strove to imitate nature as clearly as I could, and with all the perspective I could produce, to have excellent compositions with many figures."

17-51. Lorenzo Ghiberti. *Jacob and Esau*, panel of the *Gates of Paradise* (East Doors), formerly on the Baptistry of San Giovanni, Florence. c. 1435. Gilded bronze, $31^1/4$ " (79 cm) square. Museo del' Opera del Duomo, Florence.

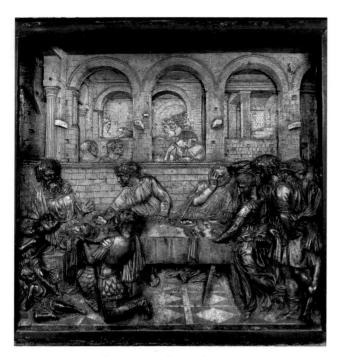

17-52. Donatello. *Feast of Herod*, panel of baptismal font, from the Siena Cathedral Baptistry. 1423–27. Gilt bronze, $23\frac{1}{2} \times 23\frac{1}{2}$ " (59.7 × 59.7 cm).

perspective in the architectural setting. Squares marked out in the pavement establish the lines of the orthogonals that recede to a central vanishing point under the loggia, and towering arches supported on piers with Corinthian pilasters define the space above the figures. The story from Genesis unfolds in a series of individual episodes. On the rooftop (upper right) Rebecca stands. listening to God, who warns of her unborn sons' future conflict; under the left-hand arch she gives birth to the twins. The adult Esau sells his rights as oldest son to Jacob, and when he goes hunting (center right), Rebecca and Jacob plot against him. Finally, in the foreground, Jacob receives Isaac's blessing. (In the Renaissance interpretation Esau symbolized the Jews and Jacob the Christians, and the story explained the conflict between the two peoples.) Ghiberti not only signed his work, but also included his self-portrait in the medallion beside the lower right-hand corner of the panel.

The great genius of early Italian Renaissance sculpture was Donatello (Donato di Niccolò de Betto di Bardi, c. 1386–1466), one of the most influential figures of the century in Italy. During his long and vigorous career, he executed each commission as if it were a new experiment in expression. Donatello took a remarkably pictorial approach to relief sculpture. He developed a technique for creating the impression of very deep space by combining the new linear perspective with the ancient Roman technique of varying heights of relief—high relief for foreground figures and very low relief, sometimes approaching engraving, for the background. The *Feast of Herod* (fig. 17-52), a gilded bronze panel made for the baptismal font in the Siena Cathedral Baptistry in the mid-1420s, illustrates this technique. As in the relief

sculpted below Nanni's *Four Crowned Martyrs* (see fig. 17-49), the contours of the foreground figures have been undercut to emphasize their mass, while figures beyond the foreground are in progressively lower relief. The lines of the brickwork and many other architectural features are incised rather than carved. Donatello used classical architecture to establish a space implied by linear perspective, yet he avoided the artificiality of precise geometric perspective by handling some peripheral areas more intuitively. The result is a spatial setting in relief sculpture as believable as any illusionistic painting.

In illustrating the biblical story of Salome's dance before her stepfather, Herod Antipas, and her morbid request to be rewarded with the head of John the Baptist on a platter (Mark 6:21-28), Donatello showed Herod's palace as a series of three chambers parallel in space. Although he established a vanishing point, the central point where the lines of the architecture converge, he placed the focus of action and emotion—the presentation of the severed head of John the Baptist—in the left foreground, leaving the central axis of the composition empty. As a result, the eye is led past horrified spectators and disinterested musicians to the prison where the beheading took place, then back to the scene in which John's head is carried forward. Donatello demonstrated the fifteenth-century artists' new interest in the individual as he recorded the different reactions to the appalling trophy. The relief demonstrates Donatello's ability to capture emotions in sculpture.

Donatello stands out from all the other artists because he constantly explored human emotions and expressions, the formal problems inherent in representing his visions and insights, and the technical problems posed by various mediums, from bronze and marble to polychromed wood. In bronze sculpture, he achieved several "firsts"—the first lifesize male nude since antiquity (*David*, fig. 17-53) and one of the first lifesize bronze equestrian portraits (*Gattamelata*, see fig. 17-55) since classical Rome.

The sculpture of David has been the subject of continuous inquiry and speculation, since nothing is known about the circumstances of its creation. It is first recorded in 1469 in the courtyard of the Medici palace, where it stood on a base engraved with an inscription extolling Florentine heroism and virtue. This inscription supports the suggestion that it celebrated the triumph of the Florentines over the Milanese in 1428. Although the statue clearly draws on the Classical tradition of heroic nudity, this sensuous, adolescent boy in jaunty laurel trimmed shepherd's hat and boots has long piqued interest in its meaning. In one interpretation, the boy's angular pose, his underdeveloped torso, and the sensation of his wavering between childish interests and adult responsibility heighten his heroism in taking on the giant and outwitting him. With Goliath's severed head now under his feet, David seems to have lost interest in warfare and to be retreating into his dreams.

As Donatello's career drew to a close, his style underwent a profound change, becoming more emotionally expressive. His *Mary Magdalen* of about 1455 shows

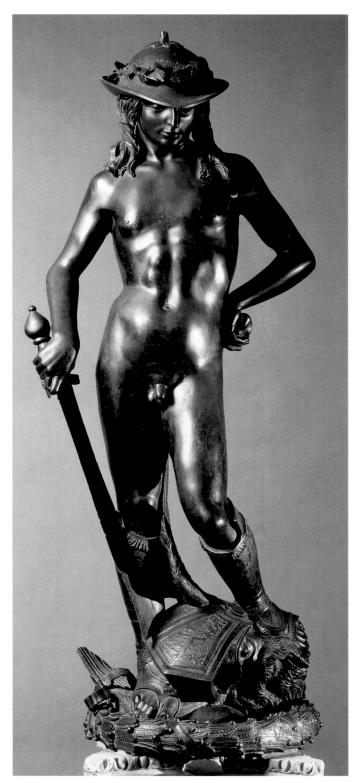

17-53. Donatello. *David.* c. 1446–60(?). Bronze, height $5'2^{1}/4''$ (1.58 m). Museo Nazionale del Bargello, Florence.

the saint known for her physical beauty as an emaciated, vacant-eyed hermit clothed by her own hair (fig. 17-54). Few can look at this figure without a wrenching reaction to the physical deterioration of aging and years of self-denial. Nothing is left for her but an ecstatic vision of the hereafter. Despite Donatello's total rejection of Classical form in this figure, the powerful force of the

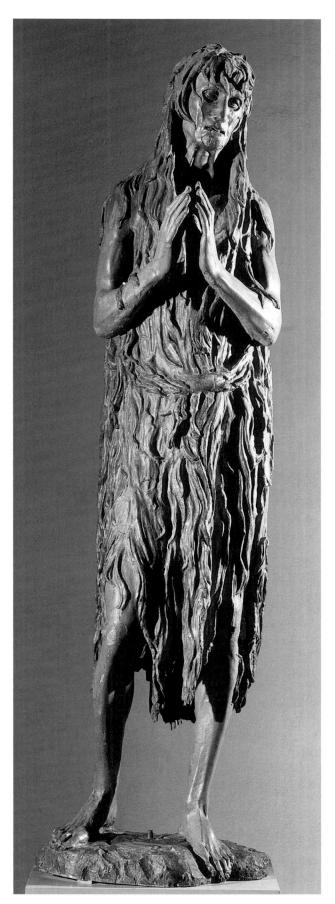

17-54. Donatello. *Mary Magdalen.* 1430s–50s(?). Polychromy and gold on wood, height 6'1" (1.85 m). Museo dell'Opera del Duomo, Florence.

17-55. Donatello. Equestrian monument of Erasmo da Narni (*Gattamelata*), Piazza del Santo, Padua. 1443–53. Bronze, height approx. 12'2" (3.71 m).

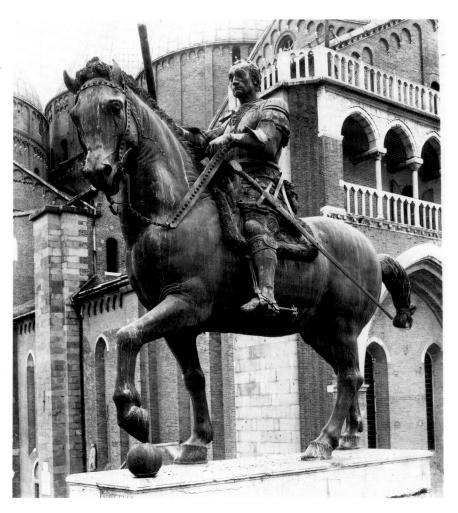

Magdalen's personality makes this a masterpiece of Renaissance imagery.

If one image were to characterize the Italian Renaissance, surely the most appropriate would be the *condottieri* ("commanders")—soldiers of fortune—the brilliant generals who organized the armies and fought for any city-state willing to pay. Two magnificent and characteristic examples stand in Padua and Venice, monuments to the tenacity and leadership of Erasmo da Narni (fig. 17-55) and Bartolommeo Colleoni (fig. 17-56).

In 1443, Donatello was called to Padua to execute the equestrian statue commemorating the Venetian general Erasmo da Narni, nicknamed Gattamelata ("Honeyed Cat," a reference to his mother, Melania Gattelli). Donatello's sources for this statue were two surviving Roman bronze equestrian portraits, one (now lost) in the north Italian city of Pavia, the other of the emperor Marcus Aurelius, which the sculptor certainly saw and probably sketched during his youthful stay in Rome. Viewed from a distance, this man-animal juggernaut, installed on a high marble base in front of the Church of Sant'Antonio, seems capable of thrusting forward at the first threat. Seen up close, however, the man's sunken cheeks, sagging jaw, ropy neck, and stern but sad expression suggest a warrior now grown old and tired from the constant need for military vigilance and rapid response.

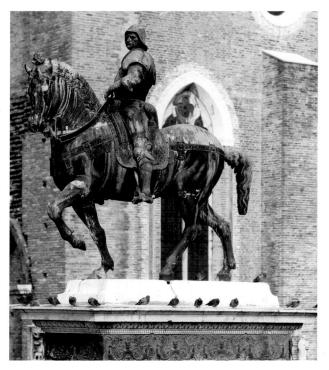

17-56. Andrea del Verrocchio. Equestrian monument of Bartolommeo Colleoni, Campo Santi Giovanni e Paolo, Venice. Clay model 1486–88; cast after 1490; placed 1496. Bronze, height approx. 13' (4 m).

During the decade that he remained in Padua, Donatello executed other commissions for the Church of Sant'Antonio, including a bronze crucifix and reliefs for the high altar. His presence in the city introduced Renaissance ideas to northeastern Italy and gave rise to a new Paduan school of painting and sculpture. The expressionism of Donatello's late work inspired some artists to add psychological intensity even in public monuments. In the early 1480s, the Florentine painter and sculptor Andrea del Verrocchio (1435-88) was commissioned to produce an equestrian memorial to another Venetian general, Bartolommeo Colleoni (d. 1475), this time in Venice itself (fig. 17-56). In contrast to the tragic overtones communicated by Donatello's Gattamelata, the impression conveyed by the tense forms of Verrocchio's equestrian monument is one of vitality and brutal energy. The general's determination is clearly expressed in his clenched jaw and staring eyes. The taut muscles of the horse, fiercely erect posture of the rider, and complex interaction of the two make this image of will and domination a singularly compelling monument. It still dominates the square of Santi Giovanni e Paolo in Venice (see fig. 26-18).

Small Bronzes. Sculptors in the fifteenth century worked not only on a monumental scale for the public sphere; they also created small works, each designed to inspire the mind and delight the eye of its private owner. The enthusiasm of European collectors in the latter part of the fifteenth century for small, easily transported bronzes contributed to the spread of classical taste. Antonio del Pollaiuolo, ambitious and multitalented-a goldsmith, embroiderer, printmaker (see fig. 17-32), sculptor, and painter-came to the Medici court in Florence about 1460 as a painter. His sculpted works were mostly small bronzes, such as his Hercules and Antaeus of about 1475 (fig. 17-57). This study of complex interlocking figures has an explosive energy that can best be appreciated by viewing it from every angle-it is meant to be held in the hand and turned. Statuettes of religious subjects were still popular, but humanist art patrons began to collect bronzes of Greek and Roman subjects like this one. Many sculptors, especially those trained as goldsmiths, began to cast small copies after well-known Classical works. Some artists also executed original designs all'antica ("in the antique style"). Although there were outright forgeries of antiquities at this time, works in the antique manner were intended simply to appeal to a cultivated humanist taste.

Works in Ceramic. Italian sculptors did not limit themselves to the traditional materials of wood, stone and marble, and bronze. They also returned to **terracotta**, a clay medium whose popularity in Italy went back to Etruscan and ancient Roman times. Techniques of working with and firing clay had been kept alive by the ceramics industry and by a few sculptors, especially in northern Italy.

Typical of the period's ceramics manufacture in shape and decoration is the *albarello* (fig. 17-58), a jar

17-57. Antonio del Pollaiuolo. *Hercules and* **Antaeus.** c. 1475. Bronze, height with base 18" (45.7 cm). Museo Nazionale del Bargello, Florence.

Among the many courageous acts by which Hercules gained immortality was the slaying of the evil Antaeus in a wrestling match by lifting him off the earth, the source of the giant's great physical power. Hercules had been attacked by Antaeus, the son of the earth goddess Ge (or Gaia), on his search for a garden that produced pure gold apples. The sculpture is a remarkable study of pain and struggle.

17-58. *Albarello*, cylindrical pharmacy jar, from Faenza. c. 1480. Glazed ceramic, height $12^3/8$ " (31.5 cm). Getty Museum, Los Angeles. Getty .84.DE.104

17-59. Luca della Robbia. *Madonna and Child with Lilies*. c. 1455–60. Enameled terra-cotta, diameter approx. 6′ (1.83 m). Orsanmichele, Florence.

designed especially for pharmacies: The tall concave shape made it easy to remove from a line of jars on pharmacy shelves, and the lip at the rim helped secure the cord that tied a parchment cover over the mouth. Sometimes the name of the owner or the contents of the jar were inscribed on a band around the center (this jar held syrup of lemon juice). The jars were glazed white and decorated in deep rich colors—orange, blue, green, and purple. The technique for making this lustrous, tinglazed earthenware had been developed by Islamic potters and then by Christian potters in Spain. It spread to Italy from the Spanish island of Mallorca—known in Italian as Majorca, which gave rise to the term majolica to describe such wares. From the fourteenth through the sixteenth century, Faenza, in northern Italy, was a leading center of majolica production. The painted decoration of broad scrolling leaves (known as "Gothic leaves"), seen in figure 17-58, is characteristic of the fifteenth century.

Ceramic—using very cheap, easy-to-work material (clay)—was also used to supply the ever-increasing demand for architectural sculpture. Luca della Robbia (1399/1400–1482), although an accomplished sculptor in marble, began to experiment in 1441–42 with tin glazing to make his ceramic sculpture both weatherproof and decorative. As his inexpensive and rapidly produced sculpture gained an immediate popularity, he added color to the traditional white glaze. His workshop even made molds so that a particularly popular work could be replicated many times. Luca favored a limited palette of clear blues, greens, and pale yellows with a great deal of

white, as seen in his *Madonna and Child with Lilies* of about 1455–60, on Orsanmichele (fig. 17-59). The elegant and lyrical della Robbia style was continued by Luca's nephew Andrea and his children long after Luca's death. The family workshop produced standard decorative forms such as image-framing swags and wreaths of fruit and foliage that are still popular today.

PAINTING

Italian patrons generally commissioned murals and large altarpieces for their local churches and smaller panel paintings for their private chapels. Artists experienced in **fresco**, mural painting on wet plaster, were in great demand and traveled widely to execute wall and ceiling decorations. Italian panel painters showed little interest in oil painting, for the most part using tempera even for their largest works until the last decades of the century, when Venetians began to use the oil medium for major panel paintings.

International Gothic-style Painting. The new Renaissance style in painting—with its solid, volumetric forms, perspectivally defined space, and references to classical antiquity—did not immediately displace the International Gothic. One of the important painters who retained International Gothic elements in their work was Gentile da Fabriano (c. 1385–1427), who in 1423 completed the *Adoration of the Magi* (fig. 17-60), a large altarpiece commissioned by the Strozzi family, the wealthiest family in Florence, for their chapel in the Church of Santa Trinità in Florence. Among the Interna-

17-60. Gentile da Fabriano. *Adoration of the Magi*, altarpiece for the Strozzi family chapel, Church of Santa Trinità, Florence. 1423. Tempera and gold on wood panel, $9'10'' \times 9'3''$ (3 × 2.85 m). Galleria degli Uffizi, Florence.

tional Gothic elements are the steeply rising ground plane, graceful figural poses, brightly colored costumes and textile patterns, glinting gold accents, and naturalistic rendering of the details of the setting. But Gentile's landscape, with its endless procession of people winding from the far distance toward Bethlehem to worship the Christ Child, also is related to the northern landscape tradition seen in Broederlam's altarpiece for the Chartreuse de Champmol (see fig. 17-8). Also like northern works, Gentile's painting celebrates the riches of the Magi (and the Strozzi patrons) as well as their piety.

Fresco Painting. The most innovative of the early Italian Renaissance painters was Tommaso di Ser Giovanni di Mone Cassai (1401–28/9?), nicknamed Masaccio (see "Italian Artists' Names and Nicknames," page 584). In his short career of less than a decade, he established a new direction in Florentine painting, much as Giotto had a century earlier. The exact chronology of his works is uncertain and perhaps not important, since he entered the painters' guild in 1422 and had left Florence for Rome by late 1427 or early 1428. His fresco of the Trinity in the Church of Santa Maria Novella in Florence is

17-61. Masaccio. *Trinity with the Virgin, Saint John the Evangelist, and Donors*, fresco in the Church of Santa Maria Novella, Florence. c. 1425-27/28. $21' \times 10'5''$ (6.4×3.2 m).

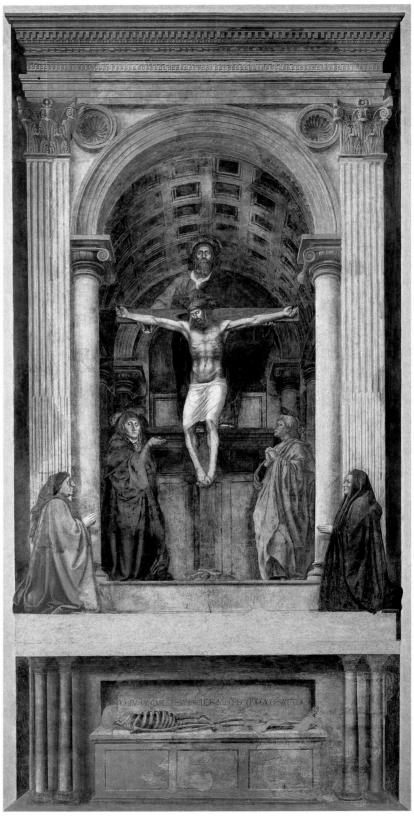

undated, (fig. 17-61). The *Trinity* was meant to give the illusion of a stone funerary monument and altar table set below a deep *aedicula* (framed niche) in the wall. The praying donors in front of the pilasters may be members of the Lenzi or the Berti families. The red robes of the male donor at the left signify that he was a member of the governing council of Florence.

Masaccio created the unusual *trompe l'oeil* effect of looking up into a barrel-vaulted niche through precisely rendered linear perspective. The eye-level of an adult viewer determined the horizon line on which the vanishing point was centered, just above the base of the cross. The painting demonstrates Masaccio's intimate knowledge of both Brunelleschi's perspective experi-

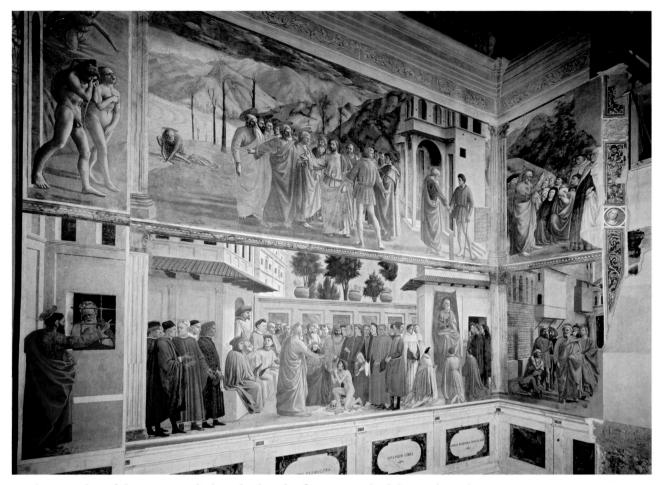

17-62. Interior of the Brancacci Chapel, Church of Santa Maria del Carmine, Florence, with frescoes by Masaccio and Masolino (1424–27) and Filippino Lippi (c. 1482–84).

ments and his architectural style (see fig. 17-36). The painted architecture is an unusual combination of classical orders; on the wall surface Corinthian pilasters support a plain architrave below a cornice, while inside the niche Renaissance variations on Ionic columns support arches on all four sides. The Trinity is represented by Jesus on the Cross, the dove of the Holy Spirit poised in downward flight above his tilted halo, and God the Father, who stands behind the Cross on a high platform apparently supported on the rear columns. The "source" of the consistent illumination modeling the figures with light and shadow lies in front of the picture, casting reflections on the coffers, or sunken panels, of the ceiling. As in many scenes of the Crucifixion, Jesus is flanked by the Virgin Mary and John the Evangelist, who contemplate the scene. Mary gazes calmly out at us, her raised hand presenting the Trinity. Below, in an open sarcophagus, is a skeleton, a grim reminder that death awaits us all and that our only hope is redemption and life in the hereafter through Christian belief. The inscription above the skeleton reads: "I was once that which you are, and what I am you also will be."

Masaccio's brief career reached its height in his collaboration with an older painter, Masolino (1383–c. 1436), on the fresco decoration of the Brancacci

Chapel in the Church of Santa Maria del Carmine in Florence (fig. 17-62). The project was ill-fated, however: The painters never finished their work—Masolino left in 1425 for Hungary, and Masaccio left in 1427 or 1428 for Rome, where he died in 1428/29—and the patron, Brancacci, was exiled in 1435. Eventually, another Florentine painter, Filippino Lippi, finished the painting in the 1480s. The chapel was originally dedicated to Saint Peter, and most frescoes illustrate events in his life.

Masaccio combined a study of the human figure with an intimate knowledge of ancient Roman sculpture. In The Expulsion from Paradise, he presented Adam and Eve as monumental nude figures (fig. 17-63, page 632). In contrast to Flemish painters, who sought to record every visible detail, Masaccio focused on the mass of bodies formed by the underlying bone and muscle structure to create a new realism. He used a generalized light shining on the figures from a single source and further emphasized their tangibility with cast shadows. Ignoring earlier interpretations of the event that emphasized wrongdoing and the fall from grace, Masaccio was concerned with the psychology of individual humans who have been cast mourning and protesting out of Paradise. Masaccio captured the essence of humanity thrown naked into the world.

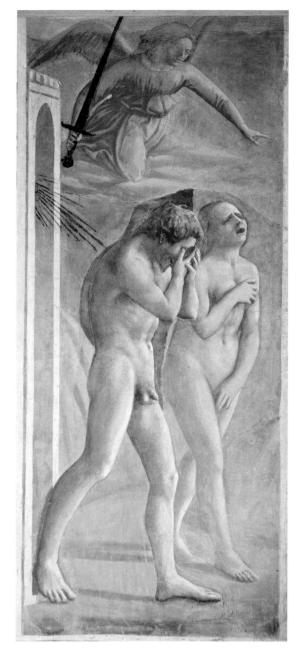

17-63. Masaccio. *The Expulsion from Paradise*, fresco in the Brancacci Chapel. c. $1427.84.25 \times 35.43$ " (214 \times 90 cm).

Cleaning and restoration of the Brancacci Chapel paintings revealed the remarkable speed and skill with which Masaccio worked. He painted Adam and Eve in four *giornate* (each *giornata* of fresh plaster representing a day's work). Working from the top down and left to right, he painted the angel on the first day; on the second day, only the portal; the magnificent figure of Adam on the third day; and Eve on the fourth day.

Masaccio's most innovative painting is the *Tribute Money* (fig. 17-64), completed about 1427, rendered in a continuous narrative of three scenes within one setting. The painting illustrates an incident in which a collector of the Jewish temple taxes (tribute money) demands payment from Peter, shown in the central group with Jesus and the other disciples (Matthew 17:24–27). Although Jesus opposes the tax, he instructs Peter to "go to

the sea, drop in a hook, and take the first fish that comes up," which Peter does at the far left. In the fish's mouth is a coin worth twice the tax demanded, which Peter gives to the tax collector at the far right. The tribute story was significant for Florentines because in 1427, to raise money for defense against military aggression, the city enacted a graduated tax, based on the value of one's personal property.

The Tribute Money is remarkable for its integration of figures, architecture, and landscape into a consistent whole. The group of Jesus and his disciples forms a clear central focus, from which the landscape seems to recede naturally into the far distance. To create this illusion, Masaccio used linear perspective in the depiction of the house, and then reinforced it by diminishing the sizes of the barren trees and reducing Peter's size at the left. At the vanishing point established by the lines of the house is the head of Jesus. A second vanishing point determines the steps and stone rail at the right. Cleaning of the fresco in 1984-90 revealed that the painting was done in thirty-two giornate and also that Masaccio used atmospheric perspective in the distant landscape, where mountains fade from grayish green to grayish white and the houses and trees on their slopes are loosely sketched.

Masaccio modeled the foreground figures with strong highlights and cast their long shadows on the ground toward the left, implying a light source at the far right, as if the scene were lit by the actual window in the rear wall of the Brancacci Chapel. Not only does the lighting give the forms sculptural definition, but the colors vary in tone according to the strength of the illumination. Masaccio used a wide range of hues—pale pink, mauve, gold, seafoam, apple green, peach—and a sophisticated color technique in which Andrew's green robe is shaded with red instead of darker green. Another discovery after the cleaning was that—allowing for the differences between rapidly applied water-based colors in fresco versus slow-drying oil—the wealth of linear details such as tiles, walls, and landscape before they were obscured by dirt and overpainting was much closer to that of Masaccio's northern European contemporaries than previously thought. Masaccio exhibits an intimate knowledge of Roman sculpture.

Stylistic innovations take time to be fully accepted, and Masaccio's genius for depicting weight and volume, consistent lighting, and spatial integration was best appreciated by a later generation. Many important sixteenth-century Italian artists, including Michelangelo, studied and sketched from Masaccio's Brancacci Chapel frescoes. In the meantime, painting in Florence after Masaccio's death developed along lines somewhat different from that of the *Tribute Money* or *Trinity*, as other artists such a Paolo Uccello experimented in their own ways of conveying the illusion of a believably receding space (see fig. 17-1).

The tradition of covering walls with paintings in fresco continued through the century. Between 1435 and 1445, the decoration of the Dominican Monastery of San Marco in Florence, where Fra Angelico served as

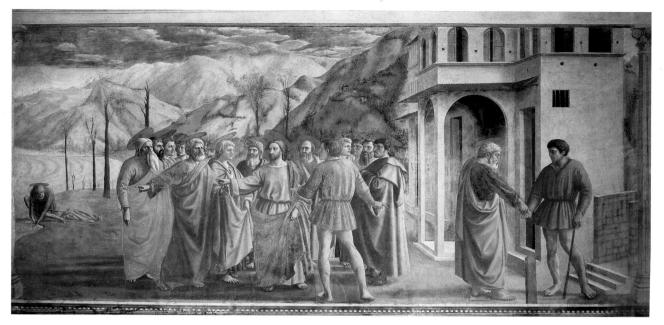

17-64. Masaccio. *Tribute Money*, fresco in the Brancacci Chapel. c. 1427. $8'1'' \times 19'7''$ (1.87 × 1.57 m).

Much valuable new information about the Brancacci Chapel frescoes was discovered during the course of a cleaning and restoration carried out between 1984 and 1990. Art historians now have a more accurate picture of how the frescoes were done and in what sequence, as well as which artist did what. One interesting discovery was that all of the figures in the *Tribute Money*, except those of the temple tax collector, originally had gold-leaf halos, several of which had flaked off. Rather than silhouette the heads against flat gold circles in the medieval manner, Masaccio conceived of the halo as a gold disk hovering in space above each head and subjected it to perspective foreshortening depending on the position of the figure.

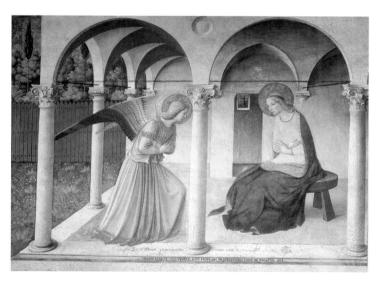

17-65. Fra Angelico. *Annunciation,* fresco in north corridor, Monastery of San Marco, Florence. c. 1438-45. $7'^{1}/_{2}" \times 19'6"$ (230 × 297 cm).

The shadowed vault of the portico is supported by a wall on one side and by slender Ionic and Corinthian columns on the other, a new building technique being used by Brunelleschi in the very years when the painting was being created. The edge of the porch, the open door, in the back wall, and the grilled windows, drawn in linear perspective, establish a complex but ample space for the figures.

the prior, was one of the most extensive projects. Born Guido di Pietro (c. 1395/1400–55) and known to his peers as Fra Giovanni da Fiesole, Fra Angelico ("Angelic Brother") earned his nickname through his piety as well as his painting. He is documented as a painter in Florence in 1417–18, and he continued to be a very active painter after taking his vows as a Dominican monk in nearby Fiesole between 1418 and 1421.

In the Monastery of San Marco, Fra Angelico and his assistants created a painting to inspire meditation in each monk's cell (forty-four in all), and they also added paintings to the chapter house and the corridors. At the top of the stairs in the north corridor Fra Angelico paint-

ed the scene of the Annunciation (fig. 17-65). Here the monks were to pause for prayer before going to their individual cells. The illusion of space created by the careful linear perspective seems to extend the stair and corridor out into a second cloister, the Virgin's home and verdant enclosed garden, where the angel Gabriel greets the modest, youthful Mary. The slender, graceful figures wearing flowing draperies assume modest poses. The natural light falling from the left models their forms and casts an almost supernatural radiance over their faces and hands. The scene is a vision that welcomes the monks to the most private areas of the monastery and prepares them for their meditations.

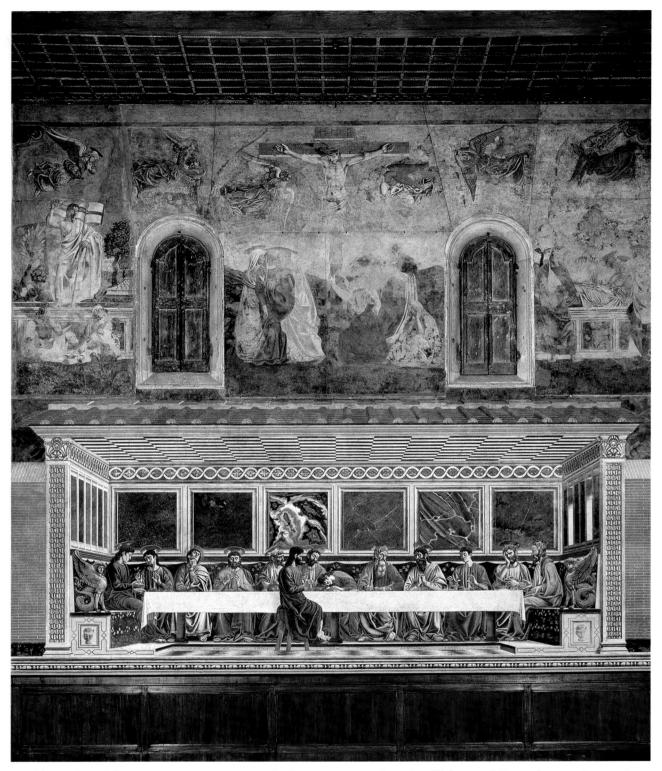

17-66. Andrea del Castagno. *Last Supper* **and, above,** *Resurrection, Crucifixion, and Entombment,* frescoes in the refectory, Convent of Sant'Apollonia, Florence. c. 1445–50. Width of wall below 32′ (9.8 m); width of wall above 39′6″ (10.25 m).

Pope Eugene IV summoned Fra Angelico to Rome in 1445, and the painter's assistants completed the frescoes in Florence. The pope may have hoped to make the painter a church official, the archbishop of Florence, but finally appointed the vicar of San Marco, Antonino Pierozzi, to the post in January 1446. The world of art was left richer because of the choice, however, for Fra Angelico dedicated the last years of his life to his paint-

ing, including the pope's private chapel in the Vatican palace.

Another notable Florentine fresco, *The Last Supper*, is the best-known work of Andrea del Castagno (c. 1417/19–57). He worked for a time in Venice before returning to Florence to paint it, in 1447, in the refectory of Sant'Apollonia, the convent of the Benedictine nuns (fig. 17-66). Extending 32 feet across the end wall of the

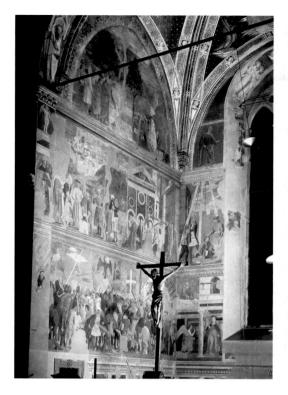

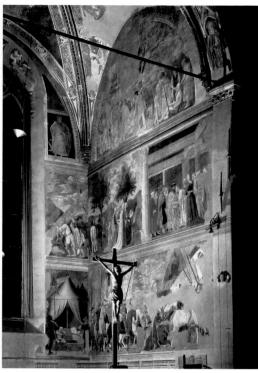

17-67.
Piero della
Francesca.
Two views of
the Bacci
Chapel, Church
of San Francesco,
Arezzo. 1454–58.

dining room and rising 15 feet high, the fresco gives the illusion of a raised alcove where Jesus and his disciples are eating their meal as if at a head table. Rather than the humble "upper room" where the biblical event took place, the setting resembles a royal audience hall with sumptuous marble panels and inlays. The *trompe l'oeil* effect is aided by a focal point on the head and shoulders of the sleeping young disciple John. Some of the lines of the architecture converge here, while others merely come close; a few converge elsewhere. Thus, Andrea appears to have adjusted many of the perspectival elements intuitively to create a more believable spatial representation.

Above the *Last Supper* and completely ignoring the illusion of a room cut into the wall, Andrea painted the Crucifixion Entombment and Resurrection of Christ. An unfortunate accident, when these paintings were damaged by water and had to be removed from the wall, provided a fascinating insight into the working methods of a mural painter. The *sinopia*, or sketch made on the wall before painters begin work, was recovered in the process of restoring the murals. By comparing the drawings and the final paintings, even in their damaged state, one can see the careful preparation necessary before frescoes were begun—as well as the amount of freedom the painter had to change and improve, to improvise and refine, his original concept.

Piero della Francesca (c. 1406/12–92) worked in Florence in the 1430s before settling down in his native Borgo San Sepolcro, a Tuscan hill town under papal control. He knew current thinking in art and art theory—including Brunelleschi's system of spatial illusion and linear perspective, Masaccio's powerful modeling of forms and atmospheric perspective, and Alberti's theo-

retical treatises. Piero was one of the few practicing artists who also wrote about his own theories. Not surprisingly, in his treatise on perspective he emphasized the geometry and the volumetric construction of forms and spaces that were so apparent in his own work.

From about 1454 to 1458, he was in Arezzo, where he decorated the Bacci Chapel of the Church of San Francesco with a cycle of frescoes illustrating the Legend of the True Cross (fig. 17-67), the cross on which Jesus was crucified. The lunettes at the top display the beginning and end of the story—the death of Adam and the adoration of the Cross. In the center section at the right, the Queen of Sheba visits Solomon (the Cross miraculously appears to her); at the left, Helena (mother of Constantine, the first Christian Roman emperor) discovers and proves the authenticity of the Cross, whose touch resurrects a man being carried to his tomb. The small scenes by the window show the burial of the Cross after the Crucifixion and the torture of the Jew who knew its hiding place. The battle scenes at the bottom illustrate Constantine's defeat of his rival Maxentius with the help of the Cross, and the recovery of the Cross from the Persian ruler Chosroes, who had stolen it and built it into his throne. The small scenes show Constantine's dream, in which he foresaw victory under a flaming cross (right), and the Annunciation (left). The Annunciation reaffirms Mary's role in making God flesh, beginning the process of redemption that culminates in the Crucifixion.

Piero's analytical modeling and perspectival projection result in a highly believable illusion of space around his monumental figures. He reduced his figures to cylindrical and ovoid shapes and painted the clothing and other details of the setting with muted colors. Particularly

remarkable are the foreshortening of figures and objects—shortening the lines of forms seen head-on to align them with the overall perspectival system—such as the cross at the right, and the anatomical accuracy of the revived youth's nude figure. Unlike many of his contemporaries, however, Piero gave his figures no expression of human emotion.

One of the most influential fifteenth-century painters born and working outside Florence was Andrea Mantegna (1431-1506) of Padua, to the north. Mantegna entered the painters' guild at the age of fifteen. The greatest influence on the young artist was the sculptor Donatello, who arrived in Padua in 1443 for a decade of work there. By the time Donatello left, Mantegna had fully absorbed the sculptor's Florentine linear-perspective system, which he pushed to its limits with experiments in radical perspective views and the foreshortening of figures. In 1459 Mantegna went to work for Ludovico Gonzaga, the ruler of Mantua, and he continued to work for the Gonzaga family for the rest of his life although he made trips to Florence and Pisa in the 1460s and to Rome in 1488-90. In Mantua the artist became a member of the humanist circle, whose interests in classical literature and archaeology he shared. He often signed his name using Greek letters.

Mantegna's mature style is characterized by the virtuosity of his use of perspective, his skillful integration of figures into their settings, and his love of naturalistic details. His finest works are the frescoes of the Camera Picta ("Painted Room"), a tower chamber in Gonzaga's ducal palace, which Mantegna decorated between 1465 and 1474. On the domed ceiling, the artist painted a tour de force of radical perspective called *di sotto in sù* ("seen from directly below"), which began a long tradition of illusionistic ceiling painting (fig. 17-68). The room appears to be open to a cloud-filled sky through a large oculus in a simulated marble- and mosaic-covered vault. On each side of a precariously balanced planter, three young women and an exotically turbaned African man peer over a marble balustrade into the room below. A fourth young woman in a veil looks dreamily upward. Joined by a large peacock, several **putti** play around the balustrade.

Rome's establishment as a Renaissance center of the arts was greatly aided by Pope Sixtus IV's decision to call to the city the best artists he could find to decorate the walls of his newly built Sistine Chapel. The resolution in 1417 of the Great Schism in the Western Church had secured the papacy in Rome, precipitating the restoration of not only the Vatican but the city as a whole. Among the artists who went to Rome was Pietro Vannucci, called Perugino (c. 1450–1523). Originally from near the town of Perugia in Umbria, Perugino had been working in Florence since 1472 and left there in 1481 to work on the Sistine wall frescoes. His contribution, *Delivery of the Keys to Saint Peter* (fig. 17-69, page 638), portrayed the event that provided biblical support

for the supremacy of papal authority, Christ's giving the keys to the kingdom of heaven to the apostle Peter (Matthew 16:19), who became the first bishop of Rome.

Delivery of the Keys is a remarkable work in carefully studied linear perspective that reveals much about Renaissance ideas and ideals. In a light-filled piazza whose banded paving stones provide a geometric grid for perspectival recession, the figures stand like chess pieces on the squares, scaled to size according to their distance from the picture plane and modeled by a consistent light source from the upper left. Horizontally, the composition is divided between the lower frieze of massive figures and the band of widely spaced buildings above. Vertically, it is divided by the open space at the center between Christ and Peter and by the symmetrical architectural forms on each side of this central axis. Triumphal arches inspired by ancient Rome frame the church and focus the attention on the center of the composition, where the vital key is being transferred. The carefully calibrated scene is softened by the subdued colors, the distant idealized landscape and cloudy skies, and the variety of the figures' positions. Perugino's painting is, among other things, a representation of Alberti's ideal city, described in his treatise on architecture as having a "temple" (that is, a church) at the very center of a great open space raised on a dais and separate from any other buildings that might obstruct its view (see fig. 17-5). His ideal church had a central plan, illustrated here as a domed octagon.

In Florence, the most important painting workshop of the later fifteenth century was that of the painter Domenico di Tommaso Bigordi (1449–94), known as Domenico Ghirlandaio ("Garland Maker"), a nickname adopted by his father, a goldsmith noted for his floral wreaths. A specialist in narrative cycles, Ghirlandaio reinterpreted the art of earlier fifteenth-century painters into a popular visual language of great descriptive immediacy. Flemish painting, seen in Florence after about 1450, had considerable impact on his style; Ghirlandaio's 1485 altarpiece, *The Nativity with Shepherd*, was inspired by Hugo's *Portinari Altarpiece* (see fig. 17-22), which Tommaso Portinari had sent home to Florence from Bruges in 1483, just two years earlier.

Among Ghirlandaio's finest total compositions were frescoes of the life of Saint Francis created between 1482 and 1486 for the Sassetti family burial chapel in the Church of Santa Trinità, Florence (fig. 17-70, page 638). In the upper-most tier of paintings, Pope Honorius confirms the Franciscan order. Ghirlandaio transferred the event from thirteenth-century Rome to the Florence of his own day, painting views of the city and portraits of Florentines, taking delight in local color and anecdotes. Perhaps Renaissance painters represented events from the distant past in contemporary terms to emphasize their current relevance, or perhaps they and their patrons simply loved to see themselves in their fine clothes acting out the dramas in the cities of which they were justifiably proud.

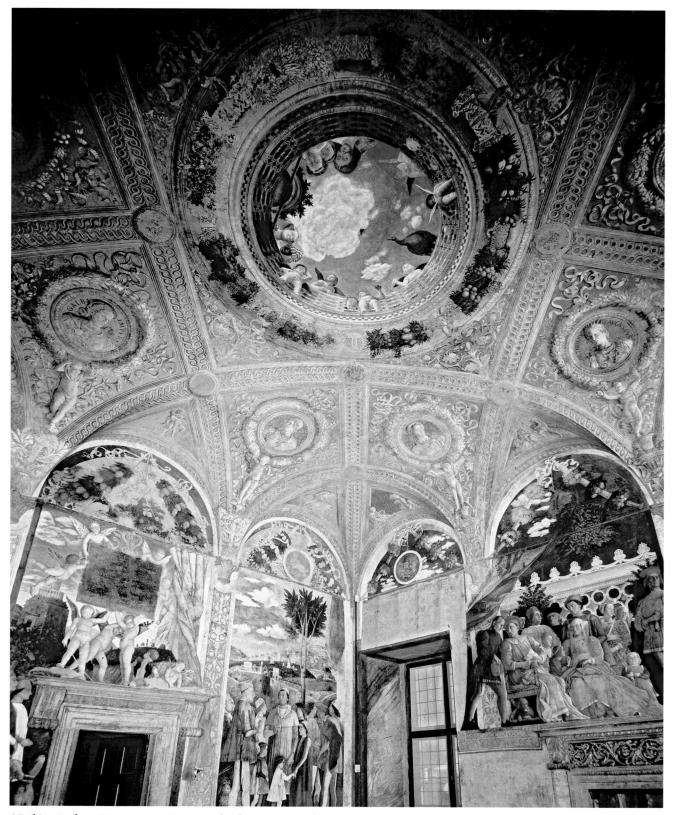

17-68. Andrea Mantegna. Frescoes in the Camera Picta, Ducal Palace, Mantua. 1465–74.

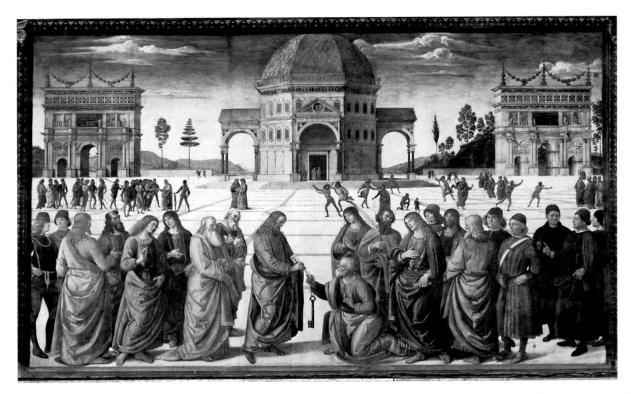

17-69. Perugino. *Delivery of the Keys to Saint Peter*, fresco on the right wall of the Sistine Chapel, Vatican, Rome. 1481. $11'5^1/2'' \times 18'8^1/2''$ (3.48 × 5.70 m).

Modern eyes accustomed to gigantic parking lots would not find a large open space in the middle of a city extraordinary, but in the fifteenth century this great piazza was purely the product of artistic imagination. A real piazza this size would have been very impractical. In summer sun or winter wind and rain, such spaces would have been extremely unpleasant for a pedestrian population, but, more important, no city could afford such extravagant use of valuable land within its walls.

17-70. Domenico Ghirlandaio. View of the Sassetti Chapel, Church of Santa Trinità, Florence. Frescoes of scenes from the Legend of Saint Francis; altarpiece with *Nativity and Adoration of the Shepherds*. 1483–86. Chapel: 12'2'' deep \times 17'2'' wide $(3.7 \times 5.25 \text{ m})$; altarpiece: $65^3/_4''$ (1.67) square.

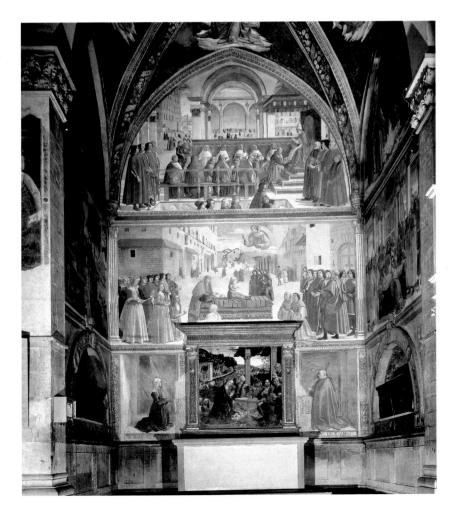

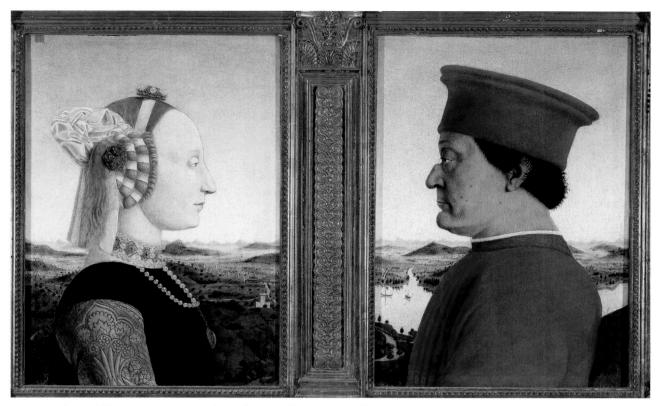

17-71. Piero della Francesca. Battista Sforza (left) and Federico da Montefeltro (right). 1474. Oil on wood panel, each $18\frac{1}{2} \times 13"$ (47 × 33 cm). Galleria degli Uffizi, Florence.

Painting in Tempera and Oil. In 1472–73, Piero della Francesca went to the court of Federico da Montefeltro at Urbino, for whom he painted a pair of pendant, or companion, portraits of Federico and his recently deceased wife, Battista Sforza (fig. 17-71). The small panels, painted in tempera in light colors, resemble Flemish painting in their detail and luminosity, their record of surfaces and textures, and their vast landscapes. In the traditional Italian fashion, the figures are portrayed in strict profile, as remote from the viewer as icons. The profile format also allowed for an accurate recording of Federico's likeness without emphasizing two disfiguring scars-the loss of his right eye and his broken nosefrom a sword blow. His good left eye is shown, and the angular profile of his nose seems like a distinctive familial trait. Typically, Piero emphasized the underlying geometry of the forms, rendering the figures with an absolute stillness. Dressed in the most elegant fashion, Battista and Federico are silhouetted against a distant view recalling the hilly landscape around Urbino. The portraits may have been hinged as a diptych, since the landscape appears to be nearly continuous across the two panels. The influence of Flemish art also is strong in the careful observation of Battista's jewels and in the well-observed atmospheric perspective. Piero used another northern European device in the harbor view near the center of Federico's panel: The water narrows into a river and leads the eye into the distant landscape.

Sandro Botticelli (1445–1510) created some of his most popular paintings under the patronage of the

Medici. Botticelli had worked as an assistant to Filippino Lippi and in the studio of Verrocchio; like most artists in the second half of the fifteenth century, he had learned to draw and paint sculptural figures that were modeled by light from a consistent source and placed in a setting rendered with strict linear perspective. An outstanding portraitist, he often included recognizable contemporary figures among the saints and angels in religious paintings. He worked in Florence, then went to Rome, one of the many artists called to decorate the Sistine Chapel.

In 1481, after returning to Florence from Rome, Botticelli entered a new phase of his career. Like other artists working for patrons steeped in classical scholarship and humanistic speculation, Botticelli was exposed to a philosophy of beauty—as well as to the examples of ancient art in their collections. For the Medici, Botticelli produced secular paintings of mythological subjects inspired by ancient works and by contemporary Neoplatonic thought, including *Primavera*, or *Spring* (fig. 17-72, page 640), and *The Birth of Venus* (see fig. 17-73).

The overall appearance of *Primavera* recalls Flemish tapestries, which were popular in Italy at the time. The decorative quality of the painting is deceptive, however, for it is a highly complex allegory, interweaving Neoplatonic ideas with esoteric references to classical sources. Neoplatonic philosophers and poets conceived of Venus, the goddess of love, as having two natures, one terrestrial and the other celestial. The first ruled over earthly, human love and the second over universal love,

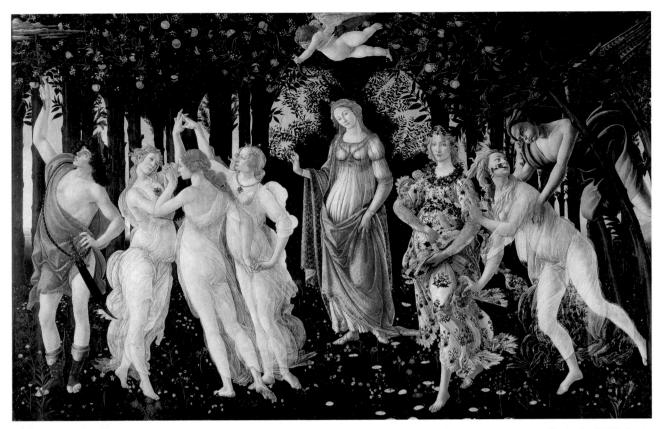

17-72. Sandro Botticelli. *Primavera*. c. 1482. Tempera on wood panel, $6'8" \times 10'4"$ (2.03 \times 3.15 m). Galleria degli Uffizi, Florence.

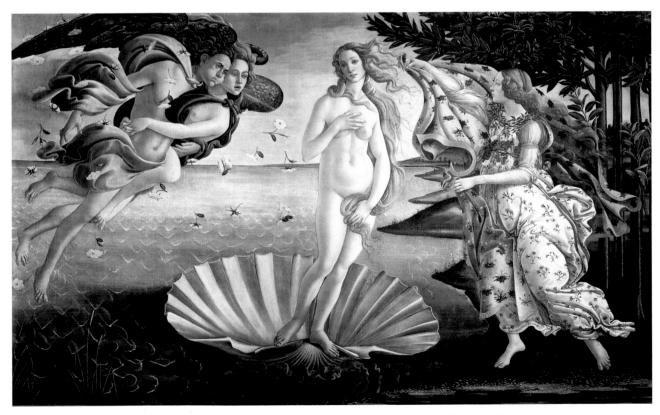

17-73. Sandro Botticelli. *The Birth of Venus*. c. 1484–86. Tempera on canvas, $5'8^{7}/8'' \times 9'1^{7}/8''$ (1.8 × 2.8 m). Galleria degli Uffizi, Florence.

making her a classical equivalent of the Virgin Mary. Primavera was painted at the time of a Medici wedding, so it may have been intended as a painting on the theme of love and fertility in marriage. Silhouetted and framed by an arching view through the trees at the center of Primavera is Venus. She is flanked on the right by Flora, a Roman goddess of flowers and fertility, and on the left by the Three Graces. Her son, Cupid, hovers above, playfully aiming an arrow at the Graces. At the far right is the wind god, Zephyr, in pursuit of the nymph Aura, his breath causing her to sprout flowers from her mouth. At the far left, the messenger god, Mercury, uses his characteristic snake-wrapped wand, the caduceus, to dispel a patch of gray clouds drifting in Venus's direction. He is the sign of the month of May, and he looks out of the painting and onto summer. Venus, clothed in contemporary costume and wearing a marriage wreath on her head, here represents her terrestrial nature, governing marital love. She stands in a grove of orange trees (a Medici symbol) weighted down with lush fruit, suggesting human fertility; Cupid embodies romantic desire, and as practiced in central Italy in ancient times, the goddess Flora's festival had definite sexual overtones.

Several years later, some of the same mythological figures reappeared in Botticelli's *Birth of Venus* (fig. 17-73), whose central image, a type known as the modest Venus, is based on an antique statue of Venus in the Medici collection (see fig. 7, Introduction). The classical goddess of love and beauty, born of sea foam, floats ashore on a scallop shell, gracefully arranging her hands and hair to hide—or enhance—her sexuality. Blown by the wind, Zephyr (and his love, the nymph Chloris), and welcomed by a devotee holding a garment embroidered with flowers, Venus arrives at her earthly home. The circumstances of this commission are uncertain, but the links between this painting and *Primavera* inspired Neoplatonic debate about the meaning of the "two Venuses"—one sacred, one profane.

Botticelli's later career was affected by a profound spiritual crisis. While Botticelli was creating his mythologies, a Dominican monk, Fra Girolamo Savonarola (active in Florence 1494–98), had begun to preach impassioned sermons denouncing the worldliness of Florence. Many Florentines reacted with orgies of self-recrimination, and processions of weeping penitents wound through the streets. Botticelli, too, fell into a state of religious fervor. In a dramatic gesture of repentance, he burned many of his earlier paintings and began to produce highly emotional pictures pervaded by an intense religiosity.

In 1500, when many people feared that the end of the world was imminent, Botticelli painted the *Mystic Nativity* (fig. 17-74) in oil, his only signed and dated painting. Botticelli's Nativity takes place in a rocky, forested landscape whose cave-stable follows the tradition of the Eastern Orthodox (Byzantine) Church, while the timber shed in front recalls the Western iconographic tradition. In the center of the painting, the Virgin Mary kneels in adoration of the Christ Child, who lies on the earth, as recorded in the vision of the fourteenth-century

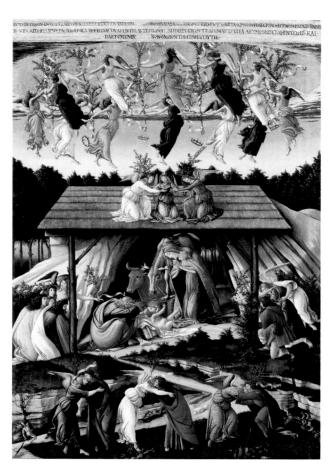

17-74. Sandro Botticelli. *Mystic Nativity.* 1500. Oil on canvas, $42\times29^{1}/_{2}"$ (106.7 \times 74.9 cm). The National Gallery, London.

This is the only work signed and dated by Botticelli (in Greek): "I Alessandro made this picture at the conclusion of the 1500th year" (National Gallery, London, files).

mystic Bridget (see also Hugo van der Goes's *Portinari Altarpiece*, fig. 17-22, which would have been a familiar precedent). Joseph crouches and hides his face, while the ox and the ass bow their heads to the Holy Child. The shepherds at the right and the Magi at the left also kneel before the Holy Family. A circle of singing angels holding golden crowns and laurel branches flies jubilantly above the central scene. Tiny devils, vanquished by the coming of Christ, try to escape from the bottom of the picture.

The most unusual element of the painting is the frieze of wrestling figures below the Holy Family. The men are ancient classical philosophers, who ceremonially struggle with angels. Each of the three pairs holds an olive branch and a scroll, as do the angels circling above, whose scrolls are inscribed with the words: "Glory to God in the Highest; peace on earth to men of good will." In fifteenth-century Florence, Palm Sunday, the festival of Christ the King, was called Olive Sunday and olive branches, symbols of peace, rather than palms were carried in processions. The inscription at the top of the painting reads (in Greek): "I Alessandro made this picture at the conclusion of . . . [a millennium and a half], according to the 11th chapter of Saint John in the

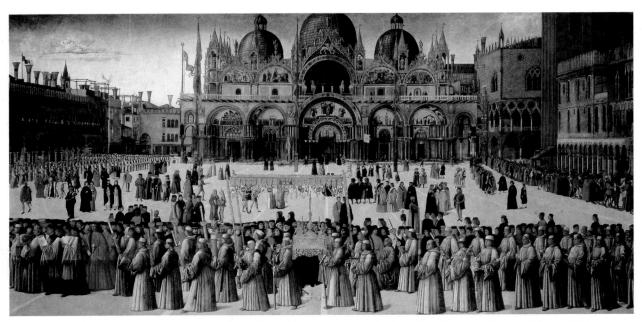

17-75. Gentile Bellini. *Procession of the Relic of the True Cross before the Church of Saint Mark.* 1496. Oil on canvas, $12' \times 24'5''$ (3.67 \times 7.45 m). Galleria dell'Accademia, Venice.

Every year on the Feast of Saint Mark (April 25) the Confraternity of Saint John the Evangelist (one of six major confraternities in Venice) carried the miracle-working relic of the True Cross in a procession through the square in front of the Church of Saint Mark, seen in the background. The relic, in a gold reliquary under a canopy, is surrounded by marchers with giant candles, led by a choir, and followed at the far right by the *doge* (the city's ruler) and other officials. The painting commemorates the miraculous recovery of a sick child whose father, the man in red kneeling to the right of the relic, prayed for help as the relic passed by.

second woe of the Apocalypse, during the loosing of the devil for three and a half years, then he will be bound in the 12th chapter and we shall see [missing word] as in this picture." The references are to the Book of Revelation, chapter 11, which describes woes to come, and Revelation 12, which includes the vision of a woman crowned with stars and clothed by the sun, taken by Christians as a prophesy of the Virgin Mary, and the description of the defeat of Satan. Thus, in this painting Christ has come to save humankind in spite of the troubles Botticelli saw all around him. Savonarola had been burned at the stake only two years before Botticelli painted this picture. By the end of his own life, Botticelli had given up painting altogether.

Oil Painting in Venice. In the last quarter of the fifteenth century, Venice—once a center of Byzantine art—emerged as a major artistic center of Renaissance painting. From the late 1470s on, the domes of the Church of Saint Mark dominated the city center, and the rich colors of its glowing mosaics captured painters' imaginations. Venetian painters embraced the oil medium for both panel and canvas painting, probably introduced by Antonello da Messina (c. 1430-79), an influential Sicilian painter who had studied in Flanders before working in Venice. The most important Venetian artists of this period were two brothers, Gentile (c. 1429-1507) and Giovanni (c. 1430-1516) Bellini, whose father, Jacopo (active c. 1423-70), also was a central figure in Venetian art. Jacopo, who had worked for a short time in Florence, was a theorist who produced

books of drawings in which he experimented with linear perspective. Andrea Mantegna was also part of this circle, for he had married Jacopo's daughter in 1453.

Gentile Bellini celebrated the daily life of the city in large, lively narratives, such as the *Procession of the Relic of the True Cross before the Church of Saint Mark* (fig. 17-75). The painting of 1496 depicted an event that had occurred fifty-two years earlier: During a procession in which a relic of the True Cross was carried through Venice's Saint Mark's Piazza, a miraculous healing occurred, which was attributed to the relic. Gentile rendered the cityscape with great accuracy and detail.

His brother, Giovanni, amazed and attracted patrons with his artistic virtuosity for almost sixty years. Virgin and Child Enthroned with Saints Francis, John the Baptist, Job, Dominic, Sebastian, and Louis of Toulouse (fig. 17-76), painted about 1478 for the Chapel of the Hospital of San Giobbe (Saint Job), exhibits a dramatic perspectival view up into a vaulted apse. Certainly Giovanni knew his father's perspective drawings well, and he may also have been influenced by his brother-in-law Mantegna's early experiments in radical foreshortening and the use of a low vanishing point. In Giovanni's painting, the vanishing point for the rapidly converging lines of the architecture lies at the center, on the feet of the lute-playing angel. Also, the pose of Saint Sebastian, his body pierced by arrows, at the right recalls a famous Saint Sebastian by Mantegna. Giovanni has placed his figures in a Classical architectural interior with a coffered barrel vault, reminiscent of Masaccio's Trinity (see fig. 17-61). The gold mosaic, with its identifying inscription and stylized

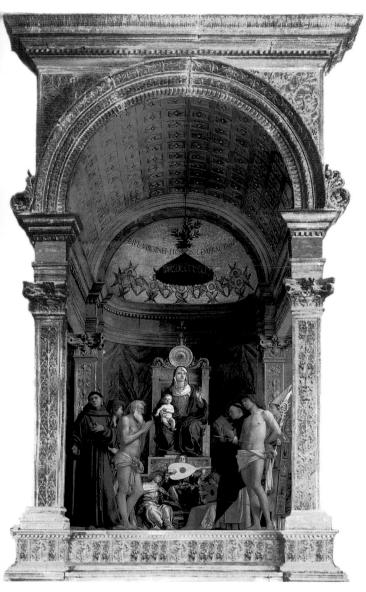

17-76. Giovanni Bellini. *Virgin and Child Enthroned with Saints Francis, John the Baptist, Job, Dominic, Sebastian, and Louis of Toulouse.* Commissioned for the Chapel of the Hospital of San Giobbe, Venice. c. 1478. Oil on wood panel, $15'4" \times 8'4"$ (4.67×2.54 m). Galleria dell'Accademia, Venice. The original frame is in the Chapel of the Hospital of San Giobbe, Venice. c.1478.

Art historians have given a special name, *sacra conversazione* ("holy conversation"), to this type of composition showing saints, angels, and sometimes even the painting's donors in the same pictorial space with the enthroned Virgin and Child. Despite the name, no conversation or other interaction among the figures takes place in a literal sense. Instead, the individuals portrayed are joined in a mystical and eternal communion occurring outside of time, in which the viewer is invited to share.

seraphim (angels of the highest rank), recalls the art of the Byzantine Empire in the eastern Mediterranean and the long tradition of Byzantine-inspired painting and mosaics produced in Venice.

Giovanni Bellini demonstrates the intense investigation and recording of nature associated with the early Renaissance. His early painting of *Saint Francis in Ecstasy*

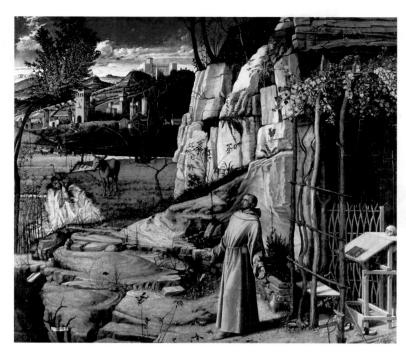

17-77. Giovanni Bellini. *Saint Francis in Ecstasy.* c. 1480. Oil and tempera on wood panel, $49 \times 55^{7}/8''$ (125 \times 142 cm). The Frick Collection, New York. Copyright the Frick Collection, New York

(fig. 17-77), painted in the 1470s, illustrates his command of an almost Flemish realism. The saint stands in communion with nature, bathed in early morning sunlight, his outspread hands showing the stigmata (the miraculous appearance of Christ's wounds on the saint's body). Francis had moved to a cave in the barren wilderness in his search for communion with God, but in this landscape, the fields blossom and flocks of animals graze. The grape arbor over his desk and the leafy tree toward which he directs his gaze add to an atmosphere of sylvan delight. True to fifteenth-century religious art, however, Bellini unites Old and New Testament themes to associate Francis with Moses and Christ: The tree symbolizes the burning bush; the stream, the miraculous spring brought forth by Moses; the grapevine and the stigmata, Christ's sacrifice. The crane and donkey represent the monastic virtue of patience. The detailed realism, luminous colors, and symbolic elements suggest Flemish art, but the golden light suffusing the painting is associated with Venice, a city of mist, reflections, and above all, color.

Giovanni's career spanned the second half of the fifteenth century, but he produced many of his greatest paintings in the early years of the sixteenth, when his work matured into a grand, simplified, idealized style. Although his work is often discussed with that of Leonardo da Vinci in the sixteenth century, it seems fitting to end our consideration of the first phase of Renaissance painting in Italy with Giovanni Bellini as an important and influential bridge to the future.

To gra facto ngozo sonegro leto chome fa lavurg agacti Flombardia ouer da levo paese Tressi Inesisia cha Forza lueve apitsa socto smoto Labarba alcielo ellamemoria semo Trullo s'evignio especto Jo darpra e Commel Copraluiso tuctamia melfor gocciando u ridro possimeto E lobi entrati miso nella peccia e passi séza ghôchí muono Thano Desimisalhion. Dinazi misalliga la chorceccia ep pregarsi aduerro suragroppa. e tédoms Comarcho sorsono po Fallact estrano Surgie ilindicio Et lamete poren A mal sitra p Cerboctana tortr Camia puturament de Fédi orma gionanni elmis onort no sédo Flog bo ne is putoro

18

RENAISSANCE ART IN SIXTEENTH-CENTURY EUROPE

ARELY BEFORE THE NINETEENTH CENTURY DID ARTISTS EXPRESS IN writing their reactions to a commission. But Michelangelo was not just an artist—he was a poet as well, and he described in a sonnet for his friend Giovanni da Pistoia (fig. 18-1) his discomfort as he clung to a scaffold, painting the ceiling of the pope's chapel:

This miserable job has given me a goitre like the cats in Lombardy get from the water there—or somewhere else. The force of it has jammed my belly up beneath my chin. Beard to the sky, I feel my seat of memory rests on a hump. I've grown a harpy's breast. Brush splatterings make a mosaic pavement of my face. My loins have moved into my guts. As counterweight, I stick my bum out like a horse's rump. Without the aid of eyes

to steer their way, my feet take aimless steps. Stretched taut in front, my skin meets up behind as I bend backward like a Syrian bow.

Just as a gun that's bent will never find its mark, so, waywardly I shoot false judgements from my mind.

Giovanni, Take up my cause, defend both my dead painting and my reputation. I'm in a poor state and I'm not a painter.

(Hughes, page 132)

Earlier, Michelangelo had successfully begun large commissions for Florence Cathedral and the Palazzo Vecchio, but Pope Julius II (papacy 1503–13) ordered him to come to Rome to work on a spectacular tomb-monument Julius planned for himself. Michelangelo began the new project, but two years later the pope changed his mind and ordered him to paint the Sistine Chapel ceiling instead (see fig. 18-14).

Michelangelo considered himself a sculptor—"I'm not a painter," he wrote bluntly at the end of his sonnet—but the strong-minded pope wanted his chapel painted and paid Michelangelo well for the work. Michelangelo had learned to use fresco in Ghirlandaio's studio in Florence (see fig. 17-70). He complained bitterly, but despite his physical misery as he stood on a scaffold, painting the ceiling just above him, he achieved the desired visual effects for viewers standing on the floor far below. Not only did he create a masterpiece of religious art, but his *Sistine Ceiling* frescoes also established a new and extraordinarily powerful style in Renaissance painting.

18-1. Michelangelo. Sonnet with a self-portrait of the artist in the right margin, painting the ceiling over his head. c. 1510. Pen and ink on paper, $11 \times 7''$ (39 \times 27.5 cm). Casa Buonarroti, Florence, Italy. Archivio Buonarroti vol. XII, fol. 11

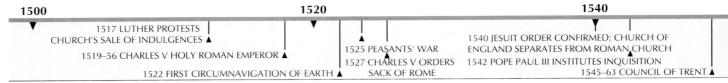

TIMELINE 18-1. Sixteenth-Century Europe. The century of the Renaissance was marked by exploration, major territorial wars, challenges to the Church, and the steady advance of secularization.

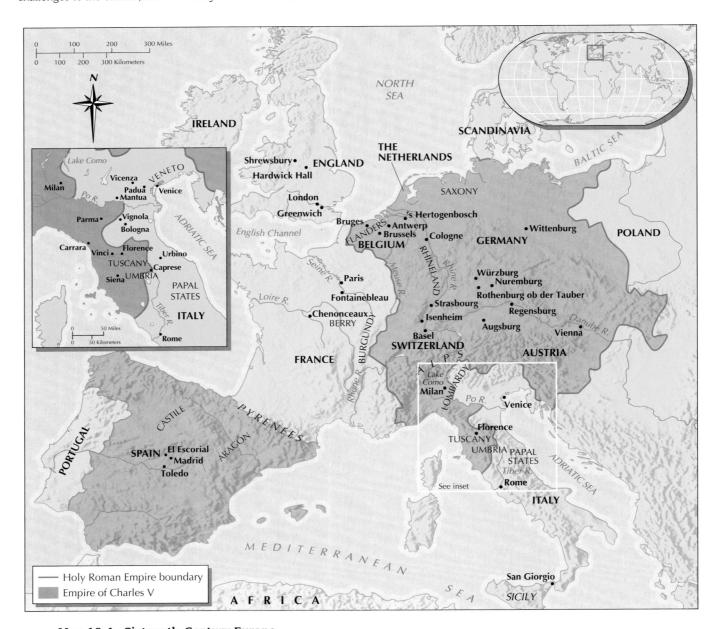

Map 18-1. Sixteenth-Century Europe.

The sixteenth century in Europe was a period of dramatic political, intellectual, religious, and artistic change, which became known as the Renaissance.

THE SIXTEENTH CENTURY

EUROPE IN The sixteenth century was an age of social, intellectual, and religious ferment that transformed European culture; it was also marked

by continual warfare triggered by the expansionist ambitions of the continent's various rulers. The humanism of the fourteenth and fifteenth centuries, with its medieval roots and its often uncritical acceptance of the

authority of classical texts, slowly gave way to a spirit of discovery that led Europeans to explore new ideas, the natural world, and lands previously unknown to them. The use of the printing press caused an explosion in the number of books available, spreading new ideas through the publication in translation of ancient and contemporary texts, broadening the horizons of educated Europeans, and enabling more people to learn to read. Travel became more common, and much more so ▲ 1550 VASARI'S *LIVES* PUBLISHED

▲ 1558-1603 ELIZABETH I QUEEN OF ENGLAND

▲ 1576 DUTCH UNITE AGAINST SPANISH RULE ▲ 1588 ENGLISH DEFEAT SPANISH NAVY IN SPANISH ARMADA

than in earlier centuries, artists and their work became mobile; consequently, artistic styles became less regional and more "international" (Timeline 18-1).

At the start of the sixteenth century, England, France, and Portugal were national states under strong monarchs (Map 18-1). Central Europe (Germany) was divided into dozens of free cities and territories ruled by nobles, but even states as powerful as Saxony and Bavaria acknowledged the overlordship of the Habsburg (Holy Roman) Empire, the greatest power in Europe. Charles V, elected Holy Roman Emperor in 1519, added Spain, the Netherlands, and vast territories in the Americas to the realm. Italy, which was divided into many small states, was a diplomatic and military battlefield where the Italian states, Habsburg Spain, France, and the papacy warred against each other in shifting alliances for much of the century. The popes themselves behaved like secular princes, using diplomacy and military force to regain control over the Papal States in central Italy and in some cases even to establish their families as hereditary rulers. The popes' incessant demands for money, particularly to finance the rebuilding of Saint Peter's (as well as their self-aggrandizing construction and art projects and luxurious life-styles) aggravated the religious dissent that had long been developing, especially north of the Alps, and contributed greatly to the rise of Protestantism.

The political maneuvering of Pope Clement VII (papacy 1523-34), a Medici, led to a direct clash with Holy Roman Emperor Charles V. In May 1527, Charles's German mercenary troops attacked Rome, beginning a sixmonth orgy of killing, looting, and burning. The Sack of Rome, as it is called, shook the sense of stability and humanistic confidence that until then had characterized the Renaissance and sent many artists fleeing the ruined city. Nevertheless, Charles led the Catholic forces, and in 1530 Clement VII crowned him emperor in Bologna.

GREAT PAPAL PATRONS OF THE SIXTEENTH CENTURY

Alexander VI (Borgia) papacy 1492-1503 Julius II (della Rovere) papacy 1503-13 Leo X (Medici) papacy 1513-21 Clement VII (Medici) papacy 1523-34 Paul III (Farnese) papacy 1534-49

THE CHANGING STATUS OF ARTISTS

Although only rare sixteenth-century artists like Michelangelo made public their feelings about their commissions, many others recorded their activities in private diaries, notebooks, and letters that have come down to us. In addition, contemporary writers reported on everything about artists, from their physical appearance to their personal reputation. Giorgio Vasari's Lives of the Most Excellent Italian Architects, Painters and Sculptors—the first art history book—appeared in 1550, followed by an expanded edition in 1568. Sixteenthcentury patrons valued artists highly and rewarded them well, not only with generous commissions but sometimes even with high social status (Charles V, for example, knighted the painter Titian). Some painters and sculptors became entrepreneurs, selling prints of their works on the side. The sale of prints was a means by which reputations and styles became widely known, and a few artists of stature became international celebrities. With their new fame and independence, the most successful artists could decide which commissions to accept or reject.

During this period, artists argued that the conception of a painting, sculpture, or work of architecture was a liberal—rather than a manual—art that required education in the classics and mathematics. The artist could express as much through painted, sculptural, and architectural forms as the poet could with words or the musician with melody. The myth of the divinely inspired creative genius—which arose during the Renaissance is still with us today. The newly elevated status of artists worked against women's participation in the visual arts, however, because genius was then believed to be reserved for men. Few women had access to the humanistic education required for the sophisticated, often esoteric, subject matter used in paintings or to the studio practice necessary to draw nude figures in foreshortened poses. Furthermore, an artist could not achieve international status without traveling extensively and frequently relocating to follow commissions. Still, women artists were active in Europe despite the obstacles to their entering any profession.

EARLY SIXTEENTH **CENTURY:** THE CLASSICAL PHASE OF THE

ITALY IN THE Italian art from the 1490s to about the time of the Sack of Rome-characterized by self-confident humanism, admiration of classical art, and a prevailing sense of stability and order-has been called variously the **RENAISSANCE** High Renaissance, the Imperial Style, and the classi-

cal phase of the Renaissance. Outstanding Italian artists, trained and practicing in Rome, Florence, and northern Italy, also worked in other Italian cities and in Spain, France, Germany, and the Netherlands, spreading Renaissance humanism and the Italian Renaissance style throughout Europe.

Two important developments at the turn of the sixteenth century affected the arts in Italy: In painting, the use of tempera gave way to the more flexible oil technique, and commissions from private sources increased.

Artists no longer depended on the patronage of the Church or royalty, as many patrons in Italy and other European countries amassed wealth and became avid collectors of paintings and small bronzes, as well as coins, minerals and fossils from the natural world, and antiquities.

THREE GREAT ARTISTS OF THE EARLY SIXTEENTH CENTURY

Florence's great fifteenth-century art works and tradition of arts patronage attracted a stream of young artists to that city, which has been considered the cradle of the Italian Renaissance since Vasari labeled it such in 1550. The frescoes in the Brancacci Chapel there (see fig. 17-62) inspired young artists, who went to study Masaccio's solid, monumental figures and eloquent facial features, poses, and gestures. For example, the young Michelangelo's sketches of the chapel frescoes clearly show the importance of Masaccio on his developing style. Along with Michelangelo, Leonardo and Raphael—together, the three leading artists of the classical phase of the Italian Renaissance-began their careers in Florence, although they soon moved to other centers of patronage and their influence spread far beyond that city.

Leonardo da Vinci. Leonardo da Vinci (1452–1519) was twelve or thirteen when his family moved to Florence from the Tuscan village of Vinci. He was apprenticed to the shop of the painter and sculptor Verrocchio until about 1476. After a few years on his own, Leonardo traveled to Milan in 1481 or 1482 to work for the court of the ruling Sforza family.

Leonardo spent much of his time in Milan on military and civil engineering projects, including an urbanrenewal plan for the city, but he also created one of the monuments of Renaissance art there: At Duke Ludovico Sforza's request, Leonardo painted The Last Supper (see fig. 18, Introduction) in the refectory, or dining hall, of the Monastery of Santa Maria delle Grazie in Milan between 1495 and 1498. In fictive space defined by a coffered ceiling and four pairs of tapestries that seem to extend the refectory into another room (fig. 18-2), Jesus and his disciples are seated at a long table placed parallel to the picture plane and to the living diners seated below. The stagelike space recedes from the table to three windows on the back wall, where the vanishing point of the onepoint perspective lies behind Jesus' head. Jesus' outstretched arms form a pyramid at the center, and the disciples are grouped in threes on each side. As a narrative, the scene captures the moment when Jesus tells his companions that one of them will betray him. They react with shock, disbelief, and horror. Judas, clutching his money bag in the shadows to the left of Jesus, has recoiled so suddenly that he has upset the salt dish, a bad omen. Leonardo was an acute observer of human beings and his art vividly expressed human emotion.

On another level, *The Last Supper* is a symbolic evocation of both Jesus' coming sacrifice for the salvation of humankind and the institution of the ritual of the Mass.

Breaking with traditional representations of the subject, such as the one by Andrea del Castagno (see fig. 17-66), Leonardo placed the traitor Judas in the first triad to the left of Jesus, with the young John the Evangelist and the elderly Peter, rather than isolating him on the opposite side of the table. Judas, Peter, and John were each to play an essential role in Jesus' mission: Judas to set in motion the events leading to Jesus' sacrifice; Peter to lead the Church after Jesus' death; and John, the visionary, to foretell the Second Coming and the Last Judgment in the Apocalypse. By arranging the disciples and architectural elements into four groups of three, Leonardo incorporated a medieval tradition of numerical symbolism. He eliminated another symbolic element—the halo—and substituted the natural light from a triple window framing Jesus' head (compare Rembrandt's reworking of the composition, fig. 19, Introduction).

The painting's careful geometry, the convergence of its perspective lines, the stability of its pyramidal forms, and Jesus' calm demeanor amid the commotion all reinforce a sense of order. The work's qualities of stability, calm, and timelessness, coupled with the established Renaissance forms modeled after those of classical sculpture, characterize the art of the Renaissance at the beginning of the sixteenth century.

Leonardo returned to Florence in 1498, when the French, who had invaded Italy in 1494, claimed Milan. (Two years later they captured Leonardo's Milanese patron, Ludovico Sforza, who remained imprisoned until his death in 1508.) About 1500, Leonardo produced a large drawing of the Virgin and Saint Anne with the Christ Child and the Young John the Baptist (fig. 18-3, page 650). This work is a full-scale model, called a cartoon, for a major painting, but no known painting can be associated with it. Scholars today believe it to be a finished work—perhaps one of the drawings artists often made as gifts in the sixteenth century. Mary sits on the knee of her mother, Anne, and turns to the right to hold the Christ Child, who strains away from her to reach toward his cousin, the young John the Baptist. Leonardo created the illusion of high relief by modeling the figures with strongly contrasted light and shadow, a technique called chiaroscuro (Italian for "light-dark"). Carefully placed highlights create a circular movement rather than a central focus, which retains the individual importance of each figure while also making each of them an integral part of the whole. This effect is emphasized by the figures' complex interactions, which are suggested by their exquisitely tender expressions, particularly those of Saint Anne and the Virgin.

Between about 1503 and 1506, Leonardo painted the renowned portrait known as *Mona Lisa* (fig. 18-4, page 650), which he kept with him for the rest of his life. The subject may have been twenty-four-year-old Lisa Gherardini del Giocondo, the wife of a prominent merchant in Florence. Remarkably for the time, the young woman is portrayed without any jewelry, not even a ring. The solid pyramidal form of her half-length figure is silhouetted against distant mountains, whose desolate grandeur reinforces the painting's mysterious

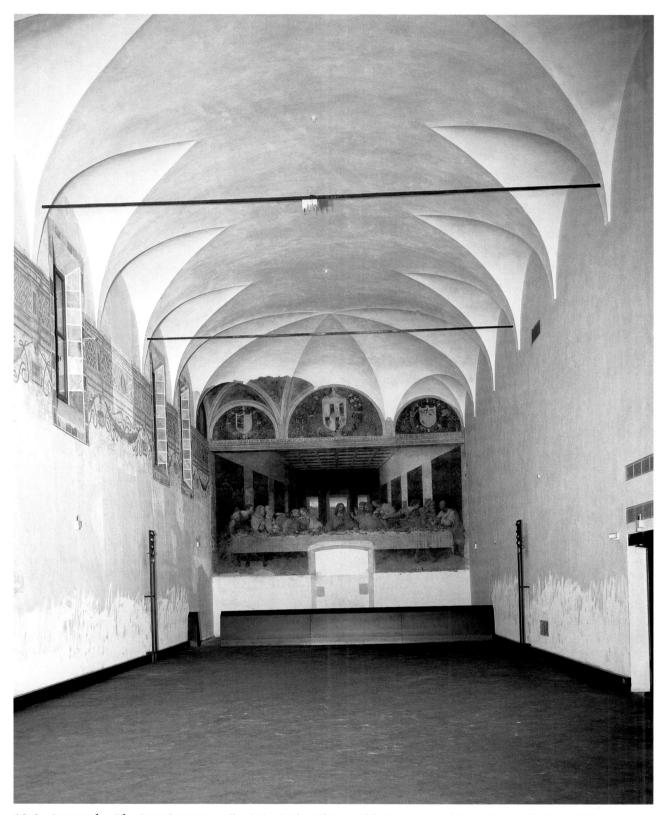

18-2. Leonardo. *The Last Supper*, wall painting in the refectory of the Monastery of Santa Maria delle Grazie, Milan, Italy. 1495–98. Tempera and oil on plaster, $15'2'' \times 28'10''$ (4.6×8.8 m).

Instead of painting in fresco, Leonardo devised an experimental technique for this mural. Hoping to achieve the freedom and flexibility of painting on wood panel, he worked directly on dry *intonaco*—a thin layer of smooth plaster—with an oil-and-tempera paint whose formula is unknown. The result was disastrous. Within a short time, the painting began to deteriorate, and by the middle of the sixteenth century its figures could be seen only with difficulty. In the seventeenth century, the monks saw no harm in cutting a doorway through the lower center of the composition. Since then the work has barely survived, despite many attempts to halt its deterioration and restore its original appearance. The painting narrowly escaped complete destruction in World War II, when the refectory was bombed to rubble around its heavily sandbagged wall. The coats of arms at the top are those of patron Ludovico Sforza, the duke of Milan (ruled 1476–99), and his wife, Beatrice.

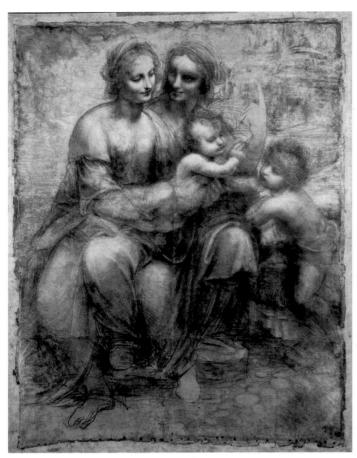

18-3. Leonardo. *Virgin and Saint Anne with the Christ Child and the Young John the Baptist.* c. 1500. Charcoal heightened with white on brown paper, $55^{1}/_{2}$ " \times 41" (141.5 \times 104.6 cm). The National Gallery, London.

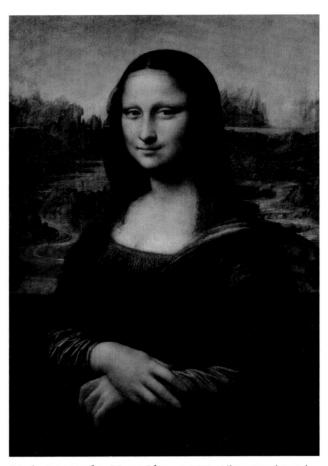

18-4. Leonardo. *Mona Lisa.* c. 1503. Oil on wood panel, $30^{1}/_{4} \times 21''$ (77× 53 cm). Musée du Louvre, Paris.

atmosphere. Mona Lisa's expression has been called enigmatic because her gentle smile is not accompanied by the warmth one would expect to see in her eyes. The contemporary fashion for plucked eyebrows and a shaved hairline to increase the height of the forehead adds to her arresting appearance. Perhaps most unsettling is the bold and slightly flirtatious way her gaze has shifted toward the right to look straight out at the viewer. The implied challenge of her direct stare, combined with her apparent serenity and inner strength, has made the *Mona Lisa* one of the most popular and best-known works in the history of art.

A fiercely debated topic in Renaissance Italy was the question of the superiority of painting or sculpture. Leonardo insisted on the supremacy of painting as the best and most complete means of creating an illusion of the natural world, while Michelangelo argued for sculpture. Yet in creating a painted illusion, Leonardo considered color to be secondary to the depiction of sculptural volume, which he achieved through his virtuosity in highlighting and shading. He also unified his compositions by covering them with a thin, lightly tinted varnish, which resulted in a smoky overall haze called *sfumato*. Because early evening light tends to produce a similar effect naturally, Leonardo considered dusk the finest

time of day and recommended that painters set up their studios in a courtyard with black walls and a linen sheet stretched overhead to reproduce twilight.

Leonardo's fame as an artist is based on only a few works, for his many interests took him away from painting. Unlike his humanist contemporaries, he was not particularly interested in classical literature or archaeology. Instead, his passions were mathematics, engineering, and the natural world; he compiled volumes of detailed drawings and notes on anatomy, botany, geology, meteorology, architectural design, and mechanics. In his drawings of human figures, he sought not only the precise details of anatomy but also the geometric basis of perfect proportions (see "The Vitruvian Man," opposite). Leonardo returned to Milan in 1508 and lived there until 1513. He also lived for a time in the Vatican at the invitation of Pope Leo X, but there is no evidence that he produced any art during his stay. In 1517 he accepted the French king Francis I's invitation to relocate to France as an adviser on architecture. He lived there until his death in 1519.

Raphael. About 1505, Raphael (Raffaello Santi or Sanzio, 1483–1520) arrived in Florence from his native Urbino. He had studied in Perugia with the leading artist

THE VITRUVIAN MAN

Artists throughout history have turned to geometric shapes and mathematical proportions to seek the ideal representation of the human form. Leonardo da Vinci, and before him Vitruvius, equated the ideal man with both circle and square. Ancient Egyptian artists laid out square grids as aids to design. Medieval artists adapted a variety of figures, from triangles to pentagrams. The Byzantines used circles swung from the bridge of the nose to create face, head, and halo.

The first-century BCE Roman architect and engineer Vitruvius, in his ten-volume *De architectura (On Architecture)*, wrote: "For if a man be placed flat on his back, with his hands and feet extended, and a pair

of compasses centered at his navel, the fingers and toes of his two hands and feet will touch the circumference of a circle described therefrom. And just as the human body yields a circular outline, so too a square figure may be found from it. For if we measure the distance from the soles of the feet to the top of the head, and then apply that measure to the outstretched arms, the breadth will be found to be the same as the height" (Book III, Chapter 1, Section 2). Vitruvius determined that the body should be eight heads high. Leonardo added his own observations in the reversed writing he always used for his notebooks when he created his well-known diagram for the ideal male figure, called the Vitruvian

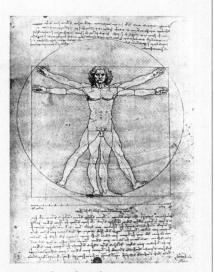

Leonardo. *Vitruvian Man.* c. 1490. Ink, $13^{1}/_{2} \times 9^{5}/_{8}$ " (34.3 × 24.5 cm). Galleria dell'Accademia, Venice.

of that city, Perugino (see fig. 17-69). Raphael quickly became successful in Florence, especially with paintings of the Virgin and Child, such as The Small Cowper Madonna (named for a modern owner) of about 1505 (fig. 18-5). Already a superb painter technically, Raphael must have studied Leonardo's work to achieve the simple grandeur of these monumental shapes, idealized faces, figure-enhancing draperies, and rich colors. The forms are modeled solidly but softly by the clear, even light that pervades the outdoor setting. In the distance on a hilltop, Raphael has painted a scene he knew well from his childhood, the domed Church of San Bernardino, two miles outside Urbino. The church contains the tombs of the dukes of Urbino, Federico and Guidobaldo da Montefeltro, and their wives (see fig. 17-71). Donato Bramante (1444-1514), who worked in Urbino before settling in Rome in 1499, may have designed the church.

Raphael left Florence about 1508 for Rome, where Pope Julius II put him to work almost immediately decorating rooms (stanze, singular stanza) in the papal apartments. In the library, Raphael painted the four branches of knowledge as conceived in the sixteenth century: religion (the Disputà, depicting the disputation over the true presence of Christ in the Communion bread), philosophy (the School of Athens), poetry (Parnassus, home of the Muses), and law (the Cardinal Virtues under Justice) (figs. 18-6, 18-7, page 652). The shape of the walls and vault of the room itself inspired the composition of the paintings—the arc of clouds intersected by Christ's mandorla in the *Disputà*, for example, or the receding arches and vaults in the School of Athens. In the Disputà, theologians and Church officials discuss the meaning of the Eucharist (fig. 18-7). Above them, the three Persons of the Trinity, flanked by the apostles, fill the upper half of the painting. The Host in its monstrance, silhouetted against the sky, rests on the altar, where Pope Julius's name appears in the embroidered altar frontal.

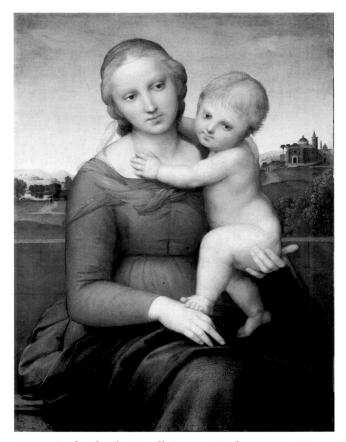

18-5. Raphael. *The Small Cowper Madonna.* c. 1505. Oil on wood panel, $23\frac{3}{8} \times 17^3/8$ " (59.5 × 44.1 cm). National Gallery of Art, Washington, D.C. Widener Collection, (1942,9.57)

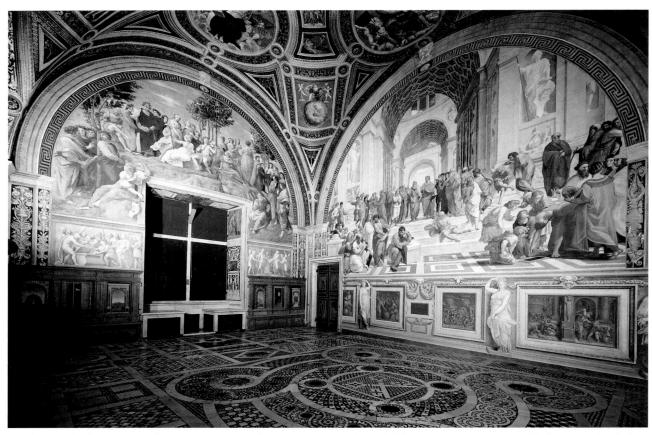

18-6. Raphael. Stanza della Segnatura, Vatican, Rome. Fresco in the left lunette *Parnassus*; in the right lunette, *School of Athens*, 1510–11. *School of Athens* $19 \times 27'$ (5.79 \times 8.24 m),

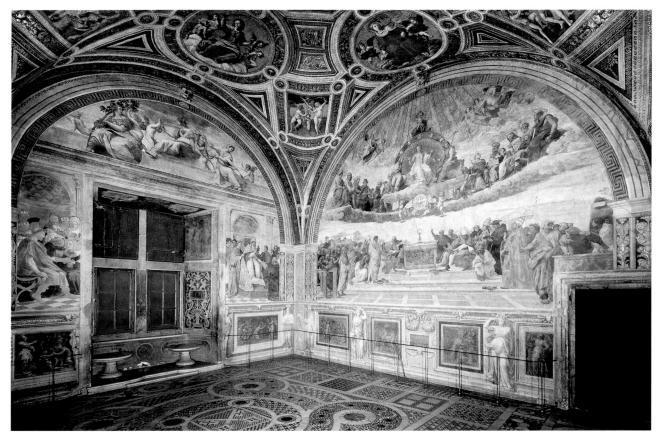

18-7. Raphael. Stanza della Segnatura. Fresco in the left lunette *Cardinal Virtues under Justice*; in the right lunette, *Disputà*. 1510-11. *Disputà* $19 \times 27'$ $(5.79 \times 8.24 \text{ m})$.

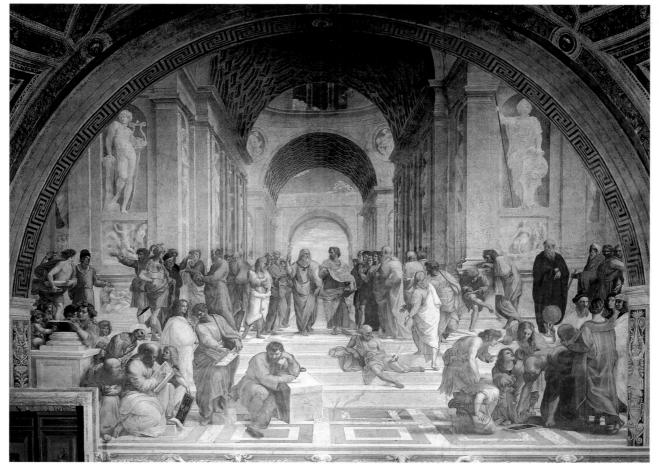

18-8. Raphael. School of Athens, fresco in the Stanza della Segnatura, Vatican, Rome. c. 1510-11. $19 \times 27'$ (5.79 \times 8.24 m).

Raphael gave many of the figures in his imaginary gathering of philosophers the features of his friends and colleagues. Plato, standing immediately to the left of the central axis and pointing to the sky, was said to have been modeled after Leonardo da Vinci; Euclid, shown inscribing a slate with a compass at the lower right, was a portrait of Raphael's friend the architect Donato Bramante. Michelangelo, who was at work on the *Sistine Ceiling* only steps away from the *stanza* where Raphael was painting his fresco, is shown as the solitary figure at the lower left center, leaning on a block of marble and sketching, in a pose reminiscent of the figures of sibyls and prophets on his great ceiling. Raphael's own features are represented on the second figure from the front group at the far right, as the face of a young man listening to a discourse by the astronomer Ptolemy.

Raphael's most outstanding achievement in the papal rooms was the *School of Athens* (fig. 18-8), painted about 1510–11, which seems to summarize the ideals of the Renaissance papacy in its grand conception of harmoniously arranged forms and rational space, as well as the calm dignity of its figures. Indeed, if the learned Julius II did not actually devise the subjects painted, he certainly must have approved them.

Viewed through a *trompe l'oeil* arch, the Greek philosophers Plato and Aristotle are silhouetted against the sky—the natural world—and command our attention. At the left, Plato holds his book *Timaeus*—in which creation is seen in terms of geometry, and humanity encompasses and explains the universe—and gestures upward to the heavens as the ultimate source of his philosophy. Aristotle, with his outstretched hand palm down, seems to emphasize the importance of gathering empirical knowledge

from observing the material world. Looking down from niches in the walls are depictions of a sculpted Apollo, the god of sunlight, rationality, poetry, music, and the fine arts, and Minerva, the goddess of wisdom and the mechanical arts. Around Plato and Aristotle are mathematicians, naturalists, astronomers, geographers, and other philosophers debating and demonstrating their theories to onlookers and to each other. The scene, flooded with a clear, even light from a single source, takes place in an immense barrelvaulted interior possibly inspired by the new design for Saint Peter's, then being rebuilt. The grandeur of the building is matched by the monumental dignity of the philosophers themselves, each of whom has a distinct physical and intellectual presence. Despite the variety and energy of the poses and gestures, these striking individuals are organized into a dynamic unity by the sweeping arcs of the composition.

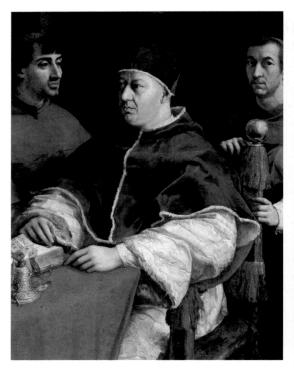

18-9. Raphael. *Leo X with Cardinals Giulio de' Medici and Luigi de' Rossi.* c. 1517. Oil on wood panel, $5^{\prime 5}/_8'' \times 3^{\prime}10^{7}/_8''$ (1.54 \times 1.19 m). Galleria degli Uffizi, Florence.

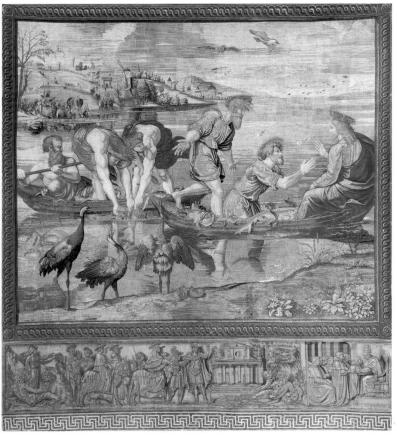

Raphael continued to work for Julius II's successor, Leo X (born Giovanni de' Medici; papacy 1613–21), as director of all archaeological and architectural projects in Rome. Raphael's portrait of Leo X (fig. 18-9) depicts the pope as a great collector of books.

Leo's driving ambition was the advancement of the Medici family, and Raphael's painting is, in effect, a dynastic group portrait. Facing the pope at the left is his cousin Giulio, Cardinal de' Medici who will become Pope Clement VII (papacy 1523-34); behind him stands Luigi de' Rossi, another relative he had made cardinal. Dressed in splendid brocades and enthroned in a velvet chair, the pope looks up from a richly illuminated fourteenthcentury manuscript that he has been examining with a magnifying glass. Raphael carefully depicted the contrasting textures and surfaces in the picture, including the visual distortion caused by the magnifying glass on the book page. The polished brass knob on the pope's chair reflects the window and the painter himself. In these telling details, Raphael acknowledges his debt-despite great stylistic differences—to the fifteenth-century Flemish artist Jan van Eyck and his followers (Chapter 17).

Like many artists, Raphael had mastered several arts. In 1515–16 he provided cartoons on themes from the Acts of the Apostles to be made into tapestries to cover the wall below the fifteenth-century wall paintings of the Sistine Chapel. For the production of tapestries, which were woven in workshops in France and Flanders and were extremely expensive, artists made charcoal drawings, then painted over them with glue-based colors for the weavers to match. The first tapestry in Raphael's

18-10. Shop of Pieter van Aelst, Brussels, after cartoons by Raphael and assistants **1515–1516**. *Miraculous Draft of Fishes*, from the nine-piece set, the *Acts of the Apostles* series; lower border, two incidents from the life of Giovanni de' Medici, later Pope Leo X. Woven 1517, installed 1519 in the Sistine Chapel. Wool and silk with silvergilt wrapped threads, $16'1'' \times 21'$ (490×640 cm). Musei Vaticani, Pinacoteca, Rome.

Raphael's Acts of the Apostles cartoons were used as the models for several sets of tapestries woven in van Aelst's Brussels shop, including one for Francis I of France and another for Henry VIII of England. In 1630, the Flemish painter Peter Paul Rubens (Chapter 19) discovered seven of the ten original cartoons in the home of a van Aelst heir and convinced his patron Charles I of England to buy them. Still part of the royal collection today, they are exhibited at the Victoria and Albert Museum in London. The tapestries themselves were stolen during the Sack of Rome in 1527, returned in the 1530s, taken to Paris by Napoleon in 1798, purchased by a private collector in 1808, and returned to the Vatican as a gift that year. They are now displayed in the Raphael Room of the Vatican Painting Gallery.

series was the *Miraculous Draft of Fishes* on the Sea of Galilee (Matthew 4:18–22) (fig. 18-10). The fisherman Simon, whom Christ called to be his first apostle Peter, became the cornerstone on which the papal claims to authority rested. Andrew, James, and John would also become apostles. The two boats establish a friezelike composition, and the huge straining figures remind us that Raphael felt himself in clear competition with Michelangelo, whose Sistine ceiling had been completed only three years earlier. Raphael studied not only his contemporaries' painting but also antique sources in his

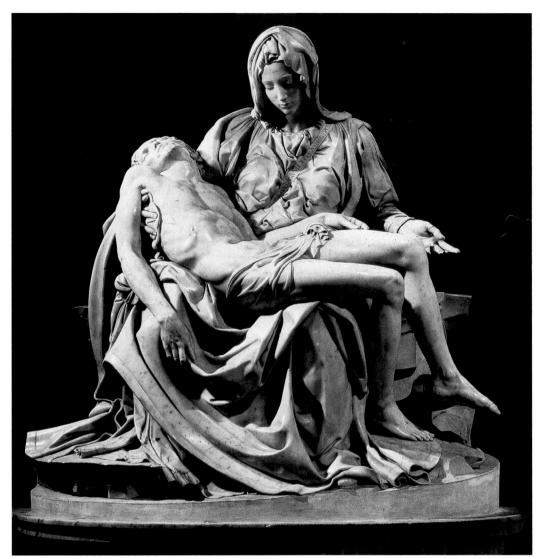

18-11. Michelangelo. *Pietà*, from Old Saint Peter's. c. 1500. Marble, height 5'8¹/₂" (1.74 m). Saint Peter's, Vatican, Rome.

efforts to achieve both monumentality and realism. For example, he copied the face of Christ from a fifteenth-century bronze copy of an ancient emerald cameo, which at the time was thought to be the true portrait of Jesus. The panoramic landscape behind the fishermen includes a crowd on the shore and the city of Rome with its walls and churches. The three cranes in the foreground were not a simple pictorial device; in the sixteenth century they symbolized the ever-alert and watchful pope, a timely addition because when the tapestries were first displayed in the Sistine Chapel on December 26, 1519, papal authority was already being challenged by reformers like Martin Luther in Germany.

Raphael died after a brief illness in 1520, at the age of thirty-seven. After a state funeral, he was buried in the ancient Roman Pantheon, originally a classical temple to the gods of Rome, but then a Christian church dedicated to the Virgin Mary. His unfinished painting of the *Transfiguration of Christ* was displayed above his body as he lay in state.

Michelangelo. Michelangelo Buonarroti (1475–1564) was born in the Tuscan town of Caprese, grew up in Florence, and spent his long career working there

and in Rome. At thirteen, he was apprenticed to Ghirlandaio, in whose workshop he learned the rudiments of fresco painting and studied drawings of classical monuments. Soon the talented youth joined the household of Lorenzo the Magnificent, head of the ruling Medici family, where he came into contact with the Neoplatonic philosophers and studied sculpture with Bertoldo di Giovanni, a pupil of Donatello. Bertoldo worked primarily in bronze, and Michelangelo later claimed that he had taught himself to carve marble by studying the Medici collection of classical statues. After Lorenzo died in 1492, Michelangelo traveled to Venice and Bologna, then returned to Florence, where he fell under the spell of the charismatic preacher Fra Girolamo Savonarola. The preacher's execution for heresy in 1498 had a traumatic effect on Michelangelo, who said in his old age that he could still hear the sound of Savonarola's voice.

Michelangelo's major early work at the turn of the century was a *pietà*, commissioned by a French cardinal and installed as a tomb monument in Old Saint Peter's in the Vatican (fig. 18-11). *Pietàs*—works in which the Virgin supports and mourns the dead Jesus—had long been popular in northern Europe but

were rare in Italian art at the time. Michelangelo traveled to the marble quarries at Carrara in central Italy to select the block from which to make this large work, a practice he was to follow for nearly all of his sculpture. His choice of stone was important, for Michelangelo envisioned the statue as already existing within the marble and needing only to be "set free" from it. He later wrote in his Sonnet 15 (1536–47): "The greatest artist has no conception which a single block of marble does not potentially contain within its mass, but only a hand obedient to the mind can penetrate to this image."

Michelangelo's *Pietà* is a very young Virgin of heroic stature holding the lifeless, smaller body of her grown son. The seeming inconsistencies of age and size are countered, however, by the sweetness of expression, the finely finished surfaces, and the softly modeled forms. Michelangelo's compelling vision of beauty is meant to be seen up close, from directly in front of the statue and on the statue's own level, so that the viewer can look into Jesus' face. The twenty-five-year-old artist is said to have slipped into Old Saint Peter's at night to sign the finished sculpture, to answer the many questions about its creator.

In 1501, Michelangelo accepted a commission for a statue of the biblical David (fig. 18-12) to be placed high atop a buttress of the Florence Cathedral. When it was finished in 1504, the David was so admired that the city council placed it in the square next to the seat of Florence's government instead. Although Michelangelo's David embodies the athletic ideal of antiquity in its muscular nudity, the emotional power of its expression and concentrated gaze is entirely new. Unlike Donatello's bronze David (see fig. 17-53), this is not a triumphant hero with the head of the giant Goliath under his feet. Instead, slingshot over his shoulder and a rock in his right hand, Michelangelo's David frowns and stares into space, seemingly preparing himself psychologically for the danger ahead. Here the male nude implies, as it had in classical antiquity, heroic or even divine qualities. No match for his opponent in experience, weaponry, or physical strength, David represents the power of right over might—a perfect emblematic figure for the Florentines, who recently had fought the forces of Milan, Siena, and Pisa.

Despite Michelangelo's contractual commitment to the Florence Cathedral for statues of the apostles, in 1505 Pope Julius II, who saw Michelangelo as his equal in mental power and dedication and thus as an ideal collaborator in the artistic aggrandizement of the papacy, arranged for him to come to Rome. The sculptor's first undertaking, the pope's tomb, was set aside in 1506 when Julius ordered Michelangelo to redecorate the ceiling of the Sistine Chapel (fig. 18-13).

Julius's initial order for the ceiling was simple: trompe l'oeil coffers to replace the original star-spangled blue ceiling. Later he wanted the Twelve Apostles seated on thrones to be painted in the triangular **spandrels**, the walls between the **lunettes** framing the windows. When Michelangelo objected to the limi-

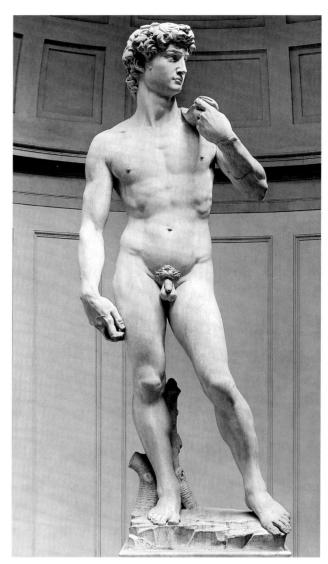

18-12. Michelangelo. *David.* 1501–4. Marble, height 17' (5.18 m) without pedestal. Galleria dell'Accademia, Florence.

Michelangelo's most famous sculpture was cut from an 18-foot-tall marble block. The sculptor began with a small model in wax, then sketched the contours of the figure as they would appear from the front on one face of the marble. Then, according to his friend and biographer Vasari, he chiseled in from the drawn-on surface, as if making a figure in very high relief. The completed statue took four days to move on tree-trunk rollers down the narrow streets of Florence from the premises of the cathedral shop where he worked to its location outside the Palazzo Vecchio (the town hall). In 1504, the Florentines gilded the tree stump and added a gilded wreath to the head and a belt of twenty-eight gilt-bronze leaves, since removed. In 1873 the statue was replaced by a copy made to scale and was moved into the museum of the Florence Academy.

tations of Julius's plan, the pope told him to paint whatever he liked. This he presumably did, although a commission of this importance probably involved some supervision by the pope and perhaps also an adviser in theology.

In Michelangelo's final composition, illusionistic marble architecture establishes a framework for the

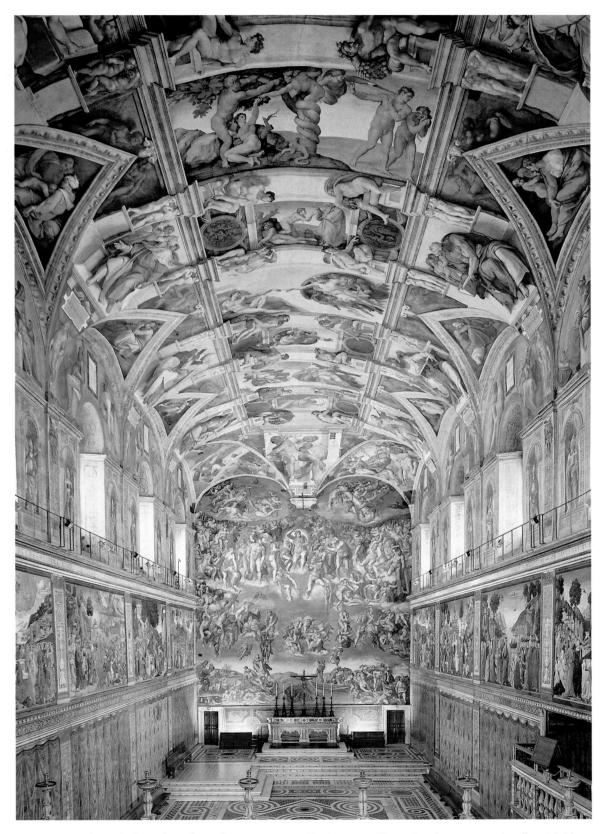

18-13. Interior, Sistine Chapel, Vatican, Rome. Built 1475–81; ceiling painted 1508–12; end wall, 1536–44. Named after its builder, Pope Sixtus (Sisto) IV, the chapel is slightly more than 130 feet long and about $143\frac{1}{2}$ feet wide, approximately the same measurements recorded in the Old Testament for the Temple of Solomon. The floor mosaic was recut from the colored stones used in the floor of an earlier papal chapel. The walls were painted in fresco between 1481 and 1483 with scenes from the lives of Moses and Jesus by Perugino, Botticelli, Ghirlandaio, and others. Below these are *trompe l'oeil* painted draperies, where Raphael's tapestries illustrating the Acts of the Apostles once hung (see fig. 18-10). Michelangelo's famous ceiling frescoes begin with the lunette scenes above the windows (see fig. 18-14). On the end above the altar is his *Last Judgment* (see figs. 18-46, 18-47).

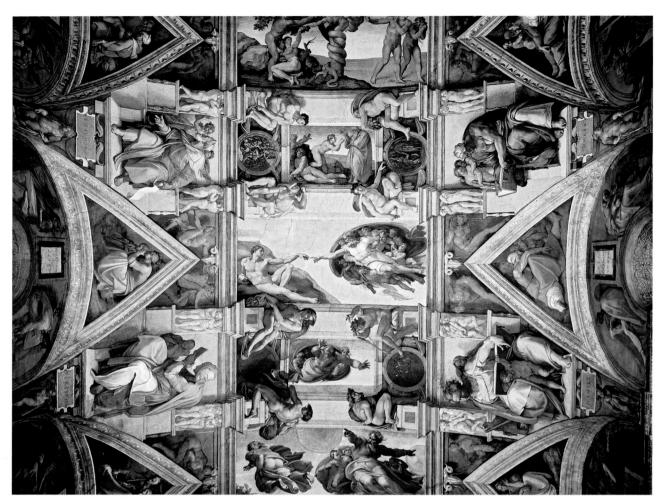

18-14. Michelangelo. Sistine Ceiling, frescoes in the Sistine Chapel. Top to bottom: Expulsion (center); Creation of Eve, with Ezekiel (left) and Cumaean Sibyl (right); Creation of Adam; God Gathering the Waters, with Persian Sibyl (left) and Daniel (right); and God Creating the Sun, Moon, and Planets. 1508–12. The spandrels and lunettes depict the ancestors of Jesus.

figures on the vault of the chapel (fig. 18-14). Running completely around the ceiling is a painted cornice with projections supported by short pilasters decorated with the figures of nude little boys, called putti. Set among these projections are figures of Old Testament prophets and classical sibyls (female prophets) who were believed to have foretold Jesus' birth. Seated on the cornice projections are heroic figures of nude young men, called ignudi (singular ignudo), holding sashes attached to large gold medallions. Rising behind the ignudi, shallow bands of fictive stone span the center of the ceiling and divide it into compartments in which are painted scenes of the Creation, the Fall, and the Flood. The narrative sequence begins over the altar and ends near the chapel entrance (fig. 18-15). God's earliest acts of creation are therefore closest to the altar, the Creation of Eve at the center of the ceiling, followed by the imperfect actions of humanity: the Temptation, the Fall, the Expulsion from Paradise, and God's eventual destruction of all people except Noah and his family by the Flood. The triangular spandrels contain paintings of the ancestors of Jesus; each is flanked by mirror-image nudes in reclining and seated poses. At the apex of each spandreltriangle is a *bucranium*, or ox skull, a **motif** (a repeated figure in a design) that appears in ancient Roman paintings and reliefs.

According to discoveries during the most recent restoration (see "The Sistine Ceiling Restoration," opposite), Michelangelo worked on the ceiling in two stages, beginning in the late summer or fall of 1508 and moving from the chapel's entrance toward the altar, in reverse of the narrative sequence. The first half of the ceiling up to the Creation of Eve was unveiled in August 1511 and the second half in October 1512. His style became broader and the composition simpler as he progressed.

Perhaps the most familiar scene is the Creation of Adam. Here Michelangelo depicts the moment when God charges the languorous Adam with the spark of life. As if to echo the biblical text, Adam's heroic body and pose mirror those of God, in whose image he has been created. Directly below Adam is an *ignudo* grasping a bundle of oak leaves and giant acorns, which refer to Pope Julius's family name (della Rovere, or "of the oak") and possibly also to a passage in the Old Testament prophecy of Isaiah (61:3), "They will be called oaks of justice, planted by the LORD to show his glory."

18-15. Diagram of scenes of the *Sistine Ceiling*.

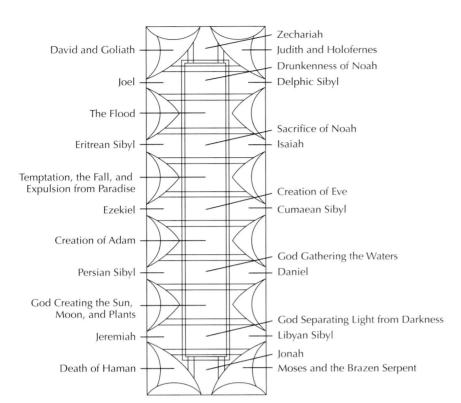

THE SISTINE CEILING RESTORATION

The cleaning of frescoes on the walls of the Sistine Chapel, done in the 1960s and 1970s, was so successful that in 1980 a single lunette from Michelangelo's ceiling decoration was cleaned as a test. Underneath layers of soot and dust was found color so brilliant and so different from the long-accepted dusky appearance of the ceiling that conservators summoned their courage and proposed a major restoration of the entire ceiling. The work was completed in the winter of 1989, and the Last Judgment over the altar was completed in the spring of 1994.

Although the restorers proceeded with great caution and frequently consulted with other experts in the field, the cleaning created serious controversy. The greatest fear was that the work was moving ahead too rapidly for absolute safety. Another concern was that the ceiling's final appearance might not resemble its original state. Some scholars, convinced that Michelangelo had reworked the surface of the fresco

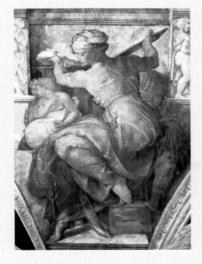

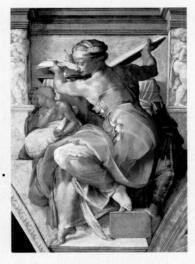

Michelangelo. *Libyan Sibyl*, fresco in the Sistine Chapel, Vatican, Rome. 1511–12. On the left, the fresco before cleaning; on the right, as it appears today.

after it had dried to tone down the colors, feared that cleaning would remove those finishing touches. In the end, the breathtaking colors that the cleaning revealed forced scholars to thoroughly revise their understanding of Michelangelo's art and

the development of sixteenth-century Italian painting. We will never know for certain if some subtleties were lost in the cleaning, and only time will tell if this restoration has prolonged the life of Michelangelo's great work.

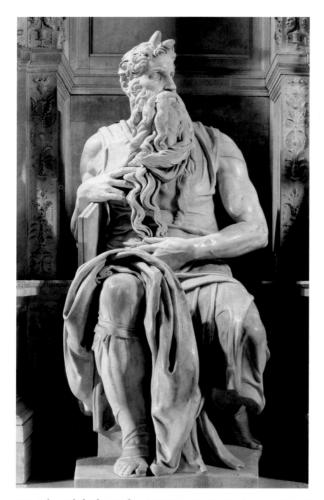

18-16. Michelangelo. *Moses*, Tomb of Julius II. 1513–16, 1542–45, Marble, height $7'8\frac{1}{2}''$ (2.35 m). Church of San Pietro in Vincoli, Rome.

Michelangelo's first papal sculpture commission, the tomb of Julius II, still incomplete at Julius's death in 1513, was to plague him and his patrons for forty years. In 1505, he presented his first designs to the pope for a huge freestanding rectangular structure crowned by the pope's sarcophagus and covered with more than forty statues and reliefs in marble and bronze. But after a year of preliminary work on the tomb, Michelangelo angrily left for Florence the day before the cornerstone was laid for the new Saint Peter's; he later explained that Julius had halted the tomb project to divert money toward building the church. After Julius died, his heirs offered the sculptor a new contract and a larger payment for a more elaborate tomb but soon began to cut back on the expense and size. At this time, between 1513 and 1516, and again in 1542-46, Michelangelo worked on the figure of Moses (fig. 18-16), the only sculpture from the original design to be incorporated into the final, muchreduced monument to Julius II. No longer an actual tomb—Julius was buried elsewhere—the monument was installed in 1545, after decades of wrangling, in the Church of San Pietro in Vincoli, Rome. In the original design, the Moses was to have been one of four seated figures subordinate to several groups, including a

Madonna and Child flanked by saints. The pope was to have been supported by angels atop a sarcophagus. In the final configuration, however, the eloquent *Moses* becomes the focus of the monument and a stand-in for the long-dead pope.

After Leo X succeeded Julius in 1513 and the Medici regained power in Florence in 1515, Michelangelo was made chief architect for Medici family projects at the Church of San Lorenzo in Florence (see figs. 17-36, 17-37)—including a new chapel for the tombs of Lorenzo the Magnificent, Giuliano, and two younger dukes, also named Lorenzo and Giuliano, ordered in 1519. The older men's tombs were never built, but the unfinished tombs for the younger relatives were placed on opposite side walls of the so-called New Sacristy (the Old Sacristy, by Filippo Brunelleschi, is at the other end of the transept).

In the New Sacristy, each of the two monuments consists of an idealized portrait of the deceased, who turns to face the family's ancestral tomb (fig. 18-17). The men are dressed in a sixteenth-century interpretation of classical armor and seated in niches above pseudoclassical sarcophagi. Balanced precariously atop the sarcophagi are male and female figures representing the times of day. Their positions would not seem so unsettling had reclining figures of river gods been installed below them, as originally planned. Giuliano, Duke of Nemours, represents the Active Life, and his sarcophagus figures are allegories of Night and Day. Night is accompanied by her symbols: a star and crescent moon on her tiara; poppies, which induce sleep; and an owl under the arch of her leg. The huge mask at her back may allude to Death, since Sleep and Death were said to be the children of Night. Lorenzo, representing Contemplative Life, is supported by Dawn and Evening. The allegorical figures for the empty niches that flank the tombs were never carved. The walls of the sacristy are articulated with Brunelleschian pietra serena pilasters and architraves in the Corinthian order.

The figures of the dukes are finely finished, but the times of day are notable for their contrasting areas of rough and polished marble, a characteristic of the artist's mature work. Some Michelangelo specialists call this his *nonfinito* ("unfinished") quality, suggesting that he had begun to view his artistic creations as symbols of human imperfection (see fig. 18-48). Indeed, Michelangelo's poetry often expressed his belief that humans could achieve perfection only in death. But the variety of finishes may simply represent his carving technique.

Construction went forward slowly at San Lorenzo, where Michelangelo was also working on the Laurentian Library, above the monastery's dormitories. He designed a grand staircase leading up to the library from a vestibule off the monastery's main cloister (fig. 18-18; for plan, see fig. 17-37). The structure's spatial proportions are somewhat unsettling: The tall vestibule is taken up almost entirely by a staircase cascading like a waterfall, its central flight of large oval steps flanked by narrower flights of rectangular steps that, at the outer

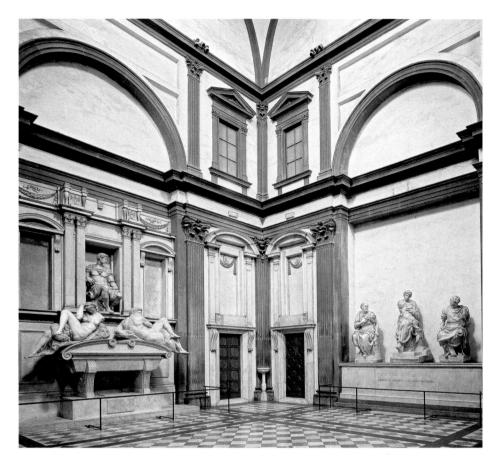

18-17. Michelangelo. Tomb of Giuliano de' Medici with allegorical figures of *Night* and *Day* (left) and the *Virgin and Child* (known as the *Medici Madonna*) flanked by *Saint Cosmas*, and *Saint Damian* (right). 1519–34. Marble, each 22'9" × 15'3" (6.94 × 4.65 m). Medici Chapel (New Sacristy), Church of San Lorenzo, Florence.

Lorenzo's tomb stands at the right, out of sight in this photograph. The *Virgin and Child* is unfinished. The statues of Saints Cosmas and Damian were made by pupils.

18-18. Michelangelo. Vestibule of the Laurentian Library, Monastery of San Lorenzo, Florence. 1524–34; staircase completed 1559.

edge, form seats with every other step until they join the main flight two-thirds of the way up. The architectural details are equally unconventional: Paired columns do not support an entablature but are simply embedded in the walls on the second-floor level; enormous volute brackets, capable of bearing great weight, are merely attached to the wall, supporting nothing. Michelangelo at one point described this project as "a certain stair that comes back to my mind as in a dream," and the strange and potent effects do indeed suggest a dreamlike imagining brought to physical reality. In its perturbing power and its use of architectural elements purely for their expressive, rather than functional, qualities, the Laurentian Library staircase is a remarkable precursor of the Mannerist style (see page 690) and would be an inspiration to the next generation of artists.

Ongoing political struggles in Florence interrupted Michelangelo's work. In 1534, detested by the new duke of Florence and fearing for his life, Michelangelo returned to Rome, where he settled permanently. He had left the New Sacristy and Laurentian Library unfinished, but the library stair was completed by others according to his designs by 1559; the Medici chapel was never finished. Michelangelo's artistic style continued to evolve throughout his career in sculpture, painting, and architecture, and he produced significant works until his death in 1564. We will return to him later in this chapter to examine his further development and his direct influence on artists of the later sixteenth century.

ARCHITECTURE IN ROME AND THE VATICAN

The French invasion of Italy in 1494 was just the beginning of what were to be four decades of war. France, Spain, and the Holy Roman Empire all had designs on Italy, primarily the northern and southernmost territories. The political turmoil that beset Florence, Milan, and other northern cities left Rome as Italy's most active artistic and intellectual center. The election of Julius II as pope in 1503 had begun a resurgence of the power of the papacy. During the ten years of his reign, he fought wars and formed alliances to consolidate his power. But he also enlisted the artists Bramante, Raphael, and Michelangelo as architects to carry out his vision of revitalizing Rome and the Vatican, the pope's residence, as the center of a new Christian art based on classical forms and principles.

Inspired by the achievements of their fifteenth-century predecessors as well as monuments of antiquity, architects working in Rome created a new ideal classical style typified by Bramante. The first-century Roman architect and engineer Vitruvius's treatise on classical architecture (see "The Vitruvian Man," page 651) became an important source for sixteenth-century Italian architects. Although most commissions were for religious architecture, opportunities also arose to build urban palaces and large country villas.

One of the leaders of the new Renaissance style in architecture was Donato Bramante (1444–1514). Born

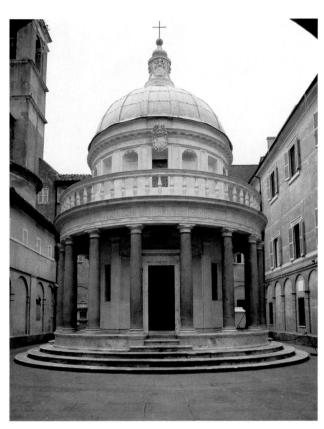

18-19. Donato Bramante. Tempietto, Church of San Pietro in Montorio, Rome. 1502–10; dome and lantern are 17th-century restorations.

near Urbino and trained as a painter, Bramante turned to architectural design early in his career. A church attributed to him, the Church of San Bernardino near Urbino, can be seen in the landscape background of Raphael's The Small Cowper Madonna (see fig. 18-5). About 1481, he became attached to the Sforza court in Milan, where he would have known Leonardo da Vinci. In 1499, Bramante settled in Rome, but work came slowly. The architect was nearing sixty when Queen Isabella and King Ferdinand of Spain commissioned him to design a small shrine over the spot in Rome where the apostle Peter was believed to have been crucified (fig. 18-19). In this tiny building, known as the Tempietto ("Little Temple"), Bramante created a Renaissance interpretation of the principles of Vitruvius and the fifteenth-century architect Leon Battista Alberti, from the stepped base to the Doric columns and frieze (Vitruvius had advised that the Doric order be used for temples to gods of particularly forceful character) to the elegant balustrade. The tall drum, or circular wall, supporting a hemispheric dome (rebuilt) and the centralized plan recall early Christian shrines built over martyrs' relics, as well as ancient Roman circular temples. Especially notable is the sculptural effect of the building's exterior, with its deep wall niches creating contrasts of light and shadow and

ELEMENTS of ARCHITECTURE

SAINT PETER'S BASILICA

The history of Saint Peter's in Rome is an interesting case of the effects of individual and institutional demands on the practical congregational needs of a major religious building. The original church, now referred to as Old Saint Peter's, was built in the fourth century CE by Constantine, the first Christian Roman emperor, to mark the grave of the apostle Peter, the first bishop of Rome and therefore the first pope. Because the site was considered the holiest in Europe, Constantine's architect had to build a structure large enough to house Saint Peter's tomb and to accommodate the crowds of pilgrims who came to visit it. To provide a platform for the church, a huge terrace was cut into the side of the Vatican Hill, across the Tiber River from the city. Here Constantine's architect erected a basilica, a type of Roman building used for law courts, markets, and other public gathering places, with a long central chamber, or nave, doubleflanking side aisles set off by colonnades, and an apse, or large nichelike recess, set into the wall opposite the main door. To allow large numbers of visitors to approach the shrine at the front of the apse, a new feature was added: a transept, or long rectangular area perpendicular to the top of the nave. The rest of the church was, in effect, a covered cemetery, carpeted with the tombs of believers who wanted to be buried near the apostle's grave. In front of the church was a walled forecourt, or atrium. When it was built, Constantine's basilica, as befitted an imperial commission, was one of the largest buildings in the world (interior length 368 feet; width 190 feet), and for more than a thousand years it was the most important pilgrim shrine in Europe.

In 1506, Pope Julius II (papacy 1503–13) made the astonishing decision to demolish the Constantinian basilica, which had fallen into disrepair, and to replace it with a new building. That anyone, even a pope, had the nerve

to pull down such a venerated building is an indication of the extraordinary sense of assurance of the age—and of Julius himself. To design and build the new church, the pope appointed Donato Bramante. Bramante envisioned the new Saint Peter's as a central-plan building, in this case a **Greek cross** (with four arms of equal length) crowned by an enormous dome. This design was intended to continue the tradition of domed and round *martyria*. In Renaissance thinking, the central plan and dome symbolized the perfection of God.

The deaths of pope and architect in 1513 and 1514 put a temporary halt to the project. Successive plans by Raphael, Antonio da Sangallo, and others changed the Greek cross to a **Latin cross** (with three shorter arms and one long one) to provide the church with a full-length nave. However, when Michelangelo was appointed architect in 1546, he returned to the Greek-cross plan. Michelangelo simplified Bramante's design to create a single, unified space covered with a hemispherical dome. The dome was finally completed some years after Michelangelo's death by Giacomo della Porta, who retained Michelangelo's basic design but gave the dome a taller profile.

By the early seventeenth century, the needs of the basilica had changed. During the Counter-Reformation, the Church emphasized congregational worship, so more space was needed for people and processions. To expand the church—and to make it more closely resemble Old Saint Peter's—Pope Paul V in 1606 commissioned the architect Carlo Maderno to change Michelangelo's Greek-cross plan to a Latin-cross plan. Maderno extended the nave to its final length of slightly more than 636 feet and added a new facade, thus completing Saint Peter's as it is today. Later in the seventeenth century, the sculptor and architect Gianlorenzo Bernini changed the square in front of the basilica by surrounding it with a great colonnade (see fig. 19-3).

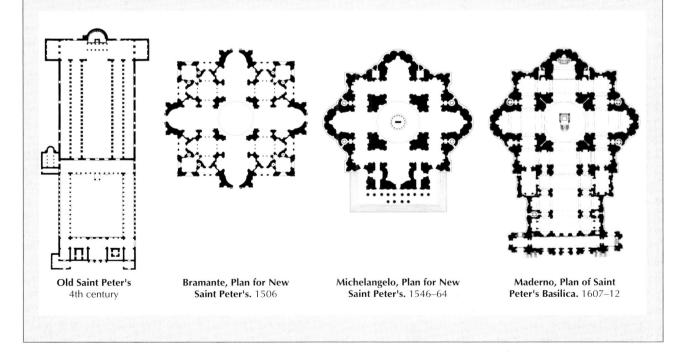

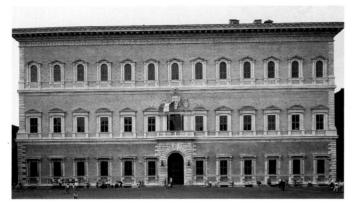

18-20. Antonio da Sangallo the Younger and Michelangelo. Palazzo Farnese, Rome. 1517–50.

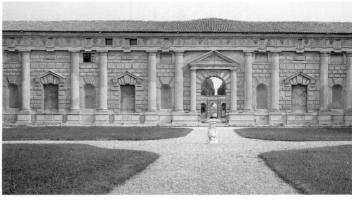

18-21. Giulio Romano. Courtyard facade, Palazzo del Tè, Mantua. 1527-34.

Doric frieze of carved papal emblems. Bramante's design called for a circular cloister around the church, but it was never built.

Shortly after Julius II's election as pope in 1503, he commissioned Bramante to renovate the Vatican Palace. Julius also appointed him chief architect of a project to replace Saint Peter's Basilica in the Vatican and laid the cornerstone on April 18, 1506. Bramante again looked to the past for his design for Saint Peter's. The plan—a Greek cross in a square resembles traditional Byzantine domed churches, and the central dome was inspired by the ancient Roman Pantheon; at about 131 feet, it was almost as wide. Construction had barely begun when Julius died, and Bramante himself died the next year, in 1514. Raphael replaced Bramante as papal architect with responsibility for building Saint Peter's, but he died in 1520. After a series of popes and architects and revisions, the new Saint Peter's was still far from completion when Michelangelo took over the project in 1546 (see "Saint Peter's Basilica," page 663).

Sixteenth-century Rome was more than a city of churches and public monuments. Wealthy families, many of whom had connections with the pope or the cardinals—the "princes of the Church"—commissioned architects to design residences to enhance their prestige (see "The Renaissance Palace Facade," page 665). For example, Cardinal Alessandro Farnese (who became Pope Paul III in 1534) set Antonio da Sangallo the Younger (1484–1546) the task of rebuilding the Palazzo Farnese into the largest, finest palace in Rome. The main facade of the great rectangular building faces a public square (fig. 18-20 and "The Renaissance Palace Facade," page 665). At the opposite side, a loggia overlooked a garden and the Tiber River. When Sangallo died, the pope turned work on the Palazzo Farnese over to Michelangelo, who added focus to the building by emphasizing the portal. He also increased the height of the top story, redesigned the inner courtyard, and capped the building with a magnificent cornice. The principal reception room

was painted by Annibale Carracci at the end of the century (see fig. 19-12). (The building continues its distinguished life today as the French Embassy.)

ARCHITECTURE AND PAINTING IN NORTHERN ITALY

While Rome ranked as Italy's preeminent arts center at the beginning of the sixteenth century, wealthy and powerful families in northern Italy also patronized the arts and letters, just as the Montefeltros had in Urbino and the Gonzagas had in Mantua during the fifteenth century. Their architects created fanciful structures and their painters developed a new colorful, illusionistic style—witty, elegant, and finely executed art designed to appeal to the jaded taste of the intellectual elite of Mantua, Parma, and Venice.

Giulio Romano. In Mantua, Federigo Gonzaga (ruled 1519–40) continued the family tradition of patronage when in 1524 he lured a Roman architect and follower of Raphael, Giulio Romano (c. 1499–1546), to Mantua to create a pleasure palace for him.

The Palazzo del Tè (fig. 18-21) is not serious architecture and was never meant to be. It was built for Federigo's enjoyment. He and his erudite friends would have known proper orders and proportions so well that they could appreciate this travesty of classical ideals—visual jokes such as lintels masquerading as arches. The building itself is skillfully constructed, and fine craft abounds in its details. Later architects and scholars have studied the palace, with its sophisticated humor and exquisite craft, as a precursor to Mannerism (see page 690).

Giulio Romano devoted more space in his design to gardens, pools, and stables than he did to living—and party—space, and he continued his witty play on the classics in the decoration of the two principal rooms. One, dedicated to the loves of the gods, depicted the marriage of Cupid and Psyche. The other room is a remarkable feat of *trompe l'oeil* painting in which the

ELEMENTS OF ARCHITECTURE

THE RENAISSANCE PALACE FACADE

Wealthy and noble families in Renaissance Italy built magnificent city palaces. More than just being large and luxurious private homes, the palaces were designed, often by the best architects of the time (see "Alberti's Art Theory in the Renaissance," page 617), to look imposing and even intimidating. The **facade**, or front face of a building, offers broad clues to what lies behind it: Its huge central door suggests power; rough, **rusticated** stonework hints of strength and castle fortifications; precious marbles or carvings connote wealth; a **cartouche**, perhaps with a family coat of arms, is an emphatic identity symbol.

Most Renaissance palaces used architectural elements derived from ancient Greek and Roman buildings—columns and pilasters in the Doric, Ionic, and/or Corinthian orders, decorated entablatures, and other such pieces—in a style known as classicism. The example illustrated here, the Palazzo Farnese in Rome, was built for the Farneses, one of whom, Cardinal Alessandro Farnese, became Pope Paul III in 1534. Designed by Sangallo the Younger, Michelangelo, and Giacomo della Porta, this immense building stands at the head of and dominates a broad open public square, or piazza. The palace's three stories are clearly defined by two horizontal bands of stonework, or stringcourses. A many-layered molded cornice encloses the facade like a weighty crown. The moldings, cornice, and entablatures are dec-

orated with classical **motifs** and with the lilies that form the Farnese family coat of arms.

The massive central door is emphasized by elaborate rusticated stonework (as are the building's corners, where the shaped stones are known as quoins) and is surmounted by a balcony suitable for ceremonial appearances, over which is set the cartouche with the Farnese arms. Windows are treated differently on each story: On the ground floor, the twelve windows sit on brackets. The story directly above is known in Italy as the piano nobile, or first floor (Americans would call it the second floor), which contains the grandest rooms. Its twelve windows are decorated with alternating triangular and arched **pediments**, supported by pairs of engaged half columns in the Corinthian order. The second floor (or American third floor) has thirteen windows, all with triangular pediments whose supporting Ionic half columns are set on brackets echoing those under the windows on the ground floor.

Renaissance city palaces, in general, were oriented inward, away from the noisy streets. Many contained open-air courtyards (see fig. 17-47), also designed with classical elements. The courtyard of the Palazzo Farnese has a *loggia* fronted by an **arcade** at the ground level. Its classical engaged columns and pilasters present all the usual parts: pedestal, base, shaft, and capital. The progression of orders from the lowest to the highest story mirrors the appearance of the orders in ancient Rome: Doric, Ionic, and Corinthian.

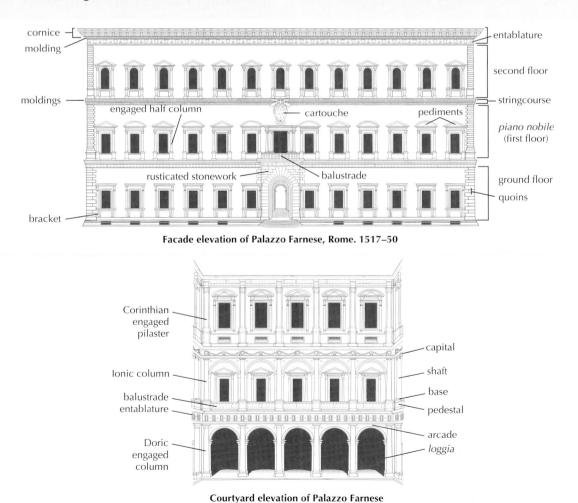

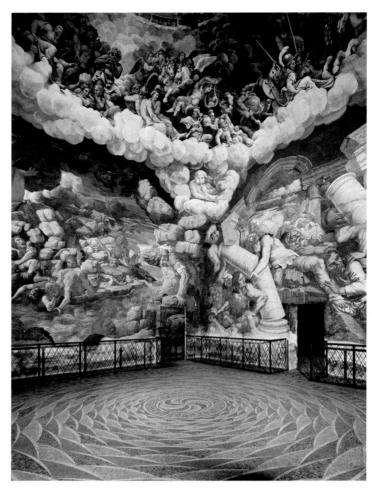

18-22. Giulio Romano. *Fall of the Giants*, fresco in the Sala dei Giganti, Palazzo del Tè. 1530–32.

entire building seems to be collapsing about the viewer as the gods defeat the Giants (fig. 18-22). Here Giulio Romano accepted the challenge Andrea Mantegna had laid down when he painted the Camera Picta of the Gonzaga palace (see fig. 17-68) for Federigo's grandfather: He painted away the very architecture. Like the building itself, the mural paintings display brilliant craft in the service of lighthearted, even superficial, goals: to distract, amuse, and enchant the viewer.

At about the same time that Giulio Romano was building and decorating the Palazzo del Tè in Mantua, in nearby Parma an equally skillful master, Correggio, was creating just as theatrical effects through dramatic foreshortening in the Parma Cathedral dome.

Correggio. In his brief but prolific career, Correggio (Antonio Allegri, c. 1489–1534) produced most of his work for patrons in Parma and Mantua. Correggio's great work, the *Assumption of the Virgin* (fig. 18-23), a fresco painted between 1526 and 1530 in the dome of Parma Cathedral, distantly recalls the illusionism of Mantegna's ceiling in the Gonzaga palace, but Leonardo clearly inspired Correggio's use of softly modeled forms, spotlighting effects of illumination, and slightly hazy overall appearance. Correggio also assimilated Raphael's

idealism as he developed his personal style. In the Assumption, Correggio created a dazzling illusion: The architecture of the dome seems to dissolve and the forms seem to explode through the building, drawing the viewer up into the swirling vortex of saints and angels who rush upward, amid billowing clouds, to accompany the Virgin as she soars into heaven. Correggio's painting of the sensuous flesh and clinging draperies of the figures in warm colors contrasts with the spirituality of the theme, which is the Virgin's miraculous transport to heaven at the moment of her death. The viewer's strongest impression is of a powerful, spiraling upward motion of alternating cool clouds and warm, sensuous figures. Illusionistic painting directly derived from this work became a hallmark of ceiling decoration in Italy in the following century.

Giorgione. The idealized style and oil painting technique, initiated by the Bellini family in the late fifteenth century (see figs. 17-75, 17-76, 17-77), were developed further by sixteenth-century painters in Venice. Venetians were the first Italians to use oils for painting on both wood panel and canvas (see "Painting on Canvas," page 669), and oil paint was particularly suited to the rich color and lighting effects employed by Giorgione

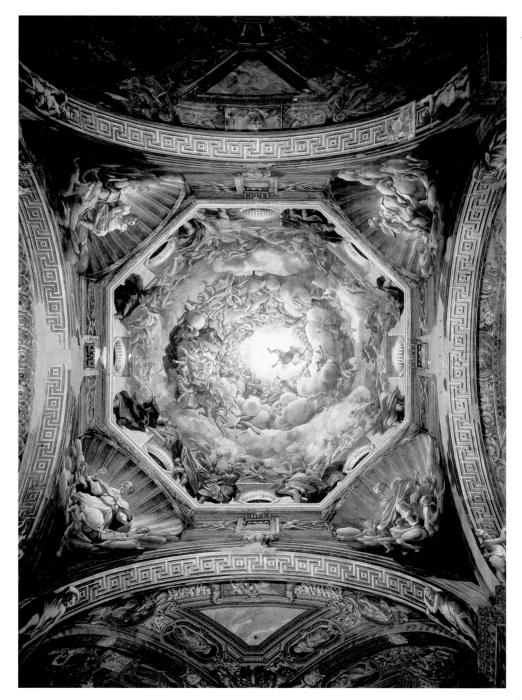

18-23. Correggio. Assumption of the Virgin, fresco in main dome interior, Parma Cathedral, Italy. c. 1526–30. Diameter of base of dome approx. 36' (11 m).

and Titian, two of the city's major painters of the sixteenth century. (Two others, Veronese and Tintoretto, will be discussed later in this chapter.)

The career of Giorgione (Giorgio da Castelfranco, c. 1475–1510) was brief—he died from the plague—and most scholars accept only four or five paintings as entirely by his hand. Nevertheless, his importance to Venetian painting is critical, as he introduced enigmatic pastoral themes, sensuous nude figures, and, above all, an appreciation of nature in landscape painting. His early life and training are undocumented, but his work suggests that he studied with Giovanni Bellini. Perhaps Leonardo da Vinci's subtle lighting system and mysterious, intensely observed landscapes also inspired him.

Giorgione's most famous work, called today *The Tempest* (fig. 18-24, page 668), was painted shortly before his death. Simply trying to understand what is happening in the picture piques our interest. At the right, a woman is seated on the ground, nude except for the end of a long white cloth thrown over her shoulders. Her nudity seems maternal rather than erotic as she nurses the baby at her side. Across the dark, rock-edged spring stands a man wearing the uniform of a German mercenary soldier. His head is turned toward the woman, but he appears to have paused for a moment before continuing to turn toward the viewer. X rays of the painting show that Giorgione altered his composition while he was still at work on it—the

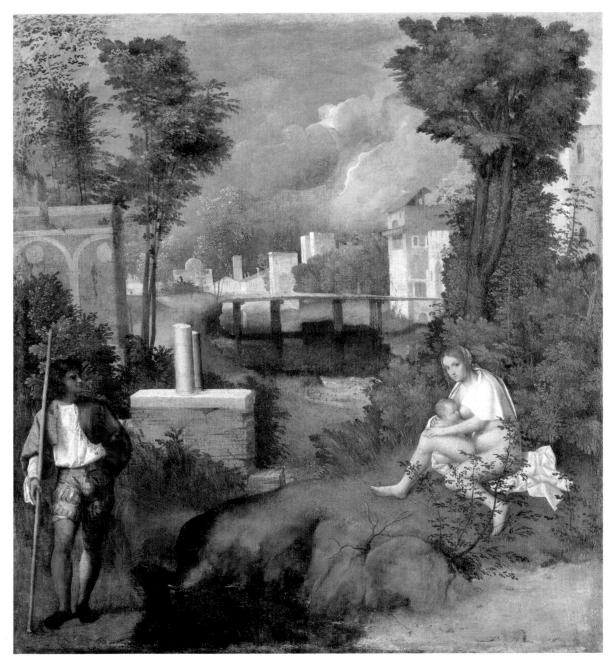

18-24. Giorgione. *The Tempest.* 1505–10. Oil on canvas, $31 \times 28^3/4$ " (79.4 \times 73 cm). Galleria dell'Accademia, Venice.

The subject of this enigmatic picture preoccupied twentieth-century art historians—many of whom came up with well-reasoned possible solutions to the mystery. However, the painting's subject seems not to have particularly intrigued sixteenth-century observers, one of whom described it matter-of-factly in 1530 as a small landscape in a storm with a gypsy woman and a soldier.

woman on the right was originally balanced by another nude woman on the left. The spring between the figures feeds a lake surrounded by substantial houses, and in the far distance a bolt of lightning splits the darkening sky. Indeed, the artist's attention seems focused on the landscape and the unruly elements of nature rather than on the figures. The painting of the nude as an inexplicable subject and the dominance of the landscape are typical of Giorgione.

Some scholars have theorized that Giorgione approached his work as many modern-day artists do, expressing private impulses in his paintings. Although he may have painted *The Tempest* for purely personal reasons, most of Giorgione's known works were of traditional subjects, produced on commission for clients: portraits, altarpieces, and paintings on the exteriors of Venetian buildings. When commissioned in 1507 to paint the exterior of the Fondaco dei Tedeschi, the

The technique of painting on canvas was fully developed by the late fifteenth century and canvas paintings were common, although—being less durable than paintings on wood

panel—few good examples survive. From contracts and payment accounts, most of these paintings—chiefly in **tempera** on linen—appear to have been decorations for private homes. Many may have served as inexpensive substitutes for tapestries, but records show that small, framed pictures of various subjects were also common. Canvas paintings, less costly than frescoes, were clearly considered less important until the Venetians began to exploit the technique of painting with **oils** on canvas in the late fifteenth century.

The Venetians were also the first to use large canvas paintings instead of frescoes for wall decoration, probably because of humidity problems. Painting on canvas allowed artists to complete the work in their studios, then carry the rolls of canvas to the location where they were to be installed. Because oils dried slowly, errors

TECHNIQUE Painting on Canvas

could be corrected and changes made easily during the work. Thus, the flexibility of the canvas support, coupled with the radiance and depth of oilsuspended color pigments, eventually

made oil painting on canvas the almost universally preferred medium.

A recent scientific study of Titian's paintings revealed that he ground his pigments much finer than had earlier wood-panel painters. The complicated process by which he produced many of his works began with a charcoal drawing on the prime coat of lead white that was used to seal the pores and smooth the surface of the rather coarse Venetian canvas. The artist then built up the forms with fine glazes of color laid on with brushes, sometimes in as many as ten to fifteen layers. Because patrons customarily paid for paintings according to the painting's size and how richly the paint was applied, thinly painted works may reflect the patron's finances rather than the artist's choice of technique.

warehouse and offices of German merchants in Venice, Giorgione hired Titian (Tiziano Vecelli, c. 1488–1576) as an assistant. For the next three years before Giorgione's untimely death, the two artists' careers were closely bound together.

The painting known as The Pastoral Concert (fig. 18-25) has been attributed to both Giorgione and Titian. As in Giorgione's The Tempest, the idyllic, fertile landscape, here bathed in golden, hazy late-afternoon sunlight, seems to be the true subject of the painting. In this mythic world, a few humans appear to idle away their time. Two men-an aristocratic musician in rich red silks and a barefoot peasant in homespun cloth-turn toward each other, ignoring the two women in front of them. One woman plays a pipe and the other pours water into a well, oblivious of the swaths of white drapery sliding to the ground and enhancing rather than hiding their nudity. In the middle ground, the sunlight catches a shepherd and his animals near lush woodland; in the distance, a few buildings and wispy trees break the horizon line. Nothing happens. Like poetry, the painting evokes a mood, a golden age of love and innocence recalled in ancient Roman pastoral poetry. Such poetic painting is new in the history of art, and *The* Pastoral Concert had a profound influence on later painters who saw and reinterpreted it (see fig. 27-57).

Titian. Everything about Titian's life is obscure, including his birth, probably about 1488. He supposedly began an apprenticeship as a mosaicist, then studied painting under Gentile and Giovanni Bellini. He was about 20 when he worked with Giorgione on the Fondaco dei Tedeschi frescoes, completed in 1508. Whatever Titian's work was like before then, he had completely absorbed Giorgione's style by the time Giorgione died two years later. Titian completed paintings that they had worked on together. When Giovanni Bellini

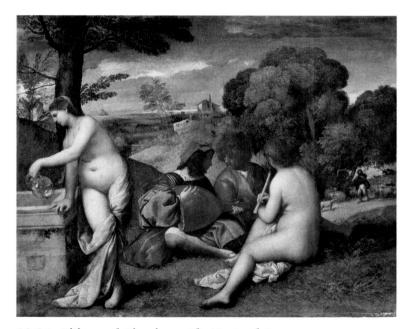

18-25. Titian and Giorgione. *The Pastoral Concert.* c. 1508. Oil on canvas, $43 \times 54''$ (109 \times 137 cm). Musée du Louvre, Paris.

died in 1516, Titian was made official painter to the Republic of Venice.

In 1519, Jacopo Pesaro, commander of the papal fleet that had defeated the Turks in 1502, commissioned Titian to commemorate the victory in a votive altarpiece for the Franciscan Church of Santa Maria Gloriosa dei Frari in Venice. Titian worked on the painting for seven years and changed the concept three times before he finally came up with a revolutionary composition: He created an asymmetrical setting of huge

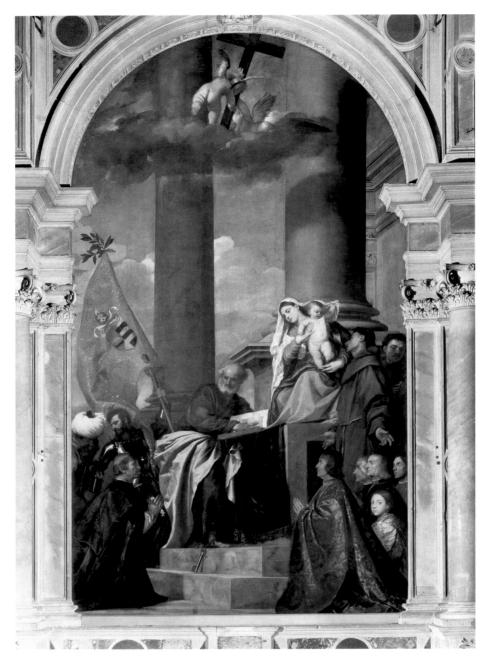

18-26. Titian. *Pesaro Madonna*. 1519–26. Oil on canvas, $16" \times 8'10"$ (4.90×2.69 m). Side aisle altarpiece, Santa Maria Gloriosa dei Frari, Venice.

columns on high bases soaring right out of the frame (fig. 18-26). Into this architectural setting, he placed the Virgin and Child on a high throne at one side and arranged saints and the Pesaro family at the sides and below on a diagonal axis, crossing at the central figure of Saint Peter. The red of Francesco Pesaro's brocade garment and of the banner diagonally across sets up a contrast of primary colors against Saint Peter's blue tunic and yellow mantle and the red and blue draperies of the Virgin. Saint Maurice (behind Jacopo at the left) holds the banner with the coat of arms of the pope, and a cowering Turkish captive reminds the viewer of the Christian victory. Light floods in from above, illuminating not only the faces but also the great columns, where

putti in the clouds carry a cross. Titian was famous for his mastery of light and color even in his own day, but this altarpiece demonstrates that he also could draw and model as solidly as any Florentine. The composition, perfectly balanced but built on diagonals, presages the art of the seventeenth century.

In 1529, Titian, who was well known outside Venice, began a long professional relationship with Emperor Charles V, who vowed to let no one else paint his portrait. Shortly after being made a count by Charles in 1533, Titian was commissioned to paint a portrait of Isabella d'Este (see "Women Patrons of the Arts," page 672). Isabella was past sixty when Titian portrayed her in 1534–36, but she asked to appear as she had in her

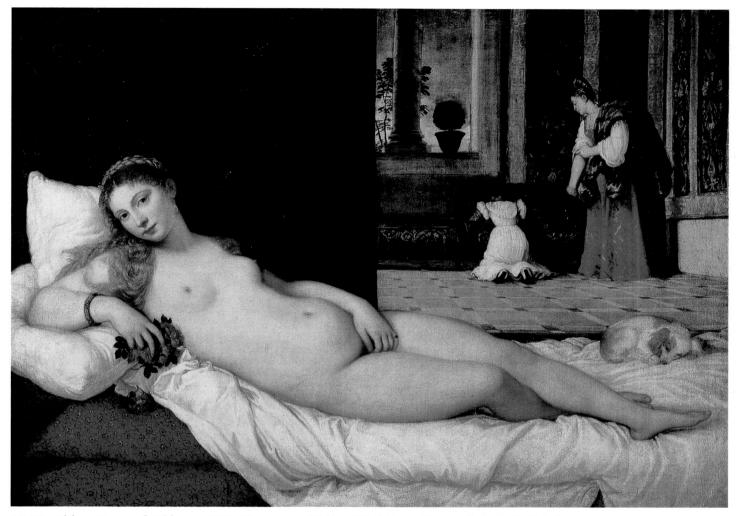

18-27. Titian. Venus of Urbino. c. 1538. Oil on canvas, 3'11" × 5'5" (1.19 × 1.65 m). Galleria degli Uffizi, Florence.

twenties. A true magician of portraiture, Titian was able to satisfy her wish by referring to an early portrait by another artist while also conveying the mature Isabella's strength, self-confidence, and energy.

No photograph can convey the vibrancy of Titian's paint surfaces, which he built up in layers of pure colors, chiefly red, white, yellow, and black. According to a contemporary, Titian could make "an excellent figure appear in four brushstrokes." His technique was admirably suited to the creation of female nudes, whose flesh seems to glow with an incandescent light. Paintings of nude reclining women became especially popular in sophisticated court circles, where male patrons could enjoy and appreciate the "Venuses" under the cloak of respectable classical mythology. Typical of such paintings is the Venus Titian painted about 1538 for the duke of Urbino (fig. 18-27). The sensuous quality of this work suggests that Titian was as inspired by flesh-and-blood beauty as by any source from mythology or the history of art. Here, a beautiful Venetian courtesan-whose gestures seem deliberately provocative—stretches languidly on her couch in a spacious palace, white sheets and pillows setting off her

glowing flesh and golden hair. A spaniel, symbolic of fidelity, sleeping at her feet and maids assembling her clothing in the background lend a comfortable domestic air. The Venus of Urbino inspired artists as distant in time as Manet (see fig. 27-58). Titian and Michelangelo both outlived the classical phase of the Renaissance and profoundly influenced Italian art of the later years of the sixteenth century (see figs. 18-48, 18-49).

THE RENAISSANCE Through carefully cal-AND REFORMATION **IN GERMANY**

culated dynastic marriages, inheritance, and some good luck, the Holy Roman Em-

peror Charles V (ruled 1519-56, also crowned Charles I of Spain) reigned over lands from the North Sea to the Mediterranean. In the northern territories, including Germany, the arts flourished from the last decades of the fifteenth century up to the 1520s. After that, religious upheavals and iconoclastic (image-smashing) purges of religious images took a toll.

Typical of the German cities with strong business, trade, and publishing interests was Nuremberg. The

WOMEN PATRONS OF THE ARTS

In the sixteenth century, many wealthy women, from both the aristocracy and the merchant class, were enthusiastic patrons of the arts. Two English queens, the Tudor half sisters Mary I and Elizabeth I, glorified their combined reigns of half a century with the aid of court artists, as did most sovereigns of the period. The Habsburg princesses Margaret of Austria and Mary of Hungary presided over brilliant humanist courts when they were regents of the Netherlands. But perhaps the Renaissance's greatest woman patron of the arts was the marchesa of Mantua, Isabella d'Este (1474-1539), who gathered painters, musicians, composers, writers, and literary scholars around her. Married to Francesco II Gonzaga at age fifteen, she had great beauty, great wealth, and a brilliant mind that made her a successful diplomat and administrator. A true Renaissance woman, her motto was the epitome of rational thinking—"Neither Hope nor Fear." An avid reader and collector of manuscripts and books, while still in her twenties she sponsored publication of an edition of Virgil. She also collected ancient art and objects, as well as works by contemporary Italian artists such as Botticelli, Mantegna, Perugino, Correggio, and Titian. Her grotto, as she called her study in the Mantuan

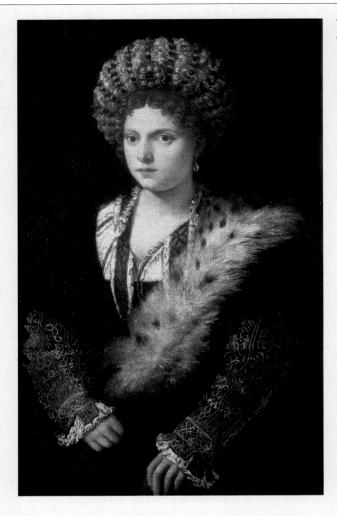

Titian. *Isabella d'Este*. 1534–36. Oil on canvas, $40\frac{1}{8} \times 25\frac{3}{16}$ " (102 × 64.1 cm). Kunsthistorisches Museum, Vienna.

palace, was a veritable museum for her collections. The walls above the storage and display cabinets were painted in fresco by Mantegna, and the carved wood ceiling was covered with mottoes and visual references to Isabella's impressive literary interests.

middle class emerged as traders, merchants, and bankers accumulated self-made, rather than inherited, wealth. An entrepreneurial artist like Albrecht Dürerwhose workshop was a major commercial success could now afford to live in a large, comfortable house, typical of the middle-class residences that were rising in Nuremberg. The city had an active group of humanists and internationally renowned artists with large workshops. Hans Krug (d. 1519) and his sons Hans the Younger and Ludwig were among the finest gold- and silversmiths in Nuremberg. They created marvelous display pieces for the wealthy, such as the silver-gilt apple cup in figure 18-28. A technical tour de force, the cup has a style that looks back toward the detailed naturalism of the fifteenth century and forward to the technical virtuosity of Mannerism (see page 690). Sculpture, painting, and architecture flourished in other northern centers as well, including Strasbourg, Isenheim, Würzburg, and Cracow.

EARLY-SIXTEENTH-CENTURY SCULPTURE

Fifteenth-century German sculpture had been closely related to that of France and Flanders, but in the sixteenth century German sculpture gradually began to show the influence of the Italian Renaissance style. Although German sculptors worked in every medium, they produced some of their finest and most original work during the period in limewood. They generally gilded and painted these wooden images, until Tilman Riemenschneider (c. 1460–1531) introduced a natural wood finish.

Tilman Riemenschneider. After about 1500, Riemenschneider had the largest workshop in Würzburg, a shop that included specialists in every medium of sculpture. Riemenschneider attracted patrons from other cities, and in 1501 signed a contract for one of his major creations, the *Altarpiece of the Holy Blood*, for the Sankt Jakobskirche (Church of Saint James) in Rothenburg ob

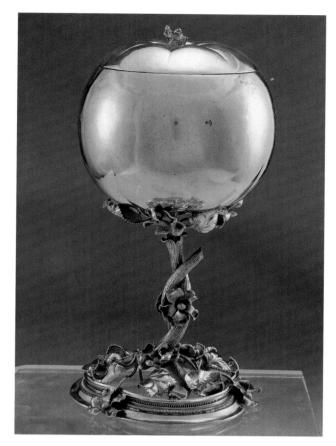

18-28. Workshop of Hans Krug (?). "Apple Cup." c. 1510-15. Gilt silver, height $53^1/_3$ " (21 cm). Germanisches Nationalmuseum, Nuremberg.

In this covered cup made about 1510, the gleaming round apple, whose stem forms the handle of the lid, balances on a leafy branch that forms the stem and base of the cup. Artists worked together to produce such works—one drawing designs, another making the models, and others creating the final piece in metal. This cup may be based on drawings by Albrecht Dürer.

der Tauber, where a relic said to be a drop of Jesus' blood was preserved. As completed, the limewood construction stood nearly 30 feet high. A specialist in architectural shrines had begun work on the frame in 1499, and Riemenschneider was to provide the figures to go within this frame. The relative value of their contributions to their contemporaries can be judged by the fact that the frame carver was paid fifty florins, almost as much as Riemenschneider's sixty. In the main scene of the altarpiece, the Last Supper (fig. 18-29), Riemenschneider depicted the moment of Jesus' revelation that one of his followers would betray him. Unlike Leonardo, Riemenschneider composed his group with Jesus offcenter at the left and his disciples seated around him. Judas, at the center, looks stricken as he holds the money bag to which he will soon add the thirty pieces of silver he received for his betrayal. As the event is described in the Gospel of John (13:21–30), the apostles look puzzled by the news that a traitor is among them,

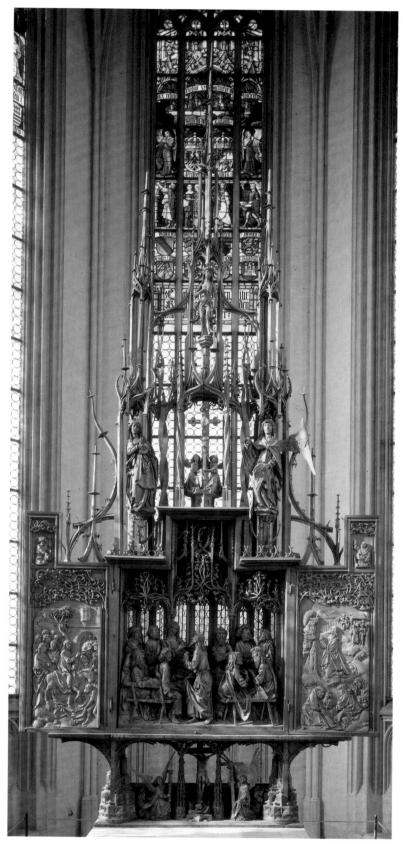

18-29. Tilman Riemenschneider. *Altarpiece of the Holy Blood*, wings open. Center, *Last Supper. c.* 1499–1505. Limewood, glass, height of tallest figure 39" (99.1 cm); height of altar 29'6" (9 m). Sankt Jakobskirche, Rothenburg ob der Tauber, Germany.

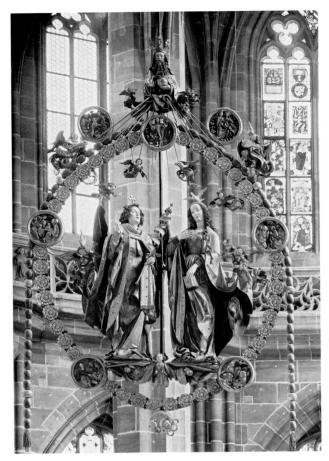

18-30. Veit Stoss. Annunciation and Virgin of the Rosary, 1517–18. Painted and gilt limewood, $12'2'' \times 10'6''$ (3.71 \times 3.20 m). Church of Saint Lawrence, Nuremberg.

and Jesus extends a morsel of food to Judas, signifying that he is the one destined to set in motion the events leading to Jesus' death. The youngest apostle, John, is asleep with his head on Jesus' lap, following a medieval tradition derived from John 13:23, where "one of his disciples, the one whom Jesus loved," is described as "reclining at Jesus' side." One of the figures in front points down toward the **predella**, where the Crucifixion is depicted, and the altar, the symbolic table of the Last Supper.

Rather than creating individual portraits, Riemenschneider simply repeated a limited number of types. His figures have large heads, prominent features, sharp cheekbones, sagging jowls, baggy eyes, and elaborate hair treatments with thick wavy locks and deeply drilled curls. The muscles, tendons, and raised veins of their hands and feet are especially lifelike. Riemenschneider's assistants copied figures and even different modes of drapery either from drawings or from other carved examples. Here, the deeply hollowed folds and active patterning of the drapery create strong highlights and dark shadows that unify the figures and the intricate carving of the framework. The scene is set in three-dimensional space, with actual benches for the figures to rest on and windows at the rear glazed with real bull's-eye glass. Natural light from the church's windows illuminates the scene, so that the effects change with the time of day and weather.

In addition to producing an enormous number of religious images for churches, Riemenschneider was politically active in the city's government. However, his career ended with the Peasants' War of 1525; his support of the peasants, who rose up against their feudal overlords because of economic and religious oppression, led to a fine and imprisonment just six years before his death.

Veit Stoss. Riemenschneider's contemporary Veit Stoss (c. 1438–1533) spent most of the years 1477–96 in Cracow, Poland, where he became wealthy from his sculpture and architectural commissions, as well as from financial investments. After returning to his native Nuremberg, he began to specialize in limewood sculpture, probably because established artists already dominated commissions in other mediums. He had a small shop whose output was characterized by an easily recognizable style expressing a taste for German realism. Stoss's unpainted limewood works show a special appreciation for the wood itself, which he exploited for its inherent colorations, grain patterns, and range of surface finishes.

Stoss carved the Annunciation and Virgin of the Rosary (fig. 18-30), one of the loveliest images in German art, for the choir of the Church of Saint Lawrence in Nuremberg in 1517-18. Gabriel's Annunciation to Mary takes place within a wreath of roses symbolizing the prayers of the rosary. Disks are carved with scenes of the Joys of the Virgin, to which are added her Dormition and Coronation. Mary and Gabriel are adored and supported by angels. Their dignified figures are encased in elaborate crinkled and fluttering drapery that seems to blend with the delicate angels and to cause the entire work to float like an apparition in the upper reaches of the choir. The sculpture continues the expressive, mystical tradition prevalent since the Middle Ages in the art of Germany, where the recitation of prayers to the Virgin known as the rosary had become an important part of personal devotion.

Nikolaus Hagenauer. Prayer continued to provide solace and relief to the ill before the advent of modern medicine. In 1505, the Strasbourg sculptor Nikolaus Hagenauer (active 1493-1530s) carved images of Saint Anthony, Saint Jerome, and Saint Augustine for an altarpiece for the Abbey of Saint Anthony in Isenheim, whose hospital specialized in the care of patients with skin diseases, including the plague and leprosy (fig. 18-31). The donor of this piece, Jean d'Orliac, and two men offering a cock and a piglet are depicted kneeling at the feet of the saints—tiny figures, as befits their subordinate status. In the predella below, Jesus and the apostles bless the altar, Host, and assembled patients in the hospital. The limewood sculpture was painted in lifelike colors and the shrine itself was gilded to enhance its resemblance to a precious reliquary. Later, Matthias Grünewald painted a wood-paneled altarpiece to cover the shrine (see figs. 18-32, 18-33).

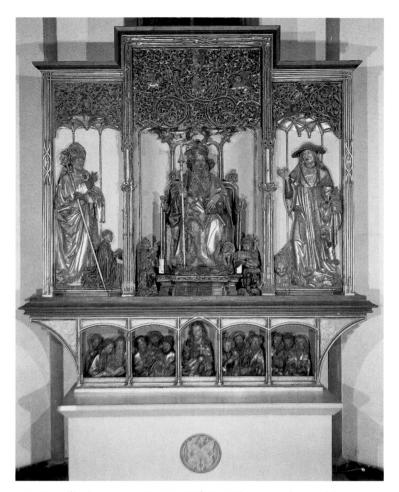

18-31. Nikolaus Hagenauer. *Saint Anthony Enthroned between Saints Augustine and Jerome*, shrine of the *Isenheim Altarpiece*. c. 1505. Painted and gilt limewood, center panel $9'9^1/_2" \times 10'9"$ (2.98 \times 3.28 m); predella $2'5^1/_2" \times 11'2"$ (0.75 \times 3.4 m).

EARLY-SIXTEENTH-CENTURY PAINTING AND PRINTMAKING

German art during the first decades of the sixteenth century was dominated by two very different artists, Matthias Gothardt (known as Matthias Grünewald) and Albrecht Dürer. Grünewald's unique style expressed the continuing currents of medieval German mysticism and emotionalism, while Dürer's intense observation of the natural world represented the scientific Renaissance interest in empirical observation, perspective, and the use of a reasoned canon of proportions for depicting the human figure.

Matthias Grünewald. As an artist in the court of the archbishop of Mainz, Matthias Grünewald (c. 1480–1528) worked as an architect and hydraulic engineer as well as a painter. The work for which Grünewald is best known today, the *Isenheim Altarpiece* (see figs. 18-32, 18-33, 18-34), created around 1510–15, illustrates the same intensity of religious feeling that motivated the religious reform movement that would soon sweep Germany. It was created to protect the shrine by Nikolaus Hagenauer (see fig. 18-31) at the Abbey of Saint Anthony in Isenheim and commemorates the abbey's patron saint, the fourth-

century hermit Anthony of Egypt (also known as Anthony Abbot). Patients at the abbey's hospital gazed upon it as they prayed for recovery.

Although the altarpiece is no longer mounted in its original frame to cover the shrine, it is nevertheless monumentally impressive in size and complexity. In their original juxtaposition, the wings and carved wooden shrine complemented one another, the inner sculpture seeming to bring the surrounding paintings to life, and the painted wings protecting the precious carvings. Grünewald painted one set of fixed wings and two sets of movable ones, plus one set of sliding panels to cover the predella, so that the altarpiece could be exhibited in different configurations depending upon the Church calendar.

On weekdays, when the altarpiece was closed, viewers saw a shocking image of the Crucifixion in a darkened landscape, a Lamentation below it on the predella, and lifesize figures of Saints Sebastian and Anthony Abbot—saints associated with the plague—standing on trompe l'oeil pedestals on the fixed wings (fig. 18-32, page 676). Grünewald represented in the most horrific details the tortured body of Jesus, covered with gashes from being beaten and pierced by the thorns used to

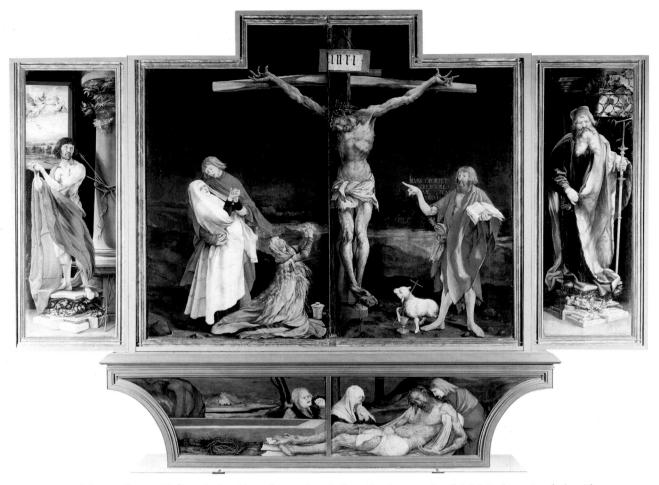

18-32. Matthias Grünewald. *Isenheim Altarpiece* (closed), from the Community of Saint Anthony, Isenheim, Alsace, France. Center panels: *Crucifixion*; predella: *Lamentation*; side panels: Saints Sebastian (left) and Anthony Abbot (right). c. 1510–15. Oil on wood panel, center panels $9'9^1/2'' \times 10'9''$ (2.97 × 3.28 m) overall, each wing $8'2^1/2'' \times 3'^1/2''$ (2.49 × 0.93 m), predella $2'5^1/2'' \times 11'2''$ (0.75 × 3.4 m). Musée d'Unterlinden, Colmar, France.

form a crown for his head. His ashen body, open mouth, and blue lips indicate that he is dead; in fact, he appears already to be decaying, an effect enhanced by the palette of putrescent green, yellow, and purplish red. A ghostlike Virgin Mary has collapsed in the arms of an emaciated John the Evangelist, and Mary Magdalen has fallen in anguish to her knees; her clasped hands with outstretched fingers seem to echo Jesus' fingers, cramped in rigor mortis. At the right, John the Baptist points at Jesus and repeats his prophecy, "He shall increase." The Baptist and the lamb holding a cross and bleeding from its breast into a golden chalice allude to the Christian rites of baptism and the Eucharist and to Christ as the Lamb of God. In the predella below, Jesus' bereaved mother and friends prepare his body for burial, which must have been a common sight in the abbey's hospital.

In contrast to these grim scenes, the altarpiece when first opened displays Christian events of great joy—the Annunciation, the Nativity, and the Resurrection—expressed in vivid reds and golds accented with high-keyed pink, lemon, and white (fig. 18–33). Unlike the awful darkness of the Crucifixion, the inner scenes are illuminated with clear natural daylight, phosphorescent auras and halos, and the glitter of stars in a night sky.

Fully aware of contemporary formal achievements in Italy, Grünewald created the illusion of three-dimensional space and volumetric figures, and he abstracted, simplified, and idealized the forms. Unlike Italian Renaissance painters, however, his aim was to strike the heart rather than the mind and to evoke sympathy rather than to create an intellectual ideal. Underlying this deliberate attempt to arouse an emotional response in the viewer is a complex religious symbolism, undoubtedly the result of close collaboration with his monastic patrons.

The Annunciation on the left wing illustrates a special liturgy called the Golden Mass, which celebrated the divine motherhood of the Virgin. The Mass included a staged reenactment of the angel's visit to her, as well as readings from the story of the Annunciation (Luke 1:26–38) and the Old Testament prophecy of the Savior's birth (Isaiah 7:14–15), which is inscribed in Latin on the pages of the Virgin's open book.

The central panels show the heavenly and earthly realms joined in one space. In a variation on the northern visionary tradition, the new mother adores her miraculous Child while envisioning her own future as Queen of Heaven amid angels and cherubs. Grünewald illustrated a range of ethnic types in the heavenly realm,

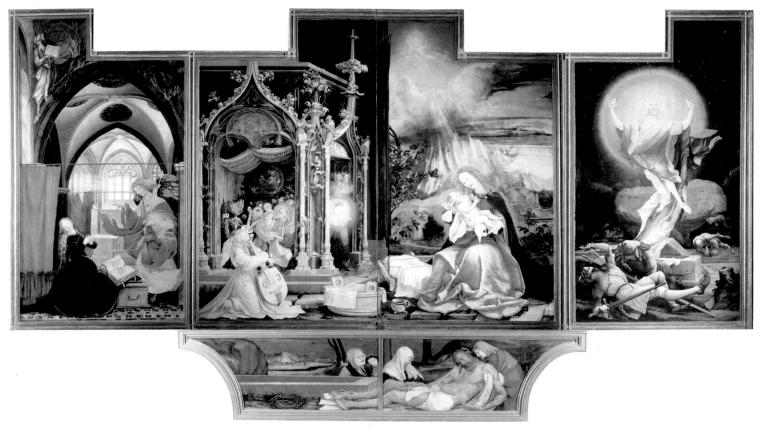

18-33. *Isenheim Altarpiece*, first opening. Left to right: *Annunciation, Virgin and Child with Angels, Resurrection.* c. 1510–15. Oil on wood panel, center panel $9'9^1/2'' \times 10'9''$ (2.97 × 3.28 m), each wing $8'2^1/2'' \times 3'^1/2''$ (2.49 × 0.92 m). Musée Unterlinden, Colmar, France.

as well as three distinct types of angels seen in the foreground—young, mature, and a feathered hybrid with a birdlike crest on its human head. Perhaps this was intended to emphasize the global dominion of the Church, whose missionary efforts were expanding as a result of European exploration. The panels are also filled with symbolic and narrative imagery related to the Annunciation. For example, the Virgin and Child are surrounded by Marian symbols: the enclosed garden, the white towel on the tub, and the clear glass cruet behind it, which signify Mary's virginity; the waterpot next to the tub, which alludes both to purity and to childbirth; and the fig tree in the background, suggesting the Virgin Birth, since figs were thought to bear fruit without pollination. The bush of red roses at the right alludes not only to Mary but also to the Passion of Jesus, thus recalling the Crucifixion on the outer wings and providing a transition to the Resurrection on the right wing. There, the shock of Christ's explosive emergence from his stone sarcophagus tumbles the guards about, and his new state of being-no longer material but not yet entirely spiritual—is vibrantly evident in his dissolving, translucent figure.

The second opening of the altarpiece (fig. 18–34), with the center panels opened to reveal Hagenauer's sculpture (see fig. 18–31), was reserved for the special festivals of Saint Anthony, who has the place of honor in the sculpture and is flanked by the scholarly saints Augustine and Jerome. The wings in this second opening (or third view) of the altarpiece are painted with the

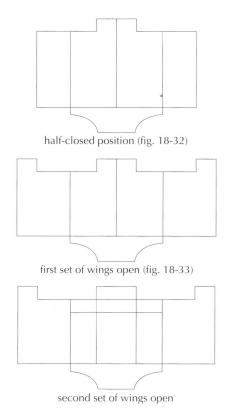

18-34. Diagram of the Isenheim Altarpiece

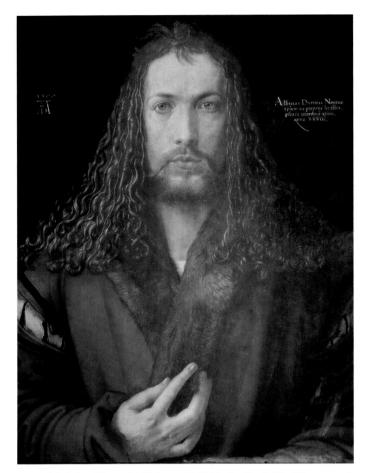

18-35. Albrecht Dürer. *Self-Portrait.* 1500. Oil on wood panel, $26\frac{1}{4} \times 19\frac{1}{4}$ " (66.3 × 49 cm). Alte Pinakothek, Munich.

temptation of Saint Anthony by horrible demons and the meeting of Saint Anthony with the hermit Saint Paul in a fantastic forested wasteland.

Grünewald's artistic career was damaged by his personal identification with and active support of the peasants in the Peasants' War in 1525. He left Mainz and spent his last years in Halle, whose ruler was a longtime patron of Grünewald's contemporary Albrecht Dürer.

Albrecht Dürer. Studious, analytical, observant, and meticulous—but as self-absorbed and difficult as Michelangelo—Albrecht Dürer (1471–1528) was one of eighteen children of a Nuremberg goldsmith. After an apprenticeship in goldworking and painting, stained-glass design, and especially the making of woodcuts, in the spring of 1490 Dürer began traveling to extend his education and gain experience as an artist. Dürer worked until early 1494 in Basel, Switzerland, providing drawings for woodcut illustrations for books published there.

His first trip to Italy, in 1494–95, introduced him to the idealism associated with art there and the concept of the artist as an independent creative genius, as Dürer showed in a self-portrait of 1500 (fig. 18-35). He represents himself as an idealized, even Christ-like, figure in a severely frontal pose, meeting the viewer's eyes like an icon. His rich fur-lined robes and flowing locks create an equilateral triangle, the timeless symbol of unity.

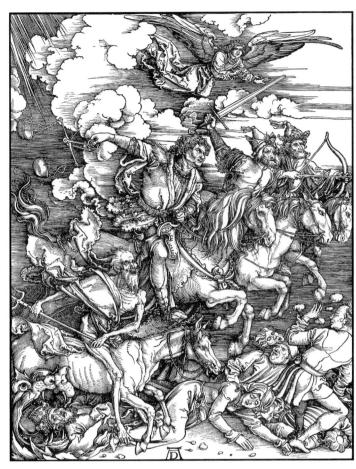

18-36. Albrecht Dürer. Four Horsemen of the Apocalypse, from *The Apocalypse*. 1497–98. Woodcut, $15^1/_2 \times 11^1/_8$ " (39.4 × 28.3 cm). The Metropolitan Museum of Art, New York. Gift of Junius S. Morgan, 1919 (19.73.209)

Back in Nuremberg, Dürer began to publish his own prints to bolster his income, and ultimately it was these prints, not his paintings, that made his fortune. His first major publication, *The Apocalypse*, appeared simultaneously in German and Latin editions in 1497–98 and consisted of a woodcut title page and fourteen full-page illustrations with the text printed on the back of each. The best known of the woodcuts is the *Four Horsemen of the Apocalypse* (fig. 18-36), based on figures described in Revelation 6:1–8: a crowned rider, armed with a bow, on a white horse (Conquest); a rider with a sword, on a red horse (War); a rider with a set of scales, on a black horse (Plague and Famine); and a rider on a sickly pale horse (Death).

Dürer probably did not cut his own woodblocks but employed a skilled carver who followed his drawings faithfully. Dürer's dynamic figures show affinities with the *Temptation of Saint Anthony* (see fig. 17-31) by Martin Schongauer, whom he admired, and he adapted for woodcut Schongauer's technique for shading **engravings**, using a complex pattern of lines that model the forms with highlights against the tonal ground. Dürer's early training as a goldsmith is evident in his meticulous attention to detail, decorative cloud

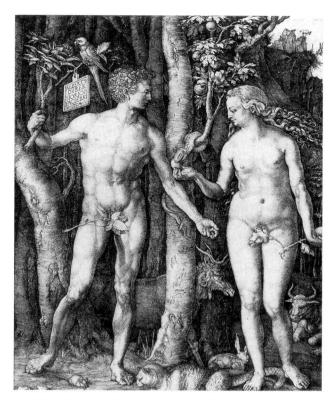

18-37. Albrecht Dürer. *Adam and Eve.* 1504. Engraving, $9^7\!/_8 \times 7^5\!/_8$ " (25.1 \times 19.4 cm). Philadelphia Museum of Art.

Purchased: Lisa Nora Elkins Fund

and drapery patterns, and foreground filled with large, active figures, typical of late-fifteenth-century art.

Perhaps as early as the summer of 1494, Dürer began to experiment with engravings, cutting the plates himself with artistry equal to Schongauer's (see Fig. 17-31). His growing interest in Italian art and theoretical investigations is reflected in his 1504 engraving Adam and Eve (fig. 18-37), which represents his first documented use of a canon of ideal human proportions based on Roman copies of Greek sculpture that he may have seen in Italy. As idealized as the human figures may be, the flora and fauna are recorded with typically northern European naturalistic detail. Dürer embedded the landscape with symbolic content related to the medieval theory that after Adam and Eve disobeyed God, they and their descendants became vulnerable to imbalances in body fluids that altered human temperament: An excess of black bile from the liver produced melancholy, despair, and greed; yellow bile caused anger, pride, and impatience; phlegm in the lungs resulted in a lack of emotion, lethargy, and disinterest; and an excess of blood made a person unusually optimistic but also compulsively interested in pleasures of the flesh. These four human temperaments, or personalities, are symbolized here by the melancholy elk, the choleric cat, the phlegmatic ox, and the sensual rabbit. The mouse is a symbol of Satan (see mousetraps in fig. 17-4), whose earthly power, already manifest in the Garden of Eden, was capable of bringing perfect human beings to a life of woe through their own bad choices. The parrot may symbolize false wisdom, since it

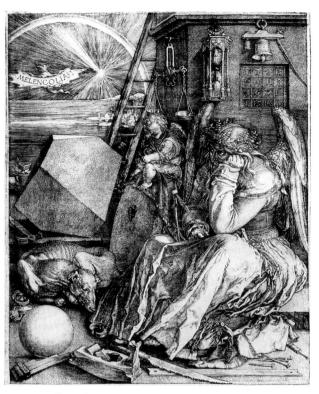

18-38. Albrecht Dürer. *Melencolia I.* 1514. Engraving, $9\frac{3}{8} \times 7\frac{1}{2}$ " (23.8 × 18.9 cm). Victoria and Albert Museum, London.

speaks but can only repeat mindlessly what is said to it. Dürer's pride in his engraving can be seen in the prominence of his signature—a placard bearing his full name and date hung on a branch of the Tree of Life.

Dürer's familiarity with Italian art was greatly enhanced by a second, more leisurely trip over the Alps in 1505–6. Thereafter, he seems to have resolved to reform the art of his own country by publishing theoretical writings and manuals that discussed Renaissance problems of perspective, ideal human proportions, and the techniques of painting. Between 1513 and 1515, Dürer created what are known today as his master prints—three engravings that are in many ways an engraver's showpiece, demonstrating his skill at implying color, texture, and space by black line alone. The prints represent the active and the contemplative Christian life (*Knight, Death and the Devil* and *Saint Jerome in His Study*) and the frustrated creativity of the secular life (*Melencolia I*, fig. 18-38).

Melencolia I seems to reflect the self-doubt that beset Dürer after he returned from Italy, caught up in the spirit of the Italian Renaissance, with its humanist ideals of the artist as a divinely inspired creator. Here Dürer created a superhuman figure caught in mental turmoil and brooding listlessly, surrounded by tools and symbols of the arts and humanities, while a bat, inscribed "Melencolia I," flits through the night. The melancholic person was thought to live under the influence of black bile—the bodily fluid associated with things dry and cold, the earth, evening, autumn, age, and the vices of

greed and despair—and the main figure's pose can be seen as that of one in deep thought as well as of sloth, weariness, and despair. In this engraving, Dürer seems to brood on the futility of art and the fleeting nature of human life. In its despair, the work foreshadows the effects of the religious turmoil, social upheaval, and civil war soon to sweep northern Europe.

THE REFORMATION AND THE ARTS

Many dissident movements had shaken but not destroyed the Church over its history. Some led to great controversy and outright war, but the unity and authority of the Church always prevailed—until the sixteenth century. Then, against a backdrop of broad dissatisfaction with financial abuses and lavish lifestyles among the clergy, religious reformers began to challenge specific Church practices and beliefs, especially Julius II's sale of indulgences—the Church's forgiveness of sins and insurance of salvation in return for a financial contribution—to finance the rebuilding of Saint Peter's. From their protests, the reformers came to be called Protestants, and their search for Church reform gave rise to a movement called the Reformation.

Two of the most important reformers in the early sixteenth century were themselves Catholic priests and trained theologians: Desiderius Erasmus of Rotterdam (1466?-1536) in Holland and Martin Luther (1483-1546) in Germany. Indeed, the Reformation may be dated to the issuing in 1517 of Luther's Ninety-Five Theses, which called for Church reform. Among his concerns were the practice of selling indulgences and the excessive veneration of saints and their relics, which he considered superstitious, even pagan. The reformers questioned not only Church teaching but also the pope's supremacy, and in time the Protestants had to break away from Rome. Instead of looking to an official church, they emphasized individual faith and regarded the Bible as the ultimate religious authority. The Church condemned Luther in 1521.

The reform movement was immeasurably aided by the widespread use of the printing press. The Bible and other Christian writings, translated into German, were readily available to laypeople, many of whom now could read. Improved communications resulting from printed materials allowed scholars throughout Europe to debate religious matters and to influence many people. The wide circulation of Luther's writingsespecially his German translation of the Bible and his works maintaining that salvation comes through faith alone-eventually led to the establishment of the Protestant Church in Germany. Meanwhile in Switzerland, John Calvin (1509-64) led another Protestant revolt, and in England, King Henry VIII (ruled 1509-47) also broke with Rome. By the end of the sixteenth century, some form of Protestantism prevailed throughout northern Europe.

Protestantism did not come easily to northern Europe, which was wracked by decades of religious civil war. Leading the Catholic cause, Emperor Charles V battled the Protestant forces in Germany from 1546 to 1555.

During this turbulent time, one of the emperor's favorite artists, Leone Leoni (1509–90), created a lifesize bronze sculpture, *Charles V Triumphing over Fury*, which was cast between 1549 and 1555. (See fig. 8 Introduction.)

Yet Leone's portrayal of a victorious Charles proved premature. After years of armed resistance, at a meeting of the provincial legislature of Augsburg in 1555, the emperor was forced to accommodate the Protestant Reformation in his lands. The terms of the peace dictated that local rulers select the religion of their subjects, furthering the establishment of Protestantism. Tired of the strain of government and prematurely aged, Charles abdicated in 1556 and retired to a monastery in Spain, where he died two years later. His son Philip II inherited Spain and the Spanish colonies; the Austrian branch of the dynasty lasted into the twentieth century.

The years of political and religious strife had a grave impact on artists and their art. Early on, some artists, such as Riemenschneider, found their careers at an end because of their sympathies for rebels and reformers. Later, as Protestantism took hold, artists who supported the Roman Catholic Church left their homes to seek patronage abroad.

One tragic consequence of the Reformation was the destruction of religious art, an outgrowth of Luther's objections to excessive devotion to religious imagery—although Luther, who saw the educational value of art, never supported iconoclasm. In some areas, Protestant zealots smashed sculpture and stained-glass windows and destroyed or whitewashed religious paintings to rid the churches of what they considered to be idolatrous images. With the sudden loss of patronage for religious art in the newly Protestant lands, many artists turned to portraiture and other secular subjects, including moralizing depictions of human folly and weaknesses. The popularity of these themes stimulated a free market for which artists created works of their own invention that were sold through dealers or by word of mouth.

Albrecht Dürer. Dürer admired the writings of Martin Luther and had hoped to engrave a portrait of him, as he had other important Reformation thinkers. In 1526, the artist openly professed his belief in Lutheranism in a pair of inscribed panels commonly referred to as the Four Apostles (fig. 18-39). The paintings show the apostles John, Peter, Mark, and Paul in an arrangement that suggests the rise of Protestantism. On the left panel, the elderly Peter, the first pope, holds up his key to the Church but seems to shrink behind the young John, Luther's favorite evangelist. On the right panel, Mark is nearly hidden behind Paul, whose teachings and epistles were greatly admired by the Protestants. Long inscriptions below the figures (not legible here) warn the viewer not to be led astray by "false prophets" but to heed the words of the New Testament. Also included are excerpts from the letters of Peter, John, and Paul and the Gospel of Mark from Luther's German translation of the New Testament.

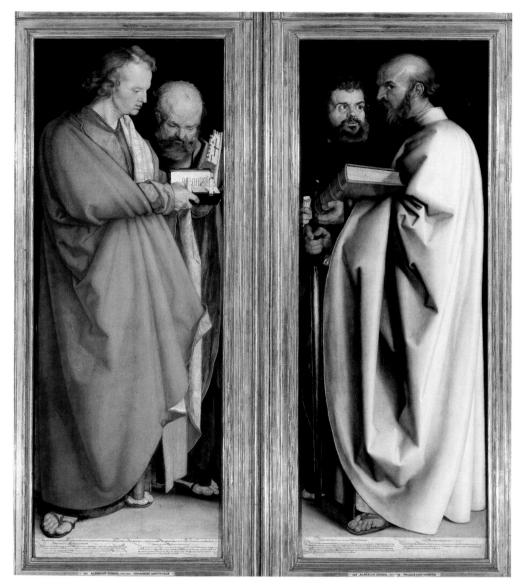

18-39. Albrecht Dürer. *Four Apostles.* 1526. Oil on wood panel, each panel $7'^{1}/_{2}'' \times 2'6''$ (2.15 × 0.76 m). Alte Pinakothek, Munich.

Dürer presented the panels to the city of Nuremberg, which had already adopted Lutheranism as its official religion. The work was surely meant to demonstrate that a Protestant art was possible. Earlier, the artist had written: "For a Christian would no more be led to superstition by a picture or effigy than an honest man to commit murder because he carries a weapon by his side. He must indeed be an unthinking man who would worship picture, wood, or stone. A picture therefore brings more good than harm, when it is honourably, artistically, and well made" (cited in Snyder, page 347).

Lucas Cranach the Elder. Martin Luther's favorite painter and one of Dürer's friends, Lucas Cranach the Elder (1472–1553), had moved his workshop to Wittenberg in 1504, after a number of years in Vienna. In addition to the humanist milieu of its university, Wittenberg offered the patronage of the Saxon court. Appointed court painter in 1505, Cranach created woodcuts, altar-

pieces, and many portraits. One of the most interesting among Cranach's roughly fifty portraits of Luther is *Martin Luther as Junker Jörg* (fig. 18-40, page 682). It was painted after the reformer's excommunication by Pope Leo X in early 1521—and after rulers of the German states met in Worms and declared Luther's ideas heresy and Luther himself an outlaw to be captured and handed over to Emperor Charles V. Smuggled out of Worms by Saxon agents, Luther returned to Wittenberg wearing a black beard and mustache, disguised as a knight named Jörg, or George. The painting shows him in this disguise.

Albrecht Altdorfer. Landscape, with or without figures, was an important new category of imagery after the Reformation. Among the most accomplished German landscape painters of the period was Albrecht Altdorfer (c. 1480–1538), who also undertook civic construction projects. He probably received his early training in Bavaria from his painter father, then became a citizen in 1505 of the city of Regensburg, in the Danube River

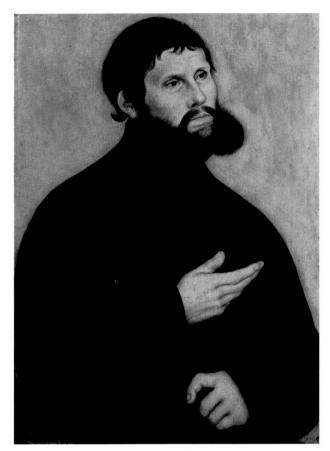

18-40. Lucas Cranach the Elder. Martin Luther as **Junker Jörg.** c. 1521. Oil on wood panel, $20^{1}/_{2} \times 13^{5}/_{8}$ " $(52.1 \times 34.6 \text{ cm})$. Kunstmuseum, Weimar, Germany.

Valley, where he remained for the rest of his life and whose portrayal became his specialty. In his paintings, Altdorfer often depicted religious and historical subjects in magnificent landscapes. The artist's varied talents are barely hinted at by the single work illustrated here, his Danube Landscape of about 1525 (fig. 18-41), a fine example of pure landscape painting—one without a narrative subject or human figures, unusual for the time. A small work on vellum laid down on a wood panel, the Landscape seems to be a minutely detailed view of the natural terrain, but a close inspection reveals an inescapable picturesqueness—far more poetic and mysterious than Dürer's scientifically observed views of nature—in the low mountains, gigantic lacy pines, neatly contoured shrubberies, and fairyland castle with redroofed towers at the end of a winding path. The eerily glowing yellow-white horizon below roiling gray and blue clouds in a sky that takes up more than half the composition suggests otherworldly scenes.

LATE-SIXTEENTH- Although it remained **CENTURY** ARCHITECTURE had profound repercus-AND ART IN ITALY

staunchly Catholic, the Protestant Reformation sions in Italy. It drove the Catholic Church not

only to launch a fight against Protestantism but also to

seek internal reform and renewal—a movement that became known as the Counter-Reformation. It also inspired the papacy to promote the Church's preeminence by undertaking an extensive program of building and art commissions. Under such patronage, the art of the Italian Late Renaissance, including a style known as Mannerism, flourished in the second half of the sixteenth century.

Another stimulus for the papal building campaign and arts patronage was brought not by Protestant but by Catholic forces. Pope Clement VII's shifting allegiance in the political struggles between France and the Holy Roman Empire had spurred Emperor Charles V to sack Rome in 1527, leaving the city in ruins. Clement also miscalculated the threat to the Church and to papal authority posed by the Protestant Reformation, and his failure to address the issues raised by the reformers enabled the movement to spread. His successor was a rich and worldly Roman noble, Alessandro Farnese, who was elected Pope Paul III (papacy 1534-49). He was the first pope to grapple directly with the rise of Protestantism, and he vigorously pursued Church reform. In 1536, he appointed a commission to investigate charges of corruption within the Church. He also convened the Council of Trent (1545-63) to define Catholic dogma, initiate disciplinary reforms, and regulate training of clerics.

Pope Paul III addressed Protestantism not only through reform, but also through repression and censorship. In 1542, he instituted the Inquisition, a papal office that sought out heretics for interrogation, trial, and sentencing. The enforcement of religious unity extended to the arts, which had to conform to guidelines issued by the Council of Trent. Traditional images of Christ and the saints continued to be used to inspire and educate, but art was scrutinized for traces of heresy and profanity. The new rules limited what could be represented in Christian art and led to the destruction of some works. At the same time, art became a powerful weapon of propaganda, especially in the hands of members of the Society of Jesus, a new religious order founded by the Spanish noble Ignatius of Loyola (1491-1556) and confirmed by Paul III in 1540. The Jesuits, dedicated to piety, education, and missionary work, spread worldwide from Il Gesù, their headquarters church in Rome (see fig. 18-45). They came to lead the Counter-Reformation movement and the revival of the Catholic Church.

ARCHITECTURE IN ROME AND THE VATICAN

Paul III set out to restore not only the Roman Catholic Church but also Roman Catholic architecture. He aimed to restore the heart of the city of Rome by rebuilding the Capitoline Hill as well as continuing work on Saint Peter's. His commissions include some of the glories of the Late Italian Renaissance.

Michelangelo. After fleeing Florence in 1534, Michelangelo resettled in Rome. Among the projects in which Paul III involved him was the redesign of the Capitoline Hill, the buildings and piazza that were once the citadel of

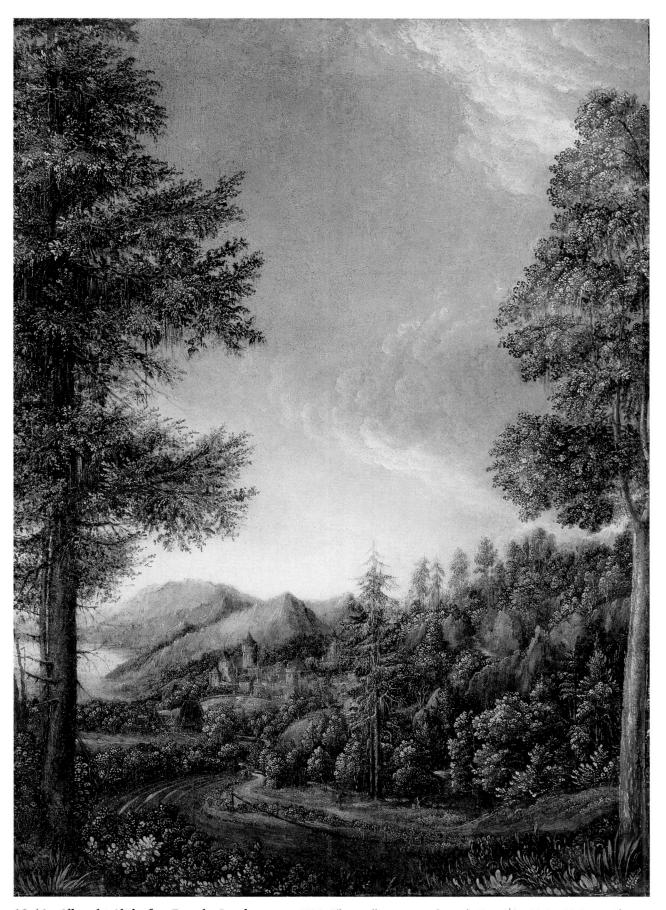

18-41. Albrecht Altdorfer. *Danube Landscape*. c. 1525. Oil on vellum on wood panel, $12 \times 8^{1}/2^{"}$ (30.5 \times 22.2 cm). Alte Pinakothek, Munich.

18-42. Michelangelo. Campidoglio, Rome.

1538–64. Engraving by Étienne Dupérac, 1569. Gabinetto Nazionale delle Stampe, Rome.

Flanking the entrance to the piazza are the so-called *Dioscuri*, two ancient Roman statues moved to the Capitol by Paul III, along with the bronze *Marcus Aurelius*, an imperial Roman equestrian statue, which was installed at the center of the piazza. At the back of the piazza is the Palazzo Senatorio, whose double-ramp grand staircase is thought to have been designed by Michelangelo and built 1545–1605. At the right is the Palazzo dei Conservatori, with a new facade designed by Michelangelo and built 1563–84; facing it is the Palazzo Nuovo, which was built 1603–55 to match the Conservatori. The pavement was executed in 1944 following Michelangelo's design.

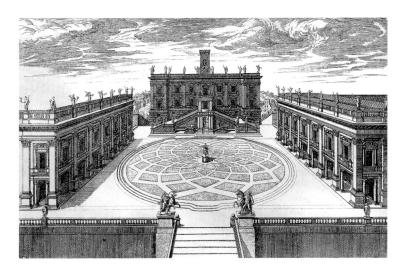

Republican Rome. The buildings covering the irregular site had fallen into disrepair, and the pope saw its renovation as a symbol of both his spiritual and his secular power. Scholars still debate Michelangelo's role in the Capitoline project, although some have connected the granting of Roman citizenship to him in 1537 with his taking charge of the work. Preserved accounts mention the artist by name only twice: In 1539, he advised reshaping the base for the ancient Roman statue of Marcus Aurelius; in 1563, payment was made "to execute the orders of master Michelangelo Buonarroti in the building of the Campidoglio." Michelangelo's comprehensive plan for what is surely among the most beautiful urban-renewal projects of all time was documented in contemporary prints (fig. 18-42); the Piazza del Campidoglio today closely resembles the plan, even though it was not finished until the seventeenth century, and Michelangelo's exquisite star design in the pavement was not installed until the twentieth century.

Another of Paul III's ambitions was to complete the new Saint Peter's, a project that had been under way for forty years. When he appointed Michelangelo architect of the project in 1546, Michelangelo was well aware of the work done by his predecessors—from Bramante to Raphael to Antonio da Sangallo the Younger—since the laying of the cornerstone in 1506. The seventy-oneyear-old sculptor, confident of his architectural expertise, demanded the right to deal directly with the pope, rather than through a committee of construction deputies. Michelangelo further shocked the deputies but not the pope—by tearing down or canceling parts of Sangallo's design and returning to Bramante's central plan, long associated with Christian martyria. Seventeenth-century additions and renovations dramatically changed the original plan of the church and the appearance of its interior, but Michelangelo's Saint Peter's (fig. 18-43) still can be seen in the contrasting forms of the flat and angled walls and the three

18-43. Michelangelo. Saint Peter's Basilica, Vatican. c. 1546–64; dome completed 1590 by Giacomo della Porta; lantern 1590–93. View from the southwest.

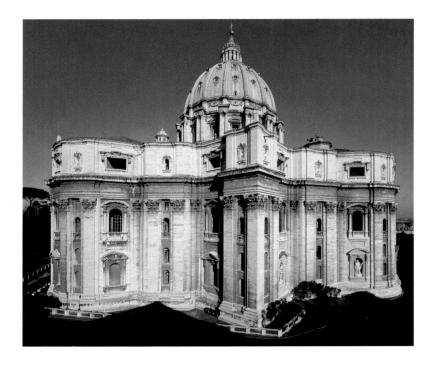

hemicycles (semicircular structures), whose colossal pilasters, blind windows (having no openings), and niches form the sanctuary of the church. The level above the heavy entablature was later given windows of a different shape. How Michelangelo would have built the great dome is not known; most scholars believe that he would have made it hemispherical. The dome that was erected by Giacomo della Porta in 1588-90 retains Michelangelo's basic design: a segmented dome with regularly spaced openings, resting on a high drum with pedimented windows between paired columns, and surmounted by a tall lantern reminiscent of Bramante's Tempietto. Della Porta's major changes were raising the dome height, narrowing its segmental bands, and changing the shape of its openings. (See "Saint Peter's Basilica," page 663.)

Vignola. Michelangelo alone could not satisfy the demand for architects. One young artist who helped meet that need was Giacomo Barozzi (1507–73), known as Vignola after his native town. He worked in Rome in the late 1530s surveying ancient Roman monuments and providing illustrations for an edition of Vitruvius, then worked from 1541 to 1543 in France with Francesco Primaticcio at the Château of Fontainebleau. After returning to Rome, he secured the patronage of the Farnese family.

Vignola profited from the Counter-Reformation program of church building. The Church's new emphasis on individual, emotional, congregational participation brought a focus on sermons and music; it also required churches to have-instead of the complex interiors of medieval and earlier Renaissance churches-wide naves and unobstructed views of the altar to accommodate worshipers. Ignatius of Loyola, founder of the Jesuit order, was determined to build its headquarters church in Rome under these precepts, but he did not live to see it finished. The cornerstone was laid in 1540, but construction of the large new Church of Il Gesù did not begin until 1568, as the Jesuits had to raise considerable funds. Cardinal Alessandro Farnese (Paul III's namesake and grandson) donated funds to the project in 1561 and selected as architect Vignola, famed as a builder and theoretician for his book on architecture. After Vignola died in 1573, Giacomo della Porta finished the dome and facade of Il Gesù.

Il Gesù was admirably suited for its congregational purpose. Vignola designed a wide, barrel-vaulted nave, shallow connected side chapels but not aisles, and short transepts that did not extend beyond the line of the outer walls—enabling all worshipers to gather in the central space; a single huge apse and dome over the crossing (fig. 18-44, page 686) directed their attention to the altar. The building fit compactly into the city block—a requirement that now often overrode the desire to orient a church east-west. The facade design emphasized the central portal with classical pilasters, engaged columns and pediments, and volutes scrolling out to hide the buttresses of the central vault and to link the tall central section with the lower sides (fig. 18-45, page 686). As finally

built by Giacomo della Porta, the facade design, in its verticality and centrality, would have significant influence on church design well into the next century (see "Parts of the Church Facade," page 686). The facade abandoned the early Renaissance grid of classical pilasters and entablatures (see fig. 17-42) for a two-story design of paired colossal order columns that reflected and tied together the two stories of the nave elevation. Each of these stories was further subdivided by moldings, niches, and windows. The entrance of the church, with its central portal and tall window, became the focus of the composition. Pediments at every level break into the level above, leading the eye upward to the cartouches with coats of arms. Both Cardinal Farnese, the patron, and the Jesuits (whose arms entail the monogram of Christ, IHS) are commemorated here on the facade.

MICHELANGELO AND TITIAN

Over the course of their lengthy careers, Michelangelo and Titian continued to explore their art's expressive potential. In their late work, they discovered new stylistic directions that would inspire succeeding generations of artists. A quarter of a century after finishing the *Sistine Ceiling* (see fig. 18-14), Michelangelo began to paint again in the Sistine Chapel. Although only in his fifties, he complained bitterly of feeling old, but he accepted the important and demanding task of painting the *Last Judgment* on the 48-foot-high end wall above the chapel altar (fig. 18-46, page 687). The *Last Judgment*, painted between 1536 and 1541, was the first major commission of Pope Paul III.

Abandoning the clearly organized medieval conceptions of the Last Judgment, in which the Saved are neatly separated from the Damned, Michelangelo painted a writhing swarm of rising and falling humanity. At the left, the dead are dragged from their graves and pushed up into a vortex of figures around Christ, who wields his arm like a sword of justice. The shrinking Virgin represents a change from Gothic tradition, where she sat enthroned beside, and equal in size to, her son. Despite the efforts of several saints to save them at the last minute, the rejected souls are plunged toward hell on the right (fig. 18-47, page 688), leaving the Elect and still-unjudged in a dazed, almost uncomprehending state. To the right of Christ's feet is Saint Bartholomew, who in legend was martyred by being skinned alive, holding his flayed skin, the face of which is painted with Michelangelo's own distorted features. On the lowest level of the mural is the gaping, fiery entrance to hell, toward which Charon, the ferryman of the dead to the underworld, propels his craft. From the beginning, conservative clergy criticized the painting for its nudity and ordered bits of drapery to be added after Michelangelo's death. The painting was long interpreted as a grim and constant reminder to the celebrants of the Mass—the pope and his cardinals—that ultimately they would be judged for their deeds. However, the brilliant colors revealed by recent cleaning seem to contradict the grim message.

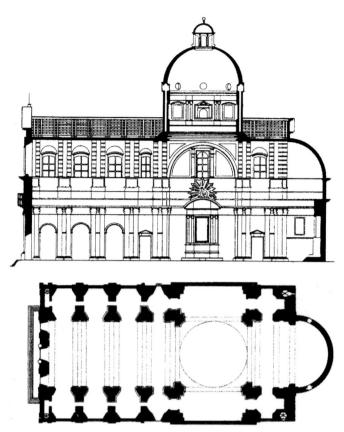

18-44. Plan and section of the Church of Il Gesù, Rome. Cornerstone laid 1540; building begun on Giacomo da Vignola's design in 1568; completed by Giacomo della Porta in 1584.

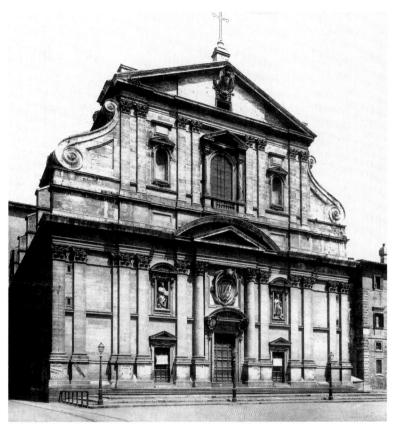

18-45. Giacomo da Vignola and Giacomo della Porta. Facade of the Church of Il Gesù, Rome. c. 1575-84.

ELEMENTS of ARCHITECTURE

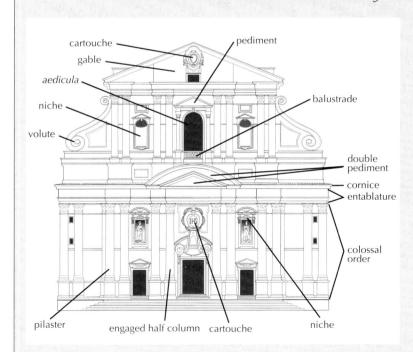

PARTS OF THE CHURCH FACADE

Giacomo da Vignola and Giacomo della Porta's facade for Il Gesù (see fig. 18-45), of about 1575–84, like Renaissance and Mannerist buildings, is firmly grounded in the clean articulation and vocabulary of classical architecture. Il Gesù's facade employs the **colossal order** and uses huge **volutes** to aid the transition from the wide lower stories to the narrower upper level. Verticality is also emphasized by the large double pediment that rises from the wide entablature and pushes into the transition zone between stories; by the repetition of triangular pedimental forms (above the *aedicula* window and in the crowning **gable**); by the rising effect of the volutes; and most obviously by the massing of upward-moving forms at the center of the facade. Cartouches, cornices, and **niches** provide concave and convex rhythms across the middle zone.

Giacomo da Vignola and Giacomo della Porta. Facade elevation of the Church of Il Gesù, Rome. c. 1575-84.

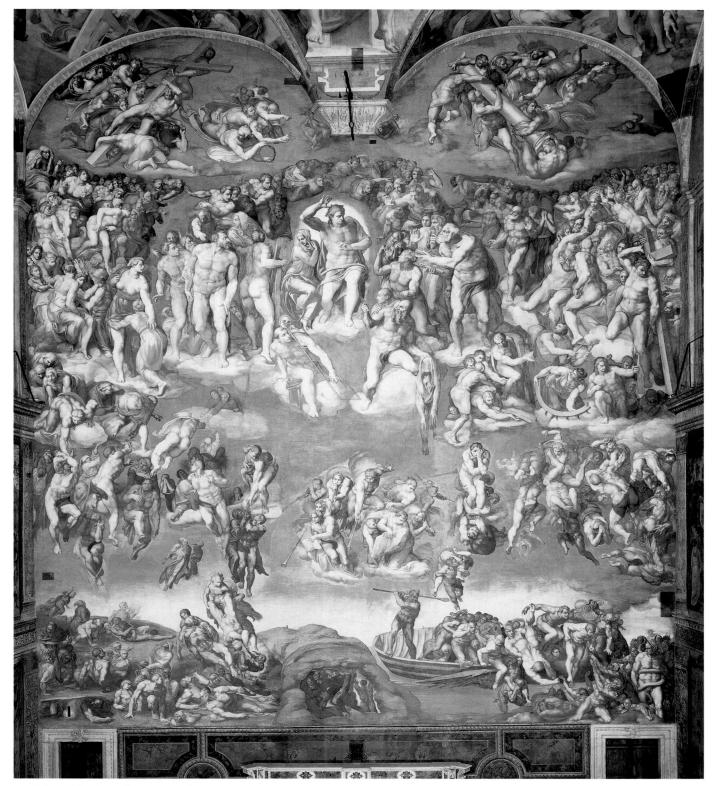

18-46. Michelangelo. *Last Judgment*, Sistine Chapel. 1536–41 (cleaning finished 1994). Fresco, $48'' \times 44'$ ($14.6 \times 13.4 \text{ m}$).

Dark, rectangular patches left by the restorers (visible, for example, in the upper left and right corners) contrast with the vibrant colors of the chapel's frescoes. These dark areas show just how dirty the walls had become over the centuries before their recent cleaning.

Michelangelo was an intense man who alternated between periods of depression and frenzied activity. He was difficult and often arrogant, yet he was devoted to his friends and helpful to young

artists. He believed that his art was divinely inspired; later in life, he became deeply absorbed in religion and dedicated himself chiefly to religious works.

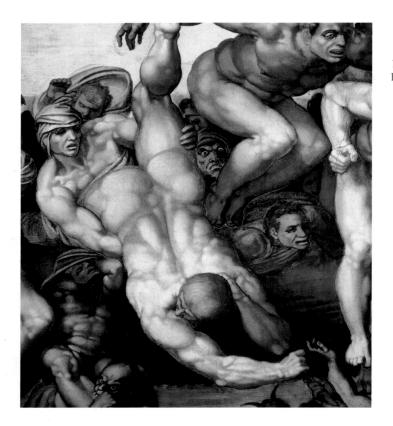

18-47. Michelangelo. *Last Judgment,* detail of the lower right corner of the fresco in the Sistine Chapel.

18-48. Michelangelo. *Pietà* (known as the *Rondanini Pietà*). 1559–64. Marble, height $5'3^3/8''$ (1.61 m). Castello Sforzesco, Milan.

Shortly before his death in 1564, Michelangelo resumed work on this sculpture group, which he had begun some years earlier. He cut down the massive figure of Jesus, merging the figure's now elongated form with that of the Virgin, who seems to carry her dead son upward toward heaven.

Michelangelo's last days were occupied by an unfinished composition now known, from the name of a modern owner, as the Rondanini Pietà (fig. 18-48). The Rondanini Pietà is the final artistic expression of a lonely, disillusioned, and physically debilitated man who struggled to end his life as he had lived it—working with his mind and his hands. In his youth, the stone had released the *Pietà* in Old Saint Peter's as a perfect, exquisitely finished work (see fig. 18-11), but this block resisted his best efforts to shape it. He was still working on the sculpture six days before his death. The ongoing struggle between artist and medium is nowhere more apparent than in this moving example of Michelangelo's nonfinito creations. In his late work, Michelangelo subverted Renaissance ideals of human perfectability and denied his own youthful idealism, uncovering new forms that mirrored the tensions in Europe during the second half of the sixteenth century.

Like Michelangelo, Titian in his late work sought the essence of the form and idea, not the surface perfection of his youthful works. And just as Michelangelo had died carving a *pietà* for his tomb, so too Titian left the *pietà* he was painting for his tomb unfinished

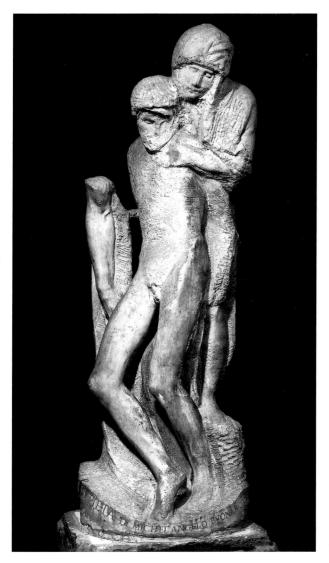

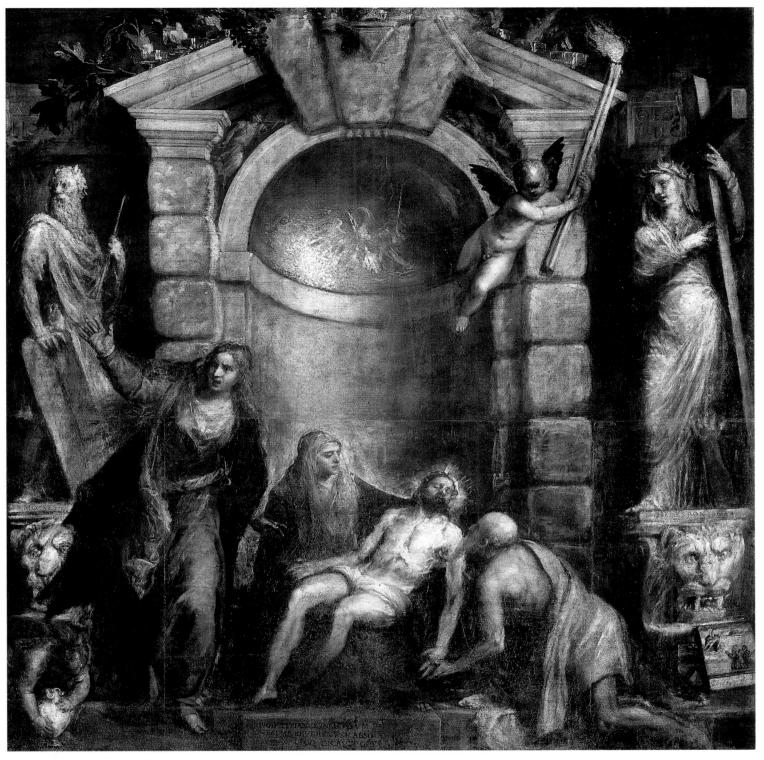

18-49. Titian (finished by Palma Giovane). *Pietà*. c. 1570–76. Oil on canvas, $11'7^{1}/_{2}" \times 11'5^{1}/_{2}"$ (3.5 × 3.5 m). Galleria dell'Accademia, Venice.

at his death in 1576 (fig. 18-49). Against a monumental arched niche, the Virgin mourns her son. Titian painted himself as Saint Jerome kneeling before Christ. The figures emerge out of darkness, their forms defined by the sweeping brushstrokes that Titian

painted with complete freedom and confidence. These elderly artists, secure in the techniques gained over decades of masterful craft, could abandon the knowledge of a lifetime as they attempted to express ultimate truths through art.

18-50. Capponi Chapel, Church of Santa Felicita, Florence. Chapel by Filippo Brunelleschi for the Barbadori family, 1419–23; acquired by the Capponi family, who ordered paintings by Pontormo, 1525–28.

ITALIAN MANNERISM

The term Mannerism comes from the Italian maniera, a word used in the sixteenth century to suggest intellectually intricate subjects, highly skilled techniques, and art concerned with beauty for its own sake. Any attempt to define Mannerism as a single style is futile, but certain characteristics occur regularly: extraordinary virtuosity; sophisticated, elegant compositions; and fearless manipulations or distortions of accepted formal conventions. Artists created irrational spatial effects and figures with elongated proportions, exaggerated poses, and enigmatic gestures and expressions. Some artists favored obscure, unsettling, and often erotic imagery; unusual colors and juxtapositions; and unfathomable secondary scenes. Mannerist sculptors exaggerated body forms and poses and preferred small size, the use of precious metals, and displays of extraordinary technical skill. Mannerist architecture defied the conventional use of the classical orders and uniformity and rationality in designs.

Mannerism, which was stimulated and supported by court patronage, began in Florence and Rome about 1520—first in painting, then in other mediums—and spread to other locations as artists traveled. Mannerist artists admired the great artists of the earlier generation: Leonardo da Vinci, Raphael, and Michelangelo, whose late style was a direct source of inspiration. Mannerism has been seen as an artistic expression of the unsettled political and religious conditions in Europe and also as an elegant, intriguing art created for sophisticated courtiers. Furthermore, a formal relationship between new art styles and aesthetic theories began to appear at this time—especially the elevation of "grace" as an ideal.

Painting. The first wave of Mannerist painters emerged in Florence in the 1520s. The frescoes and altarpiece created by Jacopo da Pontormo (1494–1557) between 1525 and 1528 for the hundred-year-old Capponi Chapel in the Church of Santa Felicita in Florence are clearly Mannerist in style (fig. 18-50).

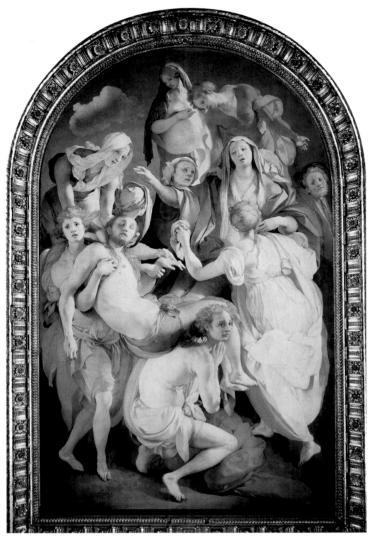

18-51. Pontormo. *Entombment.* 1525–28. Oil on wood panel, $10'3'' \times 6'4''$ (3.12 \times 1.93 m). Altarpiece in Capponi Chapel, Church of Santa Felicita. Florence.

Open on two sides, the chapel creates the effect of a loggia in which frescoes depict the Annunciation. The Virgin accepts the angel's message but also seems to have a vision of her future sorrow as she sees her son's body lowered from the Cross in the Entombment altarpiece (fig. 18-51). Pontormo's ambiguous composition in the altarpiece enhances the visionary quality of the painting. The bare ground and cloudy sky give little sense of location in space, and some figures press into the viewer's space, while others seem to levitate or stand on the smooth boulders. Pontormo chose a moment just after Jesus' removal from the Cross, when the youths who have lowered him have paused to regain their hold. The emotional atmosphere of the scene is expressed in the odd poses, and drastic shifts in scale, but perhaps most poignantly in the use of secondary color and colors

shot through with contrasting colors, like iridescent silks. The palette is predominantly blue and pink with accents of olive green, gray, scarlet, and creamy white. The overall tone of the picture is set by the color treatment of the crouching youth, whose skintight bright pink shirt is shaded in iridescent, pale gray-green.

Parmigianino (Francesco Mazzola, 1503–40) created equally intriguing variations on the classical style. Until he left his native Parma in 1524 for Rome, the strongest influence on his work had been Correggio. In Rome, Parmigianino met Mannerists Rosso Fiorentino and Giulio Romano, and he also studied the work of Raphael and Michelangelo. He assimilated what he saw into a distinctive style of Mannerism, calm but strangely unsettling. After the Sack of Rome, he moved back to Parma. Left unfinished at the time of his early death is a painting

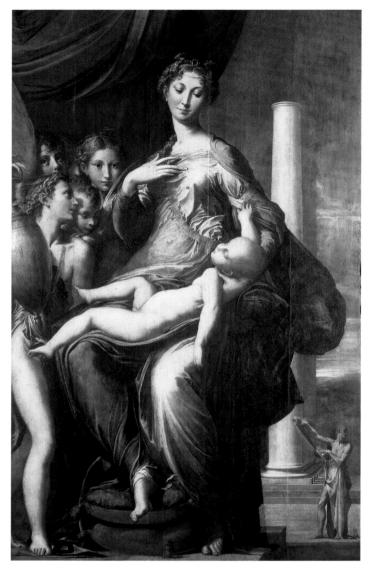

18-52. Parmigianino. *Madonna with the Long Neck.* 1534–40. Oil on wood panel, $7'1'' \times 4'4''$ (2.16 \times 1.32 m). Galleria degli Uffizi, Florence.

known as the *Madonna with the Long Neck* (fig. 18-52). The elongated figure of the Madonna, whose massive legs and lower torso contrast with her narrow shoulders and long neck and her fingers, resembles the large metal vase inexplicably being carried by the youth at the left. The sleeping Christ child recalls the pose of the *pietà*, and in the background Saint Jerome unrolls a scroll beside tall white columns, having no more substance than theater sets in the middle distance. Like Pontormo, Parmigianino presents a well-known image in a manner calculated to unsettle viewers. The painting challenges the viewer's intellect while it exerts its strange appeal to aesthetic sensibility.

Bronzino (Agnolo di Cosimo, 1503–72), whose nickname means "Copper-Colored" (just as we might call someone Red), was born near Florence. About 1522, he became Pontormo's assistant. In 1530, he established his own workshop, though he continued to work occa-

sionally with Pontormo on large projects. In 1540, Bronzino became the court painter to the Medici. Although he was a versatile artist who produced altarpieces, fresco decorations, and tapestry designs over his long career, he is best known today for his portraits in the courtly Mannerist style. Bronzino's virtuosity in rendering costumes and settings creates a rather cold and formal effect, but the self-contained demeanor of his subjects admirably conveys their haughty personalities. The Portrait of a Young Man (fig. 18-53) demonstrates Bronzino's characteristic portrayal of his subjects as intelligent, aloof, elegant, and self-assured. The youth toys with a book, suggesting his scholarly interests, but his walleyed stare creates a slightly unsettling effect and seems to associate his portrait with the carved masks surrounding him.

Bronzino's *Allegory with Venus and Cupid*, one of the strangest paintings in the sixteenth century, contains all

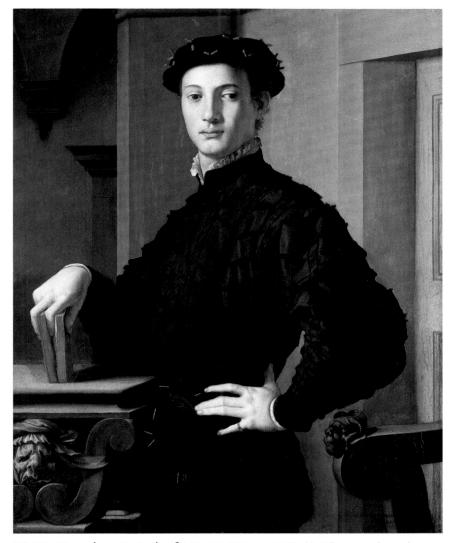

18-53. Bronzino. Portrait of a Young Man. c. 1540–45. Oil on wood panel, $37^{1}/_{2}\times29^{1}/_{2}$ " (95.5 \times 74.9 cm). The Metropolitan Museum of Art, New York. The H. O. Havemayer Collection (29.100.16)

the formal, iconographical, and psychological characteristics of Mannerist art (fig. 18-54, page 694). It could stand alone as a summary of the period. Seven figures, two masks, and a dove interweave in an intricate formal composition pressed breathlessly into the foreground plane. Taken as individual images they display the apparent ease of execution and grace of form, ideal perfection of surface and delicacy of color that characterize Mannerist art. Together they become a disturbingly erotic and inexplicable composition.

The painting defies easy explanation for it is one of the complex allegories that delighted the sophisticated courtiers who enjoyed equally esoteric wordplay and classical references. Nothing is quite what it seems. Venus and her son Cupid engage in lascivious dalliance, encouraged by a putto representing Folly, Jest, or Playfulness, who is about to throw pink roses at them. Cupid kisses his mother and squeezes her breast and nipple

while Venus lifts up an arrow from Cupid's quiver, leading some scholars to suggest that the painting's title should be Venus Disarming Cupid. Venus holds the golden apple of discord given to her by Paris; her dove seems to support Cupid's feet, while a pair of ugly red masks lying at her feet reiterates the theme of duplicity, An old man, Time or Chronos, assisted by an outraged Truth, pulls back a curtain to expose the couple. Lurking just behind Venus a monstrous serpent with a lion's legs and claws and the head of a beautiful young girl crosses her hands to hold a honeycomb and scorpion's stinger. She has been called Inconstancy and Fraud but also Pleasure. In the shadows a screaming head tears its hair—if female, she is Jealousy or Envy, but if male, he would be Pain. The complexity of the painting and the possibilities for multiple meanings are typical of the intellectual games enjoyed by sixteenth-century intellectuals. Perhaps the allegory tells of the impossibility of constant

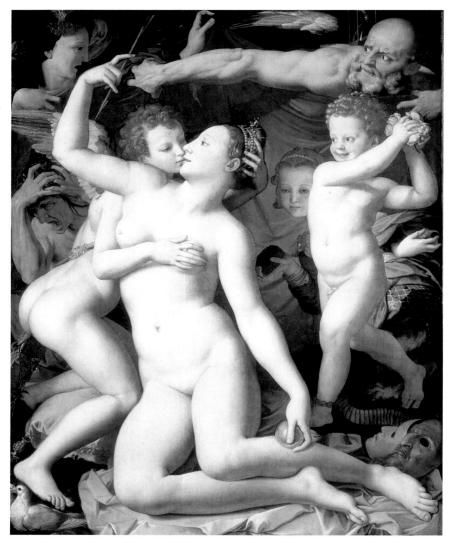

18-54. Bronzino. *Allegory with Venus and Cupid.* Mid-1540s. Oil on panel, $57\frac{1}{6} \times 46$ " (1.46 \times 1.16 m). National Gallery, London. Reproduced by courtesy of the Trustees of the National Gallery, London.

love and the folly of lovers, which will become apparent in time: But perhaps it is an allegory on sin and a condemnation of vice. In any event, Duke Cosimo ordered the painting himself, and he presented it to King Francis I of France.

Sculpture. Two sculptors exemplify the Mannerist style: Benvenuto Cellini and Giovanni da Bologna, well-traveled artists who represent the internationalism of the sixteenth century. The Florentine goldsmith and sculptor Benvenuto Cellini (1500–1571), who wrote an autobiography and a handbook for artists, traveled to the French king's court at Fontainebleau, where he made the famous *Saltcellar of Francis I* (fig. 18-55)—a table accessory transformed into an elegant sculptural ornament by fanciful imagery and superb execution in gold and enamel. The Roman sea god Neptune, representing the source of salt, sits next to a tiny boatshaped container that carries the seasoning, while a

personification of Earth guards the plant-derived pepper, contained in the triumphal arch to her right. Representations of the seasons and the times of day on the base refer to both daily meal schedules and festive seasonal celebrations. The two main figures, their poses mirroring each other with one bent and one straight leg, lean away from each other at impossible angles yet are connected and visually balanced by glances and gestures. Their supple, elongated bodies and small heads reflect the Mannerist conventions of artists like Parmigianino.

In the second half of the sixteenth century, probably the most influential sculptor in Italy was Jean de Boulogne, better known by his Italian name, Giovanni da Bologna (1529–1608). Born in Flanders, he settled by 1557 in Florence, where both the Medici family and the sizable Netherlandish community there were his patrons. He not only influenced a later generation of Italian sculptors, he also spread the Mannerist style to

the north through artists who came to study his work. Although greatly influenced by Michelangelo, Giovanni was generally more concerned than his predecessor with graceful forms and poses, as in his gilded-bronze Astronomy, or Venus Urania (fig. 18-56, page 696), of about 1573. The figure's identity is suggested by the astronomical device on the base of the plinth. Designed with a classical prototype of Venus in mind, the sculptor twisted Venus's upper torso and arms to the far right and extended her neck in the opposite direction so that her chin was over her right shoulder, straining the limits of the human body. Consequently, Giovanni's statuette may be seen from any viewpoint. The elaborate coiffure of tight ringlets and the detailed engraving of drapery texture contrast strikingly with the smooth, gleaming flesh of Venus's body. Following the common practice for cast-metal sculpture, Giovanni replicated this statuette several times for different patrons.

WOMEN PAINTERS

Northern Italy, more than any other part of the peninsula, produced a number of gifted woman artists. Sofonisba Anguissola (c. 1532–1625), born into a noble family in Cremona, was unusual in that she was not the daughter of an artist. Her father gave all his children a humanistic education and encouraged them to pursue careers in literature, music, and especially painting. He consulted Michelangelo about Sofonisba's artistic talents in 1557, asking for a drawing that she might copy and return to be critiqued. Michelangelo evidently obliged and Sofonisba Anguissola's father wrote an enthusiastic letter of thanks

Contemporaries especially admired Sofonisba Anguissola's self-portraits. One wrote that he liked to show off her painting as "two marvels, one the work, the other the artist" (quoted in Hartt and Wilkins, p. 66). She was also a skilled miniaturist, an important kind of painting

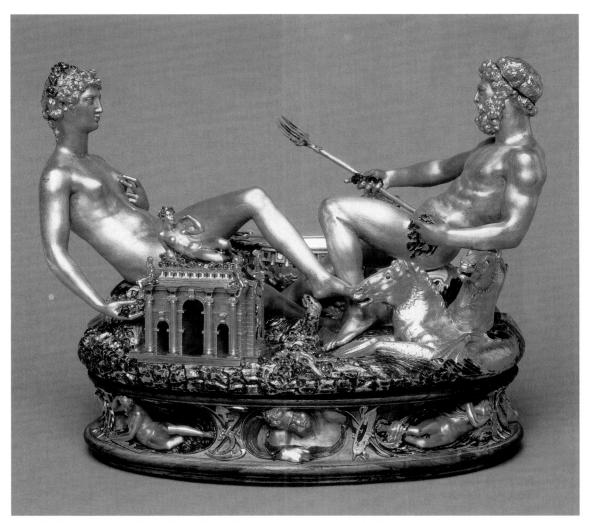

18-55. Benvenuto Cellini. *Saltcellar of Francis I.* 1539–43. Gold with enamel, $10^1/_4 \times 13^1/_8$ " (26 × 33.3 cm). Stolen from Kunsthistorisches Museum, Vienna.

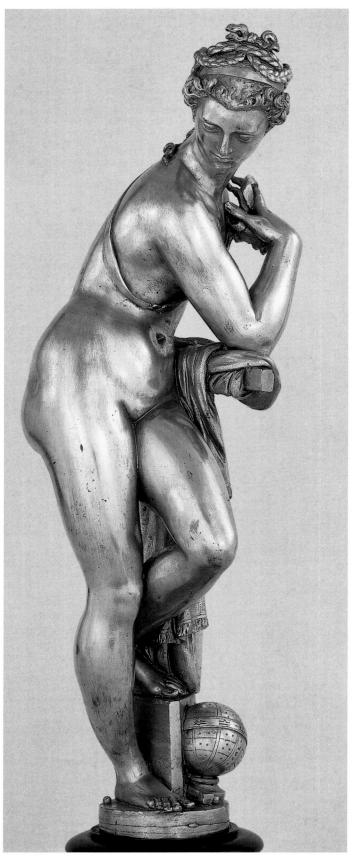

18-56. Giovanni da Bologna. *Astronomy*, or *Venus Urania*. c. 1573. Bronze gilt, height $15^{1}/_{4}$ " (38.8 cm). Kunsthistorisches Museum, Vienna.

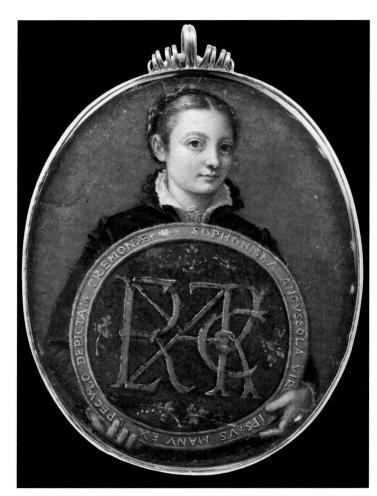

18-57. Sofonisba Anguissola. *Self-Portrait.* c. 1552. Oil on parchment on cardboard, $2^1/_2 \times 3^1/_4$ " (6.4 \times 8.3 cm). Museum of Fine Arts, Boston. EMMA F. Munroe Fund, (60.155).

in the sixteenth century, when people had few means of recording a lover, friend, or family member's features (see also fig. 18-78). Anguissola painted herself holding a medallion the border of which spells out her name and home town, Cremona (fig. 18-57). The interlaced letters at the center of the medallion are a riddle; they seem to form a monogram with the first letters of her sisters' names: Minerva, Europa, Elena. Such names are further evidence of the enthusiasm for the classics in Renaissance Italy.

In 1560, Anguissola accepted the invitation of the queen of Spain to become a lady in waiting and court painter, a post she held for twenty years. In a 1582 Spanish inventory, Anguissola is described as "an excellent painter of portraits above all the painters of this time"—extra-ordinary praise in a court that patronized Titian. Unfortunately, most of Anguissola's Spanish works were lost in a seventeenth-century palace fire. Anguissola returned to Sicily (a Spanish territory), where she died in 1625 at the age of 92.

Another northern Italian city, Bologna, was hospitable to accomplished women and boasted in the latter half of the century some two dozen women painters and

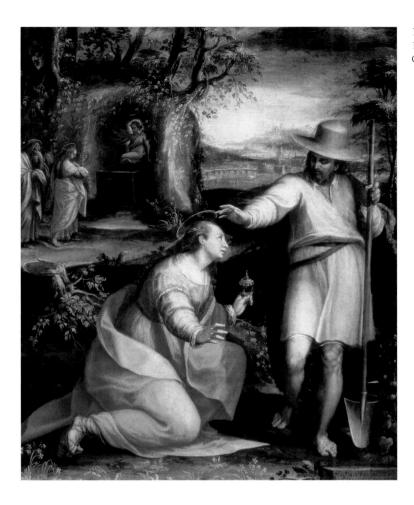

18-58. Lavinia Fontana. *Noli Me Tangere*. 1581. Oil on canvas, $47^3/_8 \times 36^5/_8$ " (120.3 \times 93 cm). Galleria degli Uffizi, Florence.

sculptors, as well as a number of women scholars who lectured at the university. There, Lavinia Fontana (1552-1614) learned to paint from her father, a Bolognese follower of Raphael. By the 1570s, she was a highly respected painter of narratives as well as of portraits, the more usual field for women artists of the time. Her success was so well rewarded, in fact, that her husband, the painter Gian Paolo Zappi, eventually gave up his own painting career to care for their large family and help his wife with such technical aspects of her work as framing. While still in her twenties, Fontana painted the Noli Me Tangere (fig. 18-58), illustrating the biblical story of Christ revealing himself before his Ascension to Mary Magdalen (Mark 16:9, John 20:17). The Latin title of the painting means "Don't touch me," Christ's words when she moved to embrace him, explaining that he now existed in a new form somewhere between physical and spiritual and had not yet joined his Father in Heaven. Christ's costume refers to the passage in the Gospel of John that says that the Magdalen at first mistook Christ for a gardener.

In 1603 Fontana moved to Rome as an official painter to the papal court. She also soon came to the attention of the Habsburgs, who paid large sums for her work. In 1611, she was honored with a commemorative medal portraying her as a dignified, elegantly coiffed woman on one side and as an intensely preoccupied artist with rolled-up sleeves and wild, uncombed hair on the other.

PAINTING AND ARCHITECTURE IN VENICE AND THE VENETO

Rather than the cool, formal, technical perfection sought by the Mannerists, painters in Venice expanded upon the techniques initiated there by Giorgione and Titian, concerning themselves above all with color, light, and expressively loose brushwork. The Veneto region, the part of northeastern Italy ruled by Venice, also gave rise to new directions in architecture under Palladio, the dominant architect of the latter half of the century.

Painting. Paolo Caliari (1528–88) took his nickname—Veronese—from his hometown, Verona, but he worked mainly in Venice. His paintings are nearly synonymous today with the popular image of Venice as a splendid city of pleasure and pageantry sustained by a nominally republican government and great mercantile wealth. Veronese's elaborate architectural settings and costumes, still lifes, anecdotal vignettes, and other everyday details, often unconnected with the main subject, proved immensely appealing to Venetian patrons. His vision of the glorious Venice reached an apogee in the ceiling of the council chamber in the ducal palace (fig. 14, Introduction).

Veronese's most famous work is a Last Supper that he renamed *Feast in the House of Levi* (fig. 18-59, "The Object Speaks", page 698), painted in 1573 for the Dominican Monastery of Santi Giovanni e Paolo. At first

THE OBJECT SPEAKS

FEAST IN THE HOUSE OF LEVI

Jesus among his disciples at the Last Supper was an image that spoke powerfully to believers during the sixteenth century. So it was not unusual when, in 1573, the highly esteemed painter Veronese revealed an enormous canvas that seemed at first glance to depict this scene-Jesus, indeed, is in the center of the painting, with his followers (fig. 18-59). But the church officials of Venice were shocked and offended-some of them by Veronese's grandiose portrayal of the subject in the midst of splendor and pageantry, others by the impiety of placing near Jesus a host of extremely unsavory characters. Veronese was called before the Inquisition to explain his reasons for including such extraneous details as a man picking his teeth, scruffy dogs, a parrot, and foreign soldiers. Veronese claimed the painting depicted the Feast in the House of Simon, a small dinner shortly before Jesus' final entry into Jerusalem. Veronese boldly justified his actions by saying: "We painters take the same license the poets and the jesters take. . . . I paint pictures as I see fit and as well as my talent permits" (from the record of the inquiry, cited in Holt, volume 2, pages 68, 69). Such artistic autonomy was unheard-of at that time, and his defense fell on unsympathetic ears. He was told to change the painting.

Accordingly, Veronese changed the picture's title so that it referred to another banquet, given by the tax collector Levi, whom Jesus had called to follow him. Thus, the "buffoons, drunkards . . . and similar vulgarities" (cited in Holt, volume 2, page 68) remained, and Veronese noted his new source—Luke, Chapter 5—on the balustrade. That Gospel reads that "Levi gave a great banquet for him [Jesus] in his house, and a large crowd of tax collectors and others were at table with them" (Luke 5:29). In changing the declared subject of the painting, Veronese also had modest revenge on the Inquisitors: When Jesus was criticized for associating with such people, he replied, "I have not come to call the righteous to repentance but sinners" (Luke 5:32).

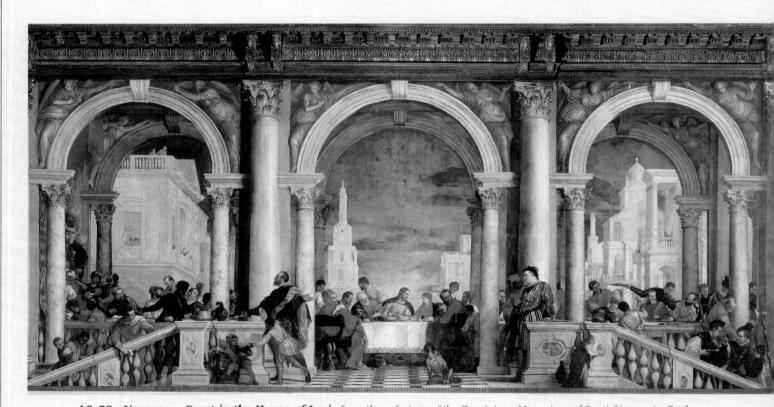

18-59. Veronese. *Feast in the House of Levi*, from the refectory of the Dominican Monastery of Santi Giovanni e Paolo, Venice. 1573. Oil on canvas, $18'3'' \times 42'$ (5.56×12.8 m). Galleria dell'Accademia, Venice.

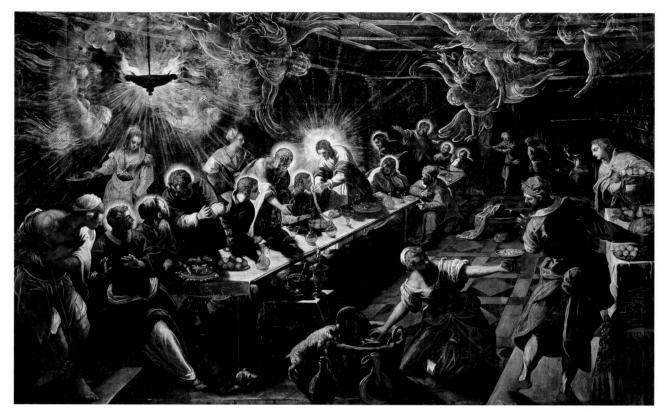

18-60. Tintoretto. *The Last Supper*. 1592–94. Oil on canvas, $12' \times 18'8''$ (3.7 \times 5.7 m). Church of San Giorgio Maggiore, Venice.

Tintoretto, who had a large workshop, often developed a composition by creating a small-scale model like a miniature stage set, which he populated with wax figures. He then adjusted the positions of the figures and the lighting until he was satisfied with the entire scene. Using a grid of horizontal and vertical threads placed in front of this model, he could easily sketch the composition onto squared paper for his assistants to copy onto a large canvas. His assistants also primed the canvas, blocking in the areas of dark and light, before the artist himself, free to concentrate on the most difficult passages, finished the painting. This efficient working method allowed Tintoretto to produce a large number of paintings in all sizes.

glance, the subject of the painting seems to be architecture and only secondarily the figures within the space. An enormous *loggia* framed by colossal triumphal arches and reached by balustraded stairs symbolizes Levi's house. Beyond the *loggia* an imaginary city of white marble gleams. Within this grand setting, realistic figures in splendid costumes assume exaggerated, theatrical poses. The huge size of the painting allowed Veronese to include the sort of anecdotal vignettes beloved by the Venetians—the parrots, monkeys, and Germans—but detested by the Inquisitors, who saw in them profane undertones.

Another Venetian master, Jacopo Robusti (1518–94), called Tintoretto ("Little Dyer") because his father was a dyer, worked in a style that developed from, and exaggerated, the techniques of Titian, in whose shop he reportedly apprenticed. Tintoretto's goal, declared on a sign in his studio, was to combine his master's color with the drawing of Michelangelo. Like Veronese, Tintoretto often received commissions to decorate huge interior spaces. He painted *The Last Supper* (fig. 18-60) for the choir of the Church of San Giorgio Maggiore, a building designed by Palladio (see fig. 18-61, page 700). Comparison with Leonardo da Vinci's painting of almost a

century earlier is instructive (see fig. 18-2 and fig. 18, Introduction). Instead of Leonardo's closed and logical space with massive figures reacting in individual ways to Jesus' statement, Tintoretto's view is from a corner, with the vanishing point on a high horizon line at the far right side. The table, coffered ceiling, and inlaid floor all seem to plunge dramatically into the distance. The figures, although still large bodies modeled by flowing draperies, turn and move in a continuous serpentine line that unites apostles, servants, and angels. Tintoretto used two light sources: one real, the other supernatural. Light streams from the oil lamp flaring dangerously over the near end of the table; angels seem to swirl out from the flame and smoke. A second light emanates from Jesus himself and is repeated in the glow of the apostles' halos. The mood of intense spirituality is enhanced by deep colors flashed with bright highlights, as well as by the elongated figures-treatments that reflect both the Byzantine art of Venice and the Mannerist aesthetic. The still lifes on the tables and the homey detail of a cat and basket emphasize the reality of the viewers' experience. At the same time, the deep chiaroscuro and brilliant dazzling lights catching forms in near-total darkness enhance the convincingly otherworldly atmosphere.

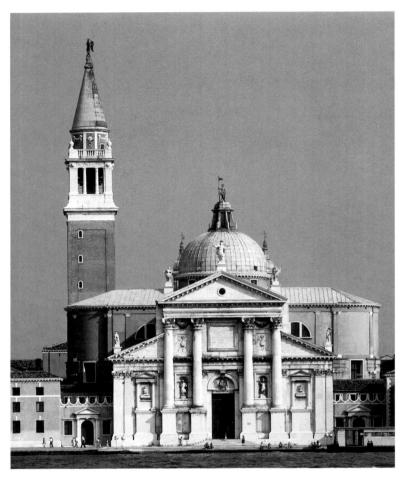

18-61. Palladio. Church of San Giorgio Maggiore, Venice. Plan 1565; construction 1565–80; facade, 1597–1610; campanile 1791.

The interpretation of the Last Supper also has changed—unlike Leonardo's more secular emphasis on personal betrayal, Tintoretto has returned to the institution of the Eucharist: Jesus offers bread and wine, a model for the priest administering the sacraments at the altar next to the painting.

The speed with which Tintoretto drew and painted was the subject of comment in his own time, and the brilliance and immediacy so admired today (his slashing brushwork was fully appreciated by the gestural painters of the twentieth century) were derided as evidence of carelessness. His rapid production may be attributed to the efficiency of his working methods: Tintoretto had a large workshop of assistants and he usually provided only the original conception, the beginning drawings, and the final brilliant colors of the finished painting. Tintoretto's workshop included members of his family—of his eight children, four became artists. His eldest, Marietta Robusti, worked with him as a portrait painter, and two or perhaps three of his sons also joined the shop. Another daughter, famous for her needlework, became a nun. Marietta, in spite of her fame and many commissions, stayed in her father's shop until she died, at the age of thirty. So skillfully did she capture her father's style and technique that today art historians cannot be certain which paintings are hers.

Architecture. Just as Veronese and Tintoretto expanded upon the rich Venetian tradition of oil painting established by Giorgione and Titian, Andrea Palladio dominated architecture during the second half of the century by expanding upon principles of Alberti and of ancient Roman architecture. His work—whether a villa, palace, or church—was characterized by harmonious symmetry and a rejection of ornamentation.

Born Andrea di Pietro della Gondola (1508–80), probably in Padua, the artist began his career as a stonecutter. After moving to Vicenza, he was hired by the noble humanist scholar and amateur architect Giangiorgio Trissino, who nicknamed him Palladio, for the Greek goddess of wisdom, Pallas Athena, and the fourthcentury Roman writer Palladius. Palladio learned Latin at Trissino's small academy and accompanied his benefactor on three trips to Rome, where he made drawings of Roman monuments. Over the years, he became involved in several publishing ventures, including a guide to Roman antiquities, an illustrated edition of Vitruvius, and books on architecture that for centuries would be valuable resources for architectural design.

By 1559, when he settled in Venice, Palladio was one of the foremost architects of Italy. In 1565, he undertook a major architectural commission: the monastery Church of San Giorgio Maggiore (fig. 18-61). His design for the Renaissance facade to the traditional basilica-plan elevation—a wide lower level fronting the nave and side aisles surmounted by a narrower front for the nave clerestory—is ingenious. Inspired by Alberti's solution for Sant'Andrea in Mantua (see fig. 17-42), Palladio created the illusion of two temple fronts of different heights and widths, one set inside the other. At the center, colossal columns on high pedestals, or bases, support an entabla-

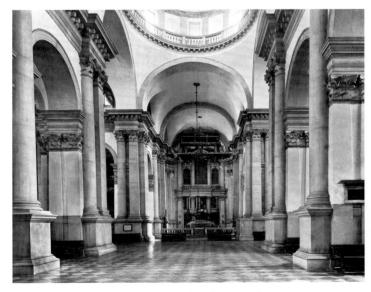

18-62. Nave, Church of San Giorgio Maggiore, Venice.

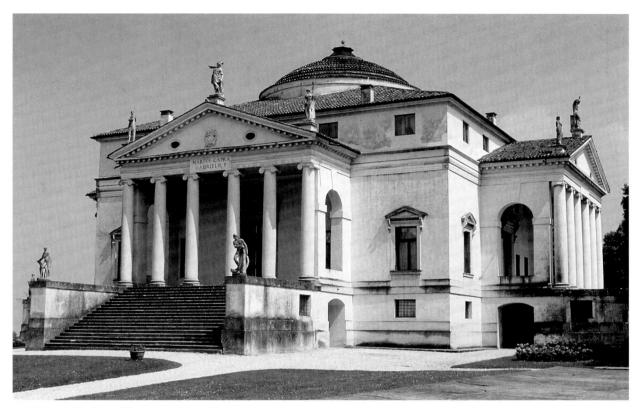

18-63. Palladio. Villa Rotunda (Villa Capra), Vicenza, Italy. 1560s.

ture and pediment that front the narrower clerestory level of the church. The lower temple front, which covers the triple-aisle width and slanted side-aisle roofs, consists of pilasters supporting an entablature and pediment running behind the columns of the taller clerestory front. Palladio retained Alberti's motif of the triumphal-arch entrance. Although the facade was not built until after the architect's death, his original design was followed.

The interior of San Giorgio (fig. 18-62) is a fine example of Palladio's harmoniously balanced geometry, expressed here in strong verticals and powerful arcs. The tall engaged columns and shorter pairs of pilasters of the nave arcade echo the two levels of orders on the facade, thus unifying the building's exterior and interior.

Palladio's versatility can best be seen in numerous villas built early in his career. In the 1560s, he started his most famous and influential villa just outside Vicenza (fig. 18-63). Although traditionally villas were working farms, Palladio designed this one as a retreat for relaxation (a party house). To afford views of the countryside, he placed an Ionic order porch on each face of the building, with a wide staircase leading up to it. The main living quarters are on the second level, as is usual in European palace architecture, and the lower level is reserved for the kitchen, storage, and other utility rooms. Upon its completion in 1569, the villa was dubbed the Villa Rotunda because it had been inspired by another rotunda (or round hall), the Roman Pantheon; after its purchase in 1591 by the Capra family, it became known as the Villa Capra. The villa plan (fig. 18-64) shows the

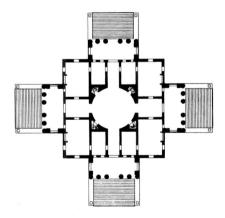

18-64. Plan of the Villa Rotunda. c. 1550.

Palladio was a scholar and an architectural theorist as well as a designer of buildings. His books on architecture provided ideal plans for country estates, using proportions derived from ancient Roman structures. Despite their theoretical bent, his writings were often more practical than earlier treatises. Perhaps his early experience as a stonemason provided him with the knowledge and self-confidence to approach technical problems and discuss them as clearly as he did theories of ideal proportion and uses of the classical orders. By the eighteenth century, Palladio's *Four Books of Architecture* had been included in the library of most educated people. Thomas Jefferson had one of the first copies in America.

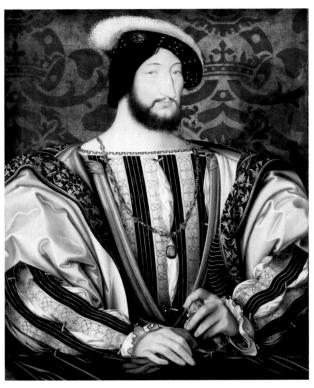

18-65. Jean Clouet. Francis I. 1525-30. Oil and tempera on wood panel, $37^{3/4} \times 29^{1/8}$ " (95.9 × 74 cm). Musée du Louvre, Paris.

geometric clarity of Palladio's conception: a circle inscribed in a small square inside a larger square, with symmetrical rectangular compartments and identical rectangular projections from each of its faces. The use of a central dome on a domestic building was a daring innovation that effectively secularized the dome. The Villa Rotunda was the first of what was to become a long tradition of domed country houses, particularly in England and the United States.

ART

RENAISSANCE The French had exerted military power in Italy since the end of the fifteenth century; IN FRANCE Italian Renaissance art, in turn, exerted its aesthetic

power over the French. The greatest French patron of Italian artists was Francis I (ruled 1515–47). Immediately after his ascent to the throne, Francis showed his desire to "modernize" the French court by acquiring the versatile talents of Leonardo da Vinci, who moved to France at his invitation in 1516 to advise on royal architectural projects. In 1526, Francis began a major campaign of supporting the arts, which he sustained throughout his reign, despite the distraction of continual wars against his brotherin-law, Emperor Charles V, to expand French territory. Under his patronage, an Italian-inspired Renaissance blossomed in France.

PAINTING

The Flemish-born artist Jean Clouet (c. 1485-c. 1540) found great favor as Francis's portraitist. Clouet's origins are obscure, but he was in France as early as 1509 and in 1530 moved to Paris as principal court painter. In his official portrait of the king (fig. 18-65), Clouet softened Francis's distinctive features but did not completely idealize them. The king's thick neck seems at odds with the delicately worked costume of silk, satin, velvet, jewels, and gold embroidery, and his shoulders are broadened by elaborate, puffy sleeves to more than fill the panel, much as parade armor turned scrawny men into giants. In creating such official portraits, artists sketched the subject, then painted a prototype that, upon approval, was the model for numerous replicas for diplomatic and family purposes. The clothing and jewels could be painted separately; lent to the artists by the subjects, they were sometimes modeled by a servant.

ARCHITECTURE AND ITS DECORATION

With the enthusiasm of Francis for things Italian and the widening distribution of Italian books on architecture, the Italian Renaissance style began to appear in French construction. Builders of elegant rural palaces, called châteaux, were quick to introduce Italianate decoration on otherwise Gothic buildings, but French architects soon adapted classical principles of building design as

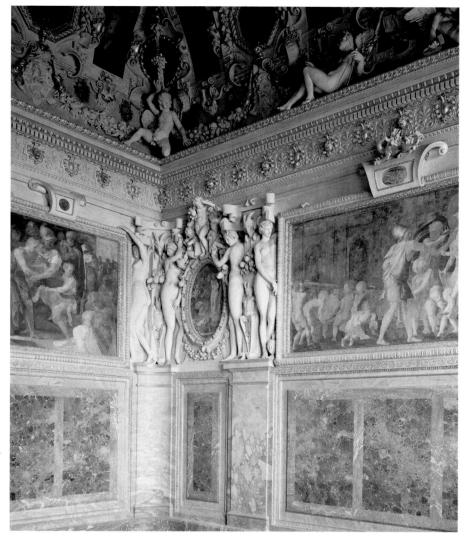

18-66. Primaticcio. Stucco and wall painting, Chamber of the Duchess of Étampes, Château of Fontainebleau, France. 1540s.

Primaticcio worked on the decoration of Fontainebleau from 1532 until his death in 1570. During that time, he also commissioned and imported a large number of copies and casts of original Roman sculpture, from the newly discovered *Laocoön* to the relief decoration on the Column of Trajan. These works provided an invaluable visual source of figures and techniques for the northern artists employed on the Fontainebleau project.

well. The king also began renovation of royal properties. Having chosen as his primary residence the medieval hunting lodge at Fontainebleau, Francis began transforming it into a grand palace. Most of the exterior structure was altered or destroyed by later renovations, but parts of the interior decoration, mainly the work of artists and artisans from Italy, have been preserved and restored. The first artistic director at Fontainebleau, the Mannerist painter Rosso Fiorentino (d. 1540), arrived in 1530. Francesco Primaticcio (1504–70), who had worked with Giulio Romano in Mantua, joined him in 1532 and succeeded him in 1540.

Following ancient tradition, the king maintained an official mistress—Anne, the duchess of Étampes, who was in residence at Fontainebleau. Among Primaticcio's

first projects was the redecoration of Anne's rooms and the stair leading to them (fig. 18-66). The artist combined woodworking, stucco relief, and fresco painting in his complex but lighthearted and graceful interior design. The lithe figures of stucco nymphs, with their long necks and small heads, recall Parmigianino's painting style (see fig. 18-52). Their spiraling postures are playfully sexual. The wall surface is almost overwhelmed with garlands, mythological figures, and Roman architectural ornament, yet the visual effect is extraordinarily confident and joyous. The first School of Fontainebleau, as this Italian phase of the palace decoration is called, established a tradition of Mannerism in painting and interior design that spread to other centers in France and the Netherlands.

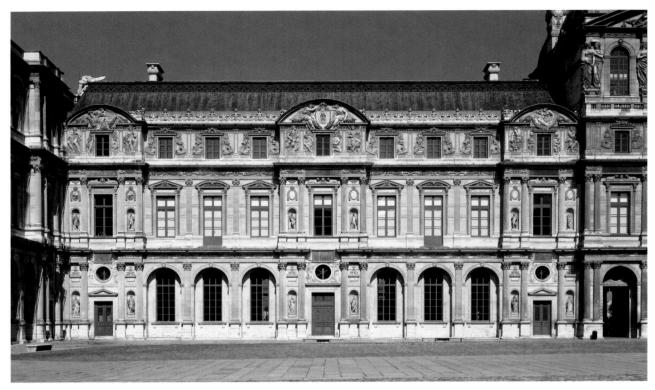

18-67. Pierre Lescot. West wing of the Cour Carré, Palais du Louvre, Paris. Begun 1546.

18-68. Attributed to Bernard Palissy. Oval plate in *"style rustique."* 1570–80/90 (?). Polychromed tin and glazed earthenware, length 20¹/₂" (52 cm). Musée du Louvre, Paris.

Paris at midcentury saw the birth of a more classical style. In 1546, the king decided to modernize the Louvre, a medieval castle in Paris. The work began with the replacement of the west wing of the square court, the Cour Carré (fig. 18-67), by the architect Pierre Lescot (c. 1515–78). Working with the sculptor Jean Goujon (1510–68), Lescot designed a building incorporating Renaissance ideals of balance and regularity with classi-

cal architectural details and rich sculptural decoration. **Turrets** with pointed roofs gave way to discreetly rounded arches, breaking the line of the facade. Classical pilasters and entablatures replaced Gothic buttresses and **stringcourses**. Pediments topped a round-arched arcade on the ground floor, suggesting an Italian *loggia*. The final effect of the building, with its rectangular windows and sumptuous decoration, is elegantly French.

Gardens played an important role in architectural designs. Usually intended to be viewed from the owners' principal rooms on the main (second) floor, Renaissance gardens had regular plantings, often in intricate patterns enlivened by sculpture and sometimes witty surprises such as trick fountains. For the gardens of the proposed Tuileries Palace facing the Louvre, Bernard Palissy (1510-89) created an earthenware grotto in 1567 (see "The Grotto," page 710). It was decorated entirely with glazed ceramic rocks, shells, crumbling statues, water creatures, a cat stalking birds, ferns, and garlands of fruits and vegetation—all reportedly made from casts of actual creatures and plants. In 1563, Palissy had been appointed the court's "inventor of rustic figurines." He also was called the Huguenot potter because of his Protestant faith and was repeatedly arrested during a period of persecution of Protestants. He died in prison, and at about the same time, his Tuileries grotto was destroyed. We can imagine its appearance from the distinctive ceramic platters decorated in high relief with plants, reptiles, and insects in the same style and technique as was the grotto (fig. 18-68). Existing examples are best called Palissy-style works, however, because

their authenticity is nearly impossible to prove. His designs were copied until the seventeenth century, and pieces in his style are still made today.

RENAISSANCE ART IN SPAIN

Philip II, the only son of Holy Roman Emperor Charles V and Isabella of Portugal, became the king of Spain, the

Netherlands, and the Americas, as well as ruler of Milan, Burgundy, and Naples, when his father abdicated. He preferred Spain as his permanent residence. From an early age, Philip was a serious art collector: For more than half a century, he patronized and supported artists in Spain and abroad. During his long reign (1556–98), the zenith of Spanish power, Spain halted the advance of Islam in the Mediterranean and secured control of much of the Americas. Despite enormous effort and wealth, however, Philip could not suppress the revolt of the northern Netherlands, nor could he prevail in his war against the English, who destroyed his navy, the famous Spanish Armada, in 1588.

ARCHITECTURE

Philip built El Escorial (fig. 18-69), the great monastery-palace complex outside Madrid, partly to comply with his father's direction to construct a "pantheon" in which all Spanish kings might be buried and partly to house his court and government. The basic plan was a collaboration between Philip and Juan Bautista de Toledo (d. 1567), Michelangelo's supervisor of work at Saint Peter's from 1546 to 1548, summoned from Italy in 1559. Juan Bautista's design reflected his indoctrination in Bramante's classical principles in Rome, but the king himself dictated its severity and size, and El Escorial's grandeur comes from its large size, excellent masonry, and fine proportions.

The complex includes not only the royal residence but also the Royal Monastery of San Lorenzo, a school, a library, and a church whose crypt served as the royal burial chamber. In 1572, Juan Bautista's original assistant, Juan de Herrera, was appointed architect and immediately changed the design, adding second stories on all wings and breaking the horizontality of the main facade with a central frontispiece that resembled superimposed temple fronts. Before beginning the church in the center of the complex, Philip solicited the advice of Italian architects—including Vignola and Palladio. The final design combined ideas that Philip approved and Herrera carried out. Although not a replica of any Italian design, the building embodies Italian classicism in its geometric clarity and symmetry and the use of super-imposed orders on the temple-front facade.

PAINTING

The most famous painter in Spain in the last quarter of the sixteenth century was the Greek painter Domenikos Theotokopoulos (1541–1614), who arrived in 1577 after working for ten years in Italy. El Greco ("The Greek"), as he is called, was trained as an icon painter in the Byzantine manner in his native Crete, then under Venetian

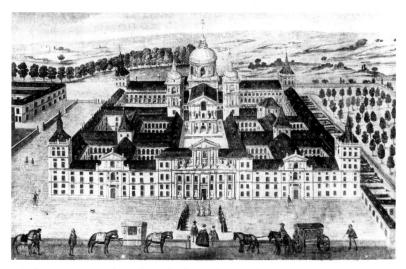

18-69. Juan Bautista de Toledo and Juan de Herrera. El Escorial, Madrid. 1563–84. Detail from an anonymous 18th-century painting.

rule. In about 1566, he went to Venice and entered Titian's shop, but he must also have closely studied the paintings of Tintoretto and Veronese. From about 1570 to 1577, he worked in Rome, apparently without finding sufficient patronage. Probably encouraged by Spanish Church officials he met in Rome, El Greco settled in Toledo, in central Spain, where he soon received major commissions. He had apparently hoped for a court appointment, but Philip II disliked the one large painting he had commissioned from the artist for El Escorial and never gave him work again. Toledo was an important cultural center, and El Greco joined the circle of humanist scholars who dominated its intellectual life.

An intense religious revival was under way in Spain, expressed in the impassioned preaching of Ignatius of Loyola, as well as in the poetry of the two great Spanish mystics, Saint Teresa of Ávila (1515–82) and her follower Saint John of the Cross (1542–91). El Greco's style—rooted in Byzantine religious art but strongly reflecting Venetian artists' rich colors and loose brushwork—expressed in paint the intense spirituality of these mystics.

In 1586, the Orgaz family commissioned El Greco to paint a large altarpiece honoring an illustrious fourteenth-century ancestor, Count Orgaz. The count had been a great benefactor of the Church, and at his funeral Saints Augustine and Stephen were said to have appeared and lowered his body into his tomb as his soul simultaneously was seen ascending to heaven. In El Greco's painting the Burial of Count Orgaz (fig. 18-70, page 706), the miraculous burial takes place slightly offcenter in the foreground, while an angel lifts Orgaz's tiny ghostly soul along the central axis through the heavenly hosts toward the enthroned Christ at the apex of the canvas. El Greco filled the space around the burial scene with a group portrait of the local aristocracy and religious notables. He placed his own eight-year-old son at the lower left next to Saint Stephen and signed the painting

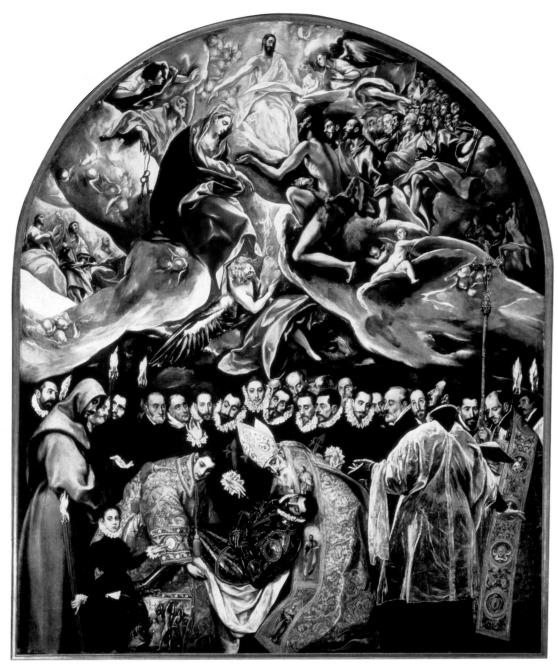

18-70. El Greco. *Burial of Count Orgaz.* 1586. Oil on canvas, $16' \times 11'10''$ (4.88 \times 3.61 m). Church of Santo Tomé, Toledo, Spain.

on the boy's white kerchief. El Greco may also have put his own features on the man just above the saint's head, the only one who looks straight out at the viewer.

In composing the painting, El Greco used a Mannerist device reminiscent of Pontormo, filling up the pictorial field with figures and eliminating specific reference to the spatial setting (see fig. 18-51). Yet he has distinguished between heaven and earth by the elongation of the heavenly figures and the light emanating from Christ, who sheds an otherworldly luminescence quite unlike the natural light below. The two realms are connected, however, by the descent of the light from heaven to strike the priestly figure in the white vestment at the lower right.

Late in his life, El Greco painted one of his rare landscapes, *View of Toledo* (fig. 18-71), a topographical cityscape transformed into a mystical illusion by a stormy sky and a narrowly restricted palette of greens and grays. This conception is very different from Altdorfer's peaceful, idealized *Danube Landscape* of nearly a century earlier (see fig. 18-41). If any precedent comes to mind, it is the lightning-rent sky and prestorm atmosphere in Giorgione's *The Tempest* (see fig. 18-24). In El Greco's painting, the precisely accurate portrayal of Toledo's geography and architecture seems to have been overridden by the artist's desire to convey his emotional response to the city, his adopted home.

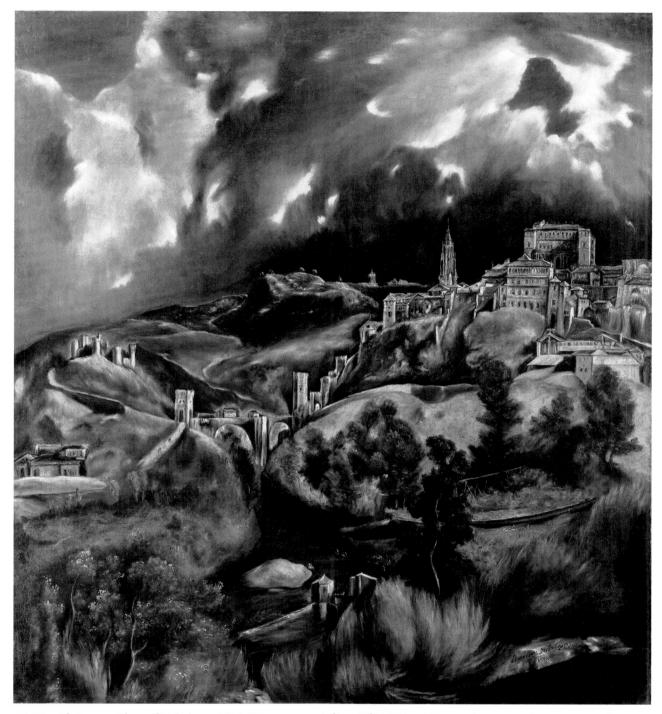

18-71. El Greco. View of Toledo. c. 1610. Oil on canvas, $47^3/_4 \times 42^3/_4$ " (121 × 109 cm). The Metropolitan Museum of Art,

The H. O. Havemeyer Collection. Bequest of Mrs. H. O. Havemeyer, 1929 (29.100.6)

PAINTING

RENAISSANCE In the Netherlands, a region that included Holland and Belgium, the sixteenth centu-IN THE ry was an age of bitter reli-**NETHERLANDS** gious and political conflict. Despite the opposition of

Charles V, who instituted book burnings and, in 1522, the Inquisition, the Protestant Reformation took hold in the northern provinces. Seeds of unrest were sown still deeper over the course of the century by continued religious persecution, economic hardship, and control by a distant king-Charles's son Philip II, in Spain. A long battle for independence began with a revolt in 1568 and lasted until Spain relinquished all claims to the region eighty years later. But as early as 1579, when the seven northern Protestant provinces declared themselves the United Provinces, the discord split the Netherlands, eventually dividing it along religious lines into Holland and Belgium.

Even with the turmoil, the Netherlanders found the resources to pay for art. Strong, affluent art centers, such as

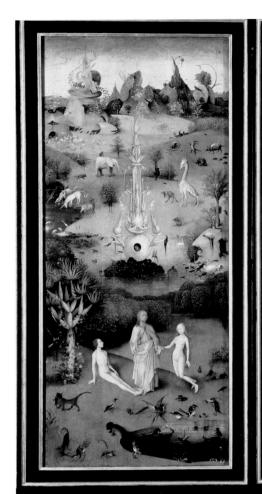

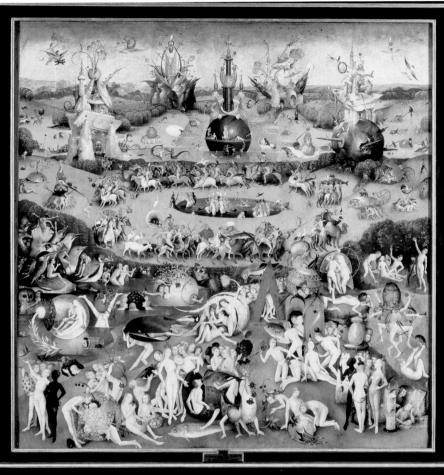

18-72. Hieronymus Bosch. Garden of Earthly Delights. c. 1505–15. Oil on wood panel, center panel $7'2^{1}/2'' \times 6'4^{3}/4''$ (2.20 × 1.95 m), each wing $7'2^{1}/2'' \times 3'2''$ (2.20 × 0.97 m). Museo del Prado, Madrid.

This work was commissioned by an aristocrat for his Brussels town house, and the artist's choice of a triptych format, which suggests an altarpiece, may have been an understated irony. As a secular work, the *Garden of Earthly Delights* may well have inspired lively discussion and even ribald comment, much as it does today in its museum setting. Despite—or perhaps because of—its bizarre subject matter, the triptych was copied in 1566 into tapestry versions, one (now in El Escorial, Madrid) for a cardinal and another for Francis I. At least one painted copy was made as well. Bosch's original triptych was sold at the onset of the Netherlands's revolt and sent in 1568 to Spain, where it entered the collection of Philip II.

Utrecht, developed in the north. In addition to painting, textile arts flourished in the Netherlands. Antwerp and Brussels were both centers of tapestry weaving and received such commissions as the Sistine Chapel tapestries, for which Raphael provided the cartoons (see fig. 18-10). Although the Roman Catholic Church continued to commission works of art, the religious controversies led Netherlandish artists to seek private patrons. A market existed for small paintings of secular subjects that were both decorative and interesting conversation pieces for homes. Certain subjects were so popular later in the century that some artists became specialists, rapidly producing variations on a particular theme, with the help of assistants.

Hieronymus Bosch. One of the greatest of the Netherlandish painters is Hieronymus Bosch (1450–1516), whose work depicts a world of fantastic imagination associated with medieval art. A superb colorist and technical virtuoso, Bosch spent his career in the town whose name he adopted, 's Hertogenbosch, near the German

border. Bosch's religious devotion is certain, and his range of subjects shows that he was well educated; a man of many talents, he was also a hydraulic engineer who designed fountains and civic waterworks.

Challenging and unsettling paintings such as Bosch's triptych *Garden of Earthly Delights* (fig. 18-72) have led modern critics to label him scholar, mystic, and social critic. There are many interpretations of the *Garden*, but a few broad conclusions can be drawn. The subject of the overall work is sin—that is, the Christian belief in human beings' natural state of sinfulness and their inability to save themselves from its consequences. Because only the damned are shown in the Last Judgment on the right, the work seems to caution that damnation is the natural outcome of a life lived in ignorance and folly, that people ensure their damnation through their self-centered pursuit of pleasures of the flesh—the sins of gluttony, lust, avarice, and sloth.

The introduction of Adam and Eve, at the left, is brought about by Christ but is watched by the owl of

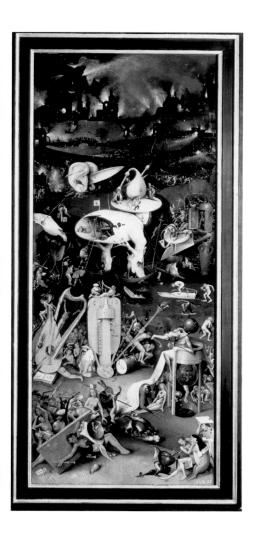

perverted wisdom. Appearing repeatedly, the owl symbolizes both wisdom and folly—a concept as important as sin to the northern humanists, who believed in the power of education: People would choose the right way if they knew it. Here the owl is in a fantastic plant in a lake from which vicious creatures creep out into the world. Bosch seems obsessed with hybrid forms, unnatural unions in the world. In the central panel, the earth teems with revelers, monstrous birds, and fruits symbolic of fertility and sexual abandon. In hell, the sensual pleasures—eating, drinking, music, and dancing—are turned into elements of torture in a dark world of fire and ice. At the right, for example, a central creature with stump legs watches his own stomach filled with lost souls in a tavern on the road to hell.

One interesting interpretation of the central panel proposes that it is a parable on human salvation in which the practice of alchemy—the process that sought to turn common metals into gold—parallels Christ's power to convert human dross into spiritual gold. In this theory, the bizarre fountain at the center of the lake in the middle distance can be seen as an alchemical "marrying chamber," complete with the glass vessels for collecting the vapors of distillation. The central pool is the setting where the power of the seductive woman—a relatively new theme in the fifteenth century—is presented: Women frolic alluringly in the pool while men dance and

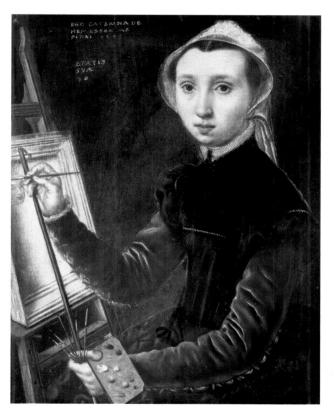

18-73. Caterina van Hemessen. *Self-Portrait*. 1548. Oil on wood panel, $12^1/_4 \times 9^1/_4$ " (31.1 \times 23.5 cm). Öffentliche Kunstsammlung, Basel, Switzerland.

The panel on the easel already has its frame. Catherine holds a small palette and brushes and steadies her right hand with a mahlstick, an essential tool for an artist doing fine, detailed work.

ride madly, trying to attract them. In this strange garden, men are slaves to their own lust.

One critic wrote about 1600 that the triptych was known as *The Strawberry Plant* because it resembled the "vanity and glory and the passing taste of strawberries or the strawberry plant and its pleasant odor that is hardly remembered once it has passed." Luscious fruits with sexual symbolism—strawberries, cherries, grapes, and pomegranates—appear everywhere in the *Garden*, serving as food, as shelter, and even as a boat. Therefore, the subject of sin is reinforced by the suggestion that life is as fleeting and insubstantial as the taste of a strawberry.

Caterina van Hemessen. With a style profoundly different from Bosch's, Caterina van Hemessen (1528–87) of Antwerp developed an illustrious international reputation. She had learned to paint from her father, the Flemish Mannerist Jan Sanders van Hemessen, with whom she collaborated on large commissions, but her quiet realism and skilled rendering had roots in the classical Renaissance style—stylistic tendencies brought back to the Netherlands by painters who had visited Italy. To maintain the focus on the foreground subject, Caterina painted her portrait backgrounds in an even, dark color on which she identified her subject and the subject's age, and signed and dated the work. In her Self-Portrait (fig. 18-73), the inscription reads: "I Caterina van

THE GROTTO

Of all the enchanting features of the Renaissance garden, none is more intriguing than a grotto, a recess typically constructed of irregular stones and shells and covered with fictive foliage and slime to suggest a natural cave. The fancifully decorated grotto usually included a spring, pool, fountain, or other waterworks. Sculpture of earth giants might support its walls, and depictions of nymphs might suggest the source of the water that nourished the garden. Great Renaissance gardens had at least one grotto where one could commune with nymphs and Muses and escape the summer heat. Alberti recommended that the contrived grotto be covered "with green wax, in imitation of mossy Slime which we always see in moist grottoes" (Alberti, On Architecture, 9.4).

The Great Grotto of the Boboli Gardens of the Pitti Palace in Florence, designed by Bernardo Buontalenti in 1583 and constructed in 1587–93, contained four marble captives (originally conceived for the tomb of Pope Julius II) carved by Michelangelo and, in its inner cave, a 1592 copy of the *Venus* by Giovanni da Bologna (see fig. 18-56).

Flowing water operated fountains, hydraulic organs, and other devices, such as mechanical birds that fluttered their wings and chirped or sang, filling the grotto with noise, if not music. Water jets concealed in the floor, stairs, or crevasses in the rockwork could be turned on by the owner to drench his guests, to the great amusement

of all. Two of the most charming garden grottoes were designed by Bernard Palissy for Catherine de Medici, Queen of France, at the Château of Écouten (1570–72) and in the Tuileries Gardens in Paris (1563). Palissy's grottoes were made

entirely of glazed ceramic, including fish and crayfish seeming to swim in the pool and reptiles slithering or creeping over mossy rocks—all of which glistened with water and surely achieved Alberti's ideal Slime.

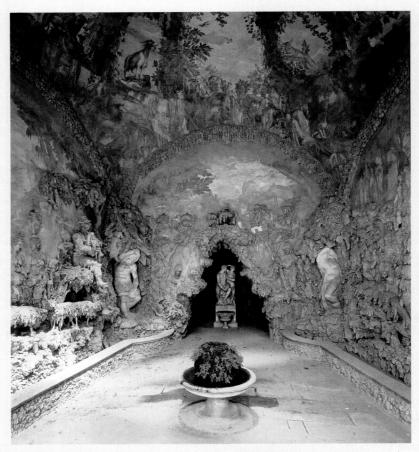

Bernardo Buontalenti. The Great Grotto, Boboli Gardens, Pitti Palace, Florence. 1583-93.

Hemessen painted myself in 1548. Her age 20." In delineating her own features, Caterina presented a serious young person without personal vanity yet seemingly already self-assured about her artistic abilities. During her early career, spent in Antwerp, she became a favored court artist to Mary of Hungary, regent of the Netherlands and sister of Emperor Charles V, for whom she painted not only portraits but also religious works. In 1554, Caterina married the organist of Antwerp Cathedral, and the couple accompanied Mary to Spain after she ceased to be regent in 1556. Unfortunately, Caterina's Spanish works have not survived or cannot be securely attributed to her.

Pieter Bruegel the Elder. So popular did the works of Hieronymus Bosch remain that, nearly half a century after his death, Pieter Bruegel (c. 1525–69) began his ca-

reer by imitating Bosch's work. Fortunately, Bruegel's talents went far beyond those of an ordinary copyist, but like his predecessor he often painted large narrative works crowded with figures and chose moralizing or satirical subject matter. Nothing is known of his early training, but shortly after entering the Antwerp Guild in 1551, he spent time in Bologna and Rome, where he studied Michelangelo's *Sistine Ceiling* and other works in the Vatican.

Bruegel maintained a shop in Antwerp from 1554 until 1563, then moved to Brussels. His style and subjects found great favor with local scholars, merchants, and bankers, who appreciated the beautifully painted, artfully composed works that also reflected contemporary social, political, and religious conditions. Bruegel visited country fairs to sketch the farmers and townspeople who became the focus of his paintings, whether

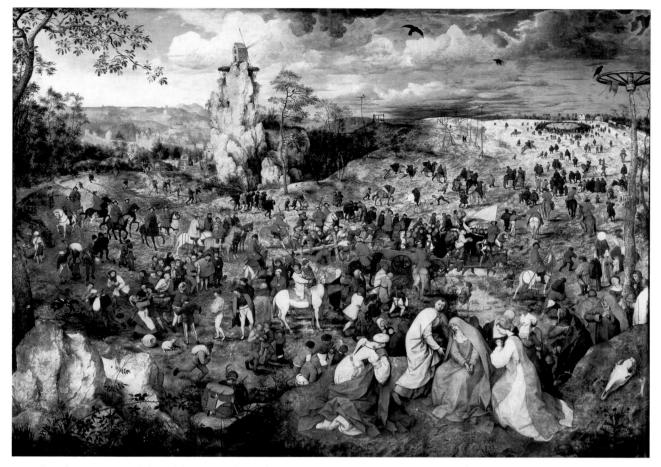

18-74. Pieter Bruegel the Elder. *Carrying of the Cross.* 1564. Oil on wood panel, $4'^3/_4" \times 5'7"$ (1.23 \times 1.7 m). Kunsthistorisches Museum, Vienna.

Christ, who has fallen under the weight of the cross, can be seen directly above the man on the white horse.

religious or secular. He depicted characters not as unique individuals but as well-observed types whose universality makes them familiar even today. Nevertheless, Bruegel presented Flemish farmers so vividly and sympathetically while also exposing their faults that the middle-class artist earned the nickname Peasant Bruegel.

True to his Mannerist heritage, Bruegel adopted Mannerist tricks of composition. The main subject of his pictures is often deliberately hidden or disguised by being placed in the distance or amid a teeming crowd of figures, as in the Carrying of the Cross (fig. 18-74) of 1564. At first glance, the large figures—Saint John and the three Marys-near the picture plane at the lower right seem to be the subject, but they are in fact secondary to the main event: Jesus carrying his Cross to Golgotha. To find Jesus, the viewer must visually enter the painting and search for the principal action while being constantly distracted by smaller dramas going on among the crowd milling about the large open field or surging around the dire events central to the painting. Bruegel's panoramic scene is carefully composed to guide our eye in swirling, circular orbits that expand, contract, and intersect. Part of this movement is accomplished by carefully placed bright red patches, the coats of guards trying to control the crowd. The figure of Jesus is finally discovered at the center of the painting. Far in the distance, on a hill caught by a beam of light in the darkening sky, people are gathering early to get a good place in the circle around the spot where the crosses will be set up—illustrating Bruegel's cynical view of crowd psychology. The landscape recedes skillfully and apparently naturally toward the distant horizon, except for the tall rock outcropping near the center with a wooden windmill on top. The exaggerated shape of the rock is a convention of sixteenth-century northern European landscapes, but the enigmatic windmill suggests the ambiguities of Italian Mannerism.

Bruegel was one of the great landscape painters of all time. His ability to depict nature in all seasons, and in all moods, shines forth in his **cycles**—series of paintings on a single allegorical subject such as the Five Senses or the Seasons, frequently commissioned as decorations for elegant Netherlandish homes. Bruegel's *Return of the Hunters* (fig. 18-75, page 712) of 1565 is one of a cycle of six panels, each representing two months of the year. In this November–December scene, Bruegel has captured the atmosphere of the damp, cold winter, with its early

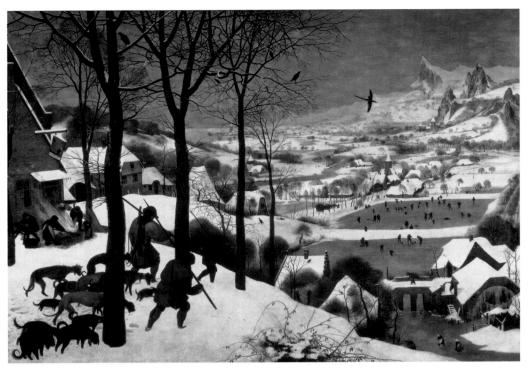

18-75. Pieter Bruegel the Elder. Return of the Hunters. 1565. Oil on wood panel, $3'10^{1}/2" \times 5'3^{3}/4"$ (1.18 × 1.61 m). Kunsthistorisches Museum, Vienna.

Between 1551 and 1554 Bruegel traveled through the Alps to Italy—to Rome, Naples, and all the way to Sicily. Unlike many Renaissance artists, he did not record the ruins of ancient Rome or the wonders of the Italian cities. Instead, he seems to have been fascinated by the landscape, particularly the formidable jagged rocks and sweeping panoramic views of Alpine valleys, which he recorded in detailed drawings. Back home in his studio, he made an impressive leap of the imagination as he painted the flat and rolling lands of Flanders as broad panoramas, even adding imaginary mountains on the horizon.

nightfall, in the same way that his compatriots the Limbourgs did 150 years earlier in the February calendar illustration for the duke of Berry (see fig. 17-6). At first, the Hunters appears neutral and realistic, but the sharp plunge into space, the juxtaposition of near and far without middle ground, is typically Mannerist. The viewer seems to hover with the birds slightly above the ground, looking down first on the busy foreground scene, then suddenly across the valley to the snowcovered village and frozen ponds. The main subjects of the painting, the hunters, have their backs turned and do not reveal their feelings as they slog through the snow, trailed by their dogs. They pass an inn, at the left, where a worker moves a table to receive the pig others are singeing in a fire before butchering it. But this is clearly not an accidental image; it is a slice of everyday life faithfully reproduced within the carefully calculated composition. The sharp diagonals, both on the picture plane and as lines receding into space, are countered by the pointed gables and roofs at the lower right as well as by the jagged mountain peaks linking the valley and the skyline along the right edge. Their rhythms are deliberately slowed and stabilized by a balance of vertical tree trunks and horizontal rectangles of water frozen over in the distance.

As a depiction of Netherlandish history, this scene represents a relative calm before the storm. Three years after it was painted, the anguished struggle of the north-

ern provinces for independence from Spain began. Pieter the Elder died young in 1569, leaving two children, Pieter the Younger and Jan, both of whom became successful painters in the next century. The dynasty continued with Jan's son Jan the Younger. (In the seventeenth century, the spelling of the family name was changed from Bruegel to Brueghel.)

IN ENGLAND

RENAISSANCE England, in contrast to conti-ART nental Europe, was economically and politically stable enough to again provide sustained support for the arts

during the Tudor dynasty in the sixteenth century. Henry VIII was known for his love of music (he was himself a composer of considerable accomplishment); but he also competed with the wealthy, sophisticated courts of Francis I and Charles V in the visual arts. Direct contacts with Italy became difficult after Henry's break with the Roman Catholic Church in 1534, and the Tudors favored Netherlandish and German artists.

English architects fared better than English painters, developing a style that incorporated classical features as seen in illustrated architectural handbooks rather than through direct Italian influence. The first architectural manual in English, published in 1563, was written by John Shute, who had spent time in Italy. Also available were stylebooks and treatises by Flemish,

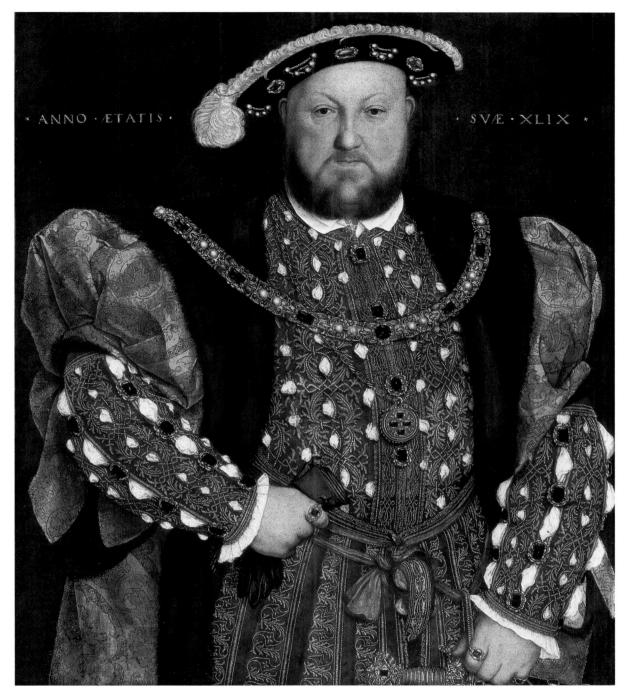

18-76. Hans Holbein the Younger. *Henry VIII*. 1540. Oil on wood panel, $32\frac{1}{2} \times 29\frac{1}{2}$ " (82.6 × 75 cm). Galleria Nazionale d'Arte Antica, Rome.

Holbein used the English king's great size to advantage for this official portrait, enhancing Henry's majestic figure with embroidered cloth, fur, and jewelry to create one of the most imposing images of power in the history of art. He is dressed for his wedding to his fourth wife, Anne of Cleves, on April 5, 1540.

French, and German architects, as well as a number of books on architectural design by the Italian architect Sebastiano Serlio.

PAINTING

A remarkable record of the appearance of Tudor monarchs survives in portraiture. Hans Holbein the Younger (c. 1497–1543), a German-born painter, shaped the taste of the English court. He first visited London from 1526 to

1528 and was introduced by the Dutch scholar Erasmus to the humanist circle around the statesman Thomas More. He returned to England in 1532 and was appointed court painter to Henry VIII about four years later. One of Holbein's official portraits of Henry (fig. 18-76), shown at age forty-nine according to the inscription on the dark blue-green background, was painted in 1540, although the king's dress and appearance had already been established in an earlier prototype based on sketches of

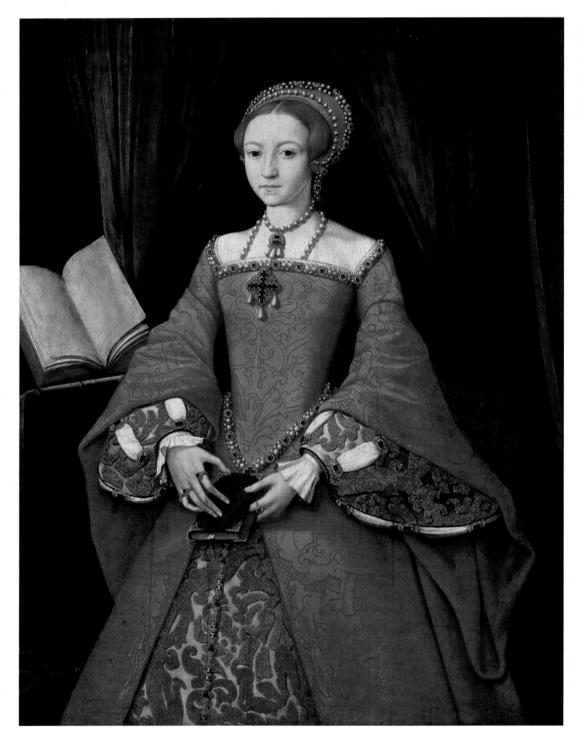

18-77. Attributed to Levina Bening Teerling or William Scrots. *Elizabeth I when Princess*. c. 1559. Oil on oak panel, $42^3/_4 \times 32^1/_4$ " (109 \times 81.8 cm). The Royal Collection, Windsor Castle, Windsor, England. (RCIN 404444, OM 46 WC 2010)

his features. Henry, who envied Francis I and attempted to outdo him in every way, imitated French fashions and even copied the French king's beard. Henry's huge frame—he was well over 6 feet tall and had a 54-inch waist in his maturity—is covered by the latest style of dress: a short puffed-sleeve coat of heavy brocade trimmed in dark fur; a narrow, stiff white collar fastened at the front; and a doublet, encrusted with gemstones and gold braid, that was slit to expose his silk shirt.

Holbein was not the highest-paid painter in Henry VIII's court. That status belonged to a Flemish woman named Levina Bening Teerling, who worked in England

for thirty years. Her anonymity in England is an arthistorical mystery. At Henry's invitation to become "King's Paintrix," she and her husband arrived in London in 1545 from Bruges, where her father was a leading manuscript illuminator. She maintained her court appointment until her death around 1576, in the reign of Elizabeth I. Because Levina was the granddaughter and daughter of Flemish manuscript illuminators, she is assumed to have painted mainly miniature portraits or scenes on vellum and ivory. One lifesize portrait frequently attributed to her—but by no means securely—depicts Elizabeth Tudor as a young princess (fig. 18-77).

Elizabeth's pearled headcap, an adaptation of the so-called French hood popularized by her mother, Anne Boleyn, is set back to expose her famous red hair. Her brocaded outer dress, worn over a rigid hoop, is split to expose an underskirt of cut velvet. Although her features are softened by youth and no doubt are idealized as well, her long, high-bridged nose and the fullness below her small lower lip give her a distinctive appearance. The prominently displayed books were no doubt included to signify Elizabeth's well-known love of learning.

About the time Elizabeth sat for this portrait, in 1551, her half brother, the Protestant Edward VI, was king, and her half sister, the Catholic Mary Tudor, was next in line for the throne. When she gained the throne in 1553, Queen Mary quickly reinstated Catholic practice, and in July 1554 she married the future King Philip II of Spain. She died four years later, and the Protestant princess Elizabeth assumed the throne. So effective was Elizabeth's rule (1558–1603) that the last decades of the sixteenth century in England are called the Elizabethan age.

In 1570, while Levina Teerling was still active at Elizabeth's court, Nicholas Hilliard (1547-1619) arrived in London from southwest England to pursue a career as a jeweler, goldsmith, and painter of miniatures. Hilliard never received a court appointment but worked instead on commission, creating miniature portraits of the queen and court notables, including George Clifford, third earl of Cumberland (fig. 18-78, page 716). This former admiral was a regular participant in the tilts (jousts) and festivals celebrating the anniversary of Elizabeth I's ascent to the throne. In Hilliard's miniature, Cumberland wears a richly engraved and gold-inlaid suit of armor, forged for his first appearance, in 1583, at the tilts (see "Armor for Royal Games," page 717). Hilliard had a special talent for giving his male subjects an appropriate air of courtly jauntiness. Cumberland, a man of about thirty with a stylish beard, mustache, and curled hair, is humanized by his direct gaze and unconcealed receding hairline. Cumberland's motto, "I bear lightning and water," is inscribed on a stormy sky, with a lightning bolt in the form of a caduceus (the classical staff with two entwined snakes), one of his emblems.

ARCHITECTURE

In the years after his 1534 break with the Roman Catholic Church, Henry VIII, as the newly declared head of the Church of England, dissolved the monastic communities in England, seized their land, and sold or gave it to favored courtiers. Many properties were bought by

speculators who divided and resold them. To increase support for the Tudor dynasty, Henry and his successors created a new nobility by granting titles to rich landowners and officials. To display their wealth and status, many of these newly created aristocrats embarked on extensive building projects after about 1550. They built lavish country residences, which sometimes surpassed the French châteaux in size and grandeur.

One of the grandest of all the Elizabethan houses was Hardwick Hall, the home of Elizabeth, Countess of Shrewsbury, known as Bess of Hardwick. The redoubtable countess-who inherited riches from all four of her deceased husbands—employed Robert Smythson (c. 1535-1614), the first English Renaissance professional architect, to build Hardwick Hall between 1591 and 1597, when she was in her seventies. At this time, Elizabethan architecture still reflected the Perpendicular style seen in Oxford colleges, with its severe walls and broad expanses of glass, although designers modernized the forms by replacing medieval ornament with classical details learned from architectural handbooks and pattern books. But Smythson's—and Bess's—plan for Hardwick was new. The medieval great hall became a two-story entrance hall, with other rooms arranged symmetrically around it—a nod to classical balance. A sequence of rooms leads to a grand stair up to the Long Gallery and High Great Chamber on the second floor (fig. 18-79, page 716), where the owners received guests, entertained, and sometimes dined. The hall had enormous windows, ornate fireplaces, and a richly carved and painted plaster frieze around the room. The frieze by the master Abraham Smith depicts Diana and her maiden hunters in a forest where they pursue stags and boars. In the window bay the frieze turns into an allegory on the seasons; Venus whipping Cupid represents spring, and the goddess Ceres, is summer. Smith based his allegories on Flemish prints. Graphic arts transmitted images from artist to artist much as photography does today.

Under Protestant patronage, art work was less overtly religious than that of the Catholic Church, but with grand palaces and portraits, the Protestants carried on the tradition of using the visual arts to promote a cause, to educate, and to glorify—just as the Catholic Church had over the centuries used great churches and religious art for their didactic as well as aesthetic values. While Protestantism had become firmly established, the effects of the Reformation and the Counter-Reformation would continue to reverberate in the arts of the following century throughout Europe and, across the Atlantic, in America.

18-78. Nicholas Hilliard. *George Clifford, 3rd Earl of Cumberland (1558–1605).* c. 1595. Watercolor on vellum on card, oval $2^3\!\!/_4 \times 2^3\!\!/_{16}"$

(7.1 × 5.8 cm). The Nelson-Atkins Museum of Art, Kansas City, Missouri.

Gift of Mr. and Mrs. John W. Starr through the Starr Foundation. F58-60/188

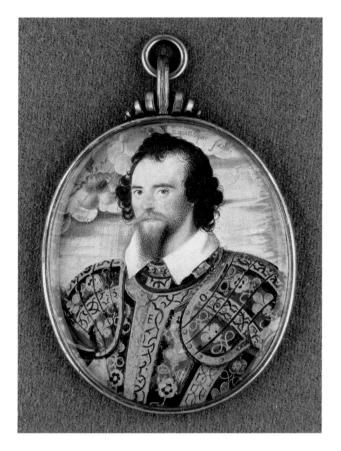

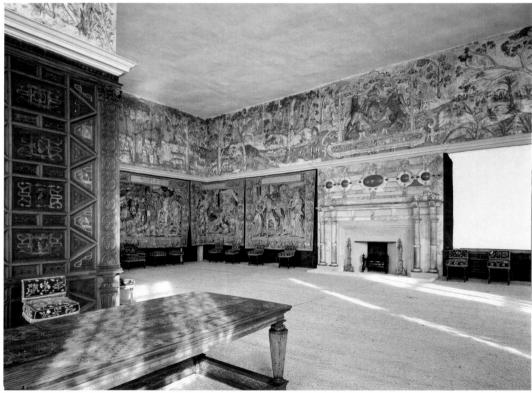

18-79. Robert Smythson. High Great Chamber, Hardwick Hall, Shrewsbury, England. 1591–97.

Elizabeth, Countess of Shrewsbury, who commissioned Smythson, participated actively in the design of her houses. (For example, she embellished the roofline with her initials, *ES*, in letters 4 feet tall.) This room was designed to accommodate sixteenth-century Brussels tapestries telling the story of Ulysses, which she had bought in 1587. Other decorations include painted plaster sculpture around the top of the walls by Abraham Smith on mythological themes, a carved and inlaid fireplace, and seventeenth-century Farthingale chairs. Rush matting covers the floor.

ARMOR FOR ROYAL GAMES

The medieval tradition of tilting, or jousting, competitions at English festivals and public celebrations continued during Renaissance times. Perhaps the most famous of these, the Accession Day Tilts were held annually to celebrate the anniversary of Elizabeth I's coronation. The gentlemen of the court, dressed in armor made especially for the occasion, rode their horses from opposite directions, trying to strike each other with long lances. Each pair of competitors galloped past each other six times, and the judges rated their performances the way boxers are awarded points today. Breaking a competitor's lance was comparable to a knockout.

The elegant armor worn by George Clifford, third earl of Cumberland, at the Accession Day Tilts has been preserved in a nearly complete state in the collection of The Metropolitan Museum of Art in New York. In honor of the queen, the armor's surface was decorated with engraved Tudor roses and back-to-back capital *Es.* As the Queen's Champion from 1590 on, Clifford also wore her jeweled glove attached to his helmet as he met all comers in the courtyard of Whitehall Palace in London.

Made by Jacob Halder in the royal armories at Greenwich, the 60-pound suit of armor is recorded in the sixteenth-century Almain Armourers Album along with its "exchange pieces." These allowed the owner to vary his appearance by changing mitts, side pieces, or leg protectors, and also provided back-up pieces if one were damaged.

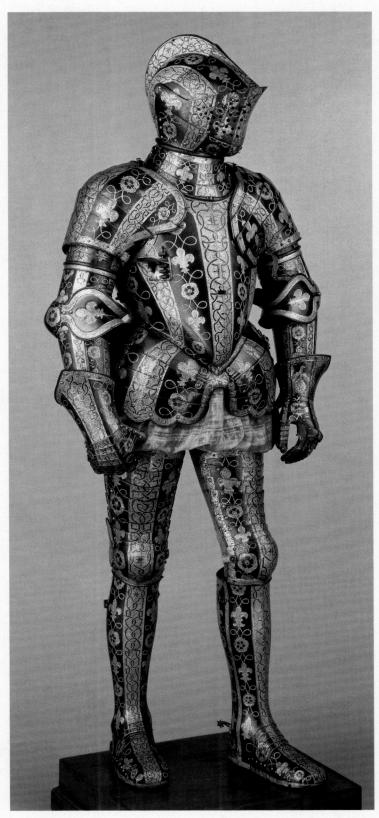

Jacob Halder. Armor of George Clifford, 3rd Earl of Cumberland, made in the royal workshop at Greenwich, England. c. 1580–85. Steel and gold, height $5'9^1/_2''$ (1.77 m). The Metropolitan Museum of Art, New York. Munsey Fund, 1932 (32.130.6)

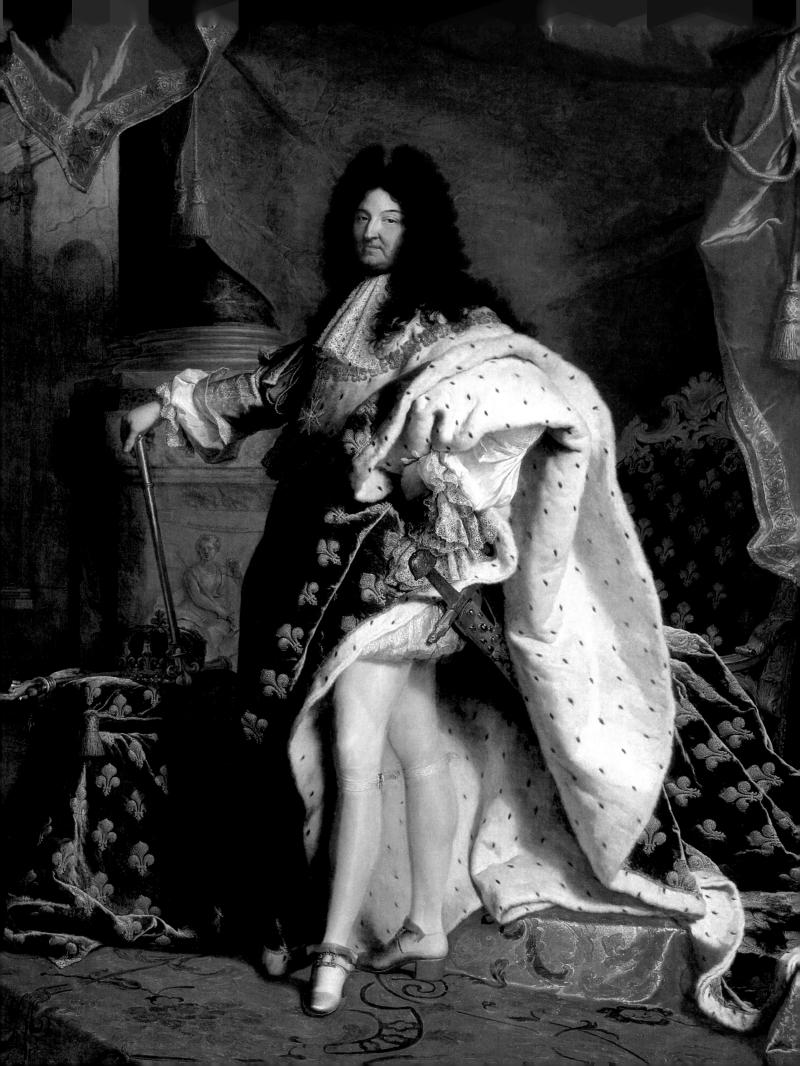

$\mathbb{I}^{\mathbb{Q}}$

BAROQUE ART IN EUROPE AND NORTH AMERICA

N HYACINTHE RIGAUD'S 1701 PORTRAIT OF LOUIS XIV (FIG. 19-1), THE RICHLY costumed monarch known as le Roi Soleil ("the Sun King") is presented to us by an unseen hand that pulls aside a huge billowing curtain. Showing off his elegant legs, of which he was quite proud, the sixty-three-year-old French monarch poses in an elaborate robe of state, decorated with gold *fleurs-de-lis* and white ermine, and he wears the red-heeled built-up shoes he had invented to compensate for his short stature. At first glance, the face under the huge wig seems almost incidental to the overall grandeur. Yet the directness of Louis XIV's gaze makes him movingly human despite the pompous pose and the overwhelming magnificence that surrounds him. Rigaud's genius in portraiture was always to capture a good likeness while idealizing his subjects' less attractive features and giving minute attention to the virtuoso rendering of textures and materials of the costume and setting.

Louis XIV had ordered this portrait as a gift for his grandson Philip, but when Rigaud finished the painting, Louis liked it so much that he kept it. Three years later, Louis ordered a copy from Rigaud to give his grandson, now Philip V of Spain (ruled 1700–46). The request for copies of portraits was not unusual, for the royal and aristocratic families of Europe were linked through marriage, and paintings made appropriate gifts for relatives. Rigaud's workshop produced between thirty and forty portraits a year. His portraits varied in price according to whether the entire figure was painted from life or whether Rigaud merely added a portrait head to a stock figure in a composition he had designed for his workshop to execute.

Rigaud's long career spanned a time of great change in Western art. Not only did new manners of representation emerge, but where art had once been under the patronage of the Church and the aristocracy, a kind of broad-based commercialism arose that was reflected both by portrait workshops such as Rigaud's and by the thousands of still-life and landscape painters producing works for the many households that could now afford them. These changes of the seventeenth and eighteenth centuries—the Baroque period in Europe—took place in a cultural context in which individuals and organizations were grappling with the effects of religious upheaval, economic growth, colonial expansion, political turbulence, and a dramatic explosion of scientific knowledge.

1618-48 THIRTY YEARS' WAR ▲ 1620 MAYFLOWER LANDS IN NORTH AMERICA

1633 GALILEO FORCED TO RECANT▲ 1643-1715 LOUIS XIV OF FRANCE 1648 FRENCH ROYAL ACADEMY OF PAINTING AND SCULPUTURE 1648 SPAIN RECOGNIZES INDEPENDENCE OF UNITED PROVINCES 1649 CHARLES I OF ENGLAND BEHEADED; ENGLAND A COMMONWEALTH

TIMELINE 19-1. The Seventeenth Century in Europe and North America. Scientific inventions and observations and national wars motivated by religious differences mark the seventeenth century in Europe.

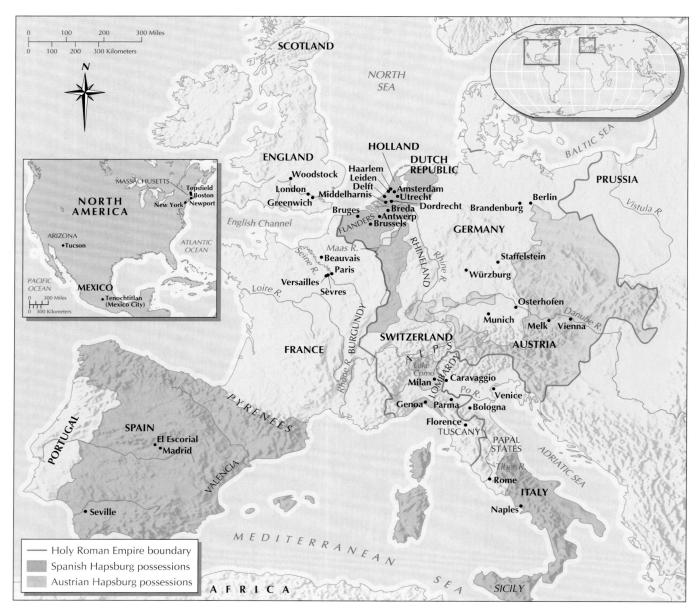

Map 19-1. The Seventeenth Century in Europe and North America.

Protestantism dominated in northern Europe, while Roman Catholicism remained strong after the Counter-Reformation in southern Europe.

THE **BAROOUE**

By the seventeenth century, Protestantism was established firmly and irrevocably in much of northern Eu-**PERIOD** rope (Map 19-1). The permanent division within Europe between

Roman Catholicism and Protestantism had a critical effect on European art. In response to the Protestant Reformation of the early sixteenth century, the Roman Catholic Church had embarked in the 1540s on a program of renewal that came to be known as the Counter-

Reformation. As part of the program that came to fruition in the seventeenth century, the Church used art to encourage piety among the faithful and to persuade those it regarded as heretics to return to the fold. Counter-Reformation art was intended to be both doctrinally correct and visually and emotionally appealing so that it could influence the largest possible audience. Both the Catholic Church and the Catholic nobility supported ambitious building and decoration projects to achieve these ends.

▲ 1675 MICROSCOPE INVENTED

▲1671 FRENCH ROYAL ACADEMY OF ARCHITECTURE

▲ 1689 GLORIOUS REVOLUTION IN ENGLAND

1698 STEAM ENGINE INVENTED A

SCIENCE AND THE CHANGING WORLDVIEW

Investigations of the natural world that had begun during the Renaissance changed the way people of the seventeenth and eighteenth centuries—including artists—saw the world. Some of the new discoveries brought a sense of the grand scale of the universe without, while others focused on the minute complexity of the world within. As frames of reference expanded and contracted, artists found new ways to mirror these changing perspectives in their own works.

The philosophers Francis Bacon (1561-1626) of England and René Descartes (1596-1650) of France established a new, scientific method of studying the world by insisting on scrupulous objectivity and logical reasoning. Bacon proposed that facts be established by observation and tested by controlled experiments. Descartes argued for the deductive method of reasoning, in which a conclusion was arrived at logically from basic premises—the most fundamental example being "I think, therefore I am." Seventeenthcentury scientists continued to believe that God had created matter. the basis of all things, and that their discoveries simply amplified human understanding of Creation, adding to God's glory. Church authorities, however, often disagreed.

In 1543, the Polish scholar Nicolaus Copernicus (1473-1543) published On the Revolutions of the Heavenly Spheres, which contradicted the long-held view that Earth is the center of the universe (the Ptolemaic theory) by arguing that Earth and other planets revolve around the Sun. The Church viewed the Copernican theory as a challenge to its doctrines and put On the Revolutions of the Heavenly Spheres on its Index of Prohibited Books in 1616. At the beginning of the seventeenth century, Johannes Kepler (1571-1630), the court mathematician and astronomer to Holy Roman Emperor Rudolf II, demonstrated that the planets revolve around the Sun in elliptical orbits. Kepler noted a number of interrelated dynamic geometric patterns in the universe, the overall design of which he believed was an expression of divine order.

Galileo Galilei (1564–1642), an astronomer, mathematician, and physicist, was the first to develop the telescope as a tool for observing the heavens. His findings provided further confirmation of the Copernican theory, but since the Church prohibited teaching that theory, Galileo was tried for heresy by the

Inquisition. Under duress, he publicly recanted his views, although at the end of his trial, according to legend, he muttered, "Nevertheless it [Earth] does move." As the first person to see the craters of the moon through a telescope, Galileo began the exploration of space that led humans to take their first steps on the moon in 1969.

Seventeenth-century science explored not only the vastness of outer space but also the smallest elements of inner space, thanks to the invention of the microscope by the Dutch lens maker and amateur scientist Antoni van Leeuwenhoek (1632-1723). Although embroiderers, textile inspectors, manuscript illuminators, and painters had long used magnifying glasses in their work, Leeuwenhoek perfected grinding techniques and increased the power of his lenses far beyond what those uses required. Ultimately, he was able to study the inner workings of plants and animals and even see microorganisms. Early scientists learned to draw or depended on artists to draw the images revealed by the microscope for further study and publication. Not until the discovery of photography in the nineteenth century could scientists communicate their discoveries without an artist's help.

Civic projects—buildings, sculpture, and paintings were also undertaken to support varied political positions throughout Europe. Private patrons too continued to commission works of art. Economic growth in most European countries helped create a large, affluent middle class eager to build and furnish fine houses and even palaces. By the late seventeenth century, the European colonies of North and South America were firmly established, creating new markets for art and architecture. Building projects in Europe and the Americas ranged from enormous churches and palaces to stage sets for plays and ballets, while painting and sculpture varied from large religious works and history paintings to portraits, still lifes, and **genre**, or scenes of everyday life. At the same time, scientific advances compelled people to question their worldview. Of great importance was the growing understanding that Earth was not the center of the universe but was a planet revolving around the Sun,

although the astronomer Galileo was forced to disavow his theories as heretical in 1633 (see "Science and the Changing Worldview," above).

The style that emerged in Europe during this time is called Baroque, a word that has come to designate certain formal characteristics of art as well as a period in the history of art lasting from the end of the sixteenth into the eighteenth century. Baroque, as a formal style, is characterized by open compositions in which elements are placed or seem to move diagonally in space. A loose, free technique using rich colors and dramatic contrasts of light and dark produces what one critic called an "absolute unity" of form. (Many of these formal characteristics can be seen in other nonclassical styles, like Hellenistic Greek and Roman styles, such as figure 25, Introduction.)

Seventeenth-century art was, above all, **naturalistic**. So admired was the quality of visual verisimilitude that

many painters and sculptors aimed to reproduce nature without any improvements—certainly without the idealization of classical and Renaissance styles. The English leader Oliver Cromwell supposedly demanded that his portrait be painted "warts and all." This desire for realism was inspired in part by the growing interest in the natural sciences: Biological sciences added to the artists' knowledge of human and animal anatomy and botany; physics and astronomy changed their concept of space and light. The new understanding of the relationship of Earth and the Sun reaffirmed the expressive power of light, not as an abstract emanation of the divine, as in the Middle Ages, but as a natural phenomenon to be treated with realism and drama.

Artists achieved spectacular technical virtuosity in every medium. Painters manipulated their mediums from the thinnest glazes to heavy impasto (thickly applied pigments), taking pleasure in the very quality of the material. The leading artists organized their studios into veritable picture factories, without an apparent diminution of quality, for their delight in technical skill permeated their studios and artisan workshops. Artists were admired for the originality of a concept or design, and their shops produced paintings on demand-including copy after copy of popular themes or portraits. The respect for the "original," or first edition, is a modern concept; at that time, an image might be painted in several versions and more than once, but the appreciation for and importance of the work were in no way lessened as long as it was finely crafted.

The role of art's viewer also changed, with a strong personal involvement in art work increasingly expected of the observer. Earlier, Renaissance painters and patrons had been fascinated with the visual possibilities of perspective, but even such displays as Mantegna's ceiling fresco at Mantua (see fig. 17-68) remained an intellectual conceit. Seventeenth-century masters, on the other hand, treated viewers as participants in the art work, and the space of the work included the world beyond the frame. In one example, Gianlorenzo Bernini's David hurls a rock at the giant Goliath, who seems to be standing behind the viewer (see fig. 19-10). In another, Diego Velázquez—in one of the finest imaginary spaces of all—paints himself painting his subject, reflected in a mirror that just misses the image of the viewer (see fig. 19-38).

Spectators were expected to be emotionally as well as intellectually involved in art. In Catholic countries, representations of horrifying scenes of martyrdom or the passionate spiritual life of a mystic in religious ecstasy inspired a renewed faith. In Protestant countries, images of civic parades and city views inspired pride in accomplishment. Viewers participated in art like audiences in a theater—vicariously but completely—as the work of art reached out visually and emotionally to draw them into its orbit. The seventeenth-century French critic Roger de Piles described this exchange when he wrote: "True painting . . . calls to us; and has so powerful an effect, that we cannot help coming near it, as if it had something to tell us" (quoted in Puttfarken, page 55).

GREAT PAPAL PATRONS OF THE SEVENTEENTH CENTURY

Paul V (Borghese)	papacy	1605-21
Urban VIII (Barberini)	papacy	1623-44
Innocent X (Pamphili)	papacy	1644-55
Alexander VII (Chigi)	papacy	1655–67

The patronage of the papal court and the **ITALY** Roman nobility dominated much of Italian art from the late sixteenth to the late seventeenth century. Major architectural projects were undertaken in Rome during this period, both to glorify the Church and to improve the city. Pope Sixtus V (papacy 1585-90) had begun the renewal by cutting long straight avenues through the city to link the major pilgrimage churches with one another and with the main gates of Rome. A major intersection created by two of Sixtus's new avenues was adorned by four fountains, one at each corner, decorated by statues, and in the seventeenth century, a church (see fig. 19-6) was erected at this crossroad. Sixtus also ordered open spaces-piazzascleared in front of the churches and marked each site with an Egyptian obelisk—a four-sided, tapered shaft ending in a pyramid—that had survived from ancient Rome. (His chief architect, Domenico Fontana, performed remarkable feats of engineering to move the huge monoliths.) Unchallengeable power and vast financial resources were required to carry out such an extensive plan of urban renewal. The Counter-Reformation popes had great wealth, although eventually they nearly bankrupted the Church with their building programs. Sixtus also began to renovate the Vatican and its library, completed the dome of Saint Peter's Basilica (see "Saint Peter's Basilica," page 663), built splendid palaces, and reopened one of the ancient aqueducts to stabilize the city's water supply. Several of Sixtus V's successors, especially Urban VIII (papacy 1623-44), were also vigorous patrons of art and architecture (see "Great Papal Patrons of the Seventeenth Century," above).

URBAN DESIGN, ARCHITECTURE, AND ARCHITECTURAL SCULPTURE

A goal of the Counter-Reformation was to embellish the Church through splendid church building. The Renaissance ideal of the **central-plan church** continued to be used for the shrines of saints, but Counter-Reformation thinking called for churches with long, wide **naves** to accommodate large congregations and the processional entry of the clergy at the Mass. In the sixteenth century, the decoration of new churches had been generally austere, but seventeenth- and eighteenth-century taste favored opulent and spectacular visual effects to heighten the emotional involvement of worshipers.

Saint Peter's Basilica in the Vatican. Half a century after Michelangelo had returned Saint Peter's Basilica to Bramante's original vision of a central-plan building, Pope Paul V (papacy 1605–21) commissioned Carlo Maderno (1556–1629) to provide the church with a

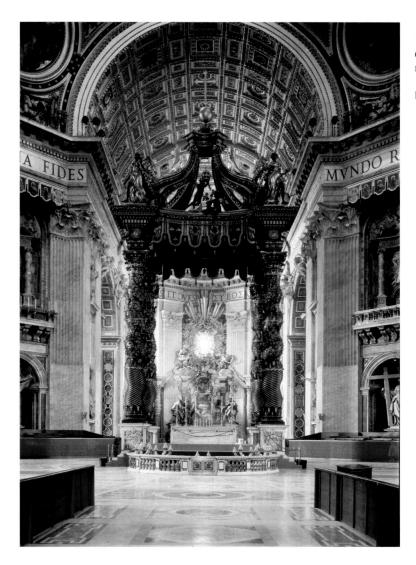

19-2. Gianlorenzo Bernini. *Baldacchino*. 1624–33. Gilt bronze, height approx. 100′ (30.48 m). Chair of Peter shrine. 1657–66. Gilt bronze, marble, stucco, and glass. Pier decorations. 1627–41. Gilt bronze and marble. Crossing, Saint Peter's Basilica, Vatican, Rome.

longer nave and a new facade (see fig. 19-3). Construction began in 1607, and everything but the facade bell towers was completed by 1615 (see "Saint Peter's Basilica," page 663). In essence, Maderno took the concept of Il Gesù's facade (see fig. 18-45 and "Parts of the Church Facade," page 686) and enhanced its scale to befit the most important church of the Catholic world. Saint Peter's facade, like Il Gesù's, "steps out" in three progressively projecting planes: from the corners to the doorways flanking the central entrance area, then the entrance area, then the central doorway itself. Similarly, the colossal orders connecting the first and second stories are flat pilasters at the corners but fully round columns where they flank the doorways. These columns support a continuous entablature that also steps out-following the columns-as it moves toward the central door, which is surmounted by a triangular pediment. Similar to the Il Gesù facade, the pediment provides a vertical thrust, as does the superimposition of pilasters on the relatively narrow attic story above the entablature.

When Maderno died in 1629, he was succeeded as Vatican architect by his collaborator of five years, Gianlorenzo Bernini (1598–1680). Bernini was born in

Naples, but his family had moved to Rome about 1605. Taught by his father, Gianlorenzo was already a proficient marble sculptor by the age of eight. Part of his training involved sketching the Vatican collection of ancient sculpture, such as *Laocoön and His Sons* (see fig. 24, Introduction), as well as the many examples of Renaissance painting in the papal palace. Throughout his life, Bernini admired antique art and considered himself a classicist, but today we consider his art a breakthrough that takes us from the Renaissance into the Baroque style.

When Urban VIII was elected pope in 1623, he unhesitatingly gave the young Bernini the demanding task of designing an enormous bronze **baldachin**, or canopy, for the high altar of Saint Peter's. The church was so large that a dramatic focus on the altar was essential. The resulting *baldacchino* (fig. 19-2), completed in 1633, stands almost 100 feet high and exemplifies the Baroque artists' desire to combine architecture and sculpture—and sometimes painting as well—so that works no longer fit into a single category or medium. The twisted columns symbolize the union of Old and New Testaments—the vine of the Eucharist climbing the columns of the Temple of Solomon. The fanciful

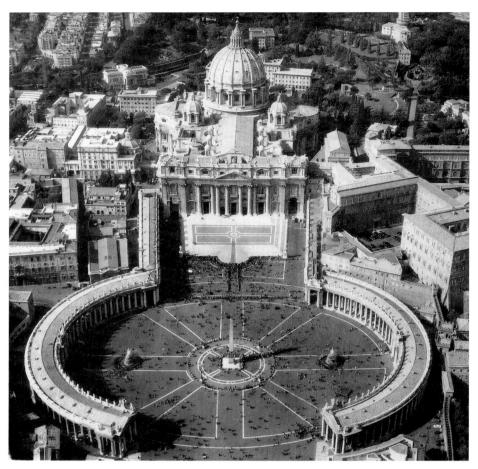

19-3. Saint Peter's Basilica and Piazza, Vatican, Rome. Carlo Maderno, facade, 1607–26; Gianlorenzo Bernini, piazza design, c. 1656–57.

Perhaps only a Baroque artist of Bernini's talents could have unified the many artistic periods and styles that come together in Saint Peter's Basilica (starting with Bramante's original design for the building in the sixteenth century). The basilica in no way suggests a piecing together of parts made by different builders at different times, but rather presents itself as a triumphal unity of all the parts in one coherent whole.

Composite capitals, combining elements of both the Ionic and the Corinthian orders, support an entablature with a crowning element topped with an orb (a sphere representing the universe) and a cross (symbolizing the reign of Christ). Figures of angels and *putti* decorate the entablature, which is hung with tasseled panels in imitation of a cloth canopy. These symbolic elements, both architectural and sculptural, not only mark the site of the tomb of Saint Peter but also serve as a monument to Urban VIII and his family, the Barberini, whose emblems—including honeybees and suns on the tasseled panels, and laurel leaves on the climbing vines—are prominently displayed.

Between 1627 and 1641, Bernini and several other sculptors, again combining architecture and sculpture, rebuilt Bramante's **crossing piers** as giant **reliquaries**. Statues of Saints Helena, Veronica, Andrew, and Longinus stand in niches below alcoves containing their relics, to the left and right of the *baldacchino*. Visible through the *baldacchino*'s columns in the apse of the church is another reliquary: the gilded stone, bronze, and stucco shrine made by Bernini between 1657 and

1666 for the ancient wooden throne thought to have been used by Saint Peter as the first bishop of Rome. The Chair of Peter symbolized the direct descent of Christian authority from Peter to the current pope, a belief rejected by Protestants and therefore deliberately emphasized in Counter-Reformation Catholicism. In Bernini's work, the chair is carried by four theologians and is lifted farther by a surge of gilded clouds moving upward to the Holy Spirit in the form of a dove adored by angels. Giltbronze rays around a stained-glass panel depicting a dove are lit from a window. The light penetrating the church from this window and reflected back by the gilding creates a dazzling effect—the sort that present-day artists achieve by resorting to electric spotlights.

At approximately the same time that he was at work on the Chair of Peter, Bernini designed and supervised the building of a colonnade to form a huge double piazza in front of the entrance to Saint Peter's (fig. 19-3). The open space that he had to work with was irregular, and an Egyptian obelisk and a fountain already in place (part of Sixtus V's plan for Rome) had to be incorporated into the overall plan. Bernini's remarkable design frames the

Section 1990 Section 1999 EM MARINE COLUMN

oval piazza with two enormous curved porticoes, or covered walkways, supported by Doric columns. These curved porticoes are connected to two straight porticoes, which lead up a slight incline to the two ends of the church facade. Bernini spoke of his conception as representing the "motherly arms of the Church" reaching out to the world. He had intended to build a third section of the colonnade closing the side of the piazza facing the church so that pilgrims, after crossing the Tiber River bridge and passing through narrow streets, would suddenly emerge into the enormous open space before the church. Even without the final colonnade section, the great church, colonnade, and piazza with its towering obelisk and monumental fountains-Bernini added the second one to balance the first—are an aweinspiring vision.

The Church of San Carlo alle Quattro Fontane.

The intersection of two of the major avenues created under the new Counter-Reformation city plan inspired planners to add a special emphasis there, with fountains marking each of the four corners of the crossing. In 1634, the Trinitarian monks decided to build a new church at the site and awarded the commission for San Carlo alle Ouattro Fontane (Saint Charles at the Four Fountains) to Francesco Borromini (1599-1667). Borromini, a nephew of architect Carlo Maderno, had arrived in Rome in 1619 from northern Italy, to enter his uncle's workshop. Later, he worked under Bernini's supervision on the decoration of Saint Peter's, and some details of the baldacchino are now attributed to him, but San Carlo was his first independent commission. From 1638 to 1641, he planned and constructed the body of this small church, although he did not receive the commission for its facade until 1665. Unfinished at Borromini's death, the church was nevertheless completed according to his design.

San Carlo stands on a narrow tract, with one corner cut off to accommodate one of the four fountains that gives the church its name. To fit the irregular site, Borromini created an elongated central-plan interior space with undulating walls (fig. 19-4), whose powerful, sweeping curves create an unexpected feeling of movement, as if the walls were heaving in and out. Robust pairs of columns support a massive entablature, over which an oval dome seems to float. The **coffers** (inset panels in geometric shapes) filling the interior of the dome form an eccentric honeycomb of crosses, elongated hexagons, and octagons (fig. 19-5). These coffers decrease sharply in size as they approach the apex, or highest point, so that the dome appears to be inflating.

It is difficult today to appreciate how audacious Borromini's design for this small church was. In it he abandoned the modular system of planning taken for granted by every architect since Brunelleschi (see figs. 17-33, 17-34) and worked instead from an overriding geometric scheme, the ideal, domed, central-plan church. Moreover, his treatment of the architectural elements as if they were malleable was unprecedented. Borromini's contemporaries understood immediately

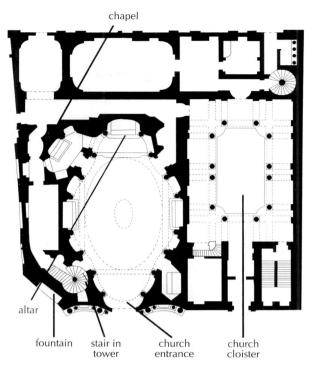

19-4. Francesco Borromini. Plan of the Church of San Carlo alle Quattro Fontane, Rome. 1638–41.

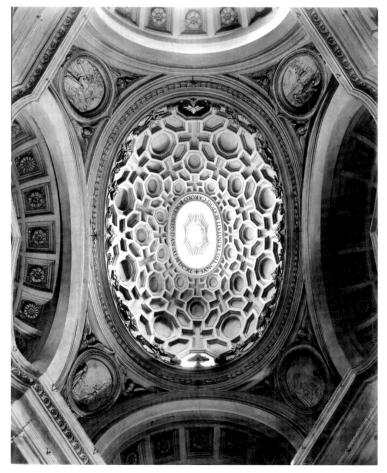

19-5. Dome interior, Church of San Carlo alle Quattro Fontane. 1638–41.

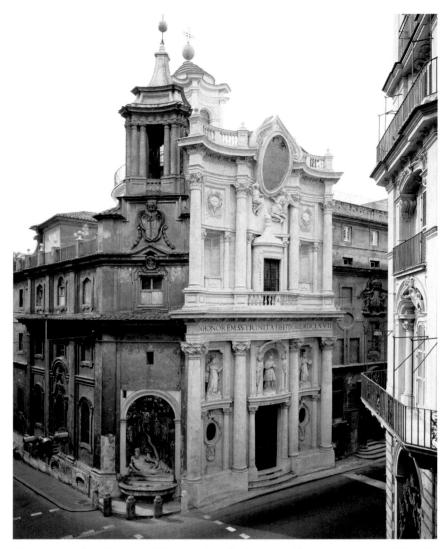

19-6. Facade, Church of San Carlo alle Quattro Fontane, Rome. 1665-67.

what an extraordinary innovation the church represented; the Trinitarian monks who had commissioned it received requests for plans from visitors from all over Europe. Although Borromini's invention had little influence on the architecture of classically minded Rome, it was widely imitated in northern Italy and beyond the Alps.

Borromini's design for San Carlo's facade (fig. 19-6), done more than two decades later, was as innovative as his plan for its interior had been. He turned the building's front into an undulating, sculpture-filled screen punctuated with large columns and deep niches that create dramatic effects of light and shadow. Borromini also gave his facade a strong vertical thrust in the center by placing over the tall doorway a statue-filled niche, then a windowed niche covered with a pointed canopy, then a giant **cartouche** (an oval or circular decorative element) held up by angels carved in such high relief that they appear to hover in front of the wall. The entire facade is crowned with a **balustrade** and the sharply pointed frame of the cartouche. Borromini's facade was

enthusiastically imitated in northern Italy and especially in northern and eastern Europe.

Piazza Navona. Rome's Piazza Navona, a popular site for festivals and celebrations, became another center of urban renewal with the election of Innocent X as pope (papacy 1644–55). Both the palace and parish church of his family, the Pamphilis, fronted on the piazza, which had been the site of a stadium built by Emperor Domitian in 86 cE and still retains the shape of the ancient stadium's racetrack. The stadium, in ruins, had been used for festivals during the Middle Ages and as a market-place since 1477. A modest shrine to Sant'Agnese stood on the site of her martyrdom.

The Pamphilis enlarged their palace in 1644–50 and in 1652 decided to rebuild their parish church, the Church of Sant'Agnese. Girolamo and Carlo Rainaldi won the original commission, and in 1653–57 Francesco Borromini designed the facade, conceiving a plan that unites church and piazza (fig. 19-7). The facade sweeps inward from two flanking towers to a monumental por-

tal approached by broad stairs. The inward curve of the facade brings the dome nearer the entrance than usual, making it clearly visible from the piazza. The templelike design of columns and pediment around the door also leads the eye to the steeply rising dome on its tall drum. The church truly dominates the urban space.

The south end of the piazza was already graced by a 1576 fountain by Giacomo della Porta. After some skillful maneuvering, Gianlorenzo Bernini, who was at his most ingenious in his fountain designs, won the commission for a second monumental fountain in the center. Bernini, who had been publicly disgraced in 1646 when a bell tower he had begun for Saint Peter's threatened to collapse, had not been invited to compete for the fountain's design. The contest was won by Borromini, who originated the fountain's theme of the Four Rivers and brought in the water supply for it in 1647. With the collusion of a papal relative, however, the pope saw Bernini's design. Pope Innocent X was so impressed

that Bernini took over the project the next year, and Bernini's assistants carved the figures after his designs.

Executed in marble and **travertine**, a porous stone that is less costly and more easily worked than marble, the now famed Fountain of the Four Rivers was completed in 1651. In the center is a rocky hill covered with animals and vegetation, from which flow the four great rivers of the world, each representing a continent and personified by a colossal figure: the Nile (Africa), covering his head; the Ganges (Asia), at the left; the Danube (Europe), at the right; and the Rio de la Plata (Americas), not visible in the photograph. The central rock formation supports a Roman imitation of an Egyptian obelisk, topped by a dove, the emblem of the pope's family and also of peace and the Trinity. The installation of the obelisk-which weighs many tons-over the grotto, a hidden collecting pool that feeds the rivers, was a technical marvel that reversed Bernini's disgrace over the bell-tower incident. Two years after the completion of

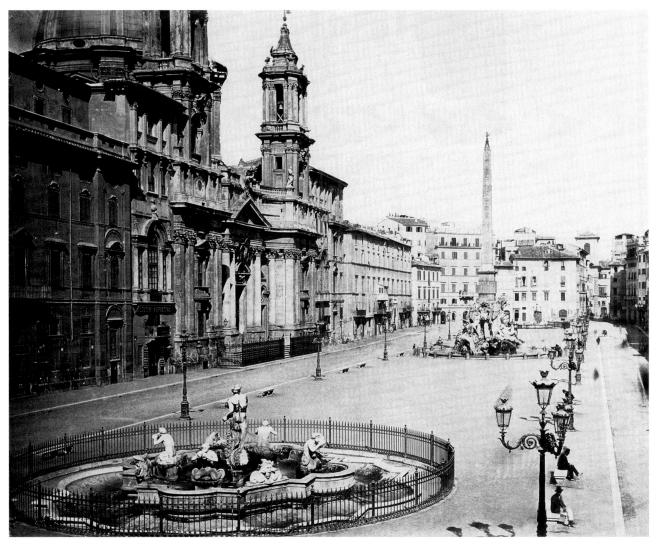

19-7. Piazza Navona, Rome. In middle ground, Gianlorenzo Bernini's Four Rivers Fountain. 1648–51. Travertine and marble. To the left of the fountain, Franceso Borromini's Church of Sant'Agnese. 1653–57. In the foreground, Giacomo della Porta's fountain of 1576.

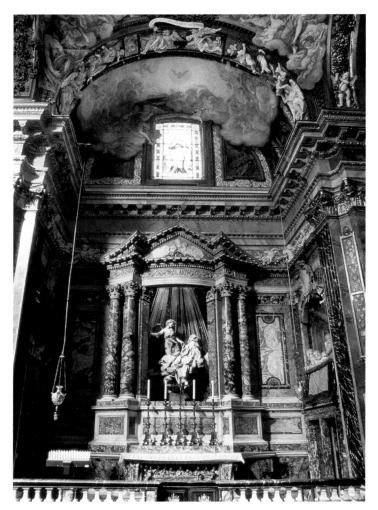

19-8. Gianlorenzo Bernini. Cornaro Chapel, Church of Santa Maria della Vittoria, Rome. 1642–52.

the major fountain, Bernini altered della Porta's fountain by replacing the principal figure (1653). In 1878, a third fountain, depicting Neptune and an octopuslike sea monster, was built at the north end of Piazza Navona.

Cornaro Chapel. Even after Bernini's appointment as Vatican architect in 1629, he was able to accept outside commissions by virtue of his large workshop. Beginning in 1642, he worked on designs for the decoration of the funerary chapel of Cardinal Federigo Cornaro (fig. 19-8) in the Church of Santa Maria della Vittoria, which had been designed by Carlo Maderno. Like Il Gesù (see fig. 18-44), the church had a single nave with shallow side chapels. The chapel of the Cornaro family was dedicated to Saint Teresa of Ávila, and near the high altar Bernini designed a rich and theatrical setting for a scene depicting Teresa's vision of the angel of the Lord. From 1642 to 1652, Bernini covered the walls with colored marble panels, crowned with a projecting **cornice** supported by marble pilasters. Above the cornice on the back wall, the curved ceiling surrounding the window

appears to dissolve into a painted vision of clouds and angels. Kneeling at what appear to be balconies on both sides of the chapel are portrait statues of Federigo, his deceased father, and six cardinals of the Cornaro family. The figures are informally posed and naturalistically portrayed. Two are reading from their prayer books, others converse, and one leans out from his seat, apparently to look at someone entering the chapel.

Framed by columns in a huge oval niche above the altar, Bernini's marble group *Saint Teresa of Ávila in Ecstasy* (fig. 19-9), created between 1645 and 1652, represents a vision described by the Spanish mystic in which an angel pierced her body repeatedly with an arrow, transporting her to a state of religious ecstasy, a sense of oneness with God. Teresa and the angel, who seem to float upward on moisture-laden clouds, are cut from a heavy mass of solid marble supported on a hidden pedestal and by metal bars sunk deep into the chapel wall. Bernini's skill at capturing the movements and emotions of these figures is matched by his virtuosity in simulating different textures and colors in the pure

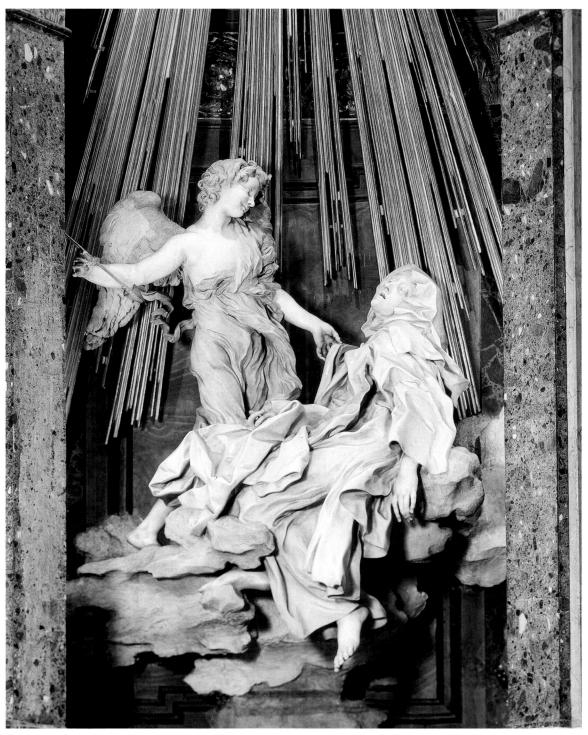

19-9. Gianlorenzo Bernini. *Saint Teresa of Ávila in Ecstasy.* 1645–52. Marble, height of the group 11'6" (3.5 m). Cornaro Chapel, Church of Santa Maria della Vittoria, Rome.

white medium of marble; the angel's gauzy, clinging draperies seem silken in contrast with Teresa's heavy woolen robe, the habit of her order. Yet Bernini effectively used the configuration of the garment's folds to convey the swooning, sensuous body beneath, even though only Teresa's face, hands, and bare feet are actu-

ally visible. The descending rays of light are of gilt bronze illuminated from above by a hidden window. Bernini's complex, theatrical interplay of the various levels of illusion in the chapel, which invites the beholder to identify with Teresa's emotion, was imitated by sculptors throughout Europe.

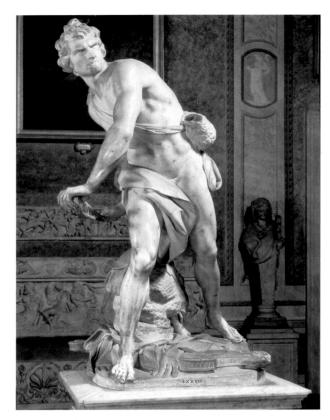

19-10. Gianlorenzo Bernini. *David.* 1623. Marble, height 5'7" (1.7 m). Galleria Borghese, Rome.

19-11. Barberini Harp. c. 1623–24, 1671. Wood, with gilt and black paint, $5'10^7/8'' \times 3'11^1/4''$ (1.8 × 1.2 m). Museo Nazionale degli Strumenti Musicali, Rome.

INDEPENDENT SCULPTURE

Bernini first became famous as a sculptor, and he continued to work as a sculptor throughout his career, for both the papacy and private clients. His David (fig. 19-10), made for a nephew of Pope Paul V in 1623, introduced a new type of three-dimensional composition that intrudes forcefully on the viewer's space. Inspired by the athletic figures Annibale Carracci had painted on a palace ceiling some twenty years earlier (see, for example, the Giant preparing to heave a boulder at the far end of figure 19-12), Bernini's David bends at the waist and twists far to one side, ready to launch the lethal rock. Unlike Michelangelo's cool and self-confident vouth (see fig. 18-12), this more mature David, with his lean, sinewy body, is all tension and determination, a frame of mind emphasized by his ferocious expression, tightly clenched mouth, and straining muscles. Bernini's energetic, twisting figure includes the surrounding space as part of the composition by implying the presence of an unseen adversary somewhere behind the viewer. Thus, the viewer becomes part of the action that is taking place at that very moment. This immediacy and the inclusion of the viewer in the work of art represent an important new direction for art.

A remarkable piece of sculpture in wood, the Barberini Harp (fig. 19-11), was carved by someone working in the circle of Bernini, probably about the time of the election of Cardinal Maffeo Barberini as Pope Urban VIII in 1623. (The harp is first mentioned in the family archives in 1631.) The harp was a functional instrument with a range of more than three octaves. The carved and gilded pillar is divided into three sections by painted black pedestals: At the bottom is a herm of a satyr decorated with the heraldic Barberini bees; in the center, two seminude youths; and at the top, putti whose lion skins refer to the classical hero Hercules, a model for the Barberini leaders. In a second reference to Hercules, the harp's curving neck ends with a lion's head. The top of the pillar is carved with the Barberini coat of arms, three bees, to which a crown and the collar of the Order of the Golden Fleece, the most highly valued continental order of chivalry, were later added (in 1671, the queen of Spain awarded the honor to Urban VIII's namesake, Maffeo Barberini). The harp was clearly prized by the family, since they saw fit to turn it into a memorial to the Golden Fleece.

ILLUSIONISTIC CEILING PAINTING

Theatricality, intricacy, and the opening of space reached an apogee in Baroque ceiling decoration, closely allied with architecture. Baroque ceiling decoration went far beyond Michelangelo's *Sistine Ceiling* (see fig. 18-14) or even Correggio's dome (see fig. 18-23). Many Baroque ceiling projects were done entirely in *trompe l'oeil* painting, and some were complex constructions combining architecture, painting, and stucco sculpture. These grand illusionistic projects were carried out on the domes and vaults of churches, civic buildings, palaces, and villas.

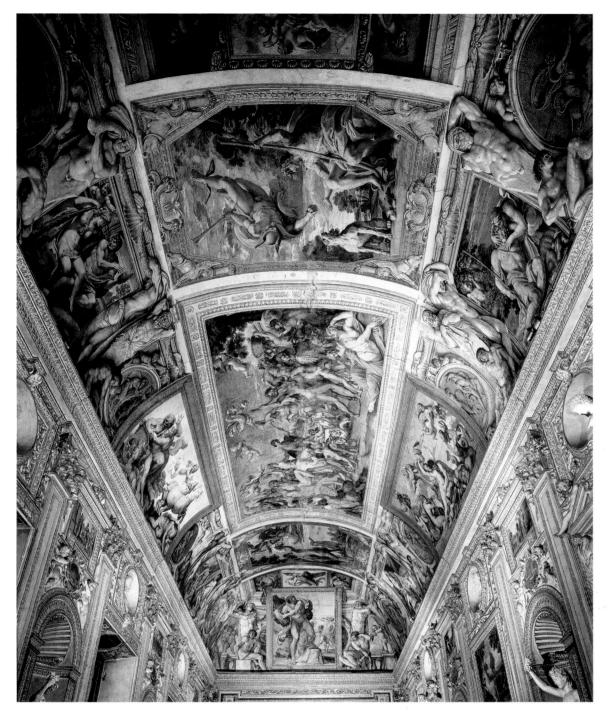

19-12. Annibale Carracci. Ceiling of gallery, Palazzo Farnese, Rome. 1597–1601. Fresco, approx. $68' \times 21'$ (20.7 m $\times 6.4$ m).

Annibale Carracci. The major monument of early Baroque classicism was a high, vaulted ceiling painted for the Farnese family in the last years of the sixteenth century. In 1597, to celebrate the wedding of Duke Ranuccio Farnese of Parma, the Farneses decided to redecorate the *galleria* ("gallery") of their immense Roman palace (fig. 19-12). Cardinal Odarico Farnese commissioned Annibale Carracci (1560–1609) to do the work. Annibale was a noted painter and the cofounder of an art academy in Bologna with his cousin Ludovico. At the academy, students were expected to study the art

of the past—that is, Renaissance painting and antique classical sculpture—as well as nature. The Bolognese painters placed a high value on drawing, complex figure compositions, narrative skills, and technical expertise in both oil and fresco painting. Annibale was assisted on the ceiling project by his brother Agostino (1557–1602), who also worked briefly in Rome.

The Farnese ceiling is an exuberant tribute to earthly love, expressed in mythological scenes. Its primary image, set in the center of the vault, is *The Triumph of Bacchus and Ariadne*, a joyous procession celebrating

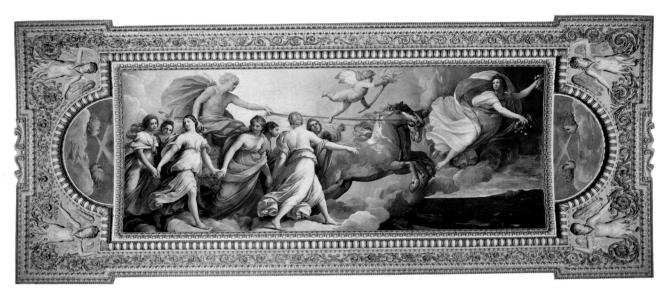

19-13. Guido Reni. Aurora, ceiling in Palazzo Rospigliosi-Palavacini, Rome. 1615–18. Fresco.

the wine god Bacchus's love for Ariadne, a woman whom he rescued after her lover, Theseus, abandoned her on the island of Naxos. In his ceiling painting, Carracci created the illusion of framed paintings, stone sculpture, bronze medallions, and ignudi (nude youths) an architectural framework—all inspired by Michelangelo's Sistine Ceiling. The figure types, true to their source, are heroic, muscular, and drawn with precise anatomical accuracy. But instead of Michelangelo's cool illumination and intellectual detachment, the Farnese ceiling glows with a warm light that recalls the work of the Venetian painters Titian and Veronese and seems buoyant with optimism. The ceiling was highly admired and became famous almost immediately. The Farnese family, proud of the gallery, generously allowed young artists to sketch the figures there, so that Carracci's masterpiece influenced Italian art well into the following century.

Guido Reni. The most important Italian Baroque classicist after Annibale Carracci was the Bolognese artist Guido Reni (1575-1642), who briefly studied at the Carracci academy in 1595. Shortly after 1600, Reni made his first trip to Rome, where he worked intermittently before returning to Bologna in 1614. In 1613-14, he decorated the ceiling of a garden house (casino in Italian) at a palace in Rome with his most famous work, Aurora (fig. 19-13). The fresco emulates the illusionistic framed mythological scenes on the Farnese ceiling, although Reni made no effort to relate his painting's space to that of the room. Indeed, Aurora appears to be a framed oil painting incongruously attached to the ceiling. The composition itself, however, is Baroque classicism at its most lyrical. Apollo is shown driving the sun chariot, escorted by Cupid and the Seasons and led by the flying figure of Aurora, goddess of the dawn. The measured, processional staging and idealized forms seem to have been derived from an antique relief, and the precise drawing owes much to Annibale Carracci and academic training. But the graceful figures, the harmonious rhythms of gesture and drapery, and the intense color are all Reni's own.

Pietro da Cortona. Pietro Berrettini (1596-1669), called Pietro da Cortona after his hometown, carried the development of the Baroque ceiling away from classicism into a more Baroque direction. Trained in Florence, the artist was commissioned in the early 1630s by the Barberini family of Pope Urban VIII to decorate the ceiling of the audience hall of their Roman palace. Pietro's great fresco there, The Glorification of the Papacy of Urban VIII, became a model for a succession of Baroque illusionistic palace ceilings throughout Europe (fig. 19-14). Its subject is an elaborate allegory, or symbolic representation, of the virtues of the papal family. Just below the center of the vault, seated at the top of a pyramid of clouds and figures personifying Time and the Fates, Divine Providence gestures toward three giant bees surrounded by a huge laurel wreath (both Barberini emblems) carried by Faith, Hope, and Charity. Immortality offers a crown of stars, while other symbolic figures present the crossed keys and the triple-tiered crown of the papacy. Around these figures are scenes of Roman gods and goddesses, who demonstrate the pope's virtues by triumphing over the vices.

Pietro, like Annibale Carracci, framed his mythological scenes with painted architecture, but in contrast to Annibale's neat separations and careful framing, Pietro partly concealed his setting with an overlay of shells, masks, garlands, and figures, which unifies the vast illusionistic space. Instead of Annibale's warm, nearly even light, Pietro's sporadic illumination, with its bursts of brilliance alternating with deep shadows, fuses the ceiling into a dense but unified whole.

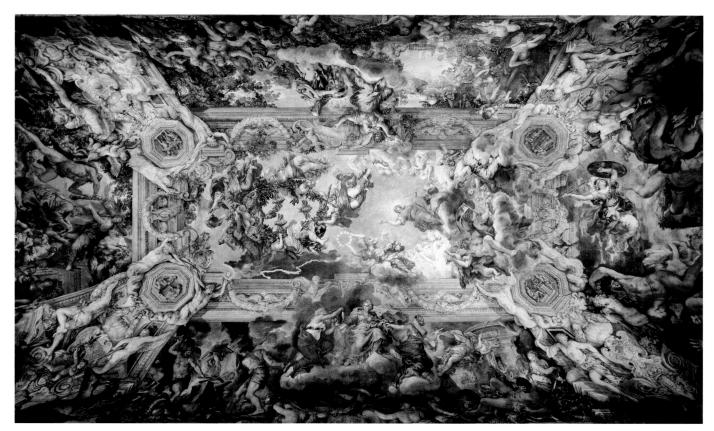

19-14. Pietro da Cortona. *The Glorification of the Papacy of Urban VIII*, ceiling in the Gran Salone, Palazzo Barberini, Rome. 1632–39. Fresco.

Giovanni Battista Gaulli. The ultimate illusionistic Baroque ceiling is The Triumph of the Name of Jesus and the Fall of the Damned (fig. 19-15, page 734), which fills the vault of Il Gesù (see fig. 18-45). In the 1560s, Giacomo da Vignola had designed an austere interior for Il Gesù, but when the Jesuits renovated their church a century later, they commissioned a religious allegory to cover the nave's plain ceiling. Giovanni Battista Gaulli (1639–1709) designed and executed the spectacular illusion between 1672 and 1685, combining sculpture and painting to eliminate the presence of architecture. It is impossible to see which figures are three-dimensional and which are painted, and some paintings are on panels that extend over the actual architecture. Gaulli, who arrived in Rome from Genoa in 1657, had worked in his youth for Bernini, from whom he absorbed a taste for drama and for multimedia effects. The elderly Bernini, who worshiped daily at Il Gesù, may well have offered his personal advice to his former assistant, and Gaulli was certainly familiar with other illusionistic paintings in Rome as well, including Pietro da Cortona's Barberini ceiling.

Gaulli's astonishing creation went beyond anything that had preceded it in unifying architecture, sculpture, and painting. Every element is dedicated to creating the illusion that clouds and angels have floated down through an opening in the church's vault into the upper reaches of the nave. The figures are projected as if seen from below, and the whole composition is focused offcenter on the golden aura around the letters *IHS*, the

monogram of Jesus and the insignia of the Jesuits. The subject is, in fact, a Last Judgment, with the Elect rising joyfully toward the name of God and the Damned plummeting through the ceiling toward the nave floor. The sweeping inclusion in the work of the space of the nave, the powerful and exciting appeal to the viewer's emotions, and the nearly total unity of visual effect have never been surpassed.

PAINTING ON CANVAS

Il Guercino. In painting, the Baroque classicism exemplified by Carracci's Farnese ceiling and Guido Reni's Aurora was the logical development of mature Renaissance styles with roots in classical antiquity. This style was also popular for altarpieces and other painting on canvas. Il Guercino ("The Little Squinter," Giovanni Francesco Barbieri, 1591-1666) painted Saint Luke Displaying a Painting of the Virgin (fig. 15, Introduction) for the high altar of the Franciscan church in Reggio nell'Emilia, near Bologna. In keeping with the desire for greater naturalism and contemporary relevance in religious art, Luke's symbol as an evangelist, the ox, has become a paperweight; and the painting of the Virgin and Child on Luke's easel copies a Byzantine icon believed by the Bolognese to have been painted by Luke himself. Although Protestants ridiculed the idea that paintings by Luke existed, Catholics staunchly defended their authenticity. Guercino's painting, then, is both an homage to the patron saint of painters and a defense of the

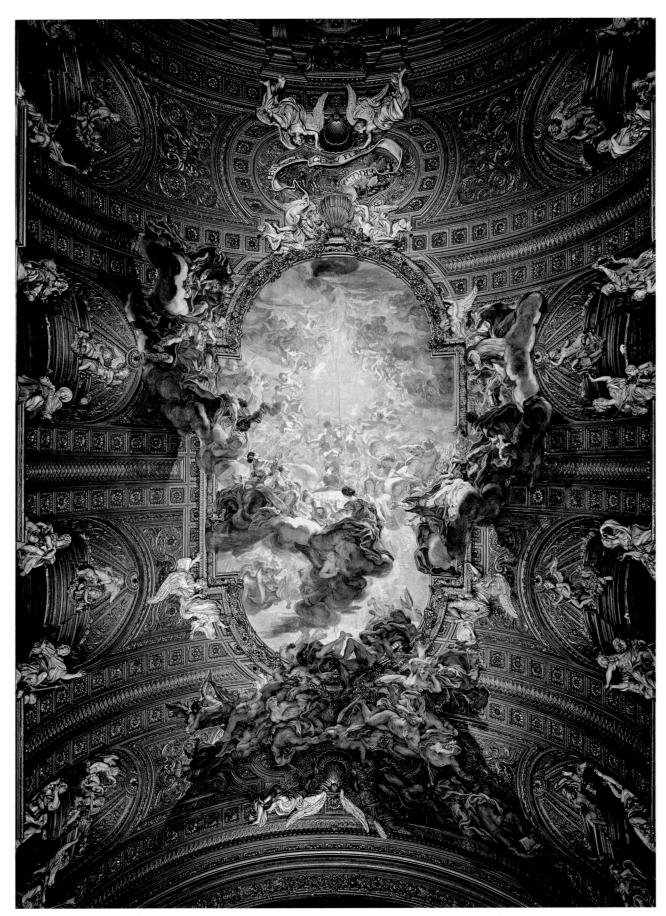

19-15. Giovanni Battista Gaulli. *The Triumph of the Name of Jesus and the Fall of the Damned.* Vault of the Church of Il Gesù, Rome. 1672–85. Fresco with stucco figures.

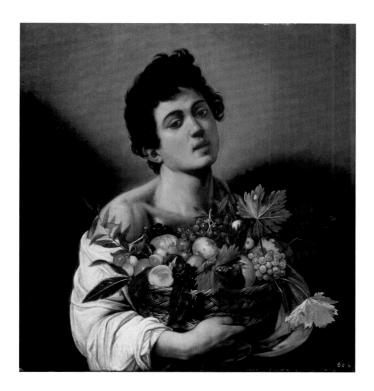

19-16. Caravaggio. *Boy with a Basket of Fruit.* c. 1593–94 Oil on canvas, $27\frac{1}{2} \times 26^{3}\frac{4}{4}$ " (70 × 67 cm). Galleria Borghese, Rome.

miracle-working Madonna di San Luca in his hometown. The classical architecture and idealized figures typify Bolognese academic art.

Caravaggio. A more naturalistic tendency was introduced by Carracci's younger contemporary Michelangelo Merisi (1571–1610), known as Caravaggio after his birthplace, a town in the northern Italian region of Lombardy. A realistic style together with careful drawing and an interest in still life, unusual at the time, characterized Lombard art. The young painter demonstrated those interests in his first known paintings after he arrived late

in 1592 in Rome, where he was employed in the studio of the Cavaliere d'Arpino as a specialist in the painting of fruit and vegetables. When he began to paint on his own, he continued to paint still lifes but also included half-length figures, as in the *Boy with a Basket of Fruit* (fig. 19-16). By this time, his reputation had grown to the extent that an agent offered to market his pictures.

Caravaggio painted for a small circle of sophisticated Roman patrons. His subjects from this early period include still lifes and low-life scenes featuring fortune-tellers, cardsharps, and street urchins dressed as musicians or mythological figures. The figures in these

CARAVAGGIO AND THE NEW REALISM

For decades after his death, Caravaggio was viewed as an "evil genius" and an "omen of the ruin and demise of painting" for his painting "without study ... with nothing but nature before him, which he simply copied in his amazing way" (Carducho, Dialogues on Painting, Madrid, 1633, in Enggass and Brown, pp. 173-74). But with the passage of another forty years, he was recognized as a great innovator who reintroduced realism into art and developed new, dramatic lighting effects, now known as tenebrism. The art historian Giovanni Bellori wrote in his Lives of the Painters (1672):

Caravaggio (for he was now generally called by the name of his native town) was making himself more

and more notable for the color scheme which he was introducing, not soft and sparingly tinted as before, but reinforced throughout with bold shadows and a great deal of black to give relief to the forms. He went so far in this manner of working that he never brought his figures out into the daylight, but placed them in the dark brown atmosphere of a closed room, using a high light that descended vertically over the principal parts of the bodies while leaving the remainder in shadow in order to give force through a strong contrast of light and dark. The painters then in Rome were greatly impressed by his novelty and the younger ones especially gathered around him and praised him as the only true imitator of nature. . . . The old painters who were accustomed to the old ways were shocked at the new concern for nature, and they did not cease to decry Caravaggio

and his manner. They spread it about that he did not know how to come out of the cellar and that, poor in invention and design, lacking in decorum and art, he painted all his figures in one light and on one plane without gradations.

There is no question that Caravaggio advanced the art of painting because he came upon the scene at a time when realism was not much in fashion and when figures were made according to convention and manner and satisfied more the taste for gracefulness than for truth. Thus by avoiding all prettiness and vanity in his color, Caravaggio strengthened his tones and gave them blood and flesh. In this way he induced his fellow painters to work from nature. . . .

(Bellori, *Lives of the Painters*, Rome, 1672, in Enggass and Brown, pp. 79, 83) pictures tend to be large, brightly lit, and set close to the picture plane.

Most of his commissions after 1600 were religious, and reactions to them were mixed. On occasion, his powerful, sometimes brutal, naturalism was rejected by patrons as unsuitable to the subject's dignity. Caravaggio's approach has been likened to the preaching of Filippo Neri (1515-95), a priest and noted mystic of the Counter-Reformation who founded a Roman religious group called the Congregation of the Oratory and was later canonized. Neri, called the Apostle of Rome, focused his missionary efforts on the people there, for whom he strove to make Christian history and doctrine understandable and meaningful. Caravaggio, too, interpreted his religious subjects directly and dramatically, combining intensely observed forms, poses, and expressions with strong effects of light and color. In the technique known as tenebrism, forms emerge from a dark background into a strong light that often falls from a single source outside the painting; the effect is that of a modern spotlight (see "Caravaggio and the New Realism," page 735).

Caravaggio's first public commission, paintings for the Contarelli Chapel in the Church of San Luigi dei Francesi, included the Calling of Saint Matthew (fig. 19-17), painted about 1599-1600. The painting depicts Jesus calling Levi, the tax collector, to join his apostles (Mark 2:14). Levi sits at a table, counting out gold coins for a boy at the left, surrounded by overdressed young men in plumed hats, velvet doublets, and satin shirts. Nearly hidden behind the cloaked apostle Peter, at the right, the gaunt-faced Jesus points dramatically at Levi, a gesture that is repeated by the tax collector's surprised response of pointing to himself. An intense raking light enters the painting from a high, unseen source at the right and spotlights the faces of the men. For all of his naturalism, Caravaggio also used antique and Renaissance sources. Jesus' outstretched arm, for example, recalls God's gesture giving life to Adam in Michelangelo's Creation of Adam on the Sistine Ceiling (see fig. 18-14), now restated as Jesus' command to Levi to begin a new life by becoming his disciple Matthew.

The emotional power of Baroque naturalism combines with a solemn, classical monumentality in

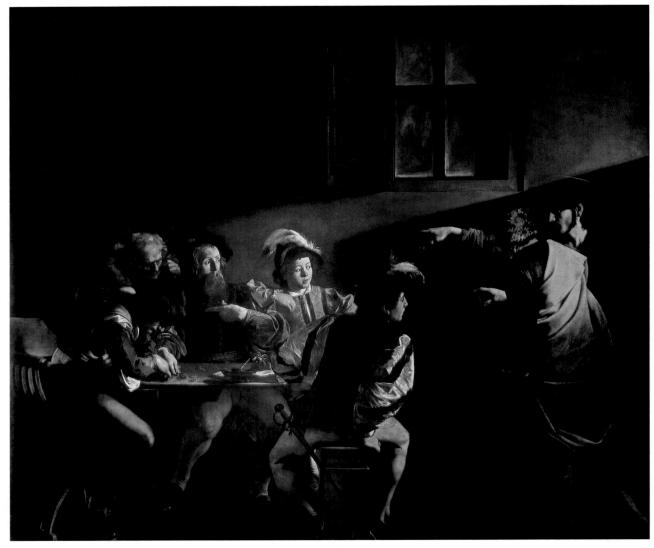

19-17. Caravaggio. *The Calling of Saint Matthew*. 1599–1600. Oil on canvas, $10'7^1/2'' \times 11'2''$ (3.24 × 3.4 m). Contarelli Chapel, Church of San Luigi dei Francesi, Rome.

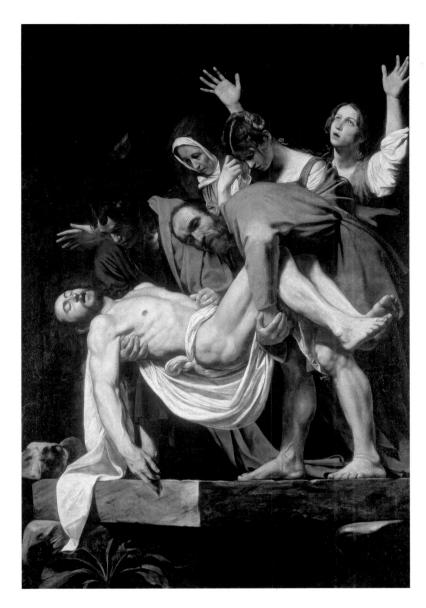

19-18. Caravaggio. *Entombment,* from the Vittrici Chapel, Church of Santa Maria in Vallicella, Rome. 1603-4. Oil on canvas, $9'10^1/8'' \times 6'7^{15}/16''$ (3×2.03 m). Musei Vaticani, Pinacoteca, Rome.

The *Entombment* was one of many paintings confiscated from Rome's churches and taken to Paris during the French occupation by Napoleon's troops in 1798 and 1808–14. It was one of the few to be returned after 1815 through the negotiations of Pius VII and his agents, who were assisted greatly by the Neoclassical sculptor Antonio Canova, a favorite of Napoleon. The decision was made not to return the works to their original churches and chapels but instead to assemble them in a gallery where the general public could enjoy them. Today, Caravaggio's painting is one of the most important in the collections of the Vatican Museums.

Caravaggio's Entombment (fig. 19-18), painted in 1603-4 for a chapel in Santa Maria in Vallicella, the church of Neri's Congregation of the Oratory. With almost physical force, the size and immediacy of this painting strike the viewer, whose perspective is from within the burial pit into which Jesus' lifeless body is to be lowered. The figures form a large off-center triangle, within which angular elements are repeated: the projecting edge of the stone slab; Jesus' bent legs; the akimbo arm, bunched coat, and knock-kneed stance of the man on the right; and even the spaces between the spread fingers of the raised hands. The Virgin and Mary Magdalen barely intrude on the scene, which, through the careful placing of the light, focuses on the dead Jesus, the sturdy-legged laborer supporting his body at the right, and the young John the Evangelist at the triangle's apex.

Despite the great esteem in which Caravaggio was held as an artist, his violent temper repeatedly got him into trouble. During the last decade of his life, he was frequently arrested, generally for minor offenses: throwing a plate of artichokes at a waiter, carrying

arms illegally, street brawling. In 1606, however, he killed a man in a fight over a tennis match and had to flee Rome. He went first to Naples, then to Malta, finding work in both places. The Knights of Malta awarded him the cross of their religious and military order in July 1608, but in October he was imprisoned for insulting one of their number, and again he had to flee. The aggrieved knight's agents tracked him to Naples in the spring of 1610 and severely wounded him; the artist recovered and fled north to Port'Ercole, where he died of a fever on July 18, 1610, just short of his thirty-ninth birthday. Caravaggio's naturalism and tenebrist lighting influenced nearly every important European artist of the seventeenth century.

Artemisia Gentileschi. One of Caravaggio's most successful Italian followers was Artemisia Gentileschi (1593–c. 1652/3), whose international reputation helped spread the Caravaggesque style beyond Rome. Born in Rome, Artemisia first studied and worked under her father, himself a follower of Caravaggio. In 1616, she

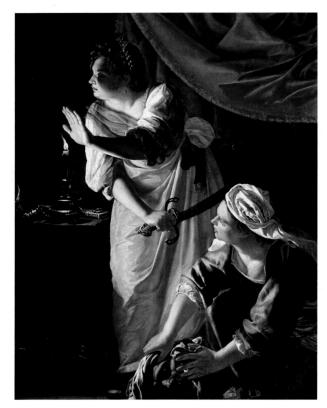

19-19. Artemisia Gentileschi. *Judith and Maidservant with the Head of Holofernes.* 1625. Oil on canvas, $6'^{1}/_{2}'' \times 4'7''$ (1.84 \times 1.41 m). The Detroit Institute of Arts. Gift of Leslie H. Green, (52.253)

19-20. Artemisia Gentileschi. *Self-Portrait as the Allegory of Painting* 1630. Oil on canvas, $38 \times 29''$ (96.5 \times 73.7 cm). The Royal Collection, Windsor Castle, Windsor, England. (RCIN 405551, ML 49 BP 2652)

moved to Florence, where she worked for the grand duke of Tuscany and was elected, at the age of twenty-three, to the Florentine Academy of Design. As a resident of Florence and member of the academy, Artemisia was well aware of the city's identification with the Jewish hero David and heroine Judith (both subjects of sculpture by Donatello and Michelangelo). In one of several versions of Judith triumphant over the Assyrian general Holofernes (fig. 19-19), Artemisia brilliantly uses Baroque naturalism and tenebrist effects, dramatically showing Judith still holding the bloody sword and hiding the candle's light as her maid stuffs the general's head into a sack.

Throughout her life, Artemisia painted images of heroic and abused women-Judith, Susanna, Bathsheba, Esther—and she also became a famous portrait painter. In 1630, she painted Self-Portrait as the Allegory of Painting (fig. 19-20). The image of a woman with palette and brushes, richly dressed, and wearing a gold necklace with a mask pendant comes from a popular sourcebook for such images, the Iconologia, by Cesare Ripa (1593), which maintains that the mask imitates the human face, as painting imitates nature. The gold chain symbolizes "the continuity and interlocking nature of painting, each man learning from his master and continuing his master's achievements in the next generation" (cited in E. Maser, no. 197). Thus, Artemisia's selfportrait not only commemorates her profession but also pays tribute to her father.

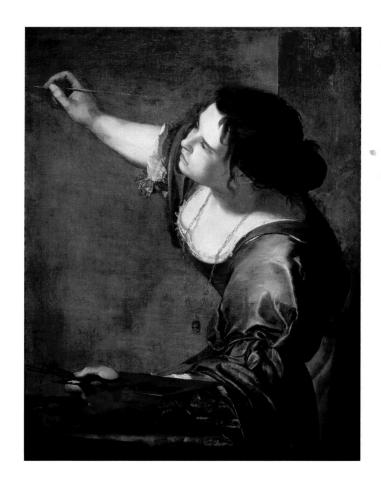

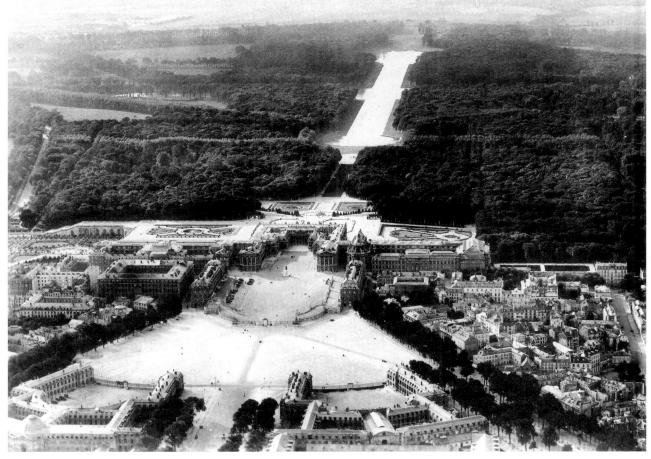

19-21. Louis Le-Vau and Jules Hardouin-Mansart. Palais de Versailles, Versailles, France. 1668–85. Gardens by André Le Nôtre.

FRANCE The early seventeenth century was a difficult period in France, marked by almost continuous foreign and civil wars. The assassination of King Henri IV in 1610 left France in the hands of the queen, Marie de' Medici (regency 1610-17), as regent for her nine-year-old son, Louis XIII (ruled 1610-43). When Louis came of age, the brilliant and unscrupulous Cardinal Richelieu became chief minister and set about increasing the power of the Crown at the expense of the French nobility. The death of Louis XIII again left France with a child king, the five-year-old Louis XIV (ruled 1643–1715). His mother, Anne of Austria, became regent, with the assistance of another powerful minister, Cardinal Mazarin. At Mazarin's death in 1661, Louis XIV (see fig. 19-1) began his long personal reign, assisted by yet another able minister, Jean-Baptiste Colbert.

An absolute monarch whose reign was the longest in European history, Louis XIV expanded royal art patronage, making the French court the envy of every ruler in Europe. In 1635, Cardinal Richelieu had founded the French Royal Academy to compile a definitive dictionary and grammar of the French language. In 1648, the Royal Academy of Painting and Sculpture was founded, which, as reorganized by Colbert in 1663, maintained strict control over the arts (see "Grading the Old Masters," page 740). Although it was not the first European arts academy, none before it had exerted

such dictatorial authority—an authority that lasted in France until the late nineteenth century. Membership in the Academy assured an artist of royal and civic commissions and financial success, but many talented artists did well outside it.

ARCHITECTURE AND ITS DECORATION AT VERSAILLES

French architecture developed along classical lines in the second half of the seventeenth century under the influence of François Mansart (1598–1666) and Louis Le Vau (1612–70). When the Royal Academy of Architecture was founded in 1671, its members developed guidelines for architectural design based on the belief that mathematics was the true basis of beauty. Their chief sources for ideal models were the books of Vitruvius (see "The Vitruvian Man," page 651), Vignola (see figs. 18-44, 18-45), and Palladio (see figs. 18-61, 18-63).

In 1668, Louis XIV began to enlarge the small château built by Louis XIII at Versailles, not far from Paris. Louis eventually required his court of 20,000 nobles to live in Versailles; 5,000 lived in the palace itself, together with 14,000 servants and military staff members. The town had another 30,000 residents, most of whom were employed by the palace. The designers of the palace and park complex at Versailles (fig. 19-21) were Le Vau, Charles Le Brun (1619–90), who oversaw

19-22. Central block of the garden facade, Palais de Versailles.

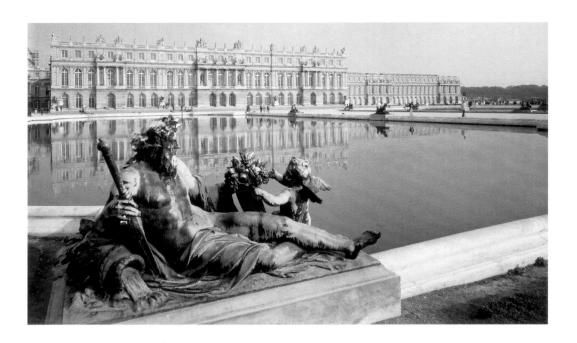

the interior decoration, and André Le Nôtre (1613–1700), who planned the gardens (see "French Baroque Garden Design," opposite). For both political and sentimental reasons, the old Versailles château was left standing, and the new building went up around it. This project consisted of two phases: the first additions by Le Vau, begun in 1668; and an enlargement completed after Le Vau's death by his successor, Jules Hardouin-Mansart (1646–1708), from 1670 to 1685.

Hardouin-Mansart was responsible for the addition of the long lateral wings and the renovation of Le Vau's central block on the garden side to match these wings (fig. 19-22). The three-story elevation has a lightly **rusticated** ground floor, a main floor lined

with enormous arched windows separated by Ionic pilasters, an attic level whose rectangular windows are also flanked by pilasters, and a flat, terraced roof. The overall design is a sensitive balance of horizontals and verticals relieved by a restrained overlay of regularly spaced projecting blocks with open, colonnaded porches.

In his renovation of Le Vau's center-block facade, Hardouin-Mansart enclosed the previously open gallery on the main level, which is about 240 feet long. He achieved architectural symmetry by lining the interior wall opposite the windows with Venetian glass mirrors—extremely expensive in the seventeenth century—the same size and shape as the arched windows, thus

GRADING THE OLD MASTERS

The members of the French Royal Academy of Painting and Sculpture considered ancient classical art to be the standard by which contemporary art should be judged. By the 1680s, however, younger artists of the Academy began to argue that modern art might equal and even surpass the art of the ancients, a radical thought sparking controversy.

A debate arose over the relative merits of drawing and color in painting. The conservatives argued that drawing was superior to color because drawing appealed to the mind, while color appealed to the senses. They saw Nicolas Poussin as embodying perfectly the classical principles of subject and design. But the young artists who admired the vivid colors of Titian, Veronese, and Rubens claimed that painting should deceive the eye, and since color achieves this deception more convincingly than drawing, application of color should be valued over drawing. The two positions were called poussinistes (in honor of Poussin) and rubénistes (for Rubens).

The portrait painter and critic Roger de Piles (1635–1709) took up the cause of the *rubénistes* in a series of pamphlets. In *The Principles* of *Painting*, Piles evaluated the most important painters on a scale of 0 to 20. He gave no score higher

than 18, since no mortal artist could achieve perfection. Caravaggio received the lowest grade, a 0 in expression and 6 in drawing, while Michelangelo and Leonardo both got a 4 in color and Rembrandt a 6 in drawing.

If we convert Piles's grades to the traditional scale of 90% = A, 80% = B, and so forth, most of the painters we have studied don't do very well. Raphael and Rubens get As, but no one gets a B; Van Dyck comes close with a C+. Poussin and Titian earn solid Cs, while Rembrandt slips by with a C-. Leonardo gets a D, and Michelangelo, Dürer, and Caravaggio all are resounding failures in Piles's view.

FRENCH BAROQUE GARDEN DESIGN

Wealthy landowners would commission garden designers to transform their large properties into gardens extending over many acres; the challenge for garden designers was to unify diverse elementsbuildings, pools, monuments, plantings, natural land formations-into a coherent whole. At Versailles, André Le Nôtre imposed order upon the vast expanses of palace gardens and park by using broad, straight avenues radiating from a series of round focal points. He succeeded so thoroughly that his plan inspired generations of urban designers as well as landscape architects.

In Le Nôtre's hands, the palace terrain became an extraordinary work of art and a visual delight for its inhabitants. Neatly contained stretches of lawn and broad, straight vistas seemed to stretch to the horizon, while the formal gardens became an exercise in precise geometry. The Versailles gardens are classically harmonious in their symmetrical, geometric design but

Baroque in their vast size and extension into the surrounding countryside, where the gardens thickened into woods cut by straight avenues.

The most formal gardens lay nearest the palace, and plantings became progressively less elaborate and larger in scale as the distance from the palace increased. Broad, intersecting paths separated reflecting pools and planting beds, which are called embroidered parterres for their colorful patterns of flowers outlined with trimmed hedges. After the formal zone of parterres came lawns, large fountains on terraces, and trees planted in thickets to conceal features such as an open-air ballroom and a colonnade. Statues carved by at least seventy sculptors also adorned the park. A mile-long canal, crossed by a second canal nearly as large, marked the main axis of the garden. Fourteen waterwheels brought the water from the river to supply the canals and the park's 1,400 fountains. Only the fountains near the palace played all day; the others were turned on when the king approached.

At the north of the secondary canal, a smaller pavilion-palace, the Trianon, was built in 1669. To satisfy the king's love of flowers yearround, the gardens of the Trianon were bedded out with blooming plants shipped in by the navy from the south: even in midwinter, the king and his guests could stroll through a summer garden. The gardener is said to have had nearly 2 million flowerpots at his disposal. The fruit and vegetable garden that supplied the palace in 1677-83 is now the National School of Horticulture. In the eighteenth century, Louis XV added greenhouses and a botanical garden.

Another royal retreat, the Little Trianon, was added in 1761 and given in 1774 to Louis XVI's queen, Marie Antoinette. Reflecting a new delight in unspoiled nature, in 1785 a miniature village in a "natural" landscape was constructed there for the queen, where she and the ladies of the court relaxed by pretending to be shepherdesses and milkmaids. Flocks of sheep assisted this illusion.

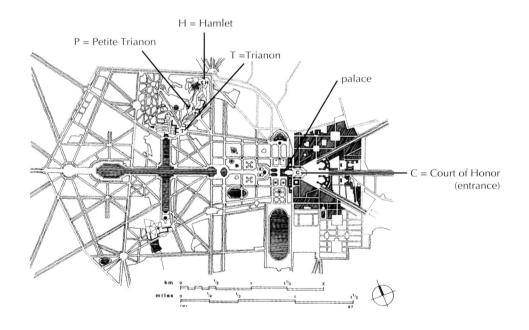

Louis Le Vau and André Le Nôtre. Plan of the Palais de Versailles, Versailles, France. c. 1661–1785. Drawing by Leland M. Roth after Delagrive's engraving of 1746.

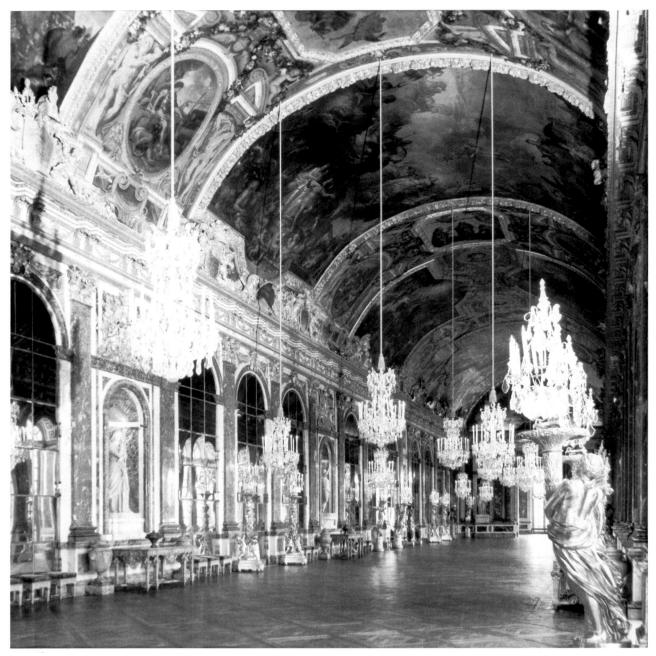

19-23. Jules Hardouin-Mansart and Charles Le Brun. Hall of Mirrors, Palais de Versailles. Begun 1678. Length approx. 240'.

In the seventeenth century, mirrors and clear window glass were enormously expensive. To furnish the Hall of Mirrors, hundreds of glass panels of manageable size had to be assembled into the proper shape and attached to one another with glazing bars, which became part of the decorative pattern of the vast room.

creating the famed Hall of Mirrors (fig. 19-23). The mirrors reflect the natural light from the windows and give the impression of an even larger space. In a tribute to Carracci's Farnese ceiling (see fig. 19-12), Le Brun decorated the vaulted ceiling with paintings glorifying the reign of Louis XIV. In 1642, Le Brun had studied in Italy, where he came under the influence of the classical style of his compatriot Nicolas Poussin, discussed later in this chapter. Stylistically, Le Brun tempered the more exuberant Baroque ceilings he had seen in Rome with Poussin's classicism in his spectacular decorations. The underlying

theme for the design and decoration of the palace was the glorification of the king as Apollo the Sun God, with whom Louis identified. Louis XIV thought of the duties of kingship, including its pageantry, as a solemn performance, so it is most appropriate that Rigaud's portrait presents him on a raised, stagelike platform, with a theatrical curtain (see fig. 19-1). Versailles was the splendid stage on which the king played this grandiose drama.

In the seventeenth century, French taste in sculpture tended to favor classicizing works inspired by antiquity and the Italian Renaissance. A highly favored sculptor in this classical style, François Girardon (1628-1715), had studied the monuments of classical antiquity in Rome in the 1640s. He had worked with Le Vau and Le Brun before he began working to decorate Versailles. In keeping with the repeated identification of Louis XIV with Apollo, he created the sculpture group Apollo Attended by the Nymphs of Thetis (fig. 19-24), executed about 1666-75, to be displayed in a classical arched niche in the Grotto of Thetis (fig. 19-25), a formal, triple-arched pavilion named after a sea nymph beloved by the Sun god (see "The Grotto," page 710). The original setting was destroyed in 1684, and today the sculpture group stands in the eighteenth-century grotto seen in figure 19-24. In the center—the group Girardon created-Apollo is attended by the nymphs of Thetis after his long journey across the heavens. At each side, Tritons, figures by Thomas Regnaudin (c. 1622-1706), rub down Apollo's horses, which were carved by the Marsy family workshop. In 1776, Louis XVI had the painter Hubert Robert design a "natural" rocky cavern for Girardon's sculpture.

PAINTING

French seventeenth-century painting was much affected by developments in Italian art. The lingering Mannerism of the sixteenth century gave way as early as the 1620s to Baroque classicism and Caravaggism—the

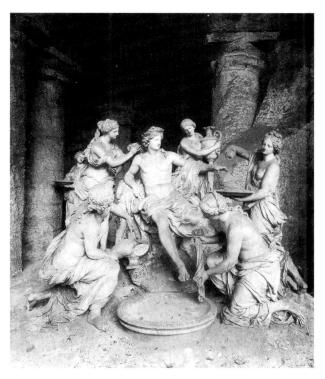

19-24. François Girardon. *Apollo Attended by the Nymphs of Thetis,* from the Grotto of Thetis, Palais de Versailles, Versailles, France. c. 1666–75. Marble, lifesize. Grotto by Hubert Robert in 1776; sculpture reinstalled in a different configuration in 1778.

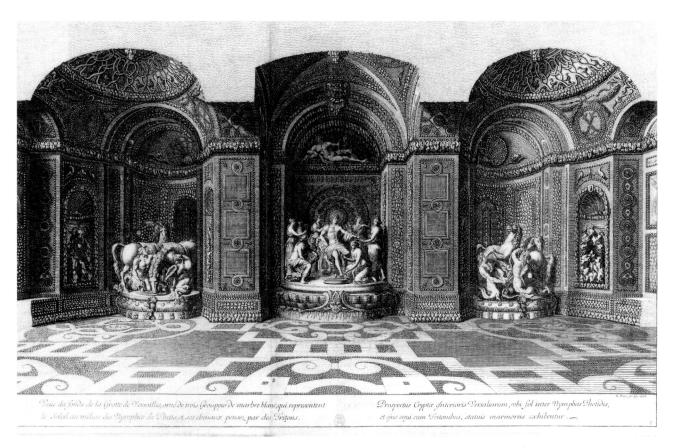

19-25. Jean Lepautre. *The Grotto of Thetis.* 1676. Engraving by Jean Lepautre showing the original setting (destroyed in 1684) of *Apollo Attended by the Nymphs of Thetis*. Bibliothèque Nationale de France, Paris.

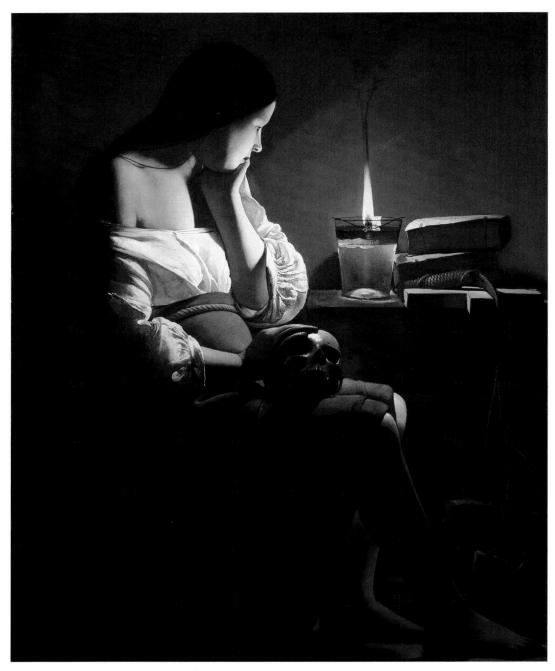

19-26. Georges de La Tour. *Magdalen with the Smoking Flame*. c. 1640. Oil on canvas, $46\frac{1}{4} \times 36\frac{1}{8}$ " (117 × 91.8 cm). Los Angeles County Museum of Art. Gift of the Ahmanson Foundation, (M. 77.73)

use of strong **chiaroscuro** (tenebrism) and raking light, and the placement of large-scale figures in the foreground.

Georges de La Tour. One of Caravaggio's most important followers in France, Georges de La Tour (1593–1652), received major royal and ducal commissions and became court painter to King Louis XIII in 1639. La Tour may have traveled to Italy in 1614–16, and in the 1620s he almost certainly visited the Netherlands, where Caravaggio's style was being enthusiasti-

cally emulated. Like Caravaggio, La Tour filled the foreground of his canvases with monumental figures, but in place of Caravaggio's detailed naturalism he used a simplified setting and a light source within the picture so intense that it often seems to be his real subject. In *Magdalen with the Smoking Flame* (fig. 19-26), as in many of his paintings, the light emanates from a candle. The hand and skull act as devices to establish a foreground plane, and the compression of the figure within the pictorial space lends a sense of intimacy. The light is the unifying element of the painting and

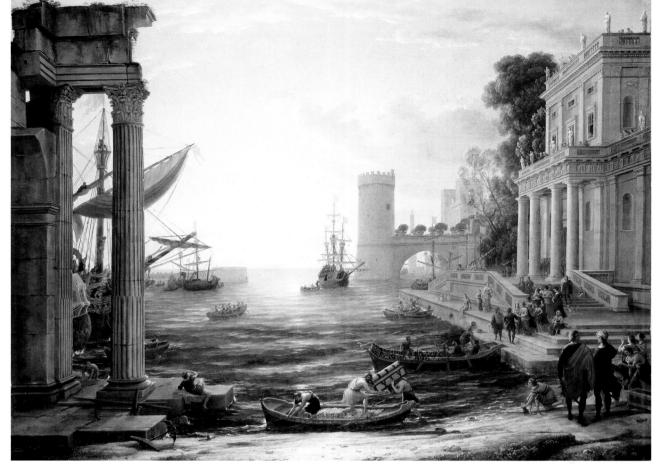

19-27. Claude Lorrain, *Embarkation of the Queen of Sheba.* 1648. Oil on canvas, $4'10'' \times 6'4''$ (1.48 \times 1.93 m). National Gallery, London. Reproduced by courtesy of the Trustees of the National Gallery, London.

conveys the mood. Mary Magdalen has put aside her rich clothing and jewels and meditates on the frailty and vanity of human life.

Claude Lorrain and Nicolas Poussin. The painters Claude Gellée (called Claude Lorrain, or simply Claude, 1600–1682) and Nicolas Poussin (1594–1665) pursued their careers in Italy although they usually worked for French patrons. They perfected the ideal "classical" landscape. They profoundly influenced painters of the eighteenth and nineteenth centuries. Claude and Poussin were classicists in that neither recorded nature as he found it but instead organized natural elements and figures into idealized compositions. Both were influenced by Annibale Carracci and to some extent by Venetian painting, yet each evolved an unmistakable personal style that conveyed an entirely different mood from that of their sources and from each other.

Claude went to Rome in 1613 where he studied with Agostino Tassi, an assistant of Guercino (see fig. 15, Introduction) and specialist in architectural painting. Claude, however, preferred landscape. He sketched outdoors for days at a time, then returned to his studio to compose his paintings. A favorite and much imitated device was to place one or two large objects in the foreground—a tree, building, or hill—past which the viewer's eye enters the scene and pro-

ceeds, often by zigzag paths, into the distance. Claude was fascinated with light, and his works are often studies of the effect of the rising or setting sun on colors and the atmosphere.

Claude used this compositional device to great effect in paintings such as The Embarkation of the Queen of Sheba (fig. 19-27). A ruined building with Corinthian cornice and columns frames the composition at the left; light catching the seashore leads the eye to the right, where a handsome palace with a grand double staircase and garden with trees establishes a middle ground. Across the water the sails and rigging of ships provide extra visual interest. More distant still is the harbor fortification with town and lighthouse, and finally the breakwater (at the left). Claude's meticulous onepoint perspective focuses on the sun with the same driving force with which earlier painters focused on Christ and the saints. Instead of balanced, symmetrically placed elements, Claude leads the viewer into the painting in a zigzag fashion. On the horizon the sun illuminates the clouds in a clearing sky and catches the waves to make a sea path to shore. The small figures seem incidental additions that give the painting a subject. Workers and onlookers in the foreground, the Queen and her courtiers waiting on the quay and about to board are little more than an excuse for painting a glowing seascape.

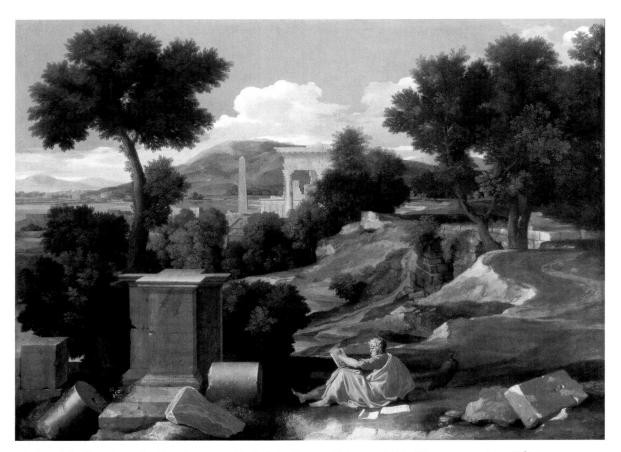

19-28. Nicolas Poussin. Landscape with Saint John on Patmos. 1640. Oil on canvas, $40 \times 53^{1/2}$ " $(101.8 \times 136.3 \text{ cm})$. The Art Institute of Chicago A. A. Munger Collection, 1930.500

Like Claude, Poussin created landscapes with figures, but to different effect. His paintings are the epitome of the orderly, arranged, classical landscape. In his Landscape with Saint John on Patmos (fig. 19-28), from 1640, Poussin created a consistent perspective progression from the picture plane back into the distance through a clearly defined foreground, middle ground, and background. These zones are marked by alternating sunlight and shade, as well as by their architectural elements. Huge, tumbled classical ruins fill the foreground and overshadow the evangelist, who concentrates on his writing of the Book of Revelation, describing the end of the world and the Last Judgment. Surrounded by the ruins of ancient Rome—and by extension all earthly empires—St. John writes of the Second Coming of Christ, a renewal of life suggested by the flourishing vegetation. This grand theme is represented in the highly intellectualized format of Poussin's classical composition. In the middle distance are a ruined temple and an obelisk, and the round building in the distant city is Hadrian's Tomb, which Poussin knew from Rome. Precisely placed trees, hills, mountains, water, and even clouds take on a solidity of form that seems almost as structural as architecture. The reclining evangelist and the eagle, his symbol, seem almost incidental to this perfect landscape. The triumph of the rational mind takes on moral overtones. The subject of Poussin's painting is in effect the balance and order of nature rather than the story of John the Evangelist.

In the second half of the seventeenth century, the French Academy took Poussin's paintings and notes on painting as a final authority. Thereafter, whether as a model to be followed or one to be reacted against, Poussin influenced French art.

Hyacinthe Rigaud. Hyacinthe Rigaud (1659–1743), trained by his painter father, won the Royal Academy's prestigious Prix de Rome in 1682, which would have paid his expenses for study at the Academy's villa in Rome. Rigaud rejected the prize, however, and opened his own Paris studio. After painting a portrait of Louis XIV's brother in 1688, he became a favorite of the king himself. One of his best-known portraits-one representing the height of royal propaganda—is the one he painted of the Sun King in 1701, with which we opened the chapter (see fig. 19-1). Although he was well known and popular-and quite influential on later French portraitists-Rigaud was far removed from both the classicizing and the Caravaggesque influences at work on other French artists of the time.

HABSBURG **GERMANY**

What had begun as a Germanic Holy Roman Empire had by the early sixteenth AND AUSTRIA century expanded through inheritance and marriage

across a broad swath of Europe (Chapter 18). But even

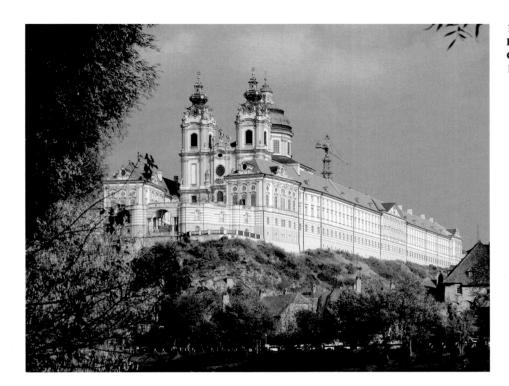

19-29. Jakob Prandtauer. Benedictine Monastery Church, Melk, Austria. 1702–36 and later.

an intelligent and dedicated ruler like the Habsburg Charles V, who had been elected emperor in 1519, could not manage the affairs of and maintain control over such a vast territory. In 1556 he abdicated, dividing the empire, and he died two years later. He left Spain and its American colonies, the Netherlands, Burgundy, Milan, and the Kingdom of Naples and Sicily to his son Philip II. The Holy Roman Empire (Germany and Austria) went to his brother Ferdinand.

The arts suffered in seventeenth-century Germanic lands during and after the Protestant Reformation. The Habsburg emperors ruled their territories from Vienna in Austria, but much of German-speaking Europe remained divided into small units in which local rulers decided on the religion of their territory. Catholicism prevailed in southern and western Germany, including Bavaria and the Rhineland, and in Austria, while the north was Lutheran. Wars over religion ravaged the land, absorbing available money. When peace finally returned in the eighteenth century, Catholic Austria and Bavaria (southern Germany) saw a remarkable burst of building activity, including the creation and refurbishing of churches and palaces with exuberant interior decoration. Emperor Charles VI (ruled 1711-40) inspired building in his capital, Vienna, and throughout Austria.

Church architecture looked to Italian Baroque developments, which were then added to German medieval forms such as the **westwork**, a tall west front, and bell towers. With these elements, German Baroque architects gave their churches an especially strong vertical emphasis. Important secular projects were also undertaken, as princes throughout Germany began building smaller versions of Louis XIV's palace and garden complex at Versailles. One of the most imposing buildings of this period is the Benedictine Abbey of Melk, built high

on a promontory overlooking the Danube River on a site where there had been a Benedictine monastery since the eleventh century. The complex combines church, monastery, library, and—true to the Benedictine tradition of hospitality—guest quarters that evolved into a splendid palace to house the traveling court (fig. 19-29). The architect, Jakob Prandtauer (1660–1726), oversaw its construction until his death in 1726.

Seen from the river, the monastery appears to be a huge twin-towered church. But the church is flanked by two long (1,050 feet) parallel wings, one of which contains a grand hall and the other, the monastery's library. The wings are joined at the lower level by a section with a curving facade forming a terrace overlooking the river in front of the church. Large windows and open galleries take advantage of the river view, while colossal pilasters and high bulbous-dome towers emphasize the building's verticality. As an ancient foundation enjoying imperial patronage, the monastery was expected to provide lodging for traveling princes and other dignitaries. Its grand and palacelike appearance—especially the interior (fig. 19-30, page 748)—was appropriate to that function.

HABSBURG SPAIN

The Spanish Habsburg kings—Philip III (ruled 1598–1621), Philip IV (ruled 1621–65), and Charles II (ruled 1665–1700)—reigned over

an increasingly weakening empire during a rich period for painting and literature that concealed a profound economic and political decline. Agriculture, industry, and trade suffered, and after repeated local rebellions Portugal reestablished its independence in 1640. The Kingdom of Naples remained in a constant state of revolt. After eighty years of war, the Protestant northern Netherlands—which had formed the United Dutch

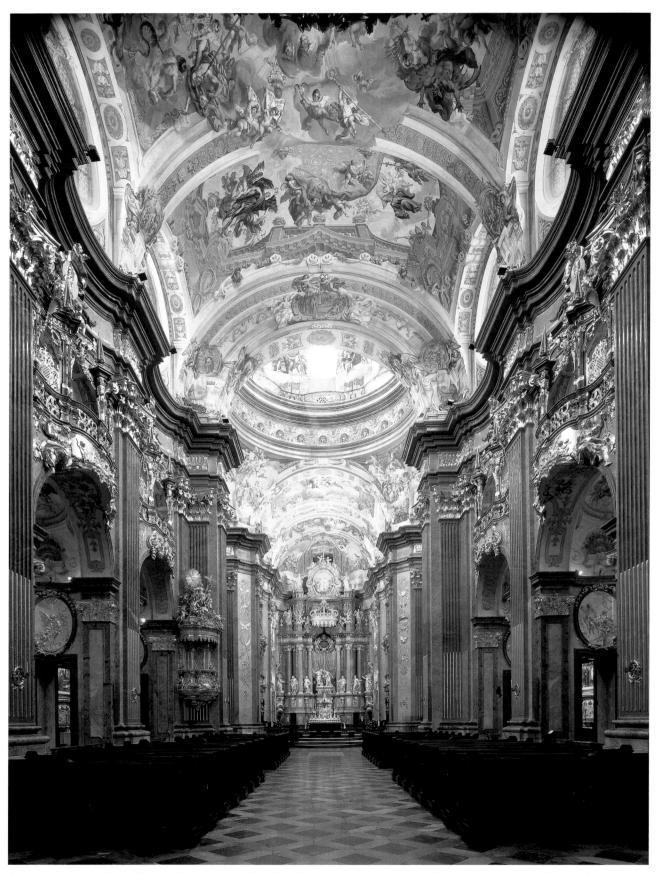

19-30. Interior, Benedictine Monastery Church, Melk, Austria. Completed after 1738, after designs by Prandtauer, Antonio Beduzzi, and Joseph Munggenast.

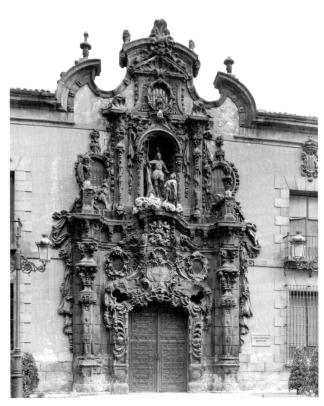

19-31. Pedro de Ribera. Portal of the Hospicio de San Fernando, Madrid. 1722.

Republic—definitively gained independence in 1648. Amsterdam grew into one of the wealthiest cities of Europe, and the Dutch Republic became an increasingly serious threat to Spanish trade and colonial possessions. Meanwhile, the Catholic southern Netherlands (Flanders) stagnated under Spanish and then Austrian Habsburg rule. (Flanders did not declare its independence until 1798, when it took the name Belgium from the original tribe of Belgae.) Furthermore, what had seemed an endless flow of gold and silver from the Americas diminished, as precious-metal production in Bolivia and Mexico lessened. Attempting to defend the Roman Catholic Church and their empire on all fronts, Spanish kings squandered their resources and finally went bankrupt in 1692. Nevertheless, despite the decline of the Habsburgs' Spanish empire, seventeenth-century writers and artists produced much of what is considered the greatest Spanish literature and art, and the century is often called the Spanish Golden Age.

ARCHITECTURE

Turning away from the severity displayed in the sixteenth-century El Escorial monastery-palace (see fig. 18-69), Spanish architects again embraced the lavish decoration that had characterized their art since the fourteenth century. The profusion of ornament typical of Moorish and Gothic architecture in Spain swept back into fashion in the work of a family of architects and sculptors named Churriguera, first in huge **retablos** (altarpieces), then in **portals**, and finally in entire build-

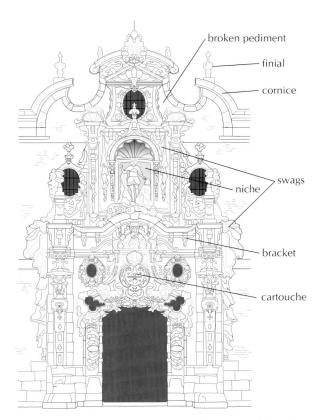

19-32. Diagram of the Portal of the Hospicio de San Fernando.

ings. Once called Churrigueresque but now known as Ultra-Baroque or Late Baroque, the style found its most exuberant expression in the work of eighteenth-century architects such as Pedro de Ribera (c. 1681–1742) and in the architecture of colonial Mexico and Peru.

Ribera's 1722 facade for the Hospicio de San Fernando is typical (figs. 19-31, 19-32). The street facade is a severe brick structure with an extraordinarily exuberant sculpted portal, which is as much like a painting as architecture becomes. Although the architect used classical elements (among them cornices, brackets, pedestals, volutes, finials, swags, and niches) in the portal and organized them symmetrically, the parts run together in a wild profusion of theatrical hollows and projections, large forms (such as the broken pediment at the roofline), and small details. Like a huge altarpiece, the portal soars upward. The structural forms of classical architecture are transformed into projecting and receding layers overlaid with foliage. Carved curtains loop back as if to reveal the doorway, and more drapery surrounds the central niche with the figure of the hospital's patron saint, Ferdinand. This florid style was carried by the conquistadores to the Americas, where it formed the basis of a splendid colonial architecture (see fig. 19-42).

PAINTING

The primary influence on Spanish painting in the fifteenth century had been the art of Flanders; in the sixteenth, it had been the art of Florence and Rome. Seventeenth-century Spanish painting, profoundly

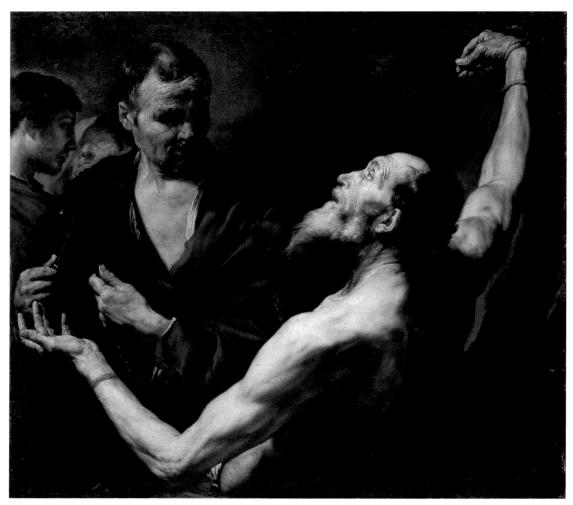

19-33. Jusepe de Ribera. *Martyrdom of Saint Bartholomew*. 1634. Oil on canvas, $41^{1}/_{4}" \times 44^{7}/_{8}"$ (1.05 \times 1.14 m). National Gallery of Art, Washington, D.C. Gift of the 50th Anniversary Gift Committee (1990.137.1)

influenced by Caravaggio's powerful art, was characterized by an ecstatic religiosity combined with intense realism whose surface details emerge from the deep shadows of tenebrism. This influence is not surprising, since the Kingdom of Naples was ruled by Spanish monarchs, and contact between Naples and the Iberian peninsula was strong and productive.

Jusepe de Ribera. First to Rome, then to Naples went the young Spanish painter Jusepe de Ribera (c. 1591–1652), also known as Lo Spagnoletto ("the Little Spaniard"). Ribera combined the classical and Caravaggesque styles he had learned in Rome, and after settling in Naples in 1620, created a new Neapolitan—and eventually Spanish—style: Ribera became the link extending from Caravaggio in Italy to two major painters in Spain, Zurbarán and Velázquez.

Aiming to draw people back to Catholicism, the Church ordered art depicting heroic martyrs who had endured shocking torments as witness to their faith or who, like Teresa in ecstasy (see fig. 19-9) reinforced the importance of personal religious experience and intuitive knowledge. A striking response to this call is Ribera's painting of Bartholomew, an apostle who was martyred

by being skinned alive (fig. 19-33). Here Ribera highlighted the intensely realistic aged faces with dramatic Caravaggesque tenebrism. The bound Bartholomew looks heavenward as his executioner tests the knife that he will soon use on his still-living victim.

Francisco de Zurbarán. Equally horrifying in its depiction of martyrdom, but represented with understated control, is the 1628 painting of *Saint Serapion* (fig. 19-34) by Francisco de Zurbarán (1598–1664). Little is known of his early years before 1625, but Zurbarán was greatly influenced by the Caravaggesque taste prevalent in Seville, a major city in southwestern Spain, where he worked. From it he evolved his own distinctive style, incorporating a Spanish taste for abstract design.

Zurbarán was closely associated with the monastic orders for which he executed his major commissions. In the painting shown here, he portrays the martyrdom of Serapion, who was a member of the thirteenth-century Mercedarians, a Spanish order founded to rescue the Christian prisoners of the Spanish Moors. Following the vows of his order, Serapion sacrificed himself in exchange for Christian captives. The dead man's pallor, his rough hands, and the coarse ropes emerge from the off-

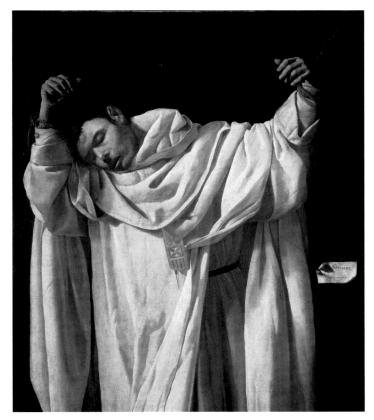

19-34. Francisco de Zurbarán. *Saint Serapion.* 1628. Oil on canvas, $47^1/_2 \times 40^3/_4$ " (120.7 \times 103.5 cm). Wadsworth Atheneum, Hartford, Connecticut. Ella Gallup Sumner and Mary Catlin Sumner Collection Fund

white of his creased Mercedarian habit, its folds carefully arranged in a pattern of highlights and varying depths of shadow. The only colors are the red and gold of the insignia. The effect of this composition, almost timeless in its stillness, is that of a tragic still life.

Juan Sánchez Cotán. Late in the sixteenth century, Spanish artists developed a significant interest in paintings of artfully arranged objects rendered with intense attention to detail. Juan Sánchez Cotán (1561-1627) was one of the earliest painters of these pure still lifes in Spain. His Still Life with Quince, Cabbage, Melon, and Cucumber (fig. 19-35), of about 1602, is a prime example of the characteristic Spanish trompe l'oeil rendering of an artificially composed still life. Sánchez Cotán's composition plays off the irregular, curved shapes of the fruits and vegetables against the angular geometry of the setting. His precisely ordered subjects, suspended from strings in a long arc from the upper left to the lower right, are set in a strong light against an impenetrable dark background. This highly artificial arrangement exemplifies a Spanish fascination with spatial ambiguity; it is not clear whether the seemingly airless space is a wall niche or a window ledge, or why these objects have been arranged in this way.

Diego Velázquez. Diego Rodríguez de Silva y Velázquez (1599–1660), the greatest painter to emerge from the Caravaggesque school of Seville and one of the most ac-

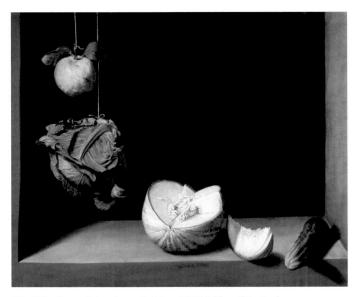

19-35. Juan Sánchez Cotán. *Still Life with Quince, Cabbage, Melon, and Cucumber*. c. 1602. Oil on canvas, $27^{1}/_{8} \times 33^{1}/_{4}$ " (68.8 \times 84.4 cm). San Diego Museum of Art. Gift of Anne R. and Amy Putnam

claimed painters of all time, entered Seville's painters' guild in 1617. Like Ribera, he was influenced at the beginning of his career by Caravaggesque tenebrism and naturalism. During his early years, he painted figural works set in taverns, markets, and kitchens, showing

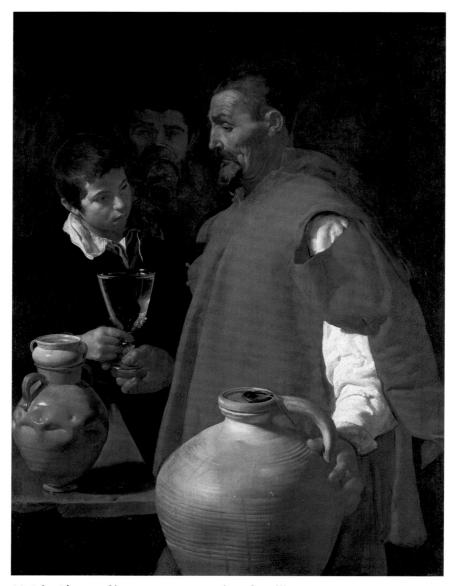

19-36. Diego Velázquez. *Water Carrier of Seville.* c. 1619. Oil on canvas, $41\frac{1}{2} \times 31\frac{1}{2}$ " (105.3 × 80 cm). Victoria and Albert Museum, London.

In the hot climate of Seville, Spain, where this painting was made, water vendors walked the streets selling cool drinks from large clay jars like the one in the foreground. In this scene, the clarity and purity of the water are proudly attested to by its seller, who offers the customer a sample poured into a glass goblet. The jug contents were usually flavored with the addition of a piece of fresh fruit or a sprinkle of aromatic herbs.

still lifes of various foods and kitchen utensils. Velázquez was devoted to studying and sketching from life, and the model for the superb *Water Carrier of Seville* (fig. 19-36), of about 1619, was a well-known Sevillian water seller. Like Sánchez Cotán, Velázquez arranged the elements of his paintings with almost mathematical rigor. The objects and figures allow the artist to exhibit his virtuosity in rendering sculptural volumes and contrasting textures illuminated by dramatic natural light, which reacts to the surfaces: reflecting off the glazed waterpot at the left and the **matte**-, or dull-, finished jug in the foreground; being absorbed by the rough wool and dense velvet of the costumes; and reflecting, being refracted, and passing through the clear glass and the waterdrops on the jug's surface.

In 1623, Velázquez moved to Madrid, where he became court painter to young King Philip IV, a comfortable position that he maintained until his death in 1660. The artist's style evolved subtly but significantly over his long career. The Flemish painter Peter Paul Rubens, during a 1628–29 diplomatic visit to the Spanish court, convinced the king that Velázquez should visit Italy, which Velázquez did in 1629–31 and again in 1649–51. Velázquez was profoundly influenced by Italian painting of that time, especially in narratives with complex figure compositions.

In his great history painting *The Surrender at Breda* (fig. 19-37), Velázquez treated the theme of triumph and conquest in an entirely new way, unlike the traditional gloating military propaganda. Years earlier, in 1625, the

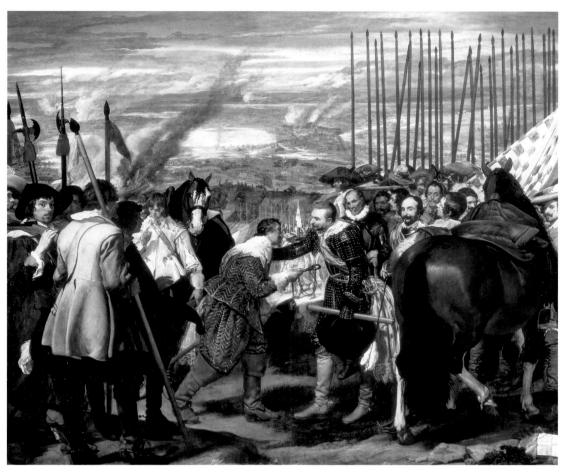

19-37. Diego Velázquez. *The Surrender at Breda (The Lances).* 1634–35. Oil on canvas, $10^{17}/8$ " \times $12^{11}/2$ " (3.07 \times 3.67 m). Museo del Prado, Madrid.

duke of Alba, the Spanish governor, had defeated the Dutch at Breda. In Velázquez's imagination, the opposing armies stand on a hilltop overlooking a vast valley where the city of Breda burns and soldiers are still deployed. The Dutch commander, Justin of Nassau, hands over the keys of Breda to the victorious Spanish commander, Ambrosio Spinola. The entire exchange seems extraordinarily gracious; the painting represents a courtly ideal of gentlemanly conduct. The victors stand at attention, holding their densely packed lances upright—giving the painting its popular name, *The Lances*—while the defeated Dutch, a motley group, stand out of order, with pikes and banners drooping.

In *The Surrender at Breda*, Velázquez displays his ability to arrange a large number of figures into an effective narrative composition. Portraitlike faces, meaningful gestures, and brilliant control of color and texture convince us of the reality of the scene. The landscape painting is almost startling. Across the huge canvas, Velázquez painted an entirely imaginary Netherlands in greens and blues worked with flowing, liquid brushstrokes. The silvery light forms a background for dramatically silhouetted figures and weapons. Velázquez revealed a breadth and intensity unsurpassed in his century that would inspire modern artists from Manet to Picasso.

Although complex compositions were characteristic of many Velázquez paintings, perhaps his most striking and enigmatic work is the enormous multiple portrait, nearly $10^{1}/_{2}$ feet tall and over 9 feet wide, known as *Las Meninas (The Maids of Honor)* (fig. 19-38, page 754). Painted in 1656, near the end of the artist's life, this painting continues to challenge the viewer. Like Caravaggio's *Entombment* (see fig. 19-18), it draws the viewer directly into its action, for the viewer is standing, apparently, in the space occupied by King Philip and his queen, whose reflections can be seen in the large mirror on the back wall. The central focus, however, is on the couple's five-year-old daughter, the *infanta* (princess) Margarita, surrounded by her attendants, most of whom are identifiable portraits.

A cleaning of *Las Meninas* in 1984 revealed much about Velázquez's methods. He used a minimum of underdrawing, building up his forms with layers of loosely applied paint and finishing off the surfaces with dashing highlights in white, lemon yellow, and pale orange. Velázquez tried to depict the optical properties of light rather than using it to model volumes in the classical manner. While his technique captures the appearance of light on surfaces, at close inspection his forms dissolve into a maze of individual strokes of paint.

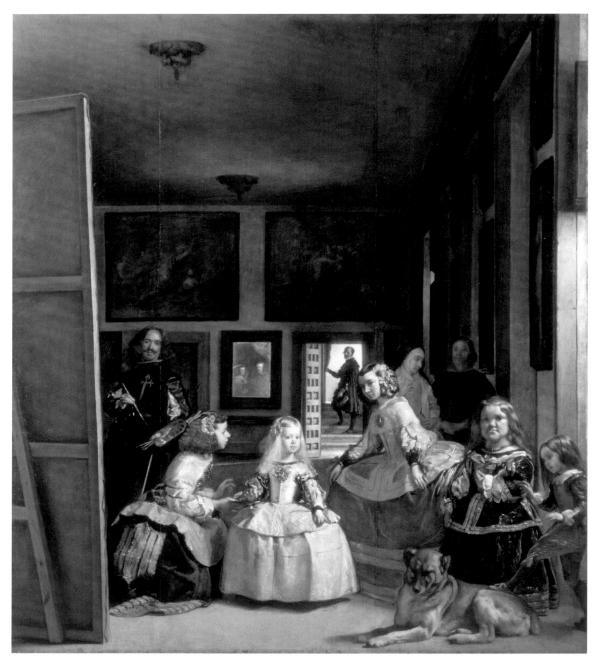

19-38. Diego Velázquez. *Las Meninas (The Maids of Honor).* 1656. Oil on canvas, $10'5'' \times 9'^{1/2}''$ (3.18 × 2.76 m). Museo del Prado, Madrid.

No consensus exists today on the meaning of this monumental painting. It is more than a portrait of the princess and her attendants. It is also a painting of the king and queen stepping into the artist's studio and a self-portrait of Velázquez standing at his easel. But more than that, *Las Meninas* seems to have been a personal statement in its own day, not a true court portrait. Throughout his life, Velázquez had sought respect and acclaim for himself and for the art of painting. Here, dressed as a courtier, the Order of Santiago on his chest and the keys of the palace in his sash, Velázquez proclaimed the dignity and importance of painting as one of the liberal arts.

Bartolomé Esteban Murillo. One of the most popular painters in his day and for the next 200 years, Bartolomé Esteban Murillo (1617–82) was reevaluated at the end of the twentieth century and his art again found adherents, who respected his rich colors and skillful technique. Murillo specialized in painting the Virgin Mary and in rendering the Immaculate Conception (fig. 19-39), the controversial idea that Mary was born free from original sin. Although the Immaculate Conception became Catholic dogma only in 1854, the concept, as well as devotion to Mary, became widespread during the seventeenth and eighteenth centuries. Murillo lived and worked in Seville, which was a center for trade with the Spanish colonies,

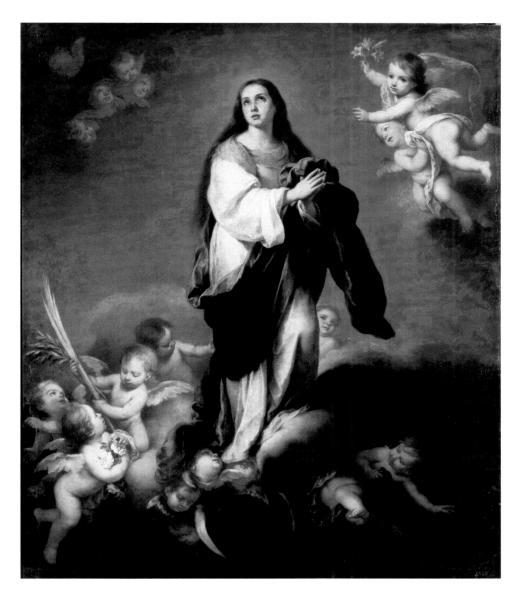

19-39. Bartolomé Esteban Murillo. The Esquilache Immaculate Conception. c. 1645-50. Oil on canvas, $7'8'' \times 6'5''$ $(2.35 \times 1.96 \text{ m})$. State Hermitage Museum, St. Petersburg, Russia.

where his work had a profound influence on art and religious iconography. Counter-Reformation authorities had provided specific instructions for artists such as Murillo painting the Virgin: Mary was to be dressed in blue and white, hands folded in prayer, as she is carried upward by angels, sometimes in large flocks. She may be surrounded by an unearthly light ("clothed in the sun") and may stand on a crescent moon. Angels often carry palms and symbols of the Virgin, such as a mirror, fountain, roses, and lilies and may vanquish the old serpent, Satan.

The Church exported many paintings by Murillo, Zurbarán, and others to the New World. When the native population began to visualize the Christian story, paintings such as Murillo's The Esquilache Immaculate Conception provided the imagery.

COLONIES IN THE AMERICAS

SPANISH The Spanish colonization of the Americas dates to 1519, when Hernán Cortés arrived off the coast of Mexico from the Spanish colony in Cuba.

Within two years, after forging alliances with enemies of

the dominant Aztec people, Cortés succeeded in taking the Aztec capital, Tenochtitlan (Mexico City). Over the next several years, Spanish forces established Mexico as a colony of Spain. In 1532, Francisco Pizarro, following Cortés's example, led an expedition to the land of the Inca, in Peru (see Map 23-1). Hearing that the Inca ruler Atahualpa, freshly victorious in the war of succession that followed the death of his father, was preparing to enter the Inca capital, Cuzco, Pizarro pressed inland to intercept him. He and his men seized Atahualpa, held him for a huge ransom in gold, then treacherously strangled him. They marched on Cuzco and seized it in 1533. The conquest was followed by a period of disorder, with Inca rebellions and struggles among the conquistadores that did not end until about 1550. In both Mexico and Peru, the Native American populations declined sharply after the conquest because of the exploitative policies of the conquerors and the ravages of diseases they brought with them, like smallpox, against which the indigenous people had no immunity.

In the wake of the conquest, the European conquerors suppressed local beliefs and practices and

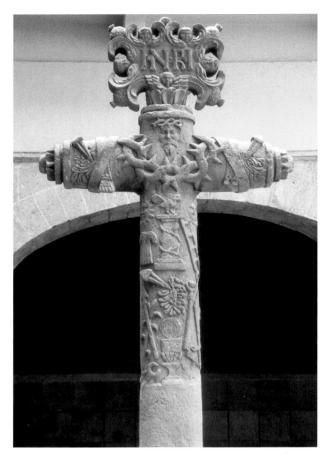

19-40. Atrial cross. Before 1556. Stone, height 11'3" (3.45 m). Chapel of the Indians, Basilica of Guadalupe, Mexico City.

imposed Roman Catholicism throughout Spanish America. Native American temples were torn down, and churches were erected in their place (see fig. 23-6). The early work of conversion fell to the Franciscan, Dominican, and Augustinian religious orders. Several missionaries were so appalled by the conquerors' treatment of the people they called Indians that they petitioned the Spanish king to improve their condition.

In the course of Native Americans' conversion to Roman Catholicism, their own symbolism was to some extent absorbed into Christian symbolism. This process can be seen in the huge early colonial atrial crosses, so called because they were located in church atriums, where large numbers of converts gathered for education in their new faith. Missionaries recruited Native American sculptors to carve these crosses. One sixteenthcentury atrial cross, now in the Basilica of Guadalupe in Mexico City, suggests pre-Hispanic sculpture in its stark form and rich surface symbols, even though the individual images were probably copied from illustrated books brought by the missionaries (fig. 19-40). The work is made from two large blocks of stone that are entirely covered with low-relief images known as the Arms of Christ, the "weapons" Christ used to defeat the devil. Jesus' Crown of Thorns hangs like a necklace around the cross bar, and with the Holy Shroud, which also wraps the arms, it frames the image of the Holy Face

(the impression on the cloth with which Veronica wiped Jesus' face). Blood gushes forth where huge nails pierce the ends of the cross. Symbols of regeneration, such as winged **cherub** heads and pomegranates, surround the inscription at the top of the cross.

The cross itself suggests an ancient Mesoamerican symbol, the World Tree or Tree of Life. The image of blood sacrifice also resonates with indigenous beliefs. Like the statue of the Aztec earth mother Coatlicue (see fig. 23-5), the cross is composed of many individual elements that seem compressed to make a shape other than their own, the dense low relief combining into a single massive form. Simplified traditional Christian imagery is clearly visible in the work, although it may not yet have had much meaning or emotional resonance for the artists who put it there.

Converts in Mexico gained their own patron saint after the Virgin Mary was believed to have appeared as an Indian to an Indian named Juan Diego in 1531. Mary is said to have asked that a church be built on a hill where the goddess Coatlicue had once been worshiped. As evidence of this vision, Juan Diego brought the archbishop flowers that the Virgin had caused to bloom, wrapped in a cloak. When he opened his bundle, the cloak bore the image of a dark-skinned Virgin Mary, an image that, light-skinned, was popular in Spain and known as the Virgin of the Immaculate Conception. The

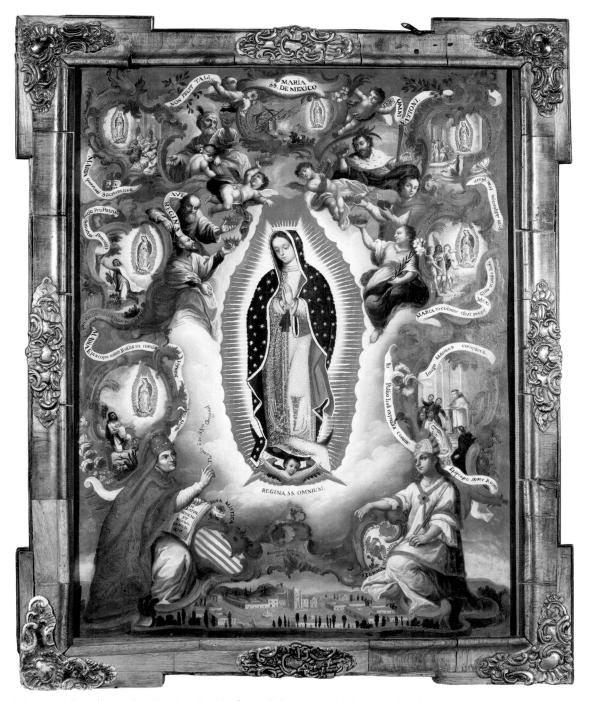

19-41. Sebastian Salcedo. *Our Lady of Guadalupe*. 1779. Oil on panel and copper, 25×19 " (63.5 \times 48.3 cm). Denver Art Museum.

Collection, funds contributed by Mr. and Mrs. George G. Anderman and an anonymous donor, (1976.56)

At the bottom right is the female personification of New Spain (Mexico) and at the left is Pope Benedict XIV (papacy 1740–1758), who in 1754 declared the Virgin of Guadalupe to be the patron of the Americas. Between the figures, the sanctuary of Guadalupe in Mexico can be seen in the distance. The four small scenes circling the Virgin represent the story of Juan Diego, and at the top, three scenes depict Mary's miracles. The six figures above the Virgin represent Old Testament prophets and patriarchs and New Testament apostles and saints.

site of the vision was renamed Guadalupe, after Our Lady of Guadalupe in Spain, and became a venerated pilgrimage center. In 1754, the pope declared the Virgin of Guadalupe the patron saint of the Americas, seen here (fig. 19-41) in an eighteenth-century work by the painter Sebastian Salcedo.

Spanish colonial builders quite naturally tried to replicate the architecture of their native country in their adopted lands. In the colonies of North America's Southwest, the builders of one of the finest examples of mission architecture, San Xavier del Bac, near Tucson, Arizona (fig. 19-42, page 758), looked to Spain for its

19-42. Mission San Xavier del Bac, near Tucson Arizona. 1784-97.

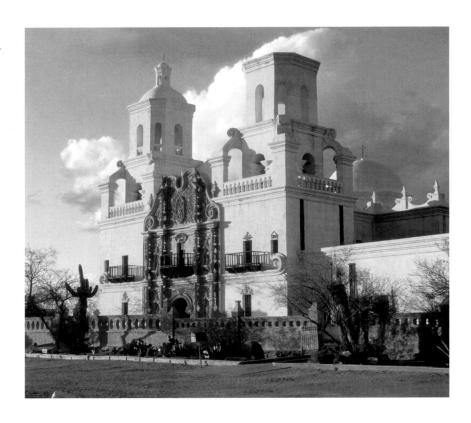

inspiration. The Jesuit priest Eusebio Kino began laying the foundations in 1700, using stone quarried locally by Native Americans of the Pima nation. The desert site had already been laid out with irrigation ditches, and Father Kino wrote in his reports that there would be running water in every room and workshop of the new mission, but the building never proceeded. The mission site was turned over to the Franciscans in 1768, after King Charles III ousted the Jesuit order from Spain and its colonies and asserted royal control over Spanish churches. Father Kino's vision was realized by the Spanish Franciscan missionary and master builder Juan Bautista Velderrain (d. 1790), who arrived at the mission in 1776.

The huge church, 99 feet long with a domed crossing and flanking bell towers, was unusual for the area in being built of brick and mortar rather than adobe, which is made of earth and straw. The basic structure was finished by the time of Velderrain's death, in 1790, and the exterior decoration was completed by 1797 under the supervision of his successor. It is generally accepted that the Spanish artists who executed the elaborate exterior, as well as the fine interior paintings and sculpture, were from central Mexico; nearly thirty artists may have been living at the mission in 1795. Although the San Xavier facade is far from a copy, the focus on the central entrance area, with its Spanish Baroque decoration, is clearly in the tradition of the earlier eighteenth-century work of Pedro de Ribera in Madrid (see fig. 19-31). The mission was dedicated to Saint Francis Xavier, whose statue once stood at the apex of the portal decoration. In the niches are statues of four female saints tentatively identified as Lucy, Cecilia, Barbara, and Catherine of

Siena. Hidden in the sculpted mass is one humorous element: a cat confronting a mouse, which inspired a local Pima saying: "When the cat catches the mouse, the end of the world will come" (cited in Chinn and McCarty, page 12). (Spanish colonial art is discussed in more detail in Chapter 23.)

NETHERLANDS/

THE SOUTHERN After a period of relative autonomy from 1598 to 1621 under a Habsburg FLANDERS regent, Flanders, the southern— and predominantly

Catholic— part of the Netherlands, returned to direct Spanish rule (until declaring independence in 1798). Antwerp, the capital city and major arts center, gradually recovered from the turmoil of the sixteenth century, and artists of great talent flourished there, establishing international reputations that brought them important commissions from foreign patrons. During the seventeenth century, however, the port silted up and trade fell off, until finally the city was financially destroyed.

Peter Paul Rubens. Peter Paul Rubens (1577–1640), whose painting has become synonymous with Flemish Baroque, was born in Germany, where his father, a Protestant, had fled from his native Antwerp to escape religious persecution. In 1587, after her husband's death, Rubens's mother and her children returned to Antwerp and to Catholicism. After a youth spent in poverty, Rubens decided in his late teens to become an artist. He was accepted into the Antwerp painters' guild at age twenty-one, a testament to his energy, intelligence, and determination.

In 1600, Rubens left for Italy, taking with him a pupil, whose father may have paid for the trip. While he was in Venice, his work came to the attention of an agent for the duke of Mantua, and Rubens was offered a court post. His activities on behalf of the duke over the next eight years did much to prepare him for the rest of his long and successful career. Surprisingly, other than designs for court entertainments and occasional portraits, the duke never acquired a single original work of art by Rubens. Instead, he had him copy famous paintings in collections all over Italy to add to the ducal collection.

Rubens visited every major Italian city, went to Madrid as the duke's emissary, and spent two extended periods in Rome, where he studied the great works of Roman antiquity and the Italian Renaissance. While in Italy, Rubens studied the work of two contemporaries, Caravaggio and Annibale Carracci. Hearing of Caravaggio's death in 1610, Rubens encouraged the duke of Mantua to buy the artist's painting *Death of the Virgin*, which had been rejected by the patron because of the shocking realism of its portrayal of the Virgin's dead body. The duke refused; later Rubens arranged the purchase of another Caravaggio painting by an Antwerp church.

In 1608, Rubens returned to Antwerp, where he accepted employment from the Habsburg governors of Flanders and, shortly afterward, married Isabella Brant. Rubens built a mansion with a large studio between 1610 and 1615 (it was restored and opened as a museum in 1946). The dining room gives an idea of the princely surroundings Rubens enjoyed (fig. 19-43). Light from a many-armed brass chandelier would have fallen on the massive furniture, carved mantel and door frames, and tiled floor and fireback. The embossed and gilded leather wall hangings provided a luxurious back-

ground for Rubens's collection of some 300 paintings. The collection was dispersed, but the paintings in the house today are typical. A nephew left a description of a typical day: Rubens ate very little during the day, finished work about 5 P.M., then rode horseback for exercise; he usually invited friends to dine with him, and after dinner everyone moved to the upstairs living room for conversation. The living room permitted access to a gallery overlooking Rubens's huge studio, a room designed to house what became virtually a painting factory. An oversized door accommodated large paintings and led to the splendid formal garden.

Rubens's first major commission in Antwerp was a large canvas triptych for the main altar of the Church of Saint Walpurga, The Raising of the Cross (fig. 19-44, page 760), painted in 1610-11. Unlike earlier triptychs, where the side panels contained related but independent images, the wings here extend the action of the central scene and surrounding landscape across the vertical framing. At the center, Herculean figures strain to haul upright the wooden cross with Jesus already stretched upon it. At the left, the followers of Jesus join in mourning, and at the right, indifferent soldiers supervise the execution. Culminating in this work are all the drama and intense emotion of Caravaggio and the virtuoso technique of Annibale Carracci, transformed and reinterpreted according to Rubens's own unique ideal of thematic and formal unity. The heroic nude figures, dramatic lighting effects, dynamic diagonal composition, and intense emotions show his debt to Italian art, but the rich colors and surface realism, with minute attention given to varied textures and forms, belong to his native Flemish tradition (see "Wölfflin's Principles of Art History," page 760).

Rubens had created a powerful, expressive visual language that was as appropriate for the secular rulers

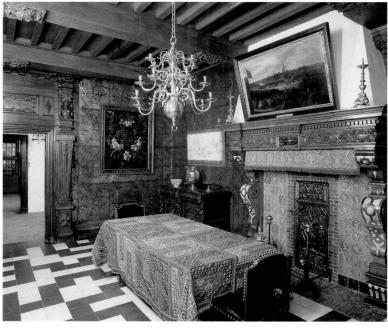

19-43. House of Peter Paul Rubens, Antwerp, Belgium. 1610–15. View of the dining room.

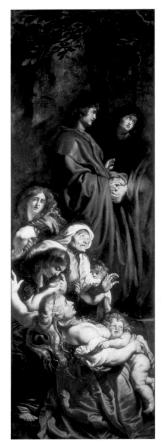

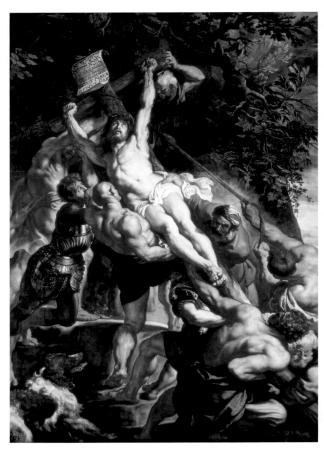

19-44. Peter Paul Rubens. The Raising of the Cross, from the Church of Saint Walpurga, Antwerp, Belgium. 1610–11. Oil on canvas, center panel $15'1^7/8'' \times 11'1^1/2''$ (4.62 × 3.39 m); each wing $15'1^7/8'' \times 4'11''$ (4.62 × 1.52 m). Cathedral of Our Lady, Antwerp. ©IRPA-KIK, Brussels.

who engaged him as it was for the Catholic Church. Moreover, his intelligence, courtly manners, and personal charm made him a valuable and trusted courtier to his royal patrons, who included Philip IV of Spain, Queen-Regent Marie de' Medici of France, and Charles I of England. In 1630, while Rubens was in England on a peace mission, Charles I knighted him and commissioned him to decorate the ceiling of the new Banqueting House at Whitehall Palace, London (see fig. 19-69). There, he painted the apotheosis of James I (Charles's

father and predecessor) and the glorification of the Stuart dynasty he had founded.

In 1621, Marie de' Medici, who had been regent for her son Louis XIII, asked Rubens to paint the story of her life, to glorify her role in ruling France and also to commemorate the founding of the new Bourbon royal dynasty. In twenty-four paintings, Rubens portrayed Marie's life and political career as one continuous triumph overseen by the gods. In fact, Marie and her husband, Henri, appear as companions of the Roman gods themselves.

WÖLFFLIN'S PRINCIPLES OF ART HISTORY

In 1915, Swiss art historian Heinrich Wölfflin published a book called *The Principles of Art History*. In it, he described five pairs of characteristics based on style (formal qualities) that he used to distinguish between Renaissance and Baroque art—and, by extension, between any "classical" and "nonclassical" style, such as Classical Greek art versus Hellenis-

tic art. His ideas can be a useful tool for learning the rudiments of formal analysis. Wölfflin compared and contrasted the paintings of Raphael and Rubens to illustrate and clarify his principles.

- Linear vs. painterly: sharp outline drawing and sculptural modeling vs. loose, free brushwork and emphasis on color
- 2. *Plane vs. depth*: elements arranged parallel to the picture plane vs. diagonal recession in depth
- Closed form vs. open form: selfcontained composition closely related to the picture frame vs. figures spilling over and beyond the frame
- Multiplicity vs. unity: each element being free and complete but all being coordinated within the frame vs. elements interlocking to create a single, total effect
- 5. *Clarity vs. unclearness*: clear and intellectually understandable vs. suggestive and intuitive.

19-45. Peter Paul Rubens. *Henri IV Receiving the Portrait of Marie de' Medici.* 1621–25. Oil on canvas, $12'11^{1}/_{8}'' \times 9'8^{1}/_{8}''$ (3.94 \times 2.95 m). Musée du Louvre, Paris.

In the painting depicting the royal engagement (fig. 19-45), Henri IV falls in love at once with Marie's portrait, shown to him by Cupid and Hymen, the god of marriage, while the supreme Roman god, Jupiter, and his wife, Juno, look down from the clouds. Henri, wearing his steel breastplate and silhouetted against a land-scape in which the smoke of a battle lingers in the distance, is encouraged by a personification of France to abandon war for love, as *putti* play with the rest of his armor. The sustained visual excitement of these enormous canvases makes them not only important works of art but also political propaganda of the highest order.

For all the grandeur of his commissioned paintings, Rubens was a sensitive, innovative painter, as the works he created for his own pleasure clearly demonstrate. One of his greatest joys was his country home, Castle Steen, a working farm with gardens, fields, woods, and streams. Steen furnished subjects for several pastoral paintings, such as *Landscape with Rainbow* (fig. 19-46, page 762), of about 1635. The atmosphere after a storm is nearly palpable, with the sun breaking through clouds and the air still moisture-laden, as farmworkers resume their labors. These magnificent landscapes had a significant impact on later painting.

Rubens had by no means "retired" to Castle Steen, however; he continued to live in Antwerp and accept large commissions from clients all over Europe. He employed dozens of assistants, many of whom were, or

19-46. Peter Paul Rubens. Landscape with Rainbow. c. 1635. Oil on panel, $4'5^3\sqrt[4]{}'' \times 7'9^1/8''$ (1.36 \times 2.36 m). Wallace Collection, London.

became, important painters in their own right. Using workshop assistants was standard practice for a major artist, but Rubens was particularly methodical, training or hiring specialists in costumes, still lifes, landscapes, portraiture, and animal painting who together could complete a work from Rubens's detailed sketches.

Anthony Van Dyck. One of Rubens's collaborators, Anthony Van Dyck (1599–1641), had an illustrious inde-

19-47. Anthony Van Dyck. Charles I at the Hunt. 1635. Oil on canvas, $8'11'' \times 6'11''$ (2.75 \times 2.14 m). Musée du Louvre, Paris.

pendent career as a portraitist. Son of an Antwerp silk merchant, he was listed as a pupil of the dean of Antwerp's Guild of Saint Luke at age ten. He had his own studio and roster of pupils at age sixteen but was not made a member of the guild until 1618, the year after he began his association with Rubens as a painter of heads. The need to blend his work seamlessly with that of Rubens enhanced Van Dyck's technical skill; the elegance and aristocratic refinement of his own work expressed his artistic character. After a trip to the English court of James I (ruled Great Britain 1603–25) in 1620, Van Dyck traveled to Italy and worked as a portrait painter to the nobility for seven years before returning to Antwerp. In 1632, he returned to England as the court painter to Charles I (ruled 1625–49), by whom he was knighted and given a studio, a summer home, and a large salary.

Van Dyck's many portraits of the royal family provide a sympathetic record of their features, especially those of King Charles. In *Charles I at the Hunt* (fig. 19-47), of 1635, Van Dyck was able, by clever manipulation of the setting, to portray the king truthfully and yet as a quietly imposing figure. Dressed casually for the hunt and standing on a bluff overlooking a distant view, Charles is shown as being taller than his pages and even than his horse, since its head is down and its heavy body is partly off the canvas. The viewer's gaze is diverted from the king's delicate and rather short frame to his pleasant features, framed by his jauntily cocked cavalier's hat. As if in decorous homage, the tree branches bow gracefully toward him, echoing the circular lines of the hat.

Jan Brueghel. Yet another painter working with Rubens, Jan Brueghel (1568–1625), painted settings rather than portraits. Brueghel and Rubens's allegories of the five senses—five paintings illustrating sight, hearing, touch, taste, and smell—in effect invited the viewer to wander in an imaginary space and to enjoy an amazing collection of works of art and scientific equipment (fig. 19-48, "The Object Speaks," opposite). This remarkable painting is a display, a virtual inventory, and a summary of the wealth, scholarship, and connoisseurship created through the patronage of the Habsburg rulers of the Spanish Netherlands.

THE OBJECT SPEAKS

BRUEGHEL AND RUBENS'S -ALLEGORY OF SIGHT

In 1599, the Habsburg Spanish princess Isabel Clara Eugenia married the Habsburg Austrian archduke Albert, uniting two branches of the family in the monarchy of the Habsburg Netherlands. These rulers were great patrons of the arts and sciences and were friends of artists—especially Peter Paul Rubens. Their interests and generous arts patronage were abundantly displayed in five allegorical paintings of the senses by Rubens and Jan Brueghel. The two artists were neighbors and frequently collaborated, Rubens rendering the figures and Brueghel creating allegorical settings for them.

Of the five paintings in the series, *Allegory of Sight* (fig. 19-48) is the most splendid; it is almost an illustrated catalog of the ducal collection. Gathered in a huge vaulted room are paintings, sculpture, furniture, objects in gold and silver, and scientific equipment—all under the magnificent double-headed eagle emblems of the Habsburgs. We explore the painting *Allegory of Sight* inch by inch, as if reading a book or a palace inventory. There on the table are

Brueghel's copies of Rubens's portraits of Archduke Albert and Princess Isabel Clara Eugenia; another portrait of the duke is on the floor. Besides the portraits, we can find Rubens's Daniel in the Lions' Den (upper left corner), The Lion and Tiger Hunt (top center), and The Drunken Silenus (lower right), as well as the popular subject Madonna and Child in a Wreath of Flowers (far right), for which Rubens painted the Madonna and Brueghel created the wreath. Brueghel also included Raphael's Saint Cecilia (behind the globe) and Titian's Venus and Psyche (over the door).

In the foreground, the classical goddess Venus, attended by Cupid (both painted by Rubens), has put aside her mirror to contemplate *Christ Healing the Blind*, a painting by an unidentified artist. Venus is surrounded by the equipment needed to see and to study: The huge globe at the right and the sphere with its gleaming rings at the upper left symbolize the extent of humanistic learning. In symbolism that speaks to viewers of our day as clearly as it did those of its own, the books and prints, ruler, compasses, magnifying glass, and the more complex astrolabe, telescope, and eyeglasses refer to spiritual blindness—to those who look but do not see.

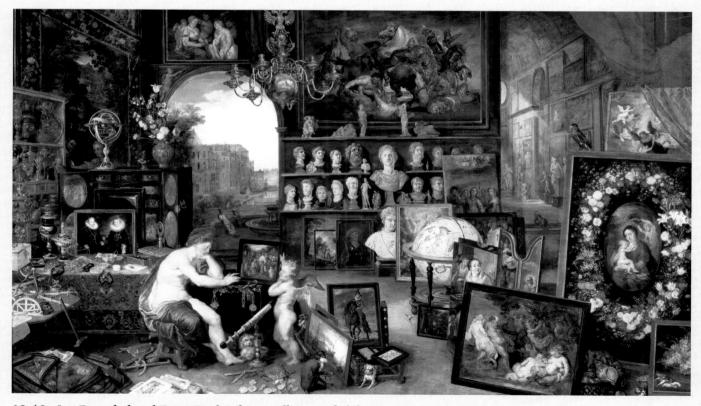

19-48. Jan Brueghel and Peter Paul Rubens. *Allegory of Sight*, from Allegories of the Five Senses. c. 1617–18. Oil on wood panel, $25^{5}/8 \times 43''$ (65 × 109 cm). Museo del Prado, Madrid.

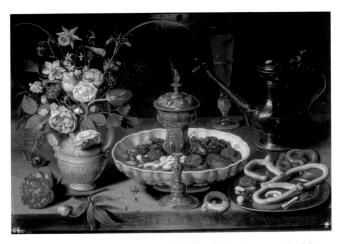

19-49. Clara Peeters. Still Life with Flowers, Goblet, **Dried Fruit, and Pretzels.** 1611. Oil on panel, $20^{1/2} \times 28^{3/4}$ " $(52 \times 73 \text{ cm})$. Museo del Prado, Madrid.

Like many breakfast pieces, this painting features a pile of pretzels among the elegant tablewares. The salty, twisted bread was called pretzel (from the Latin pretiola, meaning "small reward") because it was invented by southern German monks to reward children who had learned their prayers: The twisted shape represented the crossed arms of a child praying.

Clara Peeters. A contemporary of Van Dyck in Antwerp who was not associated with Rubens, Clara Peeters (1594-c. 1657), an early still-life specialist, was a prodigy whose career seems to have begun before she was fourteen. She married in Antwerp and was a guild member there, but she may have previously spent time in Holland. Of some fifty paintings now attributed to her (more than thirty were signed), many are of the type called ${\it breakfast}$ pieces, showing a table set for a meal of bread and fruit. She was one of the first artists to use flowers and food together in a still life. As in her Still Life with Flowers, Goblet, Dried Fruit, and Pretzels (fig. 19-49), of 1611, Peeters arranged rich tableware and food against neutral, almost black backgrounds, the better to emphasize the fall of light over the contrasting surface textures. The luxurious goblet and bowl contrast with the simple pewterware, as do the flowers with the pretzels. The pretzels, piled high on the pewter tray, are a particularly interesting Baroque element, with their complex multiple curves.

NETHERLANDS/

THE NORTHERN Led by William of Orange, the Netherlands' Protestant northern provinces UNITED DUTCH (today's Holland) rebelled REPUBLIC against Spain in 1568, joining together as the

United Provinces in 1579 to begin a long struggle for independence. The king of Spain considered the Dutch heretical rebels but finally, in 1648, what was by then the United Dutch Republic joined Spain, the Vatican, the Holy Roman Empire, and France on equal footing in peace negotiations. The Hague was the capital city and the preferred residence of the House of Orange, but Amsterdam was the true center of power, because of its sea trade and the enterprise of its merchants, who made the city an international commercial center. The House of Orange was not notable for its patronage of the arts, but patronage improved significantly under Prince Frederick Henry (ruled 1625-47), and Dutch artists found many other eager patrons among the prosperous middle class in Amsterdam, Leiden, Haarlem, Delft, and Utrecht.

The Dutch delighted in depictions of themselves and their country's landscape, cities, and domestic life, not to mention beautiful and interesting objects (see "The Dutch Art Market," opposite). A well-educated people, the Dutch were also fascinated by history, mythology, the Bible, new scientific discoveries, commercial expansion abroad, and colonial exploration.

PORTRAITS

Dutch Baroque portraiture took many forms, ranging from single portraits in sparsely furnished settings to allegorical depictions of people in elaborate costumes with appropriate symbols. Although the accurate portrayal of facial features and costumes was the most important gauge of a portrait's success, Dutch painters went beyond pure description to convey a sense of their subjects' personalities. Group portraiture that documented the membership of corporate organizations was a Dutch specialty. These large canvases, filled with many individuals who shared the cost of the commission, challenged painters to present a coherent, interesting composition that nevertheless gave equal attention to each individual portrait.

Frans Hals. Frans Hals (c. 1581/85–1666), the leading painter of Haarlem, studied with the Flemish Mannerist Karel van Mander (1548-1606), but little is certain about Hals's work before 1616. He had by then developed a style grounded in the Netherlandish love of realism and inspired by the Caravaggesque style, yet it was far from a slavish copy of that style. Like Velázquez, he tried to re-create the optical effects of light on the shapes and textures of objects. He painted boldly, with slashing strokes and angular patches of paint; when seen at a distance, all the colors merge into solid forms over which a flickering light seems to move. In Hals's hands, this seemingly effortless technique suggests a boundless joy in life.

In his painting Catharina Hooft and Her Nurse (fig. 19-50), of about 1620, Hals captured the vitality of a gesture and a fleeting moment in time. While the portrait records for posterity the great pride of the parents in their child and their wealth, it is much more than a study of rich fabrics, laces, and expensive toys (a golden rattle). Hals depicted the heartwarming delight of the child, who seems to be acknowledging the viewer as a loving family member while her doting nurse tries to distract her with an apple.

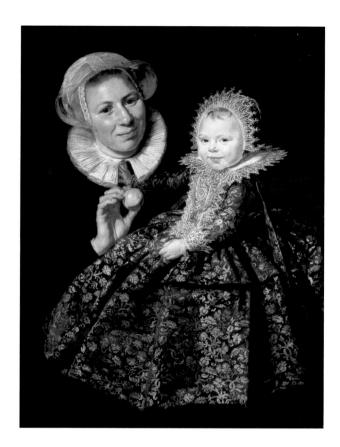

19-50. Frans Hals. *Catharina Hooft and Her Nurse*. c. 1620. Oil on canvas, $33^3/_4 \times 25^1/_2$ " (85.7 × 64.8 cm). Staatliche Museen zu Berlin, Preussischer Kultur-besitz, Gëmaldegalerie.

In contrast to this intimate individual portrait are Hals's official group portraits, such as his *Officers of the Haarlem Militia Company of Saint Adrian* (fig. 19-51), of about 1627. Less imaginative artists had arranged their sitters in neat rows to depict every face clearly. Instead, Hals's dynamic composition turned the group portrait into a lively social event, even while maintaining a strong underlying geometry of diagonal lines—gestures, banners, and sashes—balanced by the stabilizing perpendiculars of table, window, tall glass, and striped banner. The black suits and hats make the white ruffs and sashes of rose, white, and blue even more brilliant.

Judith Leyster. The most successful of Hals's contemporaries was Judith Leyster (c. 1609–60). In fact, one painting long praised as one of Hals's finest works was recently discovered to be by Leyster when a cleaning revealed her distinctive signature, the monogram *JL* with a star, in reference to her surname, which means "pole star," taken from the name of her family's Haarlem brewery.

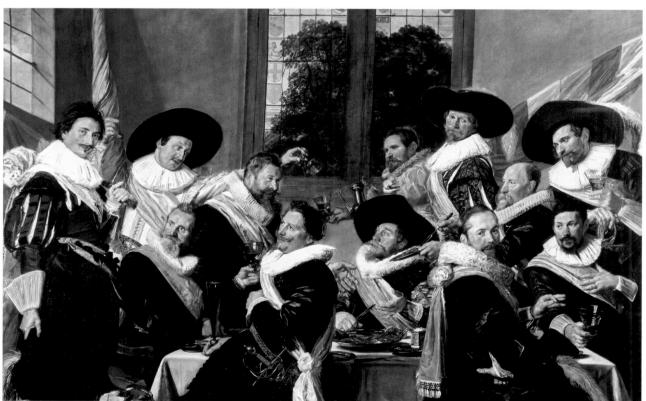

19-51. Frans Hals. Officers of the Haarlem Militia Company of Saint Adrian. c. 1627. Oil on canvas, $6' \times 8'8''$ (1.83 \times 2.67 m). Frans Halsmuseum, Haarlem.

Hals painted at least six group portraits of civic-guard organizations, including two for the Company of Saint Adrian. The company, made up of several guard units, was charged with the military protection of Haarlem whenever needed. Officers came from the upper middle class and held their commissions for three years, whereas the ordinary guards were tradespeople and craftworkers. Each company was organized like a guild, under the patronage of a saint. When the men were not on war alert, the company functioned as a fraternal order, holding archery competitions, taking part in city processions, and maintaining an altar in the local church. (See also fig. 19-54.)

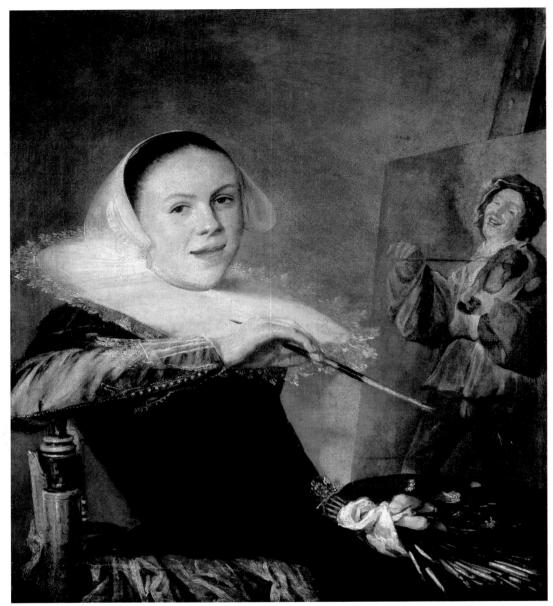

19-52. Judith Leyster. *Self-Portrait.* 1635. Oil on canvas, $29^3/_8 \times 25^5/_8$ " (72.3 × 65.3 cm). National Gallery of Art, Washington, D.C. Gift of Mr. and Mrs. Robert Woods Bliss

Although almost nothing is known of her early years, in 1628–29 she was with her family in Utrecht, where she very likely encountered artists who had traveled to Italy and fallen under the spell of Caravaggio. Leyster's work shows clear echoes of her exposure to the Utrecht painters who had enthusiastically adopted the Italian master's naturalism, the dramatic tenebrist lighting effects, the large figures pressed into the foreground plane, and, especially, the theatrically presented everyday themes. In 1631, Leyster signed as a witness at the baptism in Haarlem of one of Frans Hals's children, which has led to the probably incorrect conclusion that she was Hals's pupil. Leyster may have worked in his shop, however, since she entered Haarlem's Guild of

Saint Luke only in 1633. Membership allowed her to take pupils into her studio, and her competitive relationship with Frans Hals around that time is made clear by the complaint she lodged against him in 1635 for luring away one of her apprentices.

Leyster is known primarily for her informal scenes of daily life, which often carry an underlying moralistic theme. In her lively *Self-Portrait* of 1635 (fig. 19-52), the artist has paused momentarily in her work to look back, as if the viewer had just entered the room. Her elegant dress and the fine chair in which she sits are symbols of her success as an artist whose popularity was based on the very type of painting under way on her easel. Her subject, a man playing a violin, may be a visual pun on

the painter with palette and brush. So that the viewer would immediately see the difference between her painted portrait and the painted painting, she varied her technique, executing the image on her easel more loosely. The narrow range of colors sensitively dispersed in the composition and the warm spotlighting are typical of Leyster's mature style.

Rembrandt van Rijn. Rembrandt van Rijn (1606–69) was the most important painter working in Amsterdam in the seventeenth century and is now revered as one of the great artists of all time. Rembrandt was one of nine children born in Leiden to a miller and his wife. Rembrandt was sent to the University of Leiden in 1620 at age fourteen, but he dropped out to study painting with a Leiden artist who had worked in Italy. Later he became an assistant to Pieter Lastman (1583–1633) in Amsterdam. From Lastman he learned the naturalism, drama, and extreme tenebrism developed by Caravaggio (see "Caravaggio and the New Realism," page 735).

Back in Leiden by 1626, he painted religious pictures, but he depended on portraiture for income. Late in 1631 he returned to Amsterdam as a portrait painter,

although he also painted a wide range of narrative themes and landscapes.

Prolific and popular with Amsterdam clientele, Rembrandt ran a busy studio producing works that sold for high prices. His large workshop and the many pupils who imitated his manner have made it difficult for scholars to define his body of work, and many paintings formerly attributed to him have recently been assigned to other artists. Rembrandt's mature work reflected his new environment, his study of science and nature, and the broadening of his artistic vocabulary by the study of Italian Renaissance art, chiefly from engraved copies, which produced works such as his study of Leonardo's *Last Supper* (see fig. 19, Introduction). In 1639, he purchased a large house, which he filled with art and an enormous supply of studio props, such as costumes, weapons, and stuffed animals.

Rembrandt combined his scientific and humanistic interests when he created his first group portrait, *The Anatomy Lesson of Dr. Nicolaes Tulp*, in 1632 (fig. 19-53). For the first time a group portrait takes on a dramatic interest instead of being a simple row of figures and faces. Doctor Tulp, who was head of the surgeons' guild from

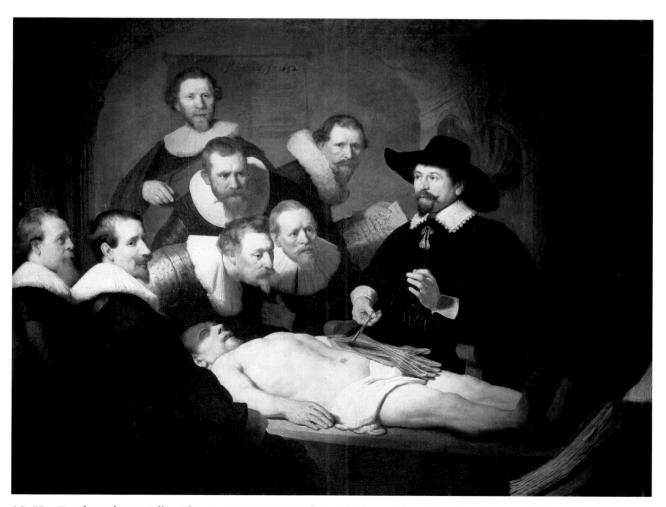

19-53. Rembrandt van Rijn. *The Anatomy Lesson of Dr. Nicolaes Tulp.* 1632. Oil on canvas, $5'3^3/4'' \times 7'1^1/4''$ (1.6 × 2.1 m). Mauritshuis, The Hague, Netherlands.

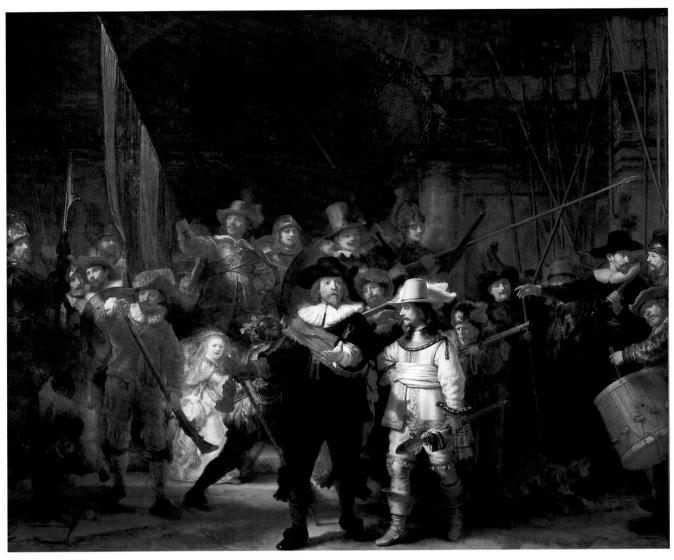

19-54. Rembrandt van Rijn. *Captain Frans Banning Cocq Mustering His Company (The Night Watch)*. 1642. Oil on canvas. 11'11" × 14'4" (3.63 × 4.37 m) (cut down from the original size). Rijksmuseum, Amsterdam.

1628 to 1653, sits right of center, and the other doctors gather around to observe the cadaver and listen to the famed anatomist. True to the seventeenth-century taste for "open" composition, Rembrandt built his composition on diagonals in space—the cadaver on the table, the calculated arrangement of doctor and listeners, and the open book. The figures emerge from a dark and undefined ambience with their faces framed by brilliant white ruffs; Rembrandt makes effective use of Caravaggio's tenebrist technique. Light streams down on the juxtaposed arms and hands, as Dr. Tulp flexes his own left hand to demonstrate the action of the cadaver's arm muscles. Unseen by the viewers are the illustrations of the huge book. It must be Andreas Vesalius's study of human anatomy, published in Basel in 1543, which was the first attempt at accurate anatomical illustrations in print. Rembrandt's painting has been seen as an homage to Vesalius and to science, as well as a portrait of the members of the Amsterdam surgeons' guild.

In 1642, Rembrandt was one of several artists commissioned by a wealthy civic-guard company to create large group portraits of its members for its new meeting hall. The result, Captain Frans Banning Cocq Mustering His Company (fig. 19-54), carries the idea of the group portrait as drama even further. Because of the dense layer of grime and darkened varnish on it and its dark background architecture, this painting was once thought to be a night scene and was therefore called The Night Watch. After cleaning and restoration in 1975–76 it now exhibits a natural golden light that sets afire the palette of rich colors-browns, blues, olive green, orange, and red-around a central core of lemon yellow in the costume of a lieutenant. To the dramatic group composition, showing a company forming for a parade in an Amsterdam street, Rembrandt added several colorful but seemingly unnecessary figures. While the officers stride purposefully forward, the rest of the men and several mischievous

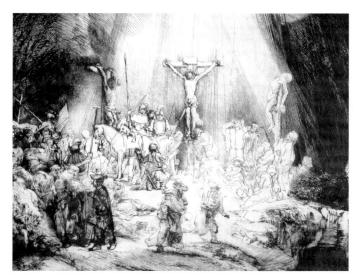

19-55. Rembrandt van Rijn. *Three Crosses* (first **state).** 1653. Drypoint and etching, $15\frac{1}{6} \times 17\frac{3}{4}$ " (38.5 × 45 cm). Rijksmuseum, Amsterdam.

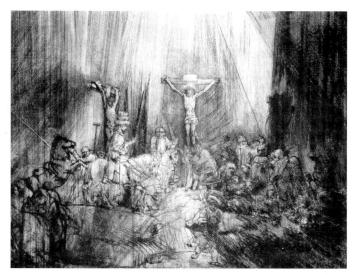

19-56. Rembrandt van Rijn. *Three Crosses* **(fourth state).** 1653. Drypoint and etching, $15\frac{1}{6} \times 17^{3}\sqrt{4}$ (38.5 × 45 cm). The Metropolitan Museum of Art, New York Gift of Felix M. Warburg and his family, 1941 (41.1.33).

children mill about. The young girl at the left, carrying a chicken and wearing a money pouch, is so unusual that attempts have been made to find symbolic or ironic meaning. From the earliest days of his career, however, Rembrandt was devoted to sketching people he encountered in the streets. The figures may simply add lively touches of interesting local color to heighten the excitement of the scene.

Rembrandt was second only to Albrecht Dürer (see figs. 18-36-18-38) in his enthusiasm for printmaking as an important art form with its own aesthetic qualities and expressiveness. His interest focused on etching, a relatively minor medium at the time, which uses acid to inscribe a design on metal plates. His earliest line etchings date from 1627. About a decade later, he began to experiment with additions in the drypoint technique, in which the artist uses a sharp needle to scratch shallow lines in a plate (see "Etching and Drypoint," page 772). Because etching and drypoint allow the artist to work directly on the plate, the style of the finished print has the relatively free and spontaneous character of a drawing. Rembrandt's commitment to the full exploitation of the medium is indicated by the fact that in these works he alone carried the creative process through, from the preparation of the plate to its inking and printing, and he constantly experimented with the technique, with methods of inking, and with papers for printing.

Rembrandt experienced a deepening religiousness that was based on his personal study of the Bible and perhaps also on his association with the pacifist Mennonite sect, whose spirit pervades his treatment of religious themes, from gentle mysticism to soul searching to belief in ultimate forgiveness. These expressions can be studied in a series of prints, *Three Crosses*, that comes down to us in four states, or stages, of the printing process. Rembrandt tried to capture the moment de-

scribed in the Gospels when, during the Crucifixion, darkness covered the earth and Jesus cried out, "Father, into thy hands I commend my spirit." In the first state (fig. 19-55), the centurion kneels in front of the cross while other terrified people run from the scene. The Virgin Mary and John share the light flooding down from heaven. By the fourth state (fig. 19-56), Rembrandt has completely reworked and reinterpreted the theme. In each version, the shattered hill of Golgotha dominates the foreground, but now a mass of vertical lines, echoing the rigid body of Jesus, fills the space, obliterates the shower of light, and virtually eliminates the former image, including even Mary and Jesus' friends. The horseman holding a lance now faces Jesus. Compared with the first state, the composition is more compact, the individual elements are simplified, and the emotions are intensified. The first state is a detailed rendering of the scene in realistic terms; the fourth state, a reduction of the event to its essence. The composition revolves in an oval of half-light around the base of the cross, and the viewer's attention is drawn to the figures of Jesus and the people, in mute confrontation. In Three Crosses, Rembrandt defined the mystery of Christianity in Jesus' sacrifice, presented in realistic terms but as something beyond rational explanation. In Rembrandt's late works, realism relates to the spirit of inner meaning, not of surface details. The eternal battles of dark and light, doom and salvation, evil and good—all seem to be waged anew.

Rembrandt remained a popular artist and teacher, but he was continually plagued by financial problems. He painted ever more brilliantly in a unique manner that distilled a lifetime of study and contemplation of life and human personalities. His sensitivity to the human condition is perhaps nowhere more powerfully expressed than in his *Self-Portrait* of 1659 (fig. 19-57, page 770). Among his other late achievements is *The Jewish*

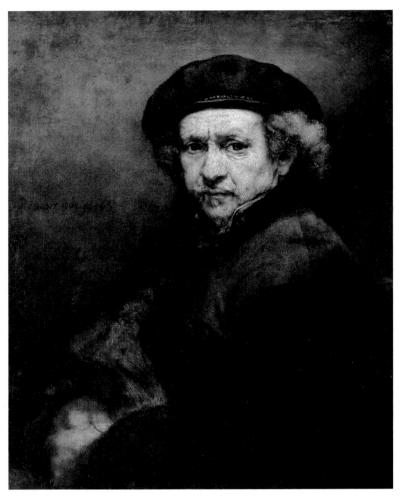

19-57. Rembrandt van Rijn. *Self-Portrait.* 1659. Oil on canvas, $33\frac{1}{4} \times 26$ " (84 × 66 cm). National Gallery of Art, Washington, D.C. Andrew W. Mellon Collection, (1937.1.72)

Bride (fig. 19-58), of about 1665. This portrait may refer to the marriage of Isaac and Rebecca or some other loving biblical couple. As in *Captain Frans Banning Cocq Mustering His Company*, the monumental figures emerge from a dark architectural background, perhaps a garden wall and portico, with the warm light suffusing the scene and setting the reds and golds of their costumes aglow. In comparison with Jan van Eyck's emotionally neutral *Portrait of Giovanni Arnolfini (?) and His Wife, Giovanna Cenami (?)* of the early fifteenth century (see fig. 17-14), where the meaning of the picture relied heavily on its symbolic setting, the significance of *The Jewish Bride* is emotional, conveyed by loving expressions and gestures, such as the groom tenderly touching his bride's breast, an ancient symbol of fertility.

Rembrandt spent money lavishly, especially on works of art. In 1656 he was forced to declare bankruptcy, and his art collection, jewelry, and splendid house were sold at well below value. From 1660 on his son Titus (d. 1668) and his common-law wife Hendrickje (d. 1665) (Saskia died in 1642) managed his financial affairs. Evidently Rembrandt lived a comfortable life with them, and to judge from his commissions he continued to be an active painter until his death in 1669.

VIEWS OF THE WORLD

The Dutch loved the landscapes and vast skies of their own country, but those who painted them were not slaves to nature as they found it. The artists were never afraid to remake a scene by rearranging, adding, or subtracting to give their compositions formal organization or a desired mood. Starting in the 1620s, view painters generally adhered to a convention in which little color was used beyond browns, grays, and beiges. After 1650, they tended to be more individualistic in their styles, but nearly all brought a broader range of colors into play. One continuing motif was the emphasis on cloud-filled expanses of sky dominating a relatively narrow horizontal band of earth below. Paintings of architectural interiors also achieved great popularity in the Baroque period and seem to have been painted for their own beauty, just as exterior views of the land, cities, and harbors were.

Emanuel de Witte. Emanuel de Witte (1617–92) of Rotterdam specialized in architectural interiors, first in Delft in 1640 and then in Amsterdam after settling there permanently in 1652. Although many of his interiors were composites of features from several locations combined in one idealized architectural view, de Witte

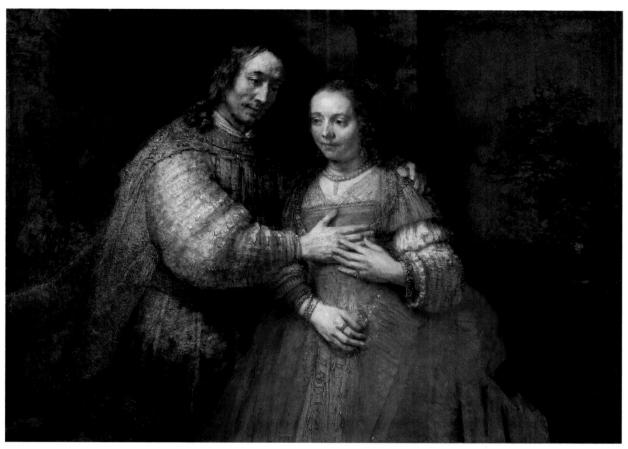

19-58. Rembrandt van Rijn. *The Jewish Bride*. c. 1665. Oil on canvas, $3'11^3/4'' \times 5'5^1/2''$ (1.21 × 1.65 m). Rijksmuseum, Amsterdam.

THE DUTCH ART MARKET

Visitors to the Netherlands in the seventeenth century noted the great popularity of art, not just among aristocrats but also among merchants and working people. Peter Mundy, an English traveler, wrote in 1640: "As For the art off Painting and the affection off the people to Pictures, I thincke none other goe beeyond them, there having bin in this Country Many excellent Men in thatt Facullty, some att presentt, as Rimbrantt, etts. [etc.] All in generall striving to adorne their houses, especially the outer or street roome, with costly peeces, Butchers and bakers not much inferiour in their shoppes, which are Fairely sett Forth, yea many tymes blacksmithes, Coblers, etts., will have some picture or other

by their Forge and in their stalle. Such is the generall Notion, enclination and delight that these Countrie Native[s] have to Paintings" (cited in Temple, page 70).

This taste for art stimulated a free market for paintings that functioned like other commodity markets. Without Church patronage and with limited civic and private commissions, artists had to compete to capture the interest of their public by painting on speculation. Naturally, specialists in particularly popular types of images were likely to be financially successful, and what most Dutch patrons wanted were paintings of themselves, their country, their homes, and the life around them. It was hard to make a living as an artist, and many artists had other jobs, such as tavern keeping and art dealing, to make ends meet. In some cases, the artist was more entrepreneur than art maker, running a "stable" of painters who made copy after copy of original works to sell.

The great demand for art gave rise to an especially active market for engravings and etchings, both for original compositions and for copies after paintings, since one copperplate could produce hundreds of impressions, and worn-out plates could be reworked and used again. Although most prints sold for modest prices, Rembrandt's etching Christ Healing the Sick (1649) was already known in 1711 as the Hundred-Guilder Print, because of the then-unheard-of price that one patron had paid for an impression of it.

Etching with acid on metal was used to decorate armor and other metal wares before it became a printmaking medium. The earliest etchings for that purpose were made in Germany

in the early 1500s, and Albrecht Dürer experimented with the technique briefly, but Rembrandt was the first artist to popularize etching as a major form of artistic expression.

In the etching process, a metal plate is coated on both sides with an acid-resistant varnish. Then, instead of laboriously cutting the lines of the desired image directly into the plate, the artist draws through the varnish with a sharp needle to expose the metal. The plate is then covered with acid, which eats into the metal exposed by the drawn lines. By controlling the amount of time the acid stays on different parts of the plate, the artist can make fine, shallow lines or heavy, deep ones. The varnish covering the plate is removed before an impression is taken. If a change needs to be made, the lines can be "erased" with a sharp metal scraper. Accidental scratches are eliminated by burnishing (polishing).

TECHNIQUE Etching and Drypoint

Another technique for registering images on a metal plate is called **drypoint**. A sharp needle is used to scratch lines in the metal, but there are two major differences in technique be-

tween the process of engraving and that of drypoint (see "Woodcuts and Engravings on Metal," page 612). The engraving tool, or burin, is held straight and throws up equal amounts of metal, called burr, on both sides of the line, but the drypoint needle is held at a slight slant and throws up most of the burr on one side. Also, in engraving the metal burr is scraped off and the plate polished to yield a clean, sharp groove to hold the ink for printing. In drypoint, the burr is left in place, and it, rather than the groove, holds the ink. The rich black appearance of drypoint lines when printed is impossible to achieve with engraving or etching. Drypoint burr is fragile, and only a few prints-a dozen or fewer-can be made before it flattens and loses its character. Rembrandt's earliest prints were pure etchings, but later he enriched his prints with drypoint to achieve greater tonal richness.

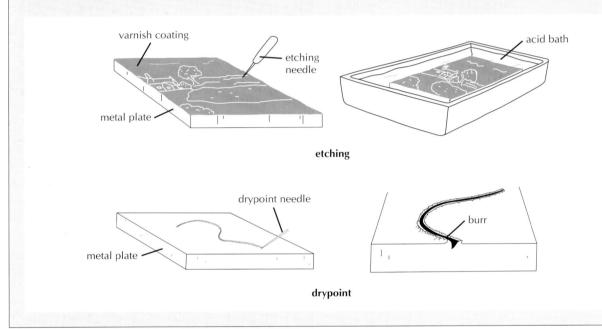

also painted faithful portraits of actual buildings. One of these is his *Portuguese Synagogue*, *Amsterdam* (fig. 19-59), of 1680. The synagogue, which still stands and is one of the most impressive buildings in Amsterdam, is shown here as a rectangular hall divided into one wide central aisle with narrow side aisles, each covered with a wooden barrel vault resting on lintels supported by columns. De Witte's shift of the viewpoint slightly to one side has created an interesting spatial composition, and strong contrasts of light and shade add dramatic movement to the simple interior. The caped figure in the foreground and the dogs provide a sense of scale for the architecture and add human interest.

Today, the painting is interesting both as a record of seventeenth-century synagogue architecture and as evi-

dence of Dutch religious tolerance in an age when Jews were often persecuted. Ousted from Spain and Portugal in the late fifteenth and early sixteenth centuries, many Jews had settled first in Flanders and then in the Netherlands. The Jews in Amsterdam enjoyed religious and personal freedom, and their synagogue was considered one of the outstanding sights of the city.

Aelbert Cuyp. From a family of artists, Aelbert Cuyp (1620–91) of Dordrecht specialized early in his career in view painting. Cuyp first worked in the older, nearly monochromatic convention for recording the Dutch countryside and waterways. About 1645, his style evolved to include a wider range of colors while also moving toward more idealized scenes drenched with a

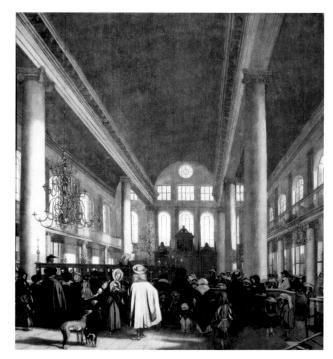

19-59. Emanuel de Witte. *Portuguese Synagogue, Amsterdam.* 1680. Oil on canvas, $43^1/_2$ " \times 39" (110.5 \times 99.1 cm). Rijksmuseum, Amsterdam. Architect Daniel Stalpaert built the synagogue in 1670–75

warm golden light, such as his *Maas at Dordrecht* (fig. 19-60), painted about 1660. This dramatic change has been attributed to Cuyp's contact with Utrecht painters who were influenced by contemporary landscape painting in Italy, especially the works of the French expatriate Claude Lorrain (see fig. 19-27). However, unlike the Italian and French artists who preferred religious, historical,

or other narrative themes expressed through the figures inhabiting the landscape, Cuyp and other Dutch painters represented the country as they saw it, although in its most pleasant aspects. At Dordrecht, the wide, deep harbor of the Maas River was always filled with cargo ships and military vessels, and Cuyp's seascapes express pride in the city's contribution to the United Dutch Republic's prosperity, independence, and peaceful life.

Jacob van Ruisdael. The Haarlem landscape specialist Jacob van Ruisdael (1628/29-82) was especially adept at both the invention of dramatic compositions and the projection of moods in his canvases. His Jewish Cemetery (fig. 19-61, page 774), of 1655-60, is a thoughtprovoking view of silent tombs, crumbling ruins, and stormy landscape, with a rainbow set against dark, scudding clouds. Ruisdael was greatly concerned with spiritual meanings of the landscape, which he expressed in his choice of such environmental factors as the time of day, the weather, the appearance of the sky, or the abstract patterning of sun and shade. The barren tree points its branches at the tombs. Here the tombs, ruins, and fallen and blasted trees suggest an allegory of transience. The melancholy mood is mitigated by the rainbow, a traditional symbol of renewal and hope.

Meyndert Hobbema. Ruisdael's popularity drew many pupils to his workshop, the most successful of whom was Meyndert Hobbema (1638–1709), who studied with him from 1657 to 1660. Although there are many similarities to Ruisdael's style in Hobbema's earlier paintings, his mature work moved away from the melancholy and dramatic moods of his master. Hobbema's love of the peaceful, orderly beauty of the civilized Dutch countryside is exemplified by one of his best-known paintings, *Avenue at Middelharnis* (fig. 19-62, page 774)—the

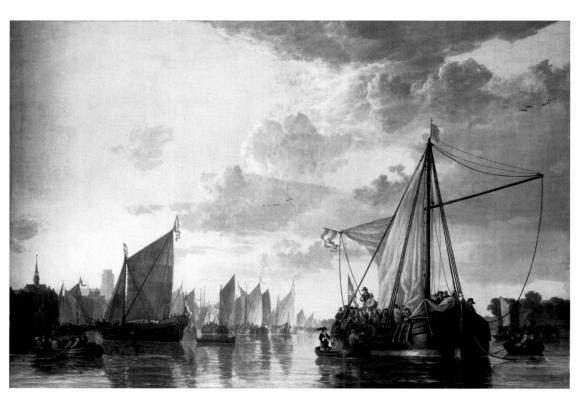

19-60.
Aelbert
Cuyp. Maas
at Dordrecht.
c. 1660. Oil on
canvas,
3'9¹/₄" × 5'7"
(1.15 × 1.70 m).
National
Gallery of Art,
Washington,
D.C.
Andrew W. Mellon
Collection

19-61. Jacob van Ruisdael. The Jewish Cemetery. 1655-60. Oil on canvas, $4'6'' \times 6'2^1/2''$ (1.42×1.89 m). The Detroit Institute of Arts. Gift of Julius H. Haass in memory of his brother Dr. Ernest W. Haass, (24.3)

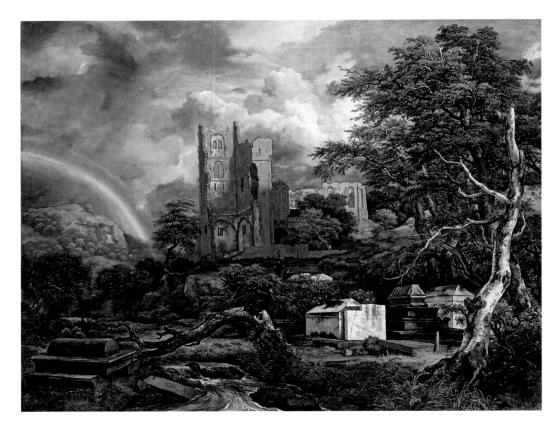

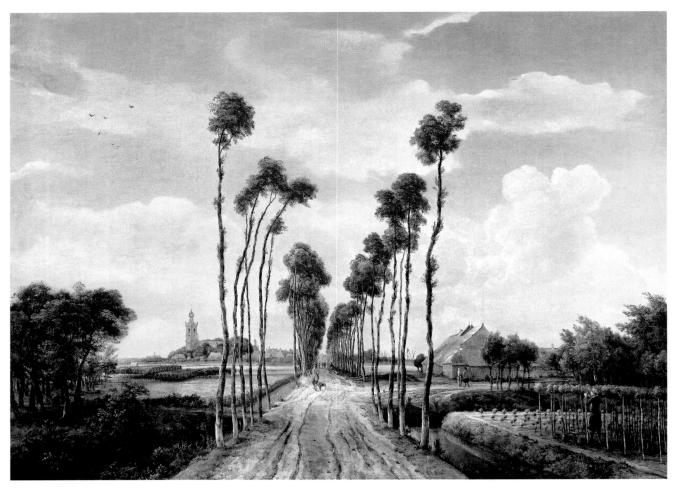

19-62. Meyndert Hobbema. *Avenue at Middelharnis.* 1689. Oil on canvas, $40^3/_4 \times 55^1/_2$ " (104×141 cm). The National Gallery, London.

The power of nature is challenged by a people who have captured their land not from a human rival but from the sea itself. They are constantly aware of the mighty forces of wind and water ever ready to reclaim it.

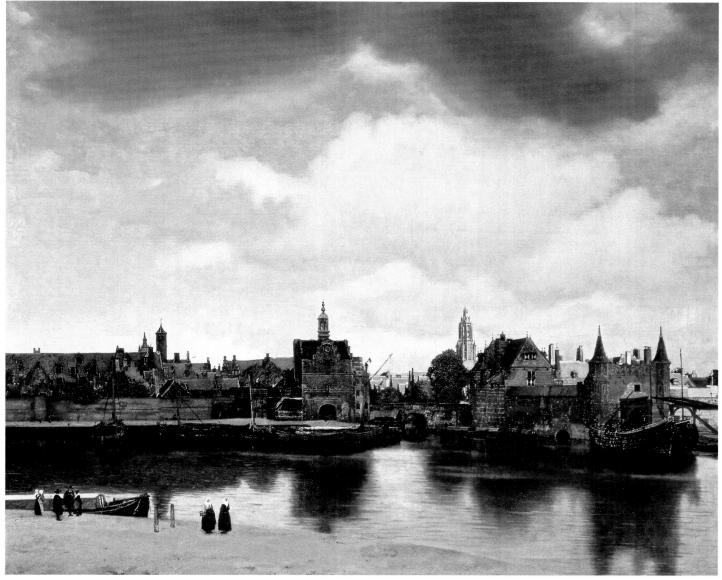

19-63. Jan Vermeer. *View of Delft.* c. 1662. Oil on canvas, $38\frac{1}{2} \times 46\frac{1}{4}$ " (97.8 \times 117.5 cm). Mauritshuis, The Hague. The Johan Maurits van Nassau Foundation

rational art of a country physically constructed by its people. In contrast with the broad horizontal orientation of many Dutch landscapes, Hobbema's composition draws the viewer into the picture and down the rutted, sandy road toward the distant village of Middelharnis in a compelling demonstration of one-point perspective.

Jan Vermeer. Jan (Johannes) Vermeer (1632–75) of Delft, an innkeeper and art dealer who painted only for local patrons, entered the Delft artists' guild in 1653. Meticulous in his technique, with a unique compositional approach and painting style, Vermeer produced only a small number of works.

Vermeer's *View of Delft* (fig. 19-63) is no simple cityscape. Although Vermeer convinces the viewer of its authenticity, he does not paint a photographic reproduction of the scene; he moves buildings around to create an ideal composition. As he also does with paintings of interior scenes, he endows the city with a timeless stability created by the careful placement of the buildings, the quiet atmosphere, and the clear, even light. Vermeer

may have experimented with the mechanical device known as the **camera obscura** (Chapter 27), not as a method of reproducing the image but as another tool in the visual analysis of the landscape. The camera obscura would have enhanced optical distortions that led to the "beading" of highlights, which creates the illusion of brilliant light but does not dissolve the underlying form.

GENRE PAINTING

Another popular art form among the Dutch was the **genre painting**. Generally painted for private patrons, genre paintings depict scenes of contemporary daily life. Continuing a long Netherlandish tradition, genre paintings of the Baroque period were often laden with symbolic references, although their meaning is not always clear.

Jan Vermeer. Vermeer worked in the genre tradition as well as the landscape form but he surpassed categorization. His genre paintings are frequently enigmatic scenes of women in their homes, alone or with a servant, who are occupied with some cultivated activity, such as writing, reading letters, or playing a musical instrument.

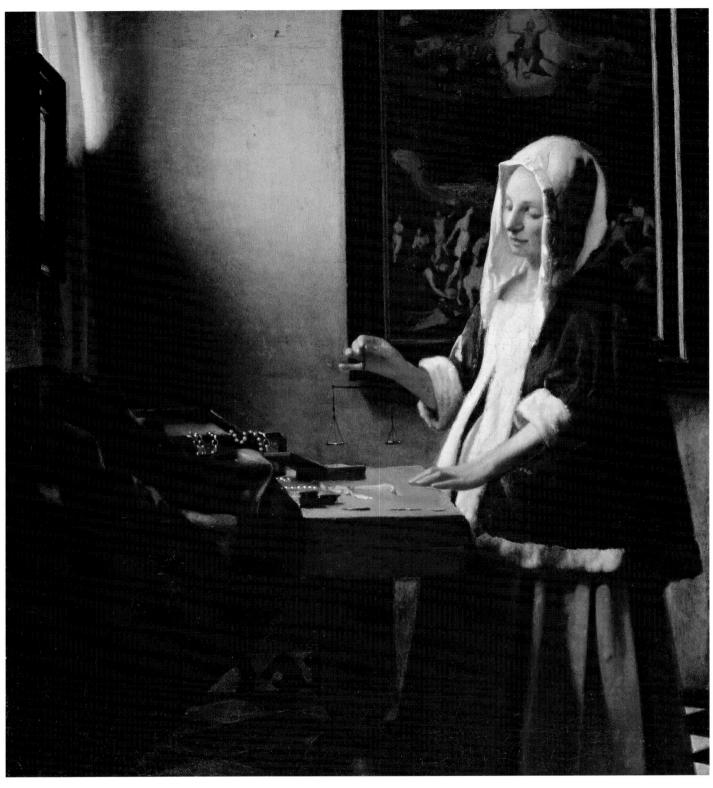

19-64. Jan Vermeer. *Woman Holding a Balance.* c. 1664. Oil on canvas, $15^{7}/8 \times 14''$ (39 \times 35 cm). National Gallery of Art, Washington, D.C. Widener Collection, (1942-9.97)

Of the fewer than forty canvases securely attributed to Vermeer, most are of a similar type—quiet interior scenes, low-key in color, and asymmetrical but strongly geometric in organization. Vermeer achieved his effects through a consistent architectonic construction of space in which every object adds to the clarity and balance of the composition. An even light from a window often

gives solidity to the figures and objects in a room. All emotion is subdued, as Vermeer evokes the stillness of meditation. Even the brushwork is so controlled that it becomes invisible, except when he paints reflected light as tiny droplets of color.

In Woman Holding a Balance (fig. 19-64), perfect balance creates a monumental composition and a moment

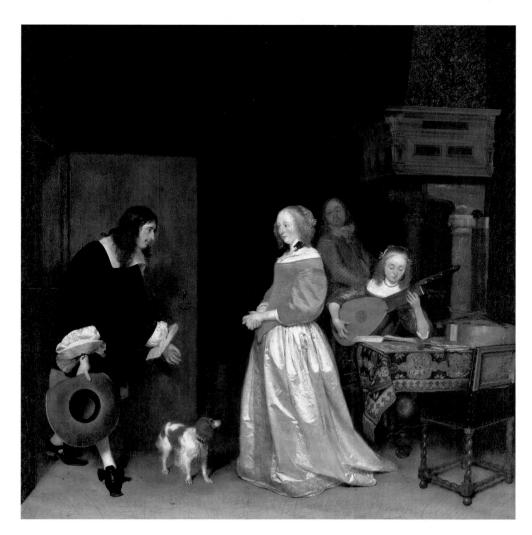

19-65. Gerard Ter Borch. *The Suitor's Visit.* c. 1658. Oil on canvas, $32\frac{1}{2} \times 29^{5}/8$ " (82.6 \times 75.3 cm). National Gallery of Art, Washington, D.C. Andrew W. Mellon Collection (1937.1.58)

of supreme stillness. The woman contemplates the balance and so calls our attention to the act of weighing and judging. Her hand and the scale are central, but directly over her, on the wall of the room, hangs a large painting of the Last Judgment. Thus, Vermeer's painting becomes a metaphor for eternal judgment. The woman's moment of quiet introspection before she touches gold or pearls also recalls the *vanitas* theme of the transience of life, allowing the painter to comment on the ephemeral quality of material things.

Gerard Ter Borch. Gerard Ter Borch (1617–81) was renowned for his exquisite rendition of lace, velvet, and especially satin, a skill he demonstrated in a work traditionally known as *The Suitor's Visit* (fig. 19-65), painted about 1658. It shows a well-dressed man bowing gracefully to an elegant woman dressed in white satin who stands in a sumptuously furnished room in which another woman plays a lute. The painting appears to represent a prosperous gentleman paying a call on a lady of equal social status, possibly a courtship scene. The dog in the painting and the musician seem to be simply part of the scene, but we are already familiar with the dog as

a symbol of fidelity, and stringed instruments were said to symbolize, through their tuning, the harmony of souls and thus, possibly, a loving relationship.

Jan Steen. Jan Steen (1626–79), whose larger brush-strokes contrast with the meticulous treatment of Ter Borch, used scenes of everyday life to portray moral tales, illustrate proverbs and folk sayings, or make puns to amuse the spectator. Steen owned a brewery for several years, and from 1670 until his death he kept a tavern in Leiden; he probably found inspiration and models all about him. Steen was influenced early in his career by Frans Hals, and his work in turn influenced a **school**, or circle of artists working in a related style, of Dutch artists who emulated his style and subjects.

Jan Steen's paintings of children are especially remarkable, for he captured not only their childish physiques but also their fleeting moods and expressions. His ability to capture such transitory dispositions was well expressed in his painting *The Drawing Lesson* (fig. 17, Introduction). Here, a youthful apprentice observes the master artist correct an example of drawing—a skill widely believed to be the foundation of art.

19-66. Maria Sibylla Merian. Plate 9 from Dissertation in Insect Generations and Metamorphosis in Surinam. 1719. Hand-colored engraving, $18^{7}/8 \times 13''$ (47.9 \times 33 cm). National Museum of Women in the Arts, Washington, D.C. Gift of Wallace and Wilhelmina Holladay

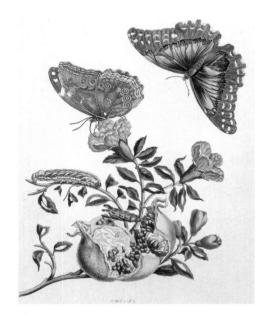

STILL LIFES AND FLOWER PIECES

The term **still life** for paintings of artfully arranged objects on a table comes from the Dutch *stilleven*, a word coined about 1650. The Dutch were so proud of their artists' still-life paintings that they presented one to the French queen Marie de' Medici when she made a state visit to Amsterdam. A still-life painting might carry moralizing connotations and commonly had a *vanitas* theme, reminding viewers of the transience of life, material possessions, and even art.

Still-life paintings in which cut-flower arrangements predominate are often referred to as **flower pieces**. Significant advances were made in botany during the Baroque period through the application of orderly scientific methods, and objective observation was greatly improved by the invention of the microscope in 1674 (see "Science and the Changing Worldview," page 721). The Dutch were also major growers and exporters of flowers, especially tulips, which appear in nearly every flower piece in dozens of exquisite variations.

Maria Sibylla Merian. Before the invention of photography, scientific investigations relied entirely on drawn and painted illustrations, and researchers hired artists to accompany them on field trips. Maria Sibylla Merian (1647-1717) was unusual in making noteworthy contributions as both researcher and artist. German by birth and Dutch by training, Merian was once described by a Dutch contemporary as a painter of flowers, fruit, birds, worms, flies, mosquitoes, spiders, "and other filth." At the time, it was believed that insects emerged spontaneously from the soil, but Merian's research on the life cycles of insects proved otherwise, findings she published in 1679 and 1683 as The Wonderful Transformation of Caterpillars and (Their) Singular Plant Nourishment. In 1699, Amsterdam subsidized Merian's research on plants and insects in the Dutch colony of Surinam in South America; her results were published as Dissertation in Insect Generations and Metamorphosis in

Surinam, illustrated with sixty large plates engraved after her watercolors (fig. 19-66). Each plate is scientifically precise, accurate, and informative, presenting insects in various stages of development, along with the plants they live on.

Rachel Ruysch. The Dutch tradition of flower painting peaked in the long career of Rachel Ruysch (1664–1750) of Amsterdam. Her flower pieces were highly prized for their sensitive, free-form arrangements and their unusual and beautiful color harmonies. During her seventyyear career, she became one of the most sought-after and highest-paid still-life painters in Europe—her paintings brought twice what Rembrandt's did. In her Flower Still Life (fig. 19-67), painted after 1700, Ruysch placed the container at the center of the canvas's width, then created an asymmetrical floral arrangement of pale oranges, pinks, and yellows rising from lower left to top right of the picture, offset by the strong diagonal of the tabletop. To further balance the painting, she placed highlighted blossoms and leaves against the dark left half of the canvas and silhouetted them against the light wall area on the right. Ruysch often emphasized the beauty of curving flower stems and enlivened her compositions with interesting additions, such as casually placed pieces of fruit or insects, in this case a large gray moth (lower left) and two snail shells.

ENGLAND England and Scotland came under the same rule in 1603 with the ascent to the English throne of James VI of Scotland, who reigned over Great Britain as James I (ruled 1603–25). James increased the royal patronage of British artists, especially in literature and architecture. William Shakespeare wrote *Macbeth*, featuring the king's legendary ancestor Banquo, in tribute to the new royal family, and it was performed at court in December 1606. James's son Charles I was also an important collector and patron of painting.

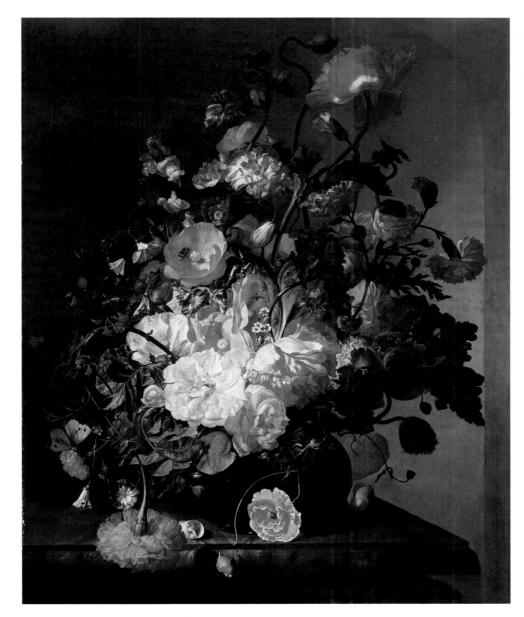

19-67. Rachel Ruysch. *Flower Still Life.* After 1700. Oil on canvas, $30 \times 24''$ (76.2 × 61 cm). The Toledo Museum of Art, Ohio.

Purchased with funds from the Libbey Endowment. Gift of Edward Drummond Libbey, (1956.57)

Flower painting was a muchadmired specialty in the seventeenth- and eighteenthcentury Netherlands. Such paintings were almost never straightforward depictions of actual fresh flowers. Instead, artists made color sketches of fresh examples of each type of flower and studied scientifically accurate color illustrations in botanical publications. Using their sketches and notebooks, in the studio they would compose bouquets of perfect specimens of a variety of flowers that could never be found blooming at the same time. The short life of blooming flowers was a poignant reminder of the fleeting nature of beauty and of human life.

However, religious and political tensions erupted into civil wars that began in 1642 and that cost Charles his throne and his life in 1649. Much of the rest of the Baroque period in England was politically uneasy, with a succession of republican and monarchical rulers who alternately supported Protestantism or Catholicism. The Protestant course was ensured by the Glorious Revolution of 1689, the bloodless overthrow of the Catholic king James II by his Protestant son-in-law and daughter, William and Mary, who ruled jointly until Mary's death in 1694. William (the Dutch great-grandson of William of Orange, who had led the Netherlands' independence movement) ruled on his own until his death in 1702. He was succeeded by Mary's sister Anne (ruled 1702–14).

ARCHITECTURE AND LANDSCAPE DESIGN

In sculpture and painting, the English court patronized primarily foreign artists and sought mainly portraiture.

The field of architecture, however, was dominated in the seventeenth century by two Englishmen, Inigo Jones and Christopher Wren. They replaced the country's long-lived Gothic style with a classical one and were followed in the classicist mode by another English architect, John Vanbrugh. Major change in **landscape architecture** took place during the eighteenth century, led by the innovative designer Lancelot "Capability" Brown.

Inigo Jones. In the early seventeenth century, the architect Inigo Jones (1573–1652) introduced to the English throne his version of Renaissance classicism, an architectural design based on the style of the Renaissance architect Andrea Palladio (see figs. 18-61, 18-63). Jones had studied Palladio's work in Venice, and Jones's copy of Palladio's *Four Books of Architecture* (which has been preserved) is filled with his notes. Jones was appointed surveyor-general in 1615 and was commissioned to design the Queen's House in Greenwich and the Banqueting House for the royal palace of Whitehall.

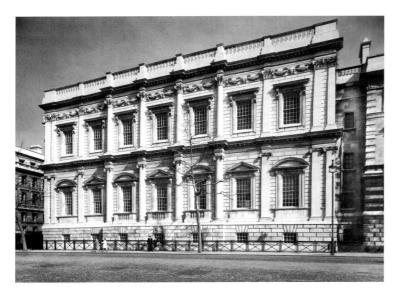

19-68. Inigo Jones. Banqueting House, Whitehall Palace, London. 1619-22.

The Whitehall Banqueting House (fig. 19-68), built in 1619-22 to replace an earlier one destroyed by fire, was used for court ceremonies and entertainments such as popular masques (see "The English Court Masque," below). The west front shown here, consisting of what appears to be two upper stories with superimposed Ionic and Composite orders raised over a plain basement level, exemplifies the understated elegance of Jones's interpretation of Palladian design. Pilasters flank the end bays (vertical divisions), and engaged columns subtly emphasize the three bays at the center. These vertical elements are repeated in the balustrade along the roofline. A rhythmic effect was created in varying window treatments from triangular and segmental (semicircular) pediments on the first level to cornices with volute (scroll-form) brackets on the second. The sculpted garlands just below the roofline add an unexpected decorative touch, as does the use of a different-color stone-pale golden, light brown, and white—for each story (no longer visible after the building was refaced in uniformly white Portland stone).

Despite the two stories presented on the exterior, the interior of the Whitehall Banqueting House (fig. 19-69) is

THE ENGLISH COURT MASQUE

James I and his successor, Charles I, were fond of dance-dramas called masques, an important form of performance in early Baroque England. Inspired by Italian theatrical entertainments, the English masque combined theater, music, and dance in a spectacle in which professional actors, courtiers, and even members of the royal family participated. The event was more than extravagant entertainment, however; the dramas also glorified the monarchy. The entertainment began with an ante-masque in which actors described a world torn by dissension and vice. Then, to the accompaniment of theatrical effects designed to amaze the spectators, richly costumed lords and ladies of the court appeared in the heavens to vanquish Evil. A dance sequence followed, symbolizing the restoration of peace and prosperity.

Inigo Jones, the court architect, was frequently called on to produce awe-inspiring special effects—storms at sea, blazing hells, dazzling heavens, and other wonders. To meet these demands, Jones revolutionized English stage design. He abandoned the Shakespearean theater, where viewers often sat on the stage with the actors, and devised a

proscenium arch that divided the audience from the stage action. He then created a bilevel stage with an upper area, where celestial visions could take place, and a main lower area, which was equipped with sliding shutters to permit rapid set changes. Jones achieved remarkable effects of deep space using linear perspective to decorate the shutters and the back cloth. His stagecraft is known today from the

many working drawings he made, such as the design shown here, which he made for the last scene in court poet Thomas Carew's Coelum Britannicum, performed in 1634. This masque, which glorified the union of England and Scotland under James I and Charles I, ended with the appearance in clouds over the royal palace of personifications of Religion, Truth, Wisdom, Concord, Reputation, and Government.

Inigo Jones. *A Garden and a Princely Villa*, sketch for set design for *Coelum Britannicum (British Heaven)*, by Thomas Carew. 1634. Pen and brown ink with green distemper wash, $18^5/8 \times 22^1/4$ " (43.7 \times 56.5 cm). Devonshire Collection, Chatsworth, England.

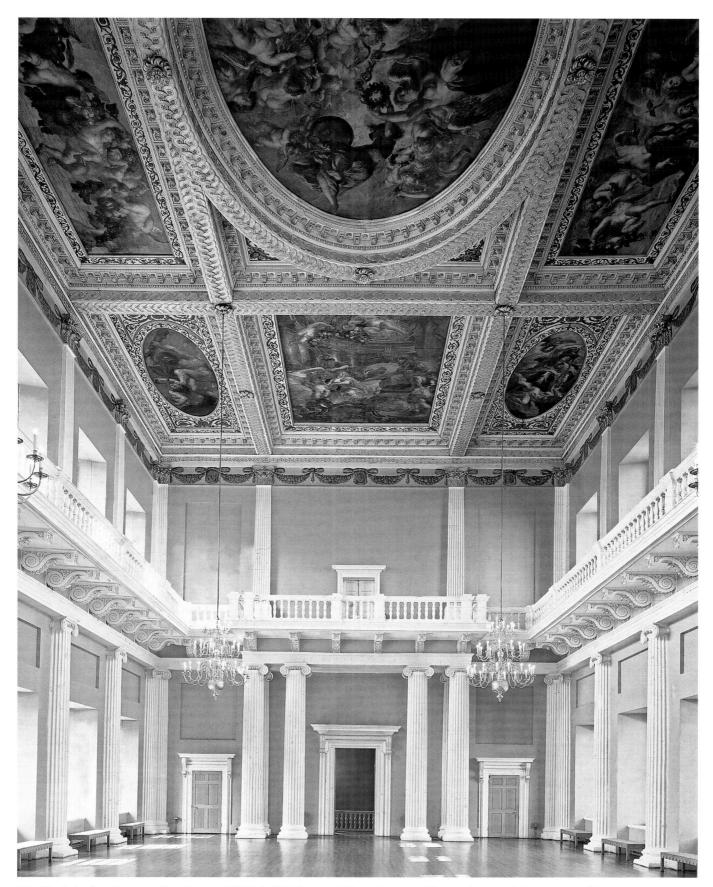

19-69. Interior, Banqueting House, Whitehall Palace. Ceiling paintings of the apotheosis of King James and the glorification of the Stuart monarchy by Peter Paul Rubens. 1630–35.

actually one large hall divided by a balcony; it has antechambers at each end. Ionic pilasters suggest a colonnade but do not impinge on the ideal, double-cube space, which measures 55 by 110 feet by 55 feet high. In 1630, Charles I commissioned Peter Paul Rubens to decorate the ceiling. Jones had divided the flat ceiling into nine compartments, for which Rubens painted canvases glorifying the reign of James I. Installed in 1635, the paintings show a series of royal triumphs ending with the king carried to heaven in clouds of glory. So proud was Charles of the result that, rather than allow the smoke of candles and torches to harm the ceiling decoration, he moved evening entertainments to an adjacent pavilion.

Christopher Wren. After Jones's death, English architecture was dominated by Christopher Wren (1632–1723). Wren began his professional career in 1659 as a professor of astronomy; architecture was a sideline until 1665, when he traveled to France to further his education. While there, he met with French architects and with Bernini, who was in Paris to consult on his designs for the Louvre. Wren returned to England with architectural books, engravings, and a greatly increased admiration for French classical Baroque design. In 1669, he was made surveyor-general, the position once held by Inigo Jones; in 1673, he was knighted.

After the Great Fire of 1666 demolished central London, Wren was continuously involved in rebuilding the city well into the next century. He built more than

fifty Baroque churches. His major project was the rebuilding of Saint Paul's Cathedral (fig. 19-70), carried out from 1675 to 1710 after failed attempts to salvage the burned-out medieval church on the site. Unlike Saint Peter's Basilica in the Vatican, Saint Paul's has a long nave and equally long sanctuary. Short transepts have semicircular ends, and a dome rises above the crossing (fig. 19-71). Wren's dome for Saint Paul's has an interior masonry vault with an oculus and an exterior sheathing of lead-covered wood, but also has a brick cone rising from the inner oculus to support a tall lantern. The columns surrounding the drum on the exterior recall Bramante's Tempietto in Rome (see fig. 18-19). On the main (west) front of Saint Paul's (see fig. 19-70), two stages of paired Corinthian columns support a carved pediment. The deep-set porches and the columned pavilions atop the towers create dramatic areas of light and shadow. The huge size of the cathedral and its triumphant verticality, complexity of form, and chiaroscuro effects make it a major monument of the English Baroque. Wren recognized the importance of the building. On the simple marble slab that forms his tomb in the crypt of the cathedral, he had engraved: "If you want to see his memorial, look around you."

John Vanbrugh. Like Wren, John Vanbrugh (1664–1726) came late to architecture. His heavy, angular style was utterly unlike Wren's, but it was well suited to buildings

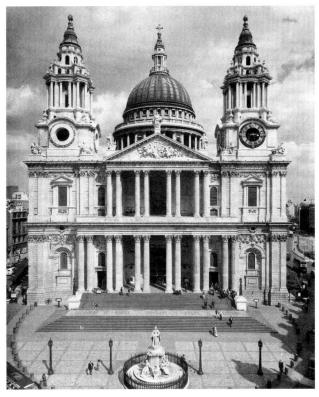

19-70. Christopher Wren. Saint Paul's Cathedral, London. Designed 1673, built 1675–1710.

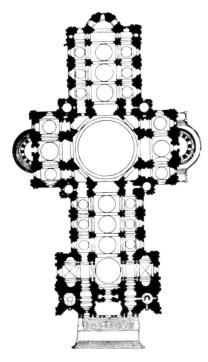

19-71. Plan of Saint Paul's Cathedral.

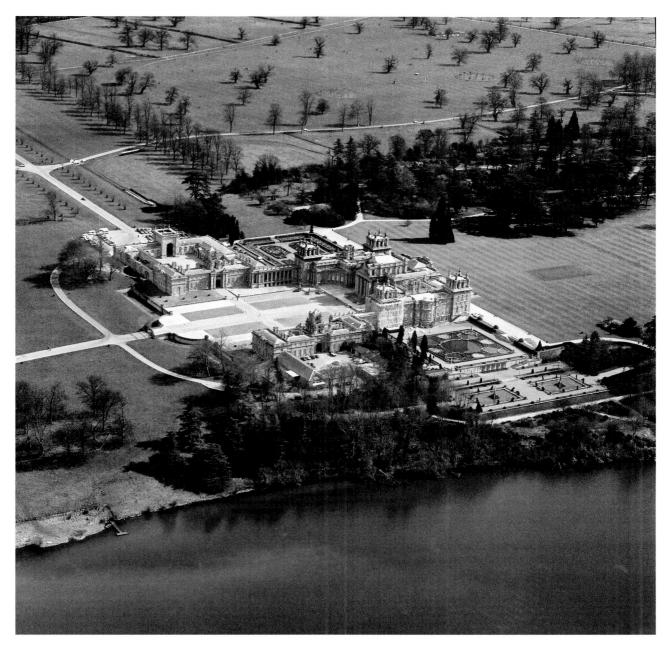

19-72. John Vanbrugh. Blenheim Palace, Woodstock, Oxfordshire, England. 1705–12 and 1715–25.

Built by Queen Anne, with funds from Parliament, for John Churchill, Duke of Marlborough, after his 1704 victory over the armies of Louis XIV at Blenheim, the palace was made a national monument as well as the residence of the dukes of Marlborough. Except for the formal gardens at each side of the center block, the informal and natural landscaping is the work of Lancelot "Capability" Brown.

intended to express power and domination. Perhaps his most important achievement was Blenheim Palace (fig. 19-72), built in two phases (1705–12 and 1715–25) in Woodstock, just northwest of London. Blenheim's enormous size and symmetrical plan, with service and stable wings flanking an entrance court, seem to reach out to encompass the surrounding terrain, recalling Versailles (compare fig. 19-21).

Lancelot "Capability" Brown. Blenheim's grounds originally comprised a practical kitchen garden, an av-

enue of elm trees, and another garden. In the 1760s, the grounds were redesigned by Lancelot "Capability" Brown (1716–83) according to his radical new style of landscape architecture. In contrast to the geometric rigor of the French garden, Brown's designs appeared to be both informal and natural. At Blenheim, Brown dammed the small river flowing by the palace to form two lakes and a rockwork cascade, then created sweeping lawns and artfully arranged trees. The formal gardens in the French style now seen at each side of Blenheim's center block were added in the twentieth century.

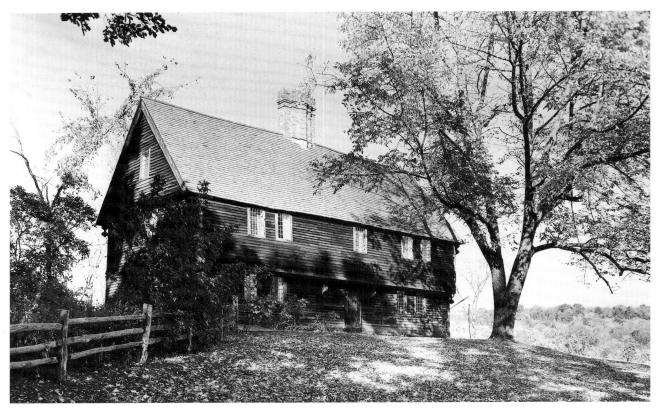

19-73. Parson Capen House, Topsfield, Massachusetts. 1683.

COLONIES IN

ENGLISH In the seventeenth century, the art of North America reflected the tastes of NORTH AMERICA the European countries that ruled the colonies,

especially, on the eastern coast, England. Not surprisingly, much of the colonial art was done by immigrant artists, and styles often lagged behind the European mainstream. Colonial life was still hard in the 1600s, and few could afford to think of fine houses and art collections; the Puritans, the religious dissenters who had left England and settled in the Northeast beginning in 1620, wanted only the simplest functional buildings for homes and churches. Architecture responded more quickly than sculpture, painting, and craft arts in the development of native styles. Although by the last decades of the seventeenth century a market for fine furniture and portraits had developed, unfortunately but understandably native artists of outstanding talent often found it advantageous to resettle in Europe.

ARCHITECTURE

Early architecture in the British North American colonies tended to derive from European provincial timber construction with medieval roots. Wood, so easily obtained in the Northeast, was used to create the same kinds of houses and churches then being built in rural England (as well as in Holland and France, which also had colonies in North America). In seventeenth-century New

England, for example, many buildings reflected the adaptation of contemporary English country buildings, which were so appropriate to the severe North American winters-framed-timber construction with steep roofs, massive central fireplaces and chimneys, overhanging upper stories, and small windows with tiny panes of glass. Following a time-honored tradition, walls consisted of wooden frames filled with wattle and daub (woven branches packed with clay), or brick in more expensive homes. Instead of leaving this construction exposed, as was common in Europe, colonists usually weatherproofed it with horizontal plank siding, called clapboard. The Parson Capen House in Topsfield, Massachusetts (fig. 19-73), built in 1683, is a wellpreserved example. The earliest homes generally consisted of a single "great room" and fireplace, but the Capen House has two stories, each with two rooms flanking the central fireplace and chimney. The main fireplace was the center of domestic life; all the cooking was done there, and the firelight provided illumination for reading and sewing.

PAINTING

Painting and sculpture had to wait for more settled and affluent times in the colonies. For a long time, the only works of sculpture were carved or engraved tombstones. Painting, too, was sponsored as a necessary part of family record keeping, and portraits done by

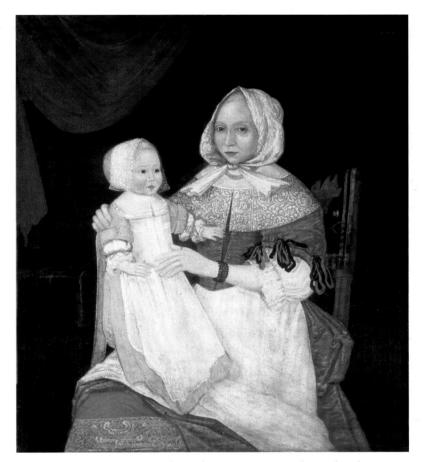

19-74. Anonymous ("Freake Painter"). *Mrs. Freake and Baby Mary.* c. 1674. Oil on canvas, $42^{1}/_{4} \times 36^{1}/_{4}$ " (108 × 92.1 cm). Worcester Museum of Art, Worcester, Massachusetts. Gift of Mr. and Mrs. Albert W. Rice

itinerant "face painters," also called **limners**, have a charm and sincerity that appeal to the modern eye. The anonymous painter of *Mrs. Freake and Baby Mary* (fig. 19-74), dated about 1674, seems to have known Dutch portraiture, probably through engraved copies that were imported and sold in the colonies. Even though the Freake painter was clearly self-taught and lacked skills in illusionistic, three-dimensional composition,

this portrait has much in common with Frans Hals's *Catharina Hooft and Her Nurse* (see fig. 19-50), especially in its spirit, in the care given to minute details of costuming, and in the focus on large figures in the foreground. Maternal pride in an infant and hope for her future are universals that seem to apply to little Mary as well as to Catharina, even though their worlds were far apart.

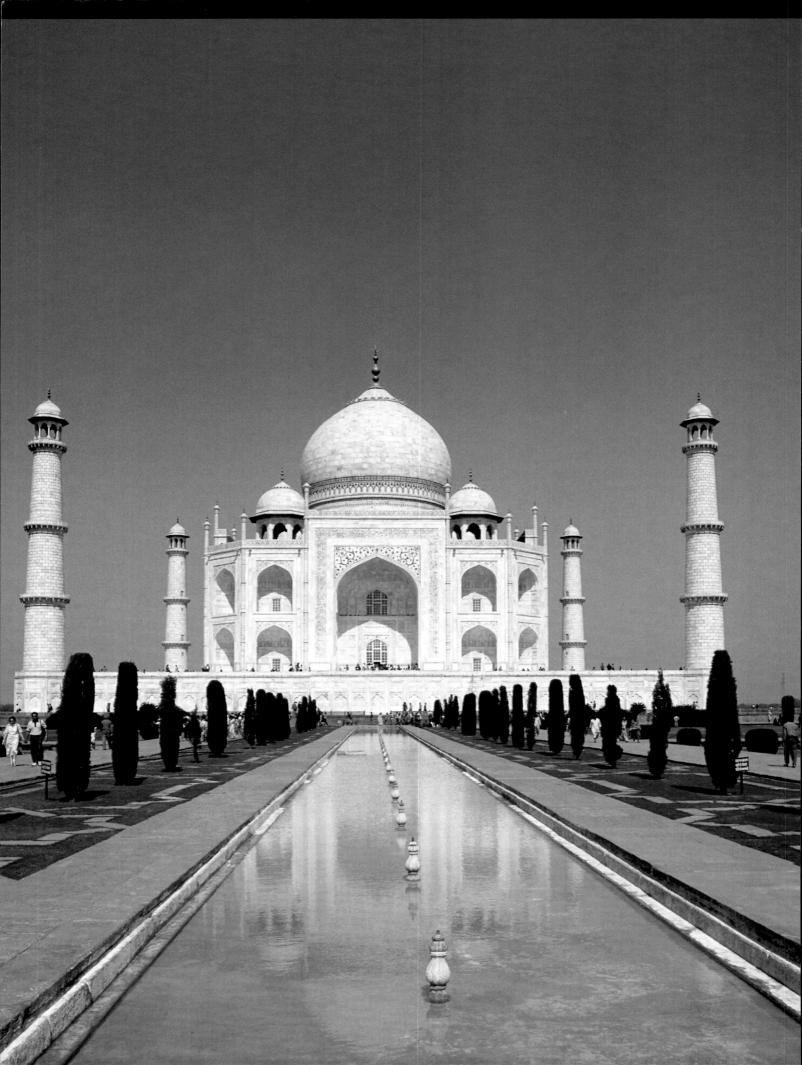

20

ART OF INDIA AFTER 1200

ISITORS CATCH THEIR BREATH. ETHEREAL, WEIGHTLESS, THE BUILDING before them barely seems to touch the ground. Its reflection shimmers in the pools of the garden meant to evoke a vision of paradise as described in the Koran, the holy book of Islam. Its facades are delicately inlaid with inscriptions and arabesques in semi-precious stones—carnelian, agate, coral, turquoise, garnet, lapis, and jasper. Above, its luminous, white marble dome reflects each shift in light, flushing rose at dawn, dissolving in its own brilliance in the noonday sun.

One of the most celebrated buildings in the world, the Taj Mahal (fig. 20-1) was built in the seventeenth century by the Mughal ruler Shah Jahan as a mausoleum for his favorite wife, Mumtaz-i-Mahal, who died in childbirth. A dynasty of Central Asian origin, the Mughals were the most successful of the many Islamic groups that established themselves in India beginning in the tenth century. Under their patronage, Persian and Central Asian influences mingled with older traditions of the South Asian subcontinent, adding yet another dimension to the already ancient and complex artistic heritage of India.

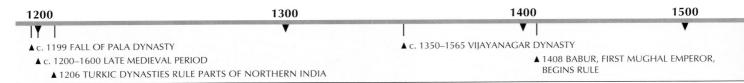

TIMELINE 20-1. India after 1200. Much of the Indian subcontinent was occupied by outside powers for nearly 750 years.

Map 20-1. India after 1200.

Throughout its history, the Indian subcontinent was subject to continual invasion that caused the borders of its kingdoms to contract and expand until the establishment of modern-day India in the twentieth century.

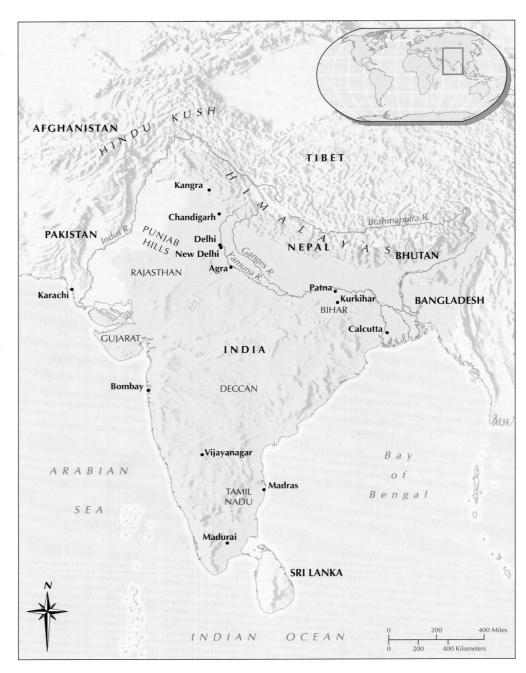

LATE MEDIEVAL PERIOD

By 1200 India was already among the world's oldest civilizations (see "Foundations of Indian Culture," page 000). The art that survives from its earlier periods is almost exclu-

sively sacred, most of it inspired by the three principal religions: Buddhism, Hinduism, and Jainism. At the start of the Late Medieval period, which extends roughly from 1200 to about 1600 (Timeline 20-1), these three religions

continued as the principal focus for Indian art, even as invaders from the northwest began to establish the new religious culture of Islam.

BUDDHIST ART

After many centuries of prominence, Buddhism had been in decline as a cultural force in India since the seventh century. At the beginning of the Late Medieval period, the principal Buddhist centers were concentrated in

▲ 1947 INDIA BECOMES INDEPENDENT NATION

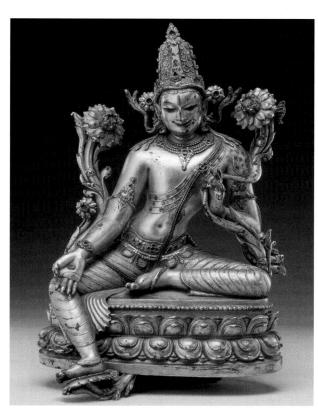

20-2. *The Bodhisattva Avalokiteshvara*, from Kurkihar, Bihar. Medieval period, Pala dynasty, 12th century. Gilt-bronze, height 10" (25.5 cm). Patna Museum, Patna.

the northeast, in the kingdom ruled since before the Early Medieval period by the Pala dynasty (750-1199). There, in great monastic universities that attracted monks from as far away as China, Korea, and Japan, was cultivated a form of Buddhism known as Tantric (Vajrayana) Mahayana. The practices of Tantric Buddhism, which included techniques for visualizing deities, encouraged the development of iconographic images such as the gilt-bronze sculpture of the bodhisattva Avalokiteshvara in figure 20-2. Bodhisattvas are beings who are well advanced on the path to buddhahood (enlightenment), the goal of Mahayana Buddhists, and who have vowed out of compassion to help others achieve enlightenment. Avalokiteshvara, the bodhisattva of greatest compassion, whose vow is to forgo buddhahood until all others become buddhas, became the most popular of these saintly beings in India and in East Asia.

Characteristic of *bodhisattvas*, Avalokiteshvara is distinguished in art by his princely garments, unlike a *buddha*, who wears a monk's robes. Avalokiteshvara is specifically recognized by the lotus flower he holds and by the presence in his crown of his "parent" *buddha*, in this case Amitabha, *buddha* of the Western Pure Land

(the Buddhist paradise). Other marks of Avalokitesh-vara's extraordinary status are the third eye (symbolizing the ability to see in miraculous ways) and the wheel on his palm (signifying the ability to teach the Buddhist truth).

Avalokiteshvara is shown here in the posture of relaxed ease known as the royal pose. One leg angles down; the other is drawn up onto the lotus seat, itself considered an emblem of spiritual purity. His body bends gracefully, if a bit stiffly, to one side. The chest scarf and lower garment cling to his body, fully revealing its shape. Delicate floral patterns enliven the textiles, and closely set parallel folds provide a wiry, linear tension that contrasts with the hard but silken surfaces of the body. Linear energy continues in the sweep of the tightly pleated hem emerging from under the right thigh, the sinuous lotus stalks on each side, and the fluttering ribbons of the elaborate crown. A profusion of details and varied textures creates an ornate effect—the lavish jewelry, the looped hair piled high and cascading over the shoulders, the ripe blossoms, the rich layers of the lotus seat. Though still friendly and human, the image is somewhat formalized. The features of the face, where we instinctively look for a human echo, are treated abstractly, and despite its reassuring smile, the statue's expression remains remote. Through richness of ornament and tension of line, this style expresses the heightened power of a perfected being.

With the fall of the Pala dynasty to Turkic invaders in 1199, the last centers of Buddhism in northern India collapsed, and the monks dispersed, mainly into Nepal and Tibet (see Map 20-1). From that time, Tibet has remained the principal stronghold of Tantric Buddhist practice and its arts. The artistic style perfected under the Palas, however, became an influential international style throughout East and Southeast Asia in the Late Medieval period.

JAIN ART

The Jain religion traces its roots to a spiritual leader called Mahavira (c. 599–527 BCE), whom it regards as the final in a series of twenty-four saviors known as pathfinders, or *tirthankaras*. Devotees seek through purification to become worthy of rebirth in the heaven of the pathfinders, a zone of pure existence at the zenith of the universe. Jain monks live a life of austerity, and even laypersons avoid killing any living creature.

As Islamic, or Muslim, territorial control over northern India expanded, non-Islamic religions resorted to more private forms of artistic expression, such as illustrating sacred texts, rather than public activities, such as building temples. In these circumstances, the Jains of western India, primarily in the region of Gujarat, created many stunningly illustrated manuscripts, such as this *Kalpa Sutra*, which explicates the lives of the pathfinders

20-3. Detail of a leaf with *The Birth of Mahavira*, from the *Kalpa Sutra*. Late Medieval period, western Indian school (probably Gujarat), c. 1375–1400. Gouache on paper, $3\frac{3}{8} \times 3$ " (8.5 × 7.6 cm). Prince of Wales Museum, Bombay.

(fig. 20-3). Produced during the late fourteenth century, it is one of the first Jain manuscripts on paper rather than palm leaf, which had previously been used.

With great economy, the illustration, inserted between blocks of Sanskrit text, depicts the birth of Mahavira. He is shown cradled in his mother's arms as she reclines in her bed under a canopy connoting royalty, attended by three ladies-in-waiting. Decorative pavilions and a shrine with peacocks on the roof suggest a luxurious palace setting. Everything appears two-dimensional against the brilliant red or blue ground. Vibrant colors and crisp outlines impart an energy to the painting that suggests the arrival of the divine in the mundane world. Transparent garments with variegated designs reveal

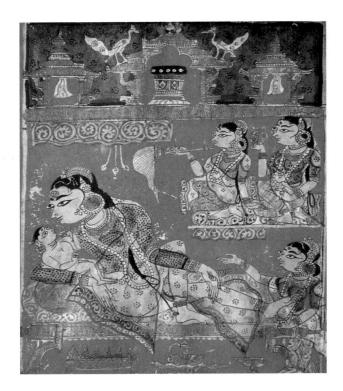

FOUNDATIONS OF INDIAN CULTURE

The earliest civilization on the Indian subcontinent flourished toward the end of the third millennium BCE along the Indus River in present-day Pakistan. Remains of its expertly engineered brick cities have been uncovered, together with works of art that intriguingly suggest spiritual practices and reveal artistic traits known in later Indian culture.

The abrupt demise of the Indus Valley civilization during the midsecond millennium BCE coincides with (and may be related to) the arrival from the northwest of a seminomadic warrior people known as the Indo-European Aryans. Over the next millennium they were influential in formulating the new civilization that gradually emerged. The most important Aryan contributions to this new civilization included the Sanskrit language and the sacred texts called the Vedas. The evolution of Vedic thought under the influence of indigenous Indian beliefs culminated in the mystical, philosophical texts called the Upanishads, which took shape sometime after 800 BCE.

The Upanishads teach that the material world is illusory; only Brahman, the universal soul, is real and eternal. We—that is, our individual souls—are trapped in this illusion in a relentless cycle of birth, death,

and rebirth. The ultimate goal of religious life is to liberate ourselves from this cycle and to unite our individual soul with Brahman.

Buddhism and Jainism are two of the many religions that developed in the climate of Upanishadic thought. Buddhism is based on the teachings of Shakyamuni Buddha, who lived in central India about 500 BCE; Jainism was shaped about the same time around the followers of the spiritual leader Mahavira. Both religions acknowledged the cyclical nature of existence and taught a means of liberation from it, but they rejected the authority, rituals, and social strictures of Vedic religion. Whereas the Vedic religion was in the hands of a hereditary priestly class, Buddhist and Jain communities welcomed all members of society, which gave them great appeal. The Vedic tradition eventually evolved into the many sects now collectively known as Hinduism.

Politically, India through most of its history was a mosaic of regional dynastic kingdoms, but from time to time, empires emerged that unified large parts of the subcontinent. The first was the Maurya dynasty (c. 322–185 BCE), whose great king Ashoka patronized Buddhism. From this time Buddhist doctrines spread widely and its artistic traditions were established.

In the first century CE the Kushans, a Central Asian people, created an empire extending from present-day Afghanistan down into central India. Buddhism prospered under Kanishka, the most powerful Kushan king, and spread into Central Asia and to East Asia.

At this time, under the evolving thought of Mahayana Buddhism, traditions first evolved for depicting the image of the Buddha in art.

Later, under the Gupta dynasty (c. 320–500 cE) in central India, Buddhist art and culture reached their high point. However, Gupta monarchs also patronized the Hindu religion, which from this time grew to become the dominant Indian religious tradition, with its emphasis on the great gods Vishnu (the Creator), Shiva (the Destroyer), and the Goddess—all with multiple forms.

During the long Medieval period, which lasted from about 950 to about 1600 ce, numerous regional dynasties prevailed, some quite powerful and long-lasting. During the early part of this period, to roughly 1200, Buddhism continued to decline as a cultural force, while artistic achievement under Hinduism soared. Hindu temples, in particular, developed monumental and complex forms that were rich in symbolism and ritual function, with each region of India producing its own variation.

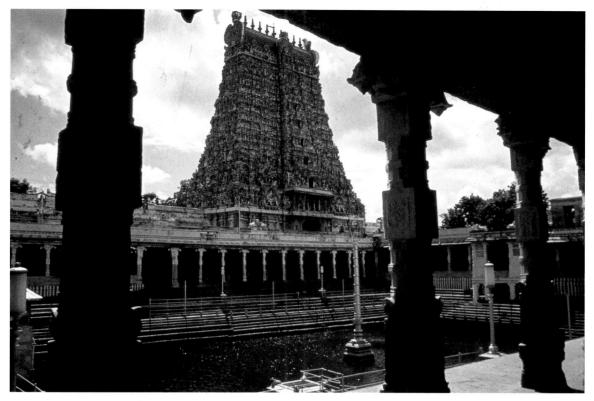

20-4. Outer *gopura* **of the Minakshi-Sundareshvara Temple, Madurai,** Tamil Nadu, South India. Late Medieval period, Nayak dynasty, mostly 13th to mid-17th century.

the swelling curves of the figures, whose alert postures and gestures convey a sense of the importance and excitement of the event. Strangely exaggerated features, such as the protruding eyes, contribute to the air of the extraordinary. With its angles and tense curves, the drawing is closely linked to the aesthetics of Sanskrit **calligraphy**, and the effect is as if the words themselves had suddenly flared into color and image.

HINDU ART

During the Early Medieval period Hinduism became the dominant religious tradition of India. With the increasing popularity of Hindu sects came the rapid development of Hindu temples. Spurred by the ambitious building programs of wealthy rulers, well-formulated regional styles had evolved by about 1000 ce. The most spectacular structures of the era were monumental, with a complexity and grandeur of proportion unequaled even in later Indian art.

During the Late Medieval period the emphasis on monumental individual temples gave way to the building of vast **temple complexes** and more moderately scaled yet more richly ornamented individual temples. These developments took place largely in the south of India, for temple building in the north virtually ceased with the consolidation of Islamic rule there from the beginning of the thirteenth century. The mightiest of the southern Hindu kingdoms was Vijayanagar (c. 1350–1565), whose rulers successfully countered the southward progress of

Islamic forces for more than 200 years. Viewing themselves as defenders and preservers of Hindu faith and culture, Vijayanagar kings lavished donations on sacred shrines. Under the patronage of the Vijayanagar and their successors, the Nayaks, the principal monuments of later Hindu architecture were created.

The enormous temple complex at Madurai, one of the capitals of the Nayaks, is an example of this late, fervent expression of Hindu faith. Founded around the thirteenth century, it is dedicated to the goddess Minakshi (the local name for Parvati, the consort of the god Shiva) and to Sundareshvara (the local name for Shiva himself). The temple complex stands in the center of the city and is the focus of Madurai life. At its heart are the two oldest shrines, one to Minakshi and the other to Sundareshvara. Successive additions over the centuries gradually expanded the complex around these small shrines and came to dominate the visual landscape of the city. The most dramatic features of this and similar "temple cities" of the south were the thousand-pillar halls, large ritual-bathing pools, and especially entrance gateways, called gopuras, which tower above the temple site and the surrounding city like modern skyscrapers (fig. 20-4).

Gopuras proliferated as a temple city grew, necessitating new and bigger enclosing walls, and thus new gateways. Successive rulers, often seeking to outdo their predecessors, donated taller and taller *gopuras*. As a result, the tallest structures in temple cities are often at

the periphery, rather than at the central temples, which are sometimes totally overwhelmed. The temple complex at Madurai has eleven gopuras, the largest well over 100 feet tall.

Formally, the gopura has its roots in the vimana, the pyramidal tower characteristic of the seventh-century southern temple style. As the gopura evolved, it took on the graceful concave silhouette shown here. The exterior is embellished with thousands of sculpted figures, evoking a teeming world of gods and goddesses. Inside, stairs lead to the top for an extraordinary view.

PERIOD

MUGHAL Islam first touched the South Asian subcontinent in the eighth century, when Arab armies captured a small territory near the Indus River. Later, be-

ginning around 1000, Turkic factions from Central Asia, relatively recent converts to Islam, began military campaigns into North India, at first purely for plunder, then seeking territorial control. From 1206, various Turkic dynasties ruled portions of the subcontinent from the northern city of Delhi. These sultanates, as they are known, constructed forts, mausoleums, monuments, and mosques. Although these early dynasties left their mark, it was the Mughal dynasty that made the most inspired and lasting contribution to the art of India.

The Mughals, too, came from Central Asia. Muhammad Zahir-ud-Din, known as Babur ("Lion" or "Panther"), was the first Mughal emperor of India (ruled 1526–30). He emphasized his Turkic heritage, though he had equally impressive Mongol ancestry. After some initial conquests in Central Asia, he amassed an empire stretching from Afghanistan to Delhi, which he conquered in 1526. Akbar (ruled 1556-1605), the third ruler, extended Mughal control over most of North India, and under his two successors, Jahangir and Shah Jahan, northern India was generally unified by 1658. The Mughal Empire lasted until 1858, when the last Mughal emperor was deposed and exiled to Burma by the British.

MUGHAL ARCHITECTURE

Mughal architects were heir to a 300-year-old tradition of Islamic building in India. The Delhi sultans who preceded them had great forts housing government and court buildings. Their architects had introduced two fundamental Islamic structures, the mosque and the tomb, along with construction based on the arch and the dome. (Earlier Indian architecture had been based primarily on post-and-lintel construction; see "Space-Spanning Construction Devices," page xxviii.) They had also drawn freely on Indian architecture, borrowing both decorative and structural elements to create a variety of hybrid styles, and had especially benefited from the centuries-old Indian virtuosity in stone carving and masonry. The Mughals followed in this tradition, synthesizing Indian, Persian, and Central Asian elements for their forts, palaces, mosques, tombs, and cenotaphs (tombs or monuments to someone whose remains are actually somewhere else). Mughal architectural style culminated in the most famous of all Indian Islamic structures, the Taj Mahal.

The Taj Mahal is sited on the bank of the Yamuna River at Agra, in northern India. Built between 1632 and 1648, it was commissioned as a mausoleum for his wife by the emperor Shah Jahan (ruled 1628-58), who is believed to have taken a major part in overseeing its design and construction.

Visually, the Taj Mahal never fails to impress (see fig. 20-1). As visitors enter through a monumental, hall-like gate, the tomb looms before them across a spacious garden set with long reflecting pools. Measuring some 1,000 by 1,900 feet, the garden is unobtrusively divided into quadrants planted with trees and flowers and framed by broad walkways and stone inlaid in geometric patterns. In Shah Jahan's time, fruit trees and cypresses—symbolic of life and death, respectively-lined the walkways, and fountains played in the shallow pools. One can imagine the melodies of court musicians that wafted through the garden. Truly, the senses were beguiled in this earthly evocation of paradise.

Set toward the rear of the garden, the tomb is flanked by two smaller structures not visible here, one a mosque and the other, its mirror image, a resting hall. They share a broad base with the tomb and serve visually as stabilizing elements. Like the entrance hall, they are made mostly of red sandstone, rendering even more startling the full glory of the tomb's white marble. The tomb is raised higher than these structures on its own marble platform. At each corner of the platform, a minaret, or slender tower, defines the surrounding space. The minarets' three levels correspond to those of the tomb, creating a bond between them. Crowning each minaret is a chattri, or pavilion. Traditional embellishments of Indian palaces, chattris quickly passed into the vocabulary of Indian Islamic architecture, where they appear prominently. Minarets occur in architecture throughout the Islamic world; from their heights, the faithful are called to prayer.

A lucid geometric symmetry pervades the tomb. It is basically square, but its **chamfered**, or sliced-off, corners create a subtle octagon. Measured to the base of the finial (the spire at the top), the tomb is almost exactly as tall as it is wide. Each facade is identical, with a central iwan flanked by two stories of smaller iwans. (A typical feature of eastern Islamic architecture, an iwan is a vaulted opening with an arched portal.) By creating voids in the facades, these *iwans* contribute markedly to the building's sense of weightlessness. On the roof, four octagonal chattris, one at each corner, create a visual transition to the lofty, bulbous dome, the crowning element that lends special power to this structure. Framed but not obscured by the chattris, the dome rises more gracefully and is lifted higher by its drum than in earlier Mughal tombs, allowing the swelling curves and lyrical lines of its beautifully proportioned, surprisingly large form to emerge with perfect clarity.

Before the fourteenth century most painting in India had been made on walls or palm leaves. With the introduction of paper, Indian artists adapted painting techniques from Persia

and over the ensuing centuries produced jewel-toned works of surpassing beauty on paper.

Painters usually began their training early. As young apprentices, they learned to make brushes and grind pigments.

Brushes were made from the curved hairs of a squirrel's tail, arranged to taper from a thick base to a single hair at the tip. Paint came from pigments of vegetables and minerals—lapis lazuli to make blue, malachite for pale green—that were ground to a paste with water, then bound with a solution of gum from the acacia plant.

Paper, too, was made by hand. Fibers of cotton and jute were crushed to a pulp, poured onto a woven mat, dried, and then burnished with a smooth piece of agate, often to a glossy finish.

Artists frequently worked from a collection of sketches belonging to a master painter's atelier. Sometimes, to transfer the drawing to a blank sheet beneath, sketches were pricked with small, closely spaced holes that were

TECHNIQUE

Indian Painting on Paper

then daubed with wet color. The dots were connected into outlines, and the process of painting began.

First, the painter applied a thin wash of a chalk-based white, which

sealed the surface of the paper while allowing the underlying sketch to show through. Next, outlines were filled with thick washes of brilliant, opaque, unmodulated color. When the colors were dry, the painting was laid facedown on a smooth marble surface and burnished with a rounded agate stone, rubbing first up and down, then side to side. The indirect pressure against the marble polished the pigments to a high luster. Then outlines, details, and modeling—depending on the style—were added with a fine brush.

Sometimes certain details were purposely left for last, such as the eyes, which were said to bring the painting to life. Along more practical lines, gold and raised details were applied when the painting was nearly finished. Gold paint, made from pulverized, 24-karat gold leaf bound with acacia gum, was applied with a brush and burnished to a high shine. Raised details such as the pearls of a necklace were made with thick, white chalkbased paint, with each pearl a single droplet hardened into a tiny raised mound.

By the seventeenth century, India was well known for exquisite craftsmanship and luxurious decorative arts (see "The Luxury Arts," page 796). The pristine surfaces of the Taj Mahal are embellished with utmost subtlety (fig. 20-5). Even the sides of the platform on which the Taj stands are carved in relief with a **blind arcade** motif, and carved relief panels of flowers. The portals are framed with verses from the Koran inlaid in black marble, while the **spandrels** are decorated with floral **arabesques** inlaid in colored semiprecious stones, a technique known by its Italian name, **pietra dura**. Not strong enough to detract from the overall purity of the white marble, the embellishments enliven the surfaces of this impressive yet delicate masterpiece.

MUGHAL PAINTING

Probably no one had more control over the solidification of the Mughal Empire and the creation of Mughal art than the emperor Akbar. A dynamic, humane, and just leader, Akbar enjoyed religious discourse and loved the arts, especially painting. He created an imperial **atelier** (workshop) of painters, which he placed under the direction of two artists from the Persian court. Learning from these two masters, the Indian painters of the atelier soon transformed Persian styles into the more vigorous, naturalistic styles that mark the Mughal school (see "Indian Painting on Paper," above).

One of the most famous and extraordinary works produced in Akbar's atelier is an illustrated manuscript of the *Hamza-nama*, a Persian classic about the adventures of Hamza, uncle of the Prophet Muhammad. Painted on cotton cloth, each illustration is more than $2^{1}/_{2}$

feet high. The entire project gathered 1,400 illustrations into twelve volumes and took fifteen years to complete.

One illustration shows Hamza's spies scaling a fortress wall and surprising some men as they sleep

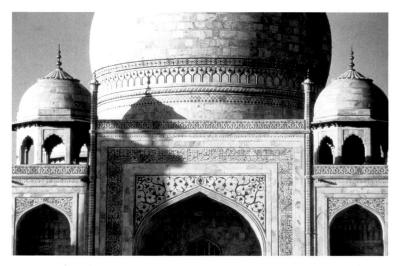

20-5. Taj Mahal, Agra, India. Mughal period, reign of Shah Jahan, c. 1632–48.

Inside, the Taj Mahal invokes the *hasht behisht*, or "eight paradises," a plan named for the eight small chambers that ring the interior—one at each corner and one behind each *iwan*, a vaulted opening with an arched portal. In two stories (for a total of sixteen chambers), the rooms ring the octagonal central area, which rises the full two stories to a domed ceiling that is lower than the outer dome. In this central chamber, surrounded by a finely carved octagonal openwork marble screen, are the exquisite inlaid cenotaphs of Shah Jahan and his wife, whose actual tombs lie in the crypt below.

(fig. 20-6). One man climbs a rope; another has already beheaded a figure in yellow and lifts his head aloftrealistic details are never avoided in paintings from the Mughal atelier. The receding lines of the architecture, viewed from a slightly elevated vantage point, provide a reasonably three-dimensional setting. Yet the sense of depth is boldly undercut by the richly variegated geometric patterns of the tilework, which are painted as though they had been set flat on the page. Contrasting with the flat geometric patterns are the large human figures, whose rounded forms and softened contours create a convincing sense of volume. The energy exuded by the figures is also characteristic of painting under Akbar-even the sleepers seem active. This robust, naturalistic figure style is quite different from the linear style seen earlier in Jain manuscripts (see fig. 20-3) and even from the Persian styles that inspired Mughal paintings.

Nearly as prominent as the architectural setting with its vivid human adventure is the sensuous land-scape in the foreground, where monkeys, foxes, and birds inhabit a grove of trees that shimmer and glow

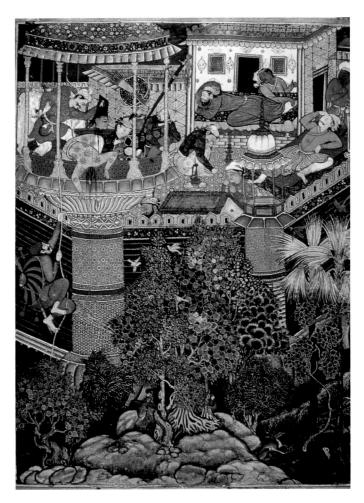

20-6. Page with *Hamza's Spies Scale the Fortress*, from the *Hamza-nama*, North India. Mughal period, Mughal, reign of Akbar, c. 1567–82. Gouache on cotton, 30×24 " (76×61 cm). Museum of Applied Arts, Vienna.

against the darkened background like precious gems. The treatment of the gold-edged leaves at first calls to mind the patterned geometry of the tilework, yet a closer look reveals a skillful naturalism born of careful observation. Each tree species is carefully distinguished—by the way its trunk grows, the way its branches twist, the shape and veining of its leaves, the silhouette of its overall form. Pink and blue rocks with lumpy, softly outlined forms add still further interest to this painting, whose every inch is full of intriguing elements.

Painting from the reign of Jahangir (ruled 1605–27) presents a different tone. Like his father, Jahangir admired painting and, if anything, paid even more attention to his atelier. Indeed, he boasted that he could recognize the hand of each of his artists even in collaborative paintings, which were common. Unlike Akbar, however, Jahangir preferred the courtly life to the adventurous one, and paintings produced for him reflect his subdued and refined tastes and his admiration for realistic detail.

One such painting is *Jahangir in Darbar* (fig. 20-7). The work, probably part of a series on Jahangir's reign, shows the emperor holding an audience, or *darbar*, at court. Jahangir himself is depicted at top center, seated on a balcony under a canopy. Members of his court, including his son, the future emperor Shah Jahan, stand somewhat stiffly to each side. The audience, too, is divided along the central axis, with figures lined up in profile or three-quarter view. In the foreground, an elephant and a horse complete the symmetrical format.

Jahangir insisted on fidelity in portraiture, including his own in old age. The figures in the audience are a medley of portraits, possibly taken from albums meticulously kept by the court artists. Some represent people known to have died before Jahangir's reign, so the painting may represent a symbolic gathering rather than an actual event. Standing out amid the bright array of garments is the black robe of a Jesuit priest from Europe. Both Akbar and Jahangir were known for their interest in things foreign, and many foreigners flocked to the courts of these open-minded rulers. The scene is formal, the composition static, and the treatment generally twodimensional. Nevertheless, the sensitively rendered portraits and the fresh colors, with their varied range of pastel tones, provide the aura of a keenly observed, exquisitely idealized reality that marks the finest paintings of Jahangir's time.

RAJPUT PAINTING

Outside of the Mughal strongholds at Delhi and Agra, much of northern India was governed regionally by local Hindu princes, descendants of the so-called Rajput warrior clans, who were allowed to keep their lands in return for allegiance to the Mughals. Like the Mughals, Rajput princes frequently supported painters at their courts, and in these settings, free from Mughal influence, a variety of strong, indigenous Indian painting styles were perpetuated.

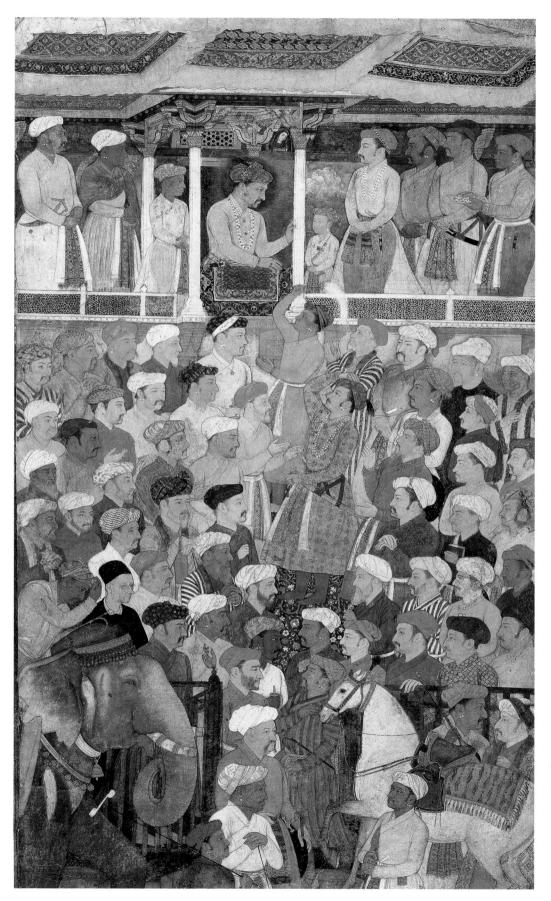

20-7. Abul Hasan and Manohar. Page with *Jahangir in Darbar***,** from the *Jahangir-nama*, North India. Mughal period, Mughal, reign of Jahangir, c. 1620. Gouache on paper, $13\frac{3}{4} \times 7^7/8$ " (35 × 20 cm). Museum of Fine Arts, Boston.

Frances Bartlett Donation of 1912 and Picture Fund, (14, 654)

LUXURY ARTS

The decorative arts of India represent the height of opulent luxury. Ornament embellishes even the invisible backs of pendants and bottoms of containers. Technically superb and crafted from precious materials, the tableware and jewelry, furniture and containers once enhanced the prestige of their owners and gave visual pleasure as well. Metalwork and work in rock crystal, agate, and jade, carving in ivory, and intricate jewelry are all characteristic Indian arts. Because of the intrinsic value of their materials, however, pieces were disassembled, melted down, and reworked, making the study of Indian luxury arts very difficult. Many pieces, like the carved ivory panel illustrated here, have no date or records of manufacture or ownership.

Frozen in timeless delight, carved in ivory against a golden ground where openwork, stylized vines with spiky leaves weave an elegant arabesque, loving couples dally under the arcades of a palace courtyard, the thin columns and cusped arches of which resemble the arcades of the palace of Tirumala Nayak (reigned 1622-62) in Madurai (Tamil Nadu). Their huge eyes under heavy brows suggest the intensity of their gaze, and the artist's choice of the profile view shows off their long noses and thick lips. Their hair is tightly controlled; the men have huge buns and the women, long braids hanging down their backs. Are they divine lovers? After all, Krishna lived and loved on earth among the cow maidens. Or are we observing scenes of courtly romance?

The rich jewelry and well-fed bodies of the couples indicate a high station in life. Men as well as women have voluptuous figures-rounded buttocks and thighs, tummies hanging over jeweled belts, and sharply indented slim waists that emphasize seductive breasts. Their smooth flesh contrasts with the diaphanous fabrics that swath their plump legs, and their long arms and elegant gestures seem designed to show off their rich jewelry-bracelets, armbands, necklaces, huge earrings, and ribbons. Such amorous couples symbolize harmony as well as fertility.

The erotic imagery suggests that the box illustrated here might have been a container for personal belongings such as jewelry, perfume, or cosmetics. In any event, the ivory relief is a brilliant example of South Indian secular arts.

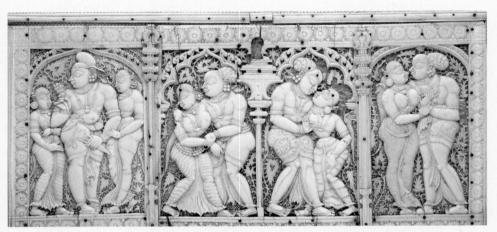

Panel from a box. Nayak dynasty Tamil Nadu, South India, late 17th–18th century. Ivory backed with gilded paper, $6 \times 12^3/_8 \times 1/_8$ " (15.2 \times 31.4 \times 0.3 cm). The Virginia Museum of Fine Arts. The Arthur and Margaret Glasgow Fund. 80.171

The Hindu devotional movement known as *bhakti*, which had done much to spread the faith in the south from around the seventh century, experienced a revival in the north beginning in the Late Medieval period. As it had earlier in the south, *bhakti* inspired an outpouring of poetic literature, this time devoted especially to Krishna, the popular human incarnation of the god Vishnu. Most renowned is the *Gita Govinda*, a cycle of rhapsodic poems about the love between God and humans expressed metaphorically through the love between the young Krishna and the cowherd Radha.

The illustration here is from a manuscript of the *Gita Govinda* produced in the region of Rajasthan about 1525–50. The blue god Krishna sits in dalliance with a group of cowherd women. Standing with her maid and consumed with love for Krishna, Radha peers through the trees, overcome by jealousy. Her feelings are indicated by the cool blue color behind her, while the crimson red behind the Krishna grouping suggests passion (fig. 20-8). The curving stalks and bold patterns of the flowering vines and trees express not only the exuberance of springtime, when the story unfolds, but also

20-8. Page with *Krishna and the Gopis,* from the *Gita Govinda*, Rajasthan, India. Mughal period, Rajput, c. 1525–50. Gouache on paper, $4^{7}/_{8} \times 7^{1}/_{2}$ " (12.3 × 19 cm). Prince of Wales Museum, Bombay.

The lyrical poem *Gita Govinda*, by the poet-saint Jayadeva, was probably written in eastern India during the latter half of the twelfth century. The episode illustrated here occurs early in the relationship of Radha and Krishna, which in the poem is a metaphor for the connection between humans and god. The poem traces the progress of their love through separation, reconciliation, and fulfillment. Intensely sensuous imagery characterizes the entire poem, as in the final song, when Krishna welcomes Radha to his bed (Narayana is the name of Vishnu in his role as cosmic creator):

Leave lotus footprints on my bed of tender shoots, loving Radha! Let my place be ravaged by your tender feet! Narayana is faithful now. Love me Radhika!

I stroke your feet with my lotus hand—you have come far. Set your golden anklet on my bed like the sun.

Narayana is faithful now. Love me Radhika!

Consent to my love. Let elixir pour from your face!
To end our separation I bare my chest of the silk that bars your breast.
Narayana is faithful now. Love me Radhika!

(Translated by Barbara Stoller Miller)

the heightened emotional tensions of the scene. Birds, trees, and flowers are brilliant as fireworks against the black, hilly landscape edged in an undulating white line. As in the Jain manuscript earlier (see fig. 20-3), all the figures are of a single type, with plump faces in profile and oversized eyes. Yet the resilient line of the drawing gives them life, and the variety of textile patterns provides some individuality. The intensity and resolute flatness of the scene seem to thrust all of its energy outward, irrevocably engaging the viewer in the drama.

Quite a different mood pervades *Hour of Cowdust*, a work from the Kangra school in the Punjab Hills, foothills of the Himalayas north of Delhi (fig. 20-9, page 798). Painted around 1790, some 250 years later than the previous work, it shows the influence of Mughal naturalism on the later schools of Indian painting. The theme is again Krishna. Wearing his peacock crown, garland of flowers, and yellow garment—all traditional iconography of Krishna-Vishnu—he returns to the village with his fellow cowherds and their cattle. All eyes are upon him as he plays his flute, said to enchant all

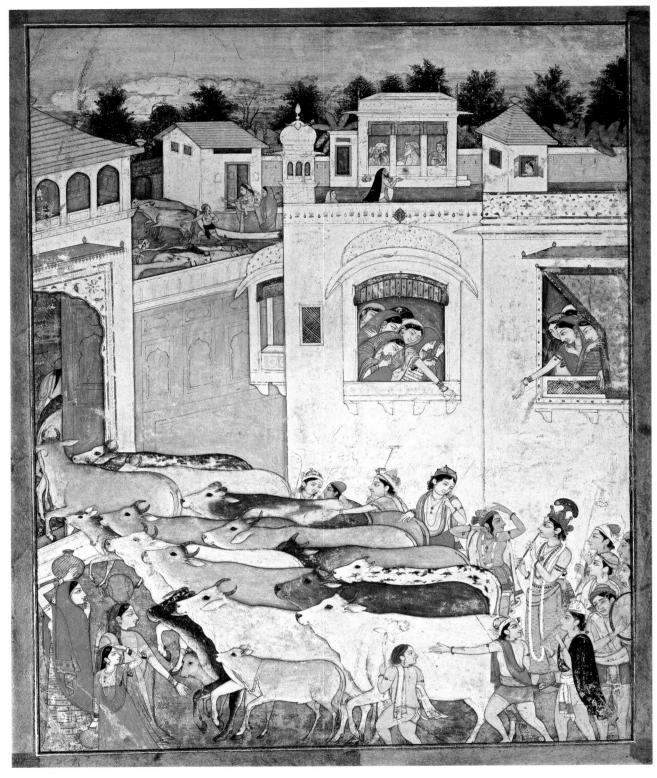

20-9. *Hour of Cowdust,* from Punjab Hills, India. Mughal period, Rajput, Kangra school, c. 1790. Gouache on paper, $14^{15}/_{16} \times 12^{9}/_{16}$ " (36 × 31.9 cm). Museum of Fine Arts, Boston. Denman W. Ross Collection, (22.683)

who heard it. Women with water jugs on their heads turn to look; others lean from windows to watch and call out to him. We are drawn into this charming village scene by the diagonal movements of the cows as they surge through the gate and into the courtyard beyond. Pastel houses and walls create a sense of space, and in

the distance we glimpse other villagers going about their work or peacefully sitting in their houses. A rim of dark trees softens the horizon, and an atmospheric sky completes the aura of enchanted naturalism. Again, all the figures are similar in type, this time with a perfection of proportion and a gentle, lyrical movement that

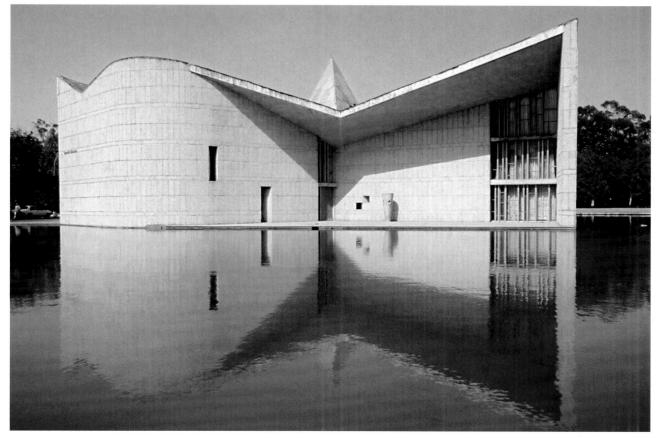

20-10. B. P. Mathur and Pierre Jeanneret. Gandhi Bhavan, Punjab University, Chandigarh, North India. Modern period, 1959-61.

complement the idealism of the setting. The scene embodies the sublime purity and grace of the divine, which, as in so much Indian art, is evoked into our human world to coexist with us as one.

PERIOD

MODERN By the time Hour of Cowdust was painted, India's regional princes had reasserted themselves, and the vast Mughal Empire had shrunk to a small

area around Delhi. At the same time, a new power, Britain, was making itself felt, inaugurating a markedly different period in Indian history. First under the mercantile interests of the British East India Company in the seventeenth century, and then under the direct control of the British government as a part of the British Empire in the eighteenth, India was brought forcefully into contact with the West and its culture.

The political concerns of the British Empire extended even to the arts, especially architecture. Over the course of the nineteenth century, the great cities of India, such as Calcutta, Madras, and Bombay, took on a European aspect as British architects built in the revivalist styles favored in England (Chapter 26). During the late nineteenth and early twentieth centuries, architects made an effort to incorporate Indian, usually Mughal, elements into their work. But the results were superficial or overly fantastic and consisted largely of adding ornamental forms such as chattris to fundamentally European buildings. The most telling imperial gesture came

in the 1920s with the construction of a new, Westernstyle capital city at New Delhi.

At the same time that the British were experimenting with Indian aesthetics, Indian artists were infusing into their own work Western styles and techniques. One example of this new synthesis is the Gandhi Bhavan at Punjab University in Chandigarh, in North India (fig. 20-10). Used for both lectures and prayer, the hall was designed in the late 1950s by Indian architect B. P. Mathur in collaboration with Pierre Jeanneret, cousin of the French modernist architect Le Corbusier (Chapter 28), whose version of the International Style had been influential in India.

The Gandhi Bhavan's three-part, pinwheel plan, abstract sculptural qualities, and fluid use of planes reflect the modern vision of the International Style. Yet other factors speak directly to India's heritage. The merging of sharp, brusque angles with lyrical curves recalls the linear tensions of the ancient Sanskrit alphabet. The pools surrounding the building evoke Mughal tombs, some of which were similarly laid out on terraces surrounded by water, as well as the ritual-bathing pools of Hindu temples. Yet the abstract style is free of specific religious associations.

The irregular stone structure, its smooth surfaces punctuated by only a few apertures, shimmers in the bright Indian sunlight like an apparition of pure form in our ordinary world. Caught between sky, earth, and water, it fittingly evokes the pulsating qualities of a world seen as imbued with divine essence, the world that has always been at the heart of Indian art.

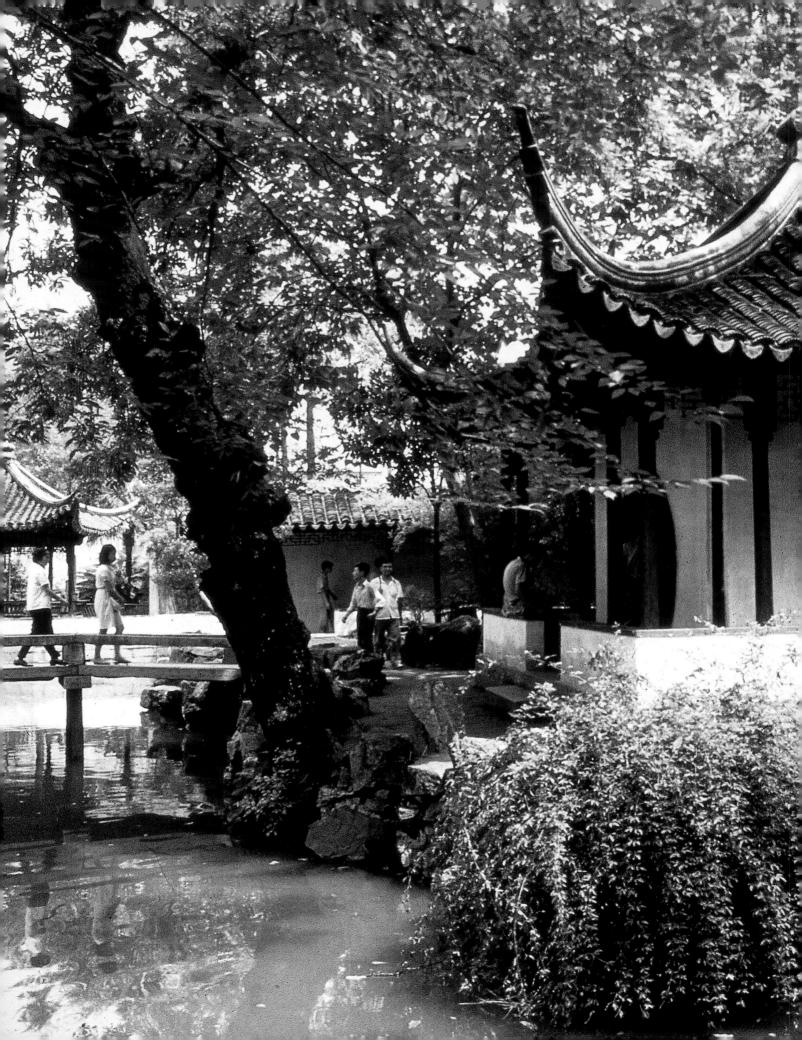

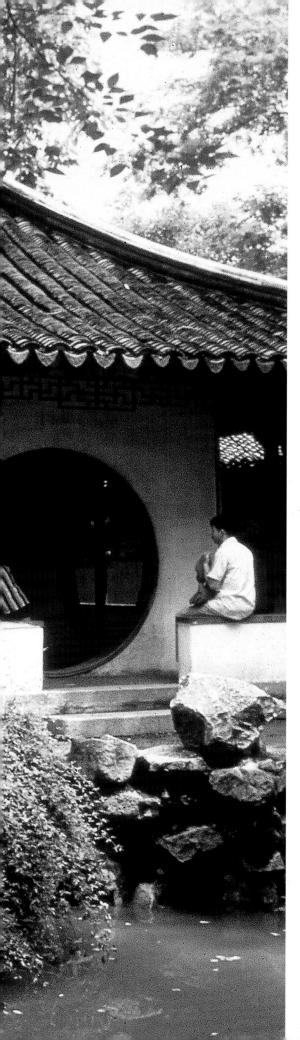

21

CHINESE ART AFTER 1280

ARLY IN THE SIXTEENTH CENTURY, AN official in Beijing, frustrated after serving in the capital for many years without promotion, returned to his home near Shanghai. Taking an ancient poem, "The Song of Leisurely Living," for his model, he began to build a garden. He called his retreat the Garden of the Cessation of Official Life (fig. 21-1) to indicate that he had exchanged his career as a bureaucrat for a life of leisure. By leisure, he meant that he could now dedicate himself to calligraphy, poetry, and painting, the three arts dear to scholars in China.

The scholar class of imperial China was a phenomenon unique in the world, the product of an examination system designed to recruit the finest minds in the country for government service. Instituted during the Tang dynasty (618–907) and based on even earlier traditions, the civil service examinations were excruciatingly difficult, but for the tiny percentage that passed at the highest level, the rewards were prestige, position, power, and wealth. During the Song dynasty (960–1279) the examinations were expanded and regularized, and more than half of all government positions came to be filled by scholars.

Steeped in the classic texts of philosophy, literature, and history, China's scholars—known as literati—shared a common bond in education and outlook. Their lives typically moved between the philosophical poles of Confucianism and Daoism (see "Foundations of Chinese Culture," page 803). Following the former, they became officials to fulfill their obligation to the world; pulled by the latter, they retreated from society in order to come to terms with nature and the universe: to create a garden, to write poetry, to paint.

Under a series of remarkably cultivated emperors, the literati reached the height of their influence during the Song dynasty. Their world was about to change dramatically, however, with lasting results for Chinese art.

21-1. Garden of the Cessation of Official Life, Suzhou, Jiangsu. Ming dynasty, early 16th century.

TIMELINE 21-1. China after 1280. After the Mongols invaded China, Kublai Khan established the Yuan dynasty. Imperial rule continued under the Ming and Qing dynasties that followed until the twentieth century.

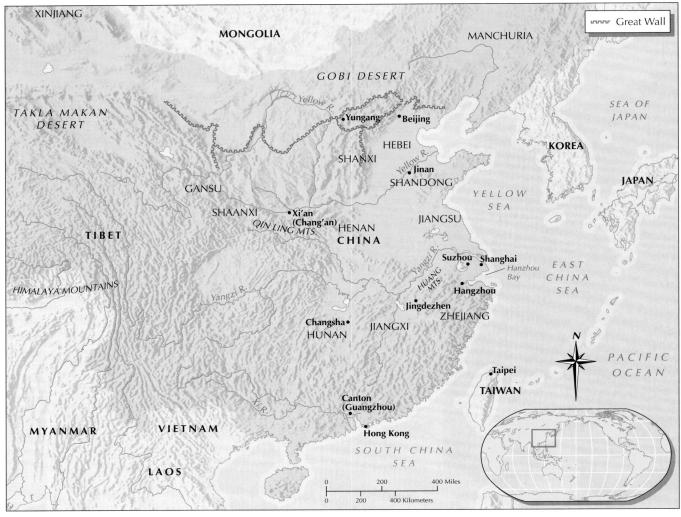

Map 21-1. China after 1280.

The Qin Ling Mountains divide China into northern and southern regions with distinctively different climates and cultures.

THE MONGOL INVASIONS

THE At the beginning of the thirteenth century the Mongols, a nomadic people from the steppelands north of China, began to amass an empire. Led first by Jenghiz Khan

(c. 1162–1227), then by his sons and grandsons, they swept westward into central Europe and overran Islamic lands from Central Asia through present-day Iraq. To the east, they quickly captured northern China, and in 1279, led by Kublai Khan, they conquered southern China as well. Grandson of the mighty Jenghiz, Kublai proclaimed himself emperor of China and founder of the Yuan dynasty (1280–1368) (Timeline 21–1).

The Mongol invasions were traumatic, and their effect on China was long lasting. During the Song

dynasty, China had grown increasingly reflective. Rejecting foreign ideas and influences, intellectuals had focused on defining the qualities that constituted true "Chinese-ness." They had drawn a clear distinction between their own people, whom they characterized as gentle, erudite, and sophisticated, and the "barbarians" outside China's borders, whom they believed to be crude, wild, and uncultured. Now, faced with the reality of barbarian occupation, China's inward gaze intensified in spiritual resistance. For centuries to come, long after the Mongols had gone, leading scholars continued to seek intellectually more challenging, philosophically more profound, and artistically more subtle expressions of all that could be identified as authentically Chinese.

FOUNDATIONS OF CHINESE CULTURE

Chinese culture is distinguished by its long and continuous development. Between 7000 and 2000 BCE a variety of Neolithic cultures flourished across China. Through long interaction these cultures became increasingly similar, and they eventually gave rise to the three Bronze Age dynastic states with which Chinese history traditionally begins: the legendary Xia, the Shang (c. 1700–1100 BCE), and the Zhou (1100–256 BCE).

The Shang developed traditions of casting ritual vessels in bronze, working jade in ceremonial shapes, and writing consistently in scripts that directly evolved into the modern Chinese written language. Society was stratified, and the ruling group maintained its authority in part by claiming power as shamans, intermediaries between the human and spirit worlds. Shamanistic practices are responsible for the earliest known examples of Chinese writing. Under the Zhou a feudal society developed, with nobles related to the king ruling over numerous small

During the latter part of the Zhou dynasty, states began to vie for supremacy through intrigue and increasingly ruthless warfare. The collapse of social order inspired China's first philosophers, who largely concerned themselves with the pragmatic question of how to bring about a stable society.

In 221 BCE rulers of the state of Qin triumphed over the remaining states, unifying China as an empire for the first time. The Qin created the mechanisms of China's centralized bureaucracy, but their rule was harsh and the dynasty was quickly overthrown. During the ensuing Han dynasty (206 BCE-220 CE), China at last knew peace and prosperity. Confucianism was made the official state ideology, in the process assuming the form and force of a religion. Developed from the thought of Confucius (551-479 BCE), one of the many philosophers of the Zhou, Confucianism is an ethical system for the management of society based on establishing correct relationships among people. Providing a counterweight was Daoism, which also came into its own during the Han dynasty. Based on the thought of Laozi, a possibly legendary contemporary of Confucius, and the philosopher Zhuangzi (369-286 BCE), Daoism is a kind of nature mysticism that seeks to harmonize the individual with the Dao, or Way, of the Universe. Confucianism and Daoism have remained central to Chinese thought—the one addressing the public realm of duty and conformity, the other the private world of individualism and creativity.

Following the collapse of the Han dynasty, China experienced a centuries-long period of disunity (220–589 cE). Invaders from the north and west established numerous kingdoms and dynasties, while a series of six precarious Chinese

dynasties held sway in the south. Buddhism, which had begun to filter over trade routes from India during the Han dynasty, now spread widely. The period also witnessed the economic and cultural development of the south (all previous dynasties had ruled from the north).

China was reunited under the Sui dynasty (581-618 cE), which guickly overreached itself and fell to the Tang (618-907 cE), one of the most successful dynasties in Chinese history. Strong and confident, Tang China fascinated and, in turn, was fascinated by the cultures around it. Caravans streamed across Central Asia to the capital, Chang'an, then the largest city in the world. Japan and Korea sent thousands of students to study Chinese culture, and Buddhism reached the height of its influence before a period of persecution signaled the start of its decline.

The mood of the Song dynasty (960-1279 CE) was quite different. The martial vigor of the Tang gave way to a culture of increasing refinement and sophistication, and Tang openness to foreign influences was replaced by a conscious cultivation of China's own traditions. In art, landscape painting emerged as the most esteemed genre, capable of expressing both philosophical and personal concerns. With the fall of the north to invaders in 1126, the Song court set up a new capital in the south, which became the cultural and economic center of the country.

YUAN DYNASTY

The Mongols established their capital in the northern city now known as Beijing (Map 21-1). The cultural centers of China, however, remained the great

cities of the south, where the Song court had been located for the previous 150 years. Combined with the tensions of Yuan rule, this separation of China's political and cultural centers created a new situation dynamic in the arts.

Throughout most of Chinese history, the imperial court had set the tone for artistic taste; artisans attached to the court produced architecture, paintings, gardens,

and objects of jade, lacquer, ceramics, and silk especially for imperial use. Over the centuries, painters and calligraphers gradually moved higher up the social scale, for these "arts of the brush" were often practiced as well by scholars and even emperors, whose high status reflected positively on whatever interested them. With the establishment of an imperial painting academy during the Song dynasty, painters finally achieved a status equal to that of court officials. For the literati, painting came to be grouped with **calligraphy** and poetry as the trio of accomplishments suited to members of the cultural elite.

But while the literati elevated the status of painting by virtue of practicing it, they also began to develop their own ideas of what painting should be. Not needing to earn an income from their art, they cultivated an amateur ideal in which personal expression counted for more than "mere" professional skill. They created for themselves a status as artists totally separate from and superior to professional painters, whose art they felt was inherently compromised, since it was done to please others, and impure, since it was tainted by money.

The conditions of Yuan rule now encouraged a clear distinction between court taste, ministered to by professional artists and artisans, and literati taste. The Yuan continued the imperial role as patron of the arts, commissioning buildings, murals, gardens, paintings, and decorative arts. Western visitors such as the Italian Marco Polo were impressed by the magnificence of the Yuan court (see "Marco Polo," below). But scholars, profoundly alienated from the new government, took no notice of these accomplishments, and thus wrote nothing about them. Nor did Yuan rulers have much use for scholars, especially those from the south. The civil service examinations were abolished, and the highest government positions were bestowed, instead, on Mongols and their foreign allies. Scholars now tended to turn inward, to search for solutions of their own and to try to express themselves in personal and symbolic terms.

Typical of this trend is Zhao Mengfu (1254–1322), a descendant of the imperial line of Song. Unlike many scholars of his time, he eventually chose to serve the Yuan government and was made a high official. A painter, calligrapher, and poet, all of the first rank, Zhao was especially known for his carefully rendered paintings of horses. But he also cultivated another manner, most famous in his landmark painting, *Autumn Colors on the Qiao and Hua Mountains* (fig. 21-2).

Zhao painted this work for a friend whose ancestors came from Jinan, the present-day capital of Shandong province, and the painting supposedly depicts the land-

21-2. Zhao Mengfu. Section of Autumn Colors on the Qiao and Hua Mountains.

Yuan dynasty, 1296. Handscroll, ink and color on paper, $11^{1}/_{4} \times 36^{3}/_{4}$ " (28.6 \times 93.3 cm). National Palace Museum, Taipei, Taiwan.

scape there. Yet the mountains and trees are not painted in the accomplished naturalism of Zhao's own time but rather in the archaic yet oddly elegant manner of the earlier Tang dynasty. The Tang dynasty was a great era in Chinese history, when the country was both militarily strong and culturally vibrant. Through his painting Zhao evoked a nostalgia not only for his friend's distant homeland but also for China's past.

This educated taste for the "spirit of the antiquity" became an important aspect of **literati painting** in later periods. Also typical of literati taste are the unassuming brushwork, the subtle colors sparingly used (many literati paintings forgo color altogether), the use of land-scape to convey personal meaning, and even the intended audience—a close friend. The literati did not paint for public display but for each other. They favored small formats such as **handscrolls**, **hanging scrolls**, or **album leaves** (book pages), which could easily be taken to show to friends or to share at small gatherings (see "Formats of Chinese Painting," page 806).

Of the considerable number of Yuan painters who took up Zhao's ideas, several became models for later

MARCO POLO

China under Kublai Khan was one of four Mongol khanates that together extended west into presentday Iraq and through Russia to the borders of Poland and Hungary. For roughly a century travelers moved freely across this vast expanse, making the era one of unprecedented crosscultural exchange. Diplomats, missionaries, chants, and adventurers flocked to the Yuan court, and Chinese envoys were dispatched to the West. The most celebrated European traveler of the time was a Venetian named Marco Polo (c. 1254-1324), whose descriptions of his travels were for several centuries the only firsthand account of China available in Europe.

Marco Polo was still in his teens when he set out for China in 1271. He traveled with his uncle and father, both merchants, bearing letters for Kublai Khan from Pope Gregory X. After a four-year journey the Polos arrived at last in Beijing. Marco became a favorite of the emperor and spent the next seventeen years in his service, during which time he traveled extensively throughout China. He eventually returned home in 1295.

Imprisoned later during a war between Venice and Genoa, a rival Italian city-state, Marco Polo passed the time by dictating an account of his experiences to a fellow prisoner. The resulting book, A Description of the World, has fascinated generations of readers with its descriptions of prosperous and sophisticated lands in the East. Translated into almost every European language, it was an important influence in stimulating further exploration. When Columbus set sail across the Atlantic in 1492, one of the places he hoped to find was a country Marco Polo called Zipangu—Japan.

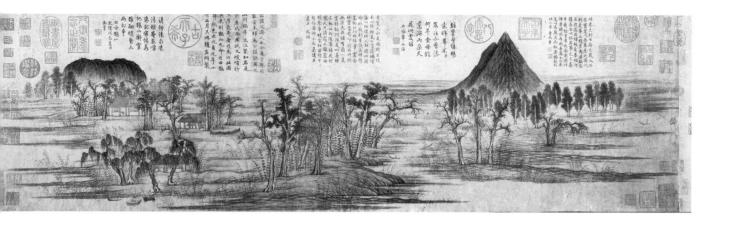

generations. One such was Ni Zan (1308–74), whose most famous surviving painting is *The Rongxi Studio* (fig. 21-3). Done entirely in ink, the painting depicts the lake region in Ni's home district. Mountains, rocks, trees, and a pavilion are sketched with a minimum of detail using a dry brush technique—a technique in which the brush is not fully loaded with ink but rather about to run out, so that white paper "breathes" through the ragged strokes. The result is a painting with a light touch and a sense of simplicity and purity. Literati styles were believed to reflect the painter's personality. Ni's spare, dry style became associated with a noble spirit, and many later painters adopted it or paid homage to it.

Ni Zan was one of those eccentrics whose behavior has become legendary in the history of Chinese art. In his early years he was one of the richest men in the region, the owner of a large estate. His pride and his aloofness from daily affairs often got him into trouble with the authorities. His cleanliness was notorious. In addition to washing himself several times daily, he also ordered his servants to wash the trees in his garden and to clean the furniture after his guests had left. He was said to be so unworldly that late in life he gave away most of his possessions and lived as a hermit in a boat, wandering on rivers and lakes.

21-3. Ni Zan. *The Rongxi Studio.* Yuan dynasty, 1372. Hanging scroll, ink on paper, height $29^3/8$ " (74.6 cm). National Palace Museum, Taipei, Taiwan.

The idea that a painting is not done to capture a likeness or to satisfy others but is executed freely and carelessly for the artist's own amusement is at the heart of the literati aesthetic. Ni Zan once wrote this comment on a painting: "What I call painting does not exceed the joy of careless sketching with a brush. I do not seek formal likeness but do it simply for my own amusement. Recently I was rambling about and came to a town. The people asked for my pictures, but wanted them exactly according to their own desires and to represent a specific occasion. [When I could not satisfy them,] they went away insulting, scolding, and cursing in every possible way. What a shame! But how can one scold a eunuch for not growing a beard?" (cited in Bush and Shih, page 266).

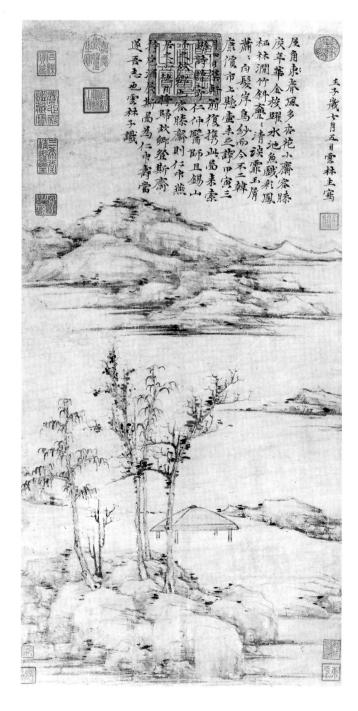

With the exception of large wall paintings that typically decorated palaces, temples, and tombs, most Chinese paintings were done in ink and waterbased colors on silk or paper. Finished

works were generally mounted on silk as a **handscroll**, a **hanging scroll**, or leaves in an **album**.

An album comprises a set of paintings of identical size mounted in an accordion-fold book. (A single painting from an album is called an **album leaf**). The paintings in an album are usually related in subject, such as various views of a famous site or a series of scenes glimpsed on one trip.

Album-sized paintings might also be mounted as a handscroll, a horizontal format generally about 12 inches high and anywhere from a few feet to dozens of feet long. More typically, however, a handscroll would be a single continuous painting. Handscrolls were not meant to be displayed all at once, the way they are commonly presented today in museums. Rather, they were unrolled only occasionally, to be savored in much the same spirit as we might put a favorite film in the VCR. Placing the scroll on a flat surface such as a table, a viewer would unroll it a foot or two at a time, moving gradually through the entire scroll from right to left, lingering over favorite details. The scroll was then rolled up and returned to its box until the next viewing.

Like handscrolls, hanging scrolls were not displayed permanently but were taken out for a limited time—a

TECHNIQUE

Formats of Chinese Painting

day, a week, a season. Unlike a handscroll, however, the painting on a hanging scroll was viewed as a whole, unrolled and put up on a wall, with the roller at the lower end acting as a

weight to help the scroll hang flat. Although some hanging scrolls are quite large, they are still fundamentally intimate works, not intended for display in a public place.

Creating a scroll was a time-consuming and exacting process. The painting was first backed with paper to strengthen it. Next, strips of paper-backed silk were pasted to the top, bottom, and sides, framing the painting on all four sides. Additional silk pieces were added to extend the scroll horizontally or vertically, depending on the format. The assembled scroll was then backed again with paper and fitted with a half-round dowel, or wooden rod, at the top (of a hanging scroll) or right end (of a handscroll), with ribbons for hanging and tying, and with a wooden roller at the other end. Hanging scrolls were often fashioned from several patterns of silk, and a variety of piecing formats were developed and codified. On a handscroll, a painting was generally preceded by a panel giving the work's title and often followed by a long panel bearing **colophons**—inscriptions related to the work, such as poems in its praise or comments by its owners over the centuries. A scroll would be remounted periodically to better preserve it, and colophons and inscriptions would be preserved in each remounting.

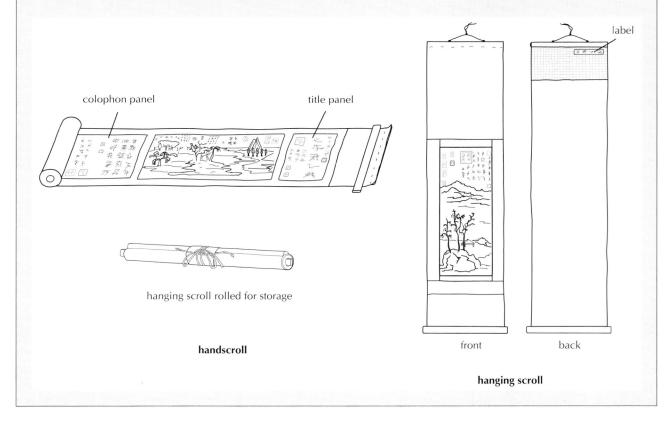

Whether these stories are true or not, they were important elements of Ni's legacy to later painters, for Ni's life as well as his art served as a model. The painting of the literati was bound up with certain views about what constituted an appropriate life. The ideal, as embodied

by Ni Zan and others, was of a brilliantly gifted scholar whose spirit was too refined for the dusty world of government service and who thus preferred to live as a recluse, or as one who had retired after having become frustrated by a brief stint as an official.

21-4. Yin Hong. Hundreds of Birds Admiring the Peacocks. Ming dynasty, c. late 15th-early 16th century. Hanging scroll, ink and color on silk, $7'10^{1}/2'' \times 6'5''$ (2.4 × 1.96 m). The Cleveland Museum of Art.

Purchase from the J. H. Wade Fund, 74.31

DYNASTY

MING The founder of the next dynasty, the Ming (1368–1644), came from a family of poor uneducated peasants. As he rose through the ranks in the army, he

enlisted the help of scholars to gain power and solidify his following. Once he had driven the Mongols from Beijing and firmly established himself as emperor, however, he grew to distrust intellectuals. His rule was despotic, even ruthless. Throughout the nearly 300 years of Ming rule, most emperors shared his attitude, so although the civil service examinations were reinstated, scholars remained alienated from the government they were trained to serve.

COURT AND PROFESSIONAL PAINTING

The contrast between the luxurious world of the court and the austere ideals of the literati continued through the Ming dynasty. A typical example of Ming court taste is Hundreds of Birds Admiring the Peacocks, a large painting on silk by Yin Hong, an artist active during the late fifteenth and early sixteenth centuries (fig. 21-4). A pupil of some well-known courtiers, Yin most probably served in the court at Beijing. The painting is an example of the birds-and-flowers genre, which had been popular with artists of the Song academy. Here the subject takes on symbolic meaning, with the homage of the birds to the

21-5. Qiu Ying. Section of *Spring Dawn in the Han Palace.* Ming dynasty, first half of the 16th century. Handscroll, ink and color on silk, $1' \times 18'^{13}/_{16}"$ (0.30 × 5.7 m). National Palace Museum, Taipei, Taiwan.

21-6. Detail of section of *Spring Dawn in the Han Palace*.

peacocks representing the homage of court officials to the emperor. The decorative style goes back to Song academy models as well, although the large format and multiplication of details are traits of the Ming.

The preeminent professional painter in the Ming period was Qiu Ying (1494–1552), who lived in Suzhou, a prosperous southern city. He inspired generations of imitators with exceptional works, such as a long hand-scroll known as *Spring Dawn in the Han Palace* (figs. 21-5, 21-6). The painting is based on Tang dynasty depictions of women in the court of the Han dynasty (206 BCE–220 CE). While in the service of a well-known collector, Qiu Ying had the opportunity to study many Tang paintings, whose artists usually concentrated on the figures, leaving out the background entirely. Qiu's graceful

and elegant figures—although modeled after those in Tang works—are portrayed in a setting of palace buildings, engaging in such pastimes as chess, music, calligraphy, and painting. With its antique subject matter, refined technique, and flawless taste in color and composition, *Spring Dawn in the Han Palace* brought professional painting to a new high point.

DECORATIVE ARTS AND GARDENS

Qiu Ying painted to satisfy his patrons in Suzhou. The cities of the south were becoming wealthy, and newly rich merchants collected paintings, antiques, and art objects. The court, too, was prosperous and patronized the arts on a lavish scale. In such a setting, the decorative arts thrived.

Like the Song dynasty before it, the Ming has become famous the world over for its exquisite ceramics, especially **porcelain** (see "The Secret of Porcelain," below). The imperial **kilns** in Jingdezhen, in Jiangxi province, became the most renowned center for porcelain not only in all of China but eventually in all the world. Particularly noteworthy are the blue-and-white wares produced there during the ten-year reign of the ruler known as the Xuande emperor (ruled 1425–35), such as the flask in figure 21-7. The subtle shape, the refined yet vigorous decoration of dragons writhing in the sea, and the flawless **glazing** embody the high achievement of Ming artisans.

Chinese furniture, made mainly for domestic use, reached the height of its development in the sixteenth

THE SECRET OF PORCELAIN

Marco Polo, it is said, was the one who named a new type of ceramic he found in China. Its translucent purity reminded him of the smooth whiteness of the cowry shell, porcellana in Italian. Porcelain is made from kaolin, an extremely refined white clay, and petuntse, a variety of the mineral feldspar. When properly combined and fired at a sufficiently high temperature, the two materials fuse into a glasslike,

translucent ceramic that is far stronger than it looks.

Porcelaneous stoneware, fired at lower temperatures, was known in China by the seventh century, but true porcelain emerged during the Song dynasty. To create blue-andwhite porcelain such as the flask in figure 21-7, blue pigment was made from cobalt oxide, finely ground and mixed with water. The decoration was painted directly onto the unfired porcelain vessel, then a layer of clear glaze was applied over it.

(In this technique, known as underglazing, the pattern is painted beneath the glaze.) After firing, the piece emerged from the kiln with a clear blue design set sharply against a snowy white background.

Entranced with the exquisite properties of porcelain, European potters tried for centuries to duplicate it. The technique was finally discovered in 1708 by Johann Friedrich Böttger in Dresden, Germany, who tried—but failed—to keep it a secret.

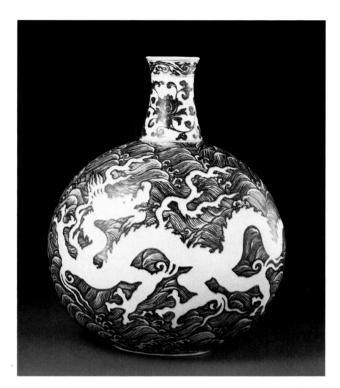

21-7. Flask. Ming dynasty, c. 1426–35. Porcelain with blue underglaze decoration. Collection of the Palace Museum, Beijing.

Dragons have featured prominently in Chinese folklore from earliest times—Neolithic examples have been found painted on pottery and carved in jade. In Bronze Age China, dragons came to be associated with powerful and sudden manifestations of nature, such as wind, thunder, and lightning. At the same time, dragons became associated with superior beings such as virtuous rulers and sages. With the emergence of China's first firmly established empire during the Han dynasty, the dragon was appropriated as an imperial symbol, and it remained so throughout Chinese history. Dragon sightings were duly recorded and considered auspicious. Yet even the Son of Heaven could not monopolize the dragon. During the Tang and Song dynasties the practice arose of painting pictures of dragons to pray for rain, and for Chan (Zen) Buddhists, the dragon was a symbol of sudden enlightenment.

and seventeenth centuries. Characteristic of Chinese furniture, the chair in figure 21-8 is constructed without the use of glue or nails. Instead, pieces fit together based on the principle of the **mortise-and-tenon joint**, in which a projecting element (tenon) on one piece fits snugly into a cavity (mortise) on another. Each piece of the chair is carved, as opposed to being bent or twisted, and the joints are crafted with great precision. The patterns of the wood grain provide subtle interest unmarred by any painting or other embellishment. The style, like that of Chinese architecture, is one of simplicity, clarity, symmetry, and balance. The effect is formal and dignified but natural and simple—virtues central to the Chinese view of proper human conduct as well.

The art of landscape gardening also reached a high point during the Ming dynasty, as many literati surrounded their homes with gardens. The most famous gardens were created in the southern cities of the Yangzi River (Chang Jiang) delta, especially Suzhou. The largest surviving garden of the era is the Garden of the Cessation of

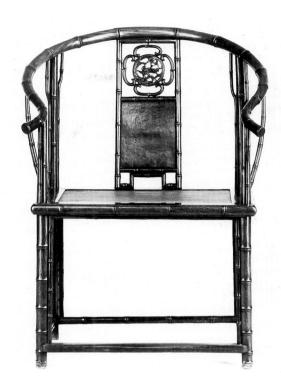

21-8. Armchair. Ming dynasty, 16th–17th century. Huanghuali wood (hardwood), $39\frac{3}{8} \times 27^1/4 \times 20''$ (100 \times 69.2 \times 50.8 cm). The Nelson-Atkins Museum of Art, Kansas City, Missouri.

Purchase, Nelson0 Trust (46-78/1)

Official Life, with which this chapter opened (see fig. 21-1). Although modified and reconstructed many times through the centuries, it still reflects many of the basic ideas of the original Ming owner. About a third of the 3-acre garden is devoted to water through artificially created brooks and ponds. The landscape is dotted with pavilions, kiosks, libraries, studios, and corridors. Many of the buildings have poetic names, such as Rain Listening Pavilion and Bridge of the Small Flying Rainbow.

ARCHITECTURE AND CITY PLANNING

Centuries of warfare and destruction have left very few Chinese architectural monuments intact. The most important remaining example of traditional Chinese architecture is the Forbidden City, the imperial palace compound in Beijing, whose principal buildings were constructed during the Ming dynasty (fig. 21-9, page 810).

The basic plan of Beijing was the work of the Mongols, who laid out their capital city according to traditional Chinese principles. City planning began early in China—in the seventh century, in the case of Chang'an (present-day Xi'an), the capital of the Sui and Tang emperors (see "Geomancy, Cosmology, and Chinese Architecture," page 811). The walled city of Chang'an was laid out on a rectangular grid, with evenly spaced streets that ran north-south and east-west. At the northern end stood a walled imperial complex.

Beijing, too, was developed as a walled, rectangular city with streets laid out in a grid. The palace enclosure

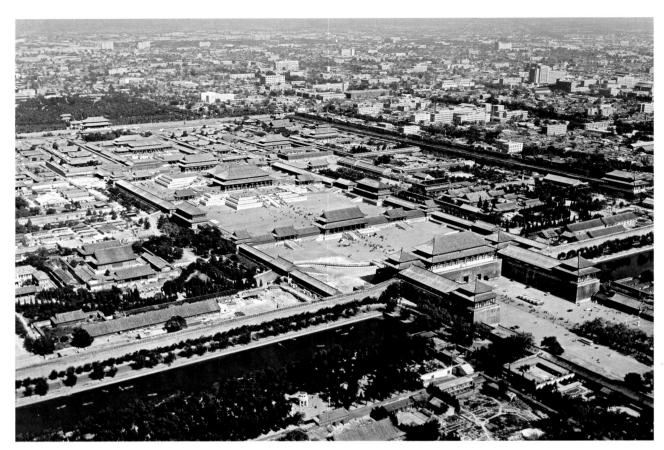

21-9. The Forbidden City, now the Palace Museum, Beijing. Mostly Ming dynasty. View from the southwest.

occupied the center of the northern part of the city, which was reserved for the Mongols. Chinese lived in the southern third of the city. Later Ming and Qing emperors preserved this division, with officials living in the northern or Inner City and commoners living in the southern or Outer City. Under the third Ming emperor, Yongle (ruled 1402–24), the Forbidden City was rebuilt as we see it today.

The approach to the Forbidden City was impressive, and it was meant to be. Visitors entered through the Meridian Gate, a monumental U-shaped gate (at the right in fig. 21-9). Inside the Meridian Gate a broad courtyard is crossed by a bow-shaped waterway that is spanned by five arched marble bridges. At the opposite end of the courtyard is the Gate of Supreme Harmony, opening onto an even larger courtyard that houses three ceremonial halls raised on a broad platform. First is the Hall of Supreme Harmony, where, on the most important state occasions, the emperor was seated on his throne, facing south. Beyond is the smaller Hall of Central Harmony, then the Hall of Protecting Harmony. Behind these vast ceremonial spaces, still on the central axis, is the inner court, again with a progression of three buildings, this time more intimate in scale. In its balance and symmetry the plan of the Forbidden City reflects ancient Chinese beliefs about the harmony of the universe, and it emphasizes the emperor's role as the Son of Heaven, whose duty was to maintain the cosmic order from his throne in the middle of the world.

LITERATI PAINTING

In the south, especially in the district of Suzhou, literati painting remained the dominant trend. One of the major literati figures from the Ming period is Shen Zhou (1427–1509), who had no desire to enter government service and spent most of his life in Suzhou. He studied the Yuan painters avidly and tried to recapture their spirit in such works as *Poet on a Mountaintop* (fig. 21–10, page 812). Although the style of the painting recalls the freedom and simplicity of Ni Zan (see fig. 21–3), the motif of a poet surveying the landscape from a mountain plateau is Shen's creation.

In earlier landscape paintings, human figures were typically shown dwarfed by the grandeur of nature. Travelers might be seen scuttling along a narrow path by a stream, while overhead towered mountains whose peaks conversed with the clouds and whose heights were inaccessible. Here, the poet has climbed the mountain and dominates the landscape. Even the clouds are beneath him. Before his gaze, a poem hangs in the air, as though he were projecting his thoughts. The painting reflects Ming philosophy, which held that the mind, not the physical world, was the basis for reality. With its perfect synthesis of poetry, calligraphy, and painting, and its harmony of mind and landscape, *Poet on a Mountaintop* represents the essence of literati painting.

The ideas underlying literati painting found their most influential expression in the writings of Dong

GEOMANCY, COSMOLOGY, AND CHINESE ARCHITECTURE

Geomancy is a form of divination that looks for signs in the topography of the earth. In China it has been known from ancient times as feng shui, or "wind and water." Still practiced today, feng shui assesses qi, the primal energy that is believed to flow through creation, to determine whether a site is suitably auspicious for building. Feng shui also advises on improving a site's qi through landscaping, planting, creating waterways, and building temples and pagodas.

One important task of *feng shui* in the past was selecting auspicious sites for imperial tombs. These were traditionally set in a landscape of hills and winding paths, protected from harmful spiritual forces by a hill to the rear and a winding waterway crossed by arched bridges in front. *Feng shui* was also called on to find and enhance sites for homes, towns, and, especially, imperial cities. The Forbidden City, for example, is "protected" by a hill outside the north wall and a bow-shaped watercourse just inside the entrance.

The layout of imperial buildings was as important as their site and reflected ancient principles of cosmology—ideas about the structure and workings of the universe. Since the Zhou dynasty (1100–221 BCE) the emperor had ruled as the Son of Heaven. If he was worthy and right-acting, it was believed, all would go well in nature and the cosmos. But if he was not, cosmic signs, natural disasters, and human

rebellions would make clear that Heaven had withdrawn his dynasty's mandate to rule—traditional histories explained the downfall of a dynasty in just these terms.

Architecture played a major role in expressing this link between imperial and cosmic order. As early as Zhou times, cities were oriented on a north-south axis and built as a collection of enclosures surrounded by a defensive wall. The first imperial city of which we have any substantial knowledge, however, is Chang'an, the capital of the Tang dynasty (618-907 cE). Chang'an was a walled city laid out on a rectangular grid measuring 5 miles by 6 miles. At the north end was an imperial enclosure. The palace within faced south, symbolic of the emperor looking out over his city and, by extension, his realm. This orientation was already traditional by Tang times. Chinese rulers-and Chinese buildings-had always turned their

backs to the north, whence came evil spirits. Confucius even framed his admiration for one early Zhou ruler by saying that all he needed to do to govern was to assume a respectful position and face south, so attuned was he to Heaven's way.

A complex of government buildings stood in front of the imperial compound, and from them a 500foot-wide avenue led to the city's principal southern gate. The city streets ran north-south and eastwest. Each of the resulting 108 blocks was like a miniature city, with its own interior streets, surrounding walls, and gates that were locked at night. Two large markets to the east and west were open at specified hours. Such was the prestige of China during the Tang dynasty that the Japanese modeled their imperial capitals at Nara (built in 710 cE) and Heian (Kyoto, built in 794 ce) on Chang'an, though without the surrounding walls.

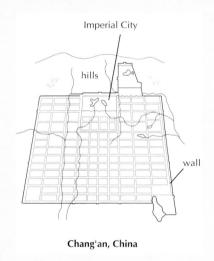

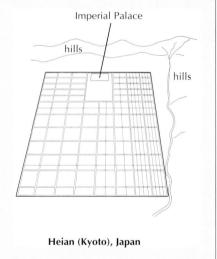

Qichang (1555–1636). A high official in the late Ming dynasty, Dong Qichang embodied the literati tradition as poet, calligrapher, and painter. He developed a view of Chinese art history that divided painters into two opposing schools, northern and southern. The names have nothing to do with geography—a painter from the south might well be classed as northern—but reflect a parallel Dong drew to the northern and southern schools of Chan (Zen) Buddhism in China. The southern school of Chan, founded by the eccentric monk Huineng (638–713), was unorthodox, radical, and innovative; the northern school was traditional and conservative. Similarly, Dong's two schools of painters represented conservative and progressive traditions. In Dong's view the conservative northern school was dominated by profes-

sional painters whose academic, often decorative style emphasized technical skill. In contrast, the progressive southern school preferred ink to color and free brushwork to meticulous detail. Its painters aimed for poetry and personal expression. In promoting this theory, Dong gave his unlimited sanction to literati painting, which he positioned as the culmination of the southern school, and he fundamentally influenced the way the Chinese viewed their own tradition.

Dong Qichang summarized his views on the proper training for literati painters in the famous statement "Read ten thousand books and walk ten thousand miles." By this he meant that one must first study the works of the great masters, then follow "heaven and earth," the world of nature. These studies prepared the

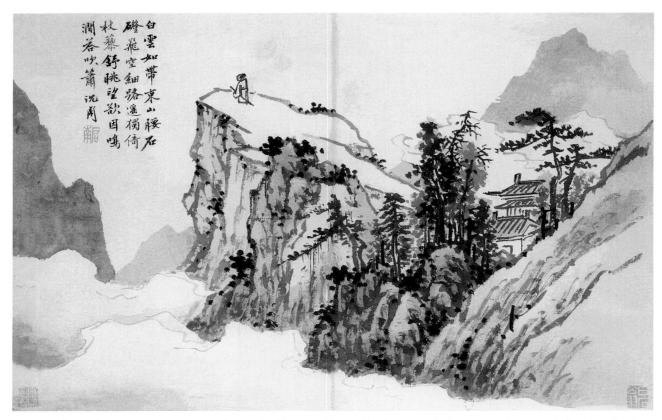

21-10. Shen Zhou. Poet on a Mountaintop, leaf from an album of landscapes; painting mounted as part of a handscroll. Ming dynasty, c. 1500. Ink and color on paper, $15\frac{1}{4} \times 23\frac{3}{4}$ " (40 × 60.2 cm). The Nelson-Atkins Museum of Art, Kansas City, Missouri. Purchase, Nelson Trust (46-51/2)

The poem at the upper left reads:

White clouds like a belt encircle the mountain's waist
A stone ledge flying in space and the far thin road.
I lean alone on my bramble staff and gazing contented into space
Wish the sounding torrent would answer to your flute.

(Translated by Richard Edwards, cited in *Eight Dynasties* of *Chinese Paintings*, page 185)

Shen Zhou composed the poem and the inscription, written at the time he painted the album. The style of the calligraphy, like the style of the painting, is informal, relaxed, and straightforward—qualities that were believed to reflect the artist's character and personality.

way for greater self-expression through brush and ink, the goal of literati painting. Dong's views rested on an awareness that a painting of scenery and the actual scenery are two very different things. The excellence of a painting does not lie in its degree of resemblance to reality—that gap can never be bridged—but in its expressive power. The expressive language of painting is inherently abstract and lies in its nature as a construction of brushstrokes. For example, in a painting of a rock, the rock itself is not expressive; rather, the brushstrokes that add up to "rock" are expressive.

With such thinking Dong brought painting close to the realm of calligraphy, which had long been considered the highest form of artistic expression in China. More than a thousand years before Dong's time, a body of critical terms and theories had evolved to discuss calligraphy in light of the formal and expressive properties of brushwork and composition. Dong introduced some of these terms—ideas such as opening and clos-

ing, rising and falling, and void and solid—to the criticism of painting.

Dong's theories are fully embodied in his painting *The Qingbian Mountains* (fig. 21-11). According to Dong's own inscription, the painting was based on a work by the tenth-century artist Dong Yuan. Dong Qichang's style, however, is quite different from the masters he admired. Although there is some indication of foreground, middle ground, and distant mountains, the space is ambiguous, as if all the elements were compressed to the surface of the picture. With this flattening of space, the trees, rocks, and mountains become more readily legible in a second way, as semiabstract forms made of brushstrokes.

Six trees diagonally arranged on a boulder define the extreme foreground and announce themes that the rest of the painting repeats, varies, and develops. The tree on the left, with its outstretched branches and full foliage, is echoed first in the shape of another tree just

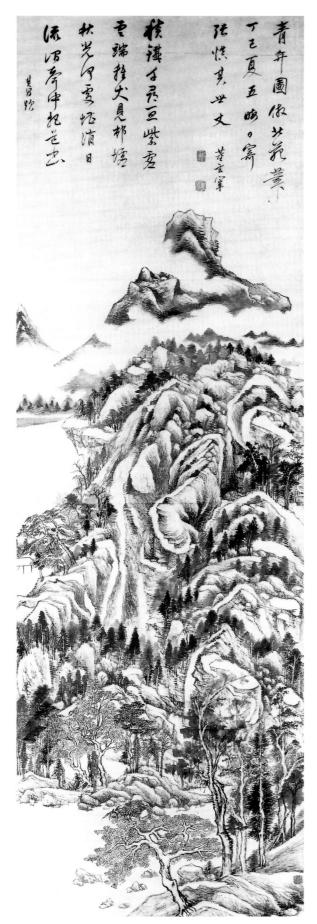

21-11. Dong Qichang. The Qingbian Mountain. Ming dynasty, 1617. Hanging scroll, ink on paper, $21'8'' \times 7'4^{3/8}''$ (6.72 × 2.25 m). The Cleveland Museum of Art. Leonard C. Hanna, Jr., Fund (1980.10)

across the river and again in a tree farther up and toward the left. The tallest tree of the foreground grouping anticipates the high peak that towers in the distance almost directly above it. The forms of the smaller foreground trees, especially the one with dark leaves, are repeated in numerous variations across the painting. At the same time, the simple and ordinary-looking boulder in the foreground is transformed in the conglomeration of rocks, ridges, hills, and mountains above. This double reading, both abstract and representational, parallels the work's double nature as a painting of a landscape and an interpretation of a traditional landscape painting.

The influence of Dong Qichang on the development of Chinese painting of later periods cannot be overstated. Indeed, nearly all Chinese painters since the early seventeenth century have reflected his ideas in one way or another.

DYNASTY

QING In 1644, when the armies of the Manchu people to the northeast of China marched into Beijing, many Chinese reacted as though the world

had come to an end. However, the situation turned out to be quite different from the Mongol invasions three centuries earlier. The Manchu had already adopted many Chinese customs and institutions before their conquest. After gaining control of all of China, they showed great respect for Chinese tradition. In art, all the major trends of the late Ming dynasty continued almost without interruption into the Manchu, or Qing, dynasty (1644-1911).

ORTHODOX PAINTING

Literati painting was by now established as the dominant tradition; it had become orthodox. Scholars followed Dong Qichang's recommendation and based their approach on the study of past masters, and they painted large numbers of works in the manner of Song and Yuan artists as a way of expressing their learning, technique, and taste.

The grand, symphonic composition A Thousand Peaks and Myriad Ravines (fig. 21-12, page 814), painted by Wang Hui (1632-1717) in 1693, exemplifies all the basic elements of Chinese landscape painting: mountains, rivers, waterfalls, trees, rocks, temples, pavilions, houses, bridges, boats, wandering scholars, fishers—the familiar and much loved cast of actors from a tradition now many centuries old. At the upper right corner, the artist has written:

Moss and weeds cover the rocks and mist hovers over the water.

The sound of dripping water is heard in front of the temple gate.

Through a thousand peaks and myriad ravines the spring flows,

And brings the flying flowers into the sacred caves.

In the fourth month of the year 1693, in an inn in the capital, I painted this based on a Tang dynasty poem in the manner of [the painters] Dong [Yuan] and Ju [ran].

(Translated by Chu-tsing Li)

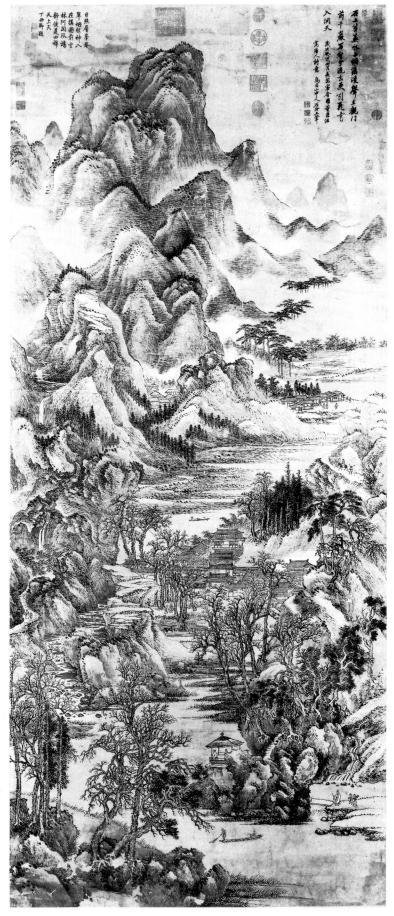

21-12. Wang Hui. *A Thousand Peaks and Myriad Ravines.* Qing dynasty, 1693. Hanging scroll, ink on paper, $8'2^{1}/_{2}'' \times 3'4^{1}/_{2}''$ (2.54 \times 1.03 m). National Palace Museum, Taipei, Taiwan.

This inscription shares Wang Hui's complex thoughts as he painted this work. In his mind were both the lines of the Tang dynasty poet Li Cheng, which offered the subject, and the paintings of the tenth-century masters Dong Yuan and Juran, which inspired his style. The temple the poem asks us to imagine is nestled on the right bank in the middle distance, but the painting shows us the scene from afar, as when a film camera pulls slowly away from some small human drama until its actors can barely be distinguished from the great flow of nature. Giving viewers the experience of dissolving their individual identity in the cosmic flow had been a goal of Chinese landscape painting since its first era of greatness during the Song dynasty.

All the Qing emperors of the late seventeenth and eighteenth centuries were painters themselves. They collected literati painting, and their conservative taste was shaped mainly by artists such as Wang Hui. Thus literati painting, long associated with reclusive scholars, ultimately became an academic style practiced at court.

INDIVIDUALIST PAINTING

In the long run, the Manchu conquest was not a great shock for China as a whole. But its first few decades were both traumatic and dangerous for those who were loyal—or worse, related—to the Ming. Some committed suicide, while others sought refuge in monasteries or wandered the countryside. Among them were several painters who expressed their anger, defiance, frustration, and melancholy in their art. They took Dong Qichang's idea of painting as an expression of the artist's personal feelings very seriously and cultivated highly original styles. These painters have become known as the individualists.

One of the individualists was Shitao (1642–1707), who was descended from the first Ming emperor and who took refuge in Buddhist temples when the dynasty fell. In his later life he brought his painting to the brink of abstraction in such works as *Landscape* (fig. 21-13). A monk sits in a small hut, looking out onto mountains that seem to be in turmoil. Dots, used for centuries to indicate vegetation on rocks, here seem to have taken on a life of their own. The rocks also seem alive—about to swallow up the monk and his hut. Throughout his life Shitao continued to identify himself with the fallen Ming, and he felt that his secure world had turned to chaos with the Manchu conquest.

THE MODERN PERIOD

THE In the mid- and late nineteenth century, China was shaken from centuries of complacency by a series of crushing military defeats by Western powers and Japan. Only then did the govern-

ment finally realize that these new rivals were not like the Mongols of the thirteenth century. China was no longer at the center of the world, a civilized country surrounded by "barbarians." Spiritual resistance was no longer enough to solve the problems brought on by change. New ideas from Japan and the West began to fil-

ter in, and the demand arose for political and cultural reforms. In 1911 the Qing dynasty was overthrown, ending 2,000 years of imperial rule, and China was reconceived as a republic.

During the first decades of the twentieth century Chinese artists traveled to Japan and Europe to study Western art. Returning to China, many sought to introduce the ideas and techniques they had learned and explored ways to synthesize the Chinese and the Western traditions. After the establishment of the present-day Communist government in 1949, individual artistic freedom was curtailed as the arts were pressed into the service of the state and its vision of a new social order. After 1979, however, cultural attitudes began to relax, and Chinese painters again pursued their own paths.

One artist who emerged during the 1980s as a leader in Chinese painting is Wu Guanzhong (b. 1919). Combining his French artistic training and Chinese background, Wu Guanzhong has developed a semiabstract style to depict scenes from the Chinese landscape. His usual method is to make preliminary sketches on site, then, back in his studio, to develop them into free interpretations based on his feeling and vision. An example of his work, Pine Spirit, depicts a scene in the Huang (Yellow) Mountains (fig. 21-14). The technique, with its sweeping gestures of paint, is clearly linked to Abstract Expressionism, an influential Western movement of the post-World War II years (Chapter 29); yet the painting also claims a place in the long tradition of Chinese landscape as exemplified by such masters as Shitao.

Like all aspects of Chinese society, Chinese art has felt the strong impact of Western influence, and the

21-13. Shitao. *Landscape*, leaf from an album of landscapes. Qing dynasty, c. 1700. Ink and color on paper, $9\frac{1}{2} \times 11"$ (24.1 \times 28 cm). Collection C. C. Wang family

question remains whether Chinese artists will absorb Western ideas without losing their traditional identity. Interestingly, landscape remains the most popular subject, as it has been for more than a thousand years. Using the techniques and methods of the West, China's painters still seek spiritual communion with nature through their art as a means to come to terms with human life and the world.

21-14. Wu Guanzhong. *Pine Spirit.* 1984. Ink and color on paper, $2'3^5/8'' \times 5'3^1/2''$ (0.70 × 1.61 m). Spencer Museum of Art, The University of Kansas, Lawrence.

Gift of the E. Rhodes and Leonard B. Carpenter Foundation

22

JAPANESE ART AFTER 1392

HE GREAT WAVE REARS UP LIKE A dragon with claws of foam, ready to crash down on the figures huddled in the boat below. Exactly at the point of imminent disaster, but far in the distance, rises Japan's most sacred peak, Mount Fuji, whose slopes, we suddenly realize, swing up like waves and whose snowy crown is like foam—comparisons the artist makes clear in the wave nearest us, caught just at the moment of greatest resemblance.

If one were forced to choose a single work of art to represent Japan, at least in the world's eye, it would have to be this woodblock print, popularly known as *The Great Wave*, by Katsushika Hokusai (fig. 22-1). Taken from his series called *Thirty-Six Views of Fuji*, it has inspired countless imitations and witty parodies, yet its forceful composition remains ever fresh.

Today, Japanese color woodblock prints of the eighteenth and nineteenth centuries are collected avidly around the world, but in their own day they were barely considered art. Commercially produced by the hundreds for ordinary people to buy, they were the fleeting secular souvenirs of their era, one of the most fascinating in Japanese history. Not until the twentieth century would the West experience anything like the pluralistic cultural atmosphere, in which so many diverse groups participate in and contribute to a common culture, as the one that produced *The Great Wave*.

22-1. Katsushika Hokusai. *The Great Wave.* Edo period, c. 1831. Polychrome woodblock print on paper, $9^{7}/_{8} \times 14^{5}/_{8}$ " (25 × 37.1 cm). Honolulu Academy of Arts, Honolulu, Hawaii. James A. Michener Collection (HAA 13, 695)

TIMELINE 22-1. Japan after 1392. Japan's centuries of isolation ended with the Meiji Restoration in 1868, ushering in the modern era.

Map 22-1. Japan after 1392. Ideas and artistic influences from the Asian continent flowed to Japan before and after the island nation's self-imposed isolation from the 17th to the 19th century.

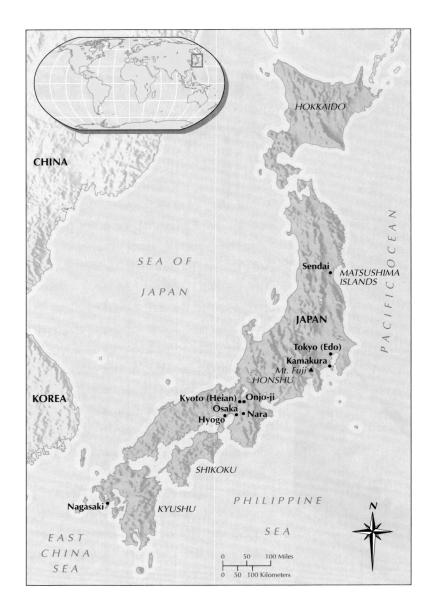

MUROMACHI PERIOD

By the year 1392, Japanese art had already developed a long and rich history (see "Foundations of Japanese Culture," op-

posite). Beginning with prehistoric pottery and tomb art, then expanding through cultural influences from China and Korea, Japanese visual expression reached high levels of sophistication in both religious and secular arts. Very early in the tradition, a particularly Japanese aesthetic emerged, including a love of natural materials, a taste for asymmetry, a sense of humor, and a tolerance for qualities that may seem paradoxical or contradictory—characteristics that continue to distinguish Japanese art, appearing and re-appearing in everchanging guises.

By the end of the twelfth century, the political and cultural dominance of the emperor and his court had given way to rule by warriors, or samurai, under the leadership of the shogun, the general-in-chief. In 1338 the Ashikaga family gained control of the shogunate and moved its headquarters to the Muromachi district in Kyoto. In 1392 they reunited northern and southern Japan and retained their grasp on the office for more than 150 years. The Muromachi period after the reunion (1392–1568) is also known as the Ashikaga era (Timeline 22-1).

The Muromachi period is especially marked by the ascendance of Zen Buddhism, whose austere ideals particularly appealed to the highly disciplined samurai. While Pure Land Buddhism, which had spread widely

FOUNDATIONS OF JAPANESE CULTURE

With the end of the last Ice Age roughly 15,000 years ago, rising sea levels submerged the lowlands connecting Japan to the Asian landmass, creating the chain of islands we know today as Japan (see Map 22-1). Not long afterward, early Paleolithic cultures gave way to a Neolithic culture known as Jomon (c. 12,000-300 BCE), after its characteristic cord-marked pottery. During the Jomon period, a sophisticated hunter-gatherer culture developed. Agriculture supplemented hunting and gathering by around 5000 BCE, and rice cultivation began some 4,000 years later.

A fully settled agricultural society emerged during the Yayoi period (c. 300 BCE-300 CE), accompanied by hierarchical social organization and morecentralized forms of government. As people learned to manufacture bronze and iron, use of those metals became widespread. Yayoi architecture, with its unpainted wood and thatched roofs, already showed the Japanese affinity for natural materials and clean lines, and the style of Yayoi granaries in particular persisted in the design of shrines in later centuries. The trend toward centralization continued during the Kofun period (c. 300-552 cE), an era characterized by the construction of large royal tombs, following the Korean practice. Veneration of leaders grew into the beginnings of the imperial system that has lasted to the present day.

The Asuka era (552–646 ce) began with a century of profound change as elements of Chinese civilization flooded into Japan, initially through the intermediary of Korea. The three most significant Chinese contributions to the developing Japanese culture were Buddhism (with its attendant art and architecture), a system of writing, and the structures of a centralized bureaucracy. The earliest extant Buddhist temple compound in Japan-the oldest currently existing wooden building in the world-dates from this period.

The arrival of Buddhism also prompted some formalization of Shinto, the loose collection of indigenous Japanese beliefs and practices. Shinto is a shamanistic religion that emphasizes ceremonial purification. Its rituals include the invocation and appeasement of spirits, including those of the recently dead. Many Shinto deities are thought to inhabit various aspects of nature, such as particularly magnificent trees, rocks, and waterfalls, and living creatures such as deer. Shinto and Buddhism have in common an intense awareness of transience, and as their goals are complementary-purification in the case of Shinto, enlightment in the case of Buddhism-they have generally existed comfortably alongside each other to the present day.

The Nara period (646–794 CE) takes its name from Japan's first permanently established imperial capital. During this time the found-

ing works of Japanese literature were compiled, among them an important collection of poetry called the *Manyoshu*. Buddhism advanced to become the most important force in Japanese culture. Its influence at court grew so great as to become worrisome, and in 794 the emperor moved the capital from Nara to Heian-kyo (present-day Kyoto), far from powerful monasteries.

During the Heian period (794–1185), an extremely refined court culture thrived, embodied today in an exquisite legacy of poetry, calligraphy, and painting. An efficient method for writing the Japanese language was developed, and with it a woman at the court wrote the world's first novel, *The Tale of Genji*. Esoteric Buddhism, as hierarchical and intricate as the aristocratic world of the court, became popular.

The end of the Heian period was marked by civil warfare as regional warrior (samurai) clans were drawn into the factional conflicts at court. Pure Land Buddhism, with its simple message of salvation, offered consolation to many in these troubled times. In 1185 the Minamoto clan defeated their arch rivals, the Taira, and their leader, Minamoto Yoritomo, assumed the position of shogun (general-in-chief). While paying respects to the emperor, Minamoto Yoritomo kept actual military and political power to himself, setting up his own capital in Kamakura. The Kamakura era (1185-1392) began a tradition of rule by shogun that lasted in various forms until 1868.

during the latter part of the Heian period (794–1185), remained popular, Zen, patronized by the samurai, became the dominant cultural force in Japan.

INK PAINTING

Several forms of visual art flourished during the Muromachi period, but **ink painting**—monochrome painting in black ink and its diluted grays—reigned supreme. Muromachi ink painting was heavily influenced by the aesthetics of Zen, yet it also marked a shift away from the earlier Zen painting tradition. As Zen moved from

an "outsider" sect to the chosen sect of the ruling group, the fierce intensity of earlier masters gave way to a more subtle and refined approach. And whereas earlier Zen artists had concentrated on rough-hewn depictions of Zen figures such as monks and teachers, now Chinese-style landscapes became the most important theme. The monk-artist Shubun (active 1414–63) is regarded as the first great master of the ink landscape. Unfortunately, no works survive that can be proven to be his. Two landscapes by Shubun's pupil Bunsei (active c. 1450–60) have survived, however. In the one shown

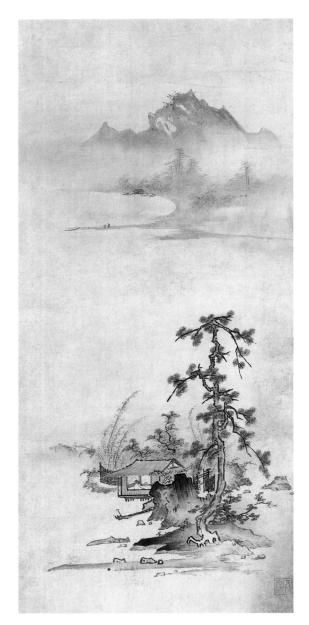

22-2. Bunsei. *Landscape.* Muromachi period, mid-15th century. Hanging scroll, ink and light colors on paper, $28^3/_4 \times 13''$ (73.2 \times 33 cm). Museum of Fine Arts, Boston. Special Chinese and Japanese Fund, (05.203)

here (fig. 22-2), the foreground reveals a spit of rocky land with an overlapping series of motifs—a spiky pine tree, a craggy rock, a poet seated in a hermitage, and a brushwood fence holding back a small garden of trees and bamboo. In the middle ground is space—emptiness, the void.

We are expected to "read" the empty paper as representing water, for subtle tones of gray ink suggest the presence of a few people fishing from their boats near the distant shore. The two parts of the painting seem to echo each other across a vast expanse, just as nature echoes the human spirit in Japanese art. The painting illustrates well the pure, lonely, and ultimately serene spirit of the Zen-influenced poetic landscape tradition.

Ink painting soon took on a different spirit. Zen monks painted—just as their Western counterparts illuminated manuscripts—but gave away their art works. By the turn of the sixteenth century, temples were asked for so many paintings that they formed ateliers staffed by monks who specialized in art rather than religious ritual or teaching. Some painters even found they could survive on their own as professional artists. Nevertheless, many of the leading masters remained monks, at least in name, including the most famous of them all, Sesshu (1420–1506). Although he lived his entire life as a monk, Sesshu devoted himself primarily to painting. Like Bunsei, he learned from the tradition of Shubun, but he also had the opportunity to visit China in 1467. Sesshu traveled extensively there, viewing the scenery, stopping at Zen monasteries, and seeing whatever Chinese paintings he could. He does not seem to have had access to works by contemporary literati masters such as Shen Zhou (see fig. 21-10) but saw instead the works of professional painters. Sesshu later claimed that he learned nothing from Chinese artists, but only from the mountains and rivers he had seen. When Sesshu returned from China, he found his homeland rent by the Onin Wars, which devastated the capital of Kyoto. Japan was to be torn apart by further civil warfare for the next hundred years. The refined art patronized by a secure society in peacetime was no longer possible. Instead, the violent new spirit of the times sounded its disturbing note, even in the peaceful world of landscape painting.

This new spirit is evident in Sesshu's Winter Landscape, which makes full use of the forceful style that he developed (fig. 22-3). A cliff descending from the mist seems to cut the composition in half. Sharp, jagged brushstrokes delineate a series of rocky hills, where a lone figure makes his way to a Zen monastery. Instead of a gradual recession into space, flat overlapping planes seem to slice the composition into crystalline facets. The white of the paper is left to indicate snow, while the sky is suggested by tones of gray. The few trees cling desperately to the rocky land, and the harsh chill of winter is boldly expressed.

A third important artist of the Muromachi period was a monk named Ikkyu (1394-1481). A genuine eccentric and one of the most famous Zen masters in Japanese history, Ikkyu derided the Zen of his day, writing, "The temples are rich but Zen is declining, there are only false teachers, no true teachers." Ikkyu recognized that success was distorting the spirit of Zen. Originally, Zen had been a form of counterculture for those who were not satisfied with prevailing ways. Now, however, Zen monks acted as government advisers, teachers, and even leaders of merchant missions to China. Although true Zen masters were able to withstand all outside pressures, many monks became involved with political matters, with factional disputes among the temples, or with their reputations as poets or artists. Ikkyu did not hesitate to mock what he regarded as "false Zen." He even paraded through the streets with a wooden sword, claiming that his sword would be as much use to a samurai as false Zen to a monk.

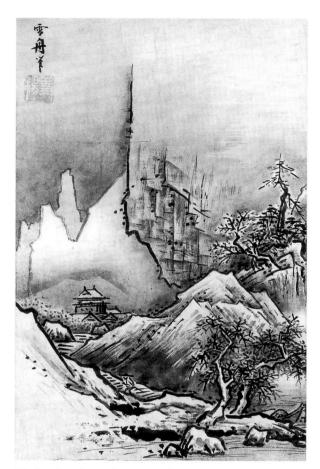

22-3. Sesshu. *Winter Landscape.* Muromachi period, c. 1470s. Ink on paper, $18^1/_4 \times 11^1/_2$ " (46.3 \times 29.3 cm). Collection of the Tokyo National Museum.

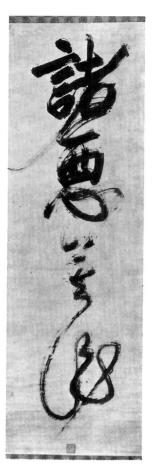

22-4. Ikkyu. *Calligraphy Pair*, from Daitoku-ji, Kyoto. Muromachi period, c. mid-15th century. Ink on paper, each $10'2^7/8'' \times 1'4^1/2''$ (3.12 × 0.42 m).

Ikkyu was very involved in the arts, although he treated traditional forms with extreme freedom. His **calligraphy**, which is especially admired, has a spirit of spontaneity. To write out the classic Buddhist couplet "Abjure evil, practice only the good," he created a pair of single-line scrolls (fig. 22-4). At the top of each scroll, Ikkyu began with standard script, in which each stroke of a character is separate and distinct. As he moved down the columns, he grew more excited and wrote in increasingly cursive script, until finally his frenzied brush did not leave the paper at all. This calligraphy displays the intensity that is the hallmark of Zen.

THE ZEN DRY GARDEN

Elegant simplicity—profound and personal—was the result of disciplined meditation coupled with manual labor, as practiced in the Zen Buddhism introduced into Japan in the late twelfth century. Zen monasteries aimed at self-sufficiency. Monks were expected to be responsible for their physical as well as spiritual needs. Consequently, the performance of simple tasks—weeding the garden, cooking meals, mending garments—became occasions for meditation in the search for enlightenment. Zen monks turned to their gardens not as the focus of detached viewing and meditation but as the

objects of constant vigilance and work—pulling weeds, tweaking unruly shoots, and raking the gravel of the dry gardens. This philosophy profoundly influenced Japanese art. An intimate relationship with nature pervades the later art of Asia, whether inspired by Buddhist, Hindu, or Shinto belief.

The dry landscape gardens of Japan (*karesansui*, literally "dried up mountains and water") exist in perfect harmony with Zen Buddhism. The dry garden in front of the abbot's quarters in the Zen temple of Ryoan-ji is one of the most renowned Zen creations in Japan (fig. 22-5, page 822). A flat rectangle of raked gravel, about 30 by 70 feet, surrounds fifteen stones of different sizes in islands of moss. The stones are set in asymmetrical groups of two, three, and five. Low, plaster-covered walls establish the garden's boundaries, but beyond the perimeter wall, maple, pine, and cherry trees add color and texture to the scene. Called "borrowed scenery," these elements are an important part of the design although they grow outside the garden. The garden is celebrated for its severe sense of space and emptiness.

Dry gardens began to be built in the fifteenth and sixteenth centuries in Japan. By the sixteenth century, Chinese landscape painting influenced the gardens' composition, and miniature clipped plants and beautiful

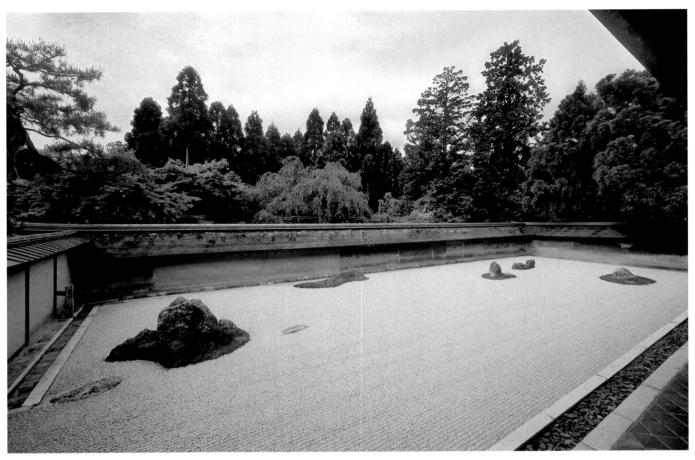

22-5. Stone and gravel garden, Ryoan-ji, Kyoto. Muromachi period, c. 1480.

The American composer John Cage once exclaimed that every stone at Ryoan-ji was in just the right place. He then said, "and every other place would also be just right." His remark is thoroughly Zen in spirit. There are many ways to experience Ryoan-ji. For example, we can imagine the rocks as having different visual "pulls" that relate them to one another. Yet there is also enough space between them to give each one a sense of self-sufficiency and permanence.

stones re-created famous paintings of trees and mountains. Especially fine and unusual stones were even stolen and carried off as war booty, such was the cultural value of these seemingly simple places.

The Kyoto garden's design, as we see it today, probably dates from the mid-seventeenth century, since earlier written sources refer only to cherry trees, not to a garden. By the time this garden was created, such stone and gravel gardens had become highly intellectualized, abstract reflections of nature. This garden has been interpreted as representing islands in the sea, or mountain peaks rising above the clouds, perhaps even a swimming tigress with her cubs, or constellations of stars and planets. All or none of these interpretations may be equally satisfying—or irrelevant—to a monk seeking clarity of mind through contemplation. The austere beauty of the naked gravel has led many people to meditation.

The Muromachi period is the only time an entire culture was strongly influenced by Zen, and the results were mixed. On one hand, works such as Ryoan-ji were created that continue to inspire people to the present day. On the other, the very success of Zen led to a secularization and professionalization of the arts that masters such as Ikkyu found intolerable.

MOMOYAMA PERIOD

The civil wars sweeping Japan laid bare the basic flaw in the Ashikaga system, which was that samurai were primarily loyal to

their own feudal lord, or *daimyo*, rather than to the central government. Battles between feudal clans grew more frequent, and it became clear that only a *daimyo* powerful and bold enough to unite the entire country could control Japan. As the Muromachi period drew to a close, three leaders emerged who would change the course of Japanese history.

The first of these leaders was Oda Nobunaga (1534–82), who marched his army into Kyoto in 1568, signaling the end of the Ashikaga family as a major force in Japanese politics. A ruthless warrior, Nobunaga went so far as to destroy a Buddhist monastery because the monks refused to join his forces. Yet he was also a patron of the most rarefied and refined arts. Assassinated in the midst of one of his military campaigns, Nobunaga was succeeded by the military commander Toyotomi Hideyoshi (1536/37–98), who soon gained complete power in Japan. He, too, patronized the arts when not leading his army, and he considered culture a vital adjunct to his rule. Hideyoshi, however, was overly

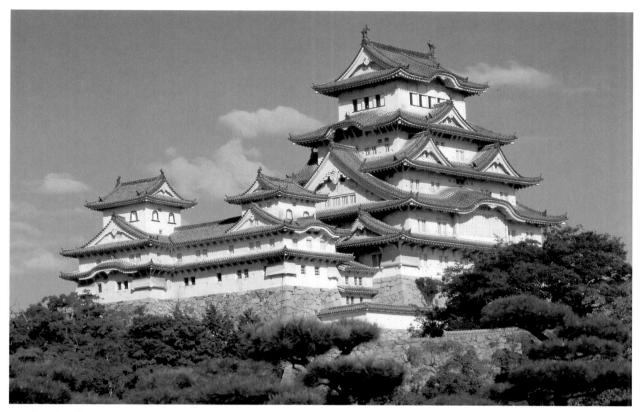

22-6. Himeji Castle, Hyogo, near Osaka. Momoyama period, 1601–1609.

ambitious. He believed that he could conquer both Korea and China, and he wasted much of his resources on two ill-fated invasions. A stable government finally emerged in 1600 with the triumph of a third leader, Tokugawa Ieyasu (1543–1616), who established his shogunate in 1603. But despite its turbulence, the era of Nobunaga and Hideyoshi, known as the Momoyama period (1568–1603), was one of the most creative eras in Japanese history.

ARCHITECTURE

Today the very word *Momoyama* conjures up images of bold warriors, luxurious palaces, screens shimmering with **gold leaf**, and magnificent ceramics. The Momoyama period was also the era when Europeans first made an impact in Japan. A few Portuguese explorers had arrived at the end of the Muromachi era in 1543, and traders and missionaries were quick to follow. It was only with the rise of Nobunaga, however, that Westerners were able to extend their activities beyond the ports of Kyushu, Japan's southernmost island. Nobunaga welcomed foreign traders, who brought him various products, the most important of which were firearms.

European muskets and cannons soon changed the nature of Japanese warfare and even influenced Japanese art. In response to the new weapons, monumental fortified castles were built in the late sixteenth century. Some were eventually lost to warfare or torn down by victorious enemies, and others have been extensively altered over the years. One of the most beautiful of the surviving castles is Himeji, not far from the city of

Osaka (fig. 22-6). Rising high on a hill above the plains, Himeji has been given the name White Heron. To reach the upper fortress, visitors must follow angular paths beneath steep walls, climbing from one area to the next past stone ramparts and through narrow fortified gates, all the while feeling as though lost in a maze, with no sense of direction or progress. At the main building, a further climb up a series of narrow ladders leads to the uppermost chamber. There, the footsore visitor is rewarded with a stunning 360-degree view of the surrounding countryside. The sense of power is overwhelming.

KANO SCHOOL DECORATIVE PAINTING

Castles such as Himeji were sumptuously decorated, offering artists unprecedented opportunities to work on a grand scale. Large murals on *fusuma*—paper-covered sliding doors—were particular features of Momoyama design, as were folding screens with gold-leaf backgrounds, whose glistening surfaces not only conveyed light within the castle rooms but also vividly demonstrated the wealth of the warrior leaders. Temples, too, commissioned large-scale paintings for their rebuilding projects after the devastation of the civil wars.

The Momoyama period produced a number of artists who were equally adept at decorative golden screens and broadly brushed *fusuma* paintings. Daitoku-ji, a celebrated Zen monastery in Kyoto, has a number of subtemples that are treasure troves of Japanese art. One, the Juko-in, possesses *fusuma* by Kano Eitoku (1543–90), one of the most brilliant painters from the professional

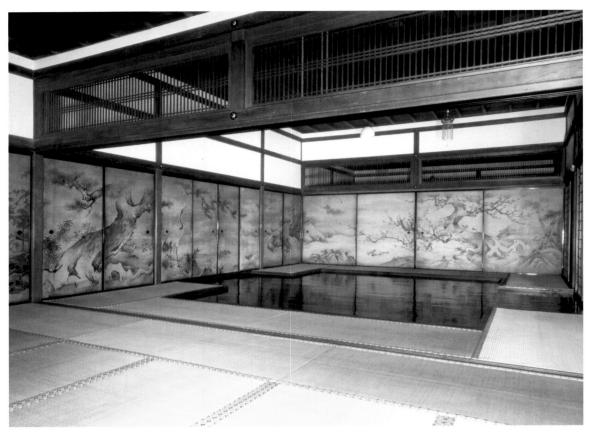

22-7. Kano Eitoku. *Fusuma* depicting pine and cranes (left) and plum tree (right), from the central room of the Juko-in, Daitoku-ji, Kyoto. Momoyama period, c. 1563–73. Ink and gold on paper, height $5'9^{1}/8''$ (1.76 m).

school of artists founded by the Kano family and patronized by government leaders for several centuries. Founded in the Muromachi period, the Kano school combined training in the ink-painting tradition with new skills in decorative subjects and styles. The illustration here shows two of the three walls of fusuma panels painted when the artist was in his mid-twenties (fig. 22-7). To the left, the subject is the familiar Kano school theme of cranes and pines, both symbols of long life; to the right is a great gnarled plum tree, symbol of spring. The trees are so massive they seem to extend far beyond the panels. An island rounding both walls of the far corner provides a focus for the outreaching trees. Ingeniously, it belongs to both compositions at the same time, thus uniting them into an organic whole. Eitoku's vigorous use of brush and ink, his powerfully jagged outlines, and his dramatic compositions all hark back to the style of Sesshu, but the bold new sense of scale in his works is a leading characteristic of the Momoyama period.

THE TEA CEREMONY

Japanese art is never one-sided. Along with castles, golden screens, and massive *fusuma* paintings there was an equal interest during the Momoyama period in the quiet, the restrained, and the natural. This was expressed primarily through the tea ceremony.

"Tea ceremony" is an unsatisfactory way to express *cha no yu*, the Japanese ritual drinking of tea, but there is no counterpart in Western culture, so this phrase has

come into common use. Tea itself had been introduced to Japan from the Asian continent hundreds of years earlier. At first tea was molded into cakes and boiled. However, the advent of Zen in the late Kamakura period (1185–1392) brought to Japan a different way of preparing tea, with the leaves crushed into powder and then whisked in bowls with hot water. Tea was used by Zen monks as a slight stimulant to aid meditation, and it also was considered a form of medicine.

The most famous tea master in Japanese history was Sen no Rikyu (1521-91). He conceived of the tea ceremony as an intimate gathering in which a few people would enter a small rustic room, drink tea carefully prepared in front of them by their host, and quietly discuss the tea utensils or a Zen scroll hanging on the wall. He did a great deal to establish the aesthetic of modesty, refinement, and rusticity that permitted the tearoom to serve as a respite from the busy and sometimes violent world outside. A traditional tearoom is quite small and simple. It is made of natural materials such as bamboo and wood, with mud walls, paper windows, and a floor covered with tatami mats-mats of woven straw. One tearoom that preserves Rikyu's design is named Tai-an (fig. 22-8). Built in 1582, it is distinguished by its tiny door (guests must crawl to enter) and its alcove, or *tokonoma*, where a Zen scroll or a simple flower arrangement may be displayed. At first glance, the room seems symmetrical. But the disposition of the tatami mats does not match the spacing of the tokonoma, providing a subtle undercurrent of irregu-

22-8. Sen no Rikyu. Tai-an tearoom, Myoki-an Temple, Kyoto. Momoyama period, 1582.

larity. A longer look reveals a blend of simple elegance and rusticity. The walls seem scratched and worn with age, but the *tatami* are replaced frequently to keep them clean and fresh. The mood is quiet; the light is muted and diffused through three small paper windows. Above all, there is a sense of spatial clarity. All nonessentials have been eliminated, so there is nothing to distract from focused attention. The tearoom aesthetic became an important element in Japanese culture, influencing secular architecture through its simple and evocative form (see "Shoin Design," below).

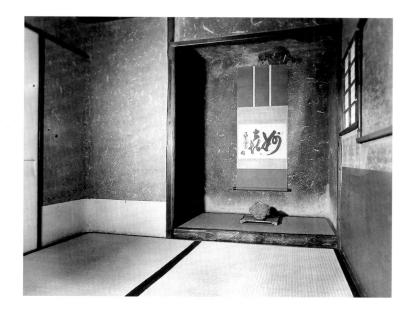

ELEMENTS of ARCHITECTURE

SHOIN DESIGN

Of the many expressions of Japanese taste that reached great refinement in the Momoyama period, **shoin** architecture has had perhaps the most enduring influence. Shoin are upper-class residences that combine a number of traditional features in more-or-less standard ways, always asymmetically. These features are wide verandas; wood posts as framing and defining decorative elements; woven straw **tatami** mats as floor and ceiling covering; several shallow alcoves for prescribed purposes; **fusuma** (sliding doors) as fields for painting or textured surfaces; and **shoji** screens—wood frames covered with translucent rice paper. The **shoin** illustrated here was built in 1601 as a guest hall, called Kojo-in, at the great Onjo-ji monastery. **Tatami**, **shoji**, alcoves, and asymmetry are still seen in Japanese interiors today.

In the original *shoin*, one of the alcoves would contain a hanging scroll, an arrangement of flowers, or a

large painted screen. Seated in front of that alcove, called *tokonoma*, the owner of the house would receive guests, who could contemplate the object above the head of their host. Another alcove contained staggered shelves, often for writing instruments. A writing space fitted with a low writing desk was on the veranda side of a room, with *shoji* that could open to the outside.

The architectural harmony of *shoin*, like virtually all Japanese buildings, was based on the mathematics of proportions and on the proportionate disposition of basic units, or **modules**. The modules were the **bay**, reckoned as the distance from the center of one post to the center of another, and the *tatami*. Room area in Japan is still expressed in terms of the number of *tatami* mats, so that, for example, a room may be described as a seven-mat room. Although varying slightly from region to region, the size of a single *tatami* is about 3 feet by 6 feet.

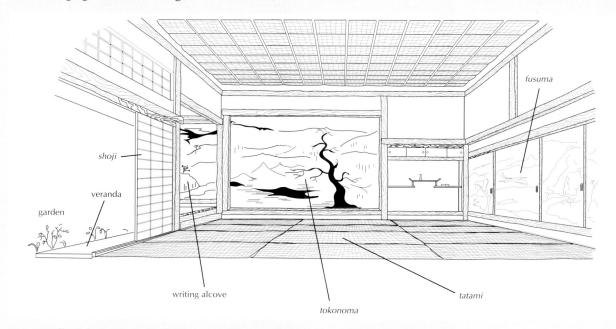

Guest Hall, Kojo-in, Onjo-ji monastery, Shiga prefecture. Momoyama period, 1601.

PERIOD

EDO Three years after Tokugawa Ieyasu gained control of Japan, he proclaimed himself shogun. His family's control of the shogunate was to last more than 250

years, a span of time known as the Edo period (1603-1868) or the Tokugawa era.

Under the rule of the Tokugawa family, peace and prosperity came to Japan at the price of an increasingly rigid and often repressive form of government. The problem of potentially rebellious daimyo was solved by ordering all feudal lords to spend either half of each year or every other year in the new capital of Edo (presentday Tokyo), where their wives and children were sometimes required to live permanently. Zen Buddhism was supplanted as the prevailing intellectual force by a form of neo-Confucianism, a philosophy formulated in Songdynasty China that emphasized loyalty to the state. More drastically, Japan was soon closed off from the rest of the world by its suspicious government. Japanese were forbidden to travel abroad, and with the exception of small Chinese and Dutch trading communities on an island off the southern port of Nagasaki, foreigners were not permitted in Japan.

Edo society was officially divided into four classes. Samurai officials constituted the highest class, followed by farmers, artisans, and finally merchants. As time went on, however, merchants began to control the money supply, and in Japan's increasingly mercantile economy they soon reached a high, if unofficial, position. Reading and writing became widespread at all levels of society. Many segments of the population—samurai, merchants, intellectuals, and even townspeople-were now able to patronize artists, and a pluralistic cultural atmosphere developed unlike anything Japan had experienced before.

THE TEA CEREMONY

The rebuilding of temples continued during the first decades of the Edo period, and for this purpose government officials, monks, and wealthy merchants needed to cooperate. The tea ceremony was one way that people of different classes could come together for intimate conversations. Every utensil connected with tea, including the waterpot, the kettle, the bamboo spoon, the whisk, the tea caddy, and, above all, the teabowl, came to be appreciated for their aesthetic qualities, and many works of art were created for use in cha no yu.

The age-old Japanese admiration for the natural and the asymmetrical found full expression in tea ceramics. Korean-style bowls made by humble farmers for their rice were suddenly considered the epitome of refined taste. Tea masters even went so far as to advise rural potters in Japan to create imperfect shapes. But not every misshapen bowl would be admired. An extremely subtle sense of beauty developed that took into consideration such factors as how well a teabowl fit into the hands, how subtly the shape and texture of the bowl appealed to the eye, and who had previously used and admired it. For this purpose, the inscribed box became

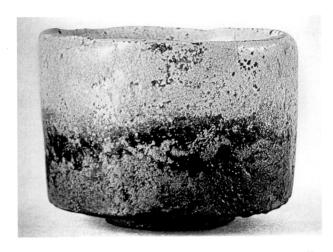

22-9. Hon'ami Koetsu. Teabowl, called Mount Fuji. Edo period, early 17th century. Raku ware, height $3^{3}/8^{"}$ (8.5 cm). Sakai Collection, Tokyo.

A specialized vocabulary developed to allow connoisseurs to discuss the subtle aesthetics of tea. A favorite term was sabi, which summoned up the particular beauty to be found in stillness or even deprivation. Sabi was borrowed from the critical vocabulary of poetry, where it was first established as a positive ideal by the earlythirteenth-century poet Fujiwara Shunzei. Other virtues were wabi, conveying a sense of great loneliness or a humble (and admirable) shabbiness, and shibui, meaning plain and astringent.

almost as important as the ceramic that fit within it, and if a bowl had been given a name by a leading tea master, it was especially treasured by later generations.

One of the finest teabowls extant is named Mount Fuji after Japan's most sacred peak (fig. 22-9). (Mount Fuji itself is depicted in figure 22-1.) An example of raku ware—a hand-built, low-fired ceramic developed especially for use in the tea ceremony—the bowl was crafted by Hon'ami Koetsu (1558–1637), a leading cultural figure of the early Edo period. Koetsu was most famous as a calligrapher, but he was also a painter, lacquer designer, poet, landscape gardener, connoisseur of swords, and potter. With its small foot, straight sides, slightly irregular shape, and crackled texture, this bowl exemplifies tea taste. In its rough exterior we sense directly the two elements of earth and fire that create pottery. Merely looking at it suggests the feeling one would get from holding it, warm with tea, cupped in one's hands.

RIMPA SCHOOL PAINTING

One of Koetsu's friends was the painter Tawaraya Sotatsu (active c. 1600-40), with whom he collaborated on several magnificent handscrolls. Sotatsu is considered the first great painter of the Rimpa school, a grouping of artists with similar tastes rather than a formal school such as the Kano school. Rimpa masters excelled in decorative designs of strong expressive force, and they frequently worked in several mediums.

Sotatsu painted some of the finest golden screens that have survived. The splendid pair here depict the celebrated islands of Matsushima near the northern city of

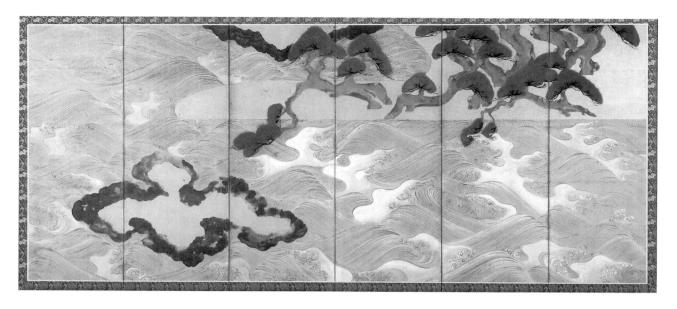

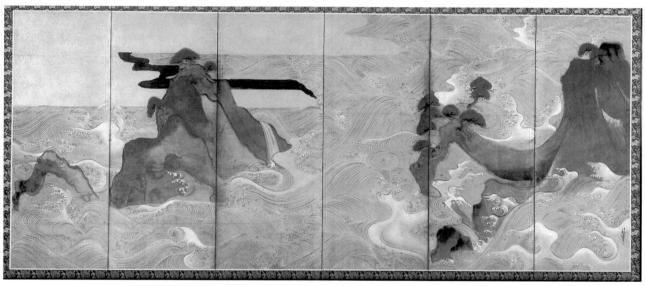

22-10. Tawaraya Sotatsu. Pair of six-panel screens, known as the Matsushima screens. Edo period, 17th century. Ink, mineral colors, and gold leaf on paper; each screen $4'9^{7}/8'' \times 11'8^{1}/2''$ (1.52 × 3.56 m). Freer Gallery of Art, Smithsonian Institution, Washington, D.C.

Gift of Charles Lang Freer, (F1906.231 & 232).

The six-panel screen format was a triumph of scale and practicality. Each panel consisted of a light wood frame surrounding a latticework interior covered with several layers of paper. Over this foundation was pasted a high-quality paper, silk, or gold-leaf ground, ready to be painted by the finest artists. Held together with ingenious paper hinges, a screen could be folded for storage or transportation, resulting in a mural-size painting light enough to be carried by a single person, ready to be displayed as needed.

Sendai (fig. 22-10). Working in a boldly decorative style, the artist has created asymmetrical and almost abstract patterns of waves, pines, and island forms. On the screen to the right, mountainous islands echo the swing and sweep of the waves, with stylized gold clouds in the upper left. The screen on the left continues the gold clouds until they become a sand spit from which twisted pines grow. Their branches seem to lean toward a strange island in the lower left, composed of an organic, amoebalike form in gold surrounded by mottled ink. This mottled effect was a specialty of Rimpa school painters.

As one of the "three famous beautiful views of Japan," Matsushima was often depicted in art. Most painters, however, emphasized the large number of

pine-covered islands that make the area famous. Sotatsu's genius was to simplify and dramatize the scene, as though the viewer were passing the islands in a boat on the roiling waters. Strong, basic mineral colors dominate, and the sparkling two-dimensional richness of the gold leaf contrasts dramatically with the threedimensional movement of the waves.

The second great master of the Rimpa school was Ogata Korin (1658–1716). Korin copied many designs after Sotatsu in homage to the master, but he also originated many remarkable works of his own, including colorful golden screens, monochrome scrolls, and paintings in glaze on his brother Kenzan's pottery. He also designed some highly prized works in **lacquer**

Lacquer is derived in Asia from the sap of the lacquer tree, *Rhus Verniciflua*. The tree is indigenous to China, where examples of lacquerware have been found dating back to the Neolith-

ic period. Knowledge of lacquer spread early to Korea and Japan, and the tree came to be grown commercially throughout East Asia.

Gathered by tapping into a tree and letting the sap flow into a container, in much the same way as maple syrup, lacquer is then strained to remove impurities and heated to evaporate excess moisture. The thickened sap can be colored with vegetable or mineral dyes and lasts for several years if carefully stored. Applied in thin coats to a surface such as wood or leather, lacquer hardens into a smooth, glasslike, protective coating that is waterproof, heat- and acid-resistant, and airtight. Lacquer's practical qualities made it ideal for storage containers and vessels for food and drink. In Japan the leather scales of samurai armor were coated in lacquer, as were leather saddles. In China, Korea, and Japan the decorative potential of lacquer was brought to exquisite perfection in the manufacture of expensive luxury items.

The creation of a piece of lacquer is a painstaking process that can take a sequence of specialized crafts-

TECHNIQUE

Lacquer

workers several years. First, the item is fashioned of wood and sanded to a flawlessly smooth finish. Next, layers of lacquer are built up. In order to dry properly, lacquer must be applied in

extremely thin coats. (If the lacquer is applied too thickly, the lacquer's exterior surface dries first, forming an airtight seal that prevents the lacquer below from ever drying.) Optimal temperature and humidity are also essential to drying, and craftsworkers quickly learned to control them artificially. Up to thirty coats of lacquer, each dried and polished before the next is brushed on, are required to build up a substantial layer.

Many techniques were developed for decorating lacquer. Particularly in China, lacquer was often applied to a thickness of up to 300 coats, then elaborately carved in low relief—dishes, containers, and even pieces of furniture were executed in carved lacquer. In Japan and Korea, **inlay** with mother-of-pearl and precious metals was brought to a high point of refinement. Japanese artisans also perfected a variety of methods known collectively as **maki-e** ("sprinkled design") that embedded flaked or powdered gold or silver in a still-damp coat of lacquer—somewhat like a very sophisticated version of the technique of decorating with glitter on glue.

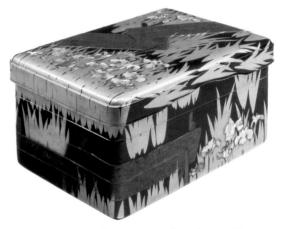

22-11. Ogata Korin. Lacquer box for writing implements. Edo period, late 17th–early 18th century. Lacquer, lead, silver, and mother-of-pearl, $5^5/8 \times 10^3/4 \times 7^3/4$ " (14.2 × 27.4 × 19.7 cm). Tokyo National Museum, Tokyo.

(see "Lacquer," above). One famous example (fig. 22-11) is a writing box, a lidded container designed to hold tools and materials for calligraphy (see "Inside a Writing Box," opposite). Korin's design for this black lacquer box sets a motif of irises and a plank bridge in a dramatic combination of mother-of-pearl, silver, lead, and gold lacquer. For Japanese viewers the decoration immediately recalls a famous passage from the tenth-century *Tales of Ise*, a classic of Japanese literature. A nobleman poet, having left his wife in the capital, pauses at a place called Eight Bridges, where a river branches into eight streams, each covered with a plank bridge. Irises are in full bloom, and his traveling companions urge the

poet to write a *tanka*—a five-line, thirty-one-syllable poem—beginning each line with a syllable from the word *ka.ki.tsu.ba.ta* ("iris"). The poet responds (substituting *ha* for *ba*):

Karagoromo
kitsutsu narenishi
tsuma shi areba
harubaru kinuru
tabi o shi zo omou.

When I remember my wife, fond and familiar as my courtly robe, I feel how far and distant my travels have taken me.

(Translated by Stephen Addiss)

The poem brought tears to all their eyes, and the scene became so famous that any painting of a group of irises, with or without a plank bridge, immediately calls it to mind.

NANGA SCHOOL PAINTING

Rimpa artists such as Sotatsu and Korin are considered quintessentially Japanese in spirit, both in the expressive power of their art and in their use of poetic themes from Japan's past. Other painters, however, responded to the new Confucian atmosphere by taking up some of the ideas of the literati painters of China. These painters are grouped together as the Nanga ("Southern") school. Nanga was not a school in the sense of a professional workshop or a family tradition. Rather, it took its name from the southern school of amateur artists described by

INSIDE A WRITING BOX

The interior of the writing box shown in figure 22-11 is fitted with compartments for holding an ink stick, an ink stone, brushes, an eyedropper, and paper—tools and materials not only for writing but also for **ink painting**.

Ink sticks are made by burning wood or oil inside a container. Soot deposited by the smoke is collected, bound into a paste with resin, heated for several hours, kneaded and pounded, then pressed into small stick-shaped or cake-shaped molds to harden. Molds are often carved to produce an ink stick (or ink cake) decorated in low relief. The tools of writing and painting are also beautiful objects in their own right.

Fresh ink is made for each writing or painting session by grinding the hard, dry ink stick in water against a fine-grained stone. A typical ink stone has a shallow well at one end sloping up to a grinding surface at the other. The artist fills the well with water from a water-

pot. The ink stick, held vertically, is dipped into the well to pick up a small amount of water, then is rubbed in a circular motion firmly on the grinding surface. The process is repeated until enough ink has been prepared. Grinding ink is viewed as a meditative task, time for collecting one's thoughts and concentrating on the painting or calligraphy ahead.

Brushes are made from animal hairs set in simple bamboo or

hollow-reed handles. Brushes taper to a fine point that responds with great sensitivity to any shift in pressure. Although great painters and calligraphers do eventually develop their own styles of holding and using the brush, all begin by learning the basic position for writing. The brush is held vertically, grasped firmly between the thumb and first two fingers, with the fourth and fifth fingers often resting against the handle for more subtle control.

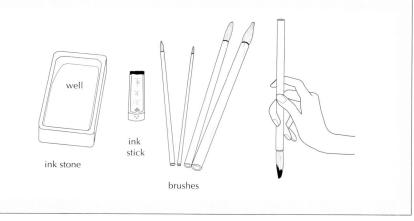

the Chinese literati theorist Dong Qichang (Chapter 21). Educated in the Confucian mold, Nanga masters were individuals and often individualists, creating their own variations of literati painting from unique blendings of Chinese models, Japanese aesthetics, and personal brushwork. They were often experts at calligraphy and poetry as well as painting, but one, Uragami Gyokudo (1745–1820), was even more famous as a musician, an expert on a seven-string Chinese zither called the *qin*. Most instruments are played for entertainment or ceremonial purposes, but the *qin* has so deep and soft a sound that it is played only for oneself or a close friend. Its music becomes a kind of meditation, and for Gyokudo it opened a way to commune with nature and his own inner spirit.

Gyokudo was a hereditary samurai official, but midway through his life he resigned from his position and spent seventeen years wandering through Japan, absorbing the beauty of its scenery, writing poems, playing music, and beginning to paint. During his later years Gyokudo produced many of the strongest and most individualistic paintings in Japanese history, although they were not appreciated by people during his lifetime. *Geese Aslant in the High Wind* is a leaf from an album Gyokudo painted in 1817, three years before his death (fig. 22-12). The creative power in this painting is remarkable. The wind seems to have the force of a hurricane, sweeping the tree branches and the geese

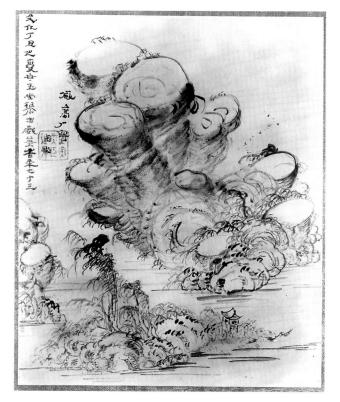

22-12. Uragami Gyokudo. *Geese Aslant in the High Wind*. Edo period, 1817. Ink and light colors on paper, $12^3/_{16} \times 9^7/_8$ " (31 × 25 cm). Takemoto Collection, Aichi.

into swirls of action. The greatest force comes from within the land itself, which mushrooms out and bursts forth in peaks and plateaus as though an inner volcano were erupting.

The style of the painting derives from the Chinese literati tradition, with layers of calligraphic brushwork building up the forms of mountains, trees, and the solitary human habitation. But the inner vision is unique to Gyokudo. In his artistic world, humans do not control nature but can exult in its power and grandeur. Gyokudo's art may have been too strong for most people in his own day, but in our violent century he has come to be appreciated as a great artist.

ZEN PAINTING

Deprived of the support of the government and samurai officials, who now favored neo-Confucianism, Zen initially went into something of a decline during the Edo period. In the early eighteenth century, however, it was revived by a monk named Hakuin Ekaku (1685–1769), who had been born in a small village not far from Mount Fuji and resolved to become a monk after hearing a fireand-brimstone sermon in his youth. For years he traveled around Japan seeking out the strictest Zen teachers. After a series of enlightenment experiences, he eventually became an important teacher himself.

In his later years Hakuin turned more and more to painting and calligraphy as forms of Zen expression and teaching. Since the government no longer sponsored Zen, Hakuin reached out to ordinary people, and many of his paintings portray everyday subjects that would be easily understood by farmers and merchants. The paintings from his sixties have great charm and humor, and by his eighties he was creating works of astonishing force. Hakuin's favorite subject was Bodhidharma, the semilegendary Indian monk who had begun the Zen tradition in China (fig. 22-13). Here he has portrayed the wide-eyed Bodhidharma during his nine years of meditation in front of a temple wall in China. Intensity, concentration, and spiritual depth are conveyed by broad and forceful brushstrokes. The inscription is the ultimate Zen message, attributed to Bodhidharma himself: "Pointing directly to the human heart, see your own nature and become Buddha."

Hakuin's pupils followed his lead in communicating their vision through brushwork. The Zen figure once again became the primary subject of Zen painting, and the painters were again Zen masters rather than primarily artists.

MARUYAMA-SHIJO SCHOOL PAINTING

Zen paintings were given away to all those who wished them, including poor farmers as well as artisans, merchants, and samurai. Many merchants, however, were more concerned with displaying their increasing wealth than with spiritual matters, and their aspirations fueled a steady demand for golden screens and other decorative works of art. One school that arose to satisfy this demand was the Maruyama-Shijo school, formed in Kyoto by Maruyama Okyo (1733–95). Okyo had studied

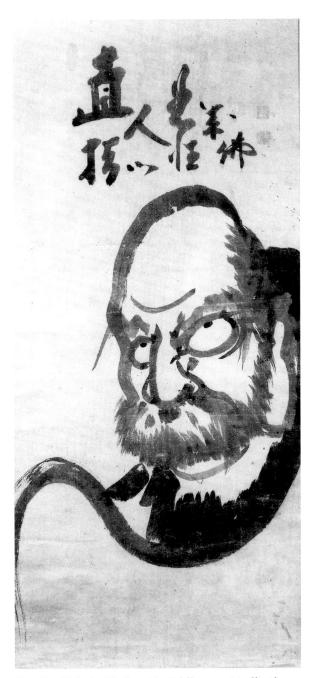

22-13. Hakuin Ekaku. *Bodhidharma Meditating.* Edo period, 18th century. Ink on paper, $49\frac{1}{2} \times 21\frac{3}{4}$ " (125.7 × 55.3 cm). On extended loan to the Spencer Museum of Art, University of Kansas, Lawrence.

Hakuin had his first enlightenment experience while meditating upon the koan (mysterious Zen riddle) about mu. One day a monk asked a Chinese Zen master, "Does a dog have the buddha nature?" Although Buddhist doctrine teaches that all living beings have buddha nature, the master answered, "Mu," meaning "has not" or "nothingness." The riddle of this answer became a problem that Zen masters gave their students as a focus for meditation. With no logical answer possible, monks were forced to go beyond the rational mind and penetrate more deeply into their own being. Hakuin, after months of meditation, reached a point where he felt "as though frozen in a sheet of ice." He then happened to hear the sound of the temple bell, and "it was as though the sheet of ice had been smashed." Later, as a teacher, Hakuin invented a koan of his own that has since become famous: "What is the sound of one hand clapping?'

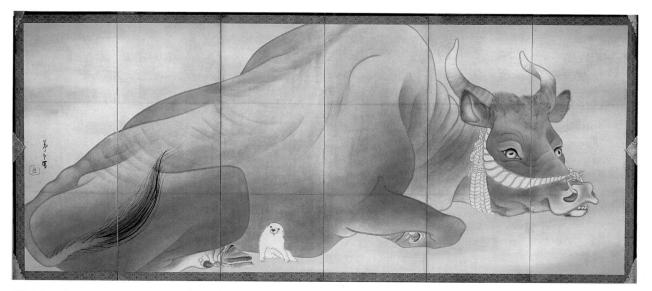

22-14. Nagasawa Rosetsu. *Bull and Puppy.* Edo period, 18th century. One of a pair of six-panel screens, ink and gold wash on paper, $5'7^{1/4}'' \times 12'3''$ (1.70 × 3.75 m). Los Angeles County Museum of Art, California. Joe and Etsuko Price Collection, (L.83.45.3a)

Western-style "perspective pictures" in his youth, and he was able in his mature works to incorporate shading and perspective into a decorative style, creating a sense of volume that was new to East Asian painting. Okyo's new style proved very popular in Kyoto, and it soon spread to Osaka and Edo (present-day Tokyo) as well. The subjects of Maruyama-Shijo painting were seldom difficult to understand. Instead of legendary Chinese themes, Maruyama-Shijo painters portrayed the birds, animals, hills, trees, farmers, and townsfolk of Japan. Although highly educated people might make a point of preferring Nanga painting, Maruyama-Shijo works were perfectly suited to the taste of the emerging upper middle class.

The leading pupil of Okyo was Nagasawa Rosetsu (1754–99), a painter of great natural talent who added his own boldness and humor to the Maruyama-Shijo tradition. Rosetsu delighted in surprising his viewers with odd juxtapositions and unusual compositions. One of his finest works is a pair of screens, the left depicting a bull and a puppy (fig. 22-14). The bull is so immense that it fills almost the entire six panels of the screen and still cannot be contained at the top, left, and bottom. The puppy, white against the dark gray of the bull, helps to emphasize the huge size of the bull by its own smallness. The puppy's relaxed and informal pose, looking happily right out at the viewer, gives this powerful painting a humorous touch that increases its charm.

In earlier centuries, when works of art were created largely under aristocratic or religious patronage, Rosetsu's painting might have seemed too mundane. In the Edo period, however, the taste for art had spread so widely through the populace that no single group of patrons could control the cultural climate. Everyday subjects like farm animals were painted as often as Zen subjects or symbolic themes from China. In the hands of a master such as Rosetsu, plebeian subject matter could become simultaneously delightful and monumental, equally pleasing to viewers with or without much education or artistic background.

UKIYO-E: PICTURES OF THE FLOATING WORLD

Not only did newly wealthy merchants patronize painters in the middle and later Edo period, but even artisans and tradespeople could purchase works of art. Especially in the new capital of Edo, bustling with commerce and cultural activities, people savored the delights of their peaceful society. Buddhism had long preached that pleasures were fleeting; the cherry tree, which blossoms so briefly, became the symbol for the transience of earthly beauty and joy. Commoners in the Edo period did not dispute this transience, but they took a new attitude: Let's enjoy it to the full as long as it lasts. Thus the Buddhist phrase *ukiyo* ("floating world") became positive rather than negative.

There was no world more transient than that of the pleasure quarters, set up in specified areas of every major city. Here were found restaurants, bathhouses, and brothels. The heroes of the day were no longer famous samurai or aristocratic poets. Instead, swashbuckling actors and beautiful courtesans were admired. These paragons of pleasure soon became immortalized in paintings and—because paintings were often too expensive for common people—in **woodblock** prints known as **ukiyo-e**, "pictures of the floating world" (see "Japanese Woodblock Prints," page 833).

At first prints were made in black and white, then colored by hand when the public so desired. The first artist to design prints to be printed in many colors was Suzuki Harunobu (1724–70). His exquisite portrayals of feminine beauty quickly became so popular that soon every artist was designing multicolored *nishiki-e* ("brocade pictures").

One print that displays Harunobu's charm and wit is *Geisha as Daruma Crossing the Sea* (fig. 22-15, page 832). Harunobu has portrayed a young woman in a red cloak crossing the water on a reed, a clear reference to one of the legends about Bodhidharma, known in Japan as Daruma. To see a young woman peering ahead to the

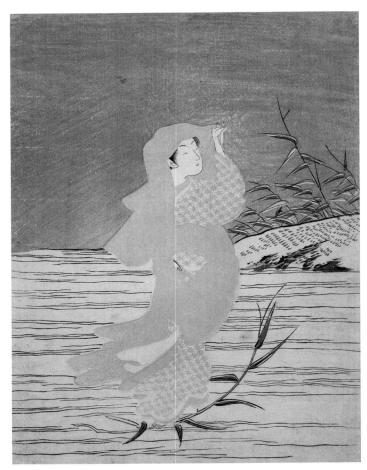

22-15. Suzuki Harunobu. *Geisha as Daruma Crossing the Sea.* Edo period, mid-18th century. Color woodcut, $10^7/8 \times 8^1/4$ " (27.6 × 21 cm). Philadelphia Museum of Art. Gift of Mrs. Emile Geyelin, in memory of Anne Hampton Barnes

other shore, rather than a grizzled Zen master staring off into space, must have greatly amused the Japanese populace. There was also another layer of meaning in this image because geishas were sometimes compared to Buddhist teachers or deities in their ability to bring ecstasy, akin to enlightenment, to humans. Harunobu's print suggests these meanings, but it also succeeds simply as a portrait of a beautiful woman, with the gently curving lines of drapery suggesting the delicate feminine form beneath.

The second great subject of *ukiyo-e* were the actors of the new form of popular theater known as kabuki. Because women had been banned from the stage after a series of scandalous incidents, male actors took both male and female roles. Much as people today buy posters of their favorite sports, music, or movie stars, so, too, in the Edo period people clamored for images of their feminine and masculine ideals.

During the nineteenth century, landscape joined courtesans and actors as a major theme—not the idealized landscape of China, but the actual sights of Japan. The two great masters of landscape prints were Utagawa Hiroshige (1797–1858) and Katsushika Hokusai (1760–1849). Hiroshige's Fifty-Three Stations of the Tokaido and Hokusai's Thirty-Six Views of Fuji became the

most successful sets of graphic art the world has known. The woodblocks were printed and printed again until they wore out. They were then recarved, and still more copies were printed. This process continued for decades, and thousands of prints from the two series are still extant.

The Great Wave (see fig. 22-1) is the most famous of the scenes from *Thirty-Six Views of Fuji*. Hokusai was already in his seventies, with a fifty-year career behind him, when he designed this image. Such was his modesty that he felt that his Fuji series was only the beginning of his creativity, and he wrote that if he could live until he was 100, he would finally learn how to become an artist.

When seen in Europe and America, these and other Japanese prints were immediately acclaimed, and they strongly influenced late-nineteenth- and early-twentieth-century Western art (Chapter 27). *Japonisme*, or "japonism," became the vogue, and Hokusai and Hiroshige became as famous in the West as in Japan. Indeed, their art was taken more seriously in the West; the first book on Hokusai was published in France, and it has been estimated that by the early twentieth century more than 90 percent of Japanese prints had been sold to Western collectors. Only within the past fifty years

Ukivo-e ("pictures of the floating world," as these woodblock prints are called in Japanese) represent the combined expertise of three people: the artist, the carver, and the printer.

Coordinating and funding the endeavor was a publisher, who commissioned the project and distributed the prints to stores or itinerant peddlers, who would sell them.

The artist supplied the master drawing for the print, executing its outlines with brush and ink on tissue-thin paper. Colors might be indicated, but more often they were understood or decided on later. The drawing was passed on to the carver, who pasted it facedown on a hardwood block, preferably cherrywood, so that the outlines showed through the paper in reverse. A light coating of oil might be brushed on to make the paper more transparent, allowing the drawing to stand out with maximum clarity. The carver then cut around the lines of the drawing with a sharp knife, always working in the same direction as the original brushstrokes. The rest of the block was chiseled away, leaving the outlines standing in relief. This block, which reproduced the master drawing, was called the key block. If the print was to be polychrome, having multiple colors, prints made from the key block were in turn pasted facedown on blocks that would be used as guides for the carver of

TECHNIQUE

Japanese **Woodblock Prints**

the color blocks. Each color generally required a separate block, although both sides of a block might be used for economy.

Once the blocks were completed, the printer took over. Paper for printing was covered lightly with animal glue (gelatin). A few hours before printing, the paper was lightly moistened so that it would take ink and color well. Water-based ink or color was brushed over the block, and the paper placed on top and rubbed with a smooth, padded device called a baren, until the design was completely transferred. The key block was printed first, then the colors one by one. Each block was carved with two small marks called registration marks, in exactly the same place in the margins, outside of the image area—an L in one corner, and a straight line in another. By aligning the paper with these marks before letting it fall over the block, the printer ensured that the colors would be placed correctly within the outlines. One of the most characteristic effects of later Japanese prints is a grading of color from dark to pale. This was achieved by wiping some of the color from the block before printing, or by moistening the block and then applying the color gradually with an unevenly loaded brush-a brush loaded on one side with full-strength color and on the other with diluted color.

An early-20th-century woodblock showing two women cutting and inking blocks

have Japanese museums and connoisseurs fully realized the stature of this "plebeian" form of art.

AND MODERN **PERIODS**

THE MEIJI Pressure from the West for entry into Japan mounted dramatically in the midnineteenth century, and in 1853 the policy of national seclu-

sion was ended. Resulting tensions precipitated the downfall of the Tokugawa shogunate, however, and in 1868 the emperor was formally restored to power, an event known as the Meiji Restoration. The court moved from Kyoto to Edo, which was renamed Tokyo, meaning "Eastern Capital."

The Meiji period marked a major change for Japan. After its long isolation Japan was deluged by the influx of the West. Western education, governmental systems,

clothing, medicine, industrialization, and technology were all adopted rapidly into Japanese culture. Teachers of sculpture and oil painting were imported from Italy, while adventurous Japanese artists traveled to Europe and America to study.

Japan's people have always been eager to be up-todate while at the same time preserving the heritage of the past. Even in the hasty scrambling to become a modern industrialized country, Japan did not lose its sense of tradition, and traditional arts continued to be created even in the days of the strongest Western influence. In modern Japan, artists still choose whether to work in an East Asian style, a Western style, or some combination of the two. Just as Japanese art in earlier periods had both Chinese style and native traditions, so Japanese art today has both Western and native aspects.

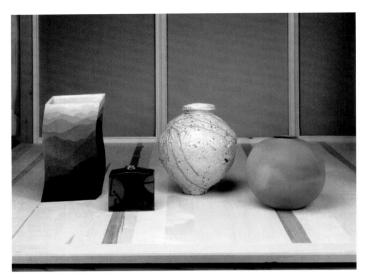

22-16. From left: Miyashita Zenji, Morino Hiroaki, Tsujimura Shiro, Ito Sekisui. Four ceramic vessels.

Modern period, after 1970. Spencer Museum of Art, University of Kansas, Lawrence.

Gift of the Friends of the Art Museum/Helen Foresman Spencer Art Acquisition Fund

Perhaps the most lively contemporary art is ceramics. Japan has retained a widespread appreciation for pottery. Many people still practice the traditional arts of the tea ceremony and flower arranging, both of which require ceramic vessels, and most people would like to own at least one fine ceramic piece. In this atmosphere many potters can earn a comfortable living by making art ceramics, an opportunity not available in other countries. Some ceramists continue to create *raku* teabowls and other traditional wares, while others experiment with new styles and new techniques. Figure 22-16 shows the work of four contemporary potters, from left to right, Miyashita Zenji (b. 1939), Morino Hiroaki (b. 1934), Tsujimura Shiro (b. 1947), and Ito Sekisui (b. 1941).

Miyashita Zenji, who lives in Kyoto, spends a great deal of time on each piece. He creates the initial form by constructing an undulating shape out of pieces of cardboard, then builds up the surface with clay of many different colors, using torn paper to create irregular shapes. When fired, the varied colors of the clay seem to form a landscape, with layers of mountains leading up to the sky. Miyashita's work is modern in shape, yet also traditional in its evocation of nature.

Morino Hiroaki's works are often abstract and sculptural, without any functional use. He has also made vases, however, and they showcase his ability to create designs in glaze that are wonderfully quirky and playful. His favorite colors of red and black bring out the asymmetrical strength of his compositions, the products of a lively individual artistic personality.

Tsujimura Shiro lives in the mountains outside Nara and makes pottery in personal variations on traditional shapes. He values the rough texture of country clay and the natural ash glaze that occurs with wood firing, and

he creates jars, vases, bowls, and cups with rough exteriors covered by rivulets of flowing green glaze that are often truly spectacular. Tsujimura's pieces are always functional, and part of their beauty comes from their suitability for holding food, flowers, or tea.

Ito Sekisui represents the fifth generation of a family of potters. Sekisui demonstrates the Japanese love of natural materials by presenting the essential nature of fired clay in his works. The shapes of his bowls and pots are beautifully balanced with simple clean lines; no ornament detracts from their fluent geometric purity. The warm tan, orange, and reddish colors of the clay reveal themselves in irregularly flowing and changing tones created by allowing different levels of oxygen into the kiln when firing.

These four artists represent the high level of contemporary ceramics in Japan, which is supported by a broad spectrum of educated and enthusiastic collectors and admirers. There is also strong public interest in contemporary painting, prints, calligraphy, textiles, lacquer, architecture, and sculpture.

One of the most adventurous and original sculptors currently working is Chuichi Fujii (b. 1941). Born into a family of sculptors in wood, Fujii found himself as a young artist more interested in the new materials of plastic, steel, and glass. However, in his mid-thirties he took stock of his progress and decided to begin again, this time with wood. At first he carved and cut into the wood, but he soon realized that he wanted to allow the material to express its own natural spirit, so he devised an ingenious new technique that preserved the individuality of each log while making of it something new. As Fujii explains it, he first studies the log to come to terms with its basic shape and to decide how far he can "push to the limit the log's balancing point with the floor" (Howard N. Fox, A Primal Spirit: Ten Contemporary Japanese Sculptors. Exh. cat., Los Angeles County Museum of Art, 1990, page 63). Next, he inserts hooks into the log and runs wires between them. Every day he tightens the wires, over a period of months gradually pulling the log into a new shape. When he has bent the log to the shape he envisioned, Fujii makes a cut and sees whether his sculpture will stand. If he has miscalculated, he discards the work and begins again.

Here, Fujii has created a circle, one of the most basic forms in nature but never before seen in such a thick tree trunk (fig. 22-17). The work strongly suggests the *enso*, the circle that Zen monks painted to express the universe, the all, the void, the moon—and even a tea cake. Yet Fujii does not try to proclaim his links with Japanese culture. He says that while his works may seem to have some connections with traditional Japanese arts, he is not conscious of them. He acknowledges, however, that people carry their own cultures inside them, and he claims that all Japanese have had "the experience of sensing with their skin the fragrance of a tree. Without saying it, the Japanese understand that a tree has warmth; I believe it breathes air, it cries" (Fox, page 63).

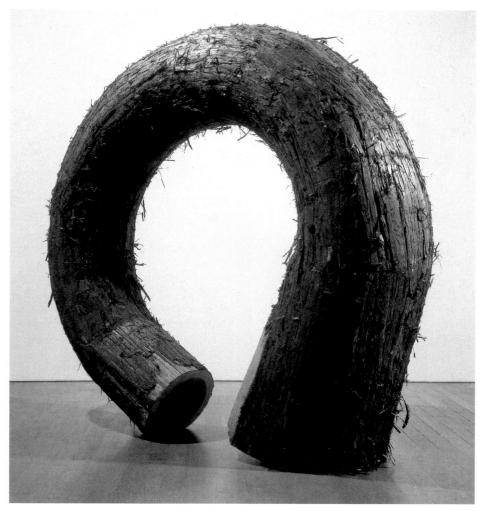

22-17. Chuichi Fujii. *Untitled '90.* Modern period, 1990. Cedar wood, height $7'5^1/_2$ " (2.3 m). Hara Museum of Contemporary Art, Tokyo.

Fujii's sculpture testifies to the depth of an artistic tradition that has continued to produce visually exciting works for 14,000 years. The artist has achieved something entirely new, yet his work also embodies the love of asymmetry, respect for natural materials, and dramat-

ic simplicity encountered throughout the history of Japanese art. Whatever the future of art in Japan, and despite influence of the West, these principles will undoubtedly continue to lead to new combinations of tradition and creativity.

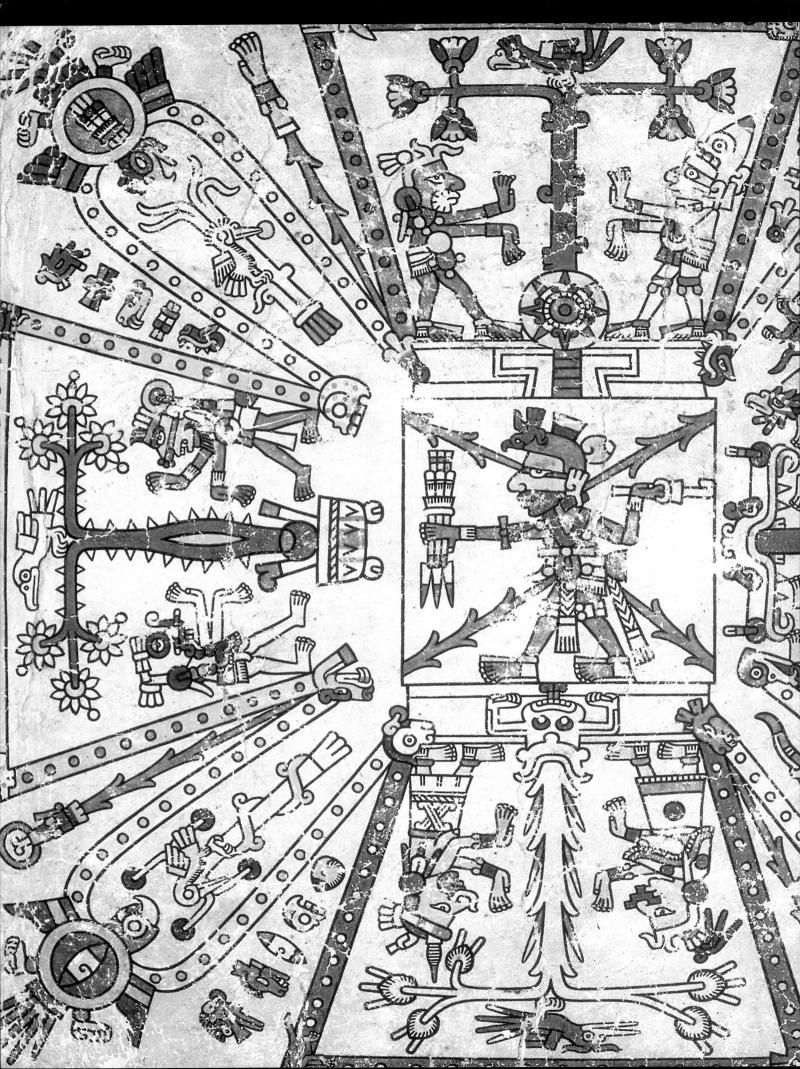

23

ART OF THE AMERICAS AFTER 1300

ARLY IN NOVEMBER 1519, THE ARMY OF THE Spanish conquistador Hernán Cortés beheld for the first time the great Aztec capital of Tenochtitlan. The shimmering city, which seemed to be floating on the water, was built on islands in the middle of Lake Texcoco in the Valley of Mexico, linked by broad causeways to the mainland. One of Cortés's companions later recalled the wonder the Spanish felt at that moment: "When we saw so many cities and villages built on the water and other great towns and that straight and level causeway going towards [Tenochtitlan], we were amazed . . . on account of the great towers and [temples] and buildings rising from the water, and all built of masonry. And some of our soldiers even asked whether the things that we saw were not a dream" (cited in Berdan, page 1).

The startling vision that riveted Cortés's soldiers was indeed real, a city of stone built on islands—a city that held many treasures and many mysteries. Much of the period before the conquistadores' arrival remains enigmatic, but a rare manuscript that survived the Spanish Conquest of Mexico depicts the preconquest worldview of the native peoples. At the center of the image here is the ancient fire god Xiuhtecutli (fig. 23-1). Radiating from him are the four directions—each associated with a specific color, a deity, and a tree with a bird in its branches. In each corner, to the right of a **U**-shaped band, is an attribute of Tezcatlipoca, the Smoking Mirror, an omnipotent, primal deity who could see humankind's thoughts and deeds—in the upper right a head, in the upper left an arm, in the lower left a foot, and in the lower right bones. Streams of blood flow from these attributes to the fire god in the center. Such images are filled with important, symbolically coded information—even the dots refer to the number of days in one aspect of the Mesoamerican calendar—and they were integral parts of the culture of the Americas.

23-1. A view of the world, page from *Codex Fejervary-Mayer*. Aztec or Mixtec, c. 1400–1519/21. Paint on animal hide, each page $6^7/_8 \times 6^7/_8$ " (17.5 × 17.5 cm), total length 13′3" (4.04 m). The National Museums and Galleries on Merseyside, Liverpool, England.

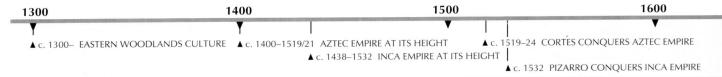

TIMELINE 23-1. The Americas after 1300. The two most powerful indigenous empires in Mesoamerica and South America after 1300 were the Aztec and the Inca. (Aztec civilization arose about 1135 ce, Inca as early as 800 ce.) Native North American cultures go back to the second millennium BCE, and major regional peoples continue their cultural heritage today.

Map 23-1. The **Americas** after 1300. Diverse peoples spread throughout the Americas, each shaping a distinct culture in the area it settled

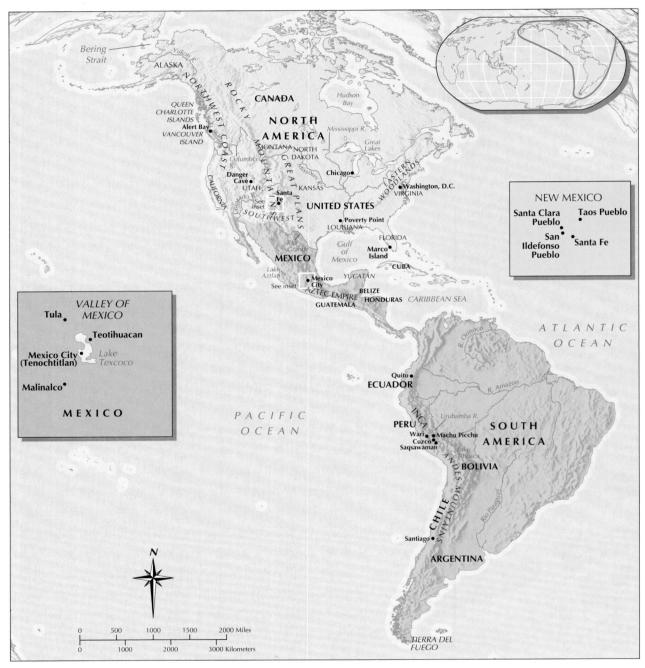

AMERICAN ART

INDIGENOUS When the first European explorers and conquerors arrived in 1519, the Western Hemisphere was already inhabited from the Arctic Circle to Tierra del Fuego

by peoples with long and complex histories and rich and varied cultural traditions (see "Foundations of Civilization in the Americas," opposite). This chapter focuses on

the arts of the indigenous peoples of Mesoamerica, Andean South America, and North America (Map 23-1) just prior to and in the wake of their encounter with an expansionist Europe.

Although art was central to their lives, the peoples of the Americas set aside no special objects as "works of art." Some objects were essentially utilitarian and others had ritual uses and symbolic associations,

▲ c. 1885–1951 WINTER CEREMONY OUTLAWED

FOUNDATIONS OF CIVILIZATION IN THE AMERICAS

Humans first arrived in the Western Hemisphere between 20,000 and 30,000 years ago by way of a land bridge in the Bering region that connected Asia and North America during the last Ice Age. By 12,000 years ago they had spread over both North and South America and in many regions developed a settled, agricultural way of life. In Mesoamerica, in the Andean region of South America, and for a time in what is now the southeastern United States, they developed hierarchical, urban societies with monumental architecture and elaborate artistic traditions.

Mesoamerica extends from north of the Valley of Mexico into Central America. The civilizations that arose there shared a number of features, including writing, a complex calendrical system, a ritual ball game, and several deities and religious beliefs. Their religious prac-

tices included blood and human sacrifice. The earliest Mesoamerican civilization, that of the Olmec, flourished between about 1200 and 400 BCE. The so-called Mesoamerican Classic period, during which rulers built hundreds of cities with large buildings, monumental sculptures, and with hieroglyphic writing recorded their deeds in astronomical and ritual contexts, lasted from about 300 to 900 ce. Two cultures were dominant during this period: the Maya and Teotihuacan.

Maya civilization dominated the area now occupied by southern Mexico, Guatemala, Belize, and northwestern Honduras. The Maya developed Mesoamerica's most sophisticated writing and calendrical systems and built large cities with monumental buildings and sculpture. The city of Teotihuacan, which exerted widespread influence throughout Mesoamerica, dominated the Valley of Mexico. New cultures and forms of government followed, stimulating another cultural florescence in the northern Yucatan Peninsula and the highlands of Guatemala. In the thirteenth century, the Aztec settled and soon dominated the Valley of Mexico. To the south, the Inca, heirs to an equally lengthy and complex cultural legacy-including the great civilizations of Chavin, Moche, Nasca, Paracas, and Wari-controlled the entire Andean region by the end of the fifteenth century.

In North America, the people of what is now the southeastern United States adopted a settled way of life by around the end of the second millennium BCE and began building monumental earthworks as early as 1700 BCE at Poverty Point, Louisiana. The people of the American Southwest developed a settled, agricultural way of life during the first millennium ce. By around 550 ce the Anasazi-the forebears of the modern Pueblo peoples-began building multistoried, apartmentlike structures with many specialized rooms

but people drew no distinctions between art and other aspects of material culture or between the fine arts and the decorative arts. Understanding Native American art thus requires an understanding of the cultural context in which it was made, a context that in many cases has been lost to time or to the disruptions of the European conquest. Fortunately, art history and archaeology have helped recover at least some of that lost context (see Craft or Art?, page 840).

AND SOUTH

MEXICO Two great empires—the Aztec in Mexico and the Inca in South America-rose to prominence in **AMERICA** the fifteenth century at about the same time that European adven-

turers began to explore the oceans in search of new trade routes to Asia (Timeline 23-1). In the encounter that followed, the Aztec and Inca empires were destroyed.

THE AZTEC EMPIRE

The Mexica people who lived in the remarkable city that Cortés found in the early sixteenth century were then rulers of much of the land that took their name. Mexico. Their rise to power had been recent and swift. Only 400 years earlier, according to their own legends, they had

been a nomadic people living northwest of the Valley of Mexico on the shores of the mythological Lake Aztlan (the source of the word Aztec, by which they are commonly known).

At the urging of their patron god, Huitzilopochtli, the Aztec began a long migration away from Lake Aztlan, arriving in the Valley of Mexico in the thirteenth century. Driven from place to place, they eventually ended up in the marshes on the edge of Lake Texcoco. There they settled on an island where they had seen an eagle perching on a prickly pear cactus (tenochtli), a sign that Huitzilopochtli told them would mark the end of their wandering. They called the place Tenochtitlan. The city grew on a collection of islands linked by canals.

Through a series of alliances and royal marriages, the Aztec rose to prominence, emerging less than a century before the arrival of Cortés as the head of a powerful alliance and the dominant power in the valley. Only then did they begin the aggressive expansion that brought them tribute from all over central Mexico and transformed Tenochtitlan into the glittering capital that so impressed the invading Spanish.

Aztec society was divided into roughly three classes: an elite of rulers and nobles, a middle class of professional merchants and luxury artisans, and a lower

CRAFT OR ART?

In many world cultures, the distinction between "fine art" and "craft" does not exist. The traditional Western academic hierarchy of materials—in which marble, bronze, oil, and fresco are valued more than terra-cotta and watercolor—and the equally artificial hierarchy of subjects in which history painting, including religious history, stands supreme are irrelevant to non-Western art.

The indigenous peoples of the Americas did not produce objects as works of art. In their eyes all pieces were utilitarian objects, adorned in ways necessary for their intended purposes. A work was valued for its effectiveness and for the role it played in society. Some, like a Sioux baby carrier (see fig. 23-10), enrich mundane life with their aesthetic qualities. Others, such as Pomo baskets (see "Basketry," page 846), commemorate important events. The function of an Inca tunic

may has conferred status on its owner or user through its material value or symbolic associations. And like art in all cultures, many pieces have had great spiritual or magical power. Such works of art cannot be fully comprehended or appreciated when they are seen only on pedestals or encased in glass boxes in museums or galleries. They must be imagined, or better yet seen, as acting in their societies. How powerfully might our minds and emotions be engaged if we saw Kwakwaka'wakw (Kwakiutl) masks functioning in religious drama, changing not only the outward appearance, but also the very essence of the individual.

At the beginning of the twentieth century, European and American artists broke away from the academic bias that extolled the classical heritage of Greece and Rome. They found new inspiration in the art—or craft, if you will—of many different non-European cultures. Artists ex-

plored a new freedom to use absolutely any material or technique that effectively challenged outmoded assumptions and opened the way for a free and unfettered delight in, and understanding of, Native American art as well as the art of other non-Western cultures. The intellectual community as well as collectors, dealers, and critics have come to appreciate the non-Western aesthetics and to treasure forgotten and ignored arts on their own terms. And the later twentiethand twenty-first centuries' conception of art as a multimedia adventure has helped validate works of art once seen only in ethnographic collections and in the homes of private collectors. Today objects once called "primitive" are recognized as great works of art and acknowledged to be an essential dimension of a twenty-first-century worldview. The line between "art" and "craft" seems more artificial and less relevant than ever before.

class of farmers and laborers. Aztec religion was based on a complex pantheon that combined the Aztec deities with more ancient ones that had long been worshiped in central Mexico. According to Aztec belief, the gods had created the current universe at the ancient city of Teotihuacan in the Valley of Mexico. Its continued existence depended on human actions, including rituals of bloodletting and human sacrifice. The end of each round of fifty-two years in the Mesoamerican calendar was a particularly dangerous time, requiring a special fire-lighting ritual. Sacrificial victims sustained the sun god, Huitzilopochtli, in his daily course through the sky. Huitzilopochtli was the son of the earth mother Coatlicue. When Coatlicue conceived Huitzilopochtli by holding within her chest a ball of hummingbird feathers (the soul of a fallen warrior) that had dropped from the sky, her other children—the stars and the moon jealously conspired to kill her. When they attacked, Huitzilopochtli emerged from his mother's body fully grown and armed, drove off his half brothers, and destroyed his half sister, the moon goddess Coyolxauhqui. As the sun born from the mother earth, Huitzilopochtli every day at dawn must again fight off the darkness, killing the stars (his 400 brothers) and the moon (his sister).

Most Aztec books were destroyed in the wake of the Spanish Conquest, but the work of Aztec scribes appears in several documents created for Spanish administrators afterward. The first page of the *Codex Mendoza*, prepared for the Spanish viceroy in the sixteenth century, can be interpreted as an idealized representation of

both the city of Tenochtitlan and its sacred ceremonial precinct (fig. 23-2). An eagle perched on a prickly pear cactus—the symbol of the city—fills the center of the page. Waterways divide the city into four quarters, which are further subdivided into wards, as represented by the seated figures. The victorious warriors at the bottom of the page represent Aztec conquests.

The focal point of the sacred precinct—probably symbolized in figure 23-2 by the temple or house at the top of the page—was the Great Pyramid, a 130-foot-high stepped double pyramid with dual temples on top, one of which was dedicated to Huitzilopochtli and the other to Tlaloc, the god of rain and fertility. Two steep staircases led up the west face of this structure from the plaza in front of it. Sacrificial victims climbed these stairs to the Temple of Huitzilopochtli, where several priests threw them over a stone and another quickly cut open their chests and pulled out their still-throbbing hearts. Their bodies were then rolled down the stairs and dismembered. Thousands of severed heads were said to have been kept on a skull rack in the plaza, represented in figure 23-2 by the rack with a single skull to the right of the eagle. During the winter rainy season the sun rose behind the Temple of Tlaloc, and during the dry season it rose behind the Temple of Huitzilopochtli. The double temple thus united two natural forces, sun and rain, or fire and water. During the spring and autumn equinoxes, the sun rose between the two temples, illuminating the Temple of Quetzalcoatl, the feathered serpent, an ancient creator god associated with the calendar, civilization, and the arts.

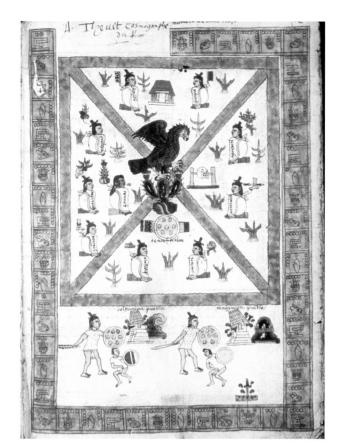

23-2. The Founding of Tenochtitlan, page from Codex Mendoza. Aztec, 16th century. Ink and color on paper, $12^3/_8 \times 8^7/_{16}$ " (21.5 × 31.5 cm). The Bodleian Library, University of Oxford, England.

MS. Arch Selden. A.1.fol. 2r

Sculpture of serpents and serpent heads on the Great Pyramid in Tenochtitlan associated it with the Hill of the Serpent, where Huitzilopochtli slew the moon goddess Coyolxauhqui. A huge circular relief of the dismembered goddess once lay at the foot of the temple stairs, as if the enraged and triumphant Huitzilopochtli had cast her there like a sacrificial victim (fig. 23-3). Her torso is in the center, surrounded by her head and limbs. A rope around her waist is attached to a skull. She has bells on her cheeks and balls of down in her hair. She wears a magnificent headdress and has distinctive ear ornaments composed of disks, rectangles, and triangles. The sculpture is two-dimensional in concept with a deeply cut background.

Like other Mesoamerican peoples, the Aztec intended their temples to resemble mountains. They also carved shrines and temples directly into the mountains surrounding the Valley of Mexico. A steep flight of stairs leads up to one such temple carved into the side of a mountain at Malinalco (fig. 23-4). The formidable entrance, meant to resemble the open mouth of the earth monster, leads into a circular room; the thatched roof is modern. If the temple itself is a mountain, surely this space is a symbolic cave, the womb of the earth. A pit for blood sacrifices opens into the heart of the moun-

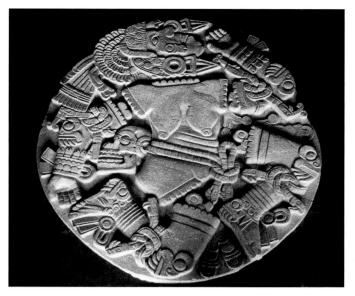

23-3. The Moon Goddess Coyolxauhqui ("She of the Golden Bells"), from the Sacred Precinct, now the Museo Templo Mayor, Tenochtitlan. Aztec, 1469 (?). Stone, diameter 10'10" (3.33 m). Museo Templo Mayor, Mexico City.

This disk was discovered in 1978 by workers from a utility company who were excavating at a street corner in central Mexico City.

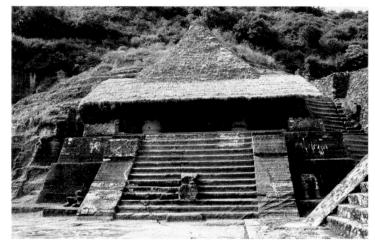

23-4. Rock-cut sanctuary, Malinalco, Mexico. Aztec, 15th century; modern thatched roof.

tain. A semicircular bench around the room is carved with stylized eagle and jaguar skins, symbols of two Aztec military orders, suggesting that members of those orders performed rites here.

The Spanish built their own capital, Mexico City, over the ruins of Tenochtitlan and built a cathedral on the site of Tenochtitlan's sacred precinct. An imposing statue of Coatlicue, mother of Huitzilopochtli, was found near the cathedral during excavations there in the late

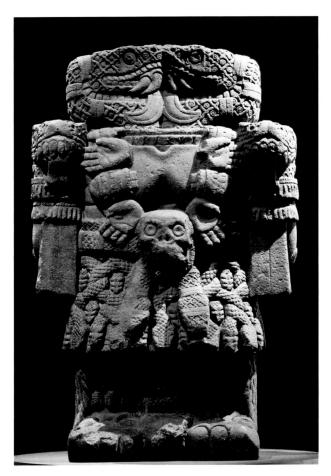

23-5. The Mother Goddess, Coatlicue. Aztec, 1487–1520. Basalt, height 8'6" (2.65 m). Museo Nacional de Antropología, Mexico City.

eighteenth century (fig. 23-5). One of the sixteenthcentury conquistadores described seeing such a statue covered with blood inside the Temple of Huitzilopochtli, where it would have stood high above the disk of the vanquished Coyolxauhqui. Coatlicue means "she of the serpent skirt," and this broad-shouldered figure with clawed hands and feet has a skirt of twisted snakes. A pair of serpents, symbols of gushing blood, rise from her neck to form her head. Their eyes are her eyes; their fangs, her tusks. The writhing serpents of her skirt also form her body. Around her stump of a neck hangs a necklace of sacrificial offerings-hands, hearts, and a dangling skull. Despite the surface intricacy, the sculpture's simple, bold, and blocky forms create a single visual whole. The colors with which it was originally painted would have heightened its dramatic impact.

THE INCA EMPIRE

At the beginning of the sixteenth century the Inca Empire was one of the largest states in the world, rivaling China in size. It extended more than 2,600 miles along western South America, encompassing most of modern Peru, Ecuador, Bolivia, and northern Chile and reaching into modern Argentina. Like the Aztec Empire, its rise had been recent and swift.

The Inca called their empire the Land of the Four Quarters. At its center was their capital, Cuzco, "the navel of the world," located high in the Andes Mountains. The early history of the Inca is obscure. The Cuzco region had been under the control of the earlier Wari Empire, and the Inca state was probably one of many small competing kingdoms that emerged in the highlands in the wake of the Wari collapse. In the fifteenth century the Inca began suddenly and rapidly to expand, and they subdued most of their vast domain-through conquest, alliance, and intimidation-by 1500. To hold their linguistically and ethnically diverse empire together, the Inca relied on an overarching state religion, a hierarchical bureaucracy, and various forms of labor taxation, in which the payment was a set amount of time spent performing tasks for the state. Agricultural lands were divided into three categories: those for the gods, which supported priests and religious authorities; those for the ruler and the state; and those for the local population itself. As part of their labor tax, people were required to work the lands of the gods and the state for part of each year. In return the state provided gifts through their local leaders and sponsored lavish ritual entertainments. Men served periodically on publicworks projects-building roads and terracing hillsides, for example-and in the army. The Inca also moved whole communities to best exploit the resources of the empire. Ranks of storehouses at Inca administrative centers assured the state's ability to feed its armies and supply the people working for it. No Andean civilization ever developed writing, but the Inca kept detailed accounts on knotted and colored cords.

To move their armies and speed transport and communication within the empire, the Inca built more than 23,000 miles of roads. These varied from 50-foot-wide thoroughfares to 3-foot-wide paths. Two main northsouth roads, one along the coast and the other through the highlands, were linked by east-west roads. Travelers went on foot, using llamas as pack animals. Stairways helped travelers negotiate steep mountain slopes, and rope suspension bridges allowed them to cross river gorges. The main road on the Pacific coast, a desert region, had walls to protect it from blowing sand. All along the roads, the Inca built administrative centers, storehouses, and roadside lodgings. These lodgingsmore than a thousand have been found—were spaced a day's journey apart. A relay system of waiting runners could carry messages between Cuzco and the farthest reaches of the empire in about a week.

Cuzco, a capital of great splendor, was home to the Inca, as the ruler of the Inca Empire was called, and the extended ruling group. The city, which may have been laid out to resemble a giant mountain lion, was a showcase of the finest Inca masonry, some of which can still be seen in the modern city. The walls of its most magnificent structure, the Temple of the Sun, served as the foundation for the Spanish colonial Church of Santo Domingo (fig. 23-6). Within the Temple of the Sun was a gold-adorned room dedicated to the sun and another, adorned with silver, dedicated to the moon.

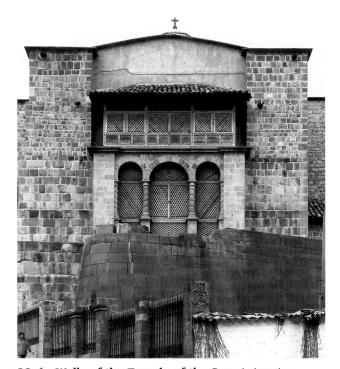

23-6. Walls of the Temple of the Sun, below the Church of Santo Domingo, Cuzco, Peru. Inca, 15th century. The curving lower wall formed part of the Inca Temple of the Sun,

The curving lower wall formed part of the Inca Temple of the Sun, also known as the Golden Enclosure or Court of Gold (*Coricancha*). Extending from this ritual center were shrines, radiating out in forty-one lines.

Inca masonry has survived earthquakes that have destroyed or seriously damaged later structures. Fine Inca masonry consisted of either rectangular blocks, as in figure 23-6, or irregular polygonal blocks. Both types were ground so that adjoining blocks fit tightly together without mortar (see "Inca Masonry," page 844). The blocks might be slightly **beveled** (cut at an angle) so that the stones had a pillowed form and each block retained its identity, or they might, as in figure 23-6, be smoothed into a continuous flowing surface in which the individual blocks form part of a seamless whole. Inca structures had gabled, thatched roofs. Doors, windows, and niches were trapezoid shaped, narrower at the top than the bottom. The effort expended on building by the Inca was prodigious. Erecting the temple fortress of Saqsawaman in Cuzco, for example, was reputed to have occupied 30,000 workers for many decades.

Machu Picchu, one of the most spectacular archaeological sites in the world, provides an excellent example of Inca architectural planning (fig. 23-7). At 9,000 feet above sea level, it straddles a ridge between two high peaks in the eastern slopes of the Andes and looks down on the Urubamba River. Stone buildings, today lacking only their thatched roofs, occupy terraces around central plazas, and narrow agricultural terraces descend into the valley. The site, near the eastern limits

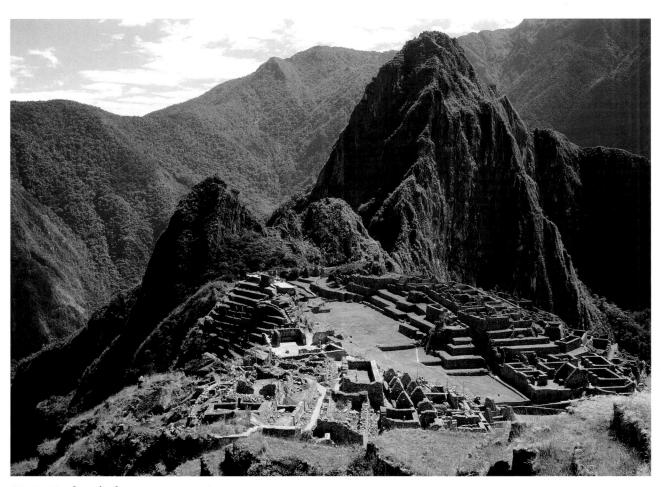

23-7. Machu Picchu, Peru. Inca, 1450–1530.

ELEMENTS of ARCHITECTURE

INCA MASONRY

Working with the simplest of tools—mainly heavy stone hammers—and using no mortar, Inca builders created stonework of great refinement and durability: roads and bridges that linked the entire empire, built-up terraces for growing crops, and structures both simple and elaborate. At Machu Picchu (see fig. 23-7), all buildings and terraces within its 3-square-mile extent were made of

granite, the hard stone occurring at the site. Commoners' houses and some walls were constructed of irregular stones that were carefully fitted together. Some walls and certain domestic and religious structures were erected using squared-off, smooth-surfaced stones laid in even rows. At a few Inca sites, the stones used in construction were boulder-size: up to 27 feet tall.

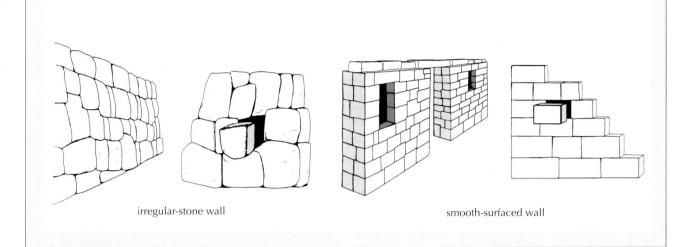

of the empire, was the estate of the Inca Pachacuti (ruled 1438–71). Its temples and carved sacred stones suggest that it also had an important religious function. Special stones, left natural, were set up in courtyard shrines.

The production of fine textiles is of ancient origin in the Andes, and textiles were one of the primary forms of wealth for the Inca. One kind of labor taxation was the required manufacture of fibers and cloth, and textiles as well as agricultural products filled Inca storehouses. Cloth was deemed a fitting offering for the gods, so fine garments were draped around golden statues, and three-dimensional images were constructed of cloth. The patterns and designs on garments were not simply decorative but also carried important symbolic messages, including indications of a person's ethnic identity and social rank. Each square in the tunic shown in figure 23-8 represents a miniature tunic, but the meaning of the individual patterns is not yet completely understood. The four-part motifs may refer to the Land of the Four Quarters. The checkerboard pattern designated military officers and royal escorts. The meaning of the diagonal key motif is not known, but it is often found on tunics with horizontal border stripes.

The Spanish, who under the conquistador Francisco Pizarro conquered the Inca Empire in 1532, were far

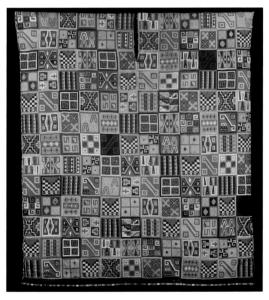

23-8. Tunic, from Peru. Inca, c. 1500. Wool and cotton, $35^{7}/_{8} \times 30''$ (91 × 76.5 cm). Dumbarton Oaks Research Library and Collections, Pre-Columbian Collection, Washington, D.C.

Inca textile patterns and colors were standardized, like European heraldry or the uniforms of today's sports teams, to convey information at a glance.

more interested in the Inca's vast quantities of gold and silver objects than in their cloth. Whatever they found, they melted down to enrich themselves and the royal coffers of Spain. The Inca, in contrast, valued gold and silver not as precious metals in themselves but because they saw in them symbols of the sun and the moon. They are said to have called gold the sweat of the sun and silver the tears of the moon. Some small figures, buried as offerings, escaped the conquerors' treasure hunt. The small llama shown in figure 23-9 was found near Lake Titicaca. The llama was thought to have a special connection with the sun, with rain, and with fertility, and one was sacrificed to the sun every morning and evening in Cuzco. Also in the capital, a white llama was kept as the symbol of the Inca. Dressed in a red tunic and wearing gold jewelry, this llama passed through the streets during April celebrations. According to Spanish commentators, these processions included lifesize gold and silver images of llamas, people, and gods.

AMERICA

NORTH In America north of Mexico, many different peoples (all with very different cultures) were established, from the upper reaches of Canada and Alaska

to the southern tip of Florida. We will look at only four areas: the Eastern Woodlands and the Great Plains, the Northwest Coast, and the Southwest. Much of the art produced in North America was small, portable, fragile, and impermanent, and until recently its aesthetic quality was unappreciated.

EASTERN WOODLANDS AND THE GREAT PLAINS

Forest-covered eastern North America was first settled by early peoples who had built great earthworks and cities, established widespread trading networks, and buried their leaders with treasures of copper and mica before being eradicated by famine, warfare, or disease. New groups then moved into the Eastern Woodlands, establishing settlements from the Hudson Bay to the Gulf of Mexico and from the Atlantic coast to the Mississippi and Missouri river watersheds. The Native American peoples of the Eastern Woodlands supported themselves by a combination of hunting and agriculture. They lived in villages and cultivated corn, squash, and beans. They used flexible, waterproof birch bark to construct their homes and their canoes, which were extremely functional watercraft. They reestablished extensive trade routes using the rivers and the Great Lakes.

The arrival in the seventeenth century on the Atlantic coast of a few boatloads of Europeans seeking religious freedom and a new life in no way resembled Cortés's and Pizarro's bloody conquests of the Aztec and Inca empires. Trade with the settlers gave the Woodlands peoples access to things they valued. They exchanged furs for such useful items as metal kettles and needles, cloth, and beads. They prized objects and materials with bright sparkling and reflecting surfaces, such

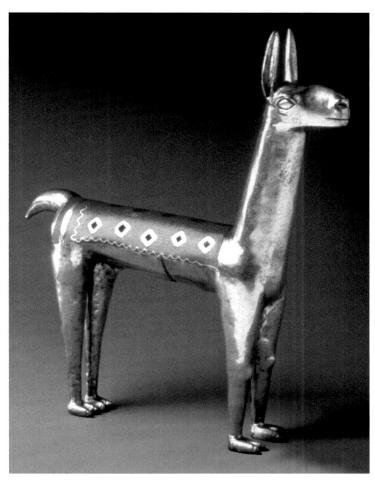

23-9. Llama, from Bolivia or Peru, found near Lake Titicaca, Bolivia. Inca, 15th century. Cast silver with gold and cinnabar, $9 \times 8^{1}/_{2} \times 1^{3}/_{4}$ " (22.9 × 21.6 × 4.4 cm). American Museum of Natural History, New York.

as mirrors, glass, and polished metal, which to them had spiritual values.

Woodlands peoples had long made wampum belts and strings of cylindrical purple and white shell beads. The Iroquois and Delaware, both Woodlands peoples, used wampum to keep records (the beads' purple patterns served as memory devices) and exchanged it to conclude treaties: Wampum strings and belts had the power of legal agreement and also symbolized a moral order.

Woodlands art focused on personal adornment tattoos, body paint, elaborate dress-and fragile arts such as quillwork. Quillwork involved soaking porcupine and bird quills to soften them, then working them into rectilinear, ornamental surface patterns on deerskin clothing and on birch-bark artifacts like baskets and boxes. A Sioux legend recounts how a mythical ancestor, Doublewoman ("double" because she was both beautiful and ugly, benign and dangerous), appeared to a woman in a dream and taught her the art of quillwork. As the legend suggests, quillwork was a woman's Basketry is the weaving of reeds, grasses, and other materials to form containers. In North America the earliest evidence of basketwork, found in danger Cave, Utah, dates to as early as

8400 BCE. Over the subsequent centuries, native American women, notably in California and the southwest, developed basketry into an art form that combined utility with great beauty.

There are three principal basket-making techniques: **coiling**, **twining**, and **plaiting**. Coiling involves sewing together a spiraling foundation of rods with some other material. Twining involves sewing together a vertical **warp** of rods. Plaiting involves weaving strips over and under each other.

The coiled basket shown here was made by the Pomo of California. According to Pomo legend, the earth was dark until their ancestral hero stole the sun and brought it to earth in a basket. He hung the basket first just over the horizon, but, dissatisfied with the light it gave, he kept suspending it in different places across the dome of the sky. He repeats this process every day, which is why the sun moves across the sky from east to west. In the Pomo basket the structure of coiled willow and bracken fern root produces a spiral surface into which the artist worked sparkling pieces of clamshell,

TECHNIQUE Basketry

trade beads, and the soft tufts of woodpecker and quail feathers. The underlying basket, the glittering shells, and the soft, moving feathers make this an exquisite container. Such bas-

kets were treasured possessions, cremated with their owners at death.

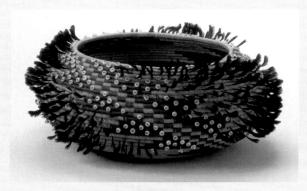

Feathered bowl wedding basket. Pomo, c. 1877. Willow, bulrush, fern, feather, shells, glass beads. Height $5^1\!\!/_2$ " (14 cm), diameter 12" (36.5 cm). Philbrook Museum, Tulsa, Oklahoma.

Clark Field Collection (1948.39.37)

art form, as was basketry (see "Basketry," above). The Sioux baby carrier shown in figure 23-10 is richly decorated with symbols of protection and well-being, including bands of antelopes in profile and thunderbirds with their heads turned and tails outspread. (The thunderbird was an especially beneficent symbol, thought to be capable of protecting against both human and supernatural adversaries.)

In spite of the use of shell beads in wampum, decorative **beadwork** did not become commonplace until after European contact. In the late eighteenth century, Native American artists began to acquire European colored glass beads, and in the nineteenth century they favored the tiny seed beads from Venice and Bohemia. Early beadwork mimicked the patterns and colors of quillwork—in some places in the nineteenth century it even replaced quillwork—but beadwork came to incorporate European design in a process known as reintegration. About 1830 Canadian nuns introduced Native American artists to embroidered European floral designs, and the embroiderers began to adapt European needlework techniques and patterns from European garments into their own work. Some of the functional aspects of those garments were transformed into purely decorative motifs; a pocket, for example, would be replaced by an area of beadwork in the form of a pocket. A shoulder bag from Kansas, made by a

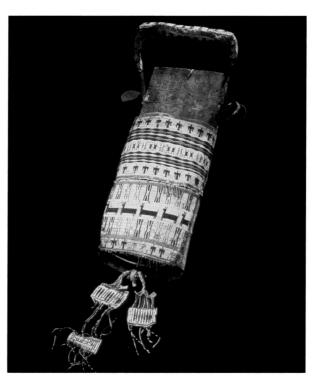

23-10. Baby carrier, from the Upper Missouri River area. Eastern Sioux, 19th century. Board, buckskin, porcupine quill, length 31" (78.8 cm). Department of Anthropology, Smithsonian Institution Libraries, Washington, D.C. (Catalogue No. #7311)

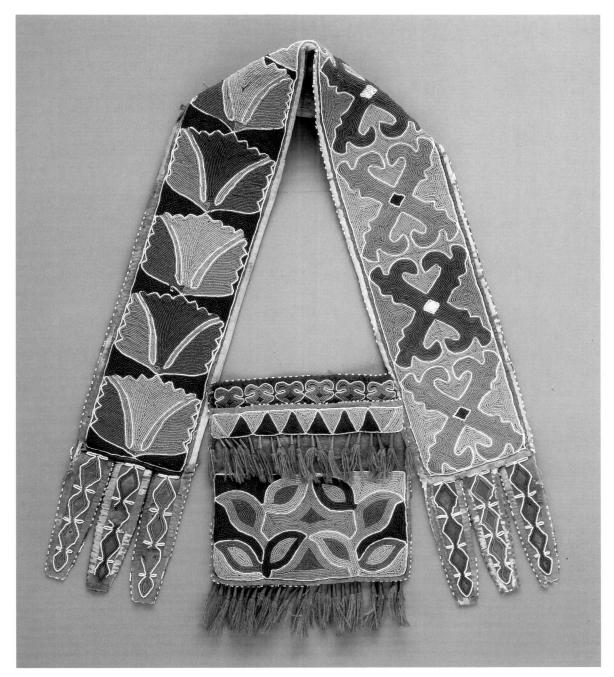

23-11. Shoulder bag, from Kansas. Delaware, c. 1860. Wool fabric, cotton fabric and thread, silk ribbon, and glass beads, $23 \times 7^3/4$ " (58.5 × 19.8 cm). The Detroit Institute of Arts. Founders Society Purchase (81.216)

Brilliant bags such as this one were worn by men at public intertribal events.

Delaware woman, exemplifies the evolution of beadwork design (fig. 23-11): In contrast to the rectilinear patterns of quillwork, this Delaware bag is covered with curvilinear plant motifs. White lines outline brilliant pink and blue leaf-shaped forms, heightening the intensity of the colors, and colors alternate within repeated patterns.

Over time, the Woodlands people were pushed westward by European settlers. They eventually reached an area of prairie grasslands now known as the Great Plains. In this sparsely inhabited region they

adopted a nomadic life-style based on the wild, free-roaming herds of horses descended from horses introduced by the Spanish. A distinctive Plains culture flourished from about 1700 to about 1870. The Plains peoples domesticated horses and, armed with rifles acquired through trade, became hunters and warriors. They also traded with Europeans for equipment and the highly prized beads.

The nomadic Plains peoples hunted buffalo for food as well as for hides from which they created clothing

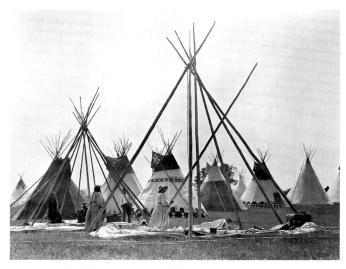

23-12. Blackfoot women raising a tepee. Photographed c. 1900. Montana Historical Society, Helena.

and a light, portable dwelling known as a tepee (fig. 23-12), which was well designed to withstand the wind, dust, and rain of the prairies. The framework of a tepee consisted of a stable frame of three or four long poles, filled out with about twenty additional poles, in a roughly egg-shaped plan. The framework was covered with hides (or, later, with canvas) to form an almost conical structure that leaned slightly in the direction of the prevailing west wind. The hides were specially prepared to make them flexible and waterproof. A typical tepee required about eighteen hides, the largest about thirtyeight hides. An opening at the top served as a smoke hole for the central hearth. The flap-covered door and smoke hole usually faced east, away from the wind. An inner lining covered the lower part of the walls and the perimeter of the floor to protect the occupants from drafts. When packed to be dragged by a horse to another location, the tepee served as a platform for transporting other possessions as well. When the Blackfoot gathered in the summer for their ceremonial Sun Dance, they formed their hundreds of tepees into a circle a mile in circumference. The Sioux encamped in two half circles—one for the sky people and one for the earth people—divided along an east-west axis.

Tepees were the property and responsibility of women, who raised them at new encampments and lowered them when the group moved on. Blackfoot women could set up their huge tepees in less than an hour. Women painted, embroidered, quilled, and beaded tepee linings, backrests, clothing, and equipment. The patterns with which tepees were decorated, as well as their proportions and colors, varied from Native American nation to nation. In general, the bottom was covered with a group's traditional motifs and the center section with personal images.

Plains men recorded their exploits in symbolic and narrative form in paintings on tepee linings and covers and on buffalo-hide robes. The earliest known painted buffalo-hide robe illustrates a battle fought in 1797 by

the Mandan of North Dakota and their allies against the Sioux (fig. 23-13). The painter, trying to capture the full extent of a conflict in which five nations took part, shows a party of warriors in twenty-two separate episodes. Their leader appears with a pipe and wears an elaborate eagle-feather headdress. The party is armed with bows and arrows, lances, clubs, and flintlock rifles. The lively stick figures of the warriors have rectangular torsos and tiny round heads. Details of equipment and emblems of rank—headdresses, sashes, shields, feathered lances, powder horns for the rifles—are accurately depicted. Horses are shown in profile with stick legs and C-shaped hooves; some have clipped manes, others have flowing manes. The figures stand out clearly against the light-colored background of the buffalo hide; to make them, the painter pressed lines into the hide, then added black, red, green, yellow, and brown pigments. A strip of colored porcupine quills runs down the spine. The robe would have been worn draped over the shoulders of the powerful warrior whose deeds it commemorates. As he moved, the painted horses and warriors would have come alive, transforming him into a living representation of his exploits.

Life on the Great Plains changed abruptly in 1869, when the Euro-Americans finished the transcontinental railway linking the coasts of the United States and providing easy access to Native American lands. By 1885 Euro-American hunters had killed off the buffalo, and soon ranchers and then farmers moved into the plains. The Euro-Americans forcibly settled the outnumbered and outgunned Native Americans on reservations, land considered worthless until the later discovery of oil there.

THE NORTHWEST COAST

From southern Alaska to northern California, the Pacific coast of North America is a region of unusually abundant resources. Its many rivers fill each year with salmon returning to spawn. Harvested and dried, the

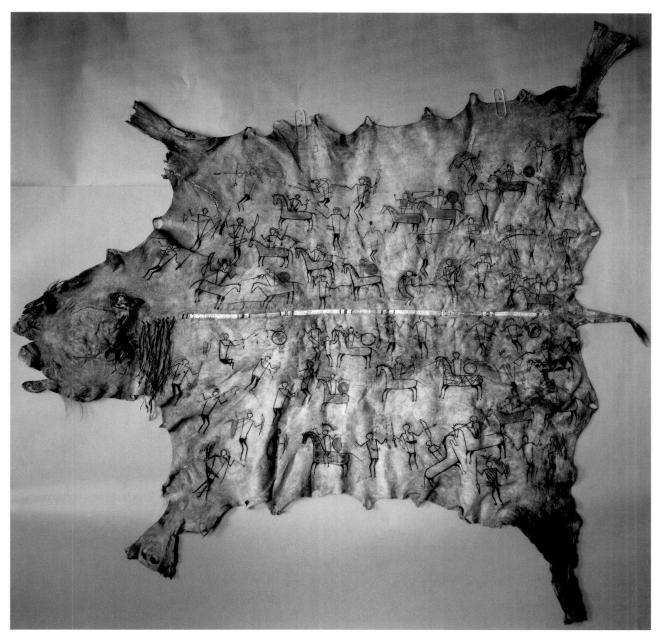

23-13. Battle-scene hide painting, from North Dakota. Mandan, 1797–1800. Tanned buffalo hide, dyed porcupine quills, and black, red, green, yellow, and brown pigment, 7'10" × 8'6" (2.44 × 2.65 m). Peabody Museum of Archaeology, Harvard University, Cambridge, Massachusetts. (99-12-10/53121)

This robe, collected in 1804 by Meriwether Lewis and William Clark on their 1804—6 expedition into western lands acquired by the United States in the Louisiana Purchase, is the earliest documented example of Plains painting. It was one of a number of Native American art works that Lewis and Clark sent to President Thomas Jefferson. Jefferson displayed the robe in the entrance hall of his home at Monticello, Virginia.

fish could sustain large populations throughout the year. The peoples of the Northwest Coast—among them the Tlingit, the Haida, and the Kwakwaka'wakw (or Kwakiutl)—exploited this abundance to develop a complex and distinctive way of life in which the arts played a central role.

Northwest Coast peoples lived in extended family groups in large, elaborately decorated communal houses made of massive timbers and thick planks. Family groups claimed descent from a mythic animal or animal-

human ancestor. Social rank within and between related families was based on genealogical closeness to the mythic ancestor. Chiefs, who were in the most direct line of descent from the ancestor, administered a family's spiritual and material resources. Chiefs validated their status and garnered prestige for themselves and their families by holding ritual feasts in which they gave valuable gifts to the invited guests. Shamans, who were sometimes also chiefs, mediated between the human and spirit worlds. A family derived its name and the right

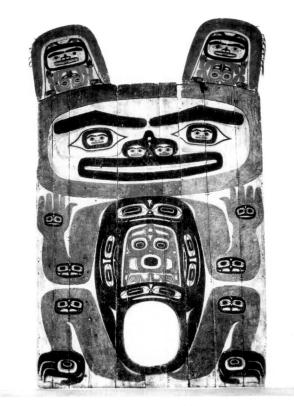

23-14. Grizzly bear house-partition screen, from the house of Chief Shakes of Wrangell, Canada. Tlingit, c. 1840. Cedar, native paint, and human hair, $15 \times 8'$ (4.57 \times 2.74 m). Denver Art Museum.

Purchase from Altmen Antiques (1951.315)

to use certain animals and spirits as totemic emblems, or crests, from its mythic ancestor. These emblems appeared prominently in Northwest Coast art, notably in carved house crests and the tall, freestanding poles erected to memorialize dead chiefs.

Carved and painted house-partition screens separated a chief's quarters from the rest of a communal house. The screen shown in figure 23-14 came from the house of Chief Shakes of Wrangell (d. 1916), whose family crest was the bear. The image of a rearing grizzly painted on the screen is itself made up of smaller bears and bear heads that appear in its ears, eyes, nostrils, joints, paws, and body. The images within the image enrich the monumental symmetrical design. The oval door opening is a symbolic vagina; passing through it reenacts the birth of the family from its ancestral spirit.

Blankets and other textiles produced by the Chilkat Tlingit had great prestige throughout the Northwest Coast (fig. 23-15). Chilkat men created the patterns, which they drew on boards, and women did the weaving. The blankets are made from shredded cedar bark wrapped with mountain-goat wool. The weavers did not use looms; instead, they hung **warp** threads from a rod and twisted colored threads back and forth through them to make the pattern. The ends of the warp formed the fringe at the bottom of the blanket.

The small face in the center of the blanket shown here represents the body of a stylized creature, perhaps a sea bear (a fur seal) or a standing eagle. On top of the body are the creature's large eyes; below it and to the sides are its legs and claws. Characteristic of Northwest painting and weaving, the images are composed of two basic elements: the **ovoid**, a slightly bent rectangle with rounded corners, and the **formline**, a continuous, shapedefining line. Here, subtly swelling black formlines define shapes with gentle curves, ovoids, and rectangular C shapes. When the blanket was worn, its two-dimensional forms would have become three-dimensional, with the dramatic central figure curving over the wearer's back and the intricate side panels crossing over his shoulders and chest.

Many Native American cultures stage ritual dance ceremonies to call upon guardian spirits. The participants in Northwest Coast dance ceremonies wore elaborate costumes and striking carved wooden masks. Among the most elaborate masks were those used by the Kwakwaka'wakw (or Kwakiutl) in their Winter Ceremony for initiating members into the shamanistic Hamatsa society (figs. 23-16, 23-17, "The Object Speaks: Hamatsa Masks," pages 852–53). The dance reenacted the taming of Hamatsa, a people-eating spirit, and his three attendant bird spirits. Magnificent carved and painted masks trans-

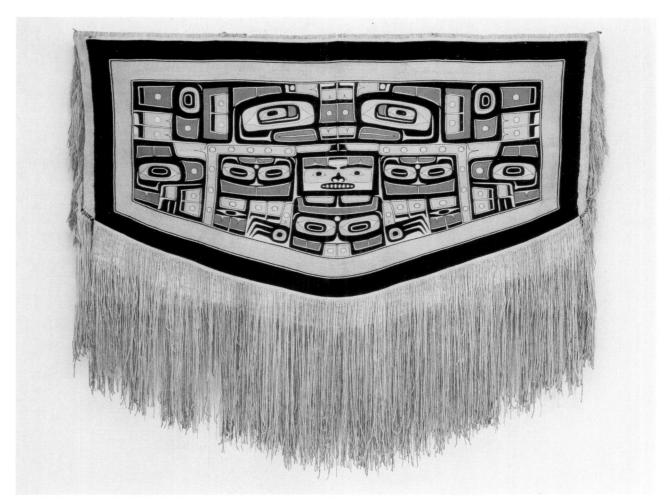

23-15. Chilkat blanket. Tlingit, before 1928. Mountain-goat wool and shredded cedar bark, $55^{1}/8$ " \times $63^{3}/4$ " (140 \times 162 cm). American Museum of Natural History, New York. Trans. #3804

formed the dancers into Hamatsa and the bird attendants, who searched for victims to eat. Strings allowed the dancers to manipulate the masks so that the beaks opened and snapped shut with spectacular effect.

THE SOUTHWEST

The Native American peoples of the southwestern United States include the Pueblo (village-dwelling) groups and the Navajo. The Pueblo groups are heirs to the ancient Anasazi and Hohokam cultures, which developed a settled, agricultural way of life around 550 ce. The Anasazi built the many large, multistoried, apartment-like villages and cliff dwellings whose ruins are found throughout northern Arizona and New Mexico. The Navajo, who moved into the region about the eleventh century or later, developed a semisedentary way of life based on agriculture and, after the introduction of sheep by the Spanish, sheepherding. Both groups succeeded in maintaining many of their traditions despite first Spanish and then Euro-American encroachments. Their arts reflect the adaptation of traditional forms to new tech-

nologies, new mediums, and the influences of the dominant American culture that surrounds them.

The Pueblos. Some Pueblo villages, like those of their Anasazi forebears, consist of multistoried, apartment-like dwellings of considerable architectural interest. One of these, Taos Pueblo, shown here in a photograph by Laura Gilpin, is located in north-central New Mexico (fig. 23-18, page 854). The northernmost of the surviving Pueblo communities, Taos once served as a trading center between Plains and Pueblo peoples. It burned in 1690 but was rebuilt about 1700 and has often been modified since. "Great houses," multifamily dwellings, stand on either side of Taos Creek, rising in a stepped fashion to form a series of roof terraces. The houses border a plaza that opens toward the neighboring mountains. The plaza and roof terraces are centers of communal life and ceremony.

Pottery traditionally was a woman's art among Pueblo peoples, whose wares were made by **coiling** and other hand-building techniques, then fired at low temperature in wood bonfires. The best-known

THE OBJECT SPEAKS

HAMATSA MASKS

Uring the harsh winter season, when spirits are thought to be most powerful, many northern people seek spiritual renewal through their ancient rituals—including the potlach, or ceremonial gift giving, and the initiation of new members into the prestigious Hamatsa Society. With snapping beaks and cries of "Hap! Hap! Hap!" ("Eat! Eat!"), Hamatsa, the people-eating spirit of the north, and his three assistants—horrible masked monster birds—begin their wild, ritual dance (fig. 23-16). The dancing birds threaten and even attack the Kwakwaka'wakw people who gather for the Winter Ceremony.

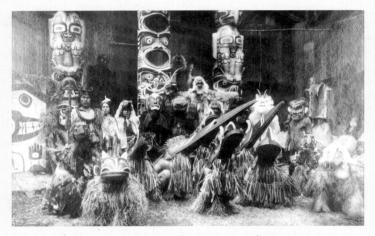

23-16. Edward S. Curtis. Hamatsa dancers, Kwakwaka'wakw, Canada. Photographed 1914. Smithsonian Institution Libraries, Washington, D.C.

The photographer Edward S. Curtis (1868–1952) devoted thirty years to documenting the lives of Native Americans. This photograph shows participants in a film he made about the Kwakwaka'wakw. For the film, his Native American assistant, Richard Hunt, borrowed family heirlooms and commissioned many new pieces from the finest Kwakwaka'wakw artists. Most of the pieces are now in museum collections. The photograph shows carved and painted posts, masked dancers (including those representing people-eating birds), a chief at the left (holding a speaker's staff and wearing a cedar neck ring), and spectators at the right.

In the Winter Ceremony, youths are captured, taught the Hamatsa lore and rituals, and then in a spectacular theater-dance performance are "tamed" and brought back into civilized life. All the members of the community, including singers, gather in the main room of the great house, which is divided by a painted screen (see fig. 23-14). The audience members fully participate in the performance; in early times, they brought containers of blood so that when the bird-dancers attacked them, they could appear to bleed and have flesh torn away.

Whistles from behind the screen announce the arrival of the Hamatsa (danced by an initiate), who enters through the central hole in the screen in a flesh-craving frenzy. Wearing hemlock, a symbol of the spirit world, he crouches and dances wildly with outstretched arms as attendants try to control him. He disappears but returns again, now wearing red cedar and dancing upright. Finally tamed, a full member of society, he even dances with the women.

Then the masked bird dancers appear-first Raven-ofthe-North-End-of-the-World, then Crooked-Beak-of-the-End-of-the-World, and finally the untranslatable Huxshukw, who cracks open skulls with his beak and eats the brains of his victims. Snapping their beaks, these masters of illusion enter the room backward, their masks pointed up as though the birds are looking skyward. They move slowly counterclockwise around the floor. At each change in the music they crouch, snap their beaks, and let out their wild cries of Hap! Hap! Essential to the ritual dances are the huge carved and painted wooden masks, articulated and operated by strings worked by the dancers. Among the finest masks are those by Willie Seaweed (1873-1967), a Kwakwaka'wakw chief (fig. 23-17), whose brilliant colors and exuberantly decorative carving style determined the direction of twentieth-century Kwakwaka'wakw sculpture.

The Canadian government, abetted by missionaries, outlawed the Winter Ceremony and potlaches in 1885, claiming the event was injurious to health, encouraged prostitution, endangered children's education, damaged the economy, and was cannibalistic. But the Kwakwaka'wakw refused to give up their "oldest and best" festival—one that spoke powerfully to them in many ways, establishing social rank and playing an important role in arranging marriages. By 1936 the government and the missionaries, who called the Kwakwaka'wakw "incorrigible," gave up. But not until 1951 could the Kwakwaka'wakw people gather for winter ceremonies, including the initiation rites of the Hamatsa Society.

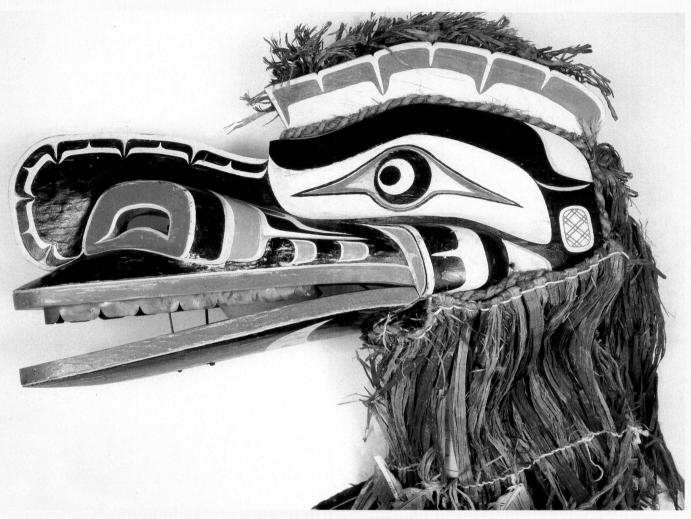

23-17. Attributed to Willie Seaweed. Kwakwaka'wakw Bird mask, from Alert Bay, Vancouver Island, Canada. Prior to 1951. Cedar wood, cedar bark, feathers, and fiber, $10 \times 72 \times 15$ " (25.4 \times 183 \times 38.1 cm). Collection of the Museum of Anthropology, Vancouver, Canada. (A6120)

The name *Seaweed* is an anglicization of the Kwakwaka'wakw name *Siwid*, meaning "Paddling Canoe," "Recipient of Paddling," or "Paddled To"—referring to a great chief to whose potlaches guests paddle from afar. Willie Seaweed was not only the chief of his clan, but a great orator, singer, and tribal historian who kept the tradition of the potlach alive during years of government repression.

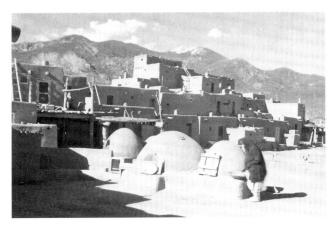

23-18. Laura Gilpin. Taos Pueblo. Tewa. Taos, New Mexico. Photographed 1947. Amon Carter Museum, Fort Worth, Texas.

© 1979 Laura Gilpin Collection (neg. # 2528.1)

twentieth-century Pueblo potter is Maria Montoya Martinez (1887–1980) of San Ildefonso Pueblo in New Mexico. Inspired by prehistoric **blackware** pottery that was unearthed at nearby archaeological excavations, she and her husband, Julian Martinez (1885–1943), developed a distinctive new ware decorated with **matte** (nongloss) black forms on a lustrous black background (fig. 23-19). Maria made pots covered with a **slip** that was then burnished. Using additional slip, Julian painted the pots with designs that combined traditional Pueblo imagery and the then fashionable Euro-American Art Deco style. After firing, the burnished

ground became a lustrous black and the slip painting retained a matte surface. Production of blackware in San Ildefonso had begun with Maria as potter and Julian as painter; by the 1930s, however, family members and friends all participated. Maria signed all the works so the entire community would profit from the market's appreciation of the Martinezes' skill.

In the 1930s Anglo-American art teachers and dealers worked with Native Americans of the Southwest to create a distinctive, stereotypical "Indian" style in several mediums—including jewelry, pottery, weaving, and painting—to appeal to tourists and collectors. A leader in this effort was Dorothy Dunn, who taught painting in the Santa Fe Indian School, a government high school in New Mexico, from 1932 to 1937. Dunn inspired her students to create a painting style that combined the outline drawing and flat colors of folk art, the decorative qualities of Art Deco, and "Indian" subject matter and came to be known as the Studio School. Restrictive as the school was, Dunn's success made painting a viable occupation for young Native American artists.

Pablita Velarde (b. 1918), a 1936 graduate of Dorothy Dunn's school, was only a teenager when one of her paintings was selected for exhibition at the Chicago World's Fair in 1933. Velarde, from Santa Clara Pueblo in New Mexico, began to document Pueblo ways of life as her work matured. Koshares of Taos (fig. 23-20) illustrates a moment during a ceremony celebrating the winter solstice when koshares, or clowns, take over the plaza from the kachinas—the supernatural counterparts of animals, natural phenomena like clouds, and geological features like mountains—who are central to traditional Pueblo religion. Kachinas become manifest in the human dancers

23-19. Maria Montoya Martinez and Julian Martinez. Blackware storage jar, from San Ildefonso Pueblo, New Mexico. c. 1942. Ceramic, height $18^3/_4$ " (47.6 cm), diameter $22^1/_2$ " (57.1 cm). Museum of Indian Arts and Culture/Laboratory of Anthropology, Museum of New Mexico, Santa Fe.

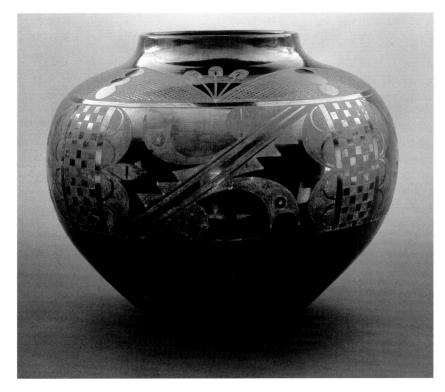

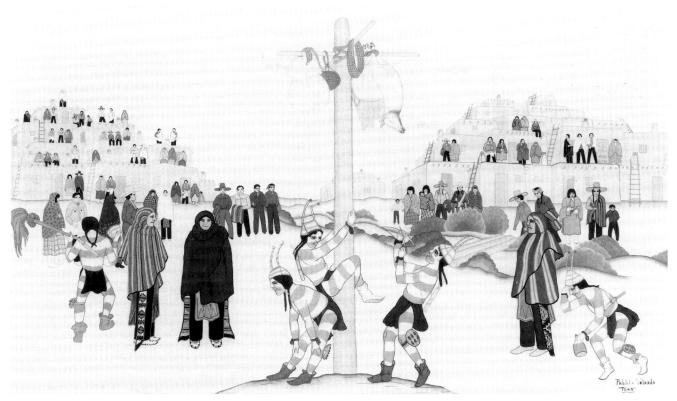

23-20. Pablita Velarde. *Koshares of Taos*, from Santa Clara Pueblo, New Mexico. 1946–47. Watercolor on paper, $13\frac{7}{8} \times 22\frac{3}{8}$ " (35.3 × 56.9 cm). Philbrook Museum of Art, Tulsa, Oklahoma. Museum Purchase (1947.37)

who impersonate them during the winter solstice ceremony, as well as in the small figures known as *kachina* dolls that are given to children. Velarde's painting combines bold, flat colors and a simplified decorative line with European perspective to produce a kind of Art Deco abstraction.

The Navajos. Navajo women are renowned for their skill as weavers. According to Navajo mythology, the universe itself is a kind of weaving, spun by Spider Woman out of sacred cosmic materials. Spider Woman taught the art of weaving to Changing Woman (a mother earth figure who constantly changes through the seasons), who in turn taught it to Navajo women. The earliest Navajo blankets have simple horizontal stripes, like those of their Pueblo neighbors, and are limited to the white, black, and brown colors of natural sheep's wool. Over time, the weavers developed finer techniques and introduced more intricate patterns. In the mid-nineteenth century, they began unraveling the fibers from commercially manufactured and dyed blan-

kets and reusing them in their own work. By 1870–90 they were weaving spectacular blankets that were valued as prestige items among the Plains peoples as well as Euro-American collectors.

Another traditional Navajo art, **sand painting**, is the exclusive province of men. Sand paintings are made to the accompaniment of chants by shaman-singers in the course of healing and blessing ceremonies and have great sacred significance (see "Navajo Night Chant," below). The paintings depict mythic heroes and events; as ritual art they follow prescribed rules and patterns that ensure their power. To make them, the singer dribbles pulverized colored stones, pollen, flowers, and other natural colors over a hide or sand ground. The rituals are intended to restore harmony to the world and so to achieve cures. The paintings are not meant for public display and are destroyed by nightfall of the day on which they are made.

In 1919 a respected shaman-singer named Hosteen Klah (1867–1937) began to incorporate sand-painting images into weavings, breaking with the traditional

NAVAIO NIGHT CHANT

This chant accompanies the creation of a sand painting during a Navajo curing ceremony. It is sung toward the end of the ceremony and indicates the restoration of inner harmony and balance.

In beauty (happily) I walk. With beauty before me I walk. With beauty behind me I walk. With beauty below me I walk. With beauty above me I walk. With beauty all around me I walk.

It is finished (again) in beauty. It is finished in beauty.

(cited in Washington Mathews, American Museum of Natural History Memoir, no. 6, New York, 1902, page 145)

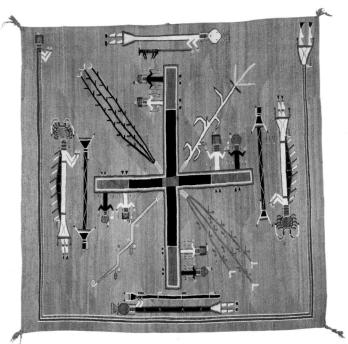

23-21. Hosteen Klah. Whirling Log Ceremony, sand painting; tapestry by Mrs. Sam Manuelito. Navajo, c. 1925. Wool, $5'5'' \times 5'10''$ (1.69 × 1.82 m). Heard Museum, Phoenix, Arizona

prohibition against making them permanent. Many Navajos took offense at Klah both for recording the sacred images and for doing so in a woman's art form. Klah had learned to weave from his mother and sister. Gender roles were strict among Native Americans, but some superior artists began to break down the barriers. Klah's work was ultimately accepted because of his great skill and prestige. His Whirling Log Ceremony sand painting, which was woven into a tapestry (fig. 23-21), depicts a part of the Navajo creation myth in which the Holy People divide the world into four parts, create the Earth Surface People (humans), and bring forth corn, beans, squash, and tobacco, the four sacred plants. The Holy People surround the image, and a male-female pair of humans stands in each of the four quarters defined by the central cross. The guardian figure of Rainbow Maiden encloses the scene on three sides. The open side represents the east. Like all Navajo artists, Hosteen Klah hoped that the excellence of the work would make it pleasing to the spirits. Recently shaman-singers started making permanent sand paintings on boards for sale, but they always introduce slight errors in them to render them ceremonially harmless.

CONTEMPORARY The Institute of American NATIVE

Indian Arts (IAIA), founded in 1962 in Santa Fe AMERICAN and attended by Native ARTISTS American students from all over North America,

replaced Dorothy Dunn's Studio School in the later years of the twentieth century. Staffed by major Native American artists, the school encourages the incorporation of indigenous ideals in the arts without creating an official "style." As alumni achieved distinction and the IAIA

museum in Santa Fe established a reputation for excellence, the institute led Native American art into the mainstream of contemporary art.

The Canadian Haida artist Bill Reid (1920-98) sought to sustain and revitalize the traditions of Northwest Coast art in his work. Trained as a wood carver, painter, and jeweler, Reid revived the art of carving dugout canoes and totem poles in the Haida homeland of Haida Gwaii—"Islands of the People"—known on maps today as the Queen Charlotte Islands. Late in life he began to create large-scale sculpture in bronze. With their black patina, these works recall traditional Haida carvings in argillite, a shiny black stone. One of them, The Spirit of Haida Gwaii, now stands outside the Canadian Embassy in Washington, D.C. This sculpture, which Reid viewed as a metaphor for modern Canada's multicultural society, depicts a collection of figures from the natural and mythic worlds struggling to paddle forward in a canoe (fig. 23-22).

The dominant figure in the center is a shaman in a spruce-root basket hat and Chilkat blanket holding a speaker's pole, a staff that gives him the right to speak with authority. In the prow, the place reserved for the chief in a war canoe, is the Bear. The Bear faces backward rather than forward, however, and is bitten by the Eagle, with formline-patterned wings. The Eagle, in turn, is bitten by the Seawolf. The Eagle and the Seawolf, together with the man behind them, nevertheless continue paddling. In the stern, steering the canoe, is the Raven, the trickster in Haida mythology. The Raven is assisted by Mousewoman, the traditional guide and escort of humans in the spirit realms. On the other side, not visible here, are the Bear mother and her twins, the Beaver, and the Dogfish Woman. According to Reid, the work represents a "mythological and environmental lifeboat," where "the entire family of living things . . . whatever their differences, . . . are paddling together in one boat, headed in one direction."

Many Native American artists today seek to move beyond the occasionally self-conscious revival of traditional forms to a broader art that acknowledges and mediates among the complex cultural forces shaping their lives. Jaune Quick-to-See Smith (b. 1940), who was born on the Confederated Salish and Kootenai Reservation in western Montana and is enrolled there, also combines traditional and contemporary forms to convey political and social messages. As Gerrit Henry wrote in Art in America (November 2001), Smith "looks at things Native and national through bifocals of the old and the new, the sacred and the profane, the divine and the witty."

During the United States' quincentennial celebration of Columbus's arrival in what came to be called the Americas-in her words, the beginning of "the age of tourism"-Quick-to-See Smith created paintings and collages of great formal beauty that also confronted viewers with their own, perhaps unwitting, stereotypes (fig. 23-23). In Trade (Gifts for Trading Land with White People), a stately canoe floats over a richly colored and textured field, which on closer inspection proves to be a dense collage of clippings from Native American news-

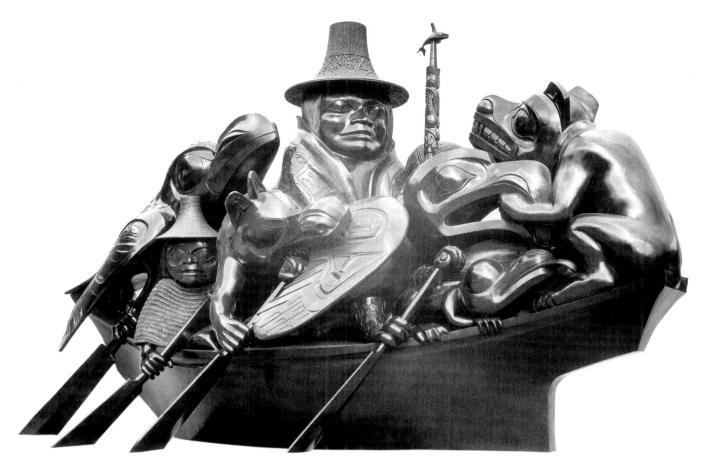

23-22. Bill Reid. The Spirit of Haida Gwaii. Haida, 1991. Bronze, approx. $13 \times 20'$ (4×6 m). Canadian Embassy, Washington, D.C.

papers. Wide swatches and rivulets of red, yellow, green, and white cascade over the newspaper collage. On a chain above the painting is a collection of Native American cultural artifacts—tomahawks, beaded belts, feather headdresses—and memorabilia for sports teams like the Atlanta Braves, the Washington Red-

skins, and the Cleveland Indians, names that many Native Americans find offensive. Surely, the painting suggests, Native Americans could trade these goods to retrieve their lost lands, just as European settlers traded trinkets with Native Americans to acquire the lands in the first place.

23-23. Jaune Quick-to-See Smith. *Trade (Gifts for Trading Land with White People).* Salish-Cree-Shoshone, 1992. Oil and collage on canvas, with other materials, $5' \times 14'2''$ (1.56 \times 4.42 m). Collection of the Chrysler Museum, Norfolk, Virginia. 93.2. Courtesy Steinbaum Krauss Collection, New York City

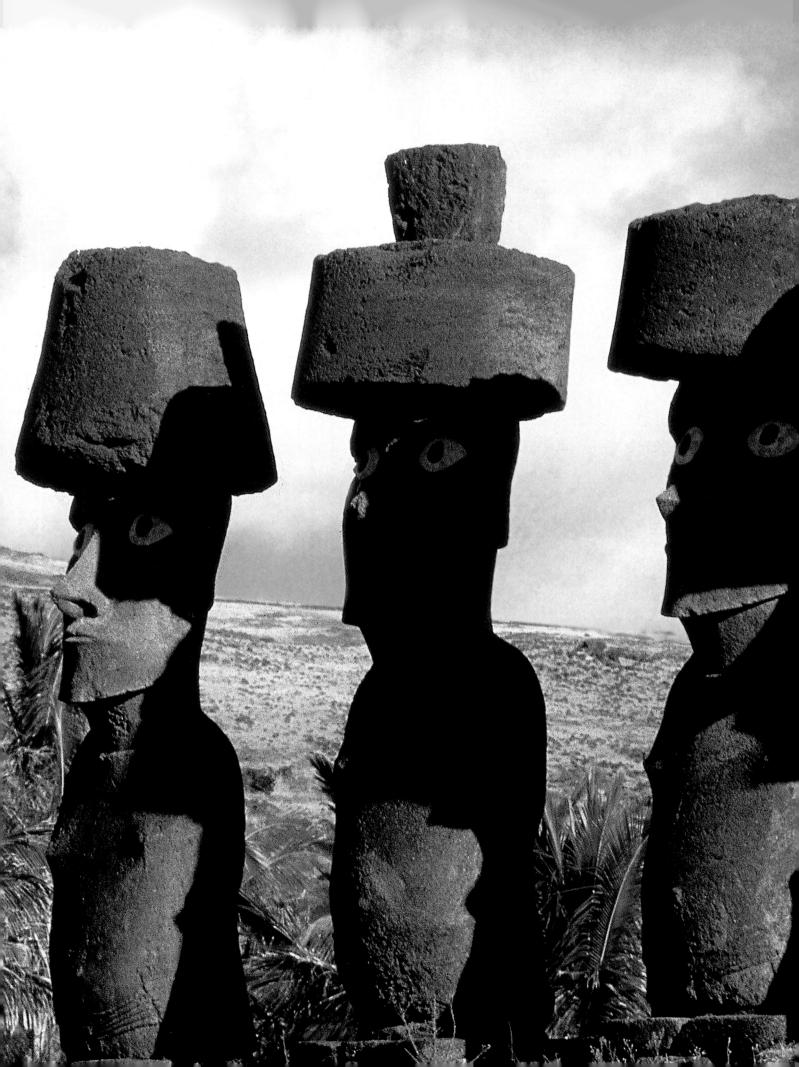

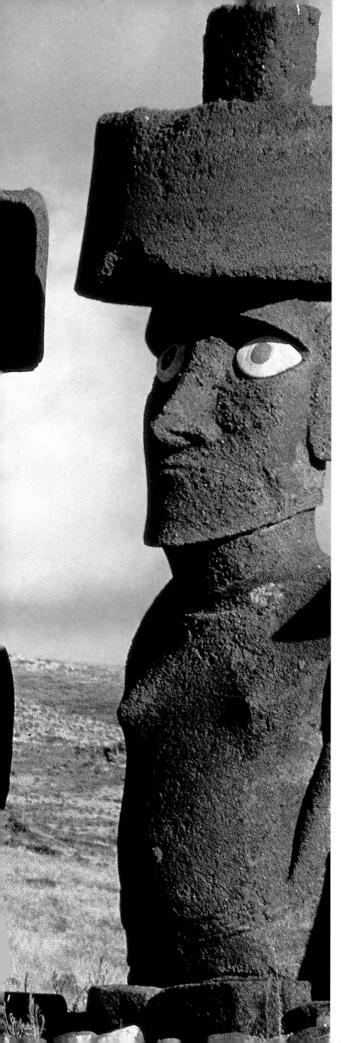

24

ART OF PACIFIC CULTURES

N THE MIDDLE OF THE GREAT OCEAN, IN A region where no one ever passes, there is a mysterious and isolated island; there is no land in the vicinity and, for more than eight hundred leagues in all directions, empty and moving vastness surrounds it. It is planted with tall, monstrous statues, the work of some now-vanished race, and its past remains an enigma" (Pierre Loti, *L'Île de Pâques*, 1872).

The early travelers who successfully reached the islands that lie in the Pacific Ocean found far more than the mysterious, "monstrous" statues of Easter Island (fig. 24-1). Those islands, which came to be described as simple paradises by romantic European and American visitors, have in fact supported widely differing ecosystems, peoples, and cultures for thousands of years. Over that span of time, their inhabitants have developed complex belief systems that have encouraged a rich, visionary life. And they have expressed their beliefs in concrete form—in ritual objects, masks, and the enrichment of their material environment.

The nineteenth-century explorers who set out from the Northern Hemisphere for the vastness of the Pacific had to rely on the earliest maps of the region, about a hundred years old, which showed only an uncertain location for an unknown "continent" that mapmakers believed extended to the South Pole. For them, as for us, maps created a view of the world usually one that put their users' origins at its center. European medieval maps, for example, placed Jerusalem in the center; later cartographers focused on Rome. Westerners are so accustomed to thinking of a world grid originating at an observatory in Greenwich, England, or to imagining a map with the United States as the center of the world that other images are almost inconceivable. From a Northern Hemisphere point of view, the great landmasses of Australia, New Guinea, and New Zealand become lands "down under," sliding off under the globe, remote from our part of the world. But a simple shift of viewpoint—or a map in which the vast Pacific Ocean forms the center of a composition—suddenly marginalizes the Americas, and Europe disappears altogether.

24-1. *Moai* ancestor figures (?), Ahu Nau Nau, Easter Island, Polynesia. c. 1000–1500, restored 1978. Volcanic stone (tufa), average height approx. 36′ (11 m).

▲ c. 4000 AUSTRALIA SEPARATES FROM MELANESIA

TIMELINE 24-1. The Pacific Cultures. Populated by peoples from Southeast Asia beginning about 50,000 years ago, the four main cultural-geographic groups of Oceania were settled at different times and rates.

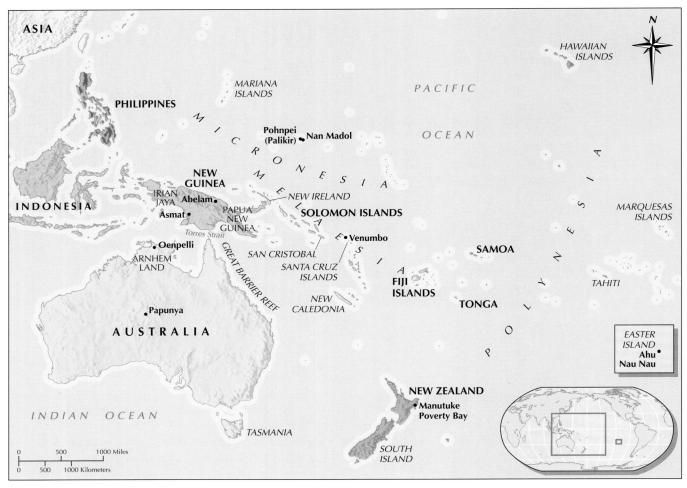

Map 24-1. Pacific Cultural-Geographic Regions.

The Pacific cultures are found in four vast areas: Australia, Melanesia, Micronesia, and Polynesia.

THE PEOPLING OF THE PACIFIC

THE On a map with the Pacific Ocean as its center, only the peripheries of the great landmasses of Asia and the Americas appear. The immense, watery

region of Oceania consists of four cultural-geographic areas: Australia, Melanesia, Micronesia, and Polynesia (see Map 24-1). Australia includes the island continent as well as the island of Tasmania to the southeast. Melanesia (meaning "black islands," a reference to the dark skin color of its inhabitants) includes New Guinea and the string of islands that extends eastward from it as far as Fiji and New Caledonia. Micronesia ("small islands"), to the north of Melanesia, is a region of small islands, including the Marianas. Polynesia ("many

islands") is scattered over a huge, triangular region defined by New Zealand in the south, Easter Island in the east, and the Hawaiian Islands to the north. The last region on earth to be inhabited by humans, Polynesia covers some 7.7 million square miles, of which fewer than 130,000 square miles are dry land—and most of that is New Zealand. Melanesia and Micronesia are also known as Near Oceania, and Polynesia as Far Oceania.

Australia, Tasmania, and New Guinea formed a single continent during the last Ice Age, which began some 2.5 million years ago. About 50,000 years ago, when the sea level was about 330 feet lower than it is today, people moved to this continent from Southeast Asia, making at least part of the journey over open water. Some 27,000 years ago they were settled on the large islands

▲ c. 1500 BCE LAPITA CULTURE IN MELANESIA

▲ c. 1000 BCE POLYNESIANS SETTLE MICRONESIA

▲ c. 500 CE HAWAII, EASTER ISLAND SETTLED

A c. 800/900–1200 NEW ZEALAND SETTLED

north and east of New Guinea as far as San Cristobal, but they ventured no farther for another 25,000 years. By about 4000 BCE—possibly as early as 7000 BCE—the people of Melanesia were raising pigs and cultivating taro, a plant with edible rootstocks. As the glaciers melted, the sea level rose, flooding low-lying coastal land. By around 4000 BCE a 70-mile-wide waterway, now called the Torres Strait, separated New Guinea from Australia, whose people retained a hunting and gathering way of life into the twentieth century.

The settling of the rest of the islands of Melanesia and the westernmost islands of Polynesia-Samoa and Tonga—coincided with the spread of the seafaring Lapita culture, named for a site in New Caledonia, after about 1500 BCE. The Lapita people were farmers and fisherfolk who lived in often large coastal villages, probably cultivated taro and yams, and produced a distinctive style of pottery. They were skilled shipbuilders and navigators and engaged in interisland trade. Over time the Lapita culture lost its widespread cohesion and evolved into various local forms. Polynesian culture apparently emerged in the eastern Lapita region on the islands of Tonga and Samoa. Around the beginning of the first millennium CE, daring Polynesian seafarers, probably in double-hulled sailing canoes, began settling the scattered islands of Far Oceania and eastern Micronesia. Voyaging over open water, sometimes for thousands of miles, they reached Hawaii and Easter Island after about 500 ce and settled New Zealand by about 800/900-1200 CE.

In this vast and diverse Pacific region, the arts display enormous variety and are generally closely linked to a community's ritual and religious life. In this context, the visual arts were often just one strand in a rich weave that also included music, dance, and oral literature.

AUSTRALIA The aboriginal inhabitants of Australia, or Aborigines, were nomadic hunter-gatherers closely attuned to the varied environments in which they lived until European settlers disrupted their way of life. The Aborigines had a complex social organization and a rich mythology that was vividly represented in the arts. As early as 18,000 years ago they were painting images on rocks and caves in western Arnhem Land, which is on the northern coast of Australia. One such painting contains a later image superimposed on an earlier one (fig. 24-2). The earlier painting is of skinny, sticklike humans that the Aborigines call mimis (ancestral spirits). Over the mimis is a kangaroo rendered in the distinctive x-ray style, in which the artist drew important bones and internal organs-including the spinal column, other bones, the heart, and the stomach—over the silhouetted form of the animal. In the picture shown here, all four of the

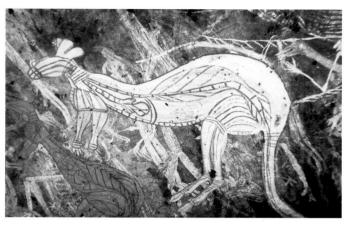

24-2. *Mimis and Kangaroo*, prehistoric rock art, Oenpelli, Arnhem Land, Australia. Older painting 16,000–7000 BCE. Red and yellow ocher and white pipe clay.

kangaroo's legs have been drawn, and the ears have been placed symmetrically on top of its head. In some images both eyes appear in the head, which is shown in profile. The x-ray style was still prevalent in western Arnhem Land when European settlers arrived in the nineteenth century.

In Arnhem Land the native people continued a stone-age lifestyle until well into the twentieth century. Their rich ceremonial life included ritual body painting as well as the ornamentation of implements and the interiors of bark houses. Eventually, as a means of communicating with outsiders and as an aid to education and memory, tribal elders recorded origin myths, rituals, and significant places and objects by painting on the bark stripped from eucalyptus trees. Bark painters from western Arnhem Land continued to use the x-ray style, but in eastern Arnhem Land, the bark painters, especially the Yolngu-speakers, developed a style based on ritual body painting.

The Yolngu rarely reveal the full meaning of a painting to outsiders, but in general they depict origin myths and ritual activities. According to their beliefs, the world and its inhabitants were created in the Dream Time. The myths explain the formation of important features of the landscape, of climatic phenomena like the monsoon season, and of human social groupings. In the beginning the world was flat, but serpents and the ancestral beings shaped it into mountains, sand hills, creeks, and water holes. Animals became the totemic ancestors of human groups, and the places associated with them became sacred sites. The rituals and the paintings associated with them are meant to restore contact with the Dream Time.

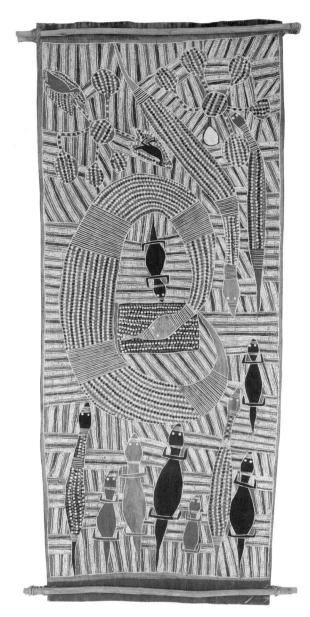

24-3. Mithinarri Gurruwiwi. *The Conference of Serpents*, **from the Wäwilak myth.** From eastern Arnhem Land, Australia. 1963. Natural pigments (ochers and clay) on eucalyptus bark. $53\frac{7}{8} \times 22^4/5$ " (137 \times 58.5 cm). Kluge-Ruhe Aboriginal Art Collection, University of Virginia, Charlottesville.

Paintings by Mithinarri Gurruwiwi (fig. 24-3) represent the part of the origin myth of eastern Arnhem Land as interpreted by the Gälpu clan. The first humans—the Wäwilak Sisters—walked about with their digging sticks, singing, dancing, naming things, and populating the land with their children. But they offended the Wititj (Olive Serpent), who swallowed them but was then called before a council of serpents representing all the clans. Wititj had to admit wrongdoing and regurgitate the humans. This conference of snakes signifies both the origin of ritual activities and the spreading of the Wäwilak story to other clans. At the center of the bark

painting, a dark rectangle represents Wititj's water hole, the clan's ceremonial center and the home of the Yolngu before and after their time on earth—both unborn souls and the dead. Wititj coils protectively around the water, slithering in and out of his hole. Wititj is represented twice again at the top of the painting among the water lilies, and at the bottom he attends the conference, with goannas (large lizards) and other serpents. The ancestral snakes are associated with water—rain, water holes, thunder and lightning—and fertility; so Wititj is covered with dots representing eggs. The dotted water lilies also remind us of the fertility of well-watered land.

The surface of the painting literally shimmers with brilliant dotting and cross hatching (called rarrk). The Yolngu artists first cover the rough matte surface of the eucalyptus bark panel with red ocher. They draw the basic design with yellow ocher or black pigment, add colors, and then outline images in white. Geometric forms represent abstract ideas as well as underlying structures and meanings, while recognizable figures are used to tell stories and to represent daily occurrences. Finally, the surface is filled with fine cross-hatching in white. Rarrk, the characteristic cross-hatching, originated in the distinctive designs painted on male chests and thighs as part of initiation ceremonies; consequently, what may appear to be simple decoration—the angle of the lines, their color, and the alternation of continuous and broken lines—has a profound meaning for the Yolngu.

The Wäwilak sisters' story is sacred, and some Yolngus believe that only the initiated clan members should see the paintings. Ritual life and the meaning of ceremonial designs still remain private, and only designated artists have rights to reproduce clan narratives and designs.

Aboriginal artists today may paint with acrylic paint on canvas instead of with ocher, clay, and charcoal on rock and eucalyptus bark, but their imagery has remained relatively constant, and their explanations of their work provide insight into the meaning of prehistoric images.

MELANESIA Exceptional seafarers spread the Lapita culture throughout the is-

lands of Melanesia beginning around 1500 BCE. They brought with them the plants and animals that colonizers needed for food, thus spreading agricultural practices through the islands. They also carried with them the distinctive ceramics whose remnants today enable us to trace the extent of their travels. Lapita potters, probably women, produced dishes, platters, bowls, and jars. Sometimes they covered their wares with a red slip, and they often decorated them with bands of incised and stamped geometric patterns—dots, lines, and hatching heightened with white lime. Most of the decoration was entirely geometric, but some was figurative. The human face that appears on one example (fig. 24-4) is among the earliest representations of a human being in Oceanic art. Over time Lapita pottery evolved into a variety of regional styles in Melanesia, but in western Polynesia,

24-4. Fragments of a large Lapita jar, from Venumbo, Reef Santa Cruz Island, Solomon Islands, Melanesia. c. 1200–1100 BCE. Clay, height of human face approx. $1^1/2$ " (4 cm).

the heartland of Polynesian culture and the easternmost part of the Lapita range, the making of pottery ceased altogether by between 100 and 300 ce.

In Melanesia, as in Australia, the arts were intimately involved with belief and provided a means for communicating with supernatural forces. Rituals and ritual arts were primarily the province of men, who devoted a great deal of time to both. In some societies most of the adult males were able to make ritual objects. Women, although barred from ritual arts, gained prestige for themselves and their families through their skill in the production of other kinds of goods. To be effective, ritual objects had to be well made, but they were often allowed to deteriorate after they had served their ceremonial function.

PAPUA NEW GUINEA

New Guinea, the largest island in Melanesia (and at 1,500 miles long and 1,000 miles wide, the second-largest island in the world), is today divided between two countries. The eastern half of the island is part of the present-day nation of Papua New Guinea; the western half is Irian Jaya, a province of present-day Indonesia. Located near the equator and with mountains that rise to 16,000 feet, the island's diverse environments range from tropical rain forest to grasslands to snow-covered peaks.

The Abelam, who live in the foothills of the mountains on the north side of Papua New Guinea, raise pigs and cultivate yams, taro, bananas, and sago palms. In traditional Abelam society, people live in extended families or clans in hamlets. Wealth among the Abelam is measured in pigs, but men gain status from participation in a yam cult that has a central place in Abelam society and in the iconography of its art and architecture. The yams that are the focus of this cult—some of which reach an extraordinary 12 feet in length—are associated

with clan ancestors and the potency of their growers. Village leaders renew their relationship with the forces of nature that yams represent during the Long Yam Festival, which is held at harvest time and involves processions, masked figures, singing, and the ritual exchange of the finest yams.

An Abelam hamlet includes sleeping houses, cooking houses, storehouses for yams, a central space for rituals, and a tamberan house. In this ceremonial structure, tamberans, the images and objects associated with the yam cult and with clan identity, are kept hidden from women and uninitiated boys. Men of the clan gather in the tamberan house to organize rituals and conduct community business. In the past, they also planned raids. The prestige of a hamlet is linked to the quality of its tamberan house and the size of its yams. Constructed on a frame of poles and rafters and roofed with split cane and thatch, tamberan houses have been as much as 280 feet long and more than 40 feet wide. The ridgepole is set at an angle, making one end higher than the other, and the roof extends forward in an overhanging peak that is braced by a carved pole. The entrance facade is thus a large, in-folded triangular form, elaborately painted and carved (fig. 24-5, page 864). Panels are painted in red, ocher, white, and black with the faces of a clan's ancestral spirits. The Abelam believe the paint itself has magical qualities. The effectiveness of the images is thought to depend in part on accurate reproduction, and master painters direct the work of younger initiates. Regular, ritual repainting revitalizes the images and ensures their continued potency. Every stage in the construction of a tamberan house is accompanied by ceremonies, which are held in the early morning while women and boys are still asleep. The completion of a house is celebrated with elaborate fertility rituals and an all-night dance. Women participate in these inaugural ceremonies and are allowed to enter the new house, which afterward is ritually cleansed and closed to them.

IRIAN JAYA

The Asmat, who live in the grasslands on the southwest coast of Irian Jaya, were known in the past as warriors and headhunters. They believe that a mythic hero carved their ancestors from trees, and to honor the dead they erect memorial poles covered with elaborate sculpture (fig. 24-6, page 864). The poles are known as *mbis*, and the rituals surrounding them are intended to reestablish the balance between life and death. The Asmat believe that *mbis* house the souls of the recent dead, and they place them in front of the village men's house so the souls can observe the rituals there. After the *mbis* ceremonies, the poles are abandoned and allowed to deteriorate.

In the past, once the poles had been carved, villagers would organize a headhunting expedition so that they could place an enemy head in a cavity at the base of each pole. The base, with its abstract voids for enemy heads, represents the twisting roots of the banyan tree. Above the base, figures representing tribal ancestors support figures of the recent dead. The bent pose of the figures associates them with the praying mantis, a

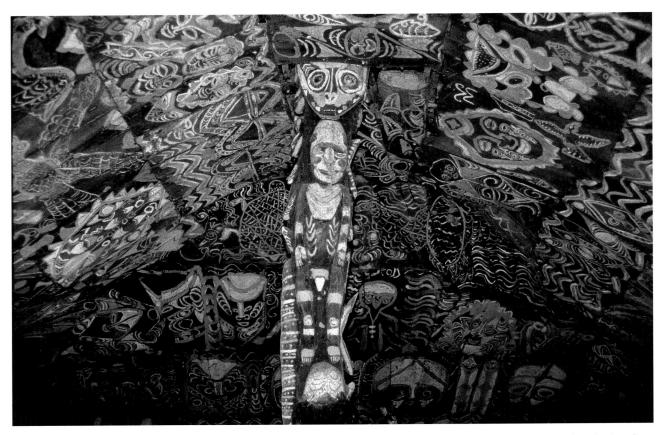

24-5. Detail of *tamberan* **house,** Sepik River, Papua New Guinea, New Guinea. Abelam, 20th century. Carved and painted wood, with ocher pigments on clay ground.

24-6. Asmat ancestral spirit poles (*mbis***),** Faretsj River, Irian Jaya, Indonesia, New Guinea. c. 1960. Wood, paint, palm leaves, and fiber, height approx. 18' (5.48 m). Photograph in The Metropolitan Museum of Art, New York.

The Michael C. Rockefeller Memorial Collection, Gift of Nelson A. Rockefeller and Mrs. Mary C. Rockefeller, 1965 (1978.412.1248-50)

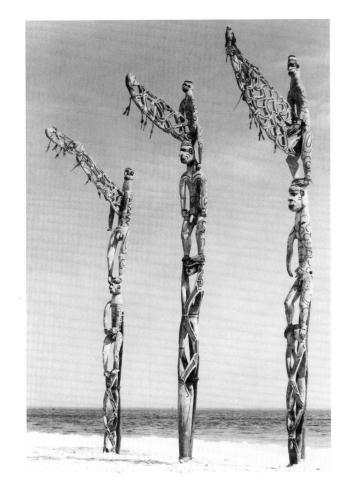

symbol of headhunting; another symbol of headhunting seen in *mbis* is birds breaking open nuts. The large, lacy phalluses emerging from the figures at the top of the poles symbolize male fertility, and the surface decoration suggests tattoos and scarification (patterned scars), common body ornamentation in Melanesia.

NEW IRELAND

The people of the central part of the island of New Ireland, which is one of the large easternmost islands of the nation of Papua New Guinea, are known for their malanggan ceremonies, elaborate funerary rituals for which striking painted carvings and masks are made. Malanggans involve an entire community as well as its neighbors and serve to validate social relations and property claims.

Because preparations are costly and time consuming, malanggans are often delayed for several months or even years after a death and might commemorate more than one person. Although preparations are hidden from women and children, everyone participates in the actual ceremonies. Arrangements begin with the selection of trees to be used for the malanggan carvings. In a ceremony marked by a feast of taro and pork, the logs are cut, transported, and ritually pierced. Once the carvings are finished, they are dried in the communal men's house, polished, and then displayed in a malanggan house in the village malanggan enclosure. Here the figures are painted and eyes made of sea snail shell are inserted. The works displayed in a malanggan house include figures on poles and freestanding sculpture representing ancestors and the honored dead, as well as masks and ritual dance equipment. They are accorded great respect for the duration of the ceremony, then allowed to decay.

Another ritual, the tatanua dance, assures male power, and men avoid contact with women for six weeks beforehand. Tatanua masks, worn for the dance, represent the spirits of the dead (fig. 24-7). The helmetlike masks are carved and painted with simple, repetitive motifs such as ladders, zigzags, and stylized feathers. The paint is applied in a ritually specified order: first lime white for magic spells; then red ocher to recall the spirits of those who died violently; then black from charcoal or burned nuts, a symbol of warfare; and finally yellow and blue from vegetable materials. The magnificent crest of plant fiber is a different color on the right and the left sides, perhaps a reflection of a long-ago hairstyle in which the hair was cut short and left naturally black on one side and dyed yellow and allowed to grow long on the other. The contrasting sides of the masks allow dancers to present a different appearance by turning from side to side. A good performance of the tatanua dance is considered a demonstration of strength, while a mistake can bring laughter and humiliation.

MICRONESIA Over the centuries the people of Oceania erected monumental stone architecture and carvings in a number of places. In some cases, in Polynesia for example, widely scat-

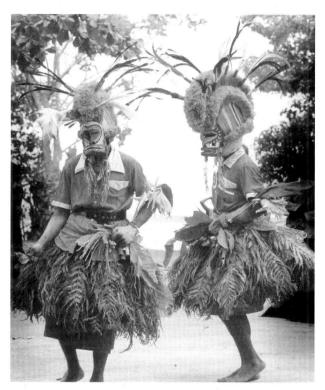

24-7. Dancers wearing *tatanua* **masks**, Pinikindu Village, central New Ireland, Papua New Guinea, New Guinea. 1979. Masks: wood, vegetable fibers, trade cloth, and pigments, approx. $17 \times 13''$ (43×33 cm).

tered structures share enough characteristics to suggest that they spring from a common origin. Others appear to be unique. The site of Nan Madol, on the southeast coast of Pohnpei in Micronesia, is the largest and one of the most remarkable stone complexes in Oceania. It and a similar, smaller complex on another island nearby are also apparently without precedent. At one time Nan Madol was home to as many as 1,000 people, but it was deserted by the time Europeans discovered it in the nineteenth century.

Pohnpei, today the location of the Federated States of Micronesia's capital city, Palikir, is a mountainous tropical island with cliffs of prismatic basalt. By the thirteenth century ce the island's inhabitants were evidently living in a hierarchical society ruled by a powerful chief with the resources to harness sufficient labor for a monumental undertaking. Nan Madol, which covers some 170 acres, consists of 92 small artificial islands set within a network of canals. Most of the islands are oriented northeast-southwest, receiving the benefit of the cooling prevailing winds. Seawalls and breakwaters 15 feet high and 35 feet thick protect Nan Madol from the ocean. Openings in the breakwaters gave canoes access to the ocean and allowed seawater to flow in and out with the tides, flushing clean the canals. The islands and structures of Nan Madol are built of prismatic basalt "logs" stacked in alternating courses (rows or layers). Through ingenious technology the logs were split from their source by alternately heating the base of a basalt cliff with fire and dousing it with water.

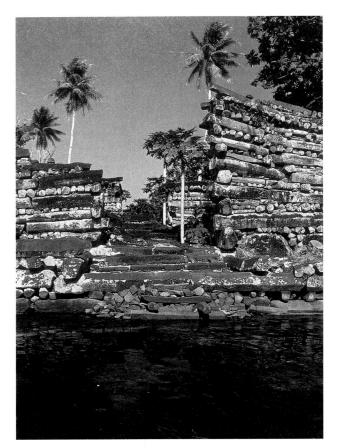

24-8. Royal mortuary compound, Nan Madol, Pohnpei, Federated States of Micronesia. c.1200/1300–c.1500/1600. Basalt blocks, wall height up to 25' (7.62 m).

The royal mortuary compound, which once dominated the southeast side of Nan Madol (fig. 24-8), has walls rising in subtle upward and outward curves to a height of 25 feet. To achieve the sweeping, rising lines, the builders increased the number of stones in the **header** courses (the courses with the ends of the stones laid facing out along the wall) relative to the **stretcher** courses (the courses with the lengths of the stones laid parallel to the wall) as they came to the corners and entryways. The plan of the structure consists simply of progressively higher rectangles within rectangles—the outer walls leading by steps up to interior walls that lead up to a center courtyard with a small, cubical tomb.

POLYNESIA The settlers of the far-flung islands of Polynesia quickly developed dis-

tinctive cultural traditions but also retained linguistic and cultural affinities that reflect their common origin. Traditional Polynesian society was generally far more stratified than Melanesian society, and Polynesian art objects served as important indicators of rank and status. Reflecting this function, they tended to be more permanent than art objects in Melanesia, and they often were handed down as heirlooms from generation to generation. European colonization had a profoundly disruptive effect on society and art in Polynesia, as elsewhere in Oceania, which stemmed, ironically, from the very high regard the outsiders felt for the art they found. European artists and collectors admired Polynesian art and purchased it avidly, but in so doing totally altered the context in which much of it was produced (see "Paul Gauguin on Oceanic Art," below).

EASTER ISLAND

Easter Island, the most remote and isolated island in Polynesia, is also the site of Polynesia's most impressive sculpture. Stone temples, or marae, with stone altar platforms, or ahu, are common throughout Polynesia. Most of the ahu are built near the coast, parallel to the shore. About 900 CE, Easter Islanders began to erect huge stone figures on ahu, perhaps as memorials to dead chiefs. Nearly 1,000 of the figures, called moai, have been found, including some unfinished in the quarries where they were being made. Carved from tufa, a yellowish brown volcanic stone, most are about 36 feet tall, but one unfinished figure measures almost 70 feet. In 1978 several figures were restored to their original condition, with red tufa topknots on their heads and white coral eyes with stone pupils (see fig. 24-1). The heads have deep-set eyes under a prominent browridge; a long, concave, pointed nose; a small mouth with pursed lips; and an angular chin. The extremely elongated earlobes have parallel engraved lines that suggest ear ornaments. The figures have schematically indicated breastbones and pectorals, and small arms with hands pressed close to the sides, but no legs.

Easter Islanders stopped erecting *moai* around 1500 and apparently entered a period of warfare among themselves, possibly because overpopulation was straining the island's available resources. Most of the *moai* were

PAUL GAUGUIN ON OCEANIC ART

At the end of the nineteenth century, French Post-Impressionist painter Paul Gauguin (1848–1903) moved to Polynesia, settling first in Tahiti and later moving to the Marquesas Islands. Seeking inspiration for his own work, he was deeply appreciative of Oceanic culture and art. He was also, as this passage from his diary reveals, concerned about the destructive impact on that

art of European collectors' and colonial administrators' commercial influence:

In the Marquesan especially there is an unparalleled sense of decoration. Give him a subject even of the most ungainly geometrical forms and he will succeed in keeping the whole harmonious and in leaving no displeasing or incongruous empty spaces. The basis is the human body or the face, especially the face. One is astonished to find a face where one thought there was

nothing but a strange geometric figure. Always the same thing, and yet never the same thing.

Today, even for gold, you can no longer find any of those beautiful objects in bone, rock, ironwood which they used to make. The police have stolen it all and sold it to amateur collectors; yet the Administration has never for an instant dreamed of establishing a museum in Tahiti, as it could so easily do, for all this Oceanic art.

(Translated by Van Wyck Brook)

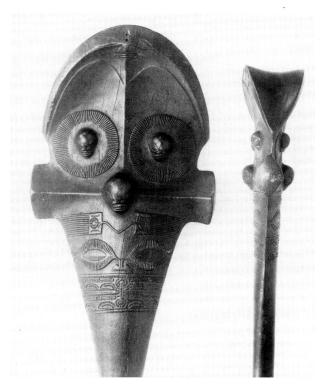

24-9. War club, from the Marquesas Islands, Polynesia. Early 19th century. Ironwood, length approx. 5' (1.52 m). Peabody Essex Museum, Salem, Massachusetts.

knocked down and destroyed during this period. The island's indigenous population, which may at one time have consisted of as many as 10,000 people, was nearly eradicated in the nineteenth century by Peruvian slave traders. The smallpox and tuberculosis they brought with them precipitated an epidemic that left only about 600 inhabitants alive on Easter Island.

MARQUESAS ISLANDS

Warfare was common in Polynesia and involved hand-to-hand combat. Warriors dressed to intimidate and to convey their rank and status, so weapons, shields, and regalia tended to be especially splendid. A 5-foot-long ironwood war club from the Marquesas Islands (fig. 24-9) is lavishly decorated, with a Janus-like double face at the end. More faces appear within these faces. The high arching eyebrows frame sunburst eyes whose pupils are tiny faces. Other patterns seem inspired by human eyes and noses. The overlay of low relief and engraved patterns suggests tattooing, a highly developed art in Polynesia (see fig. 24-12).

HAWAIIAN ISLANDS

Until about 1200 ce the Hawaiian Islands remained in contact with other parts of Polynesia; thereafter they were isolated, and rigidly stratified Hawaiian society was divided into several independent chiefdoms. By 1810 one ruler, Kamehameha I (c. 1758–1819), had consolidated the islands into a unified kingdom, but Hawaii's isolation had already come to an end with the

24-10. Skirt originally belonging to Queen Kamamalu, Hawaii. 1823–24. Paper mulberry (wauke) bark, stamped patterns, 12'3" × 5'6" (3.77 × 1.7 m). Bishop Museum, Honolulu.

Gift of Evangeline Priscilla Starbuck, 1927 (C.209)

1778 arrival of the English explorer Captain James Cook. Throughout the nineteenth century the influence of United States missionaries and economic interests increased, and Hawaii's traditional religion and culture declined. The United States annexed Hawaii in 1898, and the territory became a state in 1959.

Decorated bark cloth and featherwork, found elsewhere in Polynesia, were highly developed in Hawaii. Bark cloth, commonly known as tapa (kapa in Hawaiian), is made by pounding together moist strips of the inner bark of certain trees, particularly the mulberry tree. The cloth makers, usually women, used mallets with incised patterns that left impressions in the cloth. Like a watermark in paper, these impressions can be seen when the cloth is held up to the light. Fine bark cloth was dyed and decorated in red or black with repeated geometric patterns laboriously made with tiny bamboo stamps. One favorite design consists of parallel rows of chevrons printed close together in sets or spaced in rows. The cloth could also be worked into a kind of appliqué, in which a layer of cutout patterns, usually in red, was beaten onto a light-colored backing sheet. The traditional Hawaiian women's dress consisted of a sheet of bark cloth worn wrapped around the body either below or above the breasts. The example shown here (fig. 24-10) belonged to Queen Kamamalu. Such

24-11. Feather cloak, known as the Kearny Cloak, Hawaii.

c. 1843. Red, yellow, and black feathers, *olona* cordage, and netting, length $55^3/4$ " (143 cm). Bishop Museum, Honolulu.

Hawaiian chiefs wore feather cloaks into battle, making them prized war trophies as well as highly regarded diplomatic gifts. King Kamehameha III (ruled 1825–54) presented this cloak to Commodore Lawrence Kearny, commander of the U.S. frigate *Constellation*.

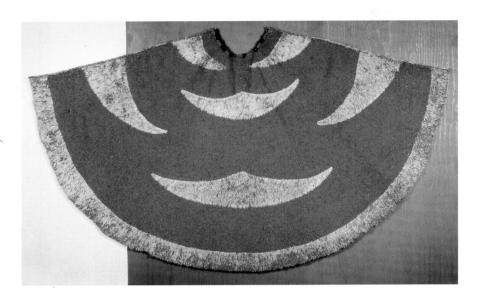

garments were highly prized and were considered to be an appropriate diplomatic gift. The queen took barkcloth garments with her when she and King Kamehameha II made a state visit to London in 1823.

The Hawaiians prized featherwork even more highly than fine bark cloth. Feather cloaks, helmets, capes, blankets, and garlands (leis) conveyed special status and prestige, and only wealthy chiefs could command the resources to make them. Tall feather pompons (kahili) mounted on long slender sticks symbolized royalty. And the images of the gods that Hawaiian warriors carried into battle were made of light, basketlike structures covered with feathers. Feather garments, made according to strict ritual guidelines, consisted of bundles of feathers tied in overlapping rows to a foundation of plant-fiber netting. Yellow feathers, which came from the Hawaiian honey eater bird, were extremely valuable because one bird produced only seven or eight suitable feathers. Some 80,000 to 90,000 honey eater birds were used to make King Kamehameha I's full-length royal cloak. Lesser men had to be satisfied with short capes. Cloaks and capes hung like upside-down funnels from the wearer's shoulders, creating a sensuously textured and colored abstract design. The typical cloak was red (the color of the gods) with a yellow border and sometimes a narrow decorative neckband. The symmetrically arranged geometric decoration in the example shown here (fig. 24-11) falls on the wearer's front and back; the paired crescents on the edge join when the garment is closed to match the forms on the back. Captain Cook, impressed by the "beauty and magnificence" of Hawaiian featherwork, compared it to "the thickest and richest velvet" (Voyage, 1784, volume 2, page 206; volume 3, page 136).

NEW ZEALAND

New Zealand was the last part of Polynesia to be settled. The first inhabitants had arrived by about the tenth century, and their descendants, the Maori, numbered in the hundreds of thousands by the time of European contact

in the seventeenth and eighteenth centuries. Captain Cook, before he landed in Hawaii, led a British scientific expedition to the Pacific that explored the coast of New Zealand in 1769. Sydney Parkinson (1745?–71), an artist on the expedition, documented aspects of Maori life and art at the time (see "Art and Science: The First Voyage of Captain Cook," page 869). An unsigned drawing by Parkinson (fig. 24-12) shows a Maori with facial tattoos (*moko*) wearing a headdress with feathers, a comb, and a *hei-tiki* (a carved pendant of a human figure).

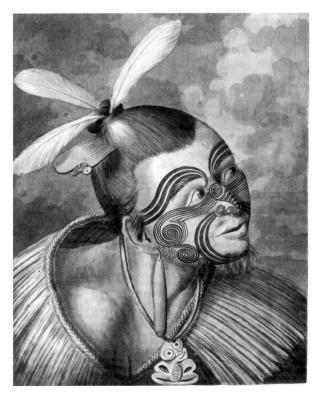

24-12. Sydney Parkinson. *Portrait of a Maori.* 1769. Wash drawing, $15^{1}/_{2} \times 11^{5}/_{8}$ " (39.37 \times 29.46 cm), later engraved and published as plate XVI in Parkinson's *Journal*, 1773. The British Library, London. Add MS 23920 f.55

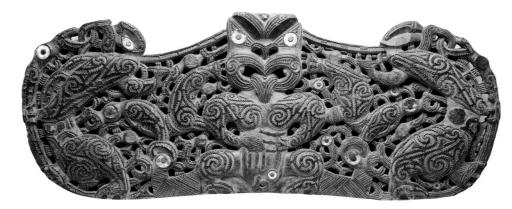

24-13. Carved lintel, from New Zealand, Polynesia. Maori, 18th century. Totara wood and haliotis shell, $40^{1}/_{4} \times 15^{3}/_{4} \times 2''$ (102.2 \times 40 \times 5.1 cm). Nelson-Atkins Museum of Art, Kansas City, Missouri. Gift of Mr. and Mrs. Morton Sosland

Combs similar to the one in the drawing can still be found in New Zealand. The long ear pendant is probably made of greenstone, a form of jade found on New Zealand's South Island that varies in color from off-white to very dark green. The Maori considered greenstone to have supernatural powers. The hei-tiki hanging on a cord around the man's neck would have been among his most precious possessions. Such tiki figures, which represented legendary heroes or ancestor figures, gained power from their association with powerful people. The tiki in this illustration has an almost embryonic appearance, with its large tilted head, huge eyes, and seated posture. Some tiki had large eyes of inlaid shell.

The art of tattoo was widespread and ancient in Oceania; bone tattoo chisels have even been found in Lapita sites. Maori men generally had tattoos on the face and on the lower body between the waist and the knees. Women were tattooed around the mouth and on the chin. The typical design of men's facial tattoos, like the striking one shown here, consisted of broad, curving parallel lines from nose to chin and over the eyebrows to the ears. Small spiral patterns adorned the cheeks

and nose. Additional spirals or other patterns were placed on the forehead and chin and in front of the ears. A formal, bilateral symmetry controlled the design. Maori men considered their *moko* designs to be so personal that they sometimes signed documents with them. Ancestor carvings in Maori meetinghouses also have distinctive *moko*. According to Maori mythology, tattooing, as well as weaving and carving, was brought to them from the underworld, the realm of the Goddess of Childbirth. *Moko* might thus have a birth-death symbolism that links the living with their ancestors.

176-571

The Maori are especially known for their wood carving, which is characterized by a combination of massive underlying forms with delicate surface ornament. This art form found expression in small works like the *hei-tiki* in Parkinson's drawing as well as in the sculpture that adorned storehouses and meetinghouses in Maori hill-top villages (fig. 24-13).

A carved lintel, probably collected on Captain Cook's second voyage in 1773, is one of the earliest surviving Maori sculptures in North America (fig. 24-13). From its place over a doorway, the sculpture confirmed

ART AND SCIENCE: THE FIRST VOYAGE OF CAPTAIN COOK

The ship *Endeavour*, under the command of Captain James Cook, a skilled geographer and navigator, sailed from Plymouth, England, in August 1768 on a scientific expedition to the Pacific Ocean. On board—in addition to a research team of astronomers, botanists, and other scientists—were two artists, Sydney Parkinson, a young Scottish botanical drafter, and Alexander Buchan, a painter of landscapes and portraits. At that time drawings and paintings served science the way

photographs and documentary films and videotapes do today, recording, as Cook wrote, "a better idea . . . than can be expressed by word. . . . " (*Journal*, 1773).

The Endeavour sailed west to Brazil, then south around South America's Cape Horn, and westward across the Pacific Ocean to Tahiti, where Buchan died. The ship went on to explore New Zealand, Tasmania, Australia, and the Great Barrier Reef before returning to England in July 1771, by sailing westward and around Africa's southern tip, the Cape of Good Hope.

Parkinson, frequently working with decaying specimens in

cramped quarters on rough seas or plagued by insects, completed more than 1,300 drawings and paintings. His watercolors of plants are especially outstanding. Although he could not replace Buchan as a portrait painter, he did make a few sketches and wash drawings of people, among them drawings of the Maori that provide valuable evidence of their traditional way of life (see fig. 24-12).

He died on the return journey, on January 21, 1771. In addition to fulfilling his duties as expedition artist, Parkinson, like the other expedition members, had kept a journal, which was later published.

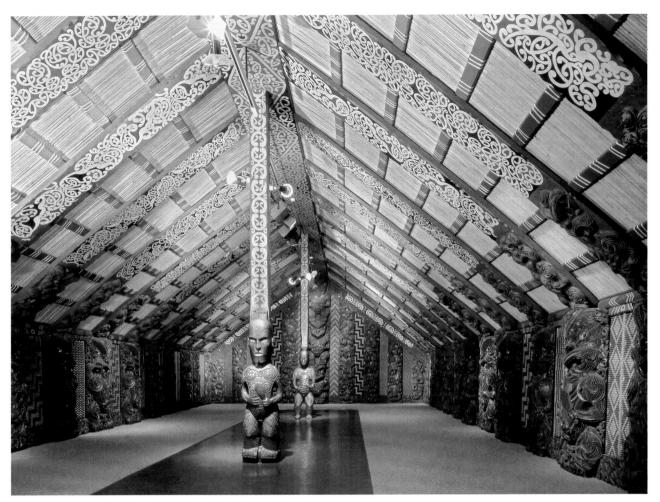

24-14. Raharuhi Rukupo, master carver. Te-Hau-ki-Turanga (Maori meetinghouse), from Manutuke Poverty Bay, New Zealand. 1842–43, restored in 1935. Wood, shell, grass, flax, and pigments. The Museum of New Zealand Te Papa Tongarewa, Wellington.

Neg. B18358

the power and prestige of its owners. The composition revolves around a central figure, a standing tiki. The fearsome square head glares at the world with glittering blue and green haliotis shell pupils set in triangular eyes under heavy eyebrows. Flaring nostrils and an open figure-eight shaped mouth with protruding tongue add to the terrifying aspect of the figure. The tongue gesture is defiant and aggressive. Massive arms and legs swell under a dense pattern of surface ornament and end in clawlike hands and feet. The tiki clutches a whale or fish. Glittering shell eyes help to sort out other fantastic, interlocking creatures, whose forms are nearly lost under the continuous spirals of surface ornament. The wood itself glows with a rich reddish-brown color, produced by rubbing the surface with a mixture of red clay and sharkliver oil, which colors and waterproofs the lintel.

Only this lintel remains of what must have been an important building, but in the Museum of New Zealand in Wellington a meetinghouse carved by the master carver Raharuhi Rakupo in 1842–43 has been restored and re-erected.

The meetinghouse became a focal point of local tradition under the influence of this one built by Rukupo as

a memorial to his brother (fig. 24-14). Rukupo, who was an artist, diplomat, warrior, priest, and early convert to Christianity, built the house with a team of eighteen wood carvers. Although they used European metal tools, they worked in the technique and style of traditional carving done with stone tools. They finished the carved wood as usual, by rubbing it with a combination of red clay and shark-liver oil.

The whole structure symbolizes the sky father. The ridgepole is his backbone, the rafters are his ribs, and the slanting **bargeboards**—the boards attached to the projecting end of the **gable**—are his outstretched enfolding arms. His head and face are carved at the peak of the roof. The curvilinear patterns on the rafters were made with a silhouetting technique. Artists first painted the rafters white, then outlined the patterns, and finally painted the background red or black, leaving the patterns in white. Characteristically Maori is the *koru* pattern, a curling stalk with a bulb at the end that is said to resemble the young tree fern.

Relief figures of ancestors—Raharuhi Rukupo included a portrait of himself among them—cover the support poles, wall planks, and the lower ends of the

rafters. The ancestors, in effect, support the house. They were thought to take an active interest in community affairs and to participate in the discussions held in the meetinghouse. Like the hei-tiki in figure 24-12, the figures have large heads. Flattened to fit within the building planks and covered all over with spirals, parallel and hatched lines, and tattoo patterns, they face the viewer head on with glittering eyes of blue-green inlaid shell. Their tongues stick out in defiance from their grimacing mouths, and they squat in the posture of the war dance.

Lattice panels made by women fill the spaces between the wall planks. Because ritual prohibitions, or taboos, prevented women from entering the meetinghouse, they worked from the outside and wove the panels from the back. They created the black, white, and orange patterns from grass, flax, and flat slats. Each pattern has a symbolic meaning: chevrons represent the teeth of the monster Taniwha; steps represent the stairs of heaven climbed by the hero-god Tawhaki; and diamonds represent the flounder.

Considered a national treasure by the Maori, this meetinghouse was restored in 1935 by Maori artists from remote areas who knew the old, traditional methods. It was moved to the Museum of New Zealand.

RECENT **ART IN**

Many contemporary artists in Oceania, in a process anthropologists call reintegration, have responded to the im-**OCEANIA** pact of European culture by adapting traditional themes and subjects to new

mediums and techniques. The work of a Hawaiian quilt maker and an Australian aboriginal painter provide two examples of the striking and challenging results of this process.

Missionaries introduced fabric patchwork and guilting to the Hawaiian Islands in 1820, and Hawaiian women were soon making distinctive, multilayered stitched quilts. Over time, as cloth became increasingly available, the new arts replaced bark cloth in prestige, and today they are held in high esteem. Quilts are brought out for display and given as gifts to mark holidays and rites of passage such as weddings, anniversaries, and funerals. They are also important gifts for establishing bonds between individuals and communities.

Royal Symbols, by contemporary quilter Deborah (Kepola) U. Kakalia, is a luxurious quilt with a two-color pattern reminiscent of bark-cloth design (fig. 24-15). It combines heraldic imagery from both Polynesian and European sources to communicate the artist's proud

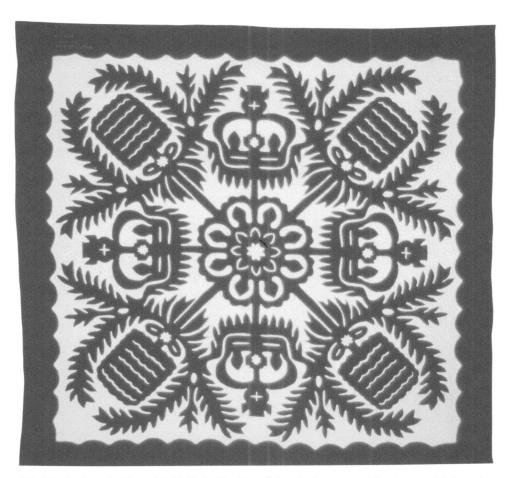

24-15. Deborah (Kepola) U. Kakalia. Royal Symbols. 1978. Quilt of cotton fabric and synthetic batting, appliqué, and contour stitching, $6'6^{1}/_{4}'' \times 6'4^{1}/_{2}''$ (1.98 × 1.96 m). Courtesy of Joyce D. Hammond, Joyce D. Hammond Collection

sense of cultural identity. The crowns, the rectangular feather standards (kahili) in the corners, and the boldly contrasting red and yellow colors-derived from traditional featherwork—are symbols of the Hawaiian monarchy, even though the crowns have been adapted from those worn by European royalty. The kahili are ancient Hawaiian symbols of authority and rule, and the eight arches arranged in a cross in the center symbolize the uniting of Hawaii's eight inhabited islands into a single Christian kingdom. The quilt's design, construction, and strong color contrasts are typically Hawaiian. The artist created the design the way children create paper snowflakes, by folding a piece of red fabric into eight triangular layers, cutting out the pattern, and then unfolding it. The red fabric was then sewn onto a yellow background and quilted with a technique known as contour stitching, in which the quilter follows the outlines of the design layer with parallel rows of tiny stitches. This technique, while effectively securing the layers of fabric and batting together, also creates a pattern that quilters liken to breaking waves.

In Australia, Aborigine artists have adopted canvas and acrylic paint for rendering imagery traditionally associated with more ephemeral mediums like bark, body, and sand painting. Sand painting is an ancient ritual art form that involves creating large colored designs on the ground. These paintings are done with red and yellow ochers, seeds, and feathers arranged on the earth in dots and other symbolic patterns. They are used to convey tribal lore to young initiates. Led by an art teacher named Geoffrey Bardon, a group of Aborigines expert in sand painting formed an art cooperative in 1971 in Papunya, in central Australia. Their success in transforming their ephemeral art into a painted mural on the school wall encouraged community elders to allow others, including women, to try their hand at painting, which soon became an economic mainstay for many aboriginal groups in the central and western desert.

Clifford Possum Tjapaltjarri (c. 1932–2002), a founder of the Papunya cooperative who gained an international reputation after an exhibition of his paintings in 1988, worked with his canvases on the floor, as in traditional sand painting, using ancient patterns and colors, principally red and yellow ochers as well as touches of blue. The superimposed layers of concentric circles and undulating lines and dots in a painting like *Man's Love Story* (fig. 24-16) create an effect of shifting

colors and lights. The painting seems entirely abstract, but it actually conveys a complex narrative involving two mythical ancestors. One of these men came to Papunya in search of honey ants; the white U shape on the left represents him seated in front of a water hole with an ants' nest, represented by the concentric circles. His digging stick lies to his right, and white sugary leaves lie to his left. The straight white "journey line" represents his trek from the west. The second man, represented by the brown-and-white U-shaped form, came from the east, leaving footprints, and sat down by another water hole nearby. He began to spin a hair string (a string made from human hair) on a spindle (the form leaning toward the upper right of the painting) but was distracted by thoughts of the woman he loved, who belonged to a kinship group into which he could not marry. When she approached, he let his hair string blow away (represented by the brown flecks below him) and lost all his work. Four women (the dotted U-shapes) from the group into which he could marry came with their digging sticks and sat around the two men. Rich symbolism fills other areas of the painting: The white footprints are those of another ancestral figure following a woman, and the wavy line at the top is the path of yet another ancestor. The black, dotted oval area indicates the site where young men were taught this story. The long horizontal bars are mirages. The wiggly shapes represent caterpillars, and the dots represent seeds, both forms of food.

The point of view of this work may be that of someone looking up from beneath the surface of the earth rather than looking down from above. Clifford Possum first painted the landscape features and the impressions left on the earth by the figures—their tracks, direction lines, and the U-shaped marks they left when sitting. Then, working carefully, dot by dot, he captured the vast expanse and shimmering light of the arid landscape. The painting's resemblance to modern Western painting styles like Abstract Expressionism, gestural painting, pointillism, or Color Field painting (Chapter 29) is accidental. Possum's work remains deeply embedded in the mythic, narrative traditions of his people. Although few artifacts remain from prehistoric times on the Pacific islands, throughout recorded history artists such as Possum have worked with remarkable robustness, freshness, and continuity. They have consistently created arts that express the deepest meanings of their culture.

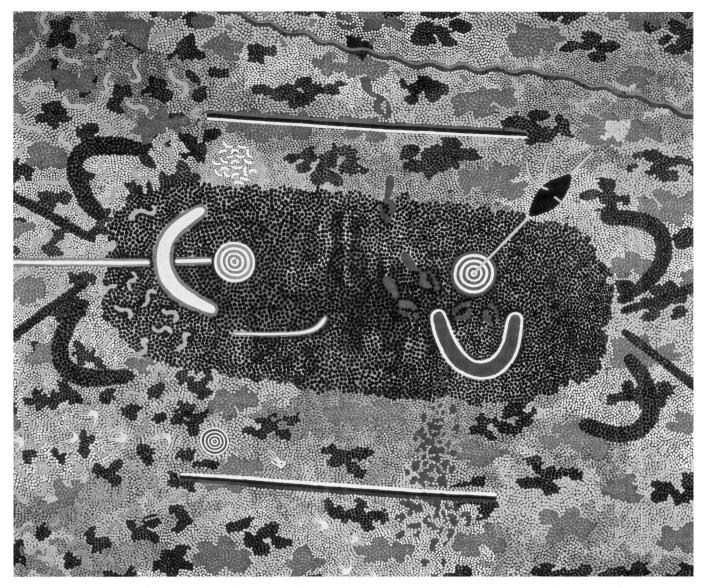

24-16. Clifford Possum Tjapaltjarri. *Man's Love Story*. 1978. Synthetic polymer paint on canvas, $6'11^3/_4'' \times 8'4^1/_4''$ (2.15 × 2.57 m). Art Gallery of South Australia, Adelaide. Visual Arts Board of the Australia Council Contemporary Art Purchase Grant, 1980

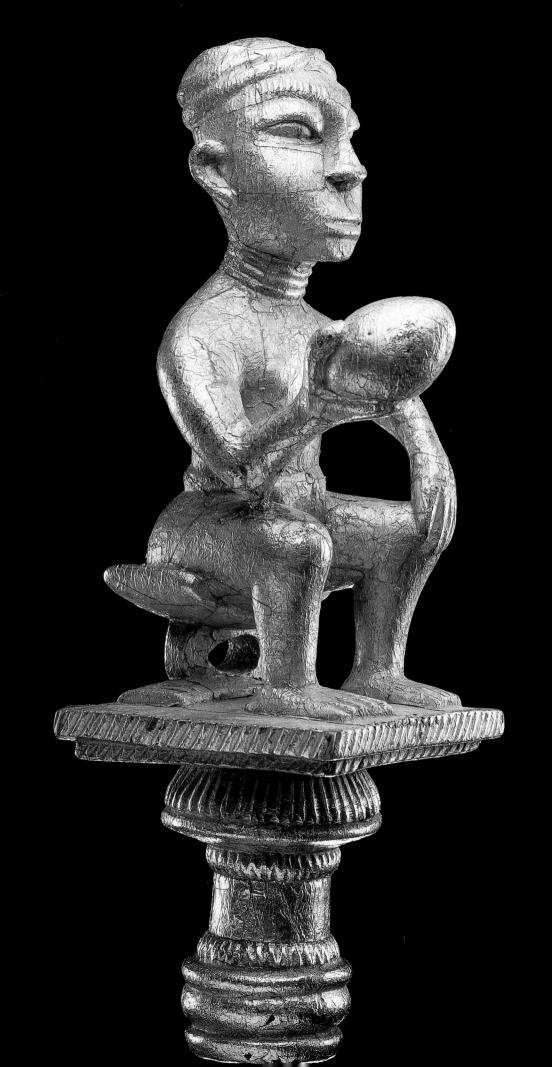

25

ART OF AFRICA IN THE MODERN ERA

OLITICAL POWER IS LIKE AN EGG, SAYS AN ASHANTI PROVERB. GRASP IT too tightly and it will shatter in your hand; hold it too loosely and it will slip from your fingers. Whenever the *okyeame*, or spokesperson, for one twentieth-century Ashanti ruler was conferring with that ruler or communicating the ruler's words to others, he held a staff with this symbolic caution on the use and abuse of power prominently displayed on the gold-leaf-covered finial (fig. 25-1).

A staff or rod is a nearly universal symbol of authority and leadership. Five thousand years before this gold-covered spokesperson's staff was carved, ancient Egyptian sculptors depicted kings holding a mace (a weighted club). The mace symbolized the king's role as a mighty ruler who brought order to the lands watered by the Nile. Today in many colleges and universities a ceremonial mace is still carried by the leader of an academic procession and placed in front of the speaker's lectern. Ashanti spokespersons who carry their image-topped staffs are part of this widespread tradition.

Since the fiftheenth century, when the first Europeans explored Africa, quantities of African artworks—such as this staff—have been shipped back to western museums of natural history or ethnography, where the works were exhibited as curious artifacts of "primitive" cultures. Toward the end of the nineteenth century, however, profound changes in western thinking about art gradually led more and more people to appreciate the inherent aesthetic qualities of these unfamiliar objects and at last to embrace them fully as art. In recent years scholars have further enchanced the world vision of traditional African arts by exploring their rich meaning from the point of view of the people who made them.

If we are to attempt to understand African art such as this staff on its own terms, we must first restore it to life. As with the art of so many periods and societies, we must take it out of the glass cases of the museums where we usually encounter it and imagine the artwork playing its vital role in a human community.

1600

TIMELINE 25-1. Africa in the Modern Era. The last six hundred years in Africa were dominated by European control, which ended in the second half of the twentieth century.

Map 25-1. Africa in the Modern Era. The vast continent of Africa is home to many countries and many cultures.

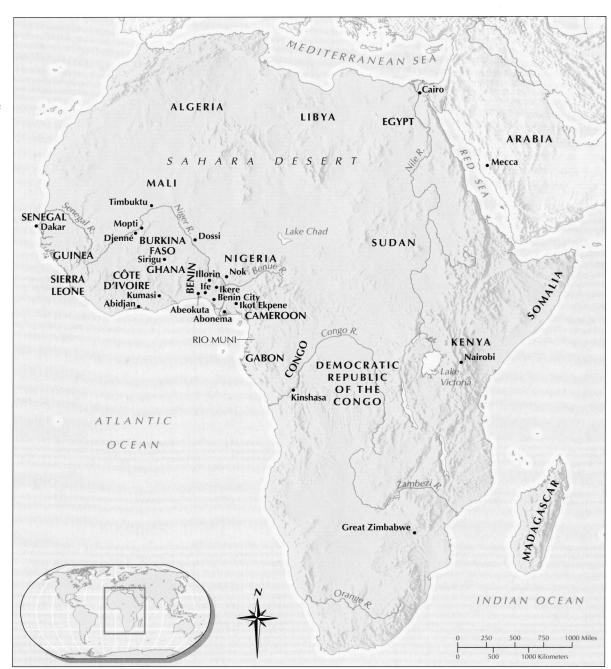

TRADITIONAL AND CONTEMPORARY AFRICA

The second-largest continent in the world, Africa is a land of enormous diversity (Map 25-1). Geographically, it ranges from vast deserts to tropi-

cal rain forest, from flat grasslands to spectacular mountains and dramatic rift valleys. Human diversity in Africa is equally impressive. More than 1,000 languages have

been identified, grouped by scholars into five major linguistic families. Various languages represent unique cultures, with their own history, customs, and art forms.

Before the nineteenth century, the most important outside influence to pervade Africa had been the religious culture of Islam, which spread gradually and largely peacefully through much of West Africa and along the East African coast (see "Foundations of African Cultures," opposite). The modern era, in con-

c. 1914 MOST OF AFRICA UNDER FOREIGN CONTROL ▲

c. 1950 MOST COLONIES GRANTED INDEPENDENCE A

FOUNDATIONS OF AFRICAN CULTURES

Africa was the site of one of the great civilizations of the ancient world, that of Egypt, which arose along the fertile banks of the Nile River over the course of the fourth millennium BCE and lasted for some 3,000 years. Egypt's rise coincided with the emergence of the Sahara, the largest desert in the world, from the formerly lush grasslands of northern Africa. Some of the oldest known African art, images inscribed and painted in the mountains of the central Sahara beginning around 8000 BCE, bears witness to this gradual transformation as well as to the lives of the pastoral peoples who once lived in the region.

As the grassland dried, its populations migrated in search of pasture and arable land. Many probably made their way to the Sudan, the broad band of savanna south of the Sahara. During the sixth century BCE, knowledge of iron smelting spread across the Sudan, enabling larger and more complex societies to emerge. One such society was the iron-working Nok culture, which arose in present-day Nigeria around 500 BCE and lasted until about 200 CE. Terra-cotta fig-

ures created by Nok artists are the earliest known sculpture from sub-Saharan Africa.

Farther south in present-day Nigeria, a remarkable culture developed in the city of Ife, which rose to prominence around 800 ce. There, from roughly 1000 to 1400, a tradition of naturalistic sculpture in bronze and terra-cotta flourished. Ife was, and remains, the sacred city of the Yoruba people. According to legend, Ife artists brought the techniques of bronze casting to the kingdom of Benin to the southeast. From 1170 to the present century Benin artists in the service of the court created numerous works in bronze, at first in the naturalistic style of Ife, then in an increasingly stylized and elaborate manner.

With the Arab conquest of North Africa during the seventh and eighth centuries, Islamic travelers and merchants became regular visitors to the Sudan. Largely through their writings, we know of the powerful West African empires of Ghana and Mali, which flourished successively from the fourth through the sixteenth centuries along the great bend in the Niger River. Both grew wealthy by controlling the flow of African gold and forest products into

the lucrative trans-Sahara trade. The city of Djenné, in Mali, served not only as a commercial hub but also as a prominent center of Islam.

Peoples along the coast of East Africa, meanwhile, since before the Common Era had participated in a maritime trade network that ringed the Indian Ocean and extended east to the islands of Indonesia. Over time, trading settlements arose along the coastline, peopled by Arab, Persian, and Indian merchants as well as Africans. By the thirteenth century these settlements were important port cities, and a new language, Swahili, had developed from the longtime mingling of Arabic with local African languages. Peoples of the interior organized extensive trade networks to funnel goods to these ports. From 1000 to 1500 many of these interior routes were controlled by the Shona people from the site called Great Zimbabwe. The extensive stone palace compound there stood in the center of a city of some 10,000 at its height. Numerous cities and kingdoms, often of great wealth and opulence, greeted the astonished eyes of the first European visitors to Africa at the end of the fifteenth century.

trast, begins with the European exploration and subsequent colonization of the African continent, developments that brought traditional African societies into sudden and traumatic contact with the "modern" world that Europe had largely created.

European ships first visited sub-Saharan Africa in the fifteenth century. For the next several hundred years, however, European contact with Africa was almost entirely limited to coastal areas, where trade, including the tragic slave trade, was carried out. During the nineteenth century, as the slave trade was gradually eliminated, European explorers began to investigate the unmapped African interior. They were soon followed by Christian missionaries, whose reports greatly fueled popular interest in the continent. Drawn by the potential wealth of Africa's natural resources, European governments began to seek territorial concessions from African rulers. Diplomacy soon gave way to force, and toward the end of the century, competition among rival powers fueled the so-called scramble for Africa, with

European governments racing to lay claim to whatever portion of the continent they were powerful enough to take. By 1914 virtually all of Africa had fallen under colonial rule.

In the years following World War I, nationalistic movements arose across Africa. Their leaders generally did not advocate a return to earlier forms of political organization but rather demanded the transformation of colonial divisions into Western-style nation-states governed by Africans. From 1945 through the mid-1970s one colony after another gained its independence, and the present-day map of modern African nations took shape.

Change has been brought about by contact between one people and another since the beginning of time, and art in Africa has both affected and been affected by such contacts. During the early twentieth century, the art of traditional African societies played a pivotal role in revitalizing the Western art tradition (see "African Furniture and the Art Deco Style," page 878).

AFRICAN FURNITURE AND THE ART DECO STYLE

In some African cultures, elaborate stools or chairs were created not only to indicate their owners' status but also to serve as altars for their souls after death. Thrones and other important seats in Africa are often carved from a single block of wood. This is the case with a chair taken from the Ngombe people, who live along the Congo River. The back is cantilevered out from the seat, which is in turn supported by four massive, braced legs. The rich surface decoration consists of Euro-

pean brass carpet tacks and darker iron tacks arranged in parallel lines and diamond patterns. The use of the tacks (imported goods) indicates that the owner had access to the extensive trade routes linking people of the inland forest to people of the coast. Both copper and iron were precious materials in central Africa; they were used as currency long before contact with Europe, and they were associated with both high social status and spirituality. The chair was thus an object of both beauty and power.

France began to colonize Africa in the late nineteenth century, and

African objects were brought to France by soldiers, administrators, and adventurers. Colonial expositions held in France in 1919 and 1923 displayed trophies from the newly vanquished territories, including household objects and art works from African courts.

Just as painters and sculptors such as Picasso and Matisse were inspired by the formal power of African masks, the French designer Pierre Legrain (1889–1929) recognized the aesthetic excellence of African sculpture. Legrain's Africainspired pieces appeared in the 1925 design exhibition International Ex-

position of Modern Decorative Industrial and Arts, where the term style moderne was given to describe the new geometric simplicity that characterized many of the objects displayed there. The exposition helped launch a popular commercial style called Art Deco (a label coined in the late 1960s).

Chair, from Democratic Republic of Congo. Ngombe culture, 20th century. Wood, brass, and iron tacks, height at tallest point $25^5/8$ " (65.1 cm). National Museum of African Art, Washington, D.C. Museum Purchases. 90-4-1

Pierre Legrain. *Tabouret*. c. 1923. Lacquered wood, horn, gilding, length $20^1/_2 \times 10^1/_2 \times 25^1/_4$ " (52 \times 26.6 \times 64.1 cm). Virginia Museum of Fine Arts, Richmond.

The Sydney and Frances Lewis Endowment Fund.

The formal inventiveness and expressive power of African sculpture were sources of inspiration for European artists trying to rethink strategies of representation. And contemporary African artists, especially those from major urban centers, who have come of age in the postcolonial culture that mingles European and African elements, can draw easily on the influences from many cultures, both African and non-African. They have established a firm place in the lively international art scene along with their European, American, and Asian counterparts, and their work is shown as readily in Paris, Tokyo, and Los Angeles as it is in the African cities of Abidjan, Kinshasa, and Dakar.

From the time of the first European explorations and continuing through the colonial era, quantities of art from traditional African societies were shipped back to Western museums—not art museums, at first, but museums of natural history or ethnography, which exhibited the works as curious artifacts of "primitive" cultures. Toward the end of the nineteenth century, however, profound changes in Western thinking about art gradually led people to appreciate the aesthetic qualities of traditional African "artifacts" and finally to embrace them fully as art. Art museums, both in Africa and in the West, began to collect African art seriously and methodically. Together with the living arts of traditional peoples today, these collections afford us a rich sampling of African art in the modern era.

Many traditional societies persist in Africa, both within and across contemporary political borders, and art continues to play a vital role in the spiritual and social life of the community. It is used to express Africans' ideas

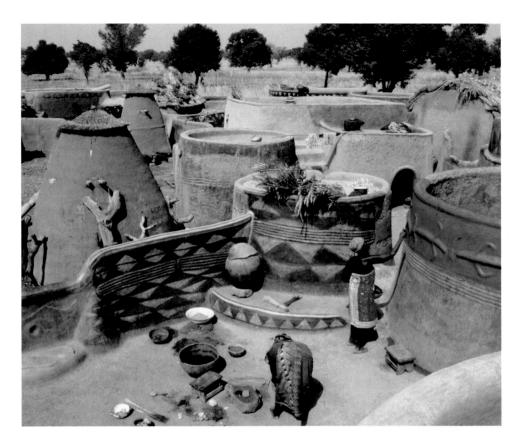

25-2. Nankani compound, Sirigu, Ghana, 1972.

Among the Nankani people, creating living areas is a cooperative but gender-specific project. Men build the structures, women decorate the surfaces. The structures are also gendered. The round dwellings shown here are women's houses located in an interior courtyard; men occupy rectangular flat-roofed houses. The bisected lozenge design on the dwelling to the left is called zalanga, the name for the braided sling that holds a woman's gourds and most treasured possessions.

about their relation to their world and as a tool to help them survive in a difficult and unpredictable environment. This chapter explores African art in light of how it addresses some of the fundamental concerns of human existence. Those concerns—rather than geographical region or time frame—form the backdrop against which we look at art works in this chapter, as African art cannot be divorced from its cultural and social contexts.

AREAS

LIVING Shelter is a basic human concern, yet each culture approaches it in a unique way that helps define that culture. The farming communities of the Nankani peo-

ple in the border area between Burkina Faso and Ghana, in West Africa, have developed a distinctive painted adobe architecture. The mud and adobe buildings of their walled compounds are low and single storied with either flat roofs that form terraces or conical roofs. Some buildings are used only by men, others by women. The Nankani men control an ancestral shrine by the entrance, a corral for cattle, a granary, and have rectangular houses. The inner courtyards, outdoor kitchen, and round houses are the women's areas (fig. 25-2). Men build the compound; women paint the buildings inside and out. The compound was designed to withstand raids. The outer wall has a single entrance on the west, and buildings inside the enclosure are placed so that they have a direct view of this entrance. Inside each door a low wall protects and hides the defenders/owners, who can observe and fire on enemies attempting to enter and cross the corral.

The women decorate the walls with horizontal molded ridges called yidoor, meaning "rows in a cultivated field" and "long eye" (long life) to express good wishes for the family. They paint the walls with rectangles and squares cut diagonally to create triangular patterns, a rectilinear surface decoration that contrasts with the curving walls. The painted patterns are called "braided sling," "broken pottery," "broken gourd," and since the triangular motifs can be seen as pointing up or down, they are sometimes called "filed teeth." The same geometric motifs are used on pottery and baskets, and for scarification of the skin. When people decorate themselves, their homes, and their possessions with the same patterns, art serves to enhance a cultural identity.

AND THE

CHILDREN Among the most fundamental of human concerns is the continuation of life from one generation CONTINUITY to the next. In traditional soci-OF LIFE eties children are especially important: Not only do they rep-

resent the future of the family and the community, but they also provide a form of "social security," guaranteeing that parents will have someone to care for them when they are old.

In the often harsh and unpredictable climates of Africa, human life can be fragile. In some areas half of all infants die before the age of five, and the average life expectancy may be as low as forty years. In these areas women may bear many children in hopes that a few will survive into adulthood, and failure to have children is a

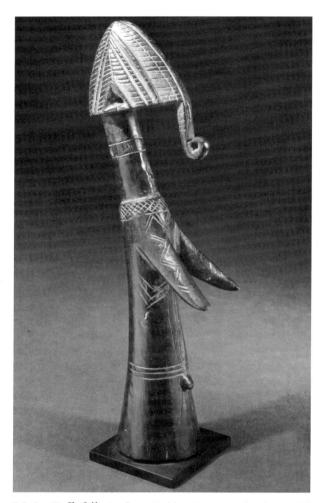

25-3. Doll (*biiga*), from Burkina Faso. Mossi culture, mid-20th century. Wood, height $11^1/_4$ " (28.57 cm). Collection Thomas G. B. Wheelock.

disaster for a wife, her husband, and her husband's lineage. It is very unusual for a man to be blamed as the cause of infertility, so women who have had difficulty bearing children appeal for help with special offerings or prayers, often involving the use of art.

The Mossi people of Burkina Faso carve a small wooden figure called *biiga*, or "child," as a plaything for little girls (fig. 25-3). The girls feed and bathe the figures and change their clothes, just as they see their mothers caring for younger siblings. At this level the figures are no more than simple dolls. Like many children's dolls around the world, they show ideals of mature beauty, including elaborate hairstyles, lovely clothing, and developed breasts. The *biiga* shown here wears its hair just as little Mossi girls do, with a long lock projecting over the face. (A married woman, in contrast, wears her lock in back.)

Other aspects of the doll, however, reveal a more complex meaning. The elongated breasts recall the practice of stretching by massaging to encourage lactation, and they mark the doll as the mother of many children. The scars that radiate from the navel mimic those applied to Mossi women following the birth of their first child. Thus, although the doll is called a child, it actually

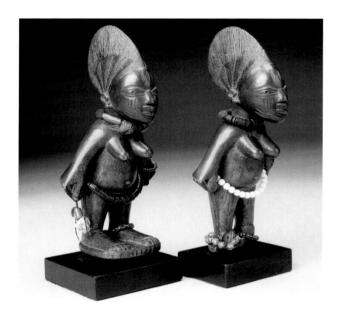

25-4. Akiode (?). Twin figures (*ere ibeji***),** from Nigeria. Yoruba culture, 20th century. Wood, height $7^7/8$ " (20 cm). The University of Iowa Museum of Art, Iowa City. The Stanley Collection (x1986.489 and x1986.488)

As with other African sculpture, patterns of use result in particular signs of wear. The facial features of *ere ibeji* are often worn down or even obliterated by repeated feedings and washings. Camwood powder applied as a cosmetic builds to a thick crust in areas that are rarely handled, and the blue indigo dye regularly applied to the hair

eventually builds to a thin layer.

represents the ideal Mossi woman, one who has achieved the goal of providing children to continue her husband's lineage.

Mossi girls do not outgrow their dolls as one would a childhood plaything. When a young woman marries, she brings the doll with her to her husband's home to serve as an aid to fertility. If she has difficulty in bearing her first child, she carries the doll on her back just as she would a baby. When she gives birth, the doll is placed on a new, clean mat just before the infant is placed there, and when she nurses, she places the doll against her breast for a moment before the newborn receives nourishment.

The Yoruba people of Nigeria have one of the highest rates of twin births in the world. The birth of twins is a joyful occasion, yet it is troubling as well, for twins are more delicate than single babies, and one or both may well die. Many African peoples believe that a dead child continues its life in a spirit world and that the parents' care and affection may reach it there, often through the medium of art. When a Yoruba twin dies, the parents consult a diviner, a specialist in ritual and spiritual practices, who may tell them that an image of a twin, or *ere ibeji*, must be carved (see fig. 25-4).

The mother cares for the "birth" of this image by sending the artist food while the figure is being carved. When the image is finished, she brings the artist gifts. Then, carrying the figure as she would a living child, she dances home accompanied by the singing of neigh-

borhood women. She places the figure in a shrine in her bedroom and lavishes care upon it, feeding it, dressing it with beautiful textiles and jewelry, anointing it with cosmetic oils. The Yoruba believe that the spirit of a dead twin thus honored may bring its parents wealth and good luck.

The twins in figure 25-4 are female. They may be the work of the Yoruba artist Akiode, who died in 1936. Like most objects that Africans produce to encourage the birth and growth of children, the figures emphasize health and well-being. They have beautiful, glossy surfaces, rings of fat as evidence that they are well fed, and the marks of mature adulthood that will one day be achieved. They represent hope for the future, for survival, and for prosperity.

INITIATION

Eventually, an adolescent must leave behind the world of children and take his or her place in the adult world. In contemporary Western societies, initiation into the adult world is extended over several years and punctuated by numerous rites, such as being confirmed in a religion, earning a driver's license, graduating from high school, and reaching the age of majority. All of these steps involve acquiring the spiritual and worldly knowledge Western society deems necessary and accepting the corresponding responsibilities. In other societies, initiation is more concentrated, and the acquisition of knowledge may be supplemented by physical tests and trials of endurance to prove that the candidate is equal to the hardships of adult life.

The Bwa people of central Burkina Faso initiate young men and women into adulthood following the onset of puberty. The initiates are first separated from younger playmates by being "kidnapped" by older relatives, though their disappearance is explained in the community by saying that they have been devoured by wild beasts. The initiates are stripped of their clothing and made to sleep on the ground without blankets. Isolated from the community, they are taught about the world of nature spirits and about the wooden masks that represent them.

The initiates have watched these masks in performance every month of their lives. Now, for the first time, they learn that the masks are made of wood and are worn by their older brothers and cousins. They learn of the spirit each mask represents, and they memorize the story of each spirit's encounter with the founding ancestors of the clan. They learn how to construct costumes from hemp to be worn with the masks, and they learn the songs and instruments that accompany the masks in performance. Only the boys wear each mask in turn and learn the dance steps that express the character and personality it represents. Returning to the community, the initiates display their new knowledge in a public ceremony. Each boy performs with one of the masks, while the girls sing the accompanying songs. At the end of the mask ceremony the young men and young women rejoin their families as adults, ready to marry, to start farms, and to begin families of their own.

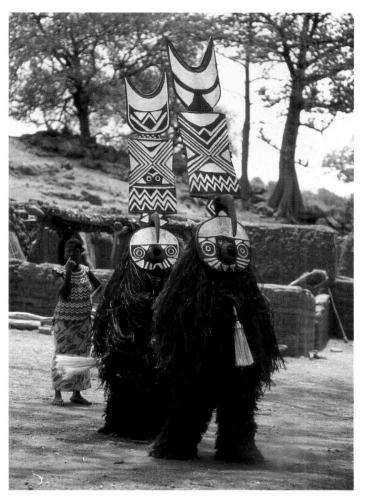

25-5. Two masks in performance, from Dossi, Burkina Faso. Bwa culture, 1984. Wood, mineral pigments, and fiber, height approx. 7′ (2.13 m).

The Bwa have been making and using such masks since well before Burkina Faso achieved its independence in 1960. We might assume their use is centuries old, but in this case, the masks are a comparatively recent innovation. The elders of the Bwa family who own these masks state that they, like all Bwa, once followed the cult of the spirit of Do, who is represented by masks made of leaves. In the last quarter of the nineteenth century the Bwa were the targets of slave raiders from the north and east. Their response to this new danger was to acquire wooden masks from their neighbors, for such masks seemed a more effective and powerful way of communicating with spirits who could help them. Thus, faced with a new form of adversity, the Bwa sought a new tradition to cope with it.

Most Bwa masks depict spirits that have taken an animal form, such as crocodile, hyena, hawk, or serpent. Others represent spirits in human form. Among the most spectacular masks, however, are those crowned with a tall, narrow plank (fig. 25-5), which are entirely **abstract** and represent spirits that have taken neither human nor animal form. The graphic patterns that cover these masks are easily recognized by the initiated. The white crescent at the top represents the quarter moon, under which the initiation is held. The white triangles below represent bull roarers—sacred sound makers that are swung around the head on a long cord to re-create spirit voices. The large central

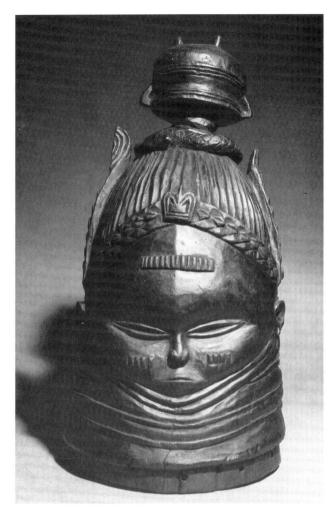

25-6. Female ancestral mask (*Nowo***),** from Sierra Leone. Mende culture, Sowei mask which embodies the guardian spirit for the Women's Sande Society. *c.* 1906. Wood, height $18^{7}\!/_{\!8} \times 8^{3}\!/_{\!5}$ " (47.7 × 21.9 cm). The Baltimore Museum of Art.

Gift of Dr. Joseph H. Seipp, Jr. (#BMA 1975.69.0001)

X represents the scar that every initiated Bwa wears as a mark of devotion. The horizontal zigzags at the bottom represent the path of ancestors and symbolize adherence to ancestral ways. That the path is difficult to follow is clearly conveyed. The curving red hook that projects in front of the face is said to represent the beak of the hornbill, a bird associated with the supernatural world and believed to be an intermediary between the living and the dead. Through abstract patterns, the mask conveys a message about the proper moral conduct of life with all the symbolic clarity and immediacy of a traffic signal.

Among the Mende people of Sierra Leone, in West Africa, the initiation of young girls into adulthood is organized by a society of older women called Sande. The initiation culminates with a ritual bath in a river, after which the girls return to the village to meet their future husbands. At the ceremony the Sande women wear black gloves and stockings, black costumes of shredded raffia fibers that cover the entire body, and black masks called *nowo* (fig. 25-6).

With its high and glossy forehead, plaited hairstyle decorated with combs, and creases of abundance around the neck, the mask represents the Mende ideal of female beauty. The meanings of the mask are complex. One scholar has shown that the entire mask can be compared to the chrysalis of a certain African butterfly, with the creases in particular representing the segments of the chrysalis. Thus, the young woman entering adulthood is like a beautiful butterfly emerging from its ugly chrysalis. The comparison extends even further, for just as the butterfly feeds on the toxic sap of the milkweed to make itself poisonous to predatory birds, so the medicine of Sande is believed to protect the young women from danger. The creases may also refer to concentric waves radiating outward as the mask emerges from calm waters to appear among humankind, just as the initiates rise from the river to take their place as members of the adult community.

A ceremony of initiation may accompany the achievement of other types of membership as well. Among the Lega people, who live in the dense forests between the headwaters of the Congo River and the great lakes of East Africa, the political system is based on a voluntary association called *bwami*, which comprises six levels or grades. Some 80 percent of all male Lega belong to *bwami*, and all aspire to the highest grade. Women can belong to *bwami* as well, although not at a higher grade than their husbands.

Promotion from one grade of bwami to the next takes many years. It is based not only on a candidate's character but also on his or her ability to pay the initiation fees, which increase dramatically with each grade. No candidate for any level of bwami can pay the fees alone; all must depend on the help of relatives to provide the necessary cowrie shells, goats, wild game, palm oil, clothing, and trade goods. Candidates who are in conflict with their relatives will never be successful in securing such support and thus will never achieve their highest goals. The ambitions of the Lega to move from one level of *bwami* to the next encourage a harmonious and well-ordered community, for all must stay on good terms if they are to advance. The association promotes a lifelong growth in moral character and an everdeepening understanding of the relationship of the individual to the community.

Bwami initiations are held in the plaza at the center of the community in the presence of all members. Dances and songs are performed, and the values and ideals of the appropriate grade are explained through proverbs and sayings. These standards are illustrated by natural or crafted objects, which are presented to the initiate as signs of membership. At the highest two levels of bwami, such objects include masks and sculpted figures.

The mask in figure 25-7 is associated with *yananio*, the second-highest grade of *bwami*. Typical of Lega masks, the head is fashioned as an oval into which is carved a concave, heart-shaped face with narrow, raised features. The masks are often colored white with clay and fitted with a beard made of hemp fibers. Too small

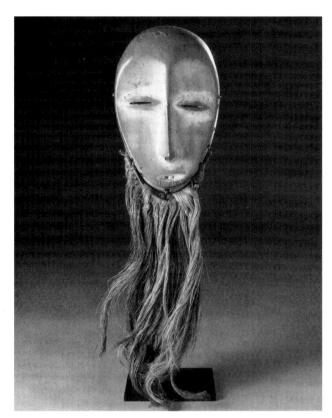

25-7. Bwami mask, from Democratic Republic of Congo (Zaire). Lega culture, early 20th century. Wood, kaolin, and hemp fibers, height $7^{5}/8$ " (19.3 cm). The University of Iowa Museum of Art, Iowa City.

The Stanley Collection, (1986.571)

to cover the face, they are displayed in other ways-held in the palm of a hand, for example, or attached to a thigh. Each means of display recalls a different value or saying, so that one mask may convey a variety of meanings. For example, held by the beard and slung over the shoulder, this mask represents "courage," for it reminds the Lega of a disastrous retreat from an enemy village during which many Lega men were slain from behind.

SPIRIT

THE Why does one child fall ill and die while its twin remains healthy? Why does one year bring rain and a bountiful crop, WORLD while the next brings drought and famine? All people everywhere confront

such fundamental and troubling questions. For traditional African societies the answers are often thought to lie in the workings of spirits. Spirits are believed to inhabit the fields that produce crops, the river that provides fish, the forest that is home to game, the land that must be cleared in order to build a new village. A family, too, includes spirits-those of its ancestors as well as those of children yet unborn. In the blessing or curse of these myriad surrounding spirits lies the difference between success and failure in life.

To communicate with these all-important spirits, African societies usually rely on a specialist in ritual the person known elsewhere in the world as priest, minister, rabbi, pastor, imam, or shaman. Whatever his or her title, the ritual specialist serves as an essential link between the supernatural and human worlds, opening the lines of communication through such techniques as prayer, sacrifice, offerings, magic, and divination. Each African people has its own name for this specialist, but for simplicity we can refer to them all as diviners. Art often plays an important role in dealings with the spirit world, for art can make the invisible visible, giving identity and personality to what is abstract and intangible.

To the Lobi people of Burkina Faso, the spirits of nature are known as thila (singular thil), and they are believed to control every aspect of life. Indeed, their power is so pervasive that they may be considered the true rulers of the community. Lobi houses may be widely scattered over miles of dry West African savanna but are considered a community when they acknowledge the same thil and agree to regulate their society by its rules, called zoser. Such rules bear comparison to those binding many religious communities around the world and may include a prohibition against killing or eating the meat of a certain animal, sleeping on a certain type of mat, or wearing a certain pattern or cloth. Totally averse to any form of kingship or centralized authority, the Lobi have no other system of rule but zoser.

Thila are normally believed to be invisible. When adversity strikes, however, the Lobi may consult a diviner, who may prescribe the carving of a wooden figure called a boteba (fig. 25-8, page 884). A boteba gives a thil physical form. More than simply a carving, a boteba is thought of as a living being who can see, move, and communicate with other boteba and with its owner. The owner of a boteba can thus address the spirit it gives form to directly, seeking its protection or aid.

Each thil has a particular skill that its representative boteba conveys through pose or expression. A boteba carved with an expression of terrible anger, for example, represents a thil whose skill is to frighten off evil forces. The boteba in figure 25-8 is carved in the characteristic Lobi pose of mourning, with its hands clasped tightly behind its back and its head turned to one side. This boteba mourns so that its owner may not be saddened by misfortune. Like a spiritual decoy, it takes on the burden of grief that might otherwise have come to the owner. Shrines may hold dozens of boteba figures, each one contributing its own unique skill to the family or community.

Among the most potent images of power in African art are the nkisi, or spirit, figures made by the Kongo and Songye peoples of Congo. The best known of these are the large wooden *nkonde*, which bristle with nails, pins, blades, and other sharp objects (fig. 25-9, page 884). An nkisi nkonde begins its life as a simple, unadorned wooden figure that may be purchased from a carver at a market or commissioned by a diviner on behalf of a client who has encountered some adversity or faces an important turning point. Drawing on vast knowledge, the diviner prescribes magical/medicinal ingredients, called bilongo, specific to the client's problem. These bilongo are added to the figure, either mixed with white

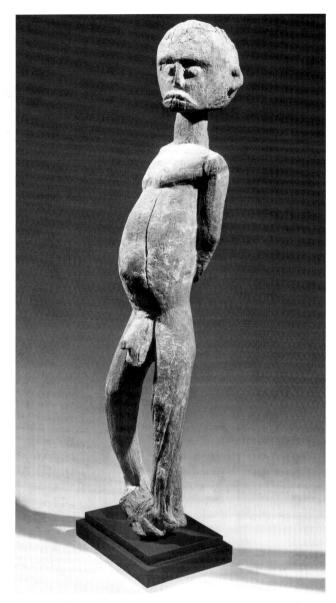

25-8. Spirit figure (*boteba*), from Burkina Faso. Lobi culture, 19th century. Wood, height $30^{11}/_{16}$ " (78 cm). Collection Kerchache, Paris.

clay and plastered directly onto the body or suspended in a packet from the neck or waist.

The *bilongo* transform the *nkonde* into a living being with frightful powers, ready to attack the forces of evil on behalf of a human client. *Bilongo* ingredients are drawn from plants, animals, and minerals, and may include human hair, nail clippings, and other materials. Each ingredient has a unique role. Some bring the figure to life by embodying the spirit of an ancestor or a soul trapped by a malevolent power. Others endow the figure with distinctive powers or focus the powers in a particular direction, often through metaphor. For example, the Kongo admire the quickness and agility of a particular species of mouse. Tufts of this mouse's hair included in the *bilongo* act as a metaphor for quickness, ensuring that the *nkisi nkonde* will act rapidly when its powers are activated.

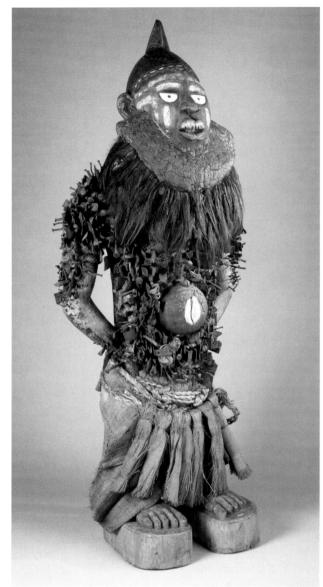

25-9. Power figure (*nkisi nkonde*), from Democratic Republic of Congo (Zaire). Kongo culture, 19th century. Wood, nails, pins, blades, and other materials, height 44" (111.7 cm). The Field Museum, Chicago. Acquisition A109979c

Nkisi nkonde provide a dramatic example of the ways in which works of African sculpture are transformed by use. When first carved, the figure is "neutral," with no particular significance or use. Magical materials applied by a diviner transform the figure into a powerful being, at the same time modifying its form. Each client who activates that power further modifies the statue. While the object is empowered, nails may also be removed as part of a healing or oath-taking process. And when the figure's particular powers are no longer needed, the additions may all be stripped away to be replaced with different magical materials that give the same figure a new function. The result is that many hands play a role in creating the work of art we see in a museum. The person we are likely to label as the "artist" is only the initial creator. Many others modify the work, and in their hands the figure becomes a visual document of the history of the conflicts and afflictions that have threatened the community.

To activate the powers, clients drive in a nail or other pointed object to get the nkonde's attention and prick it into action. An nkisi nkonde may serve many private and public functions. Two warring villages might agree to end their conflict by swearing an oath of peace in the presence of the nkonde and then driving a nail into it to seal the agreement. Two merchants might agree to a partnership by driving two small nails into the figure side by side and then make their pact binding by wrapping the nails together with a stout cord. Someone accused of a crime might swear his innocence and drive in a nail, asking the nkonde to destroy him if he lied. A mother might invoke the power of the *nkonde* to heal her sick children. The objects driven into the nkonde may also operate metaphorically. For example, the Kongo use a broad blade called a baaku to cut into palm trees, releasing sap that will eventually be fermented into palm wine. The word baaku derives from the word baaka, which means both "extract" and "destroy." Thus tiny replicas of baaku driven into the nkonde are believed to destroy those who use evil

The word *nkonde* shares a stem with *konda*, meaning "to hunt," for the figure is quick to hunt down a client's enemies and destroy them. The *nkonde* here stands in a pose called *pakalala*, a stance of alertness like that of a wrestler challenging an opponent in the ring. Other *nkonde* figures hold a knife or spear in an upraised hand, ready to strike or attack.

Some African peoples conceive of the spirit world as a parallel realm in which spirits may have families, attend markets, live in villages, and possess personalities complete with faults and virtues. The Baule people in Côte d'Ivoire believe that each of us lived in the spirit world before we were born. While there, we had a spirit spouse, whom we left behind when we entered this life. A person who has difficulty assuming his or her gender-specific role as an adult Baule—a man who has not married or achieved his expected status in life, for example, or a woman who has not borne children—may dream of his or her spirit spouse.

For such a person, the diviner may prescribe the carving of an image of the spirit spouse (fig. 25-10). A man has a female figure (blolo bla) carved; a woman has a male figure (blolo bian) carved. The figures display the most admired and desirable marks of beauty so that the spirit spouses may be encouraged to enter and inhabit them. Spirit spouse figures are broadly naturalistic, with swelling, fully rounded musculature and careful attention to details of hairstyle, jewelry, and scarification patterns. They may be carved standing in a quiet, dignified pose or seated on a traditional throne. The throne contributes to the status of the figure and thus acts as an added incentive for the spirit to take up residence there. The owner keeps the figure in his or her room, dressing it in beautiful textiles and jewelry, washing it, anointing it with oil, feeding it, and caressing it. The Baule hope that by caring for and pleasing their spirit spouse a balance may be restored that will free their human life to unfold smoothly.

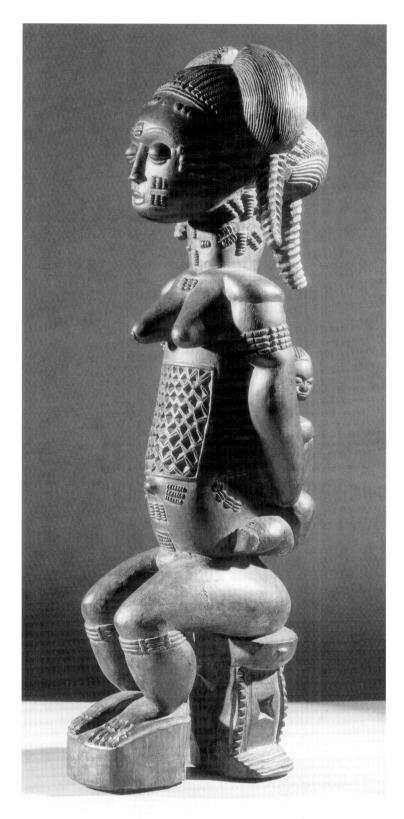

25-10. Spirit spouse (*blolo bla*), from Côte d'Ivoire. Baule culture, early 20th century. Wood, height $17^{1}/8$ " (43.5 cm). University of Pennsylvania Museum of Archeology and Anthropology, Philadelphia.

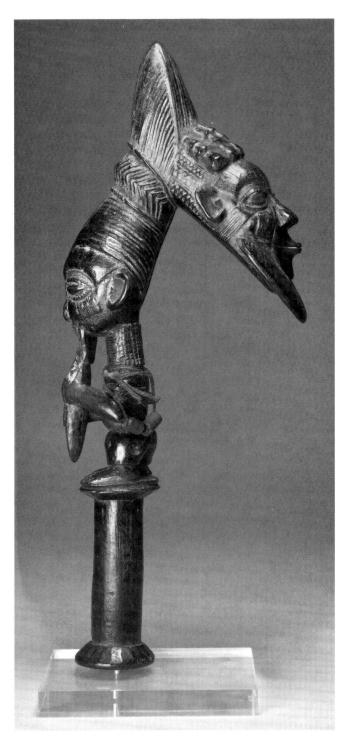

25-11. Dance staff depicting Eshu, from Nigeria. Yoruba culture, 20th century. Wood, height 17" (43.2 cm). The University of Iowa Museum of Art, Iowa City. The Stanley Collection, (1986.284)

While nature spirits are often portrayed in African art, major deities are generally considered to be far removed from the everyday lives of humans and are thus rarely depicted. Such is the case with Olodumare, also known as Olorun, the creator god of the Yoruba people of southwestern Nigeria. According to Yoruba myth, Olodumare withdrew from the earth when he was insulted by one of his eight children. When the children later sought him out to ask him to restore order on earth, they found him sitting beneath a palm tree. Olodumare refused to return, although he did consent to give humanity some tools of divination so that they could learn his will indirectly.

The Yoruba have a sizable pantheon of lesser gods, or *orisha*, who serve as intermediaries between Olodumare and his creation. One that is commonly represented in art is Eshu, also called Elegba, the messenger of the gods. Eshu is a trickster, a capricious and mischievous god who loves nothing better than to throw a wrench into the works just when everything is going well. The Yoruba acknowledge that all humans may slip up disastrously (and hilariously) when it is most important not to, and thus all must recognize and pay tribute to Eshu.

Eshu is associated with two eternal sources of human conflict, sex and money, and is usually portrayed with a long hairstyle, because the Yoruba consider long hair to represent excess libidinous energy and unrestrained sexuality. Figures of Eshu are usually adorned with long strands of cowrie shells, a traditional African currency. Shrines to Eshu are erected wherever there is the potential for encounters that lead to conflict, especially at crossroads, in markets, or in front of banks. Eshu's followers hope that their offerings will persuade the god to spare them the pitfalls he places in front of others.

Eshu is intriguingly ambivalent and may be represented as male or female, as a young prankster or a wise old man. The dance staff here beautifully embodies the dual nature of Eshu (fig. 25-11). To the left he is depicted as a boy blowing loud noises on a whistle just to annoy his elders—a gleefully antisocial act of defiance. To the right he is shown as a wise old man, with wrinkles and a beard. The two faces are joined at the hair, which is drawn up into a long phallic knot. The heads crown a dance wand meant to be carried in performance by priests and followers of Eshu, whose bodies the god is believed to enter during worship.

LEADERSHIP As in societies throughout the world, art in Africa is used to identify those who hold power, to validate their right to kingship or their authority as representatives of the family or community, and to communicate the rules for moral behavior that must be obeyed by all members of the society. The gold-and-wood spokesperson's staff with which this chapter opened is an example of the art of leadership (see fig. 25-1). It belongs to the culture of the Ashanti peoples of Ghana, in West Africa. The Ashanti greatly admire fine language—one of their

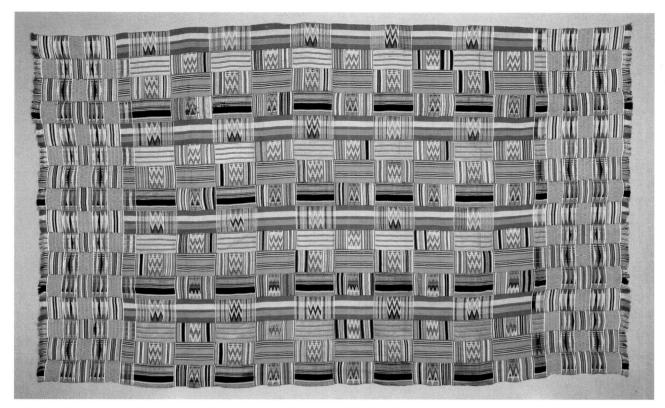

25-12. *Kente* **cloth,** from Ghana. Ashanti culture, 20th century. Silk, $6'10^9/_{16}" \times 4'3^9/_{16}" (2.09 \times 1.30 \text{ m})$. National Museum of African Art and National Museum of Natural History, Smithsonian Institution, Washington, D.C. Purchased with funds provided by the Smithsonian Collections Acquisition Program, 1983–85, (EJ 10583)

adages is, "We speak to the wise man in proverbs, not in plain speech"—and consequently their governing system includes the special post of spokesperson to the ruler. Since about 1900 these advisers have carried staffs of office such as the one pictured here. The carved figure at the top illustrates a story that may have multiple meanings when told by a witty owner. This staff was probably carved in the 1960s or 1970s by Kojo Bonsu. The son of Osei Bonsu (1900–1976), a famous carver, Kojo Bonsu lives in the Ashanti city of Kumasi and continues to carve prolifically.

The Ashanti use gold not only for objects, such as the staff, that are reserved for the use of rulers, but also for jewelry, as do other peoples of the region. But for the Ashanti, gold was long a major source of power; they traded it first via intermediaries across the Sahara to the Mediterranean world, then later directly to Europeans on the West African coast.

The Ashanti are also renowned for the beauty of their woven textiles, called *kente* (fig. 25-12). Weaving was introduced in the sixteenth century from Sudan. The weavers were, traditionally, men. Ashanti weavers work on small, light, horizontal looms that produce long, narrow strips of cloth. They begin by laying out the long **warp** threads in a brightly colored pattern. Today the threads are likely to be rayon. Formerly, however, they were silk, which the Ashanti produced by unraveling Chinese cloth obtained through European trade. **Weft** threads are woven through the warp to produce

complex patterns, including double weaves in which the front and back of the cloth display different patterns. The long strips produced by the loom are then cut to size and sewn together to form large rectangles of finished *kente* cloth.

Kente cloth was originally reserved for state regalia. A man wore a single huge piece, about 6 to 7 feet by 12 to 13 feet, wrapped like a toga with no belt and the right shoulder bare. Women wore two pieces—a skirt and a shawl. The kente cloth shown here began with a warp pattern that alternates red, green, and yellow. The pattern is known as oyokoman ogya da mu, meaning "there is a fire between two factions of the Oyoko clan," and refers to the civil war that followed the death of the Ashanti king Osai Tutu in about 1730. Traditionally, only the king of the Ashanti was allowed to wear this pattern. Other complex patterns were reserved for the royal family or members of the court. Commoners who dared to wear a restricted pattern were severely punished. In present-day Ghana the wearing of kente and other traditional textiles has been encouraged, and patterns are no longer restricted to a particular person or group.

The Kuba people of the Democratic Republic of Congo have produced elaborate and sophisticated political art since at least the seventeenth century. Kuba kings were memorialized by portrait sculpture called *ndop* (fig. 25-13, page 888). While the king was alive, his *ndop* was believed to house his double, a counterpart of his soul. After his death the portrait was

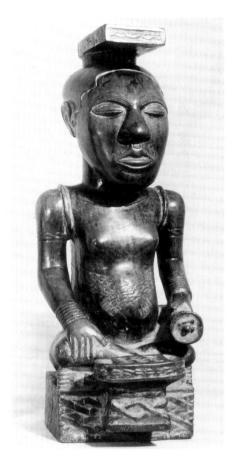

25-13. Royal portrait figure (*ndop*) of Shyaam a-Mbul a-Ngwoong, from Democratic Republic of Congo (Zaire). Baluba culture, Kuba kingdom, 18th-century copy of a mid-17th-century figure. Wood, height 21³/₈" (54.5 cm). Museum of Mankind, London.

believed to embody his spirit, which was thought to have power over the fertility both of the land and of his subjects. Together, the twenty-two known *ndop* span almost 400 years of Kuba history.

Kuba sculptors did not try to capture a physical likeness of each king. Indeed, several of the portraits seem interchangeable. Rather, each king is identified by an icon, called *ibol*, carved as part of the dais on which he is seated. The *ibol* refers to a skill for which the king was noted or an important event that took place during his lifetime. The *ndop* in figure 25-13 portrays the seventeenth-century king Shyaam a-Mbul a-Ngwoong, founder of the Kuba kingdom. Carved on the front of his dais is a board for playing mancala, a game he is said to have introduced to the Kuba. Icons of other kings include an anvil for a king who was a skilled blacksmith, a slave girl for a king who married beneath his rank, and a rooster for a twentieth-century king who was exceptionally vigilant.

Kuba *ndop* figures also feature carved representations of royal regalia, including a wide belt of cowrie shells crossing the torso. Below the cowries is a braided belt that can never be untied, symbolizing the ability of the wearer to keep the secrets of the kingdom. Cowrie-

shell bands worn on the biceps are called *mabiim*. Commoners are allowed to wear two bands; members of the royal family wear nine. The brass rings depicted on the forearms may be worn only by the king and his mother. The ornaments over each shoulder are made of cloth-covered cane. They represent hippopotamus teeth, and they reflect the prestige that accrues to a hunter of that large animal. Finally, all of the Kuba king figures wear a distinctive cap with a projecting bill. The bill reminds the Kuba of the story of a dispute that arose between the sons of their creator god in which members of one faction identified themselves by wearing the blade of a hoe balanced on their heads.

The kings of the Yoruba people manifested their power through the large, complex palaces in which they lived. In a typical palace plan, the principal rooms opened onto a veranda with elaborately carved posts fronting a courtyard. Dense, highly descriptive figure carving also covered the doors. The finest architectural sculptor of modern times was Olowe of Ise, who carved doors and veranda posts for the rulers of the Ekiti-Yoruba kingdoms in southwestern Nigeria.

The door of the royal palace in Ikere (fig. 25-14) illustrates Olowe's artistry. Its asymmetrical composition combines narrative and symbolic scenes in horizontal rectangular panels. Tall figures carved in profile end in heads facing out to confront the viewer. Their long necks and elaborate hairstyles make them appear even taller, unlike typical Yoruba sculpture, which uses short, static figures. The figures are in such high relief that the upper portions are actually carved in the round. The figures move energetically against an underlying decorative pattern, and the entire surface of the doors is also painted.

The doors commemorate celebrations honoring the divination god, Ifa, or Orunmila. In the left-hand panel, the future will be foretold by reading oracles. At the top is a man with sacrificial animal and palm nuts. Below him, a priest sits with an oracle board and the ceremonial cup for the palm nuts (see fig. 13, Introduction), and lower still are messengers and assistants. On the right, two rows of faces introduce the court. The king is represented in the second panel seated between his guard and two royal wives; the chief wife wears a European top hat, a symbol of power. Above the royals, musicians perform, while below royal wives dance. The bottom two registers depict the people—farm workers and a pair of wrestlers.

Olowe seems to have worked from the early 1900s until his death in 1938. Although he was famous throughout Yorubaland and called upon by patrons as distant as 60 miles from his home, few records of his activities remain, and only one European, Philip Allison, wrote of meeting him and watching him work. Allison described Olowe carving the iron-hard African oak "as easily as [he would] a calabash [gourd]."

Not all African peoples centralized power in a single ruler. Most of the peoples of southeastern Nigeria, for example, depended on a council of male elders or on a men's voluntary association to provide order in the life of

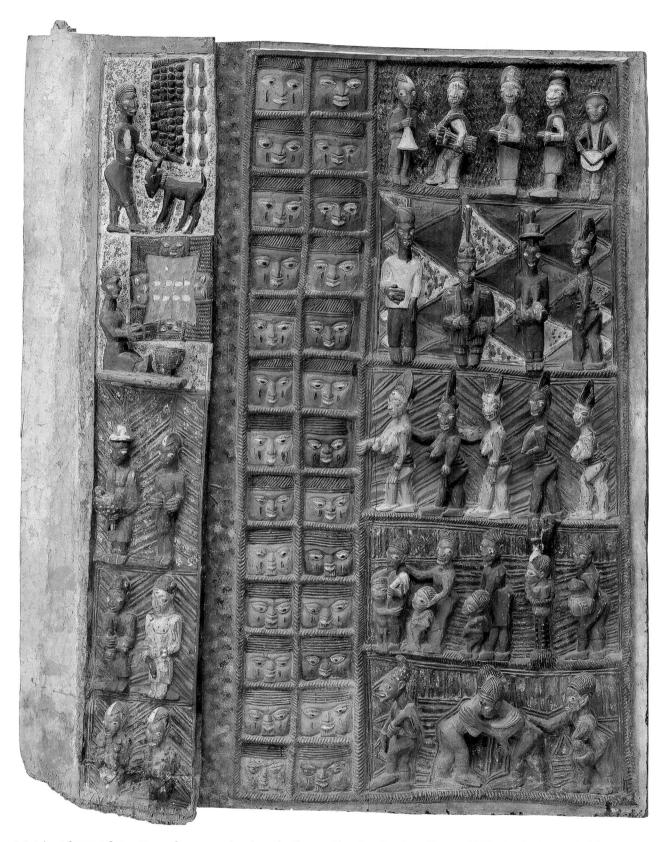

25-14. Olowe of Ise. Door from royal palace in Ikere, Nigeria. Yoruba culture, c. 1925. Wood, pigment, height 72" (182.9 cm). The Detroit Institute of the Arts.

Gift of Bethea and Irwin Green in honor of the 20th anniversary of the Department of African, Oceanic and New World Cultures, (1997.80.A)

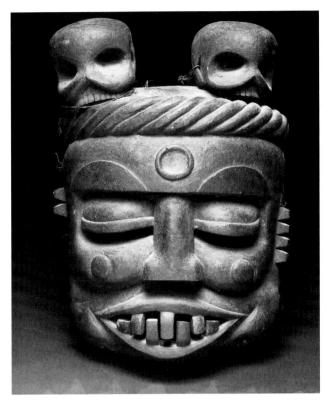

25-15. Ekpo mask, from Nigeria. Anang Ibibio culture, late 1930s. Wood, height $23^{5}/8''$ (60 cm). Musée Barbier-Mueller, Geneva.

This mask embodies many characteristics the Ibibio find repulsive or frightening, such as swollen features, matte black skin, and large, uneven teeth. The pair of skulls atop the head are potent death imagery. The circular scar on the forehead and the ropelike headband indicate membership in the diviner's cult, idiong, whose members were particularly feared for their supernatural power. The mask is in the style of the Otoro clan from the Ikot Abia Osom area near the city of Ikot Ekpene.

the community. The Anang Ibibio people of Nigeria were formerly ruled by a men's society called Ekpo. Ekpo expressed its power in part through art, especially large, dark, purposely frightening masks (fig. 25-15). In most rituals involving masks, it is "the mask," not the person wearing it, who takes the action. Such masks were worn by the younger members of the society when they were sent out to punish transgressors. Accompanied by assistants bearing torches, the mask would emerge from the Ekpo meetinghouse at night and proceed directly to the guilty person's house, where a punishment of beating or even execution might be meted out. The identity of the executioner was concealed by the mask, which identified him as an impersonal representative of Ekpo in much the same way that a uniform makes clear that a police officer represents the authority of the state.

AND **ANCESTORS**

DEATH In the traditional African view, death is not an end but a transition —the leaving behind of one phase of life and the beginning of another. Just as ceremonies mark

the initiation of young men and women into the commu-

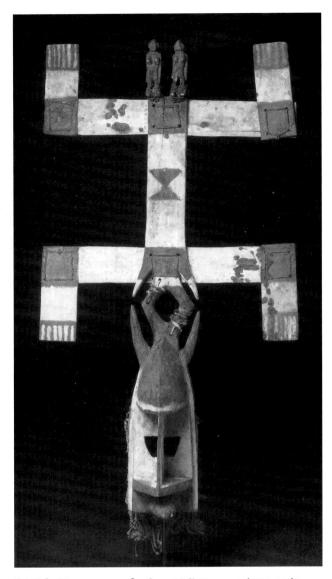

25-16. Kanaga mask, from Mali. Dogon culture, early 20th century. Wood, height $45^{1}/_{4}$ " (115 cm). Musée Barbier-Mueller, Geneva.

nity of adults, so they mark the initiation of the newly dead into the community of spirits. Like the rites of initiation into adulthood, death begins with a separation from the community, in this case the community of the living. A period of isolation and trial follows, during which the newly dead spirit may, for example, journey to the land of ancestors. Finally, the deceased is reintegrated into a community, this time the community of ancestral spirits. The living who preserve the memory of the deceased may appeal to his or her spirit to intercede on their behalf with nature spirits or to prevent the spirits of the dead from using their powers to harm.

Among the Dogon people of Mali, in West Africa, a collective funeral rite with masks (fig. 25-16) is held every twelve to thirteen years, a ceremony called dama, meaning "forbidden" or "dangerous." During dama, masks perform to the sound of gunfire to drive the soul of the deceased from the village. Among the most com-

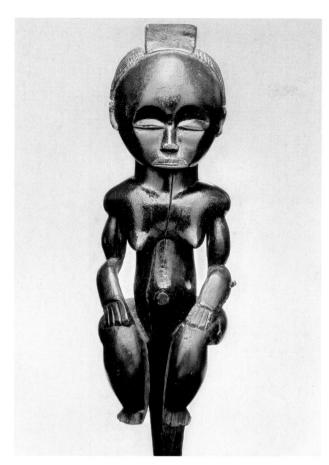

25-17. Reliquary guardian (*nlo byeri*), from Gabon. Fang culture, 19th century. Wood, height $16^{7}\!/_{8}$ " (43 cm). Musée Dapper, Paris.

mon masks is the *kanaga*, shown in figure 25-16, whose rectangular face supports a superstructure of planks that depict a woman, bird, or lizard with splayed legs.

For a deceased man, men from the community later engage in a mock battle on the roof of his home and participate in ritual hunts; for a deceased woman, the women of the community smash her cooking vessels on the threshold of her home. These portions of *dama* are reminders of human activities the deceased will no longer engage in. The *dama* may last as long as six days and include the performance of hundreds of masks. Because a *dama* is so costly, it is performed for several deceased elders, both male and female, at the same time.

The Fang people, who live near the Atlantic coast from southern Cameroon through Rio Muni and into northern Gabon, follow an ancestral religion in which the long bones and skulls of ancestors who have performed great deeds are collected after burial and placed together in a cylindrical bark container called *nsekh o byeri*, which a family would carry when it migrated. Deeds thus honored include killing an elephant, being the first to trade with Europeans, bearing an especially large number of children, or founding a particular lineage or community. On top of the container the Fang place a wooden figure called *nlo byeri*, which represents the ancestors and guards their relics from malevolent

spirit forces (fig. 25-17). *Nlo byeri* are carved in a naturalistic style, with carefully arranged hairstyles, fully rounded torsos, and heavily muscled legs and arms. Frequent applications of cleansing and purifying palm oil produce a rich, glossy black surface.

The strong symmetry of the statue is especially notable. The layout of Fang villages is also symmetrical, with pairs of houses facing each other across a single long street. At each end of the street is a large public meetinghouse. The Fang immigrated to the area they now occupy during the early nineteenth century. The experience was disruptive and disorienting, and Fang culture thus emphasizes the necessity of imposing order on a disorderly world. Many civilizations have recognized the power of symmetry to express permanence and stability (see, for example, the Forbidden City in Beijing, China, fig. 21-9).

Internally, the Fang strive to achieve a balance between the opposing forces of chaos and order, male and female, pure and impure, powerful and weak. They value an attitude of quiet composure, of reflection and tranquillity. These qualities are embodied in the powerful symmetry of the *nlo byeri* here, which communicates the calm and wisdom of the ancestor while also instilling awe and fear in those not initiated into the Fang religion.

Among the most complex funerary art in Africa are the memorial ancestral screens made during the nineteenth century by the Ijo people of southeast Nigeria (fig. 25-18, page 892). The Ijo live on the Atlantic coast, and with their great canoes formerly mediated the trade between European ships anchored offshore and communities in the interior of Nigeria. During that time groups of Ijo men organized themselves into economic associations called canoe houses, and the heads of canoe houses had much power and status in the community. When the head of a canoe house died, a screen such as the one in figure 25-18 was made in his memory. The Ijo call these screens duen fobara, meaning "foreheads of the dead." (The forehead was believed to be the seat of power and the source of success.) The screens are made of pieces of wood and cane that were joined, nailed, bound, and pegged together. The assembly technique is unusual, because most African sculpture is carved from a single piece of wood.

Although each screen commemorates a specific individual, the central figure was not intended as a physical likeness. Instead, as is common in Africa, identity was communicated through attributes of status, such as masks, weapons, or headdresses that the deceased had the right to wear or display. The central figure of the example here wears a hat that distinguishes him as a member of an important men's society called Peri. He is flanked by assistants, followers, or supporters of the canoe house, who are portrayed on a smaller scale. All three figures originally held weapons or other symbols of aggressiveness and status. Other extant screens include smaller heads attached to the top of the frame. perhaps wearing masks that the deceased had commissioned, and representations of the severed heads of defeated enemies at the feet of the figures.

25-18. Ancestral screen (duen fobara), from Abonnema village, Nigeria. Kalabari group, Ijo culture, 19th century. Wood and raffia with traces of pigment, $37^{1/2} \times 28 \times 9^{3/4}$ " $(95.3 \times 71.1 \times 24.8 \text{ cm})$. The Minneapolis Institute of Arts. The John R. Van Derlig Fund.

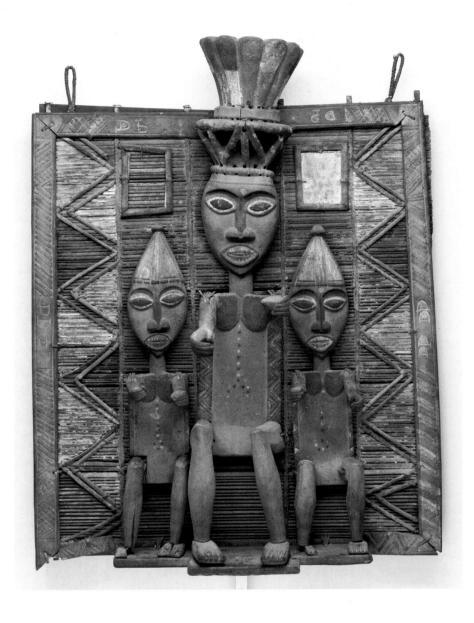

Memorial screens were placed in the ancestral altars of the canoe house, where they provided a dwelling for the spirit of the dead, who was believed to continue to participate in the affairs of the house after his death, ensuring its success in trade and war.

ART

CONTEMPORARY The photograph in this chapter of the Bwa masks in performance (see fig. 25-5) was taken in 1984.

Even as you read this chapter, new costumes are being made for this year's performance, in which the same two masks will participate. Many traditional communities continue their art in contemporary Africa. But these communities do not live as if in a museum, re-creating the forms of the past as though nothing had changed. As new experiences pose new challenges or offer new opportunities, art changes with them.

Perhaps the most obvious change in traditional African art has been in the adaptation of modern materials to traditional forms. Other peoples have similarly made use of European textiles, plastics, metal, and even Christmas tree ornaments to enhance the visual impact of their art. Some Yoruba, for example, have used photographs and bright-colored, imported plastic children's dolls in place of the traditional ere ibeji, the images of twins shown in figure 25-4. The Guro people of Côte d'Ivoire continue to commission delicate masks dressed with costly textiles and other materials. But now they paint them with oil-based enamel paints, endowing the traditional form with a new range and brilliance of color. The Guro have also added inscriptions in French and depictions of contemporary figures to sculptural forms that have persisted since before the colonial period (fig. 25-19).

Throughout the colonial period and especially during the years following World War II, Europeans established

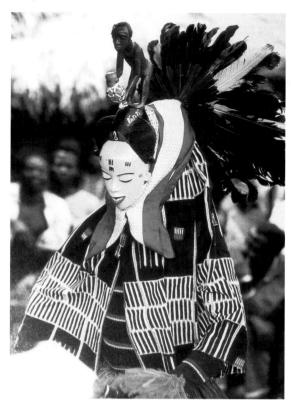

25-19. Spirit mask in performance, from Côte d'Ivoire. Guro culture, 1983. Polychrome wood, height approx. 18" (45.72 cm).

schools in Africa to train talented artists in the mediums and techniques of European art. In the postcolonial era, numerous African artists have studied in Europe and the United States, and many have become known internationally through exhibits in galleries and museums.

One such artist is Ouattara (b. 1957), represented here by *Nok Culture* (fig. 25-20). Ouattara's background exemplifies the fertile cross-cultural influences that shape the outlook of contemporary urban Africans. Born in Côte d'Ivoire, he received both formal French schooling and traditional African spiritual schooling. His father practiced both Western-style surgery and traditional African healing. At nineteen Ouattara moved to Paris to absorb firsthand the modern art of Europe. He currently lives and works in New York, Paris, and Abidjan. In paintings such as *Nok Culture*, Ouattara draws on his entire experience, synthesizing Western and African influences.

Nok Culture is dense with allusions to Africa's artistic and spiritual heritage. Its name refers to a culture that thrived in Nigeria from about 500 BCE to 200 CE and whose naturalistic works of terra-cotta sculpture are the earliest known figurative art from sub-Saharan Africa. Here, thickly applied paint has built up a surface reminiscent of the painted adobe walls of rural architecture. Tonalities of earth browns, black, and white appear frequently in traditional African art, especially in textiles. The conical horns at the upper corners evoke the ancestral shrines common in rural communities as well as the

25-20. Ouattara. *Nok Culture.* 1993. Acrylic and mixed mediums on wood, $9'8^{1}/_{2}" \times 6'7^{3}/_{4}"$ (2.96 × 2.03 m). Collection of the artist.

buttresses of West African adobe mosques. The **motif** of concentric circles at the center of the composition looks much like the traditional bull-roarer sound maker used to summon spirits. Suspended in a window that opens into the painting is a lesson board of the type used by Muslim students in Koranic schools. On the board appear Arabic writing, graphic patterns from African initiation rituals, and symbols from the Christian, ancient Egyptian, and mystical Hebrew traditions—a vivid if cryptic evocation of the many spiritual currents that run together in Africa.

Another art that has brought contemporary African artists to international attention is ceramics. Traditionally, most African pottery has been made by women (see "Numumusow and West African Ceramics," page 895). In some West African societies, potters were married to blacksmiths, both husband and wife making products that take raw ingredients from the earth and transform them by fire. These couples lived apart from the community both physically and socially, respected for their skills

25-21. Magdalene Odundo. *Asymmetrical Angled Piece*. 1991. Reduced red clay, height 17" (43.18 cm). Collection of Werner Muensterberger.

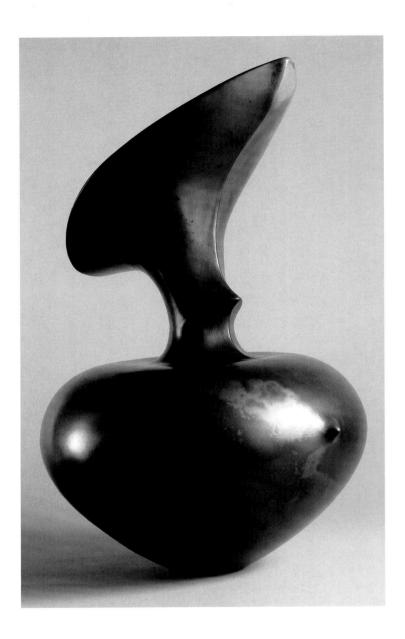

yet feared for the intimate contact they had with the powers of earth and fire.

Today, making pottery has enabled many women from traditional communities to attain a measure of economic independence. In Nigeria it is not uncommon to see large trucks stopped at a potters' village, loading up pots to be transported to distant markets. The women do not usually share their pottery income with the male head of the family but keep it to buy food for themselves and their children. In one large pottery community in Ilorin, a northern city of the Yoruba people in Nigeria, women have subcontracted the dreary and physically demanding tasks of gathering raw clay and fuel to local men so that they can concentrate on forming their wares, for which there is a great demand. In this way they control much of the local economy.

Nourished by this long tradition, some women have achieved broader recognition as artists. One is Magdalene Odundo (b. 1950), whose work displays the flawless surfaces of traditional Kenyan pottery (fig. 25-21). Indeed, she forms her pots using the same coiling tech-

nique that her Kenyan ancestors used. Like Ouattara, Odundo draws her inspiration from a tremendous variety of sources, both African and non-African. In the workshops she presents at colleges and art schools she shows hundreds of slides of pottery. She begins with images of Kenyan potters and pottery, then quickly moves on to pottery from the Middle East, China and Japan, and ancient North and South America. Odundo works in England, teaches in Europe and the United States, and shows her art through a well-known international dealer. Yet the power of traditional African forms is abundantly evident in the elegant pot illustrated here.

The painter Ouattara probably speaks for most contemporary artists around the world when he says, "[M]y vision is not based only on a country or a continent, it's beyond geography or what you see on a map, it's much more than that. Even though I localize it to make it understood better, it's wider than that. It refers to the cosmos" (cited in McEvilley, page 81). In his emphasis on the inherent spirituality of art, Ouattara voices what is most enduring about the African tradition.

NUMUMUSOW AND WEST AFRICAN CERAMICS

In many West African cultures, fired ceramics are made exclusively by women. Among the Mende people of Mali, Burkina Faso, Guinea, and Côte d'Ivoire, potters are *numumusow*, female members of *numu* lineages, and hold an important place in society. Women from these families may resolve disputes and initiate girls; their husbands, fathers, and sons are the sculptors and blacksmiths of the Mende.

Numumusow make a wide selection of vessels, including huge storage jars. The shapes of these pots reflect their intended use, from wide bowls and cooking pots to narrownecked stoppered water bottles, from large storage vessels to small eating dishes. The numumusow form the soft and sticky clay by coiling and modeling with their fingers. They decorate their vessels by burnishing (polishing), by engraving, by adding pellets or coils of clay, or by coloring with slip (a wash of colored clay). The vessels are fired at low temperatures in a shallow pit or in the open, producing a ware that can be used to cook over an open fire without breaking.

Even though most urban Africans use metal and plastic dishes and cookware today, large earthenware jars still keep water cool and clean in areas where refrigeration is expensive. In the past, waterstorage jars were public display pieces, standing near the entrance to the house, where a guest would be offered a drink of cool water as an essential part of hospitality. Mende vessels for drinking water are often decorated with incised lines and molded ridges. On older wares such as this example, raised images of figures or lizards might have referred to Mende myths or to philosophical concepts.

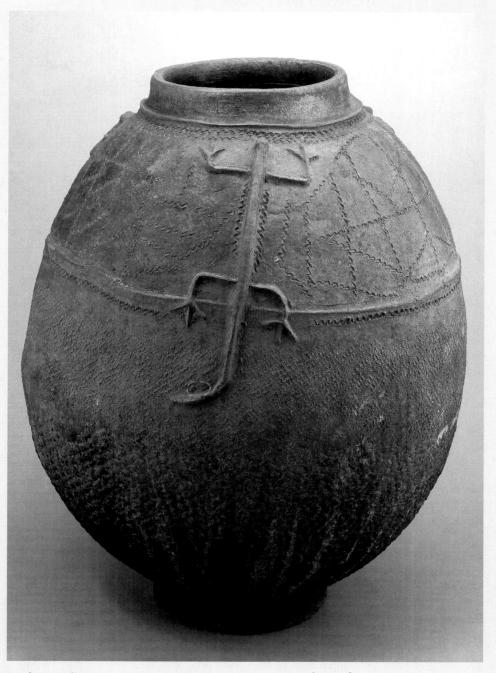

Jar, from, Mali. Bamana culture, 20th century. Earthenware, $23^1/_2 \times 18^3/_4$ " (59.7 \times 47.6 cm). The Nelson-Atkins Museum of Art, Kansas City, Missouri. Purchase: The George H. and Elizabeth O. Davis Fund

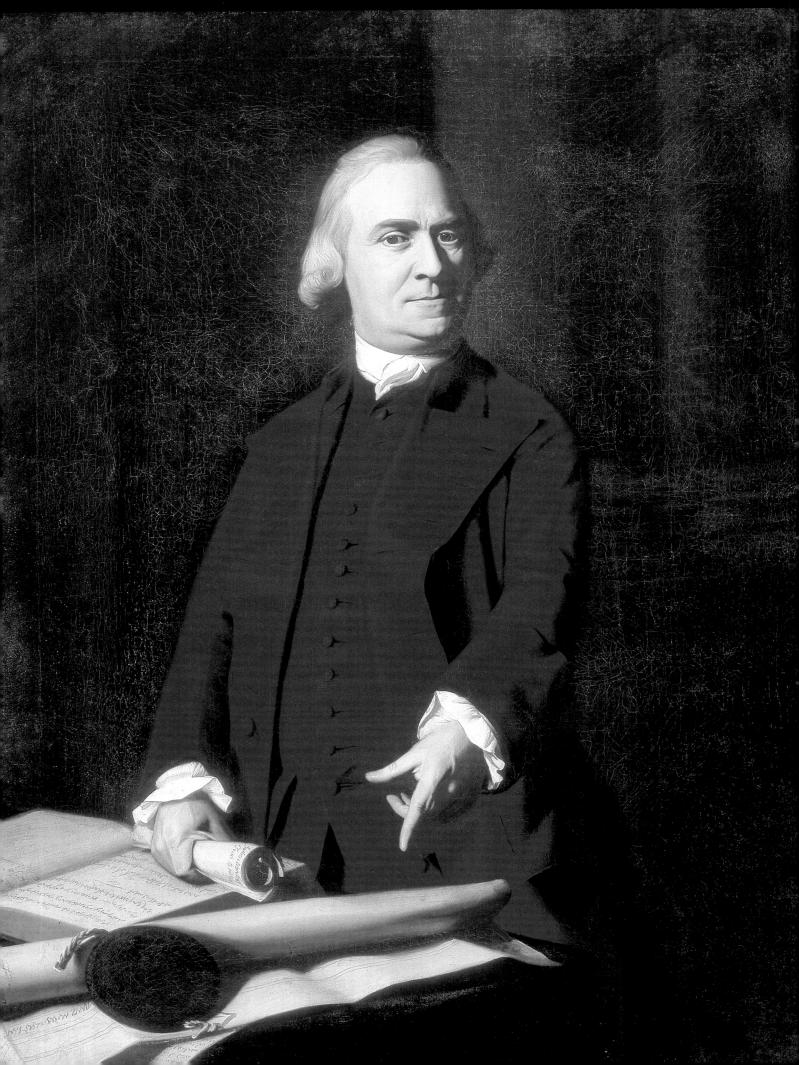

26

EIGHTEENTH-CENTURY ART IN EUROPE AND NORTH AMERICA

N MARCH 5, 1770, A STREET FIGHT BROKE OUT BETWEEN SEVERAL DOZEN residents of Boston and a squad of British soldiers. The British fired into the crowd, killing three men and wounding eight others, two of whom later died. Dubbed the Boston Massacre by anti-British patriots, the event was one of many that led to the Revolutionary War of 1775–83, which won independence from Britain for the thirteen American colonies.

The day after the Boston Massacre, Samuel Adams, a member of the Massachusetts legislature, demanded that the royal governor, Thomas Hutchinson, expel British troops from the city—a confrontation that Boston painter John Singleton Copley immortalized in oil paint (fig. 26-1). Adams, conservatively dressed in a brown suit and waistcoat, stands before a table and looks sternly out at the viewer, who occupies the place of Governor Hutchinson. With his left hand, Adams points to the charter and seal granted to Massachusetts by King William and Queen Mary; in his right, he grasps a petition prepared by the aggrieved citizens of Boston.

The vivid realism of Copley's style makes the lifesize figure of Adams seem almost to be standing before us. Adams's head and hands, dramatically lit, surge out of the darkness with a sense of immediacy appropriate to the urgency of his errand. The legislator's defiant stance and emphatic gesture convey the moral force of his demands, which are impelled not by emotion but by reason. The charter to which he points insists on the rule of law, and the faintly visible classical columns behind him connote republican virtue and rationality—important values of the Enlightenment, the major philosophical movement of eighteenth-century Europe as well as Colonial America. Enlightenment political philosophy provided the ideological basis for the American Revolution, which Adams ardently supported.

▲ 1715 LOUIS XIV OF FRANCE DIES ▲ 1715-74 LOUIS XV RULES FRANCE

TIMELINE 26-1. Europe and North America in the Eighteenth Century. With the birth of democracies and republics and the rise of industrialization, this century marks the beginning of the modern era.

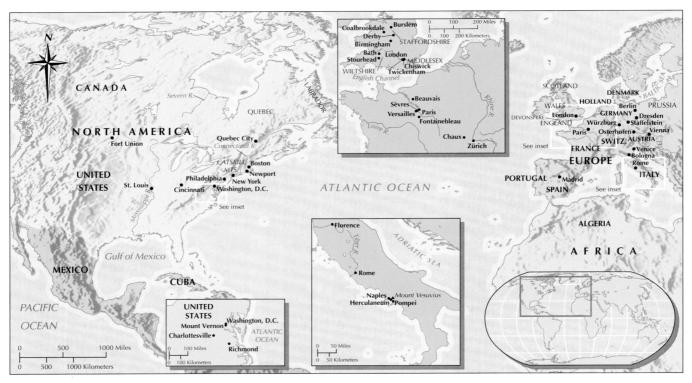

Map 26-1. Europe and North America in the Eighteenth Century.

During the eighteenth century, three major artistic styles—Rococo, Neoclassicism, and Romanticism—flourished in Europe and North America.

ENLIGHTENMENT AND ITS REVOLUTIONS

THE The eighteenth century marks a great divide in Western history. When the century opened, the UTIONS West was still semifeudal economically and

politically. Wealth and power were centered in an aristocratic elite, who owned or controlled the land worked by the largest and poorest class, the farmers. In between was a small middle class composed of doctors, lawyers, shopkeepers, artisans, and merchants—most of whom depended for their livelihood on the patronage of the rich. Only those involved in overseas trade operated outside the agrarian system, but even they aspired to membership in the landed aristocracy.

By the end of the century, the situation had changed dramatically (Timeline 26-1). A new source of wealth—industrial manufacture—was being developed, and social visionaries expected industry not only to expand the middle class but also to provide a better material existence for all classes, an interest that extended beyond purely economic concerns. What became known as the

Industrial Revolution was complemented by a revolution in politics, spurred by a new philosophy that conceived of all white men (some thinkers included women and minorities) as deserving of equal rights and opportunities. The American Revolution of 1776 and the French Revolution of 1789 were the seismic results of this dramatically new concept.

Developments in politics and economics were themselves manifestations of a broader philosophical revolution: the Enlightenment. The Enlightenment was a radically new synthesis of ideas about humanity, reason, nature, and God that had arisen during classical Greek and Roman times and during the Renaissance. What distinguished the Enlightenment proper from its antecedents was the late-seventeenth- and early-eighteenth-century thinkers' generally optimistic view that humanity and its institutions could be reformed, if not perfected. Bernard de Fontenelle, a French popularizer of seventeenth-century scientific discoveries, writing in 1702, anticipated "a century which will become more enlightened day by day, so that all previous centuries will be lost in darkness by comparison." At the end of the

- ▲ 1756-63 SEVEN YEARS' WAR
- ▲ 1768 WOMEN ADMITTED TO ENGLISH ROYAL ACADEMY
- ▲ 1774-92 LOUIS XVI RULES FRANCE
 - ▲ 1776 AMERICAN REVOLUTION ▲ 1789 FRENCH REVOLUTION

seventeenth and beginning of the eighteenth century, such hopes were expressed by a handful of people; after 1740, the number and power of such voices grew, so that their views increasingly dominated every sphere of intellectual life, including that of the European courts. The most prominent and influential of these thinkers, called philosophes (to distinguish their practical concerns from the purely academic ones of philosophers), included Jean-Jacques Rousseau, Denis Diderot, Thomas Jefferson, Benjamin Franklin, and Immanuel Kant.

The philosophes and their supporters did not agree on all matters. Perhaps the matter that most unified these thinkers was the question of the purpose of humanity. Rejecting conventional notions that men and women were here to serve God or the ruling class, the philosophes insisted that humans were born to serve themselves, to pursue their own happiness and fulfillment. The purpose of the State, they agreed, was to facilitate this pursuit. Despite the pessimism of some and the reservations of others, Enlightenment thinkers were generally optimistic that men and women, when set free from their political and religious shackles, could be expected to act both rationally and morally. Thus, in pursuing their own happiness, they would promote the happiness of others.

Nature, like humanity, was generally seen as both rational and good. The natural world, whether a pure mechanism or the creation of a beneficent deity, was amenable to human understanding and, therefore, control. Once the laws governing the natural and human realms were determined, they could be harnessed for our greater happiness. From this concept flowed the inextricably intertwined industrial and political revolutions that marked the end of the century.

Three artistic styles prevailed during the Enlightenment, but the most characteristic was Neoclassicism. In essence, Neoclassicism (neo means "new") presents classical subject matter—mythological or historical—in a style derived from classical Greek and Roman sources. Some Neoclassical art was conceived to please the senses, some to teach moral lessons. In its didactic manifestations—usually history paintings—Neoclassicism was an important means for conveying Enlightenment ideals.

The Neoclassical style arose in part in reaction to the dominant style of the early eighteenth century, known as Rococo. The term *rococo* was coined by critics who combined the Portuguese word *barroco* (which refers to an irregularly shaped pearl and is the source of the word *baroque*) and the French word *rocaille* (the artificial shell or rock ornament popular for gardens) to describe the refined, fanciful, and often playful style that became fashionable in France at the end of the seventeenth century and spread throughout Europe in the eighteenth century.

While the terms Rococo and Neoclassicism identify distinct artistic styles—the one complex and sensuous. the other simple and restrained—a third term applied to later eighteenth-century art, Romanticism, describes not only a style but also an attitude. Romanticism is chiefly concerned with imagination and the emotions, and it is often understood as a reaction against the Enlightenment focus on rationality. Romanticism celebrates the individual and the subjective rather than the universal and the objective. The movement takes its name from the medieval romances-novellas, stories, and poems written in Romance (Latin-derived) languages-that provided many of its themes. Thus, the term Romantic suggests something fantastic or novelistic, perhaps set in a remote time or place, infused by a poetic or even melancholic spirit.

Many works of art of the later eighteenth and early nineteenth centuries combined elements of Neoclassicism and Romanticism. Indeed, because a sense of remoteness in time or place characterizes both Neoclassical and Romantic art, some scholars argue that Neoclassicism is a subcategory of Romanticism.

THE ROCOCO STYLE IN EUROPE

The Rococo style is characterized by pastel colors, delicately curving forms, dainty figures, and a lighthearted mood. It may be seen partly as a reac-

tion at all levels of society, even among kings and bishops, against the art identified with the formality and rigidity of seventeenth-century court life. The movement began in French architectural decoration at the end of Louis XIV's reign (ruled 1643–1715) and quickly spread across Europe (Map 26-1). The duke of Orléans, regent for the boy-king Louis XV (ruled 1715-74), made his home in Paris, and the rest of the court—delighted to escape the palace at Versailles-also moved there and built elegant town houses (in French, hôtels), whose smaller rooms dictated new designs for layout, furniture, and décor. They became the lavish settings for intimate and fashionable intellectual gatherings and entertainments, called salons, that were hosted by accomplished, educated women of the upper class whose names are still known today—Mesdames de Staël, de La Fayette, de Sévigné, and du Châtelet being among the most familiar. The Salon de la Princesse in the Hôtel de Soubise in Paris (fig. 26-2, page 900), designed by Germain Boffrand (1667–1754) beginning in 1732, is typical of the delicacy and lightness seen in French Rococo hôtel design during the 1730s. Interior designs for palaces and churches built on traditional Baroque plans were also animated by the Rococo spirit, especially in Germany and Austria. In occasional small-scale buildings, the Rococo style was successfully applied to architectural planning as well.

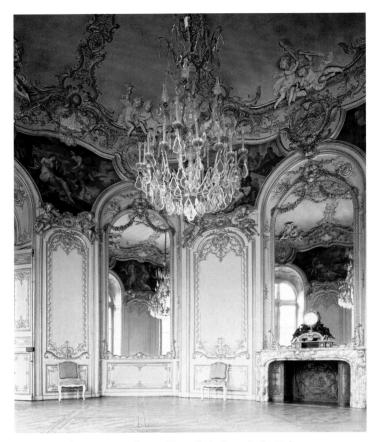

26-2. Germain Boffrand. Salon de la Princesse, Hôtel de Soubise, Paris, France. Begun 1732. Library, Getty Research, Institute, Los Angeles. Wim Swaan Photograph Collection, (96.p.21)

Typical Rococo elements in architectural decoration were **arabesques**, S shapes, C shapes, reverse-C shapes, **volutes**, and naturalistic plant forms. The glitter of silver or gold against expanses of white or pastel color, the visual confusion of mirror reflections, delicate ornament in sculpted stucco, carved wood panels called *boiseries*, and inlaid wood designs on furniture and floors were all part of the new look. In residential settings, pictorial themes were often taken from classical love stories, and sculpted ornaments were rarely devoid of **putti**, cupids, and clouds.

ARCHITECTURE AND ITS DECORATION IN GERMANY AND AUSTRIA

A major architectural project influenced by the new Rococo style was the Residenz, a splendid palace that Johann Balthasar Neumann (1687–1753) created for the princebishop of Würzburg from 1719 to 1744. The oval Kaisersaal, or Imperial Hall (fig. 26-3), illustrates Neumann's great triumph in planning and decoration. Although the clarity of the plan, the size and proportions of the marble columns, and the large windows recall the Hall of Mirrors at Versailles (see fig. 19-23) the decoration of the Kaisersaal, with its white-and-gold color scheme and its profusion of delicately curved forms, embodies the Rococospirit. Here one can see the earliest development of Neumann's aesthetic of interior design that culminated in his final project, the Church of the Vierzehnheiligen (Fourteen Auxiliary Saints) near Staffelstein (see fig. 26-7).

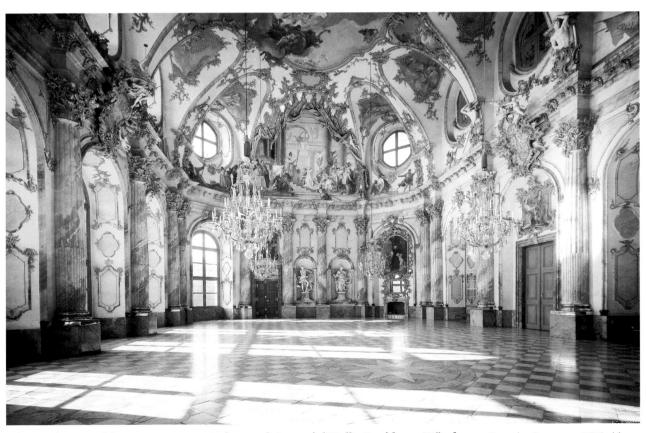

26-3. Johann Balthasar Neumann. Kaisersaal (Imperial Hall), Residenz, Würzburg, Bavaria, Germany. 1719–44. Fresco by Giovanni Battista Tiepolo. 1751–52 (see fig. 26-4).

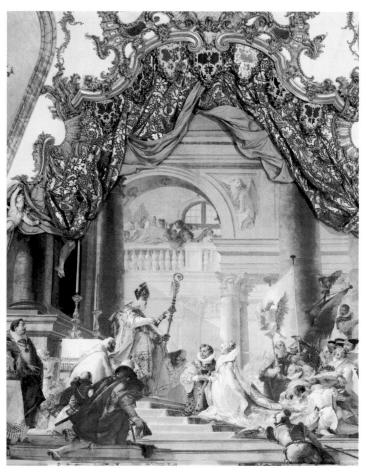

26-4. Giovanni Battista Tiepolo. *The Marriage of the Emperor Frederick and Beatrice of Burgundy,* fresco in the Kaisersaal (Imperial Hall), Residenz. Würzburg, Germany. 1751–52.

Neumann's collaborator on the Residenz was a brilliant Venetian painter, Giovanni Battista Tiepolo (1696-1770), who began to work there in 1750. Venice by the early eighteenth century had surpassed Rome as an artistic center, and Tiepolo was acclaimed internationally for his confident and optimistic expression of the illusionistic fresco painting pioneered by sixteenth-century Venetians such as Veronese (see fig. 14, Introduction; fig. 18-59). Tiepolo's work in the Kaisersaal—three scenes glorifying the twelfth-century crusader-emperor Frederick Barbarossa, who had been a patron of the bishop of Würzburg-is a superb example of his architectural painting. The Marriage of the Emperor Frederick and Beatrice of Burgundy (fig. 26-4) is presented as if it were theater, with painted and gilded stucco curtains drawn back to reveal the sumptuous costumes and splendid setting of an imperial wedding. Like Veronese's grand conceptions, Tiepolo's spectacle is populated with an assortment of character types, presented in dazzling light and sun-drenched colors with the assured hand of a virtuoso. Against the opulence of their surroundings, these heroic figures behave with the utmost decorum and, the artist suggests, nobility of purpose.

Rococo decoration in Germany was as often religious as secular. One of the many opulent Rococo church interiors still to be seen in Germany and Austria is that of the Church of the Vierzehnheiligen (fig. 26-5), which was begun by Neumann in 1743 but was not completed until

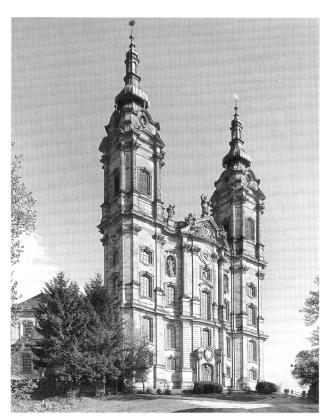

26-5. Johann Balthasar Neumann. Church of the Vierzehnheiligen, near Staffelstein, Germany. 1743–72.

In the center of the nave of the Church of the Vierzehnheiligen (Fourteen Auxiliary Saints), an elaborate shrine was built over the spot where, in the fifteenth century, a shepherd had visions of the Christ Child surrounded by saints. The saints came to be known as the Holy Helpers because they assisted people in need.

1772, long after his death. The grand Baroque facade gives little hint of the overall plan (fig. 26-6, page 902), which is based on six interpenetrating oval spaces of varying sizes around a dominant domed ovoid center. The plan, in fact, recalls Borromini's design of the Church of San Carlo alle Quattro Fontane (see fig. 19-4). On the interior of the nave (fig. 26-7, page 902), the Rococo love of undulating surfaces and overlays of decoration creates a visionary world where flat wall surfaces scarcely exist. Instead, the viewer is surrounded by clusters of pilasters and engaged columns interspersed with two levels of arched openings to the side aisles and large clerestory windows illuminating the gold and white of the interior. The foliage of the fanciful capitals is repeated in arabesques, wreaths, and the ornamented frames of the irregular panels that line the vault. What Neumann had begun in the Kaisersaal at Würzburg he brought to full fruition here in the ebullient sense of spiritual uplift achieved by the complete integration of architecture and decoration.

Many sculptors as well as painters undertook church decoration, such as the sumptuous white, gold, and polychrome wood and plaster of the monastery at Melk (see fig. 19-30) and Vierzehnheiligen. Among the Bavarian artists of southern Germany, Egid Quirin Asam (1692–1750) was one of the best. He went to Rome in 1712 with his father, a fresco painter, and his brother, Cosmas Damian (1686–1739). There, they studied Bernini's works and the illusionistic ceilings of Annibale

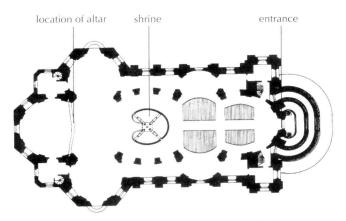

26-6. Plan of the Church of the Vierzehnheiligen. c. 1743.

Carracci and others (see figs. 19-12, 19-13). Back in Bavaria, the brothers often collaborated on interior decoration in the Italian Baroque manner, to which they soon added lighter, more fantastic elements in the French Rococo style. Cosmas specialized in fresco painting and Egid in stone, wood, and stucco sculpture. The Rococo spirit is evident in Egid's Angel Kneeling in Adoration (fig. 26-8), a detail of a tabernacle made about 1732 for the main altar of a church in Osterhofen for which Cosmas provided the altarpiece. Carved of limewood and covered with silver leaf and gilding, the overlifesize figure appears to have landed in a half-kneeling position on a large bracket swinging a censer. Bernini's angel in the Cornaro Chapel (see fig. 19-9) was the inspiration for Asam's figure, but the Bavarian artist has taken the liveliness of pose to an extreme, and the drapery, instead of revealing the underlying forms, swirls about in an independent decorative pattern.

PAINTING IN FRANCE

In painting, the work of Jean-Antoine Watteau (1684-1721) epitomizes the French Rococo style. Watteau created a new type of painting when he submitted his official examination canvas, Le Pélerinage à l'Île de Cithère (fig. 26-9), for admission to membership in the Royal Academy of Painting and Sculpture in 1717 (see "Academies and Academy Exhibitions," page 906). The academicians accepted the painting in a new category of subject matter, the *fête galante*, or elegant outdoor entertainment. The painting, whose ambiguous French title may be translated either as Pilgrimage to the Island of Cythera (Cithère in French) or Pilgrimage on the Island of Cythera, depicts a dream world in which beautifully dressed couples, accompanied by putti, either depart for or take leave of the mythical island of love. The verdant landscape would never soil the characters' exquisite satins and velvets, nor would a summer shower ever threaten them. This kind of idyllic vision, with its overtones of wistful melancholy, had a powerful attraction in early-eighteenth-century Paris and soon charmed the rest of Europe.

Tragically, Watteau died from tuberculosis when still in his thirties. During his final illness, while staying with the art dealer Edme-François Gersaint, he painted a signboard for Gersaint's shop (fig. 26-10). The dealer

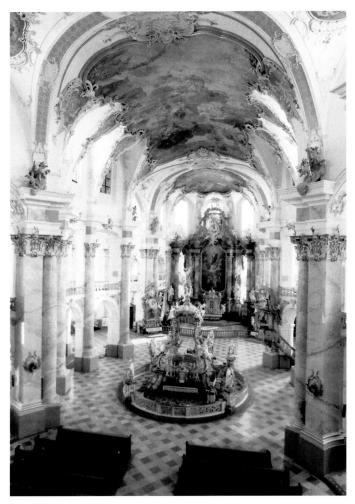

26-7. Interior, Church of the Vierzehnheiligen. 1743–72.

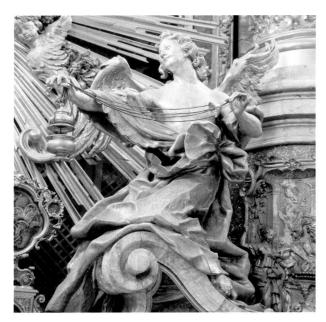

26-8. Egid Quirin Asam. Angel Kneeling in Adoration, part of a tabernacle on the main altar, Convent Church, Osterhofen, Germany. c. 1732. Limewood with gilding and silver leaf, height 6'6" (2 m).

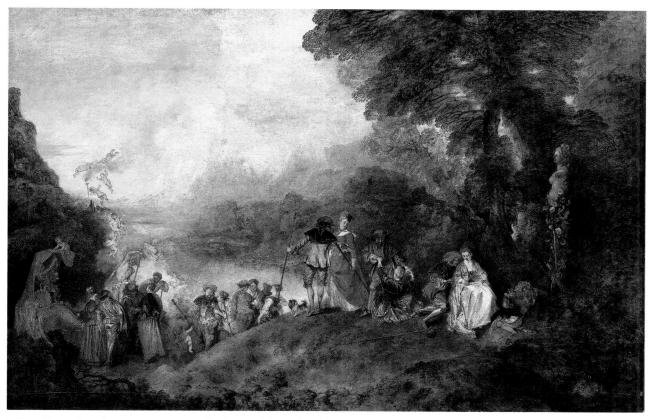

26-9. Jean-Antoine Watteau. Le Pélerinage à l'Île de Cithère. 1717. Oil on canvas, $4'3'' \times 6'4^{1/2}''$ (1.3 × 1.9 m). Musée du Louvre, Paris.

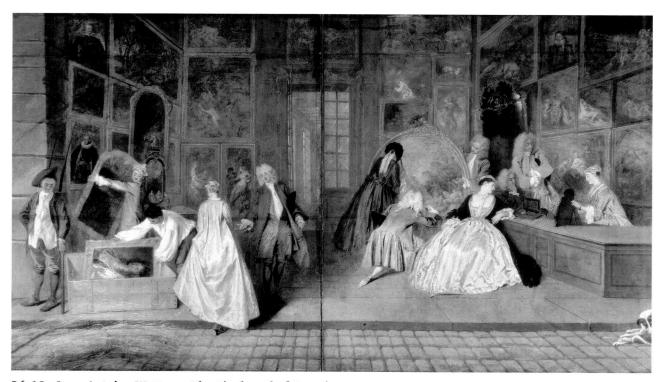

26-10. Jean-Antoine Watteau. *The Signboard of Gersaint.* c. 1721. Oil on canvas, $5'4'' \times 10'1''$ (1.62 \times 3.06 m). Stiftung Preussische Schlössen und Gärten Berlin-Brandenburg, Schloss Charlottenburg.

Watteau's sign painting was designed for the Paris art gallery of Edme-François Gersaint, who introduced the English idea of selling paintings by catalog. The systematic listing of works for sale gave the name of the artist and the title, medium, and dimensions of each work of art. The shop depicted on the signboard is not Gersaint's but an ideal gallery visited by elegant and cultivated patrons. The sign was so admired that Gersaint sold it only fifteen days after it was installed. Later it was cut down the middle and each half was framed separately, which resulted in the loss of some canvas along the sides of each section. The painting was restored and its two halves reunited in the twentieth century.

later wrote that Watteau had completed the painting in eight days, working only in the mornings because of his failing health. When the sign was installed, it was greeted with almost universal admiration, and Gersaint sold it shortly afterward.

The painting shows an art gallery filled with paintings from the Venetian and Netherlandish schools that Watteau admired. Indeed, the glowing satins and silks of the women's gowns are homage to artists like Gerard Ter Borch (see fig. 19-65). The visitors to the gallery are elegant ladies and gentlemen, at ease in these surroundings and apparently knowledgeable about paintings. Thus, they create an atmosphere of aristocratic sophistication. At the left, a woman in shimmering pink satin steps across the threshold. Ignoring her companion's outstretched hand, she is distracted by the two porters packing. While one holds a mirror, the other carefully lowers into the wooden case a portrait of Louis XIV, which may be a reference to the name of Gersaint's shop, Au Grand Monarque ("At the Sign of the Great King"). It also suggests the passage of time, for Louis had died in 1715. A number of other elements in the work also gently suggest transience. On the left, the clock positioned directly over the king's portrait, surmounted by an allegorical figure of Fame and sheltering a pair of lovers, is a traditional *memento mori*, a reminder of mortality. The figures on it suggest that both love and fame are subject to the depredations of time. Well-established vanitas emblems are the straw (in the foreground), so easily destroyed, and the young woman gazing into the mirror (set next to a vanity case on the counter), for mirrors and images of young women looking at their reflections were timehonored symbols of the fragility of human life. Watteau, dying, certainly knew how ephemeral life is, and no artist ever expressed the fleeting nature of human happiness with greater subtlety.

The artist most closely associated today with Parisian Rococo painting at its height is François Boucher (1703–70), who never met Watteau. In 1721, Boucher, the son of a minor painter, entered the workshop of an engraver to support himself as he attempted to win favor at the Academy. The young man's skill drew the attention of a devotee of Watteau, who hired Boucher to reproduce Watteau's paintings in his collection, an event that firmly established the direction of Boucher's career.

After studying at the French Academy in Rome from 1727 to 1731, Boucher settled in Paris and became an academician. Soon his life and career were intimately bound up with two women: The first was his artistically talented wife, Marie-Jeanne Buseau, who was a frequent model as well as a studio assistant to her husband. The other was Louis XV's mistress, Madame de Pompadour, who became his major patron and supporter. Pompadour was an amateur artist herself and took lessons from Boucher in printmaking. After Boucher received his first royal commission in 1735, he worked almost continuously to decorate the royal residences at Versailles and Fontainebleau. In 1755, he was made chief inspector at the Gobelins Tapestry Manufactory, and he

provided designs to it and to the Sèvres **porcelain** and Beauvais tapestry manufactories, all of which produced furnishings for the king. In 1765, Boucher became First Painter to the King.

While he painted a number of fine portraits and scenes of daily life, Boucher is best known for his mythological scenes, in which gods, goddesses, and putti-largely nude except for strategically placed draperies-frolic or relax in pastoral settings. Among the finest of Boucher's mythological paintings is Diana Resting after Her Bath (fig. 26-11), which was exhibited at the Salon of 1742. In the center of the picture, the Roman goddess of the hunt and her attendant assume complicated poses that appear natural and graceful due to Boucher's masterful orchestration of body parts into a satisfying structure of vertical, horizontal, and crossing diagonal masses. The cool greens of the forest and the blue, white, and pink hues of the drapery behind Diana throw into relief the appealing golden tones of her flesh. Her nudity is emphasized by the crescent tiara in her hair and the pearl necklace she dangles between her hands. Subordinate details relating to the hunt-the dogs and quiver at the left and the bow and dead game at the right—provide a narrative context for the central subject and demonstrate Boucher's skill as a painter of animals.

Paradoxically, many of the same royal and aristocratic patrons who prized the erotic suggestiveness of Boucher's mythological paintings also delighted in the morally uplifting genre scenes painted by his contemporary Jean-Siméon Chardin (1699-1779). A painter whose output was limited essentially to still lifes and quiet domestic scenes, Chardin tended to work on a small scale, meticulously and slowly. His early still lifes consisted of a few simple objects that were to be enjoyed for their subtle differences of shape and texture, not for any virtuoso performance, complexity of composition, or moralizing content. But in the 1730s, Chardin began to create moral genre pictures in the tradition of seventeenth-century Dutch genre paintings, which focused on simple, mildly touching scenes of everyday middle-class life. One such picture, The Governess (fig. 26-12), shows a finely dressed boy, with books under his arm, who listens to his governess as she prepares to brush his tricorn (three-cornered) hat. Scattered on the floor behind him are a racquet, a shuttlecock, and playing cards, evoking the childish pleasures that the boy leaves behind as he prepares to go to his studies and, ultimately, to a life of responsible adulthood.

When the mother of young Jean-Honoré Fragonard (1732–1806) brought her son to Boucher's studio around 1747–48, the busy court artist recommended that the boy first study the basics of painting with Chardin. Within a few months, Fragonard returned with some small paintings done on his own, and Boucher gladly welcomed him as an apprentice-assistant at no charge to his family. Boucher encouraged the boy to enter the competition for the **Prix de Rome**, the three-to-five-year scholarship awarded to the top students in painting and sculpture graduating from the French Academy's art school.

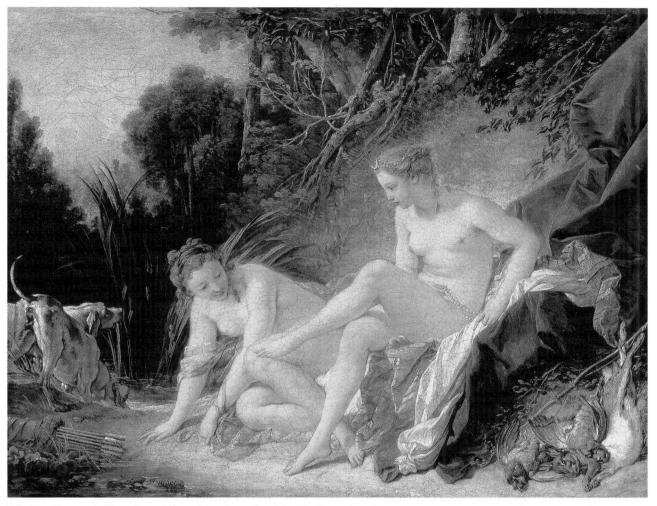

26-11. François Boucher. *Diana Resting after Her Bath.* 1742. Oil on canvas, $22 \times 29''$ (56×74 cm). Musée du Louvre, Paris.

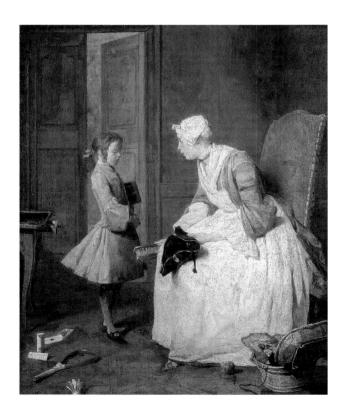

26-12. Jean-Siméon Chardin. The Governess. 1739. Oil on canvas, $18^1/_8 \times 14^3/_4$ " (46 \times 37.5 cm). National Gallery of Canada, Ottawa.

Purchase, 1956

Chardin was one of the first French artists to treat the lives of women and children with sympathy and to honor the dignity of women's work in his portrayals of young mothers, governesses, and kitchen maids. Shown at the Salon of 1739, *The Governess* was praised by contemporary critics, one of whom noted "the graciousness, sweetness, and restraint that the governess maintains in her discipline of the young man about his dirtiness, disorder, and neglect; his attention, shame, and remorse; all are expressed with great simplicity."

ACADEMIES AND ACADEMY EXHIBITIONS

During the seventeenth century, the French government founded a number of royal academies for the support and instruction of students in literature, painting and sculpture, music and dance, and architecture. In 1664, the Royal Academy of Painting and Sculpture began to mount occasional exhibitions of the members' recent work. These exhibitions came to be known as Salons because for much of the eighteenth century they were held in the Salon Carré in the Palace of the Louvre. Beginning in 1737, the Salons were held every other year. with a jury of members selecting the works to be shown. Illustrated here is a view of the Salon of 1787, with its typical floor-to-ceiling hanging of paintings. As the only public art exhibitions of any importance in Paris, the Salons were enormously influential in establishing officially approved styles and in molding public taste, and they helped consolidate the Royal Academy's dictatorial control over the production of art.

In recognition of the importance of Rome as a training ground for artists, the French Royal Academy of Painting and Sculpture opened a branch there in 1666. The competitive **Prix de Rome**, or Rome Prize, was also established, which permitted the winners to study in Rome for three to five years. A similar prize was established by the French Royal Academy of Architecture in 1720.

Many Western cultural capitals emulated the French model and opened academies of their own. Academies were established in Berlin in 1696, Dresden in 1750, London in 1768, Boston in 1780, New York in 1802, and Philadelphia in 1805. The English Royal Academy of Arts was quite different from its French prototype; although chartered by George III, it was a private institution independent of any interference from the Crown. It had only two functions, to operate an art school and to hold two annual exhibitions, one of art of the past and another of contemporary art, which was open to any exhibitor on the

basis of merit alone. The Royal Academy continues to function in this way to the present day.

In France, the Revolution of 1789 brought a number of changes to the Royal Academy. In 1791, the jury system was abolished as a relic of the monarchy, and the Salon was democratically opened to all artists. In 1793, all of the royal academies were disbanded and, in 1795, reconstituted as the newly founded Institut de France, which was to administer the art school—the École des Beaux-Arts-and sponsor the Salon exhibitions. The number of would-be exhibitors was soon so large that it became necessary to reintroduce some screening procedure, and so the jury system was revived. In 1816, with the restoration of the monarchy following the defeat of Napoleon, the division of the Institut dedicated to painting and sculpture was renamed the Académie des Beaux-Arts, and thus the old Academy was in effect restored.

Academic training, which had been established in the sixteenth century to free the artist from the restraints of guild training, became during the late eighteenth and nineteenth centuries the chief obstacle to change and independent thinking of the sort promoted by the Enlightenment philosophes and practiced

by the Romantics. The academic premise was that the principles of excellence found in the classical works of antiquity and the Renaissance could be learned by systematic training of the mind and hand. In addition to learning the kinds of rules found in Joshua Reynolds's Fifteen Discourses to the Royal Academy, students studied from plaster casts of antique sculpture. Thus, when the student was finally allowed to work from the live model, he (women were not allowed to work from the nude) was expected to "correct" nature according to the higher conception of human form he had acquired from his studies.

Artists wishing to work according to their own standards of beauty and relevance increasingly came into conflict with the academies, especially in France. As we will see in the next chapter, the history of French art from about 1830 to the end of the century is largely that of the struggle between the conservative forces of the Academy and the rebellious innovations of those who became known as the avantgarde. The Academy's chief means of keeping artists in line were the officially appointed juries of the Salons. After 1830, the juries systematically rejected work that did not conform to the Academy's formal or thematic standards.

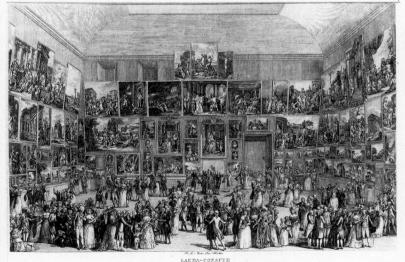

EXPOSITION AU SALON BU LOUVRE EN 1787

Piero Antonio Martini. The Salon of 1787. 1787. Engraving.

Fragonard won the prize in 1752 and spent 1756–61 in Italy, but not until 1765 was he finally accepted into the Royal Academy. Fragonard catered to the tastes of an aristocratic clientele, and he began to fill the vacuum left by Boucher's death in 1770 as a decorator of interiors.

Fragonard produced fourteen canvases commissioned around 1771 by Madame du Barry, Louis XV's last mistress, to decorate her château. These marvelously free and seemingly spontaneous visions of lovers explode in color and luxuriant vegetation. *The Meeting*

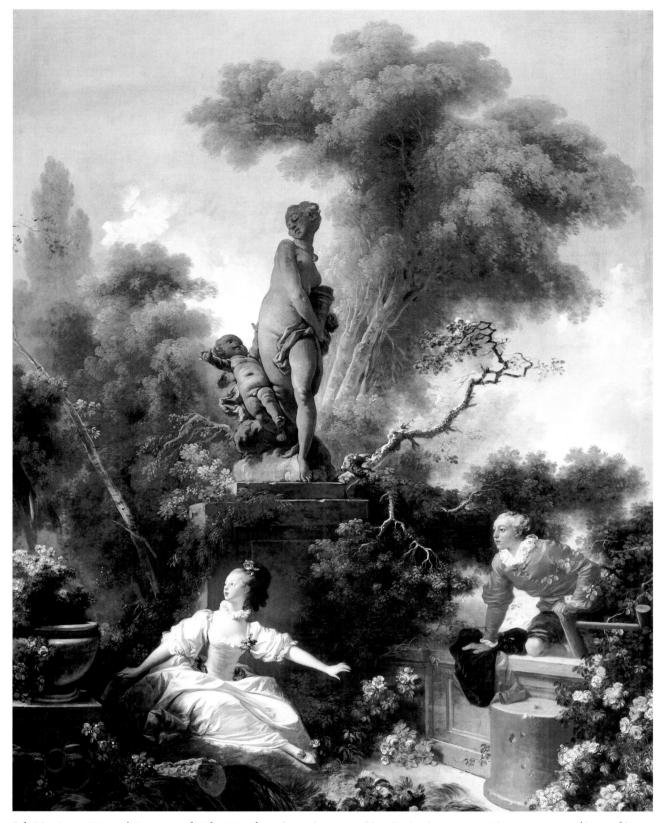

26-13. Jean-Honoré Fragonard. *The Meeting,* from *The Loves of the Shepherds.* 1771–73. Oil on canvas, $10'5^{1}/_{4}" \times 7'^{5}/_{8}"$ (3.18 × 2.15 m). The Frick Collection, New York.

(fig. 26-13) shows a secret encounter between a young man and his sweetheart, who looks anxiously over her shoulder to be sure she has not been followed and clutches the letter that arranged the tryst. The rapid brushwork that distinguishes Fragonard's technique is at its freest and most lavish here. However, Madame du Barry rejected the paintings as old-fashioned and com-

missioned another set in the newly fashionable Neoclassical style. The Rococo world was, indeed, ending, and Fragonard's erotic Rococo style had become outmoded; he spent his last years living on a small pension and the generosity of his highly successful pupil Marguerite Gérard (1761–1837), who was his wife's younger sister.

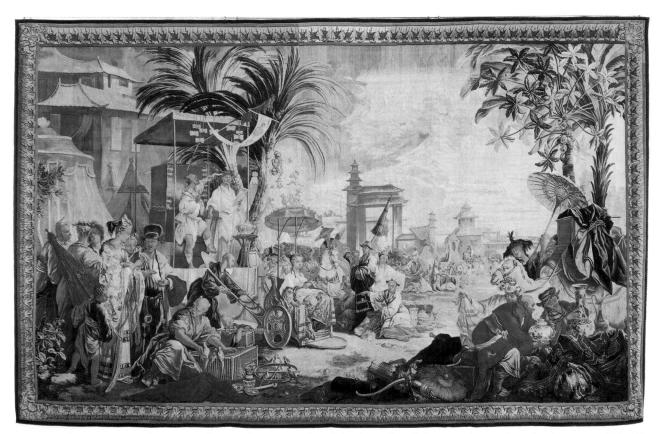

26-14. After a cartoon by François Boucher. *La Foire Chinoise (The Chinese Fair).* Designed 1743; woven 1743–75 at Beauvais, France. Tapestry of wool and silk, approx. $11'11'' \times 18'2''$ (3.63 \times 5.54 m). The Minneapolis Institute of Arts. The William Hood Dunwoody Fund

DECORATIVE ARTS AND SCULPTURE

In the eighteenth century, all media succumbed to the enchantment of Rococo. Royal factories in every country adopted the lively, elegant style in everything from chairs and tables to tapestries, porcelain, and silverware. Not only classical art but also the exotic art of the Far East inspired artists—for example, Chinese motifs, known as chinoiseries, became a decorative fantasy in La Foire Chinoise (The Chinese Fair), the tapestry from a six-piece suite done from designs by Boucher (fig. 26-14). Ten sets of the suite were woven between 1743 and 1775, most of them for the king. The artist used his imagination freely to invent a scene in a country he had never visited and probably knew little about beyond the imported Chinese porcelains. Boucher's goal was to create a mood of liveliness and exotic charm rather than an authentic depiction of China.

Europeans, especially Germans, had created their own version of hard-paste, or true, porcelain, of the type imported from China (see "The Secret of Porcelain," page 808). But many wares continued to be made in imitation of Chinese porcelain using soft paste, a cheaper clay mix containing ground glass, which can be fired at lower temperatures. A major production center of soft paste in France was the Royal Porcelain Factory at Sèvres, whose name today is synonymous with fine porcelain. Typical of its elegant creations for the

court and other patrons able to afford such luxury items is a soft-paste potpourri jar in the shape of a boat (fig. 26-15), dated 1758, which is displayed on a base created for it. This rare technical masterpiece of sculpting and enamel painting is also a prime illustration of Rococo taste. In a typical blend of realistic detail and sheer fantasy, the boat has gilded rope rigging and a rope ladder leading to the crow's nest at the top of the mast, around which curls a standard bearing the royal fleurs-de-lis. The portholes are actually open to the interior to allow the scent of the potpourri (aromatic herbs, rose petals, cinnamon bark, and the like) to escape. In emulation of Chinese vase decoration, the side of the boat is painted with birds and blossoms.

In the last quarter of the eighteenth century, French art generally moved away from Rococo style and toward the classicizing styles that would end in Neoclassicism. But one sculptor who clung to Rococo up to the threshold of the French Revolution in 1789 was Claude Michel, known as Clodion (1738–1814). His major output consisted of playful, erotic tabletop sculpture, mainly in uncolored **terra-cotta**. Typical of Clodion's Rococo designs is the terra-cotta model he submitted to win a 1784 royal commission for a large monument to the invention of the hot-air balloon (fig. 26-16). Although Clodion's enchanting piece may today seem inappropriate to commemorate a technological achievement, hot-air balloons then were elaborately decorated with painted

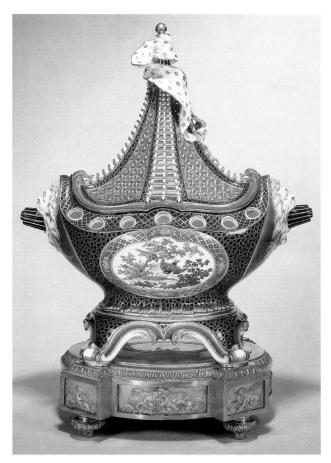

26-15. Potpourri jar, from Sèvres Royal Porcelain Factory, France. 1758. Soft-paste porcelain with polychrome and gold decoration, vase without base $14^{3}/_{4} \times 13^{3}/_{4} \times 6^{7}/_{8}$ " (37.5 × 34.6 × 17.5 cm). The Frick Collection, New York.

Rococo scenes, gold braid, and tassels. Clodion's balloon, decorated with bands of classical ornament, rises from a columnar launching pad in billowing clouds of smoke, assisted at the left by a puffing wind god with butterfly wings and heralded at the right by a trumpeting Victory. A few putti are stoking the fire basket that provided the hot air on which the balloon ascended as others gather reeds for fuel and fly up toward them.

ITALY

ART IN From the late 1600s until well into the nineteenth century, the education of a young northern European or American gentleman (and increasingly over that pe-

riod, gentlewoman) was completed on the Grand Tour, a prolonged visit to the major cultural sites of southern Europe. Accompanied by a tutor and an entourage of servants, the young man or woman began in Paris, moved on to southern France to visit a number of well-preserved Roman buildings and monuments there, then headed to Italy. Italy was the focus of the Grand Tour, repository of the classical and the Renaissance pasts and inspiration for the stylistic revival in the arts that would become Neoclassicism. There, the principal points of interest were Venice, Florence, Naples, and Rome.

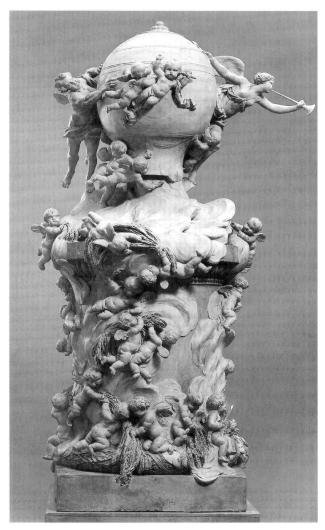

26-16. Clodion. The Invention of the Balloon. 1784. Terra-cotta model for a monument, height $43^{1}/_{2}$ " (110.5 cm). The Metropolitan Museum of Art, New York. Rogers Fund and Frederick R. Harris Gift, 1944 (44.21a b)

Clodion had a long career as a sculptor in the exuberant, Rococo manner seen in this work commemorating the 1783 invention of the hot-air balloon. During the austere revolutionary period of the First Republic (1792–95), he became one of the few Rococo artists to adopt successfully the more acceptable Neoclassical manner. In 1806, he was commissioned by Napoleon to provide the relief sculpture for two Paris monuments, the Vendôme Column and the Carrousel Arch near the Louvre

ART OF THE GRAND TOUR

Wealthy northern European visitors to Italy often sat for portraits by artists such as Rosalba Carriera (1675-1757). Carriera, the leading portraitist in Venice during the first half of the eighteenth century, began her career designing lace patterns and painting miniature portraits on the ivory lids of snuffboxes. By the first years of the eighteenth century she was making portraits with pastels, crayons of pulverized pigment bound to a chalk base by weak gum water. A versatile medium, pastel can be employed in a sketchy manner to create a vivacious and fleeting effect or can be blended through rubbing to produce a highly finished image. Carriera's

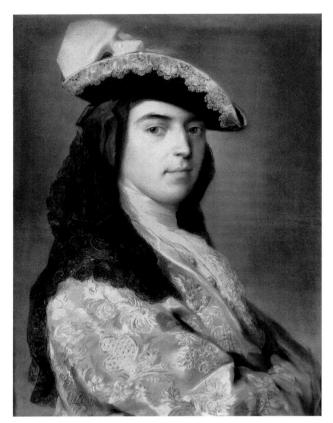

26-17. Rosalba Carriera. *Charles Sackville, 2nd Duke of Dorset.* c. 1730. Pastel on paper, 25×19 " (63.5 \times 48.3 cm). Private collection.

pastels earned her honorary membership in Rome's Academy of Saint Luke in 1705, and she later was admitted to the academies in Bologna and Florence. In 1720 she traveled to Paris, where she made a pastel portrait of the young Louis XV and was elected to the Royal Academy of Painting and Sculpture, despite the 1706 rule forbidding the admission of any more women (see "Women and Academies," below). Returning to Italy in 1721, Carriera spent much of the rest of her career in Venice, where she produced sensitive portraits of distinguished sitters such as the British aristocrat Charles Sackville (fig. 26-17).

Even more than portraits of themselves, visitors to Italy on the Grand Tour desired *vedute* (Italian for "views"; singular *veduta*), city views that they collected largely as fond reminders of their travels. These paintings were of two types. In one, known as the *capriccio* ("fanciful"), artists mixed actual features, especially ruins, into imaginatively pleasing compositions. The second, and by far the more popular type, featured naturalistic renderings of well-known tourist attractions—panoramic views that were meticulously detailed, topographically accurate, and populated with a host of contemporary figures engaged in typical activities. The Venetian artist Giovanni Antonio Canal, called Canaletto (1697–1768), became so popular among British clients for his scenes that his dealer arranged for him to

WOMEN AND ACADEMIES

Although several women were made members of the European academies of art before the eighteenth century, their inclusion amounted to little more than honorary recognition of their achievements. In France, Louis XIV had proclaimed in the founding address of the Royal Academy that its intention was to reward all worthy artists, "without regard to the difference of sex," but this resolve was not put into practice. Only seven women gained the title of Academician between 1648 and 1706, the year the Royal Academy declared itself closed to women. Nevertheless, four more women had been admitted to the Academy by 1770, when the men became worried that women members would become "too numerous," and declared four women members to be the limit at any one time. Young women were not admitted to the Academy school nor allowed to compete for Academy prizes, both of which were nearly indispensable for professional success.

Women fared even worse at London's Royal Academy. After the Swiss painters Mary Moser and Angelica Kauffmann were named as founding members in 1768, no other women were elected until 1922, and then only as associates. Johann Zoffany's 1771–72 portrait of the London academicians shows the men grouped around a male nude model, along with the Acade-

my's study collection of classical statues and plaster copies. Propriety prohibited the presence of women in this setting, so Zoffany painted Moser's and Kauffmann's portraits on the wall. In more formal portraits of the Academy, however, the two women were included.

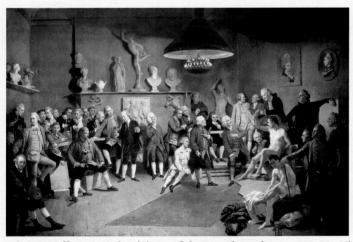

Johann Zoffany. *Academicians of the Royal Academy.* 1771–72. Oil on canvas, $47^1/_2 \times 59^1/_2$ " (120.6 × 151.2 cm). The Royal Collection, Windsor Castle, Windsor, England. (RCON-400747, OM 1210 WC 431)

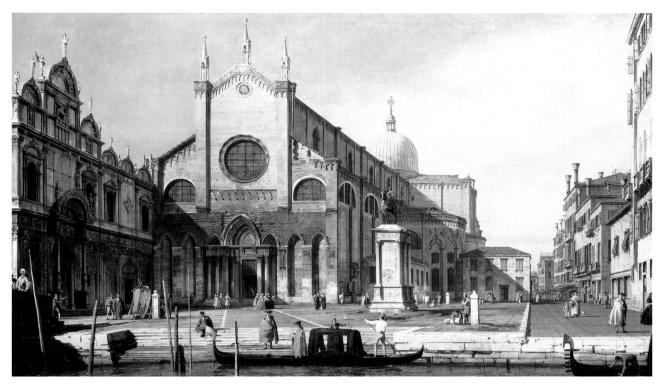

26-18. Canaletto. Santi Giovanni e Paolo and the Monument to Bartolommeo Colleoni. c. 1735–38. Oil on canvas, $18\frac{3}{8} \times 30^{7}/8$ " (46 × 78.4 cm). The Royal Collection, Windsor Castle, Windsor, England.

work from 1746 to 1755 in England, where he painted topographic views of London and the surrounding countryside, giving impetus to a school of English land-scape painting.

In 1762, the English king George III purchased Canaletto's *Santi Giovanni e Paolo and the Monument to Bartolommeo Colleoni* (fig. 26-18), painted probably in 1735–38. The Venetian square, with its famous fifteenth-century equestrian monument by Verrocchio (see fig. 17-56), is shown as if the viewer were in a gondola on a nearby canal. Immediately to the right is a perspectival plunge down the street into the distance. Many of Canaletto's views, like this one, are topographically correct. In others he rearranged the buildings to tighten the **composition** (the arrangement of the painting's elements), even occasionally adding features to produce a *capriccio*.

Very different are the Roman views of Giovanni Battista Piranesi (1720–78), one of the century's greatest printmakers. Trained in Venice as an architect, Piranesi went to Rome in 1740. After studying etching, he began in 1743 to produce portfolios of prints, and in 1761 he established his own publishing house. Piranesi is well known for his views of ancient Roman ruins, such as *The Arch of Drusus* (fig. 26-19), published in 1748 in a portfolio of etchings called *Antichità Romane de' Tempi della Repubblica (Roman Antiquities from the Time of the Republic)*. Such works are fine examples of the new taste for the **picturesque**, which contemporary British theorists defined as a landscape (actual or depicted) with an aesthetically pleasing irregularity in its shapes,

composition, and lighting. But in other respects, Piranesi's views are early manifestations of Romanticism. These ruins are emotionally compelling reminders of the passage of time and of its sobering implications: All human achievements, even the great events memorialized in such triumphal arches, eventually come to ruin.

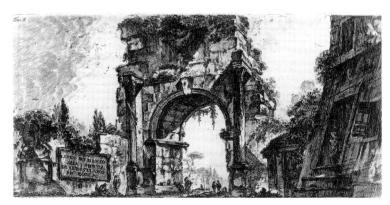

26-19. Giovanni Battista Piranesi. *The Arch of Drusus*. 1748. Etching, $14^{7}/_{16} \times 28^{3}/_{4}$ " (37 \times 73 cm). Published in *Antichità Romane de' Tempi della Repubblica* (later retitled *Alcune Vedute di Archi Trionfali*), Rome, 1748. The Pierpont Morgan Library, New York. PML 12601

Piranesi's children carried on his publishing business after his death. Encouraged by Napoleon's officials, his sons Francesco and Piero moved the operation in 1799 to Paris, where between 1800 and 1807 they made and sold restrikes (posthumous impressions) of all of their father's etchings. Later Piranesi's plates were purchased by the Royal Printing House in Rome and reprinted again.

The individual human, like those shown in the etching, is ultimately small and insignificant in relation to history and the cycle of birth and death.

Piranesi's and his patrons' interest in Roman ruins and in their symbolism was fueled by the discoveries made at Herculaneum and Pompeii, prosperous Roman towns near Naples that had been buried in 79 ce by the sudden eruption of Mount Vesuvius. In 1738, archaeologists began to uncover evidence of the catastrophe at Herculaneum, and ten years later unearthed the remains of Pompeii. The extraordinary archaeological discoveries made at the two sites, published in numerous illustrated books, excited interest in classical art and artifacts and spurred the development of Neoclassicism.

NEOCLASSICISM IN ROME

A notable sponsor of the classical revival was Cardinal Alessandro Albani (1692–1779), who amassed a huge collection of antique sculpture, **sarcophagi**, **intaglios**, **cameos**, and vases. In 1760–61, he built a villa just outside Rome to house and display his holdings. The Villa Albani became one of the most important spots on the Grand Tour. The villa was more than a museum, however; it was also a kind of shop, where many of the items he sold to satisfy the growing craze for antiquities were faked or heavily restored by artisans working in the cardinal's employ.

Albani's credentials as the foremost expert on classical art were solidified when he hired as his secretary and librarian Johann Joachim Winckelmann (1717–68),

the leading theoretician of Neoclassicism. The Prussiaborn Winckelmann had become an advocate of classical art while working in Dresden, where the French Rococo style he deplored was fashionable. In 1755, he published a pamphlet, Thoughts on the Imitation of Greek Works in Painting and Sculpture, in which he attacked the Rococo as decadent and argued that only by imitating Greek art could modern artists become great again. Winckelmann imagined that the temperate climate and natural ways of the Greeks had perfected their bodies and made their artists more sensitive to certain general ideas of what constitutes true and lasting beauty. Shortly after publishing this pamphlet, Winckelmann moved to Rome, where in 1758 he went to work for Albani. In 1764, he published the second of his widely influential treatises, The History of Ancient Art, which many consider the beginning of modern art history.

Winckelmann's closest friend and colleague in Rome was a fellow German, Anton Raphael Mengs (1728–79). Largely as a result of their friendship, Winckelmann's employer, Cardinal Albani, commissioned Mengs to do a painting for the ceiling of the great gallery in his new villa. The *Parnassus* ceiling (fig. 26-20), from 1761, is usually considered the first true Neoclassical painting. The scene takes place on Mount Parnassus in central Greece, which the ancients believed to be sacred to Apollo (the god of poetry, music, and the arts) and the nine Muses (female personifications of artistic inspiration). At the center of the composition is Apollo, his pose modeled on that of the famous *Apollo Belvedere*, an ancient marble statue in

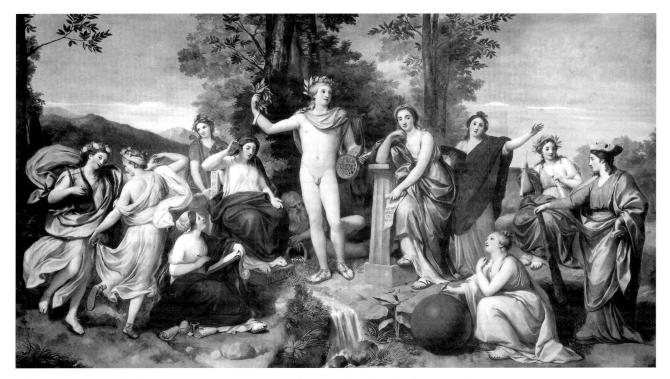

26-20. Anton Raphael Mengs. Parnassus, ceiling fresco in the Villa Albani, Rome. 1761.

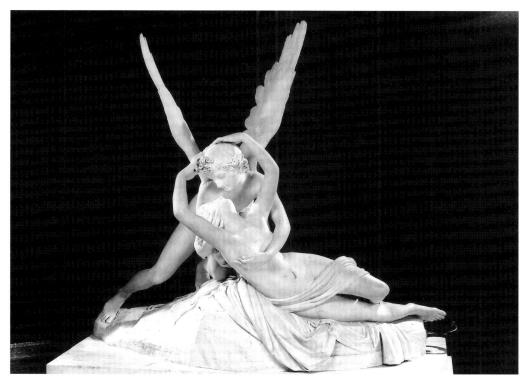

26-21. Antonio Canova. *Cupid and Psyche*. 1787–93. Marble, $6'1'' \times 6'8''$ (1.55 × 1.73 m). Musée du Louvre, Paris.

the Vatican collection. Mengs's Apollo holds a lyre and a laurel branch, symbol of artistic accomplishment. Next to him, resting on a Doric column, is Mnemosyne, the mother of the Muses, who are shown in the surrounding space practicing the various arts. Inspired by relief sculpture he had studied at Herculaneum, Mengs arranged the figures in a generally symmetrical, pyramidal grouping parallel to the picture plane. Winckelmann, not surprisingly, praised the work for achieving the "noble simplicity and calm grandeur" that he had found in Greek originals.

The aesthetic ideals of the Albani-Winckelmann circle soon affected contemporary Roman sculptors, who remained committed to this paradigm for the next 100 years. The leading Neoclassical sculptor of the late eighteenth and early nineteenth centuries was Antonio Canova (1757-1822). Born near Venice into a family of stone-masons, Canova in 1781 settled in Rome, where under the guidance of the Scottish painter Gavin Hamilton (1723-98) he adopted the Neoclassical style and quickly became the most sought-after European sculptor of the period.

Canova specialized in two types of work: grand public monuments for Europe's leaders and erotic mythological subjects, such as Cupid and Psyche (fig. 26-21), for the pleasure of private collectors. Cupid and Psyche illustrates the love story of Cupid, Venus's son, and Psyche, a beautiful mortal who had aroused the goddess's jealousy. Venus casts Psyche into a deathlike sleep; moved by Cupid's grief and love for her, the sky god

Jupiter (the Roman name for the Greek Zeus) takes pity on the pair and gives Psyche immortality. In this sculpture, Canova chose the most emotional and tender moment in the story, when Cupid revives the lifeless Psyche with a kiss. Here Canova combined a Romantic interest in emotion with a more typically Neoclassical appeal to the combined senses of sight and touch. Because the lovers gently caress each other, the viewer is tempted to run his or her fingers over the graceful contours of their cool, languorous limbs.

ROMANTICISM IN BRITAIN

REVIVALS AND British tourists and artists in Italy became the leading supporters of Neoclassicism partly because they had been prepared for it by the archi-

tectural revival of Renaissance classicism in their homeland earlier in the century.

CLASSICAL REVIVAL IN ARCHITECTURE AND LANDSCAPING

Just as the Rococo was emerging in France, a group of British professional architects and wealthy amateurs led by the Scot Colen Campbell (1676-1729) took a stance against what they saw as the immoral extravagance of the Italian Baroque. As a moral corrective, they advocated a return to the austerity and simplicity found in the architecture of Andrea Palladio.

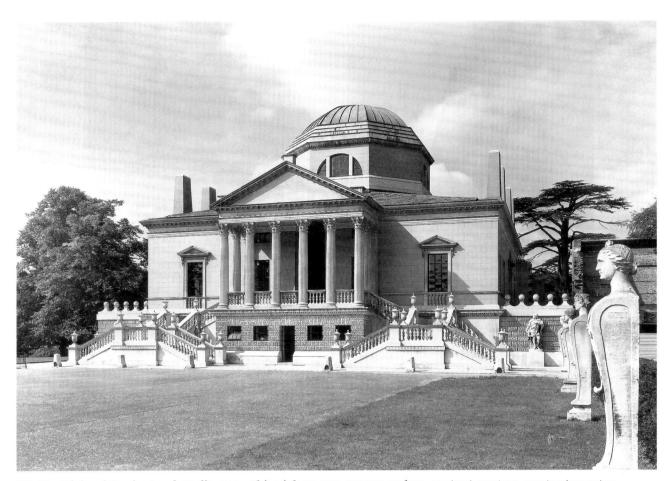

26-22. Richard Boyle, Lord Burlington. Chiswick House, West London, England. 1724–29. Interior decoration (1726–29) and new gardens (1730–40) by William Kent.

The most famous product of this group was Chiswick House (fig. 26-22), designed in 1724 by its owner, Richard Boyle, the third earl of Burlington (1695-1753). Burlington had visited Italy specifically to study Palladio's architecture, especially his Villa Rotunda (see fig. 18-63), which inspired his plan for Chiswick House. The building plan (fig. 26-23) shares the bilateral symmetry of Palladio's villa, although its central core is octagonal rather than round and there are only two entrances. The main entrance, flanked now by matching staircases, is a Roman temple front, a flattering reference to the building's inhabitant. Chiswick's elevation is characteristically Palladian, with a main floor resting on a basement, and tall rectangular windows with triangular pediments. The result is a lucid evocation of Palladio's design, with few but crisp details that seem perfectly suited to the refined proportions of the whole.

In Rome, Burlington had persuaded an English expatriate, William Kent (1685–1748), to return to London as his collaborator. Kent designed Chiswick's surprisingly ornate interior as well as the grounds, the latter in a style that became known throughout Europe as the English landscape garden. Kent's garden, in contrast to the regularity and rigid formality of Baroque gardens (see fig. 19-21), featured winding paths, a lake with a cascade, irregular plantings of shrubs, and other effects imitating the appearance of the natural rural landscape.

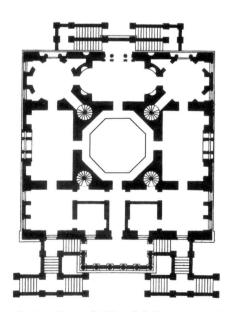

26-23. Plan of Chiswick House. 1724

The English landscape garden was another indication of the growing Enlightenment emphasis on the natural.

Following Kent's lead, **landscape architecture** flourished in the hands of such designers as Lancelot ("Capability") Brown (1716–83) (see fig. 19-72 and page

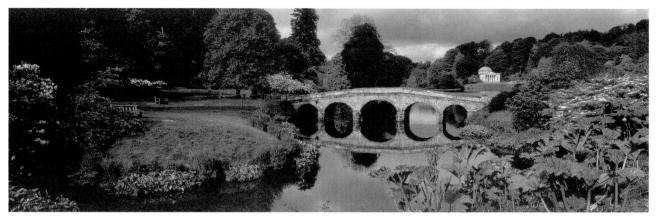

26-24. Henry Flitcroft and Henry Hoare. The Park at Stourhead, Wiltshire, England. Laid out 1743; executed 1744–65, with continuing additions.

783) and Henry Flitcroft (1697–1769). In the 1740s the banker Henry Hoare redid the grounds of his estate at Stourhead in Wiltshire (fig. 26-24) with the assistance of Flitcroft, a protégé of Burlington. The resulting gardens at Stourhead carried Kent's ideas much further. Stourhead is, in effect, an exposition of the picturesque, with orchestrated views dotted with Greek- and Roman-style temples, grottoes, copies of antique statues, and such added delights as a rural cottage, a Chinese bridge, a Gothic spire, and a Turkish tent. In the view illustrated here, a replica of the Pantheon in Rome is just visible across a carefully placed lake. While the nostalgic evocation of an idyllic classical past recalls the work of the seventeenth-century French landscape painter Claude Lorrain (see fig. 19-27), who had found a large market in

Britain, the exotic elements here are an early indication of the Romantic taste for the strange and the novel. The garden is therefore an interesting mixture of the Neoclassical and the Romantic.

Another example of the British taste for the classical that helped lay the foundation for Neoclassicism was the work of John Wood the Elder (c. 1704–54), who dreamed of turning into a new Rome his native Bath—a spa town in the west near Wales, originally built by the Romans in the first century. On a large property near the town center, Wood began in 1727 to lay out a public meeting place, sports arena, and gymnasium. Much of his plan was never carried out, but in 1754 he began building the Circus (fig. 26-25), an elegant housing project that was completed in 1758 by his son, John Wood the Younger

26-25. John Wood the Elder and John Wood the Younger. The Circus, Bath, England. 1754-58.

26-26. Horace Walpole and others. Strawberry Hill, Twickenham, England. 1749–77.

(d. 1782). The Circus was a circle of thirty-three town houses, all sharing a single three-story facade modeled on the exterior of the Roman Colosseum, with attics to house the servants' quarters and steeply pitched roofs and large chimneys as a concession to English winters. The Woods' elegant Circus houses, with their handsome yet modestly scaled classical fronts, were imitated enthusiastically in London and other British and American cities well into the nineteenth century.

GOTHIC REVIVAL IN ARCHITECTURE AND ITS DECORATION

Alongside the British classical revival of the mideighteenth century came a revival of the Gothic style, a manifestation of architectural Romanticism that spread to other nations after 1800 (see Chapter 27). An early advocate of the Gothic revival was the conservative politician and author Horace Walpole (1717–97), who shortly before 1750 decided to remodel his house, called Strawberry Hill, in the Gothic manner (fig. 26-26). Gothic renovations were commonly performed in Britain before this date, but only to buildings that dated from the medieval period. Working with a number of friends and architects, Walpole spent nearly thirty years, from 1749 to 1776, transforming his home into a Gothic castle complete with **crenellated battlements**, **tracery** windows, and **turrets**.

The interior, too, was totally changed. One of the first rooms Walpole redesigned, with the help of amateurs John Chute (1701–76) and Richard Bentley (1706–82), was the library (fig. 26-27). Here the three turned for inspiration to illustrations in the antiquarian books that the library housed. For the bookcases, they adapted designs

26-27. Horace Walpole, John Chute, and Richard Bentley. Library, Strawberry Hill. After 1754.

from the old Saint Paul's Cathedral in London which had been destroyed in 1666. Prints depicting two medieval tombs inspired the chimneypiece. For the ceiling, Walpole incorporated a number of coats of arms of his ancestors—real and imaginary. The reference to fictional relatives offers a clue to Walpole's motives in choosing the medieval style. Walpole meant his house to suggest a castle out of the medievalizing Romantic fiction that he himself was writing. In 1764, he published *The Castle of Otranto*, a highly sensational novel set in the Middle Ages that helped launch the craze for the Gothic novel.

26-28. Robert Adam. Anteroom, Syon House, Middlesex, England. 1760–69.

Adam's conviction that it was acceptable to modify details of the classical orders was generally opposed by the British architectural establishment. As a result of that opposition, Adam was never elected to the Royal Academy.

NEOCLASSICISM IN ARCHITECTURE AND THE DECORATIVE ARTS

The most important British contribution to Neoclassicism was a style of interior decoration developed by the Scottish architect Robert Adam (1728–92). On his Grand Tour in 1754-58, during which he became a member of Albani's circle of Neoclassicists, Adam largely ignored the civic architecture that had interested British classicists such as Wood and Burlington and focused instead on the applied ornament of Roman domestic architecture. When he returned to London to set up an architectural firm, he brought with him a complete inventory of decorative motifs, which he then modified in pursuit of a picturesque elegance. His stated aim to "transfuse the beautiful spirit of antiquity with novelty and variety" met with considerable opposition from the Palladian architectural establishment, but it proved ideally suited both to the evolving taste of wealthy clients and to the imperial aspirations of the new king, George III, whose reign began in 1760. In 1761, George appointed Adam and Adam's rival William Chambers (1723-96) as joint Architects of the King's Works.

Adam achieved worldwide fame for his interior renovations, such as those he carried out between 1760 and 1769 for the duke of Northumberland at his country estate, Syon, near London. The opulent colored marbles, gilded relief panels, classical statues, spirals, garlands, **rosettes**, and gilded moldings in the anteroom (fig. 26-28) are luxuriously profuse yet are restrained by the strong geometric order imposed on them and by the plain wall and ceiling surfaces. Adam's preference for bright pastel grounds and small-scale decorative elements, both inheritances from the Rococo (see fig. 26-7), also helped lighten the effect.

Such interiors were designed partly as settings for the art collections of British aristocrats, which included antiquities as well as a range of Neoclassical painting, sculpture, and decorative ware (fig. 26-29, "The Object Speaks: Georgian Silver," page 918). The most successful producer of Neoclassical decorative art was Josiah Wedgwood (1730–95). In 1768, near his native village of Burslem, he opened a pottery factory called Etruria after the ancient Etruscan civilization in central Italy known for its pottery. This production-line shop had several divisions, each with its own kilns (firing ovens) and workers trained in individual specialties. In the mid-1770s Wedgwood, a talented chemist, perfected a finegrained, unglazed, colored pottery, which he called jasperware. The most popular of his jasperware featured white figures against a blue ground, like that in

THE OBJECT SPEAKS

GEORGIAN SILVER

Since ancient times, Europeans have prized silver for its rarity, reflectivity, and beautiful luster. At some times, its use was restricted to royalty; at others, to liturgical applications such as statues of saints, manuscript illuminations, and chalices. But by the Georgian period—the years from 1714 to 1830, when Great Britain was ruled by four kings named George—wealthy British families filled their homes with a variety of objects made of fine silver, utensils and vessels that they collected not simply as useful, practical articles but as statements of their own high social status.

British gentlemen employed finely crafted silver vessels, for example, to serve and consume punch, a potent alcoholic beverage that lubricated the wheels of Georgian society. Gentlemen took pride in their own secret recipes for punch, and a small party of drinkers might even pass around an elegant punch bowl as a communal vessel so that it, along with its contents, could be admired. Larger groups would drink from cups or goblets such as the simple yet elegant goblet by Ann and Peter Bateman, which has a gilded interior to protect the silver from the acid present in alcoholic drinks. (Hester Bateman's double beaker, also

with a gilded interior, was made for use while traveling.) The punch would be poured into the goblets with a ladle such as the one shown here, by Elizabeth Morley, which has a twisted whalebone handle that floats, making it easy to retrieve from the punch bowl. Then, the filled goblets would be served on a flat salver like the one made by Elizabeth Cooke. Gentlemen also used silver containers to carry snuff, a pulverized tobacco that was inhaled by well-to-do members of both sexes. The fairly flat snuffbox, by Alice and George Burrows, has curved sides for easy insertion into the pockets of gentlemen's tight-fitting trousers.

All of the objects shown here bear the marks of silver shops run either wholly or partly by women, who played a significant role in the production of Georgian silver. While some women served formal apprenticeships and went on to become members of the goldsmiths' guild (which included silversmiths), most women became involved with silver through their relation to a master silversmith—typically a father, husband, or brother—and they frequently specialized in a specific aspect of the craft, such as engraving, **chasing**, or polishing. The widows of silversmiths often took over their husbands' shops and ran them with the help of journeymen or partners.

26-29. Elizabeth Morley, George III toddy ladle, 1802; Alice and George Burrows, George III snuffbox, 1802; Elizabeth Cooke, George III salver, 1767; Ann and Peter Bateman, George III goblet, 1797; Hester Bateman, George III double beaker, 1790. National Museum of Women in the Arts, Washington, D.C.

Silver Collection assembled by Nancy Valentine, purchased with funds donated by Mr. and Mrs. Oliver Grace and family

Hester Bateman (1708–94), the most famous woman silversmith in eighteenth-century Britain, inherited her husband's small spoonmaking shop at the age of fiftytwo and transformed it into one of the largest silver manufactories in the country. Adapting new technologies of mass production to the manufacture of silver, Bateman marketed her well-designed, functional, and relatively inexpensive wares to the newly affluent middle class, making no attempt to compete with those silversmiths who catered to the monarchy or the aristocracy. She retired when she was eighty-two after training her daughter-in-law Ann and her sons and grandson to carry on the family enterprise. Both Hester's double beaker and Ann and Peter's goblet show the restrained elegance characteristic of Bateman silver.

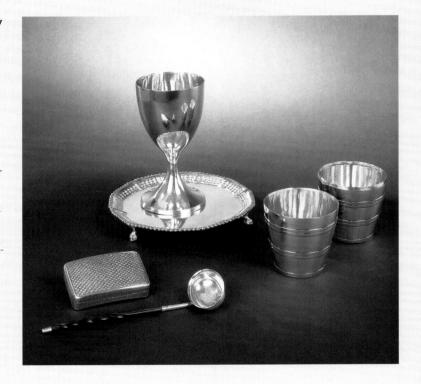

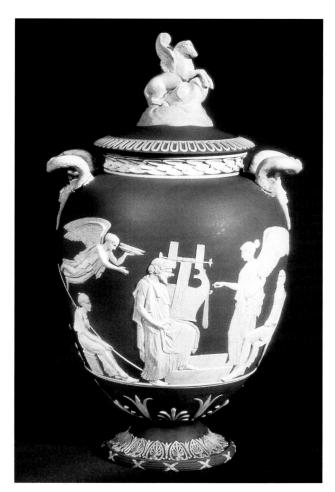

26-30. Josiah Wedgwood. Vase, made at the Wedgwood Etruria factory, Staffordshire, England. 1786. White jasper body with a mid-blue dip and white relief, height 18" (45.7 cm). Relief of *The Apotheosis of Homer* adapted from plaque by John Flaxman, Jr. 1778. Trustees of the Wedgwood Museum, Barlaston, Staffordshire, England.

The Apotheosis of Homer (fig. 26-30). The relief on the front of the vase was designed by the sculptor John Flaxman, Jr. (1755–1826), who worked for Wedgwood from 1775 to 1787. Flaxman's scene of Homer being deified was based on a book illustration documenting a classical Greek vase in the collection of William Hamilton (1730–1803), a leading collector of antiquities and one of Wedgwood's major patrons. Flaxman's design simplified the original according to the prevailing idealized notion of Greek art and the demands of mass production.

The socially conscious Wedgwood—who epitomized Enlightenment thinking—established a village for his employees and cared deeply about every aspect of their living conditions. He was also active in the organized international effort to halt the African slave trade and abolish slavery. To publicize the abolitionist cause, Wedgwood asked the sculptor William Hackwood (c. 1757–1839) to design an emblem for the British Committee to Abolish the Slave Trade, formed in 1787. The compelling image created by Hackwood was a

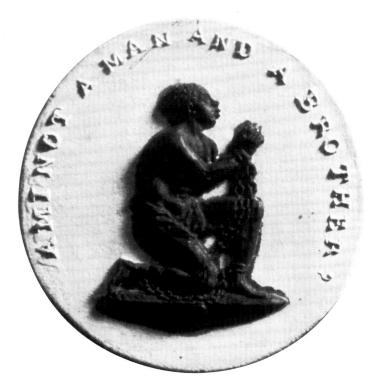

26-31. William Hackwood, for Josiah Wedgwood. "Am I Not a Man and a Brother?" 1787. Black and white jasperware, $1^3/8 \times 1^3/8$ " (3.5 × 3.5 cm). Trustees of the Wedgwood Museum, Barlaston, Staffordshire, England.

small medallion of black-and-white jasperware, cut like a cameo in the likeness of an African man kneeling in chains, with the legend "Am I Not a Man and a Brother?" (fig. 26-31). Wedgwood sent copies of the medallion to Benjamin Franklin, the president of the Philadelphia Abolition Society, and to others in the abolitionist movement. Later, those active in the women's suffrage movement in the United States adapted the image by representing a woman in chains with the motto "Am I Not a Woman and a Sister?"

PAINTING

When the newly prosperous middle classes in Britain began to buy art, they wanted portraits of themselves. But taste was also developing for other subjects, such as moralizing satire and caricature, ancient and modern history, the British landscape and people, and scenes from English literature. Whatever their subject matter, many of the paintings that emerged in Britain reflected Enlightenment values, including an interest in social progress, an embrace of natural beauty, and faith in reason and science.

The Satiric Spirit. Following the discontinuation of government censorship in 1695, there emerged in Britain a flourishing culture of literary satire, directed at a variety of political and social targets. The first painter inspired by the work of these pioneering novelists and essayists was William Hogarth (1697–1764). Trained as a portrait painter, Hogarth believed art should contribute

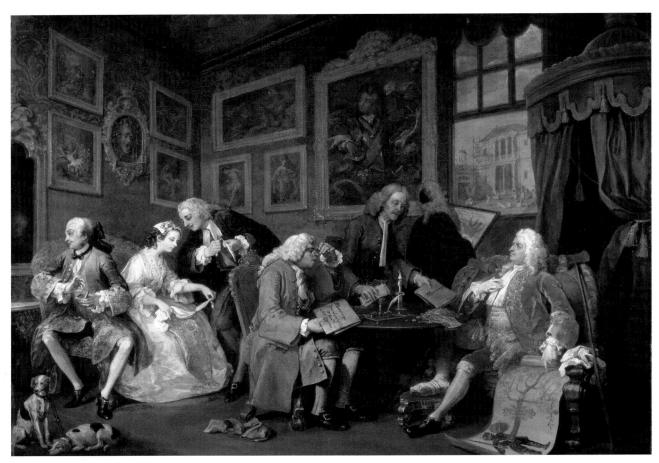

26-32. William Hogarth. *The Marriage Contract,* from *Marriage à la Mode.* 1743–45. Oil on canvas, $35^3/_4 \times 27^1/_2$ " (90.8 \times 69.9 cm). The National Gallery, London. Reproduced by Courtesy of the Trustees

to the improvement of society. About 1730, he began illustrating moralizing tales of his own invention in sequences of four to six paintings, which he then produced in sets of prints, both to maximize his profits and to influence as many people as possible.

Between 1743 and 1745, Hogarth produced the Marriage à la Mode suite, whose subject was inspired by Joseph Addison's 1712 essay in the Spectator promoting the concept of marriage based on love. The opening scene, The Marriage Contract (fig. 26-32), shows the gout-ridden Lord Squanderfield arranging the marriage of his son to the daughter of a wealthy merchant. The merchant gains entry for his family into the aristocracy, while the lord gets the money he needs to complete his Palladian house, which is visible out the window. The loveless couple who will be sacrificed to their fathers' deal sit on the couch. While the young Squanderfield stares admiringly at himself in the mirror, his unhappy fiancée is already being wooed by lawyer Silvertongue, who suggestively sharpens his pen. The next five scenes show the progressively disastrous results of such a union, culminating in the killing of Silvertongue by the young lord and the subsequent suicide of his wife.

Stylistically, Hogarth's works combine the additive approach of seventeenth-century Dutch genre painters with the nervous elegance of the Rococo. Hogarth wanted to please and entertain his audience as much as educate them. His work became so popular that in 1745 he was able to give up portraiture, which he considered a deplorable form of vanity.

Portraiture. A generation younger than Hogarth, Sir Joshua Reynolds, (1723-92) specialized in the very form of painting—portraiture—that the moralistic Hogarth despised. After studying Renaissance art in Italy, Reynolds settled in London in 1753 and worked vigorously to educate artists and patrons to appreciate classical history painting. In 1768 he was appointed first president of the Royal Academy (see "Academies and Academy Exhibitions," page 906). Reynolds's Fifteen Discourses to the Royal Academy (1769-90) set out his theories on art: Artists should follow the rules derived from studying the great masters of the past, especially those who worked in the classical tradition; art should generalize to create the universal rather than the particular; and the highest kind of art is history painting.

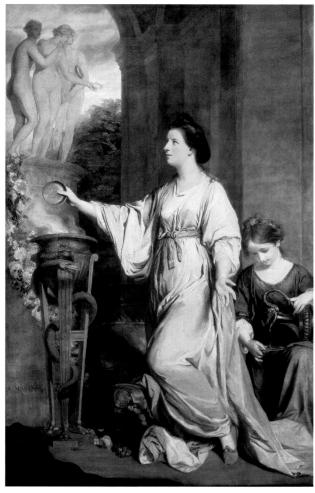

26-33. Joshua Reynolds. *Lady Sarah Bunbury Sacrificing to the Graces.* 1765. Oil on canvas, $7'10'' \times 5'$ (2.42 \times 1.53 m). The Art Institute of Chicago. Mr. and Mrs. W. W. Kimball Collection, 1922. 4468

Lady Bunbury was one of the great beauties of her era. A few years before this painting was done, she had turned down a request of marriage from George III.

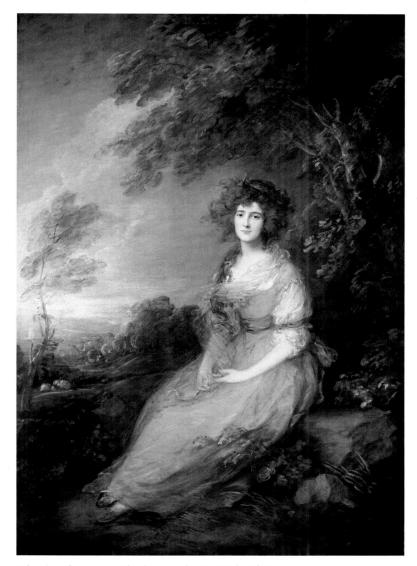

26-34. Thomas Gainsborough. *Portrait of Mrs. Richard Brinsley Sheridan.* 1785–87. Oil on canvas, $7'2^{5}/8'' \times 5'^{5}/8''$ (2.2 \times 1.54 m). National Gallery of Art, Washington, D.C. Andrew W. Mellon Collection, (1937.1.92)

Because British patrons preferred portraits of themselves to scenes of classical history, Reynolds attempted to elevate portraiture to the level of history painting by giving it a historical or mythological veneer. A good example of this type of portraiture, a form of Baroque classicism that Reynolds called the Grand Manner, is Lady Sarah Bunbury Sacrificing to the Graces (fig. 26-33). Dressed in a classicizing costume, Bunbury plays the part of a Roman priestess making a sacrifice to the personifications of female beauty, the Three Graces. The figure is further aggrandized through the use of the monumental classical arcade behind her. the emphatic classical contrapposto of her pose, and the large scale of the canvas. Such works were intended for the grand rooms, halls, and stairways of aristocratic residences.

A number of British patrons, however, remained committed to the kind of portraiture Van Dyck had brought to England in the 1620s, which had featured

more informal poses against natural vistas. Thomas Gainsborough (1727-88) achieved great success with this mode when he moved to Bath in 1759 to cater to the rich and fashionable people who had begun going there in great numbers. A good example of his mature style is the Portrait of Mrs. Richard Brinsley Sheridan (fig. 26-34), which shows the professional singer (the wife of a celebrated playwright) seated informally outdoors. The sloping view into the distance and the use of a tree to frame the sitter's head seem to have been borrowed straight from Van Dyck (see fig. 19-47). But Gainsborough modernized the formula not simply through his lighter, Rococo palette and feathery brushwork but also by integrating the woman into the landscape, thus identifying her with it. The effect is especially noticeable in the way her windblown hair matches the tree foliage overhead. The work thereby manifests one of the new values of the Enlightenment: the emphasis on nature and the natural as the sources of goodness and beauty.

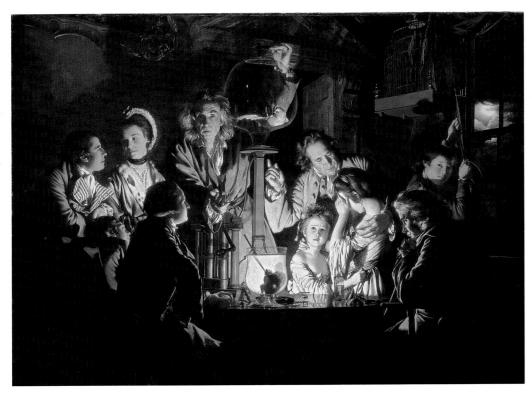

26-35. Joseph Wright. *An Experiment on a Bird in the Air-Pump.* 1768. Oil on canvas, $6 \times 8'$ (1.82 \times 2.43 m). The National Gallery, London.

The Romance of Science. An Enlightenment concern with developments in the natural sciences is seen in the dramatic depiction of An Experiment on a Bird in the Air-Pump (fig. 26-35) by Joseph Wright of Derby (1734-97). Trained as a portrait painter, Wright made the Grand Tour in 1773-75 and then returned to the English Midlands to paint local society. Many of those he painted were the self-made entrepreneurs of the first wave of the Industrial Revolution, which was centered there in towns such as Birmingham. Wright belonged to the Lunar Society, a group of industrialists (including Wedgwood), mercantilists, and progressive nobles who met in Derby. As part of the society's attempts to popularize science, Wright painted a series of "entertaining" scenes of scientific experiments, including An Experiment on a Bird in the Air-Pump.

The second half of the eighteenth century was an age of rapid technological advances (see "Iron as a Building Material," page 935), and the development of the air pump was among the many innovative scientific developments of the time. Although it was employed primarily to study the property of gases, it was also widely used to promote the public's interest in science because of its dramatic possibilities. In the experiment shown here, air was pumped out of the large glass bowl until the small creature inside, a bird, collapsed from lack of oxygen; before the animal died, air was reintroduced by a simple mechanism at the top of the bowl. In front of an audience of adults and children, a lecturer is

shown on the verge of reintroducing air into the glass receiver. Near the window at right, a boy stands ready to lower a cage when the bird revives. (The moon visible out the window is a reference to the Lunar Society.) By delaying the reintroduction of air, the scientist has created considerable suspense, as the reactions of the two girls indicate. Their father, a voice of reason, attempts to dispel their fears. The dramatic lighting not only underscores the life-and-death issue of the bird's fate but also suggests that science brings light into a world of darkness and ignorance. The lighting adds a spiritual dimension as well. During the Baroque era, such intimate lighting effects had been used for religious scenes (see fig. 19-26). Here science replaces religion as the great light and hope of humanity. This theme is emphasized through the devout expressions of some of the observers.

History Painting. European academies had long considered history painting—with subjects drawn from classical history and literature, the Bible, and mythology—as the highest form of artistic endeavor, but British patrons were reluctant to purchase such works from native artists. Instead, they favored Italian paintings bought on the Grand Tour or acquired through agents in Italy. Thus, the arrival in London in 1766 of the Italian-trained Swiss history painter Angelica Kauffmann (1741–1807) was a great encouragement to those artists in London aspiring to success as history painters. She was welcomed im-

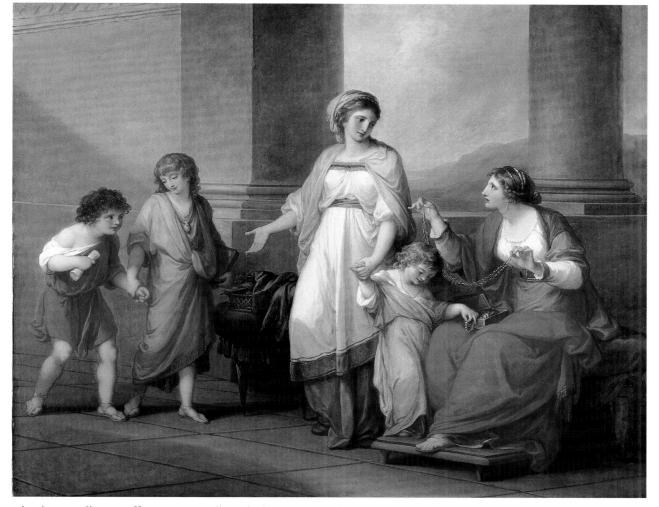

26-36. Angelica Kauffmann. *Cornelia Pointing to Her Children as Her Treasures.* c. 1785. Oil on canvas, $40 \times 50''$ (101.6×127 cm). Virginia Museum of Fine Arts, Richmond, Virginia. The Adolph D. and Wilkins C. Williams Fund

mediately into Joshua Reynolds's inner circle and in 1768 was one of two women artists named among the founding members of the Royal Academy (see "Women and Academies," page 910).

Kauffmann had assisted her father on church murals and was already accepting portrait commissions at age fifteen. She first encountered the new classicism in Rome, in the circle of Johann Winckelmann, whose portrait she painted, and where she had been elected to the Academy of Saint Luke. In a highly unusual move, she embarked on an independent career as a history painter. In London, where she lived from 1766 to 1781, Kauffmann produced numerous history paintings, many of them with subjects drawn from classical antiquity, such as Cornelia Pointing to Her Children as Her Treasures (fig. 26-36), which Kauffmann painted for an English patron after returning to Italy. The story takes place in the second century BCE, during the Republican era of Rome. A woman visitor has been showing Cornelia her jewels and then requests to see those of her hostess. In response,

Cornelia shows her two sons and says "These are my most precious jewels." Cornelia exemplifies the "good mother," a popular subject among later eighteenth-century history painters who, in the reforming spirit of the Enlightenment, often depicted subjects that would teach lessons in virtue. The value of Cornelia's maternal dedication is emphasized by the fact that under her loving care, the sons, Tiberius and Gaius Gracchus, grew up to be political reformers. Although the setting of Kauffmann's work is as severely simple as the message, the effect of the whole is softened by the warm, subdued lighting and by the tranquil grace of the leading characters.

Kauffmann's devotion to Neoclassical history painting was at first shared by her American-born friend Benjamin West (1738–1820), who, after studying in Philadelphia, traveled to Rome in 1759. There he met Winckelmann and became a student of Mengs. In 1763, West moved permanently to London, where he specialized in Neoclassical history paintings. In 1768, he became a founding member of the Royal Academy. Two

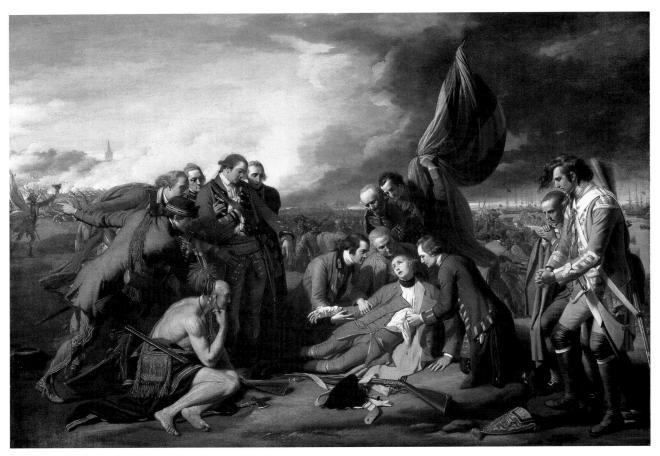

26-37. Benjamin West. *The Death of General Wolfe.* 1770. Oil on canvas, $4'11^{1}/2'' \times 7'$ (1.51 \times 2.14 m). The National Gallery of Canada, Ottawa.

Transfer from the Canadian War Memorials, 1921 (Gift of the 2nd Duke of Westminster, Eaton Hall, Cheshire, 1918)

The famous Shakespearean actor David Garrick was so moved by this painting that he enacted an impromptu interpretation of the dying Wolfe in front of the work when it was exhibited by the Academy. The mid-eighteenth-century revival of interest in Shakespeare's more dramatic plays, in which Garrick played a leading role, was both a manifestation of and a major factor in the rise of Romantic taste in Britain.

years later, he shocked Reynolds and his other academic friends with his painting *The Death of General Wolfe* (fig. 26-37) because rather than clothing the figures in ancient garb in accordance with the tenets of Neoclassicism, he chose to depict them in modern dress. When Reynolds learned what West was planning to do, he begged him not to continue this aberration of "taste." George III informed West he would not buy a painting with British heroes in modern dress.

The painting shows an important event from the Seven Years' War (1756–63), whose main issue was the struggle between Britain and France for control of various overseas territories, including Canada. The decisive battle for Canada was fought at Quebec City in 1759. Although the British won, their leader, General James Wolfe, died just after receiving word that the French were in retreat. West offers the viewer a highly dramatized account of the event. Instead of showing Wolfe at the base of a tree surrounded by two or three attendants—as actually occurred—West chose to put him under a suitably dramatic sky. Beneath the flag that provides the apex of the asymmetrical triangular composition, West placed Wolfe at the center of an intensely

concerned group of soldiers. For exotic interest and as an emblem of the natural, West added a Native American—a blatant fiction, since the Indians in this battle fought on the side of the French. The arrangement of the attendants and the posture of Wolfe were meant to suggest a kind of Lamentation over the dead Christ (see fig. 17-15). Just as Christ died for humanity, Wolfe sacrificed himself for the good of the State.

The Death of General Wolfe enjoyed such an enthusiastic reception by the British public that Reynolds apologized to West, and the king was among five patrons to commission replicas. West's innovative decision to depict a modern historical subject in the Grand Manner established the general format for the depiction of contemporary historical events for all European artists in the later eighteenth and early nineteenth centuries. And the emotional intensity of his image helped launch the Romantic movement in British painting.

Romantic Painting. The Enlightenment's faith in reason and empirical knowledge, dramatized in such works of art as Joseph Wright's *Experiment on a Bird in the Air-Pump*, was countered by Romanticism's celebration

26-38. John Henry Fuseli. *The Nightmare.* 1781. Oil on canvas, $39\sqrt[3]{4} \times 49\sqrt[1]{2}$ " (101 × 127 cm). The Detroit Institute of Arts.

Gift of Mr. and Mrs. Bert Smokler and Mr. and Mrs. Lawrence A. Fleischmann

Fuseli was not popular with the English critics. One writer said Fuseli's 1780 entry in the London Royal Academy exhibition "ought to be destroyed," and Horace Walpole called another painting in 1785 "shockingly mad, mad, mad, madder than ever." Even after achieving the highest official acknowledgment of his talents, Fuseli was called the Wild Swiss and Painter to the Devil. But the public appreciated his work, and *The Nightmare*, exhibited at the Academy in 1782, was repeated in at least three versions and its imagery disseminated by means of prints published by commercial engravers. One of these prints would one day hang in the office of the Austrian psychoanalyst Sigmund Freud, who believed that dreams were manifestations of the dreamer's repressed desires.

of the emotions and subjective forms of experience. This rebellion against reason sometimes led Romantic artists to glorify the irrational side of human nature that the Enlightenment sought to deny. In Britain, one such artist was John Henry Fuseli (1741-1825). Born Johann Heinrich Füssli in Zürich, Switzerland, he was raised in an intellectual household where all things French, from the Rococo to the Enlightenment, were opposed. Instead of sensuality and rationality, those who gathered in his father's house celebrated intensity, originality, freedom of expression, and the imaginative power of the irrational. For their models of society and art, they looked to Britain. They were especially inspired by the contemporary emotional trend in British poetry and by the example of Shakespeare, whose dramatic plays were being revived there. It is not surprising that after studying between 1770 and 1778 in Rome—focusing on Michelangelo, not the ancients—Fuseli settled permanently in London and anglicized his name. At first, he supported himself as an illustrator and translator, including works by Shakespeare (into German) and Winckelmann (into English). By the early 1780s, he had begun to make a reputation as a Romantic painter of the irrational and the erotic with works such as *The Nightmare* (fig. 26-38).

The Nightmare is not a pure fantasy but is inspired by a popular Swiss legend of the Incubus, who was believed to sit on the chest of virgins while they sleep, causing them to have distressing erotic nightmares. The content of this sleeper's dream is suggested by the way the "night mare," on which the Incubus travels, breaks through the curtains of her room. This was the first of at least four versions of the theme Fuseli would paint. His motives are perhaps revealed by the portrait on the back of the canvas, which may be that of Anna Landolt. Fuseli had met her in Zürich in the winter of 1778-79 and had fallen in love with her. Too poor to propose marriage to her, he did not declare his feelings, but after his return to London he wrote to her uncle that she could not marry another because they had made love in one of his dreams and she therefore belonged to him. The painting may be a kind of illustration of that dream.

26-39. William Blake. *Elohim Creating Adam*. 1795. Color print finished in pen and watercolor, $17 \times 21^{1}/8$ " (43.1 × 53.6 cm). Tate Gallery, London.

Made through a monotype process, Blake's large color prints of 1795 combine printing with painting and drawing. To make them, the artist first laid down his colors (possibly oil paint) on heavy paperboard. From the painted board Blake then pulled a few impressions, usually three, on separate sheets of paper. These impressions would vary in effect, with the first having fuller and deeper colors than the subsequent ones. Blake then finished each print by hand, using watercolor and pen and ink.

Also opposed to the Enlightenment emphasis on reason was Fuseli's close friend William Blake (1757–1827), a highly original poet, painter, and printmaker. Trained as an engraver, Blake enrolled briefly at the Royal Academy, where he was subjected to the teachings of Reynolds. The experience convinced him that all rules hinder rather than aid creativity, and he became a lifelong advocate of unfettered imagination. For Blake, imagination offered access to the higher realm of the spirit, while reason could only provide information about the lower world of matter.

Deeply concerned with the problem of good and evil, Blake developed an idiosyncratic form of Christian belief and drew on elements from the Bible, Greek mythology, and British legend to create his own mythology. The "prophetic books" that he designed and printed in the mid-1790s combined poetry and imagery dealing with themes of spiritual crisis and redemption. Their dominant characters include Urizen ("your reason"), the negative embodiment of rationalistic thought and repressive authority; Orc, the manifestation of energy, both creative and destructive; and Los, the artist, whose task is to create form out of chaos.

Thematically related to the prophetic books are an independent series of twelve large color prints that Blake executed for the most part in 1795, including the awe-inspiring Elohim Creating Adam (fig. 26-39). The sculpturesque volumes and muscular physiques of the figures reveal the influence of Michelangelo, whose works Blake admired in reproduction, and the subject invites direct comparison with Michelangelo's famous Creation of Adam on the ceiling of the Sistine Chapel (see fig. 18-14). But while Michelangelo, with humanist optimism, viewed the Creation as a positive act, Blake presents it in negative terms. In Blake's print, a giant worm, symbolizing matter, encircles the lower body of Adam, who, with an anguished expression, stretches out on the ground like the Crucified Christ. Above him, the winged Elohim (*Elohim* is one of the Hebrew names for God) appears anxious, even desperate—quite unlike the confident deity pictured by Michelangelo. For Blake, the Creation is tragic because it submits the spiritual human to the fallen state of a material existence. Blake's fraught and gloomy image challenges the viewer to recognize his or her fallen nature and seek to transcend it.

26-40. Jacques-Germain Soufflot. Panthéon (Church of Sainte-Geneviève), Paris. 1755-92.

This building has a strange history. Before it was completed, the revolutionary government in control of Paris confiscated all religious properties to raise desperately needed public funds. Instead of selling Sainte-Geneviève, however, they voted in 1791 to make it the Temple of Fame for the burial of Heroes of Liberty. Under Napoleon I (ruled 1799-1814), the building was resanctified as a Catholic church and was again used as such under King Louis-Philippe (ruled 1830-48) and Napoleon III (ruled 1852-70). Then it was permanently designated a nondenominational lay temple. In 1851, the building was used as a physics laboratory. Here the French physicist Jean-Bernard Foucault suspended his now-famous pendulum on the interior of the high crossing dome and by measuring the path of the pendulum's swing proved his theory that the earth rotated on its axis in a clockwise motion. In 1995, the ashes of Marie Curie, who won the Nobel Prize in chemistry in 1911, were moved into this "memorial to the great men of France," making her the first woman to be enshrined there.

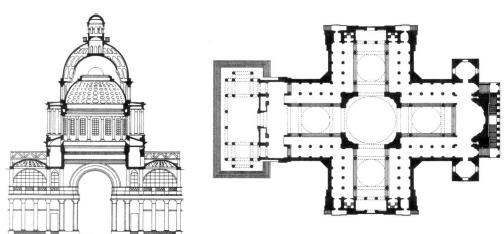

26-41. Section and plan of the Panthéon (Church of Sainte-Geneviève).

EIGHTEENTH-

LATER During the seventeenth century, the French court had resisted the influence of the Italian **CENTURY ART** Baroque and had opted instead **IN FRANCE** for a more restrained classical style. Even during the Rococo

period, the French Academy continued to promote classical principles. Consequently, French artists and architects of the late eighteenth century readily adopted the new classicism coming out of Italy. And because of their deep commitment to Neoclassicism, the French generally rejected the Romanticism arriving from England until the early nineteenth century (see Chapter 27).

ARCHITECTURE

French architects of the late eighteenth century generally considered classicism not one of many alternative styles but the single, true style. Such architects may be divided into two broad types, which we might call the traditionalists and the radical visionaries.

Representative of the traditionalists are Jacques-Germain Soufflot (1713-80) and his major accomplishment, the Church of Sainte-Geneviève (fig. 26-40), known today as the Panthéon. In this building, Soufflot attempted to integrate three traditions: the kind of Roman architecture he had seen on his trip to Italy in 1749; French and English Baroque classicism; and the Palladian style being revived at the time in England. The facade, with its huge **portico**, is modeled directly on ancient Roman temples. The dome, on the other hand, was inspired by several seventeenth-century examples, including Wren's Saint Paul's in London (see fig. 19-70). Finally, the radical geometry of its plan (fig. 26-41), a **central-plan** Greek cross, owes as much to Burlington's Chiswick House (see fig. 26-22) as it does to Christian tradition. Soufflot also seems to have been

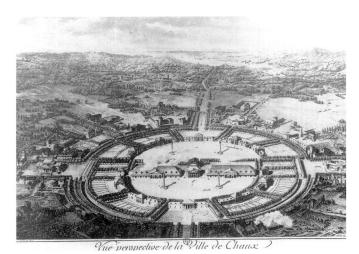

26-42. Claude-Nicolas Ledoux. Bird's-eye view of the town of Chaux (never built). Engraving, published 1804.

inspired by the plain, undecorated surfaces Burlington used in his home. The result is a building that attempts to maintain and develop the historical continuity of the classical tradition.

In the hands of the visionaries, however, classicism was stripped of its associations with the past and was remade as a vehicle of utopian Enlightenment aspirations—as can be seen in the mature work of Claude-Nicolas Ledoux (1736–1806). Early in his architectural career, Ledoux designed austere Neoclassical residences for the court of Louis XV and his last important mistress, Madame du Barry. During the 1770s and 1780s, inspired by the Enlightenment and supported by progressive government ministers, Ledoux turned his attention to town planning.

Ledoux's geometric plan for the city center of Chaux in southeastern France (fig. 26-42), which was never realized, organized a number of large private homes, a school, a church, an army barracks, two public baths, and various businesses around the city's two saltworks factories and their administrative headquarters, which occupy the very center. The different functions of the buildings are impossible to discern because all are in the same style—a stripped-down classicism. The applied decorations that to Ledoux indicated superfluous wealth were eliminated in favor of a more economical and egalitarian style. The plan indicates not only Ledoux's hopes for an orderly, homogenous, and rational future but also his assumption that industry-not the surrounding farms or the peripheral institutions of Church and State-would provide the foundation for that better future.

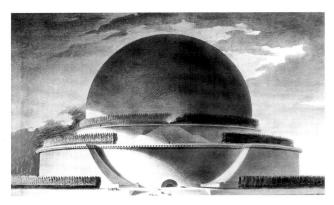

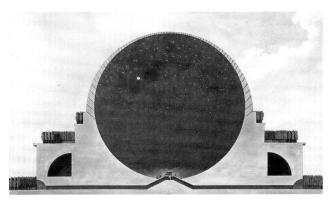

26-43. Étienne-Louis Boullée. Exterior and cross section of the cenotaph for Isaac Newton (never built). 1784. Ink and wash drawings, $15\frac{1}{2} \times 25\frac{1}{2}$ " (39.4 × 64.8 cm). Bibliothèque Nationale, Paris.

Another French architect known for his visionary projects was Étienne-Louis Boullée (1728-99), whose built work consisted mostly of homes for French aristocrats in a plain, simple brand of Neoclassicism. In 1782, he retired from private practice to devote himself to teaching, writing architectural theory, and designing visionary public buildings. Grandiose projects such as the cenotaph (funerary monument) for Isaac Newton (fig. 26-43) were never meant to be built but rather were intended to illustrate and extend the influence of Boullée's theoretical ideas. By this point, Boullée had decided that copying and adapting classical designs were insufficient; architects needed to go beyond them in the use of the pure, geometric forms of nature. Although his monument for the great English scientist who had died in 1727 was inspired by round Roman tombs that were stepped and planted with trees, Boullée used a formal vocabulary of simple spheres instead of the classical orders. Appropriately, the monument was meant to suggest a planet set within a series of circular orbits.

Although the project was eminently rational—and was meant to be read as such—its chief function was to appeal to the emotions. Boullée believed that architec-

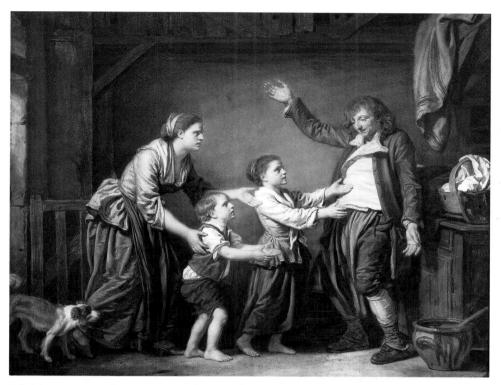

26-44. Jean-Baptiste Greuze. *The Drunken Cobbler.* Late 1770s. Oil on canvas, $29^5/_8 \times 36^3/_8$ " (75.2 \times 92.4 cm). Portland Art Museum, Portland, Oregon. Gift of Marion Bowles Hollis

In 1769, Greuze submitted a classical history painting to the Salon and requested the French Academy to change his official status from genre painter to the higher rank of history painter. The work and request were refused. Greuze was so angry that he thereafter boycotted the Salon, preferring to show his works privately.

ture should be "poetic," by which he meant that it should engender feelings appropriate to the building's purpose. Here the desired effect is **sublime**, an awesome, nearly terrifying experience of the infinite described in Edmund Burke's influential essay of 1757, A Philosophical Enquiry into the Origin of Our Ideas of the Sublime and the Beautiful. Entering the cenotaph and discovering a monumental space—empty except for a small sarcophagus at lower center—would produce such an effect. The only light would come from small holes in the ceiling, meant to suggest stars in a night sky. Boullée wished the viewer to experience the overwhelming majesty not simply of the universe but also of the Supreme Being who had designed it.

PAINTING AND SCULPTURE

While French painters such as Boucher, Fragonard, and their followers continued to work in the Rococo style in the later decades of the eighteenth century, a strong reaction against the Rococo had set in by the 1760s. A leading detractor of the Rococo was Denis Diderot (1713–84), an Enlightenment figure whom many consider the father of modern art criticism. Diderot's most notable accomplishment was editing the *Encyclopédie* (1751–72), a twenty-eight-volume compendium of knowledge and opinion to which many of the major Enlightenment thinkers contributed. In 1759, Diderot began to write reviews of the

official Salon for a periodic newsletter for wealthy subscribers. Diderot believed that it was art's proper function to "inspire virtue and purify manners." He therefore admired artists such as Chardin (see fig. 26-12) and criticized the adherents of the Rococo.

Diderot's highest praise went to Jean-Baptiste Greuze (1725-1805)—which is hardly surprising, because Greuze's major source of inspiration came from the kind of middle-class drama that Diderot had inaugurated with his plays of the late 1750s. In addition to comedy and tragedy, Diderot thought the range of theatrical works should include a "middle tragedy" that taught useful lessons to the public with clear, simple stories of ordinary life. Greuze's paintings, such as The Drunken Cobbler (fig. 26-44), of the late 1770s, became the visual counterparts of that new theatrical form, which later became known as melodrama. On a shallow, stagelike space and under a dramatic spotlight, a drunken father returns home to his angry wife and hungry children. The gestures of the children make clear that he has spent the family's grocery money on drink. In other paintings, Greuze offered wives and children similar lessons in how not to behave.

In sculpture, the first signs of the new Enlightenment values were evident in the art of those still working in the basic Rococo idiom. The leading sculptor in France during the middle of the century was

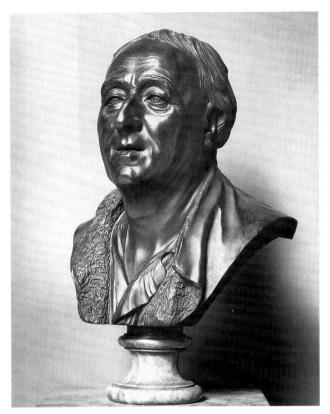

26-45. Jean-Baptiste Pigalle. *Portrait of Diderot.* 1777. Bronze, height $16^{1}/_{2}$ " (42 cm). Museé du Louvre, Paris.

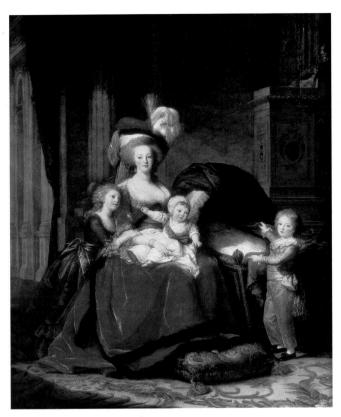

26-46. Marie-Louise-Élisabeth Vigée-Lebrun. *Portrait of Marie Antoinette with Her Children.* 1787. Oil on canvas, $9'^{1}/_{2}'' \times 7'^{5}/_{8}''$ (2.75 × 2.15 m). Musée National du Château de Versailles.

As the favorite painter to the queen, Vigée-Lebrun escaped from Paris with her daughter on the eve of the Revolution of 1789 and fled to Rome. After a very successful self-exile working in Italy, Austria, Russia, and England, the artist finally resettled in Paris in 1805 and again became popular with Parisian art patrons. Over her long career, she painted about 800 portraits in a vibrant style that changed very little over the decades.

Jean-Baptiste Pigalle (1714–85), who received commissions from the most prestigious clients, including Madame de Pompadour. In 1777, he produced a portrait bust of Diderot (fig. 26-45). The casual dress and pose are typically Rococo, although charm has here been sacrificed for intelligence. The thoughtful, faraway look in Diderot's face suggests he may be contemplating the better future he and his fellow philosophes imagined for humanity. Finally, the naturalism in Pigalle's handling of Diderot's aging features nicely underscores the sitter's own commitment to truth.

French portrait painting before the Revolution of 1789 may be characterized as a modified form of the Rococo. Elegant informality continued to be featured, but new themes were introduced, figures tended to be larger and more robust, and compositional arrangements were more stable. Many leading portraitists were women. The most famous was Marie-Louise-Élisabeth Vigée-Lebrun (1755–1842), who in the 1780s became Queen Marie-Antoinette's favorite painter. In 1787, she portrayed the queen with her children (fig. 26-46), in

conformity with the Enlightenment theme of the "good mother," already seen in Angelica Kauffmann's painting of Cornelia (see fig. 26-36). The portrait of the queen as a kindly, stabilizing presence for her offspring was meant to counter her public image as selfish, extravagant, and immoral. The princess leans affectionately against her mother, proof of the queen's natural goodness. In a further attempt to gain the viewer's sympathy, the little dauphin—the eldest son and heir to a throne he would never ascend—points to the empty cradle of a recently deceased sibling. The image also alludes to the well-known allegory of Abundance, suggesting the peace and prosperity of society under the reign of her husband, Louis XVI (ruled 1774–92).

In 1783, Vigée-Lebrun was elected to one of the four places in the French Academy available to women (see "Women and Academies," page 910). Also elected that year was Adélaïde Labille-Guiard (1749–1803), who in 1790 successfully petitioned to end the restriction on women. Labille-Guiard's commitment to increasing the number of women painters in France is

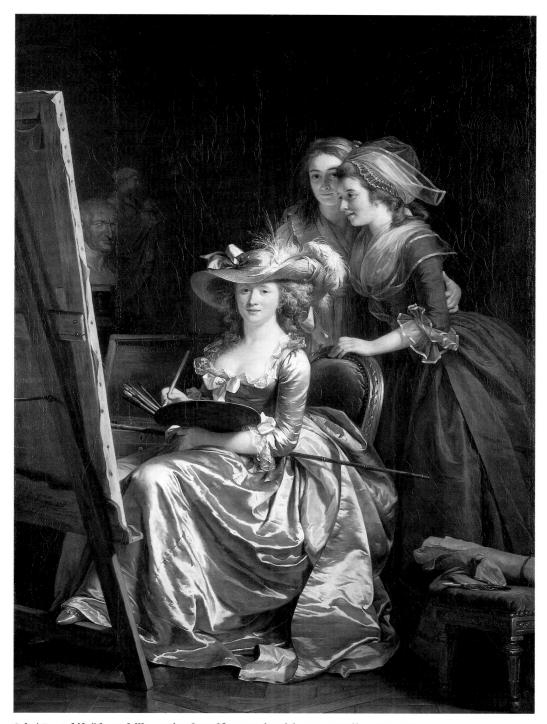

26-47. Adélaïde Labille-Guiard. *Self-Portrait with Two Pupils.* 1785. Oil on canvas, $6'11'' \times 4'11^1/2''$ (2.11 \times 1.51 m). The Metropolitan Museum of Art, New York. Gift of Julia A. Berwind, 1953 (53.225.5)

evident in a self-portrait with two pupils that she submitted to the Salon of 1785. The monumental image of the artist at her easel (fig. 26-47) was also meant to answer the sexist rumors that her paintings and those by Vigée-Lebrun had actually been painted by men. In a witty role reversal, the only male in her work is *her* muse—her father, whose bust is behind her. While the self-portrait flatters the painter's conventional feminine

charms in a manner generally consistent with the Rococo tradition, a comparison with similar images of women by artists such as Fragonard (see fig. 26-13) reveals the more monumental female type Labille-Guiard favored, in keeping with her conception of women as important contributors to national life, which is an Enlightenment impulse. The solid pyramidal arrangement of the three women adds to the effect.

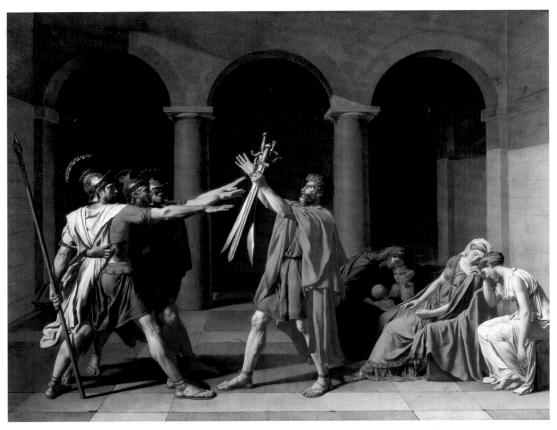

26-48. Jacques-Louis David. *Oath of the Horatii.* 1784–85. Oil on canvas, $10'8^{1}/_{4}'' \times 14'$ (3.26 \times 4.27 m). Musée du Louvre, Paris.

The leading French Neoclassical painter of the era was Jacques-Louis David (1748–1825), who dominated French art during the Revolution and subsequent reign of Napoleon (see Chapter 27). In 1774, David won the Prix de Rome. David remained in Rome until 1780, assimilating the principles of Neoclassicism. After his return, he produced a series of severely undecorated, anti-Rococo paintings that extolled the antique virtues of stoicism, masculinity, and patriotism.

The first and most influential of these was the *Oath of the Horatii* (fig. 26-48), of 1784–85, which was a royal commission. In general, the work reflects the taste and values of Louis XVI, who along with his minister of the arts, Count d'Angiviller, was sympathetic to the Enlightenment. Following Diderot's lead, d'Angiviller and the king believed art should improve public morals. Among his first official acts, d'Angiviller banned indecent nudity from the Salon of 1775 and commissioned a series of didactic paintings of French history. David's commission in 1784 was part of that general program.

David's painting was inspired by Pierre Corneille's seventeenth-century drama *Horace*, although the specific incident David records seems to have been his own invention. The story deals with the early Republican period of Roman history. Rome and Alba, a neighboring city-

state, had been at war for some time when it was decided to settle the conflict by a battle to the death between the three best soldiers of each side. The three sons of Horace (the Horatii) were chosen to represent Rome against the Curatii, representing Alba. In David's painting, the Horatii are shown with their father, pledging an oath to the State. In contrast to the upright, muscular angularity of the men is a group of limp and weeping women and frightened children. The women are upset not simply because the Horatii might die but also because one of them (Sabina, in the center) is a sister of the Curatii, married to one of the Horatii, and another (Camilla, at the far right) is engaged to one of the Curatii. David's composition effectively contrasts the men's stoic willingness to sacrifice themselves for the State with the women's emotional commitment to family ties.

David's *Oath* soon became an emblem of the French Revolution of 1789. Its harsh lesson in republican citizenship effectively captured the mood of the new leaders of the French state who came to power in 1793—especially the Jacobins, egalitarian democrats who abolished the monarchy and presided over the Reign of Terror in 1793–94. Under the leadership of Robespierre (1758–94), the Jacobin-dominated French Assembly ruthlessly executed all opponents, aristocratic

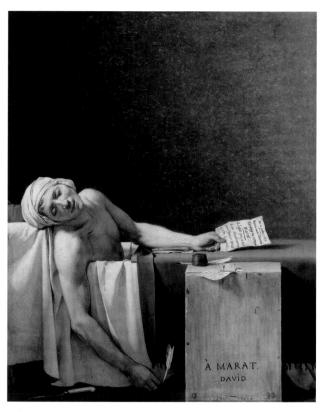

26-49. Jacques-Louis David. *Death of Marat.* 1793. Oil on canvas, $5'5'' \times 4'2^{1}/2''$ (1.65 \times 1.28 m). Musées Royaux des Beaux-Arts de Belgique, Brussels.

In 1793, David was elected a deputy to the National Convention and was named propaganda minister and director of public festivals. Because he supported Robespierre and the Reign of Terror, he was twice imprisoned after its demise in 1794, albeit under lenient circumstances that allowed him to continue painting.

In 1793, the Jacobins commissioned from David a tribute to one of their slain leaders, Jean-Paul Marat (fig. 26-49). A radical pamphleteer, Marat was partly responsible for the 1792 riots in which hundreds of helpless political prisoners deemed sympathetic to the king were killed. A young supporter of the opposition party, Charlotte Corday d'Amont, decided that Marat should pay for his actions. Because Marat suffered from a painful skin ailment, he conducted his official business sitting in a medicinal bath. While Marat was signing a petition Corday had brought as a ruse to gain entry to his office, she stabbed him, then dropped her knife and fled. Instead of handling the event in a sensational manner as a Romantic might have, David played down the drama and showed us its quiet, still aftermath. Here David combined his reductive Neoclassical style with a Caravaggesque naturalism. Both stylistically and thematically, the Death of Marat is, in fact, quite similar to Spanish Baroque religious paintings such as Zurbarán's Saint Serapion (see fig. 19-34). The two peaceful martyrs are descriptively convincing and are brought close to the picture plane to make their respective sacrifices tangibly real and accessible for their disciples.

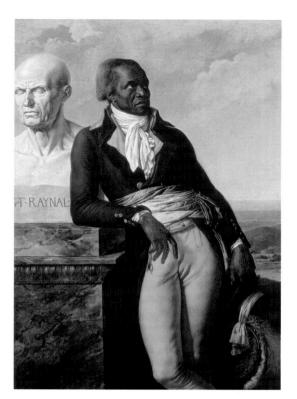

26-50. Anne-Louis Girodet-Trioson. *Portrait of Jean-Baptiste Belley*. 1797. Oil on canvas, $5'2^{1}/_{2}" \times 3'8^{1}/_{2}" (1.59 \times 1.13 \text{ m})$. Musée National du Château de Versailles.

An influential teacher, David trained many of the important French painters who emerged in the 1790s and early 1800s. The lessons of David's teaching are evident, for example, in the Portrait of Jean-Baptiste Belley (fig. 26-50) by Anne-Louis Girodet-Trioson (1767-1824). Although Girodet also painted mythological subjects in a mode derived from Canova (see fig. 26-21), which annoyed his teacher, this noncommissioned portrait is in keeping with David's early stylistic and thematic principles. Stylistically, the work combines a graceful sculptural pose with the kind of simplicity and descriptive naturalism found in David's Marat. The work also has a significant political dimension. Belley was a former slave sent by the colony of Saint-Dominique (now Haiti) as a representative to the French Republican Assembly. In 1794, he led the successful legislative campaign to abolish slavery in the colonies and grant black people full citizenship. Belley leans casually on a pedestal with the bust of the abbot Guillaume Raynal (1713-96), the French philosophe whose 1770 book condemning slavery had prepared the way for such legislation. (Unfortunately, in 1801 Napoleon reestablished slavery in the islands.) Girodet's portrait is therefore more of a tribute to the egalitarian principles of Raynal and Belley than it is a conventional portrait meant to flatter a sitter.

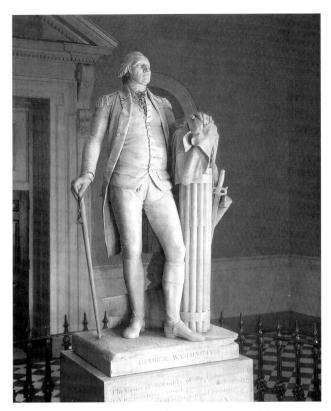

26-51. Jean-Antoine Houdon. George Washington. 1788-92. Marble, height 6'2" (1.9 m). State Capitol, Richmond, Virginia.

The plow behind Washington alludes to Cincinnatus, a Roman soldier of the fifth century BCE who was appointed dictator and dispatched to defeat the Aequi, who had besieged a Roman army. After the victory, Cincinnatus resigned the dictatorship and returned to his farm. Washington's contemporaries compared him to Cincinnatus because, after leading the Americans to victory over the British, he resigned his commission and went back to farming rather than seeking political power. Just below Washington's waistcoat hangs the badge of the Society of the Cincinnati, founded in 1783 by the officers of the disbanding Continental Army who were returning to their peacetime occupations. Washington lived in retirement at his Mount Vernon, Virginia, plantation for five years before his 1789 election as the first president of the United States.

Portraiture was the specialty of the leading Neoclassical French sculptor, Jean-Antoine Houdon (1741-1828), who had studied with Pigalle. Houdon lived in Italy between 1764 and 1768 after winning the Prix de Rome. Houdon's commitment to Neoclassicism began during his stay in Rome, where he came into contact with some of the leading artists and theorists of the movement. Houdon carved busts and full-length statues of many important figures of his era, including foreigners. On the basis of his bust of the American ambassador to France, Benjamin Franklin, Houdon was commissioned by the Virginia state legislature to do a portrait of its native son George Washington. Houdon traveled to the United States in 1785 to make a cast of Washington's features and a bust in plaster. He then executed a lifesize marble figure in Paris (fig. 26-51). For this work, Houdon combined Pigalle's naturalism with the new classicism that many were beginning to identify with republican politics. Although the military leader of the American Revolution of 1776 is dressed in his general's uniform, Washington's serene expression and relaxed contrapposto pose derive from sculpted images of classical athletes. Washington's left hand rests on a fasces, a bundle of rods tied together with an axe face, used in Roman times as a symbol of authority. The thirteen rods bound together are also a reference to the union formed by the original states. Attached to the fasces are a sword of war and a plowshare of peace. Houdon's studio turned out a regular supply of replicas of such works as part of the cult of great men promoted by Enlightenment thinkers as models for all humanity.

NORTH

ART IN Eighteenth-century art by the white inhabitants of North America remained largely dependent on the AMERICA styles of the European countries— Britain, France, and Spain-that had

colonized the continent. Throughout the century, easier and more frequent travel across the Atlantic contributed to the assimilation of the European styles, but in general North American art lagged behind the European mainstream. In the early eighteenth century, the colonies grew rapidly in population, and rising prosperity led to an increased demand among the wealthy for fine works of art and architecture. Initially this demand was met by European immigrants who came to work in the colonies, but by the middle of the century a number of native-born American artists were also achieving professional success.

ARCHITECTURE

The Palladian style, introduced to England by Inigo Jones in the seventeenth century (see fig. 19-68), continued to be popular in England and came to the British North American colonies in the mid-eighteenth century. One of the earliest examples, the work of English-born architect Peter Harrison (1716-75), is the Redwood Library (fig. 26-52), built in Newport, Rhode Island, in 1749. The fusion of the temple front with a colossal Doric order and a lower facade with a triangular pediment is not only typically Palladian (see fig. 18-63); it is, in fact, a faithful replica of a design by Palladio in his Four Books on Architecture. The elegant simplicity of this particular design made it a favorite of English architects for small pleasure buildings on the grounds of estates. The double temple front, used by Palladio for churches, is perfectly suited to a library.

During the Federal Period (1783–1830) following the colonies' victory in their War of Independence, Neoclassicism dominated American architecture. Despite the recent hostilities with Britain, American domestic architecture remained tied to developments in that country. With regard to interior design, the elegant Neoclassicism that Robert Adam had introduced to British

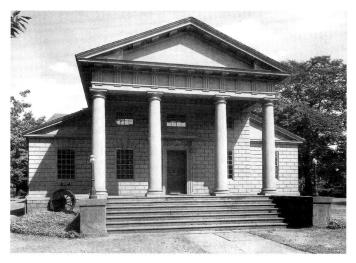

26-52. Peter Harrison. Redwood Library, Newport, Rhode Island. 1749.

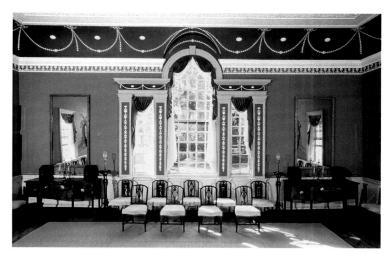

26-53. John Rawlins. Large dining room, Mount Vernon, Fairfax County, Virginia. 1786–87.

society in the 1760s (see fig. 26-28) became the model for American designers such as John Rawlins. In 1786–87, he designed the large dining room at George Washington's home, Mount Vernon (fig. 26-53). As Adam himself had often done, Rawlins set delicate off-white **beadwork** against a soft, monochromatic ground. Beneath a simple, classical cornice is the main decorative feature of the room, a Palladian window, consisting of a tall central window capped by a round arch and flanked by two shorter, rectangular windows. The overall effect is restrained, elegant, and restful.

Thomas Jefferson (1743–1826), principal author of the Declaration of Independence, designed his Virginia residence, Monticello, in a style much influenced by British examples. Jefferson was a self-taught architect who in the period before the American Revolution shared the British aristocratic taste for Palladio. His first version of Monticello, built in the 1770s, was, like Harrison's early Redwood Library, based on a design in Palladio's *Four Books on Architecture*, reminiscent of his Villa Rotunda (see fig. 18-63).

In 1784, Jefferson went to Paris and the next year became the American minister to France. There he discovered an elegant domestic architecture that made his home seem crude and provincial. After he returned in 1789 he completely redesigned Monticello, using

IRON AS A BUILDING MATERIAL

In 1779, Abraham Darby III built a bridge over the Severn River at Coalbrookdale in England—a town typical of the new industrial environment, with factories and workers' housing filling the valley. The bridge itself is important because it represents the first use of structural metal on a large scale, with iron replacing the heavy, hand-cut stone voussoirs used to construct earlier bridges. Five pairs of cast-iron, semicircular arches form a strong, economical hundred-foot span. In functional architecture such as this bridge, the available technology, the properties of the material, and the requirements of engineering in large part determine form and often produce an unintended and revolutionary new aesthetic. Here, the use of metal at last made possible the light, open, skeletal structure desired by builders since the twelfth century. Cast iron was quickly adopted by builders, giving rise to such architectural feats as the soaring train stations of the nineteenth century.

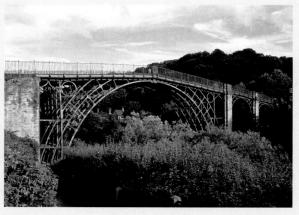

Abraham Darby III. Severn River Bridge, Coalbrookdale, England. 1779.

26-54. Thomas Jefferson. Monticello, Charlottesville, Virginia. 1770-84, 1796-1806.

French doors and tall, narrow windows (fig. 26-54). Attempting to make his home appear to be a single story, in the French manner, he used a balustrade above the unifying cornice to mask the second floor. Despite these French elements and his stated rejection of the British Palladian mode, the building's simplicity and combination of temple front and dome remain closer to Burlington's Chiswick House (see fig. 26-22) than to contemporary French buildings. Compared with Burlington's residence, however, Jefferson's is less pretentious as a result of its humbler building materials (brick, wood, and stucco), its closer relation to the ground, and its smaller scale.

PAINTING

Just as British architects immigrated to the North American colonies before the Revolution, a few traditionally trained European artists crossed the ocean to satisfy the increasingly wealthy market's demand for portrait paintings. Probably the first such artist of stature to arrive was John Smibert (1688–1751), a Scot who had studied in London and spent considerable time in Italy. He came to the colonies in 1728 with one of his patrons, George Berkeley, an Anglican minister and philosopher, to be the art professor at the college Berkeley was planning to

found in Bermuda. In 1729, while Berkeley and his entourage were in Newport, Rhode Island, to complete their arrangements for the project, Smibert painted a group portrait, *Dean George Berkeley and His Family*, commonly called *The Bermuda Group* (fig. 26-55). Berkeley, at the right, dictates to a richly dressed man at the table (John Wainwright, who commissioned the portrait but did not actually make the voyage). Seated between them are Berkeley's wife and child and their companion, a Miss Hancock. Standing behind the table are, from right to left, John James and Richard Dalton, two gentlemen adventurers who accompanied Berkeley, and Smibert himself, who looks out at the viewer.

Smibert's debt to Flemish painting, which was still favored in the English court at the time, is obvious in the balanced but asymmetrical arrangement of figures and the great attention paid to representing textures of the costumes and the pattern of the Oriental rug on the table. The men's features are individualized likenesses, but the women's are idealized according to a convention of female beauty current in English portraiture—ovoid heads with large, plain features, columnlike necks, and tastefully exposed bosoms. The Bermuda project never went forward, and Smibert settled in Boston, working as a portrait painter, art-supply dealer, and printseller.

26-55. John Smibert. *Dean George Berkeley and His Family (The Bermuda Group).* 1729. Oil on canvas, $5'9^1/2'' \times 7'9''$ (1.77 \times 2.4 m). Yale University Art Gallery, New Haven, Connecticut. Gift of Isaac Lathrop of Plymouth, Massachusetts

Among Smibert's friends was Peter Pelham, an English immigrant painter-engraver, who married a Boston widow with a tobacco shop in 1748. Pelham's stepson John Singleton Copley (1738–1815) grew up to be America's first native artist of genius. Copley's sources of inspiration were meager—Smibert's followers and his stepfather's engravings—but his work was already drawing attention when he was fifteen. Young Copley's canny instincts for survival in the colonial art world included an intuitive understanding of his upper-class clientele. They valued not only his excellent technique, which equaled that of European artists, but also his ability to dignify them while recording their features with unflinching realism, as seen in his powerful portrait of *Samuel Adams* (see fig. 26-1).

Copley's talents so outdistanced those of his colonial contemporaries that the artist aspired to a larger reputation. In 1766, he sent a portrait of his half brother, *Boy with a Squirrel*, to an exhibition in London. The critical response was rewarding, and Benjamin West, the expatriate artist from Pennsylvania, encouraged Copley to study in Europe. At that time, family ties kept him from following the advice. But in 1773, revolutionary struggles hit close to home. Colonists dressed as Native Americans boarded a ship carrying tea and threw the cargo into Boston Harbor to protest the British East India

Company's monopoly and the tax imposed on tea by the government—an event known as the Boston Tea Party. Copley was torn between two circles: his affluent inlaws and clients who were pro-British, and his radical friends, including Paul Revere, John Hancock, and Samuel Adams. Reluctant to take sides, Copley sailed in June 1774 for Europe, where he visited London and Paris, then Italy. In 1775, on the eve of the American Revolution, he settled in London, where his family joined him. Copley spent the rest of his life in London and there enjoyed moderate success as a portraitist and painter of modern history.

In 1780, the Connecticut-born John Trumbull (1756–1843) sailed to London to study under Benjamin West. The Harvard-educated son of the revolutionary governor of Connecticut, Trumbull had served as an officer in the War of Independence and had been an aidede-camp to General George Washington. At West's suggestion, and encouraged by Thomas Jefferson, then serving as the American minister to France, Trumbull in 1785 began a series of paintings depicting important events in the Revolutionary War. The first of these was The Death of General Warren at the Battle of Bunker's Hill, June 17, 1775 (fig. 26-56, page 938). Completed in 1786, the canvas was praised by West as "the best picture of a modern battle that has been painted."

26-56. John Trumbull. *The Death of General Warren at the Battle of Bunker's Hill, June 17, 1775.* 1786. Oil on canvas, 25×34 " (63.5 \times 86.4 cm). Yale University Art Gallery; Trumbull Collection.

Trumbull had himself witnessed the smoke and fire of the Battle of Bunker Hill (called Bunker's Hill by the British) through field glasses from across Boston Harbor, where he was then stationed. The famous battle actually took place not on Bunker Hill but on nearby Breed's Hill, above the Charles River north of Boston. In an attempt to prevent the British from fortifying these high positions, the Americans occupied both hills on June 16, 1775. The next day, British troops launched two unsuccessful assaults on Breed's Hill. The third British attack succeeded because the Americans, running out of gunpowder, were forced to retreat. The British gained the hill but lost more than 1,000 men, nearly three times the losses suffered by the Americans.

Trumbull's painting represents the death of the American general Joseph Warren, who, having been shot, collapses into the arms of a comrade. In a noble gesture, the British major John Small attempts to save the dying Warren from being bayonetted by a grenadier. Behind Small, the British major John Pitcairn falls dying into the arms of his son. In the background, the British, led by their generals William Howe and Henry Clinton, storm up the hill from the right, while the Americans, under the command of General Israel Putnam, retreat at the left. In the extreme right foreground, Lieutenant Thomas Grosvenor of Connecticut, wounded in the chest and hand, is shown with his African-American

servant, reacting with shock to General Warren's death.

Like all history paintings, Trumbull's depiction of this Revolutionary War contest is not an accurate record of the event but a dramatization of it, intended to tell the story of the battle and its heroes in an effective and memorable way. While clearly influenced by the example of West's Death of General Wolfe (see fig. 26-37), Trumbull's battle scene conveys a greater sense of excitement and spontaneity. For all of its drama West's composition, influenced by classical art, is relatively static and additive. The dying General Wolfe and his attendants are balanced on either side by groups of mourning figures, ranged horizontally across a stage-like foreground. Trumbull's composition, inspired by Baroque art, is more dynamic and unified. The surging British soldiers and retreating colonial troops move from right to left and far to near in a powerful diagonal, emphasized by the wedge of dark smoke in the sky at the right, the tilting flags in the background, and the sword of Lieutenant Grosvenor. Compared to West's painting, Trumbull's also features looser brushwork, brighter colors, and stronger value contrasts, adding to its greater sense of immediacy.

Trumbull painted *The Death of General Warren* and several other Revolutionary battle pictures on a small scale because they were meant to serve as models for engravings. Following his return to the United States in

1789, Trumbull set out to sell subscriptions for his prints and sought support from his compatriots for a series of nationalistic history paintings on a grand scale. Due to pressing economic and political difficulties in the new republic, however, patronage was not forthcoming. Frustrated, between 1794 and 1800 Trumbull abandoned painting and served as an American diplomat in Europe. He resumed painting in 1800, but only in 1817 did he at last receive from Congress a commission to decorate the Rotunda of the United States Capitol with four large pictures of the American Revolution. *The Death of General Warren*, however, was not among the commissioned subjects, since it showed an American defeat.

Trumbull's *Death of General Warren* recorded an event in one of the political revolutions that complemented the technological and social revolutions of the eighteenth century. The Enlightenment's generally optimistic view that nature was good and that men and women would act to promote the happiness of others and the reformation of social institutions would continue to find artistic expression in the nineteenth century—especially in Neoclassicism. But at the turn of the century, Romanticism gained in force—partly in reaction to Neoclassicism—and the distinction between the two sometimes blurred, paving the way for the strong stream of realism that would arise during the nineteenth century.

27

NINETEENTH-CENTURY ART IN EUROPE AND THE UNITED STATES

E WRITERS, PAINTERS, SCULPTORS, ARCHITECTS, AND DEVOTED lovers of the beauty of Paris . . . do protest with all our strength and all our indignation . . . against the erection, in the very heart of our capital, of the useless and monstrous Eiffel Tower, which public spitefulness . . . has already baptized, 'the Tower of Babel.'" With these words, published in *Le Temps* on February 14, 1887, a group of conservative artists announced their violent opposition to the immense iron tower just beginning to be built on the Seine River. The work of the engineer Gustave Eiffel (1832–1923), the 300-meter (984-foot) tower would upon its completion be the tallest structure in the world, dwarfing even the Egyptian pyramids and Gothic cathedrals.

The Eiffel Tower (fig. 27-1) was to be the main attraction of the 1889 Universal Exposition, one of several large fairs staged in Europe and the United States during the late nineteenth century to showcase the latest international advances in science and industry, while also displaying both fine and applied arts. But because Eiffel's marvel lacked architectural antecedents and did not conceal its construction, detractors saw it as an ugly, overblown work of engineering. For its admirers, however, it achieved a new kind of beauty derived from modern engineering and was an exhilarating symbol of technological innovation and human aspiration. One French poet called it "an iron witness raised by humanity into the azure sky to bear witness to its unwavering determination to reach the heavens and establish itself there." Perhaps more than any other monument, the Eiffel Tower embodies the nineteenth-century belief in the progress and ultimate perfection of civilization through science and technology.

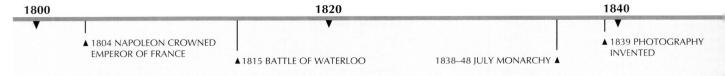

TIMELINE 27-1. The Nineteenth Century in the West. The Industrial Revolution held sway, republics rose from revolutions, and the middle class swelled in numbers and influence.

Map 27-1. Europe and North **America** in the Nineteenth Century. Europe took the lead in industrialization, and France became the cultural beacon of the Western world.

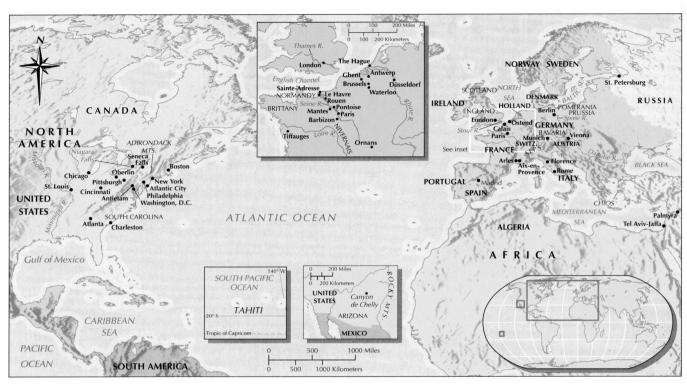

EUROPE AND THE UNITED STATES IN THE NINETEENTH CENTURY

The Enlightenment set in motion powerful forces that would dramatically transform life in Europe and the United States during the nineteenth century. Great

advances in manufacturing, transportation, and communications created new products for consumers and new wealth for entrepreneurs, fueling the rise of urban centers and improving living conditions for many (see Map 27-1). But this so-called Industrial Revolution also condemned masses of workers to poverty and catalyzed new political movements that sought to reform society. Animating these developments was the widespread belief in "progress" and the ultimate perfectibility of human civilization—a belief rooted deeply in Enlightenment thought (Chapter 26).

The Industrial Revolution had begun in the eighteenth century in Britain, where the new coal-fed steam engine ran such innovations in manufacturing as the steam-powered loom. Increasing demands for coal and iron necessitated improvements in mining, metallurgy, and transportation. Subsequent development of the locomotive and steamship in turn facilitated the shipment of raw materials and merchandise, made passenger travel easier, and encouraged the growth of new cities (Timeline 27-1).

Continuing scientific discoveries led to the telegraph, telephone, and radio. By the end of the nineteenth century, electricity powered lighting, motors, trams, and railways in most European and American cities. Developments in chemistry created many new products, such as aspirin, disinfectants, photographic chemicals, and explosives. The new material of steel, an alloy of iron and carbon, was lighter, harder, and more malleable than iron and became the standard in heavy construction and transportation. In medicine and public health, Louis Pasteur's purification of beverages through heat (pasteurization) and the development of vaccines, sterilization, and antisepsis led to a dramatic decline in death rates all over the Western world.

Some scientific discoveries challenged traditional religious beliefs and affected social philosophy. Geologists concluded that the earth was far older than the estimated 6,000 years sometimes claimed for it by biblical literalists. Contrary to the biblical account of creation, Charles Darwin proposed that all life evolved from a common ancestor and changed through genetic mutation and natural selection. Religious conservatives attacked Darwin's account of evolution, which seemed to deny the divine creation of humans and even the existence of God. Some of Darwin's supporters, however, suggested that "survival of the fittest" had advanced the human race, with certain types of people—particularly the Anglo-Saxon upper classes—achieving the pinnacle of social

▲ 1848 REVOLUTION IN FRANCE; MARX AND ENGELS PUBLISH COMMUNIST MANIFESTO; WOMEN'S RIGHT TO VOTE FORMALLY PROPOSED IN U.S.

▲ 1851 LONDON GREAT EXHIBITION

1860

▲ 1861–65 AMERICAN CIVIL WAR

1893 WORLD'S COLUMBIAN ▲ EXPOSITION, CHICAGO

1889 PARIS UNIVERSAL EXPOSITION A

evolution. "Social Darwinism" provided a rationalization for the "natural" existence of a less "evolved" working class and a justification for British and American colonization of "underdeveloped" parts of the world.

The nineteenth century witnessed the rise of imperialism. To create new markets for their products and to secure access to cheap raw materials and cheap labor, European nations established colonies in most of Africa and nearly a third of Asia, and the United States did so in the Pacific. Colonial rule brought technological improvements to non-Western countries but also threatened traditional native cultures and suppressed the economic development of the colonized countries.

The availability of inexpensive labor closer to home had been crucial to the development of the Industrial Revolution in Britain. Displaced from their small farms and traditional cottage industries by technological developments in agriculture and manufacturing, the rural poor moved to the new factory and mining towns in search of employment, and industrial laborers-many of them women and children—suffered miserable working and living conditions. Although new government regulations led to improvements during the second half of the nineteenth century, socialist movements condemned the exploitation of laborers by capitalist factory owners and advocated communal or state ownership of the means of production and distribution. The most radical of these movements was communism, which called for the abolition of private property.

Paralleling the attempts to liberate workers were the struggles of feminists to improve the status of women and those of abolitionists to end slavery. In 1848—the same year that Karl Marx and Friedrich Engels published the Communist Manifesto, which predicted the violent overthrow of the bourgeoisie (middle class) by the proletariat (working class) and the creation of a classless society—the Americans Lucretia Mott and Elizabeth Cady Stanton held the country's first women's rights convention, in Seneca Falls, New York. They called for the equality of women and men before the law, property rights for married women, the acceptance of women into institutions of higher education, the admission of women to all trades and professions, equal pay for equal work, and women's suffrage (the right to vote, not fully achieved in the United States until 1920).

Some American suffragists of the mid-nineteenth century were also active in the abolitionist movement. Slavery in the United States was finally eliminated as a result of the devastating Civil War (1861–65), which claimed more American lives than all other wars in history combined. After the Civil War, the United States became a major industrial power, and the American northeast underwent rapid urbanization, fueled by millions of immigrants from Europe seeking economic opportunities.

EARLY-NINETEENTH-CENTURY ART: NEOCLASSICISM AND ROMANTICISM

For centuries, the major sources of artistic patronage in Europe had been Church leaders and secular nobility, but as the power of both the Church and the Crown declined in the nineteenth century, so did their influence over artistic production. In their place, the capitalist bourgeoisie, nations, and national academies became major patrons of the arts. Large annual exhibitions in European and American cultural centers took on increasing importance as a means for artists to show their work, win prizes, attract buyers, and gain commissions. Art criticism proliferated in mass-printed periodicals, helping both to make and to break artistic careers. And, in the later decades of the century, commercial art dealers gained in importance as marketers of both old and new art.

Neoclassicism and Romanticism Chapter 26) remained vital in early-nineteenth-century European and American art. Neoclassicism survived past the middle of the century in both architecture and sculpture. Romanticism took a variety of forms in the early decades. Many Romantic paintings and sculptures featured dramatic and intensely emotional subject matter drawn from literature, history, or the artist's own imagination. Some Romantic artists, however, painted humble images of the rural landscape infused with religious feeling. In architecture, Romanticism took the form of revivals of historical styles that expressed, among other things, an escapist fascination with other times and places.

LATE-NINETEENTH-CENTURY ART: REALISM AND ANTIREALISM

The second half of the nineteenth century has been called the positivist age, an age of faith in the positive consequences of close observation of the natural and human realms. The term *positivism* was used by the French philosopher Auguste Comte (1798–1857) during the 1830s to describe what he saw as the final stage in the development of philosophy, in which all knowledge would derive from the objectivity of science and scientific methods. In the second half of the century, the term *positivism* came to be applied widely to any expression of the new emphasis on objectivity.

In the visual arts the positivist spirit may be most obvious in the widespread rejection of Romanticism in favor of the accurate and apparently objective description of the ordinary, observable world. Positivist thinking is evident not simply in the growth of naturalism but also in the full range of artistic developments of the period after 1850—from the development of photography, capable of recording nature with unprecedented accuracy, to the highly descriptive style of academic art, to

27-2. Jacques-Louis David. Napoleon Crossing the Saint-Bernard. 1800-01.

Oil on canvas, $8'11'' \times 7'7''$ (2.7 × 2.3 m). Musée National du Château de la Malmaison. Rueil-Malmaison

David flattered Napoleon by reminding the viewer of two other great generals from history who had accomplished this difficult feat—Charlemagne and Hannibal—by etching the names of all three in the rock in the lower left.

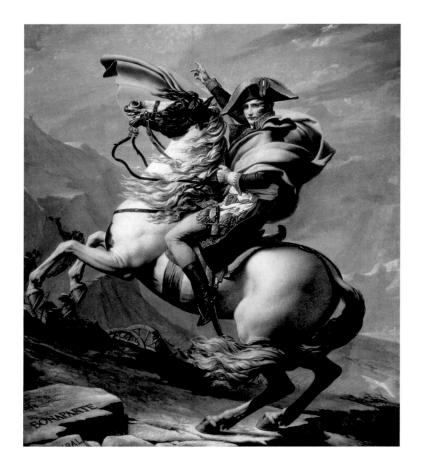

Impressionism's quasi-scientific emphasis on the optical properties of light and color. In architecture, the application of new technologies also led gradually to the abandonment of historical styles and ornamentation in favor of a more direct or "realistic" expression of structure and materials.

The late-nineteenth-century emphasis on realism did not go unchallenged, however. In the 1880s and 1890s a number of artists in both Europe and the United States rejected realistic styles, paving the way for the radically new nonrepresentational art forms that emerged shortly before World War I. Many of these artists used antirealist styles to express their personal feelings about their subjects or to evoke states of mystery or spirituality. Like the Romantic artists before them, they shunned the depiction of ordinary, modern life in favor of exploring artistically the realms of myth, fantasy, and imagination.

AND

NEOCLASSICISM The undisputed capital of the nineteenth- century Western art world was **ROMANTICISM** Paris. The Paris École des IN FRANCE Beaux-Arts attracted students from all over Europe

and the United States, as did the ateliers (studios) of Parisian academic artists who offered private instruction. Virtually every ambitious nineteenth-century European artist, and many Americans, aimed to exhibit in the Paris Salon, to receive positive reviews from the Parisian critics, and to find favor with the French artbuying public.

Conservative juries controlled the Salon exhibitions, however, and from the 1830s onward they routinely rejected paintings and sculpture that did not conform to the academic standards of slick technique, mildly idealized subject matter, and engaging, anecdotal story lines. As the century wore on, progressive and independent artists ceased submitting to the Salon and organized private exhibitions to present their work directly to the public without the intervention of a jury. The most famous of these was the first exhibition of the Impressionists, held in Paris in 1874 (see page 979). The institution of the Salon itself was democratized in 1884 with the inauguration of the Salon des Indépendants, which had no jury and awarded no prizes.

Audacious participants in such exhibitions came to think of themselves as enemies of convention and institutional authority—as pioneers of artistic expression every bit as revolutionary as the contemporary developments in science, technology, industry, and politics. Such artists, dedicated to radical artistic innovation, assumed the title of avant-garde, or vanguard, a term that in its original military usage denoted the foremost position of an advancing army.

DAVID AND HIS STUDENTS

Following Napoleon's rise to power in 1799, Jacques-Louis David (1748-1825), previously an ardent republican (see Chapter 26), switched his allegiance to the new dictator. David's new artistic task, the glorification of Napoleon, appeared in an early, idealized account of Napoleon leading his troops across the Alps into Italy in 1800 (fig. 27-2). Napoleon—who actually made the

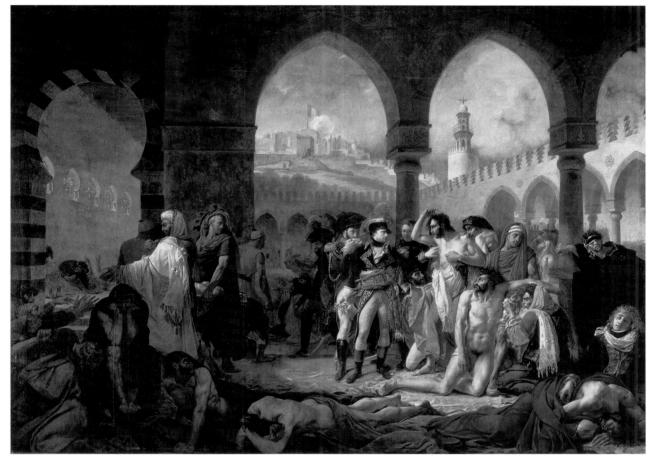

27-3. Antoine-Jean Gros. *Napoleon in the Plague House at Jaffa*. 1804. Oil on canvas, $17'5'' \times 23'7''$ (5.32 \times 7.2 m). Musée du Louvre, Paris.

crossing on a donkey—is shown calmly astride a rearing horse, exhorting us to follow him. His windblown cloak, an extension of his arm, suggests that Napoleon directs the winds as well. While Neoclassical in the firmness of its drawing, the work also takes stylistic inspiration from the Baroque—for example, in the dramatic diagonal **composition** used instead of the classical pyramid of the *Oath of the Horatii* (see fig. 26-48). When Napoleon fell from power in 1814, David moved to Brussels, where he died in 1825.

Antoine-Jean Gros (1771-1835), who began to work in David's studio as a teenager, eventually vied with his master for commissions from Napoleon. Gros also introduced elements of Romanticism into his work that proved influential for younger artists. Gros traveled with Napoleon in Italy in 1797 and later became an official chronicler of Napoleon's military campaigns. Gros's Napoleon in the Plague House at Jaffa (fig. 27-3) is an idealized account of an actual incident: During Napoleon's campaign against the Ottoman Turks in 1799, bubonic plague broke out among his troops. Napoleon decided to quiet the fears of the healthy by visiting the sick and dying, who were housed in a converted mosque in the Palestinian town of Jaffa (Palestine was then part of the Ottoman Empire). The format of the painting—a shallow stage and a series of arcades behind the main actors—is inspired by David's *Oath of the Horatii*. The overall effect is Romantic, however, not simply because of the dramatic lighting and the wealth of emotionally stimulating elements, both exotic and horrific, but also because the main action is meant to incite veneration, not republican virtue. At the center of a small group of soldiers and a doctor, Napoleon calmly reaches toward the sores of one of the victims, the image of a Christ-like figure healing the sick with his touch, consciously intended to promote him as semidivine. Not surprisingly, Gros gives no hint of the event's cruel historical aftermath: Two months later, Napoleon ordered the remaining sick to be poisoned.

Jean-Auguste-Dominique Ingres (1780–1867) thoroughly absorbed his teacher David's Neoclassical vision but reinterpreted it in a new manner. Inspired by Raphael rather than by antique art, Ingres emulated the Renaissance artist's precise drawing, formal **idealization**, classical composition, and graceful lyricism. Ingres won the **Prix de Rome** and lived in Italy from 1806 to 1824, returning to serve as director of the French Academy in Rome from 1835 to 1841. As a teacher and theorist, Ingres became the most influential artist of his time.

Although Ingres, like David, fervently desired acceptance as a history painter, his paintings of literary

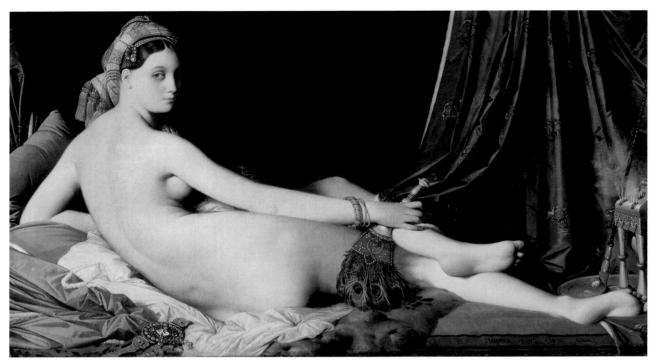

27-4. Jean-Auguste-Dominique Ingres. *Large Odalisque.* 1814. Oil on canvas, approx. 35×64 " (88.9 \times 162.5 cm). Musée du Louvre, Paris.

During Napoleon's campaigns against the British in North Africa, the French discovered the exotic Near East. Upper-middle-class European men were particularly attracted to the institution of the harem, partly as a reaction against the egalitarian demands of women of their class that had been unleashed by the French Revolution.

subjects and contemporary history were less successful than his erotically charged portraits of women and female nudes, especially his numerous representations of the **odalisque**, a female slave or concubine in a sultan's harem. In Large Odalisque (fig. 27-4), the cool gaze this odalisque levels at her master, while turning her naked body away from what we assume is his gaze, makes her simultaneously erotic and aloof. The cool blues of the couch and the curtain at the right heighten the effect of the woman's warm skin, while the tight angularity of the crumpled sheets accentuates the languid, sensual contours of her form. Although Ingres's commitment to fluid line and elegant postures was grounded in his Neoclassical training, he treated a number of Romantic themes, such as the odalisque, in a highly personal, almost Mannerist fashion. Here the elongation of the woman's back (she seems to have several extra vertebrae), the widening of her hip, and her tiny, boneless feet are anatomically incorrect but aesthetically compelling.

Although Ingres complained that making portraits was a "considerable waste of time," he was unparalleled in rendering a physical likeness and the material qualities of clothing, hairstyles, and jewelry. In addition to polished lifesize oil portraits, Ingres produced—usually in just a day—small portrait drawings that are extraordinarily fresh and lively. The exquisite *Portrait of Madame Desiré Raoul-Rochette* (fig. 27-5) is a flattering yet credible interpretation of the relaxed and elegant sitter. With her gloved right hand Madame Raoul-

Rochette has removed her left-hand glove, simultaneously drawing attention to her social status (gloves traditionally were worn by members of the European upper class, who did not work with their hands) and her marital status (on her left hand is a wedding band). Her shiny taffeta dress, with its fashionably high waist and puffed sleeves, is rendered with deft yet light strokes that suggest more than they describe. Greater emphasis is given to her refined face and elaborate coiffure, which Ingres has drawn precisely and modeled subtly through light and shade.

ROMANTIC PAINTING

Romanticism, already anticipated in French painting during Napoleon's reign, flowered during the royal restoration that lasted from 1818 to 1848, although it did not gain wide public acceptance until after 1830. French Romantic artists not only drew upon literary sources but also added the new dimension of social criticism. In general, Romantic painting featured loose, fluid brushwork, strong colors, complex compositions, powerful contrasts of light and dark, and expressive poses and gestures—all suggesting a revival of the more dramatic aspects of the Baroque.

Théodore Géricault (1791–1824) began his career painting Napoleonic military themes in a manner inspired by Gros. After a brief stay in 1816–17 in Rome, where he discovered Michelangelo, Géricault returned to Paris determined to paint a great contemporary history

27-5. Jean-Auguste-Dominique Ingres. *Portrait of Madame Desiré Raoul-Rochette.* 1830. Graphite on paper, $12^{5}/_{8} \times 9^{1}/_{2}$ " (32.2 \times 24.1 cm). The Cleveland Museum of Art. Purchase from the J. H. Wade Fund (1927.437)

Madame Raoul-Rochette (1790–1878), née Antoinette-Claude Houdon, was the youngest daughter of the famous Neoclassical sculptor Jean-Antoine Houdon (see fig. 26-51). In 1810, at the age of twenty, she married Desiré Raoul-Rochette, a noted archaeologist, who later became the secretary of the Academy of Fine Arts and a close friend of Ingres. Ingres's drawing of Madame Rochette is inscribed to her husband, whose portrait Ingres also drew around the same time.

painting. He chose for his subject the scandalous and sensational shipwreck of the *Medusa* (figs. 27-6, 27-7, 27-8, 27-9, "The Object Speaks", pages 948-49). In 1816, the ship of French colonists headed for Senegal ran aground near its destination; its captain was an incompetent aristocrat appointed by the newly restored monarchy for political reasons. Because there were insufficient lifeboats, a raft was hastily built for 152 of the passengers and crew, while the captain and his officers took the seaworthy boats. Too heavy to pull to shore, the raft was set adrift. When it was found thirteen days later, only fifteen people remained alive, having survived their

last several days on human flesh. Géricault chose to depict the moment when the survivors first spot their rescue ship.

At the Salon of 1819, Géricault showed his painting under the neutral title *A Shipwreck Scene*, perhaps to downplay its politically inflammatory aspects and to encourage appreciation of its larger philosophical theme—the eternal and tragic struggle of humanity against the elements. Most contemporary French critics interpreted the painting as political commentary, however, with liberals praising it and royalists condemning it. Because the monarchy refused to buy the canvas, Géricault

THE OBJECT SPEAKS

RAFT OF THE "MEDUSA"

héodore Géricault's monumental history painting Raft of the "Medusa" (fig. 27-6) speaks powerfully through its composition, in which the victims' largely nude, muscular bodies are organized on crossed diagonals. The diagonal beginning in the lower left and extending to the waving figures registers their rising hopes. The diagonal that begins with the dead man in the lower right and extends through the mast and billowing sail, however, directs our attention to a huge wave. The rescue of the men is not yet assured. They remain tensely suspended between salvation and death. Significantly, the "hopeful" diagonal in Géricault's painting terminates in the vigorous figure of a black man, a survivor named Jean Charles, and may carry political meaning. By placing him at the top of the pyramid of survivors and giving him the power to save his comrades by signaling to the rescue ship, Géricault suggests metaphorically that freedom for all of humanity will only occur when the most oppressed member of society is emancipated.

Typical of history paintings of the day, Géricault's work was the culmination of extensive study and experimentation. An early pen drawing (fig. 27-7) depicts the survivors' hopeful response to the appearance of the ship on the horizon at the extreme left. Their excitement is set in relief by the mournful scene of a man grieving over a dead youth on the right side of the raft. A later pen-and-wash drawing (fig. 27-8) reverses the composition, creates greater unity among the figures, and establishes the modeling of their bodies through light and shade. These developments look ahead to the final composition of the *Raft of the "Medusa,"* but the study still lacks the figures of the black man and the dead bodies at the extreme left and lower right, which fill out the composition's base.

Géricault also made separate studies of many of the figures, as well as studies of actual corpses, severed

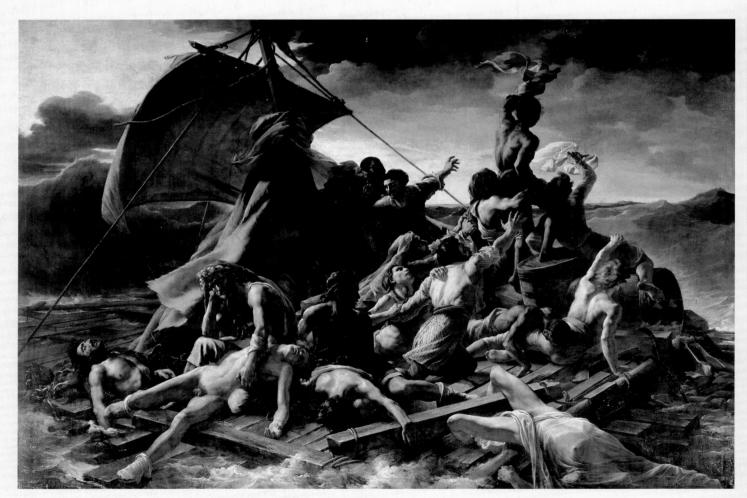

27-6. Théodore Géricault. *Raft of the "Medusa."* 1818–19. Oil on canvas, $16'1'' \times 23'6''$ (4.9×7.16 m). Musée du Louvre, Paris.

heads, and dissected limbs (fig. 27-9) supplied to him by friends who worked at a nearby hospital. For several months, according to Géricault's biographer, "his studio was a kind of morgue. He kept cadavers there until they were half-decomposed, and insisted on working in this charnel-house atmosphere. . . ." However, Géricault did not use cadavers directly in the *Raft of the "Medusa"*; to execute the final painting, he traced the outline of his composition onto a large canvas, then painted each body directly from a living model, gradually building up his composition figure by figure. He seems, rather, to have kept the corpses in his studio to create an atmosphere of

death that would provide him with a more authentic understanding of his subject.

Nevertheless, Géricault did not depict the actual physical condition of the survivors of the raft: exhausted, emaciated, sunburned, and close to death. Instead, following the dictates of the Grand Manner, he gave his men athletic bodies and vigorous poses, evoking the work of Michelangelo and Rubens (see figs. 18-47 and 19-46). He did this to generalize and ennoble his subject, elevating it above the particulars of a specific shipwreck so that it could speak to us of more fundamental conflicts: humanity against nature, hope against despair, life against death.

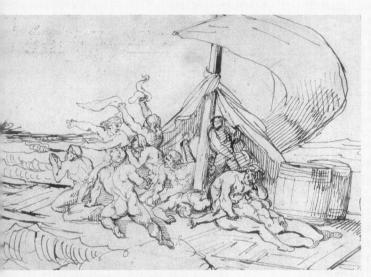

27-7. The Sighting of the "Argus." 1818. Pen and ink on paper, $13^3/_4 \times 16^1/_8$ " (34.9 \times 41 cm). Musée des Beaux-Arts, Lille.

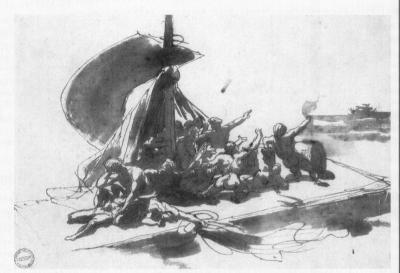

27-8. The Sighting of the "Argus." 1818. Pen and ink, sepia wash on paper, $8\frac{1}{8} \times 11^{1}/4$ " (20.6 × 28.6 cm). Musée des Beaux-Arts, Rouen.

27-9. *Study of Hands and Feet.* 1818–19. Oil on canvas, $20^{1}/_{2} \times 25''$ (52 × 64 cm). Musée Fabre, Montpellier.

27-10. Théodore Géricault. *Pity the Sorrows of a Poor Old Man.* 1821. Lithograph, 12.5×14.8 " (31.6×37.6 cm). Yale University Art Gallery, New Haven. Gift of Charles Y. Lazarus, B.A. 1936

One of the first artists to use the recently invented medium of lithography to create fine art prints, Géricault published his thirteen lithographs of *Various Subjects Drawn from Life and on Stone* in London in 1821. The title of *Pity the Sorrows of a Poor Old Man* comes from a popular English nursery rhyme of the period that began: "Pity the sorrows of a poor old man whose trembling limbs have borne him to your door. . . ."

exhibited it commercially on a two-year tour of Ireland and England, where the London exhibition attracted more than 50,000 paying visitors.

While in Britain, Géricault turned from modern history painting in the **Grand Manner** to the depiction of the urban poor in a series of **lithographs** entitled *Various Subjects Drawn from Life and on Stone* (see "Lithography," opposite). *Pity the Sorrows of a Poor Old Man* (fig. 27-10) depicts a haggard beggar, slumping against a wall and limply extending an open hand. Through the window above him, we see a baker who ignores the hungry man's plight and prepares to pass a loaf of bread to a paying customer. Although the subject's appeal to the emotions can be considered Romantic, the print does not preach or sentimentalize. Viewers are invited to draw their own conclusions.

After Géricault's death, leadership of the French Romantic movement passed to his younger colleague Eugène Delacroix (1798-1863), who had modeled for the face-down figure at the center of the Raft of the "Medusa." Like Géricault, Delacroix depicted victims and antiheroes. One of his first paintings exhibited at a Salon was Scenes from the Massacre at Chios (fig. 27-11), an event even more terrible than the shipwreck of the Medusa. In 1822, during the Greeks' struggle for independence against the Turks, the Turkish fleet stopped at the peaceful island of Chios and took revenge by killing about 20,000 of the 100,000 inhabitants and selling the rest into slavery in North Africa. Delacroix based his painting on journalistic reports, eyewitness accounts, and study of Greek and Turkish costumes. The painting is an image of savage violence and utter hopelessness the entire foreground is given over to exhausted victims awaiting their fate—paradoxically made seductive through its opulent display of handsome bodies and colorful costumes.

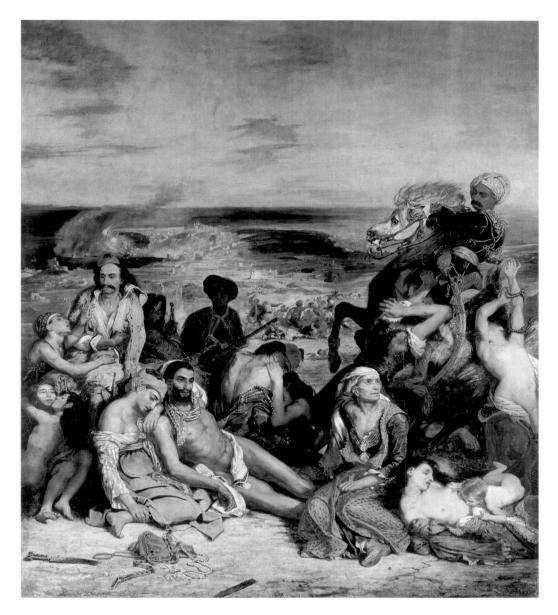

27-11. Eugène Delacroix.
Scenes from the Massacre at Chios. 1822–24.
Oil on canvas, 13'10" × 11'7" (4.22 × 3.53 m).
Musée du Louvre, Paris.

Lithography, invented in the mid-1790s, is based on the natural antagonism between oil and water. The artist draws on a flat surface—traditionally, fine-grained stone—with a greasy,

crayonlike instrument. The stone's surface is wiped with water, then with an oil-based ink. The ink adheres to the greasy areas but not to the damp ones. A sheet of paper is laid facedown on the inked stone, which is passed

TECHNIQUE

Lithography

through a flatbed press. Holding a scraper, the lithographer applies light pressure from above as the stone and paper pass under it, transferring ink from stone to paper, thus making lith-

ography a direct method of creating a printed image. Francisco Goya, Théodore Géricault, Eugène Delacroix, Honoré Daumier, and Henri de Toulouse-Lautrec used the medium to great effect.

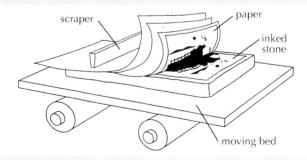

27-12. Eugène Delacroix. Women of Algiers. 1834. Oil on canvas, $5'10^{7}/8'' \times 7'6^{1}/8''$ (1.8 \times 2.29 m). Musée du Louvre, Paris

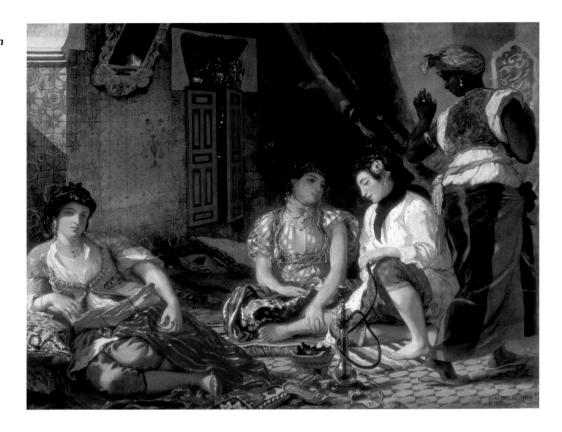

Although Delacroix generally supported liberal political aims, his visit in 1832 to Morocco seems to have stirred his more conservative side. As enthralled as Delacroix was with the brilliant color and dignified inhabitants of North Africa, his attraction to the patriarchal political and social system is also evident in paintings such as *Women of Algiers* (fig. 27-12). This image of hedonism and passivity countered the contemporaneous demands of many French women for property reform, more equitable child-custody laws, and other egalitarian initiatives.

ROMANTIC SCULPTURE

Romanticism gained general acceptance in France after 1830, when a moderate, constitutional monarchy under Louis-Philippe (the so-called July Monarchy, 1830–48) was established, bringing with it a new era of middle-class taste. This shift is most evident in sculpture, where a number of practitioners turned away from Neoclassical principles to more dramatic themes and approaches.

Early in the July Monarchy the minister of the interior decided, as an act of national reconciliation, to complete the triumphal arch on the Champs-Élysées in Paris, which Napoleon had begun in 1806. François Rude (1784–1855) received the commission to decorate the main arcade to commemorate the volunteer army that had halted a Prussian invasion in 1792–93. Beneath the violent exhortations of the winged figure of Liberty, the volunteers surge forward, some nude, some in classical armor (fig. 27-13). Despite such Neoclassical elements,

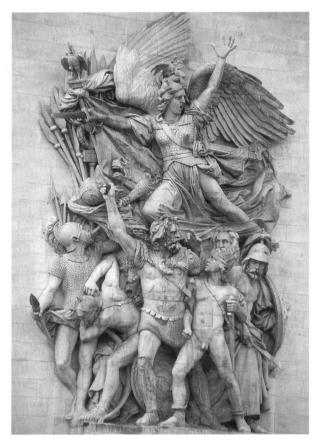

27-13. François Rude. *Departure of the Volunteers of 1792 (The Marseillaise)*. 1833–36. Limestone, height approx. 42′ (12.8 m). Arc de Triomphe, Place de l'Étoile, Paris.

the effect is Romantic. The crowded, excited grouping so stirred the patriotism of French spectators that it quickly became known as The Marseillaise, the name of the French national anthem written in the same year, 1792.

Another popular Romantic sculptor to emerge at the beginning of the July Monarchy was Antoine-Louis Barye (1796-1875), who specialized in scenes of violent animal combat. In addition to large works for wealthy patrons, including the king, Barye's studio produced small, relatively inexpensive replicas, such as Python Crushing an African Horseman (fig. 27-14), for the middle-class market. Such unlikely scenes of exotic violence may have contributed to the popular view that nature was filled with hostile forces that required human control.

ROMANTICISM In eighteenth-century Spain, in spain patrons had looked to foreign artists such as Giovanni Battista Tiepolo (see fig. 26-4) to

fill major commissions. Not until late in the century were a native painter's achievements comparable to those of Velázquez. Francisco Goya y Lucientes (1746-1828), during the first half of his long career, chiefly produced formal portraits and Rococo genre pictures, but around

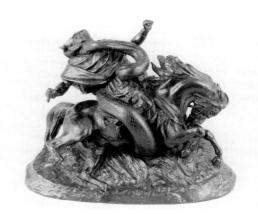

27-14. Antoine-Louis Barye. Python Crushing an African Horseman. 1845. Bronze, height 9" (22.8 cm). The Baltimore Museum of Art.

George A. Lucas Collection, purchased with funds from the State of Maryland, Laurence and Stella Bendann Fund, and contributions from individuals, foundations, and corporations throughout the Baltimore Community, (BMA1996.046.062)

1800, the influence of Velázquez and Rembrandt led Goya to develop a more Romantic style of darker tonality, freer brushwork, and more dramatic presentation.

Goya's large portrait of the Family of Charles IV (fig. 27-15) openly acknowledges the influence of Velázquez's Las Meninas (see fig. 19-38) by placing the painter

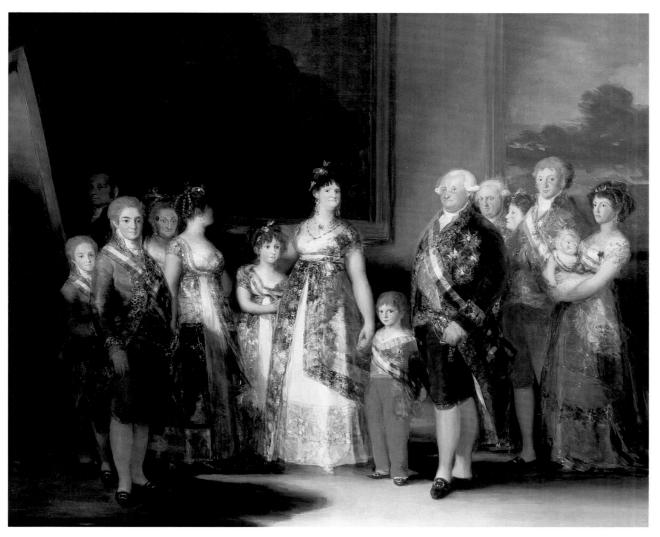

27-15. Francisco Goya. Family of Charles IV. 1800. Oil on canvas, 9'2" × 11' (2.79 × 3.36 m). Museo del Prado, Madrid

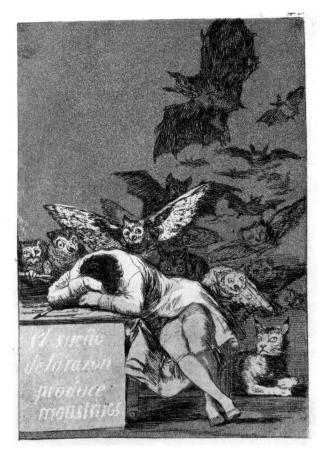

27-16. Francisco Goya. The Sleep of Reason Produces Monsters, No. 43 from Los Caprichos (The Caprices). 1796-98; published 1799. Etching and aquatint, $8^{1}/_{2} \times 6''$ (21.6 × 15.2 cm). Courtesy of the Hispanic Society of America, New York.

After printing about 300 sets of this series, Goya offered them for sale in 1799. He withdrew them from sale two days later without explanation. Historians believe that he was probably warned by the Church that if he did not he might have to appear before the Inquisition because of the unflattering portrayal of the Church in some of the etchings. In 1803 Goya donated the plates to the Royal Printing Office.

behind the easel on the left, just as Velázquez had. Goya's realistic rather than flattering depiction of the royal family has led some to see the painting as a cruel exposé of the sitters as common, ugly, and inept. Considering Goya's position at the time as principal court painter, however, it is difficult to imagine the artist deliberately mocking his most important patron. In fact, Goya made preparatory sketches for the painting, and the family apparently consented to his rendering of their faces. Viewers of the painting in 1800 would have found it striking not because it was demeaning but because its candid representation was refreshingly modern.

Goya belonged to a small but influential circle of Madrid intellectuals who subscribed to the liberal ideals of the French philosophes. After the early years of the French Revolution, however, Charles IV reinstituted the Inquisition, stopped most of the French-inspired reforms, and even halted the entry of French books into Spain. Goya responded to the new situation with Los

Caprichos (The Caprices), a folio of eighty etchings produced between 1796 and 1798 whose overall theme is suggested by The Sleep of Reason Produces Monsters (fig. 27-16). The print shows a slumbering personification of Reason, behind whom lurk the dark creatures of the night-owls, bats, and a cat-that are let loose when Reason sleeps. The rest of the Caprichos enumerate the specific follies of Spanish life that Goya and his circle considered monstrous. Goya hoped the series would show Spanish people the errors of their ways and reawaken reason. Despite the hopeful premise, however, the disturbing quality of Goya's portrait of human folly suggests he was already beginning to feel the despair that would dominate his later work.

In 1808 Napoleon conquered Spain and placed on its throne his brother Joseph Bonaparte. Many Spanish citizens, including Goya, welcomed the French because of the reforms they inaugurated, including a new, more liberal constitution. On May 2, 1808, however, a rumor spread in Madrid that the French planned to kill the royal family. The populace rose up, and a day of bloody street fighting ensued. Hundreds of Spanish people were herded into a convent, and a French firing squad executed these helpless prisoners in the predawn hours of May 3. Goya commemorated the event in a painting (fig. 27-17) that, like Delacroix's Massacre at Chios (see fig. 27-11), focuses on victims and antiheroes, the most prominent of which is a Christ-like figure in white. Gova's work is less an indictment of the French than of the faceless and mechanical forces of war itself, blindly destroying defenseless humanity. When asked why he painted such a brutal scene, Goya responded: "To warn men never to do it again."

Soon after the Spanish monarchy was restored, Ferdinand VII (ruled 1808; 1814-33) abolished the new constitution and reinstated the Inquisition, which the French had banned. In 1815 Goya was himself called before the Inquisition due to the alleged obscenity of an earlier painting of a female nude. Though found innocent, Goya gave up hope in human progress and retired to his home outside Madrid, where he vented his disillusionment in the series of nightmarish "black paintings" he did on its walls.

LANDSCAPE PAINTING IN

ROMANTIC Romantic landscape painting generally took one of two forms. One-the dramatic-emphasized turbulent or fantastic natural **EUROPE** scenery, often shaken by natural disasters such as storms and

avalanches, and aimed to stir viewers' emotions and arouse a feeling of the sublime. The other-the naturalistic-presented closely observed images of tranquil nature, meant to communicate religious reverence for the landscape and to counteract the effects of industrialization and urbanization that were rapidly transforming it.

The leading German Romantic landscapist was Caspar David Friedrich (1774-1840), a native of Pomerania on the Baltic coast who studied at the academies of

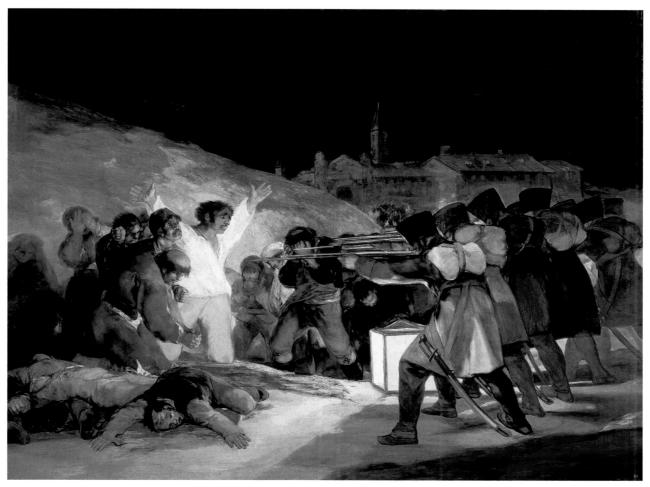

27-17. Francisco Goya. Third of May, 1808. 1814–15. Oil on canvas, 8'9" × 13'4" (2.67 × 4.06 m). Museo del Prado, Madrid.

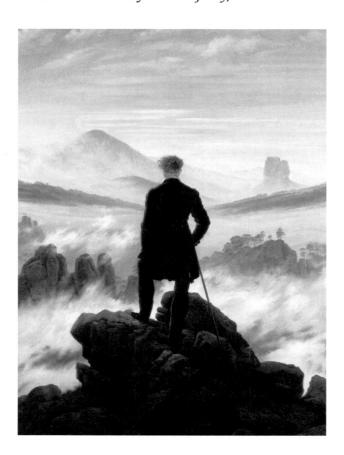

Copenhagen and Dresden and settled in the latter city. Like many Romantics, Friedrich believed that nature was a manifestation of the divine and that the contemplation of nature could be analogous to worship. Many of his landscapes feature figures seen from the back, gazing into the distance and inviting the viewer to share in their experience. In the dramatic *Wanderer Above a Sea of Mist* (fig. 27-18), the dark-suited man in the foreground stands on a craggy peak overlooking a sublime vista of mountaintops and bizarre rock formations that rise from the

27-18. Caspar David Friedrich. *Wanderer Above a Sea of Mist.* c. 1818. Oil on canvas, $37^3/_4 \times 29^3/_8$ " (94.8 \times 74.8 cm). Kunsthalle, Hamburg, Germany.

The religious feeling that Friedrich likely intended to convey in paintings such as this one is captured in the words of his follower Carl Gustav Carus (1789–1869), who in his *Letters on Landscape Painting* (1831) wrote: "Stand on the peak of a mountain, contemplate the long ranges of hills . . . and all the other glories offered to your view, and what feeling seizes you? It is a quiet prayer, you lose yourself in boundless space, your self disappears, you are nothing, God is everything."

27-19. Joseph Mallord William Turner. Snowstorm: Hannibal and His Army Crossing the Alps. 1812. Oil on canvas, 4'9" × 7'9" (1.46 × 2.39 m). The Tate Gallery, London.

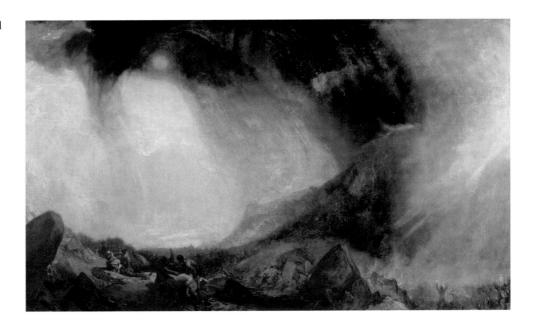

mist before him. Standing on the brink of a mysterious void, the solitary wanderer can go no further physically, suggesting that his journey is ultimately a spiritual one.

Friedrich's English contemporary Joseph Mallord William Turner (1775–1851) devoted much of his early work to the Romantic theme of nature as a cataclysmic force that overwhelms human beings and their creations. Turner entered the Royal Academy in 1789, was elected a full academician at the unusually young age of twenty-seven, and later became a professor in the Royal Academy school. During the 1790s, Turner helped revolutionize the British watercolor tradition by rejecting underpainting and topographic accuracy in favor of a freer application of paint and more generalized atmospheric effects. By the late 1790s, Turner was also exhibiting large-scale oil paintings of grand natural scenes and historical subjects.

Turner's Snowstorm: Hannibal and His Army Crossing the Alps (fig. 27-19) epitomizes the Romantic mood of sublime awe as an enormous vortex of wind, vapor, and snow threatens to annihilate the soldiers below it and even to obliterate the sun. Barely discernible in the distance is the figure of the brilliant Carthaginian general Hannibal, who, mounted on an elephant, led his troops through the Alps to defeat Roman armies in 218 BCE. Turner probably intended this painting as an allegory of the Napoleonic Wars-Napoleon himself had crossed the Alps, an event celebrated in Jacques-Louis David's Napoleon Crossing the Saint-Bernard (see fig. 27-2). But while David's painting, which Turner saw in Paris in 1802, depicts Napoleon as a powerful figure who seems to command not only his troops but nature itself, Turner reduces Hannibal to a speck on the horizon and shows his troops threatened by a cataclysmic storm, as if foretelling their eventual defeat. In 1814, just two years after the exhibition of Turner's painting, Napoleon suffered a decisive loss to his European opponents and met final defeat at Waterloo in 1815.

The fall of the Napoleonic Empire exemplified a favorite Romantic theme of Turner's, "the course of empire"—the inevitable decline and death that comes to all great national extensions, from Rome to Spain to France, and even to his own Britain. Among Turner's many meditations on Britain's eventual fate is The Fighting "Téméraire," Tugged to Her Last Berth to Be Broken Up (fig. 27-20), of 1838. The Téméraire, the second-ranking British ship in a great naval victory over the Napoleonic fleet, thirty-three years later is being pulled to the scrap heap by one of the new steam-driven paddle vessels replacing the great sailing ships. The blazing sunset in the rear not only suggests the passing of the great ship but also suggests the decline of British imperial dominion, which depended on its rule of the sea. The broad and painterly treatment of the sky, which Turner laid down largely with a palette knife, hints at the abstraction of his late works of the 1840s, in which land, sea, and sky dissolve into vaporous bursts of color and light.

If Turner's works epitomize the theatrical side of Romantic landscape painting, those of his compatriot John Constable (1776-1837) exemplify the equally Romantic impulse toward naturalism as a form of personal devotion to nature. The son of a successful miller, Constable declared that the landscape of his youth in southern England had made him a painter even before he ever picked up a brush. Although he was trained at the Royal Academy—which considered naturalism an inferior art form-he was most influenced by the British topographic watercolor tradition of the late eighteenth century and by the example of seventeenthcentury Dutch landscapists (see fig. 19-62). After moving to London in 1816, he dedicated himself to painting monumental views of the agricultural landscape of his youth.

The White Horse (fig. 27-21), a typical work of Constable's maturity, depicts a fresh early summer day in the Stour River valley after the passing of a storm. Sunlight

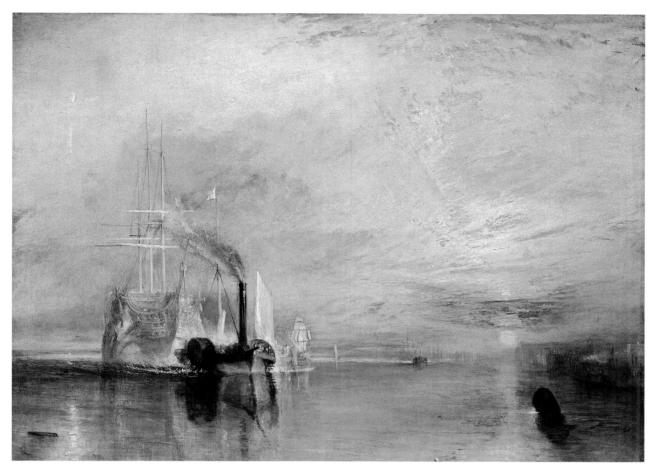

27-20. Joseph Mallord William Turner. *The Fighting "Téméraire," Tugged to Her Last Berth to Be Broken Up.* 1838. Oil on canvas, $35\frac{1}{4} \times 48$ " (90.8 × 121.9 cm). The National Gallery, London.

27-21. John Constable. *The White Horse.* 1819. Oil on canvas, $4'3^3/_4$ " \times $6'2^1/_8$ " (1.31 \times 1.88 m). The Frick Collection, New York.

27-22. Théodore Rousseau. *The Valley of Tiffauges (Marais en Vendée)*. 1837–44. Oil on canvas, $25\frac{1}{2} \times 40\frac{1}{2}$ " (64.7 × 103 cm). Cincinnati Art Museum.

Gift of Emilie L. Heine in memory of Mr. and Mrs. John Hauck (1940.1202)

Although this picture, with its informal composition and loose paint handling, looks as if it might have been painted directly on the spot, Rousseau in fact composed it in his studio and worked on it over several years. Not until the rise of Impressionism a generation later would artists routinely execute pictures on this scale outdoors, directly before the subject.

glistens off the water and foliage, an effect Constable achieved through tiny dabs of white paint. In the lower left, a farmer and his helpers ferry a workhorse across the river. Such elements were never invented by Constable, who insisted that art should be an objective record of things actually seen and who composed his paintings in the studio from sketches made on the site. Yet Constable made no reference to the region's ongoing economic depression and civil unrest. His idyllic images may have been in part a reaction against the blight attending England's industrialization.

Constable's first critical success came not in England but at the Paris Salon of 1824, where one of his landscapes won a gold medal. His example inspired a group of French landscape painters that emerged in the 1830s and became known as the Barbizon School because a number of them, including Théodore Rousseau (1812–67), lived in the rural town of Barbizon in the forest of Fontainebleau, near Paris. Trained at the academy, Rousseau turned to landscape around 1830, inspired by the works of Constable and the seventeenth-century Dutch landscapes he admired in the Louvre. Although Rousseau's first submission to the Salon in 1831 was accepted, his modest canvases of the French countryside were systematically refused between 1836 and 1841 because they were not idealized, were not peopled with

biblical or classical figures, and seemed too sketchy and "unfinished." From 1842 to 1848 he did not submit to the Salon. As a result of his exclusion from the Salon, Rousseau became known as *le grand refusé* ("the great refused one"). Like most works by Rousseau and his colleagues, *The Valley of Tiffauges* (fig. 27-22) invites the spectator to experience the soothing tranquility of unspoiled nature.

NATURALISTIC, ROMANTIC, AND NEOCLASSICAL AMERICAN ART

Before the advent of photography, artists played an important role in circulating knowledge about the natural world. One of America's most celebrated

scientific naturalists was John James Audubon (1785–1851), whose life's ambition was "to complete a collection of drawings of the Birds of our country, from Nature . . . and to acquire . . . a knowledge of their habitats and residences." To support publication of his *The Birds of America* (completed in 1839), Audubon sold paintings after his drawings. In *Common Grackle* (fig. 27-23), the birds are closely observed and in their natural habitat, and they are rendered in the combination of watercolor and drawing that Audubon favored to capture naturalistic

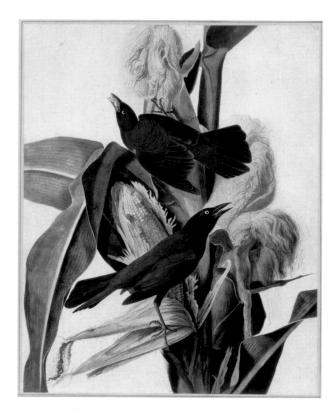

27-23. John James Audubon. *Common Grackle*, for *The Birds of America*. 1826–39. Watercolor, graphite, and selective glazing, $23^{7}/_{8} \times 18^{1}/_{2}$ " (61.2 × 47.4 cm). Collection of the New-York Historical Society, New York City. (1863.17.007).

To create Audubon's *The Birds of America*, his watercolors, like this one of grackles, were copied by the London printmaker Robert Havell using the aquatint process. Broad areas of neutral color were inked on the plates and the rest added by hand on the prints themselves. This bird encyclopedia was Audubon's first successful business venture and was followed by *The Viviparous Quadrupeds of North America* (1845–54), a multivolume work that documented the continent's mammals.

detail. Audubon's concern for accuracy and effective sense of artistic design—the two grackles are opposing diagonals—raised his work above mere illustration.

Audubon's counterpart in anthropology was George Catlin (1796-1872). After a brief law career, Catlin established himself as a portraitist in Philadelphia. Inspired by a visiting delegation of Native American chiefs, Catlin moved in 1830 to St. Louis, then a frontier city, and made five extended trips west of the Mississippi to study the life and customs of the Plains peoples. In contrast to some of his contemporaries' unflattering images of Native Americans as bloodthirsty savages, Catlin's portraits, such as Buffalo Bull's Back Fat, Head Chief, Blood Tribe (fig. 27-24), present their subjects as proud and dignified. In an encyclopedic style similar to Audubon's, Catlin described in his notes how his subjects' costumes were made and decorated. In 1837, he assembled an exhibition, called the "Indian Gallery," of over 300 paintings that included portraits of chiefs and warriors and scenes of Native American life, and a collection of

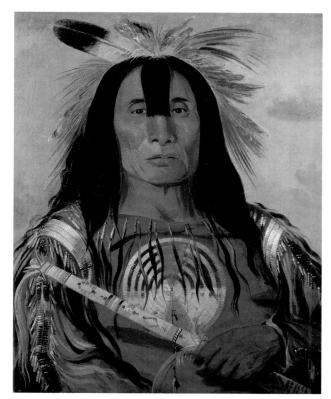

27-24. George Catlin. *Buffalo Bull's Back Fat, Head Chief, Blood Tribe.* 1832. Oil on canvas, 29 × 24" (73.7 × 60.9 cm). Smithsonian American Art Museum, Smithsonian Institution, Washington, D.C. Gift of Mrs. Joseph Harrison, Jr., (1985.66.149)

The title is Catlin's translation of this Blackfoot chief's name, which refers to the hump of fat on a male buffalo's back.

Native American art and artifacts. The exhibition toured the eastern United States before moving on to London and Paris. Catlin was unable to convince the U.S. government to purchase his life's work for a national museum, but the majority of his Indian Gallery paintings were donated to the Smithsonian Institution by the widow of one of Catlin's patrons.

LANDSCAPE AND GENRE PAINTING

America's foremost Romantic landscape painter in the first half of the nineteenth century was Thomas Cole (1801–48). He emigrated from England to the United States at seventeen and by 1820 was working as an itinerant portrait painter. On trips around New York City Cole sketched and painted the landscape, which quickly became his chief interest, and his paintings launched what became known as the Hudson River School.

With the help of a patron, Cole traveled in Europe between 1829 and 1832. In England he was impressed by Turner's landscapes, and in Italy the classical ruins aroused his interest in a subject that also preoccupied Turner: the course of empire. In the mid-1830s, while painting *The Course of Empire*, an epic account of a landscape from its primeval state through its architectural peak under an ancient empire to its final state of desolation, Cole went on a sketching trip that resulted in

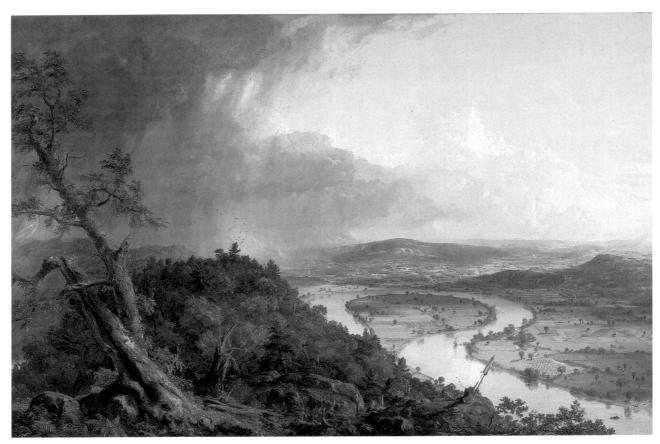

27-25. Thomas Cole. *The Oxbow*. 1836. Oil on canvas, $51^{1}/_{2} \times 76''$ (1.31 \times 1.94 m). The Metropolitan Museum of Art, New York. Gift of Mrs. Russell Sage, 1908 (08.228)

The Oxbow (fig. 27-25), which he painted for exhibition at the National Academy of Design in New York. Cole considered it one of his "view" paintings, which were usually small, although this one is monumental. The scale suits the dramatic view from the top of Mount Holyoke in western Massachusetts across a spectacular oxbow-shaped bend in the Connecticut River. To Cole, such ancient geological formations constituted America's "antiquities." Along a great sweeping arc produced by the departing dark clouds and the edge of the mountain, Cole contrasts the two sides of the American landscape: its dense, stormy wilderness and its congenial, pastoral valleys. The fading storm suggests that the wild will eventually give way to the civilized. Given Cole's current interest in the course of empire, however, he probably saw this development as merely an early phase of a larger, eventually tragic cycle.

Along with images of native scenery such as Cole's, pictures of everyday American life were also popular in the middle decades of the nineteenth century. A leading American genre painter was the Missouri artist George Caleb Bingham (1811–79), who after 1844 began to record scenes of traders and boatmen who traveled the Mississippi River and its tributaries. Fur Traders Descending the Missouri (fig. 27-26) shows two trappers with their pet bear cub in a dugout canoe, gliding peacefully through early-morning stillness. The

neatly dressed trappers gaze out at the viewer with thoughtful expressions—not at all the dirty and uncivilized types portrayed in contemporary literature. Bingham also idealized their environment: The image of the setting—the mirrorlike surface of the water, the misty background, the rosy glow filling the sky—is not only idealized but also nostalgic, for by now the independent French *voyageurs* who had opened the fur trade using canoes had been replaced by trading companies using larger, more efficient craft. Bingham's painting thus both records a vanished way of life and celebrates the early stages of white civilization and commerce on the frontier.

SCULPTURE

After the American Revolution, the demand for monumental sculpture in marble and bronze grew significantly in the United States. At first, patrons looked to European Neoclassicists, such as Canova (see fig. 26-21) and Houdon (see fig. 26-51), but they soon turned to Americans trained abroad in the Neoclassical style. Italy was the wellspring of Neoclassical inspiration in sculpture, as well as the source of the materials and skilled workers needed for large commissions in marble. The first American sculpture students began arriving in Italy around 1825, and by the 1840s they were flocking to the American artists' colonies in Florence and Rome.

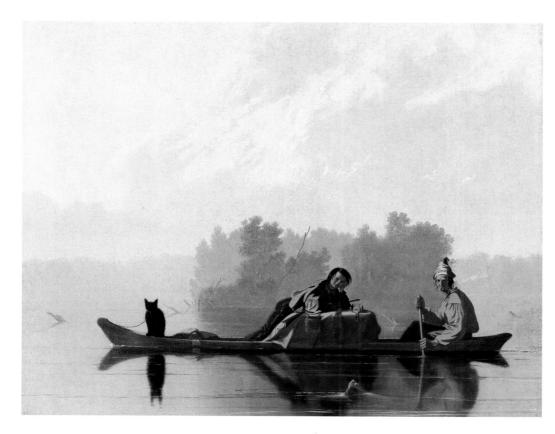

27-26. George Caleb Bingham. Fur Traders Descending the Missouri. c. 1845. Oil on canvas, 29 × 36½" (73.7 × 92.7 cm). The Metropolitan Museum of Art, New York. Morris K. Jesup Fund, 1933 (33.61)

This painting was originally titled French Trapper and His Half-Breed Son—the latter phrase identifying the boy as the mixed-race offspring of the Frenchman and a Native American Woman.

The most famous American Neoclassicist of his generation was Hiram Powers (1805-73), who called himself the "Yankee stonecutter." Born in Vermont, he grew up in Cincinnati, where as a young man he created lifesize wax figures for a historical museum. After some formal training with a local sculptor, Powers went to Europe to study, and he settled permanently in Florence in 1837. Six years later Powers created the sculpture that gained him an international reputation, The Greek Slave (fig. 27-27). Inspired by the Greeks' struggle for independence against the Turks and by accounts of atrocities such as Delacroix recorded in his Massacre at Chios (see fig. 27-11), the sculpture portrays a beautiful Greek captive put up for sale in a Turkish slave market. According to Powers's written description, "she stands exposed to the gaze of the people she abhors, and awaits her fate with intense anxiety, tempered indeed by the support of her reliance on the goodness of God." A sculpted locket and cross, evoking the woman's lost loved ones and her Christian faith, hang from the support beneath her right

27-27. Hiram Powers. *The Greek Slave.* 1843. Marble, height $5'5^1/_2$ " (1.68 m). Yale University Art Gallery, New Haven. Olive Louise Dann Fund

In time-honored tradition, the creation of a large marble statue was rarely carried through from beginning to end by the artist who conceived it. By delegating the more time-consuming processes of execution to specialists, artists were able to accept and carry out more commissions, including replicas of popular works. *The Greek Slave* exists in six full-size versions produced in Powers's Florence workshop.

27-28. Benjamin Henry Latrobe. U.S. Capitol, Washington, D.C. c. 1808. Engraving by T. Sutherland, 1825. New York Public Library.

I. N. Phelps Stokes Collection, Myriam and Ira Wallach Division of Art, Prints, and Photographs

hand. To overcome any objections to The Greek Slave's nudity—potentially offensive to his Victorian audience— Powers issued an explanatory pamphlet that declared it was "not her person but her spirit that stands exposed." The Greek Slave was privately exhibited in London in 1845 and the following year in New York, where long lines of people paid 25 cents to view it. It gained international fame through its exhibition in the American section of the first world exposition, held in London's Crystal Palace in 1851 (see fig. 27-38). Orders for fullsize copies poured in, and miniatures in plaster, marble, and china decorated many American mantels.

REVIVAL STYLES Nineteenth-century ar-IN ARCHITECTURE

chitects were trained to work in a variety of his-BEFORE 1850 torical modes, each of which was thought to

have appropriate uses, depending on its historical associations. Neoclassicism, which evoked both Greek democracy and Roman republicanism, became the favored style for government buildings in the United States. In Europe, many different kinds of public institutions, including art museums, were built in the Neoclassical style.

A major Neoclassical edifice in Washington, D.C. was the U.S. Capitol, initially designed in 1792 by William Thornton (1759–1828), an amateur architect. His monumental plan featured a large dome over a temple front flanked by two wings to accommodate the House of Representatives and the Senate. In 1803, President Thomas Jefferson, also an amateur architect (see fig. 26-54), hired a British-trained professional, Benjamin Henry Latrobe (1764-1820), to oversee the actual construction of the Capitol. Latrobe modified Thornton's design by adding a grand staircase and Corinthian colonnade on the east front (fig. 27-28). After the building was gutted by the British in the War of 1812, Latrobe repaired the wings and designed a higher dome. Seeking new symbolic forms for the nation within the traditional classical vocabulary, Latrobe also created for the interior a variation on the Corinthian order by substitut-

27-29. U.S. Capitol. Corncob capital sculpted by Giuseppe Franzoni, 1809.

ing indigenous plants—corn (fig. 27-29) and tobacco for the Corinthian order's acanthus leaves (see fig. 2, Introduction). Latrobe resigned in 1817, and the reconstruction was completed under Charles Bulfinch (1763-1844). A major renovation begun in 1850 brought the building closer to its present form.

Many European capitals in the early nineteenth century erected museums in the Neoclassical style—which, being derived chiefly from Greek and Roman religious architecture, positioned the new buildings as temples of culture. The most influential of these was the Altes ("Old") Museum in Berlin, designed in 1822 by Karl Friedrich Schinkel (1781-1841) and built between 1824 and 1830 (fig. 27-30). Commissioned to display the royal art collection, the Altes Museum was built on an island in the Spree River in the heart of the capital, directly across from the Baroque royal palace. The museum's imposing facade consists of a screen of eighteen Ionic columns, raised on a platform with a central staircase.

27-30. Karl Friedrich Schinkel. Altes Museum, Berlin. 1822-30.

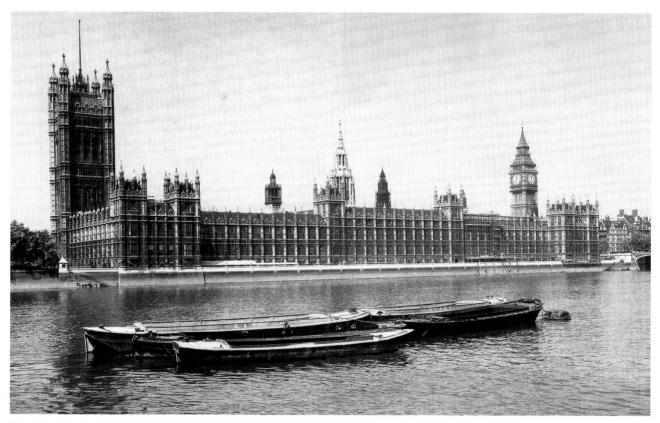

27-31. Charles Barry and Augustus Welby Northmore Pugin. Houses of Parliament, London, England. 1836–60. Royal Commission on the Historical Monuments of England, London.

Pugin published two influential books in 1836 and 1841, in which he argued that the Gothic style of Westminster Abbey was the embodiment of true English genius. In his view, the Greek and Roman classical orders were stone replications of earlier wooden forms and therefore fell short of the true principles of stone construction.

Attentive to the problem of lighting art works on both the ground and the upper floors, Schinkel created interior courtyards on either side of a central rotunda, tall windows on the museum's outer walls to provide natural illumination, and partition walls perpendicular to the windows to eliminate glare on the varnished surfaces of the paintings on display.

Schinkel also created numerous Gothic architectural designs, which many Germans considered an expression of national genius. Meanwhile, the British claimed the Gothic as part of *their* patrimony and erected a plethora of Gothic revival buildings in the nineteenth century, the most famous being the Houses of Parliament (fig. 27-31). After Parliament's Westminster Palace

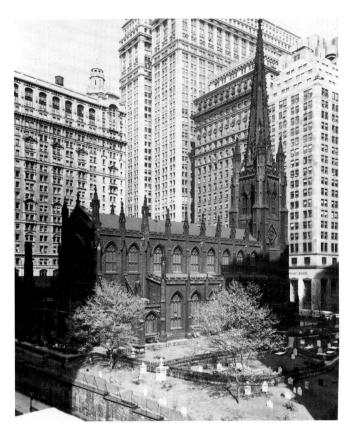

27-32. Richard Upjohn. Trinity Church, New York City. 1839-46.

burned in 1834, the government opened a competition for a new building designed in the English Perpendicular Gothic style, to be consistent with the neighboring Westminster Abbey, the thirteenth-century church where English monarchs are crowned.

Charles Barry (1795-1860) and Augustus Welby Northmore Pugin (1812-52) won the commission. Barry was responsible for the basic plan, whose symmetry suggests the balance of powers of the British system; Pugin provided the intricate Gothic decoration laid over Barry's essentially classical plan. The leading advocate of Gothic architecture in his era, Pugin in 1836 published Contrasts, which unfavorably compared the troubled modern era of materialism and mechanization with the Middle Ages, which he represented as an idyllic epoch of deep spirituality and satisfying handcraft. For Pugin, Gothic was not a style but a principle, like classicism. The Gothic, he insisted, embodied two "great rules" of architecture: "first that there should be no features about a building which are not necessary for convenience, construction or propriety; second, that all ornament should consist of enrichment of the essential structure of the building."

In nineteenth-century Europe and the United States, many architects used the Gothic style because of its religious associations, especially for the Roman Catholic Church, the Anglican Church of England, and the Episcopalian churches of Scotland and the United States. The British-born American architect Richard

Upjohn (1802-78) designed many of the most important Gothic revival churches in the United States, including Trinity Church in New York (fig. 27-32). With its tall spire, long nave, and squared-off chancel, Trinity quotes the early-fourteenth-century British Gothic style particularly dear to Anglicans and Episcopalians. Every detail is historically accurate, although the vaults are of plaster, not masonry. The stained-glass windows above the altar were among the earliest in the United States.

PHOTOGRAPHY

EARLY A prime expression of the new, positivist interest in descriptive accuracy spurred IN EUROPE by Comte's philosophy (see page 943) was the develop-

ment of photography. Photography as we know it emerged around 1840, but since the late Renaissance, artists and others had been seeking a mechanical method for exactly recording or rendering a scene. One early device was the camera obscura (Latin for "dark chamber"), which consists of a darkened room or box with a lens through which light passes, projecting onto the opposite wall or box side an upside-down image of the scene, which an artist can trace. By the seventeenth century a small, portable camera obscura, or camera, had become standard equipment for many landscape painters. Photography developed essentially as a way to fix-that is, to make permanent-the images produced by a camera obscura on light-sensitive material.

The first to make a permanent picture by the action of light was Joseph-Nicéphore Niépce (1765-1833), who, seeking a less cumbersome substitute for lithography (see "Lithography," page 951), successfully copied translucent engravings by attaching them to pewter plates covered with bitumen, a light-sensitive asphalt used by etchers. Niépce then tried this substance in the camera. Using metal and glass plates covered with bitumen, he succeeded around 1826 in making the first positive-image photographs of views from a window of his estate at Gras, France.

In 1829, Niépce formed a partnership with Louis-Jacques-Mandé Daguerre (1787-1851), a Parisian painter who, working with a lens maker, had developed an improved camera. After Niépce's death in 1833, Daguerre continued their research using copper plates coated with iodized silver, long known to be lightsensitive. In 1835 he was amazed to find an image on a copper plate he had left in a cupboard. He determined that the vapor of a few drops of spilled mercury from a broken thermometer had produced the effect. Thus Daguerre discovered that an exposure to light of only twenty to thirty minutes would produce a latent image on one of his silvered plates treated with iodine fumes, which could then be made visible through development with mercury vapor. By 1837 he had established a method of fixing the image by bathing the plate in a strong solution of common salt after exposure. The inventor's first such picture, a daguerreotype, was a still life of plaster casts, a wicker-covered bottle, a framed

27-33. Louis-Jacques-Mandé Daguerre. *The Artist's Studio.* 1837. Daguerreotype, $6^1/_2 \times 8^1/_2$ " (16.5 \times 21.6 cm). Société Française de Photographie, Paris.

27-34. William Henry Fox Talbot. *The Open Door.* 1843. Salt-paper print from a calotype negative. Science Museum, London. Fox Talbot Collection

drawing, and a curtain (fig. 27-33). This arrangement, reminiscent of a centuries-old still-life painting convention indicates Daguerre's intention to emulate not only an optical reality but also an artistic tradition.

The 1839 announcement of Daguerre's invention prompted English scientist William Henry Fox Talbot (1800–77) to publish the results of his own work on what he later named the **calotype** (from the Greek term for "beautiful image"). Talbot's process, even more than Daguerre's, became the basis of modern photography because, unlike Daguerre's, which produces a single, positive image, Talbot's calotype is a negative image from which an unlimited number of positives can be printed. In *The Pencil of Nature* (issued in six parts, 1844–46), the first books to be illustrated with photographs, Talbot described the evolution of his process from his first experiments in the mid-1830s using paper impregnated with silver chloride. At first, he copied en-

gravings, pieces of lace, and leaves in negative by laying them on chemically treated paper and exposing them to light. By the summer of 1835 he was using this paper in both large and small cameras. Then, in 1840, he discovered, independently of Daguerre, that latent images resulting from exposure to the sun for short periods of time could be developed chemically. Applying the technique he had earlier used with engravings and leaves, he was able to make positive prints from the paper negatives.

One of the calotypes hand-pasted into *The Pencil of Nature* was *The Open Door* (fig. 27-34). The subject, like many by Talbot, is rural, a nostalgic evocation of an agrarian way of life that was fast disappearing. In the doorway of an old, time-worn cottage Talbot has placed a sturdy broom, whose handle is carefully positioned to parallel the shadows on the door. This is the kind of traditional, handcrafted broom that mass production was

A camera is essentially a lightproof box with a hole, called an aperture, which is usually adjustable in size and regulates the amount of light that strikes the film. The aperture is cov-

ered with a lens, which focuses the image on the film, and a shutter, a kind of door that opens for a controlled amount of time, to regulate the length of time that the film is exposed to light—usually a small fraction of a second. Modern cameras also have a viewer that permits the photographer to see virtually the same image that the film will "see."

Photography is based on the principle that certain substances are sensitive to light and react to light by changing **value**. In early photography, a glass plate was coated with a variety of emulsions; in modern black-and-white photography, film is coated with an emulsion of silver halide crystals (silver combined with iodine,

TECHNIQUE

How Photography Works chlorine, or other halogens) suspended in a gelatin base. (Color photography uses a different light-sensitive emulsion.)

The film is then exposed. Light reflected off objects enters the camera and strikes the film. Pale objects reflect more light than do dark ones. The silver in the emulsion collects most densely where it is exposed to the most light, producing a "negative" image on the film. Later, when the film is placed in a chemical bath (developed), the silver deposits turn black, as if tarnishing. The more light the film receives, the denser the black tone created. A positive image is created from the negative in a darkroom; then the film negative is placed over a sheet of paper that, like the film, has been treated to be lightsensitive, and light is directed through the negative onto the paper. Thus, a multiple number of positive prints can be made from a single negative.

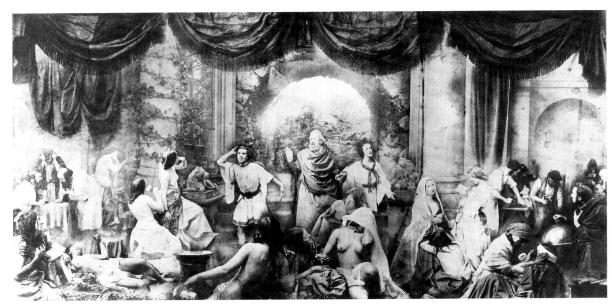

27-35. Oscar Rejlander. *The Two Paths of Life*. 1857. Combination albumen print, 16×31 " (41×79.5 cm). George Eastman House, Rochester, New York.

beginning to make obsolete, but the use of photography itself also suggests that something made by mechanical means could have a genuine value, comparable to that of the handmade. Talbot's "soliloquy of the broom," as his mother called it, gives evidence of his conviction that photography might offer a creative artistic outlet for those, like himself, without the manual talent to draw or paint.

The final step in the development of early photography was taken in 1851 by Frederick Scott Archer (1813-57), a British sculptor and photographer, who was one of many in western Europe trying to find a way to make silver nitrate adhere to glass. The result would be a glass negative, which would be reproducible, like Talbot's, and have the clarity of the daguerreotype. Archer's solution was collodion, a combination of guncotton, ether, and alcohol used in medicinal bandages. He found that a mixture of collodion and silver nitrate, when wet, needed only a few seconds' exposure to light to create an image. Although the wet-collodion process was more cumbersome than earlier techniques, it quickly replaced them because of its greater speed and the sharper tonal subtleties it produced. Moreover, it was universally available because Archer, unlike Daguerre and Talbot, generously refused to patent his invention. Thus the era of modern photography was launched (see "How Photography Works," page 965). Once a practical photographic process had been invented, the question became how to use it. The real issue was whether photography, taken on its own terms, could be considered a new art form.

Among the first photographers to argue for its artistic legitimacy was Oscar Rejlander (1813–75) of Sweden, who had studied painting in Rome, then settled in England. He first took up photography in the early 1850s as an aid for painting but was soon attempting to create photographic equivalents of the painted and engraved

moral allegories so popular in Britain since the time of Hogarth (see fig. 26-32). In 1857 he produced his most famous work, The Two Paths of Life (fig. 27-35), by combining thirty negatives. This allegory of Good and Evil, work and idleness, was loosely based on Raphael's School of Athens (see fig. 18-8). At the center, an old sage ushers two young men into life. The serene youth on the right turns toward personifications of Religion, Charity, Industry, and other virtues, while his counterpart eagerly responds to the enticements of pleasure. The figures on the left Rejlander described as personifications of "Gambling, Wine, Licentiousness and other Vices, ending in Suicide, Insanity, and Death." In the lower center, with a drapery over her head, is the hopeful figure of "Repentance." Although Queen Victoria purchased a copy of The Two Paths of Life for her husband, it was not generally well received as art. One typical response was that "mechanical contrivances" could not produce works of "high art," a criticism that would continue to be raised against photography.

Another pioneer of photography as art was Julia Margaret Cameron (1815-79), who received her first camera as a gift from her daughters when she was fortynine. Cameron's principal subjects were the great men of British arts, letters, and sciences, many of whom had long been family friends. Cameron's work was more personal and less dependent on existing forms than Reilander's. Like all of Cameron's portraits, that of the famous British historian Thomas Carlyle is deliberately slightly out of focus (fig. 27-36). Cameron was consciously rejecting the sharp stylistic precision of popular portrait photography, which she felt accentuated the merely physical attributes and neglected a subject's inner character. By blurring the details she sought to call attention to the light that suffused her subjects-a metaphor for creative genius—and to their thoughtful, often inspired expressions. In her autobiography

27-36. Julia Margaret Cameron. Portrait of Thomas Carlyle. 1867. Silver print, $10 \times 8''$ (25.4 × 20.3 cm). The Royal Photographic Society, Collection at National Museum of Photography, Film, and Television, England.

Cameron said: "When I have had such men before my camera my whole soul has endeavored to do its duty towards them in recording faithfully the greatness of the inner as well as the features of the outer man."

The Frenchman Gaspard-Félix Tournachon, known as Nadar (1820-1910), applied photography to an even more ambitious goal, initially adopting the medium in 1849 as an aid in realizing the "Panthéon-Nadar," a series of four lithographs intended to include the faces of all the well-known Parisians of the day. Nadar quickly saw both the documentary and the commercial potential of the photograph and in 1853 opened a portrait studio that became a meeting place for many of the great intellectuals and artists of the period. The first exhibition of Impressionist art was held there in 1874 (see page 979).

A realist in the tradition inaugurated by Daguerre, Nadar embraced photography because of its ability to capture people and their surroundings exactly: He took the first aerial photographs of Paris (from a hot-air balloon equipped with a darkroom), photographed the city's catacombs and sewers, produced a series on typical Parisians, and attempted to record all the leading figures of French culture. As can be seen in his portrait of the poet Charles Baudelaire (fig. 27-37), Nadar avoided props and formal poses in favor of informal ones determined by the sitters themselves. His goal was not so much an interpretation as a factual record of a sitter's characteristic appearance and demeanor.

27-37. Nadar (Gaspard-Félix Tournachon). Portrait of Charles Baudelaire. 1863. Silver print. Caisse Nationale des Monuments Historiques et des Sites, Paris.

The year this photograph was taken, Baudelaire published "The Painter of Modern Life," a newspaper article in which he called on artists to provide an accurate and insightful portrait of the times. The idea may have come from Nadar, who had been trying to do just that for some time. Although Baudelaire never wrote about the photographic work of his friend Nadar, he was highly critical of the vogue for photography and of its influence on the visual arts. In his Salon review of 1859 he said: "The exclusive taste for the True . . . oppresses and stifles the taste of the Beautiful. . . . In matters of painting and sculpture, the present-day Credo of the sophisticated is this: 'I believe in Nature . . . I believe that Art is, and cannot be other than, the exact reproduction of Nature. . . . ' A vengeful God has given ear to the prayers of this multitude. Daguerre is his Messiah."

NEW MATERIALS The positivist faith in AND TECHNOLOGY IN ARCHITECTURE AT MIDCENTURY

technological progress as the key to human progress spawned world's fairs that celebrated advances in in-

dustry and technology. The first of these fairs, the London Great Exhibition of 1851, introduced new building techniques that ultimately contributed to the temporary abandonment in the twentieth century of historicism—the use of historically based styles—in architecture.

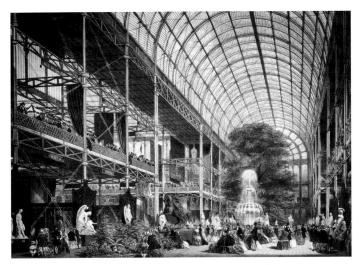

27-38. Joseph Paxton. Crystal Palace, London. 1850–51. Iron, glass, and wood.

After a competition that drew 245 entries failed to produce a design for a temporary edifice that could be completed in time for the London Great Exhibition, the commissioners approached Joseph Paxton, a professional gardener who had recently designed a number of impressive greenhouses, and asked him to submit a proposal. Paxton presented them with a design, scale drawings, and cost sheets for an exhibition hall that was, in effect, a greatly enlarged greenhouse. The commissioners, relieved but unenthusiastic, accepted his plan, and the structure was completed in the extraordinarily brief span of just over six months. After the exhibition, the Crystal Palace was dismantled and reconstructed in an enlarged form at Sydenham, where it remained until destroyed by a fire in 1936.

The revolutionary construction of the Crystal Palace (fig. 27-38), created for the London Great Exhibition by Joseph Paxton (1801-65), featured a structural skeleton of cast iron that held iron-framed glass panes measuring 49 by 30 inches, the largest size that could then be mass-produced. Prefabricated wooden ribs and bars supported the panes. The triple-tiered edifice was the largest space ever enclosed up to that time-1,851 feet long, covering more than 18 acres, and providing for almost a million square feet of exhibition space. The central vaulted transept—based on the new railway stations and, like them, meant to echo imperial Roman architecture—rose 108 feet to accommodate a row of elms dear to Prince Albert, the husband of Queen Victoria. Although everyone agreed that the Crystal Palace was a technological marvel, most architects and critics considered it a work of engineering rather than legitimate architecture. Some observers, however, were more forward-looking. One visitor called it a revolution in architecture from which a new style would date.

Bridge designers had pioneered the use of cast iron, wrought iron, and then steel, as a building material; the first cast-iron bridge had been erected in England in 1779 (see "Iron as a Building Material," page 935). The most famous early steel bridge, the Brooklyn Bridge (fig. 27-39), was designed by John Augustus Roebling (1806–69), a German-born civil engineer who had invented twisted-wire cable, a great structural advance

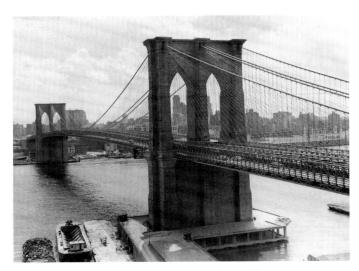

27-39. John Augustus Roebling and Washington Augustus Roebling. Brooklyn Bridge, New York City. 1867-83.

over the wrought-iron chains then used for suspension bridges. In 1867, Roebling was appointed chief engineer for the long-proposed Brooklyn–Manhattan bridge, whose main span would be the longest in the world at that time. He died two years later, and his engineer son Washington Augustus Roebling (1837–1926) completed the project.

The nearly 1,600-foot-long span hangs beneath a web of stabilizing and supporting steel-wire cables (the heaviest of which is 16 inches in diameter) suspended from two massive masonry towers that rise 276 feet above the water. The roadbed and cables are purely functional, with no decorative adornment, but the granite towers feature projecting cornices over pointed-arch openings. These historicist elements allude both to Gothic cathedrals and to Roman triumphal arches. Rather than religion or military victories, however, Roebling's arches celebrate the triumphs of modern engineers.

A less reverent attitude toward technological progress can be seen in the first attempt to incorporate structural iron into architecture proper: the Bibliothèque Sainte-Geneviève (fig. 27-40), a library in Paris designed by Henri Labrouste (1801–75). Conventionally trained at the École des Beaux-Arts and employed as one of its professors, Labrouste was something of a radical in his desire to reconcile the École's conservative design principles with the technological innovations of industrial engineers. Although reluctant to promote this goal in his teaching, he clearly pursued it in his practice.

Because of the Bibliothèque Sainte-Geneviève's educational function, Labrouste wanted the building to suggest the course of both learning and technology. The window arches on the exterior have panels with the names of 810 important contributors to Western thought from its religious origins to the positivist present, arranged chronologically from Moses to the Swedish chemist Jöns Jakob Berzelius. The exterior's strippeddown Renaissance style reflects the belief that the

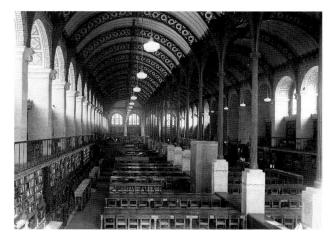

27-40. Henri Labrouste. Reading Room, Bibliothèque Sainte-Geneviève, Paris. 1843-50.

modern era of learning dates from that period. The move from outside to inside subtly outlines the general evolution of architectural techniques. The exterior of the library features the most ancient of permanent building materials, cut stone, which was considered the only "noble" construction material—that is, suitable for a serious building. The columns in the entrance hall are solid masonry with cast-iron decorative elements. In the main reading room, however, cast iron plays an undisguised structural role. Slender iron columns—cast to resemble the most ornamental Roman order, the Corinthian—support two parallel barrel vaults. The columns stand on tall concrete pedestals, a reminder that modern construction technology rests on the accomplishments of the Romans, who refined the use of concrete. The design of the delicate floral cast-iron ribs in the vaults is borrowed from the Renaissance architectural vocabulary.

ACADEMIC

FRENCH The Académie des Beaux-Arts and its official art school, the École des Beaux-ART AND Arts, exerted a powerful in-**ARCHITECTURE** fluence over the visual arts in France throughout the

nineteenth century (see "Academies and Academy Exhibitions," page 906). Academic artists controlled the Salon juries, and major public commissions routinely went to academic architects, painters, and sculptors.

Unlike Labrouste in the Bibliothèque Sainte-Geneviève, most later-nineteenth-century architects trained at the École des Beaux-Arts worked in historicist styles, typically using iron only as an internal support for conventional materials, as in the case of the Opéra, the Paris opera house (fig. 27-41) designed by Charles Garnier (1825-98). The Opéra was to be a focal point of a controversial urban redevelopment plan begun under Napoleon III by Georges-Eugène Haussmann (1809–91) in the 1850s. Garnier's design was selected in a competition despite Empress Eugénie's objection that it resembled no recognizable style. To her charge that it was "neither Louis XIV, nor Louis XV, nor Louis XVI," Garnier retorted, "It is Napoleon III." The massive facade, featuring a row of paired columns above an arcade, is essentially a heavily ornamented, Baroque version of the seventeenth-century wing of the Louvre, an association meant to suggest the continuity of French greatness and to flatter Emperor Napoleon III by comparing him favorably with King Louis XIV. The luxuriant treatment of

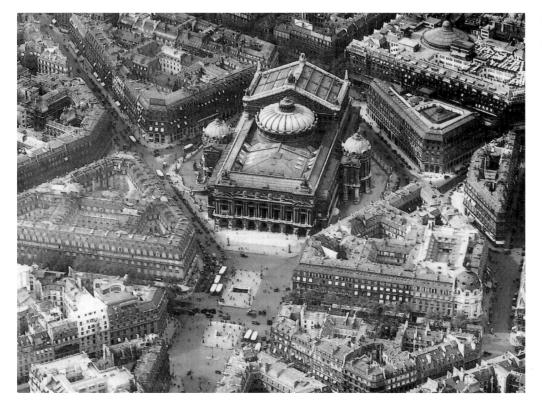

27-41. Charles Garnier. The Opéra, Paris. 1861-74.

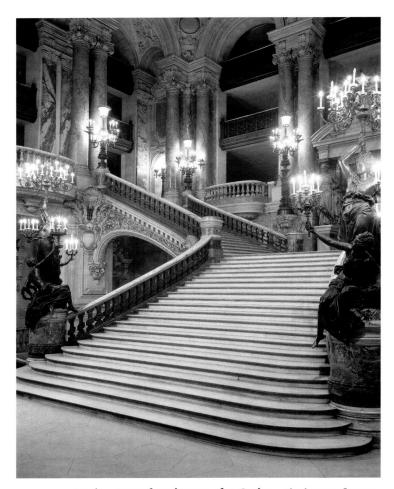

27-42. Grand staircase, the Opéra. The bronze figures holding the lights on the staircase are by Marcello, the pseudonym used by Adèle d'Affry (1836–79), the duchess Castiglione Colonna, as a precaution against the male chauvinism of the contemporary art world.

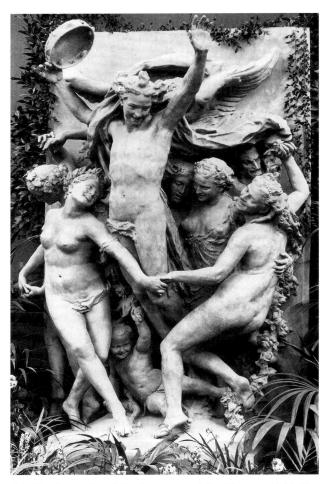

27-43. Jean-Baptiste Carpeaux. *The Dance.* 1867–68. Plaster, height approx. 15' (4.6 m). Musée de l'Opéra, Paris.

form, in conjunction with the building's primary function as a place of entertainment, was intended to celebrate the devotion to wealth and pleasure that characterized the period. The ornate architectural style was also appropriate for the home of that most flamboyant musical form, the opera.

The inside of what some critics called the "temple of pleasure" (fig. 27-42) was even more opulent, with neo-Baroque sculptural groupings, heavy, gilded decoration, and a lavish mix of expensive, polychromed materials. The highlight of the interior was not the spectacle onstage so much as the one on the great, sweeping Baroque staircase, where various members of the Paris elite—from old nobility to newly wealthy industrialists—could display themselves, the men in tailcoats accompanying women in bustles and long trains. As Garnier himself said, the purpose of the Opéra was to fulfill the most basic of human desires: to hear, to see, and to be seen.

Jean-Baptiste Carpeaux (1827–75), who had studied at the École des Beaux-Arts under the Romantic sculptor François Rude (see fig. 27-13), was commissioned to carve one of the large sculptural groups for the facade of

Garnier's Opéra (illustrated here in a plaster version). In this work, *The Dance* (fig. 27-43), a winged personification of Dance, a slender male carrying a tambourine, leaps up joyfully in the midst of a compact, entwined group of mostly nude female dancers, embodying the theme of uninhibited Dionysian revelry. The erotic implication of this wild dance is revealed by the presence in the background of a satyr, a mythological creature known for its lascivious appetite.

Carpeaux's group upset many Parisians because he had not smoothed and generalized the bodies as Neoclassical sculptors such as Canova had done (see fig. 26-21). Although the figures are idealized, their detailed musculature and bone structure (observe the knees and elbows, for example) make them appear not to be creatures of a higher, better world but to belong, instead, to the "real" world. Carpeaux's handling of the body and its parts has therefore been labeled realistic.

Carpeaux's unwillingness to idealize physical details was symptomatic of a major shift in French academic art in the second half of the nineteenth century. Although the influence of photography on the taste of the period has sometimes been cited as the probable cause of this

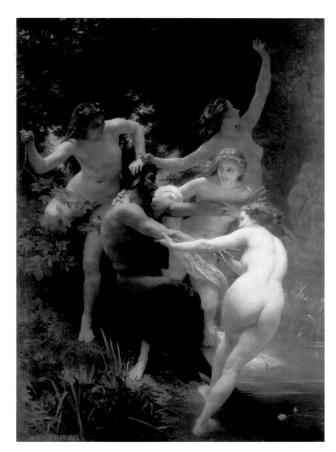

27-44. Adolphe-William Bouguereau. Nymphs and **a Satyr.** 1873. Oil on canvas, $9^{3}/8$ × $5^{10}/8$ (2.8 × 1.8 m). Sterling and Francine Clark Art Institute, Williamstown, Massachusetts.

change, both photography and the new exactitude in academic art were simply manifestations of the increasingly positivist values of the era. These values were particularly evident among the bankers and businesspeople who came to dominate French society and politics in the years after 1830. As patrons, these practical leaders of commerce were generally less interested in art that idealized than in art that brought the ideal down to earth.

The effect of this new taste on academic art is nowhere more evident than in the work of Adolphe-William Bouguereau (1825-1905), who became one of the richest and most powerful painters in France in the late nineteenth century by giving the public not only the subjects it wanted but also the factual detail it loved. In Nymphs and a Satyr (fig. 27-44), for example, four young and voluptuous wood nymphs attempt to drag a reluctant satyr into the water. The satyr's slight smile and the lack of real struggle suggest that this is good-natured teasing. The painting's power depends less on the subject than on the way Bouguereau was able to make it seem palpable and "real" through a highly detailed depiction of physical forms and textures. In order to produce a persuasive satyr

Bouguereau made careful anatomical studies of horses' ears and of the hindquarters of goats. Furthermore, Bouguereau makes the scene not only real but accessible. The figure on the right appears to lead both the satyr and the viewer into the scene—the world of the viewer and that of the painting seem continuous, so we are invited to join in the romp.

NATURALISM SPREAD

FRENCH Although the European national academies retained official control over both the AND REALISM teaching and the display of art AND THEIR in the second half of the nineteenth century, increasing numbers of artists rejected their precepts in favor of the

naturalist credo that art should faithfully record ordinary life. In the years after 1850, some of the work produced by these independent-minded landscape and figure painters was labeled realism, a term invented to describe a kind of naturalism with a socialist political message. By 1860 the term realism had lost its political meaning and had become for most artists and critics simply a synonym for naturalism.

FRENCH NATURALISM

The kind of work produced in the 1830s and 1840s by the Barbizon School (see fig. 27-22) became increasingly popular with Parisian critics and collectors after 1850, largely because of the radically changed conditions of Parisian life. Between 1831 and 1851 the city's population doubled, then the massive renovations of the entire city led by Haussmann transformed Paris from a collection of small neighborhoods to a modern, crowded, noisy, and fast-paced metropolis. Another factor in the appeal of images of peaceful country life was the widespread uneasiness over the political and social effects of the Revolution of 1848, when workers overthrew the monarchy, and fear of further disruptions.

Soothing images of the rural landscape became a specialty of Jean-Baptiste-Camille Corot (1796-1875), who during the early decades of his career had painted not only historical landscapes with subjects drawn from the Bible and classical history, but also ordinary country scenes similar to those depicted by the Barbizon School. Ironically, just as popular taste was beginning to favor the latter kind of work, Corot around 1850 moved on to a new kind of landscape painting that mixed naturalistic subject matter with Romantic, poetic effects. A fine example is First Leaves, Near Mantes (fig. 27-45, page 972), an idyllic image of budding green foliage in a warm, misty wood. The feathery brushwork in the grasses and leaves infuses the painting with a soft, dreamy atmosphere that is counterbalanced by the solidly modeled tree trunks in the foreground, which create a firm sense of structure. Beyond the trees, a dirt road meanders toward the village in the background. Two rustic figures travel along the road at the lower center, while another figure labors in the woods at the

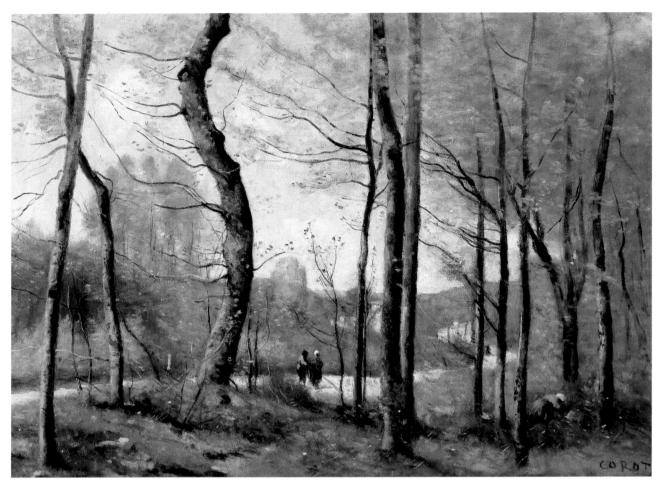

27-45. Jean-Baptiste-Camille Corot. *First Leaves, Near Mantes.* c. 1855. Oil on canvas, $13^3/8 \times 18^1/8''$ (34 × 46 cm). The Carnegie Museum of Art, Pittsburgh. Acquired through the generosity of the Sarah Mellon Scaife Family (66.19.3)

lower right. Corot invites us to identify with these figures and to share imaginatively in their simple and unhurried rural existence.

Among the period's most popular painters of farm life was Rosa Bonheur (1822–99), whose commitment to rural subjects was partly the result of her aversion to Paris, where she had been raised. Bonheur's success in what was then a male domain owed much to the socialist convictions of her parents, who belonged to a radical utopian sect founded by the Comte de Saint-Simon (1760–1825), which believed not only in the equality of women but also in a female Messiah. Bonheur's father, a drawing teacher, provided most of her artistic training.

Bonheur devoted herself to painting her beloved farm animals with complete accuracy, increasing her knowledge by reading zoology books and making detailed studies in stockyards and slaughterhouses. (To gain access to these all-male preserves, Bonheur got police permission to dress in men's clothing.) Her professional breakthrough came at the Salon of 1848, where she showed eight paintings and won a first-class medal. Shortly after, she received a government commission to paint *Plowing in the Nivernais: The Dressing of the Vines*

(fig. 27-46), a monumental composition featuring one of her favorite animals, the ox. The powerful beasts, anonymous workers, and fertile soil offer a reassuring image of the continuity of agrarian life. The stately movement of people and animals reflects the kind of carefully balanced compositional schemes taught in the academy and echoes scenes of processions found in classical art. The painting's compositional harmonythe shape of the hill is answered by and continued in the general profile of the oxen and their handler on the right—as well as its smooth illusionism and conservative theme were very appealing to the taste of the times. Bonheur became so famous that in 1865 she received France's highest award, membership in the Legion of Honor, becoming the first woman to be awarded its Grand Cross.

The most renowned of the French rural naturalists, Jean-François Millet (1814–75), grew up on a farm and, despite living in Paris between 1837 and 1848, never felt comfortable in the city. The Revolution's preoccupation with ordinary people led Millet to focus on peasant life, only a marginal concern in his early work, and his support of the Revolution earned him a state commission that allowed him to move from Paris to the village of

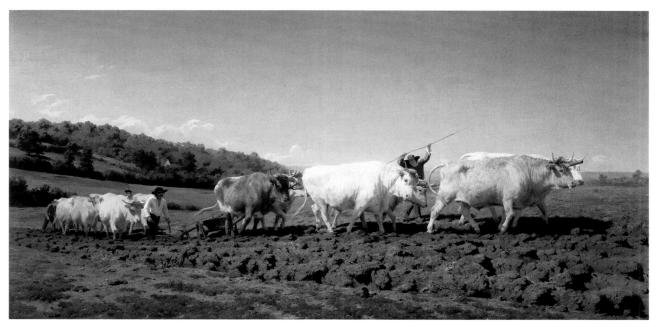

27-46. Rosa Bonheur. *Plowing in the Nivernais: The Dressing of the Vines.* 1849. Oil on canvas, $5'9'' \times 8'8''$ (1.8 \times 2.6 m). Musée d'Orsay, Paris.

Bonheur was often compared with Georges Sand, a contemporary woman writer who adopted a male name as well as male dress. Sand devoted several of her novels to the humble life of farmers and peasants. Critics at the time noted that *Plowing in the Nivernais* may have been inspired by a passage in Sand's *The Devil's Pond* (1846) that begins: "But what caught my attention was a truly beautiful sight, a noble subject for a painter. At the far end of the flat ploughland, a handsome young man was driving a magnificent team [of] oxen."

Barbizon. After settling there in 1849, he devoted his art almost exclusively to the difficulties and simple pleasures of rural existence.

Among the best known of Millet's mature works is The Gleaners (fig. 27-47), which shows three women gathering grain at harvesttime. The warm colors and slightly hazy atmosphere are soothing, but the scene is one of extreme poverty. Gleaning, or the gathering of the grains left over after the harvest, was a form of relief offered to the rural poor. It required hours of backbreaking work to gather enough wheat to produce a single loaf of bread. When the painting was shown in 1857, a number of critics thought Millet was attempting to rekindle the sympathies and passions of 1848, and he was therefore labeled a realist. Yet Millet's intentions were actually quite conservative. An avid reader of the Bible, he saw in such scenes the fate of humanity, condemned since the Expulsion of Adam and Eve from the Garden of Eden to earn its bread by the sweat of its brow. Millet was neither a revolutionary nor a reformer but a fatalist who found the peasant's heroic acceptance of the human condition exemplary.

FRENCH REALISM

Gustave Courbet (1819–77), like Millet, was inspired by the events of 1848 to turn his attention to poor and ordinary people. Born and raised in Ornans near the Swiss border and largely self-taught as an artist, he moved to Paris in 1839. The street fighting of 1848 seems to have radicalized him. He told one newspaper in 1851 that he was "not only a Socialist but a democrat

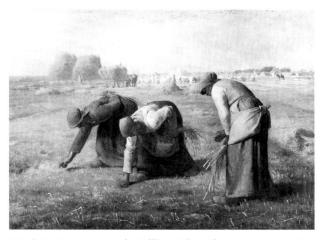

27-47. Jean-François Millet. *The Gleaners.* 1857. Oil on canvas, $33 \times 44''$ (83.8 \times 111.8 cm). Musée d'Orsay, Paris.

and a Republican: in a word, a supporter of the whole Revolution." Courbet proclaimed his new political commitment in three large paintings he submitted to the Salon of 1850–51.

One of these, *The Stone Breakers* (fig. 27-48, page 974), is a large painting showing two haggard men laboring to produce gravel used for roadbeds. In a letter he wrote while working on the painting, Courbet described its origins and considered its message:

[N]ear Maisières [in the vicinity of Ornans], I stopped to consider two men breaking stones on the highway. It's rare to meet the most complete expression of

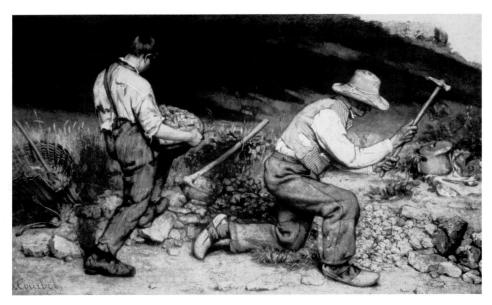

27-48. Gustave Courbet. *The Stone Breakers.* 1849. Oil on canvas, $5'3'' \times 8'6''$ (1.6 \times 2.59 m). Formerly Gemäldegalerie, Dresden. Believed to have been destroyed in World War II.

poverty, so an idea for a picture came to me on the spot. I made an appointment with them at my studio for the next day. . . . On the one side is an old man, seventy. . . . On the other side is a young fellow . . . in his filthy tattered shirt. . . . Alas, in labor such as this, one's life begins that way, and it ends the same way.

Despite its subject, the painting is not an obvious piece of political propaganda. By hiding the faces of his two protagonists, Courbet makes it difficult for the viewer to identify with them and their plight. He treats them simply as two more facts in a painting that emphasizes the appearance, texture, and weight of things, largely through the use of thickly applied paint (often laid down with a palette knife) that conveys the rugged materiality of the physical world. This impersonal treatment of the workers and the reference in Courbet's letter to the sad course of the laborer's life have led some to consider The Stone Breakers less as a political protest than an expression of conservative fatalism akin to Millet's. On the other hand, Courbet's friend the socialist philosopher Pierre-Paul Proudhon, in 1865, called The Stone Breakers the first socialist picture ever painted, "a satire on our industrial civilization, which continually invents wonderful machines to perform all kinds of labor . . . yet is unable to liberate man from the most backbreaking toil." And Courbet himself, in a letter of the following year, referred to the painting as a depiction of "injustice."

Courbet's representation of *The Stone Breakers* on an 8 ½-foot-wide canvas testified in a provocative way to the painter's respect for ordinary people. In French art before 1848, such people usually had been shown only in modestly scaled paintings, while monumental canvases had been reserved for heroic subjects and pictures of the powerful. Immediately after completing *The Stone Breakers*, Courbet began work on an even larger canvas,

roughly 10 by 21 feet, focusing on another scene of ordinary life: the funeral of an unnamed bourgeois citizen of Ornans. A Burial at Ornans (fig. 27-49), also exhibited at the Salon of 1850-51, was attacked by conservative critics, who objected to its presentation of a mundane provincial funeral on a scale normally reserved for the depiction of a major historical event and who faulted its disrespect for conventional compositional standards: Instead of arranging figures in a pyramid that would indicate a hierarchy of importance, Courbet lined them up in rows across the picture plane—an arrangement he considered more democratic. The painter's political convictions are especially evident in the individual attention and sympathetic treatment he accords the ordinary citizens of Ornans, many of them Courbet's friends and family members.

Partly for convenience, Bonheur, Millet, Courbet, and the other country-life naturalists and realists who emerged in the 1850s are sometimes referred to as the generation of 1848. Because of his sympathy with working-class people, Honoré Daumier (1808–79) is also grouped with this generation. Unlike Courbet and the others, however, Daumier often depicted urban scenes, as in his famous early lithograph Rue Transnonain, Le 15 Avril 1834 (see fig. 26, Introduction) and his later oil painting The Third-Class Carriage (fig. 27-50). The painting depicts the interior of one of the large, horse-drawn buses that transported Parisians along one of the new boulevards Haussmann had introduced as part of the city's redevelopment. Daumier places the viewer in the poor section of the bus, opposite a serene grandmother, her daughter, and her two grandchildren. Although there is a great sense of intimacy and unity among these people, they are physically and mentally separated from the upper- and middle-class passengers, whose heads appear behind them.

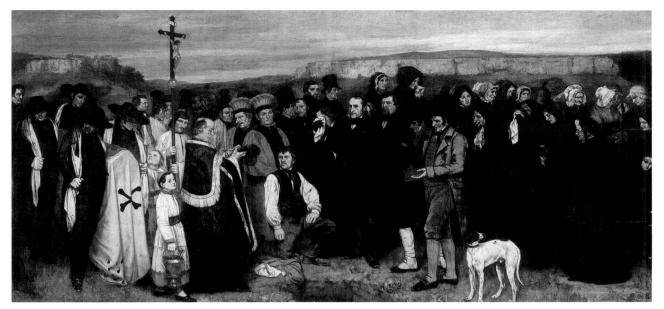

27-49. Gustave Courbet. A Burial at Ornans. 1849. Oil on canvas, $10'3^{1}/_{9}'' \times 21'9''$ (3.1 × 6.6 m). Musée de Orsay, Paris.

A Burial at Ornans was inspired by the 1848 funeral of Courbet's maternal grandfather, Jean-Antoine Oudot, a veteran of the Revolution of 1793. The painting is not meant as a record of that particular funeral, however, since Oudot is shown alive in profile at the extreme left of the canvas, his image adapted by Courbet from an earlier portrait. The two men to the right of the open grave, dressed not in contemporary but in late-eighteenth-century clothing, are also revolutionaries of Oudot's generation, and their proximity to the grave suggests that one of their peers is being buried. Courbet's picture may be interpreted as linking the revolutions of 1793 and 1848, both of which sought to advance the cause of democracy in France.

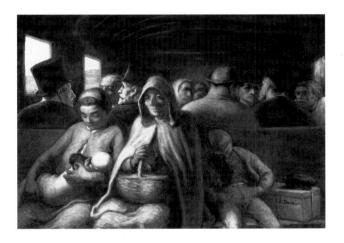

27-50. Honoré Daumier. The Third-Class Carriage.

c. 1862. Oil on canvas, $25^3/_4 \times 35^1/_2$ " (65.4 \times 90.2 cm). The National Gallery of Canada, Ottawa.

Purchase, 1946

Although he devoted himself seriously to oil painting during the later decades of his life, Daumier was known to the Parisian public primarily as a lithographer whose cartoons and caricatures appeared regularly in the press. Early in his career he drew antimonarchist caricatures critical of King Louis-Philippe, but censorship laws imposed in 1835 obliged him to focus on social and cultural themes of a nonpolitical nature.

NATURALISM AND REALISM OUTSIDE FRANCE

Following the French lead, artists of other western European nations also embraced naturalism and realism in the period after 1850. Among them was the German painter Wilhelm Leibl (1844–1900), who worked in a conventional academic style until a decisive meeting with Courbet in 1869 that spurred him to travel to Paris and familiarize himself with its naturalist currents. After Leibl's return to Germany, he lived in Munich for several years before moving to rural Bavaria, in southern Germany, where he dedicated himself to peasant subjects.

Leibl used villagers as models for his best-known painting, *Three Women in a Village Church* (fig. 27-51, page 976), which contrasts the plain but fresh beauty of

its foreground figure with the weathered faces of those behind her. More than a reverie on youthful beauty, however, the painting also extols the conservative customs and values of these traditionally dressed and ardently pious people. Even the elaborately carved pews, which seem to date from the Baroque period, suggest a faithfulness to the past. The scene is rendered with a minute care that owes more to the example of Hans Holbein (see fig. 18-76) than to that of Courbet. Leibl thereby demonstrates his own devotion to time-honored artistic standards threatened by innovation and change.

In Russia, too, realism developed in relation to a new concern for the peasantry. In 1861 the czar abolished serfdom, emancipating Russia's peasants from the virtual slavery they had endured on the large estates of the aristocracy. Two years later a group of painters

27-51. Wilhelm Leibl. *Three Women in a Village Church*. 1878–82. Oil on canvas, approx. 29×25 " (73.7 \times 63.5 cm). Kunsthalle, Hamburg.

About this painting Leibl wrote to his mother in 1879: "Here in the open country and among those who live close to nature, one can paint naturally. . . . It takes great staying power to bring such a difficult, detailed picture to completion in the circumstances. Most of the time I have literally taken my life in my hands in order to paint it. For up to now the church has been as cold as a grave, so that one's fingers get completely stiff. Sometimes, too, it is so dark that I have the greatest difficulty getting a clear enough view of the part on which I am working. . . . Several peasants came to look at it just lately, and they instinctively folded their hands in front of it. . . . I have always set greater store by the opinion of simple peasants than by that of so-called painters."

inspired by the emancipation declared allegiance to both the peasant cause and freedom from the St. Petersburg Academy of Art, which had controlled Russian art since 1754. Rejecting what they considered the escapist, "art for art's sake" aesthetics of the academy, the members of the group dedicated themselves to a socially useful realism. Committed to bringing art to the people in traveling exhibitions, they called themselves the Wanderers. By the late 1870s members of the group, like their counterparts in music and literature, had also joined a nationalistic movement to reassert what they considered to be an authentic Russian culture rooted in the traditions of the peasantry, rejecting the western European customs that had long predominated among the Russian aristocracy.

Ilya Repin (1844–1930), who attended the St. Petersburg Academy and won a scholarship to study in Paris, joined the Wanderers in 1878 after his return to Russia. Repin painted a series of works illustrating the social injustices then prevailing in his homeland, including *Bargehaulers on the Volga* (fig. 27-52). The painting fea-

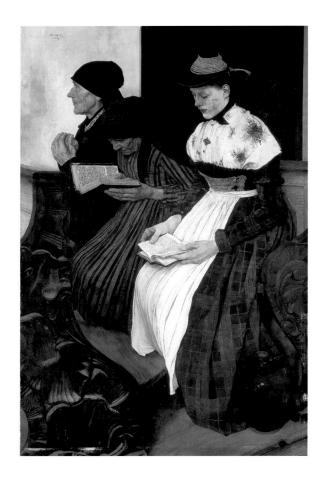

tures a group of wretchedly dressed peasants condemned to the brutal work of pulling ships up the Volga River. To heighten our sympathy for these workers, Repin placed a youth in the center of the group, a young man who will soon look as old and tired as his companions unless something is done to rescue him. In this way, the painting is a cry for action.

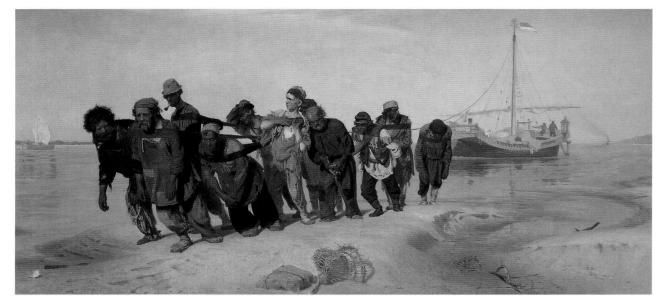

27-52. Ilya Repin. *Bargehaulers on the Volga.* 1870–73. Oil on canvas, $4'3\sqrt[3]{4}'' \times 9'3''$ (1.3 × 2.81 m). State Russian Museum, St. Petersburg.

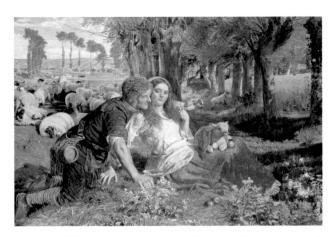

27-53. William Holman Hunt. The Hireling Shepherd. 1851. Oil on canvas, $30^{1}/_{8} \times 43^{1}/_{8}$ " (76.4 × 109.5 cm). Manchester City Art Gallery, England.

NINETEENTH-**CENTURY ART**

LATE- In 1848 seven young London artists formed the Pre-Raphaelite Brotherhood in response to what they considered the mis-IN BRITAIN guided practices of contemporary British art. Instead of the

Raphaelesque conventions taught at the Royal Academy, the Pre-Raphaelites advocated the naturalistic approach of certain early Renaissance masters, especially those of northern Europe. They advocated as well a moral approach to art, in keeping with a long tradition in Britain established by Hogarth (see fig. 26-32).

The combination of didacticism and naturalism that characterized the first phase of the movement is best represented in the work of one of its leaders, William Holman Hunt (1827-1910), for whom moral truth and visual accuracy were synonymous. A well-known painting by this academically trained artist is The Hireling Shepherd (fig. 27-53). Hunt painted the landscape portions of the composition outdoors, an innovative approach at the time, leaving space for the figures, which he painted in his London studio. The work depicts a farmhand neglecting his duties to flirt with a woman while pretending to discuss a death's-head moth that he holds in his hand. Meanwhile, some of his employer's sheep are wandering into an adjacent field, where they may become sick or die from eating green corn. Hunt later explained that he meant to satirize pastors who instead of tending their flock waste time discussing what he considered irrelevant theological questions. The painting can also be seen as a moral lesson on the perils of temptation. The woman is cast as a latter-day Eve, as she feeds an apple-a reference to humankind's fall from grace-to the lamb on her lap and distracts the shepherd from his duty.

The other major members of the group, John Everett Millais (1829-96) and Dante Gabriel Rossetti (1828-82), were less inclined to this sort of moralizing and by 1852 had broken with Hunt, which led to the dissolution of the group. In 1857 Rossetti, son of an exiled Italian poet and a poet himself, met two young Oxford students,

William Morris (1834–96) and Edward Burne-Jones (1833-98), while working on a mural at the university. Their shared interest in the Middle Ages inaugurated the second, unofficial phase of Pre-Raphaelitism.

Morris's wife, Jane Burden, became Rossetti's favorite model. Her particular blend of physical beauty and sad, aloof spirituality perfectly suited Rossetti's vision of the Middle Ages and lent itself to his yearning for the spiritual beauty he found lacking in the modern world. After Rossetti and Burden became lovers, sometime in the 1860s, his images of her took on an added biographical dimension. La Pia de' Tolommei (fig. 27-54, page 978) uses an incident from Dante's Purgatory to articulate the artist's own unhappy romantic situation. La Pia ("Pious One"), locked up by her husband in a castle, was soon to die. The rosary and prayer book in front of her refer to her piety, the banner lances of her husband on the ramparts suggest her captivity, and the sundial and ravens allude to her impending death. Her continuing love for her husband, author of the letters lying under the prayer book, is symbolized by the evergreen ivy behind her. However, the luxuriant fig leaves that surround her, traditionally associated with lust and the Fall, have no source in Dante's tale. Rossetti further personalizes the tale by showing her fingering her wedding ring, a captive not so much of her husband as of her marriage.

William Morris worked briefly as a painter under the influence of Rossetti before turning his attention to interior design and decoration. Morris's interest in handcrafts developed in the context of a widespread reaction against the gaudy design of industrially produced goods that began with the Crystal Palace exhibition of 1851. Unable to find satisfactory furnishings for their new home after marrying Burden in 1859, Morris designed and made them himself with the help of friends. He then founded a decorating firm to produce a full range of medieval-inspired objects. Although many of the furnishings offered by Morris & Company were expensive, one-of-a-kind items, others, such as the rush-seated chair illustrated here (fig. 27-55, page 978), were cheap and simple, intended to provide a handcrafted alternative to the vulgar excess characteristic of industrial furniture. Concerned with creating a "total" environment, Morris and his colleagues designed not only furniture but also stained glass, tiles, wallpaper, and fabrics, such as the Peacock and Dragon curtain seen in the background of figure 27-55.

Morris inspired what became known as the Arts and Crafts movement. His aim was to benefit not just a wealthy few but society as a whole. As he asked in the lectures he began delivering in 1877, "What business have we with art at all unless we can share it?" A socialist, Morris sought to eliminate the machine not only because he found its products ugly but also because of its deadening influence on the worker. With craftwork, he maintained, the laborer gets as much satisfaction as the consumer. Unlike his Pre-Raphaelite friends, who wished to escape into idealizations of the Middle Ages, Morris saw in that era the model for economic and social reform.

27-54. Dante Gabriel Rossetti. *La Pia de' Tolommei*.

1868–69. Oil on canvas, $41\frac{1}{2} \times 47\frac{1}{2}$ " (105.4 \times 119.4 cm). Spencer Museum of Art, University of Kansas, Lawrence.

In addition to his work as a painter and poet, Rossetti created innovative and beautiful designs for picture frames, book bindings, wallpaper, and furniture, as well as architectural sculpture and stained glass. The gilded frames he designed for his pictures were intended to enhance their decorative effect and make their meaning clearer through inscriptions and symbols. The massive frame surrounding La Pia de' Tolommei features simple moldings on either side of broad, sloping boards, into which are set a few large roundels. The title of the painting is inscribed above the paired roundels at the lower center. On either side of them appear four lines from Dante's Purgatory spoken by the spirit of La Pia, in Italian at the left and in Rossetti's English translation at the right, which reads: "Remember me who am La Pia,-me/From Siena sprung and by Maremma dead./This in his inmost heart well knoweth he/With whose fair jewel I was ringed and wed."

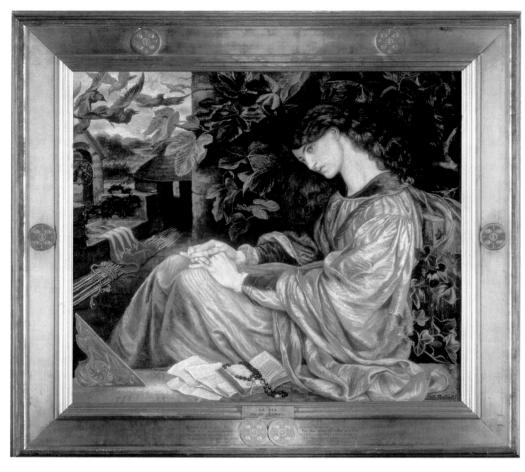

27-55. (foreground) **Philip Webb (?). Single chair from the Sussex range.** In production from c. 1865. Ebonized wood with rush seat, $33 \times 16^{1}/_{2} \times 14''$ (83.8 \times 42 \times 35.6 cm). Manufactured by Morris & Company. William Morris Gallery (London Borough of Waltham Forest). (background) **William Morris.** *Peacock and Dragon curtain.* 1878. Handloomed jacquard-woven woolen twill, $12'10^{1}/_{2}'' \times 11'5^{5}/_{8}''$ (3.96 \times 3.53 m). Manufactured at Queen Square and later at Merton Abbey. Victoria and Albert Museum, London.

Morris and his principal furniture designer, Philip Webb (1831–1915), adapted the Sussex range from traditional rush-seated chairs of the Sussex region. The handwoven curtain in the background is typical of Morris's fabric design in its use of flat patterning that affirms the two-dimensional character of the textile medium. The pattern's prolific organic motifs and soothing blue and green hues—the decorative counterpart to those of naturalistic landscape painting—were meant to provide relief from the stresses of modern urban existence.

27-56. James Abbott McNeill Whistler. Black Lion **Wharf.** 1859. Etching, $5\frac{7}{8} \times 8\frac{7}{8}$ " (15 × 22.6 cm). The Metropolitan Museum of Art, New York. Harris Brisbane Dick Fund, 1917 (17.3.35)

A copy of this work can be seen on the wall in Whistler's most famous painting, the portrait of his mother, whose formal title is Arrangement in Gray and Black, No. 1 (1871). That title communicates Whistler's priority in his later work of creating harmonious relationships of form and color over recording an accurate likeness of his subject.

Not all of those who participated in the revival of the decorative arts were committed to improving the conditions of modern life. Many, including the American expatriate James Abbott McNeill Whistler (1834-1903), saw in the Arts and Crafts revival simply another way to satisfy an elitist taste for beauty. After failing out of West Point in the early 1850s, Whistler studied art in Paris, where he came under the influence of Courbet. His first important works were etchings, such as Black Lion Wharf (fig. 27-56), a naturalistic image of life along the Thames River. Although inspired by Courbet, Whistler's etching shows little of the French artist's interest in either the solid tangibility of things or the social significance of work. Because of its horizontal emphasis and the absence of a strong focal point, our eye scans the etching's registers, making a quick survey of its picturesque details before passing on and out of the frame. This approach to composition anticipates the French Impressionists. The work is important, too, because of Whistler's crucial early place in the print revival of the later nineteenth century (see "The Print Revivals," page 984).

Whistler produced Black Lion Wharf soon after he moved, in 1859, to London, partly to distance himself from Courbet and his influence. The new vogue for the arts of Japan helped fuel in him a growing dissatisfaction with naturalism (see "Japonisme," page 988). Whistler had been one of the first to collect Japanese art when it became available in curio shops in London and Paris after the 1853 reopening of that nation to the West. The simplified, elegant forms and subtle chromatic harmonies of Japanese art (Chapter 22) had a profound influence on his paintings of the early 1860s such as Rose and Silver: The Princess from the Land of Porcelain (see fig. 21, Introduction, showing the Peacock Room Whistler later designed to house it), which shows a Caucasian woman dressed in a Japanese robe and posed amid a collection of Asian artifacts. The work is Whistler's answer to the medieval costume pieces of the Pre-Raphaelites. What Whistler saw in Japanese objects was neither a preferable world nor a way to reform European decorative arts, but rather a model for painting. As the work's main title declares, Whistler attempted to create a formal and coloristic harmony similar to that of the objects displayed in the room. Thus, delicate organic shapes are shown against a rich pattern of colors orchestrated around silver and rose. By leaving his wet brushmarks visible, Whistler emphasized the paint itself over the depicted subject.

Whistler's growing commitment to "art for art's sake," or an art of purely aesthetic values, culminated in the highly abstracted nocturnes, or night scenes, he began to paint in the mid-1860s. In pictures such as Nocturne: Blue and Gold-Old Battersea Bridge (see "Japonisme," page 988), Whistler reduced his palette to a few subtle tones and simplified the elements of the scene into smudgy silhouettes, transforming the ugly banks of the industrialized Thames into a realm of evocative beauty and mystery.

IMPRESSIONISM While British artists were moving away from the naturalism advocated by the original Pre-Raphaelite Brotherhood, their French counterparts were pushing the French realist tradition into new territory. Instead of themes of the working classes and rural life that had engaged Courbet, Corot, and the Barbizon painters, the generation that matured around 1870 was generally devoted to subjects of leisure, the upper middle class, and the city. Although many of these artists specialized in paintings of the countryside, their point of view was usually that of a city person on holiday.

In April 1874, a number of these artists, including Paul Cézanne, Edgar Degas, Claude Monet, Berthe Morisot, Camille Pissarro, and Pierre-Auguste Renoir, exhibited together in Paris as the Société Anonyme des Artistes Peintres, Sculpteurs, Graveurs, etc. (Corporation of Artists Painters, Sculptors, Engravers, etc.). All thirty participants agreed not to submit anything that year to the Salon, which had in the past often rejected their works; hence, their exhibition was a declaration of independence from the academy and a bid to gain the attention of the public without the intervention of a jury. While the exhibition received some positive reviews, it was attacked by conservative critics. Louis Leroy, writing in the comic journal Charivari, seized on the title of a painting by Monet, Impression, Sunrise (1873), and dubbed the entire exhibition "impressionist." While Leroy used the word to attack the seemingly haphazard technique and unfinished look of some of the paintings, Monet and many of his colleagues were pleased to accept the label, which spoke to their concern for capturing an instantaneous impression of a scene in nature. Seven more Impressionist exhibitions followed between 1876 and 1886, with the membership of the group

varying slightly on each occasion; only Pissarro participated in all eight shows. The exhibitions of the Impressionists inspired other artists to organize alternatives to the Salon, a development that by the end of the century ended the French Academy's centuries-old stranglehold on the display of art and thus on artistic standards.

Frustration among progressive artists with the exclusionary practices of the Salon jury had been mounting in the decades preceding the first Impressionist exhibition. Such discontent reached a crescendo in 1863 when the jury turned down nearly 3,000 works submitted to the Salon, leading to a storm of protest. In response, Napoleon III ordered an exhibition of the refused work called the Salon des Refusés ("Salon of the Rejected Ones"). Featured in it was a painting by Édouard Manet (1832–83), *Le Déjeuner sur l'Herbe* (fig. 27-57), which scandalized contemporary viewers and helped to establish Manet as a radical artist. Within a few years, many of the future Impressionists would gather around Manet and follow his lead in challenging academic conventions.

A well-born Parisian who had studied in the early 1850s with the progressive academician Thomas Couture (1815–79), Manet had by the early 1860s developed a strong commitment to realism, largely as a result of

his friendship with the poet Baudelaire (see fig. 27-37). In his article "The Painter of Modern Life," Baudelaire called for an artist who would be the painter of contemporary manners, "the painter of the passing moment and all the suggestions of eternity that it contains." Manet seems to have responded to Baudelaire's call in painting Le Déjeuner sur l'Herbe, whose frank declaration of modernity was deeply offensive to both the academic establishment and the average Salon-goer. Most disturbing to contemporary viewers was the "immorality" of Manet's theme: a suburban picnic featuring a scantily clad bathing woman in the background and, in the foreground, a completely naked woman, seated alongside two fully clothed, upperclass men. Manet's scandalized audience assumed that these women were prostitutes and that the welldressed men were their clients.

Manet apparently conceived of *Le Déjeuner sur l'Herbe* as a modern version of a famous Venetian Renaissance painting in the Louvre, the *Pastoral Concert*, then believed to be by Giorgione but now attributed to both Titian and Giorgione (see fig. 18-25 and "Artistic Allusions in Manet's Art," below). The intended meaning of *Le Déjeuner* remains a matter of considerable debate. Some see it as a portrayal of modern alienation, for the

ARTISTIC ALLUSIONS IN MANET'S ART

Édouard Manet had in his studio a copy of *The Pastoral Concert*, a work in the Louvre then attributed to Giorgione and now attributed to both Titian and Giorgione (see

fig. 18-25). His Déjeuner sur l'Herbe (see fig. 27-57) was clearly inspired by The Pastoral Concert, a modern reply to its theme of ease in nature. Manet also adapted for his composition a group of river gods and a nymph from an engraving by Marcantonio Raimondi based on Raphael's The Judgment of Paris-an image that, in turn, looked back to classical reliefs. Manet's allusion to the engraving was apparent to some observers at the time, such as the critic Ernest Chesneau, specifically noted this borrowing and objected to it.

With its deliberate allusions to Renaissance art works, Manet's painting addresses not just the subject of figures in a landscape: It

also addresses the history of art and Manet's relationship to it by encouraging the viewer to compare his painting with those that inspired it. To a viewer who has in mind the traditional perspective and the rounded modeling of forms of the two Re-

naissance works, the stark lighting of Manet's nude and the flat, cutout quality of his figures become all the more shocking. Thus, by openly referring to these exemplary works of the past, Manet emphasized his own radical innovations.

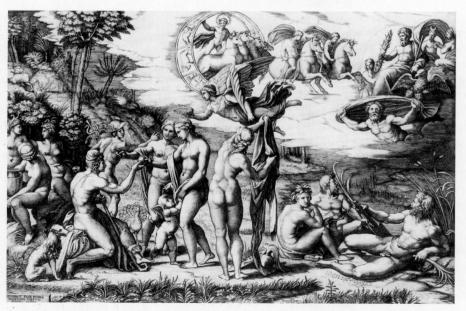

Marcantonio Raimondi, after Raphael's *The Judgment of Paris*. c. 1520. Engraving Yale University Art Gallery, New Haven.
Gift of Edward B. Greene, Yale 1990

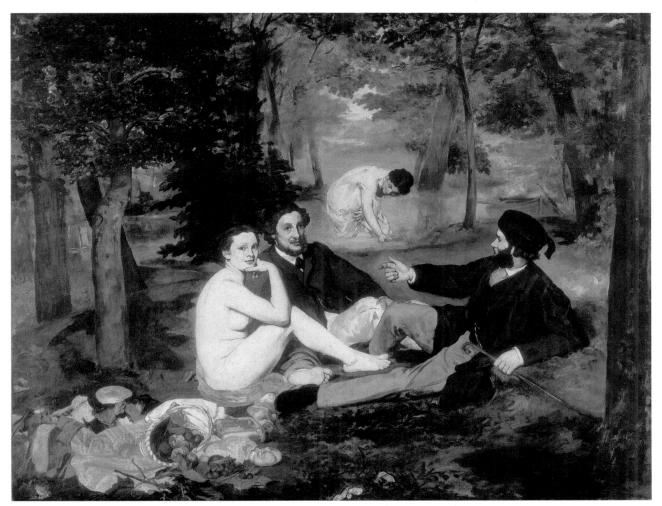

27-57. Édouard Manet. *Le Déjeuner sur l'Herbe (The Luncheon on the Grass).* 1863. Oil on canvas, $7' \times 8'8''$ (2.13 \times 2.64 m). Musée d'Orsay, Paris.

figures in Manet's painting fail to connect with one another psychologically. Although the man on the right seems to gesture toward his companions, the other man gazes off absently while the nude turns her attention away from them and to the viewer. Moreover, her gaze makes us conscious of our role as outside observers; we, too, are estranged. Manet's rejection of warm colors for a scheme of cool blues and greens plays an important role, as do his flat, sharply outlined figures, which seem starkly lit because of the near absence of modeling. The figures are not integrated with their natural surroundings, as in the *Pastoral Concert*, but seem to stand out sharply against them, as if seated before a painted backdrop.

Shortly after completing *Le Déjeuner sur l'Herbe* Manet painted *Olympia* (fig. 27-58), whose title alluded to a socially ambitious prostitute of the same name in a novel and play by Alexandre Dumas *fils* (the younger). Like *Le Déjeuner sur l'Herbe, Olympia* was based on a Venetian Renaissance source, Titian's *Venus of Urbino* (see fig. 18-27), which Manet had earlier copied in Florence. At first, Manet's painting appears to pay homage to Titian's in its subject matter (the Titian painting was then believed to be the portrait of a Venetian courtesan)

and composition. However, Manet made his modern counterpart the very antithesis of the Titian. Whereas Titian's female is curvaceous and softly rounded, Manet's is angular and flattened. Whereas Titian's looks

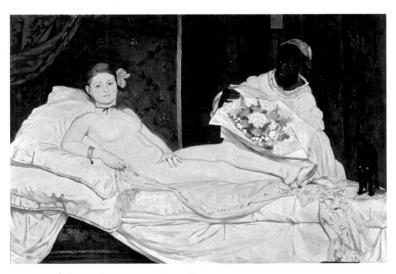

27-58. Édouard Manet. *Olympia.* 1863. Oil on canvas, $4'3'' \times 6'2^{1/4}''$ (1.31 \times 1.91 m). Musée du Louvre, Paris.

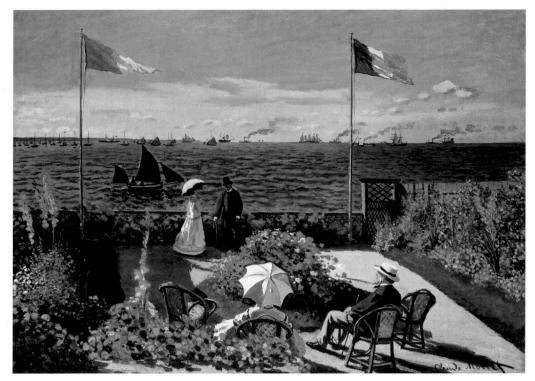

27-59. Claude Monet. *Terrace at Sainte-Adresse*. 1867. Oil on canvas, $38^{5}/_{8} \times 51^{1}/_{8}$ " (98.1 × 129.9 cm). The Metropolitan Museum of Art, New York. Purchased with special contribution and purchase fund given or bequeathed by friends of the museum, 1967 (67.241)

lovingly at the male spectator, Manet's appears coldly indifferent. Our relationship with Olympia is underscored by the reaction of her cat, who—unlike the sleeping dog in the Titian—arches its back at us. Finally, instead of looking up at us, Olympia stares down on us, indicating that she is in the position of power and that we are subordinate, akin to the black servant at the foot of the bed who brings her a bouquet of flowers. In reversing the Titian, Manet in effect subverted the entire tradition of the accommodating female nude. Not surprisingly, conservative critics vilified the *Olympia* when it was displayed at the Salon of 1865.

By this time Manet had become the unofficial leader of a group of progressive artists and writers who gathered at the Café Guerbois in the Montmartre district of Paris. Among the artists who frequented the café were Degas, Monet, Pissarro, and Renoir, who would soon exhibit together as the Impressionists. With the exception of Degas, who, like Manet, remained a studio painter, these artists began to paint outdoors, *en plein air* ("in the open air"), in an effort to record directly the fleeting effects of light and atmosphere. (*Plein air* painting was greatly facilitated by the invention in 1841 of tin tubes for oil paint.)

Born in Paris but raised in the port city of Le Havre, the academically trained Claude Monet (1840–1926) made many of his earliest efforts at *plein air* painting along the Normandy coast in the late 1860s. In 1867 he painted several beach scenes at Sainte-Adresse, a small resort town just north of Le Havre, including *Terrace at Sainte-Adresse* (fig. 27-59). With its strong light, rich

shadows, and bold colors, the painting conveys the sparkling freshness of a bright summer day on the seaside. Elegantly dressed members of the *haute bourgeoisie* (upper middle class) enjoy the weather and relax on a terrace blooming with colorful flowers. The actual setting was the seaside villa of Monet's aunt, and the models for the painting were members of Monet's family, including his father, seated at the lower right. To contemporary viewers unaware of these facts, however, the figures would have appeared simply as well-to-do vacationers taking their leisure in pleasant surroundings.

Despite its informal subject, *Terrace at Sainte-Adresse* features a carefully calculated design, inspired by the Japanese prints that fascinated so many Western artists at this time (see "*Japonisme*," page 988). The flagpoles and flags, fence, and horizon line form a geometric structure of verticals and horizontals, responding to the edges of the rectangular canvas and asserting the two-dimensionality of its surface. The high vantage point also serves to flatten out the picture's space, which seems to climb up the composition in horizontal bands rather than receding into depth. Equally assertive of the picture plane are the many discrete strokes and touches of pure color, intended to describe flowers, leaves, and waves, but also registering simply as marks of paint on the surface of the canvas.

Many of Monet's fully Impressionist pictures of the 1870s and 1880s, such as *Boulevard des Capucines*, Paris of 1873–74 (fig. 27-60), are made up almost entirely of these small dabs and blotches of paint. Monet used these discrete marks of paint to record the shifting play

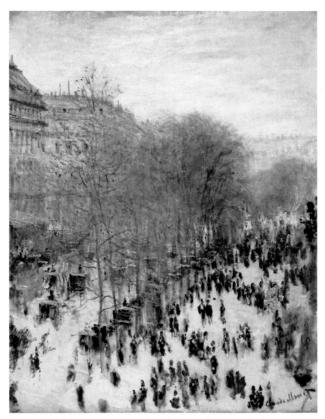

27-60. Claude Monet. *Boulevard des Capucines, Paris.* 1873–74. Oil on canvas, $31^1/_4 \times 23^1/_4$ " (80.4 × 60.3 cm). The Nelson-Atkins Museum of Art, Kansas City, Missouri. Purchase: The Kenneth A. and Helen F. Spencer Foundation Acquisition Fund (F72–35)

Monet painted this picture from the balcony of Nadar's photography studio at 35 Boulevard des Capucines (for an illustration of one of Nadar's photographs, see fig. 27-37), the site of the first Impressionist exhibition. It is one of two versions of the scene by Monet, one of which was shown in that exhibition. In an appreciative review, critic Ernest Chesnau wrote: "The extraordinary animation of the public street, the crowd swarming on the sidewalks, the carriages on the pavement, and the boulevard's trees waving in the dust and light—never has movement's elusive, fugitive, instantaneous quality been captured and fixed in all its tremendous fluidity as it has in this extraordinary, marvelous sketch that Monet has listed as *Boulevard des Capucines*."

of light on the surface of objects and the effect of that light on the eye, without concern for the physical character of the objects being represented. The American painter Lilla Cabot Perry (1848–1933), who befriended Monet in his later years, recalled him telling her:

When you go out to paint, try to forget what objects you have before you—a tree, a house, a field, or whatever. Merely think, Here is a little square of blue, here an oblong of pink, here a streak of yellow, and paint it just as it looks to you, the exact color and shape, until it gives your own naive impression of the scene before you.

Perry also reported that Monet

said he wished he had been born blind and then had suddenly gained his sight so that he could have begun to paint in this way without knowing what the objects were that he saw before him. He held that the first real look at the motif was likely to be the truest and most unprejudiced one. . . .

Two important ideas are expressed here. One is that a quickly painted oil sketch most accurately records a landscape's general appearance. This view had been a part of academic training since the late eighteenth century, but such sketches were considered merely part of the preparation for a finished work. In essence Monet attempted to raise these traditional "sketch aesthetics" to the same level as a completed painting. As a result, the major criticism at the time was that his paintings were not "finished." The second idea—that art benefits from a naive vision untainted by intellectual preconceptions—belonged to both the naturalist and the realist traditions, from which Monet's work evolved.

THE PRINT REVIVALS

A number of Romantic artists, including Théodore Géricault and Eugène Delacroix, used lithography to produce fine art prints (see "Lithography," page 951). But as lithography was more commonly used by newspaper caricaturists such as Honoré Daumier, the medium became identified with the popular arts. Another art form, etching, was then used almost exclusively to produce cheap reproductions of well-known works. although Delacroix, Corot, and Millet had produced the occasional etching (see "Etching and Drypoint," page 772). The first of the nineteenthcentury artists to devote himself to the medium was Charles-Émile Jacque (1813–94), a less well-known member of the Barbizon School, who as a student had studied and copied etchings by Rembrandt.

Inspired by the work of Jacque and by the amateur example of his brother-in-law, Francis Seymour Haden, James Abbott McNeill Whistler turned to etching in 1858, and his early work inaugurated a great age of etching. The interest it generated convinced an amateur French etcher and printer, Alfred Cadart, to organize the Society of Etchers in 1862. Cadart, who was also a print dealer, conceived the society as a way to bring before the public the kind of innovative work rejected by the Salon jury and to protest the growth and influence of photography. The Romantic poet and critic Théophile Gautier said in his preface to the first volume of etchings Cadart issued:

In these times when photography fascinates the vulgar by the mechanical fidelity of its reproductions, it is needful to assert an artistic tendency in favor of free fancy and picturesque mood. The necessity of reacting against the positivism of the mirrorlike apparatus has made many a painter take to the etcher's needle....

The critical response to Cadart's early volumes, issued annually, was so positive that even the conservative organizers of the Salon decided to dedicate an entire room to etchings at the exhibition of 1866. Cadart's efforts established a solid foundation for a tradition that eventually included the work of Edgar Degas, Mary Cassatt, and a host of French artists. Cadart contributed further to the spread of etching when he helped form the French Etching Club in New York in 1866.

A second phase in the print renaissance began around 1890 and lasted well into the next decade. It too was centered in Paris, but now the medium was chromolithography, which printed in color. The artist largely responsible for it was a poster designer, Jules Chéret (1836-1932), whose printing business employed chromolithography for a variety of commercial work, from menus to posters. Chéret's clever theater and café advertising posters of the late 1860s and 1870s attracted so much attention that in 1880 the critic Joris-Karl Huysmans advised his readers to ignore the paintings and prints at the Salon and to turn, instead, to the "astonishing fantasies of Chéret" that could be found plastered along any street.

By the end of the decade the poster vogue was in full flower, not only in France but throughout the West. Influenced by Japanese prints and Art Nouveau, with its commit-

ment to beautifying the urban environment, a number of talented and ambitious young artists turned their attention to designing them. The most famous poster artist was Henri de Toulouse-Lautrec, who produced thirty between 1891 and his death in 1901 (see fig. 27-85).

Lithography also grew with a renewal of interest in book illustration spurred by the art dealer Ambroise Vollard, who asked artists to provide original lithographs for books. The best-known English book illustrator was Aubrey Beardsley (1872–98), whose work combined influences from Whistler, the second phase of the Pre-Raphaelite movement, and Japanese prints to form a beautifully "unnatural" style.

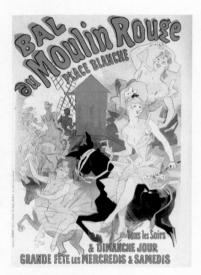

Jules Chéret. *Bal au Moulin Rouge.* 1889. Four-color lithograph, $23^{1}/_{2} \times 16^{1}/_{2}$ " (59.7 \times 41.9 cm). Jane Voorhees Zimmerli Art Museum, Rutgers, The State University of New Jersey.

Although he painted during the 1870s in a style similar to Monet's, Camille Pissarro (1830–1903) identified more strongly with peasants and rural laborers. Born in the Danish West Indies to a French family and raised near Paris, Pissarro studied art in that city during the 1850s and early 1860s. After assimilating the influences of both Corot and Courbet, Pissarro embraced Impressionism in 1870, when both he and Monet were living in London to escape the Franco-Prussian War. There they worked closely together, dedicating themselves, as Pis-

sarro later recalled, to "plein air light and fugitive effects." The result, for both painters, was a lightening of color and a loosening of the way they handled paint.

Following his return to France Pissarro settled in Pontoise, a small, hilly village northwest of Paris that retained a thoroughly rural character. There he worked for much of the 1870s in a style close to that of Monet, using high-keyed color and short brushstrokes to capture fleeting qualities of light and atmosphere. Rather than the vacationer's landscapes that Monet

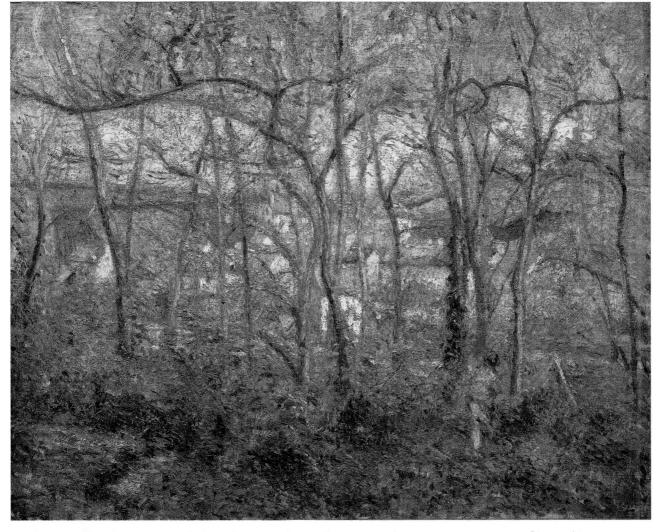

27-61. Camille Pissarro. Wooded Landscape at l'Hermitage, Pontoise. 1878. Oil on canvas, $18^5/_{16} \times 22^1/_{16}"$ (46.5 × 56 cm). The Nelson-Atkins Museum of Art, Kansas City, Missouri. Gift of Dr. And Mrs. Nicholas S. Pickard

favored, however, Pissarro chose agrarian themes such as orchards and tilled fields. In the late 1870s his painting tended toward greater visual and material complexity. Wooded Landscape at l'Hermitage, Pontoise (fig. 27-61) reflects the continuing influence of Corot (see fig. 27-45) in its composition of foreground trees that screen the view of a rural path and village and in its inclusion of a rustic figure at the lower right. Pissarro uses a brighter and more variegated palette than Corot, however, and he applies his paint more thickly, through a multitude of dabs, flecks, and short brushstrokes. The result is a dense, crusty surface of pigment that denies the academic conception of the picture plane as a transparent window and declares instead its actual status as a flat surface covered with paint.

More typical of the Impressionists in his proclivity for painting scenes of upper-middle-class recreation was Pierre-Auguste Renoir (1841–1919), who met Monet at the École des Beaux-Arts in 1862. Despite his early predilection for figure painting in a softened, Courbet-like mode, Renoir was encouraged by his more forceful friend Monet to create pleasant, light-filled landscapes, which were painted outdoors. By the mid-1870s Renoir was combining Monet's style in the rendering of natural light with his own taste for the figure.

Moulin de la Galette (fig. 27-62, page 986), for example, features dancers dappled in bright afternoon sunlight. The Moulin de la Galette (the "Pancake Mill"), in the Montmartre section of Paris, was an old-fashioned Sunday afternoon dance hall, which during good weather made use of its open courtyard. Renoir has glamorized its working-class clientele by replacing them with his young artist friends and their models. Frequently seen in Renoir's work of the period, these attractive members of the middle class are shown in attitudes of relaxed congeniality, smiling, dancing, and chatting. The innocence of their flirtations is underscored by the

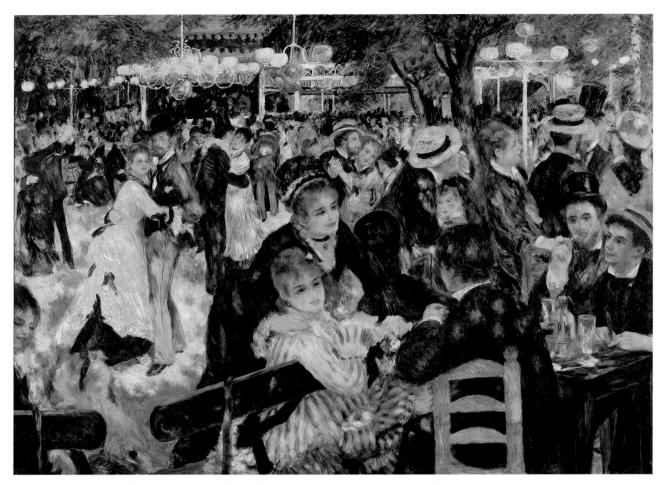

27-62. Pierre-Auguste Renoir. *Moulin de la Galette*. 1876. Oil on canvas, $4'3^{1/2}" \times 5'9"$ (1.31 × 1.75 m). Musée d'Orsay, Paris.

children in the lower left, while the ease of their relations is emphasized by the relaxed informality of the composition itself. The painting is knit together not by figural arrangement but by the overall mood, the sunlight falling through the trees, and the way Renoir's soft brushwork weaves his blues and purples through the crowd and across the canvas. This idyllic image of a carefree age of innocence, a kind of paradise, nicely encapsulates Renoir's essential notion of art: "For me a picture should be a pleasant thing, joyful and pretty—yes pretty! There are quite enough unpleasant things in life without the need for us to manufacture more."

Subjects of urban leisure also attracted Edgar Degas (1834–1917), but he did not share the *plein air* Impressionists' interest in outdoor light effects. Instead, Degas composed his pictures in the studio from working drawings—a traditional academic procedure. Degas had in fact received rigorous academic training at the École des Beaux-Arts in the mid-1850s and subsequently spent three years in Italy studying the Old Masters. Firm drawing and careful composition remained central features of his art for the duration of his career, setting it apart from the more spontaneously executed pictures of the *plein air* painters.

The son of a Parisian banker, Degas was closer to Manet than to other Impressionists in age and social background. Manet, whom he met in 1862, and his circle gradually persuaded Degas to turn from history painting to the depiction of contemporary life. After a period of painting psychologically probing portraits of friends and relatives, Degas turned in the 1870s to such Paris amusements as the racetrack, music hall, opera, and ballet. Composing his ballet scenes from carefully observed studies of rehearsals and performances, Degas, in effect, arranged his own visual choreography. The Rehearsal on Stage (fig. 27-63), for example, is not a factual record of something seen but a careful contrivance, inspired partly by Japanese prints, intended to delight the eye. The rehearsal is viewed from an opera box close to the stage, creating an abrupt foreshortening of the scene emphasized by the dark scrolls of the bass viols that jut up from the lower left.

Another artist who showed with the Impressionists was the American expatriate Mary Cassatt (1845–1926). Born near Pittsburgh to a well-to-do family, Cassatt studied at the Pennsylvania Academy of the Fine Arts in Philadelphia between 1861 and 1865 and then moved to Paris for further academic training. She lived in France for

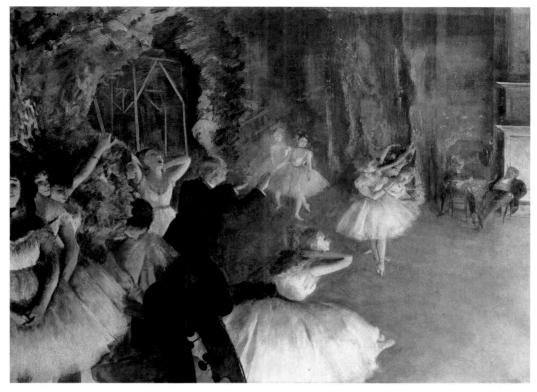

27-63. Edgar Degas. *The Rehearsal on Stage.* c. 1874. Pastel over brush-and-ink drawing on thin, cream-colored wove paper, laid on bristol board, mounted on canvas, $21^3/_8 \times 28^3/_4$ " (54.3 × 73 cm). The Metropolitan Museum of Art, New York.

Bequest of Mrs. H. O. Havemeyer Collection, Gift of Horace Havemeyer, 1929 (29.160.26)

In the right background of Degas' picture sit two well-dressed, middle-aged men, each probably a "protector" (lover) of one of the dancers. Because ballerinas generally came from lower-class families and exhibited their scantily clad bodies in public—something that "respectable" bourgeois women did not do—they were widely assumed to be sexually available, and they often attracted the attentions of wealthy men willing to support them in exchange for sexual favors. Several of Degas' ballet pictures include one or more of the dancers' mothers, who would accompany their daughters to rehearsals and performances in order to safeguard their virtue.

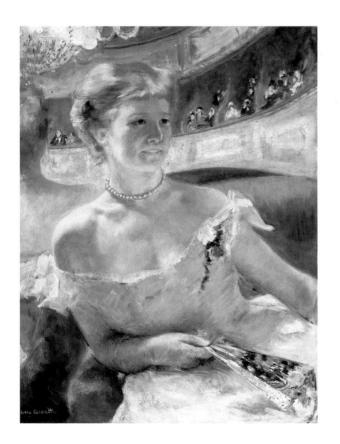

most of the rest of her life. The realism of the figure paintings she exhibited at the Salons of the early and middle 1870s attracted the attention of Degas, who invited her to participate in the fourth Impressionist exhibition, in 1879. Although she, like Degas, remained a studio painter, disinterested in *plein air* painting, her distaste for what she called the tyranny of the Salon jury system made her one of the group's staunchest supporters.

Cassatt focused her work on the world to which she had access: the domestic and social life of well-off women. One of the paintings she exhibited in 1879 was *Woman in a Loge* (fig. 27-64). The painting's bright and luminous color, fluent brushwork, and urban subject were no doubt chosen partly to demonstrate her

27-64. Mary Cassatt. Woman in a Loge. 1879. Oil on canvas, $31^{5}\!/_{\!8} \times 23''$ (80.3 \times 58.4 cm). Philadelphia Museum of Art.

Bequest of Charlotte Dorrance Wright

Long known as *Lydia in a Loge, Wearing a Pearl Necklace*, this painting was believed to portray Cassatt's sister, Lydia, who came to live with her in 1877 and posed for many of her works. The young, red-haired sitter does not resemble the older, dark-haired Lydia, however, and was probably a professional model whose name has not been recorded. The painting is now known by the title it had when shown at the fourth Impressionist exhibition, in 1879.

IAPONISME

James Abbott McNeill Whistler's etchings and paintings of the 1850s and early 1860s show London's Old Battersea Bridge as it really was: a narrow, squat, aging bridge that carried pedestrian traffic. But in his Nocturne: Blue and Gold-Old Battersea Bridge of the early 1870s, Whistler greatly exaggerated the height and curve of the bridge and increased the span between its wooden pilings. He probably did so to make it resemble the Kyobashi Bridge depicted in a woodblock print from the One Hundred Famous Views of Edo by the nineteenth-century Japanese artist Hiroshige. Japanese art (Chapter 22) also inspired the spatial flattening, asymmetrical composition, and monochro-

matic palette of this and other Whistler paintings.

Whistler's interest Japanese art was part of a widespread fascination with Japan and its culture that swept across the West in the last half of the nineteenth century. The vogue began shortly after the U.S. Navy forcibly opened Japan to Western trade and diplomacy in 1853. Soon, Japanese lacquers, fans, bronzes, hanging scrolls, kimonos, ceramics, illustrated books, and ukiyo-e (prints of the "floating world," the realm of geishas and popular entertainment) began to appear in western European specialty shops, art galleries, and even some department stores. French interest in Japan and its arts reached such proportions by 1872 that the art

critic Philippe Burty gave it a name: *japonisme*.

Japanese art profoundly influenced Western painting, printmaking, applied arts, and eventually architecture. The tendency toward simplicity, flatness, and the decorative evident in much painting and graphic art in the West between roughly 1860 and 1900 is probably the most characteristic result of that influence. Nevertheless, its impact was extraordinarily diverse. What individual artists took from the Japanese depended on their own interests. Thus, Whistler found encouragement for his decorative conception of art, while Edgar Degas discovered

both realistic subjects and interesting compositional arrangements (see fig. 27-63), and those interested in the reform of late-nineteenthcentury industrial design found in Japanese objects both fine craft and a smooth elegance lacking in the West. Some, like Vincent van Gogh, saw in the spare harmony of Japanese art and wares evidence of an idvllic society, which he considered a model for the West. Perhaps the most strongly influenced were the new printmakers, like Mary Cassatt (see fig. 27-68), who, lacking a strong tradition of their own, considered themselves part of the Japanese tradition more than the Western.

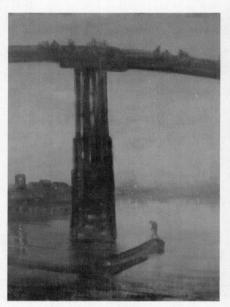

James Abbott McNeill Whistler. Nocturne: Blue and Gold—Old Battersea Bridge. 1872–75. Oil on canvas, $26^{1}/_{4} \times 19^{3}/_{4}$ " (66.7 \times 50.2 cm). Tate Gallery, London.

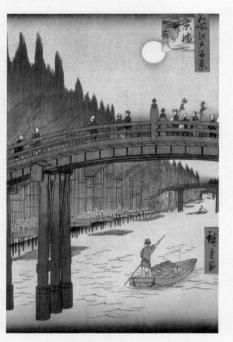

Utagawa Hiroshige. *One Hundred Views of Edo: Bamboo Yards, Kyobashi Bridge.* 1857. Color woodblock print. The Brooklyn Museum of Art.

solidarity with her new associates. (Renoir had exhibited a very similar image of a woman at the opera in 1874.) Reflected in the mirror behind the smiling woman are other operagoers, some with opera glasses trained not on the stage but on the crowd around them, scanning it for other elegant socialites. As Charles Garnier had noted, his new Opéra (see fig. 27-42) made an ideal backdrop for just this kind of display.

Cassatt decided early to have a career as a professional artist, but Berthe Morisot (1841–95) came to that decision only after years in the amateur role then conventional for women. Morisot and her sister, Edma, copied paintings in the Louvre and studied under sever-

al different teachers, including Corot, in the late 1850s and early 1860s. The sisters showed in the five Salons between 1864 and 1868, the year they met Manet. In 1869 Edma married and, following the traditional course, gave up painting to devote herself to domestic duties. Berthe, on the other hand, continued painting, even after her 1874 marriage to Manet's brother, Eugène, and the birth of their daughter in 1879. Morisot sent nine works to the first exhibition of the Impressionists in 1874 and showed in all but one of their subsequent exhibitions.

Like Cassatt, Morisot dedicated her art to the lives of bourgeois women, which she depicted in a style that

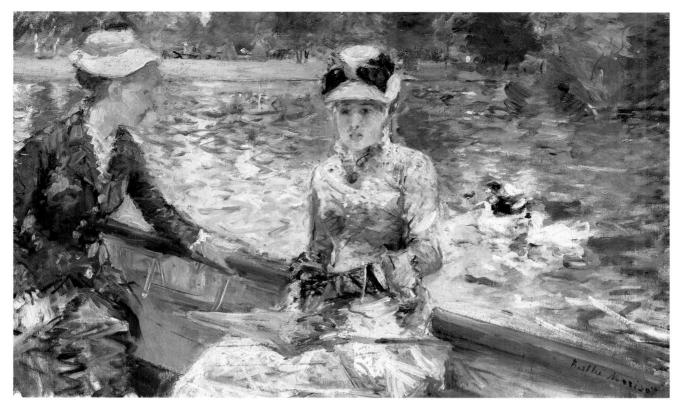

27-65. Berthe Morisot. Summer's Day. 1879. Oil on canvas, $17^{13}/_{16} \times 29^{5}/_{16}$ " (45.7 × 75.2 cm). The National Gallery, London. Lane Bequest, 1917

became increasingly loose and **painterly** over the course of the 1870s. In works such as *Summer's Day* (fig. 27-65), Morisot pushed the "sketch aesthetics" of Impressionism almost to their limit, dissolving her forms into a flurry of feathery brushstrokes. Originally exhibited in the fifth Impressionist exhibition in 1880 under the title *The Lake of the Bois du Boulogne*, Morisot's picture is typically Impressionist in its depiction of modern urban leisure in a large park on the fashionable west side of Paris. As the women apparently ride in a ferry between tiny islands in the largest of the park's lakes, the viewer occupies a seat opposite them and is invited to share their enjoyment of the delicious weather and pleasant surroundings.

Although he never exhibited with the Impressionists, preferring to submit his pictures to the official Salon, Édouard Manet nevertheless in the 1870s followed their lead by lightening his palette, loosening his brushwork, and confronting modern life in a more direct manner than he had in *Le Déjeuner sur l'Herbe* and *Olympia* (see figs. 27-57 and 27-58), both of which maintained a dialogue with the art of the past. But complicating Manet's apparent acceptance of the Impressionist viewpoint was his commitment, conscious or not, to counter Impressionism's essentially optimistic interpretation of modern life with a more pessimistic one.

Manet's last major painting, *A Bar at the Folies-Bergère* (fig. 27-66, page 990), for example, contradicts the happy aura of works such as *Moulin de la Galette* (see fig. 27-62) and *Woman in a Loge* (see fig. 27-64). In the center of the painting stands one of the barmaids at the

Folies-Bergère, a large nightclub with bars arranged around a theater that offered circus, musical, and vaudeville acts. Reflected in the mirror behind her is some of the elegant crowd, who are entertained by a trapeze act. (The legs of one of the performers can be seen in the upper left.) On the marble bartop Manet has spread a glorious still life of liquor bottles, tangerines, and flowers, associated not only with the pleasures for which the Folies-Bergère was famous but also with the barmaid herself, whose wide hips, strong neck, and closely combed golden hair are echoed in the champagne bottles. The barmaid's demeanor, however, refutes these associations. Manet puts the viewer directly in front of her, in the position of her customer. She neither smiles at this customer, as her male patrons and employers expected her to do, nor gives the slightest hint of recognition. She appears instead to be selfabsorbed and slightly depressed. But in the mirror behind her, her reflection and that of her customer tell a different story. In this reflection, which Manet has curiously shifted to the right as if the mirror were placed on a slant, the barmaid leans toward the patron, whose intent gaze she appears to meet; the physical and psychological distance between them has vanished. Exactly what Manet meant to suggest by this juxtaposition has been much debated. One possibility is that he wanted to contrast the longing for happiness and intimacy, reflected miragelike in the mirror, with the disappointing reality of ordinary existence that directly confronts the viewer of the painting.

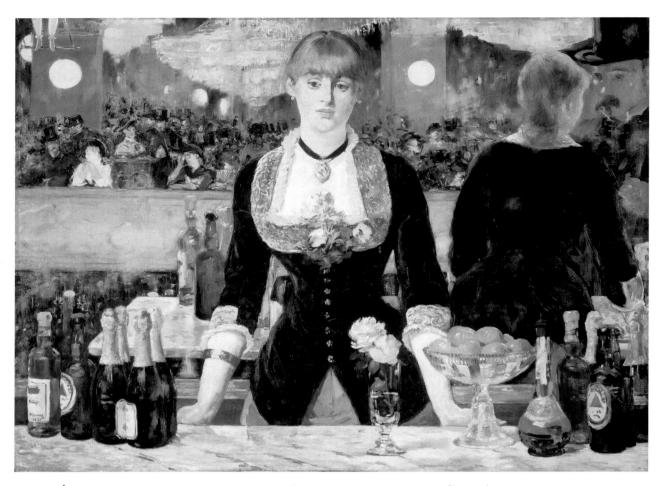

27-66. Édouard Manet. *A Bar at the Folies-Bergère*. 1881–82. Oil on canvas, $37^3/_4 \times 51^1/_4$ " (95.9 × 130 cm). Courtauld Institute of Art Gallery, London. (P.1934.SC.234)

LATER IMPRESSIONISM

In the years after 1880, Impressionism underwent what historians have termed a "crisis," as many artists grew dissatisfied with their attempts to capture momentary perceptions through spontaneous brushwork and casual compositions. In response, they began to select subjects more carefully, work longer on their pictures, and develop styles that lent their imagery a greater sense of permanence and seriousness.

The artist most strongly affected by this crisis was Renoir, whose experience of the paintings of Raphael and other Old Masters on a trip to Italy in 1881 caused him to reconsider his commitment to painting modern life. Renoir became convinced that, unlike the enduring themes of Renaissance art, his records of contemporary life (see fig. 27-62) were too bound to their time to maintain the interest of future viewers. He therefore began to focus on the nude, a subject more difficult to locate in a particular time and place. The stable, pyramidal grouping of his three female *Bathers* (fig. 27-67) was based on a seventeenth-century sculpture by François Girardon at Versailles (see fig. 19-24, which illustrates a different sculpture by Girardon). This source clearly indicates

Renoir's new commitment to the classical tradition of the female nude that originated in the Hellenistic period and was first adopted by French artists during the reign of Louis XIV. The work is perhaps closer to Bouguereau's Nymphs and a Satyr (see fig. 27-44) than to Renoir's own Moulin de la Galette. The women are shown from three different views—front, back, and side—a convention that had been established in countless paintings of the Three Graces. Their chiseled contours also reflect a move toward academicism. Only the more loosely brushed landscape, the high-key colors, and the women themselves, who look like they could be contemporary Parisians on the banks of the Seine, prevent the painting from being a wholesale rejection of Impressionism.

Cassatt, too, in the period after 1880 moved toward a firmer handling of form and more classic subjects. The shift is most apparent in her new focus on the theme of mother and child. In *Maternal Caress* (fig. 27-68), one of the many colored prints she produced in her later career, we see her sensitive response to the tradition of the Madonna and Child. Apparently fresh from the bath, the plump infant shares a tender moment with its adoring mother. Their intimacy is underscored by the subtle

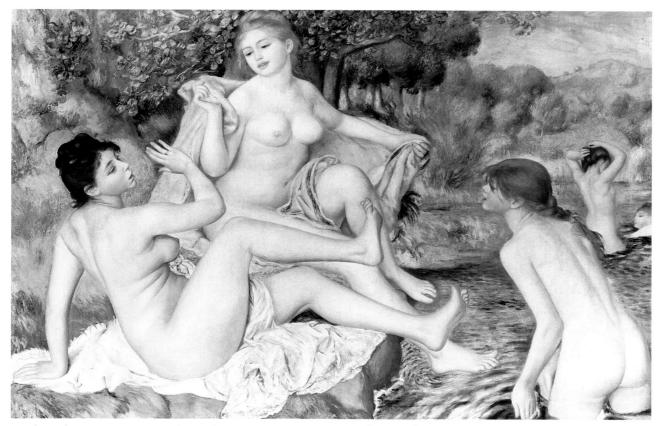

27-67. Pierre-Auguste Renoir. *Bathers.* 1887. Oil on canvas, $3'10\sqrt[3]{8}'' \times 5'7\sqrt[1]{4}''$ (1.18 × 1.71 m). Philadelphia Museum of Art. Mr. and Mrs. Carroll S. Tyson Collection

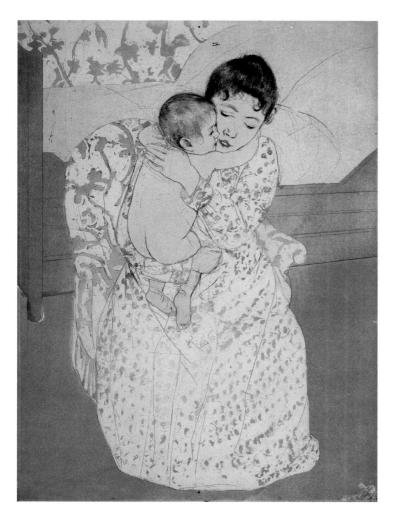

27-68. Mary Cassatt. *Maternal Caress.* 1891. Drypoint, soft-ground etching, and aquatint on paper, $14^3/_4 \times 10^3/_4$ " (37.5 × 27.3 cm). National Gallery of Art, Washington, D.C.

Chester Dale Collection, (1963.10.255)

27-69. Claude Monet. Rouen Cathedral: The Portal (in Sun). 1894. Oil on canvas, $39^{1}/_{4} \times 26''$ (99.7 × 66 cm). The Metropolitan Museum of Art, New York. Theodore M. Davis Collection, Bequest

Theodore M. Davis Collection, Bequest of Theodore M. Davis, 1915 (30.95.250)

Monet painted more than thirty views of the facade of Rouen Cathedral. He probably began each canvas during two stays in Rouen in early 1892 and early 1893, observing his subject from a second-story window across the street. He then finished the whole series in his studio at Giverny. In these paintings Monet continued to pursue his Impressionist aim of capturing fleeting effects of light and atmosphere, but his extensive reworking of them in the studio produced pictures far more carefully orchestrated and laboriously executed than his earlier, more spontaneously painted plein air canvases.

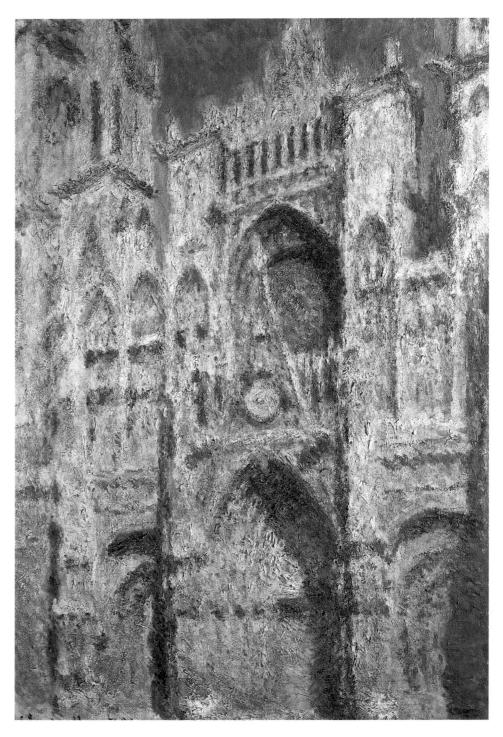

harmony of apricots and browns. Even the pairing of decorative patterns reinforces the central theme. These patterns, like the work's simple contours and sharply sloping floor, derive from Japanese prints. Works such as *Maternal Caress* appear to be Cassatt's Western answer to the work of Japanese printmakers such as Utamaro (fig. 9, Introduction), aiming for not only the timeless but also the universal.

Even Monet, who initially appeared immune to the growing crisis of Impressionism, eventually responded to it in the 1890s by choosing themes such as haystacks and poplars that had strong associations with French history and culture (the poplar, for exam-

ple, was during the French Revolution known as the Tree of Liberty). Monet's apparent desire to place Impressionism within the great traditions of French art is most evident in his famous series of paintings devoted to the play of light over the intricately carved facade of Rouen Cathedral (fig. 27-69). Monet apparently chose the subject primarily for its **iconographic** associations, for the building symbolizes the continuity of human institutions such as the Church and the enduring presence of the divine. In effect, *Rouen Cathedral: The Portal (in Sun)* seems to argue that beneath the shimmering, insubstantial veneer of shifting appearances is a complex web of durable and expanding

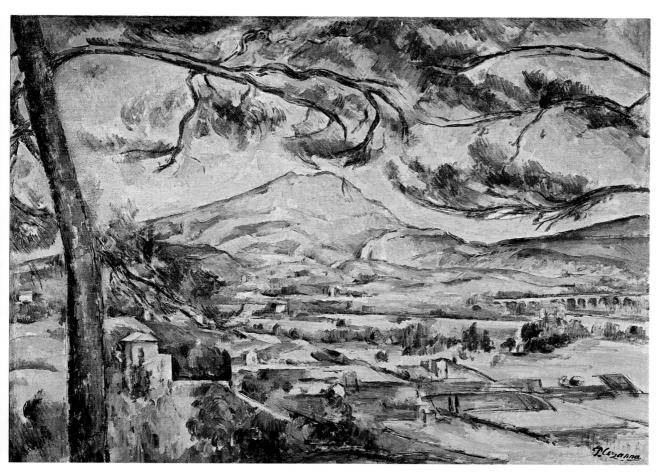

27-70. Paul Cézanne. Mont Sainte-Victoire. c. 1885-87. Oil on canvas, $25\frac{1}{2} \times 32$ " (64.8 \times 92.3 cm). Courtauld Institute of Art Gallery, London. (P.1934.SC.55)

connections. Thus, while Renoir, Cassatt, and others were moving away from Impressionism, Monet was apparently trying to place it in a more enduring, coherent context. This pattern of rejection and reform is evident, as well, in the works of the next generation of French artists, the Post-Impressionists.

POST-IMPRESSIONISM

POSTThe English critic Roger
Fry coined the term PostImpressionism in 1910 to
identify a broad reaction

against Impressionism in avant-garde painting of the late nineteenth and early twentieth centuries. Art historians recognize Paul Cézanne (1839-1906), Paul Gauguin (1848–1903), Vincent van Gogh (1853–1890), and Georges Seurat (1859-1891) as the principal Post-Impressionist artists. Each of these painters moved through an Impressionist phase and continued to use in his mature work the bright Impressionist palette. But each came also to reject Impressionism's emphasis on the spontaneous recording of light and color and instead sought to create art with a greater degree of formal order and structure. This goal led the Post-Impressionists to depart from naturalism and develop more abstract styles that would prove highly influential for the development of modernist painting in the early twentieth century (Chapter 28).

No artist had a greater impact on the next generation of modernist painters than Cézanne, who enjoyed

little professional success until the last few years of his life, when younger artists and critics began to recognize the revolutionary qualities of his art. The son of a prosperous banker in the southern French city of Aix-en-Provence, Cézanne studied art first in Aix and then in Paris, where he participated in the circle of realist artists around Manet. Cézanne's early pictures, somber in color and coarsely painted, often depicted Romantic themes of drama and violence, and were consistently rejected by the Salon.

In the early 1870s Cézanne changed his style under the influence of Pissarro and adopted the bright palette, broken brushwork, and everyday subject matter of Impressionism. Like the Impressionists, with whom he exhibited in 1874 and 1877, Cézanne now dedicated himself to the objective transcription of what he called his "sensations" of nature. Unlike the Impressionists, however, he did not seek to capture transitory effects of light and atmosphere but rather to create a sense of order in nature through a methodical application of color that merged drawing and modeling into a single process. His professed aim was to "make of Impressionism something solid and durable, like the art of the museums."

Cézanne's tireless pursuit of this goal is exemplified in his paintings of Mont Sainte-Victoire, a prominent mountain near his home in Aix that he depicted about thirty times in oil from the mid-1880s to his death. The version here (fig. 27-70) shows the mountain rising

27-71. Paul Cézanne. Still Life with Basket of Apples. 1890–94. Oil on canvas, $24\frac{3}{8} \times 31$ " (62.5 × 79.5 cm). The Art Institute of Chicago.

Helen Birch Bartlett Memorial Collection

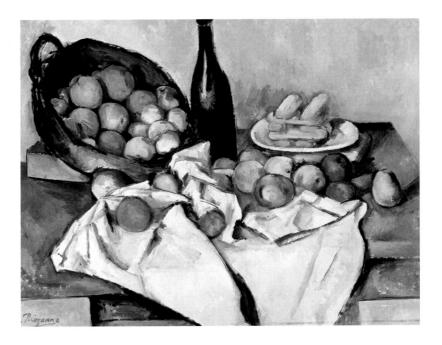

above the Arc Valley, which is dotted with houses and trees and is traversed at the far right by an aqueduct. Framing the scene at the left is an evergreen tree, which echoes the contours of the mountains, creating visual harmony between the two principal elements of the composition. The even lighting, still atmosphere, and absence of human activity in the landscape communicate a sense of timeless endurance, at odds with the Impressionists' interest in capturing a momentary aspect of the ever-changing world. Cézanne's paint handling is more deliberate and constructive than the Impressionists' spontaneous and comparatively random brushwork. His strokes, which vary from short, parallel hatchings to sketchy lines to broader swaths of flat color, not only record his "sensations" of nature but also weave every element of the landscape together into a unified surface design. That surface design coexists with the effect of spatial recession that the composition simultaneously creates, generating a fruitful tension between the illusion of three dimensions "behind" the picture plane and the physical reality of its two-dimensional surface. On the one hand, recession into depth is suggested by elements such as the foreground tree, a repoussoir (French for "something that pushes back") that helps draw the eye into the valley and toward the distant mountain range, and by the gradual transition from the saturated greens and orange-yellows of the foreground to the softer blues and pinks in the mountain, which create an effect of atmospheric perspective. On the other hand, this illusion of consistent recession into depth is challenged by the inclusion of blues, pinks, and reds in the foreground foliage, which relate the foreground forms to the background mountain and sky, and by the tree branches in the sky, which follow the contours of the

mountain, making the peak appear nearer and binding it to the foreground plane.

Spatial ambiguities of a different sort appear in Cézanne's late still lifes, in which many of the objects seem incorrectly drawn. In Still Life with Basket of Apples (fig. 27-71), for example, the right side of the table is higher than the left, the wine bottle has two different silhouettes, and the pastries on the plate next to it are tilted upward while the apples below seem to be viewed head-on. Such apparent inaccuracies are not evidence of Cézanne's incompetence, however, but of his willful disregard for the rules of traditional scientific perspective. Although scientific perspective mandates that the eye of the artist (and hence the viewer) occupy a fixed point relative to the scene being observed (see "Renaissance Perspective Systems," page 583), Cézanne studies different objects in a painting from slightly different positions. The composition as a whole, assembled from multiple sightings of its various elements, is complex and dynamic and even seems on the verge of collapse. The pastries look as if they could levitate, the bottle tilts precariously, the fruit basket appears ready to spill its contents, and only the folds and small tucks in the white cloth seem to prevent the apples from cascading to the floor. All of these physical improbabilities are designed, however, to serve the larger visual logic of the painting as a work of art, characterized by Cézanne as "something other than reality"-not a direct representation of nature but "a construction after nature."

Toward the end of his life, Cézanne's constructions after nature became increasingly abstract, as seen in the monumental *The Large Bathers* (fig. 27-72), probably begun in the last year of his life, and left unfinished. This canvas, the largest Cézanne ever painted, culminated

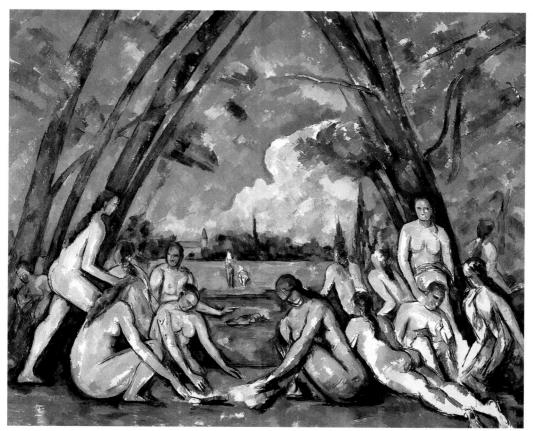

27-72. Paul Cézanne. The Large Bathers. 1906. Oil on canvas, $6'10'' \times 8'2''$ (2.08 \times 2.49 m). Philadelphia Museum of Art. The W. P. Wilstach Collection

his involvement with the subject of nude bathers in nature, a theme he had admired in the Old Masters and had depicted on numerous earlier occasions. Unlike his predecessors, however, Cézanne did not usually paint directly from models but instead worked from earlier drawings, photographs, and memory. As a result, his bathers do not appear lifelike but have simplified, schematic forms. In *The Large Bathers*, the bodies cluster in two pyramidal groups at the left and right sides of the painting, beneath a canopy of trees that opens in the middle onto a triangular expanse of water, landscape, and sky. The figures assume motionless, statuesque poses (the crouching figure at the left quotes a Hellenistic Crouching Venus that Cézanne had copied in the Louvre) and seem to exist in a timeless realm, unlike the bathers of Manet and Renoir (see figs. 27-57, 27-67), who clearly inhabit the modern world. Emphasizing the scene's serene remoteness from everyday life, the simplified yet resonant palette of blues and greens, ochers and roses, laid down in large patches over a white ground, suffuses the picture with light. Despite its unfinished state, The Large Bathers stands as a grand summation of Cézanne's art.

Another artist who, like Cézanne, adapted Impressionist discoveries to the creation of an art of greater structure and monumentality was Georges Seurat. Born in Paris and trained at the École des Beaux-Arts,

Seurat became devoted to classical aesthetics, which he combined with a rigorous study of optics and color theory, especially the "law of the simultaneous contrast of colors," first formulated by Michel-Eugène Chevreul in the 1820s. Chevreul's law holds that adjacent objects not only cast reflections of their own color onto their neighbors but also create in them the effect of their **complementary color**. Thus, when a blue object is set next to a yellow one, the eye will detect a trace of purple, the complement of yellow, and in the yellow object a trace of orange, the complement of blue.

The Impressionists knew of Chevreul's law but had not applied it systematically. Seurat, however, calculated exactly which **hues** should be combined, in what proportion, to produce the effect of a particular color. He then set these hues down in dots of pure color, next to one another, in what came to be known by the various names of divisionism (the term preferred by Seurat), pointillism, and Neo-Impressionism. In theory, these juxtaposed dots would merge in the viewer's eye to produce the impression of other colors, which would be perceived as more luminous and intense than the same hues mixed on the palette. In Seurat's work, however, this optical mixture is never complete, for his dots of color are large enough to remain separate in the eye, giving his pictures a grainy appearance.

Seurat's best-known work is *A Sunday Afternoon on the Island of La Grande Jatte* (fig. 27-73), which he first exhibited at the eighth and final Impressionist exhibition in 1886. The theme of weekend leisure is typically Impressionist, but the rigorous divisionist technique, the stiff formality of the figures, and the highly calculated geometry of the composition produce a solemn, abstract effect quite at odds with the casual naturalism of earlier Impressionism. Seurat's picture in fact depicts a contemporary subject in a highly formal style recalling much older art, such as that of the ancient Egyptians.

From its first appearance, *A Sunday Afternoon on the Island of La Grande Jatte* has generated conflicting interpretations. Contemporary accounts of the island indicate that on Sundays it was noisy, littered, and chaotic. By painting it the way he did, Seurat may have intended to show how tranquil it *should* be. Was Seurat merely criticizing the Parisian middle class, or was he trying to establish a social ideal for a more civilized way of life in the modern city? The key to Seurat's ideal may be the composure of the mother and child who stand as the still point around which the others move.

Among the many artists to experiment with divisionism was the Dutch painter Vincent van Gogh. The

oldest surviving son of a Protestant minister, van Gogh worked as an art dealer, teacher, and evangelist before deciding in 1880 to become an artist. After brief periods of study in Brussels, The Hague, and Antwerp, he moved in 1886 to Paris, where he discovered the work of the Impressionists and Neo-Impressionists. Van Gogh quickly adapted Seurat's divisionism, but rather than laying his paint down regularly in dots he typically applied it freely in multi-directional dashes of **impasto** (thick applications of pigment), which gave his pictures a greater sense of physical energy and a palpable surface texture.

During the last year and a half of his life van Gogh experienced repeated psychological crises that led to his going into a mental asylum and eventually committing suicide, in July 1890. He recorded his heightened emotional state in paintings that contributed significantly to the emergence of the **expressionistic** tradition, in which the intensity of an artist's feelings overrides fidelity to the actual appearance of things. One of the earliest and most famous examples of expressionism is *The Starry Night* (fig. 27-74), which van Gogh painted from his window in the asylum at Saint-Rémy. Above the quiet town the sky pulsates with celestial rhythms and

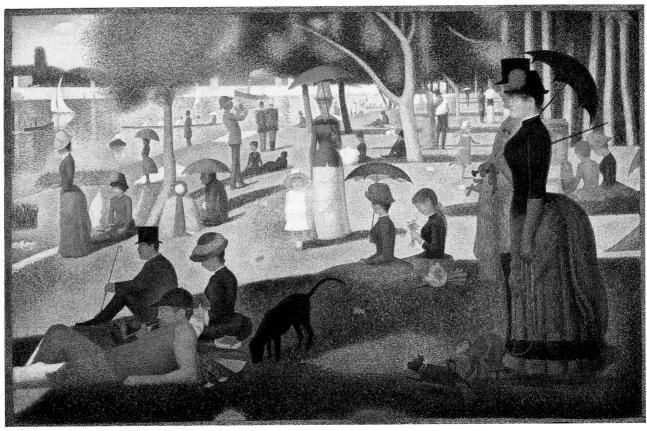

27-73. Georges Seurat. *A Sunday Afternoon on the Island of La Grande Jatte.* 1884–86. Oil on canvas, $6'9^1/2'' \times 10'1^1/4''$ (2.07 × 3.08 m). The Art Institute of Chicago. Helen Birch Bartlett Memorial Collection

Although the painting is highly stylized and carefully composed, it has a strong basis in factual observation. Seurat spent months visiting the island, making small studies, drawings, and oil paintings of the light and the people he found there. All of the characters in the final painting, including the woman with the monkey, were based on his observations at the site.

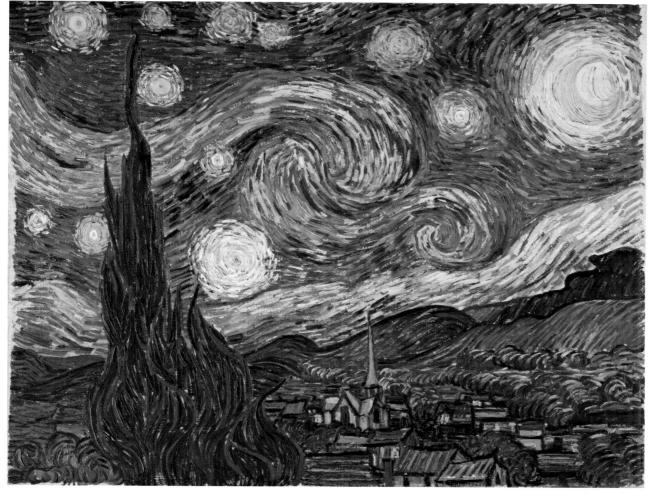

27-74. Vincent van Gogh. *The Starry Night*. 1889. Oil on canvas, $28\frac{3}{4} \times 36\frac{1}{4}$ " (73 × 93 cm). The Museum of Modern Art, New York.

Acquired through the Lillie P. Bliss Bequest, (472.1941)

blazes with exploding stars. One explanation for the intensity of van Gogh's feelings is the then-popular theory that after death people journey to a star, where they continue their lives. Contemplating immortality in a letter, van Gogh wrote: "Just as we take the train to get to Tarascon or Rouen, we take death to reach a star." The idea is given visible form in this painting by the cypress tree, a traditional symbol of both death and eternal life, which dramatically rises to link the terrestrial and celestial realms. The brightest star in the sky is actually a planet, Venus, which is associated with love. Is it possible that the picture's extraordinary excitement also expresses van Gogh's euphoric hope of gaining the companionship that had eluded him on earth?

In painting from his imagination rather than from nature in *The Starry Night*, van Gogh was perhaps following the advice of his friend Gauguin, who had once counseled another colleague, "Don't paint from nature too much. Art is an abstraction. Derive this abstraction from nature while dreaming before it, and think more of the creation that will result." Gauguin's own mature work was even more abstract than van Gogh's, and, like Cézanne's, it laid important foundations for the develop-

ment of nonrepresentational art in the twentieth century. During the 1870s and early 1880s the Parisian-born Gauguin enjoyed a comfortable bourgeois life as a stockbroker and painted in his spare time under the tutelage of Pissarro. He exhibited in the final four Impressionist exhibitions, held between 1880 and 1886. In 1883, Gauguin lost his job during a stock market crash; three years later he abandoned his wife and five children to pursue a fulltime painting career. Disgusted by what he considered the corruption of urban civilization and seeking more "primitive" existence, Gauguin lived for extended periods in the French province of Brittany between 1886 and 1891, traveled to Panama and Martinique in 1887, spent two months in Arles with van Gogh in 1888, then in 1891 sailed for Tahiti, a French colony in the South Pacific. After a final sojourn in France in 1893-95, Gauguin returned to the Pacific, where he died.

Gauguin's mature style was inspired by such nonacademic sources as medieval stained glass, folk art, and Japanese prints and featured simplified drawing, flattened space, and antinaturalistic color. Gauguin rejected Impressionism because it neglected subjective feelings and "the mysterious centers of thought."

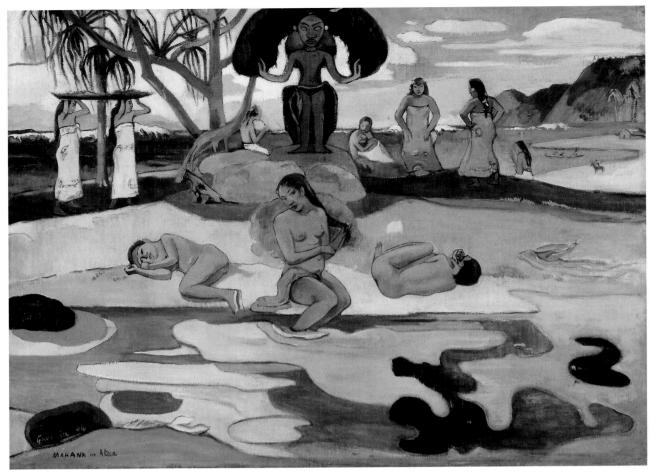

27-75. Paul Gauguin. *Mahana no atua (Day of the God).* 1894. Oil on canvas, $27^3/8 \times 35^5/8$ " (69.5 × 90.5 cm). The Art Institute of Chicago. Helen Birch Bartlett Memorial Collection (1926.198)

Gauguin called his anti-Impressionist style synthetism, because it synthesized observation of the subject in nature with the artist's feelings about that subject, expressed through abstracted line, shape, space and color. Very much a product of such synthesis is Mahana no atua (Day of the God) (fig. 27-75), which, despite its Tahitian subject, was painted in France during Gauguin's return after two years in the South Pacific. Gauguin had gone to Tahiti hoping to find an unspoiled paradise where he could live and work cheaply and "naturally." What he discovered, instead, was a thoroughly colonized country whose native culture was rapidly disappearing under the pressures of Westernization. In his paintings, Gauguin ignored this reality and depicted the Edenic ideal in his imagination, as seen in Mahana no atua, with its bright colors, stable composition, and appealing subject matter.

Gauguin divided *Mahana no atua* into three horizontal zones in styles of increasing abstraction. The upper zone, painted in the most realistic manner, centers around the statue of a god, behind which extends a beach landscape populated by Tahitians. In the middle zone, directly beneath the statue, three figures occupy a beach divided into several bands of antinaturalistic color. The central female bather dips her feet in the water and

looks out at the viewer, while on either side of her two figures recline in fetuslike postures—perhaps symbolizing birth, life, and death. Filling the bottom third of the canvas is a strikingly abstract pool whose surface does not reflect what is above it but instead offers a dazzling array of bright colors, arranged in a puzzlelike pattern of flat, curvilinear shapes. By reflecting a strange and unexpected reality exactly where we expect to see a mirror image of the familiar world, this magic pool seems the perfect symbol of Gauguin's desire to evoke "the mysterious centers of thought." Like many of Gauguin's works, *Mahana no atua* is enigmatic and suggestive of unstated meanings that cannot be literally represented but only evoked indirectly through abstract pictorial means.

SYMBOLISM IN PAINTING

Gauguin's suggestiveness is characteristic of Symbolism, an international movement in late-nineteenth-century art and literature of which he was a recognized leader. Like the Romantics before them, the Symbolists opposed the values of rationalism and material progress that dominated modern Western culture and instead explored the nonmaterial realms of emotion, imagination, and spirituality. Ultimately the Symbolists sought a deeper

and more mysterious reality than the one we encounter in everyday life, which they conveyed not through traditional iconography but through ambiguous subject matter and formal stylization suggestive of hidden and elusive meanings. Instead of objectively representing the world, they transformed appearances in order to give pictorial form to psychic experience, and they often compared their works to dreams. It seems hardly coincidental that Sigmund Freud, who compared artistic creation to the process of dreaming, wrote his pioneering *The Interpretation of Dreams* (1900) during the Symbolist period.

A dreamlike atmosphere pervades the later work of Gustave Moreau (1826–98), an older academic artist whom the Symbolists recognized as a precursor. The Symbolists particularly admired Moreau's renditions of the biblical subject of Salome, the young Judaean princess who, at the instigation of her mother, Herodias, performed an erotic dance before her stepfather, Herod, and demanded in return the head of John the Baptist (Mark 6:21–28). In *The Apparition* (fig. 27-76), exhibited at the Salon of 1876, the seductive Salome confronts a vision of the saint's severed head, which hovers open-eyed in

midair, simultaneously dripping blood and radiating holy light. Moreau depicts this macabre subject and its exotic architectural setting in elaborate linear detail with touches of jewel-like color. His style creates an atmosphere of voluptuous decadence that amplifies Salome's role as the archetypal *femme fatale*, the "fatal woman" who tempts and destroys her male victim—a fantasy that haunted the imagination of countless male Symbolists, perhaps partly in response to late-nineteenth-century feminism.

A younger artist who embraced Symbolism was Odilon Redon (1840–1916). Although he exhibited with the Impressionists in 1886, he diverged from their artistic goals by using nature as a point of departure for fantastic visions tinged with loneliness and melancholy. For the first twenty-five years of his career, Redon, a **graphic artist**, created moody images in black-and-white charcoal drawings that he referred to as *Noirs* ("Blacks") and in related etchings and lithographs, such as *The Marsh Flower, a Sad and Human Face* (fig. 27-77), one of many bizarre human-vegetal hybrids Redon invented. Despite the supernatural appearance of this plant's sorrowful but radiant human face, it was inspired

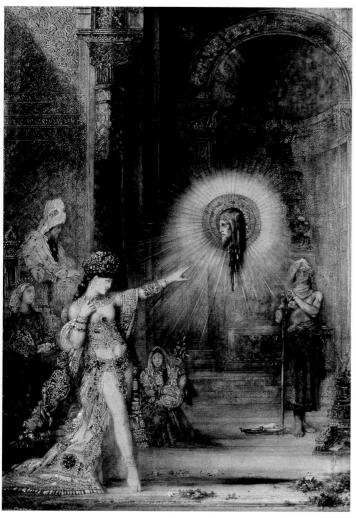

27-76. Gustave Moreau. *The Apparition.* 1874–76. Watercolor on paper, $41^5/_{16} \times 28^3/_{16}$ " (106 \times 72.2 cm). Musée du Louvre, Paris.

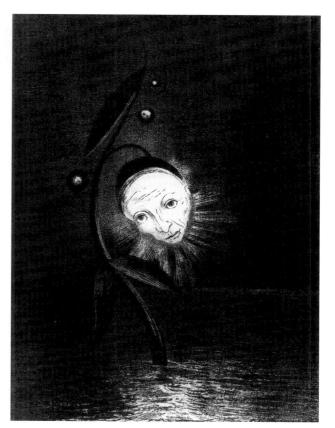

27-77. Odilon Redon. *The Marsh Flower, a Sad and Human Face,* plate 2 from *Homage to Goya.* 1885. Lithograph, $10^{7}/_{8} \times 8"$ (27.5 \times 20.3 cm). The Museum of Modern Art, New York.

Abby Aldrich Rockefeller Purchase Fund

Fascinated by the science of biology, Redon based his strange hybrid creatures on the close study of living organisms. His aim, as he wrote in his journal, was "to make improbable beings live, like human beings, according to the laws of probability by putting . . . the logic of the visible at the service of the invisible."

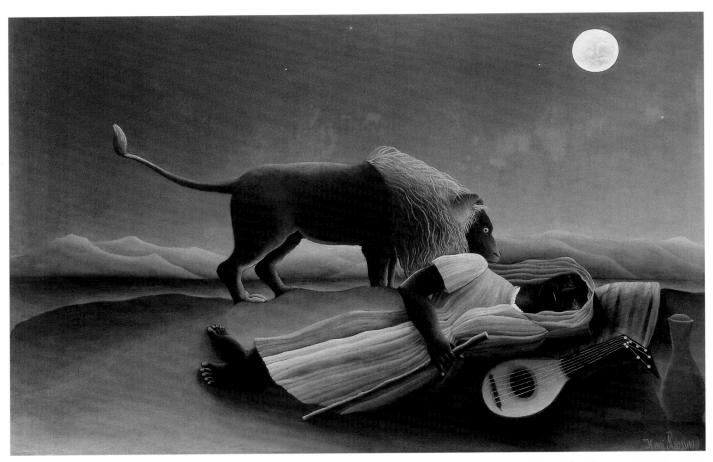

27-78. Henri Rousseau. *The Sleeping Gypsy*. 1897. Oil on canvas, $4'3'' \times 6'7''$ (1.3 \times 2.03 m). The Museum of Modern Art, New York.

Gift of Mrs. Simon Guggenheim

From 1886 until his death, Rousseau exhibited regularly at the Salon des Indépendants. While most critics dismissed his work for its stylistic naiveté, his pictures excited the admiration of a few progressive figures such as the playwright Alfred Jarry, who gave Rousseau his nickname, Le Douanier ("the customs official"). By the early twentieth century Rousseau had become a celebrity to the Parisian avant-garde, including the poet Guillaume Apollinaire and Pablo Picasso, who bought several of Rousseau's paintings and later donated them to the Louvre. In 1908 Picasso hosted a now-legendary banquet for Rousseau that confirmed his high standing among the younger generation of artists.

by contemporary Darwinian theories that posited a common ancestry for all forms of earthly life.

A contemporary of the Symbolists who shared their interest in poetic and dreamlike imagery was Henri Rousseau (1844-1910), a "naive," or untrained "primitive," painter. After a long career as a municipal toll collector in Paris, which earned him the nickname Le Douanier ("the customs official"), Rousseau retired in 1893 to devote his full energies to painting. Rousseau admired academic painting and tried to emulate its polished style, but, lacking formal training, he failed to grasp academic rules of scale, perspective, modeling, and coloring. Working in a sincere but awkward manner, he painted with strong hues, gave his forms crisp outlines, posed his figures stiffly, and positioned them in flattened and airless spaces. As a result, his compositions have a stylized quality similar to that of the Post-Impressionists. Among Rousseau's most famous works is The Sleeping Gypsy (fig. 27-78), a haunting picture whose mood of nocturnal mystery and magic anticipates the twentieth-century Surrealists, who claimed Rousseau as a precursor.

Symbolism originated in France but had a profound impact on the art of other European countries, where it often merged with expressionist tendencies. Such a melding of Symbolism and Expressionism is evident in the work of the Belgian painter and printmaker James Ensor (1860-1949), who, except for four years of study at the Brussels Academy, spent his life in the coastal resort town of Ostend. Like Redon, Ensor derived his weird and anxious visions from the observation of the real world-often grotesque papier-mâché masks that his family sold during the annual pre-Lenten carnival, one of Ostend's main holidays. In paintings such as The Intrigue (fig. 27-79), these disturbing masks seem to come to life and reveal rather than hide the character of the people wearing them—comical, stupid, and hideous. The acidic colors increase the sense of caricature, as does the crude handling of form. The rough paint is both expressive and expressionistic: Its lack of subtlety well characterizes the subjects, while its almost violent application directly records Ensor's feelings toward them.

The sense of powerful emotion that pervades Ensor's work is even more evident in that of his Norwe-

gian contemporary Edvard Munch (1863–1944). Munch's most famous work, The Scream (fig. 27-80), is an unforgettable image of modern alienation that merges Symbolist suggestiveness with expressionist intensity of feeling. Munch recorded the painting's genesis in his diary: "One evening I was walking along a path; the city was on one side, and the fjord below. I was tired and ill. ... I sensed a shriek passing through nature... I painted this picture, painted the clouds as actual blood." In the painting itself, however, the figure is on a bridge and the scream emanates from him. Although he vainly attempts to shut out its sound by covering his ears, the scream fills the landscape with clouds of "actual blood." The overwhelming anxiety that sought release in this primal scream was chiefly a dread of death, as the sky and the figure's skull-like head suggest, but the setting of the picture also suggests a fear of open spaces. The expressive abstraction of form and color in the painting reflects the influence of Gauguin and his Scandinavian followers, whose work Munch had encountered shortly before he painted *The Scream*.

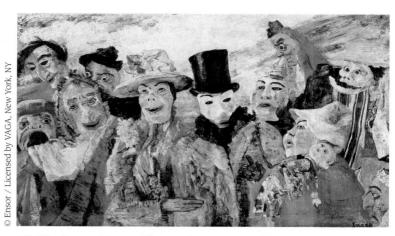

27-79. James Ensor. *The Intrigue.* 1890. Oil on canvas, $35^{1}/_{2}\times59''$ (90.3 \times 150 cm). Koninklijk Museum voor Schone Kunsten, Antwerp.

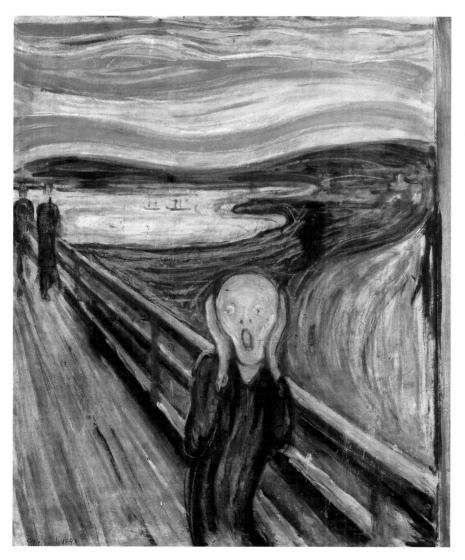

27-80. Edvard Munch. *The Scream.* 1893. Tempera and casein on cardboard, $36 \times 29''$ (91.3 \times 73.7 cm). Nasjonalgalleriet, Oslo, Norway.

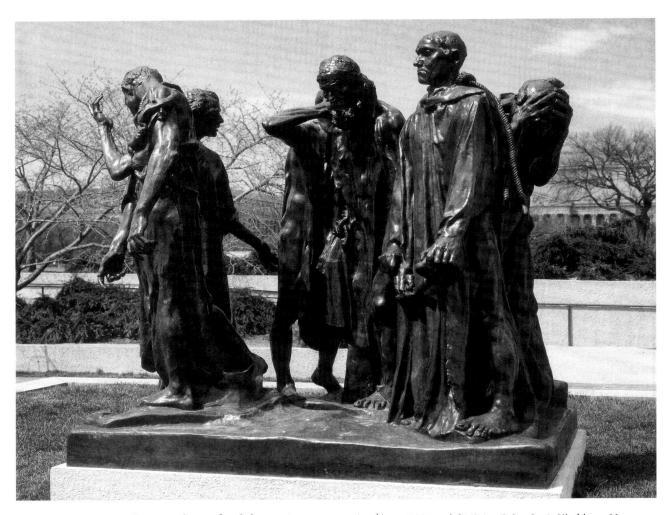

27-81. Auguste Rodin. *Burghers of Calais.* 1884–89. Bronze, $6'10^1/_2" \times 7'11" \times 6'6"$ (2.1 \times 2.4 \times 2 m). Hirshhorn Museum and Sculpture Garden, Smithsonian Institution, Washington, D.C. Gift of Joseph H. Hirshhorn, 1966

LATE-NINETEENTH-CENTURY FRENCH SCULPTURE

The most successful and influential European sculptor of the late nineteenth century was Auguste Rodin (1840–1917). Born in Paris and trained as a decorative craftsperson, Rodin failed on three occasions to gain entrance to the École des Beaux-Arts and consequently spent the first twenty years of his career as an assistant to other sculptors and decorators. After an 1875 trip to Italy, where he saw the sculpture of Donatello and Michelangelo, Rodin developed his mature style of vigorously modeled figures in unconventional poses, which were simultaneously scorned by academic critics and admired by the general public.

Rodin's status as a major sculptor was confirmed in 1884, when he won a competition for the *Burghers of Calais* (fig. 27-81), commissioned to commemorate an event from the Hundred Years' War. In 1347 Edward III of England had offered to spare the besieged city of Calais if six leading citizens (or burghers)—dressed only in sack-cloth with rope halters and carrying the keys to the city—would surrender to him for execution. Rodin shows the six volunteers preparing to give themselves over to what

they assume will be their deaths. The Calais commissioners were not pleased with Rodin's conception of the event. Instead of calm, idealized heroes, Rodin presented ordinary-looking men in various attitudes of resignation and despair. He exaggerated their facial expressions, expressively lengthened their arms, greatly enlarged their hands and feet, and swathed them in heavy fabric, showing not only how they may have looked but how they must have felt as they forced themselves to take one difficult step after another. Rodin's willingness to stylize the human body for expressive purposes was a revolutionary move that opened the way for the more radical innovations of later sculptors.

Nor were the commissioners pleased with Rodin's plan to display the group on a low pedestal. Rodin felt that the usual placement of such figures on an elevated pedestal suggested that only higher, superior humans are capable of heroic action. By placing the figures nearly at street level, Rodin hoped to convey to viewers that ordinary people, too, are capable of noble acts. Rodin's removal of public sculpture from a high to a low pedestal would lead, in the twentieth century, to the elimination of the pedestal itself and to the presentation of sculpture in the "real" space of the viewer (see fig. 29-33).

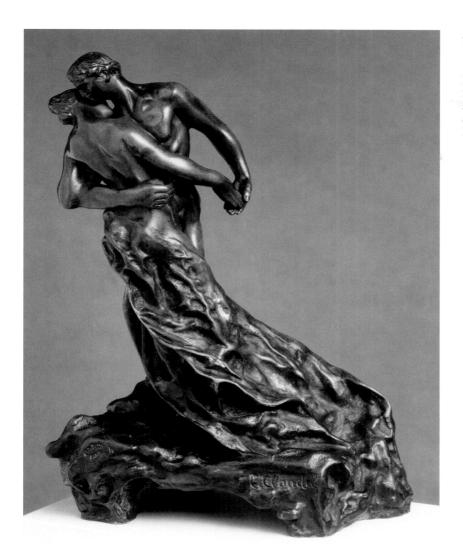

27-82. Camille Claudel. *The Waltz.* 1892–1905. Bronze, $9^{7}/8$ " (25 cm). Neue Pinakothek, Munich.

French composer Claude Debussy, a close friend of Claudel, displayed a cast of this sculpture on his piano. Debussy acknowledged the influence of art and literature on his musical innovations.

An assistant in Rodin's studio who worked on the *Burghers of Calais* was Camille Claudel (1864–1943), whose accomplishments as a sculptor were long overshadowed by the dramatic story of her life. Claudel began to study sculpture in 1879 and became Rodin's pupil four years later. After she started working in his studio, she also became his mistress, and their often stormy relationship lasted fifteen years. Both during and after her association with Rodin, Claudel enjoyed independent professional success, but she also suffered from psychological problems that eventually overtook her, and she spent the last thirty years of her life in a mental asylum.

Among Claudel's most celebrated works is *The Waltz* (fig. 27-82), which exists in several versions made between 1892 and 1905. The sculpture depicts a dancing couple, the man unclothed and the woman seminude, her lower body enveloped in a long, flowing gown. In Claudel's original conception, both figures were entirely nude, but she had to add drapery to the female figure after an inspector from the Ministry of the Beaux-Arts found the pairing of the nude bodies indecent and recommended against a state commission for a marble version of the work. After Claudel added drapery, the same

inspector endorsed the commission, but it was never carried out. Instead, Claudel modified *The Waltz* further and had it cast in bronze.

In *The Waltz*, Claudel succeeded in conveying an illusion of fluent motion as the dancing partners whirl in space, propelled by the rhythm of the music. The spiraling motion of the couple, enhanced by the woman's flowing gown, encourages the observer to view the piece from all sides, increasing its dynamic effect. Despite the physical closeness of the dancers there is little actual physical contact between them, and their facial expressions reveal no passion or sexual desire. After violating decency standards with her first version of *The Waltz*, Claudel perhaps sought in this new rendition to portray love as a union more spiritual than physical.

ART NOUVEAU

The swirling mass of drapery in Claudel's *Waltz* has a stylistic affinity with Art Nouveau (French for "new art"), a movement launched in the early 1890s that for more than a decade permeated all aspects of European art, architecture, and design. Like the contemporary Symbolists, the practitioners of Art Nouveau largely rejected the values of modern industrial society and sought new

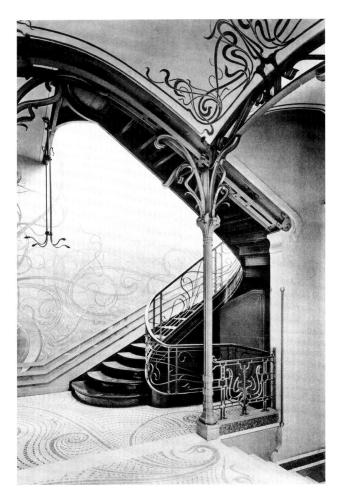

27-83. Victor Horta. Stairway, Tassel House, Brussels. 1892–93.

aesthetic forms that would retain a preindustrial sense of beauty while also appearing fresh and innovative. They drew particular inspiration from nature, especially from organisms such as vines, snakes, flowers, and winged insects, whose delicate and sinuous forms were the basis of their graceful and attenuated linear designs. Following from this commitment to organic principles, they also sought to harmonize all aspects of design into a beautiful whole, as found in nature itself.

The man largely responsible for introducing the Art Nouveau style in architecture and the decorative arts was a Belgian, Victor Horta (1861–1947). Trained at the academies in Ghent and Brussels, Horta worked in the office of a Neoclassical architect in Brussels for six years before opening his own practice in 1890. In 1892 he received his first important commission, a private residence in Brussels for a Professor Tassel. The result, especially the house's entry hall and staircase (fig. 27-83), was strikingly original. The ironwork, wall decoration, and floor tile were all designed in an intricate series of long, graceful curves. Although Horta's sources are still a matter of debate, he apparently was much impressed with the stylized linear graphics of the English Arts and Crafts movement of the 1880s. Horta's concern for inte-

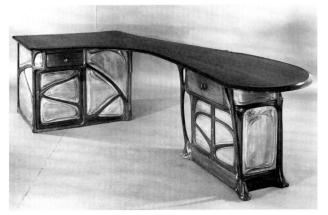

27-84. Hector Guimard. Desk. c. 1899 (remodeled after 1909). Olive wood with ash panels, $28^3/_4 \times 47^3/_4$ " (73 × 121 cm). The Museum of Modern Art, New York. Gift of Madame Hector Guimard

grating the various arts into a more unified whole, like his reliance on a refined decorative line, derived largely from English reformers.

The application of graceful linear arabesques to all aspects of design, evident in the entry hall of the Tassel House, began a vogue that spread across Europe and acquired a number of regional names. In Italy it was called *Stile floreale* ("Floral Style") and *Stile Liberty* (after the Liberty department store in London); in Germany, *Jugendstil* ("Youth Style"); in Spain, *Modernismo* ("Modernism"); in Vienna, *Sezessionstil*, after the secession from the academy led by the painter Gustav Klimt (see page 1022); in Belgium, *Paling Style* ("Eel Style"); and in France, a number of names, including *moderne*. The name eventually accepted in most countries derives from a shop, La Maison de l'Art Nouveau ("The House of the New Art"), which opened in Paris in 1895.

In France Art Nouveau was also sometimes known as *Style Guimard* after its leading French practitioner, Hector Guimard (1867–1942). Guimard worked in an eclectic manner during the early 1890s but in 1895 met and was influenced by Horta. He went on to design the famous Art Nouveau-style entrances for the Paris Métro (subway) and devoted considerable effort to interior design and furnishings, such as the desk he made for himself (fig. 27-84). Instead of a static and stable object, Guimard handcrafted an asymmetrical, organic entity that seems to undulate and grow.

The Art Nouveau style also had a powerful impact on the graphic arts, including poster design, whose most innovative French practitioner in the 1890s was Henri de Toulouse-Lautrec (1864–1901). Born into an aristocratic family in the south of France, Lautrec suffered from a genetic disorder and childhood accidents that left him dwarfed and crippled. Extremely gifted artistically, he moved to Paris in 1882 and had private academic training before discovering the work of Degas, which greatly influenced his own development. He also discovered Montmartre, a lower-class entertainment district of Paris, and soon joined its population of bohemian artists.

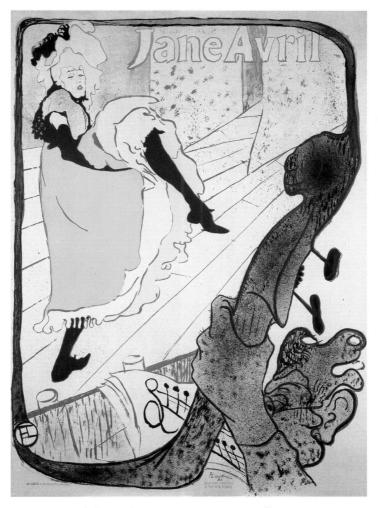

27-85. Henri de Toulouse-Lautrec. Jane Avril. 1893. Lithograph, $50^{1}/_{2} \times 37''$ (129 × 94 cm). San Diego Museum of Art. Gift of the Baldwin M. Baldwin Foundation, (1987.32)

From the late 1880s Lautrec dedicated himself to depicting the social life of the Parisian cafés, theaters, dance halls, and brothels-many of them in Montmartre-that he himself frequented.

Among these images were thirty lithographic posters Lautrec designed between 1891 and 1901 as advertisements for popular night spots and entertainers (see "The Print Revivals," page 984). His portrayal of the café dancer Jane Avril (fig. 27-85) demonstrates the remarkable originality that Lautrec brought to an essentially commercial project. The composition juxtaposes the dynamic figure of Avril dancing onstage at the upper left with the cropped image of a bass viol player and the scroll of his instrument at the lower right. The bold foreshortening of the stage and the prominent placement of the bass in the foreground both suggest the influence of Degas, who employed similar devices (see fig. 27-63). Lautrec departs radically from Degas's naturalism, however, particularly in his imaginative extension of each end of the bass viol's head into a curving frame that encapsulates Avril and connects her visually with her musical accompaniment. Also antinaturalistic are the radical simplification of form, suppression of modeling, flattening of space, and integration of blank paper into the composition, all of which suggest the influence of Japanese woodblock prints (see "Japonisme," page 988). Meanwhile, the emphasis on curving lines and the harmonization of the lettering with the rest of the design are characteristic of Art Nouveau.

NINETEENTH-STATES

LATER The tension between an academic tradition imported from western Europe and an CENTURY ART unbroken American tradi-IN THE UNITED tion of realism marked the development of art in the United States during the second half of the nineteenth

century. The advocates of realism had long considered it distinctively American and democratic; others, in contrast, saw the academic ideal as a link to a higher western European culture.

LATER NEOCLASSICAL SCULPTURE

Immediately before and after the Civil War (1861–65), sculpture-especially in marble-remained the essential medium for those committed to "high," or European, culture. A new generation of sculptors continued

the European Neoclassical tradition established in Rome by Antonio Canova (see fig. 26-21) and brought to the United States in the second quarter of the nineteenth century by artists like Hiram Powers. Most members of this new generation studied in Rome, including a number of women, whom the American author Henry James dubbed the "white, marmorean [marble] flock."

The most prominent of these women, Harriet Hosmer (1830-1908), moved to Rome in 1852 where she rapidly mastered the Neoclassical mode and began producing major exhibition pieces such as Zenobia in Chains (fig. 27-86), which she entered into an international exhibition in London in 1862 and then sent on tour around the United States. Like Powers's famous The Greek Slave (see fig. 27-27), another marble image of a chained woman, Hosmer's sculpture is Neoclassical in form but Romantic in content, representing an exotic historical subject calculated to appeal to the viewer's emotions. Zenobia, the ambitious third-century queen of the Syrian city of Palmyra, was captured by the Romans and forced to march through the streets of Rome in chains. Hosmer presents her as a noble and monumental figure, resolute even in defeat. "I have tried to make her too proud to exhibit passion or emotion of any kind," wrote Hosmer of Zenobia, "not subdued, though a prisoner; but calm, grand, and strong within herself." Thus, unlike Powers's The Greek Slave, Zenobia is not powerless but powerful, embodying an ideal of womanhood strikingly modern in its defiance of Victorian conventions of female submissiveness.

Another American woman who moved to Rome to become a sculptor was Edmonia Lewis (c. 1843/45after 1911). Born in New York State to a Chippewa mother and an African-American father and originally named Wildfire, Lewis was orphaned at the age of four and raised by her mother's family. As a teenager, with the help of abolitionists, she attended Oberlin College, the first college in the United States to grant degrees to women, then moved to Boston. Her highly successful busts and medallions of abolitionist leaders and Civil War heroes financed her move to Rome in 1867, where she was welcomed into Hosmer's circle.

In Rome, Lewis continued to dedicate herself to the causes of human freedom, especially those involving women: "I have a strong sympathy for all women who have struggled and suffered," she said. Hagar in the Wilderness (fig. 27-87), for example, tells the story of the Egyptian concubine of the biblical patriarch Abraham, given to him by his childless wife, Sarah, so that he might have a son. When Hagar's son, Ishmael, was in his teens, the elderly Sarah miraculously gave birth to a son, Isaac. Out of jealousy, she then demanded that Abraham drive Hagar and her son into the wilderness. When Hagar and Ishmael were dying from thirst, an angel led them to a well and told Hagar that her son's descendants would be a great nation (Genesis

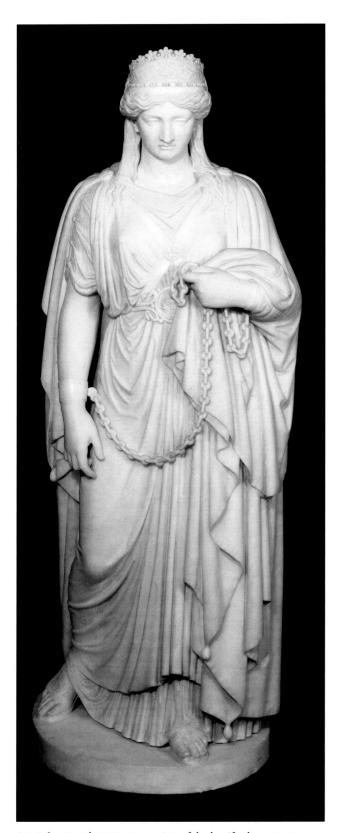

27-86. Harriet Hosmer. Zenobia in Chains. 1859. Marble, 4' (1.21 m). Wadsworth Athenaeum, Hartford, Connecticut.

Gift of Mrs. Josephine M. J. Dodge

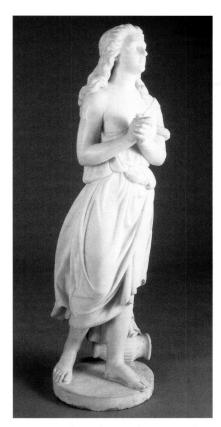

27-87. Edmonia Lewis. *Hagar in the Wilderness.* 1875. Marble, $52\frac{5}{8} \times 15\frac{1}{4} \times 17"$ (136.2 \times 39.1 \times 43.6 cm). Smithsonian American Art Museum, Smithsonian Institution, Washington, D.C. Gift of Delta Sigma Theta Sorority, Inc., (1983.95.178)

16:1–16; 21:9–21). Because of her African origins, Hagar represented for Lewis the plight and the hope of her entire race.

LANDSCAPE PAINTING AND PHOTOGRAPHY

In contrast to the late Neoclassicism prevalent in sculpture, during the years before the Civil War American landscape painters shifted from the Romantic tradition of Thomas Cole (see fig. 27-25) toward a more factual naturalism. This transition is particularly evident in the work of Frederic Edwin Church (1826-1900), Cole's only student. Like Cole, Church favored the grand spectacles of nature, such as Niagara Falls (fig. 27-88). In its epic aspirations Church's Niagara remains Romantic in conception, but its Romanticism is tempered by a scientific eye to detail. The painting's magnificent spectacle, precarious vantage point, and large scale were designed to generate grand emotions, especially nationalistic pride. By including a rainbow—a traditional symbol of divine approval over the falls, Church appealed to his compatriots' preconceptions about their national destiny. Americans flocked to see Niagara, and more than a thousand visitors in New York City bought reproductions of the work.

Albert Bierstadt (1830–1902), born in Germany and raised in Massachusetts, specialized in paintings of the American West. After studying at the Düsseldorf Academy, Bierstadt in 1859 accompanied a U.S. Army expedition, led by Colonel Frederick Lander, mapping an overland route from St. Louis to the Pacific Ocean. Working from his sketches and photographs, he produced the paintings that made his fame. The first of

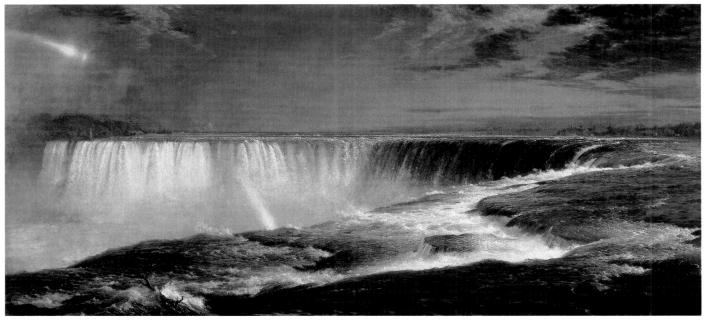

27-88. Frederic Edwin Church. *Niagara*. 1857. Oil on canvas, $3'6^{1}/_{2}" \times 7'6^{1}/_{2}"$ (1.1 × 2.3 m). The Corcoran Gallery of Art, Washington, D.C.

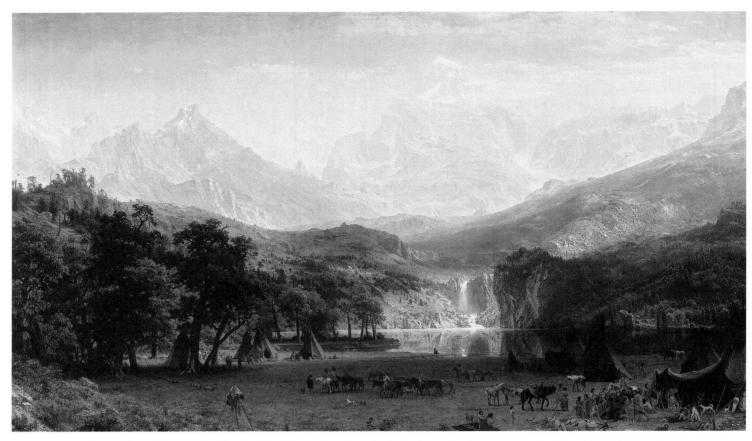

27-89. Albert Bierstadt. *The Rocky Mountains, Lander's Peak*. 1863. Oil on canvas, $6'1^{1}/_{4}" \times 10'^{3}/_{4}"$ (1.86 × 3 m). The Metropolitan Museum of Art, New York. Rogers Fund, 1907 (07.123)

these, The Rocky Mountains, Lander's Peak (fig. 27-89), attracted large crowds and sold for \$25,000, the highest price an American painting had yet brought-more than forty times what a skilled carpenter or mason then earned per year. The huge canvas, intended for Eastern audiences only slightly familiar with Native Americans and even less familiar with the Rockies, combines a documentary approach to Native American life in the tradition of George Catlin (see fig. 27-24) with an epic, composite landscape in the tradition of Church. The painting is more than a geography lesson, however. As in the work of Church and Cole, it conveys an implicit historical narrative. From the Native American encampment in the foreground, with its apparent associations to the Garden of Eden, the eye is drawn into the middle ground by the light on the waterfall, then up to Lander's Peak. To Americans who believed that it was the divinely sanctioned Manifest Destiny of the United States to expand all the way to California, the composition's spatial progression must have appeared to map out their nation's westward and "upward" course. The painting seems virtually to beckon them into this paradise to displace the Native Americans already inhabiting it.

The photographer Timothy H. O'Sullivan (1840–82), like Bierstadt, accompanied survey expeditions. His most famous Western photograph, *Ancient Ruins in the Cañon de Chelley, Arizona* (fig. 27-90), while ostensibly a documentary image, is infused with a Romantic sense of

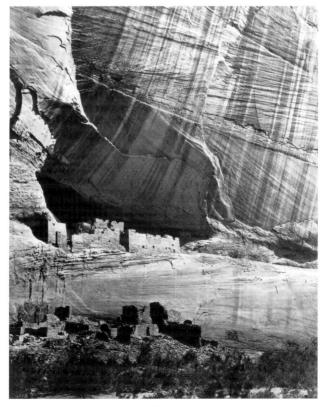

27-90. Timothy H. O'Sullivan. *Ancient Ruins in the Cañon de Chelley, Arizona*. 1873. Albumen print. National Archives, Washington, D.C.

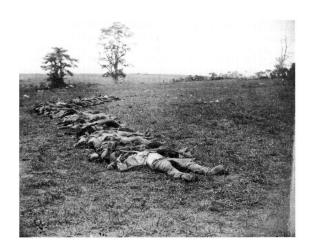

27-91. Alexander Gardner. *Confederate Dead Gathered for Burial, Antietam, September 1862.* 1862. Albumen silver print. Library of Congress, Washington, D.C.

An 1862 editorial in the *New York Times* commented that Mathew Brady and his assistants "bring home to us the terrible reality . . . of the war. If [they have] not brought bodies and laid them in our door yards . . . [they have] done something very like it."

awe before the grandeur of nature. The 700-foot canyon wall fills the composition, giving the viewer no clear vantage point and scant visual relief. The bright, raking sunlight across the rock face reveals little but the cracks and striations formed over countless eons. The image suggests not only the immensity of geological time but also humanity's insignificant place within it. Like the classical ruins that were a popular theme in European Romantic art and literature, the eleventh- to fourteenth-century Anasazi ruins suggest the inevitable passing of all civilizations. The four puny humans on the left, standing in this majestic yet barren place, reinforce the theme of human futility and insignificance.

CIVIL WAR PHOTOGRAPHY AND SCULPTURE

The sense of Romantic pessimism infusing *Ancient Ruins* in the Cañon de Chelley, *Arizona* may reflect the impact of the Civil War, which lasted four bloody years (1861–65) and cost nearly 620,000 American lives. Inspired by British war photographers in the 1850s, more than 300 American and foreign photographers eventually entered the battle zone with passes from the U.S. government.

The first photographer at the front was Mathew B. Brady (1823–96), who gained government permission to take a team and a darkroom wagon to the field of battle. After Brady himself was almost killed in an early battle, he left the photographing to his twenty assistants, among whom was Timothy O'Sullivan. Brady's Photographic Corps amassed more than 7,000 negatives documenting every aspect of the war except the actual fighting, because the cameras were still too slow to capture action scenes. Brady and his assistants took their most memorable images immediately after battles, before the dead could be buried. Confederate Dead Gathered for Burial, Antietam, September 1862 (fig. 27-91), by Brady's most acclaimed assistant, Alexander Gardner (1821–82), shows the corpses of some of the more than 10,000 Confederate soldiers who had fallen in that battle. The grim evidence of carnage in such works made a powerful impression on the American public, cutting through the so-called glamour of war.

After the war, both the North and the South commissioned public sculpture to commemorate the dead and

honor their heroes. Augustus Saint-Gaudens (1848-1907), the preeminent American sculptor of the late nineteenth century, created six Civil War memorials. Born in Ireland, Saint-Gaudens grew up in New York City, studied sculpture at the École des Beaux-Arts, and from 1870 to 1875 worked in Rome before returning to the United States. Nine years later he began work on the Robert Gould Shaw Memorial (fig. 27-92, page 1010), which pays tribute to the twenty-five-year-old white commander of the first African-American military corps in the North, the Massachusetts Fifty-fourth Regiment. In July 1863, just two months after triumphantly marching through the streets of Boston to join the Union forces, Shaw and hundreds of his men died in an attack on Fort Wagner, near Charleston, South Carolina. In Saint-Gaudens's sculpture, the mounted Shaw and his infantrymen move resolutely toward their destiny, accompanied by an allegorical figure of Peace and Death. Nearly 180,000 African Americans eventually fought for the Union, and President Abraham Lincoln believed their contributions helped tip the scales toward the Union victory.

POST-CIVIL WAR REALISM

Saint-Gaudens's use of allegorical figures tied his art to an older European tradition of idealism that other American artists such as Winslow Homer (1836-1910) rejected, believing that unadorned realism was the more appropriate style for democratic values. The Bostonborn Homer began his career in 1857 as a freelance illustrator for popular periodicals such as Harper's Weekly, which sent him to cover the Civil War in 1862. In 1866-67 Homer spent ten months in France, where the naturalist art he saw may have inspired the rural subjects he painted when he returned. Works like Snap the Whip (fig. 27-93, page 1010), with its depiction of boys playing outside a one-room schoolhouse in the Adirondack Mountains on a glorious day in early fall, evoke the innocence of childhood and the imagined charms of a preindustrial America for an audience that was increasingly urbanized. Many of these paintings were reproduced as wood engravings for illustrated books and magazines.

Homer's art changed significantly after he spent 1881–82 in a tiny English fishing village on the rugged

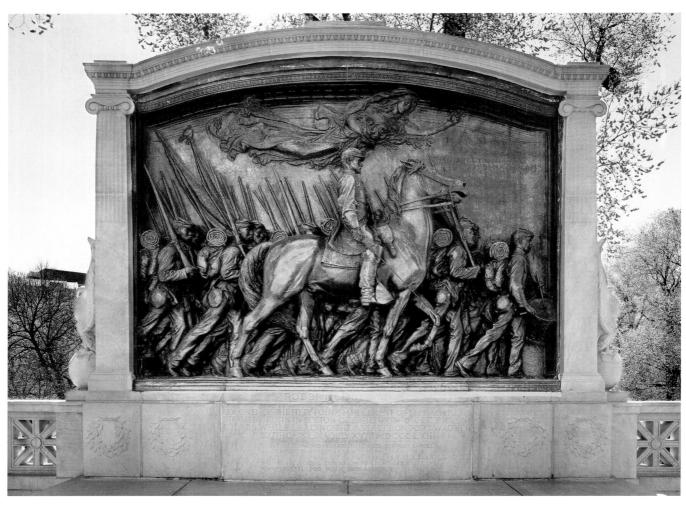

27-92. Augustus Saint-Gaudens. The Robert Gould Shaw Memorial. 1884–96. Bronze, $11 \times 14'$ (3.35 \times 4.27 m). Boston Common, Boston, Massachusetts.

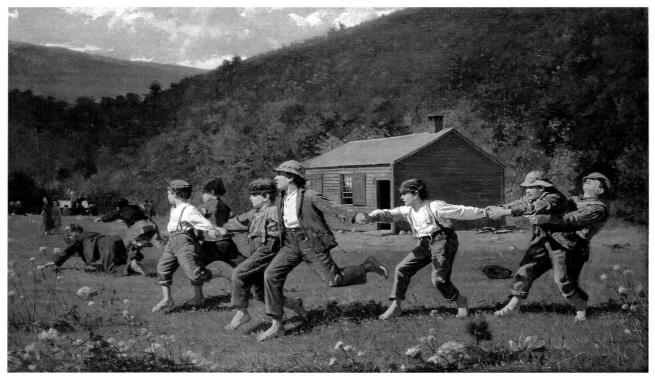

27-93. Winslow Homer. *Snap the Whip*. 1872. Oil on canvas, $22^{1}/_{4} \times 36^{1}/_{2}$ " (55.9 × 91.4 cm). The Butler Institute of American Art, Youngstown, Ohio.

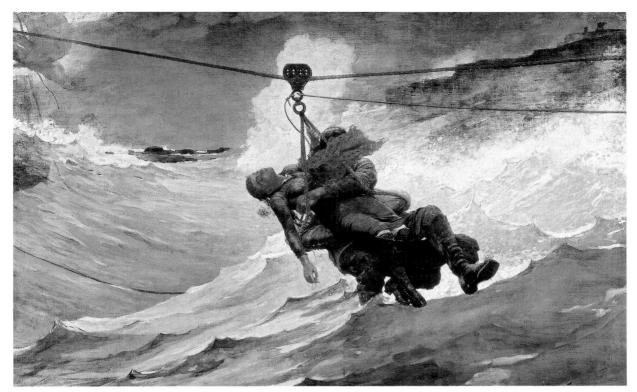

27-94. Winslow Homer. *The Life Line*. 1884. Oil on canvas, $28^3/_4 \times 44^5/_8$ " (73 × 113.3 cm). Philadelphia Museum of Art. The George W. Elkins Collection

In the early sketches for this work, the man's face was visible. The decision to cover it focuses more attention not only on the victim but also on the true hero, the mechanical apparatus known as the breeches buoy.

North Sea coast. The strength of character of the people there so inspired him that he turned from idyllic subjects to more dramatic themes involving the heroic human struggle against natural adversity. In England, he was particularly impressed with the breeches buoy, a mechanical apparatus used to rescue those aboard foundering ships. During the summer of 1883 Homer made sketches of a breeches buoy imported by the lifesaving crew in Atlantic City, New Jersey. The following year Homer painted *The Life Line* (fig. 27-94), which depicts a coastguardsman using the breeches buoy to rescue an unconscious woman and is a testament not simply to human bravery but to its ingenuity as well.

The most uncompromising American realist of the era, Thomas Eakins (1844–1916), also celebrated the human mind. Born in Philadelphia, Eakins trained at the Pennsylvania Academy of the Fine Arts and the École des Beaux-Arts in Paris, then spent six months in Spain, where he encountered the profound realism of Jusepe de Ribera and Diego Velázquez (see figs. 19-33, 19-36). After he returned to Philadelphia in 1870, he specialized in frank portraits and scenes of everyday life whose lack of conventional charm generated little popular interest.

One work did attract attention: *The Gross Clinic* (fig. 27-95, page 1012) was severely criticized and was refused exhibition space at the 1876 Philadelphia Centennial. The painting shows Dr. Samuel David Gross performing an operation with young medical students looking on. The representatives of science—a young medical student, the doctor, and his assistants—are all highlighted. This dramatic use of light, inspired by Rembrandt and the Spanish Baroque masters Eakins admired, is not meant to stir

emotions but to make a point: Amid the darkness of ignorance and fear, modern science shines the light of knowledge. The light in the center falls not on the doctor's face but on his forehead—on his mind.

In the shadows along the right-hand side of The Gross Clinic Eakins included a self-portrait, testimony to his personal knowledge of the subject. Eakins had studied anatomy, an interest that led him to photography, which he used both as an aid for painting and as a tool for studying the body in motion. He made a number of studies with the English-born American Eadweard Muybridge (1830-1904), a pioneer in motion photography. During the 1860s Muybridge made landscape photographs and worked for U.S. government geographic and military surveys. In 1872 he was hired by railroad owner and former California governor Leland Stanford, who wanted to prove that a running racehorse at one point in its stride has all four feet off the ground. Working with a fast new shutter developed by Stanford's engineer, Muybridge succeeded in 1878 in confirming Stanford's contention in Sally Gardner Running (fig. 27-96, page 1012).

URBAN PHOTOGRAPHY

Muybridge and Eakins used photography as a scientific tool, but other late-nineteenth-century photographers continued the struggle begun by Europeans such as Rejlander and Cameron to win recognition for photography as an art form (see figs. 27-35 and 27-36). Their efforts led to the rise of an international movement known as Pictorialism, in which photographers sought to create images whose aesthetic qualities matched those of painting,

27-95. Thomas Eakins. The Gross Clinic.

1875. Oil on canvas, $8'\times 6'5''$ (2.44 \times 1.98 m). Jefferson Medical College of Thomas Jefferson University, Philadelphia.

Eakins, who taught anatomy and figure drawing at the Pennsylvania Academy of the Fine Arts, disapproved of the academic technique of drawing from plaster casts. In 1879 he said, "At best, they are only imitations, and an imitation of an imitation cannot have so much life as an imitation of nature itself." He added, "The Greeks did not study the antique . . . the draped figures in the Parthenon pediment were modeled from life, undoubtedly." Eakins introduced the study of the nude model, which shocked many in staid Philadelphia society. In 1886 he caused a further scandal when he removed the loincloth from a male model in front of a class that included female students. He was given the choice of changing his teaching methods or resigning. He resigned.

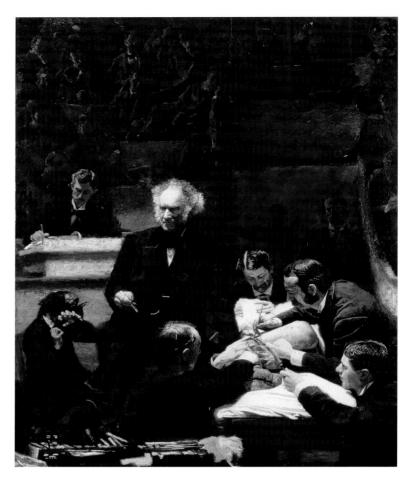

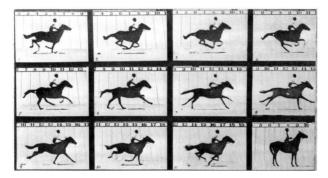

27-96. Eadweard Muybridge. *Sally Gardner Running at a 1:40 Gait, 19 June, 1878.* 1878. Wet-plate photography. Academy of Natural Sciences of Philadelphia.

This image was produced by twelve cameras with shutter speeds, according to Muybridge, of "less than two-thousand part of a second." The cameras, spaced 21 inches apart, were triggered by electric switches attached to thin black threads stretched across the track. In order to maximize the light, the ground was covered with powdered lime and a white screen was set up along the rail, with its linear divisions corresponding to the spacing of the cameras.

drawing, and printmaking. While most European Pictorialists photographed traditional artistic subjects such as rural landscapes, genre scenes, and nudes, the leading American Pictorialist, Alfred Stieglitz (1864–1946), found picturesque subjects in the street life of New York City.

Born in New Jersey to a wealthy German immigrant family, Stieglitz was educated in the early 1880s at the Technische Hochschule in Berlin, where he discovered photography and quickly recognized its artistic potential. In 1890 Stieglitz began to photograph New York City street scenes with one of the new high-speed, handheld cameras (the most popular of which, the Kodak, was invented by George Eastman in 1888), which permitted him to "await the moment when everything is in balance" and capture it. For *Winter on Fifth Avenue* (fig. 27-97), Stieglitz waited three hours on a street corner in a fierce February snowstorm before taking the shot of the coach drawn by a team of four horses. He made a further selection in the darkroom by printing only the central section of the negative, thereby enlarging the motif of the coach and transforming what was originally a horizontal composition into a vertical one, which he found more aesthetically pleasing.

The urban photographs of Jacob Riis (1849–1914) offer a harsh contrast to the essentially aesthetic views of Stieglitz. A reformer who aimed to galvanize public concern for the unfortunate poor, Riis saw photography not as an artistic medium but as a means of bringing about social change. Riis immigrated to New York City from Denmark in 1870 and was hired as a police reporter for the *New York Tribune*. He quickly established himself as a maverick among his colleagues by actually investigating slum life himself rather than merely rewriting police reports. Riis's contact with the poor convinced him that crime, poverty, and ignorance were largely environmental problems that resulted from, rather than caused, harsh slum conditions. He believed that if Americans knew the truth about slum life, they would support reforms.

Riis turned to photography in 1887 to document slum conditions, and three years later published his pho-

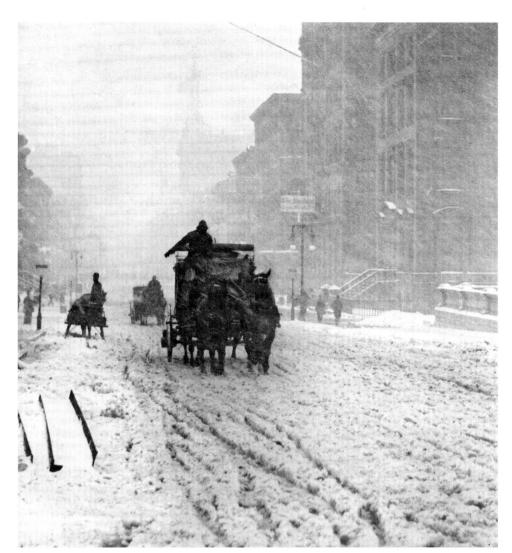

27-97. Alfred Stieglitz. *Winter on Fifth Avenue*. 1893. Photogravure. The Museum of Modern Art, New York.

tographs in a groundbreaking study, *How the Other Half Lives*. The illustrations were accompanied by texts that described their circumstances in matter-of-fact terms. Riis said he found the poor, immigrant family shown here (fig. 27-98) when he visited a house where a woman had been killed by her drunken, abusive husband:

The family in the picture lived above the rooms where the dead woman lay on a bed of straw, overrun by rats. . . . A patched and shaky stairway led up to their one bare and miserable room. . . . A heap of old rags, in which the baby slept serenely, served as the common sleeping-bunk of father, mother, and children—two bright and pretty girls, singularly out of keeping in their clean, if coarse, dresses, with their surroundings. . . . The mother, a pleasant-faced woman, was cheerful, even light-hearted. Her smile seemed the most sadly hopeless of all in the utter wretchedness of the place.

What comes through clearly in the photograph is the family's attempt to maintain a clean, orderly life despite the rats and the chaotic behavior of their neighbors. The broom behind the older girl implies as much, as does the caring way the father holds his youngest daughter. Riis shows that such slum dwellers are decent people who deserve better.

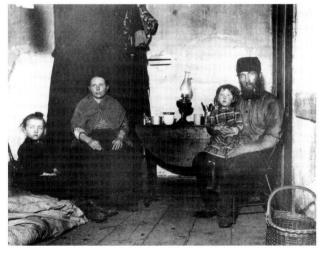

27-98. Jacob Riis. *Tenement Interior in Poverty Gap: An English Coal-Heaver's Home*. c. 1889. Museum of the City of New York.

The Jacob A. Riis Collection

During the late nineteenth and early twentieth centuries, American social and business life operated under the British sociologist Herbert Spencer's theory of Social Darwinism, which in essence held that only the fittest will survive. Riis saw this theory as merely an excuse for neglecting social problems.

27-99. Albert Pinkham Ryder. *Jonah.* c. 1885. Oil on canvas, mounted on fiberboard, $27^{1}/_{4} \times 34^{3}/_{8}$ " (69.2 × 87.3 cm). Smithsonian American Art Museum, Smithsonian Institution, Washington, D.C. Gift of John Gellatly, (1929.6.98)

RELIGIOUS ART

While Riis directly confronted the harsh conditions of slum life, many American artists of the late nineteenth century turned their backs on modern reality and, like their European Symbolist counterparts, escaped into the realms of myth, fantasy, and imagination. Some were also attracted to traditional literary, historical, and religious subjects, which they treated in unconventional ways to give them new meaning, as did Albert Pinkham Ryder (1847–1917) in his highly expressive interpretation of *Jonah* (fig. 27–99).

Ryder moved from Massachusetts to New York City around 1870 and studied at the National Academy of Design. Although he traveled to Europe four times between 1877 and 1896, he seems to have been mostly unaffected by old and modern works there. His mature painting style was an extremely personal one, as were his working methods. Ryder would paint and repaint the same canvas over a period of several years, loading glazes one on top of another to a depth of a quarter inch or more, mixing in with his oils such substances as varnish, bitumen, and candle wax. Due to chemical reactions between his materials and the uneven drying times of the layers of paint, most of Ryder's pictures have become darkened and severely cracked.

In *Jonah*, Ryder depicted the moment when the terrified Old Testament prophet, thrown overboard by his shipmates, was about to be consumed by a great fish. Appearing above in a blaze of holy light is God, shown as a bearded old man who holds the orb of divine power and makes a gesture of blessing, as if promising Jonah's eventual redemption. Both the subject—being overwhelmed by hostile nature—and its dramatic treatment through dynamic curves and sharp contrasts of light and dark are characteristically Romantic. The broad, generalized handling of the violent sea is particularly reminiscent of Turner (see figs. 27-19, 27-20), one of the few modern European artists whose work Ryder is known to have admired.

Biblical subjects became a specialty of Henry Ossawa Tanner (1859–1937), the most successful African-American painter of the late nineteenth and early twentieth centuries. The son of a bishop in the African Methodist Episcopal Church, Tanner grew up in Philadelphia, sporadically studied art under Thomas Eakins at the Pennsylvania Academy of the Fine Arts between 1879 and 1885, then worked as a photographer and drawing teacher in Atlanta. In 1891 he moved to Paris for further academic training. In the early 1890s Tanner painted a few African-American genre subjects but ultimately turned to biblical painting in order to make his art serve religion.

Tanner's *The Resurrection of Lazarus* (fig. 27-100) received a favorable critical reception at the Paris Salon of 1897 and was purchased by the Musée du Luxembourg, the museum for living artists. The subject is the biblical story in which Jesus went to the tomb of his friend Lazarus, who had been dead for four days, and revived him with the words "Lazarus, come forth" (John 11:1–44). Tanner shows the moment following the miracle, as Jesus stands before the amazed onlookers and gestures toward Lazarus, who begins to rise from his tomb. The limited palette of browns and golds, strongly reminiscent of Rembrandt, is appropriate for the somber burial cave. It also has the expressive effect of unifying the astonished witnesses in their recognition that a miracle has indeed occurred.

ARCHITECTURE

The history of late-nineteenth-century American architecture is a story of the impact of modern conditions and materials on the still-healthy Beaux-Arts historicist tradition. Unlike painting and sculpture, where antiacademic impulses gained force after 1880, in architecture the search for modern styles occurred somewhat later and met with considerably more resistance. As the École des Beaux-Arts in Paris was rapidly losing its leadership in figurative art education, it was becoming the central training ground for both European and American architects.

Richard Morris Hunt (1827–95) in 1846 became the first American to study architecture at the École des Beaux-Arts. Extraordinarily skilled in Beaux-Arts eclecticism and determined to raise the standards of American architecture, he built in every accepted style, including Gothic, French classicist, and Italian Renaissance. After the Civil War, Hunt built many lavish mansions emulating aristocratic European models for the growing class of wealthy Eastern industrialists and financiers.

Late in his career, Hunt participated in a grand project with more democratic aims: He was head of the board of architects for the 1893 World's Columbian Exposition in Chicago, organized to commemorate the 400th anniversary of Columbus's arrival in the Americas. The board abandoned the metal-and-glass architecture of earlier world's fairs (see fig. 27-38) in favor of the appearance of what it called "permanent buildings—a dream city." (The buildings were actually temporary ones composed of staff, a mixture of plaster and fibrous materials.) To create a sense of unity for all the exposition's major buildings, the board designated a single,

27-100. Henry Ossawa Tanner. *The Resurrection of Lazarus.* 1896. Oil on canvas, $37^3/8 \times 47^{13}/16''$ (94.9 × 121.4 cm). Musée d'Orsay,

Paris.

Tanner believed that biblical stories could illustrate the struggles and hopes of contemporary African Americans. He may have depicted the resurrection of Lazarus because many black preachers made a connection between the story's themes of redemption and rebirth and the Emancipation Proclamation of 1863, which freed black slaves and gave them a new life.

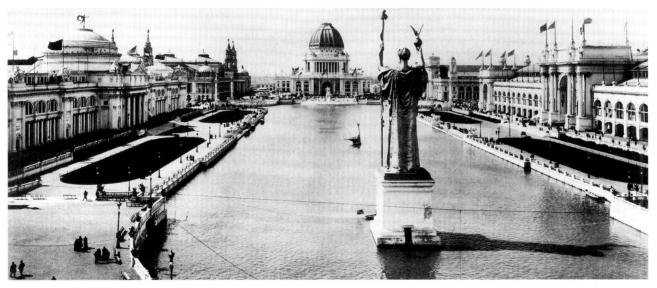

27-101. Court of Honor, World's Columbian Exposition, Chicago. 1893. View from the east.

Surrounding the Court of Honor were, from left to right, the Agriculture Building by McKim, Mead, and White; the Administration Building by Richard Morris Hunt; and the Manufactures and Liberal Arts Building by George B. Post. The architectural ensemble was collectively called The White City, a nickname by which the exposition was also popularly known. The statue in the foreground is *The Republic* by Daniel Chester French.

classical style associated with both the birth of democracy in ancient Greece and the imperial power of ancient Rome, reflecting the United States's pride in its democratic institutions and emergence as a world power. Hunt's design for the Administration Building at the end of the Court of Honor (fig. 27-101) was in the Renaissance classicist mode used by earlier American architects for civic buildings (see fig. 27-28). It was also meant to communicate that the United States was cultivating a new, more democratic renaissance after the Civil War.

The World's Columbian Exposition also provided a model for the American city of the future—reassurance that it could be clean, spacious, carefully planned, and classically beautiful, in contrast to the ill-planned, sooty, and overcrowded American urban centers rapidly emerging in the late nineteenth century. Frederick Law Olmsted, the designer of New York's Central Park (see "The City Park," page 1017), was principally responsible for the

landscape design of the Chicago exposition. He converted the marshy lakefront into lagoons, canals, ponds, and islands, some laid out formally, as in the Court of Honor, others informally, as in the section containing national and state pavilions. After the fair closed and most of its buildings were taken down, Olmsted's landscape art remained for succeeding generations to enjoy.

The second American architect to study at the École des Beaux-Arts was Henry Hobson Richardson (1838–86). Born in Louisiana and schooled at Harvard, Richardson returned from Paris in 1865 and settled in New York. Like Hunt, he worked in a variety of styles, but he became famous for a simplified Romanesque style known as Richardsonian Romanesque. His best-known building was probably the Marshall Field Wholesale Store in Chicago (fig. 27-102, page 1016). Although it is reminiscent of Renaissance palaces in form and of Romanesque churches in its heavy stonework and arches, it has no

27-102. Henry Hobson Richardson. Marshall Field Wholesale Store, Chicago. 1885–87. Demolished c. 1935.

precise historical antecedents. Instead, Richardson took a fresh approach to the design of this modern commercial building. Applied ornament is all but eliminated in favor of the intrinsic appeal of the rough stone and the subtle harmony between the dark red granite facing of the base and the red sandstone of the upper stories. The solid corner piers, the vertical structural supports, give way to the regular rhythm of the broad arches of the middle floors, which are doubled in the smaller arches above, then doubled again in the rectangular windows of the attic. The integrated mass of the whole is completed in the crisp line of the simple cornice at the top.

Richardson's plain, sturdy building was a revelation to the young architects of Chicago then engaged in rebuilding the city after the disastrous fire of 1871 and helped shape a distinctly American architecture. About this time, new technology for making inexpensive steel (an alloy of iron, carbon, and other materials) brought architecture entirely new structural possibilities. The first structural use of steel in the internal skeleton of a building was made in Chicago by William Le Baron Jenney (1832-1907), and his example was soon followed by the younger architects who became known as the Chicago School. These architects saw in the stronger, lighter material the answer to both their search for an independent style and their clients' desire for taller buildings. Interest in tall buildings was sparked because the rapidly rising cost of commercial property made its more efficient use a major consideration, and the first electric elevator, dating from 1889, made them possible.

Equipped with steel and with the improved passenger elevators, driven by new economic considerations, and inspired by Richardson's departure from Beaux-Arts historicism, the Chicago School architects produced a new kind of building, the skyscraper, and a new style (see "The Skycraper," page 1049). A fine early example of their work, and evidence of its rapid spread throughout the Midwest, is Louis Sullivan's Wainwright Building in St. Louis, Missouri (fig. 27-103). The Boston-born Sullivan (1856–1924) had studied for a year at the Massachusetts Institute of Technology (MIT), home of the United States' first architectural program, and equally

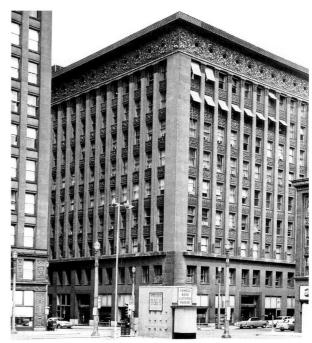

27-103. Louis Sullivan. Wainwright Building, St. Louis, Missouri. 1890–91.

briefly at the École des Beaux-Arts, where he seems to have developed his lifelong distaste for historicism. He settled in Chicago in 1875, partly because of the building boom there that followed the fire of 1871, and in 1883 entered into a partnership with the Danish-born engineer Dankmar Adler (1844–1900).

Sullivan's first major skyscraper, the Wainwright Building, has a U-shaped plan that provides an interior light well for the illumination of inside offices. The ground floor, designed to house shops, has wide plateglass windows for the display of merchandise. The second story, or mezzanine, also features large windows for the illumination of the shop offices. Above the mezzanine rise seven identical floors of offices, lit by rectangular windows. An attic story houses the building's mechanical plant and utilities. Forming a crown to the building, this richly decorated attic is wrapped in a foliate frieze of high-relief terra-cotta, punctuated by bull'seye windows, and capped by a thick cornice slab.

The Wainwright Building thus features a clearly articulated, tripartite design in which the different character of each of the building's parts is expressed through its outward appearance. This illustrates Sullivan's philosophy of functionalism, summed up in his famous motto, "form follows function," which holds that the function of a building should dictate its design. But Sullivan did not design the Wainwright Building along strictly functional lines; he also took expressive considerations into account. The thick corner piers, for example, are not structurally necessary since the building is supported by a steel-frame skeleton, but they serve to emphasize its vertical thrust. Likewise, the thinner piers between the office windows, which rise uninterruptedly from the third story to the attic, echo and reinforce the dominant verticality. Sullivan emphasized verticality in the Wainwright Building not out of functional concerns but rather out of emotional ones. A tall office building, in his words, "must be every inch a proud and soaring thing, rising in sheer exultation."

THE CITY PARK

Parks originated during the second millennium BCE in China and the Near East as enclosed hunting reserves for kings and the nobility. In Europe from the Middle Ages through the eighteenth century, they remained private recreation grounds for the privileged. The first urban park intended for the public was in Munich, Germany, laid out by Ludwig von Sckell in 1789-95 in the picturesque style of an English landscape garden (see fig. 26-24), with irregular lakes, gently sloping hills, broad meadows, and paths meandering through wooded areas.

Increased crowding and pollution during the Industrial Revolution prompted outcries for large public parks whose greenery would help purify the air and whose open spaces would provide city dwellers of all classes with a place for healthful recreation and relaxation. Numerous municipal parks were built in Britain during the 1830s and 1840s and in Paris during the 1850s and 1860s, when Georges-Eugène Haussmann redesigned the former royal hunting forests of the Bois de Boulogne and the Bois de Vincennes in the English style favored by the emperor.

In American cities before 1857, the only outdoor spaces for the public were small squares found between certain intersections, and larger gardens, such as the Boston Public Garden. Neither kind of space filled the growing need for varied recreational facilities. For a time, naturalistically landscaped suburban cemeteries became popular sites for strolling, picnicking, and even horseracing—an incongruous use that strikingly demonstrated the need for urban recreation parks.

The rapid growth of Manhattan spurred civic leaders to set aside parkland while open space still existed. The city purchased an 843acre tract in the center of the island and in 1857 announced a competition for its design as Central Park. The competition required that designs include a parade ground, playgrounds, a site for an exhibition or concert hall, sites for a fountain and for a viewing tower, a flower garden, a pond for ice skating, and four east-west cross streets so that the park would not interfere with the city's vehicular traffic.

The latter condition was pivotal to the winning design, drawn up by architect Calvert Vaux (1824–95) and park superintendent Frederick Law Olmsted (1822–1903), who sank the crosstown roads in trenches hidden below the surface of the park and designed separate routes for carriages, horseback riders, and pedestrians. Central Park contains some

formal elements, such as the stately tree-lined Mall leading to the classically styled Bethesda Terrace and Fountain, but its designers believed that the "park of any great city [should be] an antithesis to its bustling, paved, rectangular, walledin streets." Accordingly, Olmsted and Vaux followed the English tradition by designing Central Park in a naturalistic manner based on irregularities in topography and plantings. Where the land was low, they further depressed it, installing drainage tiles and carving out ponds and meadows. They planted clumps of trees to contrast with open spaces, and they emphasized natural outcroppings of schist to provide elements of dramatic, rocky scenery. They arranged walking trails, bridle paths, and carriage drives to provide a series of changing vistas. An existing reservoir divided the park into two sections. Olmsted and Vaux developed the southern half more completely and located most of the sporting facilities and amenities there, while they treated the northern half more as a nature preserve. Substantially completed by the end of the Civil War, Central Park was a tremendous success and launched a movement to build similar parks in cities across the United States and to conserve wilderness areas and establish national parks.

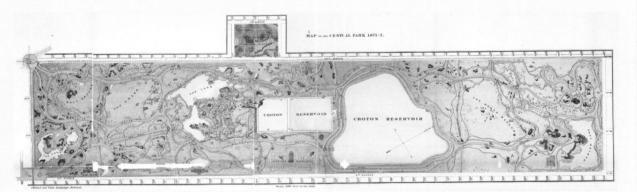

Frederick Law Olmsted and Calvert Vaux. Map of Central Park, New York City. 1858–1880. Revised and extended park layout shown in map of 1873.

The rectangular water tanks in the middle of the park were later removed and replaced by a large, elliptical meadow known as the Great Lawn.

In the Wainwright Building that exultation culminates in the rich vegetative ornament that swirls around the crown of the building, serving a decorative function very much like that of the foliated capital of a classical column. The tripartite structure of the building itself suggests the classical column with its base, shaft, and capi-

tal, reflecting the lingering influence of classical design principles even on an architect as opposed to historicism as Sullivan. It would remain for the modernist architects of the early twentieth century to break free from tradition entirely and pioneer an architectural aesthetic that was entirely new.

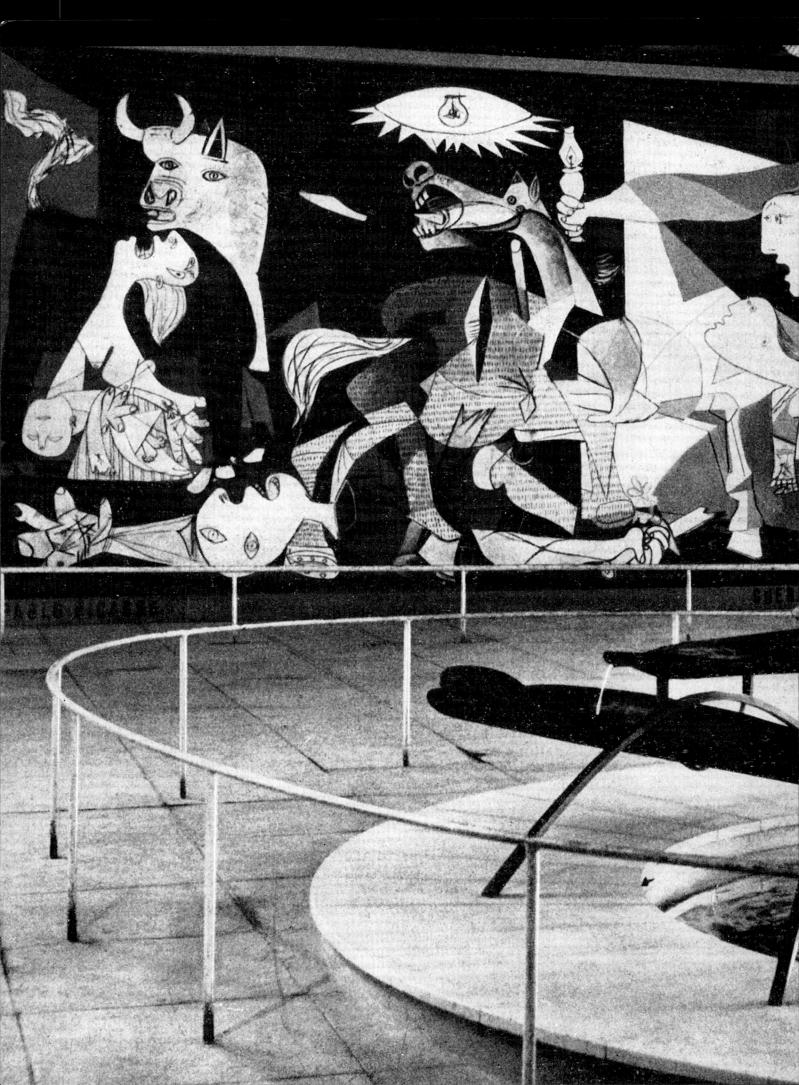

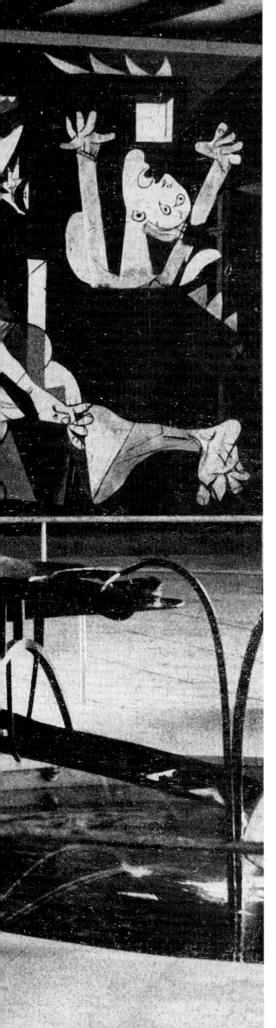

28

THE RISE OF MODERNISM IN EUROPE AND NORTH AMERICA

N APRIL 1937, DURING THE SPANISH CIVIL WAR, German pilots flying for Spanish fascist leader General Francisco Franco targeted the Basque city of Guernica. This act, the world's first bombing of civilians, killed more than 1,600 people and shocked the world. The Spanish artist Pablo Picasso, living in Paris at the time, reacted to the massacre by painting *Guernica*, a stark, hallucinatory nightmare that became a powerful symbol of the brutality of war (fig. 28-1).

Picasso, focusing on the victims, restricted his palette to black, gray, and white—the tones of the newspaper photographs that publicized the atrocity. Expressively distorted women, one holding a dead child and another trapped in a burning house, wail in desolation at the carnage. A screaming horse, an image of betrayed innocence, represents the suffering Spanish Republic, while a bull symbolizes either Franco or Spain. An electric light and a woman holding a lantern suggest Picasso's desire to reveal the event in all its horror.

During World War II, a Nazi officer showed Picasso a reproduction of *Guernica* and asked, "Is that you who did that?" Picasso is said to have replied, "No, it is you."

28-1. Pablo Picasso. *Guernica.* 1937. Oil on canvas, $11'6'' \times 25'8''$ (3.5 × 7.8 m). Museo Nacional Centro de Arte Reina Sofia, Madrid. On permanent loan from the Museo del Prado, Madrid. Shown installed in the Spanish Pavilion of the Paris Exposition, 1937. In the foreground: Alexander Calder's *Fontaine de Mercure.* 1937. Mercury, sheet metal, wire rod, pitch, and paint, $44'' \times 115'' \times 77''$ (122 × 292 × 196 cm). Fundacio Joan Miró, Barcelona

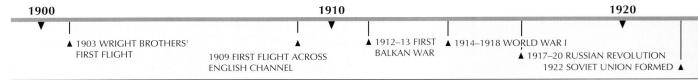

TIMELINE 28-1. Europe and North America 1900–50. The first half of the twentieth century in the West was dominated by wars in Europe and Asia. The United States took sides in both world wars.

Map 28-1. Europe and North America 1900-50. Through the end of World War II, western Europe was home to the many forms of modernism.

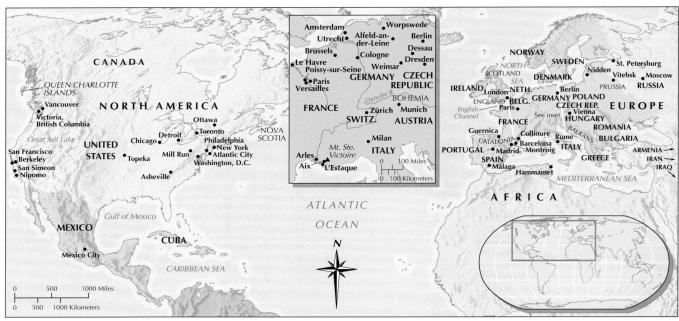

EUROPE AND THE UNITED STATES IN THE EARLY TWENTIETH CENTURY

Just as we must ponder *Guernica* within the context of the Spanish Civil War, so too must we consider the backdrop of politics, war, and technological change to

understand other twentieth-century art. As that century dawned, many Europeans and Americans believed optimistically that human society would "advance" through the spread of democracy, capitalism, and technological innovation. By 1906 representative governments existed in the United States and every major European nation (see Map 28-1), and Western power grew through colonialism throughout Africa, Asia, the Caribbean, and the Pacific. The competitive nature of both colonialism and capitalism created great instability in Europe, however, and countries joined together in rival political alliances. World War I erupted in August 1914, initially pitting Britain, France, and Russia (the Allies) against Germany and Austria (the Central Powers). U.S. troops entered the war in 1917 and contributed to an Allied victory the following year.

World War I significantly transformed European politics and economics, especially in Russia, which became the world's first Communist nation in 1917 when a popular revolution brought the Bolshevik ("Majority") Communist party of Vladimir Lenin to power. In 1922 the Soviet Union, a Communist state encompassing Russia and neighboring areas, was created.

The United States emerged from the war as the economic leader of the West, and economic recovery followed in Western Europe, but the 1929 New York stock market crash plunged the world into the Great Depression. In 1933 U.S. President Franklin D. Roosevelt responded with the New Deal, an ambitious welfare program meant to provide jobs and stimulate the American economy, and Britain and France instituted state welfare policies during the 1930s. Elsewhere in Europe, the economic crisis brought to power right-wing totalitarian regimes: Benito Mussolini had already become the fascist dictator of Italy in the mid-1920s; he was followed in Germany in 1933 by the Nazi leader Hitler and in Spain in 1939 by General Francisco Franco. Meanwhile, in the Soviet Union, Joseph Stalin (who had succeeded Lenin in 1924) consolidated his authoritarian rule through the execution or imprisonment of millions of his political opponents.

German aggression led in 1939 to the outbreak of World War II, which initially pitted Germany, Italy, Japan, and the Soviet Union against Britain and France. The Soviet Union turned against Germany in 1941, and later that year the United States was drawn into the war by the Japanese attack on the U.S. naval base at Pearl Harbor, in Hawaii. The most destructive war in history, World War II claimed the lives of between 15 and 20 million soldiers and approximately 25 million civilians, including 6 million European Jews who perished in the Nazi Holocaust. It ended first in Europe in May 1945, then in the Pacific in August 1945, when the United

▲ 1929 GREAT DEPRESSION BEGINS

▲ 1935 FIRST ANALOG COMPUTER

▲ 1945 FIRST ATOMIC BOMB USED

924 STALIN COMES TO POWER

▲ 1933 NEW DEAL IN U.S. HITLER COMES TO POWER IN GERMANY

1939-45 WORLD WAR II 1939 FIRST DIGITAL COMPUTER

States dropped atomic bombs on Hiroshima and Nagasaki, Japan, ushering in the nuclear era, with its constant threat of global annihilation.

During the two world wars, technological innovations resulted in such deadly devices as the army tank, the fighter bomber, and the atomic bomb. Yet dramatic scientific developments and improvements transformed life in times of peace: in medicine, prevention and cure of disease; in agriculture, increased production to feed the world's booming population; in communication, the radio, wireless telegraph, radar, television, and motion picture; and in transportation, the automobile and airplane. Finally, the first analog and digital computers, designed to process mass amounts of data and perform advanced calculations, were introduced in the 1930s.

Accompanying the momentous changes in politics, economics, and science were equally revolutionary developments in art and culture, which historians have gathered under the label of modernism. Although modern simply means "up-to-date," the term modernism connotes a rejection of conventions and a commitment to radical innovation; animating modernism is the desire to "make it new" (in the words of poet Ezra Pound). Like scientists and inventors, modernist artists engage in a process of experimentation and discovery, seeking to explore new possibilities of creativity and expression in a rapidly changing world.

MODERNIST

EARLY After 1900 the pace of artistic innovation increased in a dizzying succession of movements, or TENDENCIES "isms," including Fauvism, Ex-IN EUROPE pressionism, Cubism, Futurism, Dadaism, Suprematism, Con-

structivism, Purism, Neoplasticism, and Surrealism. Each was led by charismatic artists who promoted their movement's unique philosophy through written statements, some of which took the form of manifestos. Although modernism is characterized by tremendous aesthetic diversity, several broad tendencies mark many modernist artists. Foremost is a tendency toward abstraction. While some modernists presented recognizable subject matter in a distorted manner, others created completely abstract, or nonrepresentational, art, which communicates exclusively through such formal means as line, shape, color, texture, space, mass, and volume. Modernist architecture too moved toward abstraction and rejected historical styles and ornamentation in favor of simple geometric forms and undecorated surfaces. A second feature of modernism is a tendency to emphasize physical processes through visible brushstrokes and chisel marks, for example, and the materials used; this is especially true in modernist architecture, which often reveals rather than conceals the inner structure of the building, giving it a quality of "honesty"

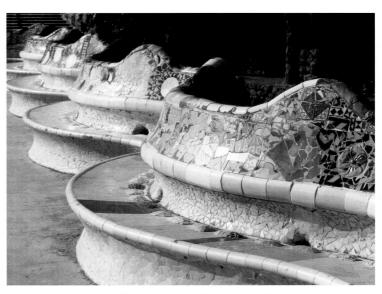

28-2. Antonio Gaudí. Serpentine bench, Güell Park, Barcelona. 1900-14.

seen in other forms of modernist art. A third feature is modernism's continual questioning of the nature of art itself through the adoption of new techniques and materials, including ordinary, "nonartistic" materials that break down distinctions between art and everyday life.

The rise of European and American modernism in the early twentieth century was driven by such exhibitions as the 1905 Salon d'Automne ("Autumn Salon") in Paris, which launched the Fauve movement; the first exhibition of Der Blaue Reiter group in Munich in 1911; and the 1913 New York Armory Show, the first largescale introduction of European modernism to American audiences. A key event in shaping the modernist canon was the 1929 opening of the Museum of Modern Art in New York, which rapidly assembled the world's finest modernist collection. State-supported museums dedicated to modern art also opened in other capitals, such as Paris, Rome, Brussels, and Madrid, signaling the transformation of modernism from an embattled fringe movement to officially recognized "high culture."

LATE-FLOWERING ART NOUVEAU

Originating in the 1890s (Chapter 27) and still flourishing in the early 1900s, Art Nouveau was the first international modernist movement of the twentieth century. In Spain, where the style was called Modernismo, the major practitioner was the Catalan architect Antonio Gaudí i Cornet (1852-1926). Gaudí attempted to integrate natural forms into his buildings and into daily life. For a public plaza on the outskirts of Barcelona, he combined architecture and sculpture in a continuous, serpentine bench that also is a boundary wall (fig. 28-2). Its surface is a

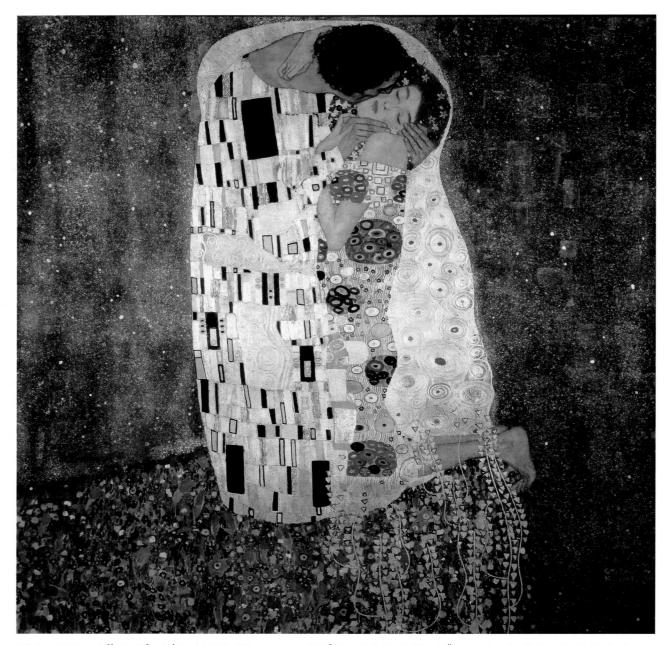

28-3. Gustav Klimt. *The Kiss.* 1907–8. Oil on canvas, $5'10^3/4'' \times 6'$ (1.8 × 1.83 m). Österreichische Nationalbibliothek, Vienna. The Secession was part of a generational revolt expressed in art, politics, literature, and the sciences. The Viennese physician Sigmund Freud, founder of psychoanalysis, may be considered part of this larger cultural movement, one of whose major aims was, according to the architect Otto Wagner, "to show modern man his true face."

glittering mosaic of broken pottery and tiles in homage to the long tradition of ceramic work in Spain.

In Austria, Art Nouveau was referred to as *Sezessionstil* because of its association with the Vienna Secession, one of several such groups formed in the late nineteenth century by progressive artists who seceded from conservative academic associations to form more liberal exhibiting bodies. The Vienna Secession's first president, Gustav Klimt (1862–1918), led a faction within the group dedicated to a richly decorative art and architecture that would offer an escape from the drab, ordinary world.

Between 1907 and 1908 Klimt perfected what is called his golden style, seen in *The Kiss* (fig. 28-3), where a couple embrace in a golden aura. The representational elements here are subservient to the decorative ones, which are characteristically Art Nouveau in their intricate, ornamental quality. Not evident at first glance is the tension in the couple's physical relationship, most noticeable in the way that the woman's head is forced uncomfortably against her shoulder. That they kneel dangerously close to the edge of a precipice further unsettles the initial impression for those willing to look behind the beautiful surface.

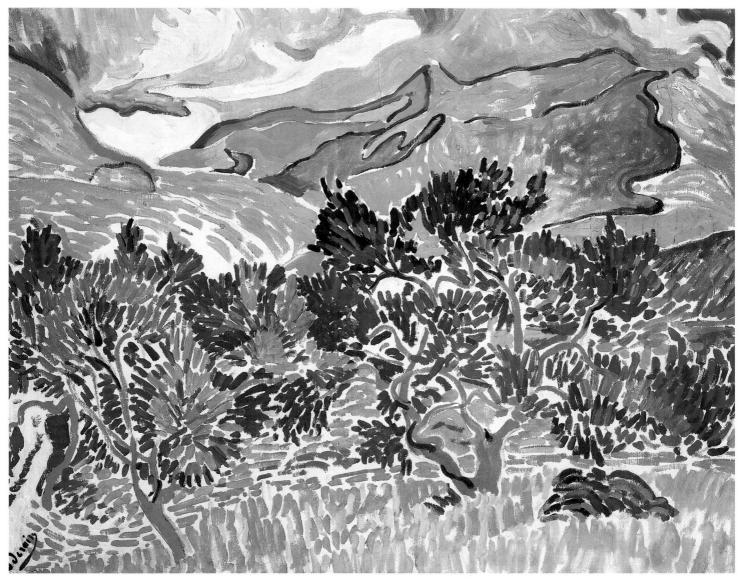

28-4. André Derain. *Mountains at Collioure.* 1905. Oil on canvas, $32 \times 39^{1}/2$ " (81.5 × 100 cm). National Gallery of Art, Washington, D.C. John Hay Whitney Collection

THE FAUVES

Reviewing the 1905 Salon d'Automne, critic Louis Vauxcelles referred to some young painters as *fauves* ("wild beasts")—a term that captured the explosive colors and impulsive brushwork that characterized their pictures. Their leaders—André Derain (1880–1954), Maurice de Vlaminck (1876–1958), and Henri Matisse (1869–1954)—had been trying to advance the colorist tradition in modern French painting, which they dated from the work of Eugène Delacroix (see figs. 27-11, 27-12) and which included that of the Impressionists, Neo-Impressionists, and Post-Impressionists such as Gauguin and van Gogh.

Among the first major Fauve works were paintings that Derain and Matisse made in 1905 in Collioure, a Mediterranean port. Derain's *Mountains at Collioure* (fig. 28-4) exemplifies so-called mixed-technique Fauvism,

in which short strokes of pure color, derived from the work of van Gogh and the Neo-Impressionists (see fig. 27-74), are combined with curvilinear planes of flat color, inspired by Gauguin's paintings and Art Nouveau decorative arts (see fig. 27-75). Derain's assertive colors, which he likened to "sticks of dynamite," do not record what he actually saw in the landscape but rather generate their own purely artistic energy. The stark juxtapositions of complementary hues-green leaves next to red tree trunks, red-orange mountainsides against blueshaded slopes—create what Derain called "deliberate disharmonies." Equally interested in such deliberate disharmonies was Matisse, whose The Woman with the Hat (fig. 28-5, page 1024) sparked controversy at the 1905 Salon d'Automne—not because of its fairly conventional subject, but because of the way its subject was depicted: with crude drawing, sketchy brushwork, and wildly arbitrary colors that create a harsh and dissonant effect.

28-5. Henri Matisse. *The Woman with the Hat.* 1905. Oil on canvas, $31^3/_4 \times 23^1/_2$ " (80.6 \times 59.7 cm). San Francisco Museum of Modern Art.

Bequest of Elise S. Haas

Both *The Woman with the Hat* and *Le Bonheur de Vivre* (fig. 28-6) were originally owned by the brother and sister Leo and Gertrude Stein, important American patrons of European avant-garde art in the early twentieth century. They hung their collection in their Paris apartment, where they hosted an informal salon that attracted many leading literary, musical, and artistic figures, including Matisse and Picasso. In 1913 Leo moved to Italy while Gertrude remained in Paris, pursuing a career as a modernist writer and continuing to host a salon with her companion, Alice B. Toklas.

Matisse himself soon reacted against his early Fauve work by developing a style of greater stability and serenity. Signaling this change was a large canvas painted during the winter of 1905–6, *Le Bonheur de Vivre (The Joy of Life)* (fig. 28-6). Although the painting's genesis was a sketch made at Collioure the previous summer, the finished work is a response not to something seen but rather something imagined: a mythical earthly paradise where uninhibited, naked revelers dance, make love, and commune with nature. The vibrant colors, applied so roughly in *The Woman with the Hat*, are now laid down broadly and without any trace of nervous excitement. The brushwork, too, is softer and more careful,

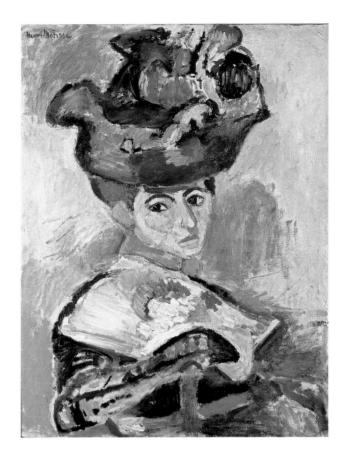

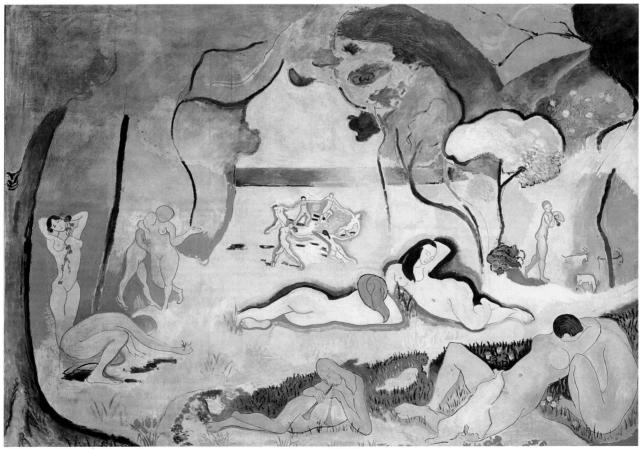

28-6. Henri Matisse. *Le Bonheur de Vivre (The Joy of Life)*. 1905–1906. Oil on canvas, $5'8^{1}/_{2}" \times 7'9^{3}/_{4}"$ (1.74 × 2.38 m). The Barnes Foundation, Merion, Pennsylvania. (BF 719)

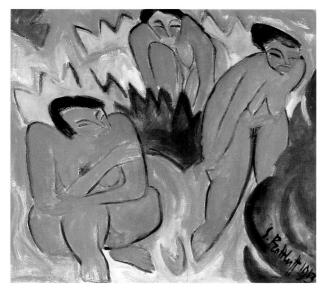

28-7. Karl Schmidt-Rottluff. *Three Nudes—Dune Picture from Nidden.* 1913. Oil on canvas, $38^5/8 \times 41^3/4$ " (98 × 106 cm). Staatliche Museen zu Berlin, Preussischer Kulturbesitz, Nationalgalerie.

subservient to the pure sensuality of the color. The only movement is in the long, flowing curves of the trees and the sinuous contours of the nude bodies. These undulating rhythms, in combination with the relaxed poses of the two reclining women at the center, establish the quality of "serenity, relief from the stress of modern life," that Matisse wanted to characterize his work from this point. "What I dream of," wrote Matisse in 1908, "is an art . . . devoid of troubling or depressing subject matter . . . which might be for every mental worker, be he businessman or writer, like . . . a mental comforter, something like a good armchair in which to rest."

DIE BRÜCKE

In northern Europe, the expressionist tradition of artists like van Gogh and Ensor expanded as younger artists used abstracted forms and colors to communicate emotional and spiritual states. Prominent in German expressionist art were Die Brücke ("The Bridge"), which formed in Dresden in 1905 when four architecture students—Fritz Bleyl (1880–1966), Erich Heckel (1883–1970), Ernst Ludwig Kirchner (1880–1938), and Karl Schmidt-Rottluff (1884–1976)—decided to devote themselves to painting and to form an exhibiting group. Other German and European artists later joined Die Brücke, which endured until 1913.

Named for a passage in Friedrich Nietzsche's *Thus Spake Zarathustra* (1883) that spoke of contemporary humanity's potential to be the evolutionary "bridge" to a more perfect "superman" of the future, Die Brücke's members nevertheless demonstrated little interest in advancing the evolutionary process. Instead, their art suggests a Gauguinesque yearning to return to imaginary origins. Among their favorite motifs were women living harmoniously in nature, such as depicted in Schmidt-Rottluff's *Three Nudes—Dune Picture from*

28-8. Erich Heckel. *Crouching Woman*. 1912. Painted linden wood, $11^{7}/_{8} \times 6^{3}/_{4} \times 3^{7}/_{8}$ " (30 × 17 × 10 cm). Estate of Erich Heckel, Hemmenhofen am Bodensee, Germany.

Nidden (fig. 28-7), which shows three simplified female nudes formally integrated with their landscape. The style is purposefully simple and direct, in keeping with the painting's evocation of the prehistoric, and is a good example of modernist **primitivism**, which drew its inspiration from so-called primitive art of Africa, Pre-Columbian America, and Oceania, as well as the work of children, folk artists, "naive" artists such as Henri Rousseau (see fig. 27-78), and the mentally ill. The bold stylization typical of such art offered a compelling alternative to the sophisticated illusionism that the modernists rejected and provided them formal models to adapt. Many modernists also believed that immersion in "primitive" aesthetics gave them access to a more authentic state of being, uncorrupted by civilization and filled with primal spiritual energies. Several Die Brücke members also made their own "primitive" sculpture. Heckel's Crouching Woman (fig. 28-8) is crudely carved in wood, rejecting the classical tradition of marble and bronze and suggesting the desire to return to nature depicted in Schmidt-Rottluff's Three Nudes.

28-9. Ernst Ludwig Kirchner. *Street, Berlin.* 1913. Oil on canvas, $47^1/_2 \times 35^7/_8$ " (120.6 × 91 cm). The Museum of Modern Art, New York. Purchase. (274.39)

During the summers, Die Brücke artists did return to nature, visiting remote areas of northern Germany, but in 1911 they moved to Berlin—perhaps preferring to imagine the simple life. Ironically, their images of cities, especially Berlin, offer powerful arguments against living there. Particularly critical of urban life are the street scenes of Kirchner, such as Street, Berlin (fig. 28-9). Dominating the left half of the painting, two prostitutes—their professions advertised by their large feathered hats and fur-trimmed coats-strut past welldressed bourgeois men, their potential clients. The women and men appear as artificial and dehumanized figures, with masklike faces and stiff gestures. Their bodies crowd together, but they are psychologically distant from one another, victims of modern urban alienation. The harsh colors, tilted perspective, and angular lines register Kirchner's expressionistic response to the subject.

INDEPENDENT EXPRESSIONISTS

While Die Brücke artists sought to further their artistic aims collectively, many expressionists in Germanspeaking countries worked independently. One, Käthe Schmidt Kollwitz (1867–1945), was committed to causes of the working class and pursued social change primarily through printmaking because of its potential to reach a wide audience. Between 1902 and 1908 she produced

28-10. Käthe Schmidt Kollwitz. *The Outbreak*, from the *Peasants' War* series. 1903. Etching $20 \times 23^1/_3$ " (50.7 × 59.2 cm). Kupferstichkabinett, Staatliche Museen zu Berlin, Preussischer Kulturbesitz.

the *Peasants' War* series, seven etchings that depict events in a sixteenth-century rebellion. *The Outbreak* (fig. 28-10) shows the peasants' built-up fury from years of mistreatment exploding against their oppressors, a lesson in the power of group action. Kollwitz said that she herself was the model for the leader of the revolt, Black Anna, who raises her hands to signal the attack.

Paula Modersohn-Becker (1876-1907), like Kollwitz, studied at the Berlin School of Art for Women, then moved in 1898 to Worpswede, a rustic artists' retreat in northern Germany. Dissatisfied with the Worpswede artists' naturalistic approach to rural life, after 1900 she made four trips to Paris to assimilate recent developments in Post-Impressionist painting. Her Self-Portrait with an Amber Necklace (fig. 28-11) testifies to the inspiration she found in Gauguin. Her simplified shapes and crude outlines are similar to those in Schmidt-Rottluff's Three Nudes (fig. 28-7), but her muted palette avoided his intense colors. By presenting herself against a screen of flowering plants and tenderly holding a flower that echoes the shape and color of her breasts, she appears as a natural being in tune with her surroundings, not an eroticized object of male design.

In contrast to Modersohn-Becker's gentle self-portrait, one by Austrian Egon Schiele (1890–1918) conveys physical and psychological torment (fig. 28-12, page 1028). Schiele's father had suffered from untreated syphilis and died insane when Egon was fourteen, leaving his son with an abiding link between sex, suffering, and death. In numerous drawings and watercolors, Schiele represented women in sexually explicit poses that emphasize the animal nature of the human body, and his selfportraits reveal deep ambivalence toward the sexual content of both his art and his life. In *Self-Portrait Nude*, the artist stares at the viewer with an anguished expression, his emaciated body stretched into an uncomfortable pose. The absent right hand suggests amputation, and the unarticulated genital region, castration. The

28-11. Paula Modersohn-Becker. *Self-Portrait with an Amber Necklace.* 1906. Oil on canvas, $24 \times 19^{3}/4''$ (61 × 50 cm). Öffentliche Kunstsammlung Basel, Kunstmuseum, Basel, Switzerland. (1748)

missing body parts have been interpreted as the artist's symbolic self-punishment for indulgence in masturbation, then commonly believed to lead to insanity.

DER BLAUE REITER

The last major pre-World War I expressionist group, Der Blaue Reiter ("The Blue Rider"), was named for a popular image of Saint George on the city emblem of

Moscow, which many believed would be the world's capital during Christ's thousand-year reign on earth following the Apocalypse prophesied by Saint John. Der Blaue Reiter formed in Munich around the painters Vasily Kandinsky (1866–1944), a Russian from Moscow, and Franz Marc (1880–1916), a native of Munich, who both considered blue the color of spirituality. Its first exhibition, in December 1911, featured fourteen very

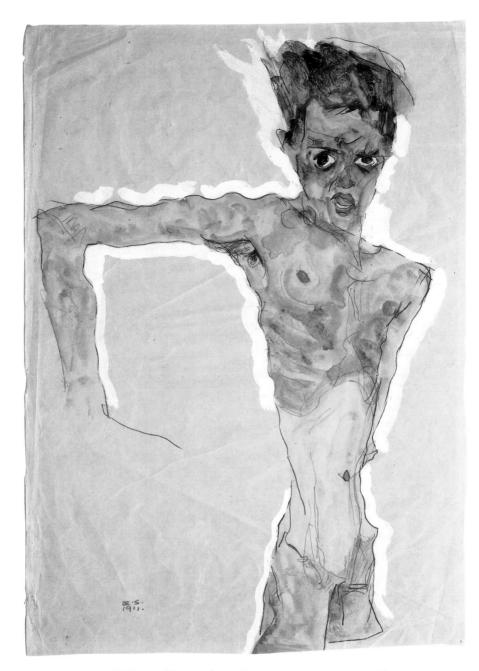

28-12. Egon Schiele. *Self-Portrait Nude.* 1911. Gouache and pencil on paper, $20^1/_4 \times 13^3/_4$ " (51.4 \times 35 cm). The Metropolitan Museum of Art, New York. Bequest of Scofield Thayer, 1982 (1984.433.298)

diverse artists, whose subjects and styles ranged widely, from the naive realism of Henri Rousseau to the radical abstraction of Kandinsky.

Millennial and apocalyptic imagery appeared often in Kandinsky's art in the years just prior to World War I. In *Improvisation No. 30 (Cannons)* (fig. 28-13), the firing cannons in the lower right combine with the intense reds, blackened sky, and precariously leaning mountains to suggest a scene from the end of the world. Such paintings, sometimes thought to reflect fear of the coming war, may instead be ecstatic visions of the destructive prelude to the Second Coming of Christ. The

schematic churches on top of the mountains are based on the churches of Moscow.

Kandinsky never expected his viewers to understand his symbolism. Instead, he intended to awaken their spirituality and thus inaugurate "a great spiritual epoch" through the sheer force of color. As he explained in his influential book, *Concerning the Spiritual in Art* (1911): "[C]olor directly influences the soul. Color is the keyboard, the eyes are the hammers, the soul is the piano with many strings. The artist is the hand that plays, touching one key or another purposively, to cause vibrations in the soul."

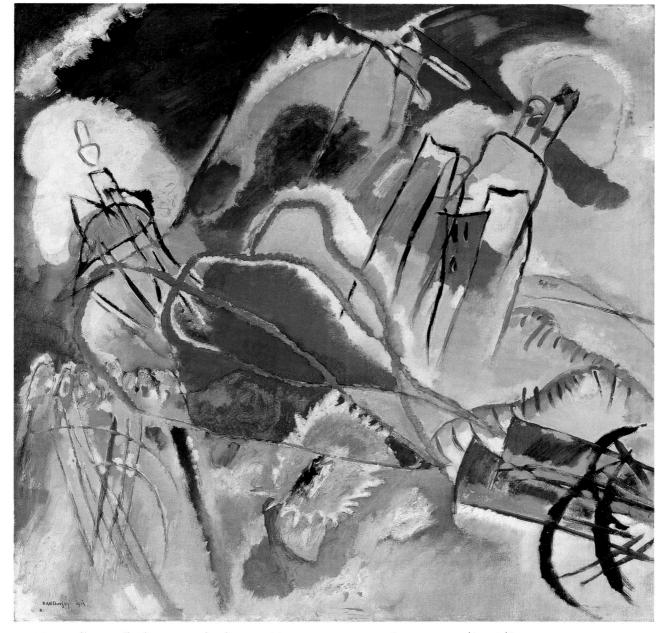

28-13. Vasily Kandinsky. *Improvisation No. 30 (Cannons).* 1913. Oil on canvas, $43^{1}/_{4} \times 43^{1}/_{4}$ " (109.9 × 109.9 cm). The Art Institute of Chicago. Arthur Jerome Eddy Memorial Collection, (1931.511)

During the early years of his career Marc moved from naturalism to a colorful form of expressionism influenced by the Fauves. By 1911 he was painting animals rather than people because he felt that animals enjoyed a purer, more spiritual relationship to nature than did humans, and he rendered them in bold, primary colors. In his *The Large Blue Horses* (fig. 28-14, page 1030) the animals merge into a homogenous unit, the fluid contours of which reflect the harmony of their collective existence and echo the lines of the hills behind them, suggesting that they are also in harmony with their surroundings. The pure, strong colors reflect their

uncomplicated yet intense experience of the world as Marc enviously imagined it.

The Swiss-born Paul Klee (1879–1940) participated in the second Blaue Reiter exhibition of 1912, but his involvement with the group was never more than tangential. A 1914 trip to Tunisia, not Der Blaue Reiter, inspired Klee's interest in the expressive potential of color. On his return Klee painted watercolors based on his memories of North Africa, including *Hammamet with Its Mosque* (fig. 28-15, page 1030). The play between geometric composition and irregular brushstrokes is reminiscent of Cézanne's work, which Klee

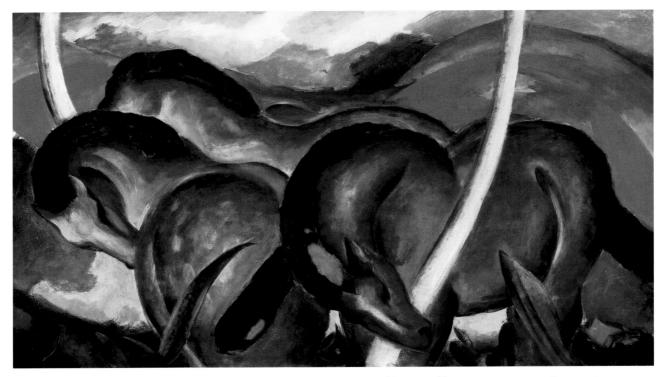

28-14. Franz Marc. The Large Blue Horses. 1911. Oil on canvas, $3'5^3/8'' \times 5'11^1/4''$ (1.05 × 1.81 m). Walker Art Center, Minneapolis.

Gift of T. B. Walker Collection, Gilbert M. Walter Fund, 1942

28-15. Paul Klee. Hammamet with Its Mosque. 1914. Watercolor and pencil on two sheets of laid paper mounted on cardboard, $8^1/_8 \times 7^5/_8$ " (20.6 \times 19.7 cm). The Metropolitan Museum of Art, New York. The Berggruen Klee Collection, 1984 (1984.315.4)

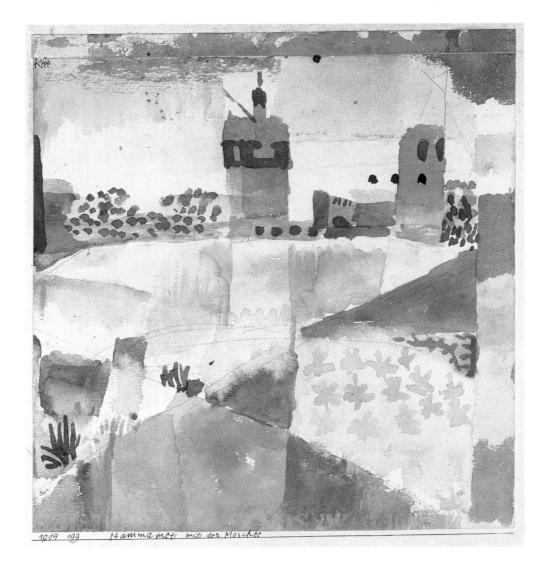

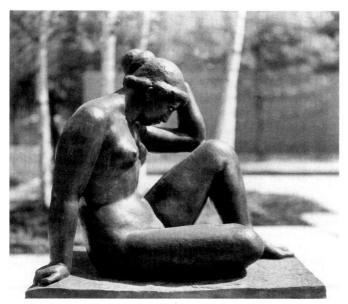

28-16. Aristide Maillol. *The Mediterranean.* 1902–5. Bronze, $41\times45\times29^{3}/_{4}$ " at base (104.1 \times 114.3 \times 75.6 cm). The Museum of Modern Art, New York. Gift of Stephen C. Clark

had recently seen. The luminous colors and delicate **washes**, or applications of dilute watercolor, result in a gently shimmering effect. The subtle modulations of red across the bottom, especially, are positively melodic. Klee, who played the violin and belonged to a musical family, seems to have wanted to use color the way a musician would use sound, not to describe appearances but to evoke subtle nuances of feeling.

EARLY MODERNIST SCULPTURE

Developments in early modernist sculpture generally followed those in painting and the graphic arts, as we saw in Heckel's *Crouching Woman* (see fig. 28-8), which translates into three dimensions the subject and style of two-dimensional Die Brücke works. Many innovators of early-twentieth-century sculpture were trained as painters, and some—such as Matisse and Picasso—remained primarily painters.

Aristide Maillol (1861–1944) turned from painting to sculpture around 1900, when an eye disease caused him to take up modeling in clay. His first major sculpture, exhibited at the 1905 Salon d'Automne, was *The Mediterranean* (fig. 28-16). The lifesize female bather sits in a relaxed pose, her body simplified into idealized forms inspired by ancient Mediterranean and Egyptian art as well as the late-nineteenth-century bathers of Renoir (see fig. 27-67). At the same time, the smooth modeling and closed, self-contained pose of *The Mediterranean* represent a deliberate rejection of the energetic handling and tortured poses favored by Rodin, the dominant sculptor of the previous generation (see fig. 27-81).

"Maillol, like the ancient masters, proceeded by volume," said his friend Henri Matisse. "I am concerned with the arabesque like the Renaissance artists." In *La Serpentine* (fig. 28-17), Matisse transformed sculptural

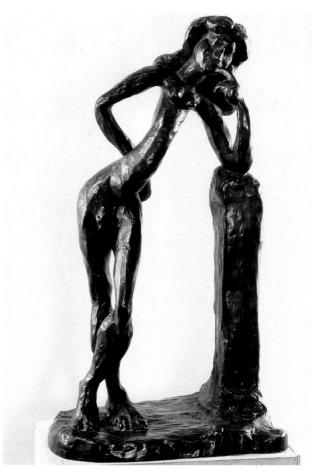

28-17. Henri Matisse. *La Serpentine*. 1909. Bronze, $22^{1}/_{4} \times 11 \times 7^{1}/_{2}$ " (56.5 \times 28.9 \times 19 cm), including base. The Museum of Modern Art, New York. Gift of Abby Aldrich Rockefeller

volumes into linear **arabesques** of the kind he had previously explored in paintings such as *Le Bonheur de Vivre* (see fig. 28-6). Matisse derived the pose of *La Serpentine* from a photograph of a model, whose stocky proportions he elongated and transformed into flexible, ropelike forms. "I thinned and composed the forms," explained Matisse, "so that the movement would be completely comprehensible from all points of view." In the finished sculpture, this movement is created as much by the open spaces between the thinned-down elements as by the elements themselves.

The most original of the early modernist sculptors was Constantin Brancusi (1876–1957), who sought to portray "the essence of things" by distilling his subjects into smooth and purified forms. In 1904 Brancusi arrived in Paris from his native Romania and enrolled at the École des Beaux-Arts. After two months as an assistant to Rodin in early 1907, Brancusi left and rejected Rodin's modeling method for the technique of direct carving in stone in a style that emphasized formal and conceptual simplicity. Motivating this change was Brancusi's interest in the ancient Greek philosophy of Plato, who held that all worldly objects and beings are imperfect imitations of their perfect models, or Ideas, which exist only in the mind of God.

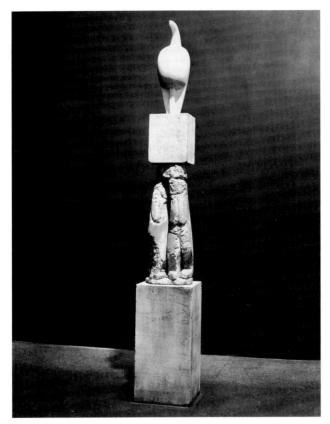

28-18. Constantin Brancusi. Magic Bird. 1908-12. White marble, height 22" (55.8 cm), on three-part limestone pedestal, height 5'10" (1.78 m), of which the middle part is the *Double Caryatid* (c. 1908); overall $7'8'' \times 12^{3}/_{4}'' \times 10^{5}/_{8}''$ $(237 \times 32 \times 27 \text{ cm})$. The Museum of Modern Art, New York. Katherine S. Dreier Bequest

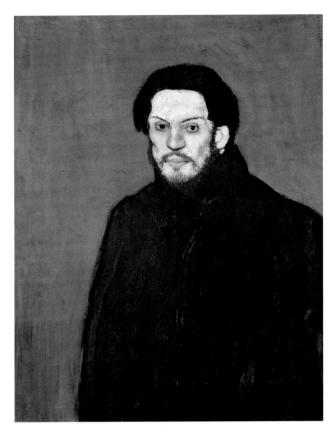

28-19. Pablo Picasso. Self-Portrait. 1901. Oil on canvas, $31^{7/8} \times 23^{5/8}$ " (81 × 60 cm). Musée Picasso, Paris.

Exemplary of Brancusi's quest for timeless essence is Magic Bird (fig. 28-18). The lower, limestone section has three parts, the middle one showing two roughhewn figures (one of which has its face buried in the other's shoulder) representing the flawed world of ordinary human existence. The top section, carved in pure white marble, symbolizes the higher world of Ideas through the elegantly simplified form of a standing bird. The bird was apparently inspired by the hit of the 1910 Paris musical season, The Firebird, a ballet scored by the Russian composer Igor Stravinsky. But unlike the mythical magic birds that inspired the ballet, which always have dazzling plumage, the beauty of Brancusi's bird lies in its utter simplicity.

IN EUROPE

CUBISM Both the splintered shapes in Kirchner's Street, Berlin (see fig. 28-9) and the flattened space and geometric blocks of color in Klee's Hammamet

with Its Mosque (see fig. 28-15) reflect the influence of Cubism, the most talked-about "ism" of early-twentiethcentury art. Cubism was the joint invention of Pablo Picasso (1881-1973) and Georges Braque (1882-1963), built upon the foundation of Picasso's early work.

PICASSO'S EARLY ART

Picasso was born in Málaga, Spain, where his father taught in the School of Fine Arts. At fourteen Picasso entered the School of Fine Arts in Barcelona and two years later was admitted as an advanced student to the academy in Madrid. Picasso's involvement in the avant-garde began in the late 1890s, when he moved back to Barcelona. Beginning in 1900 he made frequent extended visits to Paris and moved there in early 1904.

During this time Picasso was attracted to the socially conscious nineteenth-century French painting that included Honoré Daumier (see fig. 27-50) and Toulouse-Lautrec (see fig. 27-85). In what is known as his Blue Period, he painted the outcasts of Paris and Barcelona in weary poses and a coldly expressive blue, likely chosen for its associations with melancholy. These paintings seem to have been motivated by Picasso's political sensitivity to those he considered victims of modern capitalist society, which eventually led him to join the Communist party. They also reflect his own unhappiness, hinted at in his 1901 Self-Portrait (fig. 28-19), which reveals his familiarity with cold, hunger, and disappointment.

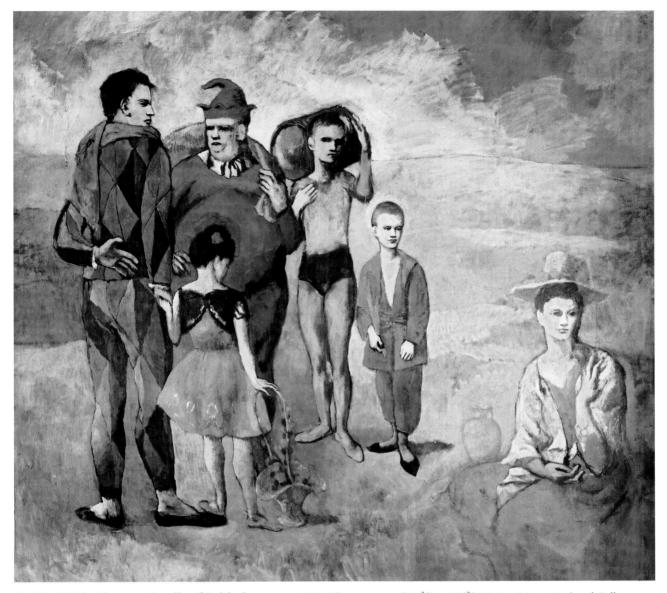

28-20. Pablo Picasso. *Family of Saltimbanques.* 1905. Oil on canvas, $6'11^3/_4" \times 7'6^3/_8"$ (2.1 × 2.3 m). National Gallery of Art, Washington, D.C. Chester Dale Collection

After he settled in Paris, Picasso's personal circumstances greatly improved. He gained a large circle of supportive friends, and his work attracted several important collectors. His works from the end of 1904 through 1905, known collectively as the Rose Period because of the introduction of that color into his palette, show the last vestiges of his earlier despair. During the Rose Period, Picasso was preoccupied with the subject of traveling acrobats, saltimbanques, whose rootless and insecure existence on the margins of society was similar to the one he too had known. Picasso rarely depicted them performing but preferred to show them at rest, as in Family of Saltimbanques (fig. 28-20). In this mysterious composition, six figures inhabit a barren landscape painted in warm tones of beige and rose sketchily brushed over a blue ground. Five of the figures cluster together in the left two-thirds of the picture while the sixth, a seated woman, curiously detached, occupies her own space in the lower right. All of the *saltimbanques* seem psychologically withdrawn and uncommunicative, as silent as the landscape they occupy is empty. Scholars have identified them as disguised portraits of members of Picasso's circle, including the dark-haired artist himself, who stands at the left in a motley costume.

In 1906 the Louvre installed a newly acquired collection of sixth- and fifth-century BCE sculpture from the Iberian region (modern Spain and Portugal). These ancient Iberian figures, which Picasso identified with the stoic dignity of the villagers in the province of his birth, became the chief influence on his work for the next year. Another important influence came from Gauguin's primitivist paintings and wood carvings, which Picasso also studied at this time.

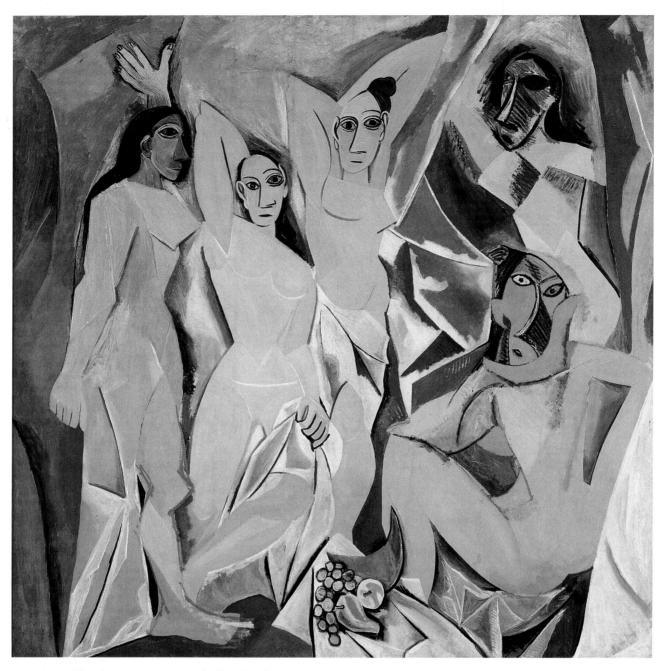

28-21. Pablo Picasso. *Les Demoiselles d'Avignon.* 1907. Oil on canvas, $8' \times 7'8''$ (2.43 \times 2.33 m). The Museum of Modern Art, New York.

Acquired through the Lillie P. Bliss Bequest, (333.1939)

Picasso's Iberian period culminated in 1907 in *Les Demoiselles d'Avignon* (fig. 28-21). The Iberian influence is seen specifically in the faces of the three leftmost figures, with their simplified features and wide, almond-shaped eyes. The faces of the two right-hand figures, painted in a radically different style, were inspired by another "primitive" source—the African masks that Picasso saw in an ethnographic museum in Paris. With this painting Picasso responded to Matisse's recent *Le Bonheur de Vivre* (see fig. 28-6), and to the larger French classical tradition, which to Picasso was embodied in the harem paintings of Ingres, exhibited in a 1905 retrospective (see fig. 27-4). Picasso, however, substituted for

the harem a bordello; the term *demoiselles*, meaning "young ladies," is a euphemism for "prostitutes," and *Avignon* refers not to the French town but to the red-light district of Barcelona.

In a preliminary study for the painting (fig. 28-22), Picasso included two men with the five women. Related preliminary drawings have led scholars to identify the man on the left holding a book as a student, and the seated man as a sailor, perhaps symbolizing, respectively, the contemplative and the active life. Picasso likely eliminated the men because the allegory they suggest detracts from the central issue of sexuality and because their confrontation with the women on display makes

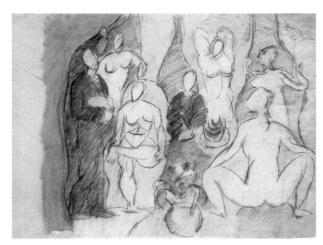

28-22. Pablo Picasso. Study for *Les Demoiselles d'Avignon*. 1907. Pastel on paper, $18^1/_4 \times 30''$ (47.6 × 63.7 cm). Öffentliche Kunstsammlung Basel, Kupferstichkabinett, Basel, Switzerland. (1967.106)

the viewer a mere onlooker. In the final painting, the viewer is a participant: The women look directly at us.

While the women in the sketch are conventionally rendered in soft curves, those in the painting are flattened and fractured into sharp curves and angles. The space they inhabit is equally fractured and convulsive. The central pair of *demoiselles* raise their arms in a traditional gesture of accessibility but contradict it with their hard, piercing gazes and firm mouths. Even the fruit displayed in the foreground, a symbol of female sexuality, seems hard and dangerous. Women, Picasso suggests, are not the gentle and passive creatures that men would like them to be. With this viewpoint he contradicts practically the entire tradition of erotic imagery since the Renaissance.

Picasso's friends were horrified by his new work. Matisse, for example, accused Picasso of making a joke of modern art and threatened to break off their friendship. But one artist, Georges Braque, responded positively, and he saw in *Les Demoiselles d'Avignon* a potential that Picasso probably had not fully intended. Picasso used broken and distorted forms expressionistically, to convey his view of women; he was not consciously trying to break with the Western pictorial tradition that dated back to the early fourteenth century painter Giotto. But what secured Picasso's place at the forefront of the Parisian avant-garde was the revolution in form that *Les Demoiselles d'Avignon* inaugurated. Braque responded eagerly to Picasso's formal innovations and set out, alongside Picasso, to develop them.

ANALYTIC CUBISM

Georges Braque was born a year after Picasso, near Le Havre, France, where he trained to become a house decorator like his father and grandfather. In 1900 he moved to Paris. The Fauve paintings in the 1905 Salon d'Automne so impressed him that he began to paint brightly colored landscapes, but it was the 1907 Cézanne retrospective that established his future course. Picasso's

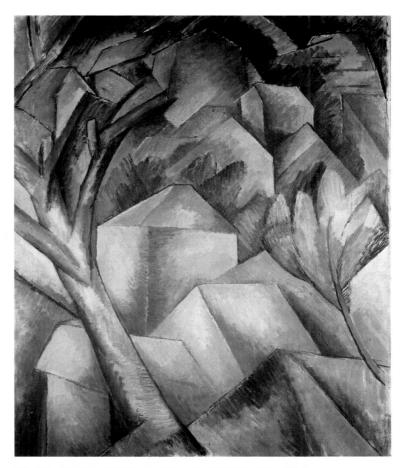

28-23. Georges Braque. *Houses at L'Estaque*. 1908. Oil on canvas, $36^{1/4} \times 23^{5/8}$ " (73×59.5 cm). Kunstmuseum, Bern, Switzerland. Collection Hermann and Magrit Rupf-Stiftung

Demoiselles sharpened his interest in altered form and compressed space and emboldened Braque to make his own advances on Cézanne's late direction.

Braque's 1908 Houses at L'Estaque (fig. 28-23) reveals the emergence of early Cubism. Inspired by Cézanne's example, Braque reduced nature's many colors to its essential browns and greens and eliminated detail to emphasize basic geometric forms. Arranging the buildings into an approximate pyramid, he pushed those in the distance closer to the foreground, so the viewer looks *up* the plane of the canvas more than into it. The painting is less a Cézannesque study of nature than an attempt to translate nature's complexity into an independent, aesthetically satisfying whole.

Braque submitted *Houses at L'Estaque* to the progressive 1908 Salon d'Automne, but the jury, which included Matisse, rejected the painting—Matisse reportedly referring to Braque's "little cubes." In a review of Braque's November 1908 solo exhibition, critic Louis Vauxcelles, who had given the Fauves their name, borrowed Matisse's observation and wrote that Braque "reduces everything, places and figures and houses, to geometrical schemes, to cubes." Thus, the name *Cubism* was born.

Braque's early Cubist work helped point Picasso in a new artistic direction. By the end of 1908 the two artists

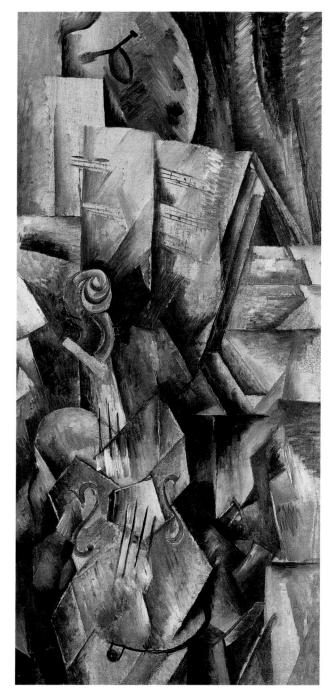

28-24. Georges Braque. *Violin and Palette.* 1909–10. Oil on canvas, $36\frac{1}{8} \times 16^{7}\frac{1}{8}$ " (91.8 \times 42.9 cm). Solomon R. Guggenheim Museum, New York. (54.1412)

had begun an intimate working relationship that lasted until Braque went off to war in 1914. "We were like two mountain climbers roped together," Braque later said. The two were engaged in a difficult quest for a new conception of painting as an arrangement of form and color on a two-dimensional surface. This arduous journey would require both Picasso's audacity and Braque's sense of purpose.

The move toward abstraction begun in Braque's landscapes in 1908 continued in moderately scaled still lifes the two artists produced over the next two and a half

years. In Braque's Violin and Palette (fig. 28-24), the gradual elimination of deep space and recognizable subject matter is well under way. The still-life items are not arranged in illusionistic depth but are pushed close to the picture plane in a shallow space. Using the **passage** technique developed by Cézanne, in which shapes closed on one side are open on another so that they can merge with adjacent shapes, Braque knit the various elements together into a single shifting surface of forms and colors. In some areas of the painting, these formal elements have lost not only their natural spatial relations but their identities as well. Where representational motifs remain—the violin, for example—Braque has fragmented them to facilitate their integration into the whole.

In the still-discernible palette, sheet music, and violin, Braque reveals his and Picasso's new conception of painting. Critic and poet Guillaume Apollinaire wrote that the two were "moving toward an entirely new art which will stand, with respect to painting as envisaged heretofore, as music stands to literature. It will be pure painting, just as music is pure literature." As the musician arranges sounds to make music, Braque arranged forms and colors to make art.

Braque's and Picasso's paintings of 1909 and 1910 initiated what is known as Analytic Cubism because of the way the artists broke objects into parts as if to analyze them. The works of 1911 and early 1912 are also grouped under the Analytic label, although they reflect a different approach to the breaking up of forms. Instead of simply fracturing an object, Picasso and Braque picked it apart and rearranged its elements. Remnants of the subject Picasso worked from are evident throughout Ma Jolie (fig. 28-25), for example, but any attempt to reconstruct that subject—a woman with a stringed instrument-would be misguided because it provided only the raw material for a formal arrangement. Ma Jolie is not a representation of a woman, or of a place, or of an event, but simply a "pure painting." Again Picasso included a musical analogy—a G clef and the words Ma Jolie ("My Pretty One"), the title of a popular songsuggesting that the viewer should approach the painting the way one would a musical composition, either by simply enjoying the arrangement of its elements or by analyzing it, but not by asking what it represents.

A subtle tension between order and disorder is maintained throughout the painting. For example, the shifting effect of the surface, a delicately patterned texture of grays and browns, is given regularity through the use of short, horizontal brushstrokes. Similarly, with the linear elements, strict horizontals and verticals dominate, although many irregular curves and angles are also to be found. The combination of horizontal brushwork and right angles firmly establishes a grid that effectively counteracts the surface flux. Moreover, the repetition of certain diagonals and the relative lack of details in the upper left and upper right create a pyramidal shape. Thus, what at first may seem a random assemblage of lines and muted colors turns out to be a well-organized unit. The aesthetic satisfaction of such a work depends on the way chaos seems to resolve itself into order.

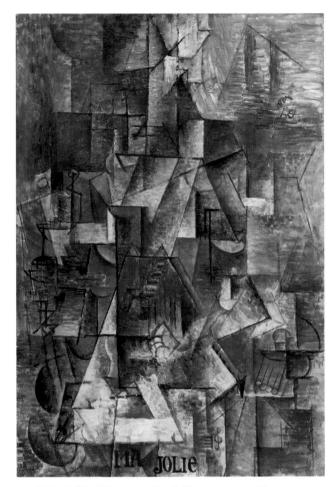

28-25. Pablo Picasso. *Ma Jolie.* 1911–12. Oil on canvas, $39^3/_8 \times 25^3/_4$ " (100 \times 65.4 cm). The Museum of Modern Art, New York.

Acquired through the Lillie P. Bliss Bequest, (176.1945)

In 1923 Picasso said, "Cubism is no different from any other school of painting. The same principles and the same elements are common to all. The fact that for a long time Cubism has not been understood . . . means nothing. I do not read English, . . . [but] this does not mean that the English language does not exist, and why should I blame anybody . . . but myself if I cannot understand [it]?"

SYNTHETIC CUBISM

Works like Ma Jolie brought Picasso and Braque to the brink of total abstraction, but in the spring of 1912 they began to create works that suggested more clearly discernible subjects. This second major phase of Cubism is known as Synthetic Cubism because of the way the artists created motifs by combining simpler elements, as in a chemical synthesis. Picasso's Glass and Bottle of Suze (fig. 28-26), like many of the works he and Braque created from 1912 to 1914, is a collage (from the French coller, "to glue"), a work composed of separate elements pasted together. At the center, newsprint and construction paper are assembled to suggest a tray or round table supporting a glass and a bottle of liquor with an actual label. Around this arrangement Picasso pasted larger pieces of newspaper and wallpaper. The elements together evoke not only a place—a bar—but also an activity: the viewer alone with a newspaper, enjoying a quiet drink.

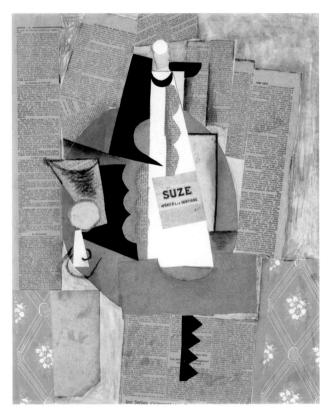

28-26. Pablo Picasso. *Glass and Bottle of Suze.* 1912. Pasted paper, gouache, and charcoal, $25^3/_4 \times 19^3/_4$ " (65.4 × 50.2 cm). Washington University Gallery of Art, St. Louis, Missouri.

University Purchase, Kende Sale Fund, 1946

The refuge from daily bustle that both art and quiet bars can provide was a central theme in the Synthetic Cubist works of Braque and Picasso. The two artists, however, used different types of newspaper clippings. Braque's clippings deal almost entirely with musical and artistic events, but Picasso often included references to political events that would soon shatter the peaceful pleasures these works evoke. In *Glass and Bottle of Suze*, for example, the newspaper clippings deal with the First Balkan War of 1912–13, which contributed to World War I.

Picasso soon extended the principle of collage into three dimensions to produce Synthetic Cubist sculpture, such as Mandolin and Clarinet (fig. 28-27, page 1038). Composed of wood scraps, the sculpture suggests the typical Cubist subject of two musical instruments at right angles to each other. In works such as this Picasso introduced the revolutionary technique of assemblage, giving sculptors the option not only of carving or modeling but also of constructing their works out of found objects and unconventional materials. Another innovative feature of assemblage was its introduction of space into the interior of the sculpture and the consequent creation of volume through contained space rather than mass. This innovation reversed the traditional conception of sculpture as a solid surrounded by void—a conception retained even in such a daring work as Matisse's La Serpentine (see fig. 28-17).

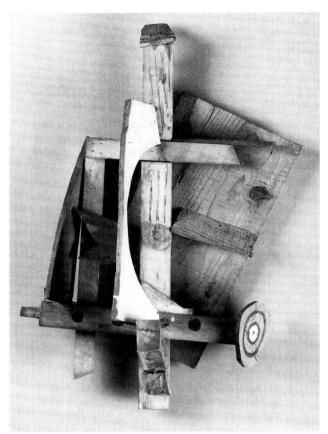

28-27. Pablo Picasso. *Mandolin and Clarinet.* 1913. Construction of painted wood with pencil marks, $22^{5}/_{8} \times 14^{1}/_{8} \times 9''$ (58 \times 36 \times 23 cm). Musée Picasso, Paris.

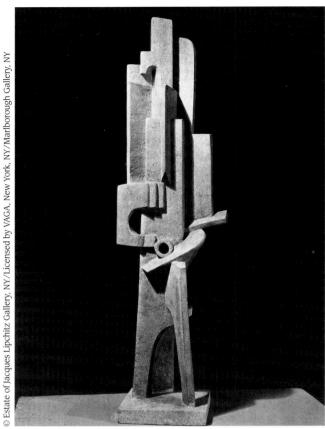

28-28. Jacques Lipchitz. *Man with a Guitar*. 1915. Limestone, $38^1/_4 \times 10^1/_2 \times 7^3/_4$ " (97.2 \times 26.7 \times 19.7 cm). The Museum of Modern Art, New York. Mrs. Simon Guggenheim Fund (by exchange)

RESPONSES TO CUBISM

As the various phases of Cubism emerged from the studios of Braque and Picasso, it became clear to the art world that something of great significance was happening. The radical innovations upset the public and most critics, but the avant-garde saw in them the future of art.

French Responses. Some artists, such as sculptor Jacques Lipchitz (1891–1973), incorporated these innovations in less radical art. Lipchitz, who came to Paris from his native Lithuania in 1909, assimilated both Analytic and Synthetic Cubism. *Man with a Guitar* (fig. 28-28), for example, is in the Synthetic Cubist mode, although it is carved rather than constructed. Like Picasso in *Mandolin and Clarinet*, Lipchitz combined curvilinear and angular shapes, in this case to evoke the familiar Cubist subject of a figure holding a guitar. The hole at the center of the work is a visual pun that suggests both the sound hole of the guitar and the figure's navel. The sculpture aims simply to create a pleasant symphony of shifting but ultimately stable forms.

At the other end of the spectrum was the radical painting of Robert Delaunay (1885–1941), who attempted to take monochromatic, static, and antisocial Analytic Cubism into a new, wholly different direction.

Neo-Impressionism and Fauvism influenced Delaunay's early painting, and his interest in the spirituality of color led him to participate in Der Blaue Reiter exhibitions. Beginning in 1910 Delaunay attempted to fuse Fauvist color with Analytic Cubist form in works dedicated to the modern city and modern technology. One of these, Homage to Blériot (fig. 28-29), pays tribute to the French pilot who in 1909 was the first to fly across the English Channel. One of Blériot's early airplanes, in the upper right, and the Eiffel Tower, below it, were symbols of technological and social progress, and the crossing of the Channel was evidence of a new, unified world without national antagonisms. The brightly colored circular forms that fill the canvas suggest both the movement of the propeller on the left and the blazing sun, as well as the great rose windows of Gothic cathedrals. By combining images of progressive science with those of divinity, Delaunay suggested that progress is part of God's divine plan. The ecstatic painting thus synthesizes not only Fauvist color and Cubist form but also conservative religion and modern technology.

The critic Apollinaire labeled Delaunay's style Orphism for its affinities with Orpheus, the legendary Greek poet whose lute playing charmed wild beasts, implying an analogy between Delaunay's painting and

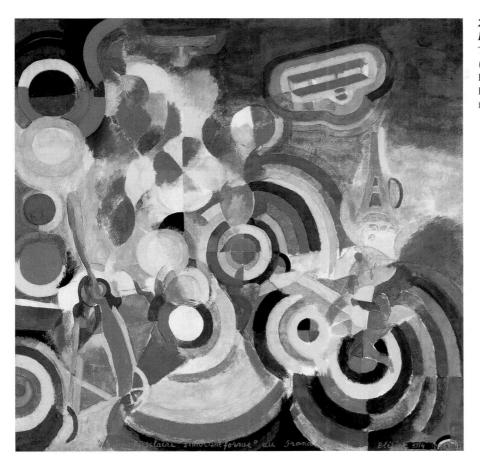

28-29. Robert Delaunay. Homage to Blériot. 1914. Tempera on canvas, $8'2^{1}/_{2}" \times 8'3"$ (2.5 × 2.51 m). Öffentliche Kunstsammlung Basel, Kunstmuseum, Basel, Switzerland. Emanuel Hoffman Foundation

music. Delaunay preferred to think of his work in terms of "simultaneity," a complicated concept he developed with his wife, the Russian-born artist Sonia Delaunay-Terk (née Sonia Stern, 1885–1979), from Michel-Eugène Chevreul's law of the simultaneous contrast of colors (see page 000). Simultaneity for Delaunay and his wife connoted the collapse of spatial distance and temporal sequence into the simultaneous "here and now," and the creation of harmonic unity out of elements normally considered disharmonious.

After marrying Delaunay in 1910, Delaunay-Terk produced paintings very similar to his, but she devoted much of her career to fabric and clothing design. Her greatest critical success came in 1925 at the International Exposition of Modern Decorative and Industrial Arts, for which she decorated a Citroën sports car to match one of her ensembles (fig. 28-30), suggesting that her bold geometric designs were an expression of the new automobile age. Delaunay-Terk chose that particular car because it was produced cheaply for a mass market, and she had recently brought out inexpensive ready-to-wear clothing. Moreover, the small three-seater was specifically designed to appeal to the "new woman," who, like Delaunay-Terk, was less tied to home and family and less dependent on men than her predecessors.

Italian Responses. Italian Futurism emerged on February 20, 1909, when a controversial Milanese poet and literary magazine editor, Filippo Marinetti (1876–1944), published his "Foundation and Manifesto of Futurism" in

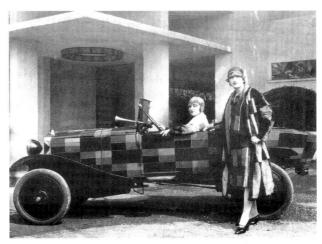

28-30. Sonia Delaunay-Terk. Clothes and customized Citroën B-12 (Expo 1925 Mannequins avec auto). From *Maison de la Mode*, 1925.

The term *Art Deco* was coined at the 1925 International Exposition of Modern Decorative and Industrial Arts in Paris to describe the kind of geometric style evident in many of the works on display, including Delaunay-Terk's clothing and fabric designs.

a Paris newspaper. An outspoken attack against everything old, dull, "feminine," and safe, Marinetti's manifesto promoted the exhilarating "masculine" experiences of warfare and reckless speed. Futurism aimed both to free Italy from its past and to promote a new taste for the thrilling speed, energy, and power of modern technology and modern urban life.

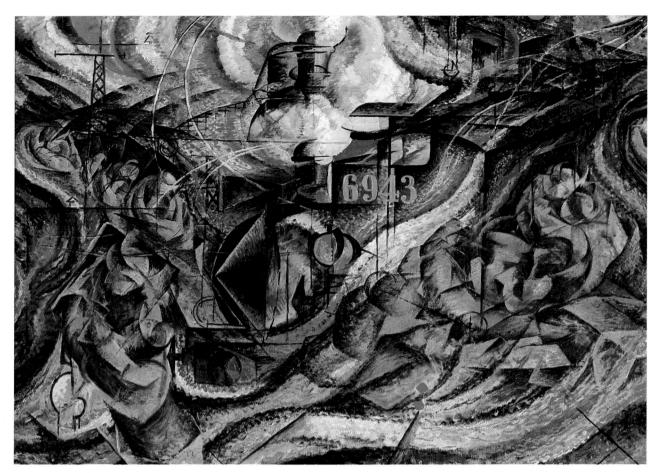

28-31. Umberto Boccioni. *States of Mind: The Farewells.* 1911. Oil on canvas, $27^{7}/8 \times 37^{7}/8$ " (70.7 × 96 cm). The Museum of Modern Art, New York.

Gift of Nelson A. Rockefeller

This painting is the first in the States of Mind trilogy of train station scenes, whose other two canvases depict Those Who Go and Those Who Remain. In each picture, Boccioni sought to capture "the rhythm specific to the emotion" of the subject as "a state of form, a state of color, each of which will give back to the viewer the 'state of mind' that produced it."

In April 1911 five Milanese artists issued the "Technical Manifesto" of Futurist painting, in which they boldly declared that "all subjects previously used must be swept aside in order to express our whirling life of steel, of pride, of fever, and of speed." The paintings of Umberto Boccioni (1882-1916), one of the manifesto's signers, celebrate the pulsating dynamism of the modern industrial city. States of Mind: The Farewells (fig. 28-31), for example, immerses the viewer in the crowded, exciting chaos of a train station. At the center, with numbers emblazoned on its front, is a powerful steam locomotive. Pulsing across the top of the work is a series of bright curves meant to suggest radio waves emanating from the steel tower in the left rear. Adding to the complexity of the tightly packed surface are the longer, more fluid rhythms that seem to pull a crowd of metallic figuresor perhaps a single couple moving through space and time—from beneath the tower down and across the picture. Although the simplified, blocky forms were borrowed from Analytic Cubism, their sequential arrangement was inspired by time-lapse photography.

Boccioni wanted to convey more than a purely physical sense of place. He wanted, as well, to evoke the sounds, smells, and emotions that made the train station the epitome of the noisy urban existence he and his colleagues loved.

In 1912 Boccioni took up sculpture and his "Technical Manifesto of Futurist Sculpture" called for a "sculpture of environment" in which closed outlines would be broken open and sculptural forms integrated with surrounding space. His major sculptural work, Unique Forms of Continuity in Space (fig. 28-32), presents an armless nude figure in full, powerful stride. The contours of the muscular body flutter and flow into the surrounding space, expressing the figure's great velocity and vitality as it rushes forward, a stirring symbol of the brave new Futurist world.

Russian Responses. Since the time of Peter the Great (ruled 1682-1725), Russia's ruling classes had turned to Western Europe for cultural models. In 1898, two wealthy young men-Aleksandr Benois (1870-1960) and

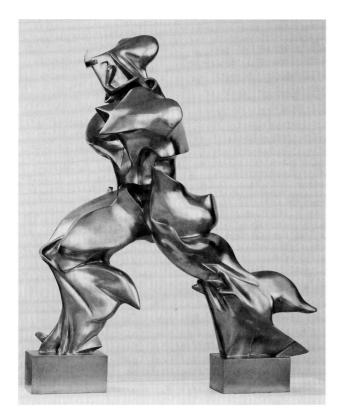

28-32. Umberto Boccioni. *Unique Forms of Continuity in Space.* 1913. Bronze, $43^{7}/_{8} \times 34^{7}/_{8} \times 15^{3}/_{4}$ " (111 \times 89 \times 40 cm). The Museum of Modern Art, New York. Acquired through the Lillie P. Bliss Bequest, (231.1948)

Boccioni and the Futurist architect Antonio Sant'Elia (see fig. 28-44) were both killed in World War I. The Futurists had ardently promoted Italian entry into the war on the side of France and England. After the war Marinetti's movement, still committed to nationalism and militarism, supported the rise of fascism under Benito Mussolini, although a number of the original members of the group rejected this direction.

Serge Diaghilev (1872–1929)—who wanted not just to import Western innovations but also to make Russia for the first time a center of innovation, launched the magazine *World of Art*, dedicated to international art, literature, and music. The following year the World of Art group, centered in Russia's capital, St. Petersburg, held its first international art exhibition, including works by Degas, Monet, and Whistler. Diaghilev took an exhibition of contemporary Russian art to Paris in 1906 and three years later brought his ballet company, the Ballets Russes, to the French capital, where it enjoyed enormous success.

The World of Art group inspired a similar group in Moscow, the Golden Fleece. In 1906 it launched an art magazine by that name and in 1908 organized a major exhibition of Russian and French art, which included works by Rodin, Maillol, Toulouse-Lautrec, Gauguin, Cézanne, Matisse, Derain, and Braque. Among the young Russian artists in the first Golden Fleece exhibition were Mikhail Larionov (1881–1964) and Natalia Goncharova (1881–1962), who had met at a Moscow art

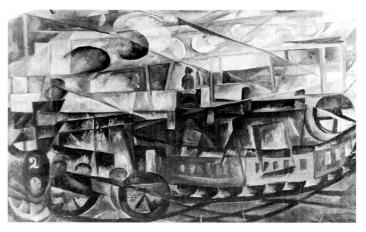

28-33. Natalia Goncharova. *Aeroplane over a Train.* 1913. Oil on canvas, $21\frac{5}{8} \times 32\frac{7}{8}$ " (55 × 83.5 cm). State Museum of the Visual Arts of Tatarstan, Kazan.

school and became lifelong companions (they married in 1955). Exposed to French modernism, Larionov and Goncharova adopted the bright colors and simplified forms of the Fauves, which they combined with a strongly nationalistic interest in "primitive" Russian art forms such as **icon** paintings, signboards, and *lubki*, the cheap woodblock prints that decorated peasant homes. Larionov and Goncharova's Neo-Primitivist paintings of the early 1910s were boldly colored and crudely stylized genre scenes of Russian peasants intended to celebrate both native Russian artistic styles and the country's traditional agrarian way of life. Their slightly later works, however, such as Goncharova's Aeroplane over a Train (fig. 28-33), reflect Western European art's promotion of modern technological progress, suggesting the conflict many Russians felt over the opposition of rural to urban, agrarian to industrial, and Russian to Western European.

Goncharova's painting combines two leading symbols of technological advance in a style derived from early Analytic Cubism and Futurism. Blocky Cubist shapes are closely packed in a dynamic Futurist rhythm across a surface also marked by sharp diagonals. Because knowledge of Analytic Cubism and Futurism arrived in Moscow almost simultaneously and they were superficially similar, artists such as Goncharova tended to link them. Thus, the style that evolved from them in 1912–14 is known as Cubo-Futurism, even though it had less to do with Cubist than with Futurist values.

After Goncharova and Larionov left for Paris in 1915, their colleague Kazimir Malevich (1878–1935) emerged as the leading figure in the Moscow avant-garde. According to his later reminiscences, "in the year 1913, in my desperate attempt to free art from the burden of the object, I took refuge in the square form and exhibited a picture which consisted of nothing more than a black square on a white field." Malevich exhibited thirty-nine works in this radically new vein at the "Last Futurist Exhibition of Paintings: 0.10" exhibition in St. Petersburg in the winter of 1915–16. One work, *Suprematist Painting*

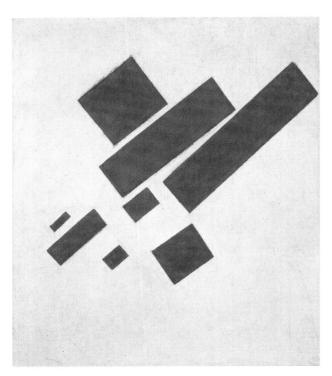

28-34. Kazimir Malevich. *Suprematist Painting (Eight Red Rectangles).* 1915. Oil on canvas, $22^{1}/_{2} \times 18^{7}/_{8}$ " (57 × 48 cm). Stedelijk Museum, Amsterdam.

(Eight Red Rectangles) (fig. 28-34), consists simply of eight red rectangles arranged diagonally on a white painted ground. Malevich called this art Suprematism, short for "the supremacy of pure feeling in creative art" motivated by "a pure feeling for plastic [that is, formal] values." By eliminating objects and focusing entirely on formal issues, Malevich intended to "liberate" the essential beauty of all great art.

While Malevich was launching an art that transcended the present, Vladimir Tatlin (1885-1953) was opening a very different direction for Russian art, inspired by Synthetic Cubism. In April 1914 Tatlin went to Paris specifically to visit Picasso's studio. Tatlin was most impressed by the Synthetic Cubist Sculpture he saw there, such as Mandolin and Clarinet (see fig. 28-27), and began to produce innovative nonrepresentational relief sculptures constructed of various materials, including metal, glass, plaster, asphalt, wire, and wood. These Counter-Reliefs, as he called them, were based on the conviction that each material generates its own repertory of forms and colors. Partly because he wanted to place "real materials in real space" and because he thought the usual placement on the wall tended to flatten his reliefs, Tatlin began at the "0.10" exhibition of 1915-16 to suspend them across the upper corners of rooms (fig. 28-35)—the traditional location for Russian icons. In effect, these Corner Counter-Reliefs were intended to replace the old symbol of Russian faith with one dedicated to respect for materials. But because his choice of materials increasingly favored the industrial over the natural, these modern icons were also incipient expressions of the post-World War I shift away from

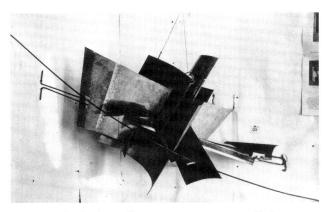

28-35. Vladimir Tatlin. *Corner Counter-Relief.* 1915. Mixed media, $31^1/_2 \times 59 \times 29^1/_2$ " (80 × 150 × 75 cm). Present whereabouts unknown.

© Estate of Vladimir Tatlin/RAO Moscow/Licensed by VAGA, New York, NY

aestheticism and toward utilitarianism in Russia, a topic explored later in this chapter.

EARLY MODERNIST TENDENCIES IN THE UNITED STATES

Artistic modernism developed more slowly in the United States than in Europe because the still-vital American realist tradition was fundamentally opposed to the abstract styles of painters like Kandinsky,

Delaunay, and Malevich. In the opening decade of the twentieth century, a vigorous realist movement coalesced in New York City around the charismatic painter and teacher Robert Henri (1865–1929). Speaking out against both the academic conventions and the impressionistic style then dominating American art, Henri told his students: "Paint what you see. Paint what is real to you."

In 1908, Henri organized an exhibition of artists who came to be known as The Eight, four of whom were former newspaper illustrators. The show was a gesture of protest against the conservative exhibition policies of the National Academy of Design, the American counterpart of the French École des Beaux-Arts. Because they depicted scenes of often gritty urban life in New York City, five of The Eight became part of what was later dubbed the Ashcan School.

Most characteristic of this school is John Sloan (1871–1951), whose *Backyards, Greenwich Village* (fig. 28-36), belies the Ashcan label, because, like the laundry in it, it seems fresh and clean—an effect that depends on both the wet look of the paint and the refreshing blues that dominate it. Balancing those cool tonalities are the warm yellows of the building and fence, which give the picture its emotional temperature. Beneath the laundry, which suggests the presence of caring parents, two warmly dressed children are building a snowman, while an alley cat looks on. Another observer is a little girl in the window at the right, a stand-in for the artist, who looks out with joy on this ordinary backyard and its simple pleasures.

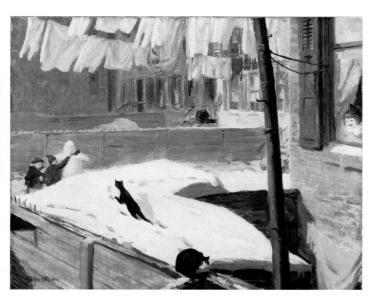

28-36. John Sloan. *Backyards, Greenwich Village*. 1914. Oil on canvas, $24 \times 20''$ (61×50.8 cm). Whitney Museum of American Art, New York. Purchase, (36.153)

An outspoken opponent of the Ashcan school aesthetic was the photographer Alfred Stieglitz (see fig. 27-97), who in the years before World War I worked to foster the American recognition of European modernism and to support its independent development by Americans. As we saw in Chapter 27, Stieglitz sought recognition for photography as a creative art form on a par with painting, drawing, and printmaking. He promoted his views through an organization called the Photo-Secession, founded in 1902, and two years later opened a gallery at 291 Fifth Avenue, soon known simply as 291, which exhibited modern art as well as photography to help break the barrier between the two.

Stieglitz's chief ally was another American photographer, Edward Steichen (1879–1973), who then lived in Paris and helped arrange exhibitions unlike any seen before in the United States, including works by Rodin (1908 and 1910), Matisse (1908 and 1912), Toulouse-Lautrec (1909), Henri Rousseau (1910), Cézanne (1911), Picasso (1911), and Brancusi (1914). Thus, in the years around 1910 Stieglitz's gallery became the American focal point not only for the advancement of photographic art but also for the larger cause of European modernism. Even more important, Stieglitz also exhibited young American artists beginning to experiment with modernist expression.

The turning point for modernist art in the United States was the 1913 exhibition known as the Armory Show. It was assembled by one of The Eight, Arthur B. Davies (1862–1928), to demonstrate how outmoded were the views of the National Academy of Design. Unhappily for the Henri group, the Armory Show also demonstrated how out of fashion their realistic approach was. Of the more than 1,300 works in the show, only about a quarter were by Europeans, but those works drew all the attention. Critics claimed that Matisse, Kandinsky, Braque, Duchamp (see fig. 28-64), and Brancusi were the agents

of "universal anarchy." The academic painter Kenyon Cox called them mere savages. When a selection of works continued on to Chicago, civic leaders there called for a morals commission to investigate the show. Faculty and students at the School of the Art Institute were so enraged they hanged Matisse in effigy.

A number of younger artists, however, responded positively and sought to assimilate the most recent developments from Europe. The issue of realism versus academicism, so critical before 1913, suddenly seemed inconsequential. For the first time in their history, American artists at home began fighting their provincial status.

Among the pioneers of American modernism who exhibited at the Armory Show was Marsden Hartley (1877–1943), who was also a regular exhibitor at Stieglitz's 291 gallery. Between 1912 and 1915 Hartley lived mostly abroad, first in Paris, where he discovered Cubism, then in Berlin, where he was drawn to the colorful, spiritually oriented expressionism of Kandinsky. Around the beginning of World War I, Hartley merged these influences into the powerfully original style seen in his *Portrait of a German Officer* (fig. 28-37, "The Object Speaks," page 1044), a tightly arranged composition of boldly colored shapes and patterns, interspersed with numbers, letters, and fragments of German military imagery that refer symbolically to its subject.

Another American artist influenced by European modernism was the photographer Paul Strand (1890-1976), who also exhibited at 291. Stimulated by the Armory Show and Stieglitz's exhibitions of Cézanne, Picasso, and Brancusi at 291, Strand in the summer of 1916 made an innovative series of abstract photographs derived from objects in the real world. Chair Abstract, Twin Lakes, Connecticut (fig. 28-38, page 1045), is a cropped view of the seat, back, and spindled arm of a chair, in the structure of which Strand discovered a formal relationship to the geometries of Cubism. By turning his camera over 45 degrees and bringing it close to the chair, he created an abstract composition that has less to do with a piece of furniture than with geometric shapes, light and dark contrasts, flattened space, and the dynamism of the diagonal.

EARLY MODERN ARCHITECTURE

New industrial materials and advances in engineering enabled twentiethcentury architects to create unprecedented architectural

forms that responded to the changing needs of society. In formal terms, modernist architecture rejected historical styles and emphasized simple, geometric forms and plain, undecorated surfaces.

AMERICAN MODERNISM

Many consider Frank Lloyd Wright (1867–1959) a pioneer of architectural modernism, the greatest American architect of the twentieth century. His mother, determined that he would be an architect, had hung engravings of cathedrals over his crib. Summers spent working on his uncle's farm in Wisconsin gave him a deep

THE OBJECT SPEAKS

PORTRAIT OF A GERMAN OFFICER

Marsden Hartley's modernist painting Portrait of a German Officer (fig. 28-37) does not literally represent its subject but speaks symbolically of it through the use of numbers, letters, and fragments of German military paraphernalia and insignia. While living in Berlin in 1914, the homosexual Hartley became enamored of a young Prussian lieutenant, Karl von Freyburg, whom he later described in a letter to his dealer, Alfred Stieglitz, as "in every way a perfect being-physically, spiritually and mentally, beautifully balanced—24 years young. . . . " Freyburg's death at the front in October 1914 devastated Hartley, and he mourned the fallen officer through the act of painting.

The black background of *Portrait of a German Officer* serves formally to heighten the intensity of its colors and expressively to create a solemn, funereal undertone. The symbolic references to Freyburg include his initials ("Kv.F"), his age ("24"), his regiment number ("4"), epaulettes, lance tips, and the Iron Cross he was awarded the day before he was killed. The cursive "E" may refer to Hartley himself, whose given name was Edmund.

Even the seemingly abstract, geometric patterns have symbolic meaning. The black-and-white checkerboard evokes Freyburg's love of chess. The blue-and-white diamond pattern comes from the flag of Bavaria. The black-and-white stripes are those of the historic flag of Prussia. And the red, white, and black bands constitute the flag of the German Empire, adopted in 1871.

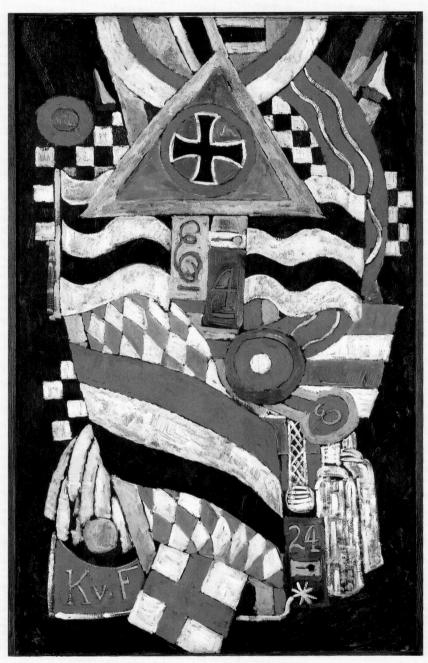

28-37. Marsden Hartley. Portrait of a German Officer. 1914. Oil on canvas, $68^{1/4} \times 41^{3/8}$ " (1.78 \times 1.05 m). The Metropolitan Museum of Art, New York. The Alfred Stieglitz Collection, 1949 (49.70.42)

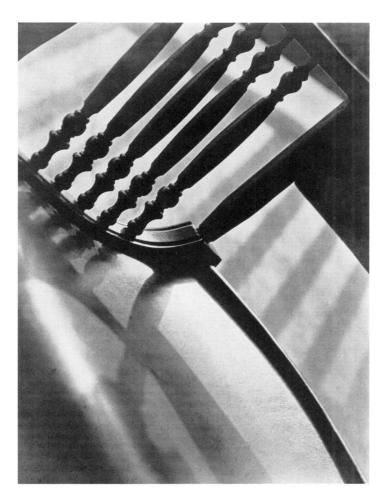

28-38. Paul Strand. *Chair Abstract, Twin Lakes, Connecticut.* 1916. Palladium print, $13 \times 9^{11}/_{16}$ " (33 × 24.6 cm). San Francisco Museum of Modern Art.

Purchase, (84.15)

Strand's pioneering abstract photographs were influenced by Cubist painting. In taking them, he said he "set out to find out what this abstract idea was all about and to discover the principles behind it. . . . I did not have any idea of imitating painting or competing with it but was trying to find out what its value might be to someone who wanted to photograph the real world."

respect for nature, natural materials, and agrarian life. After briefly studying engineering at the University of Wisconsin, Wright apprenticed for a year with a Chicago architect, then spent the next five years with Adler and Sullivan (see fig. 27-103), eventually becoming their chief drafter. In 1893, Wright opened his own office, specializing in domestic architecture. Seeking better ways to integrate house and site, he turned away from the traditional boxlike design and by 1900 was creating "organic" architecture that integrated a building with its natural surroundings.

This distinctive domestic architecture is known as the **Prairie style** because many of Wright's early houses were built in the Prairie States and were inspired by the horizontal character of the prairie itself. Its most famous expression is the Frederick C. Robie House (fig. 28-39), which, typical of the style, is organized around a central chimney mass that marks the hearth as the physical and psychological center of the home. From the chimney mass, dramatically cantilevered (see "Space-Spanning Construction Devices," page xxviii, Starter Kit) roofs and terraces radiate outward into the surrounding environment, echoing the horizontality of the prairie even as they provide a powerful sense of shelter for the family within. The windows are arranged in long rows and deeply embedded into the brick walls, adding to the fortresslike quality of the building's central mass.

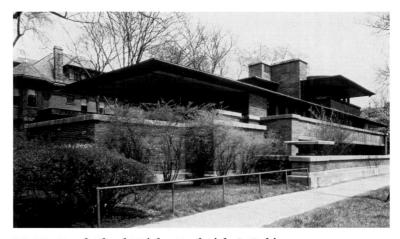

28-39. Frank Lloyd Wright. Frederick C. Robie House, Chicago. 1906–9.

The horizontal emphasis of the exterior continues inside, especially in the main living level—one long space divided into living and dining areas by a free-standing fireplace. The free flow of interior space that Wright sought was partly inspired by traditional Japanese domestic architecture, which uses screens rather than heavy walls to partition space (see "Shoin Design," page 825). In his quest to achieve organic unity among

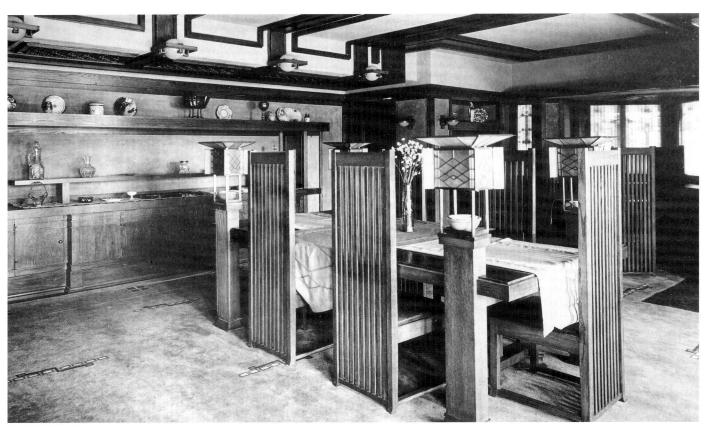

28-40. Dining room, Frederick C. Robie House.

In 1897 Wright helped found the Chicago Arts and Crafts Society, an outgrowth of the movement begun in England by William Morris (Chapter 27). But whereas his English predecessors looked nostalgically back to the Middle Ages and rejected machine production, Wright did not. He detested standardization, but he thought the machine could produce beautiful and affordable objects. The chairs seen here, for example, were built of rectilinear, machine-cut pieces. Wright, a conservationist, favored such rectilinear forms in part because they could be cut with a minimum of wasted lumber.

all parts of the house, Wright integrated lighting and heating into the ceiling and floor and designed built-in bookcases, shelves, and storage drawers. He also incorporated freestanding furniture of his own design, such as the dining room set seen in figure 28-40. The chairs feature a strikingly modern, machine-cut geometric design that harmonizes with the rest of the house. Their high backs were intended to create around the dining table the intimate effect of a room within a room. Wright also designed the table with a view to promoting intimacy: Because he felt that candles and bouquets running down the center of the table formed a barrier between people seated on either side, he integrated lighting features and flower holders into the posts near each of the table's corners.

THE AMERICAN SKYSCRAPER

After 1900 New York City assumed leadership in the development of the skyscraper, whose soaring height was made possible by the use of the steel-frame skeleton for structural support and other advances in engineering and technology (see "The Skyscraper," page 1049). New York clients rejected the innovative style of Louis Sullivan and other Chicago architects for the historicist ap-

proach still in favor in the East, as seen in the Woolworth Building (fig. 28-41), designed by the Minnesotabased Cass Gilbert (1859–1934). When completed, at 792 feet and 55 floors, it was the world's tallest building. Its Gothic-style external details, inspired by the soaring towers of late-medieval churches, resonated well with the United States' increasing worship of business. Gilbert explained that he wished to make something "spiritual" of what others called his Cathedral of Commerce.

EUROPEAN MODERNISM

In Europe, a stripped-down and severely geometric style of modernist architecture arose, partly in reaction against the ornamental excesses of Art Nouveau. A particularly harsh critic of Art Nouveau (known in Austria as *Sezessionstil*) was the Viennese writer and architect Adolf Loos (1870–1933). In the essay "Ornament and Crime" (1913), he insisted, "The evolution of a culture is synonymous with the removal of ornament from utilitarian objects." For Loos, ornament was a sign of a degenerate culture.

Exemplary of Loos's aesthetic is his Steiner House (fig. 28-42), whose stucco-covered, reinforced-concrete

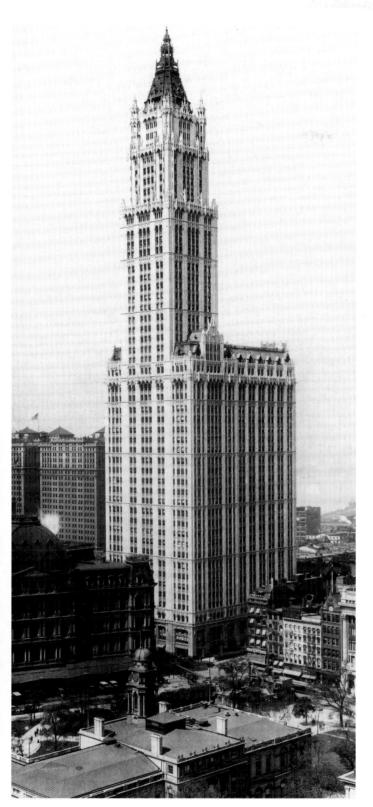

28-41. Cass Gilbert. Woolworth Building, New York. 1911–13. © Collection of The New-York Historical Society, New York City. (Neg 46309)

construction lacks embellishment. The plain, rectangular windows are placed only according to interior needs. For Loos, an exterior was simply to provide protection from the elements. The curved roof allows rain and snow to run off but, unlike the traditional pitched roof, creates no wasted space.

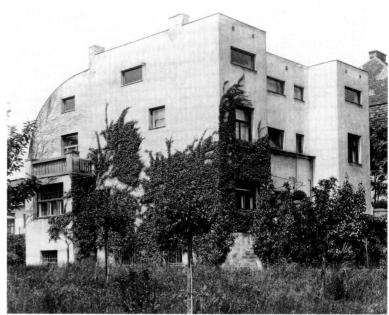

28-42. Adolf Loos. Steiner House, Vienna. 1910.

The purely functional exteriors of Loos's buildings qualify him as a founder of European modernist architecture. Another was the German Walter Gropius (1883-1969), who opened an office in 1910 with Adolf Meyer (1881-1929). Gropius's lectures on increasing workers' productivity by improving the workplace drew the attention of an industrialist who in 1911 commissioned him to design a factory for the Fagus Shoe Company (fig. 28-43, page 1048). This building represents the evolution of modernist architecture from the engineering advances of the nineteenth century. Unlike the Eiffel Tower or the Crystal Palace (see figs. 27-1, 27-38), it was conceived not to demonstrate advances or solve a problem but to function as a building. With it Gropius proclaimed that modern architecture should make intelligent and sensitive use of what the engineer can provide.

To produce a purely functional building, Gropius gave the Fagus Factory facade no elaboration beyond that dictated by its construction methods. The slender brick piers along the outer walls mark the vertical members of the building's steel frame, and the horizontal bands of brickwork at the top and bottom, like the opaque panels between them, mark floors and ceilings. A curtain wall—an exterior wall that bears no weight but simply separates the inside from the outside—hangs over the frame, and it consists largely of glass. The corner piers standard in earlier buildings, here rendered unnecessary by the steel-frame skeleton, have been eliminated. The large windows both reveal the building's structure and flood the workplace with light. This building insists that good engineering is good architecture.

Just prior to World War I, an Italian Futurist architect, Antonio Sant'Elia (1888–1916), conceived a more dynamic and visionary solution to the search for a modern

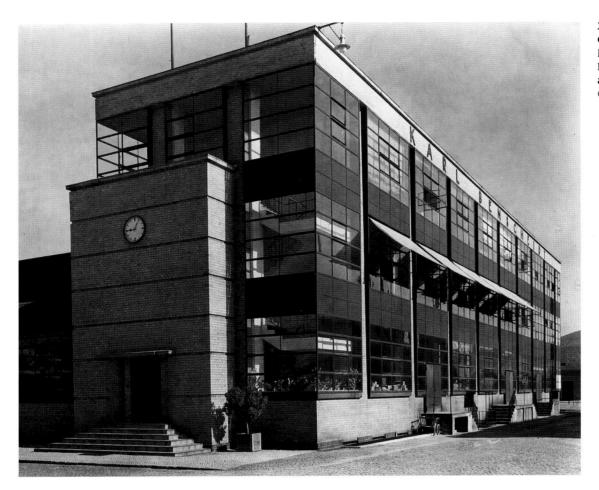

28-43. Walter **Gropius and Adolf** Meyer. Fagus Shoe Factory, Alfeldan-der-Leine. Germany. 1911-16.

style in drawings for his theoretical Città Nuova ("New City"). His conception of the new city of steel, glass, and reinforced concrete was not based on advanced technology alone but also on the way it can emphasize the energy of modern life. The basic structure of Sant'Elia's new city would be the skyscraper, whose stepped-back design would not be functional but expressive of rapid movement. Cutting through and beneath the city would be a network of roads and subways extending in places to seven levels below the ground. The nerve center of this vast transportation system would be the colossal station for trains and airplanes pictured here (fig. 28-44). Sant'Elia's fantastic station functions as a giant futurist machine in which, as one critic noted, "traffic assumes a role analogous to that of water in a fountain." But water and all other natural features are banished from Sant'Elia's city.

IN EUROPE

MODERNISM World War I had a profound effect on Europe's artists and architects. While many responded **BETWEEN** pessimistically to the unprece-THE WARS dented destruction, some sought in the war's ashes the basis for a

new, more secure civilization. Some were utopian visionaries, while others captured in their art nightmarish visions. Some sought stability in classical forms of the past, yet others looked to the precision of new geometric and industrial forms to create order from chaos.

28-44. Antonio Sant'Elia. Station for Airplanes and Trains. 1914. Musei Civici, Como.

"We are no longer the men of the cathedrals, the palaces, the assembly halls," Sant'Elia wrote in the 1914 "Manifesto of Futurist Architecture," "but of big hotels, railway stations, immense roads, colossal ports, covered markets . . . demolition and rebuilding schemes. We must invent and build the city of the future, dynamic in all its parts . . . and the house of the future must be like an enormous machine."

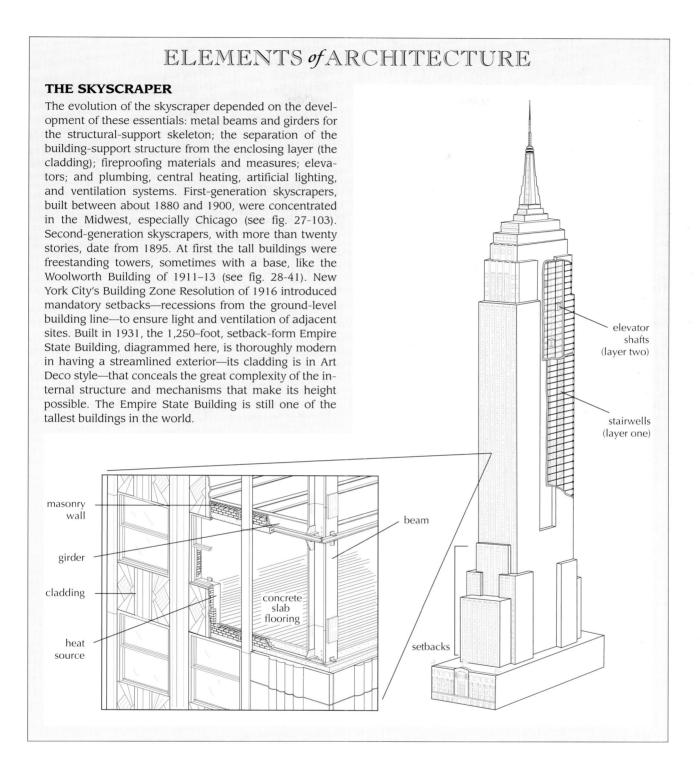

And other European artists between the wars presented barbed social criticism, deeply personal self-expression, or whimsical works that defied convention.

UTILITARIAN ART FORMS IN RUSSIA

In the 1917 Russian Revolution, the radical socialist Bolsheviks overthrew the czar, took Russia out of the world war, and turned to winning an internal civil war that lasted until 1920. Most of the Russian avant-garde enthusiastically supported the Bolsheviks, who in turn supported them. Vladimir Tatlin's case is fairly representative. In 1919, as part of his work on a committee to im-

plement Russian leader Vladimir Lenin's Plan for Monumental Propaganda, Tatlin devised the Monument to the Third International (fig. 28-45, page 1050), a 1,300-foottall building to house the organization devoted to the worldwide spread of Communism. Tatlin's visionary plan combined the appearance of avant-garde sculpture with a fully utilitarian building, a new hybrid form as revolutionary as the politics it represented. In Tatlin's model, the steel structural support, a pair of leaning spirals connected by grillwork, is on the outside, rather than the inside the building. Tatlin combined the skeletal structure of the Eiffel Tower (which his tower would

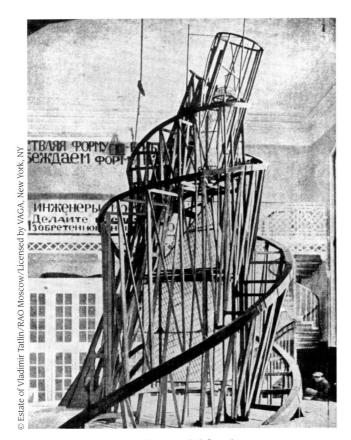

28-45. Vladimir Tatlin. Model for the Monument to the Third International. 1919–20. Wood, iron, and glass. Destroyed.

dwarf) with the formal vocabulary of the Cubo-Futurists to convey the dynamism of what Lenin called the "permanent revolution" of Communism. Inside the steel frame would be four separate spaces: a large cube to house conferences and congress meetings, a pyramid for executive committees, a cylinder for propaganda offices, and a hemisphere at the top, apparently meant for radio equipment. Each of these units would rotate at a different speed, from yearly at the bottom to hourly at the top. Although Russia lacked the resources to build Tatlin's monument, models displayed publicly were a symbolic affirmation of faith in what the country's science and technology would eventually achieve.

One of Tatlin's associates, Aleksandr Rodchenko (1891–1956), in 1921 helped launch a group known as the Constructivists, who were committed to quitting the studio and going "into the factory, where the real body of life is made." In place of artists dedicated to pleasing themselves, politically committed artists would create useful objects and promote the aims of the collective. Rodchenko came to believe that painting and sculpture did not contribute enough to practical needs, so after 1921 he gave up traditional "high art" painting and sculpture to make photographs, posters, books, textiles, and theater sets that would promote the ends of the new Soviet society.

In 1925 Rodchenko designed a model workers' club for the Soviet pavilion at the Paris International Exposition of Modern Decorative and Industrial Arts (fig. 28-46).

28-46. Aleksandr Rodchenko. View of the Workers' Club, exhibited at the International Exposition of Modern Decorative and Industrial Arts, Paris. 1925. Rodchenko-Stepanova Archive, Moscow.

© Estate of Aleksandr Rodchenko/RAO Moscow Licensed by VAGA, New York, NY

Although Rodchenko said such a club "must be built for amusement and relaxation," the space was essentially a reading room dedicated to the proper training of the Soviet mind. Designed for simplicity of use and ease of construction, the furniture was made of wood because Soviet industry was best equipped for mass production in that material. The design of the chairs is not strictly utilitarian, however. Their high, straight backs were meant to promote a physical and moral posture of uprightness among the workers.

Not all modernists were willing to give up traditional high art forms. El Lissitzky (1890-1941), for one, attempted to fit the formalism of Malevich to the new imperative that art be useful to the social order. After the revolution, Lissitzky was invited to teach architecture and graphic arts at the Vitebsk School of Fine Arts and came under the influence of Malevich, who also taught there. By 1919 he was using Malevich's Suprematist vocabulary for propaganda posters and for the new type of art work he called the Proun (pronounced "pro-oon"), possibly an acronym for the Russian proekt utverzhdenya novogo ("project for the affirmation of the new"). Most Prouns were paintings or prints, but a few were spaces (fig. 28-47) that qualify as early examples of **installation** art. Lissitzky rejected conventional painting tools as too personal and imprecise and produced his Prouns with the aid of mechanical instruments. Their engineered look was meant to encourage precise thinking among the public. Like many other Soviet artists of the late 1920s, Lissitzky grew disillusioned with the power of formalist art to communicate broadly and turned to more utilitarian projects—architectural design and typography, in particular—and began to produce, along with Rodchenko and others, propaganda photographs and **photomontages**, the combination of several photographs into one work.

The move away from abstraction was led by a group of realists, deeply antagonistic to the avant-garde, who banded together in 1922 to form the Association of

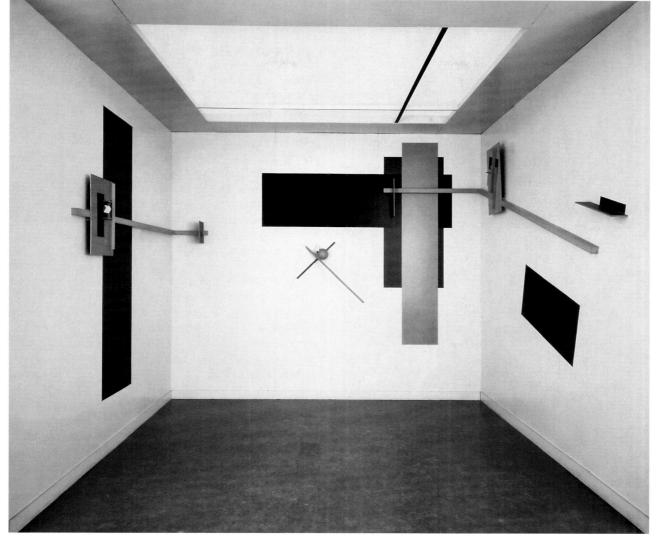

28-47. El Lissitzky. Proun space created for the Great Berlin Art Exhibition. 1923, reconstruction 1965. Stedelijk Van Abbemuseum, Eindhoven, the Netherlands.

Artists of Revolutionary Russia (AKhRR) to promote a clear, representational approach to depicting workers, peasants, revolutionary activists, and, in particular, the life and history of the Red Army. Their tendency to create huge, overly dramatic canvases and statues on heroic or inspirational themes established the basis for the Socialist Realism instituted by Stalin after he took control of the arts in 1932.

One of the sculptors who worked in this official style was Vera Mukhina (1889–1953), who is best known for her *Worker and Collective Farm Woman* (fig. 28-48, page 1052), a colossal stainless-steel sculpture made for the Soviet Pavilion at the Paris Universal Exposition of 1937. The powerfully built male factory worker and female farm laborer hold aloft their respective tools, a hammer and a sickle, to mimic the appearance of these implements on the Soviet flag. The two figures are shown as equal partners striding purposefully into the future, their determined faces looking forward and upward. The dramatic, windblown drapery and the forward propulsion of their diagonal poses enhance the sense of vigorous

idealism. After the exposition the work, intended to convince an increasingly skeptical international audience of the continuing success of the Soviet system, was relocated to Moscow, where it continued to serve the propagandistic needs of the state.

RATIONALISM IN THE NETHERLANDS

In the Netherlands, the Dutch counterpart to the inspirational formalism of Lissitzky was provided by a group known as de Stijl ("the Style"), whose leading artist was Piet Mondrian (1872–1944). The turning point in Mondrian's life came in 1912, when he went to Paris and encountered Analytic Cubism. After assimilating its influence he gradually moved from radical abstractions of landscape and architecture to a simple, austere form of geometric art inspired by them. In the Netherlands during World War I, he met Theo van Doesburg (1883–1931), another painter who shared his artistic views. In 1917 van Doesburg started a magazine, *De Stijl*, which became the focal point of a Dutch movement of artists, architects, and designers. Mondrian contributed several

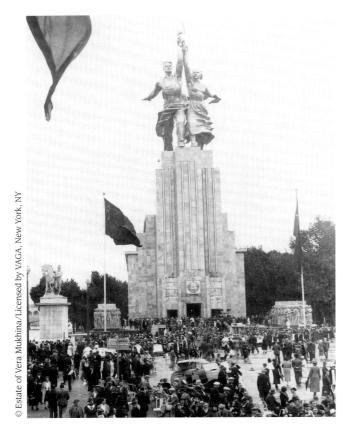

28-48. Vera Mukhina. *Worker and Collective Farm Woman*, sculpture for the Soviet Pavilion, Paris Universal Exposition. 1937. Stainless steel, height approx. 78' (23.8 m).

articles to the magazine between 1917 and 1924 before breaking from the group in the latter year.

Animating the de Stijl movement was the conviction that there are two kinds of beauty: a sensual or subjective one and a higher, rational, objective, "universal" kind. In his mature works Mondrian sought the essence of the second kind, eliminating representational elements because of their subjective associations and curves because of their sensual appeal. From about 1920 on, Mondrian's paintings, such as Composition with Yellow, Red, and Blue (fig. 28-49), all employ the same essential formal vocabulary: the three primary hues (red, yellow, and blue), the three neutrals (white, gray, and black), and horizontal and vertical lines. The two linear directions are meant to symbolize the harmony of a series of opposites, including male versus female, individual versus society, and spiritual versus material. For Mondrian the essence of higher beauty was resolved conflict, what he called dynamic equilibrium. Here, in a typical composition, Mondrian achieved this equilibrium through the precise arrangement of color areas of different size, shape, and "weight," asymmetrically grouped around the edges of a canvas whose center is dominated by a large area of white. The ultimate purpose of such a painting is to demonstrate a universal style with applications beyond the realm of art. Like Art Nouveau, de Stijl wished to redecorate the world. But Mondrian and his colleagues rejected the organic style of Art Nouveau, believing that nature's example encourages "primitive animal instincts." If, instead, we live in an environment

28-49. Piet Mondrian. *Composition with Yellow, Red, and Blue.* 1927. Oil on canvas, $15\times14"$ (38.3 \times 35.5 cm). The Menil Collection, Houston.

Mondrian so disliked the sight of nature, whose irregularities he held largely accountable for humanity's problems, that when seated at a restaurant table with a view of the outdoors, he would ask to be moved.

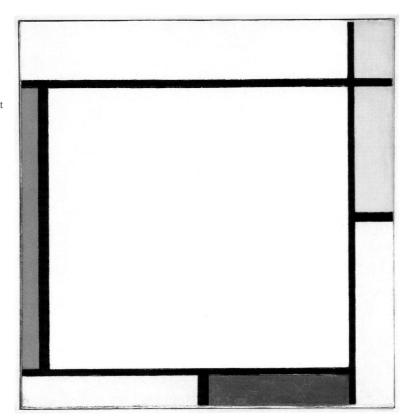

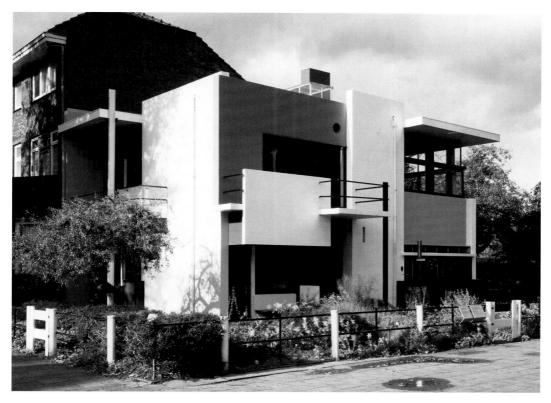

28-50. Gerrit Rietveld. Schröder House, Utrecht, the Netherlands. 1925.

designed according to the rules of "universal beauty," we, like our art, will be balanced, our natural instincts "purified." Mondrian hoped to be the world's last artist: He thought that art had provided humanity with something lacking in daily life and that, if beauty were in every aspect of our lives, we would have no need for art.

The major architect and designer of de Stijl was Gerrit Rietveld (1888-1964), whose Schröder House in Utrecht is an important example of the modernist architecture that came to be known as the International Style (see "The International Style," page 1056). Rietveld applied Mondrian's principle of a dynamic equilibrium to the entire house. The radically asymmetrical exterior (fig. 28-50) is composed of interlocking gray and white planes of varying sizes, combined with horizontal and vertical accents in primary colors and black. His "Red-Blue" chair is shown here in the interior (fig. 28-51), where sliding partitions allow modifications in the spaces used for sleeping, working, and entertaining. These innovative wall partitions were the idea of the patron, Truus Schröder-Schräder (1889-1985), a widowed interior designer. Though wealthy, Schröder-Schräder wanted her home to suggest not luxury but elegant austerity, with the basic necessities sleekly integrated into a meticulously restrained whole.

CLASSICISM AND PURISM IN FRANCE

De Stijl's pursuit of a utopian ideal of universal order and harmony was in part a response to the chaos and destruction of World War I. In France, by contrast, the desire for stability led some to reject the experimenta-

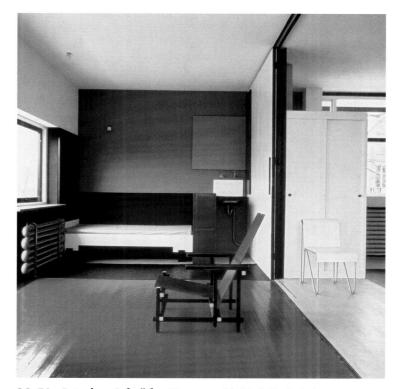

28-51. Interior, Schröder House, with "Red-Blue" chair.

tion of the avant-garde. Numerous critics advocated a revival of the noble tradition of French classicism as a means of rebuilding French culture and society—a tendency summed up by the poet and playwright Jean Cocteau as a "call to order."

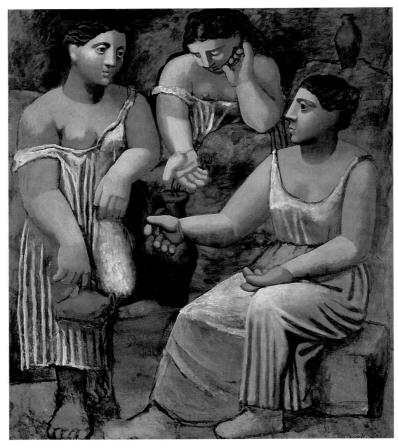

28-52. Pablo Picasso. *Three Women at the Spring.* 1921. Oil on canvas, $6'8^{1}/_{4}" \times 5'8^{1}/_{2}"$ (2.04 \times 1.74 m). The Museum of Modern Art, New York. Gift of Mr. and Mrs. Allan D. Emil

One artist who answered this call was Cocteau's close friend Picasso. While continuing to paint in the Synthetic Cubist style he had developed before World War I (see fig. 28-26), during the early 1920s Picasso also worked in a Neoclassical manner in paintings such as *Three Women at the Spring* (fig. 28-52). The large, powerfully modeled figures resemble living statues, while the treatment of the drapery suggests the **fluting** of classical columns. With their thickened limbs and bulky hands, Picasso's women lack the ideal proportions of classical Greek art, but they do embody the classical values of dignity and calm repose.

Another expression of the "call to order" in modern French art was Purism, whose leading figure was the Swiss-born Charles-Édouard Jeanneret (1887–1965). A largely self-taught and widely traveled architect and painter, Jeanneret moved to Paris in 1917, where he met the painter Amédée Ozenfant (1886–1966). Together they developed a highly disciplined form of painting, which, taking Synthetic Cubism as its starting point, emphasized the geometric purity, simplicity, and harmony of ordinary still-life objects. The Purist aesthetic was strongly inspired by the machine, whose streamlined products Ozenfant and Jeanneret saw as models of a new kind of classical beauty.

Like the Constructivists and the proponents of de Stijl, the Purists firmly believed in the power of art to change the world. In 1920 Jeanneret, partly to demonstrate his faith in the ability of individuals to remake themselves, renamed himself Le Corbusier (a variation on the surname of a maternal grandparent, Lecorbesier). He and Ozenfant believed that they were producing a new and improved Cubism that would not only provide aesthetic pleasure but also, by inducing in its viewers an orderly frame of mind, promote social order.

One of the artists strongly influenced by Purism was Fernand Léger (1881–1955). In Paris before World War I, Léger had developed a dynamic, personal form of Analytic Cubism in which he attempted to reconcile traditional artistic subjects with his radical taste for industrial metal and machinery. In the early 1920s he briefly experimented with Purism in a series of paintings that included Le Grand Déjeuner (The Large Luncheon) (fig. 28-53). The painting is Léger's updated answer to the French odalisque tradition of Ingres and Delacroix (see figs. 27-4, 27-12). The women, arranged within a geometric grid, stare out blankly at us, embodying a quality of classical calm akin to that seen in Picasso's Three Women at the Spring. Léger's women have identical faces, and their bodies seem assembled from standardized, detachable metal parts. The bright, cheerful colors and patterns that surround them suggest a positive vision of an orderly industrial society.

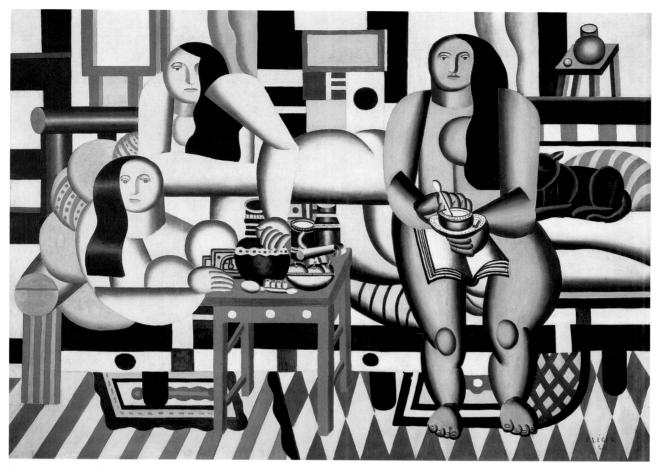

28-53. Fernand Léger. *Le Grand Déjeuner (The Large Luncheon)*. 1921. Oil on canvas, $6'^1/_2" \times 8'3"$ (1.84 × 2.52 m). The Museum of Modern Art, New York. Mrs. Simon Guggenheim Fund.

28-54. Charles-Édouard Jeanneret (Le Corbusier). Project for a Contemporary City of Three Million Inhabitants. 1922.

The skyscrapers Le Corbusier planned for the center of his city were intended to house offices, not residences. Residences would be in smaller suburban terraces of five-story houses around the periphery of the city. In 1925 Le Corbusier devised a similar plan for Paris, convinced that the center of the city needed to be torn down and rebuilt to accommodate automobile traffic. The Parisian street was a "Pack-Donkey's Way," he said. "Imagine all this junk . . . cleared off and carried away and replaced by immense clear crystals of glass, rising to a height of over six hundred feet!"

Purism's most important contributions were not in painting or sculpture but in architecture. Although Le Corbusier never gave up painting, after the early 1920s he concentrated on architecture and urban planning. One of his first mature projects was his conception for

a Contemporary City of Three Million Inhabitants (fig. 28-54), exhibited in Paris in 1922. Le Corbusier hated the crowded, noisy, chaotic, and polluted places that cities had become in the late nineteenth century. What he envisioned for the future was a city of uniform style, laid out

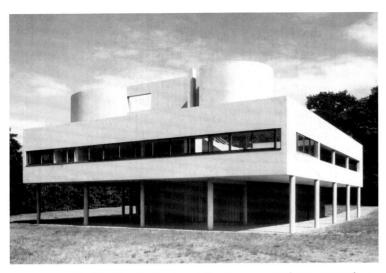

28-55. Le Corbusier. Villa Savoye, Poissy-sur-Seine, France. 1929–30.

Located 30 miles outside of Paris, near Versailles, the Villa Savoye was designed as a weekend retreat. The owners, arriving from Paris, could drive right under the house, whose ground floor curves to accommodate the turning radius of an automobile and incorporates a three-car garage.

on a grid, and dominated, like Sant'Elia's (see fig. 28-44), by skyscrapers, with wide traffic arteries that often passed beneath ground level. Le Corbusier's city would differ from Sant'Elia's, however, in two fundamental re-

spects. First, the buildings would be strictly functional, in the manner of Gropius and Meyer's Fagus Factory (see fig. 28-43). Second, nature would not be neglected. Set between the widely spaced buildings would be large expanses of parkland. The result, Le Corbusier thought, would be a clean and efficient city filled with light, air, and greenery. Le Corbusier's vision had a profound effect on later city planning, especially in the United States.

During the 1920s Le Corbusier designed a number of houses for private clients. The most well known, the Villa Savoye (fig. 28-55), is an icon, like Rietveld's Schröder House, of the International Style (see "The International Style," below). The last of his Purist villas, it culminated the so-called domino construction system begun in 1914, in which ferroconcrete (concrete reinforced with steel bars) slabs were floated on six freestanding steel posts (placed at the positions of the six dots on a domino playing piece). Over the next decade the architect explored the possibilities of this structure and in 1926 published "The Five Points of a New Architecture," which argued for elevating houses above the ground on pilotis (freestanding posts); making roofs flat for use as terraces; using partition walls slotted between supports on the interior and curtain walls on the exterior to provide freedom of design; and using ribbon windows (windows that run the length of the wall).

Although none of these ideas was new, Le Corbusier applied them in a distinctive fashion that combined two

ELEMENTS of ARCHITECTURE

THE INTERNATIONAL STYLE

After World War I, increased exchanges between modernist architects led to the development of a common formal language, transcending national boundaries, which came to be known as the International Style. The term gained wide currency as a result of a 1932 exhibition at The Museum of Modern Art in New York, "The International Style: Architecture since 1922," organized by the architectural historian Henry-Russell Hitchcock and the architect and curator Philip Johnson. Hitchcock and Johnson identified three fundamental principles of the style.

The first principle was "the conception of architecture as volume rather than mass." The use of a structural skeleton of steel and ferroconcrete made it possible to eliminate load-bearing walls on both the exterior and interior. The building could now be wrapped in a skin of glass, metal, or masonry, creating an effect of enclosed space (volume) rather than dense material (mass). Interiors could now feature open, free-flowing plans providing maximum flexibility in the use of space.

The second principle was "regularity rather than symmetry as the chief means of ordering design." Regular distribution of structural supports and the use of standard building parts promoted rectangular regularity rather than the balanced axial symmetry of classical architecture. The avoidance of classical balance also encouraged an asymmetrical disposition of the building's components.

The third principle was the rejection of "arbitrary applied decoration." The new architecture depended upon the intrinsic elegance of its materials and the formal arrangement of its elements to produce harmonious aesthetic effects.

The style originated in the Netherlands, France, and Germany, and by the end of the 1920s had spread to other industrialized countries. Important influences on the International Style included Cubism, the abstract geometry of de Stijl, the work of Frank Lloyd Wright, and the prewar experiments in industrial architecture of Germans such as Walter Gropius. The first concentrated manifestation of the trend came in 1927 at the Deutscher Werkbund's Weissenhofsiedlung exhibition in Stuttgart, Germany, directed by Mies van der Rohe. This permanent exhibition included modern houses by, among others, Mies, Gropius, and Le Corbusier. Its aim was to present models using new technologies and without reference to historical styles. All of the buildings featured flat roofs, plain walls, and asymmetrical openings, and almost all of them were rectilinear in shape.

The concepts of the International Style remained influential in architecture until the 1970s, particularly in the United States, where numerous European architects, including Mies and Gropius, settled in the 1930s. Even Frank Lloyd Wright, an individualist who professed to disdain the work of his European colleagues, adopted elements of the International Style in his later buildings such as Fallingwater (see fig. 28-83).

apparently opposed formal systems: the classical Doric architecture of ancient Greece and the clear precision of machinery. Such houses could be effectively placed in nature, as here, but they were meant to transcend it, as the elevation off the ground and pure white coloring suggest.

BAUHAUS ART IN GERMANY

The German counterpart to the total and rational planning envisioned by the de Stijl group and Le Corbusier was conceived between 1919 and 1933 at the Bauhaus ("House of Building"), the school that was the brainchild of Walter Gropius. Gropius admired the spirit of the medieval building guilds-the Bauhütten-that had built the great German cathedrals. He sought to revive and commit that spirit to the reconciliation of modern art and industry by synthesizing the efforts of architects, artists, and designers. The Bauhaus was formed in 1919, when Gropius convinced the authorities of Weimar, Germany, to allow him to combine the city's schools of art and craft. The Bauhaus moved to Dessau in 1925 and then to Berlin in 1932, where it remained for less than a year before Hitler, who detested the avant-garde, closed it (see "Suppression of the Avant-Garde in Germany," page 1059).

Although Gropius's "Bauhaus Manifesto" of 1919 declared that "the ultimate goal of all artistic activity is the building," the school offered no formal training in architecture until 1927. Gropius thought students would be ready for architecture only after they had completed the required preliminary course and received full training in the crafts taught in the Bauhaus workshops. The preliminary, or foundation, course, directed initially by the Swiss-born Johannes Itten (1888–1967), was designed, in the words of Gropius, "to liberate the individual by breaking down conventional patterns of thought in order to make way for personal experiences and discoveries." The workshops-which included pottery, metalwork, textiles, stained glass, furniture making, carving, and wall painting—were intended to teach both specific technical skills and basic design skills, on the principle of learning through doing.

Between 1919 and 1923 many Bauhaus workshops, under the influence of Itten, promoted the creation of unique, handmade objects that reflected the individualism of their maker but conflicted with Gropius's view that art should serve a socially useful function. In 1922 Gropius implemented a new emphasis on industrial design, and the next year Itten was replaced by the Hungarian-born László Moholy-Nagy (1895-1946), who reoriented the workshops toward the creation of sleek, functional designs suitable for mass production. The elegant tea and coffee service by Marianne Brandt (1893-1983), for example (fig. 28-56), though handcrafted in silver, was a prototype for mass production in a cheaper metal such as nickel silver. After the Bauhaus moved to Dessau, Brandt designed several innovative lighting fixtures and table lamps that went into mass production, earning much-needed revenue for the school. After Moholy-Nagy's departure in 1928 (the same year

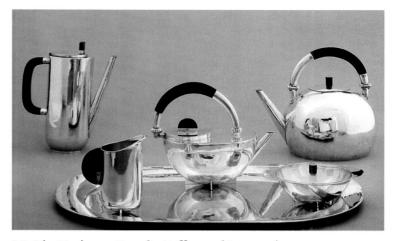

28-56. Marianne Brandt. Coffee and tea service. 1924. Silver and ebony, with Plexiglas cover for sugar bowl. Bauhaus Archiv, Berlin.

The lid of Marianne Brandt's sugar bowl is made of Plexiglas, reflecting the Bauhaus's interest in incorporating the latest advances in materials and technology into the manufacture of utilitarian objects.

Gropius left), she directed the metal workshop for a year before leaving the Bauhaus herself.

As a woman holding her own in the otherwise allmale metals workshop, Brandt was an exceptional figure at the Bauhaus. Although women were admitted to the school on an equal basis with men, Gropius opposed their education as architects and channeled them into workshops that he deemed appropriate for their gender, namely pottery and textiles. One of the most talented members of the textile workshop was the Berlin-born Anni Albers (née Annelise Fleischmann, 1899-1994), who arrived at the school in 1922 and three years later married Josef Albers (1888-1976), a Bauhaus graduate and professor. Obliged to enter the textiles workshop rather than training as a painter, Anni Albers set out to make "pictorial" weavings that would equal paintings as fine—as opposed to applied—art. Albers's wall hangings, such as the one shown in figure 28-57, page 1058, were intended to aesthetically enhance the interior of a modern building in the same way an abstract painting would. The decentralized, rectilinear design reflects the influence of de Stijl, while acknowledging weaving as a process of structural organization.

Albers's intention was "to let threads be articulate . . . and find a form for themselves to no other end than their own orchestration." Numerous other Bauhaus works reveal a similarly "honest" attitude toward materials, including Gropius's design for the new Dessau Bauhaus, built in 1925–26. The building frankly acknowledges the reinforced concrete, steel, and glass of which it is built but is not strictly utilitarian. Gropius, influenced by de Stijl, used asymmetrical balancing of the three large, cubical structural elements to convey the dynamic quality of modern life (fig. 28-58, page 1058). The expressive glass-panel wall that wraps around two sides of the workshop wing of the building recalls the glass wall of the Fagus Factory (see fig. 28-43) and sheds

28-57. Anni Albers. Wall hanging. 1926. Silk, two-ply weave, $5'11^5/_6" \times 3'11^5/_8"$ (1.83 \times 1.22 m). Busch-Reisinger Museum, Harvard University. Association Fund

Following the closure of the Bauhaus in 1933 by the Nazis, Anni Albers and her husband, Josef, immigrated to the United States, where they became influential teachers at the newly founded Black Mountain College in Asheville, North Carolina. Anni Albers exerted a powerful influence on the development of fiber art in the United States through her exhibitions, her teaching, and her many publications, including the books *On Designing* (1959) and *On Weaving* (1965).

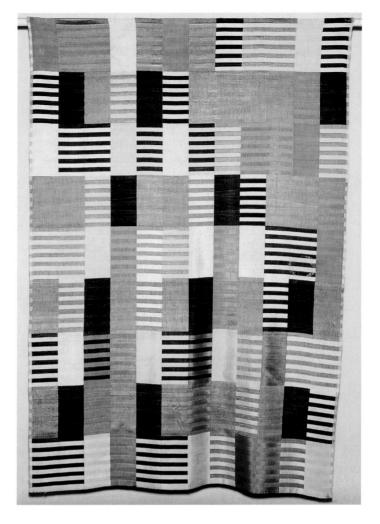

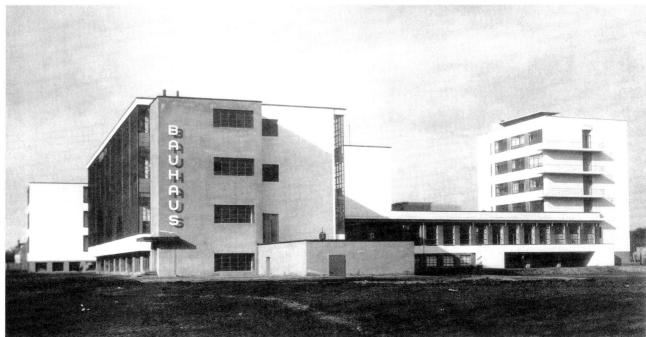

28-58. Walter Gropius. Bauhaus Building, Dessau, Germany. 1925–26. View from northwest.

One of the enduring contributions of the Bauhaus was graphic design. The sans-serif letters of the building's sign not only harmonize with the architecture's clean lines but also communicate the Bauhaus commitment to modernity. Sans-serif typography (that is, a typeface without serifs, the short lines at the end of the stroke of a letter) had been in use only since the early nineteenth century, and a host of new sans-serif typefaces was created in the 1920s.

SUPPRESSION OF THE AVANT-GARDE IN GERMANY

The 1930s in Germany witnessed a serious political reaction against avant-garde art and, eventually, a concerted effort to suppress it. One of the principal targets was the Bauhaus (see fig. 28-58), the art and design school founded in 1919 by Walter Gropius, where Paul Klee, Vasily Kandinsky, Josef Albers, Ludwig Mies van der Rohe, and many other luminaries taught. Through much of the 1920s the Bauhaus had struggled against an increasingly hostile and reactionary political climate. As early as 1924 conservatives had accused the Bauhaus of being not only educationally unsound but also politically subversive. To avoid having the school shut down by the opposition, Gropius moved it to Dessau in 1925, at the invitation of Dessau's liberal mayor, but left soon after the relocation. His successors faced increasing political pressure, as the school was a prime center of modernist practice, and the Bauhaus

was again forced to move in 1932, this time to Berlin.

After Adolf Hitler came to power in 1933, the Nazi party mounted an aggressive campaign against modern art. In his youth Hitler himself had been a mediocre academic painter, and he had developed an intense hatred of the avant-garde. During the first year of his regime, the Bauhaus was forced to close for good. A number of the artists, designers, and architects who had been on its faculty-including Albers, and Mies-Gropius. immigrated to the United States.

The Nazis also launched attacks against the German Expressionists, whose often intense depictions of German soldiers defeated in World War I and of the economic depression following the war were considered unpatriotic. Most of all, the treatment of the human form in these works, such as the expressionistic exaggeration of facial features, was deemed offensive. The works of these and other artists were removed from museums, while the artists themselves were subjected to public ridicule and often forbidden to buy canvas or paint.

As a final move against the avant-garde, the Nazi leadership organized in 1937 a notorious exhibition of banned works. The "Degenerate Art" exhibition was intended to erase modernism once and for all from the artistic life of the nation. Seeking to brand all the advanced movements of art as sick and degenerate, it presented modern art works as specimens of pathology; the organizers printed derisive slogans and comments to that effect on the gallery walls (see

illustration). The 650 paintings, sculpture, prints, and books confiscated from German public museums were viewed by 2 million people in the four months the exhibition was on view in Munich and by another million during its subsequent three-year tour of German cities.

By the time World War II broke out, the authorities had confiscated countless works from all over the country. Most were publicly burned, though the Nazi officials sold much of the looted art at public auction in Switzerland to obtain foreign currency.

Among the many artists crushed by the Nazi suppression was Ernst Ludwig Kirchner, whose *Street, Berlin* (see fig. 28-9) was included in "Degenerate Art." The state's open animosity was a factor in his suicide in 1938. Other artists, such as John Heartfield, left the country to continue their work and to voice their opposition to the Nazis. In his scathing caricatures of Hitler (see fig. 28-62), Heartfield mocked him by using some of the modernist artistic innovations that Hitler had condemned.

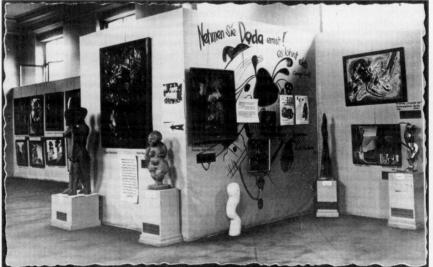

The Dada Wall in Room 3 of "Degenerate Art" (Entartete Kunst) exhibition, Munich, 1937.

natural light on the workshops inside. The raised parapet below the workshop windows demonstrates the ability of modern engineering methods to create light, airy spaces unlike the heavy spaces of past styles.

The director of the Bauhaus between 1930 and its closing in 1933 was the architect Ludwig Mies van der Rohe (1886–1969), whose well-known aphorism crystal-

lized the views of his modernist colleagues: "Less is more." Mies's great passion was the subtle perfection of structure, proportion, and detail using sumptuous materials such as travertine, richly veined marbles, tinted glass, and bronze. His abilities and interests are evident in the elegantly simple entrance pavilion to the German exhibits that he designed for the 1929 International

© Estate of George Grosz/Licensed b

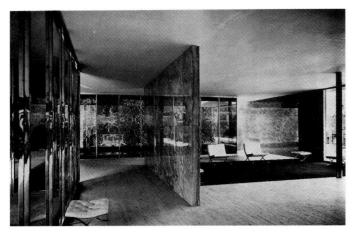

28-59. Ludwig Mies van der Rohe. Interior, German Pavilion, International Exposition, Barcelona, Spain. 1929.

Exposition held in Barcelona (fig. 28-59). For its construction, Mies relied on the domino construction system developed by Le Corbusier. Slender piers support floor and ceiling slabs. Curtain walls divide and enclose the spaces. The interior, based on the de Stijl conception of harmoniously balanced rectangles, resembles a Mondrian painting (see fig. 28-49). Mies also designed for the pavilion a pair of elegantly simple, leather-upholstered, stainless-steel chairs for the king and queen of Spain to sit in during their official visit, as well as a number of ottomans for their entourage. Although the handmade originals were designed for ceremonial use, they were later massproduced and are still a status symbol in many homes and offices today.

DADA

The emphasis on individuality and irrational instinct in the work of artists like Gauguin and many of the Expressionists did not die out entirely after World War I. It endured in the Dada movement, which began with the opening of the Cabaret Voltaire in Zürich, Switzerland, on February 5, 1916. The cabaret's founders, German actor and poet Hugo Ball (1886–1927) and his companion, Emmy Hennings (d.1949), a nightclub singer, had moved to neutral Switzerland after the war broke out. Their cabaret was inspired by the bohemian artists' cafés they had known in Berlin and Munich and attracted avant-garde writers and artists of various nationalities who shared their disgust with bourgeois culture, which they blamed for the war.

Ball's performance while reciting one of his sound poems, "Karawane" (fig. 28-60), reflects the iconoclastic spirit of the Cabaret Voltaire. His legs and body encased in blue cardboard tubes, his head surmounted by a white-and-blue "witch-doctor's hat," as he called it, and his shoulders covered with a huge, gold-painted cardboard collar that flapped when he moved his arms, he slowly and solemnly recited the poem, which consisted of non-sensical sounds. As was typical of Dada, this performance involved two both critical and playful aims. One goal was to retreat into sounds alone and thus renounce

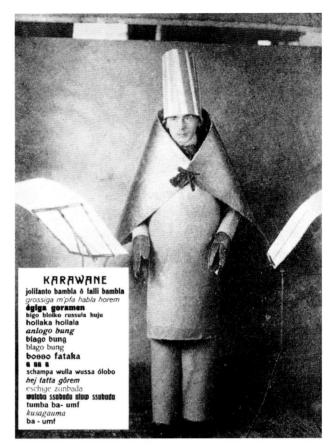

28-60. Hugo Ball reciting the sound poem "Karawane." Photographed at the Cabaret Voltaire, Zürich, 1916

"the language devastated and made impossible by journalism." Another end was simply to amuse his audience by introducing the healthy play of children back into what he considered overly restrained adult lives. The flexibility of interpretation inherent in Dada extended to its name, which, according to one account, was chosen at random from a dictionary. In German the term signifies baby talk; in French it means "hobbyhorse"; in Romanian and Russian, "yes, yes"; in the Kru African dialect, "the tail of a sacred cow." The name and therefore the movement could be defined as the individual wished.

Early in 1917 Ball and the Romanian poet Tristan Tzara (1896-1963) organized the Galerie Dada. Tzara also edited a magazine, Dada, which soon attracted the attention of like-minded men and women in various European capitals. The movement spread farther when members of Ball's circle returned to their respective homelands. Richard Huelsenbeck (1892-1974) brought Dada to Germany, where he helped form the Club Dada in Berlin in April 1918. Following the example of some of his Zürich predecessors, Johannes Baader (1875-1955) took Dada out of the cabaret and into the streets. Among his many famous "actions" was an infiltration of the meeting of the Weimar National Assembly on July 16, 1919, where he distributed a leaflet demanding the replacement of the government by Dada, with himself as president.

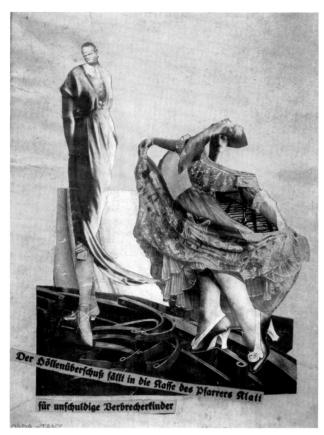

28-61. Hannah Höch. *Dada Dance.* 1922. Photomontage, $12^5/_8 \times 9^1/_8$ " (32 \times 23 cm). Israel Museum, Jerusalem.

Arturo Schwartz Collection of Dada and Surrealist Art

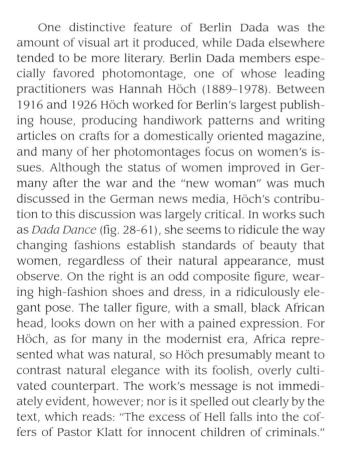

28-62. John Heartfield. *Have No Fear—He's a Vegetarian.* Photomontage in *Regards* no. 121 (153) (Paris), May 7, 1936. Stiftung Archiv der Akademie der Künste, Berlin.

Because the precise meaning of such works is difficult to decipher, their power as social commentary is limited. One of the first artists to change his approach in recognition of this limitation was John Heartfield (1891–1968). Born Helmut Herzfelde near Berlin, he was drafted in 1914 but after a feigned nervous breakdown was released from the army to work as a letter carrier. He often dumped his mail deliveries to encourage dissatisfaction with the war, and he anglicized his name to protest the nationalistic war slogan "May God Punish England." After the war he joined Berlin Dada but spent most of his time doing election posters and illustrations for Communist newspapers and magazines. Recognizing the primacy of the message, he developed a clear and simple approach to photomontage that might be called post-Dada.

Typical of his mature work is *Have No Fear—He's a Vegetarian* (fig. 28-62), a version of which appeared in a French magazine in 1936. The work shows Hitler sharpening a knife behind a rooster, the symbol of France. The warning being communicated is ironic, given that the whispering man is Pierre Laval, then the pro-German premier of France. Hitler, then rising to power in Germany on a program of nationalism, militarism, and hatred for Jews, would soon occupy France. Heartfield had left Germany in 1933, when the Nazis gained control and Hitler ordered his arrest. Heartfield literally jumped out his window to escape and moved to

28-63. Marcel Duchamp. Fountain (second version). 1950. Porcelain urinal, $12 \times 15 \times 18$ " (30.5 \times 38.1 \times 45.7 cm). Philadelphia Museum of Art.

Gift (by exchange) of Mrs. Herbert Cameron Morris, 1998, (1998–74–1)

An ordinary plumbing fixture signed by Duchamp with the pseudonym "R. Mutt" and presented as a "readymade" work of art, the original Fountain mysteriously disappeared shortly after it was rejected by the jury of the American Society of Independent Artists exhibition in 1917. The appearance of this lost original is known only from a photograph by Alfred Stieglitz. The second version of Fountain, illustrated here, was selected in Paris by the art dealer Sidney Janis at Duchamp's request for an exhibition in New York in 1950. In 1964, Duchamp supervised the production of a small edition of replicas of the original Fountain based on the Stieglitz photograph. One of these replicas sold at auction in 1999 for \$1.76 million, setting a record for a work by Duchamp.

Czechoslovakia, then to England, where he produced his powerful anti-Hitler photomontages.

A leading French Dadaist, Marcel Duchamp (1887-1968) was influential in spreading Dada to the United States when he moved to New York in 1915 to escape the war in Europe. In Paris, Duchamp had experimented successfully with Cubism before abandoning painting, which he came to consider a mindless activity. By the time he arrived in New York, Duchamp believed that art should appeal to the intellect rather than the senses. Duchamp's cerebral approach is exemplified in his readymades, which were ordinary manufactured objects transformed into art works simply through the decision of the artist. The most notorious readymade was Fountain (fig. 28-63), a porcelain urinal turned 90 degrees and signed with the pseudonym "R. Mutt," a play on the name of the fixture's manufacturer, the J. L. Mott Iron Works. Duchamp submitted Fountain anonymously in 1917 to the first annual exhibition of the American Society of Independent Artists, which was committed to staging a large, unjuried show, open to any artist who paid a \$6 entry fee. Duchamp, a founding member of the society and the head of the show's hanging committee, entered Fountain partly to test just how open the society was. A majority of the society's directors declared that Fountain was not a work of art, and, moreover, was indecent, so the piece was refused. The decision did not surprise Duchamp, who immediately resigned from the society.

A small journal that Duchamp helped to found published an unsigned editorial on the Mutt case refuting the charge of immorality and wryly noting: "The only works of Art America has given are her plumbing and bridges." In a more serious vein, the editorial added: "Whether Mr.

Mutt with his own hands made the fountain or not has no importance. He CHOSE it. He took an ordinary article of life, placed it so that its useful significance disappeared under the new title and point of view—created a new thought for that object." Duchamp's philosophy of the readymade, succinctly expressed in these lines, would have a tremendous impact on later twentieth-century artists such as Jeff Koons (see fig. 29-75).

Duchamp's most intellectually challenging work is probably The Bride Stripped Bare by Her Bachelors, Even (fig. 28-64), usually called The Large Glass. He made his first sketches for the piece in 1913 but did not begin work on it until he arrived in New York. At the most obvious level it is a pessimistic statement of the insoluble frustrations of male-female relations. The tubular elements encased in the top half of the glass represent the bride. She releases a large romantic sigh, which stimulates the bachelors below, represented by nine different moldlike forms attached to a waterwheel. The wheel resembles and is attached to a chocolate grinder, a reference to a French euphemism for masturbation. A bar separates the males from the female, preventing the fulfillment of their respective sexual desires. Duchamp reverses the conventional power roles of men and women by placing the female in the dominant position; the males merely react to her.

SURREALISM

The successor to Dada in opposing the rationalist tide of postwar art and architecture was Surrealism, a movement founded by the French writer André Breton (1896–1966). A participant in the Paris Dada movement after the war, Breton became dissatisfied with the

28-64. Marcel Duchamp. The Bride Stripped Bare by Her Bachelors, Even (The Large Glass). 1915–23. Oil, varnish, lead foil, lead wire, and dust on glass, $9'1^{1/4}'' \times 5'9^{1/8}''$ $(2.77 \times 1.76 \text{ m}).$ Philadelphia Museum of Art. Bequest of Katherine S. Dreier, (1952-98-1)

Duchamp declared The Large Glass "definitively unfinished" when he signed it in 1923, which seems appropriate to a work whose main theme is unfulfilled sexual desire. After the glass was broken in transit in 1926, Duchamp cheerfully accepted the accident as part of the work and in 1936 spent weeks painstakingly reassembling the pieces.

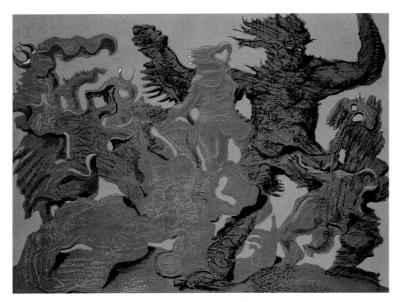

28-65. Max Ernst. *The Horde.* 1927. Oil on canvas, $44\frac{7}{8} \times 57^{1}/2$ " (114 \times 146.1 cm). Stedelijk Museum, Amsterdam.

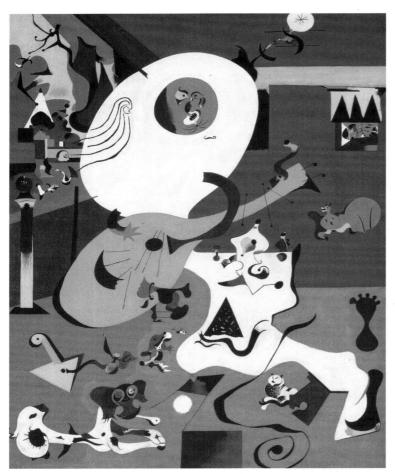

28-66. Joan Miró. *Dutch Interior I.* 1928. Oil on canvas, $36\frac{1}{8}\times28\frac{3}{4}$ " (91.8 \times 73 cm). The Museum of Modern Art, New York.

Mrs. Simon Guggenheim Fund, (163.1945)

playful nonsense activities of his colleagues and set out to make something more programmatic out of Dada's implicit desire to free human behavior. In 1924 he published his "Manifesto of Surrealism," outlining his own view of Freud's theory that the human psyche is a battleground where the rational, civilized forces of the conscious mind struggle against the irrational, instinctual urges of the unconscious. The way to achieve happiness, Breton argued, does not lie in strengthening the repressive forces of reason, as the Purists insisted, but in freeing the individual to express personal desires, as Gauguin and Die Brücke had asserted. Breton and the group around him developed a number of techniques for liberating the individual unconscious, including dream analysis, free association, automatic writing, word games, and hypnotic trances. Their aim was to help people discover the larger reality, or "surreality," that lay beyond the narrow rational notions of what is real.

Surrealist painters employed a variety of manual techniques, known collectively as automatism, which were designed to produce new and surprising forms without conscious control. Particularly inventive in his use of automatism was Max Ernst (1891-1976), a selftaught German artist who helped organize a Dada movement in Cologne and later moved to Paris, where he joined Breton's circle. In 1925 Ernst discovered the automatist technique of frottage, in which the artist rubs a pencil or crayon across a piece of paper placed on a textured surface. The resulting imprints stimulated Ernst's imagination, and he discovered in them fantastic creatures, plants, and landscapes, which he articulated through additional drawing. Ernst adapted the frottage technique to painting through grattage, creating patterns by scraping off layers of paint from a canvas laid over a textured surface. He then would extract representational forms from the patterns through overpainting. One result of this technique is The Horde (fig. 28-65), a nightmarish scene of a group of monsters, seemingly made out of wood, who advance against some unseen opponent. Like much of Ernst's work of the period, this frightening image seems to resonate with the violence of World War I—which he experienced firsthand in the German army—and also to foretell the coming of another terrible European conflict.

By contrast, a blithe and playful spirit animates the painting of Joan Miró (1893–1983), a Spanish artist who in the 1920s divided his time among Paris, his native Barcelona, and nearby Montroig. In his early work Miró attempted to reconcile diverse French influences with his devotion to his native Catalan landscape. In 1923 he began to produce a fantastic brand of landscape and figure painting, inspired, he later claimed, by the hallucinations brought on by hunger and by staring at the cracks in his ceiling. Although Miró exhibited on numerous occasions with the Surrealists, he never officially joined the group or shared its theoretical interests.

Dutch Interior I (fig. 28-66) is Miró's imaginative paraphrase of Hendrik Maertensz Sorgh's *The Lutanist* (1661), a little-known Dutch painting of a male lute player serenading a young woman, with a dog and cat on the

floor. Miró playfully translated elements from Sorgh's picture into a **biomorphic** language of curving shapes and lines that evoke organic forms and processes and seem to mutate before the viewer's eyes. The animated forms and cheerful colors create a giddy effect, counterbalanced by the crisply delineated shapes and tightly structured composition that reveal a high degree of formal control. Very much in the manner of a Renaissance artist, Miró carefully worked out the composition in preliminary drawings and then prepared a large **cartoon**, gridded for transfer, that guided his execution of the final painting.

Even more carefully executed are the paintings of Salvador Dalí (1904–89), a Catalan like Miró. Trained at the San Fernando Academy of Fine Arts in Madrid, where he mastered the traditional methods of illusionistic representation, Dalí traveled to Paris in 1928 and met Miró, who introduced him to the Surrealists. By the next year Dalí had converted fully to Surrealism and was welcomed officially into the movement by Breton. Dalí's contribution to Surrealist theory was the "paranoiaccritical method," in which the sane person cultivates the ability of the paranoiac to misread ordinary appearances and become liberated from the shackles of conventional thought. A well-known example is The Persistence of *Memory* (fig. 28-67), which is set in a landscape recalling a bay near Dalí's birthplace. According to Dalí, the idea of the soft watches came to him one evening after dinner while he was meditating on a plate of Camembert cheese. One of the limp watches drapes over an amoebalike human head, its shape inspired by a large rock on the coast. The head, which Dalí identified as a selfportrait, first appeared in a 1929 painting entitled The Great Masturbator. It may symbolize the artist's lifelong obsession with masturbation—an obsession that caused him considerable anxiety. The limp watches express one

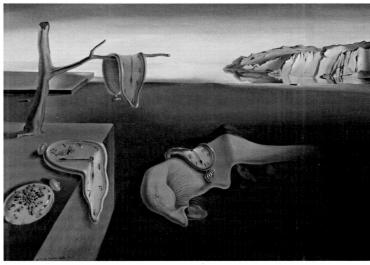

28-67. Salvador Dalí. *The Persistence of Memory.* 1931. Oil on canvas, $9^1/2 \times 13''$ (24.36 \times 33.33 cm). The Museum of Modern Art, New York. Given anonymously, (162.1934)

aspect of that anxiety by suggesting the sexual impotence that Dalí feared could result from his indulgence in autoeroticism. Another image of anxiety is the antcovered watchcase at the lower left, a bizarre *memento mori* inspired by Dalí's childhood memories of seeing dead and dying animals swarming with ants.

The absurd yet compelling image of ants feeding on a metallic watch typifies the Surrealist interest in unexpected juxtapositions of disparate realities. When created with actual rather than represented objects and materials, the strategy produced disquieting assemblages such as *Object (Le Déjeuner en fourrure)* (fig. 28-68), by Meret Oppenheim (1913-85), a Swiss

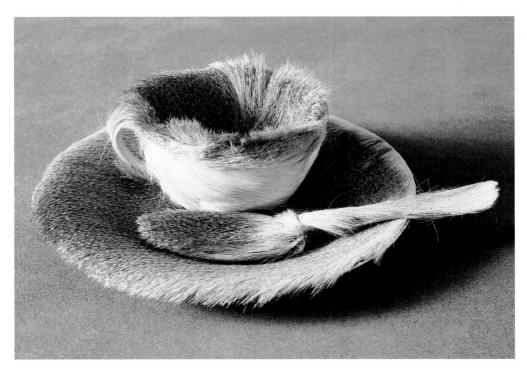

28-68. Meret
Oppenheim. Object
(Le Déjeuner en fourrure) (Luncheon in Fur). 1936.
Fur-covered cup, diameter 43/8" (10.9 cm); fur-covered saucer, diameter 93/8" (23.7 cm); fur-covered spoon, length 8" (20.2 cm); overall height, 27/8" (7.3 cm). The Museum of Modern Art, New York. Purchase

Oppenheim's Object was inspired by a café conversation with Picasso about her designs for jewelry made of fur-lined metal tubing. When Picasso remarked that one could cover just about anything with fur, Oppenheim replied, "Even this cup and saucer."

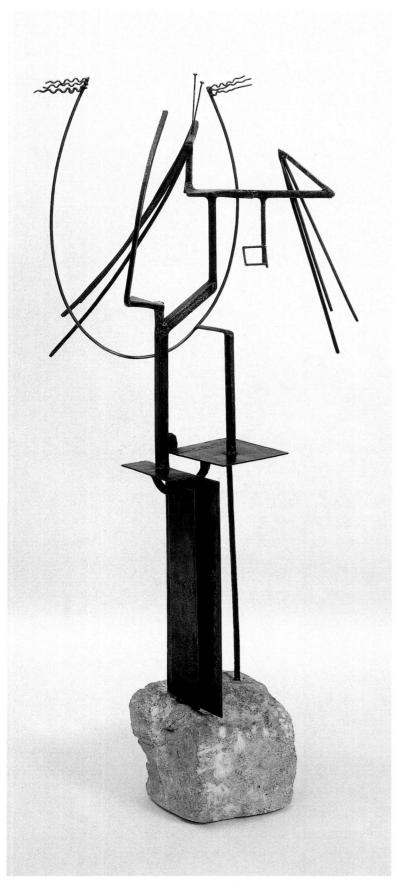

28-69. Julio González. Woman Combing Her Hair II. 1934. Welded iron, $47^5/8 \times 23^3/4 \times 11^3/8$ " (121 × 60 × 29 cm). Moderna Museet, Stockholm.

artist who was one of the few female participants in the Surrealist movement. Consisting of a cup, saucer, and spoon covered with the fur of a Chinese gazelle, Oppenheim's work transforms implements normally used for drinking tea into a hairy ensemble that simultaneously attracts and repels the viewer.

MODERNISM IN SCULPTURE

Surrealist assemblages such as Oppenheim's Object, composed of manufactured objects and found materials, build on the tradition of the readymade that Duchamp inaugurated before World War I (see fig. 28-63). A new, more technically demanding medium of assemblage was welded metal, pioneered in the years around 1930 by the Catalan Julio González (1876-1942). A friend of Picasso who also left Barcelona for Paris in 1900, González supported himself by making jewelry and decorative metalwork. He turned to sculpture in the late 1920s when Picasso asked for his technical help in constructing several works in welded iron. Their collaboration marked the emergence of the modernist medium of "direct metal" sculpture, in which the artist composes the work directly by welding pieces of metal together. In the early 1930s González developed a style of extreme openness and linearity, using iron rods to "draw in space," as in Woman Combing Her Hair II (fig. 28-69). In this highly abstracted figure, space is used as a positive sculptural element, replacing the traditional sculptural emphasis on mass with an emphasis on spatial volumes defined by a framework of lines and planes.

Although equally innovative in his abstraction of the human body, the English sculptor Henry Moore (1898-1986) was more conservative than González in his devotion to the time-honored sculptural materials of stone, wood, and bronze, the established sculptural methods of carving and modeling, and the traditional sculptural emphasis on mass. After serving in World War I, Moore studied sculpture at the Leeds School of Art and the Royal College of Art in London. The African, Oceanic, and Pre-Columbian art he saw at the British Museum had a powerful impact on his developing aesthetic. In the simplified forms of these "primitive" art works he discovered an intense vitality that interested him far more than the refinement of the Renaissance tradition, as well as a respect for the inherent qualities of the stone or wood from which the work is fashioned. In most of his own works of the 1920s and 1930s, Moore practiced direct carving in stone and wood and pursued the ideal of truth to material.

A central subject in Moore's art is the reclining female figure, such as *Recumbent Figure* (fig. 28-70), whose massive, simplified forms recall Pre-Columbian art. The carving reveals Moore's sensitivity to the inherent qualities of the stone, whose natural striations harmonize with the sinuous surfaces of the design. While certain elements of the body are clearly defined, such as the head and breasts, supporting elbow and raised knee, other parts flow together into an undulating mass more suggestive of a hilly landscape than of a human body. An open cavity penetrates the torso, emphasizing the rela-

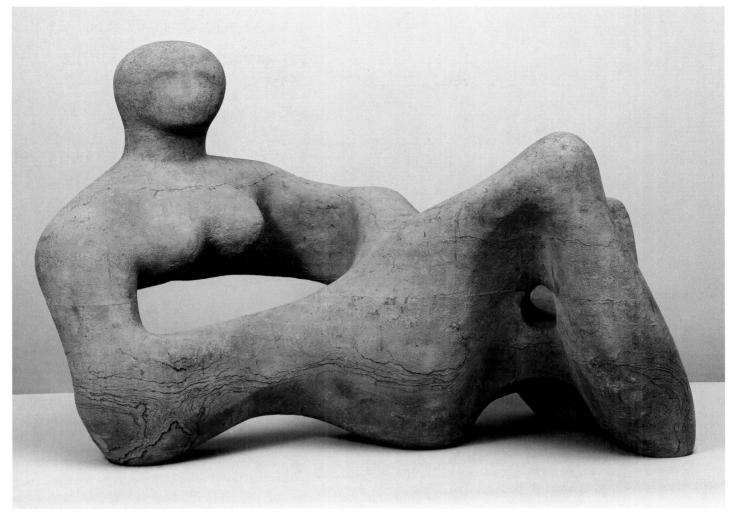

28-70. Henry Moore. *Recumbent Figure*. 1938. Hornton stone, $35 \times 52 \times 29$ " (88.9 \times 132.7 \times 73.7 cm). Tate Gallery, London.

Originally carved for the garden of the architect Serge Chermayeff in Sussex, Moore's sculpture was situated next to a low-lying modernist building with an open view of the gently rolling landscape. "My figure looked out across a great sweep of the Downs, and her gaze gathered in the horizon," Moore later recalled. "The sculpture had no specific relationship to the architecture. It had its own identity and did not need to be on Chermayeff's terrace, but it so to speak enjoyed being there, and I think it introduced a humanizing element; it became a mediator between modern house and ageless land."

tionship of solid and void fundamental to Moore's art. "The hole connects one side to the other, making it immediately more three-dimensional," the sculptor wrote in 1937. "A hole can itself have as much shape-meaning as a solid mass." Moore also remarked on "the mystery of the hole—the mysterious fascination of caves in hillsides and cliffs," identifying the landscape as a source of inspiration for his hollowing out of the human body.

ARCHITECTURE THE WARS

ART AND After World War I, the United States entered a period of isolationism that lasted IN THE UNITED until the bombing of Pearl **STATES** Harbor in 1941. Accompa-BETWEEN nying this political isolationism was an emphasis on cultural nationalism, as artists and writers pursued

what one critic called the "national spirit." Even Alfred Stieglitz, devoted in the prewar years to an international

view of modernism, adopted a cultural nationalist position following the closing of 291 in 1917. Arguing against American art with a "French flavor," Stieglitz dedicated his new venues, the Intimate Gallery (1925-29) and An American Place (1929-46), exclusively to a select group of American artists.

During these years Stieglitz reserved his strongest professional and personal commitment for Georgia O'Keeffe (1887-1986). Born in rural Wisconsin, O'Keeffe studied and taught art sporadically between 1907 and 1915, when a New York friend showed Stieglitz some of O'Keeffe's abstract charcoal drawings. On seeing them, Stieglitz is reported to have said, "At last, a woman on paper!" Stieglitz included O'Keeffe's work in a small group show at 291 in spring 1916 and gave her a oneperson exhibition the following year. One male critic wrote that O'Keeffe, with her organic abstractions, had "found expression in delicately veiled symbolism for 'what every woman knows' but what women heretofore kept to themselves." This was the beginning of much

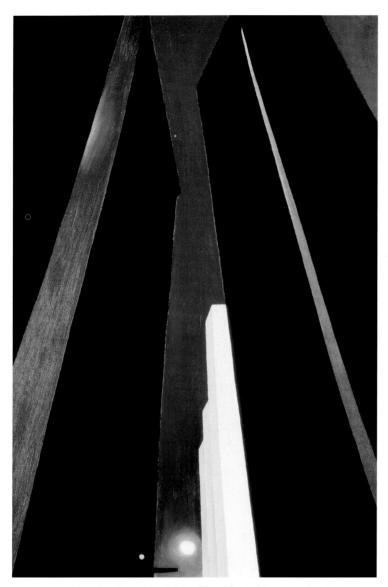

28-71. Georgia O'Keeffe. City Night. 1926. Oil on canvas, $48 \times 30''$ (123 \times 76.9 cm). Minneapolis Institute of Arts.

written criticism that focused on the artist's gender, to which O'Keeffe strongly objected. She wanted to be considered an artist, not a woman artist.

O'Keeffe went to New York in 1918, and she and Stieglitz married in 1924. In 1925 Stieglitz introduced O'Keeffe's innovative, close-up images of flowers, which remain among her best-known subjects (see fig. 5, Introduction). That same year, O'Keeffe began to paint New York skyscrapers, which artists and critics of the period recognized as an embodiment of American inventiveness and productive energy. O'Keeffe's skyscraper paintings are not unambiguous celebrations of lofty buildings, however. She often depicted them from a low vantage point so that they appear to loom ominously over the viewer, as in City Night (fig. 28-71), whose dark tonalities, stark forms, and exaggerated perspective may produce a sense of menace or claustrophobia. The painting seems to reflect O'Keeffe's own growing perception of the city as too confining. In 1929 she

began to spend her summers in New Mexico, and moved there permanently after Stieglitz's death.

PRECISIONISM

Despite their ambivalent attitude toward the city, O'Keeffe's skyscraper paintings share important thematic and formal similarities with the work of the Precisionists, a group of painters active in the 1920s and 1930s who devoted much of their art to urban and industrial subjects, and who tended to work with simplified forms, crisply defined edges, smooth brushwork, and unmodulated colors. An important influence on Precisionist painting was photography, which during these same decades also took as a subject the clean, abstract geometries of the factory and skyscraper.

The mature canvases of the leading Precisionist artist, Charles Sheeler (1883-1965), for example, were often based on his own photographs, many of which were made on commercial assignment. In 1927 Sheeler was hired to photograph the new Ford Motor Company plant at River Rouge, outside of Detroit. In 1930 he used the background of one of these photographs as the basis of American Landscape (fig. 28-72), a panoramic scene of the River Rouge boat slip, ore storage bins, and cement plant that tells, among other things, about the transformation of raw materials into industrial goods. Essentially an homage to American industry, Sheeler's painting supported the then-popular viewpoint that such factories were the new American churches, the sites of its new faith in a better future. That he painted the work a year after the great stock-market crash of 1929, which began the Great Depression, suggests that the painting may testify to Sheeler's continuing faith in American industry and in its fundamental stability.

AMERICAN SCENE PAINTING AND PHOTOGRAPHY

Sheeler's focus on a recognizable American subject, painted in a realistic style, allies his work to a broader tendency known as American Scene Painting, which flourished during the Great Depression. Struggling through economic distress and the agricultural catastrophe of the Dust Bowl, Americans turned their attention homeward; artists followed suit by painting indigenous subjects in an accessible realist style. The trend toward American Scene Painting was encouraged by several New Deal art programs that gave financial support to American artists and generally promoted American subject matter (see "Federal Patronage for American Art during the Depression," opposite). American Scene painters energetically documented the lives and circumstances of the American people and the American land. While some produced images that confronted the depressed conditions of the present, others celebrated the myths and traditions of the American past or crafted optimistic images to provide hope for the future.

A generally optimistic attitude pervades the works of the Regionalists, a group of Midwestern American Scene painters led by Grant Wood (1891–1942), Thomas

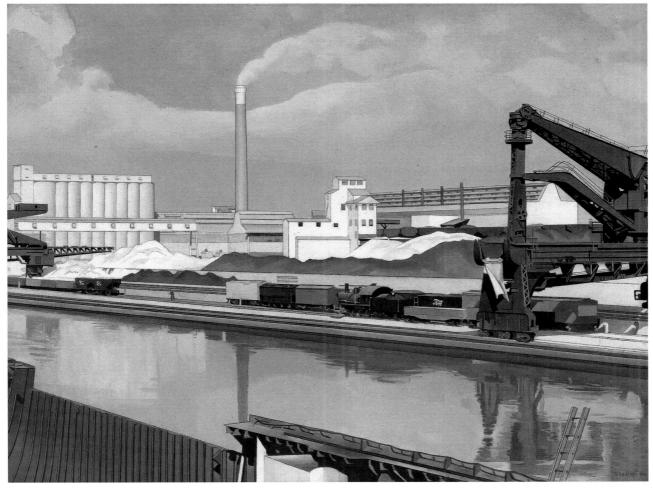

28-72. Charles Sheeler. American Landscape. 1930. Oil on canvas, $24 \times 31''$ (61×78.7 cm). The Museum of Modern Art, New York.

Gift of Abby Aldrich Rockefeller, (166.1934)

FEDERAL PATRONAGE FOR AMERICAN ART DURING THE DEPRESSION

President Franklin D. Roosevelt's New Deal, programs to provide relief for the unemployed and to revive the nation's economy, included several initiatives to give work to American artists. The Public Works of Art Project (PWAP), set up in late 1933 to employ needy artists, was in existence for only five months, but supported the activity of 4,000 artists, who produced more than 15,000 works. The Section of Painting and Sculpture in the Treasury Department, established in October 1934 and lasting until 1943, commissioned murals and sculpture for public buildings but was not a relief program; artists were paid only if their designs were accepted. The Federal Art Project (FAP) of the Works Progress Administration (WPA), which ran from 1935 to 1943, succeeded the PWAP in providing relief to unemployed artists. The most important work-relief agency of the depression era, the WPA employed more than 6 million workers by 1943. Its programs to support the arts included the Federal Theater Project and the Federal Writers' Project as well as the Federal Art Project. About 10,000 artists participated in the FAP, producing a staggering amount of art, including about 108,000 paintings, 18,000 works of sculpture, 2,500 murals, and thousands of prints, photographs, and posters. Because it was paid for by the government, all this art became public property. The murals and large works of sculpture, commissioned for public buildings such as train stations, schools, hospitals, and post offices, reached a particularly wide audience.

The FAP paid a generous average salary of about \$20 a week (a

salesclerk at Woolworth's earned only about \$11), allowing painters and sculptors to devote themselves full-time to art and to think of themselves as professionals in a way few had been able to do before 1935. New York City's painters, in particular, began to develop a group identity, largely because they now had time to meet and discuss art in the bars and coffeehouses of Greenwich Village, the city's answer to the cafés that played such an important role in the art life of Paris. Finally, the FAP gave New York's art community a sense that high culture was important in the United States. The FAP's monetary support and its professional consequences would prove crucial to the artists later known as the Abstract Expressionists, who would shortly transform New York City into the art capital of the world (see Chapter 29).

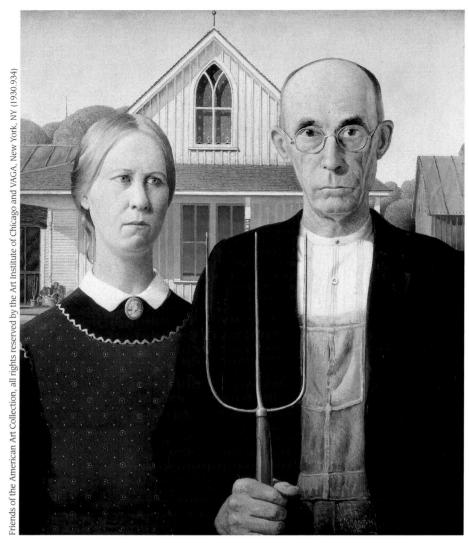

28-73. Grant Wood. *American Gothic.* 1930. Oil on beaverboard, $29 \times 24^{1}/2^{"}$ (74.3 \times 62.4 cm). The Art Institute of Chicago.

Hart Benton (1889-1975), and John Steuart Curry (1897–1946), who focused on the farms and small-town life of the American heartland (and overlooked the growing disaster of the Dust Bowl). Wood's American Gothic (fig. 28-73), the most famous Regionalist painting, is usually understood as a picture of a husband and wife but was actually meant to show an aging Iowa farmer and his unmarried daughter (posed by Wood's dentist and sister). Wood pictured the stony-faced couple standing in front of their house, built in a Victorian style known as "Carpenter Gothic" due to such details as the Gothic-style window in the gable, which suggests the importance of religion in their lives. The father's pitchfork signifies his occupation while giving him a somewhat menacing air. The daughter is associated with potted plants, seen behind her right shoulder, which symbolize traditionally feminine domestic and horticultural skills. Wood saw American Gothic as a sincerely affectionate portrayal of the small-town Iowans he had grown up with—conservative, provincial, religious Midwesterners, descendants of the pioneers—whom the artist characterized as "basically good and solid people."

The essentially positive image of agrarian life conveyed in Regionalist works ignored the growing economic problems of farmers during the depression. To build public support for federal assistance to those in need, the government, through the Resettlement Agency (RA) and Farm Securities Administration (FSA), hired photographers to document the problems of farmers, then supplied these photographs, with captions, free to newspapers and magazines. A leading RA/FSA photographer between 1935 and 1939 was the San Francisco-based Dorothea Lange (1895–1965). Many of her photographs document the plight of migrant farm laborers who had flooded California looking for work

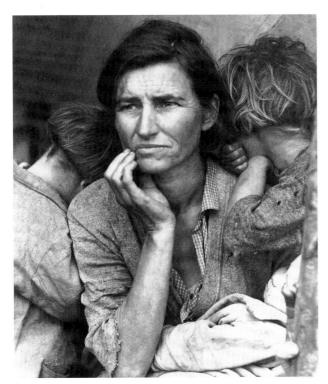

28-74. Dorothea Lange. *Migrant Mother, Nipomo, California.* February 1936. Gelatin-silver print. Library of Congress, Washington, D.C.

because of the Dust Bowl conditions on the Great Plains. *Migrant Mother, Nipomo, California* (fig. 28-74) pictures Florence Thompson, the thirty-two-year-old mother of seven children, who had gone to a pea-picking camp but found no work because the peas had frozen on the

vines. The tired mother, with her knit brow and her hand on her mouth, seems to capture the fears of an entire population of disenfranchised people.

While the Regionalist painters and RA/FSA photographers focused on rural subjects, other American Scene artists documented city life. A major urban realist of the period was Edward Hopper (1882-1967), who had studied with Robert Henri between 1900 and 1906. Hopper supported himself as a commercial illustrator until 1924, when a successful show of his watercolors allowed him to devote himself full-time to painting. From that point onward, Hopper depicted scenes of modern life that suggested isolation, alienation, and abandonment. His spare, realist style was characterized by solid forms, sober brushwork, tightly structured compositions, and bold contrasts of light and shadow. Hopper's Nighthawks (fig. 28-75), showing four people in an all-night diner, is a study in loneliness and boredom. The anonymous man with his back to us is utterly alone. The couple, too, is just as separate. While the man stares off into space, the woman examines her sandwich. They seem as cold as the fluorescent light that bathes them and as empty as the streets and stores outside. The viewer, placed on the street, is made to share in their condition.

A strong contrast to Hopper's bleak worldview is seen in the optimistic outlook of Norman Rockwell (1894–1978), whose wholesome, good-natured images of everyday life, widely circulated through the mass media, made him the most popular chronicler of the midtwentieth-century American scene. Born in New York City, Rockwell quit high school to attend the National Academy of Design and the Art Students League, where he studied illustration and mastered the meticulous style

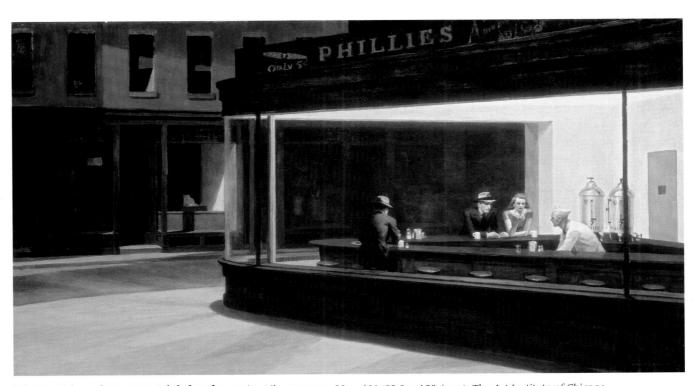

28-75. Edward Hopper. *Nighthawks*. 1942. Oil on canvas, $33 \times 60''$ (83.8×152.4 cm). The Art Institute of Chicago.

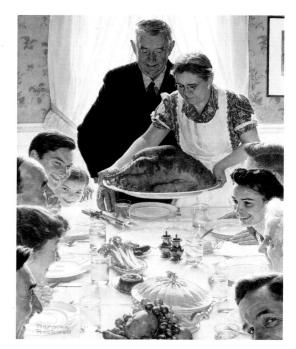

28-76. Norman Rockwell. *Freedom from Want,* story illustration, *Saturday Evening Post,* March 6, 1943. Oil on canvas, $45\sqrt[3]{4} \times 35\sqrt[1]{2}$ " (117.3 × 91 cm). Collection of the Norman Rockwell Museum at Stockbridge, Massachusetts, Norman Rockwell Art Collection Trust.

This is one of four images Rockwell made to illustrate the four freedoms that President Roosevelt had identified in his 1941 State of the Union address, with the implication that they would be objectives of World War II, which the United States entered later that year. (The other three were freedom of speech, freedom to worship, and freedom from fear.) Sent on a national tour by the Office of War Information and reproduced on posters for the Second War Loan Drive, Rockwell's Four Freedoms helped to raise \$132 million in war bonds.

of illusionism he would employ throughout his career. In 1916 he created his first of 322 covers for the *Saturday Evening Post* magazine.

While Rockwell greatly admired Picasso and other modern artists whose work often displeased the general public, his own aim was to paint pictures that "everybody would understand and like." Rockwell did not succeed in pleasing everybody—particularly modernist artists, critics, and art historians—but he undeniably created legible and vivid images, many of which have become icons of American popular culture. One is Freedom from Want (fig. 28-76), which for many is the ideal image of the traditional American Thanksgiving dinner. Dominating the composition is the stable, pyramidal group of the benign grandfather and nurturing grandmother, who prepares to set an enormous turkey on the graciously set table. The smiling members of the extended family and guests line either side of the table, and a welcoming face at the lower right invites us to join them. Despite its brilliant realism, we recognize Freedom from Want as an idealization, calculated, as were most of Rockwell's images, to reflect "life as I would like it to be."

THE HARLEM RENAISSANCE

Between the two world wars, hundreds of thousands of African Americans migrated from the rural, mostly agricultural South to the urban, industrialized North, fleeing racial and economic oppression and seeking greater social and economic opportunity. This transition gave rise to the so-called New Negro movement, which encouraged African Americans to become politically progressive and racially conscious. The New Negro movement in turn stimulated a flowering of black art and culture known as the Harlem Renaissance, because its capital was Harlem, in New York City, the country's largest black population center. The intellectual leader of the Harlem Renaissance was Alain Locke (1886-1954), a critic and philosophy professor who argued that black artists should seek their artistic roots in the traditional arts of Africa rather than in those of white America or Europe. Because leading white modernists such as Picasso and the members of Die Brücke had looked to African art for inspiration, Locke's call offered black artists the possibility of both reclaiming their racial heritage and participating in the already established history of Euro-American modernism.

The first black artist to answer Locke's call was Aaron Douglas (1898–1979), a native of Topeka, Kansas, who moved to New York City in 1925 and rapidly developed an abstracted style influenced by African art as well as the contemporary, hard-edged aesthetic of Art Deco. In paintings such as Aspects of Negro Life: From Slavery through Reconstruction (fig. 28-77), Douglas used schematic figures, silhouetted in profile with the eye rendered frontally as in ancient Egyptian reliefs and frescoes, and limited his palette to a few subtle hues, varying in value from light to dark and sometimes organized abstractly into concentric bands that suggest musical rhythms or spiritual emanations. This work, painted for the 135th Street branch of the New York Public Library under the sponsorship of the Public Works of Art Project, was intended to awaken in African Americans a sense of their place in history. At the right, Southern black people celebrate the Emancipation Proclamation of 1863, which freed the slaves. Concentric circles issue from the Proclamation, which is read by a figure in the foreground. At the center of the composition, an orator symbolizing black leaders of the Reconstruction era urges black freedmen, some still picking cotton, to cast their ballots in the box before him, while he points to a silhouette of the Capitol on a distant hill. Concentric circles highlight the ballot in his hand. In the left background, Union soldiers depart from the South at the close of Reconstruction, as the fearsome Ku Klux Klan, hooded and on horseback, invades from the left. Despite this negative image, the heroic orator at the center of Douglas's panel remains the focus of the composition, inspiring contemporary viewers to continue the struggle to improve the lot of African Americans.

Like Douglas, photographer James VanDerZee (1886–1983) created positive images of African Americans that conveyed the sense of racial pride and social

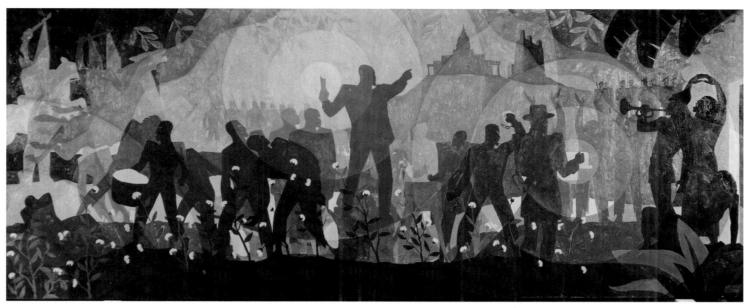

28-77. Aaron Douglas. *Aspects of Negro Life: From Slavery through Reconstruction.* 1934. Oil on canvas, $5' \times 11'7''$ (1.5 \times 3.5 m). Schomburg Center for Research in Black Culture, New York Public Library.

empowerment promoted by the New Negro movement. The largely self-taught VanDerZee maintained a studio in Harlem for nearly fifty years and specialized in portraits of the neighborhood's middle- and upper-class residents. His best-known photograph, *Couple Wearing Raccoon Coats with a Cadillac, Taken on West 127th Street, Harlem, New York* (fig. 28-78), depicts the ideal

New Negro man and woman: prosperous, confident, and cosmopolitan, thriving glamorously even in the midst of the depression.

Influenced by both Alain Locke and Aaron Douglas, the younger Harlem artist Jacob Lawrence (1917–2000) devoted much of his early work to the depiction of black history, which he carefully researched and then recounted

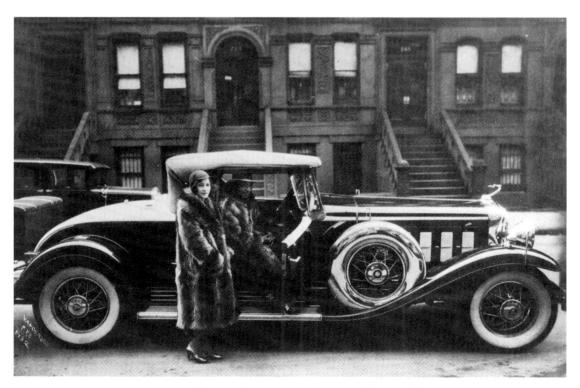

28-78. James VanDerZee. Couple Wearing Raccoon Coats with a Cadillac, Taken on West 127th Street, Harlem, New York. 1932. Photograph.

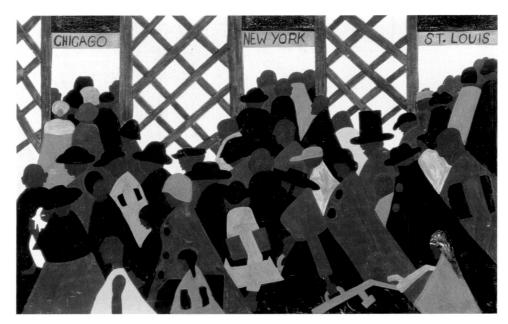

28-79. Jacob Lawrence. *During the World War There Was a Great Migration North by Southern Negroes*, panel 1 from *The Migration of the Negro*. 1940–41. Tempera on masonite, 12×18 " (30.5 \times 45.7 cm). The Phillips Collection, Washington, D.C.

This is the first image in Lawrence's sixty-panel cycle that tells the story of the migration of Southern American blacks to the industrialized North in the decades between the two world wars. The Harlem writer Alain Locke brought the series to the attention of Edith Halpert, a white New York art dealer, who arranged for the publication of several of its panels in the November 1941 issue of *Fortune* magazine and who showed the entire series the same year at her Downtown Gallery, which also represented such prominent white artists as Charles Sheeler (see fig. 28-72) and Stuart Davis (see fig. 28-80). Thus, at age 23, Lawrence became the first African-American artist to gain acclaim from whites in the segregated New York art world. The next year, the *Migration* series was jointly acquired by the Phillips Collection in Washington, D.C., and the Museum of Modern Art in New York, each of which purchased thirty paintings.

through narrative painting series comprising dozens of small panels, each accompanied by a text. In 1940-41, Lawrence created his best-known series, The Migration of the Negro, the sixty panels of which chronicled the great twentieth-century exodus of African Americans from the rural South to the urban North—an exodus that had brought Lawrence's own parents from South Carolina to Atlantic City, New Jersey, where he was born. The first panel (fig. 28-79), set in the South, depicts a train station filled with black migrants who stream through portals labeled with the names of Northern and Midwestern cities. The boldly abstracted style, with its simple shapes and bright, flat colors, suggests the influence of both Cubism and African-American folk art and was intended by Lawrence to communicate in a direct and vivid fashion.

ABSTRACTION

Although realism dominated American art in the period between the two world wars, some artists remained committed to modernist abstraction. One was Stuart Davis (1894–1964), a native of Philadelphia who studied in New York under Robert Henri between 1909 and 1912. He painted in the realistic Ashcan manner until 1913, when his discovery of European modernism at the Armory Show convinced him to move toward abstraction. By the 1920s, he had developed a personal mode of Synthetic Cubism. During the 1930s, Davis became po-

litically active, serving as president of the Artists Union and as an officer of the American Artists Congress, a left-wing artistic organization that opposed the international spread of fascism. Davis rarely allowed overt political messages to enter his art, but nevertheless considered abstract painting to be "a progressive social force" because it gave "concrete artistic formulation to the new lights, speeds, and spaces which are uniquely real in our time."

An ambitious example of Davis's abstract style of the 1930s is Swing Landscape (fig. 28-80), a mural commissioned by the Federal Art Project for the Williamsburg Housing Project in Brooklyn, New York, but never installed there. The title alludes to swing music, from which Davis, a great lover of jazz, drew inspiration for his upbeat style of painting. The mural definitely "swings," with its bouncy yet tightly ordered arrangement of colorful shapes and lines that skip, squiggle, and clamber across its surface. Embedded within the complex design are representational elements that include a mast and rigging, a chimney, a yellow house, pulleys, ropes, and a ladder. Combined with the abstract stripes and blocks of color surrounding them, they evoke a waterfront pulsating with the "new lights, speeds, and spaces" of contemporary America.

While Davis's paintings only suggest motion, Alexander Calder (1898–1976) made works of sculpture that actually move. Calder's **kinetic** works unfix the tra-

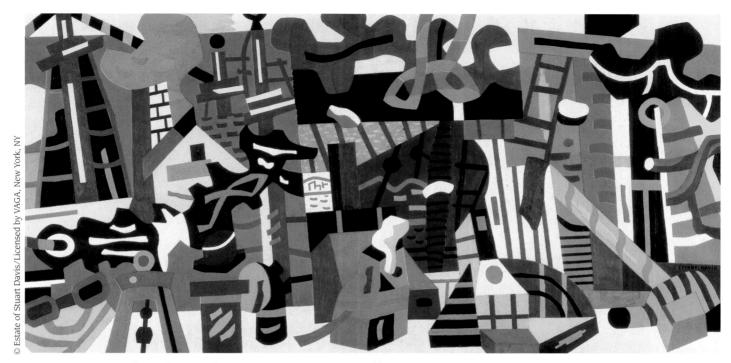

28-80. Stuart Davis. Swing Landscape. 1938. Oil on canvas, $7'2^1/2'' \times 14'5''$ (2.20 \times 4.39 m). Indiana University Art Museum.

ditional stability and timelessness of art and invest it with vital qualities of mutability and unpredictability. Born in Philadelphia and trained in both engineering and painting, Calder went to Paris in 1926 and became friendly with Surrealists such as Miró and abstractionists such as Mondrian. On a 1930 visit to Mondrian's studio. he was impressed by the rectangles of colored paper that the painter had tacked up everywhere on the walls. What would it look like, Calder wondered, if the flat shapes were moving freely in space, interacting in not just two but three dimensions? The question inspired Calder to begin creating sculpture with moving parts, known as mobiles. Calder's Lobster Trap and Fish Tail (fig. 28-81, page 1076) features delicately balanced elements that spin and bob in response to shifting currents of air. At first, the work seems almost completely abstract, but Calder's title works on our imagination, helping us find the oval trap awaiting unwary crustaceans at the right and the delicate wires at the left that suggest the backbone of a fish. The work's whimsical spirit and biomorphic form reflect the influence of Miró. The term mobile, which in French means "moving body" as well as "motive," or "driving force," came from Calder's friend Marcel Duchamp, who no doubt relished the double meaning of the word.

ARCHITECTURE

In contrast to the revolutionary architectural developments in Europe that produced the International Style, American architecture in the interwar years was dominated by an academic eclecticism that in some ways paralleled the country's political isolationism. A successful academic architect of the period was Julia

Morgan (1872–1957), one of the first women to sustain a productive architectural practice in the United States. A native of San Francisco, Morgan received an engineering degree in 1894 from the University of California, Berkeley. Although the École des Beaux-Arts did not accept women, she moved to Paris anyway and in 1896 enrolled in a private architectural studio. Two years of persistence paid off, and she was admitted to the École as its first female student. In 1904 she opened her own office in San Francisco, and over the course of her career designed more than 700 buildings. By 1927 she had a staff of fourteen architects, six of them women.

Morgan did much of her early work for friends and for women's organizations. At Mills College for women she designed several buildings in a revival of the increasingly popular Mission style, first introduced by Spanish settlers. She also designed numerous buildings throughout California for the Young Women's Christian Association (YWCA). Morgan's most important client was the newspaper magnate William Randolph Hearst, who in 1919 commissioned her to design a palatial estate in San Simeon, about 200 miles south of San Francisco. The main building, called La Casa Grande ("The Great House") (fig. 28-82, page 1076), is a free interpretation of a Mission-style church built of reinforced concrete (see "Space-Spanning Construction Devices" in the Starter Kit). Above the single doorway and below the pair of wide, sturdy towers typical of such churches, Morgan added a house front to indicate the building's function. Since the Renaissance, the Greek temple had been adapted to domestic architecture, but similar domestic adaptation of the Christian church was rare. The elaborate decoration on the facade of the Casa Grande reflects

28-81. Alexander Calder. Lobster Trap and Fish Tail. 1939. Hanging mobile: painted steel wire and sheet aluminum, approx. $8'6'' \times 9'6''$ (2.6×2.9 m). The Museum of Modern Art, New York. Commissioned by the Advisory Committee for the stairwell of the Museum, (590.139.a-d)

28-82. Julia Morgan. Front entrance, La Casa Grande, San Simeon, California.

1922–26. Special Collections, California Polytechnic State University, San Luis Obispo.

Julia Morgan Collection

Morgan regularly commuted 200 miles from San Francisco to San Simeon to supervise the construction of William Randolph Hearst's estate overlooking the Pacific Ocean. Under construction between 1920 and 1937, the property included the main mansion and three guesthouses; outdoor and indoor swimming pools, tennis courts, and a 50-seat movie theater; a poultry farm, orchard, and vegetable gardens; and a private zoo containing more than 100 exotic species, including giraffes, emus, and zebras.

28-83. Frank Lloyd Wright. Edgar Kaufmann House, Fallingwater, Mill Run, Pennsylvania. 1937.

the detailing throughout. Morgan employed a host of stonecutters, experts in ornamental plasters, wood carvers, iron casters, weavers, tapestry makers, and tile designers to copy or improvise from historical models the decorative arts that filled the estate's 127 rooms.

A very different sort of country house is Frank Lloyd Wright's Fallingwater (fig. 28-83), in rural Pennsylvania, perhaps the best-known expression of Wright's conviction that buildings ought to be not simply on the landscape but in it. The house was commissioned by Edgar Kaufmann, a Pittsburgh department store owner, to replace a family summer cottage the site of which featured a waterfall into a pool where the family children played. To the Kaufmanns' great surprise, Wright decided to build the house into the cliff over the pool, allowing the waterfall to flow around and under the house. A large boulder on which the family had sunbathed was built into the house as the hearthstone of the fireplace. In a dramatic move that engineering experts questioned, Wright cantilevered a series of broad terraces out from the cliffside, echoing the great slabs of rock below. The house is further tied to its site through materials. Although the terraces are poured concrete, the wood and stone used elsewhere are either from the site or in harmony with it. Such houses do not simply testify to the ideal of living in harmony with nature but declare war on the modern industrial city. When asked what could be done to improve the city, Wright responded: "Tear it down."

A more constructive approach to improving the city is represented by Rockefeller Center in New York City, one of the most ambitious urban designs of the twentieth century (fig. 28-84, page 1078). The project, financed by millionaire John D. Rockefeller, Jr., was designed to house the young radio and television industries, with RCA, RKO, and NBC as its principal tenants. The fourteen original buildings of Radio City (as it was first named), constructed between 1931 and 1939, were designed by three leading firms of the era: Hood & Fouilhoux; Corbett, Harrison, & MacMurray; and Reinhard & Hofmeister. The centerpieces of the complex are the slender, 70-story RCA (now GE) Building and the Art Deco-style Radio City Music Hall. The center's amenities-many of them now standard features of urban commercial complexes—include a pedestrian mall, a sunken skating rink, roof gardens, underground walkways, garages, shops, theaters, and restaurants. Adorning the buildings are sculpture, mosaics, murals, metalwork, and enamels commissioned from some of the era's best-known artists and artisans. Many of these art works address the theme of "New Frontiers and the March of Civilization," devised to express the visionary idealism of this essentially commercial project.

28-84. Reinhard & Hofmeister; Corbett, Harrison, & MacMurray; Hood & Fouilhoux. Rockefeller Center, New York. 1931-39.

MEXICO

ART IN The Mexican Revolution of 1910 overthrew the thirty-five-year-long dictatorship of General Porfirio Díaz **BETWEEN** and was followed by ten years of po-THE WARS litical instability. In 1921 the reformist president Álvaro Obregón

came to power and restored political order. In an effort to

promote Mexican cultural development and a sense of national identity, Obregón's government commissioned artists to decorate public buildings with murals celebrating the history, life, and work of the Mexican people.

Prominent in the new Mexican mural movement was Diego Rivera (1886-1957), a child prodigy who had enrolled in Mexico City's Academia de San Carlos at age eleven. From 1911 to 1919 Rivera lived in Paris, where he befriended Picasso and worked in a Synthetic Cubist style. In 1919 he met David Alfaro Siqueiros (1896-1974), another future Mexican muralist. They began to discuss Mexico's need for a national and revolutionary art. In 1920–21 Rivera traveled in Italy to study its great Renaissance frescoes, then began a series of monumental murals for Mexican government buildings, inspired by both Italian Renaissance and Pre-Columbian art of Mexico.

Between 1930 and 1934 Rivera worked in the United States, painting murals in San Francisco, Detroit, and New York. In 1932 the Rockefeller family commissioned him to paint for the lobby of the RCA Building in Rockefeller Center a fresco on the theme "Man at the Crossroads Looking with Hope and High Vision to the Choosing of a New and Better Future." When Rivera, a Communist, provocatively insisted on including a portrait of Lenin in the mural, the Rockefellers canceled his commission, paid him his fee, and had the unfinished mural destroyed. In response to what he called an "act of cultural vandalism," Rivera re-created the mural in the Palacio de Bellas Artes in Mexico City, under the new title Man, Controller of the Universe (fig. 28-85). At the center of the mural, the clear-eyed young figure in overalls represents Man, who symbolically controls the universe through the manipulation of technology. Crossing behind him are two great ellipses that represent, respectively, the microcosm of living organisms as seen through the microscope at Man's right hand, and the macrocosm of outer space as viewed through the giant

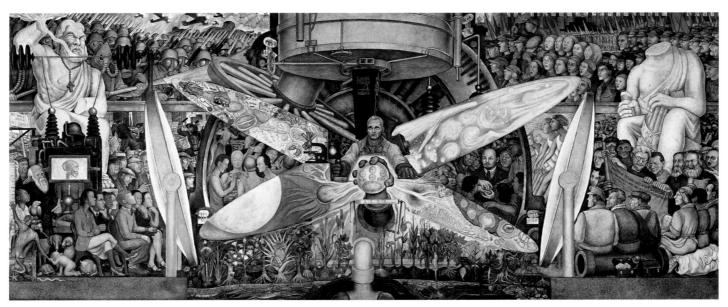

28-85. Diego Rivera. Man, Controller of the Universe. 1934. Fresco, 15'11" × 37'6" (4.85 × 11.45 m). Museo del Palacio de Bellas Artes, Mexico City.

telescope above his head. Below, fruits and vegetables rise from the earth as a result of his agricultural efforts. To Man's left (the viewer's right), Lenin joins the hands of several workers of different races. To Man's right, decadent capitalists debauch themselves in a nightclub, directly beneath the disease-causing cells in the ellipse. (Rivera vengefully included in this section a portrait of the bespectacled John D. Rockefeller, Jr.) The wings of the mural feature, to Man's left, the workers of the world embracing socialism, and, to Man's right, the capitalist world, which is cursed by militarism and labor unrest.

While Rivera and other muralists painted on walls to communicate public messages, other Mexican artists made more private, introspective statements through the medium of easel painting. One such artist was Frida Kahlo (1907-54), who was born in Mexico City of a German father and a Mexican mother. A nearly fatal trolley accident in 1925 left her crippled and in pain for the rest of her life. While convalescing from the accident, she taught herself to paint. Her work soon brought her into contact with Rivera, whom she later called her "second accident." In 1929 they married, but their relationship was always stormy and they were divorced in 1939 (they remarried the next year). While the divorce papers were being processed, Kahlo painted The Two Fridas (fig. 28-86), a large work that dealt with her personal pain. Here she presents her two ethnic selves: the European one, in a Victorian dress, and the Mexican one, wearing a traditional Mexican peasant skirt and blouse. She told an art historian at the time that the Mexican image was the Frida whom Diego loved and the European one the Frida whom he did not. The two Fridas join hands, and they are intimately connected by the artery running between them. The artery begins at the miniature of Diego as a boy that the Mexican Frida holds and ends in the lap of the other Frida, who attempts without success to stem the flow of blood from it.

In 1938 André Breton, the leader of the Surrealists, traveled to Mexico City and there met Rivera and Kahlo. Breton was so impressed by Kahlo that he wrote the introduction to the catalog of her New York exhibition that fall and arranged for her to show in Paris the following year. Although Breton claimed her as a natural Surrealist, she herself said she was not: "I never painted dreams. I painted my own reality." Nevertheless, she willingly participated in Surrealist shows, including the international Surrealist exhibition in Mexico City in 1940.

Another participant in that exhibition was the photographer Manuel Alvarez Bravo (1902-2002), whom Breton had also met in 1938 and recognized as a Surrealist. Alvarez Bravo enjoyed the friendship of Rivera and other Mexican muralists, whose work he documented photographically. His principal subjects, however, were the indigenous Indian people of Mexico, both urban and rural, and the details of their everyday world. Like many other art photographers of the interwar decades, Alvarez Bravo was committed to the aesthetics of "straight," or pure, photography, in which the photographer finds a subject, brings it into sharp focus, carefully

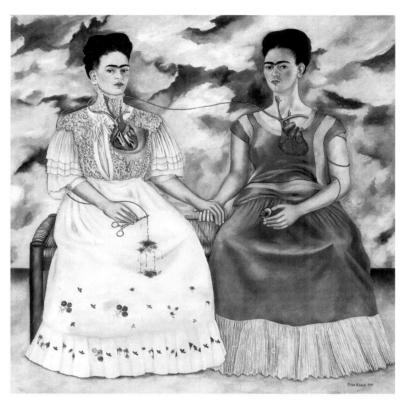

28-86. Frida Kahlo. The Two Fridas. 1939. Oil on canvas. $5'8^{1}/_{2}" \times 5'8^{1}/_{2}"$ (1.74 × 1.74 m). Museo de Arte Moderno, Instituto Nacional de Bellas Artes, Mexico City.

frames it in the viewfinder, then prints the resulting negative without any darkroom manipulation. Using this method, he discovered and photographed unexpected juxtapositions of objects that create a strange and haunting poetry of the kind Breton considered Surrealist. In Laughing Mannequins (fig. 28-87, page 1080), for example, Alvarez Bravo captured the odd sight of a row of glamorous cardboard women dressed in real clothing, hovering in the air above shoppers and stallkeepers, and smiling out at the viewer. In this uncanny juxtaposition of the animate and the inanimate, the cardboard mannequins seem strangely more alive than the flesh-and-blood people on the street below.

MODERN ART

EARLY Canadian artists of the nineteenth century, like their counterparts in the United States, IN CANADA generally worked in styles derived from European art. A

number of Canadians studied in Paris during the late nineteenth century, some of them mastering academic realism and painting figurative and genre subjects, others developing tame versions of Impressionism and Post-Impressionism that they applied to landscape painting. Back in Canada, several of the most advanced painters in 1907 formed the Canadian Art Club, an exhibiting society based in Toronto, Ontario.

In the early 1910s, a younger group of Toronto artists, many of whom worked for the same commercial art firm, became friends and began to go on weekend

28-87. Manuel Alvarez Bravo. Laughing Mannequins. 1930. Gelatin-silver

print, $7^5/_{16} \times 9^9/_{16}"$ (18.6 × 24.3 cm). The Art Institute of Chicago. Julian Levy Collection, Gift of Jean Levy and the Estate of Julian Levy (1988.157.8)

sketching trips together. They adopted the rugged landscape of the Canadian north as their principal subject and presented their art as an expression of Canadian national identity, despite its stylistic debt to European Post-Impressionism. A key figure in this development

28-88. Tom Thomson. *The Jack Pine.* 1916–17. Oil on canvas, $49^{7}/_{8} \times 54^{1}/_{2}$ " (127.9 \times 139.8 cm). National Gallery of Canada, Ottawa. Purchase, 1918.

was Tom Thomson (1877–1917), who beginning in 1912 spent the warm months of each year in Algonquin Park, a large forest reserve 180 miles north of Toronto. There he made numerous small, swiftly painted, oil-on-board sketches that were the basis for full-size paintings he executed in his studio during the winter. A sketch made in the spring of 1916 led to The Jack Pine (fig. 28-88). The tightly organized composition features a stylized pine tree rising from a rocky foreground and silhouetted against a luminous background of lake and sky, horizontally divided by cold blue hills. The glowing colors and thick brushwork suggest the influence of Post-Impressionism, while the sinuous shapes and overall decorative effect reveal a debt to Art Nouveau. The painting's arresting beauty and reverential mood, suggesting a divine presence in the lonely northern landscape, have made it an icon of Canadian art and, for many, a symbol of the nation itself.

Three years after Thomson's tragic 1917 death by drowning in an Algonquin Park lake, several of his former colleagues formed an exhibiting society called the Group of Seven. These artists traveled widely across Canada in search of pristine wilderness subjects, which they painted in styles generally influenced, as Thomson's had been, by Post-Impressionism. Overcoming initial conservative opposition to their use of simplified forms and bold color, the Group of Seven had by the late 1920s established themselves as the dominant school of Canadian painting. (The group disbanded in 1933 but continued to influence Canadian art through a larger successor organization, the Canadian Group of Painters.)

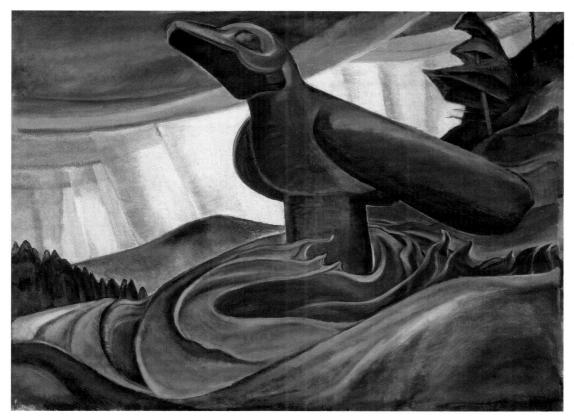

28-89. Emily Carr. Big Raven. 1931. Oil on canvas, $34 \times 44^{5/8}$ " (87.3 \times 114.4 cm). The Vancouver Art Gallery, Canada. Emily Carr Trust (VAG 42.3.11)

The Group of Seven regularly invited other likeminded artists to exhibit with them. One was the West Coast artist Emily Carr (1871-1945), who first met members of the group on a trip to Toronto in 1927. Born in Victoria, British Columbia, Carr studied art in San Francisco (1891–94), England (1899–1904), and Paris (1910–11), where she assimilated the lessons of Post-Impressionism and Fauvism. Between 1906 and 1913 she lived in Vancouver, where she became a founding member of the British Columbia Society of Art. On a 1907 trip to Alaska she was taken with the monumental carved poles of Northwest Coast Native Americans and resolved to document these "real art treasures of a passing race." Over the next twenty-three years Carr visited more than thirty native village sites across British Columbia, making drawings and watercolors as the basis for oil paintings. After a commercially unsuccessful exhibition of her Native American subjects in 1913, Carr returned to Victoria and opened a boardinghouse. Running this business left little time for art, and for the next fifteen years she hardly painted. Her life changed dramatically in 1927 when she was invited to participate in an exhibition of West Coast art at the National Gallery of Canada in Ottawa, Ontario. It was on her trip east to attend the show's opening that she met members of the Group of Seven, whose example and encouragement rekindled her interest in painting.

Under the influence of the Group of Seven, Carr developed a dramatic and powerfully sculptural style full of dark and brooding energy. An impressive example of such work is Big Raven (fig. 28-89), which Carr based on a watercolor she made in 1912 in an abandoned village in the Queen Charlotte Islands. There she discovered a carved raven raised on a pole, the surviving member of a pair that had marked a mortuary house. While in her autobiography Carr described the raven as "old and rotting," in her painting the bird appears strong and majestic, thrusting dynamically above the swirling vegetation, a symbol of enduring spiritual power. Through its focus on a Native American artifact set in a recognizably northwestern Canadian landscape, Carr's Big Raven may be interpreted, like the paintings of the Group of Seven, as an assertion of national pride.

29-1. Jannis Kounellis. *Untitled (12 Horses)*. 1969. Installation, Galleria L'Attico, Rome.

29

THE INTERNATIONAL AVANT-GARDE SINCE 1945

ISITORS TO THE 1969 JANNIS KOUNELLIS exhibition at the Galleria L'Attico in Rome did not see paintings, sculpture, drawings, or any other objects made by the artist. Instead, they encountered twelve live horses of different breeds and colors, bridled and hitched to the gallery walls (fig. 29-1). Following the example of Marcel Duchamp (see fig. 28-63), Kounellis did not create a new object but took existing entities (in this case, living ones), placed them in an art context, and designated them a work of art. This particular work existed only as long as the horses remained "installed" in the gallery (three days) and could not be bought or sold. By placing unsellable works in the exhibition space, Kounellis, who harbored leftist political views, challenged "the ideological and economic interests that are the foundations of a gallery."

Kounellis did not intend simply to criticize the capitalist values of the art market but to create also a memorable work that would generate a rich variety of interpretations. He used horses because they evoke energy and strength and have art-historical associa-

tions with equestrian statuary and portraits of mounted heroes and rulers (see figs. 17-55, 17-56, and 27-2). One critic wrote that Kounellis's horses "had only to stand in place to confirm their stature as an attribute of Europe personified" and saw them as symbols of "the heritage accumulated over great distances of time, and of the urgent need for freedom in the present moment." Another felt the installation conveyed "something of the quality of an anxiety dream." Still another suggested that Kounellis was actually mocking art by "treating the exhibition space as if it were a stable," which brought to mind one of the first-century emperor Caligula's "most insulting acts: making a horse a member of the Roman Senate."

However we interpret Kounellis's work, it stimulates our imaginations even as it defies our normal expectations of a work of art and—like much innovative art since World War II—causes us to question the nature of art itself.

TIMELINE 29-1. The World since 1945. The second half of the twentieth century saw the widespread acceptance of the digital computer, the start of the Space Age, and major political realignments.

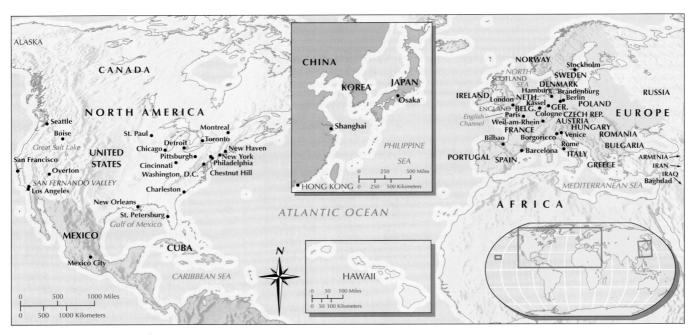

Map 29-1. The World since 1945.

The distribution of cultural sites expands to be fully global.

WORLD

THE The United States and the Soviet Union emerged from World War II as the world's most powerful na-SINCE 1945 tions and soon were engaged in the "Cold War." The Soviets set up

Communist governments in Eastern Europe and supported the development of communism elsewhere. The United States through financial aid and political support sought to contain the spread of communism in Western Europe, Japan, Latin America, and other parts of the developing world. A second huge Communist nation emerged in 1949 when Mao Tse-tung established the People's Republic of China. The United States tried to prevent the spread of communism in Asia by intervening in the Korean War (1950-53) and in the Vietnam War (1965-73).

The United States and the Soviet Union built massive nuclear arsenals aimed at each other, effectively deterring either from attacking for fear of a devastating retaliation. The Cold War ended in the late 1980s, when the Soviet leader Mikhail Gorbachev signed a nucleararms reduction treaty with the United States and instituted economic and political reforms designed to foster free enterprise and democracy. The dissolution of the Soviet Union soon followed and gave rise to numerous independent republics.

While the Soviet Union and the United States vied for world leadership, the old European states gave up

their empires. The British led the way by withdrawing from India in 1947. Other European nations gradually granted independence to colonies in Asia and Africa, which entered the United Nations as a Third World bloc not aligned with either side of the Cold War. Despite the efforts of the United Nations, deep-seated ethnic and religious hatreds have continued to spark violent conflicts around the world—in countries such as Pakistan, India, South Africa, Somalia, Ethiopia, Rwanda, the former Yugoslavia, and states throughout the Middle East. Escalating the sense of tension around the globe were the devastating terrorist attacks of September 11, 2001, on the World Trade Center and the Pentagon in the United States, and the controversial U.S.-led wars in Afghanistan and Iraq that followed.

Despite continuing political divisions, recent decades have seen increasing economic interdependence among all nations, and wealthy countries like the United States have enjoyed increasing prosperity. Third World countries have also experienced economic gains, but in many cases they have been offset by tremendous population growth—brought about largely by economic development and improvements in agriculture and medicine. Despite this growth in population, the world seems smaller, thanks to remarkable advances in transportation and communication, including space travel and the Internet. With enhanced global communication has come increased awareness of the many grave prob-

1968 ROBERT F. KENNEDY AND MARTIN LUTHER KING, JR., KILLED

▲ 1969 FIRST MOON LANDING

1990 GERMANY REUNITED ▲ 1991 USSR DISSOLVED 1994 ADVENT OF WORLD WIDE WEB A

2000 HUMAN GENOME SEQUENCE DECODED A 2001 WORLD TRADE CENTER ATTACK ▲ 2003 U.S. WAR IN IRAO

2000

lems that confront us at the dawn of the twenty-first century. Pollution, soil erosion, freshwater depletion, global warming, and other depredations threaten ecosystems everywhere. Only recently have the nations of the world begun to work together to address these global problems on whose solution the future of humanity surely depends.

THE "MAINSTREAM" CROSSES THE ATLANTIC

The United States's stature after World War II as the most powerful democratic nation was soon reflected in the arts. American artists and architects assumed leadership in artistic innovation that by the late 1950s was acknowledged across the Atlantic, even in Paris. This dominance endured until around 1970, when the belief in the existence of an identifiable mainstream, or single dominant line of artistic development, began to wane (see "The Idea of the Mainstream," page 1086).

EUROPEAN ART

POSTWAR Despite the shift of critical focus away from Europe, several European artists received worldwide attention. One, Swiss-born Alberto Giacometti (1901-66), worked as a

Surrealist sculptor until, around 1935, he returned to working directly from the model. The figures he produced were the antithesis of the classical ideal: small, frail and lumpy, their surfaces rough and crude. Shown alone or in groups, as in figure 29-2, Giacometti's anonymous men and women seemed to illustrate the bleaker side of existentialism espoused by his friend, philosopher Jean-Paul Sartre (1905-80), who asserted that humans wander alone and aimlessly in a meaningless universe.

Another European who drew international attention was the English painter Francis Bacon (1909-92). While working as an interior decorator, Bacon taught himself to paint in about 1930 but produced few pictures until the early 1940s, when the onset of World War II crystallized his harsh view of the world. His style draws on the expressionist work of Vincent van Gogh (see fig. 27-74) and Edvard Munch (see fig. 27-80), as well as on Picasso's figure paintings. His subject matter comes from a wide variety of sources, including post-Renaissance Western art. Head Surrounded by Sides of Beef (fig. 29-3), for example, is inspired by Diego Velázquez's Pope Innocent X (1650), a solid and imperious figure that Bacon transformed into an anguished, insubstantial man howling in a black void. The feeling is reminiscent of Munch's The Scream (see fig. 27-80), but Bacon's pope is enclosed in a claustrophobic box that contains his frightful cries. The figure's terror is magnified by the sides of beef behind him, copied from a Rem-

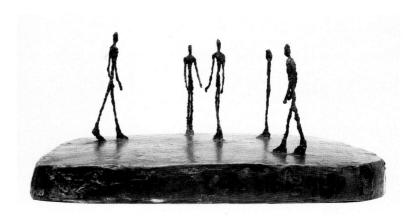

29-2. Alberto Giacometti. City Square. 1948. Bronze, $8\frac{1}{2} \times 25\frac{3}{8} \times 17\frac{1}{4}$ " (21.6 × 64.5 × 43.8 cm). The Museum of Modern Art, New York. Purchase, (337.1949)

29-3. Francis Bacon. Head Surrounded by Sides of **Beef.** 1954. Oil on canvas, $50^{3}/_{4} \times 48''$ (129 × 122 cm). The Art Institute of Chicago. Harriott A. Fox Fund

brandt painting. (Bacon said that slaughterhouses and meat brought to his mind the Crucifixion.) Bacon's pope seems to respond, then, to the realization that humanity is merely mortal flesh.

The French painter Jean Dubuffet (1901-85) developed a distinctive form of expressionism inspired by what he called *art brut* ("raw art")—the work of children and the insane—which he considered uncontaminated

THE IDEA OF THE MAINSTREAM

A central conviction of modernist artists, critics, and art historians was the existence of an artistic mainstream, the notion that some art works are more important than others—not by virtue of their aesthetic quality but because they participate in the progressive unfolding of some larger historical purpose. According to this view, the overall evolutionary pattern is what confers value, and any art that does not fit within it, regardless of its appeal, can be for the most part ignored.

Such thinking depended on two long-standing Western ideas about historical change. The first was the ancient Greek belief that history records the steady advance, or progress, of human learning and accomplishment. The second was the Judeo-Christian belief that humanity is passing through successive stages that will inevitably bring it to a final state of perfection on earth. The specifically modern notion of the mainstream arose from the reformulation of those old ideas by the Enlightenment philosopher Georg Wilhelm Friedrich Hegel (1770-1831), who argued that history is the gradual manifestation of divinity over time. It is, in other words, the process by which the divine reveals itself to us, and those who seem to shape events are only the vehicles by which the divine makes itself known. As one modern writer succinctly put it, history is "the autobiography of God." Hegel's conception of history as the record of great, impersonal forces struggling toward some transcendent end had a profound effect on succeeding generations of Western European philosophers, historians, and social theorists. Socialists in France assimilated and developed his ideas into their concept of the artistic avantgarde, a notion of artistic advance central to the rise of modernism.

The first significant discussions of what constituted the modernist mainstream emerged after World War II, shaped by the critical writings of Clement Greenberg (1909–94), whose thinking was grounded in a Hegelian concept of art's development. Greenberg argued that modern art since Édouard Manet (Chapter 27) involved the progressive disappearance of narrative, figuration, and pictorial space because art itself—regardless of what the artists may have thought they were doing—was undergoing a "process"

of self-purification" in reaction to a deteriorating civilization. Although members of the art world rejected Greenberg's concept of the mainstream during the Abstract Expressionist era, a powerful group of American critics and historians, the so-called Greenbergians, embraced it around 1960.

In the ensuing decades, belief in the concept of the mainstream gradually eroded, partly because of the narrow way it had been defined by Greenberg and his followers. Because their mainstream omitted so much of the history of recent art, observers began questioning whether a single, dominant mainstream had ever existed. The extraordinary proliferation of art styles and trends after the 1960s greatly contributed to those doubts, which were compounded by the decline of conviction in the concept of historical progress. Few historians today would disagree with the assessment of the art critic Thomas McEvilley: "History no longer seems to have any shape, nor does it seem any longer to be going any place in particular." Thus, the concept of the mainstream has been relegated to the status of another of modernism's myths.

by culture. Like artists as diverse as Gauguin and the Surrealists, Dubuffet thought that civilization corrupts innate human sensibilities. At times he applied paint mixed with tar, sand, and mud, using his fingers and ordinary kitchen utensils, in a deliberately crude and spontaneous style that imitated art brut. In the early 1950s he began to mix oil paint with new, fast-drying industrial enamels, laying them over a preliminary base of stillwet oils. The result was a texture of fissures and crackles that suggests organic surfaces, like those of Cow with the Subtile Nose (fig. 29-4). Dubuffet observed that "the sight of that animal affords me an inexhaustible feeling of well-being because of the aura of calm and serenity it gives off." The animal seems completely content and focused on its "subtile" nose, which appears to twitch just slightly, perhaps at the scent of some grassy morsel.

Dubuffet's celebration of crude, basic forms of self-expression, including **graffiti**, contributed to the emergence of the most distinctive postwar European artistic approach: *art informel* ("formless art"), which was sometimes also called *tachisme* (*tache* is French for "spot" or "stain"). *Art informel* was promoted by French critic Michel Tapié (1909–87), who opposed geometric formal-

ism as the proper response to the horrors of World War II. He insisted that Dada and the two world wars had discredited all notions of humanity as reasonable, thus clearing the way for a new and more authentic concept of the species that locates the origins of human expression in the simple, honest mark.

One participant in this broad movement was the French Canadian painter Jean-Paul Riopelle (1923–2002), who settled in Paris in 1949. In his native Montreal, Riopelle had participated in the activities of *Les Automatistes* ("The Automatists"), who applied the Surrealist technique of **automatism** to the creation of abstract paintings. In the early 1950s he began to squeeze blobs of paint directly onto the canvas and then spread them with a palette knife to create an "all-over" pattern of bright color patches, suggestive of broken shards of stained glass, and often traversed, as in *Knight Watch* (fig. 29-5), by a network of spidery lines.

Another prominent exponent of *art informel* was the Spanish painter Antoni Tàpies (b. 1923), a native of Barcelona who traveled to Paris frequently in the 1950s. An important source of Tàpies's aesthetic was his fascination with "the graffiti of the street . . . a whole world

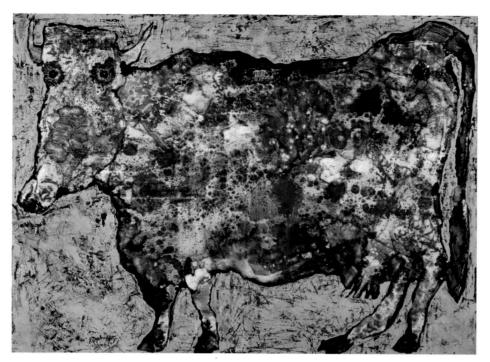

29-4. Jean Dubuffet. Cow with the Subtile Nose. 1954. Oil on enamel on canvas, $35 \times 45^{3}/4$ " (89.7 × 117.3 cm). The Museum of Modern Art, New York. Benjamin Scharps and David Scharps Fund

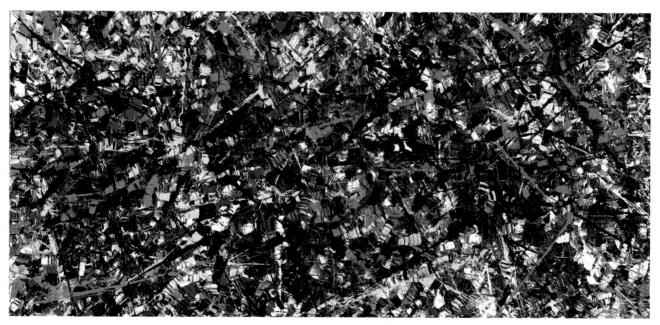

29-5. Jean-Paul Riopelle. *Knight Watch*. 1953. Oil on canvas, $38 \times 76^{\prime 5}/8^{\prime \prime}$ (96.6 \times 194.8 cm). The National Gallery of Canada, Ottawa. Purchased 1954

of protest-repressed, clandestine but full of life." In works such as White with Graphism (fig. 29-6, page 1088) Tàpies did not communicate a particular message but recorded the fundamental human urge to selfexpression. The white plasterlike surface (a mixture of sand and oil paint) with its crudely drawn and incised marks re-creates the look and feel of the city walls that inspired his work in this vein.

EXPRESSIONISM

ABSTRACT The rise of fascism and the outbreak of World War II led many leading European artists and writers to

move to the United States. By 1940 André Breton, Salvador Dalí, Fernand Léger, Piet Mondrian, and Max Ernst were living in New York. American abstract artists were most deeply affected by the ideas of the

29-6. Antoni Tàpies. White with Graphism (Blanco y Grafismos). 1957. Mixed media on canvas, $6'3^7/8'' \times 5'8^3/4''$ (1.93 \times 1.75 m). Washington University Gallery of Art, St. Louis, Missouri.

Gift of Mr. and Mrs. Richard Weil, 1963

Surrealists, from which they evolved Abstract Expressionism, a wide variety of work—not all of it abstract or expressionistic—produced in New York between 1940 and roughly 1960. Abstract Expressionism is also known as the New York School, a more neutral label many art historians prefer.

THE FORMATIVE PHASE

The earliest Abstract Expressionists found inspiration in Cubist formalism and Surrealist automatism, two very different strands of modernism. But whereas European Surrealists had derived their notion of the unconscious from Sigmund Freud, many of the Americans subscribed to the thinking of Swiss psychoanalyst Carl Jung (1875–1961). Jung's theory of the collective unconscious holds that beneath one's private memories lies a storehouse of feelings and symbolic associations common to all humans. Abstract Expressionists, dissatisfied with what they considered the provincialism of American art in the 1930s, sought the universal themes within themselves.

One of the first artists to bring these influences together was Arshile Gorky (1904–48), who was born in Armenia and immigrated to the United States in 1920 following Turkey's brutal eviction of its Armenian population, which caused the death of Gorky's mother. Converging in Gorky's mature work were his intense childhood memories of Armenia, which provided his primary subject matter; his interest in Surrealism; and his attraction to Jungian ideas. These factors came to-

gether in the early 1940s in a series of paintings that Gorky called Garden in Sochi after the Russian resort on the Black Sea but that were actually inspired by Gorky's father's garden in his native Khorkom, Armenia (fig. 29-7). According to Gorky, this garden was known as the Garden of Wish Fulfillment. It contained a rock upon which village women, including his mother, rubbed their bare breasts for the granting of wishes; above the rock stood a "Holy Tree" to which people tied strips of clothing. Gorky's painting includes the highly abstracted images of a bare-breasted woman at the left, a tree trunk at the upper center, and perhaps pennants of cloth at the upper right. The out-of-scale yellow shoes below the tree may refer to "the beautiful Armenian slippers" that Gorky and his father had worn in Khorkom. Knowledge of such autobiographical details is not necessary, however, to appreciate the painting's expressive effect, for the fluid, biomorphic formsderived from Miró (see fig. 28-66)—suggest vital life forces and signal Gorky's evocation of not only his own past but also an ancient, universal, unconscious identification with the earth. Despite their improvisational appearance, Gorky's paintings were based on detailed preparatory drawings—he wanted his paintings to touch his viewers deeply and to be formally beautiful, like the drawings of Ingres and Matisse.

Jackson Pollock (1912–56), the most famous of the Jung-influenced Abstract Expressionists, rejected this European tradition of aesthetic refinement—what he

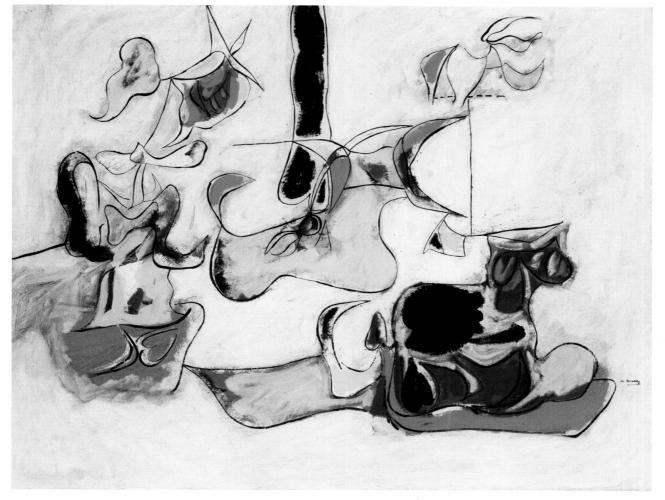

29-7. Arshile Gorky. *Garden in Sochi.* c. 1943. Oil on canvas, $31 \times 39''$ (78.7 \times 99.1 cm). The Museum of Modern Art, New York.

Acquired through the Lillie P. Bliss Bequest, (492.1969)

Born Vosdanig Adoian in Turkish Armenia, Arshile Gorky adopted his new Russian-sounding name (*Gorky* is Russian for "bitter") after settling in New York in 1925. Insecure about his Armenian origins and hoping to impress his American colleagues, Gorky often gave his birthplace as Kazan, Russia, and on one occasion claimed to be a cousin of the famous Russian writer Maksim Gorky—apparently unaware that this was the pen name of Aleksey Peshkov. Related to Gorky's fabrication of a Russian background is his naming of *Garden in Sochi* for a Russian town rather than the Armenian village of Khorkom that actually inspired it.

referred to as "French cooking"—for cruder, rougher formal values identified with the Wyoming frontier country of his birth. Pollock went to New York in 1930 and studied at the Art Students League with the Regionalist painter Thomas Hart Benton. Self-destructive and alcoholic, Pollock entered Jungian psychotherapy in 1939. Because Pollock was reluctant to talk about his problems, the therapist engaged him through his art, analyzing in terms of Jungian symbolism the drawings Pollock brought in each week.

The therapy had little apparent effect on Pollock's personal problems, but it greatly affected his work. He gained a new vocabulary of symbols and a belief in Jung's notion that artistic images that tap into primordial human consciousness can have a positive psychological effect on viewers, even if they do not understand the imagery. In paintings such as *Male and Female* (fig. 29-8, page 1090), Pollock covered the surface of the painting

with symbols he ostensibly retrieved from his unconscious through automatism. Underneath them is a firm compositional structure of strong vertical elements flanking a central rectangle—evidence, according to Pollock's therapist, of the healthy, stable adult psyche in which male and female elements are integrated. Such elements are balanced throughout the painting and within the forms suggesting two facing figures. Each figure combines soft, curving shapes suggestive of femininity with firmer, angular ones that connote masculinity. The sexual identity of both figures is therefore ambiguous; each seems to be both male and female. The painting and the two figures within it represent not only the union of Jung's anima (the female principle in the male) and animus (the male principle in the female) but also that of Pollock and his then lover, Lee Krasner (1908-84), a painter (see fig. 29-11) with whom he had an intense relationship and whom he would marry in 1945.

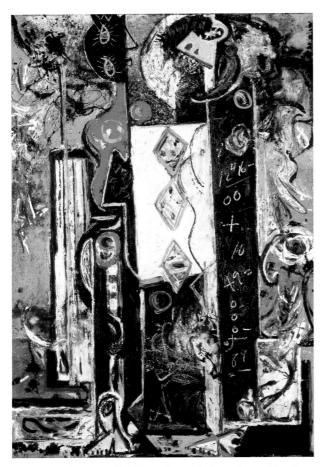

29-8. Jackson Pollock. *Male and Female.* 1942. Oil on canvas, $6'1^1/_4$ " \times 4'1" (1.86 \times 1.24 m). Philadelphia Museum of Art.

Gift of Mr. and Mrs. Gates Lloyd

The reds and yellows used here, like the diamond shapes featured at the center, were inspired by Southwestern Native American art. Native Americans, like other so-called primitive peoples, were believed to have direct access to the collective unconscious and were therefore much studied by Surrealists and early members of the New York School, including Pollock and his psychiatrist.

ACTION PAINTING

In the second phase of Abstract Expressionism, which dates from the late 1940s, two different approaches to expression emerged—one based on fields of color and the other on active handling of paint. The second approach, known as action painting, or gesturalism, first inspired the label Abstract Expressionism. The term action painting was coined by art critic Harold Rosenberg (1906-78) in his 1952 essay "The American Action Painters," in which he claimed: "At a certain moment the canvas began to appear to one American painter after another as an arena in which to actrather than a space in which to reproduce, redesign, analyze, or 'express' an object, actual or imagined. What was to go on the canvas was not a picture but an event." Although he did not mention them by name, Rosenberg was referring primarily to Pollock and to Pollock's chief rival for leadership of the New York School, Willem de Kooning (1904–97).

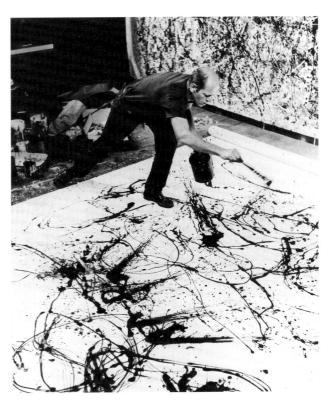

29-9. Hans Namuth. Photograph of Jackson Pollock painting, The Springs, New York. 1950.

Pollock began to replace painted images and symbols with freely applied paint as the central element of his work in the mid-1940s. After moving in 1945 to The Springs, a rural community near the tip of Long Island, New York, he created a number of rhythmic, dynamic paintings devoted to nature themes. From the fall of 1946 on he worked in a renovated barn, where he placed his canvases on the floor so that he could work on them from all four sides. Sometime in the winter of 1946–47, he also began to employ enamel house paints along with conventional oils, dripping them onto his canvases with sticks and brushes, using a variety of fluid arm and wrist movements (fig. 29-9). As a student in 1936, he had experimented with spraying and dripping industrial paints in the New York studio of the visiting Mexican muralist David Alfaro Siqueiros. He may have been reminded of those experiments by the 1946 exhibition of small drip paintings of a self-taught painter, Janet Sobel (1894-1968), which he had seen in the company of his chief artistic adviser, the critic Clement Greenberg.

Greenberg's view that the mainstream of modern art was flowing away from representational easel painting toward mural-scale abstraction may have also influenced Pollock's formal evolution, but his shift in working method was grounded in his own continuing interests in both automatism and nature. The result over the next four years was graceful linear abstractions, such as *Autumn Rhythm (Number 30)* (fig. 29-10), in which Pollock seems to have felt that the free, unselfconscious act of painting was giving vent to primal, natural forces. Soon after he began the drip paintings,

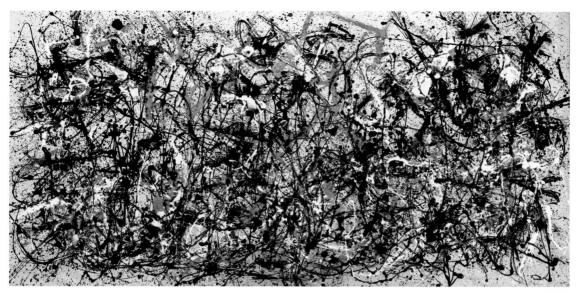

29-10. Jackson Pollock. Autumn Rhythm (Number 30). 1950. Oil on canvas, $8'9'' \times 17'3''$ (2.66 \times 5.25 m). The Metropolitan Museum of Art, New York. George A. Hearn Fund, 1957 (57.92)

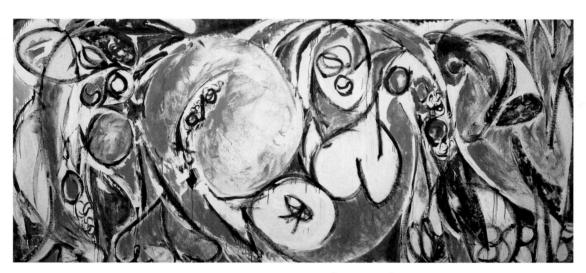

29-11. Lee Krasner. *The Seasons.* 1957. Oil on canvas, $7'8^3/4'' \times 16'11^3/4''$ (2.36 \times 5.18 m). Whitney Museum of American Art, New York.

Purchased with funds from Frances and Sydney Lewis (by exchange), the Mrs. Percy Uris Purchase Fund, and the Painting and Sculpture Committee, (87.7)

Pollock wrote: "On the floor I am more at ease. . . . [T]his way I can . . . literally be in the painting. . . . When I am in the painting I am not aware of what I am doing. . . . [T]here is pure harmony." These words suggest that while painting, Pollock took pleasure in the sense of being fully absorbed in action, which eliminated the anxiety of self-consciousness—the existential sense of estrangement between oneself and the world. Embodying this state of "harmony," the delicate skeins of paint in *Autumn Rhythm* effortlessly loop over and under one another in a mesmerizing pattern without beginning or end that spreads evenly across the surface of the canvas.

Lee Krasner, who had studied in New York with the German expatriate teacher and abstract painter Hans Hofmann (1880–1966), produced fully nonrepresenta-

tional work several years before Pollock did. After she began living with him in 1942, however, she virtually stopped painting to devote herself to the conventional role of a supportive wife. Following the couple's move to Long Island in 1945, she set up a small studio in a guest bedroom, where she produced small, tight, gestural paintings similar in composition to Pollock's but lacking their sense of freedom. After Pollock's death in an automobile crash in 1956, Krasner took over his studio and produced large, dazzling gestural paintings, known as the Earth Green series, which marked her emergence from her husband's shadow. Works such as The Seasons (fig. 29-11) feature bold, sweeping curves that express not only her new sense of liberation but also her identification with the forces of nature in the bursting, rounded forms and springlike colors.

29-12. Willem de Kooning. *Woman I.* 1950–52. Oil on canvas, $6'3^{7}/8'' \times 4'10''$ (1.93 × 1.47 m). The Museum of Modern Art, New York. Purchase, (238.1948)

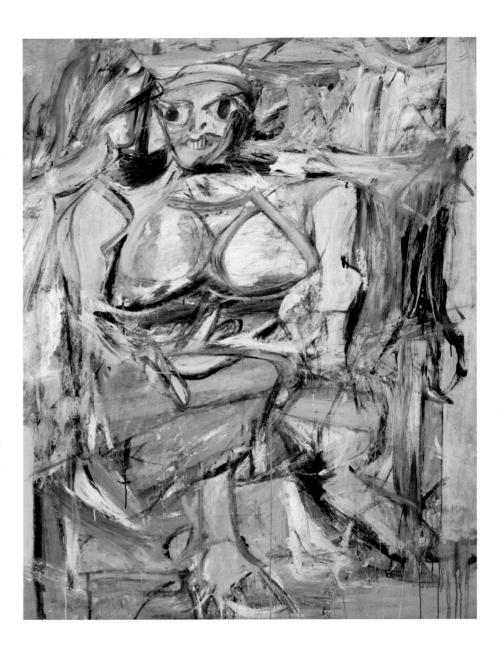

"Painting, for me, when it really 'happens' is as miraculous as any natural phenomenon," said Krasner, suggesting an attitude similar to that of Pollock, who found "pure harmony" in the act of painting. By contrast, Willem de Kooning insisted that "Art never seems to make me peaceful or pure." An immigrant from the Netherlands, de Kooning in the 1930s became friendly with several modernist painters, including Stuart Davis (see fig. 28-80) and Arshile Gorky, but resisted the shift to Jungian Surrealism. For him it was more important to record honestly and passionately his sense of the world around him, which was never simple or certain. "I work out of doubt," he once remarked. During the 1940s he expressed his nervous uncertainty in the agitated way he handled paint itself.

After painting a series of biomorphic abstractions in the late 1940s, de Kooning shocked the art world by reintroducing figuration in paintings of women—also shocking because of the brutal way he depicted his subjects. The first, *Woman I* (fig. 29-12), took him almost

two years (1950–52) to paint. His wife, the artist Elaine de Kooning (1918–89), said that he painted it, scraped it, and repainted it at least several dozen times. Part of de Kooning's dissatisfaction stemmed from the way the images in this and other paintings in the series veered away from the conventionally pretty women in advertising that inspired them. What emerged is not an elegant companion but a powerful adversary, more dangerous than alluring, a sister to Picasso's formidable demoiselles (see fig. 28-21). Only the bright primary colors and luscious paint surface give any hint of de Kooning's original sources, but these qualities are nearly lost in the furious slashing of the paint. Critics repeatedly questioned de Kooning's feelings toward women. "I like beautiful women," he explained, "in the flesh; even the models in the magazines. Women irritate me sometimes. I painted that irritation in the Woman series." But he added: "Maybe . . . I was painting the woman in me."

De Kooning, like Gorky, was committed to the highest level of aesthetic achievement historically set

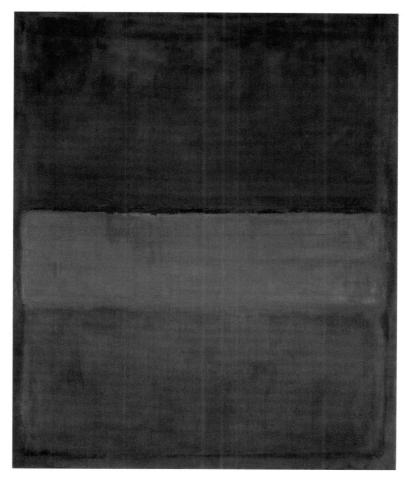

29-13. Mark Rothko. No. **61**, *Brown, Blue, Brown on Blue.* 1953. Oil on canvas, $9'7^3/_4$ " \times $7'7^1/_4$ " (2.94 \times 2.32 m). The Museum of Contemporary Art, Los Angeles. The Panza Collection

by great Western painters and created his paintings through a carefully orchestrated buildup of interwoven strokes and planes of color based largely on the example of Analytic Cubism (see figs. 28-23, 28-24, 28-25). "Liquefied Cubism" is the way one art historian described them. The deeper roots of de Kooning's work, however, lie in the coloristic tradition of artists such as Titian and Rubens, who superbly transformed flesh into paint.

COLOR FIELD PAINTING

An alternative to gestural paint handling is seen in the work of Abstract Expressionists Mark Rothko (1903–70) and Barnett Newman (1905–70), who by 1950 had evolved individual styles that relied on large rectangles of color to evoke transcendent emotional states. Because of the formal and emotional similarities of their work, they, along with a third painter, Clyfford Still (1904–80), were soon referred to collectively as Color Field painters.

Rothko's mature paintings typically feature two to four soft-edged rectangular blocks of color hovering one above another against a monochrome ground. In works such as *Brown, Blue, Brown on Blue* (fig. 29-13) Rothko

sought to harmonize into a satisfying unity the two divergent human tendencies that German philosopher Friedrich Nietzsche called the Dionysian and the Apollonian. The rich color represents the emotional, instinctual, or Dionysian element (after Dionysos, the Greek god of wine, the harvest, and inspiration), whereas the simple compositional structure is its rational, disciplined, or Apollonian counterpart (after Apollo, the Greek god of light, music, and truth). However, Rothko was convinced of Nietzsche's contention that the modern individual was "tragically divided," so his paintings are never completely unified but remain a collection of separate parts. What gives this fragmentation its particular force is that these elements offer an abstraction of the human form. In Brown, Blue, Brown on Blue, as elsewhere, the three blocks approximate the human division of head, torso, and legs. The vertical paintings, usually somewhat taller than the adult viewer, thus present the viewer with a kind of amplified mirror image of the divided self. The dark tonalities that Rothko increasingly featured in his work emphasize the tragic implications of this division. The best of his mature paintings maintain a tension between the harmony they seem to seek and the fragmentation they regretfully acknowledge.

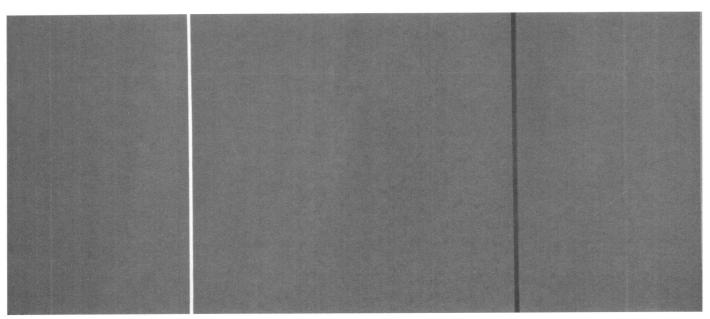

29-14. Barnett Newman. *Vir Heroicus Sublimis*. 1950–51. Oil on canvas, $7'11^3/8'' \times 17'9^1/4''$ (2.42 × 5.41 m). The Museum of Modern Art, New York. Gift of Mr. and Mrs. Ben Heller

Barnett Newman also developed a distinctive nonrepresentational art to address modern humanity's existential condition, declaring his "subject matter" to be "[t]he self, terrible and constant." Newman specialized in monochrome canvases with one or more vertical lines, or "zips," dividing the surface, as in Vir Heroicus Sublimis (fig. 29-14), whose Latin title means "Man, Heroic and Sublime." The zips, like Rothko's rectangles, can be understood as extreme abstractions of the human figure, providing an element with which viewers can identify. Newman sought to contrast the small, finite vertical of the self with the infinite and sublime expanse of the universe, suggested by the monochromatic field that seems to extend beyond our vision. But unlike the late-eighteenth and nineteenth-century painters of the natural sublime such as Turner (see fig. 27-19), Newman meant to make the viewer feel exalted, not terrified or insignificant.

SCULPTURE OF THE NEW YORK SCHOOL

The New York School included talented and successful sculptors, the most famous of whom was David Smith (1906–65). Smith gained metalworking skills at nineteen as a welder and riveter at an automobile plant in his native Indiana. He first studied painting but turned to sculpture in the early 1930s after seeing reproductions of welded metal sculptures by Picasso and Julio González (see fig. 28-69). After World War II, Smith defied the traditional values of vertical, monolithic sculpture by welding horizontally formatted, open-form pieces that extended the tradition of "drawing in space" established by González. A fine example is *Hudson River Landscape* (fig. 29-15), whose fluent metal calligraphy, reminiscent of Pollock's poured lines of paint, was inspired by views from a train window of the rolling

topography of upstate New York. Like many of his works from this period, the piece is meant to be seen from the front, like a painting.

During the last five years of his life, Smith turned from nature-based themes to formalism—a shift partly inspired by his "discovery" of stainless steel. Smith explored both its relative lightness and the beauty of its polished surfaces in the Cubi series, monumental combinations of geometric units inspired by and offering homage to the formalism of Cubism. Like the Analytic Cubist works of Braque and Picasso (see figs. 28-23, 28-24, 28-25), Cubi XIX (see fig. 6, Introduction) presents a finely tuned balance of elements that, though firmly welded together, seems ready to collapse at the slightest provocation. The viewer's aesthetic pleasure depends on this tension and on the dynamic curvilinear patterns formed by the play of light over the sculpture's burnished surfaces. The Cubi works were meant to be seen outdoors, not only because of the effect of sunlight but also because of the way natural shapes and colors complement their inorganic ones.

While many sculptors of the New York School shared Smith's devotion to welded metal, some continued to work with more traditional materials, such as wood. Wood became the signature medium of Louise Nevelson (1899–1988), a Russian immigrant who gained intimacy with the material as a child in Maine, where her father ran a lumberyard. After studying painting with Hans Hofmann, who introduced her to the formal language of Cubism, Nevelson turned to sculpture around 1940, working first in a mode reminiscent of Henry Moore (see fig. 28-70) before discovering her talent for evoking ancient ruins, monuments, and royal personages through **assemblage**, the joining together of disparate elements to construct a work of art.

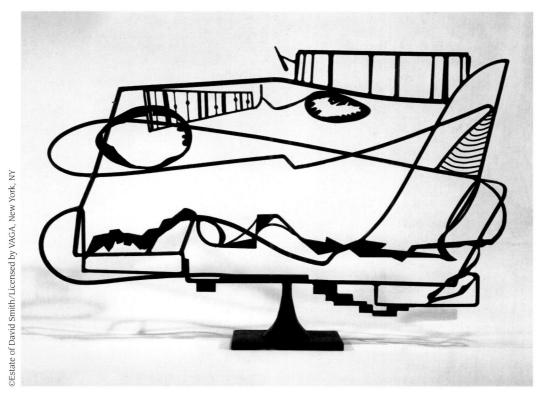

29-15. David Smith. *Hudson River Landscape*. 1951. Welded steel, $49 \times 73^3/_4 \times 16^1/_2$ " (127 \times 187 \times 42.1 cm). Whitney Museum of American Art, New York.

Nevelson's most famous works are the wall-scale assemblages she began to produce in the late 1950s out of stacked packing boxes, which she filled with carefully and sensitively arranged Analytic Cubist-style compositions of chair legs, broom handles, cabinet doors, spindles, and other wooden objects. She painted her assemblages a matte black to obscure the identity of the individual elements, to formally integrate them, and to provide an element of mystery. One of her first wall assemblages was Sky Cathedral (fig. 29-16, page 1096), which Nevelson believed could transform an ordinary space into another, higher realm—just as the prosaic elements she worked with had themselves been changed. To add a further poetic dimension, Nevelson first displayed Sky Cathedral bathed in soft blue light, like moonlight.

THE SECOND GENERATION OF ABSTRACT EXPRESSIONISM

A second generation of Abstract Expressionists, most of whom took their lead from Pollock or de Kooning, emerged in the 1950s to produce the movement's last major phase. Among these artists were a number of women, including Joan Mitchell (1926–92), Grace Hartigan (b. 1922), and Helen Frankenthaler (b. 1928). Frankenthaler, like Pollock, worked on the floor, drawn to what she described as Pollock's "dancelike use of arms and legs." She produced a huge canvas, *Mountains and Sea* (fig. 29-17, page 1097), in this way, working from watercolor sketches she had made in Nova Scotia. Instead of

using thick, full-bodied paint, as Pollock did, Franken-thaler thinned her oils and applied them in **washes** that soaked into the raw canvas, producing a watercolorlike effect. Clement Greenberg, who had introduced her to Pollock, saw in Frankenthaler's stylistic innovation a possible direction for avant-garde painting as a whole—a direction that many artists took after the waning of Abstract Expressionism at the end of the 1950s.

ALTERNATIVES TO ABSTRACT EXPRESSIONISM

In 1958–59 the Museum of Modern Art organized an exhibition of first-generation Abstract Expressionist work, "The New American

Painting," which traveled to eight European capitals before its New York showing. But just when the Museum of Modern Art and many Europeans were finally acknowledging Abstract Expressionism as "the vanguard of the world," as one Spanish critic called it, the New York art world was growing increasingly skeptical about the group's right to such a title—primarily because Abstract Expressionism was no longer, in fact, new. Thus, by the end of the 1950s many New York critics accused firstgeneration Abstract Expressionists, such as de Kooning, of faltering and dismissed the second-generation as "method actors" who faked genuine subjectivity. Amid the growing critical conviction that Abstract Expressionism had lost its innovative edge, attention turned to the question of what would succeed it as the next mainstream development. A number of options quickly emerged.

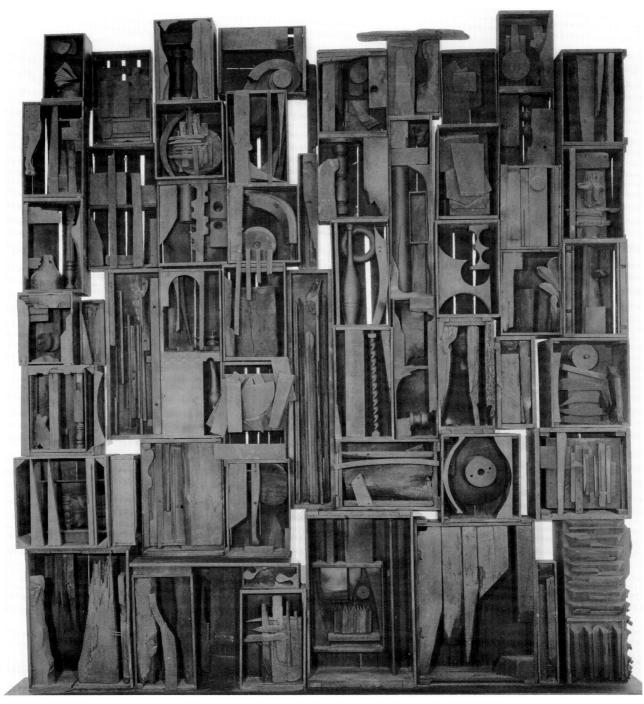

29-16. Louise Nevelson. *Sky Cathedral*. 1958. Assemblage of wood construction, painted black, $11'3^{1}/_{2}" \times 10'^{1}/_{4}" \times 1'6"$ (3.44 \times 3.05 \times 0.46 m). The Museum of Modern Art, New York. Gift of Mr. and Mrs. Mildwoff

RETURN TO THE FIGURE

Although many American artists in the 1940s and 1950s had continued to work in a representational mode, their reputations had suffered because of the belief of critics such as Greenberg that modernist art could only advance by eliminating figuration and becoming increasingly abstract. The crisis of Abstract Expressionism, however, now freed some artists to follow their long-frustrated inclination to paint or sculpt the figure.

One participant in the revival of figurative art was the sculptor George Segal (1924–2000), who during the

1950s painted large canvases of nudes in a loose, improvisatory manner derived from action painting. He turned to sculpture in 1958, fashioning crude figures out of wood, chicken wire, burlap, and plaster—materials he was comfortable with, he said, because he had used them on his New Jersey chicken farm. In 1961 he began making casts of live models with plaster-soaked bandages. He then placed these frozen, white figures in real, three-dimensional settings, heightening the tension between artifice and reality. Drained of color and thus emotion, Segal's lonely figures, as in *The Diner* (fig. 29-18), are reminiscent of Hopper's (see fig. 28-75).

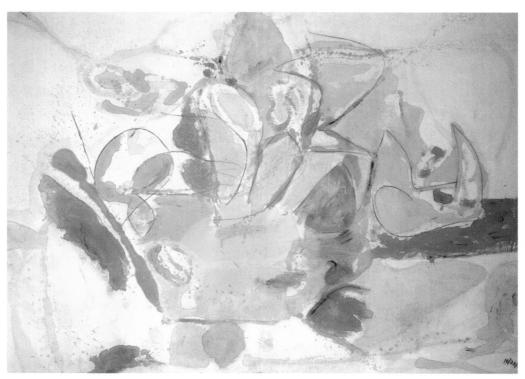

29-17. Helen Frankenthaler. *Mountains and Sea.* 1952. Oil and charcoal on canvas, $7'2^3/4'' \times 9'8^1/4''$ (2.2 × 2.95 m). Collection of the artist on extended loan to the National Gallery of Art, Washington, D.C.

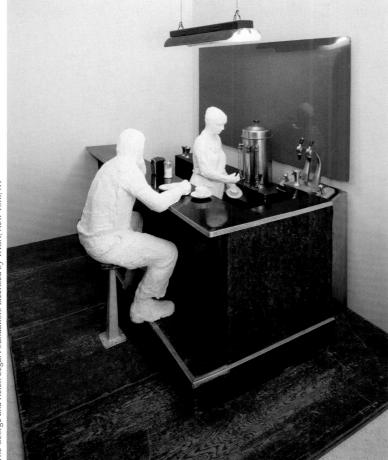

29-18. George Segal. *The Diner.* 1964–66. Plaster, wood, chrome, Formica, Masonite, fluorescent tubes, glass, and paper, $8'6'' \times 9' \times 7'3''$ (2.6 \times 2.7 \times 2.2 m). Walker Art Center, Minneapolis. Gift of the T.B. Walker Foundation, 1966

29-19. Allan Kaprow. *The Courtyard.* 1962. Happening at the Mills Hotel, New York.

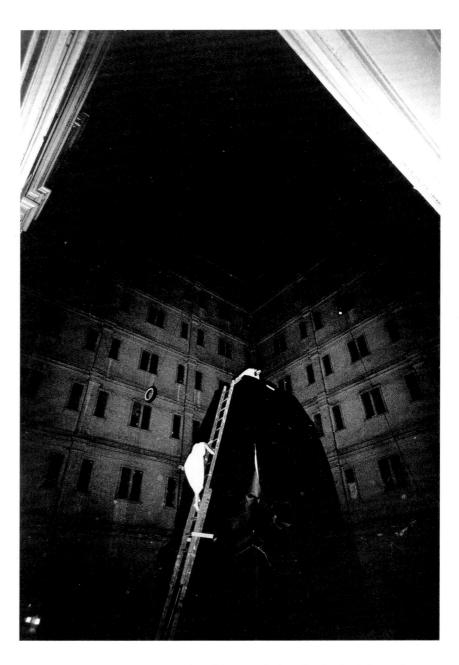

HAPPENINGS

Segal's placement of his figures in real environments reflects the influence of his friend Allan Kaprow (b. 1927), who, in turn, had been influenced by the composer and philosopher John Cage (1912-92). Opposed to the expressionist attitude typical of the New York School, Cage sought to let go of his artistic ego by basing his work on chance and by embracing everyday experience as a source of aesthetic interest. Kaprow incorporated Cage's ideas, including the notion that art should move toward theater, into an influential 1958 essay, "The Legacy of Jackson Pollock," his response to the emerging crisis of Abstract Expressionism. Kaprow argued that artists had two options: to continue working in Pollock's style or to give up making paintings altogether and develop the ritualistic aspects of Pollock's act of painting. He concluded that Pollock "left us at the point where we must become preoccupied with . . . the space and objects of

our everyday life ... chairs, food, electric and neon lights, smoke, water, old socks, a dog, movies ... or a billboard selling Draino [sic]." For modernists this was a shocking statement, for these were precisely the ordinary things they aspired to transcend.

In 1958 Kaprow began to stage **Happenings**—loosely scripted, multimedia, "live" art works that took on the character of theatrical events. A particularly ambitious Kaprow Happening of the early 1960s was *The Courtyard* (fig. 29-19), staged on three consecutive nights in the skylight-covered courtyard of a run-down Greenwich Village hotel. At the center of the courtyard stood a 30-foot-high tar paper—covered "mountain." Spectators were handed brooms by two workers and invited to help clean the courtyard, which was filled with crumpled newspaper and bits of tin foil, the latter dropped from the windows above. The workers ascended ladders to dump the refuse into the top of the mountain, while a man on a bicycle rode through the crowd,

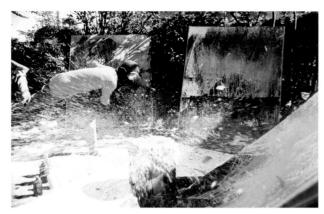

29-20. Shozo Shimamoto. *Hurling Colors.* 1956. Happening at the second Gutai Exhibition, Tokyo.

ringing his handlebar bell. After a few moments, wild noises were heard from the mountain, which then erupted in an explosion of black crepe-paper balls. This was followed by a shower of dishes that broke on the courtyard floor, while noises and activity were heard from the windows above. Mattresses and cartons were lowered to the courtyard, which the workers carried to the top of the mountain and fashioned into an "altarbed." A young woman, wearing a nightgown and carrying a transistor radio, then climbed to the top of the mountain and reclined on the mattresses. Two photographers entered, searching for the young woman. They ascended the ladder, took flash pictures of her, thanked her, and left. The happening concluded with an "inverse mountain" descending to cover the young woman.

Although Kaprow argued that Happenings lacked literary content, *The Courtyard* was for him richly symbolic—the young woman in the nightgown, for example, was the "dream girl," the "embodiment of a number of old, archetypal symbols. She is the nature goddess (Mother Nature) . . . and Aphrodite (Miss America)." Kaprow admitted that "very few of the visitors got these implications out of *The Courtyard*," but he believed that many sensed at some level "there was something like that going on."

In 1959 Kaprow learned that a Japanese group, the Gutai Bijutsu Kyokai (Concrete Art Association), had been producing **performance art** similar to what he was advocating, giving Kaprow and other artists in his circle a sense that they were participating in a truly international movement. Gutai had been formed in Osaka in 1954 by Jiro Yoshihara (1905–72), a leading prewar Japanese abstractionist, in an effort to revitalize Japanese art. Inspired by the rich heritage of the post-World War I Japanese Dada movement, Gutai organized outdoor installations, theatrical events, and dramatic displays of art making. At the second Gutai Exhibition, in 1956, for example, Shozo Shimamoto (b. 1928), dressed in protective clothing and eyewear, produced Hurling Colors (fig. 29-20) by smashing bottles of paint on a canvas laid on the floor, pushing Pollock's drip technique (see fig. 29-9) into new territory two years before Kaprow advocated doing so.

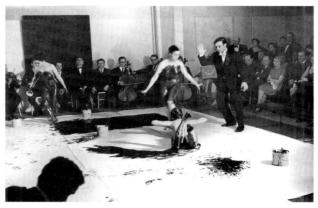

29-21. Yves Klein. *Anthropométries of the Blue Period.* 1960. Performance at the Galerie Internationale d'Art Contemporain, Paris.

Four years later, a very different painting performance was staged in Paris by Yves Klein (1928-62), who was the leading member of the Nouveaux Réalistes ("New Realists") group that formed in 1960 around the critic Pierre Restany (1930-2003). The mystical Klein had since 1950 been making transcendent monochrome paintings of various hues, and in 1957 he turned to blue alone, which he considered the most spiritual color, to free himself and the viewer from materiality and to evoke the infinite. Klein's desire to spiritualize humanity-to bring about what he called a "blue revolution"—was evident in his 1960 Anthropométries of the Blue Period (fig. 29-21): Klein invited members of the Paris art world to watch him direct three nude female models covered in blue paint press themselves against large sheets of paper. This attempt to spiritualize flesh was accompanied by Klein's Monotone Symphonytwenty minutes of a slow progression of single notes followed by twenty minutes of silence-which he considered to be the aural equivalent of the color blue.

ASSEMBLAGE

A third alternative to Abstract Expressionism was assemblage, exemplified by the kind of works that Louise Nevelson created (see fig. 29-16). In 1961 the Museum of Modern Art organized "The Art of Assemblage," whose exhibition catalog argued that assemblage was the work of artists brought up on Abstract Expressionism who sought to move beyond its tired formulas into new and unexplored terrain. Avant-garde critics were not convinced, however—partly because much of the work looked not like a new development but like a Dada revival; partly because it was mostly sculpture at a time when painting took pride of place; and partly because little of it seemed to transcend the ordinary materials from which it was composed.

Included in the exhibition was Swiss-born Jean Tinguely (1925–91), a member, like Klein, of the Nouveaux Réalistes. After producing abstract paintings, constructions of various materials, and a few edible sculptures made of grass, Tinguely moved to Paris in 1951 and gave up painting for **kinetic** sculpture, or

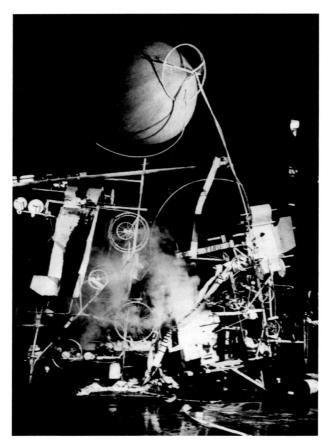

29-22. Jean Tinguely. *Homage to New York.* 1960. Self-destroying sculpture in the garden of the Museum of Modern Art, New York.

sculpture made of moving parts. His awkward and purposely unreliable motor-driven works, which he called *métamatics*, were the very antithesis of perfectly calibrated industrial machines. Tinguely, an anarchist, wanted to free the machine, to let it play. Like his Dada forebears, he created art implicitly critical of an overly restrained and practical bourgeois mentality.

Tinguely's most famous work is Homage to New York (fig. 29-22), which he designed for a special one-day exhibition in the sculpture garden of the Museum of Modern Art. He assembled the work from yards of metal tubing, several dozen bicycle and baby-carriage wheels, a washing-machine drum, an upright piano, a radio, several electric fans, a noisy old Addressograph machine, a bassinet, numerous small motors, two motordriven devices that produced abstract paintings by the yard, several bottles of chemical stinks, and various noisemakers—the whole ensemble painted white and topped by an inflated orange meteorological balloon. The machine was designed to destroy itself when activated. On the evening of March 17, 1960, before a distinguished group of guests, including New York governor Nelson A. Rockefeller, the work was plugged in. As smoke poured out of the machinery and covered the crowd, parts of the contraption broke free and scuttled off in various directions, sometimes frightening the onlookers. A device meant to douse the burning pianowhich kept playing only three notes—failed to work, and firefighters had to be called in. They extinguished the blaze and finished the work's destruction—to boos from the audience, who, except for the museum officials, had been delighted by the spectacle.

A major American artist in "The Art of Assemblage" exhibition was Robert Rauschenberg (b. 1925), who in 1948 found a mentor in John Cage. Cage's interest in breaking down the barriers between art and the everyday world is reflected in Rauschenberg's statement "Painting relates to both art and life. Neither can be made. (I try to act in the gap between the two.)" Rauschenberg's desire to work in this "gap" found perfect expression in his "combines," which chaotically mix conventional artistic materials with a wide variety of ingredients gathered from the urban environment. Canyon (fig. 29-23), for example, features an assortment of family photographs (the boy with the upraised arm is Rauschenberg's son), public imagery (the Statue of Liberty, which echoes the boy's pose), fragments of political posters (in the middle), and various objects salvaged from trash (the flattened steel drum at upper right) or purchased (the stuffed eagle). The rich disorder challenges the viewer to make sense of it. In fact, Rauschenberg meant his work to be open to various readings, so he assembled material that each viewer might interpret differently. One could, for example, see the Statue of Liberty as a symbolic invitation to interpret the work freely. Or perhaps, covered as it is with paint applied in the manner of action painting, it symbolizes that distinctively American style. Following Cage's ideas, Rauschenberg created a work of art that was to some extent beyond his control—a work of **iconographic** as well as formal disarray. Rauschenberg cheerfully accepted the chaos and unpredictability of modern urban experience and tried to find artistic metaphors for it. "I only consider myself successful," he said, "when I do something that resembles the lack of order I sense."

Another American in "The Art of Assemblage" exhibition was Jasper Johns (b. 1930), who had come to New York from South Carolina in 1948 and met Rauschenberg six years later. Unlike Rauschenberg's works, Johns's are controlled, emotionally cool, and highly cerebral. Inspired by the example of Marcel Duchamp (see figs. 28-63, 28-64), Johns produced conceptually puzzling works that seemed to bear on issues raised in contemporary art. Art critics, for example, had praised the evenly dispersed, "nonhierarchical" quality of so much Abstract Expressionist painting, particularly Pollock's. The target in Target with Four Faces (fig. 29-24, page 1102), an emphatically hierarchical, organized image, can be seen as a critical comment on this discourse. The image also raises thorny questions about the difference between representation and abstraction. The target, although arguably a representation, is flat, whereas two-dimensional representational art usually creates the illusion of three-dimensional space. The target therefore occupies a troubling middle ground between the two kinds of painting then struggling for dominance in American art.

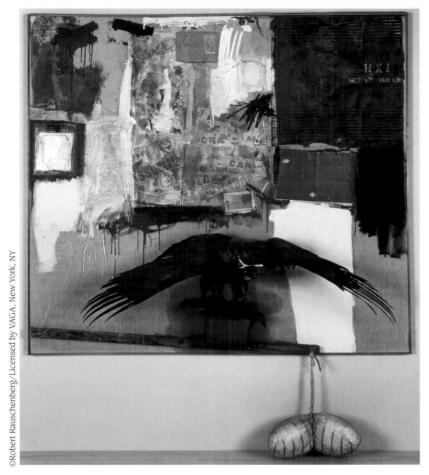

29-23. Robert Rauschenberg. *Canyon.* 1959. Combine painting: oil, pencil, paper, metal, photograph, fabric, wood on canvas, plus buttons, mirror, stuffed eagle, pillow tied with cord, and paint tube, $6'1'' \times 5'6'' \times 2'^3/4''$ (1.85 \times 1.68 \times 0.63 m). Courtesy Sonnabend Gallery, on infinite loan at the Baltimore Museum of Art. (BMA R. 10519)

Johns's works also had a psychological dimension, providing him with a way literally to cover certain personal anxieties and fears, some of which can be vaguely discerned in the **collage** materials partially buried beneath the thick **encaustic** paint. Here, for example, the outline of a lone man in a trench coat is discernible in the lower left. Johns's sense of loneliness and emptiness is perhaps also evident in the faces at the top of the work, which have been cut off at eye-level, a move that both depersonalizes them and prevents them from connecting with the viewer. Moreover, the faces are as blank and neutral as the target below. One historian suggested that Johns, as a homosexual in the homophobic climate of postwar New York, felt like a target.

Johns had a powerful effect on a number of artists who matured around 1960. The cool impersonality of his work contributed to the emerging Minimalist aesthetic, while his interest in Duchamp helped elevate that artist to a place of importance previously occupied by Picasso. Finally, Johns's conceptually intriguing use of subjects from ordinary life helped open the way for the most controversial development to emerge after Abstract Expressionism, Pop art.

POP ART

In 1961–62 several exhibitions in New York City featured art that drew on popular culture (comic books, advertisements, movies, television) for its style and subject matter and came to be called Pop art. Many critics were alarmed by Pop, uncertain whether it was embracing or parodying popular culture and fearful that it threatened the survival of both modernist art and high culture—meaning a civilization's most sophisticated, not its most representative, products. Such fears were not entirely unfounded. The Pop artists' open acknowledgment of the powerful commercial culture contributed significantly to the eclipse, about 1970, of traditional modernism and thus, some argue, the very notion of "standards" that had kept "high culture" safely insulated from "low"

Pop art did not originate in New York but in London, in the work of the Independent Group (IG), formed in 1952 by a few members of the Institute of Contemporary Art (ICA) who resisted the institute's commitment to modernist art, design, and architecture. The IG's most prominent figures included the artists Richard Hamilton

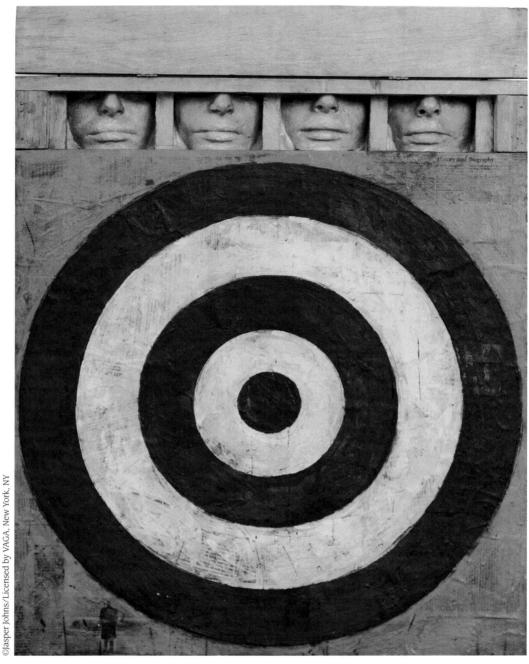

29-24. Jasper Johns. *Target with Four Faces.* 1955. Assemblage: encaustic on newspaper and cloth over canvas, surmounted by four tinted plaster faces in wood box with hinged front; overall, with box open, $33^5/_8 \times 26 \times 3''$ (85.3 \times 66 \times 7.6 cm). The Museum of Modern Art, New York. Gift of Mr. and Mrs. Robert C. Scull, (8.1958)

(b. 1922) and Eduardo Paolozzi (b. 1924), the architecture critic Reyner Banham (1922–88), and the art critic Lawrence Alloway (1926–90). At their first meeting Paolozzi showed slides of American ads, whose utopian vision of a future of contented people with ample leisure time to enjoy cheap and plentiful material goods was very appealing to those living amid the austerity of postwar Britain. Products of the American mass media and commercial culture—including Hollywood movies, Madison Avenue advertising, Detroit automobile styling, science fiction, and pop music—soon became the central subject matter of British Pop art such as \$he (fig. 29-25),

by London-born Richard Hamilton, who had once briefly worked in advertising. \$he features a "cornucopic refrigerator" from an RCA Whirlpool ad, a pop-up toaster from a General Electric ad sprouting the tube of a Westinghouse vacuum cleaner, and a stylized image of a model, Vikky Dougan, who specialized in ads for backless dresses and bathing suits. Although Hamilton said he meant to counter the artistic image of women as timeless beings with the more down-to-earth picture of them presented in advertising, the somewhat mysterious result seems closer to traditional art than to the straightforward imagery of the advertisements on which

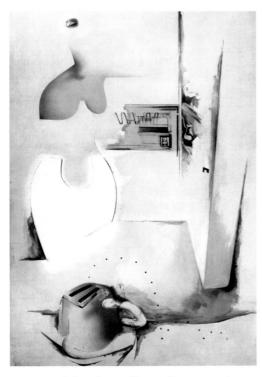

29-25. Richard Hamilton. *\$he.* 1958–61. Oil, cellulose, collage on panel, 24×16 " $(61 \times 40.6 \text{ cm})$. Tate Gallery, London.

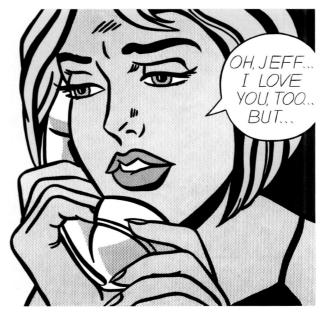

29-26. Roy Lichtenstein. *Oh, Jeff... I Love You, Too* ... *But...* 1964. Oil and Magna on canvas, 48×48 " (122 \times 122 cm). Private collection.

it draws. In short, one of the primary imperatives of modern advertising—clarity of message—has here been sacrificed to those of avant-garde art: individuality and provocative invention.

Roy Lichtenstein (1923-97) was among the first American artists to accept the look as well as the subjects of popular culture. In 1961, while teaching at Rutgers University with Allan Kaprow, Lichtenstein began producing paintings whose imagery and style—featuring heavy black outlines, flat primary colors, and the Benday dots used to add tone in printing—were drawn from advertisements and cartoons. The most famous of these early works were based on panels from war and romance comic books, which Lichtenstein said he turned to for formal reasons. Although many assume that he merely copied from the comics, in fact he made numerous subtle yet important formal adjustments that tightened, clarified, and strengthened the final image. He said that the cartoonist intended to "depict" but he intended to "unify." Nevertheless, many of the paintings retain a sense of the cartoon plots they draw on. Oh, Jeff ... I Love You, Too ... But ... (fig. 29-26), for example, compresses into a single frame the generic romancecomic story line, in which two people fall in love, face some sort of crisis, or "but," that temporarily threatens their relationship, then live happily ever after. Lichtenstein reminds us that this plot is only an adolescent fiction; real-life relationships like his own marriage, then in the process of dissolving, end, as here, with the "but."

Another Pop artist who masked personal concerns behind the impersonal veneer of American popular imagery was Andy Warhol (1928-87). While extremely successful as a commercial illustrator in New York during the 1950s, Warhol decided in 1960 to pursue a career as an artist along the general lines suggested by the work of Johns and Rauschenberg. Drawing on popular and commercial culture was more than a careerist move, however; it also allowed him to celebrate the middleclass values he had absorbed growing up in Pittsburgh during the Great Depression. Such values may be discerned in the Marilyn Diptych (fig. 29-27, page 1104), one of the first in which Warhol turned from conventional painting to the assembly-line technique of silkscreening photo-images onto canvas. The method was faster and quicker than painting by hand and thus more profitable, and Warhol could also produce many versions of the subject-all of which he considered good business. The subject of the work is also telling. Like many Americans, Warhol was fascinated by movie stars such as Marilyn Monroe, whose persona became even more compelling after her suicide in 1962, the event that prompted Warhol to begin painting her. The strip of pictures in this work suggests the sequential images of film, the medium that made Monroe famous. The face Warhol portrays, taken from a publicity photograph, is not that of Monroe the person but of Monroe the star, since Warhol was interested in her public mask, not in her personality or character. He may have borrowed the **diptych** format from the **icons** of Christian saints he recalled from the Byzantine Catholic church he attended as a youth. By symbolically treating the famous actress as a saint, Warhol shed light on his own fascination with

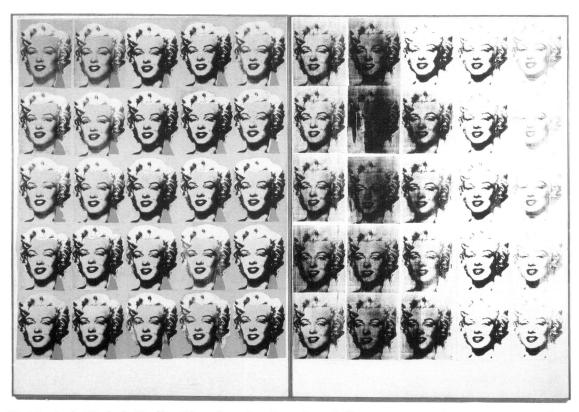

29-27. Andy Warhol. *Marilyn Diptych.* 1962. Oil, acrylic, and silk screen on enamel on canvas, two panels, each $6'10'' \times 4'9''$ (2.05 \times 1.44 m). Tate Gallery, London.

Warhol assumed that all Pop artists shared his affirmative view of ordinary culture. In his account of the beginnings of the Pop movement, he wrote: "The Pop artists did images that anybody walking down Broadway could recognize in a split second—comics, picnic tables, men's trousers, celebrities, shower curtains, refrigerators, Coke bottles—all the great modern things that the Abstract Expressionists tried so hard not to notice at all."

29-28. Claes Oldenburg. *Lipstick (Ascending) on Caterpillar Tracks.* 1969, reworked 1974. Painted steel body, aluminum tube, and fiberglass tip, $21' \times 19' \ 5^1/2'' \times 10' 11'' \ (6.70 \times 5.94 \times 3.33 \ m)$. Yale University Art Gallery, New Haven, Connecticut. Gift of Colossal Keepsake Corporation

fame. Not only does fame bring wealth and transform the ordinary into the beautiful (Warhol was dissatisfied with his own looks), it also confers, as does holiness for a saint, a kind of immortality.

Swedish-born Claes Oldenburg (b. 1929) took both a more critical and a more humorous attitude toward his popular subjects than did Warhol and Lichtenstein. Oldenburg's humor—fundamental to his project to reanimate a dull, lifeless culture—is most evident in such large-scale public projects as his Lipstick Monument for his alma mater, Yale University (fig. 29-28). Oldenburg created this work at the invitation of a group of graduate students in Yale's School of Architecture, who requested a monument to the "Second American Revolution" of the late 1960s, which was marked by student demonstrations against the Vietnam War. By mounting a giant lipstick tube on tracks from a Caterpillar tractor, Oldenburg suggested a missile grounded in a tank and

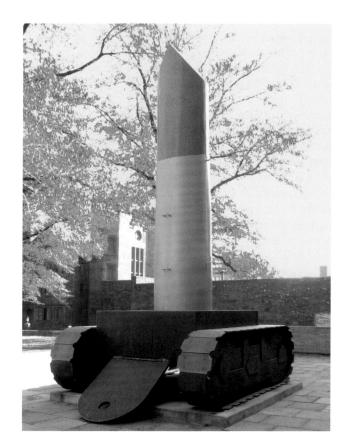

29-29. Morris Louis. *Saraband.* 1959. Acrylic resin on canvas, $8'5^{1}/8'' \times 12'5''$ (2.57 \times 3.78 m). Solomon R. Guggenheim Museum, New York. (64.1685)

simultaneously subverted the warlike reference by casting the missile in the form of a feminine cosmetic with erotic overtones. Oldenburg thus urged his audience, in the vocabulary of the time, to "make love, not war." He also addressed the issue of "potency," both sexual and military, by giving the lipstick a balloonlike vinyl tip, which, after being pumped up with air, was meant to deflate slowly. (In fact, the pump was never installed and the drooping tip, vulnerable to vandalism, was soon replaced with a metal one.) Oldenburg and the students provocatively installed the monument on a plaza fronted by the Yale War Memorial and the president's office. The university, offended by the work's irreverent humor, had Oldenburg remove it the next year. In 1974 he reworked Lipstick (Ascending) on Caterpillar Tracks in fiberglass, aluminum, and steel and donated it to the university, which this time accepted it for the courtyard of Morse College.

POST-PAINTERLY ABSTRACTION AND OP ART

During the 1960s, influential critic Clement Greenberg and his many followers considered Post-Painterly Abstraction to be the legitimate heir to Abstract Expressionism and the only truly new event in the evolution of contemporary art. Greenberg coined the term *post-painterly* to describe the style that he believed had supplanted the "painterly," or gestural, abstraction of the New York School.

In 1953 Greenberg had introduced Morris Louis (1912–62), a painter from Washington, D.C., then working in a late Cubist style, to the work of Helen Frankenthaler (see fig. 29-17). Impressed with Frankenthaler's stain technique and apparently convinced by Greenberg's ideas on the inevitability of pure formalism (see "The Idea of the Mainstream," page 1086), Louis stepped "beyond" Abstract Expressionism by eliminating all extra-artistic meanings from his work. In paintings such as *Saraband* (fig. 29-29) he purged not only the figural and thematic references found in the work of Franken-

29-30. Jack Bush. *Tall Spread.* 1966. Acrylic on canvas, $106 \times 50''$ (271 \times 127 cm). The National Gallery of Canada, Ottawa. Purchase. 1966

thaler but also the subjective, emotional connotations found in that of Pollock, de Kooning, Rothko, and Newman. Here, color does not represent emotion; it is simply color. The painting is simply a painting, not a metaphor for something beyond art. The luscious "veil" of blended colors in *Saraband*—which Louis created by tipping the canvas to allow the thinned acrylics to flow according to their inherent properties—offers pure delight to the eye.

In Canada, the leading practitioner of Post-Painterly Abstraction was the Toronto-based Jack Bush (1909–77). He adopted the mode after a 1957 meeting with Clement Greenberg, who advised Bush to seek in his oils the pared-down effect he had achieved in his watercolors. After working with thinned down oils during the first half of the 1960s, Bush switched to acrylics in 1966, the year he painted *Tall Spread* (fig. 29-30). In this large painting from Bush's Ladder series, a stack of color bars fills the right side of the canvas, held in place by a single

29-31. Bridget Riley. *Current.* 1964. Synthetic polymer on board, $58^3/8$ " $\times 58^7/8$ " (148 \times 149 cm). The Museum of Modern Art, New York. Philip Johnson Fund, (576.1964)

While the American popular media loved Op art, most avant-garde critics detested it. Lucy Lippard, for example, called it "an art of little substance," depending "on purely technical knowledge of color and design theory which, when combined with a conventional geometric . . . framework, results in jazzily respectable jumping surfaces, and nothing more." For Lippard and like-minded New York critics, Op was too involved with investigating the processes of perception to qualify as serious art.

brown vertical stripe at the left. While the bands of the ladder alternate in **value** between dark and light, Bush chose their **hues** not according to any systematic logic but rather intuitively. Similarly, he avoided geometric regularity by varying the width of each band and leaning its top and bottom edges slightly off the horizontal. Thus, for all its formalism, the painting retains a sense of unpredictability and a "hand-made" character that give it a deeply human quality.

Bush once characterized his art as "something to look at, just with the eye, and react." Greenbergian critics of the 1960s used the term optical to describe Post-Painterly Abstractions because they appealed exclusively to the sense of sight. In the mid-1960s, the term optical was also applied in a different and narrower sense to a kind of nonobjective art that used precisely structured patterns of lines and colors to affect visual perception and, often, to create illusions of motion. Optical art, popularly known as Op art, achieved its greatest notoriety in the United States when it was featured in "The Responsive Eye," an international survey of "perceptual abstraction" staged in 1965 at the Museum of Modern Art in New York. Among the Op paintings included was Current (fig. 29-31), by the English painter Bridget Riley (b. 1931). During the early 1960s Riley worked exclusively in black and white, using simple

motifs such as squares, triangles, and circles, which she distorted and arranged in patterns that produced effects of fluctuating motion. In other paintings, such as *Current*, she used tightly spaced, parallel, curved lines, creating a swimming or billowing sensation. As with many Op works, staring at the pattern may produce discomfort.

MINIMALISM AND POST-MINIMALISM

In its emphasis on hard-edged geometry, Op art held a formal relationship to Minimalism, which emerged in the mid-1960s as the dominant mode of abstraction in New York. Following Clement Greenberg's theory of modernism, Minimalists sought to purge their art of everything that was not essential to art. They banished subjective gestures and personal feelings; negated representation, narrative, and metaphor; and focused exclusively on the art work as a physical fact. They employed simple geometric forms with plain, unadorned surfaces and often used industrial techniques and materials to achieve an effect of complete impersonality.

The painter Frank Stella (b. 1936) inaugurated the Minimalist movement in the late 1950s through a series of large "Black Paintings," whose flat, symmetrical black enamel stripes, laid down on bare canvas with a house

29-32. Frank Stella. *Avicenna*. 1960. Aluminum paint on canvas, $6'2^{1}/2'' \times 6'$ (1.91 \times 1.85 m). The Menil Collection, Houston.

painter's brush, rejected the varied colors, spatial depth, asymmetrical compositions, and impulsive brushwork of gestural painters like de Kooning. In 1960 Stella created a series of "Aluminum Paintings," using a metallic paint normally applied to radiators. He chose this paint because it "had a quality of repelling the eye" and created an even flatter, more abstract effect than had the "soft" black enamel. While the Black Paintings featured straight bands that either echoed the edges of the rectangular canvas or cut across them on the diagonal, in Aluminum Paintings such as *Avicenna* (fig. 29-32) Stella arrived at a more consistent fit between the shape of the support and the stripes painted on it by cutting notches out of the corners and the center of the canvas and making the stripes "jog" in response to these irregularities.

In these and subsequent series, Stella continuously developed the possibilities of the shaped canvas. He used thick stretchers (the pieces of wood on which canvas is stretched) to give his works the appearance of slablike objects, which his friend Donald Judd (1928-94) recognized as suggesting sculpture. By the mid-1960s Judd, trained as a painter, had decided that sculpture offered a better medium for creating the kind of pure, matter-offact art that he and Stella both sought. Rather than depicting shapes, as Stella did-which Judd thought still smacked of illusionism-Judd created actual shapes. In search of maximum simplicity and clarity, he evolved a formal vocabulary featuring identical rectangular units arranged in rows and constructed of industrial materials especially galvanized iron, anodized aluminum, stainless steel, and Plexiglas. Untitled (fig. 29-33) is a typical exam-

29-33. Donald Judd. *Untitled.* 1969. Anodized aluminum and blue Plexiglas, each $47^1/_2$ " \times $59^7/_8$ " \times $59^7/_8$ " (1.2 \times 1.5 \times 1.5 m); overall $47^1/_2$ " \times $59^7/_8$ " \times $278^1/_2$ " (1.2 \times 1.5 \times 7.7 m). The St. Louis Art Museum, St. Louis, Missouri Purchase funds given by the Shoenberg Foundation, Inc. Art ©Donald Judd Estate/Licensed by VAGA, New York, NY

ple of his mature work, which the artist did not make by hand but had fabricated according to his specifications. He faced the boxes with transparent Plexiglas to avoid any uncertainty about what might be inside. He arranged them in evenly spaced rows—the most impersonal way to integrate them—and generally avoided sets of two or three because of their potential to be read as representative of something other than a row of boxes. Judd provided the viewer with a set of clear, self-contained facts, setting the conceptual clarity and physical perfection of his art against the messy complexity of the real world.

29-34. Eva Hesse. *Rope Piece.* 1969–70. Latex over rope, string, and wire; two strands, dimensions variable. Whitney Museum of American Art, New York.

Purchase, with funds from Eli and Edythe L. Broad, the Mrs. Percy Uris Purchase Fund, and the Painting and Sculpture Committee, (88.17 a-b)

Such messy complexity is exactly what the Post-Minimalists of the late 1960s allowed back into their art. While these artists retained the Minimalists' commitment to abstraction, they replaced the impersonal and timeless geometry of Minimalism with irregular forms that often suggested narrative or metaphorical content. And while the Minimalists favored hard, industrial materials, the Post-Minimalists often employed soft, flexible materials such as felt, string, latex, and rubber.

A leading Post-Minimalist was Eva Hesse (1936–70), whose brief career was cut tragically short by her death from a brain tumor at the age of thirty-four. Born in Hamburg to German Jewish parents, Hesse narrowly escaped the Nazi Holocaust by immigrating with her family to New York City in 1939. After graduating from the Yale School of Art in 1959, she painted darkly expressionistic self-portraits that reflected the emotional turbulence of her life. In 1964 she began to make nonobjective sculpture that adapted the vocabulary of Minimalism to a similarly self-expressive purpose. "For me . . .," said Hesse, "art and life are inseparable. If I can name the content . . . it's the total absurdity of life." In aesthetic terms, the "absurdity" that Hesse pursued in her last works was the complete denial of fixed form and scale, so vital to Minimalists like Judd. Her Rope Piece (fig. 29-34), for example, takes on a different shape and different dimensions each time it is installed. The work consists of several sections of rope, which Hesse and her assistant dipped in latex, knotted and tangled,

and then hung from wires attached to the ceiling. The resulting linear web extends into new territory the tradition of "drawing in space" inaugurated by Julio González (see fig. 28-69) and advanced by David Smith (see fig. 29-15). Much more than a welded sculpture, Hesse's *Rope Piece* resembles a three-dimensional version of a poured painting by Jackson Pollock, and, like Pollock's work, it achieves a sense of structure despite its chaotic appearance.

CONCEPTUAL AND PERFORMANCE ART

While Hesse and other Post-Minimalists made art works whose mutability challenged the idea of the art object as static and durable, the artists who came to be known as Conceptualists pushed Minimalism to its logical extreme by eliminating the art object itself. Although the Conceptualists always produced something physical, it was often only a printed statement, a set of directions, or a documentary photograph. This shift away from the aesthetic object toward the pure idea was largely inspired by the growing reputation of Marcel Duchamp and his assertion that making art should be a mental, not a physical, activity. Deemphasizing the art object also kept art from becoming simply another luxury item, a concern raised by the booming market for contemporary art that rose during the 1960s.

The most prominent American Conceptual artist, Joseph Kosuth (b. 1945), abandoned painting in 1965

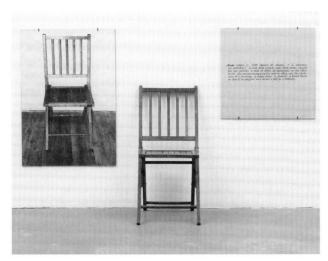

29-35. Joseph Kosuth. *One and Three Chairs.* 1965. Wood folding chair, photograph of chair, and photographic enlargement of dictionary definition of chair; chair, $32\frac{3}{8} \times 14\frac{7}{8} \times 20^{7} \frac{8}{8}$ " (82.2 \times 37.8 \times 53 cm); photo panel, $36 \times 24\frac{1}{8}$ " (91.4 \times 61.3 cm); text panel $24\frac{1}{8} \times 24\frac{1}{2}$ " (61.3 \times 62.2 cm). The Museum of Modern Art, New York. Larry Aldrich Foundation Fund, (383.1970 a-c)

and began to work with language, under the influence of Duchamp and the linguistic philosopher Ludwig Wittgenstein (1889–1951). Kosuth believed that the use of language would direct art away from aesthetic concerns and toward philosophical speculation. His *One*

and Three Chairs (fig. 29-35) invites such speculation by presenting an actual chair, a full-scale black-and-white photograph of the same chair, and a dictionary definition of the word *chair*. The work thus leads the viewer from the physical chair to the purely linguistic ideal of "chairness" and invites the question of which is the most "real."

Many Conceptual artists used their bodies as an artistic medium and engaged in simple activities or performances that they considered works of art. Use of the body offered another alternative to object-oriented mediums like painting and sculpture, and it produced no salable art work unless the artist's activity was recorded on film or video. One artist who used his body as an artistic medium in the late 1960s was the California-based Bruce Nauman (b. 1941). In 1966–67 he made a series of eleven color photographs based on wordplay and visual puns. In *Self-Portrait as a Fountain* (fig. 29-36), for example, the bare-chested artist tips his head back, spurts water into the air, and, in the spirit of Duchamp, designates himself a work of art.

As we have already seen in the case of Yves Klein (see fig. 29-21) and Jannis Kounellis (see fig. 29-1), European artists of the period also engaged in conceptual and performance art. Among the most influential of them was the German Joseph Beuys (1921–86), who dedicated his highly unconventional art to promoting social change. A Nazi fighter pilot during World War II, Beuys was shot down over the Soviet Union in 1943 and

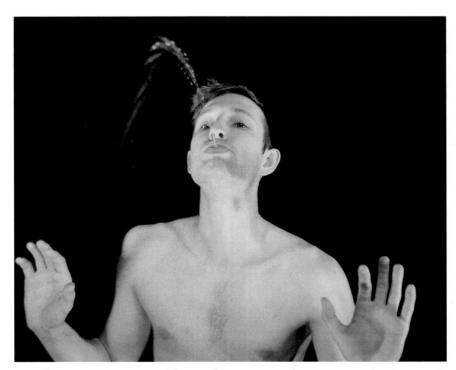

29-36. Bruce Nauman. *Self-Portrait as a Fountain*. 1966–67. Color photograph, $19^3/_4 \times 23^3/_4$ " (50.1 \times 60.3 cm).

Courtesy Leo Castelli Gallery, New York

Regarding his works of the later 1960s, Nauman observed, "I was using my body as a piece of material and manipulating it. I think of it as going into the studio and being involved in some activity. Sometimes it works out that the activity involves making something, and sometimes the activity itself is the piece."

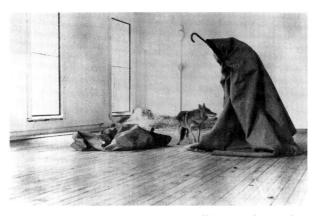

29-37. Joseph Beuys. *Coyote: I Like America and America Likes Me.* 1974. Weeklong action staged in the René Block Gallery, New York.

Courtesy Ronald Feldman Fine Arts, New York

was saved by nomadic Tatars, who, according to Beuys, saved him by wrapping him in fat and animal-hair felt to preserve his body warmth. Later, Beuys elaborated his rescue into a personal mythology of rebirth, which became central to his art. In 1962 Beuys joined Fluxus, an international movement founded largely by experimental musicians who, in the spirit of John Cage, advocated performance art as a means of eliminating the barriers between art and life. From this point forward, Beuys produced performance art, or "actions," that communicated his concern with healing and rebirth. For his 1974 action Covote: I Like America and America Likes Me (fig. 29-37), Beuys landed in New York, was wrapped in felt, and was taken by ambulance to a Manhattan gallery, part of which was cordoned off with industrial chainlink fencing. Inside was a live coyote, a symbol for Beuys of the Native American people traumatized by the European appropriation of their lands and of the American wilderness threatened with extinction by modern industrial society. For seven days Beuys and the coyote lived together. Beuys, wrapped in a felt tent from which a shepherd's crook protruded, silently followed the animal around, sometimes mimicking it. Beuys saw felt as a regenerative natural material, one capable of healing the sick. The crook is the Tatar shaman's symbol. The artist thus presented himself as the shaman, come to help save the native peoples and wildlife of the United States and in this way heal a sick nation.

POSTWAR AMERICAN PHOTOGRAPHY

Documentary photography, which flourished under New Deal patronage in the 1930s (see fig. 28-74), went into eclipse following the withdrawal of government support during World War II. Meanwhile, photojournalism, which burgeoned in the 1930s with the appearance of large-format picture magazines such as *Life*, grew in importance during the postwar decades. Fashion periodicals such as *Vogue* and *Harper's Bazaar* also provided work for professional photographers and stimulated the development of color photography.

Many photographers took on commercial assignments to earn a living while producing independent work more expressive of their personal concerns and aesthetic interests. An important noncommercial trend that emerged in the 1950s was a new form of documentary photography that rejected traditional aesthetic standards to survey in a raw and unsentimental manner what one writer called the "social landscape." The founder of this mode was the Swiss-born American photographer Robert Frank (b. 1924). Frustrated by the pressure and banality of news and fashion assignments, Frank applied successfully for a Guggenheim Fellowship in 1955 to finance a yearlong photographic tour of the United States. From more than 28,000 images, he selected 83 for a book published first in France as Les Américains in 1958 and a year later in an Englishlanguage edition as The Americans, with an introduction by the Beat writer Jack Kerouac (1922-69).

The book was poorly received by American critics, who were disturbed by Frank's often haphazard style. Frank, however, was capable of producing classically balanced and sharply focused images, but only when it suited his sense of the truth. The perfect symmetry of *Trolley, New Orleans* (fig. 29-38), for example, ironically underscores the racial prejudice of segregation that it documents. White passengers sit in the front of the trolley, African Americans in the back. At the same time, the rectangular frames of the trolley windows isolate the individuals looking through them, evoking a sense of urban alienation.

In her complete preoccupation with subject matter, Diane Arbus (1923–71), even more than Frank, rejected the concept of the elegant photograph, discarding the niceties of conventional art photography (fig. 29-39). She developed this approach partly in reaction to her experience as a fashion photographer during the 1950s—she and her husband, Allan Arbus, had been *Seventeen* magazine's favorite cover photographers—but mostly because she did not want formal concerns to distract viewers from her compelling, often disturbing subjects.

Other postwar American photographers remained largely aloof from the "social landscape" and continued the modernist tradition, taking "straight" photographs of natural and human-made subjects that possessed powerfully abstract qualities when translated into cropped, flattened, black-and-white images. A leading practitioner of this mode was Minor White (1908–76), whose aesthetically beautiful photographs were also meant to be forms of mystical expression, vehicles of self-discovery and spiritual enlightenment. Using a large-format camera, White focused sharply on weathered rocks (fig. 29-40, page 1112), swirling waves, frosted windowpanes, peeling paint, and similar "found" subjects that, as enigmatic photographic images, can induce in the viewer a meditative state.

White's student Jerry N. Uelsmann (b. 1934) departed from his teacher's commitment to straight photography by creating composite images through the combination of several negatives, a practice initiated in the midnineteenth century by photographic artists like Oscar

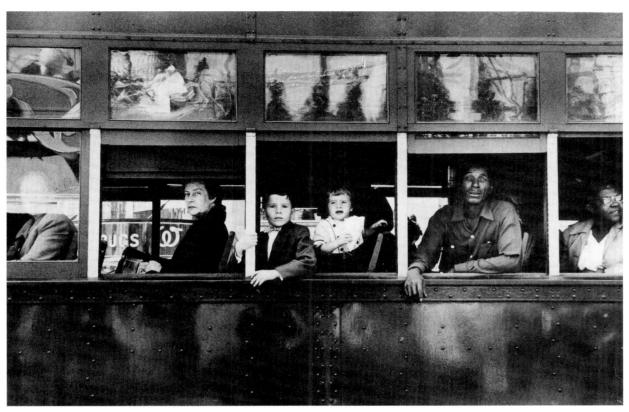

29-38. Robert Frank. *Trolley, New Orleans.* 1955–56. Gelatin-silver print, $9 \times 13''$ (23×33 cm). The Art Institute of Chicago.

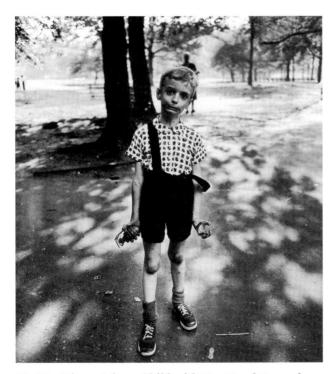

29-39. Diane Arbus. *Child with Toy Hand Grenade, New York.* 1962. Gelatin-silver print, $8^{1}/_{4} \times 7^{1}/_{4}$ " (21 × 18.4 cm). The Museum of Modern Art, New York. Purchase

Rejlander (see fig. 27-35). Uelsmann used sophisticated darkroom techniques to fuse disparate, incongruous images into a seamless, surreal whole that appears to be an objective record of the absurd (fig. 29-41, page 1112).

THE RISE OF AMERICAN CRAFT ART

Since the Renaissance, Western critics and art historians have generally maintained a distinction between the so-called high or fine arts—architecture, sculpture, painting, the graphic arts, and, more recently, photography—and the so-called minor or decorative arts—such as pottery, textiles, glassware, metalwork, furniture, and jewelry, which typically serve either a practical or an ornamental function. In the postwar decades, however, a number of artists began to push traditional craft mediums such as clay, fiber, glass, metal, and wood in new directions and to create new forms of expression that blurred the conventional distinctions between fine and decorative art, establishing a mode somewhere between the two that might best be called craft art.

A major innovator in the clay medium was the Montana-born Peter Voulkos (1924–2002), who after working briefly as a production potter came under the influence of de Kooning and other gestural painters on a visit to New York City in 1953. The radical American

29-40. Minor White. *Capitol Reef, Utah.* 1962. Gelatin-silver print. The Museum of Modern Art, New York.

Purchase. Courtesy © The Minor White Archive, Princeton, N.J.

29-41. Jerry N. Uelsmann. Untitled. 1969. Gelatin-silver print. The Art Institute of Chicago. Restricted gift of the People's Gallery (1971.558)

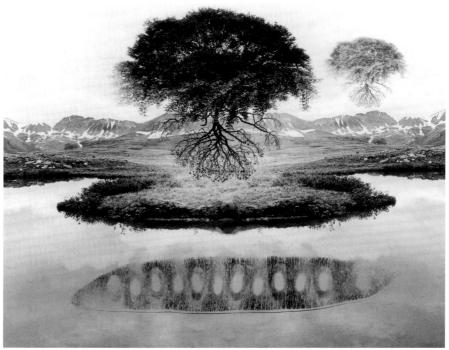

29-42. Peter Voulkos. Untitled Plate. 1962. Gas-fired stoneware with glaze, diameter $16^{1}/_{4}$ " (41.3 cm). The Oakland Museum of California.

Gift of the Art Guild of The Oakland Museum Association (62.87.4)

break from European and Asian traditions—sometimes called the "clay revolution"—began with the ruggedly sculptural ceramic works Voulkos produced in the mid-1950s, which resembled traditional pottery only in their retention of the basic form of a hollow container. By the late 1950s Voulkos had abandoned the pot form and was making large ceramic works spontaneously assembled from numerous wheel-thrown and slab-built elements, their surfaces often covered with bright, gesturally applied glazes or epoxy paint. In the early 1960s, Voulkos returned to traditional ceramic forms such as dishes (fig. 29-42), buckets, and vases but rendered them nonfunctional by tearing, gouging, and piercing them in the gestural fashion derived from Abstract Expressionism. Voulkos made many of these works, including the one illustrated here, at the workshop-demonstrations he gave throughout the country, where, much like a jazz musician, he worked improvisationally before an audience.

Despite resistance from conservative potters, the clay revolution spread rapidly across university art departments in the early 1960s. A comparable revolution in glass was initiated by Harvey Littleton (b. 1922), a ceramics professor at the University of Wisconsin who turned to glassblowing in the 1960s. Paralleling the move that Voulkos had made in clay, Littleton abandoned the production of traditional, functional vessels for experimentation with nonfunctional, sculptural forms like Implosion/Explosion (fig. 29-43). Here Littleton violated the customarily painstaking discipline of glassblowing, smashing the blown-glass bubble and then reheating it to force the walls of the piece to bend outward while appearing to cave in. As with the gesturally handled clayworks of Voulkos, the expressionistic look of Littleton's glass piece bears comparison to the work of the New York School action painters.

29-43. Harvey Littleton. Implosion/Explosion. 1964. Blown glass, height $7\frac{1}{2}$ " (19.2 cm). The Toledo Museum of Art, Ohio

Gift of Maurine B. Littleton and Carol Shay (1992.36)

In 1963, Littleton established the nation's first hot-glass studio program at the University of Wisconsin, and other glass programs soon sprang up around the country. Many of them were led by Littleton's former students, including Dale Chihuly (see fig. 16, Introduction), who established the famous Pilchuck Glass School in Seattle in 1971.

A leading American innovator in the textile medium during this period was Lenore Tawney (b. 1907), who, like Voulkos and Littleton, willingly broke the traditional rules of her craft when she found them too confining. Starting in the early 1960s, Tawney rejected the traditional rectangular tapestry format by making shaped weavings (fig. 29-44, page 1114), in which the strands of the warp are not parallel but angled or curved. Her use of an open, gauze-weave technique derived from Peruvian textiles gave her forms a sense of volume, while her invention of a special reed for the loom enabled her to vary the shape of the work as she wove it. With a series of elegantly tall and austerely beautiful tapestries that she called woven forms, Tawney transformed the surface-oriented medium of weaving into a threedimensional art form and declared, "It is sculptural."

MODERNISM TO POSTMODERNISM Outside of the work of

FROM The 1960s were a watershed period in the history of modern art. Beuys, Kounellis, and a

few other socially engaged avant-garde artists, little of the earlier modernist faith in the transformative power of art is evident in the works produced during the decade. Although the Minimalists continued to believe that the history of art had a coherent, progressive shape and that art represented a pure realm outside ordinary "bourgeois" culture, the purity, honesty, and clarity of

29-44. Lenore Tawney. *Black Woven Form (Fountain).* 1966. Linen, $8'7'' \times 1'3^{1/4}''$ (2.62 \times 0.39 m). Museum of Arts and Design, New York.

their art were not meant to change the world but to retreat from it. To the next generation, by contrast, the concepts of artistic purity and the mainstream seemed naive. In fact, the generation that came to maturity around 1970 had little faith in either purity or progress. The optimism that had characterized the beginning of the modernist era and had survived both world wars gave way to a growing uncertainty about the future and about art's power to influence it. The decline of modernism in the arts was neither uniform nor sudden. Its gradual erosion occurred over a long period and was the result of many individual transformations. The many approaches to art that have emerged from the ruins of modernism are designated by the catchall term postmodernism.

ARCHITECTURE

As in painting and sculpture, modernism endured in architecture until about 1970. The stripped-down International Style pioneered by such architects as Walter Gropius (see figs. 28-43, 28-58) and Le Corbusier (see figs. 28-54, 28-55) dominated new urban construction in much of the world after World War II. Many of the most

29-45. Ludwig Mies van der Rohe and Philip Johnson. Seagram Building, New York City. 1954–58.

famous examples of International Style architecture were built in the United States by German architects, such as Gropius and Mies van der Rohe, who during the Nazi era assumed prestigious positions at American schools of architecture.

Whether designing schools, apartments, or office buildings, Mies used the same simple, rectilinear industrial vocabulary. The differences among his buildings are to be found in their details. Because he had a large budget for the Seagram Building in New York City (fig. 29-45), for instance, he used custom-made bronze (instead of standardized steel) beams on the exterior, an example of his love of elegant materials. Mies would have preferred to leave the internal steel structural supports visible, but building codes required him to encase them in concrete. The ornamental beams on the outside thus stand in for the functional beams inside, much as the shapes on the surface of a Stella painting refer to the structural frame that holds the canvas (see fig. 29-32).

The dark glass and bronze were meant to give the Seagram Company a discreet and dignified image. The building's clean lines and crisp design seemed to epitomize the efficiency, standardization, and impersonality that had become synonymous with the modern corporation itself—which, in part, is why this particular style dominated corporate architecture after World War II. Such buildings were also economical to build. Mies believed that the industrial preoccupation with streamlined efficiency was the dominant value of the day and that the only legitimate architecture was one that expressed this modern spirit.

29-46. Eero Saarinen. Trans World Airlines Terminal, John F. Kennedy Airport, New York. 1956-62

In 2003 the National Trust for Historic Preservation added the TWA Terminal to its list of America's Eleven Most Endangered Historic Places due to plans by the building's owners, the Port Authority of New York and New Jersey, to demolish portions of the terminal and construct a large new terminal behind it, violating the integrity of Saarinen's design and rendering it useless as an aviation structure.

While Mies's pared-down, rectilinear idiom dominated skyscraper architecture well into the 1970s, other building types invited more adventuresome modernist designs that departed significantly from the principles of the International Style. A trend toward powerfully expressive, organic forms, for example, characterized the architecture of numerous buildings dedicated to religious or cultural functions. Expressionist designs sometimes appeared also in commercial architecture, as in the remarkable Trans World Airlines (TWA) Terminal at John F. Kennedy (then Idlewild) Airport in New York City, by the Finnish-born American architect Eero Saarinen (1910–61). Seeking to evoke the excitement of air travel, Saarinen gave his building dynamically flowing interior spaces and covered it with two broad, winglike canopies of reinforced concrete that suggest a huge bird about to take flight (fig. 29-46). Saarinen also designed all of the building's interior details—from ticket counters to telephone booths—to complement the gull-winged shell.

Modernist architects of the post-World War II decades also sought fresh solutions to the persistent challenge of urban housing, which had engaged pioneers of the International Style such as Le Corbusier. The desire for economy led to an interest in the use of standard, prefabricated elements for the construction of both individual houses and larger residential complexes. An innovative example of the latter is Habitat '67 (fig.

29-47, page 1116) by the Israeli-born Moshe Safdie (b. 1938). Built as a permanent exhibit for the 1967 World Exposition in Montreal, the complex consists of three stepped clusters of prefabricated concrete units attached to a zigzagging concrete frame that provides a series of elevated streets and sheltered courtyards. By stacking units that contained their own support system, Safdie eliminated the need for an external skeletal frame and allowed for expansion of the complex simply through the addition of more units. An inspired alternative to the conventional high-rise apartment block, Habitat '67 offers greater visual and spatial variety, increased light and air to individual apartments, and a sense of community not often found in a big city housing project.

Postmodern Architecture. Historians trace the origin of postmodernism in architecture to the work of the Philadelphian Robert Venturi (b. 1925) and his associates, who rejected the abstract purity of the International Style by incorporating into their designs elements drawn from vernacular (meaning popular, common, or ordinary) sources. Parodying Mies van der Rohe's famous aphorism "Less is more," Venturi claimed "Less is a bore" in his pioneering 1966 book, *Complexity and Contradiction in Architecture*. The problem with Mies and the other modernists, he argued, was their impractical

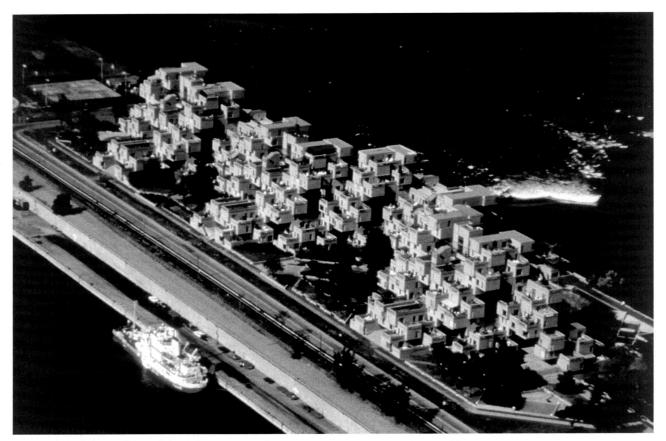

29-47. Moshe Safdie. Habitat '67, Montreal, Quebec, Canada. 1967 World Exposition.

Growing up in Israel, Safdie spent his summers on a kibbutz, or collective farm. This experience partly inspired his plans for Habitat, which adapts aspects of traditional communal living to the social, economic, and technological realities of industrial society.

unwillingness to accept the modern city for what it is: a complex, contradictory, and heterogeneous collection of "high" and "low" architectural forms.

While writing Complexity and Contradiction in Architecture, Venturi designed a house for his mother (fig. 29-48) that illustrated many of his new ideas. The building is both simple and complex. The shape of the facade returns to the archetypal "house" shape—evident in children's drawings-that modernists from Rietveld (see fig. 28-50) to Safdie had rejected. Its vocabulary of triangles, squares, and circles is also elementary, although the shapes are arranged in a complex asymmetry that skews the restful harmonies of modernist design. The most disruptive element of the facade is the deep cleavage over the door, which opens to reveal a mysterious upper wall (which turns out to be a penthouse) and chimney top. On the inside, too, complexity and contradiction reign. The irregular floor plan (fig. 29-49), especially evident in the odd stairway leading to the second floor, is further complicated by the unusual ceilings, some of which are partially covered by a barrel vault.

The Vanna Venturi House makes reference to a number of other buildings, from Michelangelo's Porta Pia in Rome to a nearby house designed by Venturi's mentor, Louis Kahn (1901–74). Although such allusions to architectural history were lost on the general public, they provided many architects, including Philip Johnson (b. 1906),

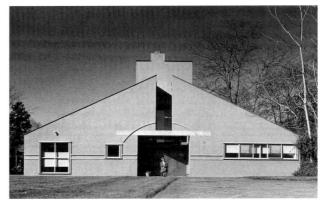

29-48. Robert Venturi. Vanna Venturi House, Chestnut Hill, Pennsylvania. 1961–64.

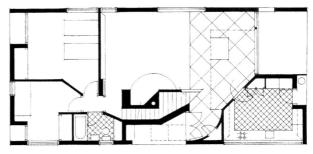

29-49. Ground-floor plan of the Vanna Venturi House.

29-50. Philip Johnson and John Burgee. Model, AT&T Corporate Headquarters, New York. 1978-83.

After collaborating on the Seagram Building (see fig. 29-45) with Mies, who had long been his architectural idol, Johnson grew tired of the limited modernist vocabulary. During the 1960s he experimented with a number of alternatives, especially a weighty, monumental style that looked back to nineteenth-century Neoclassicism. At the end of the 1970s he became fascinated with the new possibilities opened by Venturi's postmodernism, which he found "absolutely delightful."

with a path out of modernism. Johnson's major contribution to postmodernism is the AT&T Corporate Headquarters (now the Sony Building) in New York City (fig. 29-50), an elegant, granite-clad skyscraper whose thirty-six oversized floors reach the height of an ordinary sixtystory building. The skyscraper makes gestures of accommodation to its surroundings: Its smooth, uncluttered surfaces match those of its International Style neighbors, while the classically symmetrical window groupings between vertical piers echo those in more conservative Manhattan skyscrapers built in the early to middle 1900s. What critics focused on, however, was the building's resemblance to a type of eighteenth-century furniture: the Chippendale highboy, a chest of drawers with a longlegged base. Johnson seems to have intended a pun on the terms highboy and high-rise. In addition, the round notch at the top of the building and the arched entryway at the base recall the coin slot and coin return on old pay telephones. Many critics were not amused by Johnson's effort to add a touch of humor to high architecture. His purpose, however, was less to poke fun at his client or his profession than to create an architecture that would appeal to the public and at the same time, like a fine piece of furniture, meet its deeper aesthetic needs with a formal, decorative elegance.

A striking contrast to Johnson's playful postmodernism is the sober, formally reductive Neo-Rationalism of the Italian Aldo Rossi (1931–97). Rossi based his architecture on a return to certain premodernist building archetypes—such as the church, the house, and the factory—stripped of all ornamentation and reduced to their geometric essentials, much as in the designs of Neoclassicists like Claude-Nicolas Ledoux and Étienne-Louis Boullée (see figs. 26-42, 26-43). He aimed to achieve both historical continuity and universal timelessness. To enrich the emotional impact of these rationally conceived archetypes, Rossi believed that architects should use them in mysterious and evocative ways.

The New Town Hall Rossi built in Italy's industrial belt, in Borgoricco (fig. 29-51), near Venice, illustrates these concepts. The large windows, metal roof, and exhaust chimney derive from nineteenth- and early-twentieth-

Courtesy Aldo Rossi

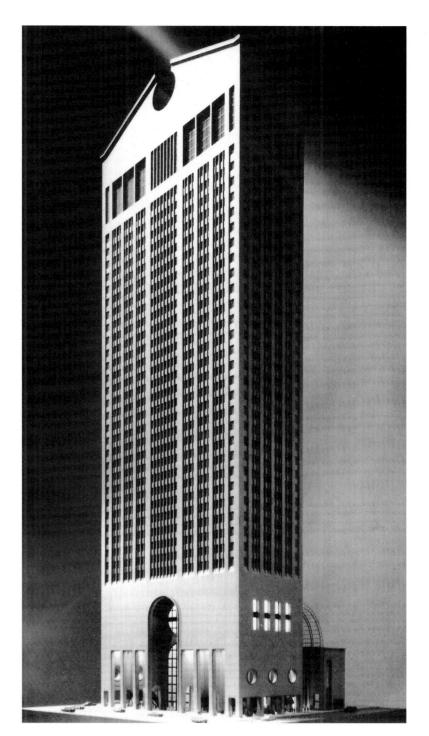

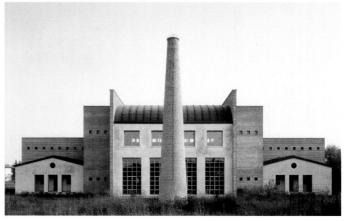

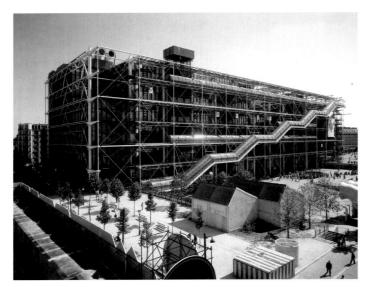

29-52. Renzo Piano and Richard Rogers. Centre National d'Art et de Culture Georges Pompidou, Paris. 1971-77.

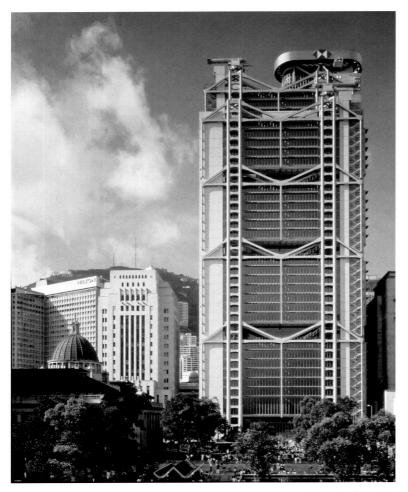

29-53. Norman Foster. HongKong & Shanghai Bank, Hong Kong. 1986.

century factory designs (see fig. 28-43), whereas the temple fronts on the flanking wings, which evoke the building's civic function, are done in a style typical of the aristocratic Palladian housing in the surrounding country-side (see fig. 18-63). The result is a provocative and unexpected marriage of local forms and other European architectural types. The simple geometry and the building's rigorous symmetry give it a stable, timeless air.

High Tech Architecture. Even as postmodernism flourished in the later 1970s and 1980s, another new architectural trend, known as High Tech, challenged it as the dominant successor to an exhausted modernism. Characterized by the expressive use of advanced building technology and industrial materials, equipment, and components, High Tech found its defining monument in the Centre National d'Art et de Culture Georges Pompidou (fig. 29-52) in Paris, designed by Renzo Piano (b. 1937) of Italy and Richard Rogers (b. 1933) of England. Responding to the need for a large, flexible building that would house several different institutions—the French national museum of modern art, a public library, and centers for industrial design and for music and acoustic research—the architects chose to turn the structure inside out, placing its supporting steel frame on the exterior and leaving its vast internal floors uninterrupted by columns. The service and circulation functions are also placed on the exterior and brightly colored, with red designating the elevators, blue the air-conditioning ducts, green the water pipes, and yellow the electrical units. While some criticized the Centre Pompidou as being too radical for its neighborhood, the design in fact makes reference to the origins of functional architecture in Paris, evoking both the glass-and-iron sheds that once stood in the historic market area adjacent to it and the most famous of the exposed-metal structures that gave birth to modernist architecture, the Eiffel Tower (see fig. 27-1).

Among the most spectacular examples of High Tech architecture is the HongKong & Shanghai Bank (fig. 29-53) by Norman Foster (b. 1935), a fellow Englishman and onetime architectural partner of Richard Rogers. Invited by his client to design the most beautiful bank in the world, Foster spared no expense in the creation of this futuristic forty-seven-story skyscraper. The rectangular plan features service towers at the east and west ends, eliminating the central service core typical of earlier skyscrapers such as the Seagram Building (see fig. 29-45). As in the Centre Pompidou, the load-bearing steel skeleton, composed of giant masts and girders, is on the exterior. The individual stories hang from this structure, allowing for uninterrupted facades and open working areas filled with natural light. The main banking hall, the lowest segment of the building, features a ten-story atrium space flooded by daylight refracted from motorized "sunscoops" at its apex, computer-programmed to track the sun and channel its rays into the building. The sole concession Foster's High Tech building makes to tradition are the two bronze lions that guard its public entrance—the only surviving elements from the bank's

29-54. Zaha Hadid. Vitra Fire Station, Weil-am-Rhein, Germany. 1989–93.

previous headquarters. A popular belief holds that touching the lions before entering the bank brings good luck.

Deconstructivist Architecture. "Deconstructivist Architecture," a 1988 exhibition at The Museum of Modern Art in New York, highlighted an international avantgarde tendency to disturb the traditional architectural values of harmony, unity, and stability through the use of skewed, distorted, and impure geometry-an aesthetic early-twentieth-century Russian Suprematist and Constructivist artists and architects (Chapter 28) employed to convey a sense of formal dynamism and, in the case of politically committed Constructivism, the worldtransforming energies of the Russian Revolution. Many architects since the 1980s have combined an awareness of these Russian sources with an interest in the theory of deconstruction developed by French philosopher Jacques Derrida (b. 1930). Concerned mostly with the analysis of verbal texts, Derridean deconstruction holds that no text possesses a single, intrinsic meaning. Rather, its meaning is always "intertextual"—a product of its relationship to other texts—and is always "decentered," or "dispersed" along an infinite chain of linguistic signs the meanings of which are themselves unstable. Deconstructivist architecture is, consequently, often "intertextual" in its use of design elements from other traditions, including modernism, and "decentered" in its denial of a unified and stable form.

A prime example of deconstructivist architecture is the Vitra Fire Station in Weil-am-Rhein, Germany

(fig. 29-54), by the Baghdad-born Zaha Hadid (b. 1950), who studied architecture in London and established her practice there in 1979. Stylistically influenced by the Suprematist paintings of Kasimir Malevich (see fig. 28-34), the Vitra Fire Station features leaning, reinforced concrete walls that meet at unexpected angles and jut dramatically into space, denying any sense of unity while creating a feeling of dynamism appropriate to the building's function.

Represented, like Hadid, in the "Deconstructivist Architecture" show was the Toronto-born, Californiabased Frank O. Gehry (b. 1929), who achieved his initial fame in the late 1970s with his inventive use of vernacular forms and cheap materials set into unstable and conflicted arrangements. After working during the 1980s in a more classically geometrical mode, in the 1990s Gehry developed a powerfully organic, sculptural style, most famously exemplified in his enormous Guggenheim Museum in Bilbao, Spain (fig. 29-55, page 1120). The building's complex steel skeleton is covered with a thin skin of silvery titanium that shimmers gold or silver depending on the light. Like the original Frank Lloyd Wright Guggenheim Museum in Manhattan (fig. 22, Introduction), Gehry's building resembles a living organism from most vantage points except the north, from which it resembles a giant ship, a reference to the shipbuilding so important to Bilbao. The inside features a huge atrium (fig. 29-56, page 1120), which both pays homage to Wright's famous one in New York (see fig. 29-95) and attempts to outdo it in size and effect. In competing with

29-55. Frank O. Gehry. Guggenheim Museum, Bilbao, Spain. 1993-97.

Philip Johnson, the dean of American architects, called the Guggenheim Museum in Bilbao the greatest building of the twentieth century.

29-56. Atrium, Guggenheim Museum, Bilbao, 1997. © The Solomon R. Guggenhein Foundation, NY.

Wright, Gehry meant to provide for the needs of artists, who he claimed "want to be in *great* buildings."

Also frequently described as a deconstructivist is the Polish-born American architect Daniel Libeskind (b. 1946), who gained international acclaim for his Jewish Museum in Berlin (1989-99)—a zinc-clad, thunderboltshaped structure. The sharp diagonals and cramped interiors of this building create feelings of discomfort and disorientation that resonate with the experience of German Jews during the Holocaust. In February 2003, Libeskind won an international design competition to rebuild the site of New York's World Trade Center, destroyed by the terrorist attacks of September 11, 2001. Libeskind's design (fig. 29-57) is centered around a sunken field incorporating the foundations of the destroyed twin towers and the concrete slurry wall that prevented the Hudson River from flooding the site—a metaphor, to Libeskind, of tenacity and survival. This area would also include a memorial to the more than 2,500 people who died there. At the edge of the field, Libeskind proposes to build a museum in his distinctive, angular style, and on the three surrounding sides a cluster of towers, including a skyscraper that will soar to the patriotic height of 1,776 feet—the world's tallest building. This tower would have seventy stories of offices, shops, and restaurants, but its spire—another thirty stories high—would contain gardens, which Libeskind calls "a constant affirmation of life." Libeskind sees the tower

29-57. Daniel Libeskind. Computer-generated design for World Trade Center site, New York. 2002-2003. Courtesy Studio Daniel Libeskind.

rising triumphant from the disaster of September 11, "an affirmation of vitality in the face of danger, an affirmation of life in the aftermath of tragedy."

EARTHWORKS AND SITE-SPECIFIC SCULPTURE

Among the many responses to Minimalism that shaped American avant-garde art of the late 1960s and 1970s was a movement to take art out of the marketplace and back to nature. A number of sculptors began to work outdoors, using raw materials found at the site to fash-

ion **earthworks**. They pioneered a new category of art making called **site-specific sculpture**, which is designed for a particular location, often outdoors.

One of the leaders of the earthworks movement was Michael Heizer (b. 1944), the California-born son of a specialist in Native American archaeology. Heizer moved to New York in 1966 but, disgusted by the growing emphasis on art as an investment, began to spend time in the Nevada desert and to create works there that could not easily be bought and sold and that required a considerable commitment of time from viewers who wanted to see them. There, in 1969–70, Heizer hired

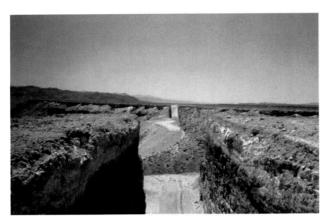

29-58. Michael Heizer. *Double Negative.* 1969–70. 240,000-ton displacement at Mormon Mesa, Overton, Nevada, $1,500 \times 50 \times 30'$ (457.2 \times 15.2 \times 9.1 m). Museum of Contemporary Art, Los Angeles. Gift of Virginia Dwan. Photograph courtesy the artist

bulldozers to produce his most famous work, *Double Negative* (fig. 29-58). Using a simple Minimalist formal vocabulary, he made two gigantic cuts on opposite sides of a canyon wall. To fully understand the work, the viewer needs to walk into the 50-foot-deep channels and experience their awe-inspiring scale. Through its creation of a pure, transcendent artistic alternative to commercialized, urban life, Heizer's work is more modernist than postmodernist.

More postmodern in intention was the work of another major earthworks artist, Robert Smithson (1938–73), a New Jersey native who first traveled to the Nevada

desert with Heizer in 1968. In his mature work Smithson sought to illustrate the "ongoing dialectic" in nature between constructive forces—those that build and shape form-and destructive forces-those that destroy it. Spiral Jetty (fig. 29-59), a 1,500-foot spiraling stone and earth platform extending into the Great Salt Lake in Utah, expresses these ideas. Smithson chose the lake because it recalls both the origins of life in the salty waters of the primordial ocean and the end of life. One of the few organisms that live in the otherwise dead lake is an alga that gives it a red tinge, suggestive of blood. Smithson also liked the way the abandoned oil rigs that dot the lake's shores suggested both prehistoric dinosaurs and some vanished civilization. He used the spiral because it is the most fundamental shape in nature, appearing, for example, in galaxies, seashells, DNA molecules, and even salt crystals. Finally, Smithson chose the spiral because, unlike modernist squares, circles, and straight lines, it is a "dialectical" shape, one that opens and closes, curls and uncurls endlessly. More than any other shape, it suggested to him the perpetual coming and going of things.

Strongly committed to the realization of temporary, site-specific art works in both rural and urban settings are Christo and Jeanne-Claude, both born on June 13, 1935. Christo Javacheff (who uses only his first name) emigrated from his native Bulgaria to Paris in 1958, where he met Jeanne-Claude de Guillebon, the Nouveaux Réalistes, and some of the Fluxus artists. His interest in "wrapping" (or otherwise defining) places or things in swaths of fabric soon became an obsession, and he began wrapping progressively larger items. Their

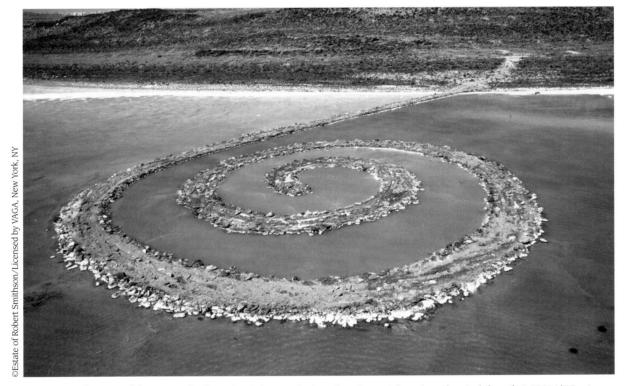

29-59. Robert Smithson. *Spiral Jetty*. 1969–70. Black rock, salt crystal, and earth spiral, length 1,500′ (457 m). Great Salt Lake, Utah. Courtesy James Cohan Gallery, New York

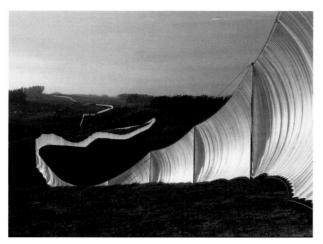

29-60. Christo and Jeanne-Claude. *Running Fence*. 1972–76. Nylon fence, height 18' (5.5 m), length $24^{1}/_{2}$ miles (40 km). Sonoma and Marin counties, California.

first collaborative work, in 1961, was Stacked Oil Barrels and Dockside Packages at the Cologne, Germany, harbor. The pair moved to New York City in 1964. Among their works after this move, in 1968 Christo and Jeanne-Claude wrapped the Kunsthalle museum in Bern, Switzerland, and the following year wrapped 1 million square feet of the Australian coastline. These artists make clear that their first tenet is freedom, so they pay all their own expenses, never accepting sponsors but rather raising funds through the sale of preparatory drawings of the intended project.

Their best-known work, *Running Fence* (fig. 29-60), consisted of a $24^{1}/_{2}$ -mile-long, 18-foot-high nylon fence that crossed two counties in northern California and extended into the Pacific Ocean. The artists chose the location in Sonoma and Marin counties for purely aesthetic reasons, as well as to call attention to the link between urban, suburban, and rural spaces. This concern with aesthetics is common to all their work, in which they reveal the joy and beauty in various spaces. At the same time, the conflict and collaboration between the artists and various social groups open the workings of the political system to scrutiny and invest

their work with a sense of social space. For example, Christo and Jeanne-Claude spent forty-two months countering the resistance of county commissioners, half of whom were for the project from the outset, as well as social and environmental organizations, before they could create *Running Fence*. Meanwhile, the project forged a community of supporters drawn from groups as diverse as college students, ranchers, lawyers, and artists. In a way, the fence broke down the social barriers among those people.

SUPER REALISM

While some avant-garde artists abandoned the studio to work with materials in nature, others remained committed to pushing the traditional mediums of painting and sculpture in new directions. An important new tendency came to public attention in 1972 in the "Sharp Focus Realism" exhibition at the Sidney Janis Gallery in New York City. Although they featured recognizable subject matter, the paintings in the show had aesthetic ties to Minimalism. Instead of being personal, deliberately rough, and painterly, works of this kind, known as Super Realist, are impersonally executed with great technical precision. Often based on color photographs, they are so illusionistic that, when seen in reproduction, they can be mistaken for color photographs themselves.

A leading Super Realist painter is the American Richard Estes (b. 1936), who during the 1970s and early 1980s produced a series of paintings on the theme of reflections, including Prescriptions Filled (Municipal Building) (fig. 29-61). Estes always eliminated people when he transcribed his source photographs to canvas, emphasizing his interest in the aesthetic pleasures of refined compositional arrangements. The window reflection in Prescriptions Filled, for example, allows Estes to create a nearly perfect symmetry. The picture's formal tension comes from the subtle differences between the two halves, especially the point between the lamppost and the edge of the glass window at the center of the painting. Without making any overt commentary on their subjects, Estes's cool, static, and closed paintings suggest that urban life is flat and empty.

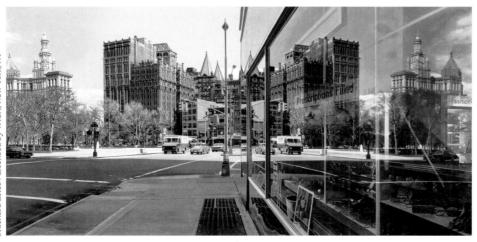

29-61. Richard Estes. *Prescriptions Filled (Municipal Building).* 1983. Oil on canvas, $3 \times 6'$ $(0.91 \times 1.83 \text{ m})$. Private collection. Courtesy Marlborough Gallery, NY

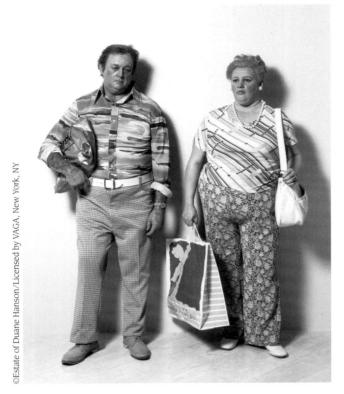

29-62. Duane Hanson. *The Shoppers.* 1976. Cast vinyl, polychromed in oil with accessories, lifesize. Collection the Nerman Family.

Duane Hanson (1925–96), the major sculptor of the Super Realist movement, created astonishingly lifelike figures cast directly from live models in polyester resin and fiberglass, vinyl, or bronze, which he then painted and outfitted with hair, glass eyes, and real clothing and other accessories. His earliest works, which dealt with large social issues such as war, poverty, and racism, were highly dramatic, but about 1970 he turned to more mundane subjects. From that point on, Hanson held up an unflattering mirror to American society's work and leisure. *The Shoppers*, for example (fig. 29-62), shows two garishly dressed, overweight consumers carrying bags with their recent purchases. As their dazed expressions tell us, the material goods that are supposed to make them happy clearly do not.

FEMINIST ART

Feminist art emerged in the context of the Women's Liberation movement of the late 1960s and early 1970s. A major aim of feminist artists and their allies was increased recognition for the accomplishment of women artists, both past and present. A 1970 survey revealed that although women constituted half of the nation's practicing artists, only 18 percent of commercial New York galleries carried works by women. Of the 143 artists in the 1969 Whitney Annual (now the Whitney Biennial), one of the country's most prominent exhibitions of the work of living artists, only eight were women. The next year, the newly formed Ad Hoc Committee of Women Artists, disappointed by the lukewarm response

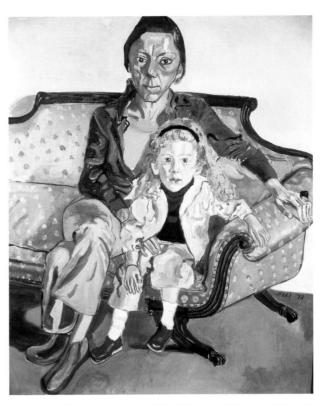

29-63. Alice Neel. *Linda Nochlin and Daisy.* 1973. Oil on canvas, $55^1/_2 \times 44''$ (141 \times 112 cm). Museum of Fine Arts, Boston.

Seth K. Sweetser Fund

Nochlin, then a professor at Vassar College, helped inaugurate feminist art history with her 1971 essay "Why Have There Been No Great Women Artists?" In it, she argued that women had been denied the opportunity to achieve greatness by their exclusion from the male-dominated institutional systems of training, patronage, and criticism that set the standards of professional accomplishment.

of the Whitney's director to their concerns, staged a protest at the opening of the 1970 Annual. To focus more attention on women in the arts, feminist artists began organizing women's cooperative galleries. While feminist art historians wrote in books and journals about women artists and the issues raised by their work, feminist curators and critics promoted the work of both emerging women artists and long-neglected ones, such as Alice Neel (1900–84), who had her first major museum retrospective at age seventy-four.

Reflecting a series of life crises, including the death in infancy of one of her children and the abduction of another by the child's father, Neel's early work featured distorted, expressionistic images of couples, mothers, and children. Her style softened after she moved from Philadelphia to New York in 1932 and began to specialize in frank and revealing images of the people she knew. She first received art world attention in the early 1960s with the revival of figurative painting, but her penetrating portraits were considered too subjective for the prevailing "cool" aesthetic. Her subjects now included well-known critics, curators, artists, and even the feminist art historian Linda Nochlin (fig. 29-63). Neel presents Nochlin as a warm, thoughtful woman, affec-

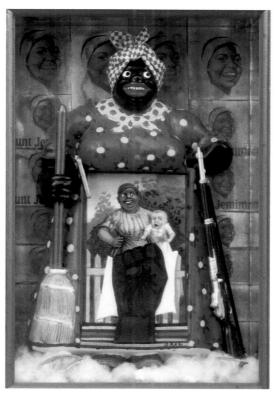

29-64. Betye Saar. The Liberation of Aunt Jemima. 1972. Mixed media, $11^3/_4 \times 11^7/_8 \times 2^3/_4$ " (29.8 \times 30.3 \times 7 cm). Berkeley Art Museum, University of California. Purchased with the aid of funds from the National Endowment for the Arts (selected by The Committee for The Acquisition of Afro-American Art)

tionately holding her daughter, a representative of all those other daughters whose future prospects Nochlin was devoted to enlarging.

Another artist who achieved widespread recognition only with the arrival of the feminist movement was the Los Angeles-based African-American sculptor Betye Saar (b. 1926). Inspired by the glass-fronted box assemblages of the American Joseph Cornell (1903-72), Saar began to construct her own boxes in which she juxtaposed found objects. Several early works in this medium reflect both feminist interests and the aims of the civil rights movement. Saar's best-known work, The Liberation of Aunt Jemima (fig. 29-64), appropriates the derogatory stereotype of the cheerfully servile "mammy" and transforms it into an icon of militant black feminist power. Set against a background papered with the smiling advertising image of Aunt Jemima, stands a note pad holder in the form of an Aunt Jemima. She holds a broom (whose handle is actually the pencil for the note pad) and pistol in one hand and a rifle in the other. In the place of the note pad is a picture of another jolly mammy holding a crying child identified by the artist as a mulatto, or person of mixed black and white ancestry. In front of this pair is a large clenched fist—a symbol of "black power" signaling African Americans' willingness to use force to achieve their aims. Saar's armed Jemima liberates herself not only from racial oppression but also from traditional gender roles that had long relegated black women to such subservient positions as domestic servant or mammy.

A younger artist who assumed a leading role in the 1970s was Judy Chicago (b. 1939), whose The Dinner Party (figs. 29-65, 29-66, "The Object Speaks," page 1126) is perhaps the best-known work of feminist art created in that decade. Born Judy Cohen, she became Judy Gerowitz after her marriage and then in 1970 adopted the surname Chicago (from the city of her birth) to free herself from "all names imposed upon her through male social dominance." Originally a Minimalist sculptor, Chicago in the late 1960s began to make abstracted images of female genitalia designed to challenge the aesthetic standards of the male-dominated art world and to validate female experience. In 1970 she established the first feminist studio art course at Fresno State College (now California State University, Fresno). The next year, she moved to Los Angeles and teamed up with the painter Miriam Schapiro (b. 1923) to establish at the new California Institute of the Arts (CalArts) the Feminist Art Program, dedicated to training women artists.

During the first year of the program, Chicago and Schapiro led a team of twenty-one female students in the creation of *Womanhouse* (1971–72), a collaborative art environment set in a run-down Hollywood mansion, which the artists renovated and filled with installations that addressed women's issues. Schapiro's work for *Womanhouse*, created in collaboration with Sherry Brody, was *The Dollhouse*, a mixed-medium construction featuring several miniature rooms adorned with richly patterned fabrics. Schapiro soon began to incorporate

THE OBJECT SPEAKS

THE DINNER PARTY

complex, mixed-medium installation that fills an en-A tire room, Judy Chicago's The Dinner Party speaks powerfully of the accomplishments of women throughout history. Five years of collaborative effort went into the creation of the work, involving hundreds of women and several men who volunteered their talents as ceramists, needleworkers, and china painters to realize Chicago's designs. The Dinner Party is composed of a large, triangular table, each side stretching 48 feet, which rests on a triangular platform covered with 2,300 triangular porcelain tiles (fig. 29-65). Chicago saw the equilateral triangle as a symbol of the equalized world sought by feminism and also identified it as one of the earliest symbols of the feminine. The porcelain "Heritage Floor" bears the names of 999 notable women from myth, legend, and history. Along each side of the triangular table, thirteen place settings each represent a famous woman. Chicago chose the number thirteen because it is the number of men who were present at the Last Supper and also of witches in a coven, and therefore a symbol of occult female power. The thirty-nine women honored through the place settings include mythical ancient goddesses like Ishtar, legendary figures like the Amazon, and historical personages such as the Egyptian queen Hatshepsut, the Roman scholar Hypatia, the medieval French queen Eleanor of Aguitaine, the medieval French author Christine de Pizan (see fig. 20, Introduction), the Italian Renaissance noblewoman Isabella d'Este (see page 672), the Italian Baroque painter Artemesia Gentileschi (see figs. 19-19 and fig. 19-20), the eighteenth-century English feminist writer Mary Wollstonecraft (fig. 29-66), the nineteenth-century American abolitionist Sojourner Truth, and the twentiethcentury American painter Georgia O'Keeffe (see figs. 5, Introduction, and 28-71).

Each place setting features a 14-inch-wide painted porcelain plate, ceramic flatware, a ceramic chalice with a gold interior, and an embroidered napkin, all set upon an elaborately decorated runner. The runners incorporate decorative motifs and techniques of stitching and weaving appropriate to the period with which each woman was associated. Most of the plates feature abstract designs based on female genitalia because, Chicago said, "that is all [the women at the table] had in common. . . . They were from different periods, classes, ethnicities, geographies, experiences, but what kept them within the same confined historical space" was the fact of their biological sex. Chicago thought it appropriate to represent the women through plates because they "had been swallowed up and obscured by history instead of being recognized and honored."

Chicago emphasized china painting and needlework in *The Dinner Party* to celebrate craft mediums traditionally practiced by women and to argue that they should be considered "high" art forms on a par with painting and sculpture. This argument complemented her larger aim of raising awareness of the many contributions women have made to history, thereby fostering women's empowerment in the present.

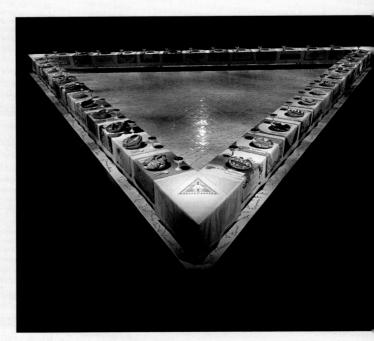

29-65. Judy Chicago. *The Dinner Party.* 1974–79. Overall installation view. White tile floor inscribed in gold with 999 women's names; triangular table with painted porcelain, sculpted porcelain plates, and needlework, each side $48' \times 42 \times 3'$ ($14.6 \times 12.8 \times 1$ m). The Brooklyn Museum of Art.

Gift of the Elizabeth A. Sackler Foundation, (2002.10)

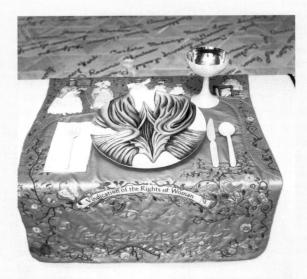

29-66. *Mary Wollstonecraft* place setting, detail of *The Dinner Party.*

29-67. Miriam Schapiro. *Personal Appearance* #3. 1973. Acrylic and fabric on canvas. $60 \times 50''$ (152.4 \times 127 cm). Private collection

Schapiro championed the theory that women have a distinct artistic sensibility that can be distinguished from that of men, and hence a specifically feminine aesthetic. During the late 1950s and 1960s she made explicitly female versions of the dominant modernist styles, including reductive, hard-edged abstractions of the female form: large X-shapes with openings at their centers. In 1973 she created *Personal Appearance #3*, using underlying hard-edge rectangles and overlaying them with a collage of fabric and paper—materials associated with women's craftwork—the formal and emotional richness of which were meant to counter the Minimalist aesthetic of the 1960s, which Schapiro and other feminists considered typically male.

pieces of fabric into her acrylic paintings, developing a type of work she called femmage (from *female* and *collage*). Schapiro's femmages, such as the exuberant *Personal Appearance #3* (fig. 29-67), celebrate traditional women's craftwork. After returning to New York from California in 1975, Schapiro became a leading figure in the Pattern and Decoration movement. Composed of both female and male artists, this movement sought to merge modernist abstraction with ornamental motifs derived from women's craft, folk art, and a variety of non-Western sources in order to break down hierarchical distinctions among them.

Not usually considered part of the Pattern and Decoration movement but closely aligned with its aims, the African-American artist Faith Ringgold (b. 1930) began in the early 1970s to paint on soft fabrics rather than stretched canvases, and to frame her images with decorative quilted borders. Ringgold's mother, Willi Posey, a fashion designer and dressmaker, made these quilted borders until her death in 1981, after which Ringgold took responsibility for both the quilting and the painting. In 1977 Ringgold began writing her autobiography (We Flew Over the Bridge: The Memoirs of Faith Ringgold, 1995). Not immediately finding a publisher, she decided to write her stories on her quilts, and in the early 1980s inaugurated what became her signature medium: the story quilt.

Animated by a powerful feminist sensibility, Ringgold's story quilts are always narrated by women, and

usually address themes related to women's lives. A splendid example is Tar Beach (fig. 29-68, page 1128), whose fictional narrator, eight-year-old Cassie Louise Lightfoot, is based on the artist's childhood memories of growing up in Harlem. The "Tar Beach" of the title is the roof of the apartment building on which Ringgold's family, lacking air conditioning, would sleep on hot summer nights. Cassie describes sleeping on Tar Beach as a magical experience. As she lies on a blanket with her brother, she dreams that she can fly, and possess everything over which she passes. Cassie can fly over the George Washington Bridge and make it hers; she can fly over the new union building and claim it for her father a half-black, half-Indian man who helps to construct it but is prevented by his race from joining the union; she can fly over an ice cream factory to guarantee her mother "ice cream every night for dessert." Ringgold's colorful painting in the center of the guilt shows Cassie and her brother lying on a blanket at the lower right while their parents and two neighbors play cards at a table at center. Directly above the adults appears a second Cassie, magically flying over the George Washington Bridge against a star-dotted sky. Cassie's childish fantasy of achieving the impossible is charming but also delivers a serious message by reminding the viewer of the real social and economic limitations that African Americans have faced throughout their history.

Many feminists, including Cuban-born Ana Mendieta (1948–85), celebrated the notion that women have a

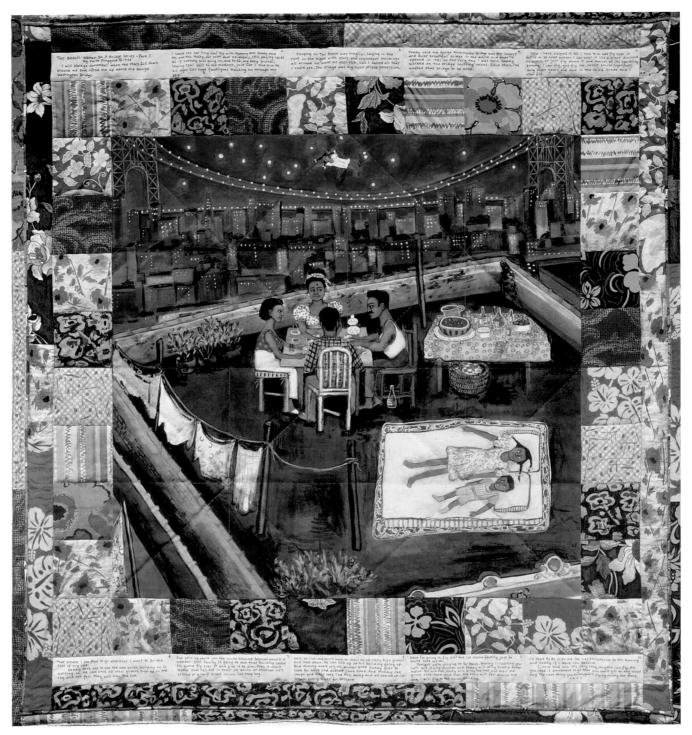

29-68. Faith Ringgold. *Tar Beach.* (Part I from the *Woman on a Bridge series*). 1988. Acrylic on canvas, bordered with printed, painted, quilted, and pieced cloth, $74^5/8 \times 68^1/2$ " (190.5 \times 174 cm). Solomon R. Guggenheim Museum, New York. Gift, Mr. and Mrs. Gus and Judith Lieber, 1988, (88.362)

Tar Beach is the first and best known work in Ringgold's Woman on a Bridge Series, which employs American bridges as settings for fantsay scenes of black female accomplishment. In 1991, Ringgold adapted Tar Beach into a highly successful children's book that won over twenty literary awards, including the prestigious Caldecott Honor Book Award and the Corretta Scott King Award for illustration. She went on to produce three more children's books over the next five years. Ringgold notes that these books "seek to explain to children some of the hard facts of ... racial prejudice ... [but] are even more about children having dreams and instilling in them the belief that they can change things."

deeper identification with nature than do men. By 1972 Mendieta had rejected painting for performance and body art. Inspired by Santería, an Afro-Caribbean religion emphasizing immersion in nature, she produced ritualistic performances on film, as well as about 200 earth-and-body works, called Silhouettes, which she

recorded in color photographs. Some were done in Mexico, and others, like the Tree of Life series (fig. 29-69), were set in Iowa, where she moved after the 1961 Cuban Revolution. In this work, Mendieta stands covered with mud, her arms upraised like a prehistoric goddess, appearing at one with nature, her "maternal source."

29-69. Ana Mendieta. Untitled work from the Tree of Life series. 1977. Color photograph, $20 \times 13^{1}/_{4}$ " (50.8 \times 33.7 cm).

Courtesy of Galerie Lelong, New York and The Estate of Ana Mendieta

POSTMODERNISM Much of the art being made by the end of the

1970s was widely considered to be postmodern. Although there is no universal agreement on what the term *postmodern* means, it involves rejection of the concept of the mainstream and recognition of artistic **pluralism**, the acceptance of a variety of artistic intentions and styles. Many critics insist that pluralism applies to modernism as well and has been a characteristic of art since at least the Post-Impressionist era. Others argue that the art world's attitude toward pluralism has changed: Where critics and artists once searched for a historically inevitable mainstream in the midst of pluralistic variety, many now accept pluralism for what it probably always was—a manifestation of our culturally heterogeneous age.

Those who resist the term *postmodern* also point to the continued use of the term *avant-garde* to describe the most recent developments in art. But whereas *avant-garde* formerly indicated a significant newness, it now lacks that connotation. Indeed, many recent avant-garde styles implicitly acknowledge the exhaustion of the old modernist faith in innovation—and in what it implied about the "progressive" course of history—by reviving older styles. For this reason, the names of a number of recent styles in both art and architecture

begin with the prefix *neo*, denoting a new and different form of something that already exists.

NEO-EXPRESSIONISM

A number of shows in leading New York art galleries in the late 1970s and early 1980s signaled the emergence of the first of the neos, Neo-Expressionism. The renewed interest in expressionism, long thought dead, was inspired partly by the emphasis on personal feeling in feminist art and by the example of the emotion-laden figurative work of such older American artists as Philip Guston (1913-80) and Leon Golub (b. 1922). Although six of the nineteen artists discussed in an early assessment of Neo-Expressionism in the magazine Art in America (December 1982) were women, some of them never fit comfortably under the label Neo-Expressionist. Other women were soon dropped from the category when critics decided, perhaps prematurely, that the style was a male phenomenon, reasserting masculine values and viewpoints.

The most prominent American Neo-Expressionist was Brooklyn-born Julian Schnabel (b. 1951), who gained notoriety in 1979 for "plate paintings," such as The Death of Fashion (fig. 29-70, page 1130). The idea for painting on crockery came to Schnabel during a 1978 visit to Barcelona, where he saw the broken glazed tiles that Art Nouveau architect Antonio Gaudí had incorporated into his buildings and park benches (see fig. 28-2). On his return to New York, Schnabel constructed large wood-and-canvas supports to which he affixed whole and broken plates. Painting over this powerfully physical surface with thick, energetic strokes, he rendered crude images such as the large sword and mutilated torso in the central panel of The Death of Fashion. In their rough vitality, these images revive the spirit of Die Brücke and other early-twentieth-century expressionists (Chapter 28). Unlike these earlier artists, however, Schnabel typically appropriated his images from other sources (see "Appropriation," page 1130), frequently combining images to create a sense of fragmentation, incompleteness, and ultimate lack of a coherent meaning, typical of much postmodern work.

Another American painter associated with the Neo-Expressionist movement was the tragically short-lived Jean-Michel Basquiat (1960–88), whose meteoric career ended with his death from a heroin overdose at age twenty-seven. The Brooklyn-born son of a Haitian father and a Puerto Rican mother, Basquiat was raised in middle-class comfort, against which he rebelled as a teenager. After quitting high school at seventeen, he left home to become a street artist, covering the walls of lower Manhattan with short and witty philosophical texts signed with the tag SAMO ©. In 1980 Basquiat participated in the highly publicized "Times Square Show," which showcased the raw and aggressive styles of subway graffiti artists. The response to Basquiat's contribution encouraged him to begin painting professionally. Although he was untrained and wanted to make "paintings that look as if they were made by a child," Basquiat was a sophisticated artist. He carefully studied the

29-70. Julian Schnabel. *The Death of Fashion.* 1978. Oil and crockery on canvas and wood, $7'6'' \times 10' \times 1'1''$ (2.29 \times 3.05 \times 0.33 m). Des Moines Art Center, Iowa. Purchased with funds from Roy Halston Frowick (1991.47)

Schnabel adapted the painting's title from a news headline about the death of a fashion model, but the work makes no apparent reference to the story. He thereby denied the title its traditional function of identifying the picture's subject matter, leaving the viewer to speculate freely on the relationship between the painting's imagery and the label attached to it.

APPROPRIATION

During the late 1970s and 1980s, appropriation (the representation of a preexisting image as one's own) became a popular technique among postmodernists in both the United States and Western Europe. The borrowing of figures or compositions has been an essential technique throughout the history of art, but the emphasis had always been on changing or personalizing the source. A copy or reproduction was not considered a legitimate work of art until Marcel Duchamp changed the rules with his readymades (see fig. 28-63), insisting that the quality of an art work depends not on formal invention but on the ideas that stand behind it. Duchamp's own sort of appropriations first inspired the Pop artists Andy Warhol and Roy Lichtenstein, whose reuse of imagery from popular culture, high art, ordinary commerce, and the tabloids then helped point the way for the artists of the 1970s and 1980s.

Critics and historians now use the term appropriation to describe the activities of two distinct groups. To the first belong artists such as Sigmar Polke (see fig. 29-73) and Julian Schnabel (see fig. 29-70), who combine and shape their borrowings in personal ways. These artists, along with earlier ones such as Robert Rauschenberg (see fig. 29-23), might be called collage appropriators. "Straight appropriators," on the other hand, are those, such as Sherrie Levine (see fig. 29-76), who simply repaint or rephotograph imagery from commerce or the history of art and present it as their own.

The work of the latter is grounded not only in the Duchampian tradition but also in the ideas of the French literary critics known as the Post-Structuralists. Of particular importance was their critique of certain basic and unexamined assumptions about art. In "The Death of the Author" (1968), for example, Roland Barthes argued that the meaning of a work of art depends not on what the author meant (which Derrida and others

argued was neither certain nor entirely recoverable) but on what the reader understands. Furthermore, Barthes questioned the modernist notion of originality, of the author as a creator of an entirely new meaning. The author merely recycles meanings from other sources; he said: A "text is a tissue of quotations drawn from the innumerable centers of culture." The work of Levine seems almost to illustrate such ideas.

Some straight appropriators have encountered legal problems. Levine's first high-art appropriations were photographic copies of Edward Weston originals. When the lawyers for the Weston estate threatened to sue her for infringement of copyright, she moved to the work Walker Evans produced during the 1930s for the Farm Security Administration (Chapter 28), which has no copyright. Others faced with the possibility of legal action, especially from owners of commercial trademarks, have taken the same cautious route.

29-71. Jean-Michel Basquiat. *Horn players.* 1983. Acrylic and oil paintstick on canvas, three panels, overall $8' \times 6'5''$ (2.44 \times 1.91 m). Broad Art Foundation, Santa Monica, California.

Abstract Expressionists, the late paintings of Picasso, and Dubuffet (see fig. 29-4), among others.

Basquiat's Horn Players (fig. 29-71) portrays jazz musicians Charlie Parker (at the upper left) and Dizzy Gillespie (at center right) and includes numerous verbal references to their lives and music. The urgent paint handling and scrawled lettering seem genuinely expressionist, conveying Basquiat's strong emotional connection to his subject (he avidly collected jazz records and considered Parker one of his personal heroes), as well as his passionate determination to make African-American subject matter visible to his predominantly white audience. "Black people," said Basquiat, "are never portrayed realistically, not even portrayed, in modern art, and I'm glad to do that."

In Germany, the revival of expressionism took on political connotations because the work of the original expressionists had been labeled degenerate and banned by the Nazis during the 1930s (see "The Suppression of the Avant-Garde in Germany," page 1059). The German Neo-Expressionist Anselm Kiefer (b. 1945) was born in the

final weeks of World War II and in his work has sought to come to grips with his country's Nazi past—"to understand the madness." The burned and barren landscape in his *Heath of the Brandenburg March* (fig. 29-72, page 1132) evokes the ravages of war that the Brandenburg area, near Berlin, has frequently experienced, most recently in World War II. The road that lures us into the landscape, a standard device in nineteenth-century landscape paintings, here invites us into the region's dark past.

Kiefer's determination to deal with his country's troubled past was shaped in part by his informal study under Joseph Beuys (see fig. 29-37) in the early 1970s. Another prominent Beuys student was Sigmar Polke (b. 1941), who grew up in Communist-controlled East Germany before moving at age twelve to West Germany. During the 1960s Polke made crude "capitalist realist" paintings that expressed a more critical view of consumer culture than did the generally celebratory work of the British and American Pop artists. Like them, Polke appropriated his images from the mass media. Subsequently, Polke began to mix diverse images from

29-72. Anselm Kiefer. *Heath of the Brandenburg March.* 1974. Oil, acrylic, and shellac on burlap, $3'10^{1}/2'' \times 8'4''$ (1.18 \times 2.54 m). Stedelijk Van Abbemuseum, Eindhoven, the Netherlands.

Kiefer often incorporates words and phrases into his paintings that amplify their meaning. Here, the words *märkische Heide* ("March Heath") evoke an old patriotic tune of the Brandenburg region, "Märkische Heide, märkische Sand," which Hitler's army adopted as a marching song.

different sources and paint them on unusual supports, such as printed fabrics, creating a complex, layered effect. *Raised Chair with Geese* (fig. 29-73), for example, juxtaposes the silhouette of a watchtower with outlined figures of geese and a printed pattern of sunglasses, umbrellas, and folding chairs. The motif of the elevated hut

29-73. Sigmar Polke. *Raised Chair with Geese.* 1987–88. Artificial resin and acrylic on various fabrics, $9'5^1/8'' \times 9'5^1/8''$ (2.9 \times 2.9 m). The Art Institute of Chicago. Restricted gift in memory of Marshall Frankel; Wilson L. Mead Endowment (1990.81)

generates many dark associations, ranging from the raised chair used by German fowl hunters (reinforced by the presence of the geese), to a sentry post for soldiers monitoring the border between East and West Germany, to a concentration camp watchtower. Set next to the decorative fabric evocative of the beach, however, the tower also evokes the more pleasurable image of a raised lifeguard chair. Such lighter touches distinguish Polke's work in general from the unrelievedly serious efforts of Kiefer.

NEO-CONCEPTUALISM

In the United States, an analytic and often cynical mode emerged in the mid-1980s that seemed to be a reaction to both the emotionalism of Neo-Expressionism and the populism of graffiti art. Known as Neo-Conceptualism, it reflected the influence of the difficult and usually skeptical ideas on literature, philosophy, and society of a group of French intellectuals known as the Post-Structuralists—among them Derrida, Roland Barthes (1915–80), Jean Baudrillard (b. 1929), and Michel Foucault (1926–84)—who had become popular among American intellectuals in the late 1970s.

The ideas of Baudrillard and Foucault were particularly important to the artistic development of Peter Halley (b. 1953), the leading painter of the Neo-Conceptualist group. Baudrillard has argued that movies, television, and advertising have made ours the age of the simulacrum, or surrogate image that simulates reality. Simulacra, moreover, often seem hyperreal, or more real than the world they purport to reflect. The television stereotype of the average American family, for example, has replaced the social reality of family life, and advertising employs supersaturated colors to make products seem hyperreal. Halley realized that the fluorescent Day-Glo colors he had been using in his work were themselves

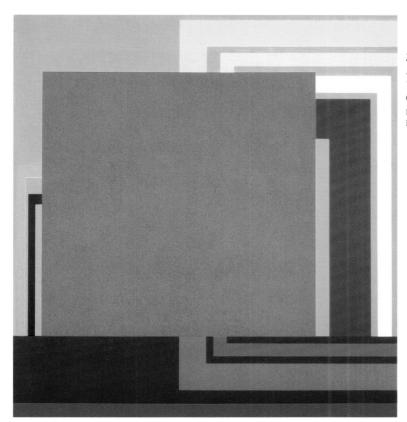

29-74. Peter Halley. *Fire in the Sky.* 1993. Acrylic, Day-Glo acrylic, and Roll-a-Tex on canvas, $7'11^{1}/_{2}" \times 7'3^{5}/_{8}"$ (2.43 \times 2.27 m). Des Moines Art Center, Iowa.

Purchased with funds from the Edmundson Art Foundation, Inc., and partial gift of Gagosian Gallery and the artist (1993.10)

signs of this new social phenomenon. He also began to question the Minimalist assertion that geometric forms are nonreferential; by the beginning of the 1980s, Halley was making abstract paintings with forms intended to be read as meaningful signs of the contemporary cultural phenomena described by Baudrillard and Foucault.

In Fire in the Sky (fig. 29-74), one of his so-called Neo-Geo (or new geometry) paintings, Halley applied hyperreal colors to canvas and to the kind of simulated stucco used in suburban housing. This false stucco surface is itself a sign of the dominance of the simulacrum. The large central square, or cell, represents both the home and the brain (which is composed of cells). The rectangular forms that connect with it refer on one level to plumbing and electrical circuitry, on another to information reaching the brain through both subconscious and conscious processes (represented by the lower and upper piping, respectively). The central cell has the further meaning of jail or imprisonment, a reference to Foucault's assertion that modern bureaucratic political regimes imprison the individual. The central square has therefore three referents: home, brain cell, and prison cell. Halley's intent is not to protest troubling social phenomena but to find a visually engaging way to illustrate them.

The most controversial Neo-Conceptualist is Jeff Koons (b. 1955), whose blatant careerism and artistic emphasis on consumerism, shocking to many critics, is informed by his admiration for Andy Warhol and his professional experience as a Wall Street commodities broker. Koons's first major series, called The New, featured brand-new vacuum cleaners encased in Plexiglas boxes and brilliantly lit by fluorescent tubes. Mimicking the display of merchandise that might be encountered in a department store, a sculpture such as *The New Shelton Wet/Dry Triple Decker* (fig. 29-75) is a commentary on the

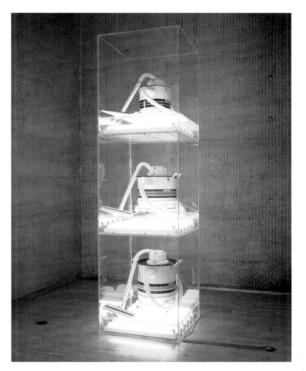

29-75. Jeff Koons. *The New Shelton Wet/Dry Triple Decker.* 1981. Vacuum cleaners in Plexiglas with fluorescent lights, $10'4^1/2'' \times 2'4'' \times 2'4'' (3.16 \times 0.72 \times 0.72 \text{ m})$. Des Moines Art Center, Iowa.

Purchased with funds from Roy Halston Frowick (1991.46)

In the spirit of Duchamp's readymades (see fig. 28-63), Koons did not make but simply selected the displayed appliances, while their cases, like the Minimalist sculpture of Donald Judd (see fig. 29-33), were fabricated according to the artist's specifications. Koons's physical detachment from his work emphasizes its conceptual status. "It's information that's important to me," he said. "I like to push myself to the point where my work is done purely mentally without having any interaction with materials in process."

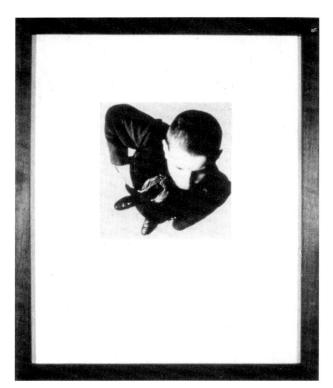

29-76. Sherrie Levine. *Untitled (After Aleksandr Rodchenko: 11).* 1987. Black-and-white photograph, 20×16 " (50.8 \times 40.6 cm). Courtesy Marian Goodman Gallery, New York

consumer's never-ending desire for the new as well as a frank declaration of art's status as a commodity under capitalism. To Koons, the work also addresses larger philosophical issues. The vacuum cleaners, though designed to suck up dirt, remain forever immaculate in their sealed cases and, in their purity, achieve a kind of immortality. "Maybe they'll die off as art," said Koons, "but they're equipped to out-survive us physically."

Sherrie Levine (b. 1947), another provocative Neo-Conceptualist, made her reputation by appropriating imagery from other artists. In 1981 she began making photographic copies of famous twentieth-century works by male artists as a way of attacking the predominantly male Neo-Expressionist movement. As she explained, "I felt angry at being excluded. As a woman, I felt there was not room for me. . . . The whole art system was geared to celebrating ... male desire." Untitled (After Aleksandr Rodchenko: 11) (fig. 29-76) is not an homage to the Russian Constructivist (see fig. 28-46) but a critique of certain ideas associated with him and with modernism. Levine's work is inspired by the deconstructionism of Derrida, in which he unravels prevailing cultural assumptions, or "myths," by revealing them to contain self-conflicting messages. By appropriating images by men associated with innovation, Levine deconstructed those concepts and suggested that all art and thought are derivative.

LATER FEMINIST ART

Levine can also be grouped with a second generation of feminist artists that emerged in the 1980s. These artists tended to believe that differences between the sexes are

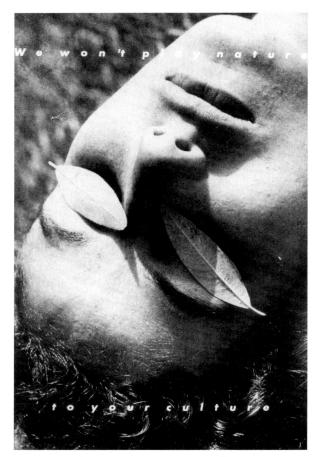

29-77. Barbara Kruger. We Won't Play Nature to Your Culture. 1983. Photostat $6'1'' \times 4'1''$ (1.85 \times 1.24 m). Courtesy Mary Boone Gallery, New York

not intrinsic but are socially constructed to suit the needs of those in power. Thus, young women learn how to behave from role models promoted in magazines, movies, and other sources of cultural coercion. The feminists considered resisting those cultural forces to be a major task of feminism and feminist art.

Barbara Kruger (b. 1945) is an important representative of this generation. Drawing on her experience as a designer and photo editor for women's magazines, she began in the late 1970s to create works that combined glossy high-contrast images, usually borrowed from old advertisements, and bold, easily readable, catchy texts. Her purpose was to undermine the media with its own devices, "to break myths, not to create them," but at times Kruger also seems to express a sense of futility. In We Won't Play Nature to Your Culture (fig. 29-77), for example, the voice is strong and defiant but the image is weak. The text declares that women will no longer accept the patriarchal definition of men as producers of culture and women as products of nature, but the woman lies passively on her back and is symbolically blinded by the leaves over her eyes.

One of the most critically acclaimed later feminists is Cindy Sherman (b. 1954), who, after moving to New York City in 1977, began creating black-and-white photographs that simulate stills from B-grade movies of the 1940s and 1950s. Each of the approximately seventy-five

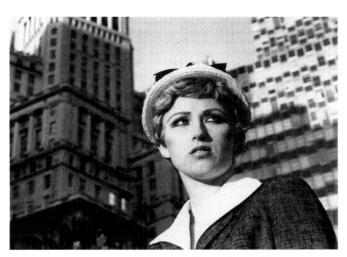

29-78. Cindy Sherman. *Untitled Film Still #21.* 1978. Black-and-white photograph, $8\times10''$ (20.3 \times 25.4 cm). Courtesy of the artist and Metro Pictures, New York

photographs in the series shows a single female figure, always Sherman in some guise. In *Untitled Film Still #21* (fig. 29-78), she poses as a perplexed young innocent apparently recently arrived in a big city, its buildings looming threateningly behind her. In the context of feminist film criticism's focus on movie representations of women as helpless creatures who need a man to care for them, Sherman's re-creation of such roles seems to be part of a critical, deconstructive agenda. She herself said she was "making fun" of the female role models from her childhood as well as engaging in a pure form of play that she had loved while growing up.

THE PERSISTENCE OF MODERNISM

Despite declarations of the death of modernism by postmodern artists and critics, many artists remain committed to its central values of formal innovation and personal expression. A leading modernist painter is the Chicago-born Elizabeth Murray (b. 1940), who moved to New York in 1967. Her artistic breakthrough came in the late 1970s, when she began to work on irregularly shaped canvases. During the 1980s her canvases, now stretched over thick plywood supports, became increasingly complex and three-dimensional physical presences over whose swelling surfaces she painted abstracted figures and familiar objects. Her bold and colorful style is inspired simultaneously by "high" modernist art and "low" popular culture: She employs Cubist-style fragmentation, Fauvist color, Surrealist biomorphism, and gestural, Abstract Expressionist paint handling, while also drawing inspiration from cartoons and animated films, which have fascinated her since childhood. Chaotic Lip (fig. 29-79) is an enormous, organically shaped canvas with rounded lobes that radiate out in several directions. Splayed across the painting's surface is an animated green table, whose square top and rubbery legs evoke a cartoonish human

29-79. Elizabeth Murray. *Chaotic Lip.* 1986. Oil on canvas, $117^{1/2}$ " \times $86^{1/2}$ " \times 12" (298.4 \times 219.7 \times 30.5 cm). Spencer Museum of Art, University of Kansas, Lawrence. Gift of the Friends of the Art Museum and the Helen Foresman Spencer Acquisitions Fund, (87.35)

figure. Constituting the figure's "head" is a squiggly red doughnut shape (the "chaotic lip"?), connected by a thin cord to a hole in the center of the table. The hole suggests a human profile and the cord and "doughnut," a cartoon speech balloon. The same motifs also suggest a vaginal opening and the flow of menstrual blood. Murray's work is characteristically modernist in its emphasis on ambiguous forms that generate a rich variety of possibilities.

Another artist devoted to the creation of evocative organic forms is the African-American sculptor Martin Puryear (b. 1941), whose early interest in biology marked an attraction to nature that would shape his mature aesthetic. As a Peace Corps volunteer in Sierra Leone on the west coast of Africa, Puryear studied the traditional, preindustrial woodworking methods of local carpenters and artisans. In 1966 he moved to Stockholm, Sweden, to study printmaking and learn the techniques of Scandinavian cabinetmakers. Two years later he began graduate studies in sculpture at Yale, where he encountered the work of a number of visiting Minimalist sculptors, including Richard Serra (see fig. 29-89). By the middle of the 1970s he had combined these formative influences into a distinctive personal style reminiscent,

29-80. Martin Puryear. *Plenty's Boast.* 1994–95. Red cedar and pine, $68 \times 83 \times 118''$ (172.7 \times 210.8 \times 299.7 cm). The Nelson-Atkins Museum of Art, Kansas City, Missouri. Purchase of the Renee C. Crowell Trust, (F95–16 A–C)

in its organic simplicity, of Constantin Brancusi (see fig. 28-18). Puryear's *Plenty's Boast* (fig. 29-80) does not represent anything in particular but suggests any number of things, including a strange sea creature or a fantastic musical instrument. Perhaps the most obvious reference is to the horn of plenty evoked in the sculpture's title. But the cone is empty, implying an "empty boast"—another phrase suggested by the title. Whatever associations one prefers, the beauty of the sculpture lies in its superb craft and its idiosyncratic yet elegant forms. Sounding like an early-twentieth-century modernist, Puryear said, "The task of any artist is to discover his own individuality at its deepest."

RECENT CRAFT ART

Puryear's impressive woodworking skills link his sculpture to the contemporary American craft art movement that has flourished in recent decades. Another master of the medium of wood is Wendell Castle (b. 1932), who during the 1960s made highly original laminated wood furniture in an organic, sculptural style. His innovative furniture designs attracted not only praise but also numerous imitators, causing him in the late 1970s to change direction and begin carving technically demanding trompe l'oeil sculpture in wood. Related to the contemporary Super Realism of artists like Duane Hanson (see fig. 29-62), Castle's carvings represent everyday objects placed on or draped over furniture he built using traditional techniques. The impressively crafted Ghost Clock (fig. 29-81), which imitates an eighteenth-century clock borrowed from an antiques dealer, is covered by a trompe l'oeil sheet carved out of bleached mahogany. The sculpture's power comes not only from its astonishing illusionism but also its haunting imagery, evoking an anthropomorphic presence forever hidden beneath the shroud.

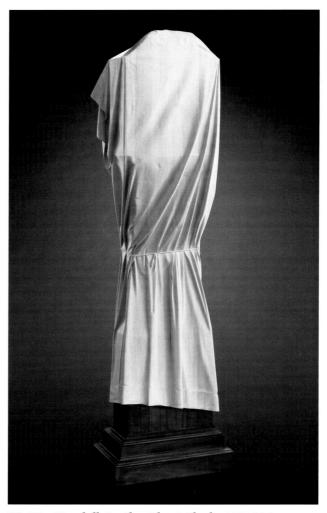

29-81. Wendell Castle. *Ghost Clock.* 1985. Mahogany and bleached Honduras mahogany, $7'2^1/_4" \times 2'^1/_2" \times 1'3"$ (2.19 \times 0.62 \times 0.38 m). Smithsonian Institution, Smithsonian American Art Museum, Washington, D.C.

Museum purchase through the Smithsonian Institution Collections Acquisition Program, (1989.68)

29-82. Albert Paley. *Lectern.* 1989. Steel and brass, $45 \times 37 \times 25''$ ($115 \times 95 \times 64$ cm). Museum of Arts and Design, New York.

Museum purchase with funds provided by the Horace W. Goldsmith Foundation and the American Craft Museum Collectors Circle

A leading craft artist in the medium of metal is Albert Paley (b. 1944). In the early 1970s Paley gained a national reputation for his large and dramatic jewelry, a form of wearable sculpture. In the mid-1970s he turned to large-scale forged and fabricated architectural metalwork, producing ornamental gates, window grilles, railings, and other forms in a sinuous, organic style inspired by late-nineteenth-century Art Nouveau (see figs 27-83, 27-84). Paley also designs independent works of sculpture, traditionally considered "fine art," and furniture, considered "applied art." All of his efforts are characterized by an emphasis on formal innovation and virtuoso craft, as seen in his *Lectern* (fig. 29-82).

In contrast to the expansive quality of Paley's metal-work are the self-contained ceramic forms of Toshiko Takaezu (b. 1922), who was born in Hawaii to Japanese parents. Since the late 1950s she has closed the tops of her vessels (leaving only a pinhole opening for the hot air to escape during firing), rendering them nonfunctional and emphasizing their status as abstract sculptural forms rather than utilitarian objects. A virtuoso

29-83. Toshiko Takaezu. *Large Form.* c. 1995. Stoneware, glaze, $32 \times 12 \times 12''$ ($82 \times 31 \times 31$ cm). Museum of Arts and Design, New York. Promised gift of Sandy and Lou Grotta

Like many craft artists, Takaezu feels a strong physical and emotional connection to her medium: "One of the best things about clay is that I can be completely free and honest with it. When I make it into a form, it is alive, and even when it is dry, it is still breathing! I can feel the response in my hands, and I don't have to force the clay. The whole process is an interplay between the clay and myself and often the clay has much to say."

colorist, she employs a rich variety of glazes to create sensuous hues and surface effects. Among her favorite colors are deep blues, purples, and blacks—seen, for example, in *Large Form* (fig. 29-83)—which evoke for the artist the beauty of her native Hawaii.

THE RETURN TO THE BODY

A great deal of recent avant-garde art has focused on the human body, which numerous postmodern critics have identified as an "object" subject to the operations of power as well as a "site" for the display and definition of race, class, gender, and sexual identity. One artist who has dealt extensively with the vulnerable yet enduring body is the Polish sculptor Magdalena Abakanowicz (b. 1930). In the late 1960s she began producing large, woven, abstract works of sculpture that soon gave way to figural pieces that challenged the conventional distinctions between craft and sculpture.

29-84. Magdalena Abakanowicz. *Backs.* 1976–80; shown installed near Calgary. Canada, 1982. Burlap and resin, each piece approx. $25\sqrt[3]{4} \times 21\sqrt[3]{4} \times 23\sqrt[3]{4}$ " ($66.4 \times 55.3 \times 60.3$ cm). Collection of Museum of Modern Art, Pusan, South Korea.

Courtesy Marlborough Gallery, NY

Typical of her work is *Backs* (fig. 29-84), a composition of eighty headless, limbless, genderless, and hollow-front burlap-and-resin impressions made on a single mold over a five-year period. The anonymous figures appear to be both resigned and worshiping. "People ask me," she said, "is this the concentration camp in Auschwitz or is it a religious ceremony in Peru . . . and I answer all these questions, 'yes,' because it is . . . about existence in general."

In sharp contrast to Abakanowicz's emphasis on the fragmented and vulnerable body, the American photographer Robert Mapplethorpe (1946-89) chose young, statuesque models whose physical perfection he celebrated in carefully crafted black-and-white photographs. While many of these images, such as Ajitto (Back) (fig. 29-85), are classically reserved, Mapplethorpe also made photographs of explicitly homoerotic subjects and sex acts. The inclusion of such images in his 1989-90 touring retrospective, funded in part by a grant from the National Endowment for the Arts, fueled a heated controversy over public funding for the arts in the United States—a matter that remains the subject of much debate (see "Recent Controversies over Public Funding for the Arts," page 1142). The Contemporary Arts Center in Cincinnati presented the show in 1990, putting the controversial works in their own room with a clearly printed advisement. Cincinnati officials nevertheless charged the museum and its director with obscenity and put them on trial. The jury failed to find that the photographs "lack[ed] serious literary, artistic, political, or scientific value"—one of the criteria for obscenity set by the Supreme Court in a 1973 decision—and acquitted the museum and its director. The jury had decided, as one juror commented, "we may not have liked the

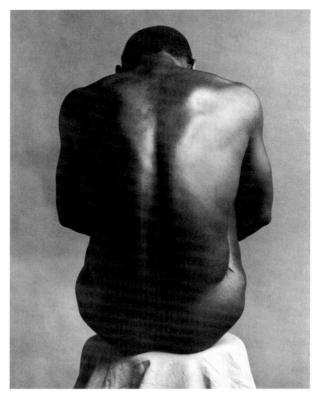

29-85. Robert Mapplethorpe. *Ajitto (Back).* 1981. Gelatin-silver print, 20×16 " (50.8 \times 40.6 cm). The Robert Mapplethorpe Foundation, New York.

pictures" but they were art. "We learned," he added, "that art doesn't have to be pretty."

A conscious rejection of the "pretty" has marked the production of numerous contemporary artists concerned with representing the base human body and its fluids, such as blood, vomit, and excrement. The American sculptor Kiki Smith (b. 1954) has thoroughly explored this territory in works such as *Untitled* (fig. 29-86). This disturbing sculpture, made of red-stained, tissuethin gampi paper, represents the flayed, bloodied, and crumpled skin of a male figure, torn into three pieces that hang limply from the wall. The body, once massive and vigorous, is now hollow and lifeless. The exposure of its interior suggests the loss of boundaries between the body and the environment.

CONSTRUCTED REALITIES

A significant difference between Kiki Smith's sculpture and Robert Mapplethorpe's photograph is that the former is obviously handmade and does not represent a "real" person, while the latter is an objective record of an actual human body set before the camera lens. Photography has traditionally been prized for its ability to document physical reality truthfully, yet, as we have seen in the cases of photographers like Oscar Rejlander (see fig. 27-35) and Jerry N. Uelsmann (see fig. 29-41), the medium also can be manipulated to produce realistic-looking images that are in fact fabrications. While Rejlander and Uelsmann both produced their illusions through the darkroom manipulation of negatives, the recent development of digital scanning technology

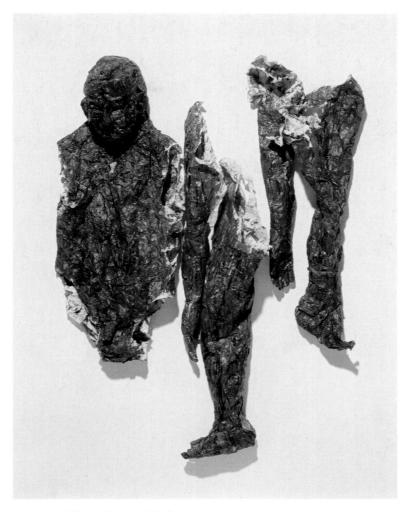

29-86. Kiki Smith. *Untitled.* 1988. Ink on gampi paper, $48 \times 38 \times 7''$ (121.9 \times 96.5 \times 17.8 cm). The Art Institute of Chicago. Gift of Lannon Foundation (1997.121)

(see "Digital Art," page 1143) has allowed photographers to rework their images on the computer to create even more seamless simulations of reality.

An accomplished producer of such constructed realities is the Japanese artist Yasumasa Morimura (b. 1951), well known for his photographic re-creations of famous European paintings and impersonations of European and Hollywood movie stars. Like Cindy Sherman (see fig. 29-78), Morimura poses for all the figures in his photographs, regardless of age, sex, or race, radically transforming his appearance through costumes and makeup. Unlike Sherman, however, Morimura also uses digital technology to manipulate his compositions and, in some cases, to combine multiple self-images in a single picture, as in Self-Portrait (Actress)/White Marilyn (fig. 29-87, page 1140), which mimics Marilyn Monroe's famous skirt-blowing scene in The Seven Year Itch. Such works display Morimura's exploration of gender ambiguity, which engages many contemporary artists. Postmodern theorists argue that gender—as opposed to anatomical sex—is not biologically determined but socially constructed. Thus, the

supposedly natural boundaries between the masculine and the feminine are in fact artificial and subject to transgression. Morimura's *Self-Portrait (Actress)/White Marilyn* represents a shift not only in gender but also in race, as an Asian actor impersonates a Caucasian star. It can be seen not only as a response to the capitalist media's global dissemination of celebrity images but also as an argument for what one critic has called a "postnational, postgendered, de-essentialized identity."

While Morimura's constructed reality, with its triplication of the artist's image, is obviously artificial, the Canadian artist Jeff Wall (b. 1946) creates detailed illusions that "feel as if they could easily be documentary photographs," even as they seek to rival in visual impact large-scale history paintings from the past as well as glossy advertisements of the present. As an art history student in the 1970s, Wall was impressed by the way nineteenth-century artists such as Delacroix and Manet (see Chapter 27) adapted the conventions of history painting to the depiction of contemporary life. Since the late 1970s his own project has been to fashion a comparable grand-scale representation of the history of his

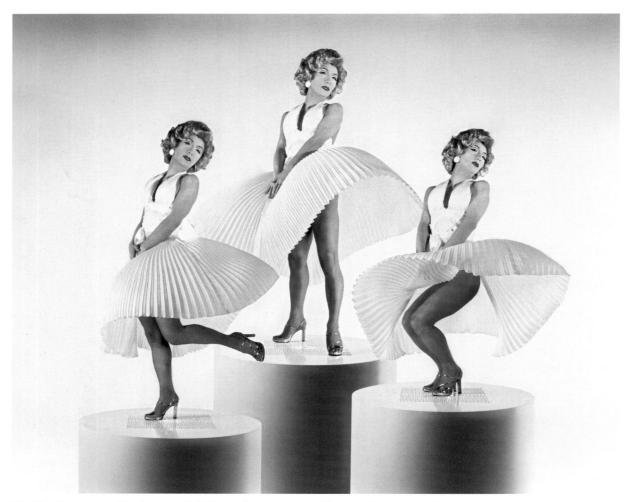

29-87. Yasumasa Morimura. *Self-Portrait (Actress)/White Marilyn.* 1996. Ilfochrome and acrylic sheet, $37^{1}/_{4} \times 47^{1}/_{4}$ " (94.6 × 120 cm).

Courtesy Luhring Augustine Gallery, New York

Known for his impersonations of male and female figures in famous Western paintings as well of actresses like Marilyn Monroe, Morimura extends the tradition of Japan's Noh and Kabuki theaters, in which men play all the roles, both male and female.

own times, presented in the form of color transparencies mounted in large light boxes—a format borrowed from modern advertising and meant to give his art the same persuasive power.

Like a stage or movie director, Wall carefully designs the settings of his scenes and directs actors to play roles within them. He then shoots multiple photographs and combines them digitally to create the final transparency. To make After "Invisible Man" by Ralph Ellison, the Preface (fig. 29-88), an especially elaborate composition, Wall spent eighteen months constructing the set and another three weeks shooting the single actor within it. The image vividly illustrates a well-known passage from the classic 1952 novel by Ralph Ellison about a black man's search for fulfillment in modern America, which ends in disillusionment and retreat. Wall shows us the cellar room "warm and full of light," in which Ellison's narrator lives beneath 1,369 lightbulbs. Powered by electricity stolen from the power company, these lights illuminate the truth of the character's existence: "Light confirms my reality, gives birth to my form. . . . Without light I am not only invisible but formless as well; and to be unaware of

one's form is to live a death. . . . The truth is the light and the light is the truth."

PUBLIC ART

Throughout history and across cultures, works of art have been placed in public spaces to address a broad audience. Prior to the modernist period, works of public art often served to honor a hero, commemorate an important event, or celebrate widely shared social or religious values and were normally readily understandable to the public. Modernist artists continued to make public art but typically worked in abstract styles that were difficult for untrained viewers to comprehend. In many cases, controversies ensued, pitting the conservative taste of the general public against the more adventuresome aesthetics of modernist artists and their supporters.

A particularly loud controversy arose over *Tilted Arc* (fig. 29-89), a Minimalist work by the American sculptor Richard Serra (b. 1939). A steel wall 12 feet high and 120 feet long that tilted 1 foot off its vertical axis, *Tilted Arc* was commissioned for the plaza of a federal government

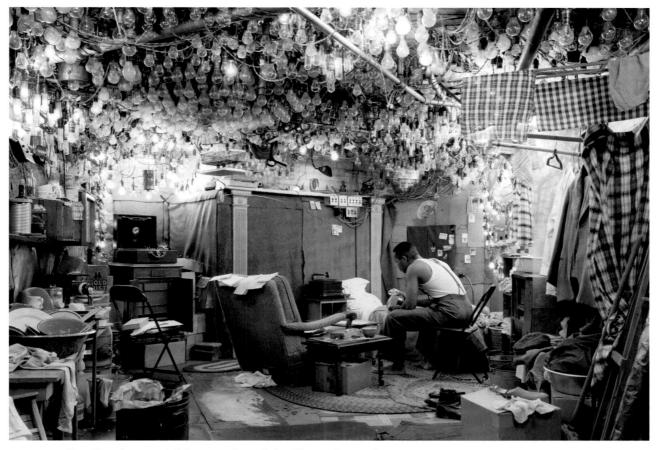

29-88. Jeff Wall. *After "Invisible Man" by Ralph Ellison, the Preface.* 1999–2001. Edition of 2. Cibachrome transparency, aluminum light box, and fluorescent bulbs, $76\frac{1}{4} \times 106\frac{1}{4} \times 10^{1}/4$ " (193.7 × 270 × 26 cm).

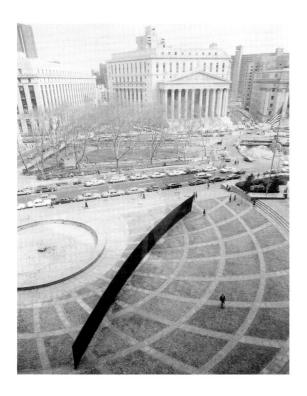

29-89. Richard Serra. *Tilted Arc.* 1981. Hot-rolled steel, height 12' (3.7 m), length 120' (36.58 m). Federal Plaza, Foley Square, New York; removed in 1989.

In his 1989 article on what he termed the "destruction" of *Tilted Arc*, Serra argued that the perception that the majority of the public wanted its removal was untrue, an exaggeration by those who simply did not like the work. He pointed out that during a three-day hearing in 1985, some 122 people spoke in favor of retaining the sculpture and only 58 spoke for its removal. Moreover, a petition for removal presented at the hearing had 3,791 signatures, representing fewer than a quarter of the approximately 12,000 employees in the federal buildings at the site—and another petition against removal had 3,763 signatures.

RECENT CONTROVERSIES OVER PUBLIC FUNDING FOR THE ARTS

Should public money support the creation or exhibition of art that some taxpayers might find indecent or offensive? This question became an issue of heated debate in 1989-90, when controversies arose around the work of the American photographers Robert Mapplethorpe and Andres Serrano (b. 1950), who had both received funding, directly or indirectly, from the National Endowment for the Arts (NEA). Serrano became notorious for a large color photograph, Piss Christ (1987), that shows a plastic crucifix immersed in the artist's urine. Although Serrano did not create that work using public money, he did receive a \$15,000 NEA grant in 1989 through the Southeastern Center for Contemporary Art (SECCA), which included Piss Christ in a group exhibition. Piss Christ came to the attention of the Reverend Donald Wildmon, leader of the American Family Association, who railed against it as "hate-filled, bigoted, anti-Christian, and obscene." Wildmon exhorted his followers to flood Congress and the NEA with letters of protest, and the attack on the NEA was quickly joined by conservative Republican politicians.

Amid the Serrano controversy, the Corcoran Gallery of Art in Washington, D.C., decided to cancel its showing of the NEA-funded Robert Mapplethorpe retrospective (organized by the Institute of Contemporary Art [ICA] in Philadelphia), because it included homoerotic and sadomasochistic images. Congress proceeded to cut NEA funding by \$45,000, equaling the \$15,000 SECCA grant to Serrano and the \$30,000 given to the ICA for the Mapplethorpe retrospective. It also added to the NEA guidelines a clause requiring that award decisions take into consideration "general standards of decency and respect for the diverse beliefs and values of the American public."

The decency clause was soon challenged as unconstitutional in federal court by a group of performance artists—Karen Finley, John Fleck, Holly Hughes, and Tim Miller, popularly dubbed the NEA Four—who in the summer of 1990 had been denied NEA grants due to the provocative nature of their work.

Finley, the best known of the group, had sought funding for a performance in which she describes a sexual assault by stripping to the waist, smearing chocolate over her breasts, and shouting profanity. The artists, whose suit was joined by a coalition of free-speech and artworld organizations, argued that the decency clause violated the First Amendment right to freedom of expression. While lower courts sided with the plaintiffs, in the summer of 1998 the United States Supreme Court ruled in favor of the government. The court allowed the decency clause to stand because it was only "advisory" and did not establish a categorical requirement that art be decent.

During the years of legal battle, the NEA underwent major restructuring under pressure from the Republican-controlled House of Representatives, some of whose members sought to eliminate the agency altogether. In 1996 Congress cut the NEA's budget by 40 percent, cut its staff in half, and replaced its seventeen discipline-based grant programs with four interdisciplinary funding categories. It also prohibited grants to individual artists in all areas except literature, making it impossible for controversial figures like Serrano and Finley to receive

Another major controversy over the use of taxpayer money to support the display of provocative art erupted in the fall of 1999, when the Brooklyn Museum of Art opened the exhibition "Sensation: Young British Artists from the Saatchi Collection" in defiance of a threat from New York City mayor Rudolph Giuliani to eliminate city funding and evict the museum from its city-owned building if it persisted in showing work that he called "sick" and "disgusting." Giuliani and Catholic leaders took particular offense at Chris Ofili's The Holy Virgin Mary, a glittering painting of a stylized African Madonna with a breast made out of elephant dung, surrounded by cutout photographic images of women's buttocks and genitalia. Ofili (b. 1968), a British-born black of Nigerian parentage who is himself Catholic, explained that he meant the painting to be a contemporary reworking of the traditional image of the Madonna surrounded by naked putti, and that the elephant dung, used for numerous practical purposes by African cultures, represents fertility. Giuliani and his allies, however, considered the picture sacrilegious.

When in late September the Brooklyn Museum of Art refused to cancel the show, Giuliani withheld the city's monthly maintenance payment to the museum of \$497,554 and filed a suit in state court to revoke its lease. The museum responded with a federal lawsuit seeking an injunction against Giuliani's actions on the grounds that they violated the First Amendment. On November 1, the U.S. District Court for the Eastern District of New York barred Giuliani and the city from punishing or retaliating against the museum in any way for mounting the exhibition. While the mayor had argued that the city should not have to subsidize art that fosters religious intolerance, the court ruled that the government has "no legitimate interest in protecting any or all religions from views distasteful to them." Taxpayers, said the court, "subsidize all manner of views with which they do not agree," even those "they abhor."

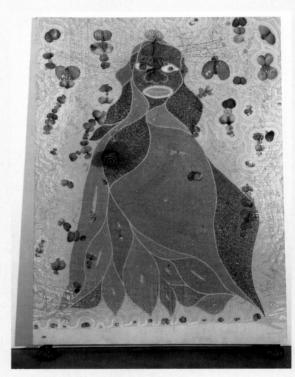

Chris Ofili. *The Holy Virgin Mary.* 1996. Paper collage, oil paint, glitter, polyester resin, map pins, and elephant dung on linen, $7'11'' \times 5'11^{5}/_{16}''$ (2.44 \times 1.83 m). The Saatchi Gallery, London.

DIGITAL ART

Visitors to the December 2002 exhibition by Jennifer Steinkamp (b. 1958) at the ACME Gallery in Los Angeles entered a large space whose three walls were completely covered with projected vertical bands of brilliantly colored flowersyellow mums, pink daisies, lilies, orchids, tulips—swaying and fluttering as if blown by a breeze. Appearing from a distance to be real flowers, these gorgeous blossoms were in fact entirely artificial, not recorded by a camera but generated by a computer. Moving in close to the wall, the viewer could see the grid of pixels that produced this ravishing illusion.

Steinkamp's work is an impressive example of digital art, a term used to identify a wide variety of art made with the help of digital computer technology, the rapid development of which in recent decades has provided artists with increasingly powerful creative tools. Artists have adopted the computer for three main reasons: to help accomplish tasks that previously would have required expertise in another medium (such as photo retouching, graphic design, video editing, or architectural rendering); to create work impossible to realize through traditional means, but the final outcome of which takes a traditional form (a print, a photograph, a video, a painting, a sculpture); and to produce new work that exists only in computer terms (a CD-ROM, a website, a telecommunications event, a work of virtual reality—that is, a computer simulation of a system on which the viewer can perform operations and see the effects in real time). Many digital works also blend traditional forms with computerbased ones.

Much of the earliest digital art, made in the 1960s, took the form of abstract drawings made by a plotter—an ink-bearing, wheeled device that moves over a piece of paper drawing a line according to programmed instructions—and was of minimal aesthetic interest. A richer creative alternative that soon

developed was the digitization of scanned drawings, photographs, and video images, the tones of which were broken down into individual units (pixels) and the lines of which were translated into sine curves. These elements, rendered as sets of digits, could then be manipulated by the computer. Since the mid-1980s, the digital manipulation of scanned photographs and video images has become increasingly common in avant-garde art (see figs. 29-87, 29-88, 29-98).

In addition to the transformation of digitized images, increasingly sophisticated computer programs, first developed in the 1970s, have given artists the ability to generate abstract and illusionistic digital images, both static and animated. Such images can be printed, displayed on computer monitors, projected (like the work of Jennifer Steinkamp reproduced here), or rendered threedimensionally as sculptures through rapid-prototyping processes that automate the fabrication of an object from a CAD (computer-aided design) model.

Since the advent of the World Wide Web in the mid-1990s, an increasing number of digital works have been placed online, where they are accessible to anyone with an Internet connection and the appropriate software. Many online digital works are interactive, inviting the viewer to navigate them or otherwise act on them, often by contributing information or data that changes the form of the work and thereby directly involves the viewer in the creative process. Most artists post online works on their own websites, but many such works can be found on the websites of museums, sometimes as the result of a special commission. Online works are also increasingly being featured in gallery and museum exhibitions, often on computer stations that visitors are invited to use in the exhibition space. As digital technology continues its astonishingly swift development it is likely to be embraced by more and more artists, who will use computers to expand the possibilities of creativity, expression, and experience in our rapidly changing world.

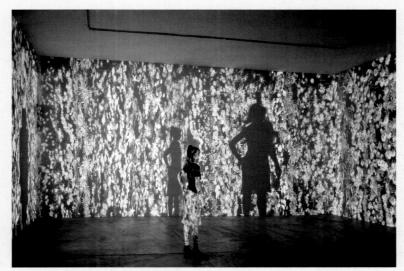

Jennifer Steinkamp. *Jimmy Carter*. 2002. Site-specific computer-generated light projection installation with 3 projectors and 3 Mac G3 computers. $35 \times 18 \times 14' \ (10.6 \times 5.5 \times 4.3 \ m)$. Courtesy ACME

Created during the tense buildup to the U.S.-led war on Iraq, Steinkamp's work, with its billowing streams of digitally created flowers, is intended to induce feelings of peace and harmony. The work's title is an homage to the former American president Jimmy Carter, who in October 2002 was awarded the Nobel Peace Prize for his ongoing efforts to promote international peace, democracy, and human rights.

building complex in New York City by the General Services Administration. Typical of Serra's work, it was strong, simple, tough, and, given its tilt, fairly threatening. Some employees in the nearby buildings found the

work objectionable. Calling it an "ugly rusted steel wall" that "rendered useless" their "once beautiful plaza," they petitioned to have it removed. The government agreed to do so, but Serra went to court to preserve his work. He

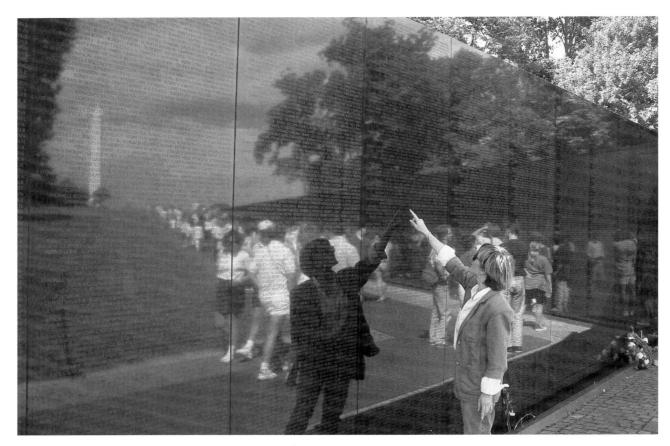

29-90. Maya Ying Lin. Vietnam Veterans Memorial. 1981–83. Black granite, each wing 246' long. The Mall, Washington, D.C.

eventually lost his case, and the sculpture was removed in 1989.

The Vietnam Veterans Memorial (fig. 29-90), now widely admired as a fitting testament to the Americans who died in that conflict, was also a subject of public controversy when it was first proposed due to its severely Minimalist style. In its request for proposals for the design of the monument, the Vietnam Veterans Memorial Fund—composed primarily of veterans themselves stipulated that the memorial be without political or military content, that it be reflective in character, that it harmonize with its surroundings, and that it include the names of the more than 58,000 dead and missing. In 1981 they awarded the commission to Maya Ying Lin (b. 1960), then an undergraduate studying in the architecture department at Yale University. Her Minimalist-inspired design called for two 200-foot-long walls (later expanded to almost 250 feet) of polished black granite, to be set into a gradual rise in Constitution Gardens on the Mall in Washington, D.C., meeting at a 136-degree angle at the point where the walls and slope would be at their full 10-foot height. The names of the dead were to be incised in the stone in the order in which they died, with only the dates of the first and last deaths, 1959 and 1975, recorded.

Lin's memorial has become one of the most compelling monuments in the United States, largely because it creates an understated encounter between the living, reflected in the mirrorlike polished granite, and the dead, whose names are etched in its black, inorganic permanence. Quiet and solemn, the work allows visitors the opportunity for contemplation. Adding significantly to the memorial's intrinsic power are the many mementos, from flowers to items of personal clothing, that have been left below the names of loved ones by friends and relatives.

Although it lists their individual names, Lin's Vietnam Veterans Memorial integrates those it commemorates, without regard to their differences in age, sex, ethnicity, race, religion, or socioeconomic class. Beginning in the 1970s another, very different sort of public art in the United States took the opposite approach, concentrating on such differences as a way of acknowledging the **multiculturalism** of American society. Leaders in the creation of this type of public art were a number of Chicano artists in Los Angeles and other California cities who in the 1970s began to paint public murals, reviving a tradition started by Diego Rivera (see fig. 28-85) and other Mexican artists following the Mexican Revolution.

While the Chicano muralists most often worked in the barrios, one, Judith F. Baca (b. 1946), created her most ambitious work at a site in the white, suburban San Fernando Valley. Painted at the invitation of the U.S. Army Corps of Engineers, Baca's *Great Wall of Los Angeles* (fig. 29-91) extends almost 2,500 feet along the wall of a drainage canal, making it perhaps the longest mural in the world. Its subject is the history of California, with an emphasis on the role of racial minorities. The twentieth-century scenes include the deportation of Mexican-American citizens during the Great Depres-

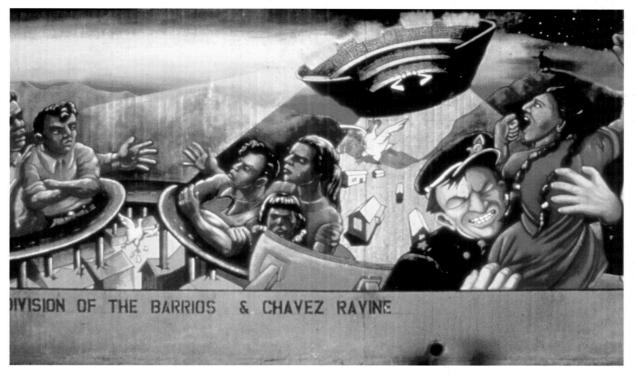

29-91. Judith F. Baca. *The Division of the Barrios,* detail from *The Great Wall of Los Angeles*. 1976–83. Height 13′ (4 m), overall length approx. 2,500′ (762 m). Tujunga Wash Flood Control Channel, Van Nuys, California.

sion, the internment of Japanese-American citizens during World War II, and residents' futile protests over the division of a Chicano neighborhood by a new freeway. The mural concludes with more positive images of the opportunities gained by minorities in the 1950s and 1960s. Typical of Baca's public work, *The Great Wall of Los Angeles* was a group effort, involving arts professionals and some 215 young people who painted the mural under Baca's direction.

Another socially minded artist strongly committed to the creation of public art is David Hammons (b. 1943), an outspoken critic of the gallery system who insists that art today is "like Novocaine. It used to wake you up but now it puts you to sleep." Only street art, uncontaminated by commerce, he maintains, can still serve the old function. Hammons for the most part aims his work at his own African-American community. His best-known work is probably Higher Goals (fig. 29-92), which he produced in several versions between 1982 and 1986. This one, temporarily set up in a Brooklyn park, has backboards and baskets set on telephone poles—a reference to communication—that rise as high as 35 feet. The poles are decorated with bottle caps, a substitute for the cowrie shells used not only in African design but also in some African cultures as money. Although the series may appear to honor the game, Hammons said it is "antibasketball sculpture." "Basketball has become a problem in the black community because kids aren't getting an education. . . . It means you should have higher goals in life than basketball."

29-92. David Hammons. *Higher Goals.* 1982; shown installed in Brooklyn, New York, 1986. Five poles of mixed mediums, including basketball hoops and bottle caps, height of tallest pole 40′ (11 m).

Courtesy of Artemis Greenberg Van Doren Gallery, NY.

29-93. Rachel Whiteread. *House.* 1993. Sprayed concrete. Corner of Grove and Roman roads, London; destroyed in 1994.

Commissioned by Artangel Trust and Beck's

Works like Higher Goals have reinforced the notion that art is most effective as a social tool when it avoids an institutional setting, takes root in a specific community, and addresses locally important issues in straightforward language. Like environmental earthworks, socially conscious art seems to function best when it is site-specific, such as House (fig. 29-93), by the British sculptor Rachel Whiteread (b. 1963). Known for her sculptural casts of negative spaces, such as the inside of a wardrobe chest, Whiteread in this instance produced a sprayed-concrete cast of the inside of an entire East London house, the last remaining from a Victorian-era terrace that was being removed to create a new green space. Whiteread intended the work both as a monument to the idea of home and as a political statement about "the state of housing in England; the ludicrous policy of knocking down homes like this and building badly designed tower blocks which themselves have to be knocked down after 20 years." Immediately upon its completion, House became the focus of public debate over not just its artistic merits but also social issues such as housing, neighborhood life, and the authority of local planners. Intended to be temporary, Whiteread's work stood for less than three months before it, too, was demolished.

In their drive to bring about positive social change, some artists have created public works meant to provoke not only discussion but also tangible improvements. Notable examples are the *Revival Fields* of the Chinese-American artist Mel Chin (b. 1951), which are designed to restore the ecological health of contaminated land through the action of "hyperaccumulating"

plants that absorb heavy metals from the soil. Chin created his first Revival Field near St. Paul, Minnesota, in the dangerously contaminated Pig's Eye Landfill (fig. 29-94). Chin gave the work the cosmological form of a circle in a square (representing heaven and earth in Chinese iconography), divided into quarters by intersecting walkways. He seeded the inside of the circle with hyperaccumulating plants and the outside with nonaccumulating plants as a control. For three years the plants were harvested and replanted and toxic metals removed from the soil. Chin went on to create other Revival Fields elsewhere in the United States and Europe. "Rather than making a metaphorical work to express a problem," said Chin, "a work can . . . tackle a problem head-on. As an art form it extends the notion of art beyond a familiar object-commodity status into the realm of process and public service."

INSTALLATION, VIDEO, AND DIGITAL ART

Many contemporary artists reject the traditional conception of a work of art as a portable object and instead make installations that are tied to a particular physical site, where they may exist permanently or for a limited time—typically, the duration of an exhibition. Contemporary installation art often experiments with new forms, materials, and mediums, including light, sound, video, and digital computer technology (See "Digital Art," page 1143).

A major installation artist is Ohio-born Jenny Holzer (b. 1950), who worked initially as a street artist in New York in the 1970s. In the mid-1970s, in a course in

29-94. Mel Chin. Revival Field: Pig's Eye Landfill. 1991-93. St. Paul, Minnesota.

Although the *Revival Fields* series serves the practical purpose of reclaiming a hazardous waste site through the use of plants that absorb toxic metals from the soil, Chin sought funding for his series not from the Environmental Protection Agency but from the National Endowment for the Arts. In 1990 his grant application, which had been approved by an NEA panel, was vetoed by NEA chair John E. Frohnmayer, who questioned the project's status as art. Frohnmayer reversed his decision after Chin eloquently compared *Revival Field* to a work of sculpture: "Soil is my marble. Plants are my chisel. Revived nature is my product. . . . This is responsibility and poetry."

the history of contemporary art, Holzer read a number of Post-Structuralist writers and then set out to rephrase their ideas as one-liners suited to the reading habits of Americans raised on advertising messages. She compiled these statements, called *Truisms*, in alphabetical lists, had them printed, and plastered them all over her neighborhood. With remarks reflecting a variety of viewpoints and voices, such as "Any Surplus Is Immoral" and "Morality Is for Little People," she hoped to "instill some sense of tolerance in the onlookers or the reader."

During the 1980s Holzer moved progressively into mediums that would address wider audiences-most notably, computer-controlled light-emitting diode (LED) machines, whose usual advertising function she subverted by programming them to display her provocative messages. Holzer often presented her works in public places, including on the Spectacolor board above Times Square in New York City. Meanwhile, increasing recognition from the art world brought her invitations to exhibit in museums. In a spectacular installation of 1989-90, Holzer wrapped her signboards in a continuous loop around three floors of the helical interior of Frank Lloyd Wright's Guggenheim Museum (fig. 29-95, page 1148). The words moved and flashed in red, green, and yellow colored lights, surrounding the visitor with Holzer's unsettling declarations ("You are a victim of the rules you live by") and disturbing commands ("Scorn Hope," "Forget Truths"). The installation also included, on the ground floor and in a side gallery, spotlighted granite benches carved with Holzer's texts. The juxtaposition of cutting-edge technology, lights, and motion with the static, hand-carved benches, evocative of antiquity and mortality, created a striking contrast fundamental to the expressive effect of the whole.

Site-specific installations have assumed a prominent place in large-scale, regularly held international exhibitions of contemporary art such as the Venice Biennale and Documenta in Kassel, Germany. While many of these shows simply sample the diversity of current art, some are organized around themes, as was the 1991 Spoleto Festival U.S.A. exhibition in Charleston, South Carolina, entitled "Places with a Past." Eighteen artists were invited to find sites in the city for temporary works that would provide an "intimate and meaningful exchange" with the citizens of Charleston on issues from its history.

Ohio artist Ann Hamilton (b. 1956) originally planned to deal with slavery in her entry. When she found an abandoned automobile repair shop on Pinkney Street, however, she decided to treat an aspect of American life neglected by most historians. The street was named for Eliza Lucas Pinkney, who in 1744 introduced to the American colonies the cultivation of indigo, the source of a blue dye used for, among other things, blue-collar work

29-95. Jenny Holzer. *Untitled* (Selections from *Truisms, Inflammatory Essays, The Living Series, The Survival Series, Under a Rock, Laments,* and *Mother and Child Text*). 1989–90. Installation at the Solomon R. Guggenheim Museum, New York, with extended helical tricolor LED electronic display signboards, site specific dimensions $16^1/_2$ " \times 162' \times 6" (41.9 cm \times 49 m \times 15.2 cm). Solomon R. Guggenheim Museum, New York.

Partial gift of the artist, 1989 (89.3626)

clothes. The focal point of Hamilton's *Indigo Blue* (fig. 29-96) was a pile of about 48,000 neatly folded work pants and shirts. However, *Indigo Blue* was more a tribute to the women who washed, ironed, and folded such clothes—in this case, Hamilton and a few women helpers, including her mother—than to the men who worked in them. In front of the great mound of shirts

and pants sat a performer erasing the contents of old history books—creating page space, Hamilton said, for the ordinary, working-class people usually omitted from conventional histories.

A number of installation artists work with video, either using the video monitor itself as a visible part of their work or projecting video imagery onto walls,

29-96. Ann Hamilton. *Indigo Blue.* 1991. Installation for "Places with a Past," Spoleto Festival U.S.A., Charleston, South Carolina.

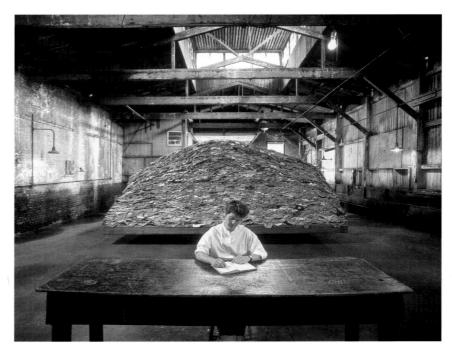

screens, or other surfaces. The pioneer of video as an artistic medium was the Korean-born, New York-based Nam June Paik (b. 1931), who proclaimed that just "as collage technique replaced oil paint, the cathode ray tube will replace the canvas." Strongly influenced by John Cage, Paik made experimental music in the late 1950s and early 1960s and participated in the performance activities of Fluxus. He began working with modified television sets in 1963 and bought his first video camera in 1965. Since then, Paik has worked with live, recorded, and computer-generated images displayed on video monitors of varying sizes, which he often combines into sculptural ensembles such as Electronic Superhighway: Continental U.S. (fig. 29-97), a sitespecific installation created for the Holly Solomon Gallery in New York. Stretching across an entire wall, the work featured a map of the continental United States outlined in neon and backed by video monitors perpetually flashing with color and movement and accompanied by sound. (Side walls featured Alaska and Hawaii.) The monitors within the borders of each state displayed images reflecting that state's culture and history, both distant and recent. The only exception was New York State, whose monitors displayed live, closed-circuit images of the gallery visitors, placing them in the art work and transforming them from passive spectators into active participants.

Paik's videos often use rapid cuts and fast motion to evoke the ceaseless flow of images and information carried by electronic communication systems. By contrast, the California-based video artist Bill Viola (b. 1951) often employs extreme slow motion to heighten sensory awareness and induce a state of contemplation at odds with the fast-paced images of the mass media. Inspired by both Eastern and Western religions, Viola frequently addresses themes relating to birth, death, and spirituality. In The Crossing (fig. 29-98), two videos, projected simultaneously on either side of a 16-foot-high screen, show a casually dressed white man on a dark set, approaching in slow motion. When his body almost fills the screen, he stops and stands impassively, facing the viewer. On one side of the screen, a small flame appears at the man's feet and gradually spreads to consume his entire body. On the other side, a trickle of water starts falling on his head, steadily increasing into a torrent that inundates him. Meanwhile, the amplified sounds of fire and water increase to a mighty roar. When the flames die down and the water subsides, the man has disappeared. What is perhaps most remarkable about this annihilation (a digitally-created illusion) is that the man does not physically resist but calmly accepts being engulfed by the elements, even stretching out his arms as if to welcome them. Viola's work dramatizes, among other things, the belief of many world religionsincluding Hinduism, Judaism, and Christianity-in the power of fire and water to purge and purify the human mind and soul.

Physical rather than spiritual trials are prominent in the work of Matthew Barney (b. 1967), a former highschool football star from Boise, Idaho, whose first New

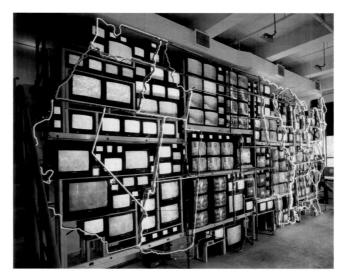

29-97. Nam June Paik. *Electronic Superhighway: Continental U.S.* 1995. Forty-seven-channel closed-circuit video installation with 313 monitors, neon, steel structure, color, and sound; approx. $15 \times 32 \times 4'$ (4.57 \times 9.75 \times 1.2 m). Courtesy the artist and Holly Solomon Gallery, New York

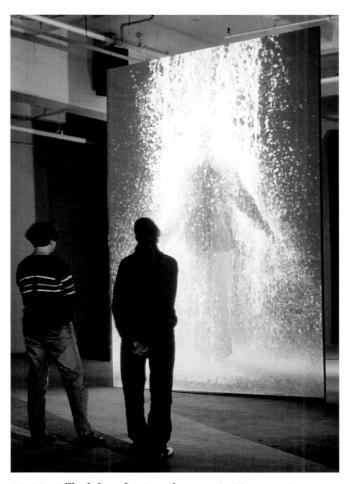

29-98. Bill Viola. *The Crossing.* 1996. Video/sound installation with two channels of color video projected onto 16-foot-high screens, $10^{1}/_{2}$ minutes. View of one screen at 1997 installation at Grand Central Market, Los Angeles. Courtesy of the Artist

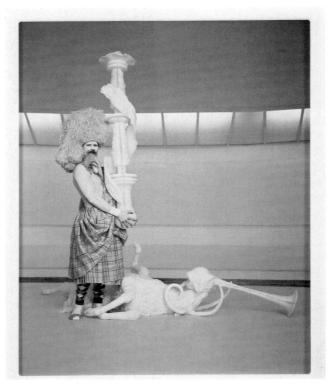

29-99. Matthew Barney. Cremaster 3: Five Points of Fellowship. 2002. C-print in acrylic frame, $54'' \times 44'' \times 1^1/2''$ (137.2 \times 111.8 \times 3.8 cm). Courtesy Barbara Gladstone Gallery, New York

York solo exhibition in 1991 featured an 87-minute-long video of the naked artist strapped into a harness and using ice hooks to climb across the gallery ceiling, down a stairwell, and into a refrigeration unit housing a weightlifter's bench made of petroleum jelly. In 1994 Barney began work on his Cremaster cycle—a series of five surreal films and related sculptures, photographs, and drawings, named for the muscle that raises and lowers the testicles in response to stimuli such as cold and fear. Barney's project is full of anatomical references to the position of the reproductive organs during the embryonic process of sexual differentiation, with Cremaster 1 representing the most "ascended" or undifferentiated state, and Cremaster 5 the most "descended" or differentiated. The cycle often returns to the early point during embryonic development in which the sex of the person is still indeterminate—a time that for Barney represents a state of pure potentiality.

The plot of *Cremaster 3*, the last completed film of the series (which Barney shot out of sequence), revolves around the construction of the Chrysler Building in New York City, and a struggle between two men who work on it: Hiram Abiff, the Architect (played by sculptor Richard Serra, see fig. 29-89), and the Entered Apprentice (played by Barney, who stars in all but one of the *Cremaster* films). They reenact the Masonic myth of Hiram Abiff, legendary architect of the Temple of Solomon, whose murder and resurrection are reenacted during Masonic initiation rites. In a sequence called

"The Order," the rites of the Masonic fraternity are staged in the guise of a game in the Solomon R. Guggenheim Museum (see fig. 22, Introduction). Barney, as the Entered Apprentice in a fantastic costume of peachcolored tartan kilt and matching military full-dress fur hat (fig. 29-99), is the game's sole contestant, and must overcome obstacles on each level of the museum's rotunda. On Level Four, shown here, he encounters an oversized, abstracted bagpipe (cast in white plastic), the bag of which is made from the flayed carcass of a Loughton Ram, a four-horned sheep indigenous to the Isle of Man (the setting of Cremaster 4). The Apprentice's challenge, based on the Scottish sport of the caber (log) toss, is to throw cast-plastic bagpipe drones into the Loughton Ram to complete the form of the instrument. Such convoluted and esoteric iconography is characteristic of Barney's Cremaster cycle, the power of which ultimately depends less on coherent meanings than on the impressively realized scope of its creator's imagination.

Comparably more straightforward is the film and video work of Shirin Neshat (b. 1957) addressing universal themes within the specific context of modern-day Islamic society. Neshat was studying art in California when revolution shook her native Iran in 1979. Returning to Iran in 1990 for the first time in twelve years, Neshat was shocked by the extent to which fundamentalist Islamic rule had transformed her homeland, particularly through the requirement that women appear in public veiled from head to foot in a *chador*, a square of fabric.

29-100. Shirin Neshat. Production stills from *Fervor***.** 2000. Video/sound installation with two channels of black-and-white video projected onto two screens, 10 minutes. Courtesy Barbara Gladstone Gallery, New York

Upon her return to the United States, Neshat began using the black *chador* as the central motif of her work.

In the late 1990s Neshat began to make visually arresting and poetically structured films and videos that offer subtle critiques of Islamic society. Fervor (fig. 29-100), in Neshat's words, "focuses on taboos regarding sexuality and desire" in Islamic society that "inhibit the contact between the sexes in public. A simple gaze, for instance, is considered a sin. . . . " Composed of two separate video channels projected simultaneously on two large, adjoining screens, Fervor presents a simple narrative. In the opening scene, a black-veiled woman and jacket-wearing man, viewed from above, cross paths in an open landscape. The viewer senses a sexual attraction between them, but they make no contact and go their separate ways. Later, they meet again while entering a public ceremony where men and women are divided by a large curtain. On a stage before the audience, a bearded man fervently recounts (in Farsi, without subtitles) a story adapted from the Koran about Yusuf (the biblical Joseph)

and Zolikha. Zolikha attempts to seduce Yusuf (her husband's slave) and then, when he resists her advances, falsely accuses him of having seduced her. The speaker passionately urges his listeners to resist such sinful desires with all their might. As his tone intensifies and the audience begins to chant in response to his exhortations, the male and female protagonists grow increasingly anxious, and the woman eventually rises and exits hurriedly. Fervor ends with the man and woman passing each other in an alley, again without verbal or physical contact.

While Neshat concentrates on dualisms and divisions—between East and West, male and female, individual desire and collective law—the Shanghai-born artist Wenda Gu (b. 1955) dedicates his art to bringing people together. Trained in traditional ink painting at China's National Academy of Fine Arts, Gu in the 1980s began to paint pseudocharacters—fake, Chineselooking ideograms of his own invention. Although he later claimed that his intent was simply to "break through the control of tradition," the Chinese authorities

29-101. Wenda Gu. *United Nations—Babel of the Millennium.* 1999. Site-specific installation made of human hair, height 75' (22.9 m), diameter 34' (10.4 m). San Francisco Museum of Modern Art.

Fractional and promised gift of Viki and Kent Logan

feared that his work contained hidden political messages and did not permit his first solo exhibition to open in 1986. The next year Gu emigrated to the United States and in 1993 began his United Nations series, which he describes as an ongoing worldwide art project. The series consists of site-specific installations or "monuments" made of human hair, which Gu collects from barbershops across the globe and presses or weaves into bricks, carpets, and curtains. Gu's "national" monuments-installed in such countries as Poland, Israel, and Taiwan—use hair collected within and address issues specific to that country. His "transnational" monuments address larger themes and blend hair collected from different countries as a metaphor for the mixture of races that the artist predicts will eventually unite humanity into "a brave new racial identity." Many of Gu's installations, such as United Nations—Babel of the Millen*nium* (fig. 29-101), also incorporate invented scripts based on Chinese, English, Hindi, and Arabic characters that, by frustrating viewers' ability to read them, "evoke the limitations of human knowledge" and help prepare them for entry into an "unknown world."

In its ambitious attempt to address in artistic terms the issue of globalism that dominates discussions of contemporary economics, society, and culture, Gu's work is remarkably timely. Yet, like all important art, it is meant to speak not only to the present but also to the future, which will recognize it as part of the fundamental quest of artists throughout history to extend the boundaries of human perception, feeling, and thought and to express humanity's deepest wishes and most powerful dreams. "A great 'utopia' of the unification of mankind probably can never exist in our reality," admits Gu, "but it is going to be fully realized in the art world."

GLOSSARY

abacus The flat slab at the top of a **capital**, directly under the **entablature**.

absolute dating A method of assigning a precise historical date to periods and objects based on known and recorded events in the region as well as technically extracted physical evidence (such as carbon-14 disintegration). See also **radiometric dating**, **relative dating**.

abstract, abstraction Any art that does not represent observable aspects of nature or transforms visible **forms** into a stylized image. Also: the formal qualities of this process.

academic art See academy, academician.

academy, academician An institution established to train artists. Most academies date from the Renaissance and later; they became powerful state-run institutions in the seventeenth and eighteenth centuries. In general, academies replaced guilds as the venue where students learned both the craft and the theory of art. Academies held exhibitions and awarded prizes; helped artists be seen as trained specialists, rather than craftspeople; and promoted the elevation of the artist's social status. An academician is an official academy-trained artist.

acanthus A leafy plant whose foliage inspired architectural ornamentation, used in the **Corinthian** and **Composite orders** and in the relief scroll known as the *rinceau*.

acropolis The **citadel** of an ancient Greek city, located at its highest point and housing temples, a **treasury**, and sometimes a royal palace. The most famous is the Acropolis in Athens.

acroterion (acroteria) An ornament at the corner or peak of a roof.

acrylic A fast-drying synthetic paint popular since the 1950s.

action painting Style of **abstract** painting emphasizing the active and spontaneous handling of paint, practiced by New York **avantgarde** artists during the late 1940s and 1950s.

adobe Sun-baked blocks made of clay mixed with straw. Also: the buildings made with this material

adyton The back room of a Greek temple. At Delphi, the place where the **oracles** were delivered. More generally, a very private space or room

aedicula (aediculae) A decorative architectural frame, usually found around a niche, door, or window. An aedicula is made up of a pediment and entablature supported by columns or pilasters.

aerial perspective See perspective.

aesthetics The philosophy of beauty, or, more broadly, of art in general.

agora An open space in a Greek town used as a central gathering place or market. *See also* **forum**.

aisle Passage or open corridor of a church, hall, or other building that parallels the main space, usually on both sides, and is delineated by a row, or **arcade**, of **columns** or **piers**. Called side aisles when they flank the **nave** of a church.

album A book consisting of blank pages (**album leaves**) on which an artist may sketch, draw, or paint.

alignment An arrangement of stones (**menhirs**) in straight rows.

allegory In a work of art, an image (or images) that symbolically illustrates an idea, concept, or principle, often moral or religious.

altar A tablelike structure where religious rites are performed. In Christian churches, the altar contains a consecrated slab of stone, the **mensa**, supported by the **stipes**.

altarpiece A painted or carved panel or **winged** structure placed at the back of or behind and above an altar. Contains religious imagery, often specific to the place of worship for which it was made. *See also* **reredos**; **retablo**.

amalaka In Hindu architecture, the circular or square-shaped element on top of a spire (**shikhara**), often crowned with a **finial**, symbolizing the cosmos.

ambulatory The passage (walkway) around the **apse** in a **basilican** church or around the central space in a **central-plan** building.

amphiprostyle Term describing a building, usually a temple, with **porticoes** at each end but without **columns** along the other two sides.

amphitheater An oval arena for athletic events and spectacles developed by ancient Roman architects from the idea of two theaters placed facing each other, with ascending tiers of seats for the audience.

amphora An ancient Greek jar for storing oil or wine, with an egg-shaped body and two curved handles.

Anastasis In the Byzantine Church, Christ's descent into hell to release and resurrect the worthy dead.

Andachtsbild (Andachtsbilder) German for "devotional image." Often a painting or sculpture that depicts themes of Christian grief and suffering, such as the **pieta**, intended to encourage meditation.

aniconic A symbolic representation without images of human figures, very often found in Islamic art.

animal interlace Decoration made of interwoven animals or serpents, often found in Celtic and early medieval Northern European art

animal style A type of imagery used in Europe and western Asia during the ancient and medieval periods, characterized by stylized animals or animal-like **forms** arranged in intricate patterns or combats.

ankh A looped cross signifying life, used by ancient Egyptians.

anta (antae) A rectangular pilaster found at the ends of the framing walls of a recessed portico.

antependium (antependia) The front panel of a **mensa** or **altar** table.

anticlassical A term designating any image, idea, or style that opposes the **classical** norm.

apotheosis Deification of a person or thing. In art, often shown as an ascent to heaven or glory, borne by an eagle, angels, or *putti*.

 $\ensuremath{\mathbf{appliqu\acute{e}}}$ A piece of any material applied to another.

apprentice A student artist or craftsperson in training. In a traditional system of artistic training established under the **guilds** and still in use today, master artists took on apprentices (students) for a specific number of years. The apprentice was taught every aspect of the

artist's craft, and he or she participated in the master's workshop or **atelier**.

appropriation Term used to describe an artist's practice of borrowing from another source for a new work of art. While in previous centuries artists often copied one another's figures, **motifs**, or **compositions**, in modern times the sources for appropriation extend from material culture to works of art.

apse, apsidal A large semicircular or polygonal (and usually **vaulted**) **niche** protruding from the end wall of a building. In the Christian church, it contains the **altar**. *Apsidal* is an adjective describing the condition of having such a space.

aquamanile A vessel holding water used for washing hands, whether during the celebration of the Catholic Mass or before eating at a secular table. An aquamanile may have the form of a human figure or a grotesque animal.

aquatint A type of **intaglio** printmaking developed in the eighteenth century that produces an area of even **tone** without laborious **cross-hatching**. The aquatint is made by using a porous resin coating on a metal plate, which when immersed in acid allows an even, all-over biting of the plate. When printed, the end result has a granular, textural effect.

aqueduct A trough to carry water through gravity, if necessary supported by **arches**.

arabesque A type of **linear** surface decoration based on foliage and **calligraphic forms**, usually characterized by flowing lines and swirling shapes.

arcade A series of **arches**, carried by **columns** or **piers** and supporting a common wall or lintel. In a blind arcade, the arches and supports are engaged (attached to the wall) and have a decorative function.

arch In architecture, a curved structural element that spans an open space. Built from wedge-shaped stone blocks called voussoirs, which, when placed together and held at the top by a trapezoidal keystone, form an effective space-spanning and weight-bearing unit. Requires buttresses at each side to contain the outward thrust caused by the weight of the structure. Corbel arch: arch or vault formed by courses of stones, each of which projects beyond the lower course until the space is enclosed; usually finished with a capstone. Horseshoe arch: an arch of more than a halfcircle; typical of western Islamic architecture. Ogival arch: a pointed arch created by S curves. Relieving arch: an arch built into a heavy wall just above a post-and-lintel structure (such as a gate, door, or window) to help support the wall above by transfening the load to the side walls.

archaic smile The curved lips of an ancient Greek statue, usually interpreted as an attempt to animate the features.

architectonic Resembling or relating to the spatial or structural aspects of architecture.

architrave The bottom element in an entablature, beneath the frieze and the cornice.

archivolt Curved **molding** formed by the **voussoirs** making up an **arch**.

art brut French for "raw art." Term introduced by Jean Dubuffet to denote the often vividly expressive art of children and the insane, which he considered uncontaminated by culture. **ashlar** A highly finished, precisely cut block of stone. When laid in even **courses**, ashlar masonry creates a uniform face with fine joints. Often used as a facing on the visible exterior of a building, especially as a veneer for the **facade**. Also called **dressed stone**.

assemblage Artwork created by gathering and manipulating two and/or three-dimensional found objects.

astragal A thin convex decorative **molding**, often found on **Classical entablatures**, and usually decorated with a continuous row of beadlike circles.

atelier The studio or workshop of a master artist or craftsperson, often including junior associates and **apprentices**.

atmospheric perspective See perspective.

atrial cross The cross placed in the **atrium** of a church. In Colonial America, used to mark a gathering and teaching place.

atrium An unroofed interior courtyard or room in a Roman house, sometimes having a pool or garden, sometimes surrounded by columns. Also: the open courtyard in front of a Christian church; or an entrance area in modern architecture.

attic story The top story of a building. In **classical** architecture, the level above the **entablature**, often decorated or carrying an inscription.

attribute The symbolic object or objects that identify a particular deity, saint, or personification in art.

automatism A technique whereby the usual intellectual control of the artist over his or her brush or pencil is foregone. The artist's aim is to allow the subconscious to create the artwork without rational interference.

avant-garde Term derived from the French military word meaning "before the group," or "vanguard". Avant-garde denotes those artists or concepts of a strikingly new, experimental, or radical nature for the time.

axial Term used to describe a **plan** or design that is based on a symmetrical, **linear** arrangement of elements along a central axis. Bilateral symmetry.

axis Imaginary central line.

axis mundi A concept of an "axis of the world," which marks sacred sites and denotes a link between the human and celestial realms. For example, in Buddhist art, the axis mundi can be marked by monumental freestanding decorative pillars.

background Within the depicted space of an artwork, the area of the image at the greatest distance from the **picture plane**.

bailey The outermost walled courtyard of a castle.

baldachin A canopy (whether suspended from the ceiling, projecting from a wall, or supported by **columns**) placed over an honorific or sacred space such as a throne or church **altar**.

balustrade A low barrier consisting of a series of short circular posts (called balusters), with a rail on top.

baptismal font A large open vessel or tank, usually of stone, containing water for the Christian ritual of baptism.

baptistry A building used for the Christian ritual of baptism. It is usually separate from the main church and often octagonal or circular in shape.

barbican An exterior defensive fortification of a gate or portal.

bargeboards Boards covering the rafters at the gable end of a building; bargeboards are often carved or painted.

barrel vault See vault

bar tracery See tracery

bas-de-page French: bottom of the page; a term used in manuscript studies to indicate pictures below the text, literally at the bottom of the page.

base Any support. Also: masonry supporting a statue or the **shaft** of a **column**.

basilica A large rectangular building. Often built with a **clerestory**, side **aisles** separated from the center **nave** by **colonnades**, and an **apse** at one or both ends. Roman centers for administration, later adapted to Christian church use. Constantine's architects added a transverse aisle at the end of the nave called a **transept**.

basilica plan A plan consisting of **nave** and side **aisles**, often with a **transept** and usually with an **apse**.

bas-relief Low-relief sculpture. *See also* **relief sculpture**.

battered wall A wall that slopes inward at the top for stability.

battlement The uppermost, fortified sections of a building or wall, usually including **crenellations** and other defensive structures.

bay A unit of space defined by architectural elements such as **columns**, **piers**, and walls.

beadwork Any decoration created with or resembling beads.

beehive tomb A **corbel-vaulted** tomb, conical in shape like a beehive, and covered by an earthen mound.

Benday dots In modern printing and typesetting, the individual dots that, together with many others, make up lettering and images. Often machine- or computer-generated, the dots are very small and closely spaced to give the effect of density and richness of **tone**.

bestiary A book describing characteristics, uses, and meaning illustrated by moralizing tales about real and imaginary animals, especially popular during the Middle Ages in western Europe. See also **herbal**.

bevel, beveling A cut made at any angle except a right angle. Also: the technique of cutting at a slant.

bi A jade disk with a hole in the center used in China for the ritual worship of the sky. Also: a badge indicating noble rank.

biomorphic Adjective used to describe forms that resemble or suggest shapes found in nature.

bird's-eye view A view from above.

black-figure A **style** or technique of ancient Greek pottery in which black figures are painted on a red clay ground. *See also* **red-figure**.

blackware A ceramic technique that produces pottery with a primarily black surface. Blackware has both **matte** and glossy patterns on the surface of the wares.

blind Adjective describing decorative elements attached to the surface of a wall, with no openings.

block printing Creation of a printed image, such as a **woodcut** or wood **engraving**, from a carved woodblock.

bobbin A cylindrical reel around which a material such as yarn or thread is wound when spinning, sewing, or weaving.

bodhisattva A deity that is far advanced in the long process of transforming itself into a *buddha*. While seeking enlightenment or emancipation from this world (*nirvana*), *bodhisattvas* help others attain this same liberation.

boiserie Decoratively carved and/or painted wood paneling or wainscotting, usually applied to seventeenth- and eighteenth-century French interiors

Book of Hours A private prayer book, having a calendar, services for the canonical hours, and sometimes special prayers.

boss A decorative knoblike element. Bosses can be found in many places, such as at the intersection of a Gothic **vault rib**. Also buttonlike projections in decorations and metalwork.

bracket, bracketing An architectural element that projects from a wall to support a horizontal part of a building, such as beams or the eaves of a roof.

breakfast piece A still life painting representing food and drink normally eaten at breakfast.

broken pediment See pediment.

bronze An alloy of copper and tin, occasionally with traces of other metals. Also: any sculpture or object made from this substance.

buon fresco See fresco.

burin A metal instrument used in **engraving** to cut lines into the metal plate. The sharp end of the burin is trimmed to give a diamond-shaped cutting point, while the other end is finished with a wooden handle that fits into the engraver's palm.

bust A portrait depicting only the head and shoulders of the subject.

buttress, buttressing An architectural support, usually consisting of massive masonry built against an exterior wall to brace the wall and counter the thrust of the vaults. Transfers the weight of the vault to the ground. Flying buttress: An arch built on the exterior of a building that transfers the thrust of the roof vaults at important stress points through the wall to a detached buttress pier leading to the wall buttress.

cairn A pile of stones or earth and stones that served both as a prehistoric burial site and as a marker of underground tombs.

calligraphy The art of highly ornamental handwriting.

calotype The first photographic process utilizing negatives and paper positives, invented by William Henry Fox Talbot in the late 1830s.

calyx krater See krater.

came (cames) A lead strip used in the making of leaded or **stained-glass** windows. Cames have an indented vertical groove on the sides into which the separate pieces of glass are fitted to hold the design together.

cameo Gemstone, clay, glass, or shell having layers of color, carved in **low relief** to create an image and ground of different colors.

camera obscura An early cameralike device used in the Renaissance and later for recording images of nature. Made from a dark box (or room) with a hole in one side (sometimes fitted with a lens), the camera obscura operates when bright light shines through the hole, casting an upside-down image of an object outside onto the inside wall of the box.

campanile The Italian term for a freestanding bell tower.

canon Established rules or standards.

canon of proportions A set of ideal mathematical ratios in art based on measurements of the human body.

cantilever A beam or structure that is anchored at one end and projects horizontally beyond its vertical support, such as a wall or **column**. It can carry loads throughout the rest of its unsupported length. Or a bracket used to carry the **cornice** or extend the eaves of a building.

capital The sculpted block that tops a **column**. According to the conventions of the **orders**, capitals include different decorative elements. *See* **order**. Also: a **historiated** capital is one displaying a narrative.

capriccio A painting or print of a fantastic, imaginary landscape, usually with architecture.

capstone The final, topmost stone in a **corbel arch** or **vault**, which joins the sides and completes the structure.

caricature An artwork that exaggerates individual peculiarities, usually with humorous or satirical intent.

cartoon A full-scale drawing used to transfer the outline of a design onto a surface (such as a wall, canvas,panel,or tapestry) to be painted, carved, or woven.

cartouche A frame for a **hieroglyphic** inscription formed by a rope design surrounding an oval space. Used to signify a sacred or honored name. Also: in architecture, a decorative device or plaque, usually with a plain center used for inscriptions or epitaphs.

caryatid A sculpture of a draped female figure acting as a column supporting an entablature.

casemate A vaulted chamber within the thickness of a fortified wall that provides storage space, usually for weapons or military equipment.

casement A window sash that opens on hinges at the side, swinging open the entire length.

catacomb A subterranean burial ground consisting of tunnels on different levels, having **niches** for urns and **sarcophagi** and often incorporating rooms (*cubiculae*).

cathedral The principal Christian church in a diocese, built in the bishop's administrative center and housing his throne (*cathedra*).

cella The principal interior room at the center of a Greek or Roman temple within which the cult statue was usually housed. Also called the **naos**.

cenotaph A funerary monument commemorating an individual or group buried elsewhere.

centaur In Greek mythology, a creature with the head, arms, and torso of a man and the legs and hind quarters of a horse.

centering A temporary structure that supports a masonry **arch** and **vault** or **dome** during construction until the mortar is fully dried and the masonry is self-sustaining.

central-plan building Any structure designed with a primary central space surrounded by symmetrical areas on each side. For example, **Greek-cross plan** (equal-armed cross)

ceramics A general term covering all types of wares made from fired clay, including **porcelain** and **terra-cotta**.

Chacmool In Mayan sculpture, a half-reclining figure, probably representing an offering bearer.

chaitya A type of Buddhist temple found in India. Built in the **form** of a hall or **basilica**, a *chaitya* hall is highly decorated with sculpture and usually is carved from a cave or natural rock location. It houses a sacred shrine or **stupa** for worship.

chakra Sanskrit term for "wheel." See also dharmachakra.

chamfer The slanted surface produced when an angle is trimmed or **beveled**, common in building and metalwork.

champlevé An enamel technique in which the cells gouged out of the metal plate hold colored glass. *See also* **cloisonné**.

chancel The end of the church containing the **choir**, **ambulatory**, and radiating chapels. Also called **chevet**.

chasing Ornamentation made on metal by incising or hammering the surface.

château (châteaux) A French country house or residential castle. A château fort is a military castle incorporating defensive works such as towers and battlements.

chattri (chattris) A decorative pavilion with an umbrella-shaped **dome** in Indian architecture.

cherub (cherubim) The second highest order of angels (see **seraph**). Popularly, an idealized small child, usually depicted naked and with wings. See also **putto**.

chevet A French term for the area of a church beyond the crossing and including the apse, ambulatory, and radiating chapels. Also called chancel.

chevron A decorative or heraldic motif of repeated Vs; a zigzag pattern.

chiaroscuro An Italian word designating the contrast of dark and light in a painting, drawing, or print. Chiaroscuro creates spatial depth and **volumetric forms** through gradations in the intensity of light and shadow.

chinoiserie The decorative imitation of Chinese art and **style** common in Europe in the eighteenth century.

chip carving A type of decorative incision on wood or metal, usually made with a knife or chisel, characterized by small triangular or square patterns.

chiton A thin sleeveless garment, fastened at waist and shoulders, worn by men and women in ancient Greece.

choir The section of a Christian church reserved for the clergy or the religious, either between the **crossing** and the **apse** or in the **nave** just before the crossing, screened or walled and fitted with stalls (seats). In convents, funeral chapels, and later Protestant churches, the choir may be raised above the nave over the entrance. Also: an area reserved for singers.

chromolithography A type of **lithographic** process utilizing color. A new stone is made for each color, and all are printed onto the same piece of paper to create a single, colorful lithographic image.

ciborium A vaulted canopy over a Christian **altar**. Also: the receptacle for the Eucharist in the Catholic Mass. *See also* **baldachin**.

circus A circular or oval arena built by ancient Romans and usually enclosed by raised seats for spectators.

citadel A fortress or defended city, if possible placed in a high, commanding location.

clapboard Horizontal overlapping planks used as protective siding for buildings, particularly houses in North America.

Classical A term referring to the art and architecture of ancient Greece between c. 480–320 BCE.

classical, classicism Any aspect of later art or architecture reminiscent of the rules, **canons**, and examples of the art of ancient Greece and Rome. Also: in general, any art aspiring to the qualities of restraint, balance, and rational order exemplified by the ancients. Also: the peak of perfection in any period.

Classical orders See order.

clerestory The topmost zone of a wall with windows in a **basilica** extending above the **aisle** roofs. Provides direct light into the central interior space (the **nave**).

cloisonné An enamel technique in which metal wire or strips are affixed to the surface to form the design. The resulting areas (cloisons) are filled with enamel (colored glass).

cloister An open space, part of a monastery, surrounded by an **arcaded** or **colonnaded** walkway, often having a fountain and garden, and dedicated to nonliturgical activities and the secular life of the religious. Members of a cloistered order do not leave the monastery or interact with outsiders.

cloth of honor A piece of fabric, usually rich and highly decorated, hung behind a person of great rank on ceremonial occasions. Signifying the exalted status of the space before them, cloths of honor may be found behind thrones, **altars**, or representations of holy figures.

codex (codices) A book, or a group of **manuscript** pages (**folios**), held together by stitching or other binding on one side.

coffer A recessed decorative panel that is used to reduce the weight of and to decorate ceilings or **vaults**. The use of coffers is called coffering.

coiling A technique in basketry. In coiled baskets a spiraling structure is held place by another material.

collage A technique in which cutout forms of paper, cloth, or found materials are pasted onto another surface. Also: a work of art created using this technique.

colonnade A row of **columns**, supporting a straight **lintel** (as in a **porch** or **portico**) or a series of **arches** (an **arcade**).

colonnette A small **column** attached to a **pier** or wall. Colonnettes are decorative features that may reach into the **vaulted** sections of the building, contributing to the vertical effect

colophon The data placed at the end of a book listing the book's author, publisher, **illuminator**, and other information related to its production.

colossal order See order.

column An architectural element used for support and/or decoration. Consists of a rounded or polygonal vertical **shaft** placed on a **base** and topped by a decorative **capital**. In classical architecture, built in accordance with the rules of one of the architectural **orders**. Columns can be freestanding or attached to a background wall (**engaged**).

column statue A column carved to depict a human figure.

complementary color The primary and secondary colors across from each other on the color wheel (red and green, blue and orange, yellow and purple). When juxtaposed, the intensity of both colors increases. When mixed together, they negate each other to make a neutral gray-brown.

Composite order See order.

composition The arrangement of **formal** elements in an artwork

compound pier A **pier** or large **column** with **shafts**, **pilasters**, or **colonnettes** attached to it on one or more sides.

conch See half dome.

concrete A building material developed by the Romans, made primarily from lime, sand, cement, and rubble mixed with water. Concrete is easily poured or **molded** when wet and hardens into a particularly strong and durable stonelike substance.

cone mosaic An early type of surface decoration created by pressing colored cones of baked clay into prepared wet plaster; associated with Sumerian architecture.

cong A square or octagonal jade tube with a cylindrical hole in the center. A symbol of the earth, it was used for ritual worship and astronomical observations in ancient China.

connoisseurship A term derived from the French word connoisseur, meaning "an expert," and signifying the study and evaluation of art based primarily on formal, visual, and stylistic analysis. A connoisseur studies the style and technique of an object to deduce its relative quality and possible maker. This is done through visual association with other, similar objects and styles. See also contextualism; formalism.

content When discussing a work of art, the term can include all of the following: its **subject matter**; the ideas contained in the work; the artist's intention; and even its meaning for the beholder.

contextualism An interpretive approach in art history that focuses on the culture surrounding an art object. Unlike **connoisseurship**, contextualism utilizes the literature, history, economics, and social developments (among other things) of a period, as well as the object itself, to explain the meaning of an artwork. *See also* **connoisseurship**.

contrapposto An Italian term mearing "set against," used to describe the twisted pose resulting from parts of the body set in opposition to each other around a central **axis**.

corbel A bracket of building material, as stone or brick, projecting from a wall and generally used to support a **cornice** or **arch**.

corbeling An early roofing and **arching** technique in which each **course** of stone projects slightly beyond the previous layer until the uppermost coourser meet. Results in a high, almost pointed **arch** or **vault**.

corbel arch See arch

corbeled vault See vault.

Corinthian order See order

cornice The uppermost section of a **Classical entablature**. More generally, a horizontally projecting element found at the top of a building wall or **pedestal**. A raking cornice is formed by the junction of two slanted cornices, most often found in **pediments**.

course A horizontal layer of stone used in building.

cove A concave **molding**, or a curved surface forming a junction between a wall and a ceiling. A **cove ceiling** incorporates such moldings on all sides.

crenellation Alternating high and low sections of a wall, giving a notched appearance and creating permanent defensive shields in the walls of fortified buildings.

crockets A stylized leaf used as decoration along the outer angle of spins, pinnacles, gables, and around capitals in Gothic architecture.

cromlech In prehistoric architecture, a circular arrangement of upright stones (**menhirs**).

cross vault See groin vault

cross-hatching A technique primarily used in printmaking and drawing, in which a set of parallel lines (hatching) is drawn across a previous set, but from a differing (usually right) angle. Cross-hatching gives a great density of **tone** and allows the artist to create the illussion of shadows efficiently.

cross vault See vault

crossing The juncture of the **nave** and the **transept** in a church, often marked on the exterior by a tower or **dome**.

cruciform A term describing anything that is cross-shaped, as in the cruciform **plan** of a church.

cruck One of a pair of curved timbers forming a principal support of a roof or wall.

crypt The **vaulted** chamber beneath the floor of a church, usually under the sanctuary, which may contain tombs and/or chapels.

cubiculum (**cubiculae**) A private chamber for burial in the **catacombs**. The **sarcophagi** of the affluent were housed there in arched wall **niches**

cuneiform An early form of writing with wedge-shaped marks impressed into wet clay with a **stylus**, primarily used by ancient Mesopotamians.

curtain wall A wall in a building that does not support any of the weight of the structure. Also: the freestanding outer wall of a castle, usually encircling the inner **bailey** (yard) and **keep** (primary defensive tower).

cycle A series of images depicting a story or theme intended to be displayed together, and forming a visual narrative.

cyclopeanconstructionormasonryAmethod of building using hugeblocks of rough-hewnstone.Any large-scale, monumental building project that impresses by sheer size. Named after the Cyclopes (sing. Cyclops)one-eyed giants of legendary strength in Greek myths.

cylinder seal A small cylindrical stone decorated with **incised** patterns. When rolled across soft clay or wax, the resulting raised pattern or design (**relief**) served in Mesopotamian and Indus Valley cultures as an identifying signature.

dado (dadoes) The lower part of a wall, differentiated in some way (by a **molding** or different coloring or paneling) from the upper section.

daguerreotype An early photographic process that makes a positive print on a light-sensitized copperplate; invented and marketed in 1839 by Louis-Jacques-Mandé Daguerre.

Day-Glo A trademark name for fluorescent materials, including pigments, inks, and paints.

Deësis In Byzantine art, the representation of Christ enthroned, flanked by the Virgin Mary and Saint John the Baptist.

demotic writing The simplified form of ancient Egyptian **hieratic** writing, used primarily for administrative and private texts.

dentil One of a series of small, toothlike blocks arranged in a continuous band to decorate a **cornice** or **molding**.

dharmachakra Sanskrit for "wheel" (**chakra**) and "law" or "doctrine" (**dharma**); often used in Buddhist iconography to signify the "wheel of the law."

di sotto in su Italian for "seen from below" (worm's eye view).

digital art Art created through the use of digital computer technology.

dipteral A building that is surrounded by two rows of **columns** (a double **peristyle**).

diptych Two panels of equal size (usually decorated with paintings or reliefs) hinged together.

dogu Small human figurines made in Japan during the Jomon period. Shaped from clay with exaggerated expressions and in contorted poses, *dogu* were probably used in religious rituals.

dolmen A prehistoric structure made up of two or more large upright stones supporting a large, flat, horizontal slab or slabs.

dome A round vault, usually over a circular space. Consists of a curved masonry vault of shapes and cross sections that can vary from hemispherical to bulbous to ovoidal. May use a supporting vertical wall (drum), from which the vault springs, and may be crowned by an open space (oculus) and/or an exterior lantern. When a dome is built over a square space, an intermediate element is required to make the transition to a circular drum. There are two types: A dome on pendentives (spherical triangles) incorporates arched, sloping intermediate sections of wall that carry the weight and thrust of the dome to heavily buttressed supporting piers. A dome on squinches uses an arch built into the wall (squinch) in the upper corners of the space to carry the weight of the dome across the corners of the square space below. A half-dome or conch may cover a semicircular space.

domino construction System of building construction introduced by the architect Le Corbusier in which reinforced concrete floor slabs are floated on six freestanding posts placed as if at the positions of the six dots on a domino playing piece.

donjon See keep

Doric order See order.

dormer A vertical window built into a sloping roof. A dormer window has its own roof and side walls that adjoin to the body of the roof proper.

dressed stone See ashlar.

drillwork The technique of using a drill for the creation of certain effects in sculpture.

drum The wall that supports a **dome**. Also: a segment of the circular **shaft** of a **column**.

drypoint An **intaglio** printmaking process by which a metal (usually copper) plate is directly inscribed with a pointed instrument (**stylus**). The resulting design of scratched lines is inked, wiped, and printed. Also: the print made by this process.

earthworks Artwork and/or sculpture, usually on a large scale, created by manipulating the natural environment. Also: the earth walls of a fort

easel painting Any painting of small to intermediate size that can be executed on an artist's easel.

echinus A cushionlike circular element found below the **abacus** of a **Doric capital**. Also: a similarly shaped **molding** (usually with **egg-and-dart motifs**) underneath the **volutes** of an lonic capital.

edition A single printing of a book or print. An edition includes only what is printed at a particular moment, usually pulled from the same press by the same publisher.

egg-and-dart A decorative **molding** made up of an alternating pattern of round (egg) and downward-pointing, tapered (dart) elements.

electron spin resonance techniques Method that uses magnetic field and microwave irradiation to date material such as tooth enamel and its surrounding soil.

elevation The arrangement, proportions, and details of any vertical side or face of a building. Also: an architectural drawing showing an exterior or interior wall of a building.

emblema (**emblemata**) In a mosaic, the elaborate central **motif** on a floor, usually a self-contained unit done in a more refined manner, with smaller **tesserae** of both marble and semiprecious stones.

embossing The technique of working metal by hammering from the back to produce a **relief**. *See also* **repoussé**.

embroidery The technique in needlework of decorating fabric by stitching designs and figures with threads. Also: the material produced by this technique.

enamel A technique in which powdered glass is applied to a metal surface in a decorative design. After firing, the glass forms an opaque or transparent substance that is fixed to the metal background. Also: an object created with enamel technique. See also **champlevé**; **cloissoné**.

encaustic A painting technique using pigments mixed with hot wax as a **medium**.

engaged column A **column** attached to a wall. See also **column**.

engraving An intaglio printmaking process of inscribing an image, design, or letters onto a metal or wood surface from which a print is made. An engraving is usually drawn with a sharp implement (**burin**) directly onto the surface of the plate. Also: the print made from this process.

entablature In the **Classical orders**, the horizontal elements above the **columns** and **capitals**. The entablature consists of, from bottom to top, an **architrave**, a **frieze**, and a **cornice**.

entasis A slight swelling of the **shaft** of a Greek **column**. The optical illusion of entasis makes the column appear from afar to be straight.

etching An intaglio printmaking process, in which a metal plate is coated with acid-resistant resin and then inscribed with a **stylus** in a design, revealing the plate below. The plate is then immersed in acid, which eats away the exposed metal. The resin is removed, leaving the design etched permanently into the metal and the plate ready to be inked, wiped, and printed. Also: the print made from this process.

Eucharist The central rite of the Christian Church, from the Greek word "thanksgiving." Also known as the Mass or Holy Communion, it is based on the Last Supper. According to traditional Catholic Christian belief, consecrated bread and wine become the body and blood of Christ; in Protestant belief, bread and wine symbolize the body and blood.

exedra (exedrae) In architecture, a semicircular **niche**. On a small scale, often used as decoration, whereas larger *exedrae* can form interior spaces (such as an **apse**).

expressive When used in describing art, **form** that seems to convey the feelings of the artist and to elicit an emotional response in the viewer.

expressionism, expressionistic Terms describing a work of art in which **forms** are created primarily to evoke subjective emotions rather than to portray objective reality.

extrados The upper, curving surface of a **vault** or **arch**. *See also intrados*.

facade The face or front wall of a building.

faience Type of **ceramic** covered with colorful, opaque **glazes** that form a smooth, impermeable surface. First developed in ancient Egypt.

fang ding A square or rectangular bronze vessel with four legs. The *fang ding* was used for ritual offerings in ancient China during the Shang dynasty.

fête galante A subject in painting depicting well-dressed people at leisure in a park or country setting. It is most often associated with eighteenth-century French Rococo painting.

filigree Delicate, lacelike ornamental work.

fillet The flat ridge between the carved out flutes of a **column shaft**. See also **fluting**.

finial A knoblike architectural decoration usually found at the top point of a spire, **pinnacle**, canopy, or **gable**. Also found on furniture.

flower piece Any painting with flowers as the primary subject; a **still life** of flowers.

fluting In architecture, evenly spaced, rounded parallel vertical grooves **incised** on **shafts** of **columns** or columnar elements (such as **pilasters**).

flying buttress See buttress

folio A page or leaf in a **manuscript** or book. Also: a large sheet of paper or parchment, which, when folded twice and cut, produces four separate sheets; more generally, any large book

foreground Within the depicted space of an artwork, the area that is closest to the **picture plane**.

foreshortening The illusion created on a flat surface in which figures and objects appear to recede or project sharply into space. Accomplished according to the rules of **perspective**.

form In speaking of a work of art or architecture, the term refers to purely visual components: line, color, shape, texture, mass, spatial qualities, and **composition**—all of which are called **formal elements**.

formal elements See form.

formalism, formalist An approach to the understanding, appreciation, and valuation of art based almost solely on considerations of **form**. This approach tends to regard an artwork as independent of its time and place of making. *See also* **connoisseurship**.

formline In Native American works of art, a line that defines and creates a space or **form**.

forum A Roman town center; site of temples and administrative buildings and used as a market or gathering area for the citizens.

four-iwan mosque See iwan and mosque.

freestanding Adjective used to describe an independent column or sculpture.

fresco A painting technique in which water-based pigments are applied to a surface of wet plaster (called **buon fresco**). The color is absorbed by the plaster, becoming a permanent part of the wall. **Fresco a secco** is created by painting on dried plaster, and the color may flake off. **Murals** made by both these techniques are called frescoes.

frieze The middle element of an entablature, between the architrave and the cornice. Usually decorated with sculpture, painting, or moldings. Also: any continuous flat band with relief sculpture or painted decorations.

fritware A type of pottery made from a mix of white clay, quartz, and other chemicals that, when fired, produces a highly brittle substance.

frontispiece An illustration opposite or preceding the title page of a book. Also: the primary **facade** or main entrance **bay** of a building.

frottage A design produced by laying a piece of paper over a textured surface and rubbing with charcoal or other soft medium.

fusuma Sliding doors covered with paper, used in traditional Japanese construction. *Fusuma* are often highly decorated with paintings and colored backgrounds.

gable The triangular wall space found on the end wall of a building between the two sides of a pitched roof. Also: a triangular decorative panel that has a gablelike shape.

gadrooning A form of decoration on architecture and in metalwork characterized by sequential convex **moldings** that curve around a circular surface; the opposite of **fluting**.

galleria See gallery

gallery In church architecture, the story found above the side **aisles** of a church, usually open to and overlooking the **nave**. Also: in secular architecture, a long room, usually above the ground floor in a private house or a public building used for entertaining, exhibiting pictures, or promenading. Also: a building or hall in which art is displayed or sold. Also: *galleria*.

garbhagriha From the Sanskrit word meaning "womb chamber," a small room or shrine in a Hindu temple containing a holy image.

genre A type or category of artistic form, subject, technique, **style**, or **medium**. *See also* **genre painting**.

genre painting A term used to loosely categorize paintings depicting scenes of everyday life, including (among others) domestic interiors, parties, inn scenes, and street scenes.

geoglyphs Earthen designs on a colossal scale, often created in a landscape as if to be seen from an aerial viewpoint.

Geometric A period in Greek art from about 1100 BCE to 600 BCE. The **style** is characterized by patterns of rectangles, squares, and other **abstract** shapes. Also: lowercased, any style or art using primarily these shapes.

gesso A ground made from glue, gypsum, and/or chalk forming the ground of a wood

panel or the priming layer of a canvas. Provides a smooth surface for painting.

gesturalism Style of painting and drawing in which the brushwork or line visibly records the artist's physical gesture at the moment the paint was applied or the lines laid down. Associated especially with expressive styles, such as Zen painting and Abstract Expressionism.

gilding The application of paper-thin **gold leaf** or gold pigment to an object made from another **medium** (for example, a sculpture or painting). Usually used as a decorative finishing detail.

giornata (giornate) Adopted from the Italian term meaning "a day's work," a *giornata* is the section of a *fresco* plastered and painted in a single day.

glaze See glazing.

glazing An outermost layer of vitreous liquid (**glaze**) that, upon firing, renders **ceramics** waterproof and forms a decorative surface. In painting, a technique particularly used with oil **mediums** in which a transparent layer of paint (**glaze**) is laid over another, usually lighter, painted or glazed area.

gloss A type of clay **slip** used in **ceramics** by ancient Greeks and Romans that, when fired, imparts a colorful sheen to the surface.

gold leaf Paper-thin sheets of hammered gold that are used in **gilding**. In some cases (such as Byzantine **icons**), also used as a ground for paintings.

golden section A ratio between the two divisions of a line in which the smaller part is the same proportion to the larger as the larger is to the whole. Said to be the ideal proportion, it was supposedly discovered by the ancient Greeks.

Good Shepherd A man carrying a sheep or calf or with a sheep or calf at his side. In **classical** art, the god Hermes carrying a calf; in Christian art, Jesus Christ with a sheep (an image inspired by the Old Testament Twentythird Psalm or the New Testament parable of the Good Shepherd).

gopura The towering gateway to an Indian Hindu **temple complex**. A temple complex can have several different *gopuras*.

gouache Opaque **watercolor** mixed with a white pigment. Also: a work made with this paint.

graffiti Crude inscriptions, designs, or drawings scratched or painted on a surface, usually meant to be seen by the public.

Grand Manner An elevated **style** of painting popular in the eighteenth century in which the artist looked to the ancients and to the Renaissance for inspiration; for portraits as well as history painting, the artist would adopt the poses, **compositions**, and attitudes of Renaissance and antique models.

Grand Tour Popular during the eighteenth and nineteenth centuries, an extended tour of cultural sites in southern Europe intended to finish the education of a young upper-class person from Britain or North America.

granulation A technique for decorating gold in which tiny balls of the precious metal are fused to the main surface.

graphic arts Arts involving the application of lines and strokes to a two-dimensional surface or support, most often paper.

graphic artist See graphic arts, graphic design.

graphic design A concern in the visual arts for shape, line, and two-dimensional pattern-

ing, often especially apparent in works including typography and lettering.

graphic designer See graphic arts, graphic design.

grattage A pattern created by scraping off layers of paint from a canvas laid over a textured surface. See also **frottage**.

Greek-cross plan See central-plan building.

Greek-key pattern A continuous rectangular scroll often used as a decorative border. Also called a **meander** pattern.

grid A system of regularly spaced horizontally and vertically crossed lines that gives regularity to an architectural **plan**. Also: in painting, a grid enables designs to be enlarged or transferred easily.

griffin An imaginary creature with the head, wings, and claws of an eagle and the body and hind legs of a lion.

grisaille A **style** of monochromatic painting in shades of gray. Also: a painting made in this style.

groin vault See vault.

groundline The solid baseline that indicates the ground plane on which the figure stands. In ancient representations, such as those of the Egyptians, the figures and the objects are placed on a series of groundlines to indicate depth (space in **registers**).

grout A soft cement placed between the **tesserae** of a **mosaic** to hold the design together. Also used in tiling.

guild An association of craftspeople. The medieval guild had great economic power, as it set standards and controlled the selling and marketing of its members' products, and as it provided economic protection, group solidarity, and training in the craft to its members.

half dome Semicircular dome that expands outward from a central dome, in Byzantine architecture to cover the narthex on one side and the sanctuary apse on the other. Also called conch.

half-timber construction A method of building, particularly in heavily timbered northern European areas, for vernacular structures. Beginning with a timber framework built in the post-and-lintel manner, the builder constructed walls between the timbers with bricks, mud, or wattle. The exterior could then be faced with plaster or other material.

hall church A church with a **nave** and **aisles** of the same height, giving the impression of a large, open hall.

halo The representation of a circle of light surrounding the head of deities, saints, or other holy beings. Also called **nimbus**. See also **mandorla**.

halos An outdoor pavement used by ancient Greeks for ceremonial dancing.

hammered gold Created by indenting a gold surface with a hammer.

handscroll A long, narrow, horizontal painting or text (or combination thereof) common in Chinese and Japanese art and of a size intended for individual use. A handscroll is stored wrapped tightly around a wooden pin and is unrolled for viewing or reading.

hanging scroll In Chinese and Japanese art, a vertical painting or text mounted within sections of silk. At the top is a semicircular rod; at the bottom is a round dowel. Hanging scrolls are kept rolled and tied except for special oc-

casions, when they are hung for display, contemplation, or commemoration.

haniwa Pottery forms, including cylinders, buildings, and human figures, that were placed on top of Japanese tombs or burial mounds.

Happening A type of art form incorporating performance and visual images developed in the 1950s. A Happening was organized without a specific narrative or intent; with audience participation, the event proceeded according to chance and individual improvisation.

header In building, a brick laid so that its end, rather than its side, faces out.

heliograph A type of early photograph created by the exposure to sunlight of a plate coated with light-sensitive asphalt.

hemicycle A semicircular interior space or structure.

henge A circular area enclosed by stones or wood posts set up by Neolithic peoples. It is usually bounded by a ditch and raised embankment.

herbal A book describing the characteristics, uses, and meanings of plants. *See also* **bestiary**.

herm A statue that has the head and torso of a human but the lower part of which is a plain, tapering pillar of rectangular shape.

hieratic In painting and sculpture, a formalized **style** for representing rulers or sacred or priestly figures.

hieratic scale The use of different sizes for significant or holy figures and those of the everyday world to indicate importance. The larger the figure, the greater the importance.

hieroglyphs Picture writing; words and ideas rendered in the form of pictorial symbols.

high relief Relief sculpture in which the image projects strongly from the background. *See also* **relief sculpture**.

himation In ancient Greece, a long loose outer garment.

historiated Bearing images or a narrative, as a historiated capital or initial.

historicism The strong consciousness of and attention to the institutions, themes, **styles**, and **forms** of the past, made accessible by historical research, textual study, and archaeology.

history painting Paintings based on historical, mythological, or biblical narratives. Once considered the noblest form of art, history paintings generally convey a high moral or intellectual idea and are often painted in a grand pictorial **style**.

hollow-casting See lost-wax casting.

horizon line A horizontal "line" formed by the implied meeting point of earth and sky. In **linear perspective**, the **vanishing point** or points are located on this line.

horseshoe arch See arch.

house-church A Christian place of worship located in a private home.

house-synagogue A Jewish place of worship located in a private home.

hue Pure color. The saturation or intensity of the hue depends on the purity of the color. Its **value** depends on its lightness or darkness.

hydria A large ancient Greek and Roman jar with three handles (horizontal ones at both sides and one vertical at the back), used for storing water.

hypostyle hall A large interior room characterized by many closely spaced **columns** that support its roof.

icon An image in any material representing a sacred figure or event in the Byzantine, and later the Orthodox, Church. Icons were venerated by the faithful, who believed them to have miraculous powers to transmit messages to God.

iconoclasm The banning or destruction of images, especially icons and religious art. Iconoclasm in eighth- and ninth-century Byzantium and sixteenth- and seventeenth-century Protestant territories arose from differing beliefs about the power, meaning, function, and purpose of imagery in religion.

iconographic See iconography.

iconography The study of the significance and interpretation of the **subject matter** of art.

iconostasis The partition screen in a Byzantine or Orthodox church between the sanctuary (where the Mass is performed) and the body of the church (where the congregation assembles). The iconostasis displays icons

idealism See idealization.

idealization A process in art through which artists strive to make their **forms** and figures attain perfection, based on pervading cultural values and/or their own mental image of beauty.

ideograph A written character or symbol representing an idea or object. Many Chinese characters are ideographs.

ignudi Heroic figures of nude young men.

illumination A painting on paper or **parchment** used as illustration and/or decoration for **manuscripts** or **albums**. Usually done in rich colors, often supplemented by gold and other precious materials. The illustrators are referred to as **illuminators**. Also: the technique of decorating manuscripts with such paintings.

illuminator See illumination.

illusionism An appearance of vivid reality in art created by the use of certain pictorial means, such as linear detail and accurate **perspective**. Art having this quality is described as **illusionistic**.

impasto Thick applications of pigment that give a painting a palpable surface texture.

impost, impost block A block, serving to concentrate the weight above, imposed between the **capital** of a **column** and the **springing** of an **arch** above.

impression Any single printing of a print. Every impression of a print is by nature different, given the possibilities for variation inherent in the printing process, which requires the plate to be inked and wiped between every impression.

in antis Term used to describe the position of **columns** set between two walls, as in a **portico** or a **cella**.

incising A technique in which a design or inscription is cut into a hard surface with a sharp instrument. Such a surface is said to be **incised**.

ink painting A monochromatic **style** of painting developed in China using black ink with gray **washes**.

inlay To set pieces of a material or materials into a surface to form a design. Also: material used in or decoration formed by this technique.

installation See installation art

installation art Artworks created for a specific site, especially a gallery or outdoor area, that create a total environment.

intaglio Term used for a technique in which the design is carved out of the surface of an object, such as an engraved seal stone. In the graphic arts, intaglio includes engraving, etching, and drypoint—all processes in which ink transfers to paper from incised, ink-filled lines cut into a metal plate.

intarsia Decoration formed through wood inlay.

interlace A type of **linear** decoration in which ribbonlike bands are **illusionistically** depicted as if woven under and over one another.

interlacing See interlace.

intrados The curving inside surface of an **arch** or **vault**. *See also extrados*.

intuitive perspective See perspective.

Ionic order See order.

isometric projection A building diagram that represents graphically the parts of a building. Isometric projections show all planes of the building parallel to one of two established vertical and horizontal axes. The vertical axis is true, while the horizontal is drawn at an angle to show the effect of recession. All dimensions in an isometric drawing are proportionally correct. *See also* **plan**, **section**.

iwan A large, vaulted chamber in a mosque with a monumental arched opening on one side.

jamb In architecture, the vertical element found on both sides of an opening in a wall, and supporting an **arch** or **lintel**.

japonisme A **style** in French and American nineteenth-century art that was highly influenced by Japanese art, especially prints.

jasperware A fine-grained, unglazed, white **ceramic** developed by Josiah Wedgwood, often colored by metallic oxides with the raised designs ramaining white.

joined-wood sculpture A method of constructing large-scale wooden sculpture developed in Japan. The entire work is constructed from smaller hollow blocks, each individually carved, and assembled when complete. The joined-wood technique allowed the production of larger sculpture, as the multiple joints alleviate the problems of drying and cracking found with sculpture carved from a single block.

ka The name given by ancient Egyptians to the human life force, or spirit.

kantharos A type of Greek vase or goblet with two large handles and a wide mouth.

keep The most heavily fortified defensive structure in a castle; a tower located at the heart of the castle complex. Also called **donion**.

kente A woven silk cloth made by the Ashanti peoples of Africa. *Kente* cloth is woven in long, narrow pieces in complex and colorful patterns, which are then sewn together.

key block A key block is the master block in the production of a colored **woodcut**, which requires different blocks for each color. The key block is a flat piece of wood with the entire design carved or drawn on its surface. From this, other blocks with partial drawings

are made for printing the areas of different colors

keystone The topmost **voussoir** at the center of an **arch**, and the last block to be placed. The pressure of this block holds the arch together. Often of a larger size and/or decorated.

kiln An oven designed to produce enough heat for the baking, or firing, of clay.

kinetic art Artwork that contains parts that can be moved either by hand, air, or motor.

kiva A structure in a Native American pueblo used for community gatherings and rituals.

kondo The main hall inside a Japanese Buddhist temple where the images of Buddha are housed

kore (korai) An Archaic Greek statue of a young woman.

kouros (kouroi) An Archaic Greek statue of a young man or boy.

krater An ancient Greek vessel for mixing wine and water, with many subtypes that each have a distinctive shape. **Calyx krater**: a bell-shaped vessel with handles near the base that resemble a flower calyx. **Volute krater**: a type of krater with handles shaped like scrolls.

kufic An ornamental, angular Arabic script.

kylix A shallow Greek vessel or cup, used for drinking, with a wide mouth and small handles near the rim.

lacquer A type of hard, glossy surface varnish used on objects in East Asian cultures, made from the sap of the Asian sumac or from shellac, a resinous secretion from the lac insect. Lacquer can be layered and manipulated or combined with pigments and other materials for various decorative effects.

lakshana Term used to designate the thirtytwo marks of the historical Buddha. The lakshana include, among others, the Buddha's golden body, his long arms, the wheel impressed on his palms and the soles of his feet, and his elongated earlobes.

lamassu Supernatural guardian-protector of ancient Near Eastern palaces and throne rooms, often represented sculpturally as a combination of the bearded head of a man, powerful body of a lion or bull, wings of an eagle, and the horned headdress of a god, and usually possessing five legs.

lamentation See pietà.

lancet A tall narrow window crowned by a sharply pointed **arch**, typically found in Gothic architecture.

landscape architecture, landscape gardening The creation of artificial landforms, lakes, and contrived planting to produce an ideal nature.

landscape painting A painting in which a natural outdoor scene or vista is the primary subject

lantern A turretlike structure situated on a roof, **vault**, or **dome**, with windows that allow light into the space below.

Latin-cross plan A cross-shaped building plan, incorporating a long arm (**nave**) and three shorter arms.

lectionary A book containing readings from Christian scripture arranged according to the Church calendar from which the officiant reads to the congregation during holy services.

lekythos (**lekythoi**) A slim Greek oil vase with one handle and a narrow mouth.

limner An artist, particularly a portrait painter, in England during the sixteenth and seventeenth centuries and in New England during the seventeenth and eighteenth centuries.

linear perspective See perspective.

linear, linearity A descriptive term indicating an emphasis on line, as opposed to mass or color, in art.

lingam shrine A place of worship centered on an object or representation in the form of a phallus (the *lingam*), which symbolizes the power of the Hindu god Shiva.

lintel A horizontal element of any material carried by two or more vertical supports to form an opening.

lists (knightly) The land between the walls in a castle or town used for jousting and archery; an enclosed field used for tournaments.

literati painting A style of painting that reflects the taste of the educated class of East Asian intellectuals and scholars. Aspects include an appreciation for the antique, small scale, and an intimate connection between maker and audience.

lithograph See lithography.

lithography Process of making a print (**lithograph**) from a design drawn on a flat stone block with greasy crayon. Ink is applied to the wet stone and adheres only to the greasy areas of the design. See also **chromolithography**.

loculus (loculi) A niche in a tomb or **catacomb** in which a **sarcophagus** was placed.

loggia Italian term for a covered open-air **gallery**. Often used as a corridor between buildings or around a courtyard, loggias usually have **arcades** or **colonnades**.

lost-wax casting A method of casting metal, such as bronze, by a process in which a wax mold is covered with clay and plaster, then fired, melting the wax and leaving a hollow form. Molten metal is then poured into the hollow space and slowly cooled. When the hardened clay and plaster exterior shell is removed, a solid metal form remains to be smoothed and polished.

low relief Relief sculpture whose figures project slightly from the background. *See also* **relief sculpture**.

lozenge A decorative **motif** in the shape of a diamond.

lunette A semicircular wall area, framed by an **arch** over a door or window. Can be either plain or decorated.

lusterware Ceramic pottery decorated with metallic **glazes**.

madrasa An Islamic institution of higher learning, where teaching is focused on theology and law.

maenad In ancient Greece, a female devotee of the wine god Dionysos who participated in orgiastic rituals. She is often depicted with swirling drapery to indicate wild movement or dance. (Also called a Bacchante, after Bacchus, the Roman name of Dionysos.)

majolica Pottery painted with a tin **glaze** that, when fired, gives a lustrous and colorful surface

maki-e In Japanese art, the effect achieved by sprinkling gold or silver powder on successive layers of **lacquer** before each layer dries.

mandala An image of the cosmos represented by an arrangement of circles or concentric geometric shapes containing diagrams or images. Used for meditation and contemplation by Buddhists.

mandapa In a Hindu temple, an open hall dedicated to ritual worship.

mandorla Light encircling, or emanating from, the entire figure of a sacred person. See also **halo**

manifesto A written declaration of an individual's or group's ideas, purposes, and intentions.

manuscript A handwritten book or document.

marginalia Notes or pictures in the margins of book pages.

maqsura An enclosure in a Muslim mosque, near the mihrab, designated for dignitaries.

martyrium (martyria) In Christian architecture, a church, chapel, or shrine built over the grave of a martyr or the site of a great miracle.

masonry Construction in stone or brick.

mastaba A flat-topped, one-story structure with slanted walls over an ancient Egyptian underground tomb.

mathematical perspective See perspective.

matte Term describing a smooth surface that is without shine or luster.

mausoleum A **monumental** building used as a tomb. Named after the tomb of Mausolos erected at Halikarnassos around 350 BCE.

meander See Greek-key pattern.

medallion Any round ornament or decoration. Also: a large medal.

medium, mediums, media In general, the material(s) from which any given object is made. In painting, the liquid substance in which pigments are suspended.

megalith A large stone used in prehistoric building. **Megalithic** architecture employs such stones.

megaron The main hall of a Mycenaean palace or grand house, having a columnar **porch** and a room with a central fireplace surrounded by four **columns**.

memento mori From Latin for "remember that you must die." An object, such as a skull or extinguished candle, typically found in a **vanitas** image, symbolizing the transience of life

memory image An image that relies on the generic shapes and relationships that readily spring to mind at the mention of an object.

menhir A single vertical megalith

menorah A Jewish lamp-stand with seven or nine branches; the nine-branched menorah is used during the celebration of Hanukkah. Representations of the seven-branched menorah, once used in the Temple of Jerusalem, became a symbol of Judaism.

mensa The consecrated stone of the **altar** in a Christian church.

metope The carved or painted rectangular panel between the **triglyphs** of a **Doric frieze**.

mezzanine The low intermediate story of a building inserted between two stories of regular size

middle ground Within the depicted space of an artwork, the area that takes up the middle distance of the image.

mihrab A recess or **niche** that distinguishes the wall oriented toward Mecca (**qibla**) in a **mosque**.

minaret A tall slender tower on the exterior of a **mosque** from which believers are called to prayer.

 ${\it minbar}$ A high platform or pulpit in a ${\it mosque}$.

miniature Anything small. In painting, miniatures may be illustrations within **albums** or **manuscripts** or intimate portraits.

minuscule See script.

mirador In Spanish and Islamic palace architecture, a room with windows and sometimes balconies on three sides overlooking gardens and courtyards.

mithuna The amorous male and female couples in Buddhist sculpture, usually found at the entrance to a sacred building. The *mithuna* symbolize the harmony and fertility of life.

moat A large ditch or canal dug around a castle or fortress for military defense. When filled with water, the moat protects the walls of the building from direct attack.

mobile A sculpture made with parts suspended in such a way that they move in a current of air

modeling In painting, the process of creating the illusion of three-dimensionality on a two-dimensional surface by use of light and shade. In sculpture, the process of molding a three-dimensional **form** out of a malleable substance

module A segment or portion of a repeated design. Also: a basic building block.

molding A shaped or sculpted strip with varying contours and patterns. Used as decoration on architecture, furniture, frames, and other objects.

monastery The buildings housing a community of men (monks) or women (nuns) living under religious vows.

monolith A single stone, often very large.

Monophysitism The Christian doctrine stating that Jesus Christ has only one nature, both divine and human. Declared a heresy in the fifth century.

monoprint A single print pulled from a hard surface (such as a blank plate or stone) that has been prepared with a painted design. Each print is an individual artwork, as the original design is a transient one, largely lost in the printing process. Also: called monotype.

monstrance A transparent vessel displaying the Host in the Catholic **Eucharist**. Also: a transparent receptacle for a **relic**. *See also* **reliquary**.

monumental A term used to designate a project or object that, whatever its physical size, gives an impression of grandeur.

mortise-and-tenon joint A method of joining two elements. A projecting pin (tenon) on one element fits snugly into a hole designed for it (mortise) on the other. Such joints are very strong and flexible.

mosaic Images formed by small colored stone or glass pieces (*tesserae*), affixed to a hard, stable surface.

mosque An edifice used for communal Muslim worship.

motif Any recurring element of a design or composition. Also: a recurring theme or subject in artwork.

movable-type printing A method of printing text in which the individual letters, cast on small pieces of metal, are assembled into words on a mechanical press. When each edition was complete, the type could be reused for the next project.

mudra A symbolic hand gesture in Buddhist art that denotes certain behaviors, actions, or feelings.

mullion A slender vertical element or **colonnette** that divides a window into subsidiary sections.

multiculturalism Recognition of all cultures and ethnicities in a society or civilization.

multiple-point perspective See perspective.

muqarnas A small nichelike component based on the **squinch** and used in Islamic architecture to achieve the transition between flat and rounded surfaces.

mural Wall-like. A large painting or decoration, done either directly on a wall or separately and affixed to it.

naos The principal room in a temple or church. In ancient architecture, the **cella**. In a Byzantine church, the **nave** and **sanctuary**.

narthex The vestibule or entrance porch of a church.

naturalism, naturalistic A **style** of depiction that seeks to imitate the appearance of nature. A naturalistic work appears to record the visible world.

nave The central space of a **basilica**, two or three stories high and usually flanked by **aisles**.

nave arcade See nave and arcade

nave colonnade See nave and colonnade.

 $\boldsymbol{necking}$ The $\boldsymbol{molding}$ at the top of the \boldsymbol{shaft} of the \boldsymbol{column} .

necropolis A large cemetery or burial area; literally a "city of the dead."

negative space Empty or open space within or bounded by the forms of a painting, sculpture, or architectural design.

niche A hollow or recess in a wall or other solid architectural element. Niches can be of varying size and shape and may be intended for many different uses, from display of objects to housing of a tomb.

niello A metal technique in which a black sulfur alloy is rubbed into fine lines engraved into a metal (usually gold or silver). When heated, the alloy becomes fused with the surrounding metal and provides contrasting detail.

nimbus A halo.

nishiki-e A multicolored and ornate Japanese print.

nocturne A night scene in painting, usually lit by artificial illumination.

nonobjective See nonrepresentational.

nonrepresentational art Abstract art that does not attempt to reproduce the appearance of objects, figures, or scenes in the natural world. Also called **nonobjective art**.

obelisk A tall, four-sided stone **shaft**, hewn from a single block, that tapers at the top and is completed by a **pyramidion**. A sun symbol erected by the ancient Egyptians in ceremonial spaces (such as entrances to **temple complexes**). Today used as a commemorative monument.

oblique perspective See perspective

oculus (oculi) In architecture, a circular opening. Oculi are usually found either as windows or at the apex of a **dome**. When at the top of a dome, an oculus is either open to the sky or covered by a decorative exterior **lantern**.

odalisque From the Turkish term for a woman in a harem. Usually represented as a reclining female nude shown among the accouterments of an exotic, luxurious environment by nineteenth- and twentieth-century European artists.

ogival arch See arch.

oil painting Any painting executed with the pigments floating in a **medium** of oil. Oil paint has particular properties that allow for greater ease of working (among others, a slow drying time, which allows for corrections, and a great range of relative opaqueness of paint layers, which permits a high degree of detail and luminescence).

oil sketch An **oil painting**, usually on a small scale, intended as a preliminary stage for the production of a larger work. Oil sketches are often very **painterly** in technique.

oinoche A Greek wine jug with a round mouth and a curved handle.

olpe Any Greek vase or jug without a spout.

one-point perspective *See* **perspective**. **onion dome** A bulbous **dome** found in Rus-

sia and Eastern Europe, usually in church architecture.

openwork Decoration, such as **tracery**, with open spaces incorporated into the pattern.

oracle A person, usually a priest or priestess, who acts as a conduit for divine information. Also: the information itself or the place at which this information is communicated.

orant The representation of a standing figure praying with outstretched and upraised arms.

orchestra The circular performance area of an ancient Greek theater. In later architecture, the section of seats nearest the stage or the entire main floor of the theater.

order A system of proportions in Classical architecture that includes every aspect of the building's plan, elevation, and decorative system. Composite: a combination of the Ionic and the Corinthian orders. The capital combines acanthus leaves with volute scrolls. Corinthian: the most ornate of the orders, the Corinthian includes a base, a fluted column shaft with a capital elaborately decorated with acanthus leaf carvings. Its entablature consists of an architrave decorated with moldings, a frieze often containing sculptured reliefs, and a cornice with dentils. Doric: the column shaft of the Doric order can be fluted or smooth-surfaced and has no base. The Doric capital consists of an undecorated echinus and abacus. The Doric entablature has a plain architrave, a frieze with metopes and triglyphs, and a simple cornice. Ionic: the column of the Ionic order has a base, a fluted shaft, and a capital decorated with volutes. The Ionic entablature consists of an architrave of three panels and moldings, a frieze usually containing sculpted relief ornament, and a cornice with dentils. Tuscan: a variation of Doric characterized by a smooth-surfaced column shaft with a base, a plain architrave, and an undecorated frieze. A colossal order is any of the above built on a large scale, rising through several stories in height and often raised from the ground by a pedestal.

orthogonal Any line running back into the represented space of a picture perpendicular to the imagined **picture plane**. In **linear per**

spective, all orthogonals converge at a single **vanishing point** in the picture and are the basis for a **grid** that maps out the internal space of the image. An orthogonal **plan** is any plan for a building or city that is based exclusively on right angles, such as the grid plan of many modern cities.

orthogonal plan See orthogonal.

overpainting A final layer of paint applied over a dry underlayer.

ovoid An adjective describing a rounded oval object or shape. Also: a characteristic **form** in Native American art, consisting of a rectangle with bent sides and rounded corners.

pagoda An East Asian **reliquary** tower built with successively smaller, repeated stories. Each story is usually marked by an elaborate projecting roof.

painterly Describing a **style** of painting that emphasizes the techniques and surface effects of brushwork.

palace complex A group of buildings used for living and governing by a ruler and his or her supporters, usually fortified.

palette A handheld support used by artists for the storage and mixing of paint during the process of painting. Also: the choice of a range of colors made by an artist in a particular work or typical of his or her **style**.

palisade A stake fence that forms a defensive barrier

Palladian An adjective describing a **style** of architecture, or an architectural detail, reminiscent of the classicizing work of the sixteenth-century Italian architect Andrea Palladio.

palmette A fan-shaped ornament with radiating leaves.

panel painting Any painting executed on a wood support. The wood is usually planed to provide a smooth surface. A panel can consist of several boards joined together, normally covered with **gesso**.

Pantokrator Byzantine depiction of Christ as universal ruler, represented holding a book and giving a blessing.

papyrus A native Egyptian river plant; a writing paper made from the stems; a popular decorative element in Egyptian architecture.

parapet A low wall at the edge of a balcony, bridge, roof, or other place from which there is a steep drop, built for safety. A parapet walk is the passageway, usually open, immediately behind the uppermost exterior wall or battlement of a fortified building.

parchment A writing surface made from treated skins of animals. Very fine parchment is known as **vellum**.

Paris Salon The annual display of art by French artists in Paris during the eighteenth and nineteenth centuries. Established in the seventeenth century as a venue to show the work of members of the French **Academy**, the Salon and its judges established the accepted official **style** of the time. *See also* **salon**.

parterre An ornamental, highly regimented flowerbed. An element of the ornate gardens of seventeenth-century palaces and **châteaux**.

passage In painting, *passage* refers to any particular area within a work, often those where **painterly** brushwork or color changes exist. Also: a term used to describe Paul Cézanne's technique of blending adjacent shapes.

passage grave A prehistoric tomb under a **cairn**, reached by a long, narrow, slab-lined access passageway or passageways.

pastel Dry pigment, chalk, and gum in stick or crayon form. Also: a work of art made with pastels.

pedestal A platform or **base** supporting a sculpture or other monument. Also: the block found below the base of a **classical column** (or **colonnade**), serving to raise the entire element off the ground.

pediment A triangular **gable** found over major architectural elements such as **Classical** Greek **porticoes**, windows, or doors. Formed by an **entablature** and the ends of a sloping roof or a raking **cornice**. A similar architectural element is often used decoratively above a door or window, sometimes with a curved upper **molding**. A broken pediment is a variation on the traditional pediment, with an open space at the center of the topmost angle and/or the horizontal cornice.

pendentive The concave triangular section of a **vault** that forms the transition between a square or polygonal space and the circular base of a **dome**.

pendentive dome See dome.

peplos A loose outer garment worn by women of ancient Greece. A cloth rectangle fastened on the shoulders and belted below the bust or at the waist.

performance art An artwork based on a live, sometimes theatrical, performance by the artist.

peripteral A term used to describe any building (or room) that is surrounded by a single row of **columns**. When such columns are engaged instead of freestanding, called pseudoperipteral.

peristyle A surrounding **colonnade** in Greek architecture. A peristyle building is surrounded on the exterior by a colonnade. Also: a peristyle court is an open colonnaded courtyard, often having a pool and garden.

perspective A system for representing threedimensional space on a two-dimensional surface. Atmospheric perspective: A method of rendering the effect of spatial distance by subtle variations in color and clarity of representation. Intuitive perspective: A method of giving the impression of recession by visual instinct, not by the use of an overall system or program. Oblique perspective: An intuitive spatial system in which a building or room is placed with one corner in the picture plane, and the other parts of the structure recede to an imaginary vanishing point on its other side. Oblique perspective is not a comprehensive, mathematical system. One-point and multiple-point perspective (also called linear, scientific or mathematical perspective): A method of creating the illusion of three-dimensional space on a two-dimensional surface by delineating a horizon line and multiple orthogonal lines. These recede to meet at one or more points on the horizon (called vanishing points), giving the appearance of spatial depth. Called scientific or mathematical because its use requires some knowledge of geometry and mathematics, as well as optics. Reverse perspective: A Byzantine perspective theory in which the orthogonals or rays of sight do not converge on a vanishing point in the picture, but are thought to originate in the viewer's eye in front of the picture. Thus, in reverse perspective the image is constructed with orthogonals that diverge, giving a slightly tipped aspect to objects.

petrograph A prehistoric drawing or painting on rock. Also called petroglyph.

photomontage A photographic work created from many smaller photographs arranged (and often overlapping) in a **composition**.

piazza The Italian word for an open city square.

pictograph A highly stylized depiction serving as a symbol for a person or object. Writing: using such symbols is called pictographic.

picture plane The theoretical spatial plane corresponding with the actual surface of a painting.

picture stone A medieval northern European memorial stone covered with figural decoration. *See also* **rune stone**.

picturesque A term describing the taste for the familiar, the pleasant, and the pretty, popular in the eighteenth and nineteenth centuries in Europe. When contrasted with the sublime, the picturesque stood for all that was ordinary but pleasant.

piece-mold casting A casting technique in which the mold consists of several sections that are connected during the pouring of molten metal, usually **bronze**. After the cast form has hardened, the pieces of the mold are disassembled, leaving the completed object. Because it is made in pieces, the mold can be reused.

pier A masonry support made up of many stones, or rubble and **concrete** (in contrast to a **column shaft** which is formed from a single stone or a series of **drums**), often square or rectangular in **plan**, and capable of carrying very heavy architectural loads. See also **compound pier**.

pietà Italian for "pity." A devotional subject in Christian religious art. After the Crucifixion, the body of Jesus was laid across the lap of his grieving mother, Mary. When others are present the subject is called the Lamentation.

pietra dura Italian for "hard stone." Semiprecious stones selected for color variation and cut in shapes to form ornamental designs such as flowers or fruit.

pietra serena A gray Tuscan limestone used in Florence.

pigment A substance that gives color to a material.

pilaster An **engaged columnar** element that is rectangular in format and used for decoration in architecture.

pillar In architecture, any large, freestanding vertical element. Usually functions as an important weight-bearing unit in buildings.

pinnacle In Gothic architecture, a steep pyramid decorating the top of another element such as a **buttress**. Also: the highest point.

plaiting In basketry, the techinique of weaving strips of fabric or other flexible substances under and over each other.

plan A graphic convention for representing the arrangement of the parts of a building.

plasticity The three-dimensional quality of an object, or the degree to which any object can be modeled, shaped, or altered.

plinth The slablike **base** or **pedestal** of a **column**, statue, wall, building, or piece of furniture.

pluralism A social structure or goal that allows members of diverse ethnic, racial, or other groups to exist peacefully within the so-

ciety while continuing to practice the customs of their own divergent cultures. Also: an adjective describing the state of having many valid contemporary **styles** available at the same time to artists.

podium A raised platform that acts as the foundation for a building, or as a platform for a speaker.

polychrome See polychromy.

polychromy The multicolored painted decoration applied to any part of a building, sculpture, or piece of furniture.

polyptych An **altarpiece** constructed from multiple panels, sometimes with hinges to allow for movable wings.

popular culture The elements of culture (arts) that are accepted by and appeal to the general public. Popular culture has the associations of something cheap, fleeting, and accessible to all.

porcelain A type of extremely hard and fine ceramic made from a mixture of kaolin and other minerals. Porcelain is fired at a very high heat, and the final product has a translucent surface.

porch The covered entrance on the exterior of a building. With a row of **columns** or **colonnade**, also called a **portico**.

portal A grand entrance, door, or gate, usually to an important public building, and often decorated with sculpture.

portcullis A fortified gate, constructed to move vertically and often made of metal bars, used for the defense of a city or castle.

portico In architecture, a projecting roof or porch supported by **columns**, often marking an entrance. *See also* **porch**.

post-and-lintel construction An architectural system of construction with two or more vertical elements (posts) supporting a horizontal element (**lintel**).

postern A side or back (often secret) exit from a fortified city or castle.

potassium-argon dating Technique used to measure the decay of a radioactive potassium isotope into a stable isotope of argon, an inert gas

potsherd A broken piece of ceramic ware.

predella The lower zone, or **base**, of an **altarpiece**, decorated with painting or sculpture related to the main **iconographic** theme of the altarpiece.

primary colors Blue, red, and yellow—the three colors from which all others are derived.

primitivism The borrowing of subjects or forms usually from non-Western or prehistoric sources by Western artists. Originally practiced by Western artists as an attempt to infuse their work with the naturalistic and expressive qualities attributed to other cultures, especially colonized cultures, primitivism also borrowed from the art of children and the insane.

Prix de Rome A prestigious scholarship offered by the French **Academy** at the time of the establishment of its Roman branch in 1666. The scholarship allowed the winner of the prize to study in Rome for three to five years at the expense of the state. Originally intended only for painters and sculptors, the prize was later expanded to include printmakers, architects, and musicians.

pronaos The enclosed vestibule of a Greek or Roman temple, found in front of the **cella** and marked by a row of **columns** at the entrance. **propylon (propylaia)** A large, often elaborate gateway to a temple or other important building or group of buildings.

proscenium The stage of an ancient Greek or Roman theater. In modern theater, the area of the stage in front of the curtain. Also: the framing **arch** that separates a stage from the audience.

prostyle A term used to describe a **classical** temple with a **colonnade** placed across the front entrance only. *See also* **amphiprostyle**.

provenance The history of ownership of a work of art from the time of its creation to the present.

psalter In Jewish and Christian scripture, a book containing the psalms, or songs, attributed to King David.

pseudo-kufic Term describing designs intended to resemble the script of the Arabic language.

pseudo-peripteral See peripteral.

punchwork Decorative designs that are stamped onto a surface, such as metal or leather, using a punch (a handheld metal implement).

putto (putti) A plump, naked little boy, often winged. In classical art, called a cupid; in Christian art, a cherub.

pylon A massive gateway formed by a pair of tapering walls of oblong shape. Erected by ancient Egyptians to mark the entrance to a **temple complex**.

pyramidion A pyramid-shaped block set as the finishing element atop an **obelisk**.

qibla The **mosque** wall oriented toward Mecca indicated by the **mihrab**.

quadrant vault See vault.

quatrefoil A four-lobed decorative pattern common in Gothic art and architecture.

quillwork A Native American decorative craft technique. The quills of porcupines and bird feathers are dyed and attached to material in patterns.

quincunx A building in which five **domed** bays are arranged within a square, with a central unit and four corner units. (When the central unit has similar units extending from each side, the form becomes a **Greek cross**.)

quoin A stone, often extra large or decorated for emphasis, forming the corner of two walls. A vertical row of such stones is called **quoining**.

radiometric dating A method of dating prehistoric works of art made from organic materials, based on the rate of degeneration of radiocarbons in these materials. *See also*

relative dating, absolute dating.

radiometry See radiometric dating

raigo A painted image that depicts the Amida Buddha and other Buddhist deities welcoming the soul of a dying worshiper to paradise.

raking cornice See cornice.

raku A type of **ceramic** pottery made by hand, coated with a thick, dark **glaze**, and fired at a low heat. The resulting vessels are irregularly shaped and glazed, and are highly prized for use in the Japanese tea ceremony.

rampart The raised walls or embankments used as primary protection in the fortification of a city or castle.

readymade An object from popular or material culture presented without further manipulation as an artwork by the artist.

realism In art, a term first used in Europe around 1850 to designate a kind of **naturalism** with a social or political message, which soon lost its didactic import and became synonymous with naturalism.

realistic Describes a style in which an artist attempts to depict objects as they are in actual, visible reality.

recto The right-hand page in the opening of a book or **manuscript**. Also: the principal or front side of a leaf of paper or **parchment**, as in the case of a drawing. The **verso** is the reverse side.

red-figure A **style** and technique of ancient Greek vase painting characterized by red clay-colored figures on a black background. (The figures are reversed against a painted ground and details are drawn, not engraved, as in black-figure.) *See also* **black-figure**.

refectory The dining hall for monks or nuns in a monastery or convent.

register A device used in systems of spatial definition. In painting, a register indicates the use of differing **groundlines** to differentiate layers of space within an image. In sculpture, the placement of self-contained bands of **reliefs** in a vertical arrangement. In printmaking, the marks at the edges used to align the print correctly on the page, especially in multiple-block color printing.

reintegration Anthropological term for the process of adaptation and transformation of European techniques and styles by artists in colonial areas.

relative chronology A practice of dating objects in relation to each other when the **absolute dating** of those objects cannot be or has not been established. Also known as **relative dating**.

relative dating See also absolute dating; relative chronology; radiometric dating.

relic A venerated object associated with a saint or martyr.

relief sculpture A three-dimensional image or design whose flat background surface is carved away to a certain depth, setting off the figure. Called high or low (bas) relief depending upon the extent of projection of the image from the background. Called sunken relief when the image is carved below the original surface of the background, which is not cut away.

relieving arch See arch

reliquary A container, often made of precious materials, used as a repository to protect and display sacred **relics**. *See also* **monstrance**.

replica A very close copy of a painting or sculpture, sometimes done by the same artist who created the original.

repoussé A technique of hammering metal from the back to create a protruding image. Elaborate **reliefs** are created with wooden armatures against which the metal sheets are pressed and hammered.

repoussoir French for "something that pushes back." An object or figure placed in the immediate **foreground** of a **composition**, usually the left or right edge, whose purpose is to direct the viewer's eye into the background and suggest recession into depth.

representational Term describing any art that attempts to depict an aspect of the external, natural world in a visually understandable way.

reredos A decorated wall or screen behind the altar of a church. *See also retablo*.

retablo Spanish for "altarpiece." The screen placed behind an **altar**. Often very large, having many painted or carved panels.

reverse perspective See perspective.

revetment A covering of cut stone, fine brick, or other solid facing material over a wall built of coarser materials. Also: surface covering used to reinforce a retaining wall, such as an embankment.

revivalism The practice of using older **styles** and modes of expression in a conscious manner. Revivalism does not usually entail the same academic and historical interest as **historicism**.

rhyton A vessel in the shape of a figure or an animal, used for drinking or pouring liquids on special occasions.

rib Projecting band at the juncture of the curved surfaces, or cells, of a **vault**. Sometimes structural and sometimes purely decorative.

rib vault See vault.

ribbon interlace A linear decoration made up of interwoven bands, often found in Celtic and northern European art of the medieval period.

ridge rib A rib running the length of the vault.

ridgepole A longitudinal timber at the apex of a roof that supports the upper ends of the rafters.

 $\emph{rinceau}$ A decorative foliage scroll, usually acanthus.

ring wall Any wall surrounding a building, town, or fortification, intended to separate and protect the enclosed area.

rock-cut tomb Ancient Egyptian multichambered burial site, hewn from solid rock and often hidden.

rood A crucifix.

rood screen In a church, a screen that separates the public **nave** from the private and sacred area of the **choir**. The screen supports a rood (crucifix).

roof comb In a Mayan building, a **masonry** wall along the apex of a roof that is built above the level of the roof proper. Roof combs support the highly decorated false **facades** that rise above the height of the building at the front.

rose window A round window, often filled with **stained glass**, with **tracery** patterns in the form of wheel spokes. Large, elaborate, and finely crafted, rose windows are usually a central element of the **facade** of French Gothic cathedrals.

rosette A round or oval ornament resembling a rose.

rotulus (rotuli) A scroll or **manuscripts** rolled in a tubular form.

rotunda Any building (or part thereof) constructed in a circular (or sometimes polygonal) shape, usually producing a large open space crowned by a **dome**.

round arch See arch

roundel Any element with a circular format, often placed as a decoration on the exterior of architecture.

rune stone A stone used in early medieval northern Europe as a commemorative monument, which is carved or inscribed with runes, a writing system used by early Germanic peoples.

running spirals A decorative **motif** based on the shape formed by a line making a continuous spiral.

rustication In building, the rough, irregular, and unfinished effect deliberately given to the exterior facing of a stone edifice. Rusticated stones are often large and used for decorative emphasis around doors or windows, or across the entire lower floors of a building. Also: **masonry** construction with conspicuous, often beveled joints.

sacristy In a Christian church, the room in which the priest's robes and the sacred vessels are housed. Sacristies are usually located close to the sanctuary and often have a place for ritual washing as well as a private door to the exterior.

sahn The central courtyard of a Muslim **mosque**.

salon A large room for entertaining guests; a periodic social or intellectual gathering, often of prominent people; a hall or **gallery** for exhibiting works of art. *See also* **Paris Salon**.

sanctuary A sacred or holy enclosure used for worship. In ancient Greece and Rome, consisted of one or more temples and an **altar**. In Christian architecture, the space around the altar in a church called the **chancel** or presbytery.

sand painting Ephemeral religious art created with different colored sands by Native Americans of North America, Australian Aborigines, and other peoples in Japan and Tibet.

sanghati The robe worn by a Buddhist monk. Draped over the left shoulder, the robe is made from a single piece of cloth wrapped around the body.

sarcophagus (sarcophagi) A stone coffin. Often rectangular and decorated with **relief sculpture**.

scarification Ornamental marks, scars, or scratches made on the human body.

school of artists An art historical term describing a group of artists, usually working at the same time and sharing similar **styles**, influences, and ideals. The artists in a particular school may not necessarily be directly associated with one another, unlike those in a workshop or **atelier**.

scientific perspective See perspective.

script Handwriting. Includes minuscule (as in lower-case type) and majuscule (capital letters). *See also* **calligraphy**.

scriptorium (scriptoria) A room in a monastery for writing or copying **manuscripts**.

scroll painting A painting executed on a rolled support. Rollers at each end permit the horizontal scroll to be unrolled as it is studied or the vertical scroll to be hung for contemplation or decoration.

sculpture in the round Three-dimensional sculpture that is carved free of any attaching background or block.

section A method of representing the three-dimensional arrangement of a building in a graphic manner. A section is produced when an imaginary vertical plane intersects with a building, laying bare all the elements that make up the (cross section of the) structure at that point. Also: a view of an element of an object as if sliced through. *See also* **elevation**.

segmental pediment A **pediment** formed when the upper **molding** is a shallow arc.

sepia An ink **medium** often used in drawing that has an extremely rich, dark brownish **tone**.

seraph (seraphim) An angel of the highest rank in the Christian hierarchy.

serdab In Egyptian tombs, the small room in which the **ka** statue was placed.

sfumato Italian term meaning "smoky," soft, and mellow. In painting, the effect of haze in an image. Resembling the color of the atmosphere at dusk, *sfumato* gives a smoky effect.

sgraffito Decoration made by **incising** or cutting away a surface layer of material to reveal a different color beneath.

shade Any area of an artwork that is shown through various technical means to be in shadow. **Shading**: the technique of making such an effect.

shaft The main vertical section of a **column** between the **capital** and the **base**, usually circular in cross section.

shater A type of roof used in Russia and the Near East with a steep pitch and tentlike shape.

shikhara In the architecture of northern India, a conical (or pyramidal) spire found atop a Hindu temple and often crowned with an **amalaka**.

shoin The architecture of the aristocracy and upper classes in Japan, built in traditional asymmetrical fashion and incorporating the traditional elements of residences, such as the **tokonoma** and **shoji** screens.

shoji A standing Japanese screen covered in translucent rice paper and used in interiors.

side aisle See aisle.

silversmith An artisan who makes silver **wares**.

sinopia The preparatory design or underdrawing of a **fresco**. Also: a reddish chalklike earth pigment.

site-specific sculpture A sculpture commissioned and/or designed for a particular spot.

slip A mixture of clay and water applied to a **ceramic** object as a final decorative coat. Also: a solution that binds different parts of a vessel together, such as the handle and the main body.

spandrel The area of wall adjoining the exterior curve of an **arch** between its **springing** and the **keystone**, or the area between two arches, as in an **arcade**.

speech scroll A scroll painted with words indicating the speech or song of a depicted figure.

springing The point at which the curve of an **arch** or **vault** meets with and rises from its support.

squinch An **arch** or **lintel** built across the upper corners of a square space, allowing a circular or polygonal **dome** to be more securely set above the walls.

stadium In ancient Greece, a race track with tiers of seats for spectators.

stained glass Molten glass is given a color that becomes intrinsic to the material. Additional colors may be fused to the surface (flashing). Stained glass is most often used in windows, for which small pieces of differently colored glass are precisely cut and assembled into a design, held together by **cames**. Additional painted details may be added to create images.

stele (stelae) A stone slab placed vertically and decorated with inscriptions or **reliefs**. Used as a grave marker or memorial.

stepped pyramid A **pyramid** consisting of successive levels of **mastaba** forms appearing to rise in staggered "steps" rather than in sloping triangular faces.

stereobate A foundation upon which a **Classical** temple stands.

stigmata The wounds of Christ; said to appear on the bodies of certain holy persons.

still life A type of painting that has as its subject inanimate objects (such as food, dishes, fruit, or flowers).

stipes The support structure of an **altar** which holds up the **mensa**, or top surface.

stoa In Greek architecture, a long roofed walkway, usually having **columns** on one long side and a wall on the other.

stockade A defensive fencelike wood fortification built around a village, house, or other enclosed area.

stretcher The wooden framework on which an artist's canvas is attached, usually with tacks, nails, or staples. Also: a reinforcing horizontal brace between the legs of a piece of furniture, such as a chair. Also: in building, a brick or stone laid so that its longer edge is parallel to the wall.

stringcourse A continuous horizontal band, such as a **molding**, decorating the face of a wall

stucco A mixture of lime, sand, and other ingredients into a material that can be easily molded or modeled. When dry, produces a very durable surface used for covering walls or for architectural sculpture and decoration.

stupa In Buddhist architecture, a bell-shaped or pyramidal religious monument, made of piled earth or stone, and containing sacred relics.

style A particular manner, **form**, or character of representation, construction, or expression typical of an individual artist or of a certain school or period.

stylization, stylized A manner of representation that conforms to an intellectual or artistic idea rather than to **naturalistic** appearances.

stylobate In **Classical** architecture, the stone foundation on which a temple **colonnade** stands.

stylus An instrument with a pointed end (used for writing and printmaking), which makes a delicate line or scratch. Also: a special writing tool for **cuneiform** writing with one pointed end and one triangular wedge end.

subject matter See content.

sublime Adjective describing a concept, thing, or state of high spiritual, moral, or intellectual value; or something awe-inspiring. The sublime was a goal to which many nineteenth-century artists aspired in their artworks.

sunken relief See relief sculpture.

swag Ornament representing a garland of fruit or flowers draped in a curve between two points.

syncretism In religion or philosophy, the union of different ideas or principles.

tablinum A large reception room in an ancient Roman house, connected to the **atrium**.

talud-tablero A design characteristic of architecture at Teotihuacan in which a sloping talud at the base of a building supports a wall-like tablero, where ornamental painting and sculpture are usually placed.

taotie A mask with a dragon or animal-like face common as a decorative **motif** in Chinese art.

tapa A cloth made in Polynesia by pounding the bark of a tree, such as the paper mulberry. It is also known as bark cloth.

tapestry Multicolored pictorial or decorative weaving meant to be hung on a wall or placed on furniture.

tatami Mats of woven straw used in Japanese houses as a floor covering.

temenos In ancient Greece, the sacred enclosure around a temple site.

tempera A painting **medium** made by blending egg yolks with water, pigments, and occasionally other materials, such as glue.

temple complex A group of buildings dedicated to a religious purpose, usually located close to one another in a **sanctuary**.

tenebrism The use of strong **chiaroscuro** and artificially illuminated areas to create a dramatic contrast of light and dark in a painting.

tepee A portable dwelling constructed from hides (later canvas) stretched on a structure of poles set at the base in a circle and leaning against one another at the top. Tepees were typically found among the nomadic Native Americans of the North American Plains.

terminal Any element of sculpture or architecture that functions as decorative closure. Terminals are usually placed in pairs at either end of an object (such as furniture) or building **facade** to help frame the **composition**.

terra-cotta A **medium** made from clay fired over a low heat and sometimes left unglazed. Also: the orange-brown color typical of this medium

tessera (**tesserae**) The small piece of stone, glass, or other object that is pieced together with many others to create a **mosaic**.

Theotokos Greek for "God-bearer." In Byzantine art, the Virgin Mary as mother of God.

thermoluminescence dating A technique that measures the irradiation of the crystal structure of material such as flint or pottery and the soil in which it is found, determined by luminescence produced when a sample is heated.

tholos A small, round building. Sometimes built underground, as in a Mycenaean tomb.

tierceron In **vault** construction, a secondary rib that arcs from a **springing** point to the rib that runs lengthwise through the **vault**, called the **ridge rib**.

tint The dominant color in an object, image, or pigment.

tokonoma A **niche** for the display of an art object (such as a screen, scroll, or flower arrangement) in a Japanese hall or tearoom.

tomb effigy A carved portraitlike image of the deceased on a tomb or **sarcophagus**.

tondo A painting or relief of circular shape.

tone The overall degree of brightness or darkness in an artwork. Also: saturation, intensity, or **value** of color and its effect.

torana In Indian architecture, an ornamented gateway **arch** in a temple, usually leading to the **stupa**.

torii The ceremonial entrance gate to a Japanese Shinto temple.

toron In West African **mosque** architecture, the wooden beams that project from the walls. *Torons* are used as support for the scaffolding erected annually for the replastering of the building.

torque A neckpiece or arm band especially favored by the Celts, fashioned as a twisted metal ring.

tracery The stone or wooden bars in a window, screen, or panel, that support the structure and often create an elaborate decorative pattern.

transept The arm of a **cruciform** church, perpendicular to the **nave**. The point where the **nave** and transept cross is called the **crossing**. Beyond the crossing lies the **sanctuary**, whether **apse**, **choir**, or **chevet**.

travertine A mineral building material similar to limestone, typically found in central Italy.

treasury A building or room for keeping valuable (and often holy) objects.

trefoil An ornamental design made up of three rounded lobes placed adjacent to one another.

triforium The element of the interior **elevation** of a church, found between the **nave arcade** or **colonnade** and the **clerestory**, covers the blind area created by the sloping roof over the aisles. The triforium can be made up of openings from a passageway or gallery, or can be wall-supporting paintings or **mosaics**.

triglyph Rectangular block between the **metopes** of a **Doric frieze**. Identified by the three carved vertical grooves, which approximate the appearance of the end of a wooden beam.

trilithon Prehistoric structure composed of two upright **monoliths** supporting a third one laid horizontally.

triptych An artwork made up of three panels. The panels may be hinged together so the side segments (**wings**) fold over the central area.

triumph In Roman times, a celebration of a particular military victory, usually granted to the commanding general upon his return to Rome. Also: in later times, any depiction of a victory.

triumphal arch A freestanding, massive stone gateway with a large central **arch**, built as urban ornament to celebrate military victories (as by the Romans).

trompe l'oeil A manner of representation in which the appearance of natural space and objects is re-created with the express intention of fooling the eye of the viewer, who may be convinced that the subject actually exists as three-dimensional reality.

trophy Captured military objects such as armor and weapons that Romans displayed on an upheld pole or tree to celebrate victory. Also: a similar grouping that recalls the Roman custom of displaying the looted armor of a defeated opponent.

trumeau A column, **pier**, or post found at the center of a large **portal** or doorway, supporting the **lintel**.

tugra A calligraphic imperial monogram used in Ottoman courts.

tunnel vault See vault.

turret A small tower or tower-shaped projection on a building.

Tuscan order See order.

twining A basketry technique in which short rods are sewn together vertically. The panels are then joined together to form a vessel.

tympanum In **classical** architecture, the vertical panel of the **pediment**. In medieval and later architecture, the area over a door enclosed by an **arch** and a **lintel**, often decorated with sculpture or **mosaic**.

types In theology, a figure or symbol of something to come, as an event in the Old Testament that foreshadows an event in the New Testament. *See also* **typology**.

typological See typology.

typology In Christian **iconography**, a system of matching Old Testament figures and events and even some **classical** and other secular sources to New Testament counterparts they were seen to prefigure.

ukiyo-e A Japanese term for a type of popular art that was favored from the sixteenth century, particularly in the form of color woodblock prints. Ukiyo-e prints often depicted the world of the common people in Japan, such as courtesans and actors, as well as landscapes and myths.

undercutting A technique in sculpture by which the material is cut back under the edges so that the remaining **form** projects strongly forward, casting deep shadows.

underdrawing In painting, drawing obscured by application of paint.

underglaze Color or decoration applied to a ceramic piece before **glazing**.

urna In Buddhist art, the curl of hair on the forehead that is a characteristic mark of a buddha. The urna is a symbol of divine wisdom

ushnisha In Asian art, a round turban or tiara symbolizing royalty and, when worn by a *buddha*, enlightenment.

value The darkness or lightness of a color (hue).

vanishing point In a **perspective** system, the point on the **horizon line** at which **orthogonals** meet. A complex system can have multiple vanishing points.

vanitas An image, especially popular in Europe during the seventeenth century, in which all the objects symbolize the transience of life. Vanitas paintings are usually of still lifes or genre subjects.

vault An arched masonry structure that spans an interior space. Barrel or tunnel vault: an elongated or continuous semicircular vault, shaped like a half-cylinder. Corbeled vault: a vault made by projecting courses of stone. Groin or cross vault: a vault created by the intersection of two barrel vaults of equal size which creates four side compartments of identical size and shape. Quadrant or half-barrel vault: as the name suggests, a half-barrel vault. Rib vault: ribs (extra masonry) demarcate the junctions of a groin vault. Ribs may function to reinforce the groins or may be purely decorative. See also corbeling.

vaulting A system of space spanning using vaults

veduta (vedute) Italian for "vista" or "view." Paintings, drawings, or prints often of expansive city scenes or of harbors.

vellum A fine animal skin prepared for writing and painting. *See also* **parchment**.

veneer In architecture, the exterior facing of a building, often in decorative patterns of fine stone or brick. In decorative arts, a thin exterior layer of finer material (such as rare wood, ivory, metal, and semiprecious stones) laid over the form.

verism A **style** in which artists concern themselves with capturing the exterior likeness of an object or person, usually by rendering its visible details in a finely executed, meticulous manner.

verso The (reverse) left-hand page of the opening of a book or **manuscript**. Also: the subordinate or back side of a leaf of paper, as in the case of drawings. *See also* **recto**.

vignette A small **motif** or scene that has no established border.

vihara From the Sanskrit term meaning "for wanderers." A vihara is, in general, a Buddhist monastery in India. It also signifies monks' cells and gathering places in such a monastery.

villa A country house.

vimana The main element of a Southern Indian Hindu temple, usually in the shape of a pyramidal or tapering tower raised on a **plinth**.

volumetric A term indicating the concern for rendering the impression of three-dimensional volumes in painting, usually achieved through **modeling** and the manipulation of light and shadow **(chiaroscuro)**.

volute A spiral scroll, as seen on an **Ionic capital**.

volute krater See krater.

votive figure An image created as a devotional offering to a god or other deity.

voussoirs The oblong, wedge-shaped stone blocks used to build an **arch**. The topmost *voussoir* is called a **keystone**.

wall painting See mural.

ware A general term designating pottery produced and decorated by the same technique.

warp The vertical threads in a weaver's loom. Warp threads make up a fixed framework that provides the structure for the entire piece of cloth, and are thus often thicker than weft threads. See also weft.

wash A diluted **watercolor** or ink. Often washes are applied to drawings or prints to add **tone** or touches of color.

watercolor A type of painting using watersoluble pigments that are floated in a water medium to make a transparent paint. The technique of watercolor is most suited to a paper support.

wattle and daub A wall construction method combining upright branches, woven with twigs (wattles) and plastered or filled with clay or mud (daub).

weft The horizontal threads in a woven piece of cloth. Weft threads are woven at right angles to and through the warp threads to make up the bulk of the decorative pattern. In carpets, the weft is often completely covered or formed by the rows of trimmed knots that form the carpet's soft surface. See also warp.

westwork The monumental, west-facing entrance section of a Carolingian, Ottonian, or Romanesque church. The exterior consists of multiple stories between two towers; the interior includes an entrance vestibule, a chapel, and a series of galleries overlooking the nave.

white-ground A type of ancient Greek pottery in which the background color of the object is painted with a slip that turns white in

the firing process. Figures and details were added by painting on or **incising** into this slip. White-ground **wares** were popular in the **Classical** period as funerary objects.

wing A side panel of a **triptych** or **polyptych** (usually found in pairs), which was hinged to fold over the central panel. Wings often held the depiction of the donors and/or subsidiary scenes relating to the central image.

woodblock print A print made from a block of wood that is carved in relief or incised. See also woodcut.

woodcut A type of print made by carving a design into a wooden block. The ink is applied to the block with a roller. As the ink remains only on the raised areas between the carvedaway lines, these carved-away areas and lines provide the white areas of the print. Also: the process by which the woodcut is made.

x-ray style In Aboriginal art, a manner of representation in which the artist depicts a figure or animal by illustrating its outline as well as essential internal organs and bones.

yaksha, yakshi The male (yaksha) and female (yakshi) nature spirits that act as agents of the Hindu gods. Their sculpted images are often found on Hindu temples and other sacred places, particularly at the entrances.

zeitgeist German for "spirit of the time," meaning the cultural and intellectual aspects of a period that pervade human experience and are expressed in all creative and social endeavors.

ziggurat In Mesopotamia, a tall stepped tower of earthen materials, often supporting a shrine.

BIBLIOGRAPHY

Susan Craig

This bibliography is composed of books in English that are appropriate "further reading" titles. Most items on this list are available in good libraries whether college, university, or public institutions. I have emphasized recently published works so that the research information would be current. There are three classifications of listings: general surveys and art history reference tools, including journals and Internet directories; surveys of large periods (ancient art in the Western tradition, European medieval art, European Renaissance through eighteenth-century art, modern art in the West, Asian art, and African and Oceanic art and art of the Americas); and books for individual chapters 1 through 29.

General Art History Surveys and Reference

Adams, Laurie Schneider. Art across Time. 2nd ed

New York: McGraw-Hill, 2002. Andrews, Malcolm, Landscape and Western Art. Oxford History of Art. Oxford: Oxford Univ. Press 1999

Barral I Altet, Xavier. Sculpture From Antiquity to the Present. 4 vols. London: Taschen, 1996

Bazin, Germain. *A Concise History of World Sculpture*. London: David & Charles, 1981. Brownston, David M., and Ilene Franck. *Timelines*

the Arts and Literature. New York: Harper-

Collins, 1994.
Chadwick, Whitney. *Women, Art, and Society.* 3rd ed. New York: Thames and Hudson, 2002.

Cole, Bruce, and Adelheid Gealt. Art of the Western World: From Ancient Greece to Post-Modernism. New York: Summit, 1989.

Crofton, Ian, comp. A Dictionary of Art Quotations.

New York: Schirmer, 1989.

Dictionary of Art, The. 34 vols. New York: Grove's Dictionaries, 1996.

Encyclopedia of World Art. 16 vols. New York: McGraw-Hill, 1972–83.
Fleming, John, Hugh Honour, and Nikolaus Pevs-

ner. The Penguin Dictionary of Architecture and Landscape Architecture. 5th ed. New York: Penguin, 1998.

Fletcher, Banister. Sir Banister Fletcher's A History of Architecture. 20th ed. Ed. Dan Cruickshank.

Oxford: Architectural Press, 1996. Gardner, Helen. *Gardner's Art through the Ages*. 11th ed. Ed. Fred S. Kleiner, Christin J. Mamiya, and Richard G. Tansey. Fort Worth: Harcourt College, 2001. Griffiths, Antony. *Prints and Printmaking: An Intro-*

duction to the History and Techniques. 2nd ed. London: British Museum Press, 1996

Hall, James. *Dictionary of Subjects and Symbols in Art.* Rev. ed. New York: Harper & Row, 1979.

Hartt, Frederick. Art: A History of Painting, Sculpture,

Architecture. 4th ed. New York: Abrams, 1993. Havercamp Begemann, Egbert and Carolyn Logan. Creative Copies: Interpretative Drawings from Michaelangelo to Picasso. London: Sotheby's, 1988

Heller, Nancy G. Women Artists: An Illustrated History. 3rd ed. New York: Abbeville, 1997.

Holt, Elizabeth Gilmore, ed. A Documentary History

of Art. 3 vols. New Haven: Yale Univ. Press, 1986. Honour, Hugh, and John Fleming. The Visual Arts: A History. 6th ed. Upper Saddle River, NJ: Prentice Hall, 2002.

Hornblower, Simon, and Antony Spawforth. The Oxford Classical Dictionary. 3rd ed. rev. Oxford: Oxford Univ. Press, 2003. Hults, Linda C. The Print in the Western World: An In-

troductory History. Madison: Univ. of Wisconsin Press. 1996. Janson, H. W., and Anthony F. Janson. History of Art.

Rev. 6th ed. Upper Saddle River, NJ: Prentice Hall. 2004

Jervis, Simon. The Penguin Dictionary of Design and Designers. London: Lane, 1984.

Jones, Lois Swan. Art Information and the Internet: How to Find It, How to Use It. Phoenix: Oryx Press, 1999.

Kemp, Martin. The Oxford History of Western Art. Oxford: Oxford Univ. Press, 2000.

Kostof, Spiro. A History of Architecture: Settings and Rituals. 2nd ed. Rev. Greg Castillo. New York: Oxford Univ. Press, 1995

Livingstone, E. A. The Concise Oxford Dictionary of the Christian Church. Oxford: Oxford Univ. Press, 2000.

Mackenzie, Lynn. Non-Western Art: A Brief Guide. Upper Saddle River, NJ: Prentice Hall, 1995.

Mair, Roslin. Key Dates in Art History: From 600 BC to the Present. Oxford: Phaidon, 1979.

McConkey, Wilfred J. Klee as in Clay: A Pronunciation Guide. 3rd ed. Lanham, MD: Madison Books, 1992.

Preble, Duane, Sarah Preble, and Patrick Frank Artforms: An Introduction to the Visual Arts. Rev. 7th ed. Upper Saddle River, NJ: Prentice Hall, 2004.

Roberts, Helene, ed. Encyclopedia of Comparative Iconography: Themes Depicted in Works of Art. 2 vols. Chicago: Fitzroy Dearborn, 1998.

Rotberg, Robert I., Theodore K. Rabb, and Jonathan Brown, eds. Art and History: Images and Their Meaning. Cambridge: Cambridge Univ. Press 1988

Sed-Rajna, Gabrielle. Jewish Art. Trans. Sara Friedman and Mira Reich. New York: Abrams, 1997 Slatkin, Wendy. Women Artists in History: From Antiq-uity to the Present. 4th ed. Upper Saddle River, NJ:

Prentice Hall, 2000. Stangos, Nikos, ed. *The Thames and Hudson Dictionary* of Art and Artists. Rev. exp. & updated ed. World of Art. New York: Thames and Hudson, 1994.

Steer, John, and Antony White. Atlas of Western Art History: Artists, Sites and Movements from Ancient Greece to the Modern Age. New York: Facts on File, 1994

Sutton, Ian. Western Architecture: From Ancient Greece to the Present. World of Art. New York: Thames and Hudson, 1999.

Thacker, Christopher. The History of Gardens. Berke-

ley: Univ. of California Press, 1979.
Trachtenberg, Marvin, and Isabelle Hyman. Architecture: From Prehistory to Postmodernity. 2nd ed. Upper Saddle River, NJ: Prentice Hall, 2001 Walker, John A. *Design History and the History of De-*

sign. London: Pluto, 1989.

West, Shearer, ed. The Bulfinch Guide to Art History. A Comprehensive Survey and Dictionary of Western Art and Architecture. Boston: Little, Brown and Co., 1996.

Wilkins, David G., Bernard Schultz, and Katheryn M. Linduff. Art Past/Art Present. 4th ed. Upper Saddle River, NJ: Prentice Hall, 2001.

Art History Journals: A Selected List

African Arts. Quarterly. Los Angeles American Art. 3/year. Washington, D.C American Journal of Archaeology. Quarterly. Boston Antiquity. Quarterly. Cambridge Apollo. Monthly. London Architectural History. Annually, Farnham, Surrey, UK Archives of American Art Journal. Quarterly. Wash-

ington, D.C. Archives of Asian Art. Annually, New York Ars Orientalis. Annual. Ann Arbor, MI Art Bulletin. Quarterly. New York Artforum. Monthly. New York Art History. 11/year. New York Art in America. Monthly. New York Art Journal. Quarterly. New York

Art News. Quarterly. Mumbai, India Arts and the Islamic World. Annually. London Asian Art and Culture. Triannually. Washington, D.C. Burlington Magazine. Monthly. London Flash Art International. Bimonthly. Milan

Gesta. Semiannually. New York History of Photography. Quarterly. London Journal of Design History. Quarterly. Oxford

Journal of Egyptian Archaeology. Annually. London Journal of Hellenic Studies. Annually. London Journal of Roman Archaeology. Annually. Portsmouth, RI

Journal of the Society of Architectural Historians. Ouarterly, Chicago

Journal of the Warburg and Courtauld Institutes. Annually. London

Marg. Quarterly. 5/year. Mumbai, India Master Drawings, Quarterly, New York Oriental Art. Quarterly. Singapore Oxford Art Journal. Semiannually. Oxford Print Quarterly. Quarterly. London Simiolus. Quarterly. Utrecht, Netherlands Woman's Art Journal. Semiannually. Laverock, PA

Internet Directories for Art History Information

THE ART HISTORY RESEARCH CENTRE http://www-fofa.concordia.ca/arth/ARHC/splash.html Sponsored by Concordia University in Montreal, this directory includes the following divisions: search engines, newsgroups, mailing lists, library catalogues and bookstores, article indexes, universities, collections, other re-sources, and citing sources. There is also a link to an article by Leif Harmsen, "The Internet as a Research Medium for Art Historians.

ART HISTORY RESOURCES ON THE WEB http://witcombe.sbc.edu/ARTHLinks.html

Authored by Christopher L. C. E. Witcombe of Sweet Briar College in Virginia, the site includes an impressive number of links for various art historical eras as well as links to research resources, museums, and galleries.

ART IMAGES FOR COLLEGE TEACHING (AICT) http://www.mcad.edu/AICT/html

These images are the property of art historian and photographer Allan T. Kohl who offers them for nonprofit use. The images are organized into the following groupings: ancient, medieval era, Renaissance and Baroque, 18th-20th century, non-Western.

ART IN FLUX: A DIRECTORY OF RESOURCES FOR RESEARCH IN CONTEMPORARY ART http://www.art.uidaho.edu/artnet/bsu/contemporary/ artinflux/intro.html

Cheryl K. Shutleff of Boise State University in Idaho has authored this directory, which includes sites selected ac-cording to their relevance to the study of national or international contemporary art and artists

MOTHER OF ALL ART HISTORY LINKS PAGES http://www.umich.edu/~hartspc/histart/mother/ index.html

Maintained by the Department of the History of Art at the University of Michigan, this directory includes useful annotations and the URLs for each site included.

VOICE OF THE SHUTTLE: ART AND ART HISTORY PAGE http://vos.ucsb.edu/shuttle/art.html

Sponsored by University of California, Santa Barbara, this is part of the larger directory, which includes all areas of humanities. A very extensive list of links including general resources, museums, institutes and centers, galleries and exhibitions, auctions, artists and works by chronology, cartography, art theory and politics, design, architectural historical preservation, art and technology, image, slide and clip-art resources, image copyright and intellectual property issues, journals and zines, studio art depts. and programs, art history depts. and programs, conferences, calls for papers, deadlines, course syllabi and teaching resources.

YAHOO! ARTS>ART HISTORY http://dir.vahoo.com/Arts/Art History/

Another extensive directory of art links. Each listing includes the name of the site as well as a few words of explanation

WORLD WIDE ARTS RESOURCES http://www.wwar.com

Interactive arts gateway offering access to artists, museums, galleries, art, art history, education, and more

ART MUSEUM NETWORK http://www.amn.org

The official website of the world's leading art museums, the Art Museum Network offers links to the websites of countless museums worldwide, as well as links to the Art Museum Image Corsortium (AMICO) (www.amico.org), an illustrated search engine of more than 50,000 works of art available by subscription and ExCalendar (www.excalendar.net), the official exhibition calendar of the world's leading art museums, among other websites.

ARTMUSEUM.NET http://www.artmuseum.net

ArtMuseum.net provides a forum for Internet-based museum exhibitions around the country.

Ancient Art in the Western Tradition, General

- Adam Robert Classical Architecture: A Comprehensive Handbook to the Tradition of Classical Style. New York: Abrams, 1991.
- Amiet, Pierre. Art in the Ancient World: A Handbook of Styles and Forms. New York: Rizzoli, 1981.
 Becatti, Giovanni. The Art of Ancient Greece and
- Rome, from the Rise of Greece to the Fall of Rome. New York: Abrams, 1967.
- Dunabin, Katherine M. D. Mosaics of the Greek and Roman World. Cambridge: Cambridge Univ. Press. 1999.
- Ehrich, Robert W., ed. Chronologies in Old World Archaeology. 3rd ed. Chicago: Univ. of Chicago Press, 1992.
- Groenewegen-Frankfort, H. A., and Bernard Ashmole. Art of the Ancient World: Painting, Pottery, Sculpture, Architecture from Egypt, Mesopotamia Crete, Greece, and Rome. Library of Art History. Upper Saddle River, NJ: Prentice Hall, 1972.
- Huyghe, René. Larousse Encyclopedia of Prehistoric and Ancient Art. Rev. ed. Art and Mankind. New York: Prometheus, 1966.
- Laing, Lloyd Robert, and Jennifer Laing. Ancient Art: The Challenge to Modern Thought. Dublin: Irish Academic, 1993.
- Lloyd, Seton, and Hans Wolfgang Muller. Ancient Ar-chitecture. New York: Rizzoli, 1986.
- Oliphant, Margaret. The Atlas of the Ancient World. Charting the Great Civilizations of the Past. New York: Simon & Schuster, 1992.
- Powell, Ann. Origins of Western Art. London: Thames and Hudson, 1973.
 Saggs, H. W. F. Civilization before Greece and Rome
- New Haven: Yale Univ. Press, 1989
- Scranton, Robert L. Aesthetic Aspects of Ancient Art. Chicago: Univ. of Chicago Press, 1964.
- Smith, William Stevenson. Interconnections in the Ancient Near East: A Study of the Relationships between the Arts of Egypt, the Aegean, and Western Asia. New Haven: Yale Univ. Press, 1965.
- Stillwell, Richard, ed. Princeton Encyclopedia of Classical Sites. Princeton: Princeton Univ. Press 1976.

European Medieval Art, General

- Andrews, Frances B. The Medieval Builder and His Methods. New York: Barnes and Noble, 1993
- Binski, Paul. Painters. Medieval Craftsmen. London: British Museum Press, 1992. Brown, Michelle P. *Understanding Illuminated Manu-*
- scripts: A Guide to Technical Terms. London: J. Paul Getty Museum, 1994.
- Brown, Sarah, and David O'Connor. Glass-painters. Medieval Craftsmen. London: British Museum Press, 1992.
- Calkins, Robert C. Medieval Architecture in Western Europe: From A.D. 300 to 1500. lv. + laser optical disc. New York: Oxford Univ. Press, 1998
- Monuments of Medieval Art. New York: Dutton 1979
- Camille, Michael. The Gothic Idol: Ideology and Image-Making in Medieval Art. Cambridge New Art History and Criticism. Cambridge: Cambridge Univ Press 1989
- The Medieval Art of Love: Objects and Subjects of Desire. New York: Abrams, 1998.
- Cherry, John F. *Goldsmiths, Medieval Craftsmen*. London: British Museum Press, 1992.
- Coldstream, Masons and Sculptors. Medieval Craftsmen. London: British Museum Press, 1991
- Conant, Kenneth John. Carolingian and Romanesque Architecture, 800–1200. 3rd ed. Pelican History of Art. Harmondsworth, UK: Penguin, 1973
- De Hamel, Christopher. Scribes and Illuminators. Medieval Craftsmen. London: British Museum Press. 1992.
- Duby, Georges. Sculpture: The Great Art of the Middle Ages from the Fifth to the Fifteenth Century. New York: Skira/Rizzoli, 1990.
- Eames, Elizabeth S. English Tilers. Medieval Craftsmen. London: British Museum Press, 1992
- Fossier, Robert, ed. The Cambridge Illustrated History of the Middle Ages. 3 vols. Trans. Janet Sondheimer and Sarah Hanbury Tenison. Cambridge Cambridge Univ. Press, 1986–97.
- Hurlimann, Martin, and Jean Bony. French Cathedrals. Rev. & enl. London: Thames and Hudson, 1967 Kenvon, John, Medieval Fortifications, Leicester,
- Leicester Univ. Press, 1990. Labarge, Margaret Wade. A Small Sound of the Trumpet: Women in Medieval Life. London: Hamilton, 1990.
- Larousse Encyclopedia of Byzantine and Medieval Art London: Hamlyn, 1963

- Mâle, Emile, Religious Art in France: The Late Middle Ages: A Study of Medieval Iconography and Its Sources. Princeton: Princeton Univ. Press, 1986.
- Pfaffenbichler, Matthias. Armourers. Medieval Crafts-men. London: British Museum Press, 1992.
- Snyder, James. Medieval Art: Painting-Sculpture-Architecture, 4th–14th Century. New York: Abrams, 1989. Staniland. Kay. Embroiderers. Medieval Craftsmen.
- London: British Museum Press, 1991 Stoddard, Whitney. Art and Architecture in Medieval France: Medieval Architecture, Sculpture, Stained Glass, Manuscripts. The Art of the Church treasuries. New York: Harper & Row, 1972.
- Stokstad, Marilyn. Medieval Art. 3rd ed. New York: Westview 2004
- Wieck, Roger S. Painted Prayers: The Book of Hours in Medieval and Renaissance Art. New York: Braziller, 1997
- Zarnecki, George. The Art of the Medieval World: Architecture, Sculpture, Painting, the Sacred Arts. New York: Abrams, 1975.

European Renaissance through Eighteenth-Century Art, General

- Black, C. F., et al. Cultural Atlas of the Renaissance. New Jersey: Prentice Hall, 1993.
- Blunt, Anthony. Art and Architecture in France, 1500-1700. 5th ed. Rev. Richard Beresford. Pelican His-
- tory of Art. New Haven: Yale Univ. Press, 1999. Brown, Jonathan. *Painting in Spain: 1500–1700*. Pelican History of Art. New Haven: Yale Univ.
- Press, 1998.

 Circa 1492: Art in the Age of Exploration. Washington, D.C.: National Gallery of Art, 1991
- Cole, Bruce. Italian Art, 1250–1550: The Relation of Renaissance Art to Life and Society. New York: Harper & Row, 1987.
- Craske, Matthew. Art in Europe, 1700–1830: A History of the Visual Arts in an Era of Unprecedented Urban Economic Growth. Oxford History of Art. Oxford: Oxford Univ. Press, 1997.
- Cuttler, Charles D. Northern Painting from Pucelle to Bruegel: Fourteenth, Fifteenth and Sixteenth Centuries. New York: Holt, Rinehart and Winston, 1973.
- Graham-Dixon. Andrew. Renaissance. Berkelev: Univ. of California Press, 1999
- Harbison, Craig. The Mirror of the Artist: Northern Renaissance Art in Its Historical Context. Perspectives. New York: Abrams, 1995.
- Harrison, Charles, Paul Wood, and Jason Gaiger. Art in Theory 1648-1815: An Anthology of Changing Ideas, Oxford: Blackwell, 2000
- Hartt, Frederick, and David G. Wilkins. History of Italian Renaissance Art: Painting, Sculpture, Architecture, 5th ed. New York: Abrams, 2003.
- Huyghe, René. Larousse Encyclopedia of Renaissance and Baroque Art. Art and Mankind. New York: Prometheus, 1964
- Kubler, George, and Martin Soria. Art and Architecture in Spain and Portugal and Their American Dominions, 1500–1800. Pelican History of Art. Harmondsworth, UK: Penguin, 1959.
- McCorquodale, Charles. The Renaissance: European Painting, 1400–1600. London: Studio Editions, 1994.
- Minor, Vernon Hyde. Baroque & Rococo: Art & Culture. New York: Abrams, 1999.
- Murray, Peter. Renaissance Architecture. History of World Architecture. Milan: Electa, 1985
- Roettgen Steffi Italian Frescoes 2 vols Trans Russell Stockman. New York: Abbeville, 1996.
- Stechow, Wolfgang. Northern Renaissance, 1600: Sources and Documents. Upper Saddle River, NJ: Prentice Hall, 1966.
- Summerson, John. Architecture in Britain: 1530-1830. 7th ed. Pelican History of Art. Harmondsworth, UK: Penguin, 1983.
- Turner, Richard. Renaissance Florence: The Invention of a New Art. Perspectives. New York: Abrams, 1997
- Waterhouse, Ellis K. Painting in Britain, 1530 to 1790. 5th ed. Yale Univ. Press Pelican History of Art. New Haven: Yale Univ. Press. 1994
- Whinney, Margaret Dickens. Sculpture in Britain: 1530-1830. 2nd ed. Rev. by John Physick. Pelican History of Art. London: Penguin, 1988.

Modern Art in the West, General

- Arnason, H. Harvard. History of Modern Art: Painting, Sculpture, Architecture, Photography. 5th ed. Rev. Peter Kalb. Upper Saddle River, NJ: Prentice Hall, 2004.
- Baigell, Matthew. A Concise History of American Painting and Sculpture. Rev. ed. New York: Icon Editions, 1996

- Bjelajac, David. American Art: A Cultural History. Upper Saddle River, NJ: Prentice Hall, 2000.
- Bowness, Alan. Modern European Art. World of Art. New York: Thames and Hudson, 1995.
- Brettell, Richard R. Modern Art, 1851–1929: Capitalism and Representation. Oxford History of Art.
- Oxford: Oxford Univ. Press, 1999.
 Brown, Milton W. American Art: Painting, Sculpture, Architecture, Decorative Arts, Photography. New
- York: Abrams, 1979. Burnett , David G. *Masterpieces of Canadian Art from* the National Gallery of Canada. Edmonton, AB: Hurtig, 1990.
- Chipp, Herschel Browning. Theories of Modern Art: A Source Book by Artists and Critics. California Studies in the History of Art. Berkeley: Univ. of California Press, 1984
- Clarke, Graham. The Photograph. Oxford History of Art. Oxford: Oxford Univ. Press, 1997.
- Craven, Wayne. American Art: History and Culture. Rev. ed. Boston: McGraw-Hill, 2003.
- Sculpture in America. An American Art Journal/Kennedy Galleries Book. Newark: Univ.
- of Delaware Press, 1984.

 Doordan, Dennis P. Twentieth-Century Architecture. New York: Abrams, 2002.
- Doss, Erika. Twentieth-Century American Art. Oxford: Oxford Univ. Press, 2002.
- Eitner, Lorenz. Neoclassicism and Romanticism, 1750-1850: An Anthology of Sources and Docu-
- ments. New York: Harper & Row, 1989. Ferebee. Ann. A History of Design from the Victorian Era to the Present. New York: Van Nostrand Reinhold, 1980.
- Frampton, Kenneth. Modern Architecture: A Critical History. 3rd ed. Rev. & enl. World of Art. New York: Thames and Hudson, 1992
- Greenough, Sarah, et al. On the Art of Fixing a Shadow: One Hundred and Fifty Years of Photography. Washington, D.C.: National Gallery of Art, 1989.
- Hamilton, George Heard. Painting and Sculpture in Europe, 1880-1940. 6th ed. Pelican History of Art. New Haven: Yale Univ. Press, 1993.
- Hammacher, A. M. Modern Sculpture: Tradition and Innovation. Enlg. ed. New York: Abrams, 1988. Handlin, David P. American Architecture. World of Art. London: Thames and Hudson, 1985.
- Harris, Ann Sutherland, and Linda Nochlin. Women Artists: 1550–1950. Los Angeles: Los Angeles County Museum of Art, 1976.
- Harrison, Charles, and Paul Wood, eds. Art in Theory: 1900-2000: An Anthology of Changing Ideas. 2nd
- ed. Oxford: Blackwell, 2002. Hitchcock, Henry Russell. Architecture: Nineteenth and Twentieth Centuries. 4th ed. Pelican History of
- Art. Harmondsworth, UK: Penguin, 1977. Hughes, Robert. The Shock of the New. Rev. ed. New York: Knopf, 1991.
- Hunter, Sam, and John Jacobus. American Art of the 20th Century: Painting, Sculpture, Architecture. New York: Abrams, 1973.
- and Daniel Wheeler. Modern Art: Painting, Sculpture, Architecture. 3rd Rev. ed. New York: Abrams, 2000.
- Krauss, Rosalinde. Passages in Modern Sculpture. Cambridge, MA: MIT Press, 1977
- Kroeber, Karl. British Romantic Art. Berkeley: Univ. of California Press, 1986.
- Lewis, Samella S. *African American Art and Artists*. 3rd ed. rev. Berkeley: Univ. of California Press, 2003. Lindsay, Jack. Death of the Hero: French Painting from David to Delacroix. London: Studio, 1960.
- Lynton, Norbert. The Story of Modern Art. 2nd ed. Oxford: Phaidon, 1989.
- McCoubrey, John W. American Art, 1700-1960: Sources and Documents. Upper Saddle River, NJ: Prentice Hall, 1965.
- Mellen, Peter. Landmarks of Canadian Art. Toronto: McClelland and Stewart, 1978.
- Middleton, Robin, and David Watkin. Neoclassical and 19th Century Architecture. 2 vols. History of World Architecture. New York: Electa/Rizzoli, 1987.
- Murray, Joan. Canadian Art in the Twentieth Century. Toronto: Dundurn, 1999.
- Newhall, Beaumont. The History of Photography: From 1839 to the Present. 5th ed. Rev. New York: Museum of Modern Art, 1997.
- Patton, Sharon F. African-American Art. Oxford History of Art. Oxford: Oxford Univ. Press, 1998.
- Pohl, Frances K. Framing America: A Social History of American Art. New York: Thames and Hudson, 2002
- Powell, Richard J. Black Art: A Cultural History. 2nd ed. World of Art. New York: Thames and Hudson, 2002. Rosenblum, Naomi. A World History of Photography. 3rd ed. New York: Abbeville, 1997.

- Roth. Leland. A Concise History of American Architecture, Icon Editions, New York: Harper & Row, 1979 Russell, John. The Meanings of Modern Art. New
- York: Museum of Modern Art, 1991 Schapiro, Meyer. Modern Art: 19th and 20th Centuries. New York: Braziller, 1978.
- Sparke, Penny. Introduction of Design and Culture in the
- Twentieth Century. New York: Harper & Row, 1986. Stangos, Nikos, ed. Concepts of Modern Art: From Fauvism to Postmodernism. 3rd ed. Exp. & updated. World of Art. New York: Thames and Hudson, 1994.
- Stiles, Kristine, and Peter Howard Selz, Theories and Documents of Contemporary Art: A Source book of Artists' Writings. California Studies in the History of Art; 35. Berkeley: Univ. of California Press. 1996.
- Tafuri, Manfredo. Modern Architecture. 2 vols. History of World Architecture. New York: Electa/ Rizzoli, 1986
- Tuchman, Maurice. The Spiritual in Art: Abstract Painting 1890–1985. Los Angeles: Los Angeles County Museum of Art, 1986.
- Upton, Dell. Architecture in the United States. Oxford History of Art. Oxford: Oxford Univ. Press, 1998. Weaver, Mike, ed. The Art of Photography, 1939-1989. New Haven: Yale Univ. Press, 1989
- Wilmerding, John, American Art, Pelican History of Art. Harmondsworth, UK: Penguin, 1976.
- Woodham, Jonathan M. Twentieth Century Design Oxford History of Art. Oxford: Oxford Univ Press. 1997

Asian Art, General

- Barnhart, Richard M. Three Thousand Years of Chinese Painting, New Haven: Yale Univ. Press, 1997 Blunden, Caroline, and Mark Elvin. Cultural Atlas of
- China. 2nd ed. New York: Checkmark Books, 1998 Bussagli, Mario. Oriental Architecture. 2 vols. Histo-
- ry of World Architecture. New York: Electa/ Rizzoli, 1989 Chang, Leon Long-Yien, and Peter Miller. Four
- Thousand Years of Chinese Calligraphy. Chicago: Univ. of Chicago Press, 1990. Clunas, Craig. Art in China. Oxford History of Art.
- Oxford: Oxford Univ. Press, 1997. Collcutt, Martin, Marius Jansen, and Isao Kumaku-
- ra. Cultural Atlas of Japan. New York: Facts on
- Craven, Roy C. *Indian Art: A Concise History*. Rev. ed. World of Art. New York: Thames and Hudson, 1997. Dehejia, Vidya. Indian Art. Art & Ideas. London: Phaidon Press, 1997.
- Ebrey, Patricia Buckley. The Cambridge Illustrated History of China. Cambridge Illustrated History. Cambridge: Cambridge Univ. Press, 1996
- Elisseeff, Danielle, and Vadime Elisseeff. *Art of Japan* Trans. I. Mark Paris. New York: Abrams, 1985.
- Fisher, Robert E. Buddhist Art and Architecture. World of Art. New York: Thames and Hudson, 1993
- Harle, James C. The Art and Architecture of the Indian Subcontinent. 2nd ed. Pelican History of Art. New Haven: Yale Univ. Press, 1994
- Heibonsha Survey of Japanese Art. 31 vols. New York Weatherhill, 1972–80. *Japanese Arts Library*. 15 vols. New York: Kodansha
- International, 1977-87.
- Kramrisch, Stella. The Art of India: Traditions of Indian Sculpture, Painting, and Architecture. 3rd ed London: Phaidon Press, 1965.
- Lee, Sherman E. A History of Far Eastern Art. 5th ed. Ed Naomi Noble Richards. New York: Abrams, 1994 China, 5000 Years: Innovation and Transformation in the Arts. New York: Solomon R. Guggenheim Museum, 1998
- Loehr, Max. The Great Painters of China. New York: Harper & Row, 1980.
- Louis-Frederic. Buddhism. Flammarion Iconographic Guides. Trans. Nissim Marshall. Paris: Flammarion, 1995.
- Martynov, Anatolii Ivanovich. Ancient Art of Northern Asia. Urbana: Univ. of Illinois Press, 1991
- Mason, Penelope. History of Japanese Art. New York Abrams, 1993
- Medley, Margaret. Chinese Potter: A Practical History of Chinese Ceramics. 3rd ed. Oxford: Phaidon, 1989. Michell, George. *The Penguin Guide to the Monu-*ments of India. 2 vols. New York: Viking, 1989.
- Paine, Robert Treat, and Alexander Soper. Art and Architecture of Japan. 3rd ed. Pelican History of Art. Harmondsworth, UK: Penguin, 1981.
- Rowland, Benjamin. Art and Architecture of India. Buddhist, Hindu, Jain. Pelican History of Art. Harmondsworth, UK: Penguin, 1977.
- Seckel, Dietrich. Art of Buddhism. Rev. ed. Art of the World. New York: Greystone Press, 1968.

- Sickman, Lawrence, and Alexander Soper. Art and Architecture of China. Int. ed. Pelican History of Art. New Haven: Yale Univ. Press, 1992
- Stanley-Baker, Joan. Japanese Art. Rev. & exp. World of Art. New York: Thames and Hudson, 2000. Stutley, Margaret. Harper's Dictionary of Hinduism: Its Mythology, Folklore, Philosophy, Literature and History. New York: Harper & Row, 1977.
- Sullivan, Michael. *The Arts of China*. 4th ed., Exp. & rev. Berkeley: Univ. of California Press, 1999.
- Tadgell, Christopher. The History of Architecture in India: From the Dawn of Civilization to the End of the Raj. London: Architecture, Design, and Technology Press, 1990.
- Thorp, Robert L., and Richard Ellis Vinograd. Chinese Art & Culture. New York: Abrams, 2001. Tregear, Mary. Chinese Art. Rev. ed. World of Art. New York: Thames and Hudson, 1997
- Vainker S. J. Chinese Pottery and Porcelain: From Prehistory to the Present. London: British Museum, 1991. Varley, H. Paul Japanese Culture, 4th ed., Updated & exp. Honolulu: Univ. of Hawaii Press, 2000.

African and Oceanic Art and Art of the Americas, General

- Anderson, Richard L. Art in Small-Scale Societies. 2nd ed. Upper Saddle River, NJ: Prentice Hall, 1989.
- Berlo, Janet Catherine, and Lee Ann Wilson. Arts of Africa, Oceania, and the Americas: Selected Read ings. Upper Saddle River, NJ: Prentice Hall, 1993. Blocker, H. Gene. *The Aesthetics of Primitive Art*. Lan-
- tham, MD: Univ. Press of America, 1994
- Coote, Jeremy, and Anthony Shelton, eds. Anthropology, Art, and Aesthetics. New York: Oxford Univ. Press, 1992.
- D'Azevedao, Warren L. The Traditional Artist in African Societies. Bloomington: Indiana Univ. Press. 1989.
- Drewal, Henry, and John Pemberton III. Yoruba: Nine Centuries of African Art and Thought. New York: Center for African Art, 1989.
- Guidoni, Enrico, Primitive Architecture, Trans, Robert Eric Wolf. History of World Architecture. New York: Rizzoli, 1987
- Hiller, Susan, ed. & comp. The Myth of Primitivism: Perspectives on Art. London: Routledge, 1991.
- Leiris, Michel, and Jacqueline Delange. African Art. Arts of Mankind. London: Thames and Hudson, 1968. Leuzinger, Elsy. *The Art of Black Africa*. Trans. Ann Keep. New York: Rizzoli, 1976.
- Mexico: Splendors of Thirty Centuries. New York: Metropolitan Museum of Art. 1990.
- Murray, Jocelyn, ed. Cultural Atlas of Africa. Rev. ed. New York: Facts on File, 1998.
- Phillips, Tom. Africa: The Art of a Continent. London: Prestel 1996.
- Price, Sally. Primitive Art in Civilized Places. Chicago: Univ. of Chicago Press, 1989.
- Schuster, Carl, and Edmund Carpenter. Patterns that Connect: Social Symbolism in Ancient & Tribal Art. New York: Abrams, 1996.
- Visonà, Monica Blackmun et al., A History of Art in Africa. New York: Abrams, 2000. Willett, Frank. African Art: An Introduction. Rev. ed.
- World of Art. New York: Thames and Hudson, 1993

Chapter 1 Prehistory and Prehistoric Art in Europe

- Anati, Emmanuel, and Tiziana Cittadini, Valcomonica Rock Art: A New History for Europe. English version ed. Thomas King and Jason Clairborne. Capo di Ponte, Italy: Edizioni del Centro, 1994.
- Bahn Paul G. The Cambridge Illustrated History of Prehistoric Art. Cambridge Illustrated History. Cambridge: Cambridge Univ. Press, 1998.
- Bandi, Hans-Georg, et al. Art of the Stone Age: Forty Thousand Years of Rock Art. 2nd ed. Trans. Ann E. Keep. Art of the World. London: Methuen, 1970. Beltrán Martínez, Antonio. Rock Art of the Spanish
- Levant. Trans. Margaret Brown. Cambridge: Cambridge Univ. Press, 1982.
- Castleden, Rodney. The Making of Stonehenge. London: Routledge, 1993.
- Chauvet, Jean-Marie, Eliette Brunel Deschamps, and Christian Hillaire. Dawn of Art: The Chauvet Cave. The Oldest Known Paintings in the World, Trans. Paul G. Bahn. New York: Abrams, 1996.
- Chippindale, Christopher. Stonehenge New York: Thames and Hudson, 1994.
- Forte, Maurizio, and Alberto Siliotti. Virtual Archaeology: Re-Creating Ancient Worlds. New York: Abrams, 1997
- Freeman, Leslie G. Altamira Revisited and Other Essays on Early Art. Chicago: Institute for Prehistoric Investigation, 1987.

- Gowlett, John A. J. Ascent to Civilization: The Archaeology of Early Humans. 2nd ed. New York: McGraw-Hill, 1993.
- Graziosi, Paolo. Paleolithic Art. New York: McGraw-Hill 1960
- Laing, Lloyd. Art of the Celts. World of Art. New York: Thames and Hudson, 1992.
- Leakey, Richard E. and Roger Lewin. Origins Reconsidered: In Search of What Makes Us Human. New York: Doubleday, 1992.
- Leroi-Gourhan, André. The Dawn of European Art: An Introduction to Paleolithic Cave Painting. Trans. Sara Champion. Cambridge: Cambridge Univ. Press, 1982
- Lhote, Henri. The Search for the Tassili Frescoes: The Story of the Prehistoric Rock-Paintings of the Sa-hara. 2nd ed. Trans. Alan Houghton Brodrick. London: Hutchinson, 1973.
- Marshack, Alexander. The Roots of Civilization: The Cognitive Beginnings of Man's First Art, Symbol, and Notation. New York: McGraw-Hill, 1971.
- Megaw, Ruth, and Vincent Megaw. Celtic Art: From Its Beginnings to the Book of Kells. New York: Thames and Hudson, 1989.
- O'Kelly, Michael J. Newgrange: Archaeology, Art, and Legend. New Aspects of Antiquity. London: Thames and Hudson, 1982.
- Powell, T. G. E. *Prehistoric Art*. World of Art. New York: Oxford Univ. Press, 1966.
- Price, T. Douglas, and Gray M. Feinman. Images of the
- Past. 3rd ed. Mountain View, CA: Mayfield, 2000. Renfrew, Colin, ed. The Megalithic Monuments of Western Europe. London: Thames and Hudson, 1983.
- Ruspoli, Mario. *The Cave of Lascaux: The Final Pho-tographs.* New York: Abrams, 1987. Sandars, N. K. *Prehistoric Art in Europe.* 2nd ed. Pelican History of Art. New Haven: Yale Univ. Press, 1995. Sura Ramos, Pedro A. The Cave of Altamira. Gen. Ed.
- Antonio Beltran. New York: Abrams, 1999. Sieveking, Ann. The Cave Artists. Ancient People and Places, vol. 93. London: Thames and Hudson, 1979.
- Soffer, Olga. The Upper Paleolithic of the Central Russian Plain. Studies in Archaeology. Orlando, FL: Academic, 1985.
- Torbrugge, Walter. Prehistoric European Art. Trans. Norbert Guterman. Panorama of World Art. New York: Abrams, 1968
- Ucko, Peter J., and Andree Rosenfeld. *Paleolithic Cave Art*. New York: McGraw-Hill, 1967.

Chapter 2 Art of the Ancient Near East

- Akurgal, Ekrem. The Art of the Hittites. Trans. Constance McNab. New York: Abrams, 1962.
- Amiet, Pierre. Art of the Ancient Near East. Trans. John Shepley and Claude Choquet. New York. Abrams, 1980
- Aruz, Joan, with Ronald Wallenfels, eds. Art of the First Cities: The Third Millenium B.C. from the Mediterranean to the Indies. New York: The Metropolitan Museum of Art; New Haven: Yale Univ. Press, 2003.
- Bienkowski, Piotr, and Alan Millard, eds. Dictionary of the Ancient Near East. Philadelphia: Univ. of Pennsylvania Press, 2000.
- Bottero, Jean. Mesopotamia: Writing, Reasoning, and the Gods. Trans. Zainab Bahrani and Marc Van De Mieroop. Chicago: Univ. of Chicago Press, 1992.
- Collon, Dominque. *Ancient Near Eastern Art.* Berkeley: Univ. of California Press, 1995.
- First Impressions: Cylinder Seals in the Ancient Near East. Chicago: Univ. of Chicago Press, 1987.
- Downey, Susan B. Mesopotamian Religious Architecture: Alexander through the Parthians. Princeton: Princeton Univ. Press, 1988.
- Ferrier, R. W., ed. Arts of Persia. New Haven: Yale Univ. Press, 1989.
- Frankfort, Henri. The Art and Architecture of the Ancient Orient. 5th ed. Pelican History of Art. New Haven: Yale Univ. Press, 1996. Ghirshman, Roman. *The Arts of Ancient Iran from Its*
- Origins to the Time of Alexander the Great. Trans. Stuart Gilbert and James Emmons. Arts of Mankind, New York: Golden, 1964
- Harper, Prudence, Joan Arz, and Françoise Tallon, eds. The Royal City of Susa: Ancient Near Eastern Treasures in the Louvre. New York: The Metropolitan Museum of Art. 1992.
- Haywood, John. Ancient Civilizations of the Near East and Mediterranean. London: Cassell, 1997
- Kramer, Samual Noah, History Begins al Sumer: Thirty Nine Firsts in Man's Recorded History. 3rd rev. ed. Philadelphia: Univ. of Pennsylvania Press, 1956.

 —. The Sumerians, Their History, Culture, and Character. Chicago: Univ. of Chicago Press, 1963.
- Lloyd, Seton. Ancient Turkey: A Traveller's History of

Maisels, Charles Keith. The Near East: Archaeology in the "Cradle of Civilization." The Experience of Archaeology. London: Routledge, 1993.

Oppenheim, A. Leo. Ancient Mesopotamia: Portrait of a Dead Civilization. Rev. ed. completed by Erica Reiner. Chicago: Univ. of Chicago Press, 1977

Parrot, André. *The Arts of Assyria*. Trans. Stuart Gilbert and James Emmons. Arts of Mankind.

New York: Golden, 1961

 Sumer: The Dawn of Art. Trans. Stuart Gilbert and James Emmons. Arts of Mankind. New York: Golden, 1961

Porada, Edith. The Art of Ancient Iran: Pre-Islamic Cultures. Art of the World. New York: Crown, 1965. Roaf, Michael. Cultural Atlas of Mesopotamia and the Ancient Near East. New York: Facts on File, 1990.

Roux, Georges. Ancient Iraq. 3rd ed. London: Penguin, 1992.

Russell, John Malcolm. Sennacherib's Palace without Rival at Nineveh. Chicago: Univ. of Chicago Press. 1991

Saggs, H. W. F. Everyday Life in Babylonia and Assyria. New York: Dorset, 1987.

Civilization before Greece and Rome. New

Haven: Yale Univ. Press, 1989. Woolley, Leonard. The Art of the Middle East including Persia, Mesopotamia and Palestine. Trans. Ann E. Keep. Art of the World. New York: Crown, 1961

Chapter 3 Art of Ancient Egypt

Aldred, Cyril. Egyptian Art in the Days of the Pharaohs, 3100–320 B.C. World of Art. London: Thames and Hudson, 1980.

Arnold, Dieter. Temples of the Last Pharaohs. New York: Oxford Univ. Press, 1999.
Baines, John, and Jaromír Málek. Atlas of Ancient

Egypt. Rev. ed. New York: Facts on File, 2000.

Breasted, James Henry. A History of Egypt from the Earliest Times to the Persian Conquest. 2nd ed. Rev. London: Hodder & Stroughton, 1920.

Brier, Bob. Egyptian Mummies: Unraveling the Secrets of an Ancient Art. New York: Morrow, 1994.

David, A. Rosalie. The Pyramid Builders of Ancient Egypt: A Modern Investigation of Pharaoh's Workforce. London: Routledge, 1986.
Egyptian Art in the Age of the Pyramids. New York:

Metropolitan Museum of Art, 1999.

The Egyptian Book of the Dead: The Book of Going Forth by Day: Being the Papyrus of Ani (Royal Scribe of the Divine Offerings). Trans. Raymond O. Faulkner. 2nd Rev. ed. San Francisco: Chronicle, 1998.

Grimal, Nicolas-Christophe. A History of Ancient Egypt. Trans. Ian Hall. Oxford: Blackwell, 1992 Kozloff, Arielle P., and Betsy M. Bryan. Egypt's Dazzling Sun: Amenhotep III and His World. Cleveland Cleveland Museum of Art, 1992

Lehner, Mark. *The Complete Pyramids*. New York: Thames and Hudson, 1997.

Malek, Jaromir. Egyptian Art. Art & Ideas. London: Phaidon, 1999

Manniche, Lise. City of the Dead: Thebes in Egypt Chicago: Univ. of Chicago Press, 1987. Martin, Geoffrey Thorndike. The Hidden Tombs of

Memphis: New Discoveries from the Time of Tutankhamun and Ramesses the Great. London: Thames and Hudson, 1991.

Menu, Bernadette. Ramesses II, Greatest of the Pharoahs. Discoveries. New York: Abrams, 1999. Montet, Pierre. Everyday Life in Egypt in the Days of Ramesses the Great. Trans. A. R. Maxwell-Hysop

and Margaret S. Drower. Philadelphia: Univ. of Pennsylvania Press, 1981. Pemberton, Delia. Ancient Egypt. Architectural Guides

for Travelers. San Francisco: Chronicle, 1992. Reeves, C. N. The Complete Tutankhamun: The King the Tomb, the Royal Treasure. London: Thames

and Hudson, 1990. Robins, Gay. The Art of Ancient Egypt. Cambridge: Harvard Univ. Press, 1997.

Russmann, Edna R. *Egyptian Sculpture: Cairo and Luxor*. Austin: Univ. of Texas Press, 1989.

Smith, W. Stevenson. The Art and Architecture of Ancient Egypt. 3rd ed. Rev. William Kelly Simpson. Pelican History of Art. New Haven: Yale Univ. Press, 1998.

Strouhal, Eugen. Life of the Ancient Egyptians. Nor-

man: Univ. of Oklahoma Press, 1992. Tiradritti, Francesco, and Araldo De Luca. *Egyptian* Treasures from the Egyptian Museum in Cairo. New York: Abrams, 1999.

Wilkinson, Richard H. Reading Egyptian Art: A Hiero-glyphic Guide to Ancient Egyptian Painting and Sculpture. London: Thames and Hudson, 1992.

Winstone, H. V. F. Howard Carter and the Discovery of the Tomb of Tutankhamun. London: Constable, 1991

Chapter 4 Aegean Art

Barber, R. L. N. The Cyclades in the Bronze Age. Iowa City: Univ. of Iowa Press, 1987.

Castleden, Rodney. The Knossos Labyrinth: A New View of the "Palace of Minos" at Knossos, London: Routledge, 1990.

Demargne, Pierre. The Birth of Greek Art. Trans. Stuart Gilbert and James Emmons. Arts of Mankind. New York: Golden, 1964.

Dickinson. Oliver. The Aegean Bronze Age. Cambridge World Archaeology. Cambridge: Cambridge Univ. Press, 1994.

Doumas, Christos. The Wall-Paintings of Thera. 2nd ed. Trans. Alex Doumas. Athens: Kapon Editions, 1999

Fitton, J. Lesley, Cycladic Art. 2nd ed. London: British Museum, 1999

Higgins, Reynold. Minoan and Mycenean Art. Rev. ed. World of Art. New York: Thames and Hudson, 1997. Immerwahr, Sara Anderson. Aegean Painting in the Bronze Age. University Park: Pennsylvania State

Univ. Press, 1990. Marinatos, Nanno. Art and Religion in Thera: Reconstructing a Bronze Age Society. Athens: Math-

ioulakis, 1984. Marinatos, Spyridon, and Max Hirmer. Crete and

Matz, Friedrich. The Art of Crete and Early Greece. Prelude to Greek Art. Trans. Ann E. Keep. Art of the World. New York: Crown, 1962.

Mycenae, New York: Abrams, 1960.

Morgan, Lyvia. The Miniature Wall Paintings of Thera: A Study in Aegean Culture and Iconography. Cambridge: Cambridge Univ. Press, 1988

Preziosi, Donald, and Louise Hitchcock, Aegean Art and Architecture. Oxford History of Art. Oxford: Oxford Univ. Press, 1999.

Pellegrino, Charles R. Unearthing Atlantis: An Archaeological Survey. New York: Random House, 1991.

Chapter 5 Art of Ancient Greece

Akurgal, Ekrem. The Art of Greece: Its Origins in the Mediterranean and Near East. Trans. Wayne Dynes. Art of the World. New York: Crown, 1968. Arias, Paolo. *A History of 1000 Years of Greek Vase Painting*. New York: Abrams, 1962.

Aruz, Joan, ed. The Golden Deer of Eurasia: Scythian and Sarmatian Treasures from the Russian Steppes. New Haven: Yale Univ. Press, 2000.

Ashmole, Bernard. Architect and Sculptor in Classical Greece. Wrightsman Lectures. New York: New York Univ. Press, 1972.

Beard, Mary, and John Henderson. Classical Art: From Greece to Rome. Oxford History of Art. Oxford: Oxford Univ. Press. 2000.

Berve, Helmut, and Gottfried Gruben. Greek Temples, Theatres, and Shrines. New York: Abrams, 1963 Biers, William. The Archaeology of Greece: An Introduction. 2nd ed. Ithaca: Cornell Univ. Press, 1996.

Blumel, Carl. Greek Sculptors at Work. 2nd ed. Trans. Lydia Holland. London: Phaidon, 1969.

Boardman, John. Early Greek Vase Painting: 11th–6th Centuries B.C.: A Handbook. World of Art. London: Thames and Hudson, 1998.

Greek Art. 4th ed., Rev. & exp. World of Art. London: Thames and Hudsom, 1997

Greek Sculpture: The Archaic Period: A Handbook. World of Art. New York: Oxford Univ. Press 1991

Greek Sculpture: The Classical Period: A Handbook. London: Thames and Hudson, 1985.

Greek Sculpture: The Late Classical Period and Sculpture in Colonies and Overseas. World of Art. New York: Thames and Hudson, 1995

Oxford History of Classical Art. Oxford: Oxford Univ. Press, 1993.

—. The Parthenon and Its Sculptures. Austin: Univ.

of Texas Press, 1985.

Buitron-Oliver, Diana, and Nicholas Gage. The Greek Miracle: Classical Sculpture from the Dawn of Democracy: The Fifth Century B.C. Washington, D.C.: National Gallery of Art, 1992.

Camp, John M. The Athenian Agora: Excavations in the Heart of Classical Athens. New York: Thames and Hudson, 1986.

Carpenter, Thomas H. Art and Myth in Ancient Greece: A Handbook. World of Art. London: Thames and Hudson, 1991.

Cartledge, Paul, ed. The Cambridge Illustrated History of Ancient Greece. Cambridge Illustrated History. Cambridge: Cambridge Univ. Press, 1998.

Charbonneaux, Jean, Robert Martin, and François Villard. Archaic Greek Art (620-480 B.C.). Trans.

James Emmons and Robert Allen. Arts of Mankind. New York: Braziller, 1971.

Classical Greek Art (480-330 B.C.). Trans. James Emmons. Arts of Mankind. New York: Braziller, 1972.

. Hellenistic Art (330–50 B.C.). Trans. Peter Green. Arts of Mankind. New York: Braziller, 1973.

De Grummond, Nancy T. and Brunilde S. Ridgway. From Pergamon to Sperlonga: Sculpture in Context. Berkeley: Univ. of California Press, 2000. Durando, Furio. Splendours of Ancient Greece.

Trans. Ann Ghitinghelli. London: Thames and Hudson, 1997.

Fildes. Alan. Alexander the Great: Son of the Gods. Los Angeles, Calif.: J. Paul Getty Museum, 2002 Fitton, J. Lesley. Cycladic Art. 2nd ed. London: British

Museum 1999 Francis, E. D. Image and Idea in Fifth-Century Greece: Art and Literature after the Persian Wars. London:

Routledge, 1990. Fullerton, Mark D. Greek Art. Cambridge: Cambridge Univ. Press, 2000.

Havelock, Christine Mitchell. Hellenistic Art: The Art of the Classical World from the Death of Alexander the Great to the Battle of Actium. 2nd ed. New York: Norton, 1981.

Homann-Wedeking, Ernst. The Art of Archaic Greece. Trans. J. R. Foster. Art of the World. New York: Crown, 1968.

Hood, Sinclair. Arts in Prehistoric Greece. Pelican History of Art. Harmondsworth, UK: Penguin, 1978. Human Figure in Early Greek Art, The. Washington, D.C.: National Gallery of Art, 1988.

Hurwit, Jeffrey M. The Art and Culture of Early Greece 1100-480 B.C. Ithaca: Cornell Univ. Press, 1985.

—. The Athenian Acropolis: History, Mythology, and Archaeology from the Neolithic Era to the Present. Cambridge: Cambridge Univ. Press, 1999.

Jenkins, Ian. The Parthenon Frieze. Austin: Univ. of Texas Press, 1994.

Lagerlof, Margaretha Rossholm. The Sculptures of the Parthenon: Aesthetics and Interpretation. New Haven: Yale Univ. Press, 2000.

Lawrence, A. W. Greek Architecture. 5th ed. Rev. R. A. Tomlinson. Pelican History of Art. New Haven: Yale Univ. Press, 1996.

Lullies, Reinhart, and Max Hirmer, Greek Sculpture, Rev. & enl. ed. Trans. Michael Bullock. New York: Abrams, 1960.

Martin, Roland. Greek Architecture: Architecture of Crete, Greece, and the Greek World. History of World Architecture. New York: Electa/Rizzoli, 1988. Onians, John. Art and Thought in the Hellenistic Age.

The Greek World View 350-50 B.C. London: Thames and Hudson, 1979. Osborne, Robin. Archaic and Classical Greek Art.

Oxford History of Art. Oxford: Oxford Univ. Press 1998 Papaioannou, Kostas. The Art of Greece. Trans. I.

Mark Paris. New York: Abrams, 1989 Pedley, John Griffiths. Greek Art and Archaeology. 2nd ed. New York: Abrams, 1998

Pollitt, J. J. Art and Experience in Classical Greece. London: Cambridge Univ. Press, 1972.

Art in the Hellenistic Age. Cambridge: Cambridge Univ. Press, 1986.

The Art of Ancient Greece: Sources and Documents. Cambridge: Cambridge Univ. Press, 1990. Powell, Anton, ed. The Greek World. London: Routledge, 1995.

Ridgway, Brunilde Sismondo. The Archaic Style in Greek Sculpture. 2nd ed. Chicago: Ares, 1993. —. Fifth Century Styles in Greek Sculpture. Prince-

ton: Princeton Univ. Press, 1981. Fourth Century Styles in Greek Sculpture. Wis-

consin Studies in Classics. Madison: Univ. of Wisconsin Press, 1997.

Hellenistic Sculpture 1: The Styles of ca. 331–200 B.C. Wisconsin Studies in Classics. Madison: Univ. of Wisconsin Press, 1990.

Robertson, Martin. Greek Painting: The Great Centuries of Painting. Geneva: Skira, 1959. Roes, Anna. Greek Geometric Art. Its Symbolism and

Its Origin. London: Oxford Univ. Press, 1933. Sacks, David, and Oswyn Murray. Encyclopedia of the Ancient Greek World. New York: Facts on File. 1995

Schefold, Karl. Classical Greece. Trans. J. R. Foster. Art of the World. London: Methuen, 1967

Scully, Vincent. The Earth, the Temple, and the Gods: Greek Sacred Architecture, Rev. ed. New Haven: Yale Univ. Press, 1979.

Smith, R. R. R. Hellenistic Sculpture: A Handbook. World of Art. New York: Thames and Hudson, 1991.

Spivey, Nigel. Greek Art. Art & Ideas. London: Phaidon Press, 1997.

Stewart, Andrew F. *Greek Sculpture: An Exploration*. 2 vols. New Haven: Yale Univ. Press, 1990.

Webster, T. B. L. The Art of Greece: The Age of Hellenism. Art of the World. New York: Crown, 1966

Chapter 6 Etruscan Art and Roman Art

Andreae, Bernard. *The Art of Rome*. Trans. Robert Erich Wolf. New York: Abrams, 1977.

Bianchi Bandinelli, Ranuccio. Rome: The Centre of Power: Roman Art to A.D. 200. Trans. Peter Green. Arts of Mankind. London: Thames and Hudson, 1970.

—. Rome: The Late Empire: Roman Art A.D. 200– 400. Trans. Peter Green. Arts of Mankind. New York: Braziller, 1971.

Bloch, Raymond. *Etruscan Art*. Greenwich, CT: New York Graphic Society, 1965.

Boethius, Axel, and J. B. Ward-Perkins. *Etruscan and Early Roman Architecture*. 2nd ed. Pelican History of Art. Harmondsworth, UK: Penguin, 1978.

Breeze, David John. *Hadrian's Wall*. 4th ed. London Penguin, 2000.

Brendel, Otto J. Etruscan Art. 2nd ed. Yale University Press Pelican History Series. New Haven: Yale Univ. Press, 1995.

Brilliant, Richard. Roman Art: From the Republic to Constantine. London: Phaidon, 1974.

Buranelli, Francesco. *The Etruscans: Legacy of a Lost Civilization from the Vatican Museums*. Memphis: Lithograph, 1992.

Christ, Karl. The Romans: An Introduction to Their History and Civilization. Berkeley: Univ. of California Press, 1984.

Cornell, Tim, and John Matthews. *Atlas of the Roman World*. New York: Facts on File, 1982.

D'Ambra, Eve. *Roman Art.* Cambridge: Cambridge Univ. Press, 1998.

Elsner, Ja's. *Imperial Rome and Christian Triumph: The Art of the Roman Empire A.D. 100–450.* Oxford
History of Art. Oxford: Oxford Univ. Press, 1998.

Gabucci, Ada. Ancient Rome: Art, Architecture, and History. Eds. Stefano Peccatori and Stephano Zuffi. Trans. T. M. Hartman. Los Angeles, CA: J. Paul Getty Museum, 2002.

—. ed. The Colosseum. Los Angeles, CA: J. Paul Getty Museum. 2002.

Grant, Michael. Art in the Roman Empire. London: Routledge, 1995.

Guillaud, Jacqueline, and Maurice Guillaud. Frescoes in the Time of Pompeii. New York: Potter, 1990. Heintze, Helga von. Roman Art. New York: Universe, 1990.

Henig, Martin, ed. A Handbook of Roman Art: A Comprehensive Survey of All the Arts of the Roman World. Ithaca: Cornell Univ. Press, 1983.

Kahler, Heinz. *The Art of Rome and Her Empire*. Trans. J. R. Foster. Art of the World. New York: Crown, 1963. Ling, Roger. *Roman Painting*. Cambridge: Cambridge Univ. Press, 1991.

L'Orange, Hans Peter. *The Roman Empire: Art Forms and Civic Life.* New York: Rizzoli, 1985.

MacDonald, William L. The Architecture of the Roman Empire: An Introductory Study. Rev. ed. 2 vols. Yale Publications in the History of Art. New Haven: Yale Univ. Press, 1982.

—. The Pantheon: Design, Meaning, and Progeny. Cambridge: Harvard Univ. Press, 1976.

—, and John A. Pinto. Hadrian's Villa and Its Legacy New Haven: Yale Univ. Press, 1995.

Mansuelli, G. A. *The Art of Etruria and Early Rome*. Art of the World. New York: Crown, 1965.

Packer, James E., and Kevin Lee Sarring. The Forum of Trajan in Rome: A Study of the Monuments. 2 vols., portfolio and microfiche. California Studies in the History of Art; 31. Berkeley: Univ. of California Press, 1997.
Pollitt, J. J. The Art of Rome, c. 753 B.C.–337 A.D.:

Pollitt, J. J. The Art of Rome, c. 753 B.C.–337 A.D.: Sources and Documents. Upper Saddle River, NJ: Prentice Hall, 1966.

Quennell, Peter. *The Colosseum*. New York: Newsweek, 1971.

Ramage, Nancy H., and Andrew Ramage. The Cambridge Illustrated History of Roman Art. Cambridge: Cambridge Univ. Press, 1991.

—. Roman Art: Romulus to Constantine. 2nd ed.

Upper Saddle River, NJ: Prentice Hall, 1996.

Rediscovering Pompeii 4th ed Rome: UFrma de

Rediscovering Pompeii. 4th ed. Rome: L'Erma di Bretschneider, 1992. Spivey, Nigel. Etruscan Art. World of Art. New York:

Thames and Hudson, 1997.

Sprenger, Maja, and Bartolini, Gilda. The Etruscans: Their History, Art, and Architecture. New York: Abrams, 1983.

Strong, Donald. *Roman Art.* 2nd ed. Rev. & annotated. Ed. Roger Ling. Pelican History of Art. New Haven: Yale Univ. Press, 1995.

Vitruvius Pollio. Ten Books on Architecture. Trans. Ingrid D. Rowland; Commentary Thomas Noble Howe, Ingrid D. Rowland, Michael J. Dewar. Cambridge: Cambridge Univ. Press, 1999.

Ward-Perkins, J. B. Roman Architecture. History of World Architecture. New York: Electa/Rizzoli, 1988.

—. Roman Imperial Architecture. Pelican History of Art. New Haven: Yale Univ. Press, 1981.

Wheeler, Robert Eric Mortimer, Sir. Roman Art and Architecture. World of Art. New York: Oxford Univ. Press, 1964.

Chapter 7 Jewish, Early Christian, and Byzantine Art

Age of Spirituality: Late Antique and Early Christian Art, Third to Seventh Century. New York: Metropolitan Museum of Art, 1979.

Beckwith, John. *The Art of Constantinople: An Introduction to Byzantine Art 330–1453.* 2nd ed. London: Phaidon, 1968.

— Early Christian and Byzantine Art. 2nd ed. Pelican History of Art. Harmondsworth, UK: Penguin, 1979.

Boyd, Susan A. *Byzantine Art.* Chicago: Univ. of Chicago Press, 1979.
Buckton, David, ed. *The Treasury of San Marco*,

Buckton, David, ed. The Treasury of San Marco Venice. Milan: Olivetti, 1985.

Carr, Annemarie Weyl. Byzantine Illumination, 1150–1250: The Study of a Provincial Tradition. Chicago: Univ. of Chicago Press, 1987.

Christe, Yves. Art of the Christian World, A.D. 200– 1500: A Handbook of Styles and Forms. New York: Rizzoli. 1982.

Cioffarelli, Ada. Guide to the Catacombs of Rome and Its Surroundings. Rome: Bonsignori, 2000.

Cormack, Robin. *Byzantine Art.* Oxford History of Art. Oxford: Oxford Univ. Press, 2000.

Cutler, Anthony. The Hand of the Master: Craftsmanship, Ivory, and Society in Byzantium (9th-11th Centuries). Princeton: Princeton Univ. Press, 1994. Demus, Otto. Byzantine Art and the West. Wrightsman

Lectures. New York: New York Univ. Press, 1970.

—. Byzantine Mosaic Decoration: Aspects of Monumental Art in Byzantium. New Rochelle:

Caratzas, 1976.

—. The Church of San Marco in Venice: History, Architecture, Sculpture. Washington, D.C.: Dumbarton Oaks, 1960.

Evans, Helen C., and William D. Wixom, eds. *The Glory of Byzantium*. New York: Abrams, 1997. Ferguson, George Wells. *Signs and Symbols in Chris*-

Ferguson, George Wells. Signs and Symbols in Christian Art. New York: Oxford Univ. Press, 1967. Gough, Michael. Origins of Christian Art. World of

Art. London: Thames and Hudson, 1973.

Grabar, André. The Art of the Byzantine Empire:

Byzantine Art in the Middle Ages. Trans. Betty

Byzantine Art in the Middle Ages. Trans. Betty Forster. Art of the World. New York: Crown, 1966. — Byzantine Painting: Historical and Critical Study. Trans. Stuart Gilbert. New York: Rizzoli, 1979.

 Early Christian Art: From the Rise of Christianity to the Death of Theodosius. Trans. Stuart Gilbert and James Emmons. Arts of Mankind. New York: Odyssey, 1969.

—. The Golden Age of Justinian from the Death of Theodosius to the Rise of Islam. Trans. Stuart Gilbert and James Emmons. Arts of Mankind. New York: Odyssey, 1967.

Hubert, Jean, Jean Porcher, and W. F. Volbach. Europe of the Invasions. Trans. Stuart Gilbert and James Emmons. Arts of Mankind. New York: Braziller, 1969.

Kitzinger, Ernst. Byzantine Art in the Making: Main Lines of Stylistic Development in Mediterranean Art, 3rd-7th Century. Cambridge: Harvard Univ. Press. 1977.

Krautheimer, Richard. Early Christian and Byzantine Architecture. 4th ed. Pelican History of Art. Harmondsworth, UK: Penguin, 1986.

—. Rome, Profile of a City, 312–1308. Princeton: Princeton Univ. Press, 1980.

Mainstone, R. J. Hagia Sophia: Architecture, Structure and Liturgy of Justinian's Great Church. London: Thames and Hudson, 1988.

Lowden, John. Early Christian and Byzantine Art. Art. & Ideas. London: Phaidon, 1997.

Mango, Cyril. Art of the Byzantine Empire, 312–1453: Sources and Documents. Upper Saddle River, NJ: Prentice Hall, 1972.

—. Byzantine Architecture. History of World Architecture. New York: Rizzoli, 1985.

Manincelli, Fabrizio. Catacombs and Basilicas: The Early Christians in Rome. Florence: Scala, 1981. Mathew, Gervase. Byzantine Aesthetics. London: J. Murray, 1963. Mathews, Thomas P. *Byzantium: From Antiquity to the Renaissance*. Perspectives. New York: Abrams, 1998. Milburn, R. L. P. *Early Christian Art and Architecture*.

Berkeley: Univ. of California Press, 1988. Oakshott, Walter Fraser. *The Mosaics of Rome: from the Third to the Fourteenth Centuries.* London:

Thames and Hudson, 1967. Rice, David Talbot. *Art of the Byzantine Era*. New York: Praeger, 1963.

—. Byzantine Art. Harmondsworth, UK: Penguin, 1968.

Rodley, Lyn. *Byzantine Art and Architecture: An Introduction.* Cambridge: Cambridge Univ. Press, 1993. Rutgers, Leonard Victor. *Subterranean Rome: In*

Rutgers, Leonard Victor. Subterranean Rome: In Search of the Roots of Christianity in the Catacombs of the Eternal City. Leuven: Peeters, 2000. Schapiro, Meyer. Late Antique, Early Christian, and

Schapiro, Meyer. Late Antique, Early Christian, and Mediaeval Art. New York: Braziller, 1979.

Simson, Otto Georg von. Sacred Fortress: Byzantine
Art and Statecraft in Ravenna. Chicago: Univ. of
Chicago Press, 1948.

Stevenson, James. The Catacombs: Rediscovered Monuments of Early Christianity. Ancient Peoples and Places. London: Thames and Hudson, 1978.

Teteriatnikov, Natalia. Mosaics of Hagia Sophia, Istanbul: The Fossati Restoration and the Work of the Byzantine Institute. Washington, D.C.: Dumbarton Oaks Research Library and Collection, 1998.

Vio, Ettore, and Eunio Concina. *The Basilica of St. Mark in Venice*. New York: Riverside, 1999.

Webb, Matilda. The Churches and Catacombs of Early Christian Rome: A Comprehensive Guide. Brighton, UK: Sussex Academic Press, 2001.

Weitzmann, Kurt. Late Antique and Early Christian Book Illumination. New York: Braziller, 1977. ——. Place of Book Illumination in Byzantine Art.

Princeton: Art Museum, Princeton Univ., 1975.
Wharton, Annabel Jane. Art of Empire: Painting and Architecture of the Byzantine Periphery: A Comparative Study of Four Provinces. University Park: Pennsylvania State Univ. Press, 1988.

Chapter 8 Islamic Art

Akurgal, Ekrem, ed. *The Art and Architecture of Turkey*. New York: Rizzoli, 1980.

Al-Faruqi, Ismail R, and Lois Lamya'al Faruqi. Cultural Atlas of Islam. New York: Macmillan, 1986. Asher, Catherine B. Architecture of Mughal India. New York: Cambridge Univ. Press, 1992. Aslanapa, Oktay. Turkish Art and Architecture. Lon-

Aslanapa, Oktay. Turkish Art and Architecture. London: Faber, 1971.

Atasoy, Nurhan. Splendors of the Ottoman Sultans. Ed. and Trans. Tulay Artan. Memphis, TN: Lithograph, 1992.

Atil, Esin. The Age of Sultan Suleyman the Magnificent. Washington, D.C.: National Gallery of Art, 1987. — Art of the Arab World. Washington, D.C.: Smithsonian Institution, 1975.

—. Islamic Art and Patronage: Treasures from Kuwait. New York: Rizzoli, 1990.

Renaissance of Islam: Art of the Mamluks. Washington, D.C.: Smithsonian Institution, 1981.

Read Mile Cleveland, Mighel and Reject Printing.

Beach, Milo Cleveland. *Mughal and Rajput Painting*. New York: Cambridge Univ. Press, 1992. Blair, Sheila S., and Jonathan Bloom. *The Art and Ar*-

Blair, Sheila S., and Jonathan Bloom. *The Art and Architecture of Islam 1250–1800*. Pelican History of Art. New Haven: Yale Univ. Press, 1994.

Brend, Barbara. *Islamic Art*. Cambridge: Harvard Univ. Press, 1991.

Podds Jarrilum D. ed. al. Andalus. The Art of Is.

Dodds, Jerrilynn D., ed. *al-Andalus: The Art of Islamic Spain.* New York: Metropolitan Museum of Art, 1992.

Ettinghausen, Richard, and Oleg Grabar. *The Art and Architecture of Islam: 650–1250*. Pelican History of Art. New Haven: Yale Univ. Press, 1994.

Falk, Toby, ed. Treasures of Islam. London: Sotheby's, 1985.

Frishman, Martin, and Hasan-Uddin Khan. The Mosque: History, Architectural Development and Regional Diversity. London: Thames and Hudson, 1994.

Glasse, Cyril. *The Concise Encyclopedia of Islam.* San Francisco: Harper & Row, 1989. Grabar, Oleg. *The Alhambra*. Cambridge: Harvard

Univ. Press, 1978.

—. The Formation of Islamic Art. Rev. ed. New Haven: Yale Univ. Press, 1987.

—. The Great Mosque of Isfahan. New York: New York Univ. Press, 1990.

—. The Mediation of Ornament. A. W. Mellon Lectures in the Fine Arts. Princeton: Princeton Univ. Press, 1992.

 Mostly Miniatures: An Introduction to Persian Painting. Princeton: Princeton Univ. Press, 2000.
 Mohammad al-Asad. Abeer Audeh, and Said

—, Mohammad al-Asad, Abeer Audeh, and Said Nuseibeh. The Shape of the Holy; Early Islamic Jerusalem. Princeton: Princeton Univ. Press, 1996. Grube, Ernest J. Architecture of the Islamic World: Its History and Social Meaning. Ed. George Mitchell. New York: Morrow, 1978.

Hillenbrand, Robert, Islamic Art and Architecture World of Art. London: Thames and Hudson, 1999 Hoag, John D. Islamic Architecture. History of World Architecture. New York: Abrams, 1977

Irwin, Robert. *Islamic Art in Context: Art, Architecture, and the Literary World.* Perspectives. New York: Abrams, 1997

Jenkins, Marilyn. Islamic Art in the Kuwait National Museum. London, 1983.

Jones, Dalu, and George Mitchell, eds. The Arts of Islam. London: Arts Council of Great Britain, 1976 Khatibi, Abdelkebir, and Mohammed Sijelmassi. *The Splendour of Islamic Calligraphy*. Rev. and exp. ed. New York: Thames and Hudson, 1996.

Lentz, Thomas W., and Glenn D. Lowry. Timur and the Princely Vision: Persian Art and Culture in the Fifteenth Century. Los Angeles: Los Angeles County Museum of Art, 1989.

Papadopoulo, Alexandre. Islam and Muslim Art. Trans. Robert Erich Wolf. New York: Abrams, 1979. Petsopoulos, Yanni, ed. Tulips, Arabesques and Turbans: Decorative Arts from the Ottoman Empire

New York: Abbeville, 1982. Raby, Julian, ed. The Art of Syria and the Jazira, 1100-1250. Oxford Studies in Islamic Art. Oxford:

Oxford Univ. Press, 1985.

Rice, David Talbot, Islamic Art, World of Art, New York: Thames and Hudson, 1965.
Robinson, Francis, ed. *The Cambridge Illustrated*

History of the Islamic World. Cambridge Univ. Press. 1996.

Schimmel, Annemarie. Calligraphy and Islamic Culture. New York: New York Univ. Press, 1983

Ward, R. M. Islamic Metalwork. New York: Thames and Hudson, 1993.

Welch, Anthony. Calligraphy in the Arts of the Muslim World. Austin: Univ. of Texas Press, 1979.

Chapter 9 Art of India before 1200

Allchin, Bridget, and Raymond Allchin. The Rise of Civilization in India and Pakistan. Cambridge World Archaeology. Cambridge: Cambridge Univ. Press 1982

Behl, Benoy K. The Ajanta Caves: Artistic Wonder of Ancient Buddhist India. New York: Abrams, 1998. Berkson, Carmel. Elephanta: The Cave of Shiva. Princeton: Princeton Univ. Press, 1983.

Brooks, Robert R. R., and Vishnu S. Wakakar. Stone Age Painting in India. New Haven: Yale Univ. Press, 1976 Chandra, Pramod. *The Sculpture of India, 3000* B.C.–1300 A.D. Washington, D.C.: National

Gallery of Art, 1985.

Czuma, Stanislaw J. Kushan Sculpture: Images from Early India. Cleveland: Cleveland Museum of Art, 1985.

Dehejia, Vidya. Art of the Imperial Cholas. New York: Columbia Univ. Press, 1990.

Early Buddhist Rock Temples. Ithaca: Cornell Univ. Press, 1972

Dessai, Vishakha N., and Darielle Mason, eds. Gods, Guardians, and Lovers: Temple Sculptures from

North India, A.D. 700-1200. New York: Asia Society Galleries, 1993. Dimmitt, Cornelia, Classical Hindu Mythology. Philadelphia: Temple Univ. Press, 1978.

Dye, Joseph M. The Arts of India. Richmond: Virginia Museum of Fine Arts/Philip Wilson, 2001.

Eck, Diana L. Darsan. Seeing the Divine Image in India. 3rd. ed. Chambersburg, PA: Anima, 1998. Flaherty, Wendy. Hindu Myths. Harmondsworth, UK:

Penguin, 1975. Gupta, S. P. The Roots of Indian Art: A Detailed Study of the Formative Period of Indian Art and Architec ture, Third and Second Centuries B.C., Mauryan

and Late Mauryan. Delhi: B. T. Pub. Corp., 1980. Harle, J. C. Gupta Sculpture. Oxford: Clarendon, 1974 Huntington, Susan L. The Arts of Ancient India: Bud-dhist, Hindu, Jain. New York: Weatherhill. 1985.

Leaves from the Bodhi Tree: The Art of Pala India (8th-12th Centuries) and Its International Legacy Dayton, OH: Dayton Art Institute, 1990.

Hutt, Michael. Nepal: A Guide to the Art and Architecture of the Kathmandu Valley. Boston: Shambala, 1995

Knox, Robert. Amaravati: Buddhist Sculpture from the Great Stupa. London: British Museum, 1992 Kramrisch, Stella. The Art of Nepal. New York:

Abrams, 1964. Presence of Siva. Princeton: Princeton Univ.

Press, 1981. Meister, Michael, ed. Discourses on Siva: On the Na

ture of Religious Imagery. Philadelphia: Univ. of Pennsylvania Press, 1984.

-. Encyclopedia of Indian Temple Architecture. 2 vols. in 7. Philadelphia: Univ. of Pennsylvania Press, 1983.

Nou, Jean-Louis. Taj Mahal. Text by Amina Okada and M.C. Joshi. New York: Abbeville, 1993.

Pal, Pratapaditya, ed. Aspects of Indian Art. Leiden:

. The Ideal Image: The Gupta Sculptural Tradition and Its Influence. New York: Asia Society, 1978 Court Paintings of India, 16th-19th Centuries.

New York: Navin Kumar, 1983.

Possehl, Gregory, ed. Ancient Cities of the Indus Durham, NC: Carolina Academic, 1979.

Harappan Civilization: A Recent Perspective. 2nd ed. New Delhi: American Institute of Indian Studies, 1993.

Poster, Amy G. From Indian Earth: 4,000 Years of Ter racotta Art. Brooklyn: Brooklyn Museum, 1986. Rosenfield, John M. The Dynastic Arts of the Kushans.

California Studies in the History of Art. Berkeley: Univ. of California Press, 1967

Sankalia, H. D. Prehistoric Art in India. Durham, N.C.: Carolina Academic Press, 1978

Shearer, Alistair. Upanishads. New York: Harper & Row, 1978.

Skelton, Robert, and Mark Francis. Arts of Bengal: The Heritage of Bangladesh and Eastern India. London: Whitechapel Gallery, 1979.

Thapar, Romila. Asoka and the Decline of the Mauryas. Rev. ed. Delhi: Oxford, 1997.

and Percival Spear. History of India. London: Penguin, 1990. Weiner, Sheila L. Aianta: Its Place in Buddhist Art.

Berkeley: Univ. of California Press, 1977.

Williams, Joanna G. Art of Gupta India, Empire and Province. Princeton: Princeton Univ. Press, 1982.

Chapter 10 Chinese Art before 1280

The Art Treasures of Dunhuang. Hong Kong: Joint, 1981. Barnhart, Richard. Along the Border of Heaven: Sung and Yuan Painting from the C. C. Wang Family Collection. New York: Metropolitan Museum of Art, 1983.

Billeter, Jean François. *The Chinese Art of Writing*. New York: Skira/Rizzoli, 1990.

Cahill, James. Art of Southern Sung China. New York:

Asia Society, 1962.

—. Index of Early Chinese Painters and Paintings: T'ang, Sung, and Yuan. Berkeley: Univ. of California Press, 1980.

Chang, Po-tuan. The Inner Teachings of Taoism Trans. Thomas Cleary. Boston: Shombhala, 1986. De Silva, Anil. *The Art of Chinese Landscape Painting*: In the Caves of Tun-huang. Art of the World. New

York: Crown, 1967.

Fong, Wen, ed. Beyond Representation: Chinese Painting and Calligraphy, 8th-14th Century. Princeton Monographs in Art and Archaeology. New York: Metropolitan Museum of Art, 1992.

The Great Bronze Age of China: An Exhibition from the People's Republic of China. New York: Metropolitan Museum of Art, 1980.

Fong, Wen, and Marilyn Fu. Sung and Yuan Paintings. New York: New York Graphic Society, 1973.

Gridley, Marilyn Leidig. Chinese Buddhist Sculpture under the Liao: Free Standing Works in Situ and Selected Examples from Public Collections. New Delhi: International Academy of Indian Culture, 1993

Ho, Wai-kam, et at. Eight Dynasties of Chinese Paint-ing: The Collections of the Nelson Gallery-Atkins Museum, Kansas City, and the Cleveland Museum of Art. Cleveland: Cleveland Museum of Art, 1980.

James, Jean M. A Guide to the Tomb and Shrine Art of the Han Dynasty 206 B.C.-A.D. 220. Chinese Studies; 2. Lewiston: E. Mellen Press, 1996.

Juliano, Annette L. Art of the Six Dynasties: Centuries of Change and Innovation, New York: China House Gallery, 1975.

Karetzky, Patricia Eichenbaum. Court Art of the Tang Lantham: Univ. Press of America, 1996.

Lawton Thomas Chinese Art of the Warring States Period: Change and Continuity, 480–222 B.C Washington, D.C.: Freer Gallery of Art, Smithsonian Institution, 1982.

Chinese Figure Painting. Washington, D.C.: Smithsonian Institution, 1973.

Lim, Lucy. Stories from China's Past: Han Dynasty Pictorial Tomb Reliefs and Archaeological Objects from Sichuan Province, People's Republic of China. San Francisco: Chinese Culture Foundation, 1987.

Ma, Ch'eng-yuan. Ancient Chinese Bronzes. Ed. Hsio-Yen Shih. Hong Kong: Oxford Univ. Press, 1986

Munakata, Kiyohiko. Sacred Mountains in Chinese Art. Champaign: Krannert Art Museum, Univ. of Illinois, 1991

Paludan, Ann. Chinese Spirit Road: The Classical Tradition of Stone Tomb Sculpture. New Haven: Yale Univ. Press, 1991.

. Chinese Tomb Figurines. Hong Kong: Oxford Univ. Press, 1994.

Powers, Martin J. Art and Political Expression in Early

China. New Haven: Yale Univ. Press, 1991. Rawson, Jessica. Ancient China: Art and Archaeology. London: British Museum, 1980.

Mysteries of Ancient China: New Discoveries from the Early Dynasties. London: British Museum Press, 1996

Rhie, Marylin M. Early Buddhist Art of China and Central Asia. Handbuch der Orientalistik. Vierte Abteinlung. China; 12. Leiden: Brill, 1999-.

Watson, William. Ancient Chinese Bronzes. 2nd ed. The Arts of the East. London: Faber and Faber, 1977

The Arts of China to AD 900. Pelican History of Art. New Haven: Yale Univ. Press, 1995.

Weidner, Marsha, ed. Latter Days of the Law: Images of Chinese Buddhism, 850–1850. Lawrence: Spencer Museum of Art, Univ. of Kansas, 1994.

Whitfield, Roderick, and Anne Farrer. Caves of the Thousand Buddhas: Chinese Art from the Silk Route. London: British Museum, 1990.

Wu Hung. Monumentality in Early Chinese Art and Architecture. Stanford: Stanford Univ. Press, 1995.

Chapter 11 Japanese Art before 1392

Cunningham, Michael R. Buddhist Treasures from Nara, Cleveland: Cleveland Museum of Art, 1998. Kidder, J. Edward. Early Buddhist Japan. Ancient People and Places. New York: Praeger, 1972.

Early Japanese Art: The Great Tombs and Treasures, Princeton: Van Nostrand, 1964.

. Japanese Temples: Sculpture, Paintings, Gardens, and Architecture. London: Thames and Hudson, 1964.

Prehistoric Japanese Arts: Jomon Pottery. Tokyo: Kodansha International, 1968.

Kurata, Bunsaku. Horyu-ji, Temple of the Exalted Law: Early Buddhist Art from Japan. New York: Japan Society, 1981.

LaMarre, Thomas. Uncovering Heian Japan: An Archaeology of Sensation and Inscription. Asia-Pacific. Durham, NC: Duke Univ. Press, 2000. Miki, Fumio. *Haniwa*. Trans. and adapted by Gino

Lee Barnes. Arts of Japan, 8. New York: Weatherhill. 1974.

Mino, Yutaka, The Great Eastern Temple: Treasures of Japanese Buddhist Art from Todai-ji. Chicago: Art Institute of Chicago, 1986.

Murase, Miyeko. *Iconography of the Tale of Genji:* Genji Monogatari Ekotoba. New York: Weatherhill, 1983

Nishiwara, Kyotaro, and Emily J. Sano. The Great Age of Japanese Buddhist Sculpture, A.D. 60-1300, Fort Worth, TX: Kimbell Art Museum, 1982

Okudaira, Hideo. Narrative Picture Scrolls. Trans. Elizabeth ten Grutenhuis. Arts of Japan, 5. New York: Weatherhill, 1973.

Pearson, Richard J. Ancient Japan. Washington, D.C.: Sackler Gallery, 1992. Rosenfield, John M., Fumiko E. Cranston, and Edwin

A. Cranston. The Courtly Tradition in Japanese Art and Literature: Selections from the Hofer and Hyde Collections. Cambridge: Fogg Art Museum, Harvard Univ., 1973.

Japanese Arts of the Heian Period: 794-1185. New York: Asia Society, 1967

Soper, Alexander Coburn. Evolution of Buddhist Architecture in Japan, Princeton Monographs in Art and Archaeology, no. 22. New York: Hacker Art, 1978.

Swann, Peter. The Art of Japan: From the Jomon to the Tokugawa Period. Art of the World. New York: Crown, 1966.

Chapter 12 Art of the Americas before 1300

Abel-Vidor, Suzanne. Between Continents/Between Seas: Precolumbian Art of Costa Rica. New York:

Abrams, Elliot Marc. How the Maya Built Their World: Energetics and Ancient Architecture. Austin: Univ. of Texas Press, 1994.

Alcina Franch, José. Pre-Columbian Art. Trans. I.

Mark Paris. New York: Abrams, 1983. Anton, Ferdinand, *Art of the Maya*. Trans. Mary Whitall. London: Thames and Hudson, 1970.

Benson, Elizabeth P., and Beatriz de la Fuente. Olmec Art of Ancient Mexico. Washington, D.C.: National Gallery of Art, 1996.

Berrin, Kathleen, ed. Feathered Serpents and Flowering Trees: Reconstructing the Murals of Teotihuacan. San Francisco: Fine Arts Museums of San Francisco, 1988.

- and Esther Pasztory. Teotihuacan: Art from the City of the Gods. New York: Thames and Hudson, 1993.
- Brody, J. J. The Anasazi: Ancient Indian People of the American Southwest. New York: Rizzoli, 1990

Anasazi and Pueblo Painting. Albuquerque

- Univ. of New Mexico Press, 1991. Coe, Michael D. *The Jacquar's Children: Pre-Classical* Central Mexico. New York: Museum of Primitive Art 1965
- Coe, Ralph T. Sacred Circles: Two Thousand Years of North American Indian Art. London: Arts Council of Great Britain, 1976.
- Donnan, Christopher B. Ceramics of Ancient Peru. Los Angeles: Fowler Museum of Cultural History, Univ. of California, 1992.
- Moche Art of Peru: Pre-Columbian Symbolic Communication. Rev. ed. Los Angeles: Fowler Museum of Cultural History, Univ. of California, 1978.
- Fash, William Leonard. Scribes, Warriors, and Kings. The City of Copan and the Ancient Maya. London: Thames and Hudson, 1991.
- Fewkes, Jesse Walter. The Mimbres: Art and Archaeology. Albuquerque: Avanyu, 1989.
- Frazier, Kendrick, People of Chaco: A Canyon and Its Culture. Rev. & updated ed. New York: Norton, 1999.
- Grimes, John B., Christian F. Feest, and Mary Lou Curran, eds. Uncommon Legacies: Native American Art from the Peabody Essex Museum. New York: American Federation of the Arts; Seattle; London: in association with the Univ. of Washington Press, 2002.
- Herreman, Frank, Power of the Sun: The Gold of Colombia. Antwerp: City of Antwerp, 1993.
- Heyden, Doris, and Paul Gendrop. Pre-Columbian Architecture of Mesoamerica. Trans. Judith Stanton. History of World Architecture. New York: Electa/Rizzoli, 1988
- Korp, Maureen. The Sacred Geography of the American Mound Builders. Native American Studies. Lewiston, NY: Mellen, 1990.
- Krumnine, Mary Louise Elliot, and Susan C. Scott, eds. Art and the Native American: Perceptions, Reality, and Influences. University Park: Pennsylvania State Univ. Press, 2001.
- Kubler, George. The Art and Architecture of Ancient America: The Mexican, Maya, and Andean Peoples 3rd ed. Pelican History of Art. New Haven: Yale Univ. Press, 1990.
- Esthetic Recognition of Ancient Amerindian Art. Yale Publications in the History of Art. New Haven: Yale Univ. Press, 1991.
- Longhena, Maria. Ancient Mexico: The History and Culture of the Maya, Aztecs, and Other Pre-Columbian Peoples. Trans. Neil Frazer Davenport. New York: Stewart, Tabori & Chang, 1998.
- Meuli, Jonathan. Shadow House: Interpretations of Northwest Coast Art. Amsterdam, The Netherlands: Harwood Academic, 2001
- Miller, Mary Ellen. The Art of Mesoamerica: from Olmec to Aztec. 3rd ed. World of Art. London: Thames and Hudson, 2001.
- Maya Art and Architecture. World of Art. London: Thames and Hudson, 1999.
- and Karl Taube. The Gods and Symbols of Ancient Mexico and the Maya: An Illustrated Dictionary of Mesoamerican Religion. New York:
- Thames and Hudson, 1993. Moseley, Michael. *The Incas and Their Ancestors*. The Archaeology of Peru. London: Thames and Hudson, 1992.
- Pang, Hildegard Delgado. Pre-Columbian Art: Investigations and Insights. Norman: Univ. of Oklahoma Press, 1992.
- Pasztory, Esther. Pre-Columbian Art. Cambridge: Cambridge Univ. Press, 1998.
- Paul, Anne. Paracas Art and Architecture: Object and Context in South Coastal Peru. Iowa City: Univ. of Iowa Press, 1991
- Schele, Linda, and David Freidel. A Forest of Kings: The Untold Story of the Ancient Maya. New York: Morrow, 1990.
- Schele, Linda, and Mary Ellen Miller. The Blood of Kings: Dynasty and Ritual in Maya Art. New York: Braziller, 1986.
- Schobinger, Juan. The Ancient Americans: A Refer ence Guide to the Art, Culture, and History of Pre-Columbian North and South America. Trans. Carys Evans Corrales. Armonk, NY: Sharp Reference, 2001.
- Stone-Miller, Rebecca. Art of the Andes: From Chavin to Inca. World of Art. New York: Thames and Hudson, 1996.
- To Weave for the Sun: Andean Textiles in the Museum of Fine Arts, Boston. Boston: Museum of Fine Arts, 1992

- Townsend, Richard, ed. The Ancient Americas: Art from Sacred Landscapes. Chicago: Art Institute of Chicago, 1992.
- The Aztecs, 2nd rev. ed. Ancient Peoples and Places. London: Thames and Hudson, 2000.
- Wuthenau, Alexander von. The Art of Terracotta Pottery in Pre-Colombian Central and South America. Art of the World. New York: Crown, 1970.

Chapter 13 Art of Ancient Africa

- Bargna, Ivan. *African Art.* Trans. Jacqueline A. Cooperman. Rev. Michael Thompson. Milano, Italy: Jaca Book; Wappingers' Falls, NY: Antique Collector's Club. 2000.
- Barley, Nigel. Smashing Pots: Feats of Clay from Africa. London: British Museum. 1994.
- Bassani, Ezio, and William Fagg. Africa and the Re naissance: Art in Ivory. New York: Center for African Art, 1988.
- Ben-Amos, Paula. The Art of Benin. Rev. ed. Washington, D.C.: Smithsonian Institution Press,
- and Arnold Rubin. The Art of Power, the Power of Art: Studies in Benin Iconography. Monograph Series, no. 19. Los Angeles: Fowler Museum of Cultural History, Univ. of California, 1983.

 Cole, Herbert M. *Igbo Arts: Community and Cosmos*
- Los Angeles: Fowler Museum of Cultural History, Univ. of California, 1984.
- Connah, Graham. African Civilizations: Precolonial Cities and States in Africa: An Archaeological Per spective. Cambridge: Cambridge Univ. Press, 1987. Eyo, Ekpo, and Frank Willett. *Treasures of Ancient*
- Nigeria. Ed. Rollyn O. Kirchbaum. New York: Knopf, 1980.
- Ezra, Kate. Royal Art of Benin: The Peris Collection in the Metropolitan Museum of Art. New York: Metropolitan Museum of Art, 1992
- Fagg, Bernard. Nok Terracottas. Lagos: Ethno graphica, 1977
- Garlake, Peter S. Early Art and Architecture of Africa. Oxford History of Art. Oxford: Oxford Univ. Press. 2002.
- Great Zimbabwe, London: Thames and Hudson. 1973.
- The Hunter's Vision: The Prehistoric Art of Zimbabwe. Seattle: Univ. of Washington Press, 1995 Huffman, Thomas N. Symbols in Stone: Unravelling the Mystery of Great Zimbabwe. Johannesburg: Witwatersrand Univ. Press, 1987.
- Lhote Henri, The Search for the Tassili Frescoes: The Story of the Prehistoric Rock-Paintings of the Sahara. 2nd ed. Trans. Alan Houghton Brodrick. London: Hutchinson, 1973.
- Mark, John, ed. Africa, Arts and Cultures. London: British Museum, 2000.
- McClusky, Pamela. Art from Africa: Long Steps Never Broke a Back. Seattle: Seattle Art Museum; Princeton: Princeton Univ. Press, 2002
- Shaw, Thurstan. Unearthing Igbo-Ukwu: Archaeological Discoveries in Eastern Nigeria. New York: Oxford Univ. Press, 1977.
- Stepan, Peter. Africa. Trans. John Gabriel and Elizabeth Schwaiger, London: Prestel, 2001
- Willcox, A. R. The Rock Art of Africa. London: Croon Helm, 1984.
- Willett, Frank. Ife in the History of West African Sculp ture. New York: McGraw-Hill, 1967

Chapter 14 Early Medieval Art in Europe

- Alexander, J. J. G. Medieval Illuminators and Their Methods of Work. New Haven: Yale Univ. Press, 1992. Art of Medieval Spain, A.D. 500–1200, The. New York: Metropolitan Museum of Art, 1993.
- Backes, Magnus, and Regine Dolling. Art of the Dark Ages. Trans. Francisca Garvie. Panorama of World Art. New York: Abrams, 1971.
- Backhouse, Janet, D. H. Turner, and Leslie Webster. The Golden Age of Anglo-Saxon Art, 966-1066. Bloomington: Indiana Univ. Press, 1984.
- Beckwith, John. Early Medieval Art: Carolingian, Ottonian, Romanesque. World of Art. New York: Oxford Univ. Press, 1974.
- Cahn Walter. Romanesque Bible Illumination. Ithaca: Cornell Univ. Press, 1982.
- Romanesque Manuscripts: The Twelfth Century 2 vols. A Survey of Manuscripts Illuminated in France. London: H. Miller, 1996.
- Calkins, Robert G. Illuminated Books of the Medieval Ages. Ithaca: Cornell Univ. Press, 1983.
- Davis-Weyer, Caecilia. Early Medieval Art, 300-1150: Sources and Documents. Upper Saddle River, NJ: Prentice Hall, 1971
- Diebold, William J. Word and Image: An Introduction to Early Medieval Art. Boulder, CO: Westview Press. 2000.

- Dodds, Jerrilynn D. Architecture and Ideology in Farly Medieval Spain. University Park: Pennsylvania State Univ. Press, 1990.
- Dodwell, C. R. Pictorial Art of the West 800-1200, Yale Univ. Press Pelican History of Art. New Haven: Yale Univ. Press, 1993.
- Eco, Umberto. Art and Beauty in the Middle Ages. Trans. Hugh Bredin. New Haven: Yale Univ. Press, 1986. Evans, Angela Care. The Sutton Hoo Ship Burial. Rev.
- ed. London: British Museum, 1994. Farr, Carol, The Book of Kells: Its Function and Audi-
- ence. London: British Library, 1997. Fergusson, Peter. Architecture of Solitude: Cistercian
- Abbeys in Twelfth-Century England. Princeton: Princeton Univ. Press, 1984. Fernie, E. C. The Architecture of the Anglo-Saxons.
- London: Batsford, 1983. Fitzhugh, William W., and Elisabeth I. Ward, eds. Vikings: The North Atlantic Saga. Washington, D.C.: Smithsonian Institution Press, 2000.
- Harbison. Peter. The Golden Age of Irish Art: The Medieval Achievement, 600-1200. London: Thames and Hudson, 1998.
- Henderson, George. Early Medieval. Style and Civi-
- lization. Harmondsworth, UK: Penguin, 1972.

 —. From Durrow to Kells: The Insular Gospel-Books, 650-800. London: Thames and Hudson, 1987
- Horn, Walter W., and Ernest Born. Plan of Saint Gall: A Study of the Architecture and Economy of and Life in a Paradigmatic Carolingian Monastery. 3 vols. California Studies in the History of Art. Berkeley: Univ. of California Press, 1979.
- Hubert, Jean, Jean Porcher, and W. F. Volbach, Carolingian Renaissance. Arts of Mankind. New York: Braziller, 1970.
- Europe of the Invasions. Trans. Stuart Gilbert and James Emmons. Arts of Mankind. New York: Braziller, 1969.
- Lasko, Peter. Ars Sacra, 800-1200. 2nd ed. Pelican History of Art. New Haven: Yale Univ. Press, 1994. Mayr-Harting, Henry. Ottoman Book Illumination: An
- Historical Study. 2 vols. 2nd rev. ed. London: Harvey Miller, 1999.
- Nees, Lawrence, Early Medieval Art, Oxford History of Art. Oxford: Oxford Univ. Press, 2003.
- Nordenfalk, Carl Adam Johan. Early Medieval Book Illumination. New York: Rizzoli, 1988.
- Palol, Pedro de, and Max Hirmer. Early Medieval Art in Spain. Trans. Alisa Jaffa. London: Thames and Hudson, 1967
- Richardson, Hilary, and John Scarry. An Introduction to Irish High Crosses. Dublin: Mercier, 1990.
- Stalley, R.A. Early Medieval Architecture. Oxford History of Art. Oxford: Oxford Univ. Press. 1999.
- Tschan Francis Joseph. Saint Hildesheim. 3 vols. Notre Dame, IN: The Univ. of Notre Dame, 1942.
- Verzone, Paola. The Art of Europe: The Dark Ages from Theodoric to Charlemagne. Art of the World.
- New York: Crown, 1968. Williams, John. Early Spanish Manuscript Illumination. New York: Braziller, 1977.
- Wilson, David M. Anglo-Saxon Art: From the Seventh Century to the Norman Conquest. London: Thames and Hudson, 1984.
- and Ole Klindt-Jensen. Viking Art. 2nd ed. Minneapolis: Univ. of Minnesota Press, 1980.

Chapter 15 Romanesque Art

- Armi, C. Edson. Masons and Sculptors in Romanesque Burgundy: The New Aesthetics of Cluny III. 2 vols. University Park: Pennsylvania State Univ. Press, 1983.
- Barral I Altet, Xavier. The Romanesque: Towns, Cathedrals and Monasteries. Taschen's World Architecture. New York: Taschen, 1998.
- Braunfels, Wolfgang. Monasteries of Western Europe: The Architecture of the Orders. Trans. Alastair
- Laing. New York: Thames and Hudson, 1993. Busch, Harald, and Bernd Lohse. Romanesque Sculpture. London: Batsford. 1962
- Cahn, Walter. Romanesque Bible Illumination. Ithaca: Cornell Univ. Press, 1982.
- Davis-Weyer, Caecilia. Early Medieval Art, 300-1150. Sources and Documents. Upper Saddle River, NJ: Prentice Hall, 1971.
- Evans, Joan. Cluniac Art of the Romanesque Period. Cambridge: Cambridge Univ. Press, 1950. Focillon, Henri. The Art of the West in the Middle Ages.
- 2 vols. Ed. Jean Bony. Trans. Donald King. Lon-
- don: Phaidon, 1963. Forsyth, Ilene H. *The Throne of Wisdom: Wood Sculp*tures of the Madonna in Romanesque France. Princeton: Princeton Univ. Press, 1972
- Gantner, Joseph, and Marvel Pobe, Romanesaue Art in France, London: Thames and Hudson, 1956.

Grape, Wolfgang. *The Bayeux Tapestry: Monument to a Norman Triumph*. New York: Prestel, 1994.

Hawthorne, John G. and Cyril S. Smith, eds. *On Divers Arts: The Treatise of Theophilus*. New York: Dover Press. 1979.

Hearn, M. F. Romanesque Sculpture: The Revival of Monumental Stone Sculptures in the Eleventh and Twelfth Centuries. Ithaca: Cornell Univ. Press, 1981. Jacobs, Michael. Northern Spain: The Road to Santia-

go de Compostela. Architectural Guides for Travelers. San Francisco: Chronicle, 1991.

Kennedy, Hugh. Crusader Castles. Cambridge: Cambridge Univ. Press, 1994.

Kubach, Hans Erich. Romanesque Architecture. History of World Architecture. New York: Electa/ Rizzoli, 1988.

Kuhnel, Biana. Crusader Art of the Twelfth Century: A Geographical, and Historical, or an Art Historical Notion? Berlin: Gebr. Mann, 1994.

Kunstler, Gustav. Romanesque Art in Europe. Greenwich, CT: New York Graphic Society, 1969.

Little, Bryan D. G. Architecture in Norman Britain. London: Batsford, 1985.

Mâle, Emile. Religious Art in France, the Twelfth Century: A Study of the Origins of Medieval Iconography. Bollingen Series. Princeton: Princeton Univ. Press, 1978.

Nebosine, George A. Journey into Romanesque: A Traveller's Guide to Romanesque Monuments in Europe. Ed. Robyn Cooper. London: Weidenfeld and Nicolson, 1969.

Norton, Christopher, and David Park. Cistercian Art and Architecture in the British Isles. Cambridge: Cambridge Univ. Press, 1986.

Petzold, Andreas, *Romanesque Art.* Perspectives. New York: Abrams, 1995.

Radding, Charles M., and William W. Clark. Medieval Architecture, Medieval Learning: Builders and Masters in the Age of Romanesque and Gothic. New Haven: Yale Univ. Press, 1992.

Schapiro, Meyer. Romanesque Art. New York Braziller, 1977.

—. The Romanesque Sculpture of Moissac. New York: Braziller. 1985.

Stones, Alison, Jeanne Krochalis, Paula Gerson, and Annie Shaver-Crandell. *The Pilgrim's Guide: A Critical Edition*. 2 vols. London: Harvey Miller, 1998.

Swarzenski, Hanns. Monuments of Romanesque Art: The Art of Church Treasures of North-Western Europe. 2nd ed. Chicago: Univ. of Chicago Press, 1967.

Tate, Robert Brian, and Marcus Tate. The Pilgrim Route to Santiago. Oxford: Phaidon, 1987.

Wilson, David M. *The Bayeux Tapestry: The Complete Tapestry in Color.* New York: Random House, 1985.

The Year 1200. 2 vols. New York: Metropolitan Museum of Art, 1970

Zarnecki, George. *Romanesque Art.* New York: Universe, 1971.

—, Janet Holt, and Tristam Holland. English Romanesque Art, 1066–1200. London: Weidenfeld and Nicolson, 1984.

Chapter 16 Gothic Art

Alexander, Jonathan, and Paul Binski, eds. *Age of Chivalry: Art in Plantagenet England, 1200–1400.*London: Royal Academy of Arts, 1987.

London: Royal Academy of Arts, 1987. Andrews, Francis B. *The Mediaeval Builder and His Methods*. New York: Barnes & Noble, 1993.

Armi, C. Edson. *The "Headmaster" of Chartres and the Origins of "Gothic" Sculpture*. University Park: Pennsylvania State Univ. Press, 1994.

Aubert Marcel. *The Art of the High Gothic Era*. Rev. ed. Art of the World. New York: Greystone, 1966. Binski. Paul. *Medieval Craftsmen: Painters*. London: British Museum, 1991.

Bony, Jean. French Gothic Architecture of the 12th and 13th Centuries. California Studies in the History of Art. Berkeley: Univ. of California Press. 1983.

Borsook, Eve, and Fiorella Superbi Gioffredi. *Italian Altarpieces, 1250–1550: Function and Design.* Oxford: Clarendon, 1994.

Branner, Robert. Manuscript Painting in Paris during the Reign of Saint Louis: A Study of Styles. California Studies in the History of Art. Berkeley: Univ. of California Press, 1977.

Camille, Michael. *Gothic Art: Glorious Visions*. Perspectives. New York: Abrams, 1996.

Cennini, Cennino. *The Craftsman's Handbook (Il libro dell'arte)*. Trans. D.V. Thompson, New York: Dover, 1954.

Coe, Brian, Stained Glass in England, 1150–1550 London: Allen, 1981.

Coldstream, Nicola, Medieval Architecture. Oxford History of Art. Oxford: Oxford Univ. Press, 2002. Crosby, Sumner McKnight. *The Royal Abbey of Saint-Denis from Its Beginnings to the Death of Suger,* 475–1151. Yale Publications in the History of Art. New Haven: Yale Univ. Press, 1987.
Erlande-Brandenburg, Alain. *Gothic Art.* Trans, I.

Erlande-Brandenburg, Alain. *Gothic Art.* Trans, I Mark Paris. New York: Abrams, 1989.

—... *Notre-Dame de Paris*. New York: Abrams, 1998. Favier, Jean. *The World of Chartres*. Trans. Francisca Garvie. New York: Abrams, 1990.

Franklin, J. W. Cathedrals of Italy. London: Batsford, 1958.

Frisch, Teresa G. Gothic Art, 1140-c.1450: Sources and Documents. Upper Saddle River, NJ: Prentice Hall, 1971.

Grodecki, Louis. *Gothic Architecture*. Trans. I. Mark Paris. History of World Architecture. New York: Electa/Rizzoli, 1985.

—, and Catherine Brisac. Gothic Stained Glass, 1200–1300. Ithaca: Cornell Univ. Press, 1985.

Mâle, Emile. Religious Art in France, the Thirteenth Century: A Study of Medieval Iconography and Its Sources. Princeton: Princeton Univ. Press, 1984.

Martindale, Andrew. *Gothic Art.* World of Art. London: Thames and Hudson, 1967.

McIntyre, Anthony. Medieval Tuscany and Umbria. Architectural Guides for Travellers. San Francisco: Chronicle. 1992.

Metropolitan Museum of Art, The. *The Secular Spirit: Life and Art at the End of the Middle Ages.* New York: Dutton, 1975.

O'Neill, John Philip, ed. *Enamels of Limoges: 1100–1350*. Trans. Sophie Hawkes, Joachim Neugroschel, and Patricia Stirneman. New York: Metropolitan Museum of Art, 1996.

Panofsky, Erwin. Abbot Suger on the Abbey Church of St.-Denis and Its Art Treasures. 2nd ed. Ed. Gerda Panofsky-Soergel. Princeton: Princeton Univ. Dress 1979

—. Gothic Architecture and Scholasticism. Latrobe, PA: Archabbey 1951.

Pevsner, Nikolas, and Priscilla Metcalf. *The Cathedrals of England*. 2 vols. Harmondsworth, UK: Viking, 1985.

Pope-Hennessy, John. *Italian Gothic Sculpture*. 3rd ed. Oxford: Phaidon, 1986.

Sauerlander, Willibald. *Gothic Sculpture in France,* 1140–1270. Trans. Janet Sandheimer. London: Thames and Hudson, 1972.

Scott, Kathleen L. *Later Gothic Manuscripts*, *1390–1490*. 2 vols. A Survey of Manuscripts Illuminated in the British Isles; 6. London: H. Miller, 1996.

Sekules, Veronica. *Medieval Art*. Oxford History of Art. Oxford: Oxford Univ. Press, 2001.
Simsom Otto Georg von. *The Gothic Cathedral: Ori-*

Simsom Otto Georg von. The Gothic Cathedral: Origins of Gothic Architecture and the Medieval Concept of Order. 3rd ed. Bollingen Series. Princeton: Princeton Univ. Press, 1988.

Smart, Alastair. *The Dawn of Italian Painting, 1250–1400.* Ithaca: Cornell Univ. Press, 1978.

White, John. Art and Architecture in Italy, 1250 to 1400. 3rd ed. Pelican History of Art. Harmondsworth, UK: Penguin, 1993.

Wieck, Roger S. Time Sanctified: The Book of Hours in Medieval Art and Life. New York: Braziller, 1988

Williamson, Paul. *Gothic Sculpture 1140–1300*. Pelican History of Art. New Haven: Yale Univ. Press, 1995.

Wilson, Christopher. *The Gothic Cathedral: The Architecture of the Great Church, 1130–1530.* New York: Thames and Hudson. 1990.

Chapter 17 Early Renaissance Art in Europe

Adams, Laurie Schneider. *Italian Renaissance Art.* Boulder, CO: Westview Press, 2001.

Alexander, J.J.G. The Painted Page: Italian Renaissance Book Illumination, 1450–1550. Munich: Prestel, 1994.

Ames-Lewis, Francis. *Drawing in Early Renaissance Italy*. New Haven: Yale Univ. Press, 2000.

—. The Intellectual Life of the Early Renaissance Artist. New Haven: Yale Univ. Press, 2000.

Baxandall, Michael. *Painting and Experience in Fifteenth-Century Italy: A Primer in the Social History of Pictorial style*. Oxford: Clarendon, 1972.

Blum, Shirley. *Early Netherlandish Triptychs: A Study in Patronage*. California Studies in the History of Art. Berkeley: Univ. of California Press, 1969.

Campbell, Lorne. Renaissance Portraits: European Portrait-Painting in the 14th, 15th, and 16th Centuries. New Haven: Yale Univ. Press, 1990.

Cavallo, Adolph S. *The Unicorn Tapestries at the Metropolitan Museum of Art.* New York: The Museum, 1998.

Chastel, Andrè. The Flowering of the Italian Renaissance. Trans. Jonathan Griffin. Arts of Mankind. New York: Odyssey, 1965.

— . Studios and Styles of the Italian Renaissance. Trans. Jonathan Griffin. Arts of Mankind. New York: Odyssey, 1966.

Christianity and the Renaissance: Image and Religious Imagination in the Quattrocento. Syracuse, NY: Syracuse Univ. Press, 1990.

Christiansen, Keith, Laurence B. Kanter, and Carl Brandon Strehlke. *Painting in Renaissance Siena, 1420–1500*. New York: Metropolitan Museum of Art. 1988.

Christine, de Pisan. *The Book of the City of Ladies*. Trans. Rosalind Brown-Grant. London: Penguin Books. 1999.

Flanders in the Fifteenth Century: Art and Civilization. Detroit: Detroit Institute of Arts, 1960.

Gilbert, Creighton, ed. *Italian Art, 1400–1500:* Sources and Documents. Evanston: Northwestern Univ. Press, 1992.

Goldwater, Robert, and Marco Treves, eds. *Artists on Art*. New York: Pantheon Booles, 1945.

Heydenreich, Ludwig Heinrich. Architecture in Italy, 1400–1500. Rev. Paul Davies. Pelican History of Art. New Haven: Yale Univ. Press, 1996.

Hind, Arthur M. An Introduction to a History of Woodcut, New York: Dover, 1963.

Huizinga, Johan. *The Autumn of the Middle Ages*. Trans. Rodney J. Payton and Ulrich Mammitzsch. Chicago: Univ. of Chicago Press, 1996.

Lane, Barbara G. The Altar and the Altarpiece: Sacramental Themes in Early Netherlandish Painting. New York: Harper & Row, 1984.

Levey, Michael. Early Renaissance. Harmondsworth, UK: Penguin, 1967.

Meiss, Millard, French Painting in the Time of Jean de Berry: Muller, Theodor. Sculpture in the Netherlands, Germany, France, and Spain: 1400–1500. Trans. Elaine and William Robson Scott. Pelican History of Art. Harmondsworth, Eng.: Penguin, 1966.

Pacht, Otto. Early Netherlandish Painting: From Rogier van der Weyden to Gerard David. Ed. Monika Rosenauer. Trans. David Britt. London: Harvey Miller,

Panofsky, Erwin. Early Netherlandish Painting. Its Origins and Character. 2 vols. Cambridge: Harvard Univ. Press, 1966.

Plummer, John. The Last Flowering: French Painting in Manuscripts, 1420–1530, from American Collections. New York: Pierpont Morgan Library, 1982.

Seymour, Charles. Sculpture in Italy 1400–1500. Pelican History of Art. Harmondsworth, UK: Penguin, 1966.

Snyder, James. Northern Renaissance Art: Painting, Sculpture, the Graphic Arts from 1350 to 1575. New York: Abrams, 1985.

Vasari, Giorgio. The Lives of the Most Excellent Italian Architects. Trans. J. C. and P. Bondanella. New York: Oxford University Press, 1991.

Welch, Evelyn S. Art and Society in Italy, 1350–1500. Oxford History of Art. Oxford: Oxford Univ. Press, 1997.

Chapter 18 Renaissance Art in Sixteenth-Century Europe

Aikema, Bernard, ed. *Renaissance Venice and the North: Crosscurrents in the Time of Bellini, Dürer, and Titian.* New York: Rizzoli, 2000.

Algranti, Gilberto, ed. Titian to Tiepolo: Three Centuries of Italian Art. New York: Rizzoli/St. Martin's Press, 2002.

Andrews, Lew. Story and Space in Renaissance Art: The Rebirth of Continuous Narrative. New York: Cambridge Univ. Press, 1995.

Bambach, Carmen. Drawing and Painting in The Italian Renaissance Workshop: Theory and Practice, 1330–1600. Cambridge: Cambridge Univ. Press. 1999.

Baxandall, Michael. *The Limewood Sculptors of Re*naissance Germany. New Haven: Yale Univ. Press, 1980.

Bosquet, Jacques. *Mannerism: The Painting and Style of the Late Renaissance*. Trans. Simon Watson Taylor. New York: Braziller, 1964.

Brown, Patricia Fortini. Art and Life in Renaissance Venice. Perspectives. New York: Abrams, 1997. Burroughs, Charles. The Italian Renaissance Palace

Burroughs, Charles. The Italian Renaissance Palace Facade: Structures of Authority, Surfaces of Sense. Cambridge: Cambridge Univ. Press, 2002.

Chastel, André. *The Age of Humanism: Europe, 1480–1530.* Trans. Katherine M. Delavenay and E. M. Gwyer. London: Thames and Hudson, 1963.

- Chelazzi Dini, Giulietta, Alessandro Angelini, and Bernardina Sani. Sienese Painting: From Duccio to the Birth of the Baroque. New York: Abrams, 1998.
- Cole, Alison. Virtue and Magnificence: Art of the Italian Renaissance Courts. Perspectives. New York: Abrams, 1995.
- Dixon, Annette, ed. Women Who Ruled: Queens, Goddesses, Amazons in Renaissance and Baroque Art. London: Merrell; Ann Arbor: University of Michigan Museum of Art, 2002.
- Farmer, John David. The Virtuoso Craftsman: Northern European Design in the Sixteenth Century. Worcester, MA: Worcester Art Museum, 1969.
- Freedberg, S. J. *Painting in Italy, 1500 to 1600.* 3rd ed. Pelican History of Art. New Haven: Yale Univ. Press, 1993.
- Grössinger, Christa. *Picturing Women in Late Me-dieval and Renaissance Art.* New York: St. Martin's Press, 1997.
- Hayum, André. The Isenheim Altarpiece: God's Medicine and the Painter's Vision. Princeton Essays on the Arts. Princeton: Princeton Univ. Press, 1989.
- Hollingsworth, Mary. Patronage in Sixteenth Century Italy. London: Murray, 1996.
- Hughes, Anthony. Michelangelo. London: Phaidon,
- Huse, Norbert, and Wolfgang Wolters. Art of Renaissance Venice: Architecture, Sculpture and Painting, 1460–1590. Trans. Edmund Jephcott. Chicago: Univ. of Chicago Press, 1990.
- Jacobs, Fredrika Herman. Defining the Renaissance Virtuosa: Women Artists and the Language of Art History and Criticism. Cambridge: Cambridge Univ. Press, 1997
- Klein, Robert, and Henri Zerner. *Italian Art, 1500–1600: Sources and Documents.* Upper Saddle River, NJ: Prentice Hall, 1966.
- Kubler, George. Building the Escorial. Princeton: Princeton Univ. Press. 1982.
- Landau, David, and Peter Parshall. *The Renais-sance Print: 1470–1550*. New Haven: Yale Univ. Press, 1994.
- Lazzaro, Claudia. The Italian Renaissance Garden: From the Conventions of Planting, Design, and Ornament to the Grand Gardens of Sixteenth-Century Central Italy. New Haven: Yale Univ. Press, 1990.
- Lieberman, Ralph. *Renaissance Architecture in Venice*, 1450–1540. New York: Abbeville, 1982.
- Lotz, Wolfgang. *Architecture in Italy, 1500–1600.* Pelican History of Art. Rev. Deborah Howard. New Haven: Yale Univ. Press, 1995.
- Manca, Joseph. Moral Essays on the High Renaissance: Art in Italy in the Age of Michelangelo. Lanham, MD: Univ. Press of America, 2001.
- Mann, Nicholas, and Luke Syson, eds. *The Image of the Individual: Portraits in the Renaissance*. London: British Museum Press, 1998.
- Martineau, Jane, and Charles Hope. The Genius of Venice, 1500–1600. New York: Abrams, 1984.
- Murray Linda. *The High Renaissance and Mannerism: Italy, the North and Spain, 1500–1600.* World of Art. London: Thames and Hudson, 1995.
- Olson, Roberta J. M. *Italian Renaissance Sculpture*. World of Art. New York: Thames and Hudson, 1992.
- Osten, Gert von der, and Horst Vey. Painting and Sculpture in Germany and the Netherlands, 1500– 1600. Pelican History of Art. Harmondsworth, UK: Penguin, 1969.
- Paoletti, John T., and Gary M. Radke. *Art in Renaissance Italy*, 2nd ed. Upper Saddle River, NJ: Prentice Hall. 2002.
- Partridge, Loren W. The Art of Renaissance Rome, 1400–1600. New York: Abrams, 1996.
- Pietrangeli, Carlo, et al. *The Sistine Chapel: The Art, the History, and the Restoration*. New York: Harmony, 1986.
- Pope-Hennessy, Sir John. *Italian High Renaissance and Baroque Sculpture*. 3rd ed. Oxford: Phaidon, 1986.

 —. *Italian Renaissance Sculpture*. 3rd ed. Oxford: Phaidon. 1986.
- Rosand, David. *Painting in Cinquecento Venice: Titian, Veronese, Tintoretto*. Rev. ed. Cambridge: Cambridge Univ. Press, 1997.
- Rowland, Ingrid D. The Culture of the High Renaissance: Ancients and Moderns in Sixteenth Century Rome. Cambridge: Cambridge Univ. Press, 1998
- Shearman, John. *Mannerism*. Harmondsworth, UK: Penguin, 1967.
- Smith, Jeffrey Chipps. *Nuremberg, a Renaissance City,* 1500–1618. Austin: Huntington Art Gallery, Univ. of Texas, 1983.

- Strong, Roy C. Artists of the Tudor Court: The Portrait Miniature Rediscovered, 1520–1620. London: Victoria and Albert Museum, 1983.
- Vasari, Giorgio. *The Lives of the Artists*. Trans. Julia Conaway Bondanella and Peter Bondanella. New York: Oxford Univ. Press, 1991.
- Verheyen, Egon. The Paintings in the Studiolo of Isabella d'Este at Mantua. Monographs on Archaeology and Fine Arts. New York: New York Univ. Press. 1971.
- Williams, Robert. Art, Theory, and Culture in Sixteenth-Century Italy: From Techne to Metateche. Cambridge: Cambridge Univ. Press, 1997.

Chapter 19 Baroque Art in Europe and North America

- Ackley, Clifford S. *Printmaking in the Age of Rembrandt*. Boston: Museum of Fine Arts, 1981.

 Bazin, Germain. *Baroque and Rococo*. Trans.
- Bazin, Germain. *Baroque and Rococo*. Trans. Jonathan Griffin. World of Art. New York: Praeger, 1964.
- Berger, Robert W. *The Palace of the Sun: The Louvre of Louis XIV*. University Park: Pennsylvania State Univ. Press, 1993.
- Versailles: The Chateau of Louis XIV. Monographs on the Fine Arts. University Park: Pennsylvania State Univ. Press, 1985.
- Blunt, Anthony, et al. *Baroque and Rococo Architecture and Decoration*. New York: Harper & Row, 1982.
- Boucher, Bruce. *Italian Baroque Sculpture*. World of Art. New York: Thames and Hudson, 1998.
- Brown, Christopher. Scenes of Everyday Life: Dutch Genre Painting of the Seventeenth Century. London: Faber & Faber, 1984.
- Chinn, Celestine, and Kieran McCarty. *Bac: Where the Waters Gather.* Tucson, Az, 1977.
- Enggass, Robert, and Jonathan Brown. *Italy and Spain 1600–1750: Sources and Documents.* Upper Saddle River, NJ: Prentice Hall, 1970.
- Fuchs, R. H. *Dutch Painting*. World of Art. New York: Oxford Univ. Press, 1978.
- Gerson, Horst, and E. H. ter Kuile. *Art and Architecture in Belgium, 1600–1800.* Pelican History of Art. Baltimore: Penguin, 1960.
- Haak, Bob. *The Golden Age: Dutch Painters of the Seventeenth Century*. Trans. and ed. Elizabeth Willems-Treeman. New York: Abrams, 1984.
- Held, Julius Samuel, and Donald Posner. 17th and 18th Century Art: Baroque Painting, Sculpture, Architecture. Library of Art History. New York: Abrams, 1971.
- Hempel, Eberhard. Baroque Art and Architecture in Central Europe: Germany, Austria, Switzerland, Hungary, Czechoslovakia, Poland. Painting and Sculpture: 17th and 18th Centuries. Architecture: 16th to 18th Centuries. Trans. Elisabeth Hempel and Marguerite Kay. Pelican History of Art. Harmondsworth, UK: Penguin, 1965.
- Kiers, Judikje, et al. *Glory of the Golden Age: Dutch Art of the 17th Century*. Amsterdam: Waanders, Rijksmuseum, 2000.
- —, and Fieke Tissink. Golden Age of Dutch Art: Painting, Sculpture, Decorative Art. London: Thames and Hudson, 2000.
- Lagerlof, Margaretha Rossholm. *Ideal Landscape:* Annibale Caracci, Nicolas Poussin, and Claude Lorrain. New Haven: Yale Univ. Press, 1990.
- Maser, Edward A. Baroque and Rococo Pictorial Imagery. The 1758–60 Hertel Edition of Ripa's "Iconologia," Introduction, translation and 200 commentaries by Edward A. Maser, New York: Dover. 1971.
- Montagu, Jennifer. Roman Baroque Sculpture: The Industry of Art. New Haven: Yale Univ. Press, 1989. Norberg-Schulz, Christian. Baroque Architecture. New York: Rizzoli. 1986.
- Late Baroque and Rococo Architecture. History of World Architecture. New York: Rizzoli, 1985. Puttfarken, Thomas. Roger de Piles Theory of Art. New Haven. Yale Univ. Press, 1985.
- Rosenberg, Jakob, Seymour Slive, and E.H. Ter Kuile. *Dutch Art and Architecture 1600 to 1800*. Pelican History of Art. New Haven: Yale Univ. Press. 1977.
- Slive, Seymour. *Dutch Painting 1600–1800*. Pelican History of Art. New Haven: Yale Univ. Press, 1995. Stechow, Wolfgang. *Dutch Landscape Painting of* the Seventeenth Century. 3rd ed. Oxford:
- Phaidon, 1981.
 Temple, R. C., ed. *The Travels of Peter Mundy in Eu*
- rope and Asia, 1608–1667. London: n.p., 1925. Vlieghe, Hans. Flemish Art and Architecture, 1585– 1700. Pelican History of Art. New Haven: Yale Univ. Press, 1998.

- Westerman, Mariët. Art and Home: Dutch Interiors in the Age of Rembrandt. Denver, CO: Denver Art Museum; Netherlands: Waanders, 2001.
- —. A Worldly Art: The Dutch Republic 1585–1718. Perspectives: New York: Abrams, 1996.
- Wittkower, Rudolf. Art and Architecture in Italy, 1600 to 1750. 3 vols. 6th ed. Rev. Joseph Connors and Jennifer Montagu. Pelican History of Art. New Haven: Yale Univ. Press, 1999.

Chapter 20 Art of India after 1200

- Asher, Catherine B. Architecture of Mughal India. New York: Cambridge Univ. Press, 1992. Beach, Milo Cleveland. Grand Mogul: Imperial Paint-
- Beach, Milo Cleveland. Grand Mogul: Imperial Painting in India, 1600–1660. Williamstowm: Sterling and Francine Clark Art Institute, 1978.
- ... Imperial Image, Paintings for the Mughal Court. Washington, D.C.: Freer Gallery of Art, Smithsonian Institution, 1981.
- —. Mughal and Rajput Painting. New York: Cambridge Univ. Press, 1992.
- Blurton, T. Richard. *Hindu Art*. Cambridge: Harvard Univ. Press, 1993.
- Davies, Philip. Splendours of the Raj: British Architecture in India, 1660 to 1947. London: Murray, 1985.
- Desai, Vishakha N. *Life at Court: Art for India's Rulers,* 16th–19th Centuries. Boston: Museum of Fine Arts, 1985.
- Guy, John, and Deborah Swallow, eds. *Arts of India*, 1550–1900. London: Victoria and Albert Museum, 1990.
- Khanna, Balraj, and Aziz Kurtha. *Art of Modern India*. London: Thames and Hudson, 1998.
- Losty, Jeremiah P. *The Art of the Book in India*. London: British Library, 1982.
- Miller, Barbara Stoller. Love Song of the Dark Lord: Jayadeva's Gitagovinda. New York: Columbia Univ. Press. 1977.
- Press, 1977.
 Mitchell, George. *The Royal Palaces of India*. London: Thames and Hudson, 1994.
- Nou, Jean-Louis. *Taj Mahal*. Text by Amina Okada and M. C. Joshi. New York: Abbeville, 1993.
- Pal, Pratapaditya. Court Paintings of India, 16th-19th Centuries. New York: Navin Kumar, 1983.
- —, et al. Romance of the Taj Mahal. Los Angeles: Los Angeles County Museum of Art, 1989. Tillotson, G. H. R. Mughal India. Architectural Guides
- for Travelers. San Francisco: Chronicle, 1990.

 —, The Rajput Palaces: The Development of an Ar
- chitectural Style, 1450–1750. New York: Oxford Univ. Press, 1999.

 The Tradition of Indian Architecture: Continuity.
- Controversy and Change since 1850. New Haven: Yale Univ. Press, 1989.
- Welch, Stuart Cary. The Emperors' Album: Images of Mughal India. New York: Metropolitan Museum of Art, 1987.
- —. *India: Art and Culture 1300–1900.* New York: Metropolitan Museum of Art, 1985.

Chapter 21 Chinese Art after 1280

- Andrews, Julia Frances. *Painters and Politics in the People's Republic of China, 1949–1979*. Berkeley: Univ. of California Press, 1994.
- Barnhart, Richard M. *Painters of the Great Ming: The Imperial Court and the Zhe School.* Dallas: Dallas Museum of Art, 1993.
- Peach Blossom Spring: Gardens and Flowers in Chinese Painting. New York: Metropolitan Museum of Art, 1983.
- —, et al. The Jade Studio: Masterpieces of Ming and Qing Painting and Calligraphy from the Wong Nanp'ing Collection. New Haven: Yale Univ. Art Gallery, 1994.
- Beurdeley, Michael. Chinese Furniture. Trans. Katherine Watson. Tokyo: Kodansha International, 1979. Billeter, Jean François. The Chinese Art of Writing. New York: Skira/Rizzoli, 1990.
- Bush, Susan, and Hsui-yen Shih, eds. *Early Chinese Texts on Painting*. Cambridge: Harvard Univ. Press, 1985.
- Cahill, James. The Compelling Image: Nature and Style in Seventeenth-Century Chinese Painting. Charles Norton Lectures 1978–79. Cambridge: Harvard Univ. Press, 1982.
- —. The Distant Mountains: Chinese Painting in the Late Ming Dynasty, 1580–1644. New York: Weatherhill, 1982.
- —. Hills beyond a River: Chinese Painting of the Y'uan Dynasty, 1279–1368. New York: Weatherhill, 1976.
- —. Parting at the Shore: Chinese Painting of the Early and Middle Ming Dynasty 1368–1580. New York: Weatherhill, 1978.

- Chan, Charis. *Imperial China*. Architectural Guides for Travelers. San Francisco: Chronicle, 1992. Clunas, Craig. *Pictures and Visualities in Early Modern*
- Clunas, Craig. *Pictures and Visualities in Early Modern China*. Princeton: Princeton Univ. Press, 1997.
- Fang, Jing Pei. Treasures of the Chinese Scholar Form, Function and Symbolism. Ed. J. May Lee Barrett. New York: Weatherhill, 1997.
- Fong Wen C., and James C. Y. Watt. Possessing the Past: Treasures from the National Palace Museum, Taipei. New York: Metropolitan Museum of Art, 1996.
- In Pursuit of the Dragon: Traditions and Transitions in Ming Ceramics: An Exhibition from the Idemitsu Museum of Arts. Seattle: Seattle Art Museum, 1988. Jenyns, Soame. Later Chinese Porcelain: The Ch'ing.
- Jenyns, Soame. Later Chinese Porcelain: The Ch'ing Dynasty, 1644–1912. 4th ed. London: Faber & Faber, 1971.
- Keswick, Maggie. The Chinese Garden: History, Art and Architecture. New York: Rizzoli, 1978.
- Knapp, Ronald G. China's Vernacular Architecture: House Form and Culture. Honolulu: Univ. of Hawaii Press, 1989.
- Lee, Sherman, and Wai-Kam Ho. Chinese Art under the Mongols: The Y'uan Dynasty, 1279–1368. Cleveland: Cleveland Museum of Art. 1968.
- Lim, Lucy. Contemporary Chinese Painting: An Exhibition from the People's Republic of China. San Francisco: Chinese Culture Foundation of San Francisco, 1983.
- —, ed. Wu Guanzhong: A Contemporary Chinese Artist. San Francisco: Chinese Culture Foundation, 1989.
- Liu, Laurence G. Chinese Architecture. New York: Rizzoli, 1989.
- Ng, So Kam. *Brushstrokes: Styles and Techniques of Chinese Painting*. San Francisco: Asian Art Museum of San Francisco, 1993.
- Polo, Marco. *The Travels of Marco Polo*. Trans. Teresa Waugh and Maria Bellonci. New York: Facts on File. 1984.
- Shih-t'ao. Returning Home: Tao-chi's Album of Landscapes and Flowers. Commentary by Wen Fong. New York: Braziller, 1976.
- Sullivan, Michael. Art and Artists of Twentieth-Century China. Berkeley: Univ. of California Press, 1996.
- ——. Symbols of Eternity: The Art of Landscape Painting in China. Stanford: Stanford Univ. Press, 1979.Tsu, Frances Ya-sing. Landscape Design in Chinese
- Gardens. New York: McGraw-Hill, 1988. Vainker, S. J. Chinese Pottery and Porcelain: From Prehistory to the Present. London: British Museum,
- history to the Present. London: British Museum, 1991. Walters, Derek. Feng Shui: The Chinese Art of Design-
- Walters, Derek. Feng Shui: The Chinese Art of Designing a Harmonious Environment. New York: Simon & Schuster, 1988.
- Watson, William. *The Arts of China 900–1620*. Pelican History of Art. New Haven: Yale Univ. Press, 2000. Weidner, Marsha Smith. *Views from Jade Terrace*:
- Chinese Women Artists, 1300–1912. Indianapolis, IN: Indianapolis Museum of Art, 1988.
- Yu Zhuoyun, comp. *Palaces of the Forbidden City.*Trans. Ng Mau-Sang, Chan Sinwai, and Puwen
 Lee. New York: Viking, 1984.

Chapter 22 Japanese Art after 1392

- Addiss, Stephen. The Art of Zen: Painting and Calligraphy by Japanese Monks, 1600–1925. New York: Abrams, 1989.
- —. Zenga and Nanga: Paintings by Japanese Monks and Scholars, Selections from the Kurt and Millie Gitter Collection. New Orleans: New Orleans Museum of Art, 1976.
- Baekeland, Frederick, and Robert Moes. *Modern Japanese Ceramics in American Collections*. New York: Japan Society, 1993.
- Guth, Christine. Art of Edo Japan: The Artist and the City 1615–1868. Perspectives. New York: Abrams. 1996.
- Hickman, Money L. *Japan's Golden Age: Momoyama*. New Haven: Yale Univ. Press, 1996.
- Hiesinger, Kathryn B., and Felice Fischer. *Japanese Design: A Survey Since 1950*. Philadelphia: Philadelphia Museum of Art, 1994.
- Meech-Pekarik, Julia. *The world of the Meiji Print: Impressions of a New Civilization*. New York: Weatherhill, 1986.
- Merritt, Helen. *Modern Japanese Woodblock Prints: The Early Years*. Honolulu: Univ. of Hawaii Press, 1990.
- —, and Nanako Yamada. Guide to Modern Japanese Woodblock Prints: 1900–1975. Honolulu: Univ. of Hawaii Press, 1995.
- Michener, James A. *The Floating World*. New York: Random House, 1954.
- Munroe, Alexandra. *Japanese Art after 1945: Scream Against the Sky.* New York: Abrams, 1994.

- Murase, Miyeko. *Emaki, Narrative Scrolls from Japan*. New York: Asia Society, 1983.
- Masterpieces of Japanese Screen Painting: The American Collections. New York: Braziller, 1990.
- —. Tales of Japan: Scrolls and Prints from the New York Public Library. Oxford: Oxford Univ. Press, 1986.
- Okakura, Kakuzo. *The Book of Tea.* Ed. Everett F. Bleiler. New York: Dover, 1964.
- Okyo and the Maruyama-Shijo School of Japanese Painting. Trans. Miyeko Murase and Sarah Thompson. St. Louis: St. Louis Art Museum, 1980.
- Seo, Aubrey Yoshiko. The Art of Twentieth-Century Zen: Paintings and Calligraphy by Japanese Masters. Boston: Shambala, 1998.
- Singer, Robert T., with John T. Carpenter. *Edo, Art in Japan 1615–1868*. Washington, D.C.: National Gallery of Art, 1998.
- Takeuchi, Melinda. Taiga's True Views: The Language of Landscape Painting in Eighteenth-Century Japan. Stanford: Stanford Univ. Press, 1992.
- Thompson, Sarah E., and H. D. Harpptunian. Undercurrents in the Floating World: Censorship and Japanese Prints. New York: Asia Society Gallery, 1992.
- Till, Barry. The Arts of Meiji Japan, 1868–1912: Changing Aesthetics. Victoria, BC: Art Gallery of Victoria, 1995.

Chapter 23 Art of the Americas after 1300

- Archuleta, Margaret, and Rennard Strickland. Shared Visions: Native American Painters and Sculptors in the Twentieh Century. Phoenix: Heard Museum, 1991.
- Baquedano, Elizabeth. *Aztec Sculpture*. London: British Museum, 1984. Berdan, Frances F. *The Aztecs of Central Mexico: An*
- Berdan, Frances F. The Aztecs of Central Mexico. Imperial Society. New York: Holt, 1982.
- Berlo, Janet Catherine, and Ruth B. Phillips. *Native North American Art. Oxford History of Art.* Oxford: Oxford Univ. Pres, 1998.
- Bringhurst, Robert. The Black Canoe: Bill Reid and the Spirit of Haida Gwaii. Seattle: Univ. of Washington
- Press, 1991.
 Broder, Patricia Janis. American Indian Painting and
- Sculpture. New York: Abbeville, 1981.

 —. Earth Songs, Moon Dreams: Paintings by American Indian Women. New York: St. Martin's Press, 1999.
- Coe, Ralph. Lost and Found Traditions: Native American Art 1965–1985. Ed. Irene Gordon. Seattle: Univ. of Washington Press, 1986.
- Conn, Richard. Circles of the World: Traditional Art of the Plains Indians. Denver: Denver Art Museum,
- Crandall, Richard C. *Inuit Art: A History*. Jefferson, NC: McFarland. 2000.
- Dockstader, Frederick J. *The Way of the Loom: New Traditions in Navajo Weaving*. New York: Hudson Hills. 1987.
- Feest, Christian F. *Native Arts of North America*. Updated ed. World of Art. New York: Thames and Hudson, 1992.
- Haberland, Wolfgang. Art of North America. Rev. ed. Art of the World. New York: Greystone, 1968.
- Hawthorn, Audrey. Art of the Kwakiutl Indians and Other Northwest Coast Tribes. Vancouver: Univ. of British Columbia Press, 1967.
- Hemming, John. *Monuments of the Incas*. Boston: Little, Brown, and Co., 1982.
- Highwater, Jamake. The Sweet Grass Lives On: Fifty Contemporary North American Indian Artists. New York: Lippincott and Crowell, 1980.
- Jonaitis, Aldona. Art of the Northern Tlingit. Seattle: Univ. of Washington Press, 1986.
- —, ed. Chiefly Feasts: The Enduring Kwakiutl Potlatch. Seattle: Univ. of Washington Press, 1991. Kahlenberg, Mary Hunt, and Anthony Berlant. The
- Navajo Blanket. New York: Praeger, 1972. Levi-Strauss, Claude. Way of the Masks. Trans. Sylvia Modelski. Seattle: Univ. of Washington Press. 1982.
- MacDonald, George F. *Haida Art*. Seattle: Univ. of Washington Press, 1996.
- Maurer, Evan M. Visions of the People: A Pictorial History of Plains Indian Life. Minneapolis: Minneapolis Institute of Arts, 1992.
- McNair, Peter L., Alan L. Hoover, and Kevin Neary. Legacy: Tradition and Innovation in Northwest Coast Indian Art. Vancouver: Douglas and McIntyre 1984
- Nicholson, H. B., and Eloise Quinones Keber. Art of Aztec Mexico: Treasures of Tenochtitlan. Washington, D.C.: National Gallery of Art, 1983.

- Parezo, Nancy J. Navajo Sandpainting: From Religious Act to Commercial Art. Tucson: Univ. of Arizona Press, 1983.
- Pasztory, Esther. *Aztec Art*. New York: Abrams, 1983. Penney, David. *Art of the American Indian Frontier: The Chandler-Pohrt Collection*. Detroit: Detroit Institute of Arts, 1992.
- Peterson, Susan. *The Living Tradition of Maria Martinéz*. Tokyo: Kodansha International, 1977.
- Smith, Jaune Quick-to-See, and Harmony Hammond. Women of Sweetgrass: Cedar and Sage. New York: American Indian Center, 1984.
- Stewart, Hilary. *Totem Poles*. Seattle: Univ. of Washington Press, 1990.
- Stierlin, Henri. Art of the Aztecs and Its Origins. New York: Rizzoli, 1982.
- —. Art of the Incas and its Origins. New York: Rizzoli. 1984.
- Trimble, Stephen. *Talking with the Clay: The Art of Pueblo Pottery*. Santa Fe: School of American Research Press, 1987.
- Wade, Edwin, and Carol Haralson, eds. *The Arts of the North American Indian: Native Traditions in Evolution*. New York: Hudson Hills, 1986.
- Walters, Anna Lee. Spirit of Native America: Beauty and Mysticism in American Indian Art. San Francisco: Chronicle, 1989.
- Wood, Nancy C. *Taos Pueblo*. New York: Knopf, 1989.

Chapter 24 Art of Pacific Cultures

- Allen, Louis A. *Time before Morning: Art and Myth of the Australian Aborigines*. New York: Crowell, 1975.
- Barrow, Terrence. The Art of Tahiti and the Neighbouring Society, Austral and Cook Islands. New York: Thames and Hudson, 1979.
- —. An Illustrated Guide to Maori Art. Honolulu: Univ. of Hawaii Press, 1984.
- Buhler, Alfred, Terry Barrow, and Charles P. Montford. The Art of the South Sea Islands, including Australia and New Zealand. Art of the World. New York: Crown, 1962.
- Caruana, Wally. *Aboriginal Art*. World of Art. New York: Thames and Hudson, 1996.
- Craig, Robert D. Dictionary of Polynesian Mythology.
- New York: Greenwood, 1989. D'Alleva, Anne. Arts of the Pacific Islands. Perspec-
- tives. New York: Abrams, 1998. Gell, Alfred. *Wrapping in Images: Tattooing in Polynesia*. Oxford Studies in Social and Cultural Anthro-
- pology. New York: Oxford Univ. Press, 1993. Greub, Suzanne, ed. Art of Northwest New Guinea: From Geelvink Bay, Humboldt Bay, and Lake Sen-
- tani. New York: Rizzoli, 1992.

 Guiart, Jean. The Arts of the South Pacific. Trans.

 Anthony Christie. Arts of Mankind. New York:
- Golden, 1963. Hammond, Joyce D. *Tifaifai and Quilts of Polynesia*. Honolulu: Univ. of Hawaii Press, 1986.
- Hanson, Allan, and Louise Hanson. *Art and Identity in Oceania*. Honolulu: Univ. of Hawaii Press,
- Heyerdahl, Thor. *The Art of Easter Island*. Garden City, NY: Doubleday, 1975.

 Jones, Stella M. *Hawaiian Quilts*. Rev. 2nd ed. Hon-
- Jones, Stella M. Hawaiian Quilts. Rev. 2nd ed. Honolulu: Daughters of Hawaii, 1973.
- Kaeppler, Adrienne Lois, Christian Kaufmann, and Douglas Newton. *Oceanic Art*. Trans. Nora Scott and Sabine Bouladon. New York: Abrams, 1997. Layton, Robert. *Australian Rock Art*. A *New Synthesis*.
- New York: Cambridge Univ. Press, 1992. Leonard, Anne, and John Terrell. Patterns of Paradise: The Style and Signficance of Bark Cloth
- around the World. Chicago: Field Museum of Natural History, 1980. Mead, Sydney Moko, ed. Te Maori: Maori Art from New Zealand Collections. New York: Abrams, 1984. Morphy, Howard. Ancestral Connections: Art and an
- Aboriginal System of Knowledge. Chicago: Univ. of Chicago Press, 1991. People of the River, People of the Trees: Change and Continuity in Sepik and Asmat Art. St. Paul: Min-
- nesota Museum of Art, 1989. Rabineau, Phyllis. Feather Arts: Beauty, Wealth, and Spirit from Five Continents. Chicago: Field Muse-
- um of Natural History, 1979. Scutt, R. W. B., and Christopher Gotch. Art, Sex, and Symbol: The Mystery of Tattooing. 2nd ed. New York: Cornell Univ. Press, 1986.
- Serra, Eudaldo, and Alberto Folch. *The Art of Papua and New Guinea*. New York: Rizzoli, 1977.
- Sutton, Peter, ed. *Dreamings, the Art of Aboriginal Australia*. New York: Braziller, 1988.
- Thomas, Nicholas. *Oceanic Art.* World of Art. New York: Thames and Hudson, 1995.

Wardwell, Allen. Island Ancestors: Oceania Art from the Masco Collection. Seattle: Univ. of Washington Press, 1994.

Chapter 25 Art of Africa in the Modern Era

Abiodun, Rowland, Henry J. Drewal, and John Pemberton III, eds. The Yoruba Artist: New Theoretical Perspectives on African Arts. Washington, D.C.: Smithsonian Institution, 1994.

Adler, Peter, and Nicholas Barnard. African Majesty The Textile Art of the Ashanti and Ewe. New York:

Thames and Hudson, 1992

- Astonishment and Power. Washington, D.C.: National Museum of African Art, Smithsonian Institution, 1993.
- Bacquart, Jean-Baptiste. The Tribal Arts of Africa. New York: Thames and Hudson, 1998.
- Barley, Nigel. Foreheads of the Dead: An Anthropological View of Kalabari Ancestral Screens. Washington, D.C.: National Museum of African Art, Smithsonian Institution, 1988.
- Smashing Pots: Feats of Clay from Africa, London: British Museum, 1994
- Biebuyck, Daniel P. Lega Culture: Art, Initiation, and Moral Philosophy among a Central African People. Berkeley: Univ. of California Press, 1973.
- Brincard, Marie-Therese, ed. The Art of Metal in Africa. Trans. Evelyn Fischel. New York: African-American Institute, 1984.
- Cole, Herbert M., ed. I Am Not Myself: The Art of African Masquerade. Los Angeles: Fowler Muse-um of Cultural History, Univ. of California, 1985. —. Icons: Ideals and Power in the Art of Africa.
- Washington, D.C.: National Museum of African Art, Smithsonian Institution, 1989.
- Mbari, Art and Life among the Owerri Igbo. Bloomington: Indiana Univ. Press, 1982
- Drewal, Henry John. African Artistry: Technique and Aesthetics in Yoruba Sculpture. Atlanta: High Museum of Art, 1980.
- and Margaret Thompson Drewal. Gelede: Art and Female Power among the Yoruba. Bloomington: Indiana Univ. Press, 1983.
- Fagg, William Buller, and John Pemberton III. Yoruba Sculpture of West Africa. Ed. Bryce Holcombe. New York: Knopf, 1982.
- Gilfoy, Peggy S. Patterns of Life: West African Strip Weaving Traditions. Washington, D.C.: National Museum of African Art, Smithsonian Institution, 1992.
- Glaze, Anita. Art and Death in a Senufo Village.
- Bloomington: Indiana Univ. Press, 1981. Heathcote, David. *The Arts of the Hausa*. Chicago: Univ. of Chicago Press, 1976.
- Kasfir, Sidney Littlefield. Contemporary African Art. World of Art. London: Thames and Hudson, 2000
- Kennedy, Jean. New Currents, Ancient Rivers: Contemporary Artists in a Generation of Change. Washington, D.C.: Smithsonian Institution, 1992.
- Laude, Jean. African Art of the Dogon: The Myths of the Cliff Dwellers. Trans. Joachim Neugroschell. New York: Brooklyn Museum, 1973.
- Martin, Phyllis, and Patrick O'Meara, eds. Africa. 3rd ed. Bloomington: Indiana Univ. Press, 1995
- McEvilley Thomas. Fusion: West African Artists at the Venice Biennale. New York: Museum for African Art, 1993.
- McNaughton, Patrick R. The Mande Blacksmiths: Knowledge, Power and Art in West Africa. Bloomington: Indiana Univ. Press, 1988.
- Neyt, François. Luba: To the Sources of the Zaire. Trans. Murray Wyllie. Paris: Editions Dapper, 1994. Perrois, Louis, and Marta Sierra Delage. The Art of Equatorial Guinea: The Fang Tribes. New York: Rizzoli, 1990.
- Picon, John, and John Mack. African Textiles. New York: Harper & Row, 1989.
- Roy, Christopher D. Art of the Upper Volta Rivers. Meudon, France: Chaffin, 1987
- Schildkrout, Enid, and Curtis A. Keim. African Reflec tions: Art from Northeastern Zaire. Seattle: Univ. of Washington Press, 1990.
- Sieber, Roy. African Furniture and Household Objects. Bloomington: Indiana Univ. Press, 1980.
- African Textiles and Decorative Arts. New York: Museum of Modern Art, 1972.
- and Roslyn Adele Walker. African Art in the Cycle of Life. Washington, D.C.: National Museum of African Art, Smithsonian Institution, 1987
- Thompson, Robert Farris, and Joseph Cornet. The Four Moments of the Sun: Kongo Art in Two Worlds. Washington, D.C.: National Gallery of Art, 1981
- Vogel, Susan. Africa Explores: 20th Century African Art. New York: Center for African Art, 1991.

Chapter 26 Eighteenth-Century Art in Europe and North America

- (See the bibliography for Chapter 19 for additional information on Rococo art)
- Age of Neoclassicism. London: Arts Council of Great Britain, 1972
- Boime, Albert. Art in an Age of Revolution, 1750-1800. Chicago: Univ. of Chicago Press, 1987. Braham, Allan. The Architecture of the French Enlight
- enment. Berkeley: Univ. of California Press, 1980. Clark, Kenneth. The Romantic Rebellion: Romantic
- versus Clossic Art. New York: Harper & Row, 1973. Crow, Thomas E. Painters and Public Life in Eighteenth-Century Paris. New Haven: Yale Univ. Press, 1985
- Denvir, Bernard, The Eighteenth Century: Art, Design and Society 1689-1789. London: Longman. 1983.
- Fried, Michael. Absorption and Theatricality: Painting and Beholder in the Age of Diderot. Berkeley: Univ. of California Press, 1980.
- Honour, Hugh. Neo-Classicism. Harmondsworth, UK: Penguin, 1968.
- Kalnein, Wend von. Architecture in France in the Eighteenth Century. Trans. David Britt. Pelican History of Art. New Haven: Yale Univ. Press, 1990.
- Levey, Michael. Painting and Sculpture in France, 1700-1789. Pelican History of Art. New Haven: Yale Univ. Press, 1993
- Montgomery, Charles F., and Patrick E. Kane, eds. *American Art, 1750–1800: Towards Independence.* Boston: New York Graphic Society, 1976.
- Robert. Transformations Eighteenth-Century Art. Princeton: Princeton Univ. Press, 1967
- Summerson, John. Architecture of the Eighteenth Century. World of Art. New York: Thames and Hudson 1986

Chapter 27 Nineteenth-Century Art in Europe and North America

- Adams, Steven. The Barbizon School and the Origins of Impressionism. London: Phaidon, 1994
- of the July Monarchy: France, 1830 to 1848. Columbia: Univ. of Missouri Press, 1989. Barger, M. Susan, and William B. White. *The Da-*
- guerreotype: Nineteenth-Century Technology and Modern Science. Washington, D.C.: Smithsonian Institution, 1991.
- Baudelaire, Charles. The Painter of Modern Life, and Other Essays. 2nd ed. Trans. and ed. Jonathan Mayne, London: Phaidon, 1995.
- Berger, Klaus. Japonisme in Western Painting from Whistler to Matisse. Trans. David Britt. Cambridge Studies in the History of Art. Cambridge: Cambridge Univ. Press, 1992.
- Boime, Albert. Art in an Age of Bonapartism, 1800– 1815. Chicago: Univ. of Chicago Press, 1990. Brion, Marcel. Art of the Romantic Era: Romanticism,
- Classicism, Realism. World of Art. New York: Praeger, 1966
- Chu, Petra ten-Doesschate. Nineteenth Century European Art. New York: Abrams, 2003.
- Clark, T. J. The Absolute Bourgeois: Artists and Politics in France, 1848-1851. Berkeley: Univ. of California Press, 1999.
- Image of the People: Gustave Courbet and the 1848 Revolution. Berkeley: Univ. of California Press, 1999.
- The Painting of Modern Life: Paris in the Art of Manet and His Followers. Rev. ed. Princeton: Princeton Univ. Press, 1999.
- Cooper, Wendy A. Classical Taste in America 1800-1840. Baltimore: Baltimore Museum of Art, 1993.
- Cumming, Elizabeth, and Wendy Caplan. Arts and Crafts Movement. World of Art. New York: Thames and Hudson, 1991.
- Denis, Rafael Cardoso, and Colin Trodd. *Art and the Academy in the Nineteenth Century.* New Brunswick, NJ: Rutgers Univ. Press, 2000
- Denvir, Bernard. Post Impressionism. World of Art. New York: Thames and Hudson, 1992.
- The Thames and Hudson Encyclopedia of Imessionism. World of Art. New York: Thames and Hudson, 1990.
- Duncan, Alastair. Art Nouveau. World of Art. New York: Thames and Hudson, 1994.
- Eisenman, Stephen. Nineteenth Century Art: A Crit ical History. 2nd ed. New York: Thames and Hudson, 2002.
- Eitner, Lorenz, Nineteenth Century European Paint ing: David to Cezanne. Rev. ed. Boulder: Westview Press, 2002.
- Gerdts, William H. American Impressionism. New York: Abbeville, 1984.

- Goldwater, Robert, Symbolism, Icon Editions, New York: Harper & Row, 1979. Groseclose, Barbara. *Nineteenth-Century American*
- Art. Oxford: Oxford Univ. Press, 2000.
- Harrison, Charles, Paul Wood, and Jason Gaiger. Art in Theory 1815-1900: An Anthology of Changing Ideas. Oxford: Blackwell, 1998.
- Hemingway, Andrew, and William Vaughan. Art in Bourgeois Society, 1790-1850. Cambridge: Cambridge Univ. Press, 1998.
- Herbert, Robert L. Impressionism: Art, Leisure, and Parisian Society. New Haven: Yale Univ. Press, 1988.
- Hilton, Timothy. Pre-Raphaelites. World of Art. London: Thames and Hudson, 1970
- Holt, Elizabeth Gilmore, ed. *The Expanding World of Art, 1874–1902*. New Haven: Yale Univ. Press, 1988. Honour, Hugh. Romanticism. London: Allen Lane,
- Needham, Gerald. 19th-Century Realist Art. New York: Harper & Row, 1988.
- Nochlin, Linda. Impressionism and Post-Impressionism, 1874-1904: Sources and Documents. Upper Saddle River, NJ: Prentice Hall, 1966.
- Realism and Tradition in Art, 1848-1900: Sources and Documents. Upper Saddle River, NJ:
- Prentice Half, 1966. Novotny, Fritz. *Painting and Sculpture in Europe,* 1780–1880. 2nd ed. Pelican History of Art. New Haven: Yale Univ. Press, 1995.
- Pool, Phoebe, Impressionism, World of Art. New York: Praeger, 1967.
- Post-Impressionism: Cross-currents in European and American Painting, 1880-1906. Washington, D.C.: National Gallery of Art, 1980.
- Rewald, John. The History of Impressionism. 4th rev. ed. New York: Museum of Modern Art, 1973.
- Post-impressionism: From Van Gogh to Gauguin 3rd ed. New York: Museum of Modern Art, 1978 Rosenblum, Robert, and H. W. Janson. 19th Century
- Art. New York: Abrams, 1984. Rubin, James H. Impressionism: Art and Ideas. Lon-
- don: Phaidon, 1999. Stansky, Peter. Redesigning the World: William Morris, the 1880s, and the Arts and Crafts. Princeton: Princeton Univ. Press, 1985.
- Sutter, Jean, ed. The Neo-Impressionists. Greenwich, CT: New York Graphic Society, 1970.
- Triumph of Realism. Brooklyn: Brooklyn Museum,
- Vaughan, William, and Francoise Cachin. Arts of the 19th Century. 2 vols. New York: Abrams, 1998. Vaughan, William. Romanticism and Art. World of
- Art. New York: Thames and Hudson, 1994. Weisberg, Gabriel P. The European Realist Tradition. Bloomington: Indiana Univ. Press, 1982.

Chapter 28 The Rise of Modernism in Europe and America

- Ades, Dawn. Photomontage. Rev. ed. World of Art. New York: Thames and Hudson, 1986.
- Art into Life: Russian Constructivism, 1914-32. New York: Rizzoli, 1990.
- Baigell, Matthew. The American Scene: American Painting of the 1930s. New York: Praeger, 1974. Banham, Reyner. Theory and Design in the First Machine Age. 2nd ed. Cambridge: MIT Press, 1980
- Barr, Alfred H., Jr. Cubism and Abstract Art: Painting, Sculpture, Constructions, Photography, Architecture, Industrial Arts, Theatre, Films, Posters, Typography. Cambridge, MA: Belknap, 1986.
- Barron, Stephanie, ed. *Degenerate Art: The Fate of the Avant-Garde in Nazi Germany.* Los Angeles: Los Angeles County Museum of Art, 1991.
- Bayer, Herbert, Walter Gropius, and Ise Gropius. Bauhaus, 1919-1928. New York: Museum of Modern Art. 1975.
- Brown, Milton. Story of the Armory Show: The 1913 Exhibition That Changed American Art. 2nd ed. New York: Abbeville, 1988.
- Corn. Wanda M. The Great American Thing: Modern Art and National Identity, 1915–1935. Berkeley: Univ. of California Press, 1999.
- Curtis, James. Mind's Eye, Mind's Truth: FSA Photography Reconsidered. Philadelphia: Temple Univ. Press, 1989.
- Curtis, Penelope. Sculpture 1900-1945: After Rodin. Oxford History of Art. Oxford: Oxford Univ. Press, 1999.
- Dachy, Marc. The Dada Movement, 1915-1923. New York: Skira/Rizzoli, 1990.
- Davidson, Abraham A. Early American Modernist Painting, 1910–1935. New York: Harper & Row,

- Dube, Wolf-Dieter. *Expressionists*. Trans. Mary Whittall. World of Art. New York: Thames and Hudson, 1998.
- Fer, Briony, David Batchelor, and Paul Wood. Realism, Rationalism, Surrealism: Art between the Wars. New Haven: Yale Univ. Press, 1993.
- Freeman, Judi. *The Fauve Landscape*. Los Angeles: Los Angeles County Museum of Art, 1990. Fry, Edward. *Cubism*. New York: McGraw-Hill, 1966.
- Fry, Edward. *Cubism*. New York: McGraw-Hill, 1966. Golding, John. *Cubism: A History and an Analysis,* 1907–1914. Cambridge, MA: Belknap,1988.
- Gordon, Donald E. *Expressionism: Art and Idea*. New Haven: Yale Univ. Press, 1987.
- Gray, Camilla. Russian Experiment in Art, 1863– 1922. Rev. and enlarged by Marion Burleigh-Motley. World of Art. London: Thames and Hudson, 1986.
- Green, Christopher. *Art in France: 1900–1940.* Pelican History of Art. New Haven: Yale Univ. Press, 2000.
- Haiko, Peter, ed. *Architecture of the Early XX Century* Trans. Gordon Clough. New York: Rizzoli, 1989
- Harrison, Charles, Francis Frascina, and Gill Perry Primitivism, Cubism, Abstraction: The Early Twentieth Century. New Haven: Yale Univ. Press, 1993
- Haskell, Barbara. *The American Century: Art & Culture, 1900–1950.* New York: Whitney Museum of American Art, 1999.
- Herbert, James D. Fauve Painting: The Making of Cultural Politics. New Haven: Yale Univ. Press, 1992.
 Hulten. Pontus. Futurism and Futurisms. New York:
- Abbeville, 1986. Jaffe, Hans L. C. De Stijl, 1917–1931: The Dutch
- Contribution to Modern Art. Cambridge, MA: Belknap, 1986.
- Lane, John R., and Susan C. Larsen, *Abstract Painting* and *Sculpture in America 1927–1944*. Pittsburgh: Museum of Art, Carnegie Institute, 1984.
- Lloyd, Jill. German Expressionism: Primitivism and Modernity. New Haven: Yale Univ. Press, 1991.
- Overy Paul. *De Stijl*. World of Art. New York: Thames and Hudson, 1991.

 Picon. Gaetan. *Surrealists and Surrealism*. 1919–1939.
- Trans. James Emmons. New York: Rizzoli, 1977 Rickey, George. Constructivism: Origins and Evolution. Rev. ed. New York: G. Braziller. 1995
- tion. Rev. ed. New York: G. Braziller, 1995. Rosenblum, Robert. Cubism and Twentieth-Century Art. Rev. ed. New York: Abrams, 1984.
- Spate, Virginia. Orphism: The Evolution of Non-Figurative Painting in Paris, 1910–1914. Oxford Studies in the History of Art and Architecture. Oxford: Clarendon, 1979.
- Stich, Sidra. *Anxious Visions: Surrealist Art.* New York: Abbeville, 1990.
 Tisdall, Caroline, and Angelo Bozzolla. *Futurism*.
- Tisdall, Caroline, and Angelo Bozzolla. Futurism.
 World of Art. New York: Oxford Univ. Press, 1978.
 Weiss Leffrey S. The Popular Culture of Modern Art
- Weiss, Jeffrey S. The Popular Culture of Modern Art: Picasso, Duchamp, and Avant-Gardism. New Haven, Yale Univ. Press, 1994.
- Whitfield, Sarah. *Fauvism*. World of Art. New York: Thames and Hudson, 1996.
- Whitford, Frank. Bauhaus. World of Art. London: Thames and Hudson, 1984.
- Zurier, Rebecca, Robert W. Snyder, and Virginia M. Mecklenburg. *Metropolitan Lives: The Ashcan Artists and Their New York*. Washington, D.C.: National Museum of American Art, 1995.

Chapter 29 The International Avant-Garde since 1945

- Alberro, Alexander, and Blake Stimson, eds. Conceptual Art: A Critical Anthology. Cambridge: MIT Press, 1999.
- Andersen, Wayne. American Sculpture in Process, 1930–1970. Boston: New York Graphic Society, 1975.
- Anfam, David. *Abstract Expressionism*. World of Art. New York: Thames and Hudson, 1996.
- Archer, Michael. Art Since 1960. 2nd ed. World of Art. New York: Thames and Hudson, 2002.
- Ashton, Dore. American Art since 1945. New York: Oxford Univ. Press, 1982.
- The New York School: A Cultural Reckoning. Harmondsworth, UK: Penguin, 1979. Atkins. Robert. Artspeak: A Guide to Contemporary
- Atkins. Robert. *Artspeak: A Guide to Contemporary Ideas, Movements, and Buzzwords.* 2nd ed. New York: Abbeville, 1997.
- Baker, Kenneth. *Minimalism: Art of Circumstance*. New York: Abbeville, 1988.
- Battcock, Gregory. *Idea Art: A Critical Anthology*. New York: Dutton, 1973.
- —. Minimal Art: A Critical Anthology. Berkeley: Univ. of California Press, 1995.
- —, and Robert Nickas. *The Art of Performance: A Critical Anthology*. New York: Dutton, 1984.

- Beardsley, John. Earthworks and Beyond: Contemporary Art in the Landscape. 3rd ed. New York: Abbeville, 1998.
- Blake, Peter. No Place Like Utopia: Modern Architecture and the Company We Kept. New York: Knopf, 1993.
- Bolton, Richard, ed. Culture Wars: Documents from the Recent Controversies in the Arts. New York: New, 1992.
- Broude, Norma, and Mary D. Garrard. *The Power of Feminist Art: The American Movement of the 1970s, History and Impact*. New York: Abrams, 1994.
- Castleman, Riva, ed. Art of the Forties. New York: Museum of Modern Art, 1991.
- Chase, Linda. *Hyperrealism*. New York: Rizzoli, 1975. Causey, Andrew. *Sculpture since 1945*. Oxford History of Art. Oxford: Oxford Univ. Press, 1998.
- Collins, Michael, and Andreas Papadakis. *Post-Modern Design*. New York: Rizzoli, 1989.
- Crow, Thomas. *The Rise of the Sixties: American and European Art in the Era of Dissent.* Perspectives. New York: Abrams, 1996.
- New York: Abrams, 1996.

 De Oliveira, Nicolas, Nicola Oxley, and Michael Petry. *Installation Art*. Washington, D.C.: Smithsonian Institution Press, 1994.
- sonian Institution Press, 1994.

 Dormer, Peter. *Design since 1945*. World of Art. New York: Thames and Hudson, 1993.
- Endgame: Reference and Simulation in Recent Painting and Sculpture. Boston: Institute of Contemporary Art, 1986.
- Fabozzi, Paul F. Artists, Critics, Context: Readings In and Around American Art Since 1945. Upper Saddle River, NJ: Prentice Hall, 2002.
- Ferguson, Russell, ed. *Discourses: Conversations In Postmodern Art and Culture.* Documentary Sources in Contemporary Art. Cambridge: MIT Press, 1990.
- —. Out There: Marginalization and Contemporary Cultures. Documentary Sources in Contemporary Art; 4. New York: New Museum of Contemporary Art, 1990.
- Fineberg, Jonathan David. Art Since 1940: Strategies of Being. 2nd ed. New York: Abrams, 2000.
- Ghirardo, Diane. Architecture after Modernism. World of Art. New York: Thames and Hudson, 1996.
- Godfrey, Tony. Conceptual Art. Art & Ideas. London: Phaidon, 1998.
- Goldberg, RoseLee. *Performance Art: From Futurism to the Present*. Rev. ed. World of Art. London: Thames and Hudson, 2001.
- Green, Jonathan. American Photography: A Critical History since 1945 to the Present. New York: Abrams. 1984.
- Grundberg, Andy. *Photography and Art: Interactions* since 1945. New York: Abbeville, 1987.
- Hays, K. Michael, and Carol Burns, eds. Thinking the Present: Recent American Architecture. New York: Princeton Architectural, 1990.
- Henri, Adrian. *Total Art: Environments, Happenings, and Performance*. World of Art. New York: Oxford Univ. Press, 1974.
- Hertz, Richard. *Theories of Contemporary Art*. 2nd ed Upper Saddle River, NJ: Prentice Hall, 1993.
- Hobbs, Robert Carleton, and Gail Levin. Abstract Expressionism: The Formative Years. Ithaca: Cornell Univ. Press, 1981
- Hoffman, Katherine. *Explorations: The Visual Arts* since 1945. New York: HarperCollins, 1991.
- Hopkins, David. After Modern Art: 1945–2000. Oxford: Oxford Univ. Press, 2000.
- Jencks, Charles. *Architecture Today*. 2nd ed. London: Academy, 1993.
- —... The New Moderns from Late to Neo-Modernism. New York: Rizzoli, 1990.
- —. What Is Post-Modernism? 4th rev., enl. ed. London: Academy Editions, 1996.
- Joachimedes, Christos M., Norman Rosenthal, and Nicholas Serota, eds. *New Spirit in Painting*. London: Royal Academy of Arts. 1981.
- Johnson, Ellen H., ed. *American Artists on Art from* 1940 to 1980. New York: Harper & Row, 1982. Joselit, David. *American Art Since* 1945. World of Art.
- London: Thames and Hudson, 2003. Kaprow Allan. Assemblage Environments & Happen-
- ings. New York: Abrams, 1965.
 Kingsley, April. The Turning Point: The Abstract Ex-
- pressionists and the Transformation of American Art. New York: Simon & Schuster, 1992.
- Land and Environment Art. Ed. Jeffrey Kastner. Survey Brian Wallis. Themes and Movements. London: Phaidon Press, 1998.
- Lippard, Lucy. *Pop Art.* World of Art. New York: Praeger, 1966.
- Livingstone, Marco. Pop Art: A Continuing History. New York: Abrams, 1990.

- Lucie-Smith, Edward. Art in the Eighties. Oxford: Phaidon, 1990.
- —. Art in the Seventies. Ithaca: Cornell Univ. Press. 1980.
- —. Art Today. London: Phaidon, 1995
- —. Movements in Art since 1945. World of Art. London: Thames and Hudson, 2001.
- —. Sculpture since 1945. Oxford: Phaidon, 1987.
 —. Super Realism. Oxford: Phaidon, 1979.
- Manhart, Marcia, and Tom Manhart, eds. The Eloquent Object: The Evolution of American Art in Craft Media since 1945. Tulsa: Philbrook Museum of Art, 1987.
- Meisel, Louis K. *Photo-Realism*. New York: Abrams, 1989.
- Meyer, James,ed. *Minimalism*. Themes and Move-
- ments. London: Phaidon, 2000. Paul, Christiane. *Digital Art*. World of Art. London: Thames and Hudson, 2003.
- Phillips, Lisa. *The American Century: Art and Culture,* 1950–2000. New York: Whitney Museum of American Art, 1999.
- Polcari, Stephen. Abstract Expressionism and the Modern Experience. Cambridge: Cambridge Univ. Press. 1991.
- Risatti, Howard, ed. *Postmodern Perspectives: Issues in Contemporary Art.* 2nd ed. Upper Saddle River, NJ: Prentice Hall, 1998.
- Rosen, Randy, and Catherine C. Brawer, comps. Making Their Mark: Women Artists Move into the Mainstream, 1970–85. New York: Abbeville, 1989
- Rush, Michael. New Media in Late 20th-Century Art. World of Art. London: Thames and Hudson, 1999. Russell, John. Pop Art Redefined. New York:
- Praeger, 1969. Sandler, Irving. *American Art of the 1960s*. New York: Harper & Row, 1988.
- Art of the Postmodern Era: From the Late 1960s to the Early 1990s. New York: Icon Editions, 1996.
 The New York School: The Painters and Sculptors
- of the Fifties. New York: Harper & Row, 1978.

 —. The Triumph of American Painting: A History of Abstract Expressionism. New York: Harper & Row,
- Sayre, Henry M. *The Object of Performance: The American Avant-Garde since 1970.* Chicago: Univ. of Chicago Press, 1989.
- Shapiro, David, and Cecile Shapiro. Abstract Expressionism: A Critical Record. New York: Cambridge Univ. Press, 1990,
- Shohat, Ella. *Talking Visions: Multicultural Feminism in a Transnational Age.* Documentary Sources in Contemporary Art; 5. New York: New Museum of Contemporary Art, 1998.
- Skilled Work: American Craft in the Renwick Gallery National Museum of American Art, Smithsonian Institution. Washington, D.C.: Smithsonian Institution Press, 1998.
- Smith, Paul J., and Edward Lucie-Smith. *Craft Today:*Poetry of the Physical. New York: American Craft Museum, 1986.
- Stich, Sidra. *Made in USA: An Americanization in Modern Art, the '50s & '60s*. Berkeley: Univ. of California Press. 1987.
- Taylor, Brandon. Avant-Garde and After. Rethinking Art Now. Perspectives. New York: Abrams, 1995. Taylor, Paul, ed. Post-Pop Art. Cambridge: MIT
- Press, 1989.

 Waldman, Diane. Collage, Assemblage, and the Found Object. New York: Abrams, 1992.
 - —. Transformations in Sculpture: Four Decades of American and European Art. New York: Solomon R. Guggenheim Foundation, 1985.
- Wallis, Brian, ed. Art after Modernism: Rethinking Representation. Documentary Sources in Contemporary Art; 1. New York: New Museum of Contemporary Art. 1984.
- Blasted Allegories: An Anthology of Writings by Contemporary Artists. Documentary Sources in Contemporary Art, 2. New York: New Museum of Contemporary Art, 1987.
- Weintraub, Linda. Art on the Edge and Over: Searching for Art's Meaning in Contemporary Society, 1970s-1990s. Litchfield, CT: Art Insights, 1996.
- Wheeler, Daniel. Art since Mid-Century: 1945 to the Present. Upper Saddle River, NJ: Prentice Hall, 1991. Wood, Paul. Modernism in Dispute: Art Since the For-
- ties. New Haven: Yale Univ. Press, 1993.

 Word as Image: American Art, 1960–1990. Milwaukee: Milwaukee Art Museum, 1990.
- Zolberg, Vera L., and Joni Maya Cherbo, eds. Outsider Art: Contesting Boundaries in Contemporary Culture. Cambridge Cultural Social Studies. Cambridge: Cambridge Univ. Press, 1997.

CREDITS

Credits and Copyrights

Introduction

Page xxix: Roger Wood/CORBIS; page xxx: © Archaeological Receipts Fund/Hellenic Republic Ministry of Culture; page xxxi: Photograph @ 2000, The Art Institute of Chicago, All Rights Reserved; page xxxii (top): @ 1981 Center for Creative Photography, Arizona Board of Regents; page xxxiii: Tate Gallery, London/Art Resource, NY; page xxxiv (left): Scala/ Art Resource, NY; page xxxiv (right): O Museo Nacional del Prado, Madrid; page xxxv (right): Photo by E.G. Schempf/© 1987 The Nelson Gallery Foundation-All Reproduction Rights Reserved; page xxxvi: © Smithsonian American Art Museum, Washington, DC/Art Resource, NY: page xxxvii (left): Photo by Philip A. Charles/Image © 2004 Board of Trustees, National Gallery of Art, Washington; page xxxvii (right): Photo by Franko Khoury/National Museum of African Art, Smithsonian Institution, Washington DC; page xxxviii: Scala/Art Resource, NY; page xxxix (left): © 2000 The Nelson Gallery Foundation-All Reproduction Rights Reserved; page xl (bottom): Ghigo Roli/INDEX, Firenze; page xli: Photograph © 1983 The Metropolitan Museum of Art; page xliii (left): Photo by David Heald/© The Solomon R. Guggenheim Foundation, New York; page xliv: Photo by M. Sarri/Archivio Musei Vaticani; page xlv (left): Hirmer Verlag, Munich; page xlv (right): Giraudon/Art Resource, NY; page xlvii: O The Nelson Gallery Foundation-All Reproduction Rights Reserved.

Chapter 1

Pages xlviii-1: Cliché Ministère de la Culture et de la Communication, Régionale Direction des Affaires Culturelles de Rhône-Alpes, Service Régional de l'Archéologie; page 4 (left): Photo by K.-H. Augustin, Esslingen/© Ulmer Museum; page 4 (right): Erich Lessing/Art Resource, NY; page 5 (right): Sisse Brimberg/National Geographic Image Collection; page 6: Michael Lorblanchet, France; page 8: Sisse Brimberg/National Geographic Image Collection; page 9 (top): Sisse Brimberg/National Geographic Image Collection; page 9 (bottom): Jean Vertut Archives, Issy-les-Moulineaux; page 11 (top): Photo YAN (Jean Dieuzaide), Toulouse; page 11 (bottom): Réunion des Musées Nationaux/Art Resource, NY; page 13: Institut Amatller d'Art Hispànic, Barcelona; page 15: © Mick Sharp; page 16: Department of the Environment, Heritage and Local Government, Ireland; page 17: Yann Arthus-Bertrand/Altitude/ Photo Researchers, Inc.; page 18: Aerofilms Ltd., UK; page 19: © Paul Caponigro, 1967; page 21 (top): Erich Lessing/Art Resource, NY; page 21 (bottom): Erich Lessing/Art Resource, NY; page 24: © National Museum of Ireland.

Chapter 2

Page 26 Photograph © 1981 The Metropolitan Museum of Art; page 29 (top): © Dr. Brian Byrd, University of California, San Diego; page 29 (bottom): Photo by Peter Dorrell and Stuart Laidlaw, Courtesy University of London, Institute of Archaeology, © Dr. Gary Rollefson; page 31: © Copyright The British Museum, London; page 32: Michael S. Yamashita/CORBIS; page 33 (left): Hirmer Verlag, Munich; page 34 (top): Photo by Victor J. Boswell/Courtesy The Oriental Institute of the University of Chicago; page 34 (bottom): Photo Jean Mazenod, "L'Art du Proche-Orient"/Citadelles & Mazendod, Paris; page 35, left: University of Pennsylvania Museum, Philadelphia (T4-29C); page 35 (right): University of Pennsylvania Museum, Philadelphia (T4-29C); page 37 (left): University of Pennsylvania Museum, Philadelphia (T35-2399); page 37 (right): Réunion des Musées Nationaux/Art Resource, NY; page 38: Réunion des Musées Nationaux/Art Resource, NY; page 39: Photo by Hervé

Lewandowski/Réunion des Musées Nationaux/Art Resource, NY; page 40: Lauros/Giraudon/Bridgeman Art Library; page 41 (top): HIP/Scala/Art Resource, NY; page 41 (bottom): Drawing by C.B. Altman/Courtesy The Oriental Institute of the University of Chicago; page 42 (top): © Copyright The British Museum, London; page 42 (bottom): Barry Iverson/Getty Images; page 43: Courtesy The Oriental Institute of the University of Chicago; page 44: Bildarchiv Preussischer Kulturbesitz/Art Resource, NY; page 45: Réunion des Musées Nationaux/Art Resource, NY; page 47 (top): Réunion des Musées Nationaux/Art Resource, NY; page 47 (bottom): The Art Archive/Dagli Orti (A); page 49: Gérard Degeorge/CORBIS; page 50: Courtesy The Oriental Institute of the University of Chicago.

Chapter 3

Page 52: O Kodansha Ltd, Tokyo; page 57 (left): Scala/Art Resource, NY; page 57 (right): Scala/Art Resource, NY; page 58: Egyptian Museum, Cairo/Art Resource, NY; page 61 (top): O Ancient Art & Architecture/Danita Delimont; page 61 (bottom): Wim Swaan Photograph Collection, (96.P.21)/Library, Getty Research Institute, Los Angeles; page 63 (top): Norbert Schiller/The Image Works; page 63 (bottom): Photo by Carl Andrews/© President and Fellows of Harvard College for the Semitic Museum: page 65 (left): Araldo De Luca/INDEX Firenze: page 65 (right): Reproduced with permission. © 2001 Museum of Fine Arts, Boston. All Rights Reserved; page 66 (bottom): Photo by Hervé Lewandowski/Réunion des Musées Nationaux/Art Resource, NY; page 67: Jean Vertut Archives, Issy-les-Moulineaux; page 68: Werner Forman Archive/Art Resource, NY; page 69: Photograph © 1992 The Metropolitan Museum of Art; page 70 (left top): Jean Vertut Archives, Issy-les-Moulineaux; page 70 (right top): Photo by Graham Harrison/© The British Museum Press; page 70 (bottom): Metropolitan Museum of Art Excavations, (1915-1916). Photo by Araldo De Luca/INDEX. Firenze; page 71: Photo by E.G. Schempf/© 1987 The Nelson Gallery Foundation - All Reproduction Rights Reserved; page 72: © Copyright The British Museum, London; page 73 (top): Photograph © 1997 The Metropolitan Museum of Art; page 73 (bottom): Photograph © 1983 The Metropolitan Museum of Art; page 74: Yann Arthus-Bertrand/CORBIS; page 75: Jean Vertut Archives, Issy-les-Moulineaux; page 76 (left): The Art Archive/Dagli Orti; page 77: © Photo Peter Clayton; page 78: Bildarchiv Preussischer Kulturbesitz/Art Resource, NY; page 79 (left): Bildarchiv Preussischer Kulturbesitz/Art Resource, NY; page 79 (right): Bildarchiv Preussischer Kulturbesitz/Art Resource, NY; page 79 (bottom): © Copyright The British Museum, London; page 81 (top): Photo by Burton/Courtesy Griffith Institute, Oxford; page 81 (bottom): Araldo De Luca/INDEX, Firenze; page 82 (top): The Art Archive/Dagli Orti; page 82 (bottom): © G. Dagli Orti; page 83: H. Champollion/ Agence Top; page 84 (top): Photo by Guillermo Aldana/© The J. Paul Getty Trust, 2001. All Rights Reserved; page 84 (bottom): © Copyright The British Museum, London; page 85 (top): Photo by Guillermo Aldana/© The J. Paul Getty Trust, 1991. All Rights Reserved; page 86: © Copyright The British Museum, London; page 87 (left): O Copyright The British Museum, London; page 87 (right): © Copyright The British Museum, London.

Chapter 4

Pages 88–89: Nimatallah/Art Resource, NY; page 92 (left): © Studio Kontos/Photostock, Greece; page 92 (right): © N.P. Goulandris Foundation - Museum of Cycladic Art, Athens; page 93: Photograph ©1996 The Metropolitan Museum of Art; page 94: Smith College Archives, Smith College, Massachusetts; page 95: Courtesy McRae Books, Florence; page 96: Hirmer Verlag, Munich; page 97: © Studio Kontos/

Photostock, Greece; page 98 l(eft): Hirmer Verlag, Munich; page 98 (right): © Archaeological Receipts Fund/Hellenic Republic Ministry of Culture; page 99 (left): © Archaeological Receipts Fund/Hellenic Republic Ministry of Culture; page 99 (right): © Archaeological Receipts Fund/Hellenic Republic Ministry of Culture; page 100: © Studio Kontos/ Photostock, Greece; page 101: Ch. Doumas, "The Wall Paintings of Thera", Idryma Theras-Petros M. Nomikos, Athens, 1992; page 102: © Archaeological Receipts Fund/Hellenic Republic Ministry of Culture; page 103 (top): O Studio Kontos/Photostock, Greece; page 103 (bottom): © Studio Kontos/Photostock, Greece; page 104 (top): © Studio Kontos/Photostock, Greece; page 104 (bottom): Deutsches Archäologisches Institut, Athens; page 106: Hirmer Verlag, Munich; page 107 (top): C.M. Dixon, Canterbury, UK; page 107 (bottom): Conway Library, Courtauld Institute of Art, London; page 108: Spectrum Colour Library, London; page 109: Courtesy of The Department of Classics, The University of Cincinnati; page 110: © Studio Kontos/Photostock, Greece; page 111 (top): Nimatallah/Art Resource, NY; page 111 (bottom): © Studio Kontos/Photostock, Greece.

Chapter 5

Page 112: Foto Vasari/INDEX Firenze: page 117. top: The Art Archive/Dagli Orti; page 119 (left): © Archaeological Receipts Fund/Hellenic Republic Ministry of Culture; page 119 (right): Photograph © 1996 The Metropolitan Museum of Art; page 120: Photograph ©1996 The Metropolitan Museum of Art; page 121 (left): Hirmer Verlag, Munich; page 122 (top): Erich Lessing/Art Resource, NY; page 122 (bottom right): Canali Photobank, Milan; page 125: Gian Berto Vanni/Art Resource, NY; page 126 (top): Dr. Franz Stoedtner, Dusseldorf; page 126 (bottom): Hirmer Verlag, Munich; page 127: Photo by Koppermaun/Staatliche Antikensammlungen und Glyptothek München; page 128: Photograph © 1997 The Metropolitan Museum of Art; page 129 (left): © Studio Kontos/Photostock, Greece; page 129 (right): Bildarchiv Preussischer Kulturbesitz/Art Resource. NY; page 130 (left): © Studio Kontos/Photostock, Greece; page 130 (right): © Studio Kontos/Photostock, Greece; page 131: Walter Hege, "Die Akropolis". Deutscher Kunstverlag, Berlin, 1930; page 132: Canali Photobank, Milan; page 133: Réunion des Musées Nationaux/Art Resource, NY; page 134: Laboratoires Photographiques Devos; page 135: Photograph © 2004 Museum of Fine Arts, Boston; page 136: Photograph © 1999 The Metropolitan Museum of Art; page 137: Bildarchiv Preussischer Kulturbesitz/Art Resource, NY; page 138: © Studio Kontos/Photostock, Greece; page 139: Hirmer Verlag, Munich; page 140: Hirmer Verlag, Munich; page 141: © Studio Kontos/Photostock, Greece; page 142 (left): Scala/Art Resource, NY; page 142 (right): Scala/Art Resource, NY; page 143: Photograph © 2004 Museum of Fine Arts, Boston; page 144: Museo Archeologico Nazionale di Reggio Calabria; page 145: Canali Photobank, Milan; page 147 (top): With permission of the Royal Ontario Museum © ROM; page 149 (left): Gennadius Library, American School of Classical Studies, Athens; page 149 (right): Avery Architecture and Fine Arts Library, Columbia University in the City of New York; page 150: © Copyright The British Museum, London; page 151 (top): © Copyright The British Museum, London; page 151 (center): Hirmer Verlag, Munich; page 151 (bottom): Hirmer Verlag, Munich; page 152, top: © Copyright The British Museum, London; page 152 (bottom): Giraudon/Bridgeman Art Library; page 153: Michael Holford Photography; page 154 (top): Hirmer Verlag, Munich; page 154 (bottom): Alison Frantz Photographic Collection, American School of Classical Studies at Athens; page 155: © Archaeological Receipts Fund/Hellenic Republic Ministry of Nassau Foundation/Mauritshuis, The Hague; page 776: Photo by Richard Carafelli/Image © 2004 Board of Trustees, National Gallery of Art, Washington; page 777: Photo by Richard Carafelli/Image © 2004 Board of Trustees, National Gallery of Art, Washington; page 780 (top): A.F. Kersting, London; page 780 (bottom): Devonshire Collection, Chatworth. Reproduced by permission of the Duke of Devonshire and the Chatsworth Settlement Trustees. Photograph Photographic Survey of Private Collections, Courtauld Institute of Art; page 781: Crown copyright Historic Royal Palaces; page 782 (left): A.F. Kersting, London; page 783: Aerofilms Ltd., UK; page 784: © Wayne Andrews/ESTO.

Chapter 20

Pages 786–787: © Steve Vidler/SuperStock; page 789: Photograph © 1985 Dirk Bakker; page 790: Asian Art Archives, University of Michigan; page 791: Asian Art Archives, University of Michigan; page 793: Michael Flinn, Courtesy Marylin Rhie; page 794: Asian Art Archives, University of Michigan; page 795: Photograph © 2004 Museum of Fine Arts, Boston; page 796: Photo by Katharine Wetzel/© Virginia Museum of Fine Arts; page 797: Asian Art Archives, University of Michigan; page 798: Photograph © 2004 Museum of Fine Arts, Boston; page 799: Dinodia Photo Library.

Chapter 21

Pages 800–801: Wolfgang Kaehler, Bellevue, WA; page 807: © The Cleveland Museum of Art, 2001; page 809 (left): Collection of the Imperial Palace Museum, Beijing; page 809 (right): © The Nelson Gallery Foundation-All Reproduction Rights Reserved; page 810: Palace Museum, Beijing/Wan-go Weng Inc. Archive/Yang Boda; page 812: Photo by Robert Newcombe/© 1991 The Nelson Gallery Foundation-All Reproduction Rights Reserved; page 813: © The Cleveland Museum of Art, 2001.

Chapter 22

Pages 816–817: Photo by Tibor Franyo/Honolulu Academy of Arts; page 820: Photograph © 2004 Museum of Fine Arts, Boston; page 821 (right): Stephen Addiss, Midlothian, VA; page 822: Mike Yamashita/Woodfin Camp and Associates; page 823: © Steve Vidler/SuperStock; page 824: Sakamoto Manschichi Photo Research Library, Tokyo; page 825: Sakamoto Manschichi Photo Research Library, Tokyo; page 829: Sakamoto Manschichi Photo Research Library, Tokyo; page 830: Private Collection; page 831: Photograph ©2003 Museum Associates/LACMA; page 835: Photo Tadasu Yamamoto, Tokyo.

Chapter 23

Pages 836-837: Board of Trustees of the National Museums and Galleries on Merseyside, Liverpool, England; page 841 (right): Enrique Franco Torrijos, Mexico City; page 841 (bottom): George Stewart/ National Geographic Image Collection; page 842: Werner Forman/Art Resource, NY; page 843 (top): Wim Swaan Photograph Collection, (96.P.21)/Library, Getty Research Institute, Los Angeles; page 843 (bottom): The Art Archive/Dagli Orti; page 844: © Justin Kerr, New York; page 845: Photo by John Bigelow Taylor/AMNH; page 846 (top): Philbrook Museum of Art, Tulsa, Oklahoma. Clark Field Collection (1948.39.37); page 846 (bottom): Department of Anthropology, Smithsonian Institution, Washington, DC. (Catalogue No.#7311); page 847: Photograph © 1992 The Detroit Institute of Arts; page 849: Photo by Hillel Burger/© President and Fellows of Harvard College, Harvard University, Massachusetts; page 851: Photo by Stephen S. Meyers, New York/AMNH; page 852: Smithsonian Institution Libraries, Washington, DC; page 853: Museum of Anthropology, University of British Columbia, Vancouver; page 854 (top): © 1979, Amon Carter Museum; page 854 (bottom): Photo by Blair Clark/Museum of Indian Arts and Culture/Laboratory of Anthropology, www.miaclab.org; page 855: Philbrook Museum of Art, Tulsa, Oklahoma. Museum Purchase (1947.37); page 857 (bottom): Courtesy Steinbaum Krauss Collection, NY.

Chapter 24

Pages 858–859: James Balog/Black Star; page 861: Photo by E.Brandl/Courtesy AIATSIS Pictorial Col-

lection; page 864 (top): Wolfgang Kaehler, Bellevue, WA; page 865: Brenda J. Clay, Lexington, KY; page 867 (right): Photo by Ben Patnoi/Bishop Museum; page 868 (top): Photo by Ben Patnoi/Bishop Museum; page 869: Photo by Robert Newcombe/© 1998 The Nelson Gallery Foundation-All Reproduction Rights Reserved; page 870: The Museum of New Zealand Te Papa Tongarewa, Wellington, New Zealand, (Neg. #B18358); page 871: Courtesy of Joyce D. Hammond; page 873: Art Gallery of South Australia, Adelaide/Visual Arts Board of the Australia Council Contemporary.

Chapter 25

Page 874: Pierre-Alain Ferrazzini, Geneva, Switzerland; page 878: Photo by Ron Jennings/© Virginia Museum of Fine Arts; page 879: Margaret Courtney-Clarke/CORBIS; page 880 (left): Robin Grace, New York; page 880 (right): © The University of Iowa Museum; page 881: © Christopher Roy, Iowa City; page 883: © The University of Iowa Museum; page 884 (right): Photo by Diane A. White/© The Field Museum, Chicago; page 885: University of Pennsylvania Museum, Philadelphia (Neg. # S5-23115); page 886: © The University of Iowa Museum; page 887: Photo by Franko Khoury/National Museum of African Art and National Museum of Natural History; page 888: © Copyright The British Museum, London; page 889: Photograph © 1998 The Detroit Institute of Arts; page 890 (left): Pierre-Alain Ferrazzini, Geneva; page 890 (right): Pierre-Alain Ferrazzini, Geneva; page 891: Photo by Hughes Dubois/Archives Musée Dapper, Paris; page 893 (left): Lorenz Homberger, 1983; page 894: Maggie Nimkin, New York/Courtesy of Anthony Slayter-Ralph/US.

Chapter 26

Page 896: Reproduced with permission. © 2001 Museum of Fine Arts, Boston. All Rights Reserved; page 900 (top): Wim Swaan Photograph Collection, (96.P.21)/Library, Getty Research Institute, Los Angeles; page 900 (bottom): Foto Zwicker-Berberich, Gerchsheim/Würzburg, Germany; page 901 (left): Foto Zwicker-Berberich, Gerchsheim/Würzburg, Germany; page 901 (right): Erich Müller, Kassel, Germany; page 902 (top): OBB Verlag Bornschlegel; page 902 (bottom): Herlinde Koelbl, Munich; page 903 (top): Photo by Gérard Blot/Réunion des Musées Nationaux/Art Resource, NY; page 903 (bottom): Bildarchiv Preussischer Kulturbesitz, Berlin; page 905 (top): Photo by Herve Lewandowski/Reunion des Musées Nationaux/Art Resource, NY; page 905 (bottom): © National Gallery of Canada, Ottawa. Purchase, 1956; page 906: Philip Pocock; page 907: © The Frick Collection, New York; page 909 (left): © The Frick Collection, New York; page 910 (top): Photo by John Hammond/National Trust Photographic Library, England; page 910 (bottom): The Royal Collection © 2004, HM Queen Elizabeth II. (RCON400747, OM 1210 WC 431); page 911 (top): The Royal Collection © 2001, Her Royal Majesty Queen Elizabeth II; page 911 (bottom): The Pierpont Morgan Library/Art Resource, NY; page 912: Alinari/Art Resource, NY; page 913: Réunion des Musées Nationaux/Art Resource, NY; page 914: Courtesy Department of the Environment London: page 915 (top): Photo by Nick Meers/National Trust Photographic Library, England; page 915 (bottom): © London Aerial Photo Library; page 916 (top): © Crown copyright, National Monuments Record; page 916 (bottom): A.F. Kersting, London; page 917: Richard Bryant/Arcaid; page 918: Collection assembled by Nancy Valentine and purchased with funds donated by Mr. and Mrs. Oliver R. Grace and Family/The National Museum of Women in the Arts, Washington DC; page 919 (left): Courtesy of the Wedgwood Museum Trust Limited, Barlaston, Staffordshire, England; page 919 (right): Courtesy of the Wedgwood Museum Trust Limited, Barlaston, Staffordshire, England; page 920: © The National Gallery, London; page 921 (left): Photograph © The Art Institute of Chicago, All Rights Reserved: page 921 (right): Image © 2004 Board of Trustees, National Gallery of Art, Washington; page 922: © The National Gallery, London; page 923: Photo by Katherine Wetzel/© Virginia Museum of Fine Arts; page 924: The National Gallery of Canada, Ottawa. Transfer from the Canadian War Memorials, 1921

(Gift of the 2nd Duke of Westminister, Eaton Hall, Cheshire, 1918); page 925: Photograph © 1996 The Detroit Institute of Arts; page 926: Tate Gallery, London/Art Resource, NY; page 927: Réunion des Musées Nationaux/Art Resource, NY; page 928 (right): Réunion des Musées Nationaux/Art Resource, NY; page 929: © The Portland Art Association; page 930 (left): © Centre des Monuments Nationaux, Paris; page 930 (right): Réunion des Musées Nationaux/Art Resource, NY; page 931: Photograph © 1980 The Metropolitan Museum of Art; page 932: Réunion des Musées Nationaux/Art Resource, NY; page 933 (left): Musées Royaux des Beaux-Arts de Belgique/Giraudon/Art Resource, NY; page 933 (right): Réunion des Musées Nationaux/Art Resource, NY; page 934: Whitaker Studio, Richmond, VA; page 935 (left): Henry Curtis, Newport, RI; page 935 (right): Courtesy of Mount Vernon Ladies' Association; page 936: Lautman Photography, Washington, DC.

Chapter 27

Page 940: Lauros-Giraudon/Art Resource, NY; page 944: Réunion des Musées Nationaux/Art Resource, NY; page 945: Réunion des Musées Nationaux/Art Resource, NY; page 946: Photo by Hervé Lewandowski/ Réunion des Musées Nationaux/Art Resource, NY: page 947: © The Cleveland Museum of Art. 2001; page 948: Réunion des Musées Nationaux/Art Resource, NY; page 949 (left): Photo by P. Bernard/ Réunion des Musées Nationaux/Art Resource, NY; page 949 (right): Photo by P. Bernard/Réunion des Musées Nationaux/Art Resource, NY; page 951: Photo by Le Mage/Réunion des Musées Nationaux/ Art Resource, NY; page 952 (top): Réunion des Musées Nationaux/Art Resource, NY; page 952 (bottom): Bernard Boutrit/Woodfin Camp and Associates; page 953 (bottom): Oroñoz, Madrid; page 955 (top): Oroñoz, Madrid; page 955 (bottom): Hamburg Kunsthalle, Germany/Bridgeman Art Library; page 956: Tate Gallery, London/Art Resource, NY; page 957 (top): © The National Gallery, London; page 957 (bottom): © The Frick Collection, New York; page 959 (right): © Smithsonian American Art Museum, Washington, DC/Art Resource, NY; page 960: Photograph ©1995 The Metropolitan Museum of Art; page 961 (top): Photograph © 1992 The Metropolitan Museum of Art; page 962 (left): The New York Public Library, Astor, Lenox, and Tilden Foundations/Art Resource, NY; page 962 (right): Library of Congress, Washington, DC; page 963 (top): Karl Friedrich Schinkel, "Sammlung Architecktonischer Entwürfe, Princeton Architectural Press, 1989; page 963 (bottom): Royal Commission on the Historical Monuments of England, London. © Crown copyright. NMR; page 965 (left): © Société Française de Photographie; page 965 (right): Science Museum Picture Library; page 967 (left): Royal Photographic Society Collection at National Museum Photography, Film and Television, England; page 967 (right): © Centre des Monuments Nationaux, Paris; page 968 (right): Gendreau Collection/CORBIS; page 969 (top): Bibliothèque Nationale de France, Paris; page 969 (bottom): Roger-Viollet, Paris; page 970 (left): Giraudon/Art Resource, NY; page 971: © Sterling and Francine Clark Art Institute, Williamstown, Massachusetts; page 973 (top): Erich Lessing/Art Resource, NY; page 973 (bottom): Réunion des Musées Nationaux/Art Resource, NY; page 974: Bridgeman Art Library; page 975 (top): Photo by Hervé Lewandowski/Réunion des Musées Nationaux/Art Resource, NY; page 975 (bottom): © National Gallery of Canada, Ottawa. Purchase, 1946; page 976 (top): Hamburger Kunsthalle, Hamburg, Germany/Bridgeman Art Library; page 977: © Manchester City Art Galleries; page 978 (bottom): © William Morris Gallery, London; page 981 (top): Réunion des Musées Nationaux/Art Resource, NY; page 981 (bottom): Photo by Hervé Lewandowski/Réunion des Musées Nationaux/Art Resource, NY; page 982: Photograph © 1989 The Metropolitan Museum of Art; page 983: Photo by Robert Newcombe/© 1998 The Nelson Gallery Foundation-All Reproduction Rights Reserved; page 984: Photo by Victor Pustai/Jane Voorhees Zimmerli Art Museum; page 985: Photo by Mel McLean/© 1988 The Nelson Gallery Foundation-All Reproduction Rights Reserved; page 986: Réunion des Musées Nationaux/Art Resource, NY; page 987 (top): Photograph © 1980 The Metropolitan Museum of Art; page 988 (left): Tate Gallery, London/Art Resource, NY; page 989: © The National Gallery, London; page 991 (bottom): Photo by Dean Beasom/Image © 2004 Board of Trustees, National Gallery of Art, Washington; page 992: Photograph © 1996 The Metropolitan Museum of Art; page 994 Photograph © The Art Institute of Chicago, All Rights Reserved; page 996: Photograph © The Art Institute of Chicago, All Rights Reserved; page 997: Digital Image @ The Museum of Modern Art/Licensed by SCALA/Art Resource, NY; page 998: Photograph © The Art Institute of Chicago, All Rights Reserved; page 999 (left): Photo by J. G. Berizzi/Réunion des Musées Nationaux/Art Resource, NY; page 999 (right): Photograph © 2001 The Museum of Modern Art, New York; page 1000: Photograph © 2001 The Museum of Modern Art, New York; page 1002: Photo by Lee Stalsworth/Hirshhorn Museum and Sculpture Garden; page 1003: Bayerische Staatsgemäldesammlungen/Kunstdia-Archiv ARTOTHEK, D-Peissenberg; page 1004 (left): Photograph courtesy The Museum of Modern Art, New York; page 1004 (right): Photograph © 2001 The Museum of Modern Art, New York; page 1007 (top): © Smithsonian American Art Museum, Washington, DC/Art Resource, NY; page 1008 (top): Photograph @ 1985 The Metropolitan Museum of Art; page 1010 (top): © Jeffrey Nintzel; page 1012 (top): Jefferson College, Philadelphia/Bridgeman Art Library; page 1012 (bottom): Courtesy Academy of Natural Sciences of Philadelphia; page 1013 (top): Copy Print @ 2001 The Museum of Modern Art, New York; page 1014: © Smithsonian American Art Museum, Washington, DC/Art Resource, NY; page 1015 (top): Erich Lessing/Art Resource, NY; page 1015 (bottom): Bettmann/ CORBIS; page 1016 (left): Chicago Architectural Photographing Company; page 1017: New York City Parks Photo Archive.

Chapter 28

Pages 1018-1019: Cahiers d'Art. #8-10, 1937. Art & Architecture Collection, Miriam and Ira D. Wallach Division of Art. Photo The New York Public Library, Astor Lenox, and Tilden Foundations/Art Resource. NY; page 1021: Adam Woolfitt/CORBIS; page 1022 Bildarchiv d. ÖNB, Wein; page 1023: Image © 2001 Board of Trustees, National Gallery of Art, Washington; page 1024 (bottom): Photograph @ Reproduced with the Permission of The Barnes Foundation™, All Rights Reserved; page 1025 (left): Bildarchiv Preussischer Kulturbesitz, Berlin; page 1026 (left): Digital Image @ The Museum of Modern Art/Licensed by SCALA/Art Resource, NY; page 1026, (right): Photo by Joerg P. Anders/Bildarchiv Preussischer Kulturbesitz/Art Resource, NY; page 1027: Photo by Martin Bühler/Oeffentliche Kunstsammlung Basel, Kunstmuseum, Basel; page 1028: Photograph © 1985 The Metropolitan Museum of Art; page 1029: Photograph © The Art Institute of Chicago, All Rights Reserved; page 1030 (bottom): Photograph © 2003 The Metropolitan Museum of Art; page 1031 (left): Photograph @ 2001 The Museum of Modern Art, New York; page 1031 (right): Photograph © 2001 The Museum of Modern Art, New York; page 1032 (left): Photograph © 2001 The Museum of Modern Art, New York; page 1032 (right): Réunion des Musées Nationaux/Art Resource, NY; page 1033: Photo by Bob Grove/Image © 2001 Board of Trustees, National Gallery of Art, Washington; page 1034: Digital Image @ The Museum of Modern Art/Licensed by SCALA/Art Resource, NY; page 1035 (left): Photo by Martin Bühler/Oeffentliche Kunstsammlung Basel, Kupferstichkabinett, Basel; page 1036: Photo by Lee B. Ewing/© The Solomon R. Guggenheim Foundation, New York; page 1037 (left): Digital Image © The Museum of Modern Art/Licensed by SCALA/Art Resource, NY; page 1038 (left): Réunion des Musées Nationaux/Art Resource, NY; page 1038 (right): Photograph © 2001 The Museum of Modern Art, New York; page 1039 (top): Colorphoto Hinz, Allschwil-Basel, Switzerland/© L & M Services B.V. Amsterdam, 20031010; page 1039 (bottom): L & M Services B.V. Amsterdam, 20031010; page 1040: Photograph © 2001 The Museum of Modern Art, New York; page 1041 (left): Digital Image @ The Museum of Modern Art/Licensed by SCALA/Art Resource, NY; page 1043: Photograph © Whitney Museum of American Art, New York; page 1044: Photograph © 1986 The Met-

ropolitan Museum of Art; page 1045 (top): Photo by Ben Blackwell/San Francisco Museum of Modern Art; page 1045 (bottom): © Hedrich Blessing/Chicago Historical Society; page 1046: David R. Phillips/ Chicago Architectural Photographing Company; page 1047 (left): Collection of The New-York Historical Society, (Neg #46309); page 1047 (right): Albertina, Wien; page 1048 (top): Art Resource, NY; page 1052 (top): Roger-Viollet, Paris; page 1052 (bottom): Photo by Hickey-Robertson, Houston/The Menil Collection; page 1053 (top): © Florian Monheim/ artur architekturbilder agentur; page 1053 (bottom): James Linders, Rotterdam; page 1054: Photograph © 2001 The Museum of Modern Art, New York; page 1055 (top): Photograph © 2001 The Museum of Modern Art, New York; page 1055 (bottom): © Foundation Le Corbusier; page 1056: © Foundation Le Corbusier; page 1057: Photo by Fred Kraus/© Bauhaus Archiv, Berlin; page 1058 (top): Photo by Michael Nedzweski/© President and Fellows of Harvard College, Harvard University, Massachusetts; page 1058 (bottom): Photograph courtesy The Museum of Modern Art, New York; page 1059: George Grosz-Archiv/Akademie des Kunste, Berlin; page 1060 (left): Photograph courtesy The Museum of Modern Art, New York; page 1060 (right): Photo courtesy Harry N. Abrams, Inc. New York. From "Performance Live Art 1909 to the Present," 1979; page 1061 (left): The Vera, Sylvia and Arturo Schwarz Collection of Dada and Surrealist Art Collection, Israel Museum, Jerusalem; page 1064 (bottom): Digital Image © The Museum of Modern Art/Licensed by SCALA/Art Resource, NY; page 1065 (top): Digital Image © The Museum of Modern Art/Licensed by SCALA/Art Resource, NY; page 1065 (bottom): Photograph © 2001 The Museum of Modern Art, New York; page 1067: Tate Gallery, London/Art Resource, NY; page 1069: Digital Image © Museum of Modern Art/Licensed by SCALA/Art Resource, NY; page 1070: Photograph © The Art Institute of Chicago, All Rights Reserved; page 1071 (bottom): Photograph © The Art Institute of Chicago, All Rights Reserved; page 1073 (top): Photo by Manu Sassoonian/Schomburg Center for Research in Black Culture/New York Public Library, Astor, Lenox and Tilden Foundations; page 1073 (bottom): Courtesy Donna Mussenden VanDerZee; page 1075: Photo by Michael Cavanagh and Kevin Montague/© 2001 Indiana University Art Museum; page 1076 (top): Digital Image @ The Museum of Modern Art/Licensed by SCALA/Art Resource, NY; page 1076 (bottom): Photo by Victoria Garagliano/© Hearst Castle ®/California State Parks; page 1077: Thomas A. Heinz/CORBIS; page 1078 (top): Bettmann/CORBIS; page 1078 (bottom): Bob Schalkwijk/Art Resource, NY; page 1079: Instituto Nacional de Bellas Artes y Literatura, Dirección de Asuntos Juridicos, Mexico; page 1080 (top): Photograph @ 2001, Art Institute of Chicago, All Rights Reserved; page 1080 (bottom): O National Gallery of Canada, Ottawa. Purchased 1918; page 1081: Photo by Trevor Mills/Vancouver Art Gallery, British Columbia

Chapter 29

Pages 1082-1083: Claudio Abate/INDEX, Firenze; page 1085 (top): Digital Image © The Museum of Modern Art/Licensed by SCALA/Art Resource, NY; page 1085 (bottom): Photograph © The Art Institute of Chicago, All Rights Reserved; page 1087 (top): Photograph © 2001 The Museum of Modern Art, New York; page 1087 (bottom): O National Gallery of Canada, Ottawa. Purchased 1954; page 1089: Digital Image © The Museum of Modern Art/Licensed by SCALA/Art Resource, NY; page 1090 (right): Estate of Hans Namuth, New York; page 1091 (top): Photograph ©1998 The Metropolitan Museum of Art; page 1091 (bottom): Photograph © 1997 Whitney Museum of American Art, New York; page 1092: Digital Image © The Museum of Modern Art/Licensed by SCALA/Art Resource, NY; page 1093: Photo by Valerie Walker/The Museum of Contemporary Art, Los Angeles; page 1094: Photograph © 2001 The Museum of Modern Art, New York; page 1095: Photograph © 2001 Whitney Museum of American Art, New York; page 1096: Digital Image © The Museum of Modern Art/Licensed by SCALA/Art Resource, NY; page 1097 (top): Image © 2004 Board of Trustees, National Gallery of Art, Washington; page

1098: Lawrence Shustack; page 1099 (left): Courtesy Shozo Shimamoto; page 1099 (right): Harry Shunk, New York; page 1100: Photograph @ The Museum of Modern Art, New York; page 1102: Digital Image © The Museum of Modern Art/Licensed by SCALA/ Art Resource, NY; page 1103 (left): Tate Gallery, London/Art Resource, NY; page 1103 (right): Roy Lichtenstein Inc.; page 1104 (top): Tate Gallery London/Art Resource, NY; page 1105 (left): © The Solomon R. Guggenheim Foundation, New York; page 1105 (right): O National Gallery of Canada, Ottawa. Purchased 1966; page 1106: Digital Image © The Museum of Modern Art/Licensed by SCALA/ Art Resource, NY; page 1108: Photo by Geoffrey Clements/Photograph © 1996 Whitney Museum of American Art, New York; page 1109 (top): Digital Image @ The Museum of Modern Art/Licensed by SCALA/Art Resource, NY; page 1109 (bottom): Photo by Eric Pollitzer/Leo Castelli Photo Archives; page 1110: © 1974 Caroline Tisdall; page 1111 (top): Photograph © The Art Institute of Chicago, All Rights Reserved; page 1111 (bottom): Photograph © 2001 The Museum of Modern Art, New York; page 1112 (top): Courtesy and @ The Minor White Archive, Princeton, NJ; page 1112 (bottom): Photograph courtesy and © 2001, The Art Institute of Chicago, All Rights Reserved; page 1113 (left): Photo by M. Lee Fatherree/Oakland Museum of California; page 1114 (left): Photo by Sheldan Comfort Collins/Collection of the American Craft Museum, NY; page 1114 (right): © Esto; page 1115: © Ezra Stoller/ ESTO; page 1116 (top): Photo by Timothy Hursley. Courtesy of Moshe Safdie and Associates; page 1116 (center): Venturi, Scott Brown and Associates, Inc.; page 1116 (bottom): Venturi, Scott Brown and Associates, Inc.; page 1117 (bottom): Burg/Olivier Schuh; page 1118 (top): Réunion des Musées Nationaux/Art Resource, NY; page 1118 (bottom): Photo by Ian Lambot, London/Courtesy Foster and Partners; page 1119: © Richard Bryant/ESTO/Arcaid; page 1120 (top): Javier Bauluz/AP Wide World; page 1120 (bottom): Photo by David Heald/© The Solomon R. Guggenheim Foundation, New York; page 1121: © Archimation. Courtesy Studio Daniel Libeskind; page 1122 (top): © Michael Heizer; page 1122 (bottom): Photo by Gianfranco Gorgoni/Courtesy James Cohan Gallery, NY/Collection DIA Center for the Arts, NY; page 1123 (top): ©1976 Christo; page 1124 (left): © Bret Gustafson; page 1125: Photo by Benjamin Blackwell/UC Berkeley Art Museum; page 1126 (top): Photo © Donald Woodman/ Through The Flower, New Mexico; page 1126 (bottom): Photo © Donald Woodman/Through the Flower; page 1127: Robert Hickerson; page 1128: © The Solomon R. Guggenheim Foundation, New York; page 1129: Courtesy of the Estate of Ana Mendieta and Galerie Lelong, New York; page 1132 (bottom): Photograph © 2001, The Art Institute of Chicago, All Rights Reserved; page 1133 (top): Photo by Michael Tropea/The Des Moines Art Center; page 1134 (right): Fred Scruton, Courtesy John Weber Gallery, New York; page 1135 (right): Courtesy Paula Cooper Gallery; page 1136 (top): Photo by Robert Newcombe/© 1995 The Nelson Gallery Foundation-All Reproduction Rights Reserved; page 1136 (bottom): O Smithsonian American Art Museum, Washington DC/Art Resource, NY; page 1137 (right): Photo by Eva Heyd/Collection of the American Craft Museum, New York; page 1138 (right): Courtesy Art + Commerce Anthology; page 1139: Photo by Susan Einstein/Photograph © 2000, The Art Institute of Chicago, All Rights Reserved; page 1141 (top): Jeff Wall Studio; page 1141 (bottom): Edward Nausner/The New York Times Pictures; page 1142: Courtesy of Victoria Miro Gallery, London; page 1143: Jennifer Steinkamp, courtesy ACME, Los Angeles, California; page 1144: © Peter Aaron/Esto; page 1145 (top): Social and Public Art Resource Center (SPARC), Venice, CA; page 1146: © John Davies, Cardiff, Wales; page 1148 (top): Photo by David Heald/© The Solomon R. Guggenheim Foundation, New York; page 1148 (bottom): William Struhs; page 1149 (bottom): Photo © 1997 Fotoworks - Benny Chan; page 1150: Courtesy Barbara Gladstone; page 1151 (top): Photo by Larry Barns/Courtesy Barbara Gladstone; page 1151 (bottom): Photo by Larry Barns/Courtesy Barbara Gladstone; page 1152: Photo by Ben Blackwell/San Francisco Museum of Modern Art

Artist Copyrights

Page xxxii (bottom): © 2005 The Georgia O'Keefe Foundation/Artists Rights Society (ARS), New York; page xxxiii: © Estate of David Smith/Licensed by VAGA, New York, NY; page xxxix: © Dale Chihuly; page xliii: © 2005 Frank Lloyd Wright Foundation/ Artists Rights Society (ARS), New York; page 835: © Chuichi Fujii; page 857 (bottom): © Jaune Quick-to-See Smith; page 1001 (top): © 2005 Artists Rights Society (ARS), New York/SABAM, Brussels; page 1001 (bottom): © 2005 The Munch Museum/ The Munch-Ellingsen Group/Artists Rights Society (ARS), New York; page 1013 (top): © 2005 The Georgia O'Keeffe Foundation/Artists Rights Society (ARS), New York; pages 1018–1019: © 2005 Estate of Pablo Picasso/Artist Rights Society (ARS), New York; © 2005 Estate of Alexander Calder/Artist Rights Society (ARS), New York; page 1023: © 2005 Artist Rights Society (ARS)/ADAGP, Paris; page 1024 (top): © 2005 Succession H. Matisse, Paris/Artists Rights Society (ARS), New York; page 1024 (bottom): © 2005 Succession H. Matisse, Paris/Artists Rights Society (ARS), New York; page 1025 (left): © 2005 Arists Rights Society (ARS), New York/VG Bild-Kunst, Bonn; page 1025 (right): © 2005 Artists Rights Society (ARS), New York/VG Bild-Kunst, Bonn; page 1026 (left): Ernst Ludwig Kirchner, © by Dr. Wolfgang & Ingeborg Henze-Ketterer, Wichtrach/Bern; page 1026 (right): © 2005 Artists Rights Society (ARS), New York/VG Bild-Kunst, Bonn; page 1029 © 2005 Artists Rights Society, (ARS) New York/ ADAGP, Paris; page 1030 (bottom): © 2005 Artist Rights Society (ARS), New York/VG Bild-Kunst, Bonn; page 1031 (left): © 2005 Artists Rights Society (ARS), New York/ADAGP, Paris; page 1031 (right): © 2005 Succession H. Matisse, Paris/Artist Rights Society (ARS), New York; page 1032 (left): © 2005 Artists Rights Society (ARS), New York/ADAGP, Paris; page 1032 (right): © 2005 Estate of Pablo Picasso/Artists Rights Society (ARS), New York; page 1033: © 2005 Estate of Pablo Picasso/Artist Rights Society (ARS), New York; page 1034: © 2005 Estate of Pablo Picasso/Artists Rights Society (ARS), New York; page 1035 (left): © 2005 Estate of Pablo Picasso/Artists Rights Society (ARS), New York; page 1035 (right): © 2005 Artists Rights Society (ARS), New York/ADAGP, Paris; page 1036: © 2005 Artists Rights Society (ARS), New York/ADAGP, Paris; page 1037 (left): © 2005 Estate of Pablo Picasso/Artists Rights Society, New York; page 1037 (right): © 2005 Estate of Pablo Picasso/Artists Rights Society (ARS), New York; page 1038 (left): © 2005 Estate of Pablo Picasso/Artists Rights Society (ARS), New York; page 1038 (right): © Estate of Jacques Lipchitz, Courtesy Marlborough Gallery, New York; page 1039 (top): © L & M Services B.V. Amsterdam, 20031010; page 1039 (bottom): © L & M Services B.V. Amsterdam, 20031010; page 1041 (right): © Artists Rights Society (ARS), York/ADAGP, Paris; page 1042 (right): © Estate of Vladimir Tatlin/RAO, Moscow/VAGA, New York; page 1045 (top): © Estate of Paul Strand; page 1045 (bottom): © 2005 Frank Lloyd Wright Foundation/ Artists Rights Society (ARS), New York; page 1046: © 2005 Frank Lloyd Wright Foundation/Artists Rights Society (ARS), New York; page 1047 (right): © 2005 Artists Rights Society (ARS), New York/VBK, Vienna; page 1048 (top): © 2005 Artists Rights Society (ARS), New York/VG Bild-Kunst, Bonn; page 1050 (left): © Estate of Vladimir Tatlin/Licensed by VAGA, New York, NY; page 1050 (right): © Estate of Alexander Rodchenko/RAO, Moscow/VAGA, New York; page 1051: © 2005 Artists Rights Society (ARS), New York/VG Bild-Kunst, Bonn; page 1052 (top): © Estate of Vera Mukhina; page 1052 (bottom): © 2005 Mondrian/Holtzman Trust/c/o Artists Rights Society (ARS), New York; page 1053 (top): © 2005 Artists Rights Society (ARS), New York/Beeldrecht, Amsterdam; page 1053 (bottom): © 2005 Artists Rights Society (ARS), New York/Beeldrecht, Amsterdam; page 1054: © 2005 Estate of Pablo Picasso/Artist Rights Society (ARS), New York; page 1055 (top): © 2005 Artists Rights Society (ARS), New York/ADAGP, Paris; page 1055 (bottom): © 2005 Artists Rights Society (ARS), New York/ADAGP,

Paris; page 1056: © 2005 Artists Rights Society (ARS), New York/ADAGP, Paris; page 1057: © 2005 Artists Rights Society (ARS), New York/VG Bild-Kunst, Bonn; page 1058 (top): © 2005 The Joseph and Anni Albers Foundation/Artists Rights Society (ARS), New York; page 1058 (bottom): © 2005 Artists Rights Society (ARS), New York/VG Bild-Kunst, Bonn; page 1059: © Estate of George Grosz/Licensed by VAGA, New York, NY; page 1060 (left): © 2005 Artists Rights Society (ARS), New York/VG Bild-Kunst, Bonn; page 1061 (left): © 2005 Artists Rights Society (ARS), New York/VG Bild-Kunst, Bonn; page 1061 (right): © 2005 Artists Rights Society (ARS), New York/VG Bild-Kunst, Bonn; page 1062: © 2005 Artists Rights Society (ARS), New York/ADAGP, Paris/Estate of Marcel Duchamp; page 1063: © 2005 Artists Rights Society (ARS), New York/ADAGP, Paris/Estate of Marcel Duchamp; page 1064 (top): © 2005 Artists Rights Society (ARS), New York/ADAGP, Paris; page 1064 (bottom): © 2005 Artists Rights Society (ARS), New York/ ADAGP, Paris; page 1065 (top): © 2005 Kingdom of Spain, Gala-Salvador Dali Foundation/ Artists Rights Society (ARS), New York; page 1065 (bottom): © 2005 Artists Rights Society (ARS), New York/Pro-Litteris, Zürich; page 1066: © 2005 Artists Rights Society (ARS), New York/ADAGP, Paris; page 1067: Reproduced by permission of © The Henry Moore Foundation; page 1068: © 2005 The Georgia O'Keefe Foundation/Artists Rights Society (ARS), New York; page 1073 (top): Aaron and Alta Douglas Foundation; page1073 (bottom): © Donna Mussenden Van-DerZee; page 1074: © 2005 Gwendolyn Knight Lawrence/Artist Rights Society (ARS), New York; page 1075; © Estate of Stuart Davis/Licensed by VAGA, New York, NY; page 1076 (top): © 2005 Estate of Alexander Calder/Artist Rights Society (ARS), New York; page 1077: © 2005 Frank Lloyd Wright Foundation/Artists Rights Society (ARS), New York; page 1078 (bottom): © 2001 Banco de México Diego Rivera & Frida Kahlo Museums Trust. Av. Cinco de Mayo No. 2, Col. Centro, Del. Cuauhtémoc 06059, Mèxico, D.F.; page 1079: © 2001 Banco de México, Diego Rivera & Fridas Kahlo Museums Trust. Av., Cinco de Mayo No. 2, Col. Centro, Del. Cuauhtémoc 06059, Mexico, D.F.; page 1080 (top): © Manuel Alvarez-Bravo; page 1085 (top): @ 2005 Artists Rights Society (ARS), New York/ProLitteris, Zürich; page 1085 (bottom): © 2005 The Estate of Francis Bacon/ARS, New York/DACS, London; page 1087 (top): © 2005 Artists Rights Society (ARS), New York/ADAGP, Paris; page 1087 (bottom): © 2005 Artist Rights Society (ARS), New York/ADAGP, Paris; page 1088: © 2005 Artists Rights Society (ARS), New York/ADAGP, Paris; page 1089: © 2005 Estate of Arshile Gorky/Artists Rights Society (ARS), New York; page 1090 (left): © 2005 The Pollock-Krasner Foundation/Artists Rights Society (ARS), New York; page 1090 (right): © Estate of Hans Namuth, New York; page 1091 (top): © 2005 The Pollock-Krasner Foundation/Artist Rights Society (ARS), New York; page 1091 (bottom): © 2005 Pollack-Krasner Foundation/Artists Rights Society (ARS), New York; page 1092: © 2005 The Willem de Kooning Foundation/ Artists Rights Society (ARS), New York; page 1093: © 1998 Kate Rothko Prizel & Christopher Rothko/ Artists Rights Society (ARS), New York; page 1094: © 2005 Barnett Newman Foundation/ Artist Rights Society (ARS), New York; page 1095: © Estate of David Smith/Licensed by VAGA, New York; page 1096: © 2005 Estate of Louise Nevelson/Artists Rights Society (ARS), New York; page 1097 (top): © Helen Frankenthaler; page 1097 (bottom): © The George and Helen Segal Foundation/Licensed by VAGA, New York, NY; page 1099 (right): © 2005 Artists Rights Society (ARS), New York/ADAGP, Paris; page 1100: © 2005 Artists Rights Society (ARS), New York/ADAGP, Paris; page 1101: © Robert Rauschenberg/Licensed by VAGA, New York, NY; page 1102: © Jasper Johns/Licensed by VAGA, New York, NY; page 1103 (left): @ 2005 Artists Rights Society (ARS), New York/DACS, London; page 1103 (right): © Estate of Roy Lichtenstein; page 1104 (top): © 2005 Andy Warhol Foundation for the Visual Arts/(ARS), New York; page 1104 (bottom): © The

Claes Oldenburg Studio; page 1105 (right): © 2005 Artists Rights Society (ARS), New York/SODRAC, Montreal; page 1106: 2005 © Bridget Riley, All Rights Reserved. Courtesy Karsten Schubert, London; page 1107 (top): © 2005 Frank Stella/Artist Rights Society (ARS), New York; page 1107 (bottom): Art © Donald Judd Estate/Licensed by VAGA, New York, NY; page 1108: Reproduced courtesy of Estate of Eva Hesse, Gallerie Hauser&Wirth, Zurich; page 1109 (top): © 1998 Joseph Kosuth/Artists Rights Society (ARS), New York; page 1109 (bottom): © 2005 Bruce Nauman/Artist Rights Society (ARS), New York; page 1110: © 2005 Artists Rights Society (ARS), New York/VG Bild-Kunst, Bonn; page 1111 (top): Copyright © The Americans, Robert Frank, courtesy Pace/MacGill Gallery, New York; page 1111 (bottom): Copyright © 2001 Estate of Diane Arbus; page 1112 (top): © The Minor White Archive, Princeton, NJ; page 1112 (bottom): © Jerry Uelsmann; page 1113 (left): Estate of Peter Voulkos; page 1113 (right): © The Minor White Archive, Princeton, NJ; page 1114 (right): © 2005 Artists Rights Society (ARS), New York/VG Bild-Kunst, Bonn; page 1116 (center): Venturi, Scott Brown and Associates, Inc.; page 1116 (bottom): Venturi, Scott Brown and Associates, Inc.: page 1121: @ Archimation. Courtesy Studio Daniel Libeskind; page 1122 (top): © Michael Heizer; page 1122 (bottom): © Estate of Robert Smithson/Licensed by VAGA, New York, NY; page 1123 bottom: © Richard Estes, Courtesy Marlborough Gallery, New York; page 1124 (left): © Estate of Duane Hanson/Licensed by VAGA, New York, NY; page 1124 (right): © The Estate of Alice Neel, Courtesy of the Robert Miller Gallery, New York; page 1126 (top): © Judy Chicago, 1979. Courtesy of Through The Flower, New Mexico; page 1126 (bottom): © Judy Chicago, 1979. Courtesy of Through The Flower, New Mexico; page 1127: © Miriam Schapiro, courtesy of the artist; page 1128: © Faith Ringgold, Inc.; page 1129: Courtesy of the Estate of Ana Mendieta and Galerie Lelong, New York; page 1131: © 2005 Artist Rights Society (ARS), New York/ADAGP, Paris; page 1132 (top): @ Anselm Kiefer, Courtesy of the Gagosian Gallery, New York; page 1132 (bottom): © Sigmar Polke; page 1133 (top): © Peter Halley; page 1135 (left): Courtesy of the artist and Metro Pictures, New York; page 1135 (right): © Elizabeth Murray, Reproduced courtesy of the artist, Paula Cooper Gallery, NY; page 1136 (top): © Martin Puryear; page 1136 (bottom): ©1985 Wendell Castle; page 1138 (left): © Magdalena Abakanowicz, Courtesy Marlborough Gallery, New York; page 1138 (right): "Ajitto, 1981" © The Robert Mapplethorpe Foundation. Courtesy, Art + Commerce Anthology; page 1139: © Kiki Smith, reproduced courtesy of the artist; page 1140: Courtesy of the artist and Luhring Augustine Gallery, New York; page 1141 (top): Jeff Wall Studio; page 1141 (bottom): © 2005 Richard Serra/Artists Rights Society (ARS), New York; page 1142: © Chris Ofili, Courtesy of Victoria Miro Gallery, London; page 1143: Jennifer Steinkamp, courtesy ACME, Los Angeles, California; page 1146: Courtesy of the artist and Luhring Augustine Gallery, New York; page 1147: © Mel Chin, Reproduced courtesy of the artist; page 1148 (top): © 2005 Jenny Holzer/Artists Rights Society (ARS), New York; page 1149 (bottom): Bill Viola Studio; page 1150: © 2002 Matthew Barney; page 1151 (top): © 2000 Shirin Neshat; page 1151 (bottom): © 2000 Shirin Neshat.

Text Copyrights

Pages 606, 632, 658, 698 Scripture selections are taken from the New American Bible (c) 1970, 1986, 1990 by Confraternity of Christian Doctrine, Washington, D.C. Used with permission; page 645 Anthony Hughes, Michelangelo. Reprinted by permission of Phaidon Press, London, 1997; page 797: From Love Song of the Dark Lord by Barbara Stoller Miller. Copyright ©1977 by Barbara Stoller Miller. Reprinted by permission of Columbia University Press; page 812: Reprinted from Eight Dynasties of Chinese Painting: The Collections of the Nelson Gallery-Atkins Museum, Kansas City and Cleveland Museum of Art, Cleveland Museum of Art & University Press, 1980.

INDEX

Illustration references are in italic type. A Abakanowicz, Magdalena, Backs, 1137-1138, Abelam, 863 Aborigines, Australia, 861–862, 861, 862, 872 Abstract Expressionism, 815, 872, 1087–1095, alternatives to, 1095–1105 Abstraction, xxxii, 881, 993, 1021, 1074–1075, Post-Painterly, 1105–1106, *1105, 1106* Abul Hasan and Manohar, *Jahangir in Darbar*, 793, 795 Academicians of the Royal Academy (Zoffany), 910, 910
Academies, 906, 910
Action painting (gesturalism), 872, 1090–1093, 1090, 1091, 1092
Adam, Robert, 934–935 Adam, Robert, 934–935
Anteroom, Syon House, England, 917, 917
Adam and Eve (Dürer), 679, 679
Adams, Samuel, 896, 897
Adoration of the Magi (Gentile da Fabriano), 628–629, 629
Aedicula, 630, 686 Aerial (atmospheric) perspective, 579, 583, 994 Aeroplane over a Train (Goncharova), 1041, 1041 Aesthetics, xxx Africa cultures in, 877 historical view of, 876–879 historical view of, 876–879 map of, 876 timeline, 876–877 African American artists Douglas, Aaron, 1072, 1073 Harlem Renaissance, 1072–1074, 1073, 1074 Lawrence, Jacob, 1073–1074, 1074 Lewis, Edmonia, 1006–1007, 1007 Puryear, Martin, 1135–1136, 1136 Ringgold, Faith, 1127, 1128 Saar, Betye, 1125, 1125 Tanner Henry Ossawa, 1014, 1015 Tanner, Henry Ossawa, 1014, 1015 VanDerZee, James, 1072–1073, 1073 African art

Ashanti Kente cloth, Ghana, 887, 887 Ashanti staff Ghana, 874, 875, 886–887 Baule spirit figure (blolo bla), Côte d'Ivoire,

Bwa masks, Burkina Faso, 881-882, 881 ceramics, 893–895, 894, 895 contemporary, 892–895, 893, 894, 895 dance staff depicting Eshu, Yoruba, Nigeria, 886, 886

Dogon Kanaga mask, Mali, 890–891, 890 Ekpo mask, Anang Ibibio, Nigeria, 890, 890 Fang, Nlo byeri guardian, Gabon, 891, 891

Fang, Nlo byeri guardian, Gabon, 891, 891 funerary, 890–892, 891, 892 furniture, Art Deco style, 878, 878 Guro spirit mask, Côte d'Ivoire, 892, 893 Ijo ancestral screens, Nigeria, 891–892, 892 initiation, 881–883, 881, 882, 883 Kongo spirit figure (nkisi nkonde),

Democratic Republic of the Congo,

Democratic Republic of the Congo, 883–885, 884

Kuba portrait sculpture, Democratic Republic of the Congo, 887–888, 887

Lega bwami masks, Democratic Republic of the Congo, 882–883, 883

Lobi spirit figure (boteba), Burkina Faso,

883, 884

883, 884 Mende masks, Sierra Leone, 882, 882 Mossi dolls (biiga), Burkina Faso, 880, 880 Nankani compound, Ghana, 879, 879 Olowe of Ise, door of palace, Yoruba, Nigeria,

spirit world, 883-886, 884, 885, 886 twin figures (ere ibeji), Yoruba, Nigeria,

880–881, 880
After "Invisible Man" by Ralph Ellison, the Preface (Wall), 1139–1140, 1141
Ajitto (Back) (Mapplethorpe), 1138, 1138
Akbar, Indian ruler, 792, 793

Akiode, Twin figures (ere ibeji), Yoruba culture, Nigeria, 880–881, *880* Albani, Alessandro, 912 Albarello, Renaissance jar, 627–628, 627

Albers, Anni, Wall hanging, 1057, 1058

Alberts, Josef, 1057 Alberti, Leon Battista, 583 On Architecture, 710, 717 On Painting, 617 On Sculpture, 617

On Sculpture, 617
Palazzo Rucellai, 617, 617
Sant' Andrea church, 618, 618, 619
Album leaves, 804, 806
Alexander VI, pope, 647
Alexander VII, pope, 722
Allegory, 617, 732
Allegory of Sight, from Allegories of the Five
Senses (Brueghel and Rubens), 763, 763
Allegory with Venus and Cupid (Bronzino),
602-604, 604

692–694, 694 Alma-Tadema, Lawrence, Pheidias and the Frieze of the Parthenon, Athens, xliii, xliii Frieze of the Parthenon, Alhens, XIIII, XIIII
Altarpiece of Saint Vincent (Gonçalves), 607, 607
Altarpiece of the Holy Blood (Riemenschneider),
672-674, 673
Altars and altarpieces, 590
Portinari Altarpiece, 601-602, 601
Altdorfer, Albrecht, 681

Altdorler, Albrecht, 681

Danube Landscape, 682, 683

Altes Museum (Schinkel), Berlin, 962–963, 963

Alvarez Bravo, Manuel, Laughing Mannequins, 1079, 1080

America

art and architecture between World War I and

World War II, 1067–1077 English colonies, 783 federal patronage of art, 1069 Gothic Revival in, 964, 964 Industrial Revolution, 942–943

map of, in the nineteenth century, 942 naturalism in, 968–969, 959
Neoclassicism in, 934–939, 960–961, 961, 962
timeline, 1020–1021

twentieth century in, 1020–1021 American art

Abstract Expressionism, 815, 872, 1087–1095, 1088–1097
Abstraction, 1074–1075, 1075
architecture, early, 783–784, 784
architecture, Gothic Revival, 964, 964

architecture, interwar years, 1075, 1076, 1077, 1077, 1078 architecture, late nineteenth century, 1014–1017, 1015, 1016 architecture, Modernism, 1043, 1045–1046,

1045, 1046

architecture, Neoclassicism, 934-936, 935, 936, 962, 962 craft art, 1111, 1113, 1113, 1136–1137,

Craft art, 1113, 1113, 1113, 1113, 1136–1131, 1136, 1137
English influence, 783–784, 784, 785
genre painting, 960, 961
Harlem Renaissance, 1072–1074, 1073, 1074
landscape painting, 959–960, 960
Modernism, 1042–1046, 1045, 1046
New York School, 815, 872, 1087–1095, 1098

1088-1097

painting, early, 784, 785 painting, landscape, 1007–1008, 1007, 1008 painting, naturalism, 958–959, 959 painting, Neoclassicism, 936–939, 937, 938

painting, Neoclassicism, 936–939, 937, 9 painting, religious, 1014, 1014, 1015 painting, scene, 1068, 1070, 1070 photography, 1011–1013, 1012, 1013, 1070–1072, 1071, 1072 photography, Civil War, 1009, 1009 photography, postwar, 1110–1111, 1111 Pop art, 1101–1105, 1103, 1104 Precisionism 1068, 1069 Precisionism, 1068, 1069

Precisionism, 1068, 1069
Realism, post-Civil War, 1009, 1010, 1011
sculpture, Civil War, 1009, 1010
sculpture, Neoclassicism, 960–961, 961, 1005–1007, 1006, 1007
skycrapers, 1016, 1046, 1049, 1047
American Gothic (Wood), 1070, 1070

American Landscape (Sheeler), 1068, 1069

American Place, An, 1067 American Revolution, 897, 898, 937–939

Americans, The (Frank), 1110 Americas. See Mesoamerica

Analytic Cubism, 1035-1037, 1035, 1036, 1037

Anang Ibibio, 890, 890 Anasazi, 839, 851

Anatomy Lesson of Dr. Nicolaes Tulp (Rembrandt), 767–768, 767 Ancestral screens, Ijo, Nigeria, 891–892, 892

Anciestial Scieetis, 130, Nigeria, 891–892, 892
Ancient Ruins in the Cañon de Chelley, Arizona
(O'Sullivan), 1008–1009, 1008
Andrea del Castagno, The Last Supper,
634–635, 634

Angelico, Fra (Guido di Pietro), 584, 632

Angelico, Fra (Guido di Pietro), 584, 632 Annunciation, 633–634, 633 Angel Kneeling in Adoration (Asam), 902, 902 Anguissola, Sofonisba, 695 Self-Portrait, 696, 696 Annunciation (Jan van Eyck), 593, 593 Annunciation (Jan van Eyck), 593, 593

Annunciation and Virgin of the Rosary (Stoss), 674, 674

Annunciation and Visitation (Broederlam), 588, 588 Antependium, 590

Anthropométries of the Blue Period (Klein), 1099, 1099

1099, 1099
Antonello da Messina, 642
Apollinaire, Guillaume, 1036, 1038
Apollo Attended by the Nymphs of Thetis
(Girardon), 743, 743
Apparition (Moreau), 999, 999
Apple Cup, silver (Krug), 672, 673
Appliqué, 867
Appropriation, 1125, 1130
Apse, 663
Aguinas, Thomas, 579

Aquinas, Thomas, 579 Arabesques, 793, 900, 1031 Arbus, Diane, *Child with Toy Hand Grenade*,

1110, 1111
Arcades, 616, 665, 792, 969
Arc de Triomphe, Paris, Departure of the
Volunteers of 1792 (The Marseillaise) (Rude), 952-953, 952

Archer, Frederick Scott, 966 Arches, pointed, 612 Architecture

Abelam tamberan houses, 863, 864 American, early, 783–784, 784 American, interwar years, 1075, 1076, 1077,

1077, 1078 American, late nineteenth century, 1014–1017, 1015, 1016 American, Modernism, 1043, 1045–1046,

1045, 1046 American, Neoclassicism, 934-936, 935, 936,

962, 962 Aztec, 840, 841 bridges, 935, 935, 968, 968 Chinese, 809–810, 811, 810 Deconstructivist, 1119–1121, 1119,

1120, 1121 de Stijl, 1053, 1053

elements of, 663, 665, 686, 825, 900,

1049, 1056 English Baroque, 779–780, 781, 782–783,

782, 783 English Classical Revival, 914–916, 914–916 English Gothic Revival, 916, 916,

English Gothic Revival, 916, 916, 963–964, 963
English Neoclassicism, 917, 917
English Renaissance, 715, 716
European Modernism, 1046–1049, 1047, 1048
Flamboyant style, 588–589, 589
French Baroque, 739–742, 739–742

French Neoclassicism, 927-929, 927, 928 French nineteenth century, 968–969, 969 French Purism, 1055–1057, 1055, 1056 French Renaissance, 702–706, 703, 704 German Neoclassicism, 962–963, 963

German/Austria Rococo, 900–902, 900, 901, 902

High Tech, 1118-1119, 1118 Hindu, 791-792, 791 Incas, 842-845, 843, 844

Architecture (cont.)	Steiner House (Loos), 1046-1047, 1047	Bateman, Ann, 918
Indian (Mughal period), 786–787, 787,	Automatism, 1064, 1086	Bateman, Hester, 918
792, <i>792</i> International style, 1056, 1114–1115	Autumn Colors on the Qiao and Hua Mountains (Zhao Mengfu), 804, 804–805	Bateman, Peter, 918 Bathers (Renoir), 990, 991
Italian Baroque, 722–729, 723–729	Autumn Rhythm (Number 30) (Pollock),	Battista Sforza and Federico da Montefeltro (Pier
Italian Renaissance, 611–622, 613–622,	1090–1091, 1091	della Francesca), 639, 639
662-665, 662, 664, 682, 684-685, 684, 686,	Avalokiteshvara, 789, 789	Battle of San Romano (Uccello), 576-577, 577
700–702, 700, 701	Avant-garde, xlii, 906, 944	Battle of the Nudes (Pollaiuolo), 611, 611
Japanese, 823, 823, 825	Bauhaus art in Germany, 1057, 1057, 1058,	Battle scene on buffalo-hide, 848, 849
landscape, 779–780, 914–916, <i>914–916</i> Maori, 870–871, <i>870</i>	1059–1060, <i>1060</i> postwar, 1086	Baudelaire, Charles, 967, 967, 980 Baudrillard, jean, 1132
Micronesia, 866, 866	Avenue at Middelharnis (Hobbema), 773,	Bauhaus art in Germany, 1057, 1057, 1058,
Nankani compound, Ghana, 879, 879	774, 775	1059–1060, 1060
nineteenth century use of new materials and	Avicenna (Stella), 1107, 1107	suppression of, 1059
methods, 967–969	Aztecs, 755, 836–837, 837, 839–842	Bauhaus Building (Gropius), Dessau, Germany,
Postmodernism, 1115–1118, <i>1116–1117</i> Pueblos, 851, 854, <i>854</i>	В	1057, <i>1058</i> , 1059 Baule spirit figure (blolo bla), Côte d'Ivoire,
Rococo, 900	D	885, 885
skyscrapers, 1016, 1046, 1049, 1047	Baader, Johannes, 1060	Bays, 615, 780, 825
Spanish Baroque, 748, 749, 749	Baby carrier, Sioux, 846, 846	Beadwork, 846–847, 846, 847, 935
Spanish Renaissance, 705, 705 Architraves, 617, 660	Baca, Judith F., <i>Division of the Barrios</i> , from <i>Great Wall of Los Angeles</i> , 1144–1145, <i>1145</i>	Beardsley, Aubrey, 984 Beijing, Ming dynasty, 809–810, <i>810</i>
Arch of Drusus (Piranesi), 911–912, 911	Bacci Chapel, San Francesco church, Arezzo,	Belgium, 749, 1004
Aristotle, xxx	635–636, 635	Bellini, Gentile, Procession of the Relic of the
Armor of George Clifford (Halder), 717, 717	Backs (Abakanowicz), 1137-1138, 1138	True Cross before the Church of Saint Mark,
Armory Show, 1043	Backyards, Greenwich Village (Sloan),	642, 642
Arnhem Land, Australia, 861 Art	1042, <i>1043</i> Bacon, Francis, 721	Bellini, Giovanni Saint Francis in Ecstasy, 643, 643
craft versus, 840	Bacon, Francis (20 th century artist), <i>Head</i>	Virgin and Child Enthroned with Saints Francis
defined, xxx-xxxi	Surrounded by Sides of Beef, 1085, 1085	John the Baptist, Job, Dominic, Sebastian,
endangered objects, xliv-xlv	Baerze, Jacques de, 587	and Louis of Toulouse, 642-643, 643
history, xliii	Bal au Moulin Rouge (Chéret), 984, 984	Bellini, Jacopa, 642
human body as idea and ideal, xxxiii–xxxv nature of, xxxi	Baldacchino (Bernini), 723–724, 723 Baldachin, 723	Bellori, Giovanni, 736 Benday dots, 1103
reasons for having, xxxv-xxxvi	Ball, Hugo, 1060, 1060	Benedictine Abbey of Melk (Prandtauer),
search for meaning and, xxxvi-xxxvii	Balustrades, 589, 726	Austria, 747, 747, 748
social context and, xxvii-xxviii	Banham, Reyner, 1102	Benin, 877
sociopolitical intentions, xlv–xlvi	Banqueting House (Jones), Whitehall Palace,	Benois, Aleksandr, 1040–1041
study of, xliii–xliv styles of representation, xxxi–xxxiii	London, 779–780, 780, 781, 782 Bar at the Folies-Bergère, A, (Manet), 989, 990	Bentley, Richard, 916 Bento, Thomas Hart, 1069, 1070
viewers, responsibilities of, xlvi–xlvii	Barberini Harp, 730, 730	Berkeley, George, 936
Art brut, 1085–1086	Barbizon School, 958	Berlin
Art Deco, 854, 855, 878, 878	Bardon, Geoffrey, 872	Altes Museum (Schinkel), Berlin,
Art informel, 1086–1087 Artists	Bargehaulers on the Volga (Repin), 976, 976	962–963, <i>963</i> Jewish Museum (Libeskind), 1120
changing status of, in the Renaissance, 647	Bark clothing, 867–868, <i>867</i> Barney, Matthew, 1149	Bernini, Gianlorenzo
names and nicknames of, 584	Cremaster cycle, 1150, 1150	Baldacchino, 723–724, 723
who are, xxxviii-xli	Baroque architecture	Cornaro Chapel, Santa Maria della Vittoria
Artist's Studio, The (Daguerre), 965, 965	English, 779–780, 781, 782–783, 782, 783	church, 728, 728
Art Nouveau, 1003–1005, 1004, 1005, 1021–1022, 1021, 1023, 1046	French, 739–742, <i>739–742</i> German, 747, <i>747, 748</i>	<i>David</i> , 722, 730, <i>730</i> Four Rivers Fountain, 727, <i>727</i>
Arts and Crafts movement, 977, 979	Italian, 722–729, 723–729	Saint Peter's Basilica piazza design,
Asam, Egid Quirin, 901	Spanish, 748, 749, 749	724–725, 724
Angel Kneeling in Adoration, 902, 902	Baroque art	Saint Teresa of Ávila in Ecstacy,
Ashanti, Ghana Kente cloth, 887, 887	in the colonies in North America, 783–785	728–729, 729
staff, 874, 875, 886–887	difference between Renaissance and, 760 in England, 778–783	Bertoldo di Giovanni, 655 Bestiary, 605
Ashcan School, 1042–1043	Flemish, 758–764	Beuys, Joseph, 1109, 1131
Ashikaga (Muromachi) period, 818-822	in France, 739–746	Coyote: I Like America and America Likes Me,
Ashoka, king of India, 790	in Germany, 746–747	1110, 1110
Asmat spirit poles (mbis), Irian Jaya, 863, 864, 865	in Italy, 722–738 in Mesoamerica, 755–758	Beveled blocks, 843 Bibliothèque Sanite-Geneviève (Labrouste),
Aspects of Negro Life: From Slavery through	in the Netherlands/United Dutch Republic,	Paris, 968–969, 969
Reconstruction (Douglas), 1072, 1073	764–778	Bierstadt, Albert, 1007
Assemblage, 1037, 1094, 1099–1101,	in Spain, 747–755	Rocky Mountains, Lander's Peak, 1008, 1008
1100, 1101 Association of Artists of Revolutionary Russia	style of, 721–722	Big Raven (Carr), 1081, 1081
(AKhRR), 1050–1051	Baroque painting Dutch portrait, 764–778, 765–770	Bilbao, Spain, Guggenheim Museum, Solomon R. (Gehry), xliii, 1119–1120, <i>1120</i>
Assumption of the Virgin (Correggio), 666, 667	Flemish, 758–764, 759–764	Bingham, George Caleb, Fur Traders Descending
Astronomy, or Venus Urania (Giovanni da	French, 743-746, 743-746	the Missouri, 960, 961
Bologna), 695, 696	Italian canvas, 733, 734, 735–738, 735–738	Biomorphic language, 1065, 1088
Asuka period, 819 Asymmetrical Angled Piece (Odundo), 894, 894	Italian illusionistic ceiling, 730–733, 731–733	Birds of America (Audubon), 958
AT&T Corporate Headquarters (Johnson and	Spanish, 749–755, 750–755 Baroque period	Birth of Mahavira, from Kalpa Sutra, 789–790, 790
Burgee), New York City, 1117, 1117	map of Europe and North America in, 720	Birth of Venus (Botticelli), 639, 640, 641
Ateliers, 793, 944	science and worldview in, 721	Black Lion Wharf (Whistler), 979, 979
Athanadoros, <i>Laocoön and His Sons</i> , xliv–xlv,	timeline, 720–721	Blackware pottery, 854
xliv, xlv Atmospheric (aerial) perspective, 579, 583, 994	Barroque sculpture, Italian, 722, 730, 730	Black Woven Form (Fountain) (Tawney),
Atrial crosses, 756, 756	Barrel vaults, 969 Barry, Charles, Houses of Parliament, London,	1113, 1114 Blake, William, Elohim Creating Adam, 926, 926
Atriums, 663, 756	963–964, <i>963</i>	Blenheim Palace (Vanbrugh), England, 783, 783
Audubon, John James	Barry, Madame du, 906, 907, 928	Bleyl, Fritz, 1025
Birds of America, 958	Barthes, Roland, 1130, 1132	Blind arcades, 793
Common Grackle, 958–959, 959 Aurora (Reni), 732, 732	Bartolomeo, Michelozzo di. See Michelozzo di Bartolomeo	Blind windows, 685 Block printed, 603
Australia, 861–862, 861, 862	Barye, Antoine-Louis, <i>Python Crushing an</i>	Boccaccio, Giovanni, 579
Austria	African Horseman, 953, 953	Thamyris from Concerning Famous Women,
Art Nouveau, 1004, 1022, 1022	Basilica, 663	585, 585
Baroque period in, 746–747	Basketry, 846, 846	Boccioni, Umberto
Rococo architecture, 900–902, 900, 901, 902	Basquiat, Jean-Michel, 1129 Horn Players, 1131, 1131	States of Mind: The Farewells, 1040, 1040 Unique Forms of Continuity in Space, 1040, 1041
/		enque i onno of continuity in space, 1040, 1041

Bodhidharma Meditating (Hakuin), 830, 830,	Buddhism	Carr, Emily, Big Raven, 1081, 1081
Bodhisattva Avalokiteshvara, 789, 789	in China, 811	Carracci, Agostino, 731
Body, back to the, 1137–1138, 1138	in India, 788–789, 790	Carracci, Annibale, 730
Boffrand, Germain, Salon de la Princesse, Hôtel	in Japan, 818–819 Buddhist art	Palazzo Farnese, Rome, 664, 664, 665, 665, 731–732, <i>731</i>
de Soubise, Paris, 899, 900 Bonheur, Rosa, <i>Plowing in the Nivernais: The</i>	in India, 789, 789	Carriera, Rosalba, 909
Dressing of the Vines, 972, 973	in Japan, 819–821, <i>820, 821</i> , 830, <i>830</i>	Charles Sackville, 2 nd Duke of Dorset, 910, 910
Bonheur de Vivre, Le (The Joy of Life) (Matisse),	Buffalo Bull's Back Fat, Head Chief, Blood Tribe	Carrying of the Cross (Bruegel the Elder), 711, 711
1024–1025, 1024	(Catlin), 959, 959	Carthusians, 587
Bonsu, Kojo, Staff (Ashanti), Nigeria, <i>874</i> , 875, 886–887	Buffalo-hide robe, battle scene on, 848, 849 Bulfinch, Charles, 962	Cartoon, 648, 1065 Cartouches, 665, 685, 726
Bonsu, Osei, 887	Bull and Puppy (Rosetsu), 831, 831	Cassatt, Mary, 986
Books, printing of, 603, 608–609	Bunsei, 819	Maternal Caress, 990, 991, 992
Borromini, Francesco	Landscape, 820, 820	Woman in a Loge, 987–988, 987
San Carlo alle Quattro Fontane church,	Buontalenti, Bernardo, The Great Grotto, Boboli	Castle, Wendell, Ghost Clock, 1136, 1136
725–726, <i>725, 726</i> Sant'Agnese church, 726–727, <i>727</i>	Gardens, Florence, 710, <i>710</i> Burden, Jane, 977	Castle of Otranto, The (Walpole), 916 Catharina Hooft and Her Nurse (Hals),
Bosch, Hieronymus, <i>Garden of Earthly Delights</i> ,	Burgee, John, AT&T Corporate Headquarters,	764–765, 765
708–709, 708–709	New York City, 1117, 1117	Cathedrals. See under name of
Boston Massacre, 897	Burghers of Calais (Rodin), 1002, 1002	Catholicism, 720
Boston Tea Party, 897, 937	Burial at Ornans, A (Courbet), 974, 975	Catlin, George, Buffalo Bull's Back Fat, Head Chief, Blood Tribe, 959, 959
Botticello, Sandro Birth of Venus, 639, 640, 641	Burial of Count Orgaz (El Greco), 705–706, 706 Burins, 612, 772	Cave art, Australian, 861–862, 861, 862
Mystic Nativity, 641–642, 641	Burke, Edmund, 929	Caxton, William, 603
Primavera, 639, 640, 641	Burkina Faso	Cellini, Benvenuto, Saltcellar of Francis I,
real name of, 584	Bwa masks, 881–882, 881	694, 695
Boucher, François	Lobi spirit figure (boteba), 883, 884	Cenotaphs, 792 Boullée's for Isaac Newton, 928–929, 928
Diana Resting after Her Bath, 904, 905 La Foire Chinoise (The Chinese Fair), 908, 908	Mossi dolls (biiga), 880, 880 Burlington, Lord (Richard Boyle), Chiswick	Centering, 612
Bouguereau, Adolphe-William, Nymphs and a	House, England, 914, 914	Central Park (Olmsted and Vaux), New York
Satyr, 971, 971	Burne-Jones, Edward, 977	City, 1017, 1017
Boulevard des Capucines (Monet), 982–983, 983	Burrows, Alice, 918	Central-plan churches, 618, 722, 927
Boullée, Étienne-Louis, Cenotaph for Isaac	Burrows, George, 918	Centre National d'Art et de Culture Georges Pompidou (Piano and Rogers), Paris,
Newton, 928–929, <i>928</i> Bourgot, illuminator, 585	Buseau, Marie-Jeanne, 904 Bush, Jack, <i>Tall Spread</i> , 1105–1106, <i>1106</i>	1118, 1118
Bouts, Dirck	Buttresses, 588	Ceramics
Justice of Otto III, 599–600, 599	Buxheim Saint Christopher, woodcut, 609, 609	See also Pottery
Wrongful Execution of the Count, 599, 599	Bwa masks, Burkina Faso, 881–882, 881	African, 893–895, 894, 895
Boy with a Basket of Fruit (Caravaggio), 735, 735	Bwami masks, Lega, Democratic Republic of the Congo, 882–883, 883	Italian Renaissance, 627–628, <i>627, 628</i> Japanese, 834, <i>834</i>
Boy with a Squirrel (Copley), 937 Brackets, 665, 749	the Congo, 862–863, 863	Japanese tea, 826, 826
Brady, Mathew B., 1009	\mathbf{C}	Cézanne, Paul, 979
Bramante, Donato, 651	C	Large Bathers, 994–995, 995
Saint Peter's basilica, plan for, 663, 663, 664	Cadart, Alfred, 984	Mont Sainte-Victoire, 993–994, 993
Tempietto, San Pietro church, Rome, 662, 662, 664	Cage, John, 1098, 1100	Still Life with Basket of Apples, 994, 994 Chair Abstract, Twin Lakes, Connecticut (Strand),
Brancacci Chapel, Santa Maria del Carmine	Calder, Alexander, 1074 Lobster Trap and Fish Tail, 1075, 1076	1043, 1045
church, Florence, 631, 631, 632, 633	Calligraphy, 791	Chalice of Abbot Suger, Church of Saint-Denis,
Brancusi, Constantin, 1031	Chinese, 803	France, xxxvi, xxxvii
Magic Bird, 1032, 1032	Japanese, 821, 821	Chambers, William, 917 Chamfered, 792
Brandt, Marianne, Coffee and tea service, 1057, <i>1057</i>	Calligraphy Pair (Ikkyu), 821, 821 Calling of Saint Matthew (Caravaggio), 735, 736	Chan Buddhism, 811
Braque, Georges, 1032	Calotype, 965	Chancel, 964
Analytic Cubism, 1035–1037, 1035,	Calvin, John, 680	Chaotic Lip (Murray), 1135, 1135
1036, 1037	Cameos, 912	Chardin, Jean-Siméon, <i>The Governess</i> , 904, 905 Charles I, king of England, 760, 762, 778, 779,
Houses at L'Estaque, 1035, 1035 Violin and Palette, 1036, 1036	Camera obscura, 775, 964	780, 782
Breakfast pieces, 764	Cameron, Julia Margaret, Portrait of Thomas Carlyle, 966–967, 967	Charles I, king of Spain, 671
Breton, André, 1062, 1064, 1079, 1087	Campbell, Colen, 913	Charles I at the Hunt (Van Dyck), 762, 762
Bride Stripped Bare by Her Bachelors,	Campin, Robert, 591–592	Charles II, king of Spain, 747
Even (The Large Glass) (Duchamp),	Joseph in His Carpentry Shop, 581–582, 582	Charles IV, king of Spain, 953, 954 Charles V, Holy Roman emperor, 647, 670, 671,
1062, 1063 Bridges, iron, 935, 935, 968, 968	Mérode Altarpiece (Triptych of the Annunication), 581, 591–592, 591	680, 682, 707, 747
Brody, Sherry, <i>Dollhouse, The</i> , 1125	Canada, modern art in, 1079–1081, 1080, 1081	Charles V Triumphing Over Fury (Leoni),
Broederlam, Melchior, 587	Canaletto (Giovanni Antonio Canal), 910	xxxiv-xxxv, xxxiv, 680
Annunciation and Visitation, 588, 588	Santi Giovanni e Paolo and the Monument to	Charles VI, Holy Roman emperor, 747
Presentation in the Temple and Flight into	Bartolommeo Colleoni, 911, 911	Charles VI, king of France, 607 Charles VII, king of France, 607
Egypt, 588, 588 Broken pediment, 749	Canon of proportions, xxxiv Canova, Antonio, <i>Cupid and Psyche</i> , 913, <i>913</i>	Charles Sackville, 2 nd Duke of Dorset (Carriera),
Bronzes, Renaissance, 627, 627	Cantilevered, 1045	910, 910
Bronzino (Agnolo di Cosimo)	Canvas painting, 669	Chartreuse de Champmol, Dijon, France,
Allegory with Venus and Cupid, 692–694, 694	Canyon (Rauschenberg), 1100, 1101	587–588, 587, 588
Portrait of a Young Man, 692, 693	Capital, xxx, xxx, 615	Chasing, 918 Châteaux, 702
Brooklyn Bridge (Roebling), New York City, 968, 968	Capitol Reef, Utah (White), 1110, 1112 Capponi chapel, Santa Felicita church,	Châtelet, Madame du, 899
Brooklyn Museum of Art, "Sensation"	Florence, 690–691, 690	Chattri, 792
exhibition, 1142	Capriccio, 910	Chaux town plan (Ledoux), 928, 928
Brown, Blue, Brown on Blue, (Rothko),	Caprichos (Caprices) (Goya), 954	Chéret, Jules, Bal au Moulin Rouge, 984, 984
1093, 1093 Brown, Lancelot, 783, 914	Captain Frans Banning Cocq Mustering His	Cherub, 756 Chevalier, Étienne, 607, 608
Brown, Lancelot, 783, 914 Brueghel, Jan, 762	Company (The Night Watch) (Rembrandt), 768–769, 768	Chevreul, Michel-Eugène, 995
Allegory of Sight, from Allegories of the Five	Caravaggio (Michelangelo da Caravaggio),	Chevrons, 867
Senses, 763, 763	584, 740	Chiange
Bruegel the Elder, Pieter, 710	Boy with a Basket of Fruit, 735, 735	Chicago Frederick C. Robi House (Wright), 1045–1046,
Carrying of the Cross, 711, 711 Return of the Hunters, 711–712, 712	Calling of Saint Matthew, 735, 736	1045, 1046
Brunelleschi, Filippo, 583	Death of the Virgin, 759 Entombment, 737, 737	Marshall Field Wholesale Store (Richardson),
Cathedral Dome, 611-613, 613, 615	Cardinal Virtues under Justice (Raphael),	1015–1016, <i>1016</i>
Foundling Hospital, 613, 614, 614	651, 652	World's Columbian Exposition (Hunt),
San Lorenzo church, 613, 615–616, 615	Carlyle, Thomas, 966, 967	1014–1015 <i>, 1015</i> Chicago, Judy, <i>Dinner Party,</i> 1125, 1126, <i>1126</i>
Buchan, Alexander, 869	Carpeaux, Jean-Baptiste, Dance, The, 970, 970	5.11.50go, judy, 5111101 1 utty, 1120, 1120, 1120

3

Chicago School, 1016 Chicano muralists, 1144–1146, <i>1145</i>	Color field painting, 1093–1094, 1093, 1094 Colossal order, 685, 686	Cubo-Futurism, 1041 Cupid and Psyche (Canova), 913, 913
Chihuly, Dale, Violet Persian Set with Red Lip Wraps, xxxix, xxxix	Columns, 665 Common Grackle (Audubon), 958–959, 959	Current (Riley), 1106, 1106 Curry, John Steuart, 1070
Child with Toy Hand Grenade (Arbus), 1110, 1111	Complementary color, 995, 1023 Complexity and Contradiction in Architecture	Curtain wall, 1047, 1056
Chilkat blanket, 850, 851	(Venturi), 1115	Curtis, Edward S., 852 Cuyp, Aelbert, 772
Chin, Mel, <i>Revival Fields</i> , 1146, <i>1147</i> China	Composite capitals, 621, 724 Composition, 911, 945	Maas at Dordrecht, 773, 773 Cuzco, Peru, (Inca), 842–845, 843, 844
dynasties, 803 map of, after 1280, <i>802</i>	Composition with Yellow, Red, and Blue (Mondrian), 1052, 1052	Cycles, 711
Ming dynasty, 807–813 Mongol invasions, 802	Comte, Auguste, 943, 964	D
Qing (Manchu) dynasty, 813–814	Conceptual art, 1108–1110, 1109, 1110 Concerning Famous Women (Boccaccio), 585, 585	Dada Dance (Höch), 1061, 1061
timeline, 802–803 Yuan dynasty, 802, 803–806	Concerning the Spiritual in Art (Kandinsky), 1028 Confederate Dead Gathered for Burial, Antietam,	Dadaism, 1021, 1060–1062, 1060, 1061, 1062 Daguerre, Louis-Jacques-Mandé, 964
Chinese art architecture and city planning, 809–810,	September 1862, (Gardner), 1009, 1009 Conference of Serpents, (Gurruwiwi), 862, 862	Artist's Studio, The, 965, 965 Daguerreotypes, 964–965
811, <i>810</i> furniture, 808–809, <i>809</i>	Confucius, 803	Daitoku-ji, Kyoto, Fusuma (Kano Eitoku),
painting, individualist, 814, 815	Connoisseurship, xliii Constable, John, <i>White Horse</i> , 956, 957, 958	823–824, <i>824</i> Dali, Salvador, 1087
painting, literati, 810–813, <i>812, 813</i> painting, Ming dynasty, 807–808, <i>807, 808</i>	Constructed realities, 1138–1140, <i>1140, 1141</i> Constructivism, 1021, 1050	Persistence of Memory, 1065, 1065 Damian, Cosmas, 901, 902
painting, modern, 814–815, <i>815</i> painting, orthodox, 813–814, <i>814</i>	Content, xxv Contextualism, xxxiii, xliii	Dance, The (Carpeaux), 970, 970 Dance staff depicting Eshu, Yoruba, Nigeria,
painting, Yuan dynasty, 802, 803–806, 804–805	Contrapposto, 921	886, 886
porcelain, 808, 808	Cook, James, 867, 868, 869 Cooke, Elizabeth, 918	Dante, 579 Danube Landscape (Altdorfer), 682, 683
Chinoiseries, 908 Chiswick House (Lord Burlington), England,	Cope of the Order of the Golden Fleece, Flemish, 604, 604	Darby, Abraham III, Severn River Bridge, England, 935, 935
914, <i>914</i> Christine de Pizan, 585	Copernicus, Nicolaus, 721 Copley, John Singleton	Darwin, Charles, 942–943
Christine de Pizan Presenting Her Book to the	Boy with a Squirrel, 937	Daumier, Honoré, 951 Rue Transonain, Le 15 Avril 1834, xlv–xlvi,
Queen of France, xlii, xlii, Christo (Christo Javacheff), 1122	Samuel Adams, 896, 897, 937 Corbett, Harrison, & MacMurray, 1077, 1078	xlv, 974 Third-Class Carriage, 974, 975
Running Fence, 1123, 1123 Christus, Petrus, A Goldsmith (Saint Eligius?) in	Corinthian columns, 615 Corinthian order, 617	David (Bernini), 722, 730, 730 David (Donatello), 624, 625
<i>His Shop</i> , 597, 599, <i>599</i> Church, Frederic Edwin, <i>Niagara</i> , 1007, <i>1007</i>	Cornaro Chapel (Bernini), Santa Maria della	David (Michelangelo), 656, 656
Churches	Vittoria church, 728–729, 728 Cornelia Pointing to Her Children as Her	David, Jacques-Louis Death of Marat, 933, 933
See also under name of altars and altarpieces, 590	Treasures (Kauffmann), 923, 923 Cornell, Joseph, 1125	Napoleon Crossing the Saint-Bernard, 944–945, 944
central-plan, 618, 722, 927 Greek-cross plan, 618, 663, 664, 927	Corner Counter-Relief (Tatlin), 1042, 1042 Cornices, 589, 658, 665, 728	Oath of the Horatii, 932, 932 Davies, Arthur B., 1043
Latin-cross plan, 618, 618, 663 Chute, John, 916	Corot, Jean-Baptiste-Camille, First Leaves, Near Mantes, 971–972, 972	Davis, Stuart, 1092
Cimabue (Cenni di Pepi), 579	Correggio (Antonio Allegri), Assumption of the	Swing Landscape, 1074, 1075 Dean George Berkeley and His Family (The
Circus (John Wood the Elder and Younger), Bath, England, 915–916, <i>915</i>	<i>Virgin</i> , 666, <i>667</i> Cortés, Hernán, 755, 837	Bermuda Group) (Smibert), 936, 937 Death of Fashion (Schnabel), 1129, 1130
City Night (O'Keeffe), 1068, 1068 City plans	Cortona, Pietro da (Pietro Berrettini), Glorification of the Papacy of Urban VIII,	Death of General Warren at the Battle of Bunker's Hill, June 17, 1775 (Trumbull), 937–939, 938
Chaux town plan (Ledoux), 928, <i>928</i> Chinese, 809–810, 811, <i>810</i>	732, 733 Côte d'Ivoire	Death of General Wolfe (West), 924, 924
Contemporary City of Three Million	Baule spirit figure (blolo bla), 885, 885	Death of Marat (David), 933, 933 Deconstructivist architecture, 1119–1121, 1119,
Inhabitants (Le Corbusier), 1055–1056, <i>1055</i>	Guro spirit mask, 892, 893 Council of Trent, 682	1120, 1121 Degas, Edgar, 979
City Square (Giacometti), 1085, 1085 Civil War, American, 943, 1009, 1009, 1010	Counter-Reformation, 682, 720, 722 Couple Wearing Raccoon Coats with a Cadillac,	Rehearsal on Stage, 986, 987 Degenerate Art exhibition, Munich, 1059
Clapboard, 784 Classical Revival in England, 913–916	Taken on West 127 th Street, Harlem, New York (VanDerZee), 1073, 1073	Déjeuner sur l'Herbe, Le, (Manet), 980–981, 981
Classicism, 665	Courbet, Gustave	De Kooning, Elaine, 1092 De Kooning, Willem, 1090
architecture, French, 927–929, <i>927, 928</i> , 1055–1057, <i>1055, 1056</i>	Burial at Ornans, A, 974, 975 Stone Breakers, 973–974, 974	<i>Woman I</i> , 1092–1093, <i>1092</i> Delacroix, Eugène
in France, 927–934, 1053–1057, <i>1054–1056</i> painting, French, 929–934, <i>929–933</i> , 1054,	Courses, 613, 865 Courtyard, The (Kaprow), 1098–1099, 1098	Scenes from the Massacre at Chios, 950, 951 Women of Algiers, 952, 952
1054, 1055 sculpture, French, 929–930, 934, 930, 934	Couture, Thomas, 980 Cow with the Subtile Nose (Dubuffet), 1086, 1087	De La Tour, Georges, Magdalen with the
Claudel, Camille, Waltz, The, 1003, 1003	Cox, Kenyon, 1043	Smoking Flame, 744–745, 744 Delaunay, Robert, Homage to Blériot,
Clement VII, pope, 647, 654, 682 Clerestory, 615	Coyote: I Like America and America Likes Me (Beuys), 1110, 1110	1038–1039, 1039 Delaunay-Terk, Sonia, Clothes and customized
Clifford, George, 3 rd Earl of Cumberland, 715, 716, 717, 717	Craft, art versus, 840 Craft art, American, 1111, 1113, <i>1113</i> ,	Citroën, 1039, <i>1039</i> Delaware, 845, 846–847
Clodion (Claude Michel), <i>Invention of the Balloon</i> , 908–909, 909	1136–1137, <i>1136, 1137</i> Cranach the Elder, Lucas, 681	Delivery of the Keys to Saint Peter (Perugino),
Clouet, Jean, Francis I, 702, 702	Martin Luther as Junker Jörg, 681, 682	636, 638 Della Porta, Giacomo
Codex Fejervary-Mayer (Aztec), 836–837, 837 Codex Mendoza (Aztec), 840, 841	Cremaster cycle (Barney), 1150, 1150 Crenellated battlements, 916	fountain, 727, <i>727</i> Il Gesù church, 685, <i>686</i>
Coeur, Jacques, 589 Coffee and tea service (Brandt), 1057, <i>1057</i>	Crockets, 588 Cromwell, Oliver, 722	Democratic Republic of the Congo Kongo spirit figure (nkisi nkonde),
Coffers, 631, 648, 725 Coiling, 846, 851	Crossing, 611	883–885, 884
Colbert, Jean-Baptiste, 739	Crossing, The (Viola), 1149, 1149 Crossing piers, 724	Kuba portrait sculpture, 887–888, <i>887</i> Lega bwami masks, 882–883, <i>883</i>
Cole, Thomas Course of Empire, 959–960	Crouching Woman (Heckel), 1025, 1025 Crystal Palace (Paxton), London, 968, 968	Ngombe chair, 878, 878 Demoiselles d'Avignon, Les (Picasso),
Oxbow, The, 960, 960 Collage, 1037, 1101, 1130	Cubi XIX (Smith), xxxiii, xxxiii, 1094 Cubism, 1021	1034–1035, 1034, 1035 Departure of the Volunteers of 1792 (The
Colleoni, Bartolommeo, 626, 627 Colonna, Francesco de, Hypnerotomachia	analytic, 1035-1037, 1035, 1036, 1037	Marseillaise) (Rude), Arc de Triomphe,
Poliphili, Garden of Love page, 603, 603	Picasso, work of, 1032–1035, <i>1032, 1033, 1034, 1035</i>	Paris, 952–953, <i>952</i> Deposition (Weyden), 595–596, <i>596</i>
Colonnades, 663 Colophons, 806	responses to, 1038–1042, <i>1038–1042</i> synthetic, 1037, <i>1037, 1038</i>	Depression of 1929, 1020, 1068–1070 Derain, André, <i>Mountains at Collioure</i> , 1023, <i>1023</i>

Der Blaue Reiter, 1027-1029, 1029, 1030, 1031 Encyclopédie (Diderot), 929 Derrida, Jacques, 1119, 1132 Descartes, René, 721 Ende, 585 Engaged columns, 665 de Stijl, 1051–1053, 1052, 1053 De Witte, Emanuel, 770 Engels, Friedrich, 943 England Portuguese Synagogue, Amsterdam, 772, 773 Diaghilev, Serge, 1041 Diana Resting after Her Bath (Boucher), 904, 905 Baroque period in, 778–783 city parks in, 1017 Diana Resting after Her Bath (Boucher), 904, Diary (Shimomura), xlvi, xlvi Diderot, Denis, 899, 929, 930 Die Brücke, 1025–1026, 1025, 1026 Digital art, 1138–1139, 1143 Dijon, France, Chartreuse de Champmol, 587–588, 587, 588 Diner, The (Segal), 1096, 1097 Dinner Party (Chicago), 1125, 1126, 1126 Diptych, 590, 597, 1103 Disputà (Raphael), 651, 652 Documenta, Kassel, Germany, 1147 Dogon Kanaga mask, Mali, 890–891, 890 Dollhouse, The (Schapiro and Brody), 1125 Domino construction system, 1056 Classical Revival in, 913–916 Classical Revival III, 913–916 Gothic Revival in, 916, 963–964, 963 Industrial Revolution, 942–943 Neoclassicism in, 917–926 Renaissance in, 712–717 English art nglish art architecture, Baroque, 779–780, 781, 782–783, 782, 783 architecture, Neoclassicism, 917, 917 architecture, Gothic Revival, 916, 916, 963–964, 963 architecture, Renaissance, 715, 716 architecture and landscape architecture, Classical Revival, 914–916, 914–916 Georgian silver, 918, 918
landscape garden, 914–915, 915
painting, late nineteenth century, 977, 978, 979, 979 Domino construction system, 1056 Donatello David, 624, 625 equestrian monument of Erasmo da Narni, 626, 626 Feast of Herod, 624, 624 painting, Neoclassicism, 919–926, 920–926 influence of, 627 painting, Renaissance, 713-715, 713, 714 Engravings, 603, 609, 612, 678 Mary Magdalen, 624, 625, 626 Mary Magdatert, 624, 624
real name of, 584, 624
Dong Qichang, 810–813, 829 *Qingbian Mountains*, 812–813, 813
Doric order, 617 Enlightenment
map of Europe and North America, 898
science and, 922 timeline, 898-899 Ensor, James, *Intrigue, The*, 1000–1001, *1001*Entablature, 662, 665, 723
Entombment (Caravaggio), 737, 737
Entombment (Pontormo), 691, 691
Epidauros, theater in, Corinthian capital from, Double Negative (Heizer), 1122, 1122 Douglas, Aaron, Aspects of Negro Life: From Slavery through Reconstruction, 1072, 1073

Drawing Lesson, The (Steen), xxxix-xl, xl, 777

Drum, 612, 662 Drum, 612, 662
Drumken Cobbler (Greuze), 929, 929
Drypoint technique, 769, 772
Dubuffet, Jean, 1085
Cow with the Subtile Nose, 1086, 1087
Ducal Palace, Mantua, Italy, 636, 637
Ducal Palace, Urbino, Italy, 621, 621, 622
Duccio di Buoninsegna, 579
frescoes, Scrovegni (Arena) Chapel, Padua, 579, 580, 581
Duchamp, Marcel 1130 XXX, XXX Equestrian monument of Bartolommeo Colleoni (Verrocchio), 626, 627 Equestrian monument of Erasmo da Narni (Donatello), 626, 626 Erasmo da Narni, 626, 626 Erasmus, Desiderius, 680 Ernst, Max, 1087 Horde, The, 1064, 1064 Eshu, 886, 886 579, 580, 581
Duchamp, Marcel, 1130
Bride Stripped Bare by Her Bachelors, Even
(The Large Glass), 1062, 1063
Fountain, 1062, 1062
Dunn, Dorothy, 854, 856
Dürer, Albrecht, 583, 672, 740 Esquilache Immaculate Conception (Murillo), Estes, Richard, Prescriptions Filled (Municipal Building), 1123, 1123 Etchings, 769, 772, 954, 984 Étienne Chevalier and Saint Stephen (Fouquet), 607–608, 608 uter, Albrecht, 583, 612, 740
Adam and Eve, 679, 679
Four Apostles, 680–681, 681
Four Horsemen of the Apocalypse, 678, 678
Melencolia 1, 679–680, 679
Self-Portrait, 678, 678 Eugénie, empress, 969 Europe urope
See also under specific country
map of, in Baroque period, 720
map of, in the Enlightenment, 898
map of, in the nineteenth century, 942 Dutch art, Baroque portrait painting, 764-778, Dutch Interior I (Miró), 1064-1065, 1064 map of, in the twentieth century, 1020 maps of, in the Renaissance, 578, 646 Modernism in, 1046–1049 postwar art, 1085–1087 timeline, 1020–1021 twentieth century in, 1020–1021 Eakins, Thomas, Gross Clinic, 1011, 1012

Eakins, Inomas, *cross Clinic*, 1011, 1012 Earthworks, 839, 845, 1121–1123, 1122, 1123 Easter Island, 858–859, 859, 866–867 Eastern Woodlands, 845–847 Eastman, George, 1012 École des Beaux-Arts, 944, 969 Edition, 608, 612 Edo period, 826–833 Edward III, king of England, 1002 Edward VI, king of England, 715 Egypt, 877
Eiffel, Gustave, Eiffel Tower, Paris, 940, 941
Eight, The, 1042
Eitoku, Kano, Fusuma, 823–824, 824 Ekpo mask, Anang Ibibio, Nigeria, 890, 890 Electronic Superhighway: Continental U.S. (Paik), 1149, 1149 Elizabeth I, queen of England, 672 Elizabeth I when Princess (Teerling), 714–715, 714, El Escorial, Madrid, 705, 705 Elohim Creating Adam (Blake), 926, 926 Embarkation of the Queen of Sheba, (Lorrain), 745, 745 Empire State Building, New York City, 1049, 1049 Encaustic paint, 1101

Evans, Walker, 1130

Experiment on a Bird in the Air-Pump, An (Wright), 922, 922, 924–925

Expressionism, xxxi, 996, 1021, 1085

Abstract, 1087–1095, 1088–1097 Der Blaue Reiter, 1027-1029, 1029, 1030, 1031 German, 1025–1026, 1059 independent, 1026–1027, 1026–1027 independent, 1026–1027, 1026–1027 Expulsion from Paradise (Masaccio), 631, 632 Eyck, Jan van, 583, 584, 591, 592–593 Annunciation, 593, 593 Man in a Red Turban, 594, 594 Portrait of Giovanni Arnolfini and His Wife, Giovanna Cenami, 594, 595 F

Facade, 665 Fagus Shoe Company (Gropius and Meyer), Germany, 1047, 1048 Fallingwater, Kaufmann House (Wright), Mill Run, Pennsylvania, 1077, 1077 Fall of the Giants (Romano), 666, 666

Family of Charles IV (Goya), 953–954, 953 Family of Saltimbanques (Picasso), 1033, 1033 Fang, Nlo byeri guardian, Gabon, 891, 891 Farnese, Alessandro, 664, 682, 685 Fauvism, 1021, 1023–1025, 1023, 1024 Feast in the House of Levi (Veronese), 697-699, 698 Feast of Herod (Donatello), 624, 624 Feather cloak (Kearny Cloak), Hawaiian, 868, 868 Federal Art Project (FAP), 1069 Federal Period, 934 Federico da Montefeltro, 621, 639, 639, 651 Feminist art, 1124–1128, *1124–1129*, 1134–1135, *1134*, *1135* Fen shui, 811 Ferdinand VII, king of Spain, 954 Fervor (Neshat), 1151, 1151 Fête galante, 902 Fiber arts, Flemish, 604, 604 Fifteen Discourses to the Royal Academy (Reynolds), 920 Fifty-Three Stations of the Tokaido (Hiroshige), 832 Fighting "Téméraire," Tugged to Her Last Berth to Be Broken Up (Turner), 956, 957 Figurative art, 1096, 1097 Baule spirit figure (blolo bla), Côte d'Ivoire, 885. 885 dance staff depicting Eshu, Yoruba, Nigeria, Fang, Nlo byeri guardian, Gabon, 891, 891 Kongo spirit figure (nkisi nkonde), Democratic Republic of the Congo, 883–885, 884 Lobi spirit figure (boteba), Burkina Faso, Moai ancestor figures, Easter Island, 858–859, 895, 866–867
Mossi dolls (biiga), Burkina Faso, 880, 880 twin figures (ere ibeji), Yoruba culture, Nigeria, 880–881, 880
Finials, 749, 792 Finley, Karen, 1142 Fiorentino, Rosso, 703 Fire in the Sky (Halley), 1133, 1133 First Leaves, Near Mantes (Corot), 971–972, 972 Flamboyant-style architecture, 588-589, 589 Flanders, 749, 758-764 Flaxman, John, Jr., 919 Fleck, John, 1142 Flemish art, 589–590 Baroque, 758–764, 759–764 manuscripts, illuminated, 589, 602–604, 602 panel painting, 591–602 tapestry, 604–606, 605 textiles (fiber arts), 604, 604 Flitcroft, Henry, Stourhead park, Wiltshire, England, 915, 915 architecture in, 611–617, *613–617* Brancacci Chapel, Santa Maria del Carmine church, 631, 631, 632 Cathedral Dome, 611–613, 613, 615 Foundling Hospital, 613, 614, 614 Great Grotto, Boboli Gardens, 710, 710 Mannerism, 690–694, 690–694 Medici-Riccardi palace, 616-617, 616 Orsanmichele church, 622, 623 Palazzo Rucellai, 617, 617 San Giovanni baptistry, 622, 623, 624 San Lorenzo church, 613, 615–616, 615, 660, 661, 662 Flower pieces, 778 Flower Piece with Curtain (Spelt and Mieris), xxxi, xxxi Flower Still Life (Ruysch), 778, 779
Foire Chinoise, La (The Chinese Fair) (Boucher), 908, 908 Fondaco dei Tedeschi frescoes, 668, 669 Fontainebleau, France, Chamber of the Duchess of Étampes, 703, 703 Fontana, Domenico, 702 Fontana, Lavinia, *Noli Me Tangere*, 697, 697 Forbidden City, Beijing, Ming dynasty, 809–810, *810* Foreshortening, 583, 621 Form, xxiii color, xxiii composition, xxiv

5

Form, (cont.)	Furniture	German Pavilion, International Exposition,
line and shape, xxiii	African, 878, 878	Barcelona, 1060, 1060
texture, xxiv	Art Nouveau, 1004, 1004, 1021–1022, 1021	Germany
Formalism, xliii	Chinese, 808–809, 809	See also Holy Roman Empire
Formline, 850	Morris & Company, 977, 978	Baroque period in, 746–747
Foster, Norman, HongKong & Shanghai Bank,	Fur Traders Descending the Missouri (Bingham),	Bauhaus Building, Dessau, 1057, 1058, 1059
Hong Kong, 1118–1119, 1118	960, 961	city parks in, 1017
Foucault, Michel, 1132	Fuseli, John Henry (Füssli, Johann Heinrich), The	Fagus Shoe Company (Gropius and Meyer),
Fountain (Duchamp), 1062, 1062	Nightmare, 925, 925	1047, 1048
Four Apostles (Dürer), 680–681, 681	Fusuma (Kano Eitoku), 823–824, 824	Nazi, 1020
Four Crowned Martyrs (Nanni di Banco),	Fusuma, sliding doors, 823–824, 824, 825	Reformation in, 680–682
Orsanmichele church, 622, 623	Futurism, 1021, 1039–1040, <i>1040, 1041</i>	Renaissance in, 671–680
Four Horsemen of the Apocalypse (Dürer),		Gesso, 592
678, 678	G	Gestural painting, 872, 1090–1093, 1090,
Foundling Hospital (Brunelleschi), 613, 614, 614	U	1091, 1092
Fouquet, Jean, Melun Diptych	Gables, 588, 686	Ghana, 877
Étienne Chevalier and Saint Stephen,	Gabon, Fang, Nlo byeri guardian, 891, 891	Ashanti Kente cloth, 887, 887
607–608, 608	Gainsborough, Thomas, Portrait of Mrs. Richard	Ashanti staff, 874, 875, 886–887
Virgin and Child, 608	Brinsley Sheridan, 921, 921	Nankani compound, 879, 879
Fra Angelico. See Angelico, Fra (Guido di Pietro)	Galileo Galilei, 721	Ghiberti, Lorenzo, San Giovanni baptistry, door
Fragonard, Jean-Honoré, 904	Galleria, 731	panels, 622, 623, 624
The Meeting, 906–907, 907	Gandhi Bhavan, Punjab University (Mathur and	Ghirlandaio, Domenico, 655
France	Jeanneret), India, 799, 799	Nativity with Shepherd, 636, 638
Baroque period in, 739–746	Garden and a Princely Villa (Jones), 780, 780	real name of, 584, 636
city parks in, 1017	Garden in Sochi (Gorky), 1088, 1089	Ghost Clock (Castle), 1136, 1136
Classicism in, 927–934	Garden of Earthly Delights (Bosch), 708–709,	Giacometti, Alberto, City Square, 1085, 1085
ducal courts, 583–584	708–709	Gilbert, Cass, Woolworth Building, New York
Renaissance in, 607–608, 702–705	Garden of Love page from, Hypnerotomachia	City, 1046, 1047
Rococo style in, 902–909	Poliphili (Colonna), 603, 603	Gilded, 595
Romanticism in, 946–953	Garden of the Cessation of Official Life, Ming	Gilpin, Laura, Taos Pueblo, 851, 854
Francis I, king of France, 702	dynasty, China, 800-801, 801	Giorgione (Giorgio da Castelfranco), 666
Francis I (Clouet), 702, 702	Gardens	Pastoral Concert, The, 669, 669
Franco, Francisco, 1020	Baroque, 741	Tempest, The, 667–669, 668
Frank, Robert	Chinese, 800–801, 801, 809	Giotto di Bondone, 579
Americans, The, 1110	English landscape, 914–915, 915	frescoes, Scrovegni (Arena) Chapel, Padua,
Trolley, New Orleans, 1110, 1111	Japanese, 821–822, 822	579, 580, 581
Frankenthaler, Helen, Mountains and Sea,	Gardner, Alexander, Confederate Dead Gathered	Marriage at Cana, Raising of Lazarus,
1095, 1097	for Burial, Antietam, September 1862, 1009,	Resurrection and Noli Me Tangere and
Franklin, Benjamin, 899, 919, 934	1009	Lamentation, Scrovegni (Arena) Chapel,
Frederick Barbarossa, 901	Garnier, Charles, Opéra, Paris, 969-970, 969, 970	Padua, 579, 580, 581
Frederick C. Robi House (Wright), Chicago,	Gates of Paradise, San Giovanni baptistry,	Giovane, Palma, 689
1045–1046, 1045, 1046	Florence, 622, 623, 624	Giovanni da Bologna, 694
Freedom from Want, from Saturday Evening Post	Gaudí i Cornet, Antonio, Serpentine bench,	Astronomy, or Venus Urania, 695, 696
(Rockwell), 1072, 1072	1021–1022, <i>1021</i>	Girardon, François, Apollo Attended by the
French art	Gauguin, Paul, 866, 993, 997	Nymphs of Thetis, 743, 743
academic, 969–971	Mahana no atua (Day of the God), 998, 998	Girodet-Trioson, Anne-Louis, Portrait of Jean-
academies, 906	Gaulli, Giovanni Battista, Triumph of the Name of	Baptiste Belley, 933, 933
architecture, Baroque, 739–742, 739–742	Jesus and the Fall of the Damned, 733, 734	Gita Govinda, India, 796–797, 797
architecture, Classicism, 927–929, 927, 928	Gautier, Théophile, 984	Giuliani, Rudolph, 1142
architecture, nineteenth century,	Geese Aslant in the High Wind (Gyokudo),	Giuliano da Sangallo, Santa Maria delle Carceri
968–969, 969	829–830, <i>830</i>	church, 618, 620–621, 620
architecture, Renaissance, 702–706, 703, 704	Gehry, Frank, Guggenheim Museum, Solomon	Glass and Bottle of Suze (Picasso), 1037, 1037
Art Nouveau, 1004 Classicism revival and Purism, 1053–1057,	R., Bilbao, Spain, xliii, 1119-1120, 1120	Glazes (glazing), 592, 593, 722, 808
1054–1056	Geisha as Daruma Crossing the Sea (Harunobu),	Gleaners, The (Millet), 973, 973
Cubism, 1038–1039, 1038, 1039	831–832, <i>832</i>	Glorification of the Papacy of Urban VIII
Dadaism, 1062, 1062	Genghis Khan, 802	(Cortona), 732, 733
painting, Baroque, 743–746, 743–746	Genre, 721	Goes, Hugo van der, Portinari Altarpiece,
painting, Baroque, 743–740, 743–740 painting, Classicism, 929–934, 929–933	painting, 775–777, 807, 904, 960, 961	601–602, 601
painting, Classicism, 727–734, 727–733 painting, Fauvism, 1021, 1023–1025,	Gentile da Fabriano, Adoration of the Magi,	Gogh, Vincent van, Large Plane Trees, xlvi–xlvii,
1023, 1024	628–629, 629	XIVII
painting, naturalism, 971–973, 972, 973	Gentileschi, Artemisia, 737	Golden Fleece, 1041 Gold leaf, 823
painting, Realism, 973–974, 974, 975	Judith and Maidservant with the Head of	
painting, Renaissance, 702, 702	Holofernes, 738, 739	Goldsmith (Saint Eligius?) in His Shop, A
painting, Rococo, 902, 903, 904, 905,	Self-Portrait as the Allegory of Painting, 738, 738	(Christus), 597, 599, <i>599</i> Gold work, Inca, 845, <i>845</i>
906–907, 907	Geomancy, 811	
painting, Romanticism, 946–952, 948–952	George III, king of England, 911, 917, 924	Golub, Leon, 1129 Gonçalves, Nuño, 606
Salons, 899, 906	George Clifford, 3 rd Earl of Cumberland (Hilliard),	Saint Vincent with the Portuguese Royal Family
sculpture, Baroque, 743, 743	715, 716	
sculpture, Classicism, 929-930, 934,	George Washington (Houdon), 934, 934	from Altarpiece of Saint Vincent, 607, 607
930, 934	Georgian silver, 918, 918	Goncharova, Natalia <i>, Aeroplane over a Train,</i> 1041 <i>, 1041</i>
sculpture, late nineteenth century,	Gérard, Marguerite, 907	
1002–1003, 1002, 1003	Géricault, Théodore, 946, 951	Gonzaga, Federigo, 664
sculpture, Rococo, 908–909, 909	Pity the Sorrows of a Poor Old Man, 950, 950	Gonzaga family (Mantua), 636
sculpture, Romanticism, 952–953, 952, 953	Raft of the "Medusa," 947–950, 948–949	González, Julio, Woman Combing Her Hair II,
tapestry, Rococo, 908, 908	German art	1066, 1066
French Revolution, 898, 932–933	architecture, Neoclassicism, 962–963, 963	Gopuras, of the Minakshi-Sundareshvara
French Royal Academy of Painting and	architecture, Rococo, 900–901, 900, 901, 902	Temple, India, 791–792, 791
Sculpture, 906	Art Nouveau, 1004	Gorky, Arshile, 1092
Frescoes	Baroque, 746–747, 747, 748	Garden in Sochi, 1088, 1089
Italian Renaissance, 629–636, 630–638	Bauhaus art, 1057, 1057, 1058,	Gothic art
Santa' Agostino church, San Gimignano, Italy,	1059–1060, 1060	architecture, American Gothic Revival,
583, <i>5</i> 83	Dadaism, 1060–1062, 1060, 1061	964, 964
Scrovegni (Arena) Chapel, Padua, 579,	Die Brücke, 1025–1026, 1025, 1026	architecture, English Gothic Revival, 916, 916
580, 581	Nazi suppression of, 1059	international, 584, 628–629
Freud, Sigmund, 999, 1088	painting, expressionism, 1026–1027,	Goujon, Jean, 704
	1026–1027, 1059	Governess, The (Chardin), 904, 905
Friedrich, Caspar David, 954 Wanderer Above a Sea of Mist, 955, 956, 955	painting, Realism, 975, 976	Goya, Francisco, 951
Wanderer Above a Sea of Mist, 955–956, 955	painting, Renaissance, 675–678, 676, 677	Caprichos (Caprices), 954
Fry Roger 993	printmaking, 608, 678–680	Family of Charles IV, 953–954, 953
Fry, Roger, 993	sculpture, Renaissance, 672–674, 673, 674, 675	Sleep of Reason Produces Monsters, 954, 954
Fujii, Chuichi, <i>Untitled '90</i> , 834–835, 835	sculpture, Rococo, 901–902, 902	Third of May, 1808, 954, 955

Gozzoli, Benozzo, Saint Augustine Reading Halley, Peter, 1132 Rhetoric in Rome, Santa' Agostino church, San Gimignano, Italy, 583, 583 Fire in the Sky, 1133, 1133 Hall of Mirrors (Le Brun and Hardouin-Mansart), Versailles, 742, 742 Graffiti, 1086 Grand Déjeuner, Le (The Large Luncheon) (Léger), 1054, 1055 Catharina Hooft and Her Nurse, 764–765, 765 Officers of the Haarlem Militia Company of Saint Adrian, 765, 765 Hamatsa masks, Kwakwaka'wakw (Kwakiutl), 850–851, 852, 852, 853 Grand Manner, 921, 950 Grand Tour, 909–912 Graphic artist, 999 Graphic arts Art Nouveau, 1004–1005, 1005 Hamilton, Ann, Indigo Blue, 1147-1148, 1148 Hamilton, Gavin, 913 Hamilton, Richard, 1101 \$he, 1102–1103, 1103 Hamilton, William, 919 Renaissance, 608-610 Grattage, 1064 Great Grotto (Buontalenti), Boboli Gardens, Florence, 710, 710 Great Plains, 846–848 Hammamet with its Mosque (Klee), 1029, Great Pyramid (Aztec), 840 1030, 1031 Hammons, David, Higher Goals, 1145–1146, 1145 Hampton, James, Throne of the Third Heaven of the Nations' Millennium General Assembly, xxxvi, xxxvi Great Sphinx, Egypt, xxix, xxix Great Wall of Los Angeles (Baca), 1144–1145, Great Wave, The (Hokusai), 816–817, 817, 832 Greco, El (Domenikos Theotokopoulos) Burial of Count Orgaz, 705–706, 706 View of Toledo, 706, 707 Hamza-nama, 793, 794 Handscrolls, 804–805, 806 Han dynasty, 803, 808 Hanging scrolls, 804, 806 Hanson, Duane, *Shoppers, The*, 1124, *1124* Happenings, 1098–1099, *1098*, *1099* Hardouin-Mansart, Jules, Palais de Versailles, Greek-cross plan churches, 618, 663, 664, 927 Greek Slave (Powers), 961–962, 961 Greenberg, Clement, 1086, 1090, 1105 Hardouin-Mansart, Jules, Palais de Versallies, 739–743, 739, 740, 742
Hardwick Hall (Smythson), Shrewsbury, England, 715, 716
Harlem Renaissance, 1072–1074, 1073, 1074
Harmony in Blue and Gold, Peacock Room, for Greuze, Jean-Baptiste, Drunken Cobbler, 929, 929 Grisaille, 589 Grizzly bear house partition screen, Tlingit, 850, 850 Gropius, Walter, 1057 Bauhaus Building, Dessau, Germany, 1057, Frederick Leyland (Whistler), xlii, xlii Harp, Barberini, 730, 730 1058, 1059 Fagus Shoe Company, 1047, 1048 Gros, Antoine-Jean, Napoleon in the Plague House at Jaffa, 945, 945 Gross Clinic (Eakins), 1011, 1012 Grotto, 710 Grotto of Thetis (Lepautre), 743, 743 Group of Seven, 1080–1081 Grünewald, Matthias, 678 Isenheim Altarpiece, 675–677, 676, 677 Gu, Wenda, United Nations—Babel of the Millennium, 1151–1152, 1152 Hawaiian Islands, 867-868, 867, 868, Guda, 585 Guda, 385 Guercino (Giovanni Francesco Barbieri) Saint Luke Displaying a Painting of the Virgin, xxix, xxxix, 733, 735 Guernica (Picasso), 1018–1019, 1019 Heartfield, John, 1059–1062 Guggenheim Foundation, xlii-xliii Guggenheim Museum, Solomon R. (Gehry), Bilbao, Spain, xliii, 1119–1120, 1120 Guggenheim Museum, Solomon R. (Wright), New York City, xlii–xliii, xliii Guido di Pietro. See Angelico, Fra (Guido di Heian period, 819 Heizer, Michael, 1121 Double Negative, 1122, 1122 Hemessen, Caterina van, Self-Portrait, Pietro) Guilds, 590 Guimard, Hector, Desk, 1004, 1004 Guro spirit mask, Côte d'Ivoire, 892, 893 709–710, 709 Hemicycles, 685 Hennings, Emmy, 1060 Gurruwiwi, Mithinarri, Conference of Serpents, 862, 862 Guston, Philip, 1129 Gutai Bijutsu Kyokai (Concrete Art Association), Henri, Robert, 1042 Henri IV, king of France, 739 1099 Gutenberg, Johann, 603 Gyokudo, Uragami, *Geese Aslant in the High Wind*, 829–830, 830 H

Habitat '67 (Safdie), Montreal, Canada, 1115, 1116 Hackwood, William, "Am I Not a Man and a Brother?" jasperware, 919, 919
Haden, Francis Seymour, 984
Hadid, Zaha, Vitra Fire Station, Germany, 1119, 1119 Hagar in the Wilderness (Lewis), 1006–1007, 1007 Hagenauer, Nikolaus, Saint Anthony Enthroned between Saints Augustine and Jerome, Hagesandros, Laocoön and His Sons, xliv-xlv, xliv, xlv Haida, 849, 856, 857 Hakuin Ekaku, Bodhidharma Meditating, Halder, Jacob, Armor of George Clifford,

717, 717

Harrison, Peter, Redwood Library, Newport, Rhode Island, 934, 934
Hartingan, Grace, 1095
Hartley, Marsden, Portrait of a German Officer, 1043, 1044, 1044 Harunobu, Suzuki, *Geisha as Daruma Crossing* the Sea, 831–832, 832 Haussmann, Georges-Eugène, 969, 1017 Have No Fear—He's a Vegetarian (Heartfield), 1061, 1061 871–872, 871

Head Surrounded by Sides of Beef (Bacon), 1085, 1085

Hearst, William Randolph, 1075 Have No Fear—He's a Vegetarian, 1061, 1061 Heath of the Brandenburg March (Kiefer), 1131, 1132 Heckel, Erich, Crouching Woman, 1025, 1025 Hegel, Wilhelm Friedrich, 1086 Henri IV Receiving the Portrait of Marie de' Medici (Rubens), 760–761, 761 Henry VI, king of England, 607 Henry VIII, king of England, 680, 713, 715 Henry VIII (Holbein the Younger), 713–714, 713 Hercules and Antaeus (Pollaiuolo), 611, 627, 627 Herrera, Juan de, El Escorial, Madrid, 705, 705 Hesse, Eva, Rope Piece, 1108, 1108 Hideyoshi, Toyotomi, 822-823 Higher Goals (Hammons), 1145–1146, 1145 High Tech architecture, 1118–1119, 1118 High Tech architecture, 1118–1119, 1118
Hilliard, Nicholas, George Clifford, 3rd Earl of Cumberland, 715, 716
Himeji Castle, Hyogo, Japan, 823, 823
Hindu art, 791–792, 791
Hinduism, 791
Hireling Shepherd (Hunt), 977, 977
Hiroaki, Morino, ceramic vessel, 834, 834 Hiroshige, Utagawa Fifty-Three Stations of the Tokaido, 832 One Hundred Views of Edo: Bamboo Yards, Kyobashi Bridge, 988, 988 Historicism, 967 History of Ancient Art (Winckelmann), 912 History paintings, 899
English Neoclassicism, 922–924, 923, 924

773, 774, 775 Höch, Hannah, *Dada Dance*, 1061, *1061* Hofmann, Hans, 1091 Hogarth, William, 919 Marriage Contract, from Marriage à la Mode, 920, 920 Hohokam culture, 851 Hokusai, Katsushika Great Wave, The, 816–817, 817, 832 Thirty-Six Views of Fuji, 832 Holbein the Younger, Hans, Henry VIII, 713-714, 713 Holocaust, 1020 Holy Roman Empire, 746 See also Germany
Renaissance (early) in, 608, 609
Holy Virgin Mary (Ofili), 1142, 1142
Holzer, Jenny, Truisms, 1146–1147, 1148
Homage to Blériot (Delaunay), 1038–1039, 1039 Homage to New York (Tinguely), 1100, 1100 Homer, Winslow Life Line, 1011, 1011 Snap the Whip, 1009, 1010 HongKong & Shanghai Bank (Foster), Hong Kong, 1118–1119, 1118
Hood & Fouilhoux, 1077, 1078
Hopper, Edward, Nighthawks, 1071, 1071
Horde, The (Ernst), 1064, 1064
Horn Players (Basquiat), 1131, 1131 Horta, Victor, Stairway, Tassel House, Brussels, 1004, 1004
Hosmer, Harriet, Zenobia in Chains, 1006, 1006
Houdon, Jean-Antoine, George Washington, 934, 934 Hour of Cowdust, India, 797-799, 798 Hours of Mary of Burgundy (Mary of Burgundy Painter), Mary at Her Devotions from, 589, 602–604, 602 House (Whiteread), 1146, 1146 House of Jacques Coeur, Bourges, France, Houses at L'Estaque (Braque), 1035, 1035 Houses of Parliament (Barry and Pugin), London, 963–964, 963 Housing Nankani compound, Ghana, 879, 879 tepees, 848, 848 How the Other Half Lives (Riis), 1013 Hudson River Landscape (Smith), 1094, 1095 Hudson River School, 959 Huelsenbeck, Richard, 1060 Hues, 995, 1106 Hughes, Holly, 1142 Huineng, 811 Humanism, 579, 580–581 Humareds of Birds Admiring the Peacocks (Ying Hong), 807–808, 807 Hundred Years' War, 584, 1002 Hunt, Richard Morris, World's Columbian Exposition, Chicago, 1014–1015, 1015
Hunt, William Holman, Hireling Shepherd, 977, 977
Hunt of the Unicorn tapestry, 604–606, 605 Hurling Colors (Shimamoto), 1099, 1099 Huysmans, Joris-Karl, 984 Hyogo, Japan, Himeji Castle, 823, 823 Hypnerotomachia Poliphili (Colonna), 603, 603

Hitler, Adolph, 1020, 1057, 1059, 1061 Hoare, Henry, Stourhead park, Wiltshire, England, 915, 915

Hobbema, Meyndert, Avenue at Middelharnis,

Ι

Iberian peninsula, spread of Flemish art in, 606-607 Iconography, xxxi, 789, 992, 1100 Icons, 1041, 1103 Ideal City with a Fountain and Statues of the Virtues (Anonymous), 582, 582 Idealism, xxx, 597, 945 Ieyasu, Tokugawa, 823 Ife culture, 877 Ignatius of Loyola, 682, 685, 705 Ignudi, 658, 732 Ijo ancestral screens, Nigeria, 891-892, 892 Íkkyu, 820 Calligraphy Pair, 821, 821 Il Gesù church (Vignola and della Porta), 685, 686 Illuminated manuscripts. See Manuscripts, illuminated

Impasto, 722, 996 Implosion/Explosion (Littleton), 1113, 1113	Italy Grand Tour, 909–912	K
Impost block, 615	Neoclassicism in, 912–913, 912, 913	Kabuki, 832
Impressionism, 944 exhibitions, 979–980	Rococo in, 909–912 Itten, Johannes, 1057	Kahlo, Frida, <i>Two Fridas, The</i> , 1079, <i>1079</i> Kahn, Louis, 1116
later, 990, 991, 992–993, 992	Iwans, 792	Kaisersaal (Imperial Hall), Residenz (Neumann),
plein air painting, 982–987 Post-, 993–998, 993–998	T	Germany, 900–901, <i>900, 901</i> Kakalia, Deborah (Kepola) U., <i>Royal Symbols</i> ,
use of word, 979	J	871–872, 871
Improvisation No. 30 (Cannons) (Kandinsky), 1028, 1029	Jack Pine (Thomson), 1080, 1080	Kalpa Sutra, 789-791, 790
Incas, 755, 842–845, <i>843</i> , <i>844</i>	Jacopo da Pontormo, 690 Jacque, Charles-Émile, 984	Kamakura, 819, 824 Kamamalu, queen of Hawaii, skirt of,
Incised, 862 Independent Group (IG), 1101	Jahan, shah of India, 787, 792	867–868, 867
India	Jahangir, 792, 793 Jahangir in Darbar, 793, 795	Kamehameha I, king of Hawaii, 867, 868 Kamehameha II, king of Hawaii, 868
architecture, Mughal, 786–787, 787, 792, 792 Buddhist art, 788–789, 789	Jain art, 789–790, 790	Kanaga mask, Dogon, Mali, 890–891, 890
culture of, 790	Jainism, 789 James, Henry, 1006	Kandinsky, Vasily, 1027 Concerning the Spiritual in Art, 1028
Hindu temples, 791–792, 791	James I, king of England, 778, 780	Improvisation No. 30 (Cannons), 1028, 1029
Jain art, 789–790, <i>790</i> Late Medieval period, 788–792	James II, king of England, 779 Jane Avril (Toulouse-Lautrec), 1005, 1005	Kano decorative painting, 823–824, 824 Kant, Immanuel, 899
luxury arts, 796, 796	Jan van Eyck. See Eyck, Jan van	Kaprow, Allan, <i>Courtyard, The</i> , 1098–1099, <i>1098</i>
map of, after 1200, 788 modern, 799, 799	Japan Edo period, 826–833	Kauffmann, Angelica, 910, 922
Mughal period, 792–794	map of, after 1392, 818	Cornelia Pointing to Her Children as Her Treasures, 923, 923
painting, Mughal, 793–794, <i>794</i> painting, Rajput, 794, 796–799, <i>797, 798</i>	Meiji period, 833	Kaufmann, Edgar, 1077
Taj Mahal, 786–787, 787, 792, 792	Modern, 833–835 Momoyama period, 822–825	Kearny Cloak, Hawaiian, 868, 868 Kent, William, 914
timeline, 788–789	Muromachi (Ashikaga) period, 818-822	Kenyan pottery, 894, 894
Indigo Blue (Hamilton), 1147–1148, 1148 Industrial Revolution, 898	periods in, 819 timeline, 818–819	Kepler, Johannes, 721 Kerouac, Jack, 1110
description of, 942–943	Japanese art	Key block, 833
map of Europe and America in the nineteenth century, 942	architecture, 823, <i>823</i> , 825 Buddhist, 819–821, <i>820, 821</i> , 830, <i>830</i>	Kiefer, Anselm, Heath of the Brandenburg March, 1131, 1132
timeline, 942-943	ceramics, 834, 834	Kilns, 808, 917
Ingres, Jean-Auguste-Dominique, 945 Large Odalisque, 946, 946	ink painting, 819–821, <i>820, 821</i> kabuki, 832	Kinetic, 1074, 1099–1100
Portrait of Madame Desiré Raoul-Rochette,	Kano decorative painting, 823–824, 824	Kino, Eusebio, 768 Kirchner, Ernst Ludwig, 1025
946, 947 Initiation art, 881–883, 881, 882, 883	Maruyama-Shijo school painting, 830–831, 831	Street, Berlin, 1026, 1026, 1059
Ink painting, 819-821, 820, 821, 829	Modern, 833–835, <i>834</i> , <i>835</i>	Kiss, The (Klimt), 1022, 1022 Klah, Hosteen, 855
Inlay, 828 Innocent X, pope, 722, 726, 727	Nanga school painting, 828–830, <i>829</i> Rimpa school painting, 826–828, <i>827, 828</i>	Whirling Log Ceremony, 856, 856
Installation art, 1050, 1126, 1146–1152, 1148–1151	sculpture, 834–835, 835 tea ceremony, 824–825, 825, 826, 826	Klee, Paul, Hammamet with its Mosque, 1029, 1030, 1031 Klein, Yves, Anthropométries of the Blue Period,
Institute of American Indian Arts (IAIA), 856	ukiyo-e (woodblocks), 831-833, 832	1099, 1099
Institute of Contemporary Art (ICA), 1101 Intaglios, 612, 912	Zen dry gardens, 821–822, <i>822</i> Zen painting, 830, <i>830</i>	Klimt, Gustav, 1004 <i>Kiss, The</i> , 1022, <i>1022</i>
Intarsia, 621	Japonisme, 832, 988	Knight Watch (Riopelle), 1086, 1087
International Exposition (1929), German Pavilion, Barcelona, 1060, 1060	Jasperware, 917, 918, <i>918</i> Jean, duke of Berry, 585	Koetsu, Hon'ami, <i>Mount Fuji</i> teabowl, 826, <i>826</i> Kofun period, 819
International Gothic art, 584, 628-629	Jean de Marville, 587	Kollwitz, Käthe Schmidt, <i>Outbreak, The</i> ,
International style, 1056, 1114–1115 Interpretation of Dreams, The (Freud), 999	Jean le Noir, 585 Jeanne-Claude (de Guillebon), 1122	1026, 1026 Kongo spirit figure (nkisi nkonde), Democratic
Intimate Gallery, 1067	Running Fence, 1123, 1123	Republic of the Congo, 883–885, 884
Intrigue, The (Ensor), 1000–1001, 1001 Intuitive perspective, 583	Jeanneret, Charles-Édouard. See Le Corbusier	Koons, Jeff, New Shelton Wet/Dry Triple Decker, 1133–1134, 1133
Invention of the Balloon (Clodion), 908–909, 909	Jeanneret, Pierre, Gandhi Bhavan, Punjab University, India, 799, 799	Korin, Ogata, Lacquer box for writing
Ionic order, 617 Irian Jaya, 863, 864, 865	Jefferson, Thomas, 899, 962	implements, 827–828, 828 Koshares of Taos (Velarde), 854–855, 855
Iron bridges, 935, 935, 968, 968	Monticello, Virginia, 935–936, 936 Jenney, William Le Baron, 1016	Kosuth, Joseph, 1108
Iroquois, 845 Isabella, princess, 593	Jesuits, 682	One and Three Chairs, 1109, 1109 Kounellis, Jannis, <i>Untitled (12 Horses)</i> ,
Isabella, queen of Castile, 606	Jewish Bride (Rembrandt), 769–770, 771 Jewish Cemetery, The (Ruisdael), 773, 774	1082–1083, 1083
Isabella d'Este (Titian), 670–671, 672 Isenheim Altarpiece (Grünewald), 675–677,	Jewish Museum (Libeskind), Berlin, 1120	Kraser, Lee, 1089, 1092
676, 677	Jews, Holocaust, 1020 Jimmy Carter (Steinkamp), 1143, 1143	Seasons, The, 1091, 1091 Krishna and the Gopis, Gita Govinda, India,
Italian art architecture, Baroque, 722–729, 723–729	Joan of Arc, 607	796–797, 797
architecture, Baroque, 722–729, 723–729 architecture, Renaissance, 611–622, 613–622,	Johns, Jaspar, <i>Target with Four Faces</i> , 1100–1101, <i>1102</i>	Krug, Hans, 672 Apple Cup, 672, 673
662–665, 662, 664, 682, 684–685, 684, 686,	Johnson, Philip, 1116	Kruger, Barbara, We Won't Play Nature to Your
700–702, <i>700, 701</i> Art Nouveau, 1004	AT&T Corporate Headquarters, New York City, 1117, <i>1117</i>	Culture, 1134, 1134 Kuba portrait sculpture, Democratic Republic of
Cubism and Futurism, 1039–1040, 1040, 1041	Seagram Building, New York City,	the Congo, 887–888, 887
Mannerism, 682, 690–695 names and nicknames of artists, 584	1114, <i>1114</i> Jomon period, 819	Kublai Khan, 802 Kwakwaka'wakw (Kwakiutl), 849, 850–851,
painting, Baroque canvas, 733, 734, 735-738,	Jonah (Ryder), 1014, 1014	852, <i>852, 853</i>
735–738 painting, Baroque illusionistic ceiling,	Jones, Inigo, 779, 934 Banqueting House (Jones), Whitehall Palace,	Kyoto, Japan Fusuma, 823–824, <i>824</i>
730–733, 731–733	London, 779–780, 780, 781, 782	Ryoan-ji, Zen dry garden, 821-822, 822
painting, Neoclassicism, 912–913, 912 painting, Renaissance, 628–643, 629–635,	Garden and a Princely Villa, 780, 780 Joseph in His Carpentry Shop (Campin),	Tai-an tearoom (Rijyu), 824–825, 825
637–643, 648–655, 649–654, 656, 657,	581–582, <i>582</i>	L
658–659, 658, 659, 666–671, 666–671, 685–688, 687, 688, 689, 697–700,	Judd, Donald, Untitled, 1107, 1107	
698, 699	Judgment of Paris (Raphael), 980 Judith and Maidservant with the Head of	Labille-Guiard, Adélaïde, 930 Self-Portrait with Two Pupils, 931, 931
Rococo in, 909–912	Holofernes (Gentileschi), 738, 739	Labrouste, Henri, Bibliothèque Sanite-
sculpture, Baroque, 722, 730, <i>730</i> sculpture, Neoclassicism, 913, <i>913</i>	Julius II, pope, 645, 647, 651, 656, 660, 662, 663, 664	Geneviève, Paris, 968–969, 969 La Casa Grande, San Simeon (Morgan),
sculpture, Renaissance, 622-628, 623-628,	Jung, Carl, 1088	California, 1075, 1076, 1077
655–656, 655, 660, 660, 661, 662	Justice of Otto III (Bouts), 599–600, 599	Lacquer, 827–828

Levine, Sherrie, 1130 Majolica, 591 Lacquer box for writing implements (Korin), 827–828, *828* Untitled (After Aleksandr Rodchenko: 11), Ma Jolie (Picasso), 1036, 1036 Lady Sarah Bunbury Sacrificing to the Graces (Reynolds), 921, 921 La Fayette, Madame de, 899 1134, 1134 Lewis, Edmonia, *Hagar in the Wilderness*, 1006–1007, 1007 Maki-e. 828 Malanggan carvings, New Ireland, 865 Male and Female (Pollock), 1089, 1090 Landscape Leyland, Frederick, xlii Malevich, Kazimir, Suprematist Painting (Eight architecture, 779-780, 914-916, 914-916 Leyster, Judith, 765 Red Rectangles), 1041–1042, 1042 Self-Portrait, 766-767, 766 English garden, 914-915, 915 Mali, 877 Liberation of Aunt Jemima (Saar), 1125, 1125 Dogon Kanaga mask, 890-891, 890 Landscape (Bunsei), 820, 820 Landscape (Shitao), 814, 814 Landscape painting American, 959–960, 960, 961, 1007–1008, 1007, 1008 Libeskind, Daniel jar from, 895 Malinalco, rock-cut sanctuary, Aztec, 841, 841 Jewish Museum, Berlin, 1120 World Trade Center, computer-generated Man, Controller of the Universe (Rivera), design, 1120-1121, 1121 1078-1079, 1078 Manchu (Qing) dynasty, 813–814 Mander, Karel van, 764 *Mandolin and Clarinet* (Picasso), 1037, *1038* German, 681-682, 683 Libyan Sibyl (Michelangelo), 659 Lichtenstein, Roy, Oh Jeff...I Love You, Too...But..., 1103, 1103 Life Line (Homer), 1011, 1011 Romantic, 954-958, 955-958 Landscape with Rainbow (Rubens), 761-762, 762 Manet, Édouard Landscape with Saint John on Patmos (Poussin), Limbourg brothers, *Très Riches Heures*, 584, 586, 586 Bar at the Folies-Bergère, A, 989, 990 Le Déjeuner sur l'Herbe, 980–981, 981 746, 746 Lange, Dorothea, 1070 *Olympia*, 981–982, *981* Manifestos, 1021 Migrant Mother, Nipomo, California, Limners, 784 Lin, Maya Ying, Vietnam Veterans Memorial, 1144, *1144* 1071, 1071 Man in a Red Turban (Jan van Eyck), 594, 594 Lantern, 612, 685 Laocoön and His Sons (Hagesandros Linda Nochlin and Daisy (Neel), 1124-1125, Mannerism, 682, 690-695 Polydoros, and Athanadoros), xliv–xlv, Mansart, François, 739 Mansart, François, 759
Mansart, Jules. See Hardouin-Mansart, Jules
Man's Love Story (Possum Tjapaltjarri), 872, 873
Mantegna, Andrea, frescoes in Camera Picta,
Ducal Palace, Mantua, Italy, 636, 637 xliv, xlv, 723 Lapita, 861, 862–863, 863 Linear perspective, 577, 582, 583 Lionardo Bartolini Salimbeni, 577 Lapita, 861, 862–865, 865
Large Bathers (Cézanne), 994–995, 995
Large Blue Horses (Marc), 1029, 1030
Large Form (Takaezu), 1137, 1137
Large Odalisque (Ingres), 946, 946
Large Plane Trees (van Gogh), xlvi–xlvii, xlvii Lipchitz, Jacques, *Man with a Guitar*, 1038, *1038* Lippi, Filippino, Brancacci Chapel, Santa Maria del Carmine church, 631, *631*, *632* Mantua, duke of, 759 Lipstick (Ascending) on Caterpillar Tracks (Oldenburg), 1104–1105, 1104 Mantua, Italy architecture in, 617–618 Ducal Palace, 636, 637 Palazzo del Tè, Mantua, 664, 664, 666, 666 Sant'Andrea church, 618, 618, 619 Lissitzky, El, Proun space, 1050, 1051 Literati painting, 804, 810–813, 812, 813 Lithography, 950, 951, 984 Littleton, Harvey, Implosion/Explosion, Larionov, Mikhail, 1041 Las Meninas (The Maids of Honor) (Velázquez), 722, 753–754, 754 Last Judgment (Michelangelo), 685, 687, Manuscripts, illuminated, Renaissance, 584–586, 602–604 Manuzio, Aldo (Aldus Manutius), 603 1113, 1113 687, 688 Lives of the Most Excellent Italian Architects, Last Judgment Altarpiece (Weyden), 596-597, Painters and Sculptors (Vasari), xliii, 647 Llama, Inca, 845, 845 Lobi spirit figure (boteba), Burkina Faso, 883, 884 Lobster Trap and Fish Tail (Calder), 1075, 1076 Man with a Guitar (Lipchitz), 1038, 1038 Maori, New Zealand, 868–871, 868, 869, 870 Mapplethorpe, Robert, 1142 Lastman, Pieter, 767 Last Supper, The (Andrea del Castagno), 634-635, 634 Last Supper, The (Leonardo), xl, xl, 648, 649 Ajitto (Back), 1138, 1138 Maps Locke, Alain, 1072 of Africa, 876 of America in the nineteenth century, 942 of China, after 1280, 802 Last Supper, The (Rembrandt), xli, xli Loggia, 616, 664, 665 Last Supper, The (Tintoretto), 699-700, 699 Banqueting House (Jones), Whitehall Palace, 779–780, 780, 781, 782 Last Supper from Altarpiece of the Holy Blood (Riemenschneider), 673–674, 673 Latin American art. See Mesoamerica; Mexico of Europe in Baroque period, 720 of Europe in Enlightenment, 898 of Europe in the nineteenth century, 942 of Europe in the Renaissance, 578, 646 of Europe in the twentieth century, 1020 of India, after 1200, 788 Crystal Palace (Paxton), 968, 968 ExHibition of 1851, 967–968 Latin-cross plan churches, 618, 618, 663 Houses of Parliament (Barry and Pugin), 963–964, 963 Latrobe, Benjamin Henry, 962 Laughing Mannequins (Alvarez Bravo), Saint Paul's Cathedral (Wren), 782, 782 1079, 1080 Laurana, Luciano, Ducal Palace, 621, 621, 622 Lawrence, Jacob, 1073 *Migration of the Negro*, 1074, 1074 Loos, Adolf, Steiner House, Vienna, 1046-1047, of Japan, after 1392, 818 of Mesoamerica, after 1300, 838 Lorenzo the Magnificent. See Medici, Lorenzo of North America in Baroque period, 720 de' (the Magnificent) Lorrain, Claude (Claude Gellé), 915 Embarkation of the Queen of Sheba, 745, 745 of North America in Enlightenment, 898 of North America in the twentieth century, Le Brun, Charles, Hall of Mirrors, Versailles, 742, 742 1020 Le Corbusier, 1054 Contemporary City of Three Million Inhabitants, 1055–1056, 1055 Villa Savoye, France, 1056–1057, 1056 Lectern (Paley), 1137, 1137 Lost-Wax casting, xxvii of the world, since 1945, 1084 Louis, Morris, Saraband, 1105, 1105 Marat, Jean-Paul, 933 Louis XI, king of France, 607 Marc, Franz, 1027 Louis XIII, king of France, 739, 744 Louis XIV, king of France, 719, 739, 739, Large Blue Horses, 1029, 1030 Marco Polo, 804, 808 Margaret of Austria, 672 Ledoux, Claude-Nicolas, Chaux town plan, 742, 899 928, 928 Marie Antoinette, queen of France, 741, 930 Marilyn Diptych (Warhol), 1103–1104, 1104 Marinetti, Filippo, 1039 Louis XIV (Rigaud), 718, 719, 746 Leeuwenhoek, Antoni van, 721 Louis XV, king of France, 741, 899, 907, Lega bwami masks, Democratic Republic of the 910, 928 Congo, 882-883, 883 Louis XVI, king of France, 741, 743, 930, 932 Louvre, palais du (Lescot), Paris, 704–705, 704 Lunettes, 615, 656, 659 Léger, Fernand, 1087 Marquesas Islands, 867, 867 Marriage at Cana, Raising of Lazarus, Resurrection and Noli Me Tangere and Grand Déjeuner, Le (The Large Luncheon), 1054, 1055 Legrain, Pierre, Tabouret, 878, 878 Leibl, Wilhelm, *Three Women in a Village* Luther, Martin, 680, 681 Lamentation Giotto di Bondone), 579, 581 Marriage Contract, from Marriage à la Mode (Hogarth), 920, 920

Marriage of the Emperor Frederick and Beatrice of Burgundy (Tiepolo), 901, 901

Marshall Field Wholesale Store (Richardson), Church, 975, 976 M Lenin, Vladimir, 1020, 1078, 1079 Le Nôtre, André, 740, 741 Leo X, pope, 647, 654 Maas at Dordrecht (Cuyp), 773, 773 Machu Picchu, Peru (Inca), 843-844, 843 Chicago, 1015-1016, 1016 Leo X with Cardinals Giulio de' Medici and Luigi de' Rossi (Raphael), 654, 654 Leonardo da Vinci, xxxi-xxxii, 583, 584, Maderno, Carlo, 728 Marsh Flower, a Sad and Human Face (Redon), Saint Peter's basilica, plan for, 663, 663, 999-1000, 999 722–723, 724 Madonna and Child with Lilies (Luca della 702, 740 Martinez, Julian, 854 Robbia), 628, 628 Madonna with the Long Neck (Parmigianino), Last Supper, The, xl, xl, 648, 649 Martinez, Maria Montoya, Blackware storage jar, 854, 854 Martini, Piero Antonio, *Salon of 1787*, 906, 906 Mona Lisa, 648, 650, 650 Virgin and Saint Anne with the Christ Child and Madrid, El Escorial, 705, 705 Magdalen with the Smoking Flame, (De La Tour), 744–745, 744 the Young John the Baptist, 648, 650 Vitruvian Man, 651, 651 Leoni, Leone, Charles V Triumphing Over Fury, xxxiv–xxxv, xxxiv, 680 Martin Luther as Junker Jörg (Cranach the Elder), 681, 682 Martyrdom of Saint Bartholomew (J. Ribera), Magic Bird (Brancusi), 1032, 1032 750, *750* Lepautre, Jean, Grotto of Thetis, 743, 743 Mahana no atua (Day of the God) (Gauguin), Martyrdom of Saint Ursula (Memling), 600-601, Leroy, Louis, 979 998, 998 601 Martyrium, 618, 663 Maruyama-Shijo school painting, 830–831, *831* Lescot, Pierre, Louvre, palais du, 704-705, 704 Mahavira, 789, 790 Mahayana Buddhism, 789, 790 Le Vau, Louis, Palais de Versailles, 739-743, Maillol, Aristide, Mediterranean, 1031, 1031 Mary I, queen of England, 672, 715

739, 740, 741

Mary at Her Devotions from Hours of Mary of	Aztecs, 755, 836-837, 837, 839-842	use of term, 1021
Burgundy (Mary of Burgundy Painter), 589,	European conquest of, 755–756	Modernismo, 1021–1022, 1021
602-604, 602 Many Magdalon (Donatollo), 624, 625, 626	Incas, 755, 842–845, <i>843, 844</i>	Modersohn-Becker, Paula, Self-Portrait with an
<i>Mary Magdalen</i> (Donatello), 624, 625, 626 Mary of Burgundy Painter, <i>Mary at Her</i>	map of, after 1300, <i>838</i> Spanish art, influence of, 755–758, <i>756,</i>	Amber Necklace, 1026, 1027 Modules, 615, 825
Devotions from Hours of Mary of Burgundy,	757, 758	Moholy-Nagy, László, 1057
589, 602–604, <i>602</i>	timeline, 838–839	Moldings, 588, 665, 685
Mary of Hungary, 672	Mexico	Momoyama period, 822–825
Marx, Karl, 943	art in, interwar years, 1078–1079, 1078,	Mona Lisa (Leonardo), 648, 650, 650
Masaccio	1079, 1090	Mondrian, Piet, 1051, 1087
Brancacci Chapel, Santa Maria del Carmine	Aztecs, 755, 836-837, 837, 839-842	Composition with Yellow, Red, and Blue,
church, 631, 631, 632, 633	Meyer, Adolf, Fagus Shoe Company, 1047, 1048	1052, <i>1052</i>
Expulsion from Paradise, 631, 632	Michelangelo Buonarroti, 584, 655–662, 740	Monet, Claude, 979
real name of, 584, 629	Capitoline Hill, 682, 684	Boulevard des Capucines, 982–983, 983
Tribute Money, 632, 633 Tripit with the Virgin, Saint John the	David, 656, 656	Impression, Sunrise, 979
Trinity with the Virgin, Saint John the	Last Judgment, 685, 687, 687, 688	Rouen Cathedral: The Portal (in Sun),
Evangelist, and Donors, 629–631, 630 Masks	Libyan Sibyl, 659 Moses, 660, 660	992–993, 992 Terrace at Sainte-Adresse, 982, 982
Bwa, Burkina Faso, 881–882, <i>881</i>	Palazzo Farnese, 664, 664, 665, 665	Mongols, 802, 809, 810
Dogon Kanaga, Mali, 890–891, 890	Piazza del Campidoglio, 684, 684	Monkey Cup, Flemish, 606, 606
Ekpo, Anang Ibibio, Nigeria, 890, 890	Pietà, 655–656, 655	Montbaston, Jeanne de, 585
Guro spirit, Côte d'Ivoire, 892, 893	Rondanini Pietà, 688, 688	Monticello (Jefferson), Virginia, 935–936, 936
Hamatsa, Kwakwaka'wakw (Kwakiutl),	Saint Peter's basilica, plan for, 663, 663, 664,	Montreal, Canada, Habitat '67 (Safdie),
850–851, 852, <i>852, 853</i>	684–685, 684	1115, 1116
Lega bwami, Democratic Republic of the	Sistine Chapel, 656, 657, 658-659	Mont Sainte-Victoire (Cézanne), 993-994, 993
Congo, 882–883, 883	sonnet by, with self-portrait, 644, 645, 656	Monument to the Third International (Tatlin),
Mende, Sierra Leone, 882, 882	Michelangelo da Caravaggio. See Caravaggio	1049–1050, <i>1050</i>
tatanua, New Ireland, 865, 865	Michelozzo di Bartolomeo	Moon Goddess Coyolxauhqui, Aztec, 841, 841
Masolino, Brancacci Chapel, Santa Maria del	Cathedral Dome, 615, 615	Moore, Henry, Recumbent Figure, 1066–1067,
Carmine church, 631, 631, 632	Medici-Riccardi palace, 616–617, 616	1067
Masonry, Inca, 843–844, 843 Masque, English court, 780	Micronesia, 865–866, <i>866</i> Middle Ages, 585	Moreau, Gustave, <i>Apparition</i> , 999, 999 Morgan, Julia, La Casa Grande, San Simeon,
Master of Flémalle. See Campin, Robert	Mieris, Frans van, <i>Flower Piece with Curtain</i> ,	California, 1075, 1076, 1077
Maternal Caress (Cassatt), 990, 991, 992	XXXI, XXXI	Morimura, Yasumasa, Self-Portrait
Mathur, B. P., Gandhi Bhavan, Punjab	Mies van der Rohe, Ludwig, 1059	(Actress)/White Marilyn, 1139, 1140
University, India, 799, 799	German Pavilion, International Exposition,	Morisot, Berthe, 979, 988
Matisse, Henri	Barcelona, 1060, 1060	Summer's Day, 989, 989
Bonheur de Vivre (The Joy of Life), Le,	Seagram Building, New York City, 1114, 1114	Morisot, Edma, 988
1024–1025 <i>, 1024</i>	Migrant Mother, Nipomo, California (Lange),	Morley, Elizabeth, 918
Serpentine, La, 1031, 1031	1071, 1071	Morris, William, <i>Peacock and Dragon</i> curtain,
Woman with the Hat, 1023, 1024 Matsushima screens (Sotatsu), 826, 827, 827	Milan Santa Maria della Gragia manastary	977, 978
Matsushima screens (Sotatsu), 826–827, <i>827</i> Matte, 752, 854	Milan, Santa Maria delle Grazie monastery, 648, 648	Mortise-and-tenon joint, 809
Mausoleum. See Tombs	Millais, John Everett, 977	Moser, Mary, 910 Moses (Michelangelo), 660, 660
Maya, 839	Miller, Tim, 1142	Mosques, 792
Mazarin, Cardinal, 739	Millet, Jean-François, 972	Mossi dolls (biiga), Burkina Faso, 880, 880
Mbis (spirit poles), Asmat, Irian Jaya, 863,	Gleaners, The, 973, 973	Mother Goddess, Coatlicue, Aztec, 842, 842
864, 865	Mill Run, Pennsylvania, Fallingwater,	Motif, 658, 665, 893
McEvilley, Thomas, 1086	Kaufmann House (Wright), 1077, 1077	Mott, Lucretia, 943
Medici, Catherine de, 710	Mimis and Kangaroo, prehistoric cave art,	Moulin de la Galette (Renoir), 985–986, 986
Medici, Cosimo de' (the Elder), 610, 614, 616	Australia, 861, 861	Mountains and Sea (Frankenthaler), 1095, 1097
Medici, Giovanni de Bicci de', 615	Minamoto Yoritomo, 819	Mountains at Collioure (Derain), 1023, 1023
Medici, Giuliano de', 660, 661 Medici, Lorenzo de' (the Magnificent), 618, 655,	Minarets, 792	Mount Fuji teabowl (Koetsu), 826, 826
660, 661	Ming dynasty, 807–813 Minimalism, 1106–1107, <i>1107</i>	Mount Vernon (Rawlins), Virginia, 935, 935 Mrs Freake and Baby Mary (anonymous),
Medici, Marie de', 739, 760–761	Miraculous Draft of Fish (Witz), 608, 609	784, 785
Medici family, 639, 660	Miraculous Draft of Fishes (Raphael), 654–655, 654	Mughal period, India, 792–794
Medici-Riccardi palace, 616-617, 616	Miró, Joan, <i>Dutch Interior I</i> , 1064–1065, <i>1064</i>	Mukhina, Vera, Worker and Collective Farm
Medici Venus, statue, xxxiv, xxxiv	Mission style, 1075	Woman, 1051, 1052
Mediterranean (Maillol), 1031, 1031	Mitchell, Joan, 1095	Multiculturalism, 1144-1146, 1145,
Medium, xxv	Moai ancestor figures, Easter Island, 858-859,	1146, 1147
architecture, xxvi	895, 866–867	Munch, Edvard, Scream, The, 1001, 1001
ephemeral arts, xxvi	Mobiles, 1075	Murals
graphic arts, xxvi	Modern, use of term, 1021	Mexican interwar years, 1078–1079, 1078
painting, xxvi photography, xxvi	Modernism	multicultural, 1144–1145, 1145
sculpture, xxvi	Abstraction, xxxii, 881, 993, 1021, 1074–1075, <i>1075</i>	Muromachi (Ashikaga) period, 818–822 Murray, Elizabeth, <i>Chaotic Lip</i> , 1135, <i>1135</i>
Meeting, The (Fragonard), 906–907, 907	American, 1042–1046, <i>1045, 1046</i>	Murrillo, Bartolomé Esteban, 754
Meetinghouse (Rukupo), Maori, 870–871, 870	Art Nouveau, 1003–1005, 1004, 1005,	Esquilache Immaculate Conception, 755, 755
Meiji period, 833	1021–1022, 1021, 1022	Museum of Modern Art, New York City
Melanesia, 862–863, 863	Bauhaus art in Germany, 1057, 1057, 1058,	"Art of Assemblage" exhibition, 1099–1101
Melencolia I (Dürer), 679-680, 679	1059–1060, <i>1060</i>	"Deconstructivist Architecture" exhibition,
Melun Diptych (Fouquet), 608	Canadian, 1079-1081, 1080, 1081	1119-1121, 1119, 1120, 1121
Memento mori, 904	Cubism, 1021, 1032-1042, 1032-1042	"New American Painting" exhibition, 1095
Memling, Hans	Dadaism, 1021, 1060-1062, 1060, 1061, 1062	"Responsive Eye" survey, 1106
Martyrdom of Saint Ursula, 600–601, 601	Der Blaue Reiter, 1027–1029, 1029,	opening of, 1021
Saint Ursula reliquary, 600, 601	1030, 1031	Museums, art, 1021
Mende masks, Sierra Leone, 882, 882	Die Brücke, 1025–1026, 1025, 1026	Music, Chinese zither (qin), 829
Mendieta, Ana, 1127	early, 1021	Mussolini, Benito, 1020
Untitled work from the Tree of Life series,	European, 1046–1049	Muybridge, Eadweard, <i>Sally Gardner Running</i> , 1011
1128, 1129 Managa Anton Banhard Barnassus 013, 013	expressionism, 1026–1027, 1026–1027	Mystic Nativity (Botticelli), 641–642, 641
Mengs, Anton Raphael, <i>Parnassus</i> , 912–913, 912	Fauvism, 1021, 1023–1025, <i>1023, 1024</i> Mexican, 1078–1079, <i>1078, 1079, 1080</i>	
Mensa, 590	Nazi suppression of, 1059	NI
Merian, Maria Sibylla, Wonderful Transformation	persistence of, 1135–1136, 1135, 1136	N
of Caterpillars and (Their) Singular Plant	primitivism, 1025	Nadar (Gaspard-Félix Tournachon), Portrait of
Nourishment, 778, 778	Rationalism, 1051–1053, 1052, 1053	Charles Baudelaire, 967, 967
<i>Mérode Altarpiece (Triptych of the Annunication)</i>	sculpture, 1066–1067, 1066, 1067	Namuth, Hans, Photograph of Jackson Pollock
(Campin), 581, 591–592, 591	sculpture and early, 1031-1032, 1031, 1032	painting, 1090
Mesoamerica	Surrealism, 1021, 1062, 1064-1066,	Nanga school painting, 828-830, 829
See also Mexico; Native American art	1064, 1065	Nankani compound, Ghana, 879, 879

Central Park, New York City (Olmsted and Open Door (Talbot), 965-966, 965 Nan Madol, 865-866, 866 Nanni di Banco, Four Crowned Martyrs, Vaux), 1017, 1017 Opéra, (Garnier), Paris, 969-970, 969, 970 Empire State Building, 1049, 1049 Orsanmichele church, 622, 623 Oppenheim, Meret, Object (Le Déjeuner en Napoleon, 954 Guggenheim Museum, Solomon R. (Wright), fourrure) (Luncheon in Fur), 1065-1066, 1065 Orgaz family, 705
Orsanmichele church, 622, 623
Orthogonals, 583
O'Sullivan, Timothy H., Ancient Ruins in the
Cañon de Chelley, Arizona, 1008–1009, 1008 New York City, xlii–xliii, xliii
Rockerfeller Center, 1077, 1078
Seagram Building (Mies van der Rohe and Johnson), New York City, 1114, 1114
skycrapers, 1016, 1046, 1049, 1047 Napoleon III, 969, 980 Napoleon Crossing the Saint-Bernard (David), 944–945, 944 Napoleon in the Plague House at Jaffa (Gros), 945, 945 Nara period, 819 Trans World Airlines Terminal (Saarinen), Ouattara, 894 John F. Kennedy Airport, 1115, 1115 Trinity Church (Upjohn), 964, 964 Woolworth Building, New York City, National Endowment for the Arts (NEA), 1142 Nok Culture, 893, 893 Our Lady of Guadalupe (Salcedo), 757, 757 Outbreak, The (Kollwitz), 1026, 1026 Native American art
Aztecs, 755, 836–837, 837, 839–842
Catlin's Indian Gallery, 959
contemporary, 856–857, 857 Ovoid, 850 World Trade Center (Libeskind), computer-Oxbow, The (Cole), 960, 960 generated design, 1120–1121, 1121 New York School, 815, 872, 1087–1095, 1088–1097 New Zealand, 868–871, 868, 869, 870 Eastern Woodland and the Great Plains, Ozenfant, Amédée, 1054 845-848, 846-848 European conquest of, 755–756 Incas, 755, 842–845, *843, 844* Kwakwaka'wakw (Kwakiutl), 849, 850–851, P Ngombe culture, Chair, 878, 878 Pachacuti, 844 852, 852, 853 Niagara (Church), 1007, 1007 Pacific cultures and art Navajo, 851, 855-856, 856 Niches, 686 Australia, 861–862, 861, 862 Easter Island, 858–859, 895, 866–867 Hawaiian Islands, 867–868, 867, 868 Irian Jaya, 863, 864, 865 Marquesas Islands, 867, 867 Niépce, Joseph-Nicéphore, 964 Nietzsche, Friedrich, 1093 Northwest Coast, 848-851, 849-853 Pueblos, 851, 854–855, 854 Southwest, 851, 854–856, 854, 855, 856 Spanish art, influence of, 755–658, 756, Nigeria Ekpo mask, Anang Ibibio, 890, 890 Ijo ancestral screens, 891–892, 892 757, 758 Melanesia, 862-863, 863 Nativity with Shepherd (Ghirlandaio), 636, 638 Nigeria, Yoruba culture, 877 Nativity with Shepherd (Ghirlandaio), 636, 6.
Naturalism, xxx, 579, 721–722, 958–959
French, 971–973, 972, 973
Nauman, Bruce, Self-Portrait as a Fountain,
1109, 1109
Navajo, 851, 855–856, 856
Navajo Night Chant, 855
Nave, 615, 663, 722
Nazis, 1020, 1059
Neel, Alice, Linda Nochlin and Daisy,
1124–1125, 1124
Neoclassicism, 899
in America, 934–939, 960–962, 961, 962, Micronesia, 865-866, 866 dance staff depicting Eshu, 886, 886 offering bowl, xxxvi–xxxvii, xxxvii Olowe of Ise, door of palace, 888, 889 twin figures (ere ibeji), 880–881, 880 New Ireland, 865, 865, 865 New Zealand, 868–871, 868, 869, 870 Papua New Guinea, 863, 864 peopling of, 860-861 Nighthawks (Hopper), 1071, 107. Polynesia, 866 Nighthawks (Hoppet), 1071, 1071 Nightmare, The, (Fuseli), 925, 925 Nishiki-e, 831 Ni Zan, 805–806 Rongxi Studio, 805, 805 Nobunaga, Oda, 822 recent art in Oceania, 871–872 timeline, 860–961 Padua, Italy, frescoes, Scrovegni (Arena) Chapel, 579, 580, 581 Paik, Nam June, Electronic Superhighway: Nochlin, Linda, 1124 Continental U.S., 1149, 1149 Nocturne: Blue and Gold—Old Battersea Bridge, (Whistler), 988, 988 Nocturnes, 979 in America, 934–939, 960–962, 961, 962, 1005–1007, 1006, 1007 Painterly, 989 Painting
See also Murals; Portraiture architecture, American, 934-936, 935, 936, architecture, American, 934–936, 935, 936, 962, 962
architecture, English, 917, 917
architecture, French, 927–929, 927, 928
architecture, German, 962–963, 963
in England, 917–926
in France, 927–934
in the nineteenth century, 943
painting, American, 936–939, 937, 938
painting, English, 919–926, 920–926
painting, French, 929–934, 929–933
in Rome, 912–913, 912, 913
sculpture, American, 960–961, 961, 1005–1007, 1006, 1007
sculpture, French, 929–930, 934, 930, 934
Neo-Conceptualism, 1132–1134, 1133, 1134
Neo-Confucianism, 826 Nok culture, 877 Nok Culture (Ouattara), 893, 893 Abstract Expressionism, 815, 872, 1087–1095, 1088–1097 Noli Me Tangere (Fontana), 697, 697 Nonrepresentational art, xxxiii, 1021 Abstraction, xxxii, 881, 993, 1021, 1074-1075, 1075 North America See also America map of, in Baroque period, 720 Action (gesturalism), 872, 1090–1093, *1090, 1091, 1092* American early, 784, 785 American early, 784, 785

American landscape, 959–960, 960, 961, 1007–1008, 1007, 1008

American naturalism, 958–959, 959

American Neoclassicism, 936–939, 937, 938

American religious, 1014, 1014, 1015

American Scene, 1068, 1070, 1070 map of, in Enlightenment, 898 map of, in the twentieth century, 1020 North American art. See American art; Native American art Northwest Coast Native Americans, 848-851, Nouveaux Réalistes (New Realists), 1099 on canvas, 669 Chinese, Ming dynasty, 807–808, 807, 808
Chinese, Qing dynasty, 813–814, 814
Chinese, Yuan dynasty, 804–806, 804–805
color field, 1093–1094, 1093, 1094 Numumusow (potters), 895 Nymphs and a Satyr (Bouguereau), 971, 971 Neo-Confucianism, 826 Neo-Expressionism, 1129-1132, 1130, 1131, 1132 O Neo-Impressionism, 995 Neoplasticism, 1021 Neoplatonists, 610 Cubism, 1021, 1032-1042, 1032-1042 Der Blaue Reiter, 1027-1029, 1029, Oath of the Horatii (David), 932, 932 Obelisk, 722 1030, 1031 Neri, Filippo, 735 Neshat, Shirin, 1150 Die Brücke, 1025-1026, 1025, 1026 Object (Le Déjeuner en fourrure) (Luncheon in Dutch Baroque portrait painting, 764-778, Fur) (Oppenheim), 1065-1066, 1065 Oculus, 612, 782 Odalisque, 946 Odundo, Magdalene, Asymmetrical Angled Piece, 894, 894 Fervor, 1151, 1151 Netherlands English late nineteenth century, 977, 977, Baroque painting, 764–778
Rationalism in, 1051–1053, 1052, 1053
Renaissance painting, 707–712, 708–712
Schröder House (Rietveld), 1053, 1053
Neumann, Johann Balthasar 978, 979, 979 English Neoclassicism, 919-926, 920-926 English Neoclassicish, 919–926, 920–92 English Renaissance, 713–715, 713, 714 expressionism, 1026–1027, 1026–1027 Fauvism, 1021, 1023–1025, 1023, 1024 Flemish Baroque, 743–746, 743–746 French Baroque, 743–746, 743–746 Officers of the Haarlem Militia Company of Saint Adrian (Hals), 765, 765 Ofili, Chris, Holy Virgin Mary, 1142, 1142 Oh Jeff...I Love You, Too...But..., (Lichtenstein), Church of the Vierzehnheiligen, 901, 901, 902 Kaisersaal (Imperial Hall), Residenz, Germany, 900–901, 900, 901 1103, 1103 O'Keeffe, Georgia, 1067 City Night, 1068, 1068 Red Canna, xxxii-xxxiii, xxxii French naturalism, 971-973, 972, 973 Nevelson, Louise, 1094 French Neoclassicism, 929-934, 929-933, Sky Cathedral, 1095, 1096 1054, 1054, 1055 Sky Cathedral, 1095, 1096
New Ireland, 865, 865
Newman, Barnett, 1093
Vir Heroicus Sublimis, 1094, 1094
New Negro movement, 1072
New Shelton Wet/Dry Triple Decker (Koons), 1133–1134, 1133
Newton, Isaac, 928
New Town Hall (Rossi), Borgoricco, Italy, 1117–1118, 1117 French Realism, 973–974, 974, 975 French Renaissance, 702, 702 French Rococo, 902, 903, 904, 905, 906–907, 907 Okyo, Maruyama, 830-831 Oldenburg, Claes, Lipstick (Ascending) on Caterpillar Tracks, 1104-1105, 1104 Olmsted, Frederick Law Central Park, New York City, 1017, 1017 World's Columbian Exposition, Chicago, 1015 French romanticism, 946-952, 948-952 fresco, 629–636, 630–638 genre, 775–777, 960, 961 Olowe of Ise, door of palace, Yoruba, Nigeria, German expressionism, 1026-1027, 888, 889 1117-1118, 1117 Olympia (Manet), 981-982, 981 1026-1027 One and Three Chairs (Kosuth), 1109, 1109
One Hundred Views of Edo: Bamboo Yards,
Kyobashi Bridge (Hiroshige), 988, 988
One-point perspective, 577, 582, 583, 648 German landscape, 681–682, 683 German Realism, 975, 976 German Renaissance, 675–678, 676, 677 New York City See also Museum of Modern Art AT&T Corporate Headquarters (Johnson and Burgee), 1117, 1117 Harlem Renaissance, 1072-1074, 1073, 1074 Brooklyn Bridge (Roebling), 968, 968 Op Art, 1106, 1106 history, 899, 922-924, 923, 924

Painting (cont.)	Departure of the Volunteers of 1792 (The	Civil War, 1009, 1009
Impressionism, 944, 979–989, 980–990	Marseillaise) (Rude), Arc de Triomphe,	constructed realities, 1138–1140,
Indian, Mughal, 793–794, <i>794</i> Indian, Rajput, 794, 796–799, <i>797, 798</i>	Paris, 952–953, <i>952</i> École des Beaux-Arts, 944, 969	1140, 1141 digital scanning technology, use of,
ink, 819–821, <i>820, 821</i> , 829	Eiffel Tower, Paris, 940, 941	1138–1139, 1143
International Gothic, 628–629	Louvre, palais du (Lescot), 704-705, 704	early, 964-967, 965, 966, 967
Italian Baroque canvas, 733, 734, 735–738,	Opéra, (Garnier), 969-970, 969, 970	Modernism, 1043
735–738	Panthéon, Sainte-Geneviève (Soufflot),	urban, 1011–1013, <i>1013</i>
Italian Baroque illusionistic ceiling, 730–733, 731–733	927–928, <i>927</i> Salon de la Princesse (Boffrand), Hôtel de	Photomontages, 1050
Italian Neoclassicism, 912–913, 912	Soubise, 899, 900	Dadaism, 1021, 1060–1062, <i>1060, 1061, 106</i> Photo-Secession, 1043
Italian Renaissance, 628-643, 629-635,	Parkinson, Sydney	Pia de' Tolommei, La (Rossetti), 977, 978
637-643, 648-655, 649-654, 656, 657,	as an expedition artist, 869	Piano, Renzo, Centre National d'Art et de
658-659, 658, 659, 666-671, 666-671,	Portrait of a Maori, 868–869, 868	Culture Georges Pompidou, Paris, 1118,
685–688, 687, 688, 689, 695–697, 696, 697, 697–700, 698, 699	Parks Central Park, New York City, 1017, <i>1017</i>	1118 Piazza del Campidoglio (Michelangelo),
Japanese ink, 819–821, 820, 821, 829	early designs, 1017	684, 684
Japanese Kano decorative, 823-824, 824	Parma Cathedral, Italy, Assumption of the Virgin	Piazza Navona, Rome, 726–728, 727
Japanese Maruyama-Shijo school,	(Correggio), 666, 667	Piazzas, 665, 772
830–831, <i>831</i>	Parmigianino (Francesco Mazzola), 691	Picasso, Pablo
Japanese Nanga school, 828–830, 829 Japanese Rimpa school, 826–828, 827, 828	Madonna with the Long Neck, 692, 692 Parnassus (Mengs), 912–913, 912	Analytic Cubism, 1035–1037, <i>1035,</i> <i>1036, 1037</i>
landscape, 954–958, 955–958, 959–960, 960,	Parnassus (Raphael), 651, 652	Blue Period, 1032
961, 1007–1008, 1007, 1008	Parrhasios, xxxi	Demoiselles d'Avignon, Les, 1034-1035,
literati, 804, 810–813, <i>812, 813</i>	Parson Capen House, Massachusetts, 784, 784	1034, 1035
Mannerism, 690–694, 690–694	Parterres, 741	Family of Saltimbanques, 1033, 1033
Mexican, interwar years, 1078–1079, <i>1078,</i> 1079, 1090	Passage, 1036 Pastels, 909–910	Glass and Bottle of Suze, 1037, 1037 Guernica, 1018–1019, 1019
Navajo sand, 855	Pastoral Concert, The (Giorgione and Titian),	Iberian Period, 1033–1034
New Zealand, 868, 868	669, 669, 980	Ma Jolie, 1036, 1036
oil, 592, 593, 639, 641–643, <i>639–643</i> , 669	Patrons of art	Mandolin and Clarinet, 1037, 1038
panel, 591–602 pastels, 909–910	See also under name of	Rose Period, 1033
plein air, 982–987	American government, 1069 controveries over public funding, 1142	Self-Portrait, 1032, 1032 Synthetic Cubism, 1037, 1037, 1038
Post-Impressionism, 993–998, 993–998	defined, xli	Three Women at the Spring, 1054, 1054
Precisionism, 1068, 1069	in France, 702	Pictorialism, 1011–1012
Romantic, 924–926, 925, 926	individuals as, xli–xlii, 721, 763, 778, 912	Picture plane, 592, 617, 648
Romantic landscape, 954–958, <i>955–958</i> Russian Realism, 975–976, <i>976</i>	in Italy, 610, 647–648 museums and civic bodies as, xlii–xliii	Piero della Francesca Bacci Chapel, San Francesco church, Arezzo
sand, 855, 872	in the nineteenth century, 943	635–636, <i>635</i>
Spanish Baroque, 749-755, 750-755	popes who were, 647, 682, 722	Battista Sforza and Federico da Montefeltro,
Spanish Renaissance, 705–706, 706, 707	women as, 672, 760	639, 639
Spanish Romanticism, 953–954, <i>953, 954</i> still life, 778	Pattern and Decoration movement, 1127 Paul III, pope, 647, 664, 682, 685	Pietà (Michelangelo), 655–656, 655
Symbolism, 998–1001, 999–1001	Paul V, pope, 722	<i>Pietà</i> (Titan and Giovane), 688, <i>689</i> Pietra dura, 793
tempera and oil, 639, 641-643, 639-643,	Paxton, Joseph, Crystal Palace, London,	Pietra serena, 615
666–669	968, 968	Pigalle, Jean-Baptiste, Portrait of Diderot,
Zen, 830, <i>830</i>	Peacock and Dragon curtain (Morris), 977, 978	930, 930
Palace(s) Blenheim (Vanbrugh), England, 783, <i>783</i>	Pediments, 665, 685, 723, 780 Peeters, Clara, <i>Still Life with Flowers, Goblet,</i>	Pilasters, 658, 660, 665, 723, 780 Piles, Roger de, <i>Principles of Painting</i> , 740
Ducal Palace, Urbino, Italy, 621, 621, 622	Dried Fruit, and Pretzels, 764, 764	Pine Spirit (Wu Guanzhong), 815, 815
Louvre (Lescot), Paris, 704–705, 704	Pélerinage à l'Île de Cithère, Le (Watteau),	Pinnacles, 588
Medici-Riccardi palace, Florence, 616-617, 616	902, 903	Piranesi, Giovanni Battista, Arch of Drusus,
Renaissance, 664, 664, 665, 704–705, 704	Pelham, Peter, 937 Pencil of Nature, The (Talbot), 965	911–912, 911
Residenz (Neumann), Germany, 900–901, 900, 901	Pendentive domes, 614	Pissarro, Camille, 979, 980, 984 Wooded Landscape at l'Hermitage, Pontoise,
Rucellai, Florence, 617, 617	Performance art, 1099, 1108–1110, 1109, 1110	985, 985
Versailles, 739-743, 739, 740, 741, 742	Pericles, xliii	Piss Christ (Serrano), 1142
Whitehall Palace, London, 779–780, 780,	Perry, Lilla Cabot, 983	Pity the Sorrows of a Poor Old Man (Géricault),
781, 782 Pala dynasty, 789	Persistence of Memory (Dalí), 1065, 1065	950, <i>950</i> Pizarro, Francisco, 755, 844
Palazzo del Tè, Mantua, 664, 664, 666, 666	Personal Appearance #3 (Schapiro), 1127, 1127 Perspective	Plaiting, 846
Palazzo Farnese, Rome, 664, 664, 665, 665,	aerial (atmospheric), 579, 583, 994	Plato, xxx
731–732, 731	intuitive, 583	Plein air painting, 982-987
Palazzo Medici-Riccardi, Florence, 616–617, 616	one-point (linear or mathematical), 577, 582,	Plenty's Boast (Puryear), 1136, 1136
alazzo Rucellai, Florence, 617, <i>617</i> aley, Albert, <i>Lectern</i> , 1137, <i>1137</i>	583, 648 Peru	Plowing in the Nivernais: The Dressing of the Vines (Bonheur), 972, 973
alissy, Bernard, 704–705, 710	Cuzco (Inca), 755, 842–845, 843, 844	Pluralism, 1129
alladian style, 934	Machu Picchu (Inca), 843–844, 843	Poet on a Mountaintop (Shen Zhou), 810, 812
alladio (Andrea di Pietro della Gondola), 913,	Perugino, 651	Pohnpei, 865-866, 866
914, 934	Delivery of the Keys to Saint Peter, 636, 638	Pointed Arch, 612
San Giorgio Maggiore church, Venice, 700–701, 701	real name of, 636	Pointillism, 995
Villa Rotunda, 701–702, 701	Pesaro, Jacopo, 669 <i>Pesaro Madonna</i> (Titian), 669–670, <i>670</i>	Polke, Sigmar, 1130, 1131 Raised Chair with Geese, 1132, 1132
anel painters	Petrarch, 579	Pollaiuolo, Antonio del
first-generation, 591–597	Pheidias and the Frieze of the Parthenon, Athens	Battle of the Nudes, 611, 611
second-generation, 597–602	(Alma-Tadema), xliii, xliii	Hercules and Antaeus, 611, 627, 627
anthéon (Soufflot), Sainte-Geneviève, Paris, 927–928, <i>927</i>	Philip II, king of Spain, 680, 705, 707	Pollock, Jackson, 1088
aolozzi, Eduardo, 1102	Philip III, king of Spain, 747 Philip IV, king of Spain, 747, 752, 760	Autumn Rhythm (Number 30), 1090–1091, 1091
apacy	Philip V, King of Spain, 747, 752, 760	Male and Female, 1089, 1090
See also under name of pope	Philip the Bold, duke of Burgundy, 587	Namuth's photograph of Pollock painting,
list of popes who were patrons of the arts,	Philip the Good, duke of Burgundy, 593, 606	1090
647, 682, 722 aper Indian painting on 793	Philosophical Enquiry into the Origin of Our	Polydoros, Laccoon and His Sons, vliv, vlv, vliv
aper, Indian painting on, 793 apua New Guinea, 863, 864	Ideas of the Sublime and the Beautiful, A (Burke), 929	Polydoros, <i>Laocoön and His Sons</i> , xliv–xlv, <i>xliv</i> , <i>xlv</i> , 174–175, <i>174</i>
aris	Photography	Polynesia, 866
Bibliothèque Sanite-Geneviève (Labrouste),	American, 1008-1009, 1008, 1009,	Polyptych, 590, 596
968–969, 969	1011–1013, 1013, 1070–1072, 1071, 1072	Pompadour, Madame de, 904, 930
Centre National d'Art et de Culture Georges Pompidou (Piano and Rogers), 1118, <i>1118</i>	American postwar documentary, 1110–1111, <i>1111</i>	Pontormo, Entombment, 691, 691
	1110 1111, 1111	Pop art, 1101–1105, <i>1103, 1104</i>

Porcelain	Purism, 1021	Renaissance
Chinese, 808, 809	in France, 1053–1057, 1054–1056	artists, changing status of, 647
Sèvres, 904, 908, <i>909</i> Portals, 749	Puryear, Martin, 1135 Plenty's Boast, 1136, 1136	development and meaning of, 579–583 difference between Baroque and, 760
Porticoes, 725, 927	Putti, 636, 658, 724, 900	in England, 712–717
Portinari Altarpiece (Goes), 601–602, 601	Python Crushing an African Horseman (Barye),	in Flanders, 589–606
Portrait of a German Officer (Hartley), 1043,	953, 953	in France, 607–608, 702–705
1044, 1044 Portrait of a Lady (Mayden), 597, 598	0	in Germany, 671–680 graphic arts, 608–610
Portrait of a Lady (Weyden), 597, 598 Portrait of a Maori (Parkinson), 868–869, 868	Q	in Holy Roman Empire, 608
Portrait of a Young Man (Bronzino), 692, 693	Qingbian Mountains (Dong Qichang), 812–813,	in the Iberian peninsula, 606–607
Portrait of Charles Baudelaire (Nadar), 967, 967	813	in Italy, 610–643, 647–671
Portrait of Diderot (Pigalle), 930, 930	Qing dynasty, 813–814	luxury arts, 602–606
Portrait of Giovanni Arnolfini and His Wife, Giovanna Cenami, (Jan van Eyck), 594, 595	Qiu Ying, <i>Spring Dawn in the Han Palace</i> , 808, 808	Mannerism, 682, 690–695 manuscripts, illuminated, 584–586
Portrait of Jean-Baptiste Belley (Girodet-Trioson),	Ouillwork, 845–846	maps of Europe in, 578, 646
933, 933	Quiltwork, 871–872, 871	in the Netherlands, 707–712
Portrait of Madame Desiré Raoul-Rochette	Quoins, 665	patrons of the arts, 647–648, 672, 702
(Ingres), 946, 947 Portrait of Marie Antoinette with Her Children	ъ	printmaking, 608, 678–680 in Spain, 705–706
(Vigée-Lebrun), 930, 930	R	tapestry, 604–606, 605
Portrait of Mrs. Richard Brinsley Sheridan	Radio City Music Hall, 1077	timelines, 578–579, 646–647
(Gainsborough), 921, 921	Raft of the "Medusa," (Géricault), 947–950,	women artists, 585, 695–697
Portraiture Baroque, <i>718</i> , 719, 746, 762, <i>762</i>	948–949	Renaissance architecture early, 611–622, 613–622
Dutch Baroque, 764–778, 765–770	Raimondi, Marcantonio, 980	English, 715, 716
English Neoclassicism, 920-921, 921	Rainaldi, Carlo, 726 Rainaldi, Girolamo, 726	French, 702-706, 703, 704
Renaissance, 579–580	Raised Chair with Geese (Polke), 1132, 1132	High, 662–665, 662, 664
Rococo, 909–910, 910 Portuguese Synagogue, Amsterdam (de Witte),	Raising of the Cross (Rubens), 759–760, 760	Italian, 611–622, 613–622, 662–665, 662, 664, 682, 684–685, 684, 686, 700–702, 700, 701
772, 773	Rajput, India, 794, 796–799, 797, 798	Late, 682, 684–685, 684, 686, 700–702,
Positivism, 943	Raku, 826 Raphael, 650–651, 653–655	700, 701
Possum Tjapaltjarri, Clifford, Man's Love Story,	Cardinal Virtues under Justice, 651, 652	Spanish, 705, 705
872, 873	Disputà, 651, 652	Renaissance painting English, 713–715, 713, 714
Post-Impressionism, 993–998, 993–998 Post-Minimalism, 1108, 1108	Judgment of Paris, 980	German, 675–678, 676, 677
Postmodernism, 1113, 1129	Leo X with Cardinals Giulio de' Medici and Luigi de' Rossi, 654, 654	Italian, 648-655, 649-654, 656, 657, 658-659,
architecture, 1115-1118, 1116-1117	Miraculous Draft of Fishes, 654–655, 654	658, 659, 666–671, 666–671, 697–700,
Post-Painterly Abstraction, 1105–1106,	Parnassus, 651, 652	698, 699 Late, 685–688, 687, 688, 689, 695–697,
1105, 1106 Potpourri jar, Sèvres porcelain, 908, 909	Saint Peter's basilica, plans for, 663, 663, 664	696, 697
Pottery	School of Athens, 651, 652, 653, 653 Small Cowper Madonna, The, 651, 651	Netherlands, 707-712, 708-712
See also Ceramics	Transfiguration of Christ, 655	panel painting, 591–602
African, 893–895, 894, 895	Rationalism, 1051–1053, 1052, 1053	perspective systems, 583 Spanish, 705–706, <i>706, 707</i>
Lapita, 862–863, 863	Rauschenberg, Robert, 1130	Renaissance sculpture
Pueblo, 851, 854, <i>854</i> Wedgwood, 917, 919, <i>919</i>	Canyon, 1100, 1101 Rawlins, John, Mount Vernon, Virginia,	early, 622–628, 623–628
Poussin, Nicolas, 740, 742, 745	935, 935	German, 672–674, 673, 674, 675
Landscape with Saint John on Patmos,	Readymades, 1062, 1130	Italian, 655–656, 655, 656, 660, 660, 661, 662
746, 746	Realism	Reni, Guido, <i>Aurora</i> , 732, <i>732</i> Renoir, Pierre-Auguste, 979
Poussinistes, 740 Powers, Hiram, 1006	American post-Civil War, 1009, <i>1010</i> , 1111 constructed, 1138–1140, <i>1140, 1141</i>	Bathers, 990, 991
Greek Slave, 961–962, 961	French, 973–974, 974, 975	Moulin de la Galette, 985-986, 986
Prairie style, 1045	German, 975, 976	Repin, Ilya, <i>Bargehaulers on the Volga</i> , 976, 976 Repoussoir, 994
Prandtauer, Jakob, Benedictine Abbey of Melk,	in the nineteenth century, 943–944	Resettlement Agency (RA)/Farm Securities
Austria, 747, <i>74, 748</i> Prato, Italy	Russian, 975–976, <i>976</i> Super, 1123–1124, <i>1123, 1124</i>	Administration (FSA), 1070
architecture in, 617–618	use of term, 971	Residenz, Kaisersaal (Imperial Hall) (Neumann),
Santa Maria delle Carceri church, 618,	Realistic style, xxx, 735, 736	Germany, 900–901, 900, 901
620–621, 620 Providentian 1068, 1068	Recumbent Figure (Moore), 1066–1067, 1067	Restany, Pierre, 1099 Restoration, xliv–xlv
Precisionism, 1068, <i>1069</i> Predella, 590, 674	Red Canna (O'Keeffe), xxxii–xxxiii, xxxii Redon, Odilon, Marsh Flower, a Sad and Human	of Sistine Ceiling, 659
Pre-Raphaelite Brotherhood, 977, 979	Face, 999–1000, 999	Resurrection of Lazarus (Tanner), 1014, 1015
Prescriptions Filled (Municipal Building) (Estes),	Redwood Library (Harrison), Newport, Rhode	Retablos, 749
1123, 1123	Island, 934, 934	Return of the Hunters (Bruegel the Elder), 711–712, 712
Presentation in the Temple and Flight into Egypt (Broederlam), 588, 588	Reformation, in Germany, 680–682 Regionalists, 1068, 1070–1071	Revival Fields (Chin), 1146, 1147
Primaticcio, Francesco, Chamber of the	Register, 579	Reynolds, Joshua, 906
Duchess of Étampes, Fontainebleau,	Registration marks, 833	Fifteen Discourses to the Royal Academy, 920
France, 703, 703	Regnaudin, Thomas, 743	Lady Sarah Bunbury Sacrificing to the Graces, 921, 921
Primavera (Botticelli), 639, 640, 641	Rehearsal on Stage (Degas), 986, 987	Ribera, Jusepe de, Martyrdom of Saint
Primitivism, 1025 Princess from the Land of Porcelain (Whistler), xlii	Reid, Bill, <i>Spirit of Haida Gwaii</i> , 856, 857 Reinhard & Hofmeister, 1077, <i>1078</i>	Bartholomew, 750, 750
Principles of Art History (Wölfflin), 760	Reintegration, 846	Ribera, Pedro de, Hospicio de San Fernando,
Printing, 603, 608–609, 646	Rejlander, Oscar, 1138	749, 749
Printmaking, 608, 678–680	Two Paths of Life, 966, 966	Ribs, 612, 969 Richardson, Henry Hobson, Marshall Field
Prints, revival of, 984 Prix de Rome, 904, 906, 945	Relief. See Sculpture, relief Religious beliefs	Wholesale Store, Chicago, 1015–1016, 1016
Procession of the Relic of the True Cross before	See also under name of religion	Richardsonian Romanesque, 1015
the Church of Saint Mark (Gentile Bellini),	Aztec, 840	Richelieu, Cardinal, 739
642, 642	Reliquaries, 600, 724	Riemenschneider, Tilman, 680 Altarpiece of the Holy Blood, 672–674, 673
Protestantism, 682, 720 Proun space (Lissitzky), 1050, 1051	Rembrandt van Rijn, xl, 740 Anatomy Lesson of Dr. Nicolaes Tulp,	Rietveld, Gerrit, Schröder House, Netherlands,
Provenance, xlvii	767–768, 767	1053, <i>1053</i>
Public art, controversy over, 1140, 1141,	Captain Frans Banning Cocq Mustering His	Rigaud, Hyacinthe, Louis XIV, 718, 719, 746
1143-1146, 1144, 1145, 1146	Company (The Night Watch), 768–769, 768	Riis, Jacob, 1012 How the Other Half Lives, 1013
Pueblos, 851, 854–855, 854 Pugin, Augustus Welby Northmore, Houses of	Christ Healing the Sick, 771 Jewish Bride, 769–770, 771	Tenement Interior in Poverty Gap: An English
Parliament, London, 963–964, 963	Last Supper, The, xli, xli	Coal-Heaver's Home, 1013, 1013
Punitavati, Shiva saint, xxxv, xxxv	Self-Portrait, 769–770, 770	Rikyu, Sen no, Tai-an tearoom, Kyoto, Japan,
Pure Land Buddhism, 818–819	Three Crosses, 769, 769	824–825 <i>, 825</i>

Riley, Bridget, *Current*, 1106, *1106* Rimpa school painting, 826–828, 827, 828 Ringgold, Faith, *Tar Beach*, 1127, *1128* Roundels, 594 Saltcellar of Francis I (Cellini), 694, 695 Rousseau, Henri, *Sleeping Gypsy*, 1000, *1000* Rousseau, Jean-Jacques, 899 Samoa, 861 Samuel Adams (Copley), 896, 897, 937 Samurai, 818, 819, 826 Riopelle, Jean-Paul, Knight Watch, 1086, 1087 Rousseau, Théodore, Valley of Tiffauges, Rivera, Diego, Man, Controller of the Universe, 958, 958 San Bernardino church, 651 San Carlo alle Quattro Fontane church (Borromini), 725–726, 725, 726 Sánchez Cotán, Juan, Still Life with Quince, Cabbage, Melon, and Cucumber, 751, 751 1078–1079, 1078 Robbia, Andrea della, 614 Robbia, Luca della, *Madonna and Child with* Royal mortuary compound, Nan Madol, Pohnpei, Micronesia, 866, 866 Royal Symbols (Kakalia), 871–872, 871 Lilies, 628, 628 Rubénistes, 740 Robert, Hubert, 743 Rubens, Peter Paul, 740, 758 Sanctuary, 615 Allegory of Sight, from Allegories of the Five Senses, 763, 763 Robert Gould Shaw Memorial (Saint-Gaudens), Sande, 882 1009, 1009 Robespierre, 932–933 Robin, Pierre, Saint-Maclou church, Normandy, Sand painting, 855, 872 San Francesco church, Bacci Chapel, Arezzo, ceiling paintings at Whitehall Palace, 760, 781, 782 Henri IV Receiving the Portrait of Marie de' 635-636, 635 France, 588-589, 589 Sangallo the Younger, Antonio da, 664 Rock-cut sanctuary, Malinalco, Aztec, 841, 841 Rockefeller, John D., Jr., 1077, 1079 Rockefeller Center, New York City, 1077, 1078 Rockwell, Norman, 1071 *Medici*, 760–761, 761 house of, 759, 759 San Giorgio Maggiore church, Venice, 700-701, San Giovanni baptistry, Florence, 622, 623, 624 San Lorenzo church, Florence, 613, 615–616, 615, 660, 661, 662 San Pietro church, Rome, 662, 662, 664 Landscape with Rainbow, 761–762, 762 Raising of the Cross, 759–760, 760 Rucellai, Giovanni, 610, 617 Freedom from Want, from Saturday Evening Post, 1072, 1072 Rude, François, Departure of the Volunteers of Rocky Mountains, Lander's Peak (Bierstadt), 1792 (The Marseillaise), Arc de Triomphe, San Simeon, California, La Casa Grande 1008, 1008 Paris, 952-953, 952 (Morgan), 1075, 1076, 1077 Rococo academies, 906, 910 in France, 902–909 Rue Transonain, Le 15 Avril 1834 (Daumier), xlv–xlvi, xlv, 974 Santa' Agostino church, San Gimignano, Italy, 583. 583 Ruisdael, Jacob van, Jewish Cemetery, The, Santa Felicita church, Florence, 690-691, 690 in Germany and Austria, 900-902 773, 774 Sant'Agnese church, Rome, 726-727, 727 Grand Tour, 909–912 in Italy, 909–912 Salons, 899, 906 Rukupo, Raharuhi, Maori Meetinghouse, New Santa Maria del Carmine church, Brancacci Żealand, 870–871, 870 Chapel, Florence, 631, 631, 632, 633 Running Fence (Christo and Jeanne-Claude), 1123, 1123 Santa Maria della Vittoria church, Rome, use of term, 899 728 728 Rococo style Santa Maria delle Carceri church, Prato, Italy, Russian art architecture, 900-902, 900, 901, 902 Cubism and Futurism, 1040-1042, 1041, 1042 618, 620-621, 620 painting, Realism, 975–976, 976 utilitarian forms, 1049–1051, 1050 defined, 899 Santa Maria delle Grazie monastery, Milan, painting, French, 902, 903, 904, 905, 906–907, 907 sculpture, French, 908–909, 909 sculpture, German, 901–902, 902 Italy, 648, 648 Santa Maria Novella church, Florence, 629–631, Rusticated, 616, 665, 740 Ruysch, Rachel, *Flower Still Life*, 778, 779 Ryder, Albert Pinkham, *Jonah*, 1014, 1014 630 Sant'Andrea church, Mantua, Italy, 618, tapestry, French, 908, 908 Ryoan-ji, Kyoto, Japan, Zen dry garden, 618, 619 Rodchenko, Aleksandr, Workers' Club, 821-822, 822 Sant'Elia, Antonio, Station for Airplanes and 1050, 1050 Rodin, Auguste, Burghers of Calais, 1002, 1002 Trains, 1047-1048, 1048 Santi Giovanni e Paolo and the Monument to Bartolommeo Colleoni (Canaletto), 911, 911 San Xavier del Bac mission, Arizona, 757–758, Roebling, John Augustus, Brooklyn Bridge, New York City, 968, 968 Saar, Betye, Liberation of Aunt Jemima, 1125, Roebling, Washington Augustus, Brooklyn Bridge, New York City, 968, 968 Rogers, Richard, Centre National d'Art et de Culture Georges Pompidou, Paris, 1118, Saraband (Louis), 1105, 1105 Saarinen, Eero, Trans World Airlines Terminal, Sarcophagi, 912 Sartre, Jean-Paul, 1085 Savonarola, Girolamo, 641, 655 John F. Kennedy Airport, New York City, 1115, *1115* Sacristy, 613, 615 Romanesque, Richardsonian, 1015 Safdie, Moshe, Habitat '67, Montreal, Canada, Scenes from the Massacre at Chios, (Delacroix), Romano, Giulio, Palazzo del Tè, Mantua, 664, 664, 666, 666 1115, 1116 950, 951 Saint Anthony Enthroned between Saints Schapiro, Miriam Romanticism Dollhouse, The, 1125 Personal Appearance #3, 1127, 1127 Augustine and Jerome (Hagenauer), 674, omanticism
English painting, 924–926, 925, 926
French painting, 946–952, 948–952
French sculpture, 952–953, 952, 953
landscape painting, 954–958, 955–958
in the nineteenth century, 943 675 Schiele, Egon, Self-Portrait Nude, 1026–1027, Saint Augustine Reading Rhetoric in Rome (Gozzoli), Santa' Agostino church, San Gimignano, Italy, 583, 583 Schinkel, Karl Friedrich, Altes Museum, Berlin, Saint Christopher, woodcut, 609, 609 Sainte-Geneviève, Panthéon (Soufflot), Paris, 927–928, 927 962–963, 963
Schmidt-Rottluff, Three Nudes—Dune Picture from Nidden, 1025, 1025
Schnabel, Julian, Death of Fashion, 1129, 1130 in Spain, 953-954 Spanish painting, 953-954, 953, 954 use of term, 899 Saint Francis, 636 Rome Saint Francis in Ecstasy (Giovanni Bellini), Scholasticism, 579 See also Vatican 643, 643 Schongauer, Martin, Temptation of Saint Capitoline Hill, 682, 684 Saint-Gaudens, Augustus, Robert Gould Shaw Memorial, 1009, 1009 Saint John of the Cross, 705 St. Louis, Missouri, Wainwright Building (Sullivan), 1016–1017, 1016 Anthony, 609, 610 School of Athens (Raphael), 651, 652, 653, 653 Schröder House (Rietveld), Netherlands, Cornaro Chapel, Santa Maria della Vittoria church, 728, 728 Neoclassicism in, 912-913, 912, 913 1053, 1053 Palazzo Farnese, 664, 664, 665, 665, Schröder-Schräder, Truus, 1053 731–732, *731* Piazza del Campidoglio, 684, *684* Piazza Navona, *726–728*, *727* Saint Luke Displaying a Painting of the Virgin Science (Guercino), xxix, xxxix, 733, 735 Baroque period and, 721 Saint-Maclou church, Normandy, France, 588–589, 589 Saint Paul's Cathedral (Wren), London, 782, 782 Enlightenment and, 922 Sckell, Ludwig von, 1017 Scream, The (Munch), 1001, 1001 sack of, 647, 682 San Carlo alle Quattro Fontane church (Borromini), 725–726, 725, 726 Tempietto, San Pietro church, Rome, 662, 662, 664 Saint Peter's basilica, 663, 663, 664, 684-685, Scrovegni (Arena) Chapel, Padua, 579, 684, 722-723, 723, 724 Saint Serapion (Zurbarán), 750-751, 751 Sculpture Rondanini Pietà (Michelangelo), 688, 688 Rongxi Studio (Ni Zan), 805, 805 Roosevelt, Franklin D., 1020, 1069 Saint-Simon, comte de, 972 Saint-Teresa of Ávila, 705 Saint Teresa of Ávila in Ecstacy (Bernini), 728–729, 729 American Civil War, 1009, 1010 American Neoclassicism, 960–961, 961, 1005–1007, 1006, 1007 Aztec, 841, 841 Rope Piece (Hesse), 1108, 1108 Rosenberg, Harold, 1090 Saint Ursula reliquary (Memling), 600, 601 Saint Vincent with the Portuguese Royal Family Cubism, 1038, 1038 Easter Island, 858–859, 895, 866–867 Rosetsu, Nagasawa, Bull and Puppy, 831, 831 Rosettes, 917 from Altarpiece of Saint Vincent (Gonçalves), French Baroque, 743, 743 Rose windows, 1038 Rossetti, Dante Gabriel, *La Pia de' Tolommei*, 607, 607 Salcedo, Sebastian, Our Lady of Guadalupe, French late nineteenth century, 1002-1003, 1002, 1003 French Neoclassicism, 929–930, 934, 930, 934 French Rococo, 908–909, 909 757, 757 Sally Gardner Running (Muybridge), 1011 Salon d'Automne, 1021, 1023 Rossi, Aldo, New Town Hall, Borgoricco, Italy, 1117-1118, 1117 French Romanticism, 952–953, 952, 953 Rothko, Mark, *Brown, Blue, Brown on Blue*, 1093, 1093 Salon de la Princesse (Boffrand), Hôtel de Futurism, 1040, 1041 Soubise, Paris, 899, 900 Salon of 1787 (Martini), 906, 906 Salons, 899, 906, 944 German Renaissance, 672–674, 673, 674, 675 German Rococo, 901–902, 902 Rouen Cathedral: The Portal (in Sun) (Monet), 992-993, 992 Haida, 856, 857

Delivery of the Keys to Saint Peter (Perugino), Still, Clyfford, 1093 Sculpture (cont.) Still, Clynord, 1093 Still life, 778 Still Life with Basket of Apples (Cézanne), Italian Baroque, 722, 730, 730 Italian Neoclassicism, 913, 913 Last Judgment, 685, 687, 687, 688 Italian Renaissance, 622–628, 623–628, 655–656, 655, 656, 660, 660, 661, 662 Michelangelo work on, 656, 657, 658-659 994, 994 994, 994 Still Life with Flowers, Goblet, Dried Fruit, and Pretzels (Peeters), 764, 764 Still Life with Quince, Cabbage, Melon, and Cucumber (Sánchez Cotán), 751, 751 Site-specific sculpture, 1121–1123, 1122, 1123 Sixtus IV, pope, 636 Sixtus IV, pope, 722 Sky Cathedral (Nevelson), 1095, 1096 Skyscrapers, 1016, 1046, 1049, 1047 Sleeping Gypsy (Rousseau), 1000, 1000 Japanese, 834-835, 835 Japanese, 834–835, 835
Kuba portrait sculpture, Democratic Republic of the Congo, 887–888, 887
Mannerism, 694–695, 695
Maori wood, 869–870, 869, 870
Modernist, 1066–1067, 1066, 1067
Modernist, early, 1031–1032, 1031, 1032 Stipes, 590 Stipes, 590
Stone Breakers (Courbet), 973–974, 974
Stoss, Veit, Annunciation and Virgin of the Rosary, 674, 674
Stourhead park (Flitcroft and Hoare), Wiltshire, Sleep of Reason Produces Monsters (Goya), Modernist, early, 1031–1032, 1031, 1032
New York School, 1094–1095, 1095
primitivism, 1025
relief, high, 612
site-specific, 1121–1123, 1122, 1123
Seagram Building (Mies van der Rohe and
Johnson), New York City, 1114, 1114
Seasons, The (Kraser), 1091, 1091
Seaweed, Willie, Kwakwaka'wakw Bird Mask,
852, 853
Segal, George, Diner, The, 1096, 1097
Segmental pediments, 780
Sekisui, Ito, ceramic vessel, 834, 834 954, 954 Slip, 854, 862 Sloan, John, *Backyards, Greenwich Village*, England, 915, 915
Strand, Paul, Chair Abstract, Twin Lakes,
Connecticut, 1043, 1045
Strawberry Hill (Walpole), England, 916, 916
Street, Berlin (Kirchner), 1026, 1026, 1059 1042, 1043 Sluter, Claus, Well of Moses, 587, 587 Small Cowper Madonna, The (Raphael), 651, 651 Smibert, John, Dean George Berkeley and His Family (The Bermuda Group), 936, 937 Stringcourses, 665, 704 Suringcourses, 605, 704 Strozzi family chapel, Adoration of the Magi (Gentile da Fabriano), 628–629, 629 Studio School (Native American), 854, 856 Smith, David Cubi XIX, xxxiii, xxxiii, 1094 Hudson River Landscape, 1094, 1095 Smith, Jaune Quick-to-See, Trade (Gifts for Trading Land with White People), 856–857, Style, xxv abstract, xxv Sekisui, Ito, ceramic vessel, 834, 834 Self-Portrait (Dürer), 678, 696, 696 Self-Portrait (Dürer), 678, 678 Self-Portrait (Hemessen), 709–710, 709 Self-Portrait (Leyster), 766–767, 766 Self-Portrait (Picasso), 1032, 1032 linear, xxv Smith, Kiki, *Untitled*, 1138, 1139 moderne, 878 moderne, 878
painterly, xxv
period, xxv
regional, xxv
representational, xxv
Sublime, 929, 954
Succulent (Weston), xxxi, xxxii Smithson, Robert, *Spiral Jetty*, 1122, *1122* Smythson, Robert, Hardwick Hall, Shrewsbury, England, 715, 716

Snap the Whip (Homer), 1009, 1010

Snowstorm: Hannibal and His Army Crossing the Alps (Turner), 956, 956

Sobel, Janet, 1090 Self-Portrait (Rembrandt), 769-770, 770 Self-Portrait (Actress)/White Marilyn (Morimura), Self-Portrait (Actress)/White Marilyn (Morimura), 1139, 1140 Self-Portrait as a Fountain (Nauman), 1109, 1109 Self-Portrait as the Allegory of Painting (Gentileschi), 738, 739 Self-Portrait Nuide (Schiele), 1026–1027, 1028 Self-Portrait with an Amber Necklace (Modersohn-Becker), 1026, 1027 Self-Portrait with Two Pupils (Labille-Guiard), 931, 931 Sui dynasty, 803
Sui dynasty, 803
Suitor's Visit (Ter Borch), 777, 777
Sullivan, Louis, Wainwright Building, St. Louis,
Missouri, 1016–1017, 1016
Summer's Day (B. Morisot), 989, 989 Société Anonyme des Artistes Peintres, Sculpteurs, Graveurs, Etc., 979 Society of Jesus, 682 Song dynasty, 801, 802, 803 Sorel, Agnès, 607 Summer's Day (B. Morisot), 989, 989
Sunday Afternoon on the Island of La Grande
Jatte, A (Seurat), 996, 996
Super Realism, 1123–1124, 1123, 1124
Suprematism, 1021, 1042
Suprematist Painting (Eight Red Rectangles)
(Malevich), 1041–1042, 1042
Surrealism, 1021, 1062, 1064–1066,
1064, 1065
Surrender at Breda (Velázquez), 752–753, 753
Swaos, 749 Sotatsu, Tawaraya, Matsushima screens, 826-827, 827 931, 931 931, 931
Seraphim, 643
Serpentine, La (Matisse), 1031, 1031
Serra, Richard, 1135
Tilted Arc, 1140, 1141, 1143–1144
Serrano, Andres, Piss Christ, 1142
Sesshu, Winter Landscape, 820, 821
Seurat, Georges, 993, 995
Sunday Afternoon on the Island of La Grande
Jatte, A, 996, 996
Seven Years' War, 924
Severn River Bridge (Darby III), England,
935, 935 Soufflot, Jacques-Germain, Panthéon, Sainte-Geneviève, Paris, 927–928, 927 South America, Incas, 755, 842–845, 843, 844 Soviet Union, 1020 See also Russian art Space-spanning construction devices, xxviii Swags, 749 Baroque period in, 747–755 Civil War in, 1019 colonies in America, 755–758 Swing Landscape (Davis), 1074, 1075 Symbolism, 998–1001, 999–1001 Synthetic Cubism, 1037, 1037, 1038 Syon House (Adam), England, 917, 917 Renaissance, 705–706 Romanticism in, 953–954 Spandrels, 614, 656 Spanish art Severn River Bridge (Darby III), I 935, 935 Sévigné, Madame de, 899 Sèvres porcelain, 904, 908, 909 Sezessionstil, 1022 Sforza, Battista, 639, 639 Sforza, Ludovico, 648 Sforza family, 648 \mathbf{T} architecture, Baroque, 748, 749, 749 Tabouret (Legrain), 878, 878 architecture, Renaissance, 705, 705 Tai-an tearoom (Rikyu), Kyoto, Japan, 824-825, Art Nouveau (Modernismo), 1004, 1021–1022, 1021 painting, Baroque, 749–755, 750–755 painting, Renaissance, 705–706, 706, 707 painting, Romanticism, 953–954, 953, 954 Taj Mahal, 786–787, 787, 792, 792 Takaezu, Toshiko, *Large Form*, 1137, 1137 Sfumato, 650 Stumato, 650
Sgraffito, 616
Shakes of Wrangell, chief, 850
Shakespeare, William, 779
Shamans, 849
Shaman singers, 855, 856
Shang dynasty, 803
\$he (Hamilton), 1102–1103, 1103 Talbot, William Henry Fox Open Door, 965–966, 965
Pencil of Nature, 965
Tall Spread (Bush), 1105–1106, 1106
Tamberan houses, Abelam, Papua New Guinea, Spelt, Adriaen van der, Flower Piece with Spelt, Adriaen van der, Flower Piece With Curtain, xxxi, xxxi Spiral Jetty (Smithson), 1122, 1122 Spirit of Haida Gwaii (Reid), 856, 857 Spoleto Festival U.S.A. exhibition, South Carolina, 1147 Spring Dawn in the Han Palace (Qiu Ying), 808, 808 863, 864
Tang dynasty, 801, 803, 811
Tanner, Henry Ossawa, Resurrection of Lazarus, 1014, 1015 Sheeler, Charles, American Landscape, 1068, 1069 1068, 1069 Shen Zhou, *Poet on a Mountaintop*, 810, 812 Sherman, Cindy, *Untitled Film Still #21*, 1134–1135, 1135 Shimamoto, Shozo, *Hurling Colors*, Tantric Buddhism, 789 808, 808 Staël, Madame de, 899 Staff, Ashanti, 874, 875 Stairway (Horta), Tassel House, Brussels, 1004, 1004 Stalin, Joseph, 1020 Stanton, Elizabeth Cady, 943 Stanza della Segnatura, 651, 652, 652, 653, 653 Taos Pueblo, 851, 854
Tapa, 867
Tapestry
Beauvais, 904
Flemish, 604–606, 605 1099, 1099 Shimomura, Roger, Diary, xlvi, xlvi Shiro, Tsujimura, ceramic vessel, 834, 834 Shitao, *Landscape*, 814, 814 Shogun, 818 Shoin design, 825 French Rococo, 908, 908 Tapié, Michel, 1086 Stanza della Segnatura, 651, 652, 652, 653 Stanzy Night, The (Van Gogh), 996–997, 997 States of Mind: The Farewells (Boccioni), 1040, 1040 Station for Airplanes and Trains (Sant'Elia), 1047–1048, 1048 Steel, early use of, 1016 Steen, Jan, Drawing Lesson, The, xxxix–xl, Tapies, Michel, 1086 White with Graphism, 1087, 1088 Tar Beach (Ringgold), 1127, 1128 Target with Four Faces (Johns), 1100–1101, 1102 Shoji screens, 825 Shona, 877 Shoppers, The (Hanson), 1124, 1124 Tatami mats, 824, 825 Shoulder bag, Delaware, 846–847, 847 Shubun, 819 Shute, John, 712 Shyaam a-Mbul a-Ngwoong, 888, 888 Tatanua masks, New Ireland, 865, 865 Tatlin, Vladimir Corner Counter-Relief, 1042, 1042 Monument to the Third International, 1049–1050, 1050 Tattooing, 867, 868–869, 868 Steichen, Edward, 1043 Steiner House (Loos), Vienna, 1046–1047, 1047 Steinkamp, Jennifer, *Jimmy Carter*, 1143, 1143 Siena Cathedral baptistry, 624, 624 Sierra Leone, Mende masks, 882, 882 Signboard of Gersaint (Watteau), 902, 903, 904 Silver, Georgian, 918, 918 Sioux, 845–846, 848 Siqueiros, David Alfaro, 1078, 1090 Stella, Frank, 1106
Avicenna, 1107, 1107
Stieglitz, Alfred, 1043, 1067, 1068
Winter on Fifth Avenue, 1012, 1013 Tawney, Lenore, Black Woven Form (Fountain), 1113, 1114 Tea ceremony, 824–825, 825, 826, 826 Teerling, Levina Bening, *Elizabeth I when Princess*, 714–715, 714, Sistine Chapel, Vatican Stigmata, 643

Tempera, 592, 593	Triptych, 587, 590, 759	Vatican
Renaissance, 639, 641-643, 639-643, 669	Triumph of Bacchus and Ariadne (Carracci),	<i>Pietà</i> (Michelangelo), 655–656, 655
Tempest, The (Giorgione), 667–669, 668	731–732	Saint Peter's basilica, 663, 663, 664, 684–685
Tempietto, San Pietro church, Rome, 662,	Triumph of the Name of Jesus and the Fall of the	684, 722–723, 723, 724
662, 664	Damned (Gaulli), 733, 734	
Temples		Stanza della Segnatura, 651, 652, 652, 653
Aztec, 841, 841	Triumph of Venice (Veronese), xxxvii–xxxviii,	Vatican, Sistine Chapel
Hindu, 791–792, 791	XXXVIII	Delivery of the Keys to Saint Peter (Perugino),
	Trolley, New Orleans, (Frank), 1110, 1111	636, 638
Incas, 842–843, 843	Trompe l'oeil, 621, 730, 1136	Last Judgment, 685, 687, 687, 688
Temptation of Saint Anthony (Schongauer),	Truisms (Holzer), 1146-1147, 1148	Michelangelo work on, 656, 657, 658–659
609, 610	Trumbull, John, Death of General Warren at the	Vaults, 612
Tenebrism, 735	Battle of Bunker's Hill, June 17, 1775,	barrel, 969
Tenement Interior in Poverty Gap: An English	937–939, 938	Vaux, Calvert, Central Park, New York City,
Coal-Heaver's Home (Riis), 1013, 1013	Tunic, Inca, 844, 844	1017, 1017
Tenochtitlan, Mexico, 839-842	Turner, Joseph Mallord William	Vauxcelles, Louis, 1023
Tepees, 848, 848	Fighting "Téméraire," Tugged to Her Last Berth	Vedute, 910
Ter Borch, Gerard, Suitor's Visit, 777, 777	to Be Broken Up, 956, 957	Velarde, Pabilita, Koshares of Taos, 854-855, 855
Terrace at Sainte-Adresse (Monet), 982, 982	Snowstorm: Hannibal and His Army Crossing	Velázquez, Diego, 751
Terra-cotta, 614, 627, 908	the Alps, 956, 956	Las Meninas (The Maids of Honor), 722,
Textiles	Turrets, 704, 916	753–754, 754
Ashanti, 887, 887	Twin figures (ere ibeji), Yoruba culture, Nigeria,	Surrender at Breda, 752–753, 753
Bauhaus, 1057, 1058	880–881, <i>880</i>	
Flemish, 604, 604	Twining, 846	Water Carrier of Seville, 752, 752
Inca, 844, 844		Velderrain, Juan Bautista, 758
Thamyris from Concerning Famous Women	Two Fridas, The (Kahlo), 1079, 1079	Venice
	Two Paths of Life (Rejlander), 966, 966	architecture, 700–702, 700, 701
(Boccaccio), 585, 585,	Tympana, 589	Biennale, 1147
Theaters, Japanese kabuki, 832	Typology, 579	painting in, 697–700, 698, 699
Third-Class Carriage (Daumier), 974, 975	Tzara, Tristan, 1060	Renaissance oil painting, 642–643, 642, 643,
Third of May, 1808 (Goya), 954, 955	* *	666–669
Thirty-Six Views of Fuji, Great Wave, The,	U	Venturi, Robert
(Hokusai), 816–817, 817, 832		Complexity and Contradiction in Architecture,
Tholos, 618	Uccello, Paolo, 583	1115
Thomson, Tom, Jack Pine, 1080, 1080	Battle of San Romano, 576-577, 577	Vanna Venturi House, 1116, 1116
Thornton, William, United States Capitol,	Uelsmann, Jerry N., 1110, 1138	Venus of Urbino (Titian), 671, 671, 981
Washington, D.C., 962, 962	Untitled, 1111, 1112	Vermeer, Jan
Thousand Peaks and Myriad Ravines, A (Wang	Ukiyo-e (woodblocks), 831–833, 832, 988	View of Delft, 775, 775
Hui), 813–814, 814	Undercut, 622	Woman Holding a Balance, 776–777, 776
Three Crosses (Rembrandt), 769, 769	Unicorn Is Found at the Fountain from	Veronese (Paolo Caliari)
Three Nudes—Dune Picture from Nidden	Hunt of the Unicorn tapestry,	Feast in the House of Levi, 697–699, 698
(Schmidt-Rottluff), 1025, 1025	605–606, 605	Triumph of Venice, xxxvii–xxxviii, xxxviii
Three Women at the Spring (Picasso),		Verrocchio, Andrea del, Equestrian monument
1054, 1054	Unique Forms of Continuity in Space (Boccioni),	of Bartolommeo Colleoni, 626, 627, 648
Three Women in a Village Church (Leibl),	1040, 1041 United Nations - Rabal of the Millennium (Cu)	Versailles, palais de (Le Vau, Hardouin-
975, 976	United Nations—Babel of the Millennium (Gu),	
Throne of the Third Heaven of the Nations'	1151–1152, 1152	Mansart), 739–743, 739, 740
Millennium General Assembly (Hampton),	United States. See American art	Hall of Mirrors (Le Brun and Hardouin-
xxxvi, xxxvi	United States Capitol (Latrobe), Washington,	Mansart), 742, 742
Tiepolo, Giovanni Battista, Marriage of the	D.C., 962, 962	plan of, 741, 741
	Untitled (Judd), 1107, 1107	Victoria, queen of England, 966
Emperor Frederick and Beatrice of Burgundy, 901, 901	Untitled (Smith), 1138, 1139	Video, 1148–1151, 1149, 1150, 1151
	Untitled (Uelsmann), 1111, 1112	Vienna, Steiner House (Loos), 1046–1047, 1047
Tilted Arc (Serra), 1140, 1141, 1143–1144	Untitled (After Aleksandr Rodchenko: 11),	Vienna Secession, 1022
Tinguely, Jean, 1099	(Levine), 1134, 1134	Vierzehnheiligen church (Neumann), Germany,
Homage to New York, 1100, 1100	Untitled Film Still #21 (Sherman), 1134-1135,	901, 901, 902
Tintoretto (Jacopo Robusti), Last Supper, The,	1135	Vietnam Veterans Memorial (Lin), 1144, 1144
699–700, 699	Untitled '90 (Fujii), 834–835, 835	View of Delft (Vermeer), 775, 775
Titian (Tiziano Vecelli), 740	Untitled Plate (Voulkos), 1113, 1113	View of Toledo (El Greco), 706, 707
Isabella d'Este, 670–671, 672	Untitled (12 Horses) (Kounellis), 1082–1083,	Vigée-Lebrun, Marie-Louise-Élisabeth, Portrait of
Pastoral Concert, The, 669, 669	1083	Marie Antoinette with Her Children, 930, 930
Pesaro Madonna, 669–670, 670	Untitled work from the Tree of Life series	Vignoia (Giacomo Barozzi), 739
Pietà, 688, 689	(Mendieta), 1128, 1129	Il Gesù church, 685, 686
Venus of Urbino, 671, 671, 981	Upanishads, 790	Vijayanagar, 791
Tlingit, 849, 850, <i>850, 851</i>	Upjohn, Richard, Trinity Church, New York City,	Villa Rotunda (Palladio), 701–702, 701
Tokonoma, 824, 825	964, 964	Villa Savoye (Le Corbusier), France, 1056-1057,
Tokugawa, 826	Urban VIII, pope, 722, 723, 732, 733	1056
Toledo, Juan Bautista de, El Escorial, Madrid,	Urbino, Italy	Vimana, 792
705 <i>, 705</i>	architecture in, 617–618	Viola, Bill, Crossing, The, 1149, 1149
Tombs	Ducal Palace, 621, 621, 622	Violet Persian Set with Red Lip Wraps (Chihuly),
of Medici, Giuliano and Lorenzo de', 660, 661	Ursula, saint, 600–601	xxxix, xxxix
royal mortuary compound, Nan Madol,	Utamaro, Kitagawa, <i>Woman at the Height of Her</i>	Violin and Palette (Braque), 1036, 1036
Pohnpei, Micronesia, 866, 866	Beauty, xxxv, xxxv	Virgin and Child Enthroned with Saints Francis.
Taj Mahal, 786–787, 787, 792, 792	Deddiy, ARRV, NORV	John the Baptist, Job, Dominic, Sebastian,
Tonga, 861	T 7	and Louis of Toulouse (Giovanni Bellini),
Totem poles, 850, 856	\mathbf{V}	642-643, 643
Toulouse-Lautrec, Henri de, 951, 984, 1004	V-II	Virgin and Saint Anne with the Christ Child and the
	Valley of Tiffauges (Rousseau), 958, 958	Young John the Baptist (Leonardo), 648, 650
Jane Avril, 1005, 1005	Value, 965, 1106	
Tracery, 588, 916	Vanbrugh, John, 782	Vir Heroicus Sublimis (Newman), 1094, 1094
Trade (Gifts for Trading Land with White People)	Blenheim Palace, England, 783, 783	Vitra Fire Station (Hadid), Germany, 1119, 1119
(Smith), 856–857, 857	VanDerZee, James, 1072	Vitruvian Man (Leonardo), 651, 651
Transfiguration of Christ (Raphael), 655	Couple Wearing Raccoon Coats with a Cadillac, Taken on West 127 th Street, Harlem, New	Vitruvius, 651, 739
Transept, 615, 663	Taken on West 127 th Street, Harlem, New	Vlaminck, Maurice de, 1023
Trans World Airlines Terminal (Saarinen), John	York, 1073, 1073	Volutes, 621, 662, 686, 749, 900
F. Kennedy Airport, New York City,	Van Doesburg, Theo, 1051	Voulkos, Peter, 1111
1115, 1115	Van Dyck, Anthony, 740	Untitled Plate, 1113, 1113
Travertine, 727	Charles I at the Hunt, 762, 762	
Très Riches Heures (Limbourg brothers), 584,	Van Gogh, Vincent, 993	\mathbf{W}
586, 586	Starry Night, The, 996–997, 997	YY
Tribute Money (Masaccio), 632, 633	Vanishing point, 624	Wainwright Building (Cullings) Ct. I
Trinity Church (Upjohn), New York City,	Vanitas, 777, 904	Wainwright Building (Sullivan), St. Louis,
964, 964	Vanna Venturi House (Venturi), 1116, 1116	Missouri, 1016–1017, 1016
Trinity with the Virgin, Saint John the Evangelist,		Wall, Jeff, 1139
and Donors (Masaccio), 629–631, 630	Vasas Wedgwood 917, 919, 949	After "Invisible Man" by Ralph Ellison, the
and Donors (Masaccio), 027-031, 030	Vases, Wedgwood, 917, 919, 919	Preface, 1140, 1141

Wall hanging (Albers), 1057, 1058 Walpole, Horace, Strawberry Hill, England, 916, 916 Waltz, The (Claudel), 1003, 1003 Wampum strings and belts, 845 Wanderer Above a Sea of Mist (Friedrich), 955-956, 955 Wanderers, 976 Wang Hui, *Thousand Peaks and Myriad Ravines*, A, 813–814, 814 War club, Marquesas Islands, 867, 867 Warhol, Andy, *Marilyn Diptych*, 1103–1104, *1104* Warp, 846, 850, 887, 1113 Washes, 1031, 1095 Washington, D.C.
United States Capitol (Latrobe), 962, 962
Vietnam Veterans Memorial (Lin), 1144, 1144
Washington, George, 934, 935
Water Carrier of Seville (Velázquez), 752, 752 Watercolor paints, 609 Watteau, Jean-Antoine

Le Pélerinage à l'Île de Cithère, 902, 903

Signboard of Gersaint, 902, 903, 904 Wattle and daub, 783-784 Wäwilak myth, Conference of Serpents, (Gurruwiwi), 862, 862 Weaving See also Textiles Chilkat blanket, 850, 851 Navajo, 855 Webb, Philip, Chair, 978 Wedgwood, Josiah, pottery, 917, 919, 919 Weft. 887 Well of Moses (Sluter), 587, 587 West, Benjamin, 923, 937 Death of General Wolfe, 924, 924 Weston, Edward, 1130 Succulent, xxxi, xxxii Westwork, 747
We Won't Play Nature to Your Culture (Kruger),
1134, 1134 1134, 1134 Weyden, Rogier van der, 591, 594–595 Deposition, 595–596, 596 Last Judgment Altarpiece, 596–597, 597 Portrait of a Lady, 597, 598 Whirling Log Ceremony (Klab), 856, 856 Whistler, James Abbott McNeill, 984 Black Lion Wharf, 979, 979 Harmony in Blue and Gold, Peacock Room, for Frederick Leyland, xlii, xlii Nocturne: Blue and Gold—Old Battersea Bridge, 988, 988 Princess from the Land of Porcelain, xlii White, Minor, Capitol Reef, Utah, 1110, 1112 White Horse (Constable), 956, 957, 958
White with Graphism (Tapies), 1087, 1088 Wildom, Donald, 1142 William of Orange, 764 Winckelmann, Johann Joachim, 912 Wings, 587
Winter Landscape (Sesshu), 820, 821
Winter on Fifth Avenue (Stieglitz), 1012, 1013
Wittgenstein, Ludwig, 1109
Witz, Konrad, Miraculous Draft of Fish, 608, 609 Wolfe, James, 924 Wölfflin, Heinrich, 760 Woman I, (De Kooning), 1092–1093, 1092 Woman at the Height of Her Beauty (Utamaro), XXXV, XXXV Woman Combing Her Hair II (González), 1066, 1066 Woman Holding a Balance (Vermeer), 776-777, Womanhouse, 1125 Woman in a Loge (Cassatt), 987–988, 987 Woman with the Hat (Matisse), 1023, 1024 Women academies and, 910 African American artists, 1006–1007, 1007, 1125, 1125, 1127, 1128

Baroque artists, 737–738, 738, 764, 764, 765–767, 766

feminist art, 1124–1128, 1124–1129, 1134–1135, 1134, 1135

Mende masks, Sierra Leone, 882, 882

Native American artists, 845-847, 850, 851, as patrons, 672, 760, 763 Renaissance artists, 585, 695–697 rights, 943 salons and role of, 899 voting rights, 943 in West Africa, 895 Women artists Abakanowicz, Magdalena, 1137–1138, 1138 Albers, Anni, 1057, 1058 Anguissola, Sofonisba, 695, 696, 696 Anguissola, Sofonisba, 695, 696, Arbus, Diane, 1110, 1111
Baca, Judith F., 1144–1145, 1145
Bateman, Hester, 918
Bonheur, Rosa, 972, 973
Bourgot, 585
Brandt, Marianne, 1057, 1057
Corporator, Iulia Margaret, 966, 96 Brandt, Marianne, 1057, 1057
Cameron, Julia Margaret, 966–967, 967
Carr, Emily, 1081, 1081
Carriera, Rosalba, 909–910, 910
Cassatt, Mary, 986–988, 987, 990, 991, 992
Chicago, Judy, 1125, 1126, 1126
Christine de Pizan, 585
Claudel, Camille, 1003, 1003
Delaunay-Terk, Sonia, 1039, 1039
Fontana, Lavinia, 697, 697
Frankenthaler, Helen, 1095, 1097
Gentileschi, Artemisia, 737, 738, 739 Gentileschi, Artemisia, 737, 738, 739 Gentileschi, Artemisia, 737, 738, 739 Georgian silver, 918, 918 Gérard, Marguerite, 907 Girodet-Trioson, Anne-Louis, 933, 933 Goncharova, Natalia, 1041, 1041 Hamilton, Ann, 1147–1148, 1148 Hartigan, Grace, 1095 Hesse, Eva, 1108, 1108 Hesse, Eva, 1108, 1108

Höch, Hannah, 1061, 1061

Holzer, Jenny, 1146–1147, 1148

Hosmer, Harriet, 1006, 1006

Kahlo, Frida, 1079, 1079

Kauffmann, Angelica, 910, 922–923, 923

Kollwitz, Käthe Schmidt, 1026, 1026 Kounellis, Jannis, 1082–1083, 1083 Kraser, Lee, 1089, 1091–1092, 1091 Kruger, Barbara, 1134, 1134 Lange, Dorothea, 1070-1071, 1071 Levine, Sherrie, 1130, 1134, 1134 Lewis, Edmonia, 1006–1007, 1007 Leyster, Judith, 765–767, 766 Martinez, Maria Montoya, 854, 854 Mendieta, Ana, 1127–1128, 1129 Merian, Maria Sibylla, 778, 778 Mitchell, Joan, 1095 Modersohn-Becker, Paula, 1026, 1027 Montbaston, Jeanne de, 585 Morgan, Julia, 1075, 1076, 1077 Morisot, Berthe, 979, 988 Morisot, Edma, 988 Moser, Mary, 910 Moser, Mary, 910 Mukhina, Vera, 1051, 1052 Murray, Elizabeth, 1135, 1135 Neel, Alice, 1124–1125, 1124 Neshat, Shirin, 1150–1151, 1151 Nevelson, Louise, 1094–1095, 1096 Odundo, Magdalene, 894, 894 O'Keeffe, Georgia, xxxii-xxxiii, xxxiii, O'Keeffe, Georgia, xxxii–xxxiii 1067–1068, 1068 Peeters, Clara, 764, 764 Pompadour, Madame de, 904 Riley, Bridget, 1106, 1106 Ringgold, Faith, 1127, 1128 Ruysch, Rachel, 778, 779 Saar, Betye, 1125, 1125 Schapiro, Miriam, 1125, 1127, 1127 Schapiro, Miriam, 1125, 1127, 1127
Sherman, Cindy, 1134–1135, 1135
Smith, Jaune Quick-to-See, 856–857, 857
Steinkamp, Jennifer, 1143, 1143
Takaezu, Toshiko, 1137, 1137
Tawney, Lenore, 1113, 1114
Velarde, Pabilita, 854–855, 855 Vigée-Lebrun, Marie-Louise-Élisabeth, 930, 930 Whiteread, Rachel, 1146, 1146 Women of Algiers (Delacroix), 952, 952 Wonderful Transformation of Caterpillars and (Their) Singular Plant Nourishment, (Merian), 778, 778

Wood, Grant, 1068 American Gothic, 1070, 1070 Wood, John the Elder, Circus, Bath, England, 915-916, 915 Wood, John the Younger, Circus, Bath, England, 915-916, 915 Woodblocks, 608 Japanese ukiyo-e, 831–833, *832* prints, 1041 Woodcuts, 603, 609, 612 Wooded Landscape at l'Hermitage, Pontoise (Pissarro), 985, 985 Woolworth Building (Gilbert), New York City, 1046, 1047 Worker and Collective Farm Woman (Mukhina), 1051, 1052 Workers' Club (Rodchenko), 1050, 1050 World, since 1945, 1084-1085 map of, 1084 timeline, 1084–1085 World of Art group, 1041 World's Columbian Exposition (Hunt), Chicago, 1014-1015, 1015 World Trade Center (Libeskind), computergenerated design, New York City, 1120-1121, *1121*World War I, 1020
World War II, 1020–1021 World War II, 1020–1021
Wren, Christopher, Saint Paul's Cathedral,
London, 782, 782
Wright, Frank Lloyd, 1043
Fallingwater, Kaufmann House, Mill Run,
Pennsylvania, 1077, 1077
Frederick C. Robi House, Chicago, 1045-1046, 1045, 1046 Guggenheim Museum, Solomon R., New York City, xlii–xliii, xliii Wright, Joseph, Experiment on a Bird in the Air– Pump, An, 922, 922, 924–925 Writing Chinese calligraphy, 803 Incas and method of, 842
Japanese calligraphy, 821, 821
Wrongful Execution of the Count (Bouts), 599, 599 Wu Guanzhong, *Pine Spirit*, 815, 815 Würzburg, Germany, Kaisersaal (Imperial Hall), Residenz (Neumann), 900–901, *900*, *901*

X-ray style, 861 Xuande, emperor of China, 808

\mathbf{Y}

Yayoi period, 819 Yin Hong, *Hundreds of Birds Admiring the Peacocks*, 807–808, *807* Yolngu, 861, 862 Yongle, emperor of China, 810 Yoruba, 877 dance staff depicting Eshu, 886, 886 offering bowl, xxxvi–xxxvii, xxxvii Olowe of Ise, door of palace, 888, 889 twin figures (ere ibeji), 880–881, 880 Yoshihara, Jiro, 1099 Yuan dynasty, 802, 803-806

\mathbf{Z}

Zahir-ud-Din, Muhammad, Mughal emperor, Zen Buddhism, 818–821 Zenji, Miyashita, ceramic vessel, 834, 834 Zenobia in Chains (Hosmer), 1006, 1006 Zen painting, 830, 830 Zeuxis, xxxi Zhao Mengfu, Autumn Colors on the Qiao and Hua Mountains, 804, 804-805 Zhou dynasty, 803, 811 Zhuangzi, 803, 811 Zhuangzi, 803 Zoffany, Johann, *Academicians of the Royal Academy*, 910, 910 Zurbarán, Francisco de, *Saint Serapion*, 750-751, 751

INTERNAL DOCUMENT: PEARSON EDUCATION HIGHER EDUCATION & PROFESSIONAL

SINGLE PC LICENSE AGREEMENT AND LIMITED WARRANTY

READ THIS LICENSE CAREFULLY BEFORE OPENING THIS PACKAGE. BY OPENING THIS PACKAGE, YOU ARE AGREEING TO THE TERMS AND CONDITIONS OF THIS LICENSE. IF YOU DO NOT AGREE, DO NOT OPEN THE PACKAGE. PROMPTLY RETURN THE UNOPENED PACKAGE AND ALL ACCOMPANYING ITEMS TO THE PLACE YOU OBTAINED THEM.

- 1. GRANT OF LICENSE and OWNERSHIP: The enclosed computer programs << and data>> ("Software") are licensed, not sold, to you by Pearson Education, Inc. publishing as Pearson Prentice Hall ("We" or the "Company") and in consideration of your purchase or adoption of the accompanying Company textbooks and/or other materials, and your agreement to these terms. We reserve any rights not granted to you. You own only the disk(s) but we and/or our licensors own the Software itself. This license allows you to use and display your copy of the Software on a single computer (i.e., with a single CPU) at a single location for <u>academic</u> use only, so long as you comply with the terms of this Agreement. You may make one copy for back up, or transfer your copy to another CPU, provided that the Software is usable on only one computer.
- **2. RESTRICTIONS:** You may <u>not</u> transfer or distribute the Software or documentation to anyone else. Except for backup, you may <u>not</u> copy the documentation or the Software. You may <u>not</u> network the Software or otherwise use it on more than one computer or computer terminal at the same time. You may <u>not</u> reverse engineer, disassemble, decompile, modify, adapt, translate, or create derivative works based on the Software or the Documentation. You may be held legally responsible for any copyrigh tinfringement that is caused by your failure to abide by the terms of these restrictions.
- **3. TERMINATION:** This license is effective until terminated. This license will terminate automatically without notice from the Company if you fail to comply with any provisions or limitations of this license. Upon termination, you shall destroy the Documentation and all copies of the Software. All provisions of this Agreement as to limitation and disclaimer of warranties, limitation of liability, remedies or damages, and our ownership rights shall survive termination.
- 4. LIMITED WARRANTY AND DISCLAIMER OF WARRANTY: Company warrants that for a period of 60 days from the date you purchase this SOFTWARE (or purchase or adopt the accompanying textbook), the Software, when properly installed and used in accordance with the Documentation, will operate in substantial conformity with the description of the Software set forth in the Documentation, and that for a period of 30 days the disk(s) on which the Software is delivered shall be free from defects in materials and workmanship under normal use. The Company does not warrant that the Software will meet your requirements or that the operation of the Software will be uninterrupted or error-free. Your only remedy and the Company's only obligation under these limited warranties is, at the Company's option, return of the disk for a refund of any amounts paid for it by you or replacement of the disk. THIS LIMITED WARRANTY IS THE ONLY WARRANTY PROVIDED BY THE COMPANY AND ITS LICENSORS, AND THE COMPANY AND ITS LICENSORS DISCLAIM ALL OTHER WARRANTIES, EXPRESS OR IMPLIED, INCLUDING WITHOUT LIMITATION, THE IMPLIED WARRANTIES OF MERCHANTABILITY AND FITNESS FOR A PARTICULAR PURPOSE. THE COMPANY DOES NOT WARRANT, GUARANTEE OR MAKE ANY REPRESENTATION REGARDING THE ACCURACY, RELIABILITY, CURRENTNESS, USE, OR RESULTS OF USE, OF THE SOFTWARE.
- 5. LIMITATION OF REMEDIES AND DAMAGES: IN NO EVENT, SHALL THE COMPANY OR ITS EMPLOYEES, AGENTS, LICENSORS, OR CONTRACTORS BE LIABLE FOR ANY INCIDENTAL, INDIRECT, SPECIAL, OR CONSEQUENTIAL DAMAGES ARISING OUT OF OR IN CONNECTION WITH THIS LICENSE OR THE SOFTWARE, INCLUDING FOR LOSS OF USE, LOSS OF DATA, LOSS OF INCOME OR PROFIT, OR OTHER LOSSES, SUSTAINED AS A RESULT OF INJURY TO ANY PERSON, OR LOSS OF OR DAMAGE TO PROPERTY, OR CLAIMS OF THIRD PARTIES, EVEN IF THE COMPANY OR AN AUTHORIZED REPRESENTATIVE OF THE COMPANY HAS BEEN ADVISED OF THE POSSIBILITY OF SUCH DAMAGES. IN NO EVENT SHALL THE LIABILITY OF THE COMPANY FOR DAMAGES WITH RESPECT TO THE SOFTWARE EXCEED THE AMOUNTS ACTUALLY PAID BY YOU, IF ANY, FOR THE SOFTWARE OR THE ACCOMPANYING TEXTBOOK. BECAUSE SOME JURISDICTIONS DO NOT ALLOW THE LIMITATION OF LIABILITY IN CERTAIN CIRCUMSTANCES, THE ABOVE LIMITATIONS MAY NOT ALWAYS APPLY TO YOU.
- **6. GENERAL:** THIS AGREEMENT SHALL BE CONSTRUED IN ACCORDANCE WITH THE LAWS OF THE UNITED STATES OF AMERICA AND THE STATE OF NEW YORK, APPLICABLE TO CONTRACTS MADE IN NEW YORK, EXCLUDING THE STATE'S LAWS AND POLICIES ON CONFLICTS OF LAW, AND SHALL BENEFIT THE COMPANY, ITS AFFILIATES AND ASSIGNEES. THIS AGREEMENT IS THE COMPLETE AND EXCLUSIVE STATEMENT OF THE AGREEMENT BETWEEN YOU AND THE COMPANY AND SUPERSEDES ALL PROPOSALS OR PRIOR AGREEMENTS, ORAL, OR WRITTEN, AND ANY OTHER COMMUNICATIONS BETWEEN YOU AND THE COMPANY OR ANY REPRESENTATIVE OF THE COMPANY RELATING TO THE SUBJECT MATTER OF THIS AGREEMENT. If you are a U.S. Government user, this Software is licensed with "restricted rights" as set forth in subparagraphs (a)-(d) of the Commercial Computer-Restricted Rights clause at FAR 52.227-19 or in subparagraphs (c)(1)(ii) of the Rights in Technical Data and Computer Software clause at DFARS 252.227-7013, and similar clauses, as applicable.

Should you have any questions concerning this agreement or if you wish to contact the Company for any reason, please contact in writing: Legal Department, Prentice Hall, 1 Lake Street, Upper Saddle River, NJ 07450 or call Pearson Education Product Support at 1-800-677-6337.